THE STORY OF
PAINTING

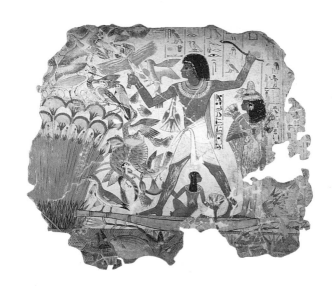

THE STORY OF PAINTING

SISTER WENDY BECKETT

Contributing Consultant PATRICIA WRIGHT

IN ASSOCIATION WITH THE NATIONAL GALLERY OF ART, WASHINGTON, D.C.

www.dk.com

A DK PUBLISHING BOOK

www.dk.com

Project editors *Janice Lacock,*
Edward Bunting, Susannah Steel
Art editors *Claire Legemah, Tassy King*
Editor *Joanna Warwick*
Assistant editor *Neil Lockley*
Senior editor *Gwen Edmonds*
Managing editor *Sean Moore*
Managing art editor *Toni Kay*
U.S. editor *Laaren Brown*
Production manager *Meryl Silbert*

All views and interpretations expressed in this book are the authors.'

Author's acknowledgments

I dedicate this book to Toby Eady. With him I would like to associate all
at Dorling Kindersley who worked so hard on it, especially Sean Moore,
who commissioned the book, and Patricia Wright, my gifted co-writer;
and Gwen Edmonds, Janice Lacock, Susannah Steel, and Edward
Bunting, who labored with such patience to get it right.

Note on painting titles

In *The Story of Painting* we have used authentic titles for paintings where they are known or,
in their absence, one that will serve as well, e.g., *Still Life with Peaches*. Where paintings have
a popular title that was obviously not given by the artist, the title appears in quotation
marks, e.g., *"The Arnolfini Marriage."* For ancient works we use a simple description,
not set in italics, e.g., Fresco with dolphins.

First American Edition, 1994
10 9
Published in the United States by
DK Publishing, Inc.,
95 Madison Avenue,
New York, New York 10016

Library of Congress Cataloging-in-Publication Data
Beckett, Wendy
 The story of painting/by Wendy Beckett and
Patricia Wright.
 — 1st American ed.
 p. cm.
Includes index.
ISBN 1–56458–615–4
1. Painting, European. 2. Painting, American.
I. Wright. Patricia, 1962– . II. Title.
ND450.B43 1994 94-6322
759—dc20 CIP

Color reproduction by GRB Editrice s.r.l.
Printed in Italy by A. Mondadori Editore, Verona

FOREWORD

Donatello, Florentine
heraldic lion, 1418–20

Mantegna, ceiling fresco in
the Gonzaga Palace, c. 1470

Art has long been a passionate concern to me, and I have often been puzzled by media questions as to why this is so, and when my interest began. It seems to me that we are all born with the potential to respond to art. Unfortunately, not all of us have the good fortune to have this potential activated, as it were. This book is my faltering attempt to offer the security of a knowledgeable background, which will help to make whatever art we see more accessible. Some people are certainly held back from a fearless gaze at painting because they fear their own ignorance. Truly to look remains one's personal responsibility, and nobody else's response (and certainly not my own) can be a substitute. But knowledge must come to us from outside, from reading, listening, and viewing. If we know that we know, we can perhaps dare to look. Love and knowledge go hand in hand. When we love, we always want to know, and this book will succeed if it starts the reader on the track that leads to more reading, greater knowledge, greater love, and, of course, greater happiness.

Pisanello, *Duke of Rimini*
(portrait medal), 1445

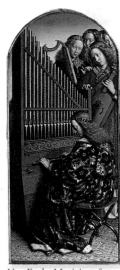

Van Eyck, *Musicians* from
the *Ghent Altarpiece*, 1432

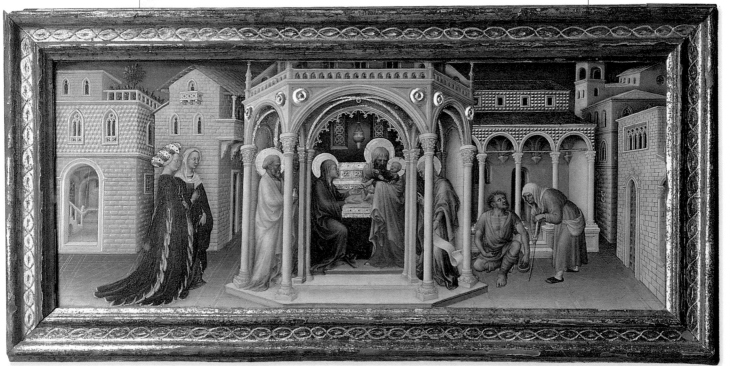

Gentile da Fabriano, *The Presentation of the Child in the Temple*, 1423

CONTENTS

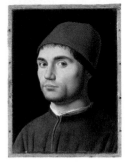

Antonello da Messina,
Portrait of a Young Man

Giotto,
Madonna and Child

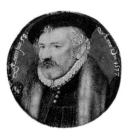

Paolo Uccello,
Study of a Chalice

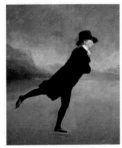

Nicholas Hilliard, *The
Artist's Father* (miniature)

Sir Henry Raeburn, *The
Rev. Robert Walker Skating*

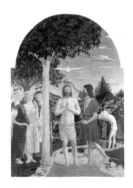

Piero della Francesca,
The Baptism of Christ

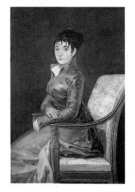

Francisco Goya,
Doña Teresa Sureda

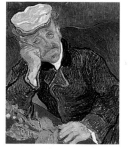

Vincent van Gogh,
Dr. Gachet

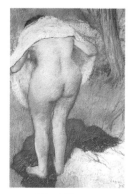

Edgar Degas,
Girl Drying Herself

THE AGE OF IMPRESSIONISM 272

POST-IMPRESSIONISM 306

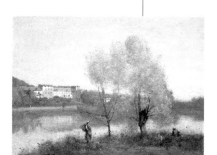

Camille Corot,
Ville d'Avray

THE 20TH CENTURY 330

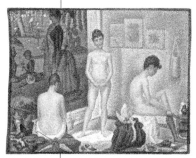

Georges Seurat,
Les Poseuses

Anton Mengs,
Portrait of Winkelmann

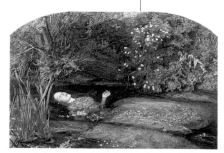

Sir John Everett Millais, *Death of Ophelia*

Ernst Ludwig Kirchner,
Berlin Street Scene

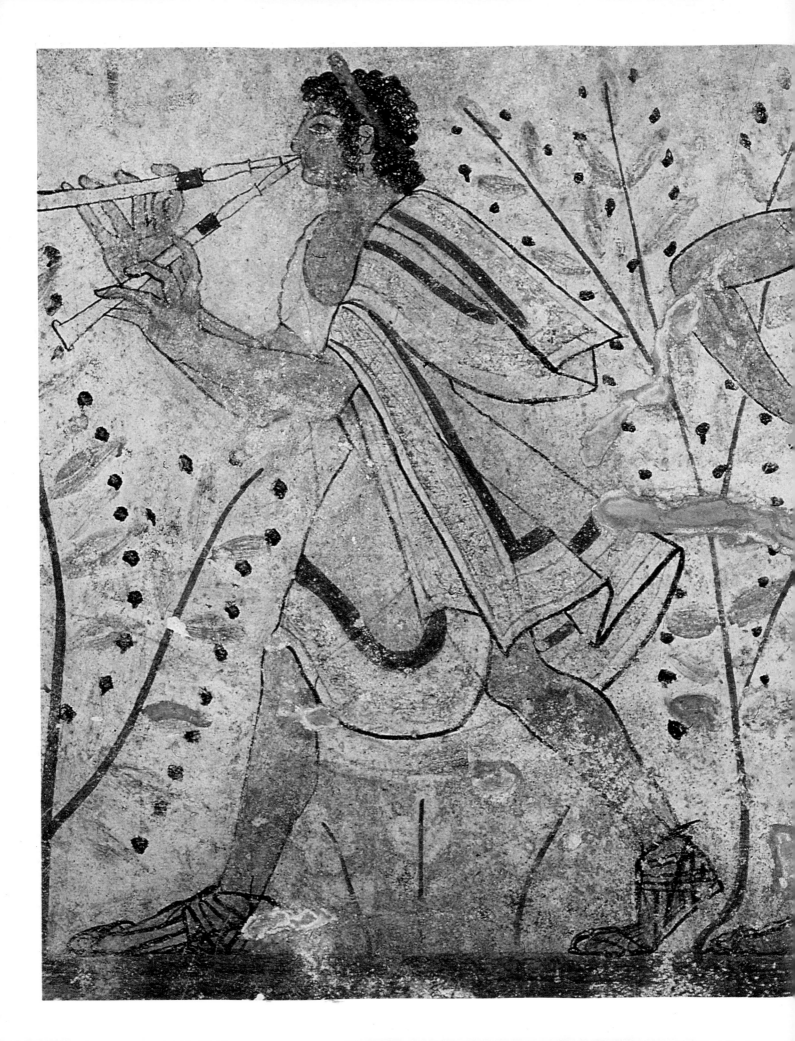

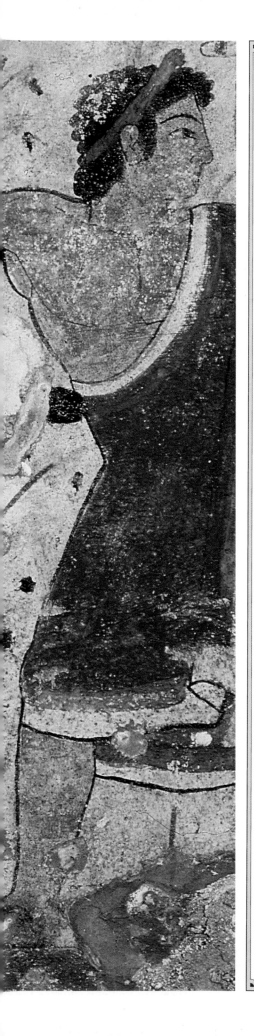

INTRODUCTION
PAINTING BEFORE GIOTTO

Our word "history" comes, by way of Latin, from the Greek word *historien*, which means "to narrate", and that word comes from another Greek word, *histor*, "a judge". History not only tells a story, but it passes judgment on it, puts it in order, and gives it meaning. The story of painting is one that is immensely rich in meaning, yet its value is all too often hidden from us by the complexities of its historians. We must forget the densities of "history" and simply surrender to the wonder of the story.

The preface to our story opens with the earliest examples of Western painting, created by our first artistic ancestors: Paleolithic man. From here to Giotto – with whom the story really begins – we pass through the ancient worlds of Egypt and Greece, the great Roman Empire, and the early Christian and Byzantine worlds, and we close with the magnificent illuminated manuscripts created by European monks during the Middle Ages.

Revelers, *from the Tomb of the Leopards, Tarquinia, Italy, c. 470 BC*

THE FIRST PAINTINGS

That art is truly our birthright can be seen from its ancient beginnings. It does not begin in history, but actually in prehistory, thousands of years ago. Our Paleolithic ancestors, living between 30,000 and 8,000 BC, were small, hairy, and unlettered, and even archaeology can say little about them with certainty. But one thing is radiantly clear, and that is that these

Stone Age cave dwellers were artists, and not only artists in that they could describe in visual terms the animals with which they came into daily contact – such art may be no more than illustration. Cave painting is much more than this: it is art in the grand manner, great art, manifested in works of subtlety and power that have never been surpassed.

The paintings on the walls of the Altamira caves were the first to be discovered in modern times, in 1879. The caves are near Santander in northern Spain. The discovery had such fundamental implications for archaeology that it was at first dismissed as a forgery. This great bison *(1)* is painted on the ceiling of a long, narrow corridor leading from a subterranean cave in Altamira. It does not stand alone. A whole herd surges majestically across the roof, one animal overlapping another – horses, boars, mammoths, and other creatures, all the desired quarry of the Stone Age huntsman. They assert a powerful animal presence, despite the confusion.

CAVE PAINTING TECHNIQUE

The caves are fully underground, and therefore permanently in darkness. Archaeologists have discovered that the artists painted with the aid of small stone lamps, filled with animal fat or marrow. The initial designs were engraved into the soft rock, or thin lines of paint were blown onto the wall through a hollow reed. To make colored paint, the artists used ochre, a natural mineral that could be crushed to a powder that would yield red, brown, and yellow pigments, while black may have been made from powdered charcoal. Powdered pigments were either rubbed onto the wall with the hands,

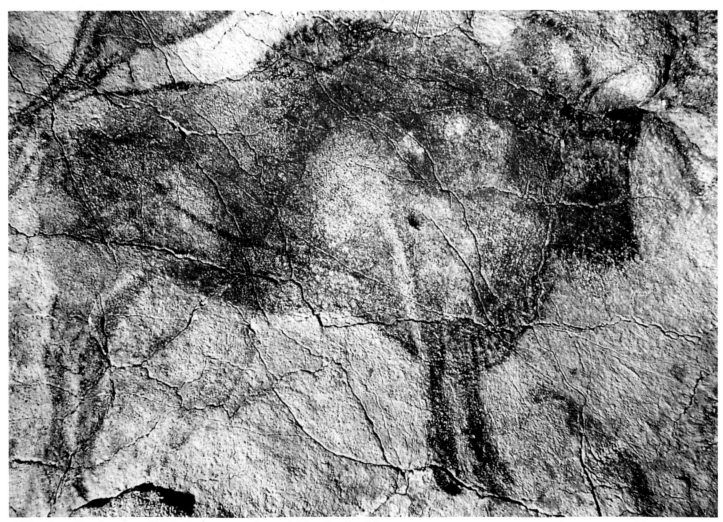

1 *Bison from Altamira cave, c. 15,000–12,000 BC, 77 in (195 cm) (bison length only)*

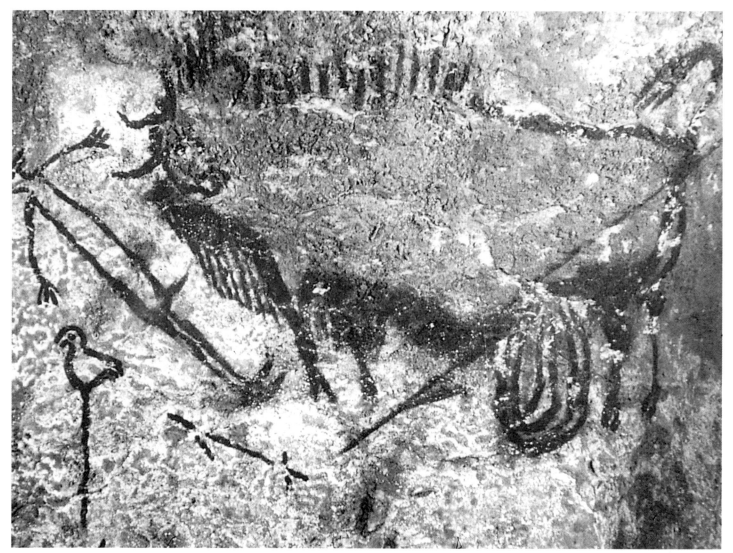

2 Wounded bison attacking a man, detail from cave painting at Lascaux, France, c. 15,000–10,000 BC, 43 in (110 cm) (bison length only)

producing very delicate gradations of tone akin to soft pastel painting, or mixed with some form of binding fluid, such as animal fat, and applied with crude reed or bristle brushes. The means were simple, yet the effect, especially in the strange silence of the cave, is overwhelming.

SIGNIFICANCE OF THE CAVE PAINTINGS

It is thought that these paintings had some deep importance to prehistoric society. The bison seems to be almost quivering with power as it displays its massive chest, dense hindquarters, and short, thin legs. It brandishes an aggressive pair of horns. Was this animal sacred to some ritual? We may never know the true significance of the cave paintings, but they almost certainly served a ritualistic, even magical function. How much the art was produced for its own sake – and this cannot be entirely ruled out – will remain a mystery.

The extraordinary naturalism and anatomical accuracy in the portrayal of animals in these paintings is believed to be connected with the purpose they served. The artists were also hunters, and their lives depended on the animals whose images they painted in the caves. Is it possible that these hunter-artists believed that by accurately depicting the

animals' power, strength, and speed, they would acquire magical power? With this they might be able to take control of the animal's spirit and remove its strength before the hunt. Many of the paintings show the animals wounded or pierced with arrows, and some examples even show evidence of actual physical attacks on the painted image.

The naturalism with which animals are painted and drawn does not extend to the portrayal of humans – perhaps for this very reason. People are rarely represented, but when they are, it is by the crudest recognizably human shape, or more often by symbolic forms, as can be seen in the image of the prostrate man in this startling painting (2), which dates from between 15,000 and 10,000 BC. It is in the most celebrated of all sites of ancient cave paintings: the Lascaux caves in the Dordogne, France. The sticklike man is lying in front of a bristling, disemboweled bison. Below him is a figure that looks as if it could be a bird, or possibly a totem or banner displaying an image of a bird. The painting has an awesome power: we have to confess our ignorance of its meaning, yet this lack of knowledge does not affect our response – unless, indeed, it deepens it. In this alone, prehistoric art is representative of all art to follow.

THE ANCIENT WORLD

Strangely enough, it is a long time before painting rises again to the quality of the cave art of Stone Age society. The Egyptians were interested mainly in architecture and sculpture, and in many of their paintings, particularly those that decorated their tombs, they gave drawing precedence over color.

Some paintings, or fragments, have been preserved from a variety of other cultures of ancient Europe: Minoan, Mycenaean, and Etruscan. Then came the civilizations of Greece and Rome. From a modern point of view, a feature common to almost all ancient painting traditions is a shortage of examples surviving today.

The Egyptians loved the terrestrial world too much to believe that its pleasures necessarily ended with death. Egyptians believed that the rich and the powerful, at least, could enjoy the pleasures of life in perpetuity, as long as the image of the deceased was reproduced on their tomb walls. Much Egyptian painting, therefore, was done for the sake of the dead. It is possible, however, that the Egyptians did not feel that great expense was required to ensure a good afterlife, and that they chose painting as a labor-saving and cost-cutting device. Instead of the expensive art of the sculptor or the stone carver, a cheaper art form – painting – was employed. It is certain, at any rate, that the ceremonial, formal painting style used for tomb walls was not the only one available. We now know that living (and wealthy) Egyptians had murals in their homes, and that these were done in richly textured, painterly styles. Unfortunately, only small fragments of these murals survive.

ANCIENT EGYPTIAN TOMB PAINTING

Perhaps one of the most impressive images from Egyptian tombs is that of the "*Geese of Medum*" *(3)*, three majestic birds from the tomb of Nefermaat (a son of Sneferu, the first pharaoh of the 4th dynasty) and his wife Itet, dating from over 2,000 years before Christ. The geese form only a detail in a pictorial frieze in a tomb at the ancient town of Medum, but already they hint at the vitality and power of the sculptural triumphs to come in the years ahead. Another Egyptian tomb painting, from the tomb of Ramose, shows a funeral procession of *Lamenting Women (4)*. Ramose was a minister under two pharaohs of the 18th dynasty, Amenhotep III and Amenhotep IV (Akhenaten). The women in the painting are flat and schematic (look at their feet), but their anguished gestures vibrate with grief.

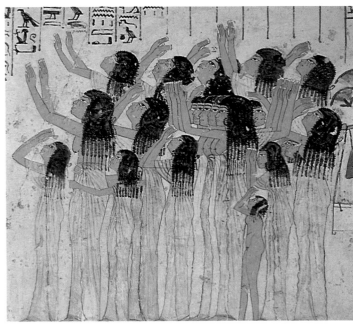

4 Lamenting Women, *wall painting from the tomb of Ramose, Thebes (Egypt), c. 1370 BC*

To the ancient Egyptians it was the "eternal essence" that mattered: what constituted their view of constant, unchanging reality. Thus their art was not concerned with the changeable variation of externals for visual appeal, and even their keen observations of nature (evidently painted from memory) were subject to rigid standardization of forms, often becoming symbols. It is not from any kind of "primitivism" that their scenes appear decidedly unreal – their technical skill and evident understanding of natural forms makes this clear enough. It is, rather, the direct consequence of the essentially

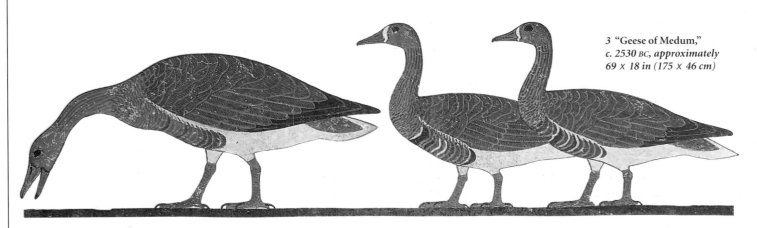

3 "Geese of Medum,"
*c. 2530 BC, approximately
69 x 18 in (175 x 46 cm)*

intellectual function of their art. Each subject was shown from whatever angle would make it most clearly identifiable, and according to a rank-based scale, large or small dependent on social hierarchy. This resulted in a highly patterned, schematic, and almost diagrammatic appearance. This over-riding concern with clarity and "thorough" representation applied to all subject matter: hence, the human head is always shown in profile, yet the eyes are always drawn from the front. For this reason, there is no perspective in Egyptian paintings – everything appears two-dimensional.

STYLE AND COMPOSITION

Most Egyptian wall paintings, as in this example, a *Fowling Scene (5)* from a nobleman's tomb in Thebes, were created with the *fresco secco* technique. In this method, tempera (see glossary, p.390) is applied to plaster that has been allowed to dry first, unlike the true *buon fresco* technique in which the

6 **Pharaoh Tuthmosis III**, *Egyptian painting on a drawing board, c. 1450 BC,* 14½ in (37 cm) high

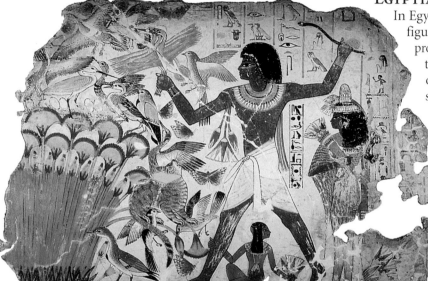

5 **Fowling Scene** *from the tomb of Nebamun, Thebes, Egypt, c. 1400 BC,* 31 in (81 cm) high

painting is made on wet plaster (see p.46). The wildlife of the papyrus marshes and Nebamun's retriever cat are shown in great detail, yet the scene is idealized. The nobleman stands in his boat, holding three birds he has just caught in his right hand, and his throwing-stick in his left. He is accompanied by his wife, who appears in an elaborate costume with a perfumed cone on her head, holding a bouquet. Between Nebamun's legs squats the small figure of his daughter, picking a lotus flower from the water (this is an example of how, as mentioned above, it was conventional for figures to be shown large or small according to their status). Originally this painting was only one part of a larger work, which also included a fishing scene.

EGYPTIAN RULES OF REPRESENTATION

In Egyptian art, representation of the full-length human figure was organized within the so-called "rule of proportion," a strict, geometric grid system that ensured the accurate repetition of the Egyptian ideal form on any scale and in any position. It was a foolproof system, regulating the exact distances between parts of the body, which was divided into 18 equal-sized units and placed in relation to fixed points on the grid. It even specified the exact width of the stride in walking figures, and the distance between the feet (which were both shown from the inside view) in standing figures. Before beginning a figure, artists would first draw a grid of the required size onto the surface, and then fit the figure within it. A surviving 18th-dynasty wooden drawing board shows the Pharaoh Tuthmosis III drawn within such a grid *(6)*.

It was not only tombs that the Egyptians decorated: they also painted sculpture. This beautiful painted limestone sculpture of the *Head of Nefertiti (7)*, who was wife of the Pharaoh Akhenaten, is thought to have been a workshop model, because it was found in the ruins of a sculptor's studio. It is as poignant as a Botticelli head (see p.94), with the same touching and exquisite wistfulness. It shows a loosening of the rigid conventions that governed earlier (and later) Egyptian art, because Akhenaten broke with the traditional style. During his reign, paintings, carvings, and sculptures that were produced were refreshingly graceful and original.

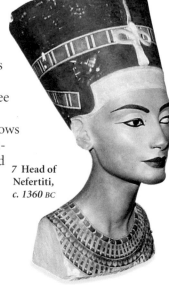

7 **Head of Nefertiti,** c. 1360 BC

AEGEAN CULTURES OF THE BRONZE AGE

The Bronze Age Minoan civilization (3000–1100 BC), named after the mythical King Minos, was the earliest to develop in Europe. Its home was the small island of Crete, in the Aegean Sea between Greece and Turkey, and its society developed roughly in parallel to that of its African neighbor, Egypt. Despite their proximity and certain shared influences, Egyptian and Minoan cultures remained very separate, though the latter was to have enormous influence on the art of ancient Greece. Crete formed the center, both culturally and geographically, of the Aegean world. Also in parallel with Minoan civilization was that of the Cyclades, an Aegean island group. Idols have been recovered from this society *(8)*, objects whose ancient, quasi-neolithic forms are reduced to the barest abstraction, but still retain the magical power of the fetish. Here we have a weird forerunner of the abstract art of our own century, in which the human body is seen in geometrical terms with an immense raw power, contained and controlled by linear force. Originally the idols had painted eyes, mouths, and other features.

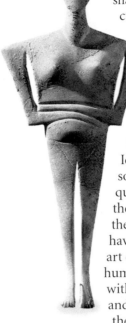

8 Female idol from Amorgos, an island in the Cyclades Archipelago (now part of Greece), c. 2000 BC

MINOAN AND MYCENAEAN ART

Minoan art is largely represented by its carvings and painted pottery, and it is not until 1500 BC, during the great "Palace period," that we see paintings at all, and generally these have only survived in fragments. Although a certain degree of Egyptian stylization is apparent in the schematic repetition of human figures, for instance, Minoan representation reveals a naturalism and suppleness largely absent in Egyptian art. The Minoans took inspiration from nature and their art exhibits an astonishing degree of realism. They were a seafaring civilization and their paintings reflected their knowledge of the oceans and of sea creatures, such as dolphins.

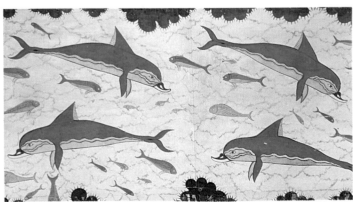

9 Fresco with dolphins, from the Palace of Knossos, Crete, c. 1500–1450 BC

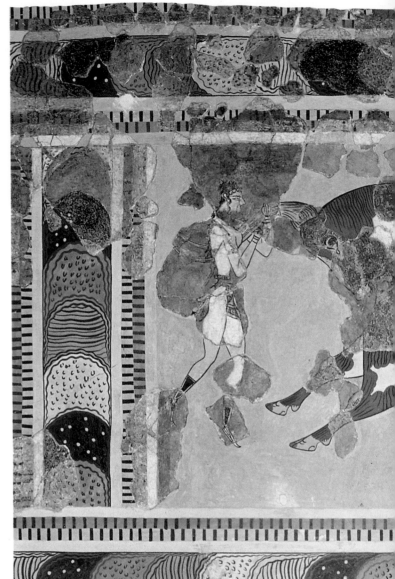

10 "Toreador Fresco" from the royal palace at Knossos, Crete (restored detail), c. 1500 BC, 31½ in (80 cm) high including borders

This lively example *(9)* is from the Palace of Knossos, which was excavated in the first two decades of the 20th century. Another recurrent Minoan theme is bull jumping, a ritual thought to be connected with Minoan religion. A second work from the royal palace of Knossos, the *Toreador Fresco* *(10)*, is one of the best-preserved Minoan paintings, although fragmentary. The fragments have been pieced together to reveal three acrobats, two girls (they are fair-skinned), and a darker-skinned man somersaulting over a magnificent bull. The usual interpretation of this picture is as a "time-lapse" sequence. The girl on the left is taking hold of the bull's horns in preparation to leap; the man is in mid-vault; the girl on the right has landed and steadies herself with arms outstretched, like a modern gymnast.

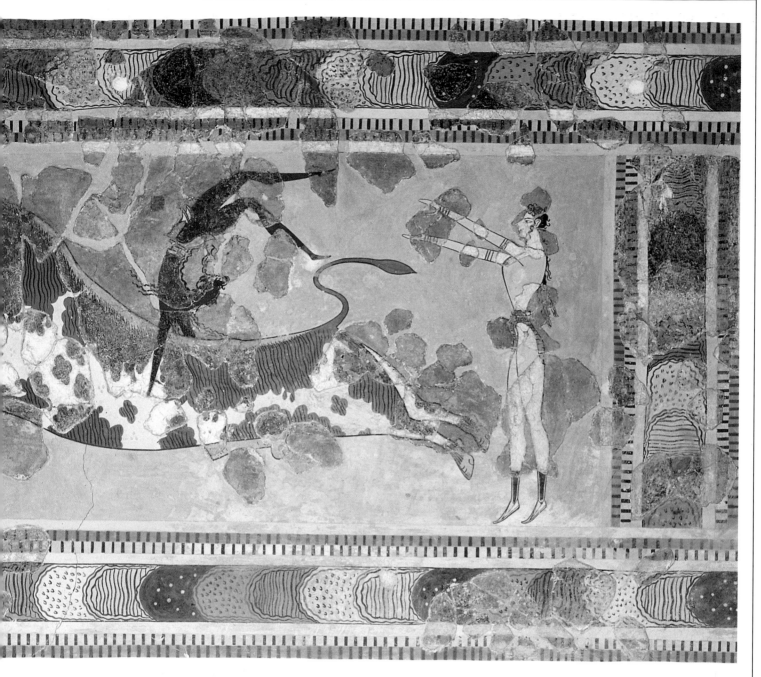

The Mycenaean civilization was a Bronze Age culture of mainland Greece. It came to succeed the ancient Minoan culture in Crete, emerging around 1400 BC to became the dominant culture on the island. Its history and legends form the background to the writings of the Greek poet Homer (c. 750 BC), whose epic poems, the *Odyssey* and the *Iliad*, reflect the "heroic age": the end of the Mycenaean period. One of the most enduring images from Mycenaean art is this funeral mask *(11)*, thought for a time to be of the Mycenaean King Agamemnon, who, in Homeric legend, was the leader of the Greeks in the Trojan Wars. All that is certain is that it is a death mask, and that it was taken from one of the royal tombs of the Mycenaean period, in the 16th century BC. Besides a certain love of gold, it reveals the immense dignity of the Mycenaean image of humankind. This highly expressive mask is a great iconic depiction of what it means to be a human being.

Fragments of Mycenaean paintings found at two sites (Tiryns and Pylos) in Greece represent what must have been impressive mural cycles. Many of the Mycenaean and Minoan murals were not frescoes in the usual sense of the word, but, like the Egyptian murals, were produced by applying tempera paint (see glossary, p.390) to plaster that had already dried. Subjects of Mycenaean murals included scenes from everyday

11 Funeral mask from the royal tombs at Mycenae, c. 1500 BC

life, as well as depictions of the natural world. Mycenean art was rather solemn in nature in comparison with Minoan art. These two traditions formed the background from which the art of the Greeks later emerged.

The Mycenaean civilization collapsed around 1100 BC. Its ending marks the end of the Bronze Age in Greece. There followed a period of around 100–150 years, known as the "Dark Age," about which less is known in Aegean culture. After that, prehistory ended, and the period of written history began. Around 650 BC, archaic Greece emerged as Europe's most advanced civilization.

GREECE'S NEW VISION

Like their Cretan predecessors, the Greeks were far less conscious of the tomb than the Egyptians. They have left us a number of bronze statuettes, which are highly esteemed. But their painting – an art on which their writers assure us they lavished great skill – is almost totally lost. One of the reasons for this is that, unlike the Egyptians, the Minoans, and the Mycenaeans, who painted only murals, the Greeks painted mainly on wooden panels that have perished over time.

The Roman scholar Pliny the Elder (AD 23/4–79), whose detailed descriptions of Greek painting and the ancient world greatly influenced successive generations, is the major source of information on Greek painting. In every other school of art, the truth of such descriptions can be judged by the painting that survives. This is not true of Greek painting, and so the value of what Pliny said can never be assessed.

Almost our only hint of the beauty of Greek painting is in the relatively minor, especially utilitarian art of vase painting. The word *vase*, first used as a broad term for ancient Greek pottery in the 18th century, can be misleading. The Greeks never made vases purely for decorative purposes, as can happen today, but always had a specific purpose in mind. Greek potters made a range of products, in a variety of shapes, such as storage jars, drinking vessels, bottles for perfume and ointment, and containers for liquids used in ceremonies.

In the Greek vase paintings we can see a concern with anatomy, and a preoccupation with the human figure, which became the central motif of Greek art and philosophy. We see a departure from what the Egyptian tomb paintings showed, with their preconceived formulas for representing the world, and a whole new way of viewing art opens up with respect to what the eye can see, and what the mind dictates.

STYLES IN GREEK VASE PAINTING

If vase painting is a minor art, then it has some major practitioners. The Athenian artist Exekias, who lived about 535 BC, signed at least two of his black-figure pots as their "painter," and his style, with its poetry and perfection of balance, is instantly recognizable. It is worth noting that he made the pottery as well as its decoration. Exekias's work is important because it reveals the direction representational art would take, signifying the leap from a "hieroglyphic" symbolic representation of objects in the world to one that attempted to show the world as it really appears. This is particularly evident in his treatment of the boat's sail in this superb kylix (a shallow, two-handled drinking cup), *Dionysos in His Boat (12)*. Dionysos, the god of wine, vegetation, and fruitfulness, lies stretched out in repose as he carries the secret of wine to humankind. His symbolic vines twirl around the mast and soar fruitfully into the sky, a wonderful adaption to the difficult circular composition of the kylix. The ship, with its gleaming sail, glides majestically over the pink and orange world of Heaven and Earth, where dolphins swim and play around the sacred presence, and the scene is alive with an amazing sense of wholeness.

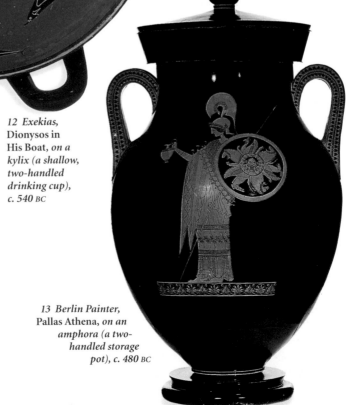

12 Exekias, Dionysos in His Boat, *on a kylix (a shallow, two-handled drinking cup), c. 540 BC*

13 Berlin Painter, Pallas Athena, *on an amphora (a two-handled storage pot), c. 480 BC*

14 Brygos Painter, "The End of the Party" on a drinking bowl, c. 490 BC

Greek vase painting is typically concerned with storytelling, and many vases carry images of incidents recounted in Homer's *Iliad* and *Odyssey*, written in the 8th century BC. Vases decorated with narratives date from times preceding Homer to the Classical Greek period, which succeeded the Archaic period around 480 BC, and indeed long beyond.

We cannot fully appreciate Greek vase painting unless we see both the image and the vase as a whole. A key figure in the *Odyssey*, Pallas Athena, the guardian deity of Athens, appears on a lidded shoulder amphora (a storage pot with two handles) by an anonymous artist whom scholars have named the Berlin Painter, around 480 BC *(13)*. The darkly gleaming, black-glazed curve of the jar makes the goddess seem to retreat from our gaze, while allowing us to glimpse her in her stately sweetness. She is shown holding out a jug of wine to Hercules, who is on the other side on the jar, both keeping their privacy inviolate, yet communicating. It is a wonderfully controlled and reverent work, both simple and complex.

The amphora is an example of the red-figure technique, invented around 530 BC, which succeeded black-figure pottery. In the red-figure technique, the "figures" were not painted; instead, the black background was painted around them, leaving the red clay color to stand for the figures, which were then painted with anatomical details. Greater naturalistic effects were possible, and the vivid scenes depicted on the vases became more and more complex and ambitious. A good example of this new development is the painting from the interior of a drinking bowl *(14)* made by the potter Brygos (the artist is known simply as the Brygos Painter). Although the subject matter – a woman holding the head of a drunken youth while he is sick – is not appealing, the figures are presented with subtlety and dignity. The woman's clothing in particular gives her a tender grace.

PORTRAYING THE HUMAN FORM

The way the Greeks represented the human body had a direct influence on the development of Roman art, and all later Western art. Since we can no longer see many Greek paintings themselves, we have to rely on Greek sculpture to trace the progress of the human nude. Early Greek statues, such as the 6th-century BC *Kouros* shown here *(15)*, were based on the grid system of the ancient Egyptians. (*Kouros* means a young man, and in the sculpture of the time it means a statue of a standing youth.) Gradually the lines softened, as shown in the 5th-century BC "*Kritios Boy*" *(16)*, named after the sculptor Kritios, in whose style it was made. Eventually we see the realistic musculature of classical 5th-century BC statues, such as the *Discus Thrower (17)*. This is a Roman copy of the original by the Greek sculptor Myron.

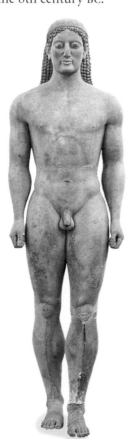

15 Kouros (statue of a standing youth), late 6th century BC

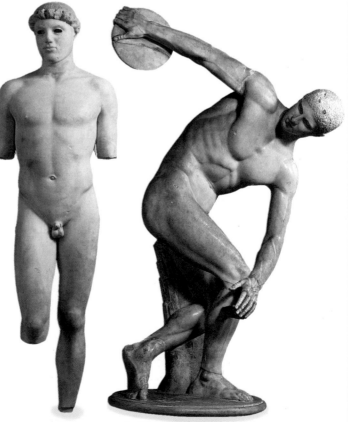

16 "Kritios Boy," c. 480 BC

17 Discus Thrower (Roman copy), original c. 450 BC

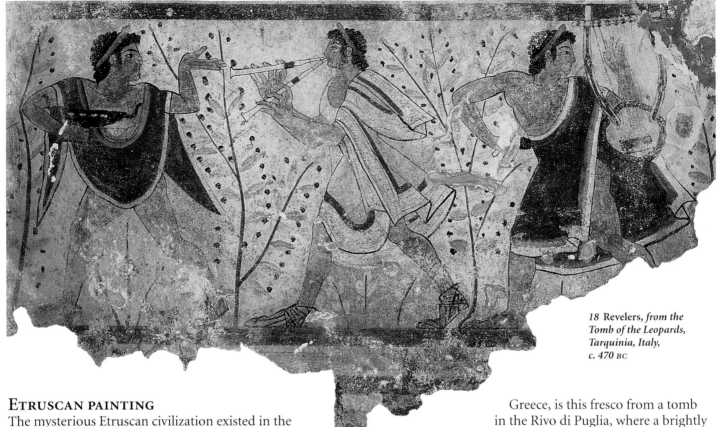

18 Revelers, *from the Tomb of the Leopards, Tarquinia, Italy, c. 470 BC*

ETRUSCAN PAINTING

The mysterious Etruscan civilization existed in the Italian peninsula at the time Greek civilization spread to southern Italy in the 8th century BC. Once thought to have come from Asia Minor, it is now more commonly believed to have originated in Italy. Its art was influenced by Greek art, but maintained a style of its own, which the Greeks valued highly. Some early Etruscan art, as typified by a wall painting from the Tomb of the Leopards at Tarquinia *(18)*, displays a joyful quality. The men, who may be dancing, carry a cup of wine, a double flute, and a lyre.

However, much of the surviving art has a slightly sinister edge to it, an awareness of the uncontrollable nature of life and all its implications. Among some impressive Etruscan tomb paintings, contemporary with the classical period in Greece, is this fresco from a tomb in the Rivo di Puglia, where a brightly colored procession of *Mourning Women (19)* advances with implacable force. They form a fascinating contrast to the mourning women in Ramose's tomb (see p.12). The Egyptian women grieve over the human loss that death brings with it, while the Etruscans mourn the remorseless and inescapable advance of fate.

PAINTING IN CLASSICAL GREECE

The most significant Greek painter of the early classical period (c. 475–450 BC) is Polygnotos, who has been credited with being the first to give life and character to the art of painting. None of his pictures survive, but Pliny left a description of his *"Discus Thrower."* The most important Greek painting surviving from the 4th century BC is *The Rape of Persephone (20)*, on the wall of a tomb in the same burial complex as that of Philip II of Macedon, who died in 356 BC. Full of the vitality and naturalism of art at that time, this haunting image shows how the Greeks explained the seasons. Persephone is the daughter of Demeter, goddess of fertility. Persephone is carried off by Hades to the underworld, from which she will emerge as the new growth of spring. The great cycle of the seasons is tapped by this painting, and the myth lives on through it.

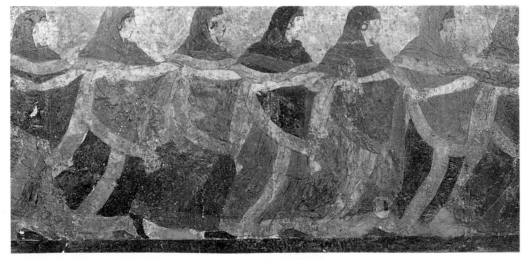

19 Mourning Women, *from a tomb at Rivo di Puglia, Italy (detail), late 5th century BC, height 22 in (55 cm)*

20 **The Rape of Persephone,** *from a tomb at Vergina, Greece, c. 340* BC

HELLENISTIC ART

By the time of his death in 323 BC, Alexander the Great (356–323 BC) had extended his Empire as far as the Middle East, conquering Greece's old enemy Persia, and also Egypt. However, the empire was then divided up among Alexander's generals, who established a series of independent states, throughout which there spread a new cosmopolitan culture, blending that of both East and West. This is known today as Hellenistic culture, and it prevailed in the Mediterranean region until well after the Roman Empire became the dominant power. Its heart was Athens but its other important centers (ruled by Greek kings and speaking Greek) were in Syria, Egypt, and Asia Minor. A Roman mosaic known as the *"Alexander Mosaic" (21),* found at the House of the Faun at Pompeii, is known to have been based on a Hellenistic painting. It depicts the Battle of Issus, fought between Alexander and the Persian King Darius III in 333 BC. The scene is violent and lively, and the artist displays sophisticated technical skills (he knows about foreshortening – see glossary, p.390) that gives the work a great immediacy of impact.

Hellenistic culture soon developed a love of "art for its own sake." The Eastern influence led to a more decorative, sumptuous art, and religious elements retired to the background. In their place were paintings of gardens (including, arguably, the first landscapes), still lifes, portraits, and everyday scenes of contemporary life. The popularity of this tendency, curiously dubbed "baroque" by historians (see p.172), is recorded by Pliny, who wrote that art could be found in barbers' and cobblers' shops, as well as palaces.

An overwhelming concern of Hellenistic artists was "truth" to reality, and they tended to depict dramatic, often violent action. They developed a style that paralleled the vivid literary tradition of the Roman poet Virgil (70–19 BC). A definitive example of the artistic philosophy of Hellenistic

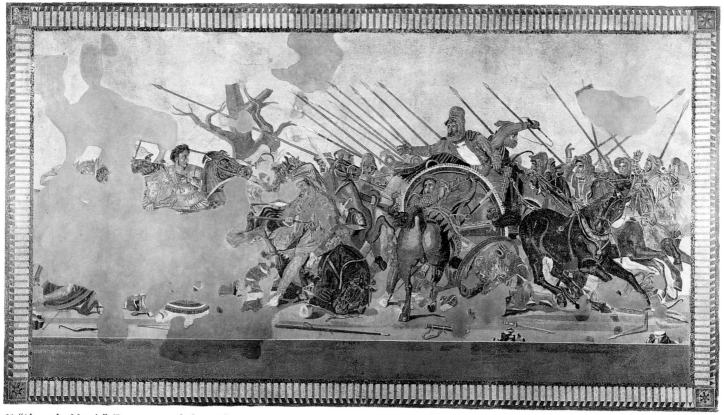

21 "Alexander Mosaic" *(Roman copy of a late Hellenistic painting), c. 80* BC

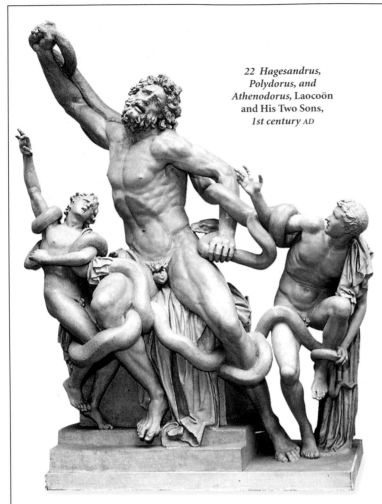

22 Hagesandrus, Polydorus, and Athenodorus, Laocoön and His Two Sons, 1st century AD

unprecedented naturalism and a relaxed, lyrical quality. These features are especially evident in this beautiful and modern-looking wall painting from the Roman town of Stabiae, *Young Girl Gathering Flowers (23)*. (Stabiae was a small resort, less well known than Pompeii or Herculaneum, that was destroyed together with these towns in the same eruption of the volcano Vesuvius in AD 79.) The young woman glides gently away from us with a poignant charm. We do not see her face, as if she were deliberately withholding from us the unearthly beauty that seems appropriately associated with the ethereal flowers she plucks. She vanishes into the mists and eludes us, leaving behind her only a suggestion of what Roman painting may have been like.

The happy accident that left us the young girl makes it even more painful to realize how much we must have lost. We can easily forget the vulnerability of painting, and how easily master works can be destroyed.

ILLUSIONISTIC WALL PAINTINGS

We also have a substantial number of examples of Roman paintings from Pompeii, but many of these are clearly works of provincial artists. Massively influenced by Greek painting (which the Romans admired as much as Greek sculpture and copied for wealthy houses), these do not necessarily reflect

art, dating from the 1st century AD, is *Laocoön and His Two Sons (22)*. This sculpture depicts a horrifying scene from Virgil's *Aeneid*, in which a Trojan priest named Laocoön and his two sons were strangled by two sea snakes. This was a punishment from the gods because Laocoön had tried to warn the Trojans about the Greeks' wooden horse. Without the warning, the Trojans were tricked, pulling the horse into their city and bringing about their own downfall. This is a sculpture, not a painting, but it does give us some hint of what Hellenistic painting must have been like. The sculpture was rediscovered in 1506 and had a strong influence on many Renaissance artists, including Michelangelo (p.116), who referred to it as "a singular miracle of art." Among those who were inspired by it was the Mannerist El Greco (see p.146), who is known to have produced three paintings featuring the Laocoön story.

PAINTINGS OF THE ROMAN EMPIRE

Hellenistic styles continued to exert strong influences on artists long past the official end of the Hellenistic period, set by historians at the Battle of Actium in 27 BC. Soon after this battle the Roman Republic, under Caesar Augustus, was transformed into an Empire and became the dominant power in the Western world for three centuries and more. All Hellenistic paintings that survive today are from the Roman period, many being by Roman artists who copied Hellenistic paintings. These 1st-century Roman paintings reveal an

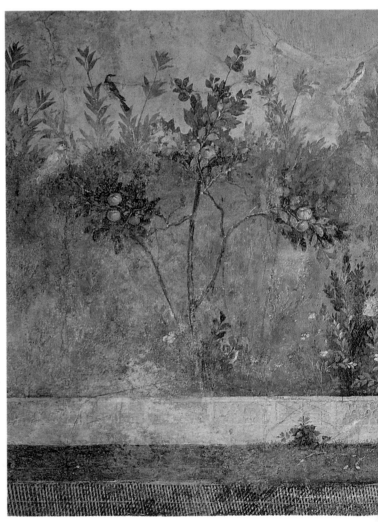

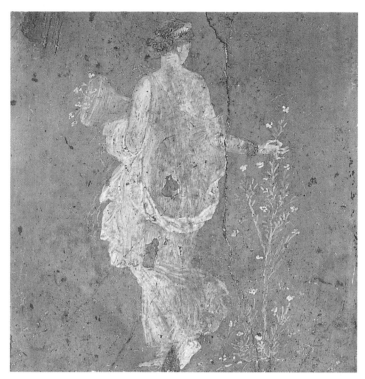

23 **Young Girl Gathering Flowers,** *c. 15* BC–AD *60,* **height 12 in (30 cm)**

the achievements of more talented painters. Still, these works have great charm. It is to their credit that the Romans, even in the small remaining sample of their homes that we can look at today, commissioned so many paintings.

The Romans' interest in landscape, as such, is likely to be Hellenistic in origin. Roman artists were also probably continuing a Hellenistic tradition when they embellished the interior walls of houses with illusions of expensive decorative facings and slabs of colored marble. Such skills were applied in the palaces of the Caesars on the Palatine Hill.

What sets Roman art apart from Hellenistic influences is an interest in facts – in places, faces, and historical events. Roman artists were specially interested in space (which may shed an interesting light on the collective Roman psyche). They also knew how to open up space on a wall by means of mock images of porticoes, architraves, and parapets, which themselves framed illusions of landscapes and figures.

This wall painting *(24)*, from the hall of the Villa of Livia in Prima Porta, just outside Rome, is a charming example of an artist's attempt to create an illusion of a garden, as though the wall did not exist. Painted in the fresco technique, it shows birds, fruit, and trees in realistic detail. A low trellis separates us from a narrow patch of grass. Beyond that is another low wall, before the fruit trees begin.

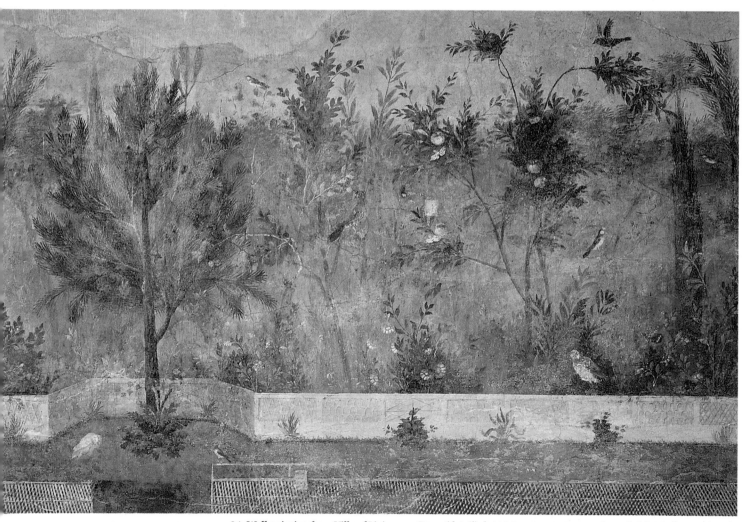

24 **Wall painting from Villa of Livia, near Rome (detail), late 1st century** AD, **approximately 9 ft 2 in (275 cm) wide**

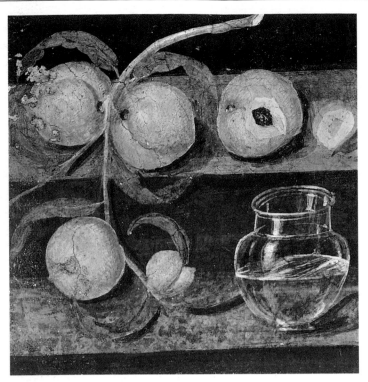

25 **Still Life with Peaches,** *c. AD 50, approximately 13½ x 14 in (34 x 35 cm)*

This illusionism is seen not only in large-scale wall paintings, but also in small works, such as this remarkably fresh and modern-looking still life of peaches and a jug of water, painted in about AD 50, in Herculaneum *(25)*. It reveals an understanding of natural light, where the artist has attempted to show the various effects of light falling onto and through objects, and displays consistent use of chiaroscuro (the depiction of light and dark) as a means of giving volume to form and enhancing the illusion of reality. Once again, this skill is first seen in Hellenistic work, revealing the extent to which ideas were imported into Rome.

ROMAN PORTRAITURE

The wall painting known as "*The Baker and His Wife*" *(26)*, a 1st-century work from Pompeii, is now thought not to portray a baker, but a lawyer and his wife. (Archaeologists are still trying to establish who owned the house in which this mural was found.) But, whoever this young couple was, the portrait remains essentially Roman, with all the interest concentrated on their personalities. The husband, a slightly uncouth, gawky, earnest young man, looks at the viewer with anxious appeal, while the wife looks away into the distance, musing and holding her writing stylus to her delicately pointed chin. Both seem lonely, as if their differently directed gazes reveal something of their marriage. They live together, but they do not share their lives, and there is an added

poignancy; the house of Neo (whatever his profession may prove to be, we do know that this was the name of the building in which the painting was situated) was still unfinished at the time of the eruption, so it is possible that this lonely marriage was of tragically short duration.

THE FAIYUM MUMMIES

Perhaps the most compelling Roman painting has an equal claim to be called Egyptian: the two cultures blended together with an eerie aptness when European realism met African lyricism during the Roman control of North Africa. Excavations have unearthed mummies from the cemetery in Faiyum, a town (today, a district rather than a town) near Cairo. These mummies are protected in a variety of wrappings ranging from papier-mâché to wooden boxes. With each mummy is a panel on which a portrait of the deceased is painted in encaustic (a medium consisting of pigments suspended in hot wax). This mummy case *(27)* is known to have been made for the body of a man named Artemidorus, for this name is inscribed on it. The silhouettes below his portrait show Egyptian deities.

The Faiyum portraits show all ages, from young to old, but those of young adults are the most touching. It may be that they were intended to give a sense of the individual's nature, his or her spirit, rather than the outer appearance, and for this purpose, some may have been idealized. Yet this *Bearded Youth (28)*, whose large eyes look so solemnly into ours, seems hauntingly real. Whether he looked like this or not, it is easy to believe that this was what he was like within.

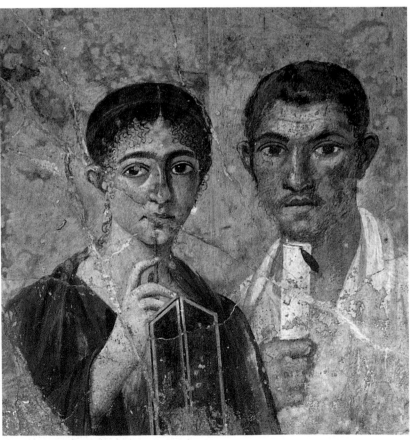

26 "**The Baker and His Wife**" ("**Neo and His Wife**"), *1st century AD, 20½ x 23 in (52 x 58 cm)*

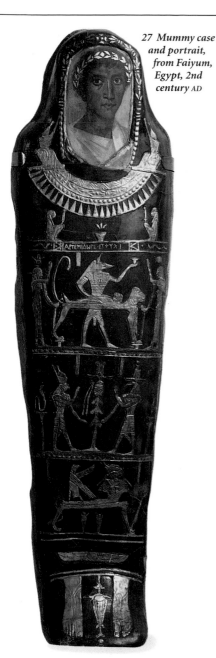

27 Mummy case and portrait, from Faiyum, Egypt, 2nd century AD

28 Bearded Youth, 2nd century AD, 8½ x 17 in (22 x 43 cm)

is carved into the likeness of a scroll that twists in a spiral up the column. The "scroll" is more than 600ft (180m) in length and contains over 2,500 human figures. It shows a series of scenes from Trajan's triumphant campaigns in Dacia (the present-day Romania). The examples shown on this page depict soldiers and builders at work constructing the walls of a fortification *(29)*. The reliefs are shallow and have a painterly feel to them. They make up a continuous and clearly intelligible narrative, leading the "reader" through 150 episodes in succession.

During the 16th century the carvings on this column were an important inspiration and influence for the artists of the Renaissance (see p.80), who regarded the column's dense carvings as an idealized, three-dimensional demonstration of what two-dimensional art was really about.

ROMAN SCULPTURE

Long after the ancient Roman civilization had disappeared, examples of its sculpture have continued to be visible in all parts of the empire. In Rome itself, the great narrative reliefs on Trajan's Column and the Arch of Titus in the Forum were on display to visitors and inhabitants of the city. Trajan's Column is as tall as a ten-story building and stands on a pedestal two stories high. It was built in AD 113 to honor the Emperor Trajan, a gilded statue of whom (replaced in the 16th century by a statue of St. Peter) was placed at the top. The marble outer surface of the column

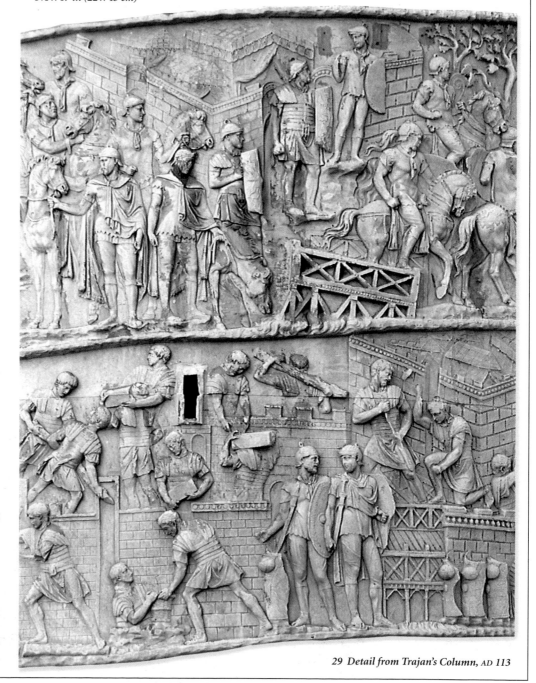

29 Detail from Trajan's Column, AD 113

EARLY CHRISTIAN AND MEDIEVAL ART

The great Roman empire was in decline by the early 2nd century AD, and by the 3rd century its political life had degenerated into chaos. When the Emperor Diocletian divided the empire in half, splitting East from West, the final collapse of the Western section was set in motion. In the 5th century, the Western empire succumbed to the Germanic barbarians. In the East, at Byzantium, a new, Christian-based empire slowly emerged, destined to endure for a thousand years, and with it a new art form, born out of Christianity.

In Rome, in the network of ancient burial chambers known as the catacombs, there is a series of wall paintings dating from the time when the Christians were persecuted in the 3rd and 4th centuries AD. In style, these paintings bear the marks of the continuing Greco-Roman tradition. Unimpressive as art, this figure *(30)* is nonetheless deeply moving as an image of faith. It carries a secret charge of conviction that compensates for any technical incompetence.

THE FIRST GOLDEN AGE OF BYZANTINE ART

In 313, after 300 years of Christian persecution, the Emperor Constantine recognized the Christian church as the official religion of the Roman Empire. Early Christian art differed from the Greco-Roman tradition in subject matter more than style. Later, in the east, it evolved into Byzantine art, as artists turned away from Greco-Roman style to develop an entirely new style. The importance of Byzantine art is seen in

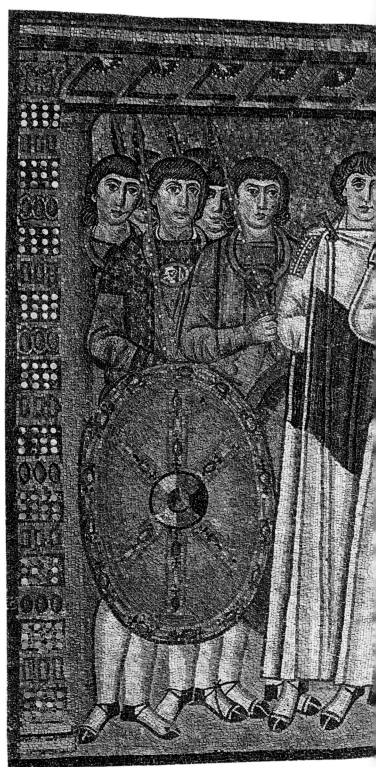

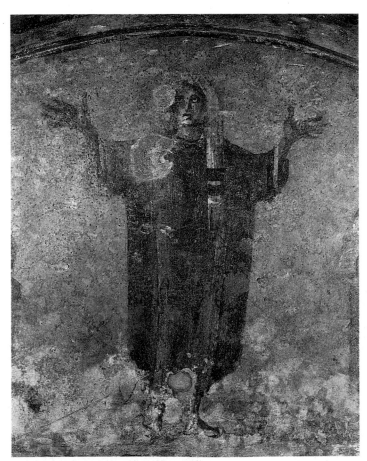

30 Wall painting from catacombs of Rome, 3rd century, 10½ x 16 in (27 x 40 cm)

its profound influence on Gothic art (see pp.36–77). It was the first part of a tradition that was to remain predominantly Christian, and was to run right through the Middle Ages to the time of the Renaissance.

The emotional yet straight-faced intensity of the "Faiyum" paintings of 2nd-century Egypt (see p.22) lingers on into the early Christian mosaics created between 526 and 547 in the church of San Vitale, Ravenna, capital of the area liberated from the Goths by Byzantium. These mosaics achieved a maturity of stylistic convention – restrained elegance,

emotional austerity, and a "frozen," authoritative solemnity – that would form the basis for all Byzantine art. The artist who created the image of *Justinian and His Attendants (31)* gave us a great and lordly image of a mid 6th-century Byzantine emperor. Slender, imperious, remote, and exalted, Justinian is shown with his bishop, clergy, and a representative section of his army: an image of the united forces of church and state, and an echo of the deification of kings practiced during the Roman Empire. All Justinian's princely qualities are also seen, in due proportion, in his

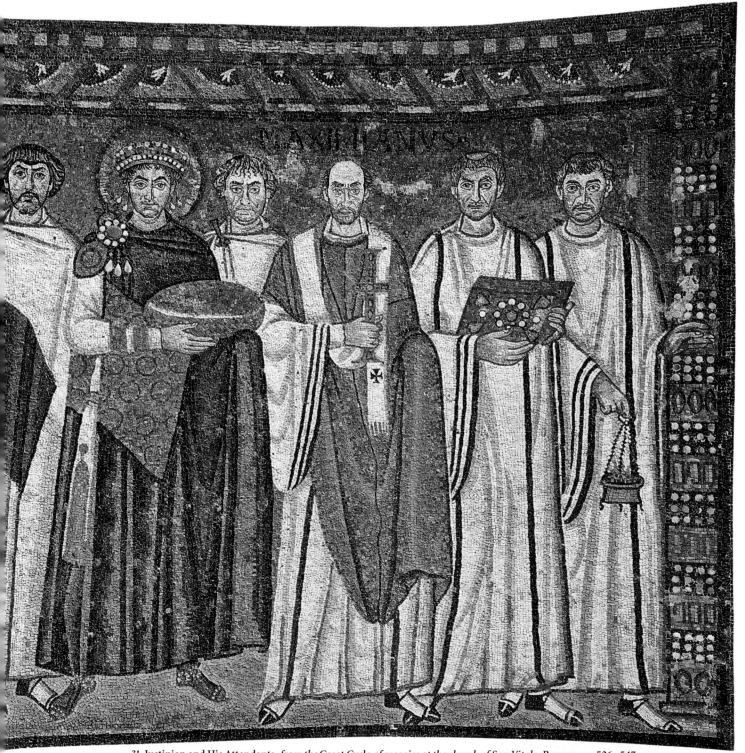

31 Justinian and His Attendants, *from the* Great Cycle *of mosaics at the church of San Vitale, Ravenna, c. 526–547*

attendant lords. They gleam far above us, both materially and spiritually, aloft on the Basilica walls. There is an equally glittering companion mosaic on the other side of the altar, depicting Justinian's wife, the Empress Theodora.

That same century, we can find both the emotional intensity of Faiyum and the priestly remoteness of Ravenna, in an icon from the Monastery of St. Catherine on Mount Sinai. Icons, a great tradition within the life of the Eastern church, were religious images, usually of Christ, the Madonna, or the saints. They were painted on small and often portable panels for devotional purposes, and each detail of the image could be charged with a special religious significance. The *Virgin and Child Enthroned Between St. Theodore and St. George (32)*

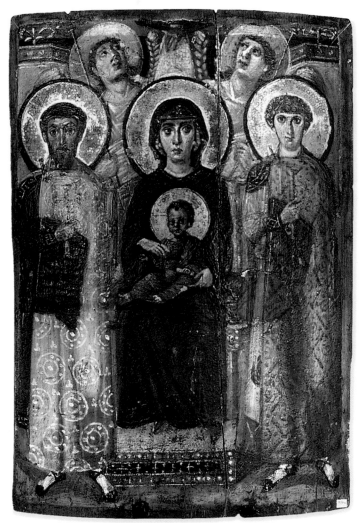

32 Virgin and Child Enthroned Between St. Theodore and St. George, icon from Mount Sinai, c. 6th century AD, 19 x 27 in (48 x 68 cm)

has all the sacred beauty that gives icons their unique power. Mary has wide eyes, which are intended to suggest her purity of heart: she is a woman of vision, one who sees God. She does not look at the small King on her lap: as her Lord, the Child can, as it were, fend for Himself, and it is on us that the Virgin bends her sternly maternal look. The two accompanying saints are dear to the Eastern church tradition – George, the holy warrior and dragon killer (though here his sword is sheathed), and Theodore, less well known to us today, another

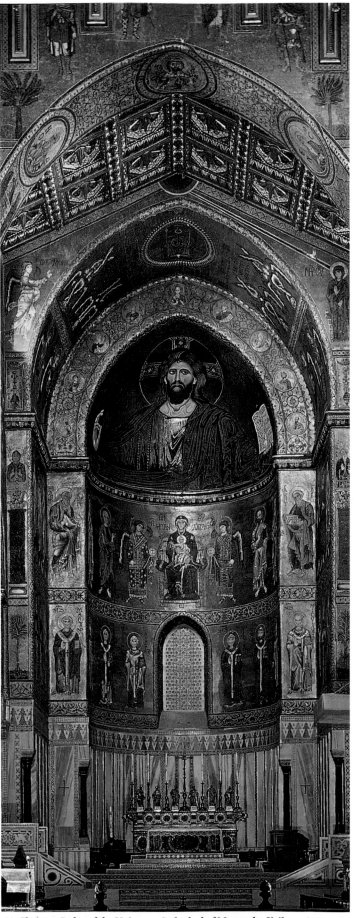

33 Christ as Ruler of the Universe, Cathedral of Monreale, Sicily, c. 1190

warrior. Both saints wear the uniforms of the Imperial Guard, but as weapons each now holds a Cross. The angels behind the throne look upward, alerting us to the hand of God that beckons and announces the Child. The Child holds in His hand a symbolic scroll. God is silent; only the angels see Him, though the eyes of the saintly figures seem to suggest that they sense the divine presence. The four halos of the Madonna, Child, and saints form a Cross and alert us to the message that the closed scroll must contain. It is a strange, mystical work, and this kind of painting continues to this day in Eastern churches.

THE SECOND GOLDEN AGE OF BYZANTINE ART

In the 8th and 9th centuries, the Byzantine world was torn with bitter controversy over the use of pictures or carvings in religious life. Any human image that was at all realistic could be seen as a violation of the commandment not to worship any "graven image." In 730, Emperor Leo III decreed any image of Christ, the Virgin, or any saint or angel, in human form, to be illegal. The decree gave power to religious militants known as iconoclasts (image breakers) who saw to it that, for over a century, religious art was restricted to nonhuman imagery such as leaves or abstract patterns. There was a steady migration of Byzantine artists to the West.

When the law was abolished in 843, and human images were tolerated again, resumption of contact with the artists of the West led to a renewed influence of classical form and illusionistic qualities.

This mosaic, from the apse (a domed recess behind the altar) of the Cathedral of Monreale, Sicily (33), is a large-scale, quintessentially Byzantine work in which the figure of Christ is huge and authoritative. He looms out at us from the sanctuary, a great, luminous image of power; not the gentle Jesus, but the "Judge." Beneath Him, the enthroned Madonna with Child, and the standing figures of archangels and saints, are all seen, rightfully, as small. They are beautiful, but relatively unimportant. The golden background of the mosaic is one of the most distinctive features of Byzantine art and continued into the Gothic era (see p.40).

INTIMATE ICON

Not all Byzantine art was on such a grand scale. One of the most beautiful small icons from the period is the so-called "*Vladimir Madonna*" (34). This was probably painted in Constantinople in the 12th century and later taken to Russia. The position of the Virgin and Child, their faces touching tenderly, introduces a new note in sacred art. Previously the two figures had appeared as symbols of the Christian faith – Christ and His Mother not sharing any emotional closeness. Here they appear in their intimate, human relationship.

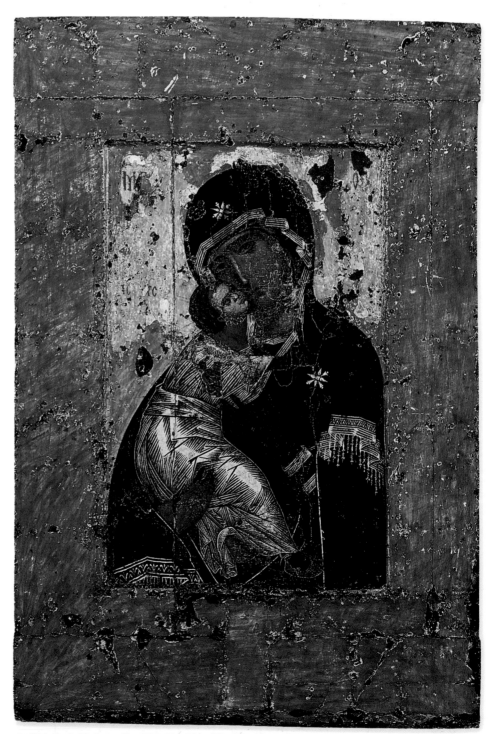

34 "Vladimir Madonna," c. 1125, 21 x 30 in (53 x 75 cm)

RUSSIAN ART

Russia was converted to Christianity in the 10th century, and eventually took over the Byzantine tradition, making it very much its own. The most exquisite example of this meeting of two very dissimilar cultures, at the highest point in the development of Russian Byzantine art, is surely this vivid *Trinity (35)*, painted by Andrei Rublev (c. 1360–1430). Rublev is the most famous of Russian icon painters. The figures represent the three angels that appeared to Abraham in the Old Testament. This is grace made visible, and it is this Byzantine heritage that gives special poignancy to the mysterious works of El Greco (see p.146) 300 years later.

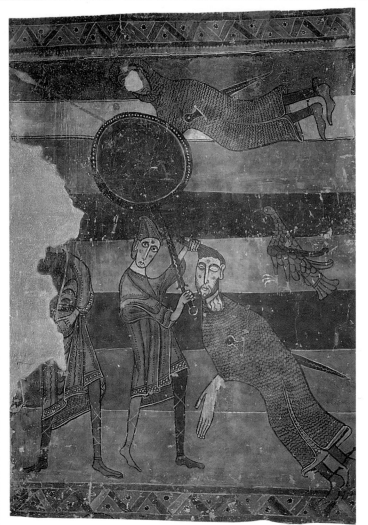

36 David and Goliath, fresco at Tahull, Spain, c. 1123

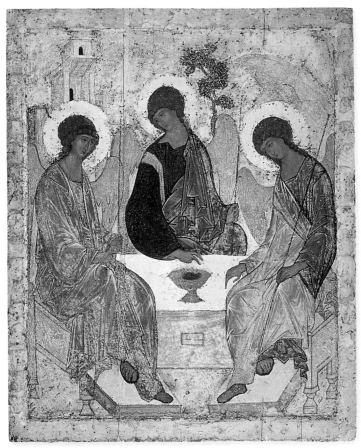

35 Andrei Rublev, Trinity, c. 1422–27, 44 x 55 in (112 x 140 cm)

THE "DARK AGES" IN WESTERN EUROPE

Despite its pejorative implication, the phrase "Dark Ages" is sometimes used to refer to the early Middle Ages in European civilization, up to the beginning of the High Middle Ages around 1100. The thousand-year period from 400 to 1400 was a time of gradual mingling of influences from the Greco-Roman tradition, Christianity, and Byzantine art, as well as the growing Celtic and Germanic cultures of the North. Far from being an artistically barren or regressive period filling the empty space between the Roman empire and the Renaissance, as was believed for centuries, it was a period of development and metamorphosis within the stronghold of Christianity. The "Dark Ages" held the seeds of future scientific and technical innovation and prepared the way for such things as the coming invention of printing.

The art of the Western church was less mystical and more human than that of the Byzantine empire, and throughout the Middle Ages, painting was the preferred manner of popular religious instruction, at a time when a large majority of people were illiterate. Even the poorest church buildings covered their walls with brightly colored biblical stories, often to spectacular effect. In the tiny Catalan church of Santa Maria, at Tahull, Spain, the 12th-century frescoes have only four main colors: white, black, ochre, and vermilion, with touches of blue and orange. This passionate simplicity is repeated in the forms as David sways forward to decapitate an inert Goliath *(36)*. David, in adolescent garb, is slight, dreamy, and defenseless, while Goliath, immense in his huge armor, is the consummate worldling whom the children of God, even poor shepherds such as the young David, defeat.

ILLUMINATED MANUSCRIPTS

The art of the nomadic barbarian peoples who had conquered the West was mostly object based, small scale, and portable. After conversion to Christianity, it was logical that this highly decorative art form should be translated into a religious art that is also small scale and portable: the illuminated manuscript. This most accessible and perhaps even most lovely of early medieval artifacts has been discussed by some critics as

being the work of craftsmen, but where do we draw the line? The original meaning of the Latin word *ars* was "craftsmanship," the exact equivalent of the Old High German word *kunst,* which originally meant knowledge or wisdom, and by extension came to mean a craft or skill. The discipline of a trained eye and a trained hand was essential to create an object either for delight or for function or – the continual desire of the creator – for both. The distinction between aristocratic art and plebeian craft is only a modern one. It dwindles away into insignificance when we look at the work of the great "craftsmen" of the Middle Ages.

THE CAROLINGIAN EMPIRE

The single most powerful political figure in Europe in the early Middle Ages was Charlemagne. His contemporary name translates to "Charles the Great," and Charlemagne is a version of the Latin for this. The adjective relating to his time is Carolingian.

Charlemagne's armies took control of extensive territories in northern Europe from 768 to 814. With his military might, he was responsible for the enforcement of Christianity in the North, and for a revival of the art of antiquity that had flourished before the collapse of the Roman Empire in the West 300 years earlier.

When Charlemagne was crowned emperor of what is now France and Germany in 800, he became a great patron of the arts. He was fluent in Latin and could understand Greek, though he could hardly write at all. He wanted his artists to reflect both the Christian message and the magnificence and importance of his own empire. For his court at Aachen, he recruited the greatest scholar known in Europe at that time, Alcuin of York, an Englishman from Northumbria.

Charlemagne commissioned several glorious sets of illuminated Latin Gospels. Some of the work that these contain has an almost classical majesty, a magnificent serenity. The emperor sent artists to Ravenna (see p.25), where they could study the early Christian and Byzantine murals and mosaics, whose style offered itself as more appropriate to the religious development of the new empire than did the pagan art of Greece and Rome. He may have employed Greek artists to work on some of the illuminated Gospels. The Byzantine influence, together with elements from early Christian,

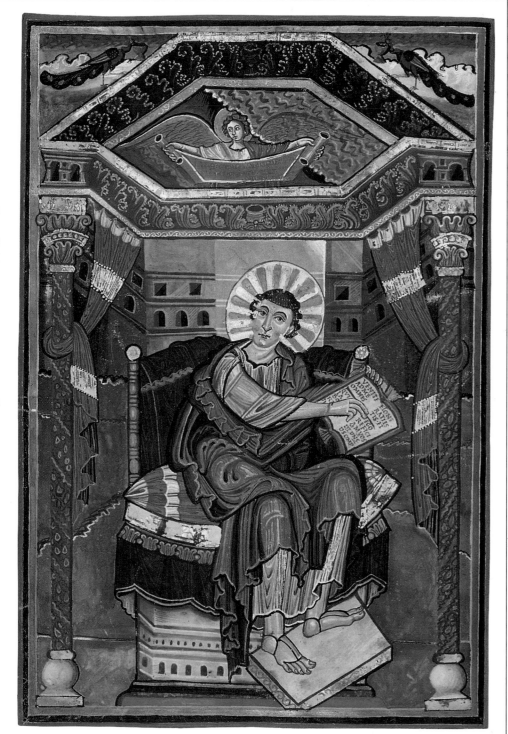

37 St. Matthew *from the* Harley Golden Gospels, *c. 800, 10 x 14½ in (25 x 37 cm)*

Anglo-Saxon, and Germanic art, are seen in these illuminated manuscripts. These traditions combined to produce the Carolingian style, embodied in this painting *(37)* from the *Harley Golden Gospels.* This book was produced under Charlemagne and takes its present name from a collector, Lord Harley, who once owned it. St. Matthew writes his Gospel in a setting that displays a rather lopsided perspective, but is eminently balanced emotionally. He leans forward to listen to the Holy Spirit, calmly collected, half smiling. His emblem, an angel, hovers above him with equal poise, and expressing the same quiet happiness.

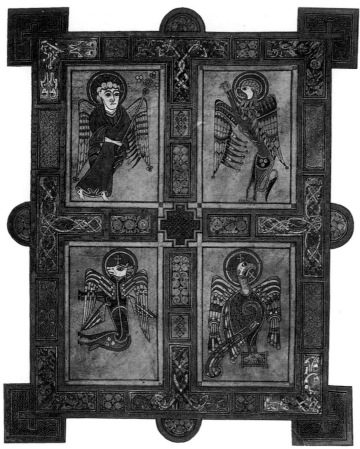

38 Symbols of the Evangelists, from the Book of Kells, *c. 800, 9½ × 13 in (24 × 33 cm)*

CELTIC ILLUMINATION

The missionary zeal of the Christian church, which spread its influence across Europe, is seen at its most intense in the relatively tiny Christian stronghold of Celtic Ireland, which had converted to Christianity in the 5th century. Advanced Celtic monastic communities were also established in Britain and northern Europe. The intricate art that was created in all these communities reveals a blend of Celtic and Germanic styles. In their convoluted manner, the Celtic manuscripts appeal to us across the centuries with a remarkable intensity.

There can be few works of art more exquisite in every sense than the *Book of Durrow*, the *Lindisfarne Gospels*, or the *Book of Kells*. This last, created by Irish monks on the island of Iona in the 8th and early 9th centuries, and later taken to the monastery of Kells in Ireland, is possibly the greatest work of manuscript illumination ever created. The figurative images have an iconic strength, as we see in the page that shows the symbols of the four evangelists: Matthew's angel, Mark's lion, Luke's ox, and John's eagle *(38)*.

ILLUMINATED INITIALS

But the true glory of the *Book of Kells* is in the illuminated initials. Here intricacy becomes so integrated, so wild yet so controlled – a marvelous paradox – that it is impossible even to imagine how such lacelike perfection could have been drawn by the unaided human hand. One of the most

wonderful initial pages presents the words *Christi autem generatio* ("the birth of Christ") from St. Matthew's Gospel. The word *Christi*, shortened to "*XPI*," fills most of the page; *autem* is abbreviated as *h*, while *generatio* is spelled out *(40)*.

The shortened form of the name of Christ is made out of the two characters XP, the Greek letters *chi* and *rho*. This is the symbolic abbreviation known as the *Chi-Rho*. The entire ornate pattern is based upon the material form and spiritual meaning of these two characters.

The whole page is densely covered with a network of lines, faces, shapes, and animals (human figures are not often the main focus of Irish illuminations). There are three figures of men (or angels), three being the mystic trinitarian number; there are butterflies, cats playing with mice (or are they kittens?), and a fine otter, upside down and clutching a fish in its mouth. But we have to search these creatures out, disguised as they are by a glorious swirl of geometric patterning. The floating human faces, glimpsed here and there amid the tracery, make clear to us that the central and all-encompassing reality in life is Christ. His very name, even in its abbreviated form, simply subsumes all else.

The ambitious approach of this page is more easily appreciated if we compare it with its equivalent in the *Lindisfarne Gospels (39)*. This manuscript was produced in Northumberland, in northern England, shortly before 698, by the monk Eadfrith. Here too the illumination is magnificent, but it is much less complicated in its layout and scope.

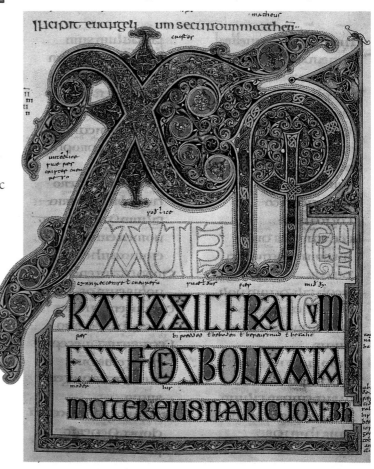

39 Chi-Rho page from the Lindisfarne Gospels, *c. 690, 10 × 13½ in (25 × 34 cm)*

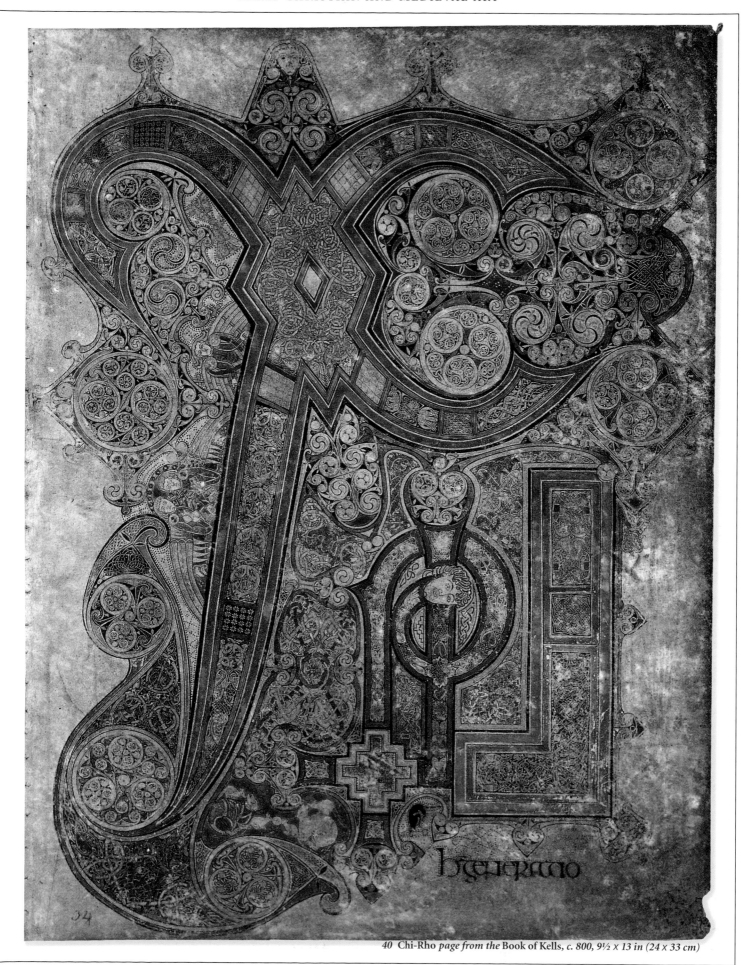

40 Chi-Rho page from the Book of Kells, *c. 800, 9½ x 13 in (24 x 33 cm)*

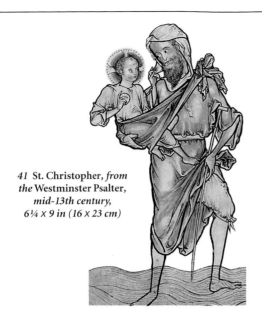

41 St. Christopher, from the Westminster Psalter, *mid-13th century, 6¼ x 9 in (16 x 23 cm)*

43 Christ and the 24 Elders, from the Apocalypse of Beatus, *c. 1028–72, 22 x 14½ in (55 x 37 cm)*

SPANISH ILLUMINATION

The very smallness of manuscript art gives it an intimacy that can prove tremendous. The most dramatic of medieval illuminations tend to be Spanish. The book of Revelation, the final and apocalyptic book of the Bible, provided a never-failing source of blazingly powerful images. The monk Beatus, who lived in the 8th century at Liebana in Spain, wrote a commentary on the Apocalypse (as Revelation is also known) that entranced the visual imaginations of a whole series of painters for centuries to come. Here is how another monk (probably Spanish or Spanish-trained), who worked at the monastery of Saint-Sever in Gascony, envisioned *Christ and the 24 Elders* in an 11th-century copy of Beatus *(43)*. Around the outer edge of a great circle containing Christ and His blessed are the souls of the saints, pure and free as birds. There is a wonderful exhilaration in the image of the elders, including the four evangelists, waving their goblets to toast the triumphant Lord, while the winged saints stretch out longing hands toward the celestial glory.

ENGLISH ILLUMINATION

Like the Irish monks, the British also produced manuscripts of great beauty, this being one of the very few periods in which the least visual of national groups, the English speakers, attained international fame as artists. Matthew Paris, who died in 1259, was a monk at the flourishing Abbey of St. Albans, just outside London, and his 42 years in the cloister were mainly distinguished by a series of books that he not only wrote, but illustrated, giving them the benefit of his remarkable draftsmanship. In this example from the *Westminster Psalter*, the patron saint of travelers, *St. Christopher (41)*, is shown carrying the Christ Child across the river.

Another outstanding work from St. Albans, known as the *Oscott Psalter (42)*, illustrated by an artist who is not named, shows the same nervous delicacy of line, with an elegance and psychological subtlety that enchant the viewer. St. Peter, identifiable by the keys he holds and the fact that he stands on a rock, is one of ten saints depicted in the psalter.

42 St. Peter, from the Oscott Psalter, *c. 1270, 7½ x 12 in (19 x 30 cm)*

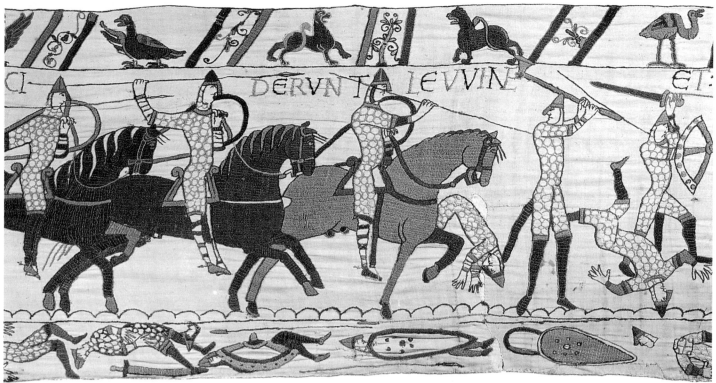

44 The Death of Harold's Brothers, *from the* Bayeux Tapestry, *c. 1066–77 (detail)*

45 *Page from the* St. Denis Missal, *c. 1350, 6¼ x 9 in (16 x 23 cm)*

ENGLISH EMBROIDERY

The so-called *Bayeux Tapestry* is not really a tapestry, but a woolen embroidery supported by cloth. For a long time it was thought to have been made in Normandy for Queen Matilda, wife of William the Conqueror, by her "court ladies." However, it has recently been proved to have been commissioned by Bishop Odo, William's half-brother, and made in England. It displays the same jerky animation that we find in English manuscripts. A sort of Anglo-Saxon glorified comic strip, it tells its exciting story of the Norman Conquest of England with economy and charm. It takes the form of a long cloth frieze, with upper and lower borders that provide a commentary on the action in the main panel. In this particular scene *(44)*, the brothers of the English King Harold are slain by Norman soldiers. The top border is given over to decorative, almost emblematic animals, while the bottom one is filled with images of dead soldiers and an assortment of their abandoned weapons and armor.

FRENCH ILLUMINATION

A lovely missal (a book of texts for church services through the year) survives from the 14th century at the abbey of St. Denis in Paris. It is by a follower of Jean Pucelle, an illuminator with a workshop in Paris. One page shows liturgical text for the feast day of St. Denis *(45)*, with a magnificent pictorial "O" and two other miniatures telling of the saint's relationships with the royal family. Even if we do not know the legends about the stag that hid in a church when pursued by Prince Dagobert, and how the prince and his father King Clotaire are eventually reconciled through a dream appearance of St. Denis, we can still enjoy the pale and meticulous figurines, living out their holy adventures in the missal.

Romanesque painting

In an illustration in a mid 13th-century French *Bible moralisée* (biblical text with moralizing commentary), God the Father is seen as an architect *(46)*. This work shows the increasing return to the natural-looking style of Roman art (see p.20) – especially visible in the relaxed drapery and the suggestion of volume beneath – a style that would reach unprecedented heights of realism in Gothic painting. Although, as was typical of medieval paintings, the artist did not leave us his name, the picture has an almost Giottoesque power (see p.46). Almost 600 years later, William Blake would also show God bending over a compass in an illustration in his book *The Ancient of Days (47)*. But Blake's God is narrowed by geometry, and this artist is rebelling against the rule of cold law, glorying in the majesty of a strong, free deity. God strides through space, barely contained by the brilliant blue and scarlet borders of the human imagination. The great swirls of His royal robes recall the sculptural pleats on the figures in Reims Cathedral. God is utterly intent upon his creative work, putting forth every effort of his mighty will to control and discipline the wild waters, stars, planets, and earths of His world. He will soon, we feel, send it spinning into space, but first, He orders it. He labors with barefoot concentration, the perfect integrator of art and skill.

When the Florentine artist Giotto (see p.46) started producing frescoes in the early 14th century, his genius was so massive that he changed the course of European painting. However, the illuminators' art did not come to an immediate end. Contemporary with Giotto and past his time, influenced but yet distinct, the manuscript artists continued with their intricate craft, reaching greater heights precisely because Giotto had set them free from any imaginative limitation.

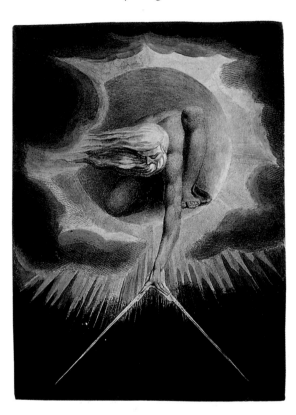

47 William Blake, illustration from The Ancient of Days, *1794*

Classical influences

Other works that can be seen to prefigure Giotto's naturalism include the paintings and mosaics of the Italian artist Pietro Cavallini (active 1273–1308). He worked mainly in Rome, and Giotto would have seen examples of his art there early in his career. Cavallini's style was strongly influenced by classical Roman art. Unfortunately, his work has been preserved for us, for the most part, only in fragments.

This example is a detail from his best surviving fresco, in the church of Santa Cecilia in Trastevere, Rome *(48)*. The three seated apostles shown here form part of a larger group surrounding the figure of Christ in the Last Judgment. In the unidentified but youthful apostle in the center, we see a sweetness and a gravity that has great human appeal as well as a supernatural power. He is an accessible saint, yet still incontrovertibly a "saint."

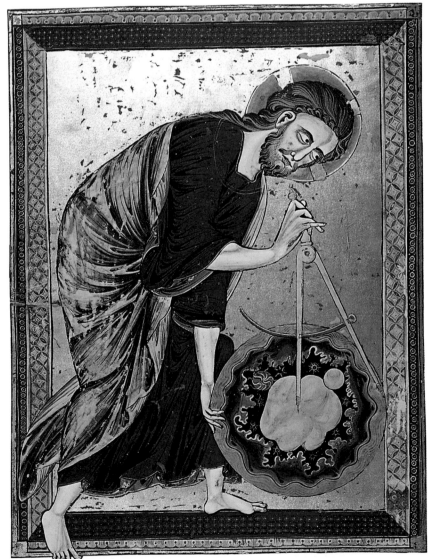

46 God the Father as Architect, *illustration in a French* Bible moralisée *from the mid-13th century, 10 x 13½ in (25 x 34 cm)*

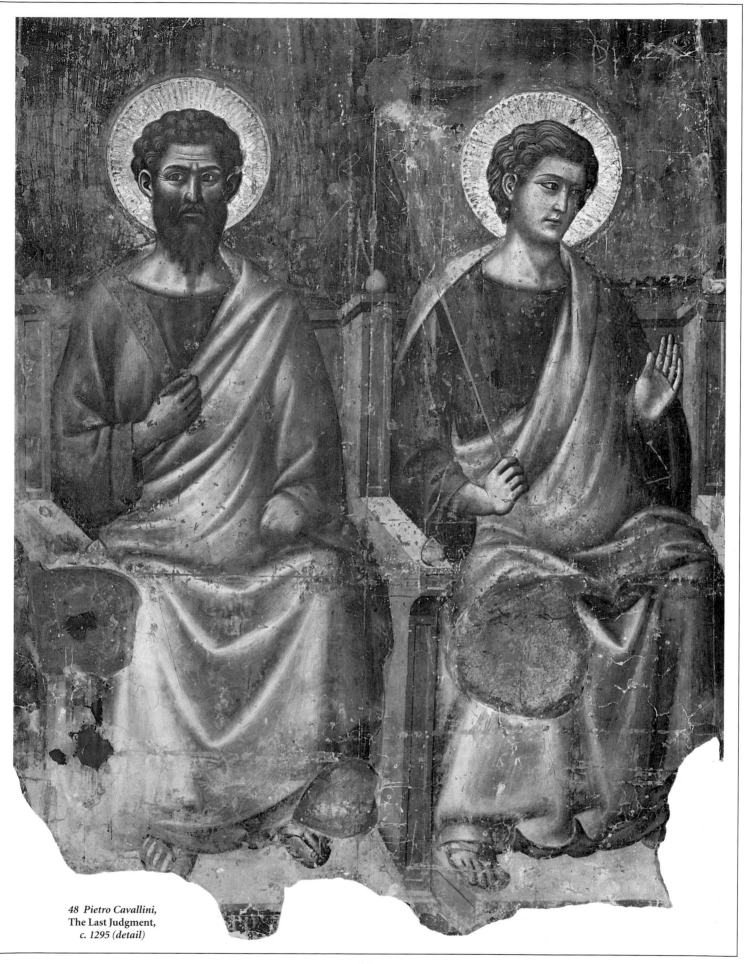

48 Pietro Cavallini,
The Last Judgment,
c. 1295 (detail)

GOTHIC PAINTING

The Gothic style began with the architecture of the 12th century, at the height of the Middle Ages, when Europe was putting the memory of the Dark Ages behind it and moving into a radiant new era of prosperity and confidence. At the same time, Christianity was entering a new and triumphant phase of its history, and so the age of chivalry was also the time of the building of the magnificent Gothic cathedrals, such as those in the northern French towns of Chartres, Reims, and Amiens. In the realm of painting, the change to the new style became visible about a century after the first of these cathedrals rose. In contrast to the Romanesque and Byzantine styles, the most noticeable feature of the art of the Gothic period is its increased naturalism. This quality, which first appeared in the work of Italian artists in the late 13th century, became the dominant painting style throughout Europe until the end of the 15th century.

Ambrogio Lorenzetti, **Allegory of Good Government: Effects of Good Government in the City and in the Country,** *1338–39 (detail)*

GOTHIC TIMELINE

The Gothic era in painting spanned more than 200 years, starting in Italy and spreading to the rest of Europe. Toward the end of this period there were some artists in parts of the North who resisted Renaissance influences and kept to the Gothic tradition. As a result, the end of the Gothic timeline overlaps with both the Italian and the Northern Renaissance timelines (see pp.80–81, 150–51).

CIMABUE, MAESTA, 1280–85
Although this painting shows strong Byzantine influences, Cimabue's work marked a departure from that tradition in the more three-dimensional rendering of space and the apparent humanity of his Madonna. In addition, the drapery is much softer than that in Byzantine art (p.42).

GIOTTO, DEPOSITION OF CHRIST, C. 1304–13
Giotto's art heralded an entirely new tradition of painting, and his art even belongs in some ways to the Renaissance. This fresco from the Arena Chapel, Padua, is a good example of his characteristic psychological intensity, spatial clarity, and solidity of form (p.47).

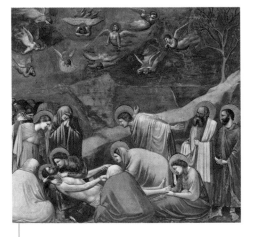

WILTON DIPTYCH, C. 1395
Although little is known about the origin of this work, it is a perfect example of the courtly International Gothic style that swept Europe at the end of the 14th century. The rich blue and the crowded composition of the panel showing the Virgin surrounded by angels contrasts with the simplicity of the left-hand panel, with its gold background (p.54).

1290	1310	1330	1350	1370	1390

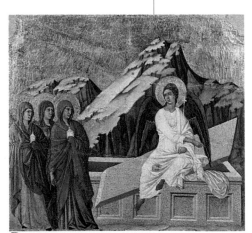

DUCCIO, THE HOLY WOMEN AT THE SEPULCHRE, 1308–11
Duccio's most celebrated work is his wonderful Maestà altarpiece. It still impresses, even though now dismembered and partially dispersed, with its huge Virgin in Majesty. It was free-standing, and the back showed scenes from the life of Christ (p.45).

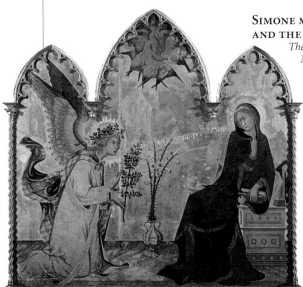

SIMONE MARTINI, THE ANGEL AND THE ANNUNCIATION, 1333
The Sienese artist Simone Martini painted several versions of the Annunciation. In this glittering example, the fluid lines of the draperies of the Virgin and the angel clearly reveal the solid forms beneath them – a characteristic feature of Gothic painting (p.50). The similarly named Angel of the Annunciation, a diptych panel showing the angel without Mary, is another display of Martini's consummate skill in the portrayal of drapery (p.51).

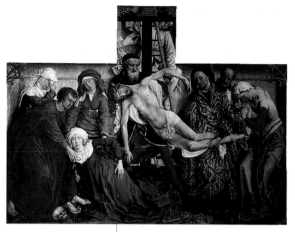

ROGIER VAN DER WEYDEN, DEPOSITION, C. 1435
In the hands of this great Flemish artist, the removal of Christ's body from the Cross is a moment of intense emotional drama. Everyone in the scene is overwhelmed by grief, though each expresses it differently (p.67).

ROBERT CAMPIN, PORTRAIT OF A WOMAN, C. 1420–30
Northern artists began to show individual personalities in their head-and-shoulders portraits of wealthy townsfolk (p.61).

HIERONYMUS BOSCH, TEMPTATION OF ST. ANTHONY, 1505
Bosch stands out among his peers for the bizarre and fantastic images that appear in many of his paintings (p.72).

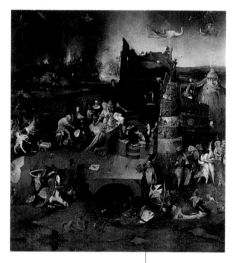

MASTER OF AVIGNON PIETA, PIETA, C. 1470
Depictions of the Pietà, the Virgin Mary viewing or holding the dead body of her Son, abound in Gothic art. This poignant 15th-century version was created by an anonymous artist in France (p.66).

1410	1430	1450	1470	1490	1510

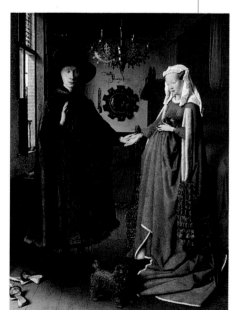

JAN VAN EYCK, THE ARNOLFINI MARRIAGE, 1434
Van Eyck was one of the first artists to exploit the new medium of oil paint. In this double portrait, one of his most famous paintings, he uses it to great effect in the realistic rendering of light and shadows. The unifying result of this treatment was extremely original in its time. The interior domestic setting is found in many of the paintings of contemporary Netherlandish artists (p.65).

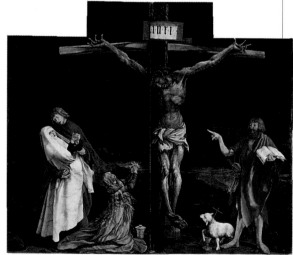

MATTHIAS GRÜNEWALD, CRUCIFIXION, C. 1510–15
The German artist Grünewald typifies the emphasis on horrific suffering of some late Gothic art. His Crucifixion scene has a harrowing intensity (p.76).

EARLY GOTHIC ART

In the early Gothic period, art was produced chiefly for religious purposes. Many paintings were teaching aids, to make Christianity "visible" to an illiterate population; others were displayed, like icons (see p.27), to enhance contemplation and prayer. The early Gothic masters created images of great spiritual purity and intensity, and, in doing so, preserved the memory of the Byzantine tradition. But there was much that was new as well: strikingly persuasive figures, perspective, and a wonderful elegance of line.

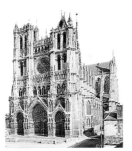

AMIENS CATHEDRAL
This cathedral, with its pointed arches and ornate stonework, is typical of the High Gothic architecture of 13th-century France. Building work commenced in 1220.

THE MIDDLE AGES
Gothic art belongs chiefly to the last three centuries of the Middle Ages. The Middle Ages extended from the fall of Rome in 410 to the start of the Renaissance in the 15th century.

The term "Gothic" denotes a period of time rather than describing a set of identifiable features. Although there are certain recognizable characteristics of Gothic style, Gothic art's numerous manifestations are easier to make sense of if we bear in mind that the period spanned over 200 years, and that its influence spread throughout Europe. The Italians were the first to use the term "Gothic," and they used it as a derogatory word for art that was produced during the late Renaissance (see p.139), but that was of a medieval appearance. The word was a reference to the "barbaric past" – in particular to the Goths, a Northern, Germanic people of ancient times whose armies had invaded Italy and sacked Rome in the year 410. Eventually the word "Gothic" lost its derogatory overtones and was adopted as a broad term describing the new style of architecture and art that emerged after the Romanesque period (see p.34) and before the Renaissance.

THE INFLUENCE OF GOTHIC ARCHITECTURE

The innovation that separates the churches of the Gothic period from the Romanesque architecture was a new type of ceiling construction, the ribbed vault. With this strengthening structure, the supporting walls no longer needed to be so massive. In addition, flying buttresses were employed as load-bearing devices on the outside of the building, so that not all the weight of the roof needed to be supported by the columns and walls. Thus the walls could be thinner and large parts could be given over to glass, allowing in more light.

A common misconception about Gothic architecture is that the pointed arch was one of its innovations. In fact, such arches were not new, but enjoyed much greater popularity in Gothic designs than at any earlier time. More variable in shape than semicircular arches, they offered architects greater freedom of choice.

The first churches to be built in the Gothic style were in France, notably at Notre Dame in Paris, St. Denis in Paris, and at Chartres. A less elaborate, but similar, style appeared in England, for instance at Salisbury; and Gothic churches were also built in Germany, Italy, Spain, and the Netherlands. In all of them there was a startling

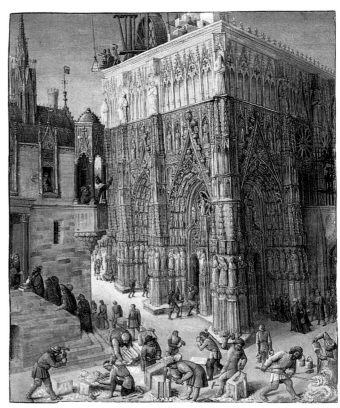

*49 Jean Fouquet, **The Building of a Cathedral**, from a 15th-century manuscript copy of the writings of the 1st-century Jewish historian Josephus*

and revolutionary use of stained glass. Colored light now flooded the interior, creating a new and unearthly atmosphere. While before each colored panel had to be held in place by stonework, Gothic craftsmen learned to make a mesh of lead tracery to hold the glass in place. The art of making stained glass windows reached its greatest height in the church of Sainte Chapelle in Paris (50), where windows make up three-quarters of the wall area.

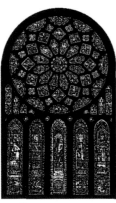

STAINED GLASS
The Gothic cathedral at Chartres attracted the most accomplished makers of stained glass. It has three rose windows, a popular Gothic feature. In the windows under the north rose (above), completed c. 1230, are the figures of St. Anne, holding the Virgin Mary as a child, and four Old Testament figures, including David and Solomon.

EMERGENCE OF GOTHIC PAINTING

Gothic painting has its beginnings in Italy. Painting in 13th-century Italy was still dominated by Byzantine art, which was known in Italy as "the Greek manner." Painting was much slower to assimilate the Gothic influence than architecture and sculpture. It was not until the end of the 13th century that the Gothic style appeared in painting, in the brilliant panel paintings of Florence and Siena. Early Gothic painting displayed a greater realism than had been found in Romanesque and Byzantine art. There is an obvious fascination with the effects of perspective and in creating an illusion of real-looking space.

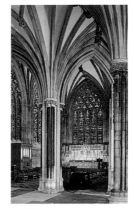

RIBBED VAULTS
The ribbed vaulting and delicate pointed arches of the Lady Chapel in Wells Cathedral, England, are typical of the Gothic style. So too is the light that streams into the chapel through the large windows. This part of the cathedral was completed in 1326.

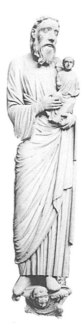

SCULPTURE
This figure of Simeon holding Christ is from the exterior of the north transept of Chartres Cathedral. It illustrates the shift from the rigid Romanesque style of sculpture toward more personalized and elegant figures, typified by the folds in the drapery. This was echoed in Gothic painting.

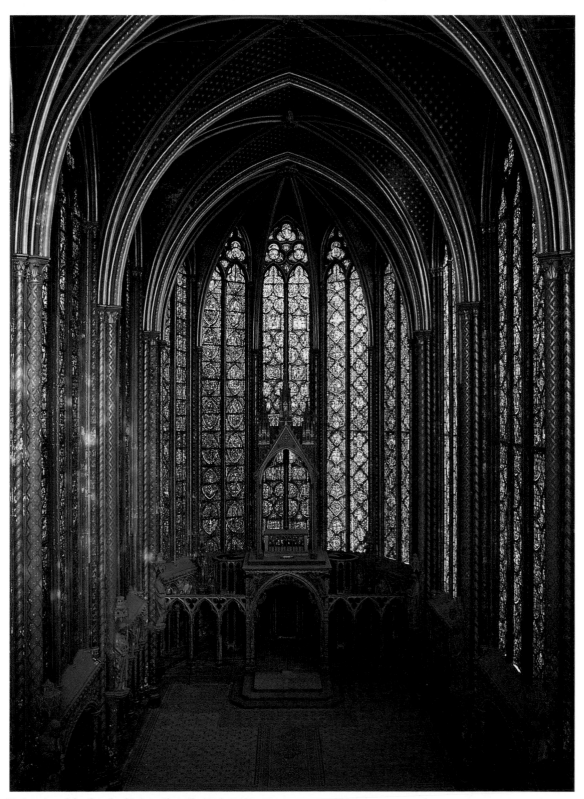

50 Interior of the church of Sainte Chapelle, Paris, 1243–48

Many of the pictures show a sinuous elegance and delicacy. Other characteristics of the Early Gothic style are an interest in pictorial story-telling, and a heightened, often passionate, expression of spirituality.

Turning away from byzantine art

The most prominent artist working in Florence at the end of the 13th century was Cimabue (Cenni di Peppi, c.1240–c.1302), who is traditionally held to be Giotto's teacher. So many works have been attributed to him that his name has almost come to represent a group of like-minded artists rather than an individual, though we know he existed.

Although Cimabue remained a painter in the Byzantine style, he went a long way toward liberating himself from the flatness of traditional icon painting, and in doing this he took the first steps in the quest for realism that has played such a fundamental role in Western painting.

We know that in 1272 Cimabue traveled to Rome, which was then the main center in Italy for muralists. The mural painters and mosaic makers of that time were particularly interested in creating a greater naturalism in their work,

51 Cimabue, Maestà, 1280–85, 7 ft 5 in x 12 ft 8 in (225 x 386 cm)

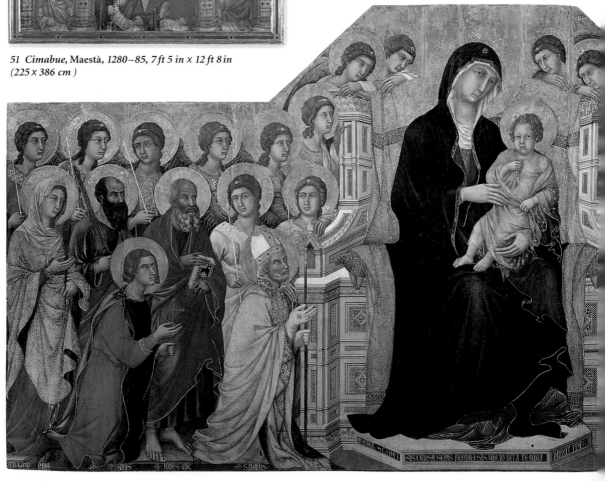

52 Duccio, Maestà, main front panel, 1308–11, 13 x 7 ft (396 x 213 cm)

and Cimabue may well have shared their concern. Cimabue is best known for his *Maestà (51)*, originally on the altar of the church of Santa Trinità in Florence. The word *maestà* means "majesty," and was used to refer to a painting of the Madonna and Child in which the figure of Mary sits on a throne and is surrounded by angels. Cimabue's *Maestà* has a great sweetness and dignity, surpassing in emotional content the rigid, stylized figures of the Byzantine icon. The handling of the soft texture of the drapery, together with the "open," three-dimensional space created by the inlaid throne on which the Madonna and Child sit – all this is new and exciting.

DUCCIO AND THE SIENESE SCHOOL

Regardless of all the developments he initiated, Cimabue's work still has a certain flatness if we compare it with the works of the great, and almost contemporary, Sienese painter Duccio (Duccio di Buoninsegna, active 1278–1318/19).

During the 13th and 14th centuries the city of Siena vied with Florence in the splendor of its arts. If Giotto (see p.46) revolutionized Florentine art, then Duccio and his followers were responsible for their own smaller, but very significant, revolution to the south. Duccio is a painter of tremendous power. His greatest work was his *Maestà*, commissioned for Siena Cathedral in 1308 and installed there in 1311 with great ceremony. A chronicler recorded the

53 *Duccio,* **The Holy Women at the Sepulchre** *(from the* Maestà*), 1308–11, 21 × 40 in (53 × 102 cm)*

festivities: "The Sienese took [the *Maestà*] to the cathedral on the 9th June, with great devotions and processions ... ringing all the bells for joy, and this day the shops stayed closed for devotions." It is extraordinary that this great work was in later times cut up and sold, at least in part because it was no longer appreciated. The beneficial result of this cultural folly is that museums all around the world now have panels from the *Maestà*.

Duccio's *Maestà* was painted on both sides; the front was in three parts. The main panel *(52)* showed the Mother and Child enthroned, surrounded by angels and saints. At the base of the main panel ran a predella (a pictorial strip along the bottom), decorated with scenes from Christ's childhood. A corresponding strip at the top displayed scenes from the last years of the life of the Virgin. Both these strips are now lost. The reverse was painted with scenes from the life of Christ (26 are known).

Among the scenes from the back of the *Maestà* that remain in Siena is *The Holy Women at the Sepulchre (53)*. It is the moment in the Passion when the three Marys discover Christ's empty tomb and are told by the Angel Gabriel that He has risen. This painting is a work of such powerful austerity and grace that we become conscious of the urgency of its Christian message.

It is not the psychology of the women that interests Duccio (as it would Giotto), but the wonder of the sacred interaction between them at this all-important point in the story of the Passion. The figures in the painting sway toward one another, yet there is never actual contact. We are being shown a world of inwardness that none of us can understand, not even the artist himself. The wonderful self-containment and detachment of Duccio's work is one of his most distinctive qualities.

RECONSTRUCTING THE MAESTA

Duccio's masterpiece was dismantled in 1771, and individual panels can now be seen in a number of cities, including Washington, New York, and London, as well as Siena. Art historians have made a visual reconstruction of the work by matching the grain of the wood and wormholes. However, because some sections have disappeared we still cannot envisage the exact arrangement of the whole work.

ITALY

During the Gothic period the independent states of the Italian peninsula were generous and competitive patrons of the arts. The political map of Italy changed many times – this one dates from 1450. In earlier times, the Papal States had occupied a larger area in the north, and the southern mainland was part of the Kingdom of Naples, which was taken over by Sicily in 1443. The Papal States and the north of Italy were both parts of the Holy Roman Empire.

He seems to paint from a distance, whereas Giotto (see p.46) wholly identifies with his stories, creating real dramas and involving us as he tells them. Although the stiffly formal composition of the front of the *Maestà* reveals strong ties with the Byzantine tradition, the influence of Northern Europe (which Duccio received secondhand through the sculpture of Nicola and Giovanni Pisano, see p.46) can be seen in the graceful, undulating forms of the figures – an early example of the refined charm that characterizes the whole period of Gothic art.

With Duccio, we see a real change of style, and his influence was greater than Cimabue's. His figures seem to have volume, and their robes relax into fluid, sinuous lines, which also describe the forms beneath. Though the panels on the reverse of the *Maestà* are small, they are painted with an epic sense of scale and a bold simplicity new to Italian painting. The *Maestà* is the only extant work we know to be by Duccio, although not all of it is by his hand. As far as we know, he always worked on a small scale.

JESUS CALLING THE APOSTLES

Another small panel from the predella on the reverse of Duccio's masterpiece, *The Calling of the Apostles Peter and Andrew (54)*, is a luminous and bare image of tremendous power.

Duccio divides the world into three: a great golden heaven, a greeny gold sea, and a rocky shore, where Jesus stands at the picture's edge. At the center are the two brothers Andrew and Peter, stunned by the incursion of the miraculous into their workaday existence. They have fished all night in vain; Jesus shouts to them to cast their net to one side, and they humor the stranger by obeying Him. The net comes up laden with fish, but they hardly seem to look at it. Peter turns questioningly to Jesus while Andrew stands motionless, looking out at us.

The clothes of the two disciples are pale in hue, whereas Jesus, in token of His spiritual profundity, wears blood crimson to symbolize His Passion and purple to indicate His royal status; the gold edging of His robe outlines His figure, dividing it from the golden background.

MARCO POLO
In 1271, Marco Polo, a Venetian merchant, traveled to China with his father and uncle. This French miniature shows the Polos receiving their safe-conduct documents from Kublai Khan, the emperor of the Mongol empire in China. While acting as an ambassador for Kublai Khan, Marco Polo saw lapis-lazuli stone being extracted from quarries in Afghanistan. This was to become an important pigment in Italian painting. When Polo returned to Italy in 1295, accounts of his travels provoked a fashion for all things oriental.

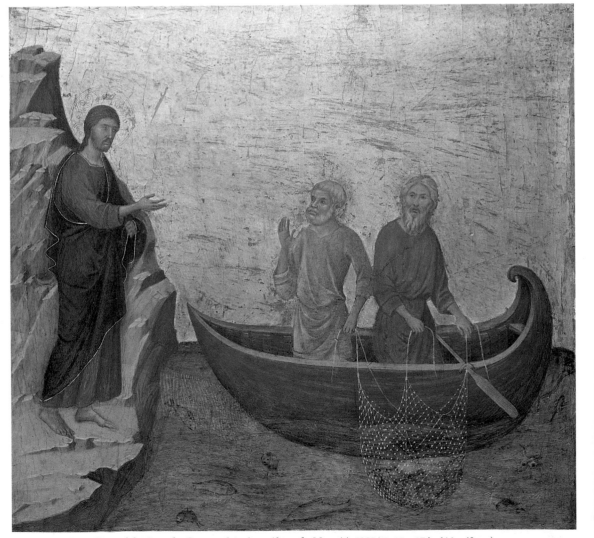

54 Duccio, **The Calling of the Apostles Peter and Andrew** *(from the* Maestà*), 1308/11, 18 x 17 in (46 x 43 cm)*

THE CALLING OF THE APOSTLES PETER AND ANDREW

In this panel from his *Maestà*, Duccio portrays the scene from Christ's life when He summons the two Galilean fishermen, Peter and his brother Andrew, to be His disciples. He is calling them to become "fishers of men" and bring new followers to Christ.

THE APOSTLE ANDREW

Andrew is shown in the moment of the revelation of his faith. While his brother Peter (who, according to the Scriptures, was always the active one) confronts Jesus, Andrew appears to be listening to another, unseen calling. As he pauses in his task of hauling in the nets laden with fish, he stands transfixed, with an expression of slow comprehension dawning on his face.

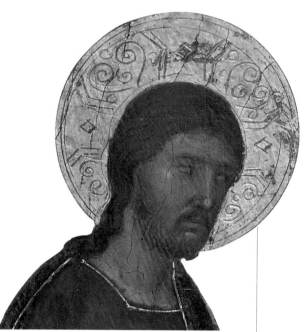

JESUS' CARVED HALO

The halo as a symbol of divinity was originally attributed to the sun gods Apollo, Mithras and Helios, and signified the sun's radiance and power. It first appeared in Christian art in the 4th century. Here, Christ's halo is carved into the wooden panel – a feature of Gothic panel painting, which would also often incorporate precious stones. The patterned surface of the halo attracts and reflects light, thereby intensifying its radiance and distinguishing it from the background.

CHRIST CALLING

Duccio portrays Jesus as a regal, authoritative figure. With His hand outstretched toward the two fishermen Peter and Andrew, He does not exactly invite, but gently commands. He stands barefoot on the rock, a symbol for the Church, and communes with Peter, whose name, meaning "the rock," was chosen by Jesus.

THE FISHING NET

The net comes up full, and this suggests that the apostolic mission will be richly rewarding. Although clearly suspended in the water, the net is superimposed over the transparent green sea (enlivened by the layer of warm gold beneath). Duccio shows little concern with three-dimensional space – the boat is a kind of wooden "envelope" slicing into the water with just enough depth to accommodate the two fishermen.

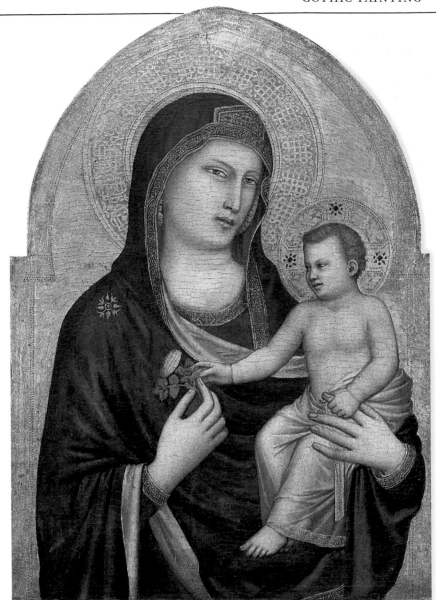

55 Giotto, Madonna and Child, probably c. 1320/30, 24½ x 34 in (62 x 85 cm)

GIOTTO

Duccio was a reinterpreter of Byzantine art. His great Florentine contemporary, Giotto (Giotto di Bondone, c. 1267–1337), transformed it. His revolutionary approach to form, and his way of depicting realistic "architectural" space (so that his figures are in scale in relation to his buildings and the surrounding landscape), mark a great leap forward in the story of painting. Gothic painting is widely regarded as reaching its height in Giotto, who so splendidly subsumed and reinvigorated all that had gone before. For the first time, we have in European painting what the historian Michael Levey calls "a great creative personality." The true age of the "personalities," however, was the Renaissance, and it is not without cause that writers on the Renaissance always begin with Giotto. Giant-like, he straddles two periods, being both of his

EARLY SCULPTURE
Guido da Como (active 1240–60) was a contemporary of the sculptors Nicola and Giovanni Pisano. However, his work belongs to the earlier, rigidly stylistic tradition. His figures, such as these riders and their horses, lack physical vitality.

time and before his time. His dates, however, place him firmly in the time we call Gothic, with its climate of spiritual grace and delight in the freshness of color and the beauty of the visible world. Gothic artists learned to depict a solidity of form, while earlier painters had shown an essentially linear world that was lacking in bulk and thin in substance despite spiritual forcefulness.

INFLUENCES ON GIOTTO

We know that Giotto went to Rome in 1300 and painted a fresco in the Lateran Palace. He understood the innovations of Pietro Cavallini (see p.34), the Roman artist whose strong, beautiful frescoes and mosaics show an amazing grasp of naturalism. Giotto's frescoes did not assimilate the Roman influence from within the Byzantine style, as Cimabue's panel paintings did; they went further, and transcended it. The real world was primary for Giotto. He had a true feeling for natural form, a wonderful sculptural solidity, and an unaffected humanity that changed the course of art.

Equal with Giotto in stature and innovation, and massively important to the way Giotto visualized his world, were Italy's greatest sculptors of the period, Nicola Pisano (d. 1278) and his son Giovanni (c. 1250 until after 1314).

Nicola Pisano came to live in Tuscany, Giotto's native province, in 1250. He was devoted to studying the sculptures of classical Rome, but more importantly, he brought with him a new and vital influence: the Gothic art of Northern Europe. The French court of Anjou, which had established itself in Naples in c. 1260, had brought a new influence to Italian sculpture (see column, p.41). Pisano's own art showed a convincing solidity of form and human individuality (see column, right), far removed from the rather wooden, stylized nature of all other sculpture that existed in Tuscany in his time (see column, left).

If we look at Giotto's paintings in direct relation to Pisano's sculpture, Giotto's pictorial "leap" is partly explained: sculptural form and space have entered the flat space of painting, and the paintings breathe, released once and for all from the rigid and stylized Byzantine tradition.

Giotto's panel paintings are necessarily physically smaller than his frescoes, but in them he seems to transcend size. Even a small *Madonna and Child (55)* has a weight of human significance that makes it seem large. Mary looks out on us with tender dignity, and the Child, kingly in person, sits on her arm as on a throne. Yet we are not kept at a distance: we approach with reverence, but we can identify with the emotion.

GIOTTO'S FRESCOES

The Arena Chapel in Padua is decorated with Giotto's greatest surviving work, a cycle of frescoes painted about 1305–06 showing scenes from the life of the Virgin and from the Passion. The frescoes run all the way around the chapel.

Giotto's *Deposition of Christ (56)*, which is one of the frescoes on the north wall of the Arena Chapel, is the end of the same adventure we see starting in Duccio's *Calling of the Apostles* (see p.44). Giotto has called all his forces into play in this visualization of one of the great episodes in the story of Christ. In contrast to the towering, remote heights of Duccio's and Cimabue's enthroned Madonnas, Giotto brings the action down to our human eye level, creating a startling truthfulness and transforming the familiar event into a humanly real, intensely moving drama. The great square is vibrant with activity, with saintly mourners, each clearly distinct and intent on a specific action. His Mother, a woman of almost masculine determination (Giotto always

depicts her as tall and stately), clasps the dead body to her, controlled and tragic. Mary Magdalene humbly holds His feet, contemplating through her tears the marks of the nails. St. John makes a wild gesture of despairing grief, flinging back his arms, offering his breast to the terrible reality. The older men, Nicodemus and Joseph of Arimathea, stand to the side, reticent, mournful, while Mary's companions, who supported her at the foot of the cross, wail and lament and shed the tears that she does not. Such a bloodstained earth is no place for the angels, but they swoop and somersault with the roarings of their sorrow.

One lone and leafless tree on the arid hillside behind hints at the horror of the death, yet the darkened blue of the sky has a secret luminosity. Giotto and his contemporaries knew, even if the wildly passionate angels do not, that Christ would rise again. The strange self-possession of the Virgin may spring from this prophetic inner certainty, and it is a measure of Giotto's narrative conviction that we should ponder these

DANTE
Dante Alighieri (1265–1321) is one of Italy's greatest poets. His most famous work, the *Divine Comedy*, was considered innovative because it was written in Tuscan (the language of the common people) rather than Latin. The allegorical poem was divided into three parts and told the story of the poet's journey through Hell, Purgatory, and Paradise. It is filled with detailed descriptions of real people as well as legendary ones. Giotto, for example, appears in the *Purgatorio* section. Here, Dante is shown reading from the *Divine Comedy*.

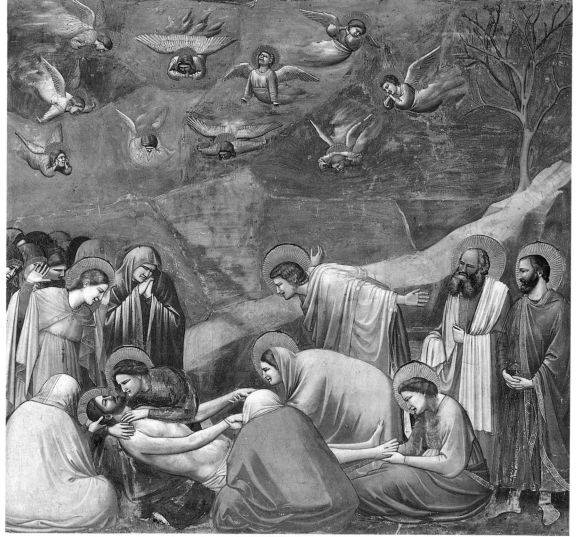

56 Giotto, Deposition of Christ, c. 1304–13, 6 ft 7 in x 7 ft 7 in (200 x 230 cm)

PISANO'S SCULPTURES
Nicola Pisano's *Allegory of Strength* is one of the supporting column figures from the Baptistery pulpit at Pisa, Italy. Completed in 1260, the pulpit is acknowledged as Pisano's masterpiece. Many of Pisano's sculptures had a strong influence on Giotto.

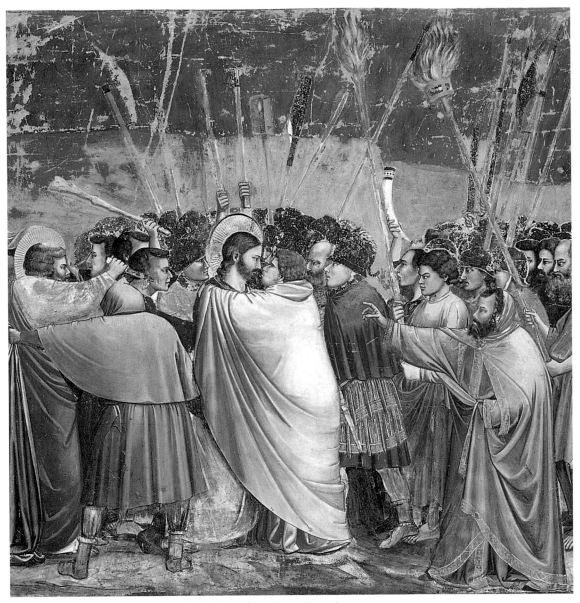

57 Giotto, **The Kiss of Judas,** *c. 1305–06, 6 ft 1 in x 6 ft 7 in (185 x 200 cm)*

GIOTTO´S CAMPANILE

Although we now think of Giotto primarily as a painter, he was also a skilled architect and sculptor. In 1334 he was appointed architect of Florence's city walls and fortifications. He also designed a campanile (bell tower) for the cathedral, although when it was built (above), only the lower sections were completed to Giotto's original specifications.

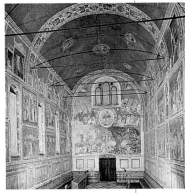

ARENA CHAPEL

The Arena Chapel in Padua was founded by Enrico Scrovegni in 1303 to atone for the sins of his father, a notorious usurer. The chapel contains many of Giotto's finest frescoes, including *The Kiss of Judas.*

possibilities. The very color and forms, so clear, solid, and whole, so forthright, reassert this mystic certainty, without any concession to the apparent hopelessness. Six centuries afterward, the great French artist Henri Matisse (see p. 336) was to say that we need not know the Gospel story to catch the meaning of a Giotto painting: it carries its own truth within.

MOMENT OF BETRAYAL

Giotto has a startling power to organize the excitement of a scene around a central image. *The Kiss of Judas (57),* another fresco from the Arena Chapel, sways and surges, every actor alive and functioning, either for or against Christ. Torches blaze and weapons whirl. But at the heart there is only a tragic stillness,

as Jesus looks into the mock-friendly eyes of His disciple Judas, and truth confronts falsehood with sorrowful love. The betrayer and the betrayed form the solid center, with the jaundiced yellow of Judas's cloak billowing over the figure of Christ as if to swallow Him up. As in all Giotto's work, the heads are of the utmost importance, the natural focal point of the human dramas.

Time and again in the cycle, it is the facial expression, the direction of the eyes, sheer body language that expresses the emotion. Artists working in the Byzantine style had a formula for the head: they painted a three-quarter view, and so the characters looked sideways. The effect of this was to exclude any personal involvement with the viewer or among themselves. But for Giotto, art was all about involvement.

THE KISS OF JUDAS

Judas Iscariot was the apostle who betrayed Jesus to the authorities, and then, unable to live with the consequences of his action, hanged himself. Giotto's painting depicts the moment when Judas identifies Jesus to the high priests and soldiers, with a kiss.

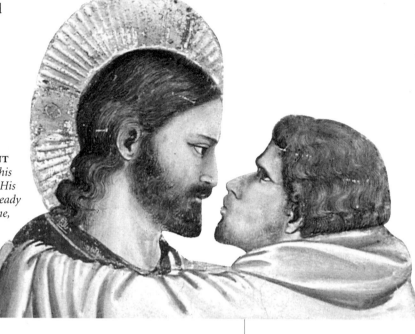

A FROZEN MOMENT

Christ and Judas provide the only still part in this impassioned scene. Christ is an image of constancy, His calm brow and steady eye contrasting with Judas's already troubled, frowning face. Giotto has suspended time, and Jesus' searching gaze silently communicates both foreknowledge that He is being betrayed, and understanding of Judas's heart.

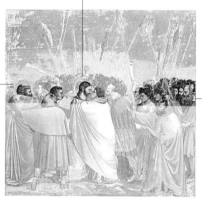

PETER DEFENDS JESUS

All action draws our attention to the main figures of Christ and Judas. The swords and torches either fan out from them, almost as an extended halo, or sway toward them. The gesticulating priest on the right is counterbalanced by the apostle Peter on the left, who, in his anger, has cut off a soldier's ear.

THE ARREST

In the dense, organic mass of soldiers, Giotto creates an unstoppable tidal force. They advance in one movement toward Christ, who is already engulfed in Judas's cloak. Many are indistinguishable, nonpersons, their ranks merely punctuated by the repeated diagonals of their weapons.

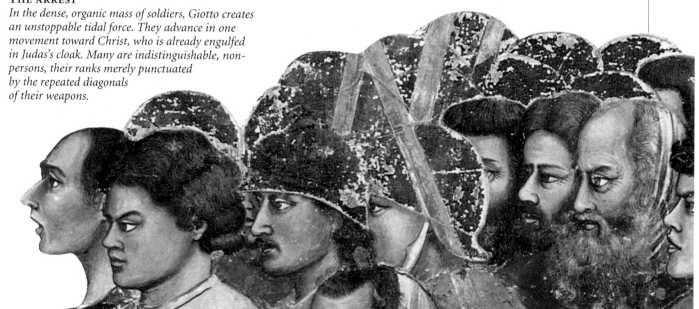

OTHER WORKS BY GIOTTO

Stigmata of St. Francis
(Louvre, Paris)

Madonna Enthroned
(Uffizi, Florence)

Dormition of the Virgin
(Staatliche Museen, Berlin-Dahlem)

John the Baptist Cycle
(Peruzzi Chapel, Santa Croce, Florence)

Crucifix
(Museo Civico, Padua)

COMBINING GOTHIC ELEMENTS

The most quintessential Gothic artist is Simone Martini (c. 1285–1344). Of the Sienese painters, he is the only one who can be said to have rivaled his teacher, the great Duccio. As Simone was, artistically, a direct descendant of Duccio, his art still held links with the Byzantine tradition of remote spirituality. It also acknowledged Giotto's spatial innovations and the elegant Gothic style of Northern Europe (represented by France), which was by then popular in Siena. As early as 1260, the French monarch, Robert of Anjou, brought his court to Naples, and before 1317, Simone was called to the court to paint a commission for the king. Simone was greatly influenced by the art of the Angevin court, with its characteristic elegance and courtly refinement, which distinguished the French Gothic tradition from the early Italian developments. The influence of Northern Gothic style (see p.60) on Italian art is strongest in Simone's work: his concern with graceful form and with uninterrupted, free-flowing line and pattern; the mannerisms and delicate gestures of his figures; and the "precious" quality and craftsmanship of his paintings reveal him as the definitive artist of the "Gothic-Italian" genre, and an early exponent of the International Gothic style (see p.54).

GOTHIC GRACE

Simone's figures have an extraordinary physical fluidity: whether angelic or human, they sway and sweep across the scene, dazzlingly beautiful, like some magical inhabitants both of our

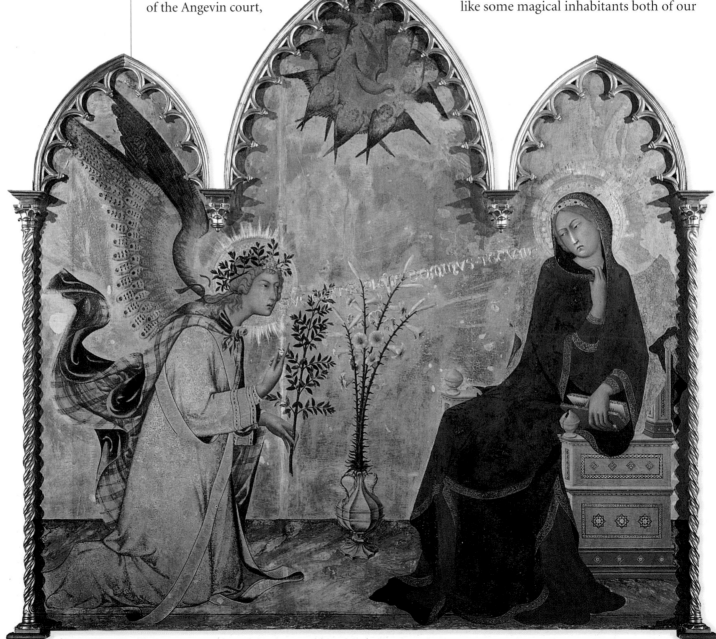

58 Simone Martini, The Angel and the Annunciation, 1333, 10 ft x 8 ft 8 in (305 x 265 cm)

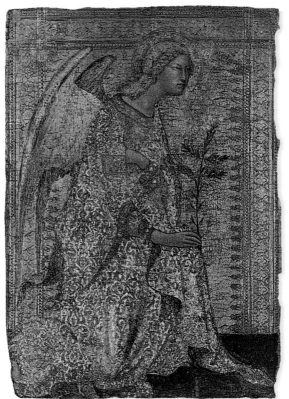

59 Simone Martini, **The Angel of the Annunciation***, c. 1333, 8½ × 12 in (22 × 30.5 cm)*

event, is believed to have been a diptych, the right panel of which is now lost. It contained the Virgin, to whom the angel extends an arm, holding an olive branch. The absence of the Virgin is almost a felix culpa (happy mischance) since we are each forced to take her place, entering into the silent drama.

FAMILY CONFLICT

Simone's graciousness and love of beautiful clothes are not superficial. He can combine them with an electric sense of conflict. *Christ Discovered in the Temple (60)* is an extraordinary evocation of the generation gap, as the Child Jesus and His Mother oppose each other with dismaying incomprehension, and St. Joseph tries ineffectually to bridge the gap between them. This is the chilling moment when Jesus reaches that crucial stage in growing up, when we come to realize that even those we love and trust do not understand, and cannot be expected to. We are each alone, each unique, and this can cause problems in even the best of families.

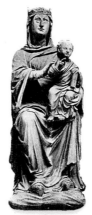

CULT OF THE VIRGIN

When the cathedral at Chartres was rebuilt in the Gothic style after a fire in 1194, it was dedicated to Christ's Mother. This set a trend among new churches and was part of the growing cult of the Virgin. Many Gothic artists also chose the Virgin as their subject, which is reflected in the numerous Annunciation paintings and her prominence in Crucifixion pictures. This sculpture, completed c. 1330, in the Opera del Duomo in Florence, is by Arnolfo di Cambio.

world and of Heaven; feet are firmly on the earth, yet the whole being breathes the enchantments of another reality. There is no artist quite like Simone, both in the great daring of his color combinations and in the persuasive force with which he invites us to enter the world of his singular imagination. This applies equally to his later, more intensely passionate works. His sense of drama is poignantly clear in *The Angel and the Annunciation (58)* in the Uffizi Gallery, Florence. In it we see Mary shrinking, almost aghast at the solemnity of being asked to bear God's Son.

But even at this moment of profound spiritual bewilderment, Mary sways with the Gothic grace that is so characteristic of Simone's art. She is all in blue, usually understood to symbolize the heavens. The angel is a dazzle of golden color. The observer is aware of a sacred encounter in which Heaven and earth become one. Mary and the angel lock eyes, each affecting the other. *The Angel of the Annunciation (59)*, another version of the same

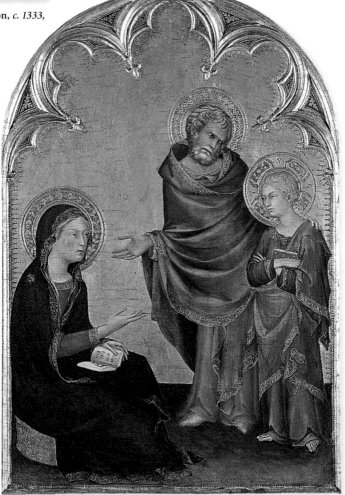

60 Simone Martini, **Christ Discovered in the Temple***, 1342, 14 × 20 in (35 × 50 cm)*

PETRARCH

Francesco Petrarca (Petrarch, 1304–74) was an Italian poet, famous for his *Canzoniere,* a collection of poems inspired by his idealized love for a woman named Laura. He was a friend of Simone Martini, whom he mentions in two of his sonnets. Simone returned the compliment by painting this frontispiece to Petrarch's copy of Maurius Servius Honoratus's *Commentary on Virgil.*

61 Pietro Lorenzetti, St. Sabinus Before the Governor, *c. 1342,
13 X 14¾ in (33 X 37.5 cm)*

THE LORENZETTI BROTHERS

If Simone is a worthy disciple of Duccio, then his contemporaries, the two Lorenzetti brothers, Pietro (active 1320–48) and Ambrogio (active 1319–48), are stamped with the mark of Giotto, though both are Sienese. They represent Giotto "Duccioed," painting great columnar forms that yet have a tender grace. Their paintings reveal a stronger affinity with Giotto's unique psychological vitality than with the conscious elegance and refined craftsmanship of their own most illustrious contemporary, Simone Martini. Both brothers died suddenly in 1348, probably victims of the terrible European epidemic, the Black Death (see p.58).

There is near-monumentality as well as a great gentleness in Pietro Lorenzetti's panel painting of *St. Sabinus Before the Governor (61)*. Sabinus, one of the four patron saints of Siena, refuses to offer sacrifice to the strange little idol as directed by the Roman Governor of Tuscany. The white-clad figure of the saint, who exudes an air of calm stillness and resolution, commands our attention, while the seated figure of the governor is depicted with his back to the observer. We are aware of spaciousness, both literally and of the mind.

Ambrogio, the younger brother, combines the weighty and the perceptive in his small painting *The Charity of St. Nicholas of Bari (63)*. It depicts the moment in the legend when the saint throws the three golden balls into the bedroom of the daughters of an impoverished aristocrat.

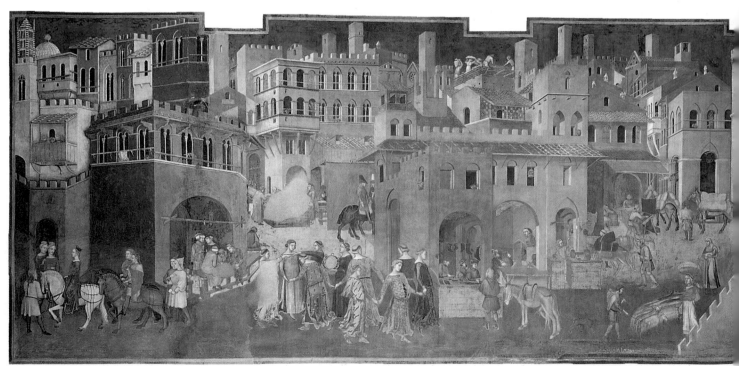

62 Ambrogio Lorenzetti, Allegory of Good Government: Effects of Good Government in the City and the Country *, 1338–39, 46 X 8 ft (14 X 2.4 m)*

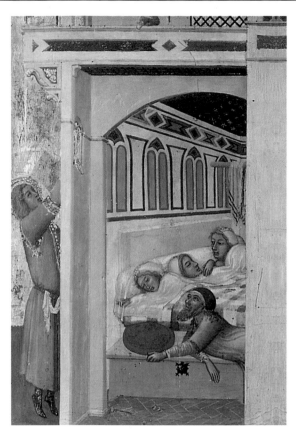

63 Ambrogio Lorenzetti, **The Charity of St. Nicholas of Bari,** *c. 1332, 8 X 11¾ in (20 X 30 cm)*

The balls (from which we derive the pawnbroker's sign) will serve as dowries for the girls. Their father looks up, stunned, and the eldest daughter raises an astonished head as well.

PANORAMIC LANDSCAPE

The masterpiece of early landscape painting that is Ambrogio's particular claim to fame is his fresco depicting the *Effects of Good Government in the City and the Country (62),* commissioned for the interior of the Palazzo Pubblico in Siena. Never did any state have its ideal so superbly set before it. The Lorenzetti vision is of a world blissfully ordered, painted with remarkable naturalism and sharp observation, based on the city of Siena itself. A companion painting, representing the consequences of bad government in the city, is also in the Palazzo Pubblico, but is, unfortunately, badly damaged.

This sort of bird's-eye, panoramic view is so familiar to us today, though more commonly in the form of a photograph, that we may not realize the extraordinarily avant-garde nature of this painting. It is the first attempt to show a real place in a real setting with its real inhabitants, and to make this wholly secular theme appear as jewellike and precious as anything religious. This is not Bethlehem or Nazareth, but the actual worldly city of Siena, with its streets and shops and its patchwork of fields. Parts of the present-day town can even be recognized.

The panorama is painted from a variety of viewpoints and the buildings are not in scale with the figures. It depicts a time of peace, in which commerce, industry and agriculture are all shown to be flourishing, and the inhabitants, who are depicted in a variety of pursuits, are clearly contented.

PALAZZO PUBBLICO
Building work on the Palazzo Pubblico (town hall) in Siena began in 1298. Ambrogio Lorenzetti's panoramas of the city were painted on its interior walls.

CONTEMPORARY ARTS

1322
Consecration of Cologne Cathedral, one of Germany's great Gothic buildings.

1330
Andrea Pisano begins work on the bronze doors of the Florence Baptistery.

1348
Italian poet Boccaccio starts writing *The Decameron,* a collection of 100 short stories told by evacuees from a plague-bound city.

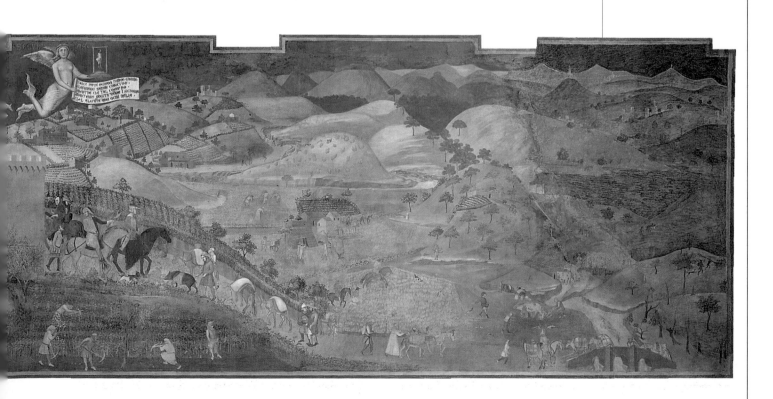

INTERNATIONAL GOTHIC STYLE

By the end of the 14th century, the fusion of Italian and Northern European art had led to the development of an International Gothic style. For the next quarter of a century, leading artists traveled from Italy to France, and vice versa, and all over Europe. As a consequence, ideas spread and merged, until eventually painters in this International Gothic style could be found in France, Italy, England, Germany, Austria, and Bohemia.

FROISSART'S CHRONICLES

In the mid-14th century the French cleric Jean Froissart wrote a history of contemporary wars. The chronicle was richly decorated throughout; this illustration shows the Battle of Crécy, which took place in 1346. The battle was one of a series fought by France and England between 1337 and 1453, a period referred to as the Hundred Years' War. By 1360, the English, under Edward III, had captured much of northern France and profited financially while the French suffered. However, gradually the French regained territory and had reconquered most of France by 1453.

DIPTYCH

Diptychs are paintings in two, normally equal, parts, often linked together with hinges. Most Gothic diptychs depict the praying figure of the owner or donor of the painting in one panel, and the Madonna and Child in the other.

The influence of Simone Martini (see p.50) had spread far. He had left Italy in either 1340 or 1341 to work at the papal court, which was then in Avignon, France (see column, right). His extreme pictorial refinement was very much to the court's taste. The International Gothic style had a particularly courtly and aristocratic flavor, infused with a specially Flemish concern for naturalistic detail and, unlike the diverse strands of early Gothic art, it had a distinct and unified character. One classic example of the truly International style is the *Wilton Diptych (64)* now kept in the National Gallery, London. This exquisitely delicate, self-consciously monarchial work has proven impossible to attribute, and difficult to date. In fact, it could have been painted at any time during the reign of

Richard II (1377–99) and, even more significantly – attesting to its truly international style – scholars have been unable to agree on the nationality of the artist, only that he could have been English, French, Flemish, or Bohemian. The title of the painting is not original: it was once housed at Wilton House in Wiltshire, England.

The *Wilton Diptych* depicts Richard II of England kneeling before the Madonna and Child. He is accompanied by two English saints, Edmund (carrying an arrow) and Edward the Confessor (holding a ring); the third figure is John the Baptist. All the angels wear jewels in the form of a white hart, the personal emblem of King Richard. The painting may be intended to emphasize Richard's "divine right" (royal authority) as confirmed by the blessing he receives from the Christ Child. It also contains a clear reference to the Epiphany, with three kings worshiping the infant Jesus.

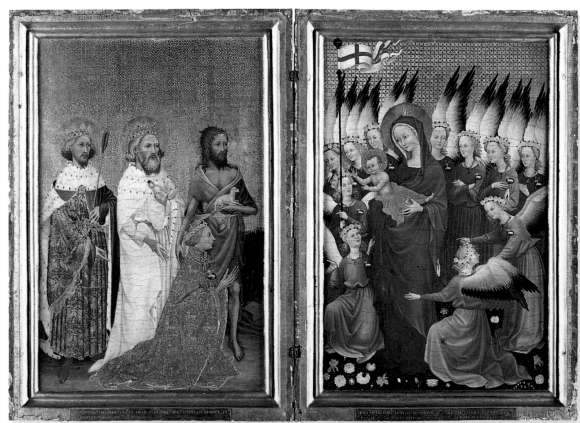

64 **Anonymous**, **The Wilton Diptych**, *c. 1395, 11½ x 18 in (29 x 46 cm) each panel*

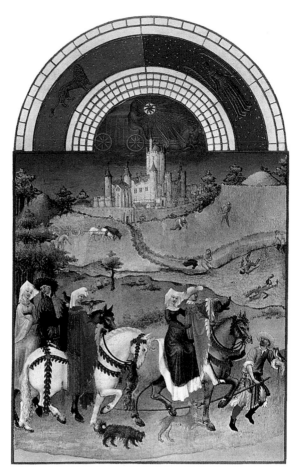

65 The Limbourg Brothers, August, from Les Très Riches Heures du Duc de Berry, 1413–16, 8 x 11½ in (20 x 29 cm)

MASTERS OF ILLUMINATION

The ancient art of book illumination (see pp.28–33) was still the prevailing form of painting in France at the beginning of the 15th century. It reached new heights, however, in the work of the Limbourg brothers, Pol, Herman, and Jehanequin, exponents of the International Gothic style. They came from Gelderland, a province of the Netherlands, but worked in France. They were the only other Gothic painters to take such orderly joy as that shown by Ambrogio Lorenzetti (see p.52) in the city and its environment, its people, and its rulers. The Limbourg brothers all died suddenly in 1416, probably of the plague.

The Limbourgs' joint master-piece, *Les Très Riches Heures*, was commissioned by the wealthy and extravagant manuscript collector, the Duc de Berry (see column, right).

Les Très Riches Heures is one of a genre of 15th-century illustrated prayer books known as "books of hours." The "hours" were prayers to be said at one of seven hours of the day. A book of hours would naturally contain a calendar, and this became the opportunity for a display of the illuminator's talent. Sadly, this particular example was unfinished at the time of the Limbourgs' and the Duc de Berry's deaths.

Each month is marked by an enchanting scene, usually showing appropriate seasonal activities. In *August (65)* we see courtly lovers riding to hunt with their falcons, while the great white ducal castle gleams in the distance and the peasants swim happily in the winding stream. The blue upper part of the painting shows an astrological hemisphere. With its mixture of courtly refinement and everyday reality, this miniature is representative of many in the book.

The Garden of Eden (66) was painted separately from the rest of *Les Très Riches Heures* and inserted into it later. It is a great enclosed circle showing the world as it was intended to remain before Adam and Eve's fall from grace. The whole story of the loss of Eden and human self-will is set graphically before us. Adam and Eve are finally ejected from the lush greenery of Eden onto a dangerous rocky shore. The Limbourgs' consciousness of tragedy is no less acute for being so chivalric in its manner. For all their elegance, they are as aware as all great artists that pain is our human lot.

66 The Limbourg Brothers, The Garden of Eden from Les Très Riches Heures du Duc de Berry, 1413–16, 8 x 8 in (20 x 20 cm)

MANUSCRIPT ILLUMINATION
This 15th-century illumination shows a lady painting the Virgin and Child. Women of the upper classes were not expected to work, but activities such as illuminating and weaving were acceptable occupations.

DUC DE BERRY
Jean, Duc de Berry, was a younger brother of Charles V of France. He ordered the building of a number of castles and filled each with specially commissioned works of art, including tapestries, paintings, and jewels. He is reputed to have owned 1,500 dogs.

POPE MARTIN V
The election of Pope Martin V in 1417 ended a period of crisis in the Western church known as the Great Schism (1378–1417), during which rival French and Italian popes held office. There were disagreements even before the Schism, and for 67 years (1309–76) the papal court was relocated from Rome to Avignon in France. During this period, Avignon became an important center for artists.

GENTILE DA FABRIANO

International Gothic art is also exemplified by the well-traveled and influential Italian artist Gentile da Fabriano (c. 1370–1427), who helped spread the International Gothic style across extensive areas of Italy. He crams every sector of his great panels with romantic activity, delighting, with his affectionate detail, in the sheer variety of a world he does not present too realistically, but just realistically enough to be convincing. It is a novelist's world, rich in human interest and engagingly plotted.

Most of Gentile's works, on which his reputation was made in his own lifetime, have not survived. Of those that are still known today, the most extraordinary is *The Adoration of the Magi (67)*. In this scene a cast of

thousands, or so it seems, throngs the stage, providing constant interest and animation, but without any confusion of the story line. The Magi – the three kings from the East (see also column, p.98) – have come to adore the Christ Child with all their exotic retinue: camels, horses, dogs, dwarfs, and courtiers. But all attention is focused on the tiny figure of Christ, leaning forward from His Mother's clasp to lay a loving hand on the great hulking mass of the old king kneeling before Him.

As in the case of Simone Martini's *Angel of the Annunciation (58)*, the elaborate and sumptuously decorated, vaulted Gothic frame is an integral part of the work and has direct bearing on the compositional structure. The *Adoration* was commissioned by Palla Strozzi, the richest man in Florence, for the church of Santa Trinità.

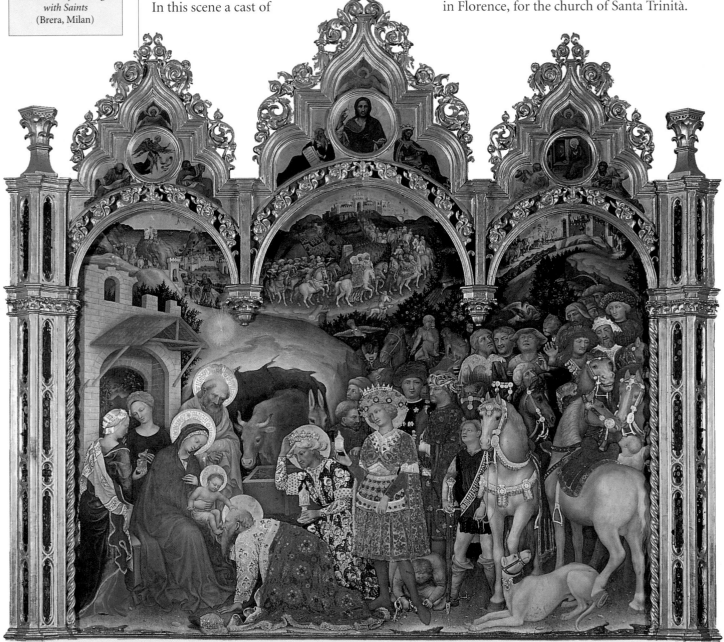

67 Gentile da Fabriano, **The Adoration of the Magi,** *finished 1423, 9 ft 4 in x 9 ft 10 in (285 x 300 cm)*

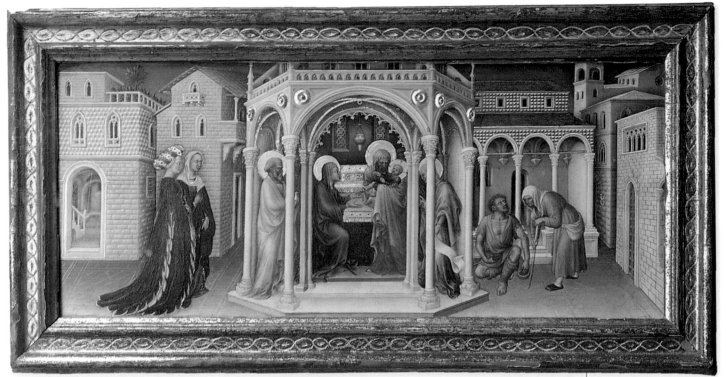

68 Gentile da Fabriano, **The Presentation of the Child in the Temple,** *1423, 26 x 10 in (65 x 25 cm)*

The strong anecdotal feeling in Gentile da Fabriano's work is also clear in *The Presentation of the Child in the Temple (68).* The sacred event is the central feature of the painting, but on either side life goes on, with two stately women gossiping and beggars seeking alms.

PAINTER AND MEDALIST

This same lucidity of Gentile's is also seen in his fellow Italian artist Antonio Pisanello (c. 1395–1455/6). For decades it was thought that almost all of his frescoes had perished. Happily, a number have recently been uncovered in Mantua.

His panel painting *The Virgin and Child with Saints George and Anthony Abbot (69)* shows an extraordinary confrontation. The almost savage rusticity of St. Anthony the Hermit, in his rust-colored cloak, is contrasted with the urban sophistication of St. George, attired with the utmost modishness from large white hat to elaborately spurred bootlets. (St. George has no halo, but this is more than compensated for by his hat.)

Yet, despite the bizarre fascination of these two saintly figures, never for a single moment does Pisanello let us forget the importance of the Virgin and Child. They hang in the air, enclosed in what seems to be the circle of the sun, and it is they who integrate and give meaning to the scene.

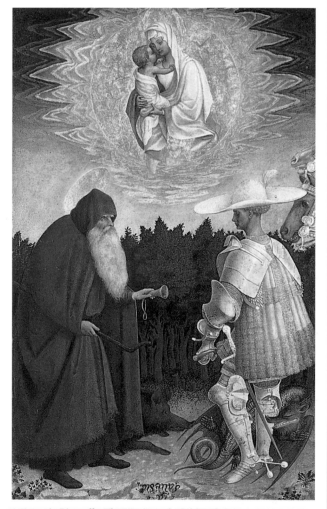

69 Antonio Pisanello, **The Virgin and Child with Saints George and Anthony Abbot,** *mid-15th century, 11½ x 18½ in (29 x 47 cm)*

" Michelangelo …in speaking of Gentile [da Fabriano] used to say that his hand in painting corresponded to his name. "

Giorgio Vasari,
Lives of the Painters,
1568

PISANELLO MEDAL

Pisanello was as famous for his portrait medals as he was for his paintings. The medals carried a likeness of the patron on one side and an allegory or landscape on the reverse. This example, produced c. 1445, shows the Duke of Rimini.

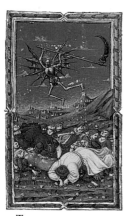

THE BLACK DEATH

In 1347, the plague, known as the Black Death, spread down the trade routes from China. By 1348, it had taken hold in most of Europe. The key symptoms were glandular swellings and black boils, leading to a swift but painful death.

In some towns, the population was reduced by 40 percent; whole villages were wiped out. The severity of the epidemic led to heightened religious fervor and an obsession with death. This illustration shows the Angel of Death indiscriminately destroying all classes of people, as did the Black Death.

70 The Master of the Rohan Hours, The Dead Man Before His Judge, *c. 1418–25, 7½ x 10½ in (19 x 27 cm)*

THE BLACK DEATH AND THE ARTS

Some Gothic art clearly shows the impact of the great medieval disaster: the Black Death. This epidemic, now though to be of bubonic and pneumonic plague, devastated Europe from 1347 to 1351, claiming almost a third of the population. Many contemporaries viewed the Black Death as a judgment from God on the corruption of His people. This provoked a wave of popular enthusiasm, not, unfortunately, for religion itself, but for the "comfort religion" that excessive penances, like flagellation, provide. Artists, such as the Master of the Rohan Hours, reflected their interest in death and judgment in their work. The terrible realism of the miniature illumination *The Dead Man Before His Judge (70)*, for example, presents a striking contrast with the Limbourgs' miniatures (see p.55). Here, the unknown artist shows his unflinching consciousness of the meaning and inevitability of death. The painting, despite its archaic perspective and spatial ambiguities, is

extremely impressive. The horror of such death is intensified by the way the pock-marked and rotting corpse fills the page, seeming near to us, and striking even the most casual of viewers with a sense of holy dread.

The dead man's last prayer is written in Latin on a white scroll: "Into Thy hands I commend my spirit; thou hast redeemed me, O Lord, the God of truth."

God holds a globe and a sword as symbols of His power as both creator and Supreme Judge. In response to the dead man's prayers, He replies in French: "For your sins you shall do penance. On judgment day you shall be with Me."

The small figures at the top left of the miniature depict St. Michael, aided by his army of inconspicuous angels, attacking a devil who is attempting to take possession of the dead man's soul, represented by an adolescent nude.

SIENESE ASSURANCE

Other examples of contemporary art in the International Gothic style seem to be unaffected by the terror of the Black Death. Indeed, there seems to be a happy inner security in many of the Gothic painters that is infinitely poignant. It may have a touch of the fairy tale about it, as it does in the delightful Sienese master Sassetta (Stefano di Giovanni, 1392– 1450), whose panel painting *The Meeting of St. Anthony and St. Paul (71)* shows the enduring influence of French illuminated manuscripts. The two hermits meet in a "Red Riding Hood" sort of forest, and embrace as simply as children, affirming their love.

The panel is one of a series telling the story of St. Anthony Abbot, said to be the founder of monasticism. At the top, we see St. Anthony, who at the age of 90 abandoned his hermit life after having a vision, setting out to visit St. Paul the Hermit, who was by then 113. On his journey he encounters a centaur (half man and half horse), a symbol of paganism. St. Anthony blesses him and converts him to Christianity.

The foreground of the picture shows the story's conclusion as the two saints exchange fond greetings, their staffs lying on the ground beside them (St. Anthony's staff is always shown as a T-shaped crutch) as they lean forward onto each other.

For almost all of Sassetta's life, the Sienese people lived peacefully (apart from a short period in the 1430s) under a republican government. This meant that they could enjoy a fertile relationship with their rival, the bigger and more powerful neighboring city of Florence.

Sassetta was the most important Sienese artist of the 15th century. His art was steeped in the Sienese Gothic tradition, but he happily absorbed influences from the great, innovative Florentine artists of the day, such as Masaccio (see p.82) and the sculptor Donatello (see p.83).

CHAUCER

By 1500, the language of the English court had changed from French to English. The change to the use of English is seen much earlier in the writings of Geoffrey Chaucer. Born in 1343 to a wealthy London family, he became one of King Edward III's attendants, a position that enabled him to travel and earn enough money to write. His most famous work, *The Canterbury Tales*, describes a wonderful cross-section of 14th-century society, while for the first time using a poetic language that could be understood by everybody in the country.

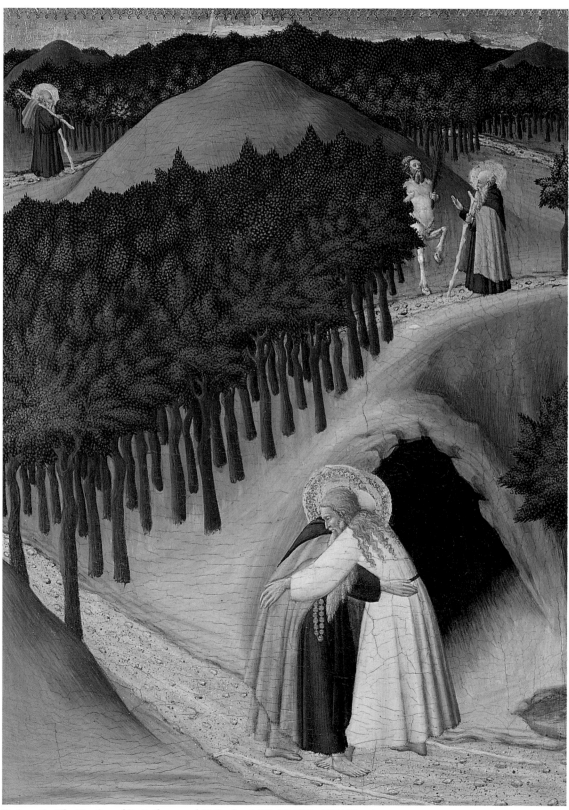

71 **Sassetta**, The Meeting of St. Anthony and St. Paul, *c. 1440, 14 x 19 in (35 x 48 cm)*

OTHER WORKS BY SASSETTA

St. Thomas Aquinas Before a Crucifix (Vatican Museum, Rome)

St. Francis Renounces His Earthly Father (National Gallery, London)

The Mystic Marriage of St. Francis (Musée Condé, Chantilly)

The Journey of the Magi (Metropolitan Museum of Art, New York)

The Burning of Jan Geus (National Gallery of Victoria, Melbourne)

The Betrayal of Christ (Detroit Institute of Arts)

INNOVATION IN THE NORTH

In the 15th century the International Gothic style developed in two directions. Both could be called revolutions. One was in the South, in Florence, and was the birth of the Italian Renaissance (see p.82). The other took place in the North, in the Low Countries, where painting went through an independent but equally radical transformation: this was the beginning of the Northern Renaissance movement (see p.148).

THE NETHERLANDS

In the 15th century, the area shown above (with modern boundaries) was known either as the Low Countries or the Netherlands. Flanders (shaded) was the center of artistic activity. Netherlandish and Flemish were used interchangeably, although the latter refers to the smaller area of Flanders.

The new form of painting that appeared in the Netherlands at the beginning of the 15th century was distinguished by a depth of pictorial reality that had not been seen before. It rejected the seductive elegance and overtly decorative elements of the International Gothic style, and whereas before, in the sacred painting of the 14th century, there was a sense of the viewer being offered glimpses of Heaven – of putting an insignificant foot in the door, so to speak – the Flemish painters brought the sacred down to our real world. Instead of depicting a form of high drama for which the world served as a kind of grand stage, artists chose to portray real-life domestic interiors – living rooms and bedrooms that revealed the commonplace belongings of everyday human existence. We find a growing peace with the world and one's place in it in the work of the Northern painters. Robert Campin (active 1406–44), one of the earliest great Northern innovators and the teacher of van der Weyden (see p.67), is now believed to be the artist known as the Master of Flémalle. (This name is derived from a group of panel paintings that were thought to have originated in an abbey at Flémalle-lez-Liège.) In fact, Campin lived and worked in Tournai (both these places were in Flanders).

THE SACRED IN THE EVERYDAY

In his *Nativity (72)*, Campin presents an intense abundance, a world crowded with individuals and the unromantic realities of being alive. He portrays a puny newborn Christ, a sullen midwife, coarse shepherds, and a cow in its rickety stable, yet everything is solid, lovely, true, and despite its realism, all is pervaded by a deep though unself-conscious faith.

Even more striking is Campin's *Virgin and Child Before a Firescreen (73)*, where simple domesticity is emphasized by the wickerwork firescreen that provides the Virgin's halo. By tradition, International Gothic style indicated holiness with a golden circle.

The painting's upper left-hand corner contains a view of a town seen through the open window. Little landscapes like this were

72 Robert Campin, Nativity, c. 1425, 28 x 34 in (71 x 85 cm)

73 Robert Campin, **The Virgin and Child Before a Firescreen,**
c. 1430, 19½ x 25 in (49 x 63 cm)

GLIMPSE OF A TOWNSCAPE
This detail from Virgin and Child Before
a Firescreen *shows a miniature landscape
glimpsed through the open window.
Campin depicts a busy town dominated
by a Gothic-style church. The gabled
buildings are typical of contemporary
Netherlandish architecture.*

CHIVALRY
Many medieval paintings
illustrated chivalry,
which was part of the
contemporary concept
of knighthood. Gradually
the basic forms of chivalry,
with an emphasis on valor,
honor, courtesy, loyalty,
and chastity, gave way
to the courtly love
inspired by Arthurian
romances. This was a
movement toward
the idea of unfulfilled
desire – love as a religion
in itself. On this painted
Flemish shield, a lady
stands before a kneeling
knight who vows to
honor her or die.

often seen in Netherlandish painting, and
the idea of encapsulating the world through
a window was later attractive to Italian artists.

Spirituality and reality are now brought
together, and the setting is Campin's own world:
the bourgeois interior. Once we have an alliance
of the sacred and the commonplace, it becomes
possible for representational painting in all its
specificity to express the sacred. The close
attention given to ordinary objects – each
awarded absolute clarity – invested them with
a quality of silent, mystical significance. There
is an aura of mystery here as the seemingly
ordinary becomes startling and powerfully
present, and this is fully applicable to portraiture.

Up to this time, portraiture as we understand it
today had not existed since antiquity.
Paintings that resembled "portraits" had served
specific functions, such as recording an event.
Robert Campin was the first to look at people
with a new artistic eye, bringing out the
psychological individuality of the subject.
His *Portrait of a Woman (74),* with its animated
face peering out from a plain white headdress,
shows his mastery of light effects. His focus
is sharp, forcing us to look at what he paints.

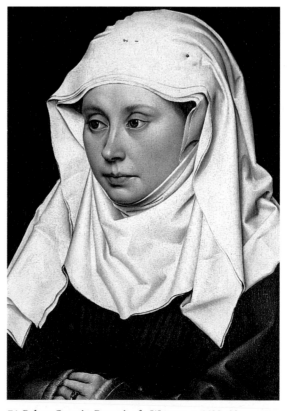

74 Robert Campin, **Portrait of a Woman,** *c. 1420–30,
11 x 16 in (28 x 40 cm)*

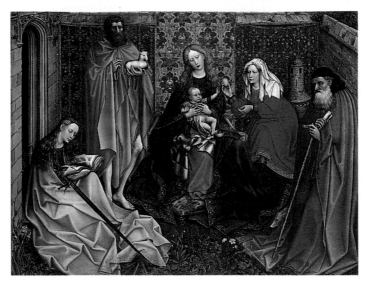

75 Follower of Robert Campin, **Madonna and Child with Saints in an Enclosed Garden,** *c. 1440/60, 58½ x 47 in (150 x 120 cm)*

The portrait is a good example of the new style of painting in the Netherlands. Portraits began to reveal less of a family look and more of the individuality of the sitter. Campin introduced a new facial type that continued in van der Weyden (see p.67).

In *Madonna and Child with Saints in an Enclosed Garden (75),* a follower of Campin attains the same comforting assurance that Campin showed in his *Nativity* (see p.60). The enclosed garden in which Mother and Child are shown with a group of saints is the Garden of Paradise – a "managed" Paradise. A walled or fenced garden is a traditional symbol of the virginity of Mary.

A NEW REALISM

This inner certainty reaches its peak in Jan van Eyck (1385–1441), a contemporary of Campin and one of the enduring influences on his century. He had an eye almost miraculously responsive to every detail of his world, not just in that he saw it, but that he understood its value. Van Eyck's natural habitat was one of luminous clarity; he saw the most ordinary things with a wonderful sharpness and a great sense of their awesome beauty. We know little about him personally, but he is the most overwhelming of painters in the convictions he enables us to share.

Like the 17th-century Dutch painter Vermeer (see p.208), van Eyck takes us into the light, and makes us feel that we too belong there. Van Eyck's meticulously detailed *Adoration of the Lamb (76)* is part of a huge altarpiece; painted

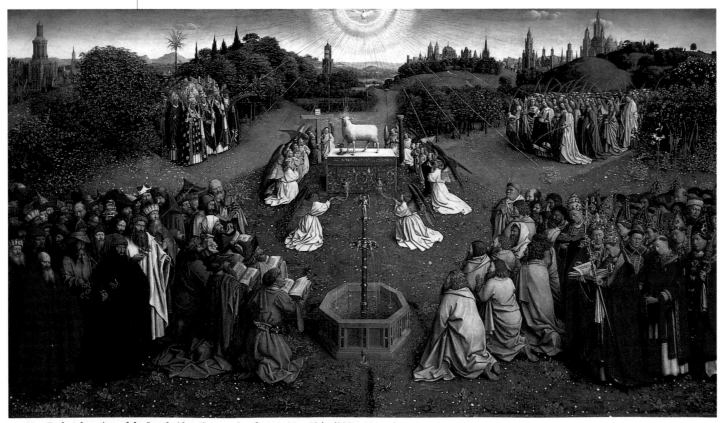

76 Van Eyck, **Adoration of the Lamb** *(detail), completed 1432, 93 x 53 in (235 x 135 cm)*

*77 Jan van Eyck, Annunciation, c. 1434/36,
14½ x 37 in (37 x 95 cm)*

Jan, about whom we have the most information, was mostly responsible, or whether it was Hubert, about whom we know almost nothing. For what it is worth, Hubert is given precedence in the inscription. It reads: "The painter Hubrecht Eyck, than whom none was greater, began this work, which his brother Jan, who was second to him in art, completed at the behest of Jodoc Vijdt…"

This panel shows the sacrificial Lamb on the high altar, its sacred blood pouring into a chalice. Angels surround the altar, carrying reminders of the Crucifixion, and in the foreground gushes the fountain of life. Coming from the four corners of the earth are the worshipers, a diverse collection that includes prophets, martyrs, popes, virgins, pilgrims, knights, and hermits. It is likely, as with many great religious works of the time, that van Eyck would have been advised by a theologian, and these figures seem to represent the hierarchy of the Church. Set in a beautiful, lush landscape, the holy city gleams on the horizon, its outline very much that of a Dutch city; the church on the right is probably Utrecht Cathedral. This is a detail from the vast altarpiece, but its very perfection and accuracy, its convincingness, explain why this mystic vision has taken such a hold on the affections of those who see it. The *Ghent Altarpiece* envelops the viewer in a mood of contemplation, but any more rigorous analysis becomes a massive intellectual effort. We can move more easily into a smaller painting, such as his long, slender *Annunciation (77)*.

SYMBOLIC LIGHT IN VAN EYCK

As we look at the *Annunciation*, we become warmly conscious of the gentle radiance of the light, illuminating everything it embraces, from the dim upper roofing to the glancing gleam of the angel's jewels. The clarity would be too intense were it not also soft, an integrating, enveloping presence. This diffused presence, impartial in its luminescence, is also a spiritual light, surrogate of God Himself, who loves all that He has made.

The symbolism goes even deeper: the upper church is dark, and the solitary window depicts God the Father. Below though, wholly translucent, are three bright windows that remind us of the Trinity, and of how Christ is the light of the world. This holy light comes in all directions, most obviously streaming down toward the Virgin as the Holy Spirit comes to overshadow her: from this sacred shadow will arise divine brightness. Her robes swell out as if in anticipation, and she answers the angelic salutation "*Ave Gratia Plena*" ("Hail, full of

on both sides, it is the largest and most complex altarpiece produced in the Netherlands in the 15th century. This monumental work still hangs in its original setting, the Cathedral of St. Bavo in Ghent, drawing the worshiper deeper and deeper into the sacred world it makes visible. There has been much debate over the parts the two van Eyck brothers, Jan and Hubert, played in the creation of the *Ghent Altarpiece*: whether

COPIED ELEMENTS
In this book illustration (attributed to a later Flemish painter), elements derived from *"The Arnolfini Marriage"* include the inscription, mirror, beads, and brush.

grace") with a humble *"Ecce Ancilla Domini"* ("Behold the handmaid of the Lord"). But with charming literalness, van Eyck writes her words reversed and inverted, so that the Holy Spirit can read them. The angel is all joy, all smiles, all brightness: the Virgin is pensive, amazed, unbejeweled. She knows, as the angel apparently does not, what will be the cost of her surrender to God. Her heart will be pierced with grief when her Child is crucified, and we notice that she holds up her hands in the symbolic gesture of devotion, but also as if in unconscious anticipation of a piercing.

The angel advances over the tiles of a church, where we can make out David slaying Goliath. (Goliath represents the power – ultimately fruitless – of the Devil.) The message the angel gives Mary sets her forth on her own road to the giant-slaying that is her motherhood and holiness.

OIL: A NEW PAINTING MEDIUM

The van Eycks started their careers as manuscript illuminators. The often miniature detail and exquisite rendering found in van Eyck paintings, including the *Annunciation,* reveal a strong affinity with this art form. However, the single factor that most distinguishes the van Eycks from the art of manuscript illumination was the medium they used.

For many years Jan van Eyck was wrongly credited with the "discovery of painting in oil." In fact, oil painting was already in existence, used to paint sculptures and to glaze over tempera paintings. The van Eycks' real achievement was the development – after much experimentation – of a stable varnish that would dry at a consistent rate. This was created with linseed and nut oils and mixed with resins.

The breakthrough came when Jan or Hubert mixed the oil into the actual paints they were using, instead of the egg medium that constituted tempera paint. The result was brilliance, translucence, and intensity of color as the pigment was suspended in a layer of oil that also trapped light. The flat, dull surface of tempera was transformed into a jewellike medium, at once perfectly suited to the representation of precious metals and gems and, more significantly, to the vivid, convincing depiction of natural light.

Van Eyck's inspired observations of light and its effects, executed with technical virtuosity through this new, transparent medium, enabled him to create a brilliant and lucid kind of reality. The invention of this technique transformed the appearance of painting.

A MARRIAGE PORTRAIT

"The Arnolfini Marriage" (78) is a name that has been given to this untitled double portrait by Jan van Eyck, now in the National Gallery, London. It is one of the greatest celebrations of human mutuality. Like Rembrandt's *"Jewish Bride"* (see p.204, another picture that had no known title of its maker's giving), this painting reveals to us the inner meaning of a true marriage.

The bed, the single burning candle, the solemn moment of joining as the young groom is about to place his raised hand in his betrothed's, the fruit, the faithful little dog, the rosary, the unshod feet (since this is the ground of a holy union), and even the respectful space between Giovanni Arnolfini and his wife, Giovanna Cenami, are all united in the mirror's reflection. All these details exalt us and at the same time make us aware of the human potential for goodness and fulfillment.

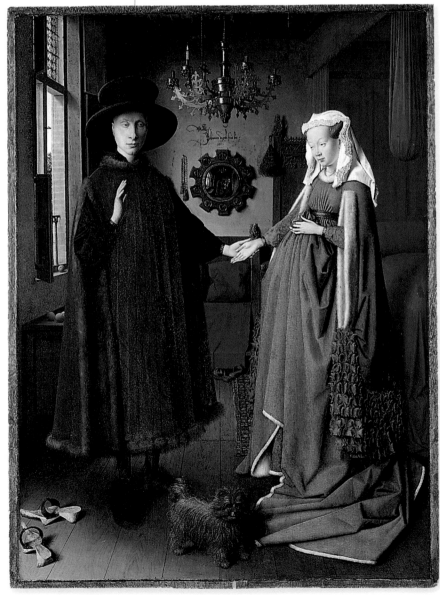

78 Jan van Eyck, "The Arnolfini Marriage," 1434, 23½ x 32¼ in (60 x 83 cm)

"The Arnolfini Marriage"

This title has traditionally been given to this painting because it was thought to be a form of "marriage certificate" for Giovanni Arnolfini and Giovanna Cenami, who married in Bruges in 1434. He was an Italian merchant, she the daughter of an Italian merchant. Their grave, youthful faces both have a lovely responsibility that is typical of van Eyck.

Convex mirror
The mirror is painted with almost miraculous skill. Its carved frame is inset with ten miniature medallions depicting scenes from the life of Christ. Yet more remarkable is the mirror's reflection, which includes van Eyck's own tiny self-portrait, accompanied by another man who may have been the official witness to the ceremony.

Symbolic candle
The solitary flame burning in bright daylight can be interpreted as the bridal candle, or God's all-seeing eye, or simply as a devotional candle. Another symbol is St. Margaret (the patron saint of women in childbirth), whose image is carved on the high chairback.

An elaborate signature
As today, marriages in 15th-century Flanders could take place privately rather than in church. Van Eyck's Latin signature, in the Gothic calligraphy used for legal documents, reads "Jan van Eyck was present," and has been interpreted by some as an indication that the artist himself served as a witness.

Symbol of faithfulness
Almost every detail can be interpreted as a symbol. The companion dog is seen as a symbol of faithfulness and love. The fruits on the window ledge probably stand for fertility and our fall from paradise. Even the discarded shoes are not thought to be incidental, but to signify the sanctity of marriage.

79 Master of the Avignon Pietà, Pietà, c. 1470, 7 ft 1 in x 5 ft 3 in (215 x 160 cm)

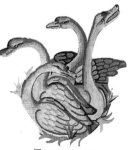

TAPESTRIES
During the 15th century, Arras and Tournai, in Flanders, were important centers for the profitable tapestry industry. The Devonshire Hunting Tapestries were woven on the looms of Tournai between 1425 and 1430. Their subject matter appears to be related to the marriage of Henry VI of England to Margaret, the daughter of King René of Anjou.

THE SPREAD OF NATURALISM

The new realism of the Netherlands had begun to spread in the first quarter of the 15th century, and by the 1450s its influence was widespread throughout northern Europe and as far as Spain and the Baltic. The *Pietà (79)*, painted by an unknown artist in Avignon, France, retains the flat golden background of early Gothic and Byzantine painting, but we hardly notice. Our attention is completely absorbed by this passionate meditation on the death of Christ. It takes place in no earthly location, only in the heart of the praying and kneeling donor on the left. For sheer impact, this wonderful and terrible painting is unsurpassed until we meet the Passion scenes of Bosch (see p.72). We can see that the Gothic era was a freely emotional period, one that accepted tears as a natural expression of humanity's frail vulnerability.

The strangely named Petrus Christus (1410–72/3) is another Fleming with a mysterious sense of emotional truth. He was a follower of van Eyck (who was possibly his teacher) and many of his works reveal his debt to the older Fleming.

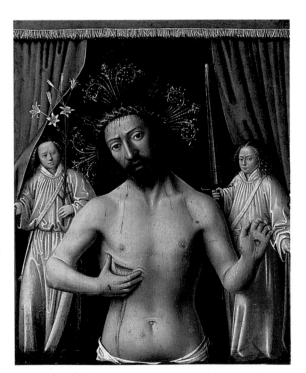

80 Petrus Christus, The Man of Sorrows, c. 1444–72/3, 3⅜ x 4½ in (8.5 x 11.5 cm)

To van Eyck's influence was added that of Antonello da Messina (see p.111), whose art Petrus Christus certainly knew. This led Christus to somewhat "Italianize" van Eyck's style. The tiny picture *Man of Sorrows (80)* in Birmingham, England, shows the crucified Jesus wearing His crown of thorns and displaying three of His wounds. He is flanked by two angels, one of whom holds a lily and the other a sword, symbolizing innocence and guilt. This is the Last Judgment, at which every man must face his judge: it captures the attention of the viewer, making it impossible to avoid the reality of the Passion and, ultimately, its significance for us.

THE INFLUENTIAL VAN DER WEYDEN

Rogier van der Weyden (1399/1400–64) is another giant of the Northern Renaissance movement. He was a pupil of van Eyck and Campin, and became the most influential Northern artist of the first half of the 15th century. Though he began his career relatively late (in his late twenties), he was very successful and had a large workshop with many assistants. The success of his art at the court of Philip the Good, Duke of Burgundy (see right), ensured the popularity of his style. His paintings were exported to other parts of Europe, reaching Castille, Spain, in 1445 and Ferrara, Italy, in 1449, and his fame became widespread.

Van der Weyden was a master of expressing human emotion; he moves us in a way that van Eyck cannot. Perhaps the best example of this is his *Deposition (81)*. It is of its nature an emotional subject; the handling of any dead body is a disturbing experience, let alone that of a young man executed in the full flower of his beauty, and this young man is, of course, Christ. But no artist has ever imbued this scene with more majestic pathos than van der Weyden. Like a great sculptured frieze, the holy mourners spread across the surface of the painting. Christ and His mother echo the same position: He falls from the cross physically dead; she falls to the ground emotionally dead.

Van der Weyden explores all the degrees and kinds of grief, from the controlled and grave anguish of St. John on the left, prominent in pink, to the anguished abandon of Mary Magdalene on the right, a striking color composition of red, palest yellow, and purple.

The extravagance of the emotion never escapes the artist's control. All remains firmly believable, and we are swept into an experience that is at once beautiful and terrible.

PHILIP THE GOOD

The Duke of Burgundy, Philip the Good (1396–1467), was a brother of the Duc de Berry (see p.55) and another great patron of the arts. As Duke of Burgundy he was also the Count of Flanders. In 1425, he employed van Eyck as his official court painter and equerry. Later, van der Weyden, too, received the patronage of the Duke's court. Philip is said to have prided himself on his appearance – here he wears the popular fashion of the period.

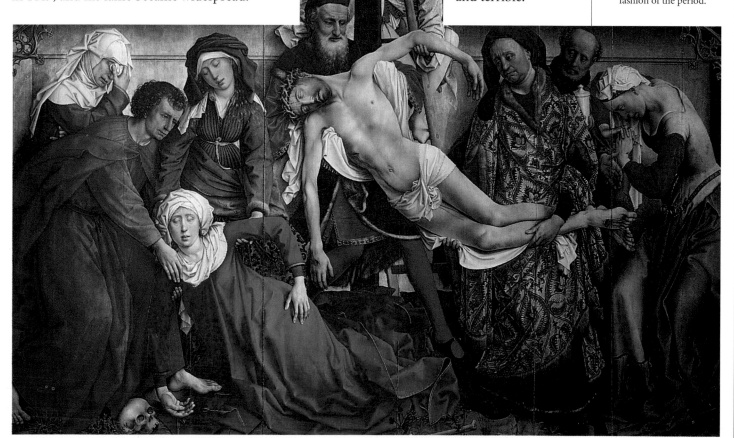

81 Rogier van der Weyden, **Deposition (The Descent from the Cross)**, *c. 1435, 8 ft 6 in x 7 ft 3 in (260 x 220 cm)*

GUILDS

In medieval Europe,
most tradespeople and
artisans, including
painters, belonged to
a guild. These men
(above) would have
been members of the
glassblowers' guild.
Guilds served to keep
a particular craft
profitable, protect
standards, and provide
social benefits. They
were a vital part of city
life, and members were
often represented on
town councils. Some
of the large guilds,
representing several
crafts, were split into
confraternities, each
with a patron saint.

POWERFUL PORTRAITURE

The compositional structure of the *Deposition*, with its shallow space and cropped shape, deliberately excludes any distracting background, thereby concentrating all attention on the dramatic scene. A similar effect is achieved in another van der Weyden painting, his *Portrait of a Lady (82)*. Here, the stark background focuses all our attention on the sitter. The subject has a haunting quality, a sense of almost painful reserve, as if she was willing to give the artist only her exterior. Yet he has circumvented her resistance and brought us into contact with the emotional character of the woman.

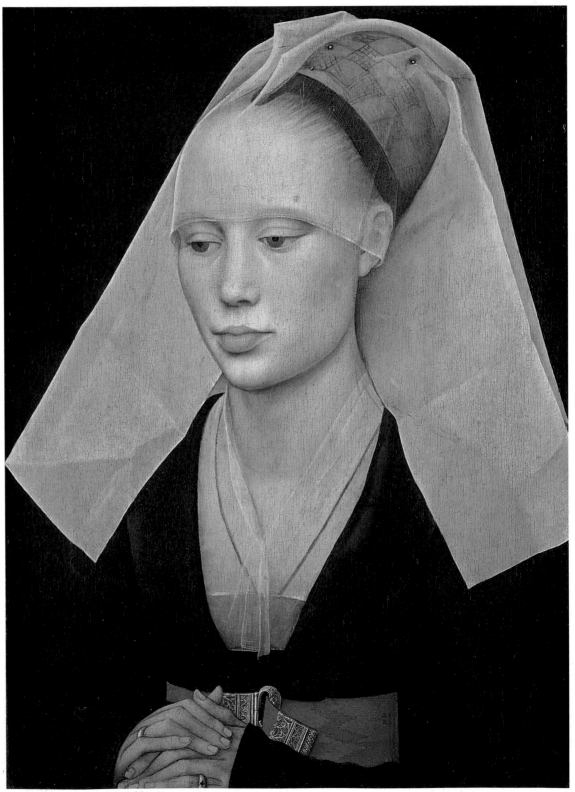

82 Rogier van der Weyden, Portrait of a Lady, *c. 1460, 10¾ x 14½ in (27 x 37 cm)*

83 Hugo van der Goes, The Portinari Altarpiece, *c. 1476, 55 × 100 in (140 × 254 cm) each wing, 10 ft × 8 ft 4 in (305 × 254 cm) central panel*

Her unadorned clothing and downcast gaze suggest modesty. To the modern observer she has an exceptionally high forehead; in fact, this was the fashion, achieved by plucking the hairline.

It has been suggested that the woman is Marie de Valengin, the daughter of Philip the Good, Duke of Burgundy (see p.67), but this identification is somewhat doubtful.

A GRAND SCALE

Hugo van der Goes (c. 1436–82) is an extraordinary painter and produced paintings on a surprisingly large scale, both literally and in the unprecedented monumentality of the figures. His most famous work, *The Portinari Altarpiece (83),* now in the Uffizi, Florence, was to prove very influential in Italy, where it decorated the church of the Hospital of Santa Maria Nuova in Florence. It was commissioned by a Florentine banker, Tommaso Portinari, who lived in Bruges and acted as the Flanders agent for the powerful Italian de' Medici family (see pp.93, 97). The dimensions of the painting, which when open measures over 8 ft (2.5 m) long, were dictated by a Florentine precedent.

Van der Goes is said to have died of religious melancholia, and knowing this, we may persuade ourselves that we see a barely controlled passion in his work. But without this biographical information, it may simply strike us as immensely dignified. Like the wings, the central panel, *The Adoration of the Shepherds,* shows two different scales in use, with the angels strangely small in comparison to the rest of the scene. This was a common device in medieval painting; it makes it easy to spot the important characters.

SAINTS AND THE DONOR'S FAMILY
The two large figures of St. Margaret and St. Mary Magdalene, who appear in the right panel of The Portinari Altarpiece, *are presenting Portinari's wife, Maria, and their daughter. St. Margaret (patron saint of childbirth) can be identified by the fact that she is standing on a dragon. According to legend, she was swallowed by a monster, but burst out of it. Mary Magdalene carries the jar of ointment with which she anointed Christ's feet.*

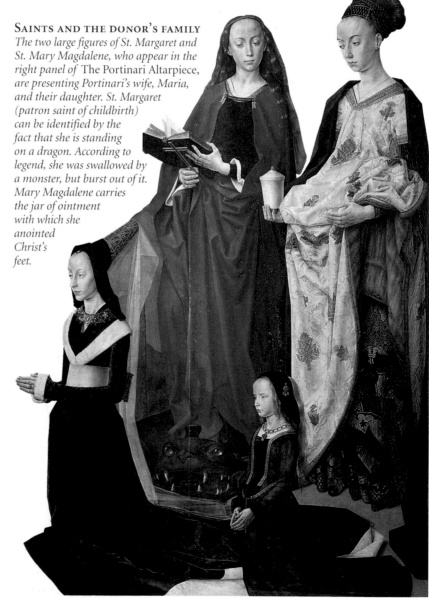

MEMLING'S PLACIDITY

Van der Goes's vision is immensely powerful, and his paintings combine the gravity of van Eyck and the emotional intensity of van der Weyden. Certainly the power in his work is absent in that of the other Flemings, such as Gerard David (see p.71) and Hans Memling. Memling (also known as Memlinc; c. 1430/35–94) was possibly trained in the workshop of van der Weyden (see p.67), but also contains influences from Dieric Bouts (see below), a follower of van Eyck. Although a German by birth, Memling settled in Bruges, Flanders, and it was there that he lived and worked. In fact, he worked so successfully that he became one of Bruges' wealthiest citizens.

Memling is a gentle artist, unobtrusively regarding the world about him and sharing his response with us. His *Portrait of a Man with an Arrow (84)* is immediately likeable. Various possibilities have been suggested as to the meaning of the arrow: something about his kindly and mild countenance seems to rule out

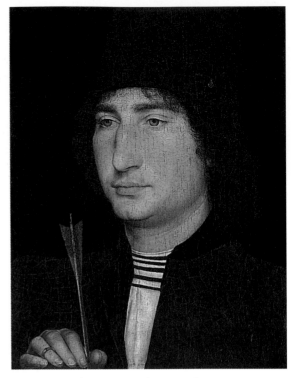

84 Hans Memling, **Portrait of a Man with an Arrow,**
c. 1470/5, 10¼ x 12¾ in (25 x 32 cm)

the possibility that he is a soldier. We are shown a very human gentleman, but one with firm and sensual lips. This small masterpiece grows on us the longer we contemplate it.

There could not be a greater contrast than between this and the work of Memling's contemporary, Bosch (see p.72), in whose work we often find a face that appears harsh with suppressed hatreds.

A VAN DER WEYDEN FOLLOWER

Of all the Northern painters, the greatest influence on the Dutch-born painter Dieric Bouts (c. 1415–75) was van der Weyden (see p.67), who may have been his teacher. Bouts did most of his work in Louvain, Flanders, where he was appointed the official city painter in 1468. His paintings are recognizable for their solemn dignity and deeply religious feeling. The spare composition and simple rendering of the drapery folds in Bouts's sensitively painted and elegant *Portrait of a Man (85)* are typical. He was an accomplished landscape painter, and here we get a glimpse of a landscape through the open window.

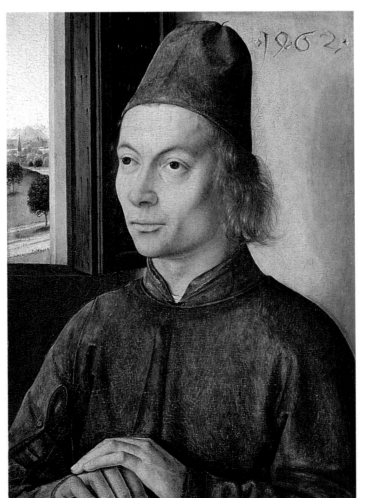

85 Dieric Bouts, **Portrait of a Man,** *1462, 8 x 12½ in (20.5 x 31.5 cm)*

LATE GOTHIC PAINTING

Gerard David, Hieronymus Bosch, and Matthias Grünewald were all early 16th-century artists and contemporaries of the other Northern artists Albrecht Dürer, Lucas Cranach, and Hans Holbein (see pp.148–162). However, the paintings of the former artists maintain connections with the Gothic tradition, while the latter were strongly influenced by the Italian Renaissance (see p.79). Thus the two strands of Gothic and Renaissance art coexisted and combined in Northern Europe in the first half of the 16th century.

Gerard David (c. 1460–1523) was Memling's natural successor in Bruges at the end of the 15th century, and was a highly successful artist with a busy workshop. He is a wholly delightful painter, whose childlike Madonna makes an immediate and unforced emotional appeal. In *The Rest on the Flight into Egypt (86)*, she holds grapes for her baby, symbol of the wine of His adult Passion, yet her quiet and abstracted expression is not one of foreboding. She seems enwrapped with her baby Jesus in a timeless reverie, while all the burden is borne by the active St. Joseph in the background, and the watchful ass.

The distinct early 15th-century style of the Low Countries, which we see in the paintings of Campin and van Eyck (see pp.60–65), comes to its peak in David's paintings. We find in him the

THE HANSA
The Hanseatic League was formed in the 14th century as an association of German towns to protect its merchants in foreign parts and to extend trade. It grew to encompass 200 cities in Germany, the Low Countries, and England. Hansa merchants exported wool, cloth, metals, and furs to the East, and imported pigments, raw materials, silk, spices, and a variety of other oriental goods into Europe.

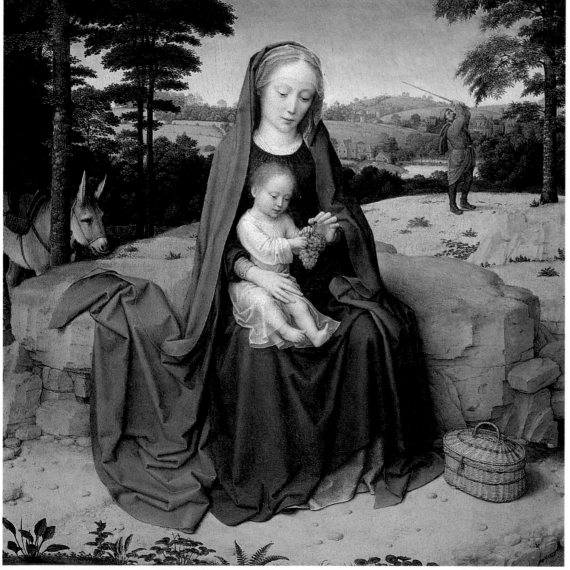

86 Gerard David, The Rest on the Flight into Egypt, c. 1510, 17½ x 17½ in (45 x 45 cm)

BRUGES
Until the late 15th century, Bruges was the hub of international commerce in northern Europe. Bruges was an independent commune, and the city was also the headquarters of the Hanseatic League. Although self-governing, the city was, like the rest of Flanders, under the overlordship of the Dukes of Burgundy until 1477. Bruges lost its trading dominance after the River Zwijn became unnavigable, and Antwerp assumed its position of influence.

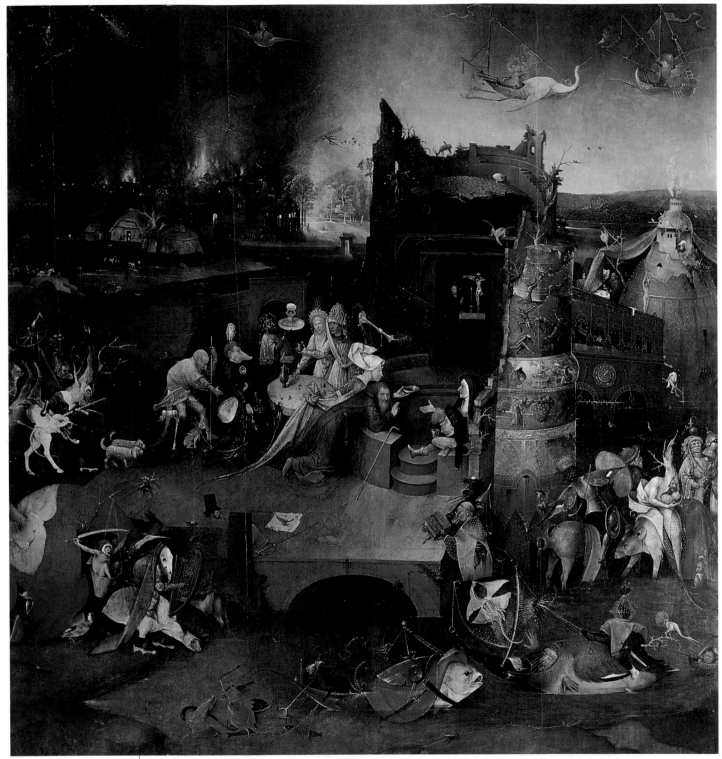

87 Hieronymus Bosch, **The Temptation of St. Anthony** *(central panel), c. 1505, 47 x 52 in (120 x 132 cm)*

monumental qualities of the Northern tradition, vitalized by a new pictorial vision, that would influence Quentin Massys and Jan Gossaert (see p.163). In these two, the divergent traditions of North and South come together again though this happened later, when Italian Renaissance art was exerting an enormous and compelling influence. Northern art kept its sharp veracity, but with Italian modulations.

THE UNIQUE VISION OF BOSCH

The extraordinary painter Hieronymus Bosch (c. 1450–1516) stands apart from the prevailing Flemish traditions in painting. His style was unique, strikingly free, and his symbolism, unforgettably vivid, remains unparalleled to this day. Marvelous and terrifying, he expresses an intense pessimism and reflects the anxieties of his time, one of social and political upheaval.

Very little is known about Bosch, which somehow seems fitting since his work is so enigmatic. We know that he adopted the name of the Dutch town of s'Hertogenbosch (near Antwerp) as his own, that he belonged to an ultra-orthodox religious community called the Brotherhood of Mary, and that in his own day he was famous. Many of his paintings are devotional, and there are several on the theme of the Passion. He is especially famous for his fantastic, demon-filled works, one of which is *The Temptation of St. Anthony (87)*.

The central panel of this triptych illustrates the kneeling figure of St. Anthony being tormented by devils. These include a man with a thistle for a head, and a fish that is half gondola. Bizarre and singular as such images seem to us, many would have been familiar to Bosch's contemporaries because they relate to Flemish proverbs and religious terminology. What is so extraordinary is that these imaginary creatures are painted with utter conviction, as though

88 Hieronymus Bosch, **The Path of Life,** *c. 1500–02, 35½ x 53 in (90 x 135 cm)*

they truly existed. He has invested each bizarre or outlandish creation with the same obvious realism as the naturalistic animal and human elements. His nightmarish images seem to possess an inexplicable surrealistic power.

Even a more naturalistic painting like *The Path of Life (88)* contains sinister elements. Apart from the dog snarling at the poverty-stricken old man, and the animal bones and skull in the foreground, robbers attack a traveler in the background, and a gallows is visible on the skyline above the old man's head. *The Path of Life* is on the outer face of the wings of a triptych. The three inside panels display Bosch's tragic view of human existence, dwelling upon the triumph of sin. Man's exile from paradise is shown on the left, the infinite variation of human vice in the center, and its consequence – exile to Hell – on the right.

ILLUSTRATED ALLEGORIES

In *The Ship of Fools (89)*, Bosch is imagining that the whole of mankind is voyaging through the seas of time on a ship, a small ship, that is representative of humanity. Sadly, every one of the representatives is a fool. This is how we live, says Bosch – we eat, drink, flirt, cheat, play silly games, pursue unattainable objectives. Meanwhile our ship drifts aimlessly and we never reach the harbor. The fools are not

89 Hieronymus Bosch, **The Ship of Fools,** *c. 1490–1500, 13 x 23 in (33 x 58 cm)*

❝ The master of the monstrous… the discoverer of the unconscious.❞

Carl Gustav Jung, on Hieronymus Bosch

DRAMA
Mummers like these, who appear in a 14th-century French illumination, were a common sight in the Middle Ages in the towns of northern Europe. They were masked players who traveled around in groups and put on entertainments and mystery plays in the streets and private houses. The religious community that Bosch belonged to is also known to have performed mystery plays.

DEATH AND THE MISER

This moralistic panel from Bosch's middle phase is an example of the 15th-century Flemish insistence on exposing the folly and vices of humanity. Religious sects proliferated in the Low Countries at that time, and Bosch belonged to one with strongly orthodox beliefs.

A FINAL TEMPTATION
A grotesque devil, understanding the miser's weakness, proffers a bag of gold in the hope of securing the miser's soul. We are left to draw our own conclusions as to the outcome of this human drama, but the gesture of compulsive greed made by the dying man, still eager for material gain, suggests the battle is already lost.

UNSEEN CRUCIFIX
At the heart of this painting is the battle for the miser's soul. His guardian angel pleads – perhaps in vain – for his salvation and attempts to guide the dying man's attention to the small crucifix off to the upper left, unseen by the miser and ignored.

MONEY – THE FOCAL POINT
Lust, gluttony, and material greed were ranked among the worst vices and were popular subjects of 15th-century religious sermons. The strongbox is given a prominent position, as the cause of the miser's probable damnation. He does not seem to see, as Bosch ensures we do, that the strongbox is alive with malicious, verminous creatures from the underworld, and that he carrries his key next to his rosary in vain.

SELF-PORTRAIT?
In the foreground, a small demon looks sideways at us amid the miser's discarded silks with an expression often seen in Bosch paintings – lean, pinched, and hopeless. It has been suggested that this is a sardonic portrait of Bosch himself.

irreligious, since prominent among them are a monk and a nun, but they are all those who live "in stupidity." Bosch laughs, and it is a sad laugh. Which one of us does not sail in the wretched discomfort of the ship of human folly? Eccentric

and secret genius that he was, Bosch not only moved the heart, but scandalized it into full awareness. The sinister and monstrous things that he brought forth are the hidden creatures of our inward self-love: he externalizes the ugliness within, and so his misshapen demons have an effect beyond curiosity. We feel a hateful kinship with them. *The Ship of Fools* is not about other people. It is about us.

A MORAL TALE

Another of Bosch's panel paintings, *Death and the Miser (90)*, is a warning to anyone so obsessed with grabbing at life's pleasures that they have lost all sense of retribution. As a result, the worldly one is not prepared to die. Who can feel indifferent to this fable? In a long, concentrated format Bosch sets out the whole painful scenario.

The naked and dying man has been a person of power: at the bed's foot, strewn by a low wall, lies his discarded armor. His riches have come through combat; the sick man has fought for his wealth and stored it close to him. The miser appears twice, the second time in full health, simply dressed because he hoards his gold, dense with satisfaction as he adds another coin. Demons lurk everywhere. Death puts a leering head around the door (notice the sick man's surprise: death is never expected), and the final battle begins. It is one he must wage without his armor. Behind him stands a pleading angel. Before him, even now proffering gold, lurks a demon. Above the bed, expectant and interested, peers yet another demon. The outcome of the story is left undecided. We hope desperately that the miser will relinquish empty possessiveness and accept the truth of death.

GRÜNEWALD'S DARK VISION

The final flowering of the Gothic came relatively late, in the work of the German artist Matthias Grünewald (his real name was Mathis Neithart, otherwise Gothart, 1470/80–1528). He may have been an exact contemporary of Dürer (see p.152), but while Dürer was deeply influenced by the Renaissance, Grünewald ignored it in his choice of subject matter. Much of his work has not survived to this day, but even from the small amount that has come down to us, it is possible to see Grünewald as one of the most powerful of all painters. No other painter has ever so terribly and truthfully exposed the horror of suffering, and yet kept before us, as Bosch does not, the conviction of salvation. His *Crucifixion (91)*, part of the many-paneled *Isenheim Altarpiece*,

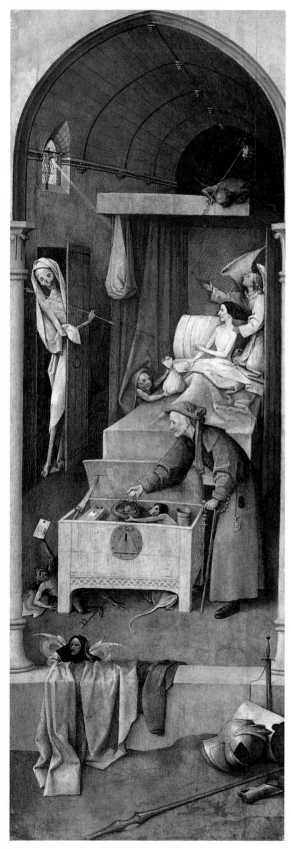

90 Hieronymus Bosch, Death and the Miser, c. 1485/90, 12 x 36½ in (30.5 x 93 cm)

PHILIP II
The Spanish King Philip II (1527–98) was an admirer of the work of Bosch and amassed a substantial collection of his paintings. The son of Emperor Charles V, Philip brought Spain out of the Middle Ages and into the Renaissance era. He commissioned many works by Titian (see p.131).

PANEL PAINTINGS
While painting on wooden panels was widespread across Europe, the timber used varied. In Italy poplar was the most common. North of the Alps there was a greater choice of wood, and oak, pine, silver fir, linden, beech, and chestnut were all used. Italian panels were left rough at the back while Northern European panels were beautifully finished. Those from Bruges were often stamped with a seal.

WORLD'S END
As at the end of most centuries, a number of people feared that the world would end in 1500. As a result, apocalyptic images of death were widespread.

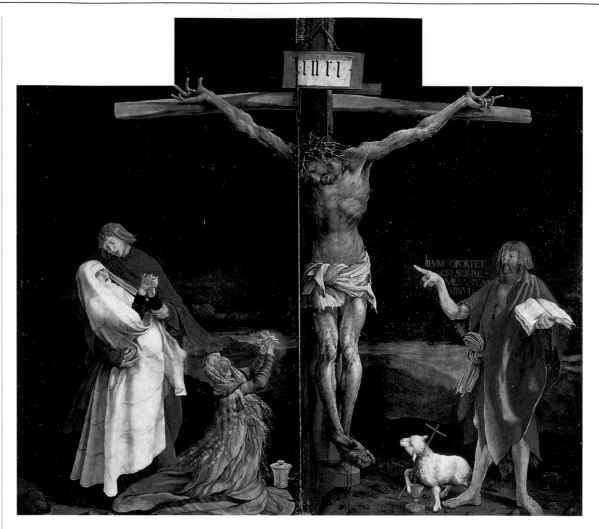

MEDIEVAL MEDICINE
Up until the Renaissance, medical knowledge was rudimentary. Diseases and ailments were usually treated with herbal cures, blood-letting by leeches, or by supernatural "cures." Superstition dictated, for example, that sickness could be avoided by carrying holy relics or texts taken from the Bible. This illustration, dating from the 14th century, shows a very docile patient undergoing a primitive lobotomy operation.

91 Matthias Grünewald, Crucifixion, *c. 1510 – 15, 10 ft × 8 ft 10 in (305 × 270 cm)*

is now kept in Colmar. It was commissioned for the Antonite monastery at Isenheim and was intended to give support to patients in the monastic hospital. Christ appears hideous, his skin swollen and torn as a result of the flagellation and torture that He endured. This was understandably a powerful image in a hospital that specialized in caring for those suffering from skin complaints.

The more accessible *Small Crucifixion (92)* engages us very directly with the actual death of the Savior. The crucified Lord leans down into our space, crushing us, leaving us no escape, filling the painting with his agony. We are hemmed in by the immensities of darkness and mountain, alone with pain, forced to face the truth. The Old Testament often talks of a "suffering servant," describing him in Psalm 22 as "a worm and no man": it is of Grünewald's Christ that we think. In this noble veracity, Gothic art reached an electrifying greatness.

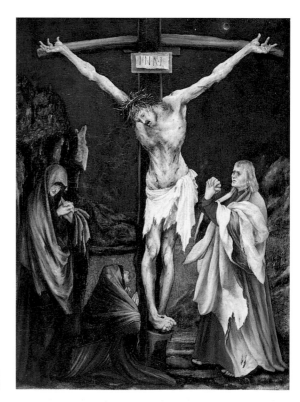

92 Matthias Grünewald, The Small Crucifixion, *c. 1511/20, 18 × 24 in (46 × 61 cm)*

CRUCIFIXION

This is the central panel of Grünewald's large, multipaneled *Isenheim Altarpiece*. It is an extraordinary record of intense and disfiguring human suffering. Because he worked in a hospital, Grünewald based his image of suffering on the patients whose torments he witnessed. These were mostly sufferers from skin diseases, which were common at the time.

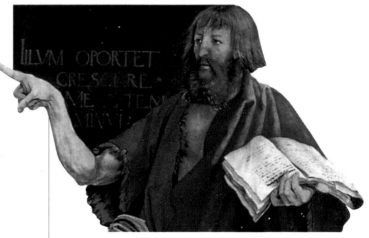

PHYSICAL PAIN
The crossbar of the crucifix is a simple, rough-hewn branch, bending under the weight of the dying man. Christ's arms are abnormally elongated and His hand, contorted into a physical scream, seems both a desperate reproach and a surrender to God.

FAMILY GRIEF
Divided from the stoic figure of John the Baptist by the monstrous dying Christ are the traumatized relatives and friends. Mary collapses into herself, either swooning from exhaustion or from a need to shut out the vision of her crucified son. Grünewald originally painted her as an upright figure, but later arched her body into this pitiful state. She is supported by the despairing St. John the Evangelist.

ST. JOHN'S PROPHECY
St. John the Baptist stands barefoot, wearing the animal skins that symbolize his time in the wilderness, and carrying a book. He seems unbowed by the horror of the moment and is unshakable in his prophetic conviction – inscribed against the night sky – "He will increase while I decrease." John delivers the Christian message of hope and redemption, balancing the desolation of the scene.

AGONY VISUALIZED
Grünewald takes the Gothic concern with suffering, sin, and mortality to its furthest extreme. Here in graphic detail is Christ the victim, physically repulsive in His brutalized condition and far removed from the heroic, athletically beautiful Christs of the Renaissance. Grünewald's vision is one of horror, a metaphor for the supreme cruelty and degradation of which humanity is capable, and by the same token, of the supreme mercy of Christ's benediction.

LAMB OF GOD
The lamb, used as a sacrificial animal by the Jews, was adopted by the early Christians as a symbol of Christ's sacrifice. It is associated with St. John, who on seeing Jesus declared, "Behold the Lamb of God." The lamb normally holds a Cross and its sacrifical blood flows into a chalice.

THE ITALIAN RENAISSANCE

In the arts and sciences as well as society and government, Italy was the major catalyst for progress during the Renaissance, the rich period of development that occurred in Europe at the end of the Middle Ages. Because of the number of different fields in which it applied, "Renaissance" is a word with many layers of meaning. Accordingly, Renaissance painting cannot signify any one common or clearly definable style. Since Gothic painting had been shaped by the feudal societies of the Middle Ages, with its roots in the Romanesque and Byzantine traditions, Renaissance art was born out of a new, rapidly evolving civilization. It marked the point of departure from the medieval to the modern world and, as such, laid the foundations for modern Western values and society.

Giovanni Bellini, The Feast of the Gods, *1514 (detail)*

ITALIAN RENAISSANCE TIMELINE

The Renaissance in Italy started gradually, its beginnings being apparent even in Giotto's work, a century before Masaccio was active (see p.46). The quest for scientific precision and greater realism culminated in the superb balance and harmony of Leonardo, Raphael, and Michelangelo. The influence of Humanism (see p.82) is reflected in the increase of secular subjects. In the final phase of the Renaissance, Mannerism became the dominant style.

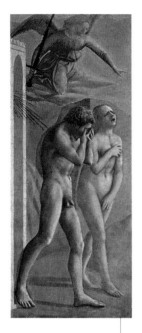

MASACCIO, ADAM AND EVE, 1427
Leonardo wrote that Masaccio "showed by his perfect works, how those who take for their inspiration anything but Nature – mistress of all masters – weary themselves in vain". In 1830, Eugène Delacroix wrote of him: "Born in poverty, almost unknown during the best part of his short life, he carried out single-handed the greatest revolution ever known in painting." This revolution was his vision of the world: of mortal beings portrayed with honesty and tenderness, living and breathing in a terrestrial world of air, light, and space (p.83).

PIERO DELLA FRANCESCA, RESURRECTION OF CHRIST, C. 1450
Clarity and dignity characterize Piero's art. Influenced by Roman Classicism and Florentine innovation, his paintings combine complex mathematical structures with brilliant color and crystalline light (p.102).

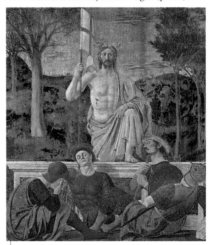

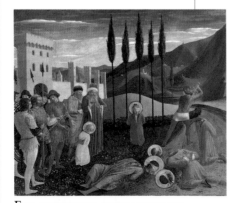

LEONARDO DA VINCI, VIRGIN OF THE ROCKS, C. 1508
A true Renaissance man, Leonardo was a great painter as well as a sculptor, architect, inventor, engineer, and an expert in such fields as botany, anatomy, and geology. His distinctively lyrical art reveals his compelling belief in nature as a source of inspiration (p.120).

1420	1440	1460	1480	1500

FRA ANGELICO, BEHEADING OF ST. COSMAS AND ST. DAMIAN, 1438–40
This is part of the predella (a strip along the lower edge) of the altarpiece in the priory of San Marco, Florence. Fra Angelico's paintings have a delicate grace that belies their dynamism. There are elements of Gothic style, but the figures move in real, observed landscapes and are defined by natural light (p.90).

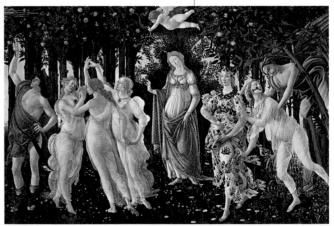

SANDRO BOTTICELLI, PRIMAVERA, C. 1482
Botticelli is known best for his secular paintings – elaborate pagan allegories and mythological scenes. But his paintings are recognizable for their sheer beauty of line, free of discord. His art is notable for its peculiarly gentle, wistful melancholy. As he aged, this deepened to an anxious sadness; his figures became emaciated, sometimes with tortured expressions. This was possibly a reaction to contemporary political and religious tensions (p.94).

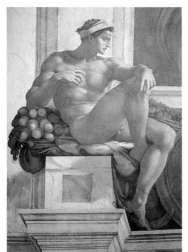

MICHELANGELO, IGNUDO (NUDE) FROM THE SISTINE CHAPEL, c. 1508–12
Michelangelo is another "giant" of the High Renaissance. However, in contrast with the lyricism of Leonardo's paintings, Michelangelo's art is characterized by gravity. Created on an epic scale, it is peopled with superhuman forms, of severe athletic beauty (p.122).

TITIAN, VENUS AND ADONIS, c. 1560
Titian was the greatest of the Venetian artists and one of the world's supreme artists, with a profound influence on the development of Western painting. His late works are unsurpassed in their haunting and fragile beauty, strikingly suggestive of some 20th-century art (p.134).

EL GRECO, MADONNA AND CHILD WITH ST. MARTINA AND ST. AGNES, c. 1597–99
El Greco is the great religious Mannerist. His passionate vision surpasses the stylish manipulations of later Mannerists. After travels in Venice and Rome, he settled in Toledo in Spain. His work displays a mystic fervor that accurately represents the religious intensity of Counter-Reformation Spain (p.145).

CORREGGIO, VENUS, SATYR, AND CUPID, c. 1514–30
Correggio's imagery can seem too sweet for modern tastes. But beneath the outward charm is a tough appreciation of sensual truth (p.142).

1520 **1540** **1560** **1580** **1600**

TINTORETTO, THE CONVERSION OF ST. PAUL, c. 1545
The Venetian artist Tintoretto was a leading late Renaissance painter. After studying briefly under Titian, he evolved a distinctive, dynamic style with startling contrasts of color and tone, sweeping vistas, and dramatic movement. His paintings exhibit a religious intensity and a passionate "expressionism" that move him into the realm of Mannerism, away from the Classicism of the High and Early Renaissance (p.134).

RAPHAEL, BINDO ALTOVITI, c. 1515
Raphael was a successor to Leonardo, whose early influence on him was profound. Raphael was also attracted to classical art, so that his paintings possess heroic grandeur and his portraits a new, graceful spontaneity (p.128).

THE EARLY RENAISSANCE

The name "Renaissance"– meaning "rebirth"– is given to a period of broad cultural achievement spanning three centuries. The idea of rebirth lies at the heart of all Renaissance achievement: artists, scholars, scientists, philosophers, architects, and rulers believed that the way to greatness and enlightenment was through the study of the golden ages of the ancient Greeks and Romans. They rejected the more recent, medieval past, which constituted the Gothic era. Instead of this, inspired by Humanism, they looked to the literary and philosophical traditions, and the artistic and engineering achievements, of Greco-Roman antiquity.

Renaissance painting began in Italy in the middle of the 13th century, and its influence rapidly spread throughout Europe, reaching its peak at the end of the 15th century. Renaissance artists believed their art was a continuation of the great antique tradition of Greece and Rome, an insight that originally came from Giotto (see p.46). With his joyful spiritual vision, Giotto is like the Gothic artists. But his ability to present stories from the Bible as very naturalistic, human dramas and his way of depicting his figures as solid, weighty characters were Renaissance qualities. Giotto showed what could be done, how an artistic vision could encompass the exciting new understanding of Humanism and Classicism, which were to be so important to Renaissance artists. With antiquity as a model and Giotto as a guide, painters of the early Italian Renaissance entered a new phase of pictorial representation, based on the reality of human existence.

MASACCIO AND FLORENCE

Of course the transition from Gothic to Renaissance did not happen overnight, but it can come as a surprise to see that the next great Italian painter after Giotto (who died in 1337) was not born until 1401, and therefore was not active until nearly a century after Giotto's death. This gap is largely explained by the Black Death (see p.58), the first spread of which devastated Europe in the 14th century, reaching Italy first in 1347 and sweeping across Europe over the next four years. The consequences were far-reaching, and in addition to the enormous loss of life, medieval society underwent great changes. Artistic revolution in the North, in

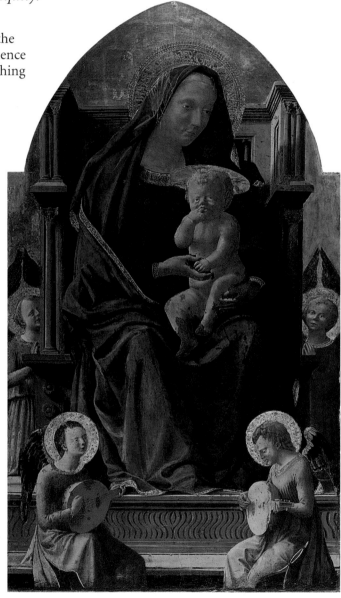

93 Masaccio, **The Virgin and Child**, *1426, 29½ in x 53 in (75 x 135 cm)*

the Low Countries (see pp.60–70), was leading painting in new directions through its increasing naturalism, secularism, and technical mastery. In the South, it seemed as if Giotto had never been. Miraculously, there was a second spring with the birth of the Florentine painter

Masaccio (Tomasso de Giovanni di Simone Guidi, 1401–28). It is Masaccio who is the revolutionary founder of Renaissance painting. Of the Italian painters, he was the one who really saw what Giotto had initiated and made it accessible to all who followed.

Masaccio is forever young because he died when he was 27. Yet his art seems to be outstandingly mature. His name is a nickname, meaning something like "Tom the Hulk," and his art is hulking, too. But it is the hulk of genius, monumental, strong, and convincing, true heir to the humanity and spatial depth of Giotto. One of his early works, painted for a church in Pisa, has an almost architectonic concentration. In *The Virgin and Child (93)*, the central panel of a now scattered polyptych (multiple painting), the Madonna is sculptural in her blocky dignity, seated on a throne of classic weight, shadowed and austere, with her Child completely stripped of Byzantine kingliness. This Jesus is a real baby, sucking his fingers and staring into space. It represents the antithesis of the courtly refinement of the International Gothic style of Gentile da Fabriano, for instance (see p.56). Yet the pathos is heightened, not diminished: there is strength and vulnerability, beautifully combined, and even the angel musicians have a chubby earnestness.

LINKS WITH SCULPTURE

As Giotto was influenced by the sculpture of the Pisanos (see p.46), so was Masaccio by their Florentine sculptural descendants, the senior artists Donatello (Donato di Niccolo, 1386–1466, see right) and Lorenzo Ghiberti (1378–1455, see column, p.102). The great influence of sculpture on early Renaissance painting, and inherently on the development of the Western tradition in painting, cannot be overstressed. Masaccio's understanding of three-dimensional form, architectural space, and perspective owed a great debt to the technical and scientific achievements pioneered by Donatello, Ghiberti, and the Florentine architect Brunelleschi (Filippo di Ser Brunelleschi, 1377–1446, see column, left). Sculptural realism lies at the heart of Renaissance painting, culminating in the epic monumentality of Michelangelo's art during the High Renaissance (see p.120).

As Giotto translated Pisano's carvings into pictorial form, Masaccio drew inspiration from Donatello's freestanding sculptures and reliefs, and applied sculptural considerations to his paintings, creating images of convincingly solid objects in a feasible space, using optical perspective. More significantly, he applied the sculptor's understanding of the effects of real light falling onto objects and filtering through spaces, surpassing Giotto's already monumental leap toward understanding and reinventing the world through painting.

From now on, the lovely play that can characterize the finest Gothic art (though less often that of Giotto or Duccio) disappears. Masaccio lives in a wholly serious world. His *Adam and Eve Expelled from Paradise (94)*, in Florence's Brancacci Chapel, wail with unselfconscious horror, blinded with grief,

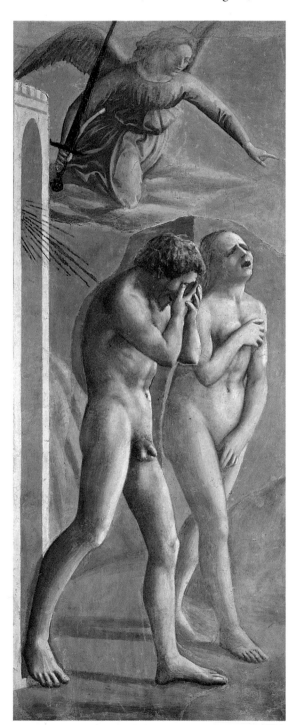

94 Masaccio, Adam and Eve Expelled from Paradise, c. 1427, 35½ x 81 in (90 x 205 cm)

DONATELLO'S DAVID
Donatello was one of a group of brilliant sculptors who led the way for painters in the early Renaissance (see also p.105). He visited Rome, where he was inspired by the freedom of movement achieved in the nude figures of classical sculpture, and afterward (c. 1434) created this bronze figure of the young King David. This overtly sensual work was one of the first nude statues of the Renaissance.

RESTORATION OF FRESCOES
Time and the elements, in particular modern pollution, have caused serious deterioration in the surface of many of the frescoes produced during the Renaissance. As a result, to repair the damage and to prevent more from occurring, many famous works, including Masaccio's Brancacci Chapel frescoes and Michelangelo's Sistine Chapel ceiling (see p.122), have been substantially restored. This has resulted in some controversy: not all art critics and historians are in agreement that the work has been sensitively carried out. Some argue that the tonal values of the work have been ignored.

THE TRINITY

The doctrine of the Trinity – of God as three separate beings, yet remaining one entity – lies at the heart of the Christian "mystery." It is first mentioned in Matthew's Gospel (28: 19) as comprising Father, Son, and Holy Spirit. Masaccio's *Trinity* was commissioned for the church of Santa Maria Novella in 1425. It was covered over in 1570 with a panel painting by Vasari (see p.98), and only rediscovered in 1861.

MOTHER OF CHRIST
Mary the Virgin is the only one of the nondivine beings who looks directly out at us. She stands upright and dry-eyed, and points with a gesture both implacable and supplicating toward her crucified Child, giving the viewer a concentrated glance of terrible reproach.

THE TRINITY
Masaccio's Trinity *is part of a Renaissance pictorial tradition in which the Father is generally depicted as an aged and bearded patriarch, standing behind and above the crucified Son. He is often shown supporting both ends of the crossbar of the crucifix, thus echoing His Son's sacrifice. Between them hovers the white geometry of the Holy Spirit, traditionally depicted as a dove (see p.101). The Holy Spirit is the third person of the Trinity, but is here perhaps the most eye-catching in the sheer brilliance of the white smudge that bisects the fresco.*

THE DONORS
The figures of the Trinity, and of Mary and St. John, appear as solidly real as the two donors. Yet the donors are both included in and excluded from this timeless scene. Spatially they belong: they share the same scale (traditionally donors were shown on a specially reduced scale) and are bathed in the same light that illuminates the interior of the vault. But symbolically the donors remain "outside" the scene, because they have been positioned on a lower step, as though on the predella (a painted border strip) of an altarpiece, which locates them firmly in the world of the viewer.

PERSPECTIVE
Vasari recorded his admiration for Masaccio's Trinity *when he described its sophisticated spatial structure as: "a barrel vault drawn in perspective, and divided into squares with rosettes that diminish and are foreshortened so well that there seems to be a hole in the wall." Masaccio had interpreted Brunelleschi's (p.82) theories of perspective with such clarity that in the past it was believed that Brunelleschi was actually directly involved in the production of the painting.*

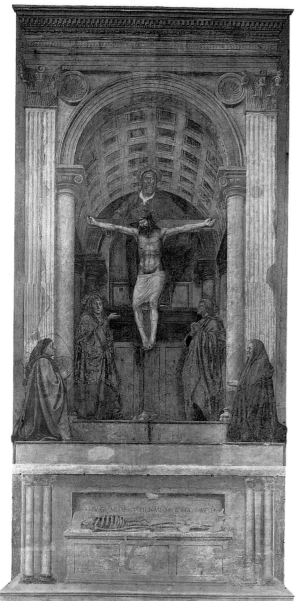

95 Masaccio, **The Trinity,** *1425, 10 ft 4 in x 22 ft (315 x 670 cm)*

majesty, we can well accept that these two figures are divine. Divinity is by definition a mystery, something we cannot comprehend, but Masaccio makes the mystery of the Trinity humanly accessible. Below the great central vertical pole of the Trinity, symmetrically fanning out on either side, are the four non-divine actors in the drama. Only one – Mary – is looking directly out of the picture. Balancing the figure of Christ's mother, on the other side of the Cross is St. John, equally massive, equally solid, though he is looking not toward us, but toward Christ.

Beyond them, sealing in the picture, are the donors – large, profiled, solidly present as the viewers' representatives. At the very bottom of the painting there is a seventh character: the skeleton, representing Adam and Everyman. This is the human truth that underlies all religious dogma. Above the skeleton, on the stone wall of the narrow tomb in which it lies, is written the inscription "I was once what you are and what I am you will become." The universal nature of Masaccio's *Trinity*, encompassing the wide realm of mortal decay and spiritual salvation, belongs to a medieval tradition.

There is an immense authority about this young artist. *St. Peter Healing with His Shadow (96)* is one of a pair of scenes from the Brancacci Chapel cycle, situated at either side of the altar. (The other is *The Distribution of the Goods of the Church*, and the pair share a common perspective.) St. Peter strides toward the viewer down a narrow street of houses built in the Florentine style. One man in his entourage, wearing the short smock of a stonecutter, might be intended as a portrait of Donatello; another, younger man, his beard not yet grown, might be Masaccio's self-portrait (he is positioned facing directly out of the picture in the manner of self-portraits of the time.) Peter's shadow is rendered with remarkable confidence in view of the fact that, prior to this, no technique for painting shadows had been developed. The cripples are depicted with a vividness and individuality astonishingly advanced for the early 15th century.

Masaccio's concerns with the true appearance of things earned him this singular appraisal from the art historian Vasari (see p.98):

THE BRANCACCI CHAPEL

Several of Masaccio's frescoes cover the upper walls of the Brancacci family chapel in the church of Santa Maria del Carmine in Florence. This cycle of frescoes became a model for Florentine artists in the late Renaissance, including Michelangelo (see p.120).

OTHER WORKS BY MASACCIO

Crucifixion of St. Peter (Staatliche Museen, Berlin-Dahlem)

Virgin with St. Anne (Uffizi, Florence)

Tribute Money (Brancacci Chapel, Florence)

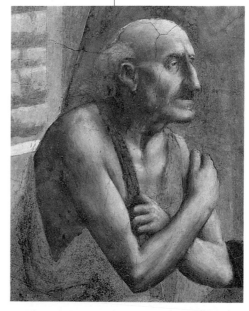

96 Masaccio, **St. Peter Healing with His Shadow,** *1425 (detail of fresco)*

unaware of anything but their loss of happiness. Eve is so sheerly ugly as she screams aloud from misery that we are startled into attention and into pity.

MASACCIO'S TRINITY

What distinguishes Masaccio is his majesty; there never was a more massive, more dignified, more noble, and yet more human painter. The wonder of this painting of *The Trinity (95)* is that it shows us six *human* images. Central are the Father and Son. Although they are in the most moving way human (a real, suffering Jesus showing compassion for His fellow men and women as He dies, and a real Father upright in His splendid dignity as He holds up the Crucifix and shows us His surrendered Son) in Their

"With regard to painting we are indebted most of all to Masaccio, who first painted people's feet actually standing on the ground, and by doing so eliminated that awkwardness, common to all artists before him, of having the figures standing on tiptoe. We must also be grateful to him for having given his figures such liveliness and relief that he deserves the same credit as if he had invented art itself."

THE "SMALLER" ART OF MASOLINO

Masaccio's greatness can best be seen if we compare him with Masolino (Tommaso di Cristoforo Fini da Panicale, 1383– c. 1447), nearly 20 years his senior, with whom he often worked. (It has been suggested that "Masolino," also a nickname, was coined to mark the difference between "Big Tom," Masaccio, and "Small Tom," Masolino.) He is unfairly seen as small, but only in comparison. On his own, he is still temperamentally in the Gothic era, as we

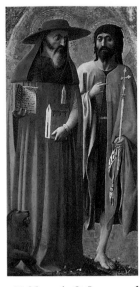

98 Masaccio, St. Jerome and St. John the Baptist, c. 1428, 21½ x 45 in (55 x 115 cm)

99 Masolino, St. Liberius and St. Matthias, c. 1428, 21½ x 45 in (55 x 115 cm)

see in his graceful *Annunciation (97)*, in which he shows us his love of the decorative and elegant, flowing line that is truly Gothic. But when paired with the bigger Tom, Masolino too stretched out into the true Renaissance.

The best proof of Masolino's ability to grow can be seen in a comparison between two panels, *St. Jerome and St. John the Baptist (98)* and *St. Liberius and St. Matthias (99)*, which hang to either side of an altarpiece. All four saints have a hulking presence typical of Masaccio – they certainly stand with their feet flat on the ground – yet it is now fairly certain that the former panel is largely by Masaccio, while the latter is mainly the work of Masolino. (Previously, both were attributed to Masaccio.)

DOMENICO THE INNOVATOR

The Venetian artist Domenico Veneziano (Domenico di Bartolomeo di Venezia, active c.1438–61) was one of the most important painters working in Florence in the early Renaissance. His importance lies not so much in his personal achievement as in the breadth and significance of his influence – for he was the teacher of Piero della Francesca (see p.100).

What we find so beautifully in Domenico is a splendor of light that emanates from a single source, breathing air into the space and unifying forms within it. He gives us the first radiant indication of that water-born silveriness that is one of the Venetian gifts to the visual world. Domenico also had a dazzlingly original mind. We admire – rightly – the great Masaccio; we love the limpid Domenico. His *St. John in the Desert (100)* is a magical work. Light pours in blinding clarity over a glittering barrenness,

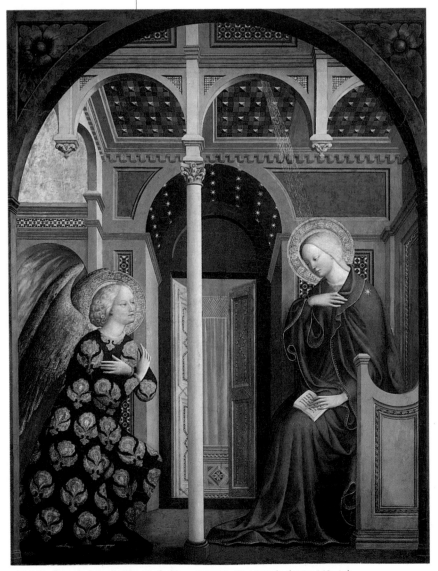

97 Masolino, Annunciation, *probably c. 1425/30, 45 x 58¼ in (115 x 148 cm)*

100 Domenico Veneziano, St. John in the Desert, c. 1445, 12¾ x 11¼ in (32.5 x 28.5 cm)

with the tender, naked saint the only softness to be seen. He is stripping off his worldly clothes, like a young athlete getting ready for the race. That the race is very present to him, and that it is a contest of the spirit, is sublimely clear. But if it is an all-demanding vocation to which this slender youth is called, it is one lived in the exhilaration of a high plateau.

There is a strange relationship between this classical-looking nude, with his medieval golden halo, and his setting in a landscape reminiscent of Netherlandish (even Byzantine) art; this juxtaposition illustrates the meeting of spiritual, pagan, and physical worlds. This is a deeply Renaissance way of visualizing the story, as we can see if we compare it with the painting of the same subject by Giovanni di Paolo (c. 1403–83). This is Giovanni's *St. John the Baptist Retiring to the Desert (101)*, an archaic and bewitching Gothic fantasy that sends the youthful saint out like a young adventurer to seek his heavenly fortune.

101 Giovanni di Paolo, St. John the Baptist Retiring to the Desert, c. 1454, 15½ x 11¾ in (39 x 30 cm)

ALBERTI
The Florentine artist, architect, and antiquarian Leon Battista Alberti (1404–72) was one of the first to construct a formula of perspective that could be applied to two-dimensional paintings.

PERSPECTIVE: SCIENCE INTO ART

The Renaissance concept that most gripped the Florentine artist Paolo Uccello (Paolo di Dono, 1397–1475), whose name is also a nickname (*uccello* means "bird" – given to him for his love of birds), was not so much that of light as perspective. Significantly, he was apprenticed with the architect Ghiberti (see column, p.102) at the beginning of his career.

In a story recounted by Vasari, Uccello once worked all night on this science, whereby the confusion of the world could be ordered into submission. His wife reported him crying out in ecstasy, "Oh, how great is this perspective!" and, on being called to bed, saying that he would not leave his "sweet mistress perspective." He seized upon it with an intellectual passion that might have produced a rather rigid art.

Put very simply, the art of perspective is the representation of solid objects and three-dimensional space in accordance with our optical perception of these things (and in direct opposition to a purely symbolic or decorative form of representation.) We see the world "in perspective": objects appear smaller as they recede into the distance; the walls of a corridor or an avenue of trees, for instance, appear to converge as they stretch into the distance. The laws of perspective are based upon these converging lines meeting eventually at a single, fixed "vanishing point," which may be visible – such as when an avenue of trees stretches as far as the eye can see – or is an imagined "vanishing point" – as when the converging lines of a room continue, in our imagination only, beyond the far wall.

One of Uccello's greatest works, which demonstrates his fascination with perspective, is *The Hunt in the Forest (102)*. Everything in it is organized upon a distant and almost unseen stag, a vanishing stag: the vanishing point. The bright little hunters, with their horses, hounds,

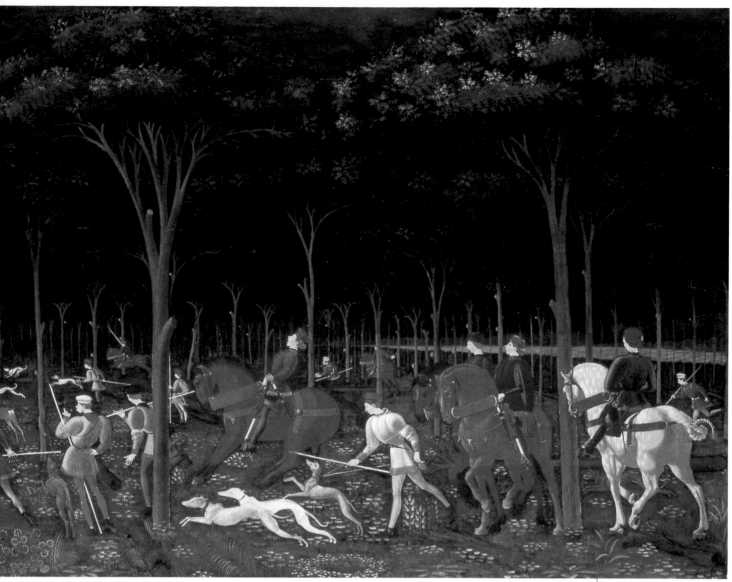

102 Paolo Uccello, **The Hunt in the Forest,** *1460s, 70 x 29½ in (178 x 75 cm)*

and beaters, run from all sides among the slim, bare trunks of a darkly wooded landscape. While all this activity is frenzied, it is exquisitely purposeful and sane. Throughout this painting, we feel Uccello's comfort and his poetry.

Uccello was not the first Florentine to explore perspective. Brunelleschi, the architect who built Florence Cathedral's revolutionary dome (see p.82), demonstrated linear perspective as an element in architectural design in about 1413. However, it was Leon Battista Alberti (see columnleft) who pioneered its application to painting. His 1435 treatise *On Painting* had a widespread influence on contemporary artists. How widespread it was is something that we can never really prove. The fact remains that after Uccello, Brunelleschi, and above all Alberti, every artist had become alerted to the potential of this astonishing new insight.

UCCELLO'S STUDIES

The complex perspective framework of Uccello's paintings was the result of meticulous study. In this drawing of a chalice, he tackles the perspective problems of drawing a rounded object in three-dimensional space.

THE VANISHING POINT
That Uccello's Hunt in the Forest *demonstrates an effective rendering of perspective is shown in this miniature version. Lines have been added artificially to draw attention to features of the general composition that lead the eye to the vanishing point. At this point, the leading stag is disappearing into the forest.*

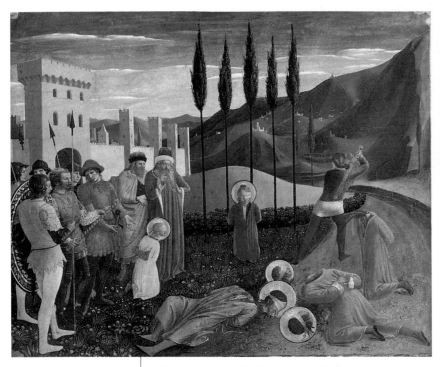

103 Fra Angelico, **The Beheading of St. Cosmas and St. Damian,** *c. 1438–40, 18 x 14½ in (46 x 37 cm)*

THE DEVOUT ART OF FRA ANGELICO

The Dominican monk Fra Angelico (Fra Giovanni da Fiesole, c. 1400–55) was active at about the same time as Masaccio. He painted with great religious gravity and in remarkably luminous tones, but he is insufficiently seen as the bold experimenter that he truly was – not in theme, but in manner.

Despite the implications of his name, there is a satisfying humanity about Fra Angelico that takes pleasure in the substance of the material world. No questions are left unanswered in his *Beheading of St. Cosmas and St. Damian (103)*. It is a scene of intense chromatic brightness, every form and hue bathed in the relentless light of a summer morning. The landscape is wholly realized, from the clarity of the white towers to the tall, dark cypresses and the receding swoops and rises of a hilly countryside. The two saints wait, blindfolded against the brightness and horror, and the three already decapitated sprawl in the messy scarlet of their blood, each head rolling on the grass in its hoop of halo. It is real death, painted without recourse to melodrama, but seen with the half-smile of a total believer.

It is tempting to look at the *Virgin and Child Enthroned with Angels and Saints (104)* and regard it as charming but conventional, since the graceful, sinewy lines and strong local color are derived from the Gothic tradition. But a closer look reveals that Fra Angelico was fully aware of the progressive tendencies in painting – of perspective and use of light especially – and the

The Dominican order, of which Fra Angelico was a member, moved to the convent of San Marco in Florence in 1436. It was funded by Cosimo de' Medici, who also donated more than 400 classical texts to the library. It was at San Marco that Fra Angelico painted many of his best-known frescoes, including *The Annunciation*.

LUCA DELLA ROBBIA

Much admired in his time, Luca della Robbia (1400–82) was a Florentine sculptor. He carved the beautiful marble *cantoria* (choir gallery) for Florence Cathedral in 1431–38. The carvings illustrate the 150th Psalm and depict angels, boys, and girls playing musical instruments, singing, and dancing.

OTHER WORKS BY FRA ANGELICO

The Madonna of Humility (National Gallery of Art, Washington)

The Annunciation (Convent of San Marco, Florence)

St. James Freeing Hermogenes (Kimbell Art Museum, Fort Worth, Texas)

Virgin and Child with St. Dominic and St. Peter Martyr (Church of San Domencino, Cortona)

Virgin and Child (Cincinnati Art Museum)

104 Fra Angelico, **The Virgin and Child Enthroned with Angels and Saints,** *c. 1438–40, 7 ft 3 in x 7 ft 6 in (220 x 229 cm)*

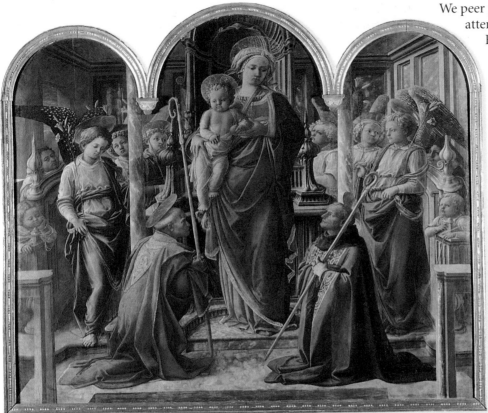

105 Fra Filippo Lippi, Virgin and Child, c. 1440–45, 8 ft x 7 ft 1 in (244 x 215 cm)

We peer past the agonized figure on the Cross to attempt – in vain – to decipher the carpet. Equally, past the reverential angels beside the throne, in a naturalistic landscape, we see light catching the tips of trees, glancing off leaves, escaping past the trunks to reveal a distant land. The total effect is anything but conventional.

SACRED AND PROFANE

All the same, Fra Angelico was the model of a good monk, just as Fra Filippo Lippi (c.1406–69) was not. Giovanni da Fiesole chose in his young maturity to become a monk, and his admiring brethren called him the "Reverend Angel" (*Fra Angelico*). In the 19th century he was thought to be a saint. But young Filippo (Lippo) was left an orphan and brought up by the Carmine monks in Florence: no other calling was suggested to him, though it became scandalously clear that he had no capacity for a life of frugal chastity. It is a story with a happy ending, in that he eventually met a woman to cherish (incidentally, a nun who had been "conventized" in much the same unthinking fashion as he was encouraged in his choice) and both were dispensed from their vows, and their marriage blessed.

Lippi's version of the *Virgin and Child (105)* surrounded by angels and saints may be compared with that of his truly devout brother in religion (see p.91). Lippi painted his version some years after Masaccio produced his frescoes in the Brancacci Chapel in Florence (see p.85), and these were a crucial influence on Lippi's work.

OTHER WORKS BY
FRA FILIPPO LIPPI

Virgin and Child
(Walters Art Gallery,
Baltimore)

Madonna and Child
(Uffizi, Florence)

Adoration in a Wood
(Staatliche Museen,
Berlin-Dahlem)

sculptural influence on his representation of physical space is pronounced. There is a strong formal patterning, real bodies stand in true relation to one another, and there is an unconventional delight in the near-primitivism of the animals in the carpet and in the tiny but significant Crucifixion that looms sternly up in the center.

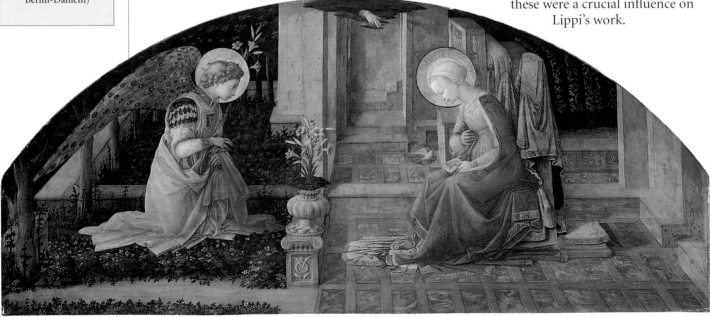

106 Fra Filippo Lippi, Annunciation, c. 1448–50, 60 x 27 in (152 x 68 cm)

However, the monumentality of form Lippi learned from Masaccio was to be tempered with a delicacy and sweetness similar to that found in Fra Angelico's paintings, and the serene mystical quality of his later paintings reveal growing Netherlandish influences in Italy.

Lippi's Virgin has a rounded physical presence, statuesque and forbidding despite its fullness, and the chubby Child looks rather disparagingly down on the kneeling St. Frediano. The angels too are heavily present, crowded in upon one another in a confusion of light-filled space. There is too much going on. The marbled walls behind push down on us, and the jeweled brightness of material and form takes on an almost claustrophobic weight. But when he simplifies his scene, it is rare to find a painter more moving than Fra Lippi.

His *Annunciation (106)* is a heavenly little work, with diaphanous veilings exquisitely rendered, and a lovely tenderness in the pure and gentle girl and her angelic messenger. This panel is thought to have been part of the bedroom furniture of some great noble, possibly Piero de' Medici (who patronized Lippi). The Medici family emblem – three feathers in a diamond ring – appears carved in stone beneath the vase of lilies, and in the companion piece, *Seven Saints (108)*, all the saints are "connected" with the Medici: name saints of the family males. The seven sit dreamily on a marble garden seat, only St. Peter Martyr, with his emblematic hatchet in his head, looking glum.

That saints in general are happy seems a congenial belief to Filippo. His own son, the model for many of the Infant Jesus images, was himself to become a painter and likewise express a fundamental well-being. But Lippi junior, Filippino

(1457–1504), was orphaned at ten and brought up by Botticelli (see p.94), who had been taught by Lippi senior. Filippino's work shows that Lippi tendency to happiness, shadowed by the Botticelli sense of human frailty. There is a quivering gentleness in Filippino that is uniquely his own. *Tobias and the Angel (107)* is a moving work, but it floats ethereally before us, scarcely seeming to acknowledge the earth.

COSIMO DE' MEDICI

The Medici family dominated Florentine political life for much of the 15th and 16th centuries. The glorious epoch of the family began with Cosimo (1389–1464) who commissioned work from Ghiberti, Donatello, and Fra Angelico. His descendent, Cosimo I (1519–1574), depicted above, became Duke of Florence in 1537. He was a skilled but ruthless soldier who managed to annex the republic of Siena to Tuscany in 1555. He too was a great patron of the arts and had his own collection of Etruscan antiquities. This portrait, painted in 1537, is by Jacopo Pontormo (see pp.139-141).

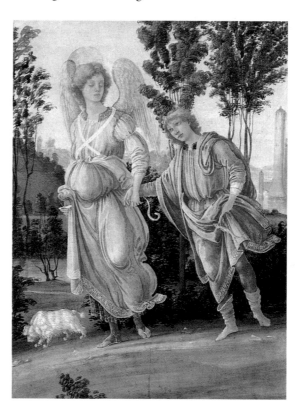

107 *Filippino Lippi,* **Tobias and the Angel,** *probably c. 1480, 9 x 12¾ in (23.5 x 32.5 cm)*

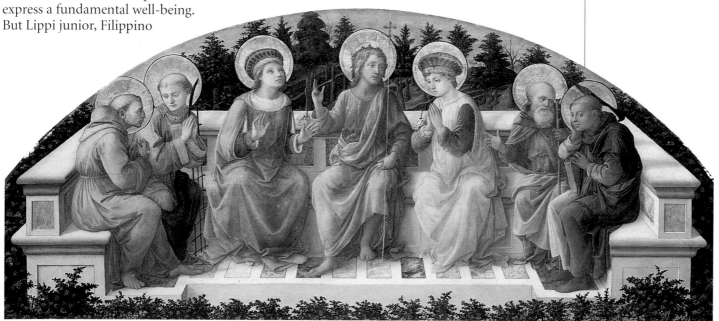

108 *Fra Filippo Lippi,* **Seven Saints,** *c. 1448–50, 60 x 27 in (152 x 68 cm)*

BOTTICELLI: LYRICAL PRECISION

After Masaccio, Sandro Botticelli (Alessandro di Moriano Filipepi, 1444/5–1510) comes as the next great painter of the Florentine tradition. The new, sharply contoured, slender form and rippling sinuous line that is synonymous with Botticelli was influenced by the brilliant, precise draftsmanship of the Pollaiuolo brothers (see column, left), who trained not only as painters, but as goldsmiths, engravers, sculptors, and embroidery designers. However, the rather stiff, scientifically formulaic appearance of the Pollaiuolos' painting of *The Martyrdom of St. Sebastian* (see column left), for instance, which

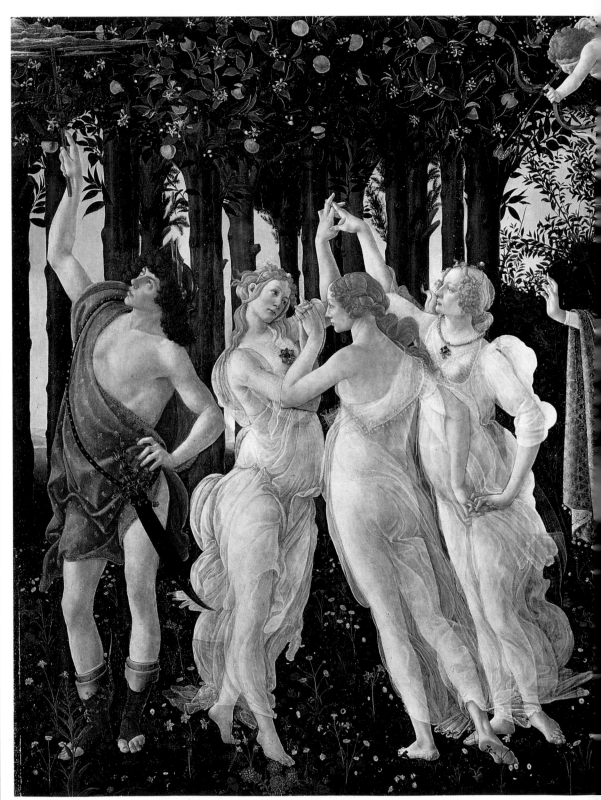

109 Sandro Botticelli, Primavera, c. 1482, 10 ft 4 in x 6 ft 9 in (315 x 205 cm)

clearly follows anatomical dictates, finds no place in the paintings of Botticelli. His sophisticated understanding of perspective, anatomy, and the Humanist debate of the Medici court (see column p.82) never overshadows the sheer poetry of his vision. Nothing is more gracious, in lyrical beauty, than Botticelli's mythological paintings *Primavera* and *The Birth of Venus* (see p.96), where the pagan story is taken with reverent seriousness and Venus is the Virgin Mary in another form. But it is also significant that no one has ever agreed on the actual subject of *Primavera (109)*, and a whole shelf in a library can be taken up with different theories;

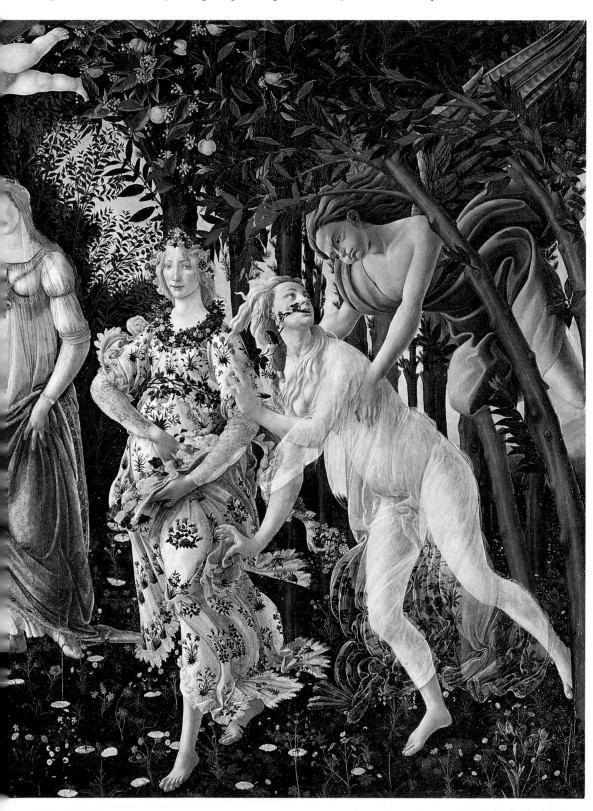

> **"** *… [Botticelli] appears almost as if haunted by the idea of communicating the unembodied values of touch and movement.* **"**
> B. Berenson,
> *The Italian Painters of the Renaissance*, 1896

MYTHICAL FIGURES

Botticelli's *Primavera* is an allegory on the harmony of nature and humankind and contains many mythical figures, including Venus (the link between nature and civilization) and Mercury. At the extreme right of the painting, the figure of Zephyr (the west wind of spring) is seen chasing Chloris, who is then transformed into Flora, the goddess of flowers. A blindfolded Cupid shoots his arrows at the Three Graces (the handmaidens of Venus) who were believed to represent the three phases of love: beauty, desire, and fulfillment. This illustration shows a woodcut of Cupid, who was one of the most popular figures in Renaissance art.

THE BIRTH OF VENUS

This secular work was painted onto canvas, which was a less expensive painting surface than the wooden panels used in church and court pictures. A wooden surface would certainly be impractical for a work on this scale. Canvas is known to have been the preferred material for the paintings of nonreligious and pagan subjects that were sometimes commissioned to decorate country villas in 15th-century Italy.

WOODED SHORE
The trees form part of a flowering orange grove – corresponding to the sacred garden of the Hesperides in Greek myth – and each small white blossom is tipped with gold. Gold is used throughout the painting, accentuating its role as a precious object and echoing the divine status of Venus. Each dark green leaf has a gold spine and outline, and the tree trunks are highlighted with short diagonal lines of gold.

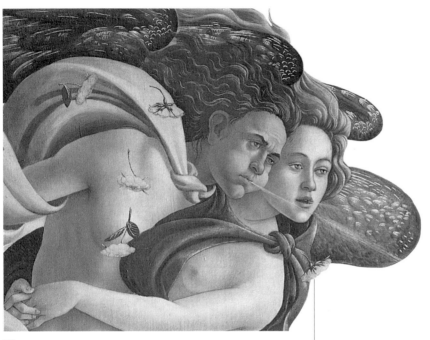

THE WEST WIND
Zephyr and Chloris fly with limbs entwined as a twofold entity: the ruddy Zephyr (his name is Greek for "the west wind") is puffing vigorously, while the fair Chloris gently sighs the warm breath that wafts Venus ashore. All around them fall roses – each with a golden heart – which, according to legend, came into being at Venus's birth.

THE SHELL
Botticelli portrays Venus in the very first suggestion of action, with a complex and beautiful series of twists and turns, as she is about to step off her giant gilded scallop shell onto the shore. Venus was conceived when the Titan Cronus castrated his father, the god Uranus – the severed genitals fell into the sea and fertilized it. Here what we see is actually not Venus's birth out of the waves, but the moment when, having been conveyed by the shell, she lands at Paphos in Cyprus.

NYMPH
The nymph may well be one of the three Horae, or "The Hours," Greek goddesses of the seasons, who were attendants to Venus. Both her lavishly decorated dress and the gorgeous robe she holds out to Venus are embroidered with red and white daisies, yellow primroses, and blue cornflowers – all spring flowers appropriate to the theme of birth. She wears a garland of myrtle – the tree of Venus – and a sash of pink roses, as worn by the goddess Flora in Botticelli's Primavera *(p.94–95).*

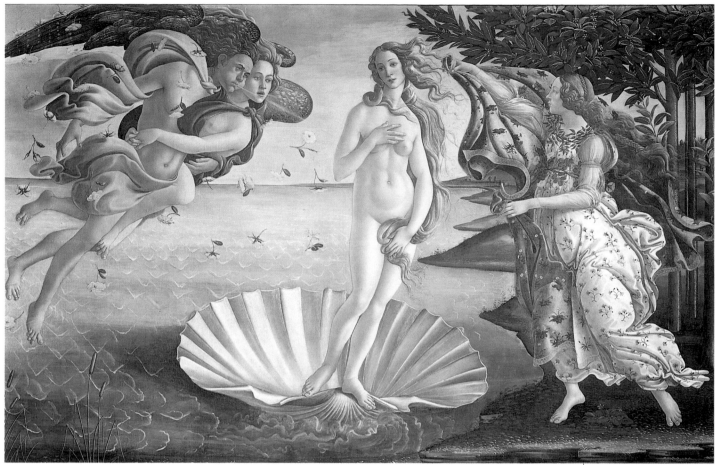

110 Sandro Botticelli, **The Birth of Venus,** *c. 1485–86, 9 ft 2 in x 5 ft 9 in (280 x 175 cm)*

but though scholars may argue, we need no theories to make *Primavera (109)* dear to us. In this allegory of life, beauty, and knowledge united by love, Botticelli catches the freshness of an early spring morning, with the pale light shining through the tall, straight trees, already laden with their golden fruit: oranges, or the mythical golden apples of the Hesperides?

At the right, Zephyr, the warm wind of spring, embraces the Roman goddess Flora, or perhaps the earth nymph Chloris, diaphanously clad and running from his amorous clasp. She is shown at the moment of her metamorphosis into Flora, as her breath turns to flowers that take root over the countryside. Across from her, we see Flora as a goddess, in all her glory (or perhaps her daughter Persephone, who spends half her time beneath the earth, as befits the patron saint of flowers) as she steps forward clad in blossoms. In the center is a gentle Venus, all dignity and promise of spiritual joy, and above her, the infant Cupid aims his loving arrows. To the left, the Three Graces dance in a silent reverie removed from the others in time also, as indicated by the breeze that wafts their hair and clothes in the opposite direction from Zephyr's gusts. Mercury, the messenger of the

gods, provides another male counterpart to the Zephyr. Zephyr initiates, breathing love into the warmth he brings to a wintry world, and Mercury sublimates, taking the hopes of humanity and opening the way to the gods.

Everything in this miraculous work is profoundly life-enhancing. Yet it offers no safeguards against pain or accident: Cupid is blindfolded as he flies, and the Graces seem enclosed in their own private bliss. So the poetry has an underlying wistfulness, a sort of musing nostalgia for something that we cannot possess, yet something with which we feel so deeply in tune. Even the gentle yet strong colors speak of this ambivalence: the figures have an unmistakable presence and weight as they stand before us, moving in the slowest of rhythms. Yet they also seem insubstantial, a dream of what might be rather than a sight of what is.

This longing, this hauntingly intangible sadness is even more visible in the lovely face of Venus as she is wafted to our dark shores by the winds, and the garment, rich though it is, waits ready to cover up her sweet and naked body. We cannot look upon love unclothed, says *The Birth of Venus (110)*; we are too weak, maybe too polluted, to bear the beauty.

LORENZO DE' MEDICI
Succeeding in 1469 as head of the Medici family, Lorenzo *"Il Magnifico"* (the Magnificent) was a courageous, if autocratic, leader. He was a patron of the arts and assisted many artists, including Michelangelo and Leonardo da Vinci. Botticelli had some patronage from Lorenzo, but his chief patron was a cousin of *Il Magnifico* called Lorenzo di Pierfrancesco de' Medici, or "Lorenzino."

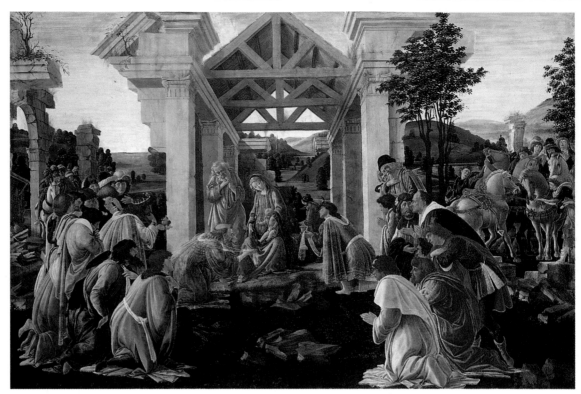

111 Sandro Botticelli, **The Adoration of the Magi,** *c. 1485–86, 9 ft 2 in x 5 ft 9 in (280 x 175 cm)*

Botticelli accepted that paganism, too, was a religion and could bear profoundly philosophical significance. His religious paintings manifest this belief by converging all truths into one.

He seems to have had a personal devotion to the biblical account of *The Adoration of The Magi (111)*, setting it in a ruined classical world. This was not an uncommon Renaissance device, suggesting that the birth of Christ brought fulfillment to the hopes of everyone, completing the achievements of the past.

But no painter felt this with the intensity of Botticelli. We feel that he desperately needed this psychic reassurance, and that the wild graphic power of his *Adoration*'s great circles of activity, coming to rest on the still center of the Virgin and her Child, made visible his own interior circlings. Even the far green hills sway in sympathy with the clustered humans as if by magnetic attraction around the incarnate Lord.

Botticelli was not the only Florentine to be blessed or afflicted by an intensely anxious temperament. In the 1490s, the city of Florence was overtaken by a political crisis. The Medici government fell, and there followed a four-year period of extremist religious rule under the zealot Savonarola (see column, facing page). Either in response to this, or possibly out of some desire of his own for stylistic experimentation, Botticelli produced a series of rather clumsy-looking religious works – the *San Bernabo Altarpiece* is an example.

THE STRANGE WORLD OF PIERO DI COSIMO

Piero di Cosimo (1462–1521) did not live, like Botticelli, in the enlightened ambience of the Medici court. He was a man who actively required some sort of seclusion so as to conserve his energies and explore his preoccupations. (He even went so far as to live on boiled eggs, we are told, cooking them 50 at a time, so as to be free of the mundane concerns of the mere body.) Yet in *The Visitation with St. Nicholas and St. Anthony Abbot (112)*, he displays a wonderful sense of the body, its weight and presence. When he shows the Virgin Mary, still bewildered by the angelic annunciation of her sacred pregnancy, coming to greet her elderly cousin Elizabeth, also blessed with a miraculous pregnancy, the two women approach each other with a touching reverence.

Each is primarily conscious of the child in her womb, and Elizabeth is about to cry out to tell Mary that the unborn John the Baptist within her has leapt for joy at the nearness of the unborn Jesus. Piero merely shows us the two touching each other with a wondering reverence, yet the profundities are all the more present for being unexpressed.

But, as in all Piero's pictures, there are strange elements here. The women are flanked by two elderly saints: St. Nicholas, identifiable by the three golden balls at his feet (the dowry he anonymously threw into the house of an impoverished father of three marriageable

daughters, see p.53); and St. Anthony Abbot, whose unromantic emblem of a pig rootles happily in the background. To the right, behind Elizabeth, a furious scene, swarming with violence, depicts the massacre of the innocents, and in the shadows behind Mary, we find a quiet and almost insignificant nativity. Do the saints, engrossed in their reading and writing, "see" these things in their minds? What is actually happening and what is imagined?

Piero leaves us with engrossing problems to ponder. "The strangeness of Piero's brain," as Vasari (see column, left) described it, is seen even more in his nonreligious paintings like this mysterious *Allegory (113)*, with its mermaid, comical white stallion, and winged maiden, standing on a tiny island and holding the beast by a thread. We look with delight, but never find an answer. Piero's interest in animals and the exotic is revealed in many of his paintings. He included a snake in his *Portrait of Simonetta Vespucci*, a satyr and a dog in *Mythological Scene*, and various animals in his *Hunting Scene.*

113 Piero di Cosimo, Allegory, *c. 1500, 17⅓ x 22 in (44 x 56 cm)*

SAVONAROLA

This medallion of the Dominican friar, reformer, and martyr Girolamo Savonarola (1452–98) was made by Ambrogio della Robbia. As prior of San Marco, Savonarola strongly criticized the Medici government. Then, in 1494, Piero de' Medici's regime was overthrown and Savonarola became the effective leader of Florence. He set up a popular government, based on a council of 3,200 citizens, which aimed to enforce religious observance in all aspects of daily life. Unfortunately, in the years that followed, the city was afflicted by famine, plague, and war, which so reduced his popularity that he was asked to leave. He was declared a heretic, and in 1498 he was hanged and his body burned.

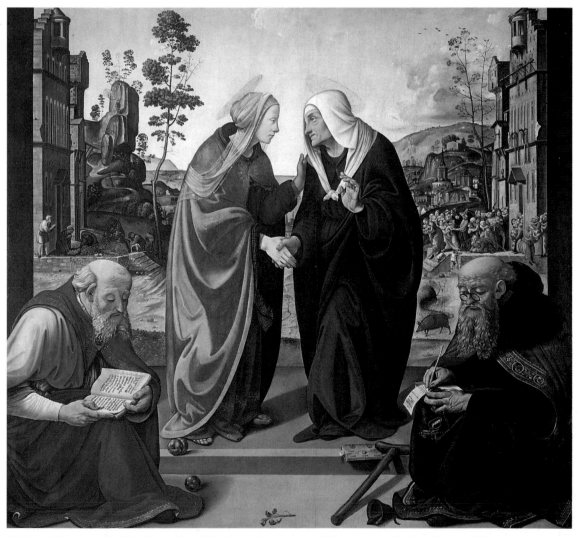

112 Piero di Cosimo, The Visitation with St. Nicholas and St. Anthony Abbot, *c. 1490, 6 ft 2 in x 6 ft ½ in (189 x 184 cm)*

MAJOLICA WARE

A type of tin-glazed earthenware known as majolica ware (or maiolica ware) was popular in Italy during the Renaissance. The name is derived from Majorca, the island off Spain through which the pottery was originally imported from North Africa and the Near East. This example is by Nicola da Urbino, one of the finest Majolica painters.

PIERO DELLA FRANCESCA'S SOLEMN GENIUS

The "other" Piero is far better known, and with justice. It can come as a shock to learn that the present admiration for Piero della Francesca (c. 1410/20–92) is of comparatively recent origin. His intensely still and silent art went out of fashion not long after his death, and its sublime restraint of expression was seen as inadequacy. Yet Piero della Francesca is one of the truly great masters of all time. He was born in the small town of Borgo Sansepolcro in Umbria, central Italy. In Piero's wide vision we can see the lovely defining light and sculptural form of Masaccio (see p.82) and Donatello (see p.83), brilliant clarity of color, together with a new interest in "real" landscape, which was influenced by his master Domenico Veneziano (see p.86) and by Flemish artists. When his eyes dimmed in later life, Piero turned increasingly to his other abiding interest, mathematics, and as a branch of mathematics, perspective (see p.88). He was also a theorist, and, like Alberti (see p.88), wrote two treatises on the mathematics of art.

RELIGIOUS LANDSCAPES

The Baptism of Christ (114) takes place in an eternal dimension, even though those little streams and terraced hills are purely Umbrian. Piero's admiration of ancient art, which he studied in Rome around 1450, is manifested in the dignity and classical form of Christ, and of St. John and the angels. The tall and slender column of manhood that is Jesus, Son of the Most High, is paired with the tall and slender column of the tree. The tree in turn is aligned with the majestic figures of the waiting angels. John the Baptist is another vertical, a slightly inclining one, solemnly performing his sacramental baptism with water from the river that, as told in legend, has stopped flowing at Christ's feet. A disrobing penitent, leaning forward, both continues and varies the vertical theme. A group of theologians debates, clothes brightly reflected in the stilled water.

The invisible element, the Holy Spirit, is all-pervading, as a pure, crystalline early morning light, and in material form as a dove hovering horizontally with outspread wings, sanctifying the baptism with golden rays (only barely visible now), that shine down over Christ's head. The dove is the only presence in the baptismal group that could be reflected in the limpidity of the waters, but is not; it is unseen by all eyes but our own. There is such poetry in the sunlight and the high sky, the flowers, and the simple brightness of the garments that it is impossible not to believe, as Piero does, that we who contemplate the scene are literally blessed.

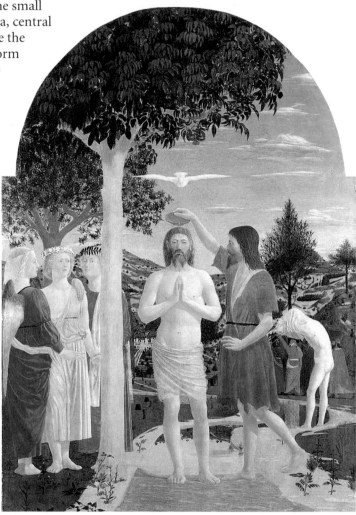

114 Piero della Francesca, **The Baptism of Christ,** *1450s, 46 x 66 in (117 x 168 cm)*

Even a detail like the great overarching mass of foliage in the trees overhead seems to be weighted with holy significance. But Piero never presses home any symbolism, he never intrudes to put forward an interpretation. It has been remarked that everything in this picture is mathematically calculated to give the maximum impact, and one can even draw diagrams to show the underlying intelligence behind the structure. But our response comes immediately, affected unconsciously by this intelligence. Piero has that rare gift: he is effective – his pictures work; and he affects – we are moved by them.

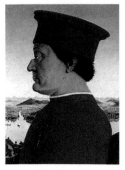

THE DUKE OF URBINO

One of Piero della Francesca's patrons was the first Duke of Urbino, Federigo da Montefeltro, whose portrait he painted (above). The Duke led several armies during the territorial battles of the 15th century, but was also a renowned scholar. His palace at Urbino was one of the important small courts of Italy and contained his extensive library.

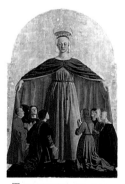

THE MISERICORDIA

The Compagnia della Misericordia was founded in Florence in the 13th century to carry out missions of mercy, such as transporting the sick to hospitals, and the dead to burial. In 1445, the organization commissioned Piero della Francesca to paint an altarpiece for Borgo Sansepolcro. The central figure in the work is the Madonna of Mercy, who was patroness of the Misericordia. The organization is still active today.

THE BAPTISM OF CHRIST

This was originally the central panel of a large triptych. The rest of this triptych was painted by Matteo di Giovanni in about 1464. Piero's natural, almost casual depiction of this solemn ritual belies the work's sophisticated composition, and though its structure can be reduced to strict mathematical proportions, it is one of Piero's least mathematically controlled paintings.

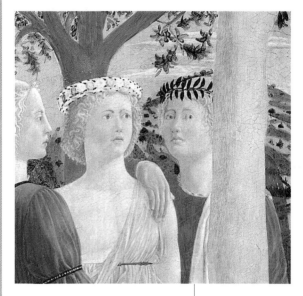

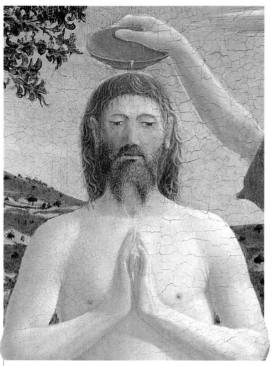

ANGELS

The compact trio of angels is divided from the mortal world by the tree. They stand together with a charming degagé *air, holding hands, their large and lovely flat feet planted solidly on the grassy meadow. The angels are witnessing Christ's baptism and affirm its importance with serene certainty. Piero shows us only a glimpse of the wing of the far angel, in which a few flecks of gold are still visible, and the landscape visible beneath.*

CHRIST

The ritual anointing is performed in the deep, silent absorption of prayer, signified by the quiet concentration of John and Jesus. Christ's body has the whiteness of a bleached shell, His outer cleanliness echoing His symbolic purification through baptism – presided over by the Holy Spirit in the form of a white dove. A kind of spiritual force field separates John from Christ. He moves toward Christ, yet his free hand does not enter the unbroken divide between them.

DISTANT TOWN

Piero shows us the small town of Borgo Sansepolcro, with its fortified towers appearing piteously small and insignificant in the distance. Piero's treatment of the distinctly Umbrian landscape immediately distinguishes him from his contemporaries and displays an unprecedented naturalism. It reveals the extent to which Piero was influenced by Netherlandish art.

BENDING FIGURE

The half-naked figure standing at the river's edge in the middle distance is stripping off his clothes in readiness for his own baptism. His nakedness is symbolic of his humility before the Almighty, and contrasts sharply with the extravagant and even kingly headgear and costume of the high priests, who stand farthest away and are given the smallest stature in Piero's hierarchy. The identity of the penitent is hidden – a temporary concealment hinting at the new life he will begin after baptism. His body – like Christ's – is bathed in a brilliant white light.

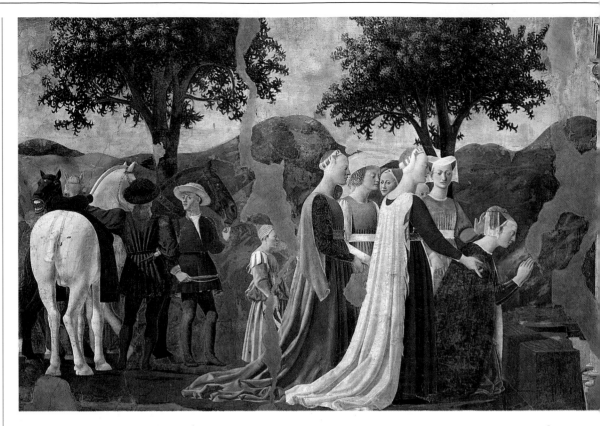

THE BAPTISTERY DOORS

In 1401, a competition was launched to produce a set of panels for the east doors of the Baptistery, a building next to the cathedral in Florence. Seven sculptors, including Brunelleschi (see column, p.82), were chosen to compete, using the Sacrifice of Isaac as a theme. The winner was Lorenzo Ghiberti (1378–1455). The subject was changed to the Life of Christ. This took Ghiberti 20 years to complete, and was finally installed on the north doors. Ghiberti then began the work that was actually installed on the east doors. These ten bronze panels, which include the one shown above, were called the "gates of Paradise" by Michelangelo.

PIERO'S MASTERPIECES

Although Piero has a claim to being the perfect painter, every one of whose paintings is wonderfully good, his greatest work is the fresco that makes magnificent the church of St. Francis in the town of Arezzo, near Piero's birthplace. *The Story of the True Cross (115)* runs around the walls, telling all aspects of the legend, from the supposed beginning of the Cross as a

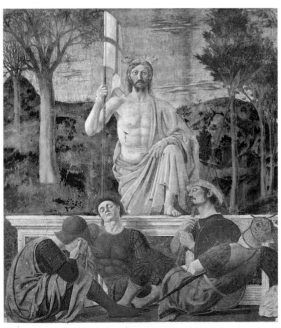

116 Piero della Francesca, Resurrection of Christ, early 1450s, 6 ft 9 in x 7 ft 5 in (205 x 225 cm)

tree growing in Paradise, up to the miraculous Finding of the Cross by St. Helena, the mother of Constantine the Great. The story is legend from start to finish, yet Piero treats it with such reverent solidity that archetypal truths are revealed. When the Queen of Sheba, proceeding in stately fashion toward her encounter with Solomon, "adores the wood of the Cross," the quiet passion of that bending neck tells us of the meaning of adoration, and its loveliness.

Although she and her maidens are cut from the same cloth pictorially (tall, willowy, swan-necked beauties) it is only the queen who understands the challenge of the holy and prostrates her regal self. Behind her the pages gossip, beside her the maids of honor look interestedly on. She alone has understood the full dimensions of the finding. As ever in Piero, there is an air of silence so profound as to halt all movement in its tracks, and immortalize the scene that is depicted.

Another work, the *Resurrection of Christ (116)*, has actually been described as the greatest picture ever painted (its only rival for this honor being Velázquez's *Las Meninas*, see p.194). The two masterpieces are utterly different, Piero's having a unique sublimity. Its gravely heroic Christ, impassive and heraldic, enters life as a somberly compassionate Conqueror, lifting the sleeping world up onto a new plane of being. It was painted for the town hall of Borgo Sansepolcro – Italian for "the Holy Sepulcher."

examples of work by Donatello (see pp.83, 105). Many of Mantegna's paintings take on the appearance of a pictorial bas-relief akin to Donatello's and Ghiberti's sculpted panels (see p.102), and these works subsequently influenced High Renaissance painting, notably that of Raphael (see p.125).

For some, this sculptural bias has made Mantegna's art seem bloodless. It is severe, monumental, thought out from within. But it can strike us as all the more impressively emotional for that very need, experienced so intensely, to protect himself from the vulnerability of self-exposure. The task is impossible, since every major artist can only create from his own heart, and the attempt to conceal is as revealing as the desire to expose. Mantegna had left Padua to be court artist at Mantua when he painted *The Death of the Virgin (117)*, a great tableau where emotion is frozen into a sort of

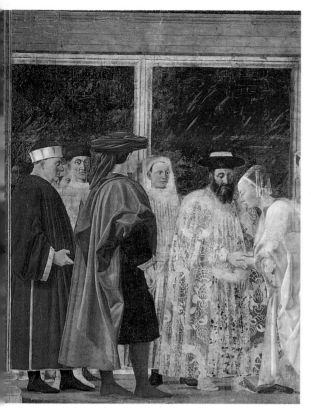

115 Piero della Francesca, **The Story of the True Cross,** *c. 1452–57, 24 ft 6 in × 11 ft in (747 × 335 cm)*

SOLIDITY IN MANTEGNA'S ART

There is something of Piero's silent massiveness in Andrea Mantegna (1431–1506), the first great artist from northern Italy. He belongs to the Florentine tradition in that his art showed the expressly Florentine concerns with scientific debate and classical aspiration, but as the leading artist of northern Italy he belonged also to that of nearby Venice. He is first heard of as a young man in Padua, struggling, by means of a lawsuit, to free himself from his teacher and adoptive father, Francesco Squarcione.

A sort of lonely freedom is basic to Mantegna's temperament, as we understand it, and there is something rather appropriate in his dual attempt to gain his legal independence and to plot with fierce intellectual clarity the frescoes on the walls of the Eremitani chapel. Although nearly all this work was destroyed or damaged during World War II, enough remains to indicate the almost awesome originality of his painterly approach.

The irony is that Mantegna would have claimed not originality, but a rigorous conservatism, and his art is a rejection of the more relaxed, painterly styles that were emerging in Venetian art. He may have benefitted from the teaching of Squarcione, who did at least possess an unrivaled set of antique drawings, but the sculptural quality of Mantegna's art makes it far more likely that he was influenced by local

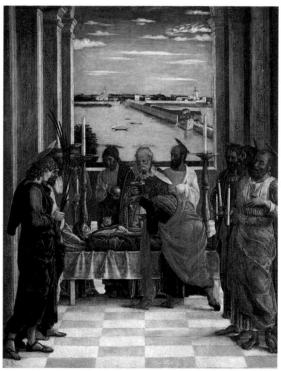

117 Andrea Mantegna, **The Death of the Virgin,** *c.1460, 16½ × 21¼ in (42 × 54 cm)*

icy passion. The apostles gathered around the bier are heavy with minutely observed grief. The Virgin is revealed with direct, personal simplicity in the humiliation of death. The drama is framed and given its context by the vast Mantuan landscape, which gleams in remote perfection behind the window. The waters lie still, the ramparts offer the pretense of human inviolability, and the serene sun bathes lakes, palaces, priests, and the dead Virgin in the same quiet light.

PERSPECTIVE SKILLS

This fresco was painted on a ceiling of the Gonzaga Palace in Mantua by Mantegna in 1465–74. In creating the illusion of an opening to the sky, the artist makes humorous use of Albertian perspective (see p.89), especially in the foreshortening of the winged figures.

OTHER WORKS BY PIERO DELLA FRANCESCA

Madonna of Mercy (Borgo Sansepolcro)

Federigo da Montefeltro (Uffizi, Florence)

The Nativity (National Gallery, London)

St. Jerome in the Desert (Staatliche Museen, Berlin-Dahlem)

SINOPIA

This was a technique of using red ochre to draw initial guides for fresco painting. Each day, a section of the sinopia was plastered over and painted. The 1966 flood in Florence damaged a number of Renaissance frescoes. As part of the restoration work, some were removed from the walls on which they were created, thereby exposing the sinopia. This provided insight into the artists' working practices and showed that they often introduced changes between the drawing of the original guides and the final representations.

118 Andrea Mantegna, Portrait of a Man, *probably c. 1460, 7½ x 9½ in (19 x 24 cm)*

her people's oppressor. Her expression is remote and impassive, and we perceive her extreme detachment of will in the way she averts her head, refusing to confront emotionally the reality of what she has done, as she passes the head to her shrinking attendant. She has resolutely turned her back on the pathos of Holofernes's dead foot, which rises up behind her like an accusing ghost. On one level, the painting is all calmness and immobility; on another, there is a revulsion of spirit so violent that there has to be a total psychological distancing.

This wonderful paradox, Mantegna's special gift, is fortuitously duplicated for us, for he painted another version *(119)*, in somber richness of color. The stony non-color of the tent and the figures contained within its shade changes to a harmony of radiant pinks, oranges, ochres, and blue-greens. One work, in Washington *(120)*, emphasizes the distancing; the other, in Dublin *(119)*, the intensity. Both have a still and stately beauty that is unforgettable.

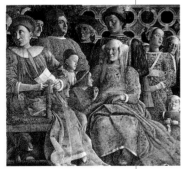

THE GONZAGA FAMILY
The Gonzaga court at Mantua was an important center for the arts. Ludovico Gonzaga was a generous patron who had traveled to the Medici court to gain ideas about leadership. This inspired him to undertake a plan of urban renewal, commissioning Alberti (see column, p.88) to build several churches. Another artist to benefit from Gonzaga patronage was Mantegna. The illustration above is a detail from a family portrait of the Gonzagas that he completed in 1474.

PORTRAITS OF THE GONZAGAS
Mantegna was commissioned to paint portraits of members of the influential Gonzaga family in Mantua. Even in these intimate pictures, which are unique for their historical immediacy, he always contrives to show us both the actual, which we can recognize, and the hidden ideal, which we can revere.

This is apparent even in this small-scale work, the *Portrait of a Man (118)*, where the unknown sitter is strongly individual and yet recalls to us the moral imperatives of duty and courage.

MANTEGNA'S GRISAILLE
In his love for the solid reality of sculpture, Mantegna went so far as to perfect a form of grisaille (monochrome painting that imitates the effect and color of stone relief). The texture resembles stone, yet in his hands it was fully alive. He might have chiseled out the dramatic panel of *Judith and Holofernes (119)*, where the Junoesque heroine stands impassively before the rigid folds of the tent in which she has murdered

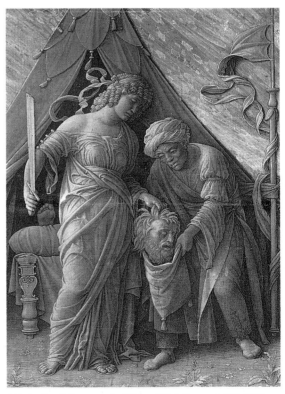

119 Andrea Mantegna, Judith and Holofernes, *1495–1500, 14½ x 19 in (37 x 48 cm)*

DONATELLO'S JUDITH

As a close personal friend of Cosimo de' Medici, Donatello was given the artistic freedom to produce this highly controversial sculpture of Judith slaying Holofernes in 1456. The Jewish heroine who murdered the Philistine (Assyrian) general Holofernes to protect her people was meant to symbolize humility overcoming pride, but the bronze was considered too disturbing by many Florentines, who petitioned successfully for its removal from the Piazza della Signoria.

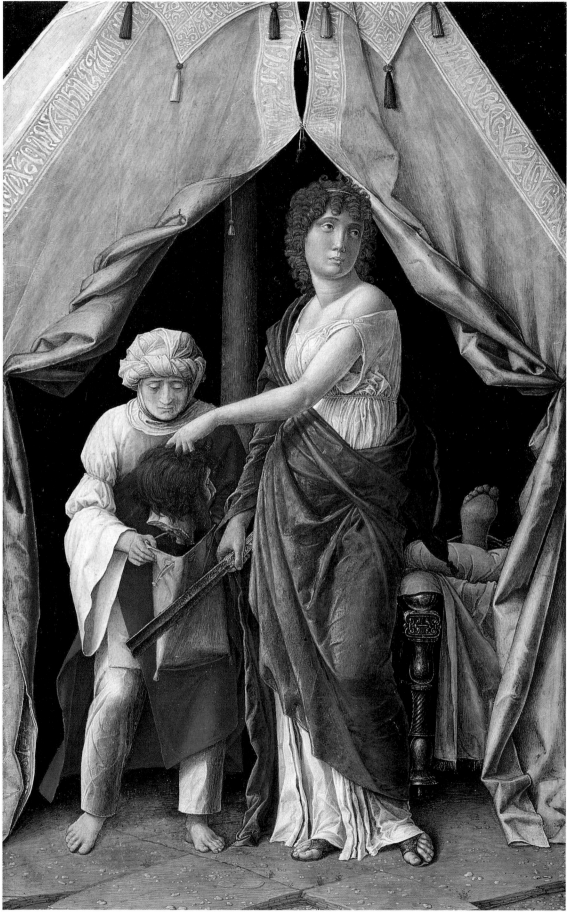

120 *Andrea Mantegna,* **Judith and Holofernes,** *c. 1495, 7 x 12 in (18 x 30 cm)*

OTHER WORKS BY MANTEGNA

Crucifixion
(Louvre, Paris)

St. Sebastian
(Kunsthistorisches Museum, Vienna)

Dead Christ
(Brera Gallery, Milan)

Virgin and Child with the Magdalen and St. John the Baptist
(National Gallery, London)

Dido
(Montreal Museum of Fine Arts)

The Dead Christ with Two Angels
(Statens Museum for Kunst, Copenhagen)

RENAISSANCE VENICE

Painting that was produced in Renaissance Venice belonged to the northern Italian tradition and had an identity and genealogy all its own. While Venetian artists also explored problems of perspective and mathematics and were unavoidably influenced by the fertile art of Medician Florence – the heartland of the Renaissance – there emerged in Venice a new, essentially "painterly" tradition. Venetian painting showed less concern with sculptural form and hard-edged delineation, placing more emphasis on color and nuances of light. From the beginning, it contained a peculiarly gentle lyricism, quite distinct from the Florentine tradition.

VENETIAN TRADE

In the 16th century, Venice was an independent and imperial city with a state-owned arsenal of ships employing 10,000 workers. The city was the Italian gateway to the Mediterranean for trading in silks, pigments, and spices. Venice was renowned as the center of the pigment trade, and it is known that Raphael, for example, sent an assistant there from Rome to purchase particular colors.

The artist great enough to lead painting into its next phase, and in doing so, greatly influence the course of Western painting since, was Giovanni Bellini (c. 1427–1516). He belonged to a family of artists, composed of his father Jacopo (c. 1400 –70/71) and his brother Gentile (c. 1429–1507). The two brothers were taught by their father (who had been a pupil of Gentile da Fabriano, see p.56) in accordance with the artistic tradition in Venice, in which skills were passed down through generations. The two generations of Bellinis became the most influential group of artists in northern Italy, and just as the early Renaissance is bound up with 15th-century Florentine culture, the Bellinis were responsible for the distinctly Venetian heritage of the High Renaissance of the late 15th to early 16th centuries.

INFLUENCE OF MANTEGNA

Although Mantegna (see p.103) stands alone, he had, in fact, a close and fruitful relationship with the Bellini family of Venice. (He was even a literal relation, in that he married Nicolosia, sister to Giovanni and Gentile. She does not seem to have softened him much – he remained litigious and oversensitive to the end.) But the hard beauty of

AGONY IN THE GARDEN

This theme was popularized in the Renaissance by artists such as Bellini, Mantegna, and El Greco (see p.146). After the Last Supper and before His arrest, Christ retired to the Mount of Olives to pray. The "agony" is the contest between Christ's human weakness and His divine confidence and belief in His resurrection. In Renaissance paintings of this scene, Christ traditionally kneels on a rocky outcrop as the three disciples sleep.

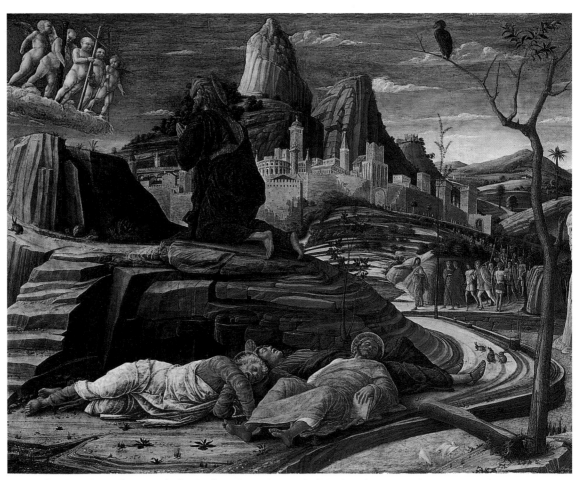

*121 Andrea Mantegna, **The Agony in the Garden**, c. 1460, 32 × 25 in (81 × 63 cm)*

Mantegna's own work certainly affected that of his brothers-in-law. Giovanni Bellini is one of the supreme painters of all the ages, able to accept the spare majesty of Mantegna and yet transform it into his own subtle sweetness. Sometimes we can actually watch influences being absorbed.

Both painters, coincidentally, have a version of *The Agony in the Garden* in the National Gallery, London. Mantegna's *(121)* is thought to have been painted about five years before Bellini's, and the younger artist, Bellini, always regarded his own work as lesser in quality. Yet the contest is very close; both paintings have a gaunt and rocky landscape setting, appropriate for the austerity of the drama. Both excel in figural perspective, showing the sleeping apostles in abrupt foreshortening. Both have the praying Christ half turned away, isolated on His jut of stone, bare feet vulnerable in His absorption upon His Father and His fate. In both paintings we see in the distance the approaching figures of the soldiers coming to arrest Jesus, led by the betraying disciple Judas.

But the two works are subtly different. It is not just that Mantegna is far more interested in the actual geophysical structure of the rocks, but that Bellini's world *(122)* is less aggressive, less confrontational. It may only be a question of degree, yet it modifies the feeling of the picture, makes it more tender, more visually ambiguous. It is here that Bellini's greatest gift is displayed: his sense of light in all its specificity.

It is sacred "time" in Mantegna, the "hour" of which Jesus spoke, removed from the mundane time of the normal day. Mantegna's sky, like his frozen and brooding city, is eternal. But Bellini shows us a real city faintly glimmering into visibility beneath the gentle skies of early morning. Light is beginning to flood with its warmth the cold night where Jesus has labored in painful prayer, and the angel of consolation, solid in Mantegna, floats solitary and ethereal in Bellini, a dawn apparition that will dissolve into cloud.

The mature Bellini understood light with mystical fervor. It had a sacred significance for him, one that he could share with us without ever lapsing into the explicit. Bellini is an extraordinary artist, a man sensitive to beauty, aware of the significance of form, and inspired by a passionate love, both of the visible and the invisible, that makes his work moving on every level. There is no Bellini painting that we cannot respond to with joy and a deeper understanding of what our existence is all about.

BELLINI FAMILY

The Bellinis formed one of the most prominent and successful families of Renaissance painters. Father Jacopo's silverpoint sketchbook was the inspiration for many of Giovanni's paintings, which in turn inspired the young Giorgione and Titian. It featured mythological characters (such as Perseus with the head of the Gorgon, shown here), as well as classical, biblical, and imaginative subjects.

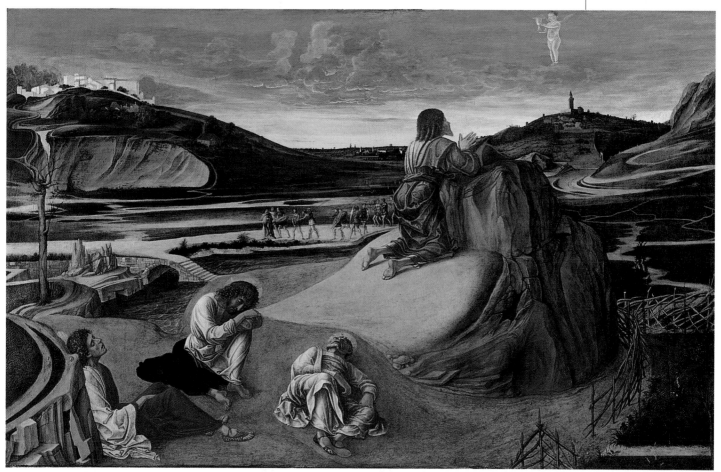

122 Giovanni Bellini, **The Agony in the Garden,** *c. 1460, 50 x 32 in (127 x 81 cm)*

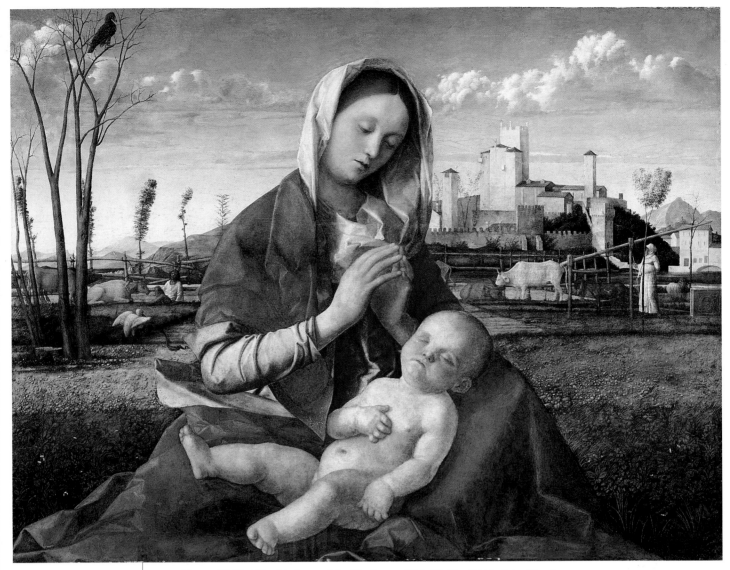

123 *Giovanni Bellini,* The Madonna of the Meadow, *c. 1500–05, 34 x 26½ in (86 x 67 cm)*

ST. JEROME

This detail from *St. Jerome* by Ghirlandaio (see p.121) shows equipment used to copy ancient texts. Jerome was a popular figure in Renaissance art, as he symbolized the ideal of the Humanist scholar. His great achievement was to translate the Bible into Latin.

The Madonna of the Meadow (123) may appear to be a typical Madonna, albeit a very enchanting one. But it is, in its understated manner, almost a revolutionary painting. Scholars have always pitted Florence against Venice, ever since Vasari, the great early art historian (see p.98), quoted his hero, Michelangelo, as lauding form above color, and deploring the Venetian concentration on the latter. In this sense, Giovanni Bellini is the "first" Venetian painter.

He initiates in us the awareness of a magical, enveloping brightness, a palpable light in which all colors shine at their loveliest. In this color-world, there is no longer man and woman in the midst of nature, but humanity as part of nature, another expression of its truth. The very texture of the harsh soil, the low lattices, the defended well, all have an undemonstrative integrity that has some mysterious, inexplicable connection with the strong pyramid of Mother and Child at the center of the picture.

Madonnas are a common idiom in Renaissance painting. There was hardly an artist who did not attempt this great theme. We can understand why. The wonderful thing about the Madonna and Child theme is that it appeals both to the specifics of Christianity (where the humanity of Christ is a central mystery) and to the human values on which all religion is based, throughout the world.

Every painter had a mother. Every psyche has been affected by this fact. To explore this fundamental of human existence had an irresistible fascination for the artist. No one has ever been more sensitive to this fundamental subject than Bellini. Every one of his Madonnas has an aesthetic and a spiritual force that makes them all memorable. He understands, at an elemental level, the meaning of motherhood and childhood, and this is the basis of the conviction that we see behind his Madonnas. This is only a sample, but an excellent one.

MADONNA OF THE MEADOW

Bellini was famed for his paintings of the Madonna and Child. From his 65-year-long career, no fewer than 14 of the major works that survive center on this, his favorite theme. It is one of the most ancient of all religious subjects, yet Bellini was able to invigorate what had become a formula, an icon, with a fully convincing depiction of the sacred and the human.

HARBINGER OF DEATH

A large raven broods heavily over the meadows, a reminder of the ever-present figure of death. Death, however, assumes a small scale in comparison to the monumental serenity of the Madonna and Child, who affirm life after death. The bird perches high up in the small, thin, leafless trees that sway imperceptibly against the luminous pallor of the sky. Though its role is symbolic, the bird is integrated into the natural order of life.

VENETIAN LANDSCAPE

On the right, divided from death by the towering figure of Mary, are the sober activities of life. Despite the gloomy presence of death, the daily life of the natural world goes calmly on. A farmer tends to the livestock in the field. Above them, an insubstantial line of cloud drifts slowly over the softly gleaming ramparts of the little city, whose concerns of government and commerce are rightly distanced from the great theme of life and death that Bellini dwells upon. And this is no walled garden, with cherubim and angels floating amid exotic flowers and cultivated hedgerows, but the real, solid world – Bellini's world – in the province of Venice.

MORTAL STRUGGLE

Easy to miss in the middle distance, and on the side of death, is a little egret, fighting with a snake. Wings raised in a threatening gesture, the egret circles the snake. This combat symbolizes the fight between good and evil. It may also refer to Christ's struggle before His sacrifice, and the reason for His sacrifice – the serpent's entry into the Garden of Eden. (It is interesting to note that there is also a pair of little egrets in the foreground of Mantegna's Agony in the Garden, *see p.106.)*

MOTHER AND CHILD

The blue and russet of Mary's robes are intensifications of the material world that surrounds her: earth and sky. She sits on bare earth, not as a queen enthroned in majesty (think of Duccio's Maestà, p.42), but as the Madonna of Humility, a 14th-century tradition. Though her robes form a pyramid and her scale is monumental, her humility appears real, and no mere pictorial convention. This is Bellini's greatness: the uniting of the symbolic and the real, drawn together by a common and natural light source, in chromatic harmony with each other, so that we believe in Mary all the more implicitly.

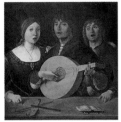

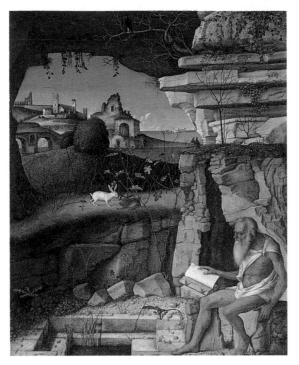

124 *Giovanni Bellini*, St. Jerome Reading, *c. 1480/90, 15½ x 19½ in (39 x 49 cm)*

There is this same magical involvement in his *St. Jerome Reading (124)*, where the center of attention is not the noble saint, still less his attendant lion comfortably snuggled at his back, but the wonderful white hare, nibbling at the leaves with the same disinterested attitude as the saint brings to his mental fodder, his book. St. Jerome, that renowned scholar, is oblivious, but the little animal is bright in the wintry sunlight, and makes us aware of the beauty of the created world, with its rocks, leaves, lagoons, and stones.

A splendid Bellini, *The Feast of the Gods (125)*, was modified into even greater splendor by no less an artist than Titian (see p.131). It is still quintessentially Bellini: all the gods are characterized and something of their legends and relationships given pictorial form, all in a golden light of high classical dignity. Another sign of his greatness as an artist is that having led the way for Giorgione and Titian (who heralded an entirely new phase of painting), the aging Bellini allowed himself to be led by the younger artists and, adapting his own style, produced masterpieces even in his eighties.

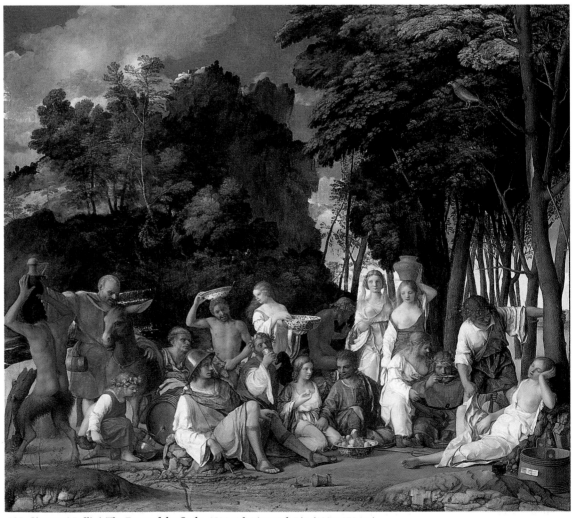

125 *Giovanni Bellini*, The Feast of the Gods, *1514, 6 ft 2 in x 5 ft 7 in (188 x 170 cm)*

OIL PAINT AND THE FLEMISH INFLUENCE IN VENICE

If Bellini eventually outgrew Mantegna's influence, there were other, perhaps lesser artists, who were guided by it on their way to reaching their own summits, and to remaining there.

The Sicilian artist Antonello da Messina (c. 1430–79) is a rather perplexing figure, mainly because Vasari falsely credited him with the sole popularization in Italy of van Eyck's use of oil (see p.64). Antonello is the first important artist from southern Italy, but he did not belong to any Southern school; instead he found his influences abroad, in Flemish art.

Because the influence of Flemish art is strikingly visible in his paintings, Antonello provides an important bridge between Italy and the Netherlands. His visit to Venice in 1475, where he came into close contact with Giovanni Bellini, was to play a major role in the history of Venetian painting.

Some people, then, consider that Antonello introduced oil painting techniques, after they had already been mastered by the Flemish artists, to Venice. Others take the view that he had a sophisticated knowledge of the medium, having learned it in Naples, where he probably studied under a Flemish-influenced artist, and that this made the crucial impact on artists who were already experimenting with oil paints. The argument is not a terribly important one. Whatever the case, the result of this meeting of

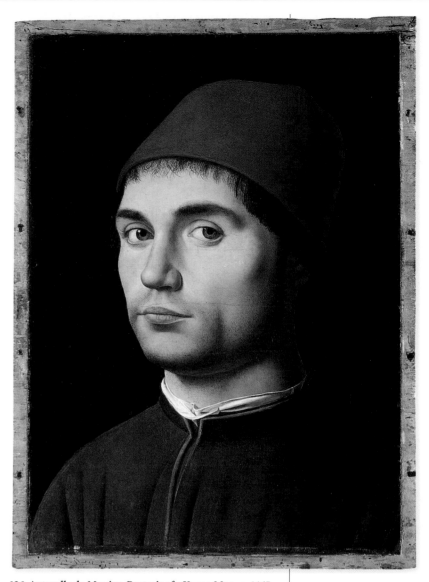

126 *Antonello da Messina,* Portrait of a Young Man, *c. 1465, 10 x 14 in (25 x 35 cm)*

the traditions was that, in Italy, oil painting techniques were pioneered exclusively by Venetian artists before they spread to other artistic centers. Antonello himself needs no spurious claims to attention. From the example of Piero della Francesca (see p.100), and especially Mantegna, he learned the importance of solid truth telling. His forms are almost too clear and sharp; in them we see a "Flemish" intense scrutiny of detail contrasted with an Italian broad generosity of form. He bathes his forms in the most romantic of lights.

His *Portrait of a Young Man (126)* is lit from within, despite the unexceptional and pudgy face, and in a great work like the *Virgin Annunciate (127),* there is a concentrated simplicity that makes the Virgin affect us with immense impact. Interestingly, the artist presents the Virgin as a devotional portrait, rather than showing the Annunciation itself.

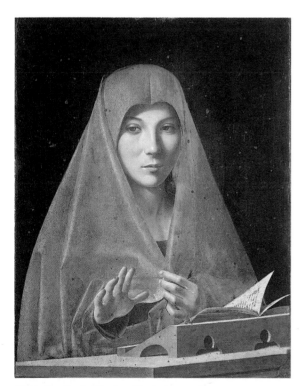

127 *Antonello da Messina,* Virgin Annunciate, *c. 1465, 13½ x 17¾ in (34 x 45 cm)*

MODERN ANATOMY

In 1543, the Flemish professor Andrea Vesalio (1514–64) wrote his *De Humani Corporis Fabrica,* which became the first standard work of modern anatomy. It has been suggested that the drawings in the book were produced in Titian's studio in Venice.

FASCINATION WITH EXTERNALS

Carlo Crivelli (1430/5–c. 1495) also belongs to a Venetian artistic family. Like Antonello da Messina, he, too, has a clear-cut manner that is unmistakable, influenced by Mantegna but applying the fine wire of his outline in an almost mannered style. "Fashion" is the word that springs to mind.

Crivelli's art reveals an ardent interest in externals and their lucid perfections – perhaps also partly owing to the Flemish influence of Antonello – but never in the actual spiritual substances involved (surprising, since he painted only religious subjects).

It is rather in material substance that Crivelli excels, enthralling us with the rotundity of a pear or the angular swirl of a damask skirt, winning us over to share his delight in gorgeous things. When he attempts an emotional theme we may feel embarrassed, but on his own level, he is superb. His *Madonna and Child Enthroned, with Donor (128)* soars aloft with such elegance

128 Carlo Crivelli, Madonna and Child Enthroned, with Donor, c. 1470, 21½ x 51 in (55 x 130 cm)

129 Cima da Conegliano, St. Helena, c. 1495, 12¾ x 16 in (32.5 x 40 cm)

and wit (note the dragonlike arms of the throne: brutality subdued to the service of religion) that we may miss the tiny, kneeling donor. He is tacked onto the real interest of the artist, which is not holiness and people praying, but shapes and their self-assured interplay.

Cima da Conegliano (Giovanni Battista Cima, c. 1459/60–1517/18) lived all his life in the environs of Venice, in the small provincial town of Conegliano (from which his name is derived). The strongest influence on him was that of Mantegna, though from early in his career he was also influenced by Giovanni Bellini. Cima is not a great painter, and his work developed very little throughout his artistic life, but he has a spontaneous innocence, a sense of the fitting,

and a technical amplitude as well, that make his work very appealing. *St. Helena (129)* is a fine example of his work. She is tall and stately, with her slender Cross on one side and a slender living tree on the other, and dominates the green hills before which she appears. The hills are crowned by little cities where, we sense, her discovery of the True Cross (see column, p.102), however apocryphal, has changed the lives of the citizens. It is not by accident that she looms so large. Her stature is built into the picture's meaning as much as are her queenly bearing and her severe self-possession.

130 *Cosimo Tura*, **Madonna and Child in a Garden**, *c. 1455, 14½ x 21 in (37 x 53 cm)*

THE FERRARESE SCHOOL

Tura and Cossa, artists in the independent city-state of Ferrara (see column, p.115), were also admiring contemporaries of Mantegna. Cosimo Tura (c. 1430–95) is perhaps the greater of the two, with his highly original and easily recognizable blending of the suave and the exciting. Like Crivelli, he rarely goes deep, but he gives us a superbly integrated surface, with a similar metallic wiriness and hard-edged control. There is wit and a tenderness in *Madonna and Child in a Garden (130)*, exquisite in its form and its daring chromatic contrasts. The Virgin steeples her long, thin fingers over the sleeping child as if to make a refuge for him, and the rosy blooms that cluster behind her, like a cushioned throne make us conscious that both these tender creatures of God are in need of cushioning: there are dark gleams from the night background, caused only by light catching on fruit and leaf, but the effect is subtly sinister.

Francesco del Cossa (c. 1435–c. 1477) has humanized this insouciant austerity. Though Cossa was Ferrarese, his *St. Lucy (131)* belongs to the Florentine tradition, infused with the hard-edged contours of Mantegna and tinged with the peculiar metallic quality of his contemporary, Tura – though the effect is a softer one, largely due to its being painted in the more gently luminous medium of oil paint.

Cossa's St. Lucy is so monumental, so luminously afloat in her golden air, it takes us time to realize the spray she holds is not of flowers, but two stalked eyes. The original Lucy was wrongly credited with being martyred by having her eyes torn out (see column right), and this grisly emblem always accompanies her depiction.

131 *Francesco del Cossa*, **St. Lucy**, *after 1470, 22 x 31 in (56 x 79 cm)*

STORY OF HASDRUBAL'S WIFE

Hasdrubal was a Carthaginian general who fought against the Romans in the second century BC. He surrendered to Scipio in 146 BC. His wife is reputed to have been so ashamed of his cowardice that she threw herself and her children into the fire at the temple where they were sheltering.

CASSONI

The workshops of Renaissance painters were busy for much of the time in the production of objects other than paintings and altarpieces, such as plates, chests (*cassoni*), beds, and coats of arms. *Cassoni* were carved, inlaid, painted chests for storing linen, clothes, and household items. Brides often used them to keep their trousseaux, and many *cassoni* were decorated with narrative paintings and family coats of arms.

THE FLIGHT INTO EGYPT

After being warned in a dream that Herod was seeking to kill the infant Jesus, Joseph took Mary and the Child away to Egypt until after Herod's death. The story of their journey to Egypt was a popular theme in Renaissance art and often contained guardian angels and a dramatic evening landscape.

The last of the great Ferrarese artists, Ercole de' Roberti, maintained the Mantegna–Tura–Cossa sobriety and classic formality. *The Wife of Hasdrubal and Her Children (132)* may be an unusual subject (see column, left), but we respond immediately to the solidity of these three human creatures, anguished, in frantic motion, yet still with a semisculptural stillness.

CARPACCIO: THE STORYTELLER

Vittore Carpaccio (1455/65–1525/26), though essentially Venetian, was clearly influenced by the great artists of the Ferrarese school, and also by Giovanni Bellini's brother, Gentile. Carpaccio had probably been taught by the Bellini patriarch, Jacopo, and was an assistant to Giovanni. The element that is peculiarly his own is that of storytelling, of which he had an instinctive mastery. The delicacy of detail in his work may suggest a medieval naïveté, yet he is a highly sophisticated painter who can use narrative simplicities as a pleasurable means to his ends.

Carpaccio can rise above the picturesque. *The Flight into Egypt (133)* may not present us with wholly serious actors: Mary is most sumptuously clad and has obviously used some of her rose red silks to fashion a tunic for St. Joseph. But all lightheartedness is forgotten in the glory of the setting. In a sunset sky of striking verisimilitude, we see why Carpaccio gives us the impression of being, despite all, a major artist. The light bathes an ordinary

132 Ercole de' Roberti, **The Wife of Hasdrubal and Her Children,** *c. 1480/90, 12 x 18½ in (30.5 x 47 cm)*

lakeside town and its surroundings – unimpressive, undramatic, and yet completely satisfying and convincing. There can be a deliberately Gothic

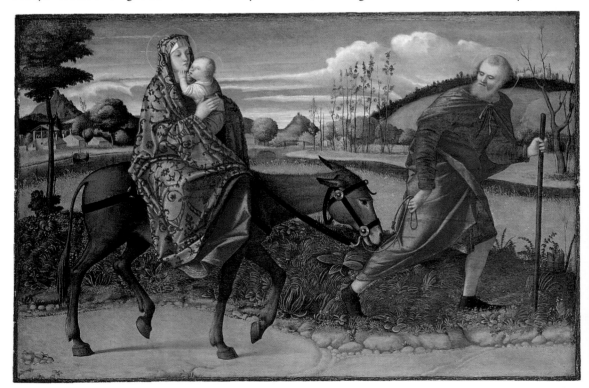

133 Vittore Carpaccio, **The Flight into Egypt,** *c. 1500, 44 x 28¼ in (112 x 72 cm)*

134 Vittore Carpaccio, **The Dream of St. Ursula,** *1494, 8 ft 8 in x 9 ft (265 x 275 cm)*

charm in Carpaccio's legend cycles, as in the wholly delightful *Dream of St. Ursula (134).* This is one of a series of paintings Carpaccio produced for the confraternity of St. Ursula. She was a legendary Breton princess who led a pilgrimage to Rome with 11,000 virgins, who had converted to Christianity. The story ends with the massacre of the entire company by villainous Huns (see column, p.70). The neat little bed and the sleeping saint have an enameled

charm that will happily survive her coming martyrdom, signified by the entering angel bearing the symbolic palm. Carpaccio's meticulous recording of the material world has provided historians with insight into the material reality of 15th-century Venice. This faithful representation of the visible world, composed of many tiny parts, reappears in the work of another Venetian artist in the 18th century, Canaletto (see p.234).

FERRARA

During the Renaissance, Ferrara became a lively center for the arts, and the court of the Este family encouraged individual artists from throughout Italy. Many impressive secular buildings were built in the city during the 15th century, including the Palazzo dei Diamanti.

THE HIGH RENAISSANCE

Since Renaissance means "new birth," it is obvious that it cannot stand still. Once something is born, it begins to grow. But never has there been growth as lovely as that of painting as it matured into the High Renaissance. Here we find some of the greatest artists ever known: the mighty Florentines, Leonardo da Vinci and Michelangelo; the Umbrian, Raphael; and, equal in might, the Venetians – Titian, Tintoretto, and Veronese.

By a happy chance, a common theme links the lives of four of the famous masters of the High Renaissance – Leonardo, Michelangelo, Raphael, and Titian. Each began his artistic career with an apprenticeship to a painter who was already of good standing, and each took the same path of first accepting, then transcending, the influence of his master. The first of these, Leonardo da

SFUMATO

This term, derived from the Italian *fumo*, meaning "smoke," is particularly applied to the work of Leonardo da Vinci. It defines the gradual and imperceptible transition between areas of different color, without the use of sharp outlines. The capacity to blur over harsh outlines, especially in portrait paintings, was considered the sign of a highly skilled and distinguished painter.

EQUESTRIAN MONUMENTS

This monument to Bartolommeo Colleoni was begun by Verrocchio c. 1481 and completed after his death. During this period, riders on horseback were a popular subject for monuments. Their popularity is attributed to the influence of the classical statue of Emperor Marcus Aurelius that stood in the Campidoglio in Rome. Both Donatello and Verrocchio made works commemorating Renaissance soldiers.

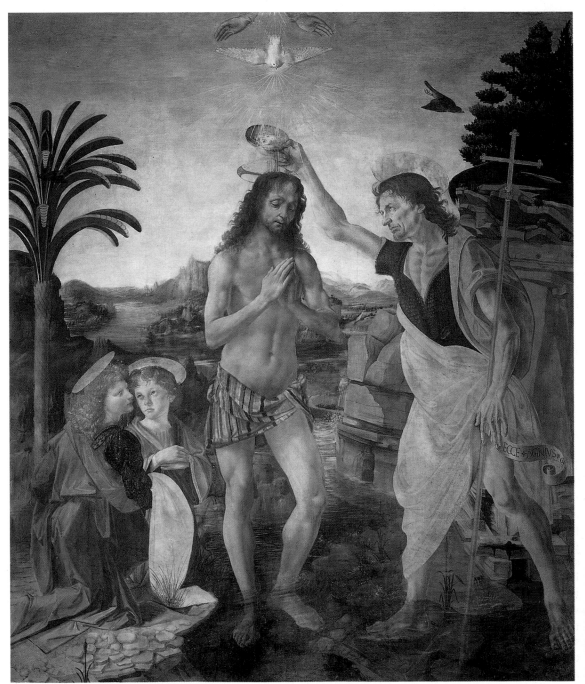

135 Andrea del Verrocchio, **The Baptism of Christ,** *c. 1470, 5 ft x 5 ft 11 in (152 x 180 cm)*

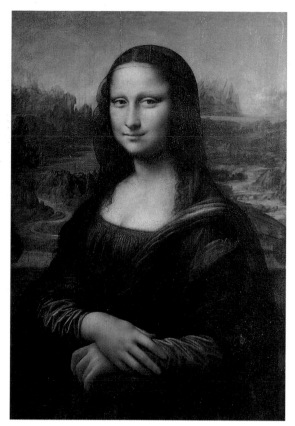

*136 Leonardo da Vinci, Mona Lisa, 1503,
21 x 30½ in (53 x 75 cm)*

mathematical excellence, scientific daring ...
the list is endless. This overabundance of talents
caused him to treat his artistry lightly, seldom
finishing a picture, and sometimes making rash
technical experiments. *The Last Supper*, in the
church of Santa Maria delle Grazie in Milan,
for example, has almost vanished, so inadequate
were his innovations in fresco preparation.

Yet the works that we have salvaged remain
the most dazzlingly poetic pictures ever created.
The *Mona Lisa (136)* has the innocent disadvantage
of being too famous. It can only be seen behind
thick glass in a heaving crowd of awe-struck
sightseers. It has been reproduced in every
conceivable medium; it remains intact in its
magic, forever defying the human insistence
on comprehending. It is a work that we can
only gaze at in silence.

Leonardo's three great portraits of women
all have a secret wistfulness. This quality is at its
most appealing in *Cecilia Gallarani (137)*, at its
most enigmatic in the *Mona Lisa*, and at its most

> *" The
> first object of
> the painter is
> to make a flat
> plane appear as
> a body in relief
> and projecting
> from that
> plane. "*
>
> Leonardo da Vinci

Vinci (1452–1519), was the elder of the two
Florentine masters. He was taught by Andrea
del Verrocchio (1435–88), an engaging painter
whose great achievement was his sculpture (see
column, p.116). Verrocchio also had considerable
influence on the early work of Michelangelo (see
p.120). Verrocchio's best-known painting is the
famous *Baptism of Christ (135)*, famous because
the youthful Leonardo is said to have painted
the dreamy and romantic angel on the far left,
who compares more than favorably with the
stubby lack of distinction in the master's own
angel immediately beside him.

LEONARDO: RENAISSANCE POLYMATH

There has never been an artist who was more
fittingly, and without qualification, described
as a genius. Like Shakespeare, Leonardo came
from an insignificant background and rose to
universal acclaim. Leonardo was the illegitimate
son of a local lawyer in the small town of Vinci
in the Tuscan region. His father acknowledged
him and paid for his training, but we may
wonder whether the strangely self-sufficient
tone of Leonardo's mind was not perhaps
affected by his early ambiguity of status. The
definitive polymath, he had almost too many
gifts, including superlative male beauty, a
splendid singing voice, magnificent physique,

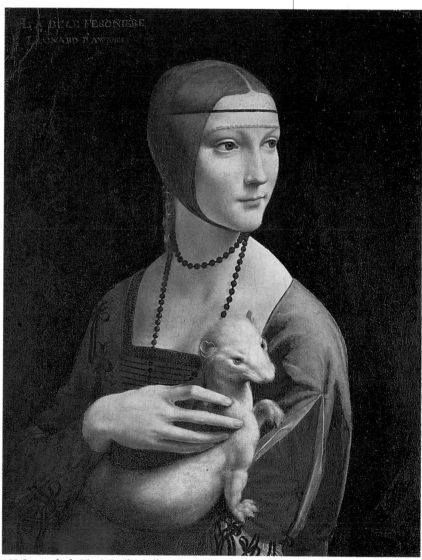

137 Leonardo da Vinci, Cecilia Gallarani, c. 1485, 15½ x 21½ in (39 x 54 cm)

confrontational in *Ginevra de' Benci (138)*. It is hard to gaze at the *Mona Lisa* because we have so many expectations of it. Perhaps we can look more truly at a less famous portrait, *Ginevra de' Benci*. It has that haunting, almost unearthly beauty peculiar to Leonardo da Vinci.

A WITHHELD IDENTITY

The subject of *Ginevra de' Benci* has nothing of the Mona Lisa's inward amusement, and also nothing of Cecilia's gentle submissiveness. The young woman looks past us with a wonderful luminous sulkiness. Her mouth is set in an unforgiving line of sensitive disgruntlement, her proud and perfect head is taut above the unyielding column of her neck, and her eyes seem to narrow as she endures the painter and his art. Her ringlets, infinitely subtle, cascade down from the breadth of her gleaming forehead (the forehead, incidentally, of one of the most gifted intellectuals of her time). These delicate ripples are repeated in the spikes of the juniper bush.

The desolate waters, the mists, the dark trees, the reflected gleams of still waters – all these surround and illuminate the sitter. She is totally fleshly and totally impermeable to the artist. He observes, held rapt by her perfection of form, and shows us the thin veil of her upper bodice and the delicate flushing of her throat. What she is truly like she conceals; what Leonardo reveals to us is precisely this concealment, a self-absorption that spares no outward glance.

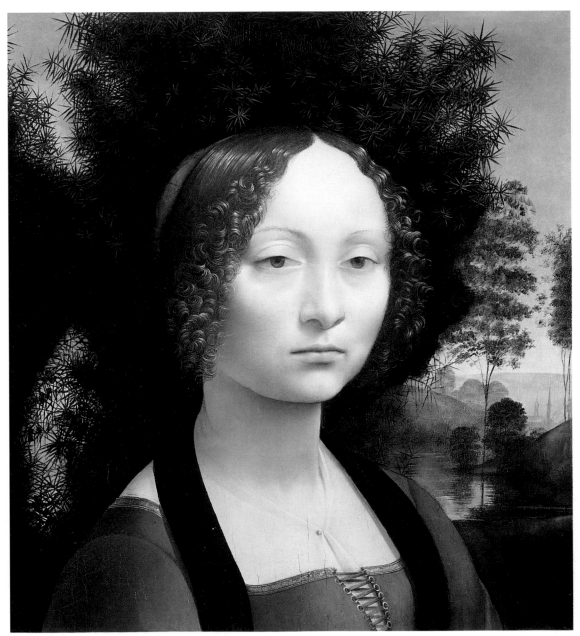

138 Leonardo da Vinci, Ginevra de' Benci, c. 1474, 14½ x 15½ in (37 x 39 cm)

GINEVRA DE' BENCI

Leonardo's exquisite portrait of Ginevra de' Benci was described by Vasari (see p.98) as a "beautiful thing." It was originally larger, but was cut down (because of damage) to this powerfully compact format by later owners. The back of the panel depicts a wreath of laurel and palm encircling a juniper sprig (see right). The three are connected by a scroll bearing the inscription "She adorns her beauty with virtue."

JUNIPER LEAVES

The young woman's name, Ginevra, is related to the Italian word ginepro, *meaning "juniper." Appropriately, Leonardo has set her pale, marblelike beauty against the dark, spiky leaves of a juniper bush. She is well described by spikiness, we may imagine, and the bitter appeal of the gin that comes from the juniper berry is also adumbrated by this setting.*

RESERVED CHARACTER

Ginevra's rose pink cheek and lips are painted with supreme delicacy and restraint. This effect is so subtle, so cool, that it admirably conveys her inner restraint, her firm control over her emotions. Her heavy, half-closed lids cast a shadow over the irises of her eyes, and the almost total absence of reflected light serves to reduce the communication between us and her. A slight cast in her left eye accentuates the lack of focus in her expression, and her gaze is directed over our shoulder.

SKIN UNDER THE BODICE

Ginevra's skin is rendered with absolutely smooth, "invisible" brushstrokes. This is achieved by working wet-in-wet, and by the use of glazes and loose, "oily" paint, so that the color and contours of each brushstroke blend imperceptibly to form a continuous, uninterrupted surface. It is seen through her diaphanous bodice, which is given only the slightest definition. If it were not for the gilt pin holding it together, we would perhaps not notice it at all.

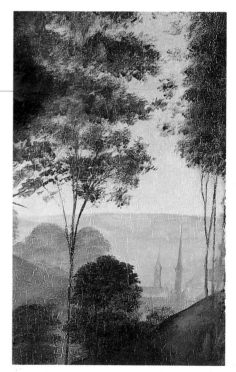

INSUBSTANTIAL LANDSCAPE

In contrast to the woman, with her firm, sculptural presence, the middle-distance landscape quivers with uncertainty, rendered with thin, fluid paint. Each brushmark is visible over the next, and the trees are merely thin stalks, their trunks painted with delicate, tremulous brushstrokes.

**❝ . . . I
cannot live
under pressures
from patrons,
let alone
paint. ❞**

Michelangelo, quoted
in Vasari's *Lives
of the Artists*

MACHIAVELLI
The Florentine statesman
Niccolo Machiavelli
(1469–1527) is remembered
as the author of *Il Principe*
(The Prince, 1532),
a rational analysis of political
power. His main argument
was that a ruler must be
prepared to do evil if he
judges that good will come
of it. After his death he
developed a reputation as
an amoral cynic, and this
was reinforced by criticism
from his enemies in
Church and state. In the
present century a more
balanced view prevails.

*139 Leonardo da Vinci, Virgin of the Rocks, c. 1508,
47 x 75 in (120 x 190 cm)*

INTERIOR DEPTH
We can always tell a Leonardo work by his
treatment of hair, angelic in its fineness, and
by the lack of any rigidity of contour. One form
glides imperceptibly into another (the Italian
term is *sfumato*; see column, p.116), a wonder
of glazes creating the most subtle of transitions
between tones and shapes. The angel's face in
the painting known as the *Virgin of the Rocks
(139)* in the National Gallery, London, or the
Virgin's face in the Paris version of the same
picture, have an interior wisdom, an artistic
wisdom that has no pictorial rival.

This unrivaled quality meant that few artists
actually show Leonardo's influence: it is as if
he seemed to be in a world apart from them.
Indeed he did move apart, accepting the French
King Francis I's summons to live in France. Those
who did imitate him, like Bernardino Luini of
Milan (c. 1485–1532), caught only the outer
manner, the half-smile, the mistiness *(140)*.

The shadow of a great genius is a peculiar
thing. Under Rembrandt's shadow, painters
flourished to the extent that we can no longer
distinguish their work from his own. But
Leonardo's was a chilling shadow, too deep,
too dark, too overpowering.

MICHELANGELO: A DOMINANT FORCE
IN FLORENCE AND ROME
Michelangelo Buonarroti (1475–1564), on
the contrary, exerted enormous influence. He
too was universally acknowledged as a supreme
artist in his own lifetime, but again, his followers
all too often present us with only the master's
outward manner, his muscularity and gigantic
grandeur; they miss the inspiration. Sebastiano
del Piombo (c. 1485–1547), for example, actually
used a drawing (at least a sketch) made for
him by Michelangelo for his masterwork, *The
Raising of Lazarus*. Masterwork it is – yet how
melodramatic it appears if compared with
Michelangelo's own painting,

Michelangelo resisted the paintbrush, vowing
with characteristic vehemence that his sole tool
was the chisel. As a well-born Florentine, a
member of the minor aristocracy, he was
resistant to coercion at any time. Only the
power of the pope, tyrannical by position and
by nature, forced him to the Sistine Chapel and
the reluctant achievement of the world's greatest
single fresco. His contemporaries spoke about
his *terribilità*, which means, of course, not so
much being terrible as being awesome. There
has never been a more literally awesome artist
than Michelangelo: awesome in the scope of his
imagination, awesome in his awareness of the
significance – the spiritual significance – of
beauty. Beauty was to him divine, one of the
ways God communicated Himself to humanity.

*140 Bernardino Luini, Portrait of a Lady,
c. 1520/25, 22½ x 30½ in (58 x 75 cm)*

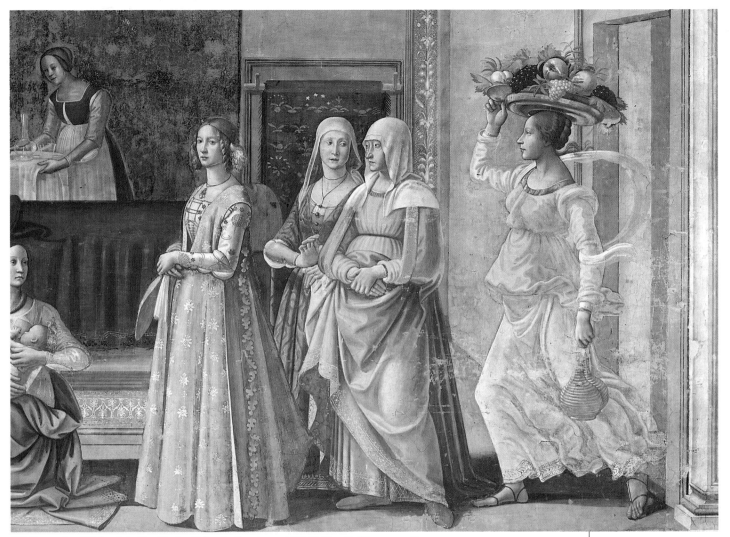

141 *Domenico Ghirlandaio,* **The Birth of John the Baptist,** *c. 1485-90 (detail of fresco panel)*

Like Leonardo, Michelangelo too had a good Florentine teacher, the delightful Domenico Ghirlandaio (c. 1448–94). Later, he was to claim that he never had a teacher, and figuratively, this is a meaningful enough statement. However, his handling of the claw chisel does reveal his debt to Ghirlandaio's early influence, and this is evident in the cross-hatching of Michelangelo's drawings – a technique he undoubtedly learned from his master. The gentle accomplishments of a work like *The Birth of John the Baptist (141)* bear not the slightest resemblance to the huge intelligence of an early work of Michelangelo's like *The Holy Family (142* also known as the *Doni Tondo).* This is somehow not an attractive picture, with its chilly, remote beauty, but its stark power stays in the mind when more accessible paintings have been forgotten.

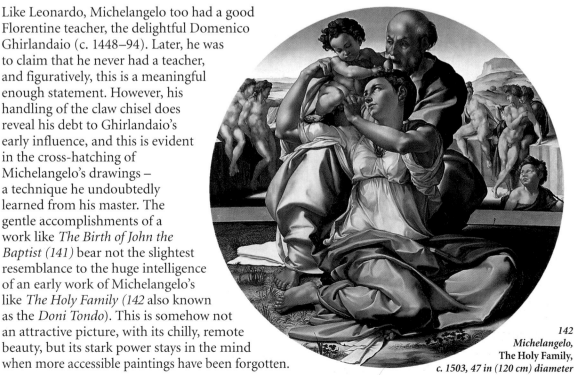

142
Michelangelo,
The Holy Family,
c. 1503, 47 in (120 cm) diameter

POPE JULIUS II
On becoming pope in 1503, Julius II reasserted papal authority over the Roman barons and successfully backed the restoration of the Medici in Florence. He was a liberal patron of the arts, commissioning Bramante to build St. Peter's Church, Michelangelo to paint the Sistine Chapel, and Raphael to decorate the Vatican apartments.

OTHER WORKS BY MICHELANGELO

The Pietà
(St. Peter's, Rome)

Bacchus
(The Bargello, Florence)

Bruges Madonna
(Church of Onze Lieve Vrouwe, Bruges)

Entombment
(National Gallery, London)

Martyrdom of St. Peter
(The Vatican, Rome)

SIBYLS

These were female seers of ancient Greece and Rome. They were also known as oracles. Like the Jewish prophets of the Old Testament, many sibyls had their sayings recorded in books. Jewish prophets spoke unbidden, whereas sibyls tended to speak only if consulted on specific questions. They sometimes responded with riddles or rhetorical questions.

THE SISTINE CHAPEL

All the same, it is the Sistine ceiling that displays Michelangelo at the full stretch of his majesty. Recent cleaning and restoration have exposed this astonishing work in the original vigor of its color. The sublime forms, surging with desperate energy, tremendous with vitality, have always been recognized as uniquely grand. Now these splendid shapes are seen to be intensely alive in their color, indeed shockingly so for those who liked them in their previous dim grandeur.

The story of the Creation that the ceiling spells out is far from simple, partly because Michelangelo was an exceedingly complicated man, partly because he dwells here on profundities of theology that most people need to have spelled out for them, and partly because he has balanced his biblical themes and events with giant *ignudi*, naked youths of superhuman grace *(143)*. They express a truth with surpassing strength, yet we do not clearly see what this truth actually is. The meaning of the *ignudi* is a personal one: it cannot be verbalized or indeed theologized, but it is experienced with the utmost force.

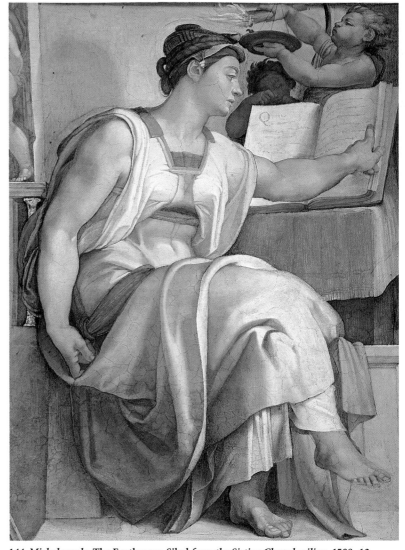

144 Michelangelo, **The Erythraean Sibyl** *from the Sistine Chapel ceiling, 1508–12*

SEERS AND PROPHETS

There is the same power, though in more comprehensible form, in the great prophets and seers that sit in solemn niches below the naked athletes. Sibyls were the oracles of Greece and Rome (see column, left). One of the most famous was the Sibyl of Cumae, who, in the *Aeneid*, gives guidance to Aeneas on his journey to the underworld. Michelangelo was a heavyweight intellectual and poet, a profoundly educated man and a man of utmost faith; his vision of God was of a deity all "fire and ice," terrible, august in His severe purity. The prophets and the seers who are called by divine vocation to look upon the hidden countenance of God have an appropriate largeness of spirit. They are all persons without chitchat in them.

The *Erythraean Sibyl (144)* leans forward, lost in her book. The artist makes no attempt to show any of the sibyls in appropriate historical garb, or to recall the legends told of them by the classical authors. His interest lies in their symbolic value for humanity, proof that there have always been the spiritual enlightened ones, removed from the sad confusions of blind time.

The fact that the sibyls originated in a myth, and one dead to his heart, which longed for Christian orthodoxy, only heightens the drama. At some level we all resent the vulnerability of our condition, and if only in image, not reality, we take deep comfort in these godlike human figures. Some of the sibylline seers are shown as aged, bent, alarmed by their prophetic insight.

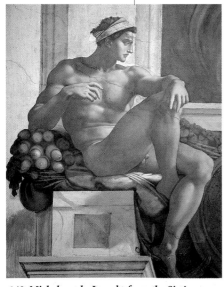

143 Michelangelo, **Ignudo** *from the Sistine Chapel ceiling, 1508–12*

THE ERYTHRAEAN SIBYL

In the Sistine Chapel, sibyls from the ancient Greek and Roman culture are "twinned" with Old Testament prophets. The God of the Jews spoke to the prophets. The sibyls, too, were wise women with superior spiritual inspiration, capable of explaining God's message to all humanity. The prophets proclaimed to the Jews alone, whereas the sibyls prophesied to the Greeks. The Erythraean Sibyl lived in the town of Erythrae in Ionia (in what is now southwest Turkey). There were many others, such as, for instance, the Egyptian Sibyl.

SYMBOLIC LIGHT
The cherub holds a lit torch, and the flame that issues from it looks almost like a fiery bird, the Holy Spirit come before His Pentecostal time. Significantly, the sibyl has not needed to wait for the lamp to be lighted: her light is from within, and her sureness of vision is contrasted with a dim little cherub, who rubs his eyes with baby fists.

FLOWING ROBE
Michelangelo's original colors are believed to have had a startling, luminous quality. The Sistine Chapel frescoes gradually darkened with the passage of time, and in the present century three attempts have been made – the latest from 1980 to 1990 – to restore their original appearance.

TURNING THE PAGES OF TIME
The great stature of the pacific sibyl reassures us at a subliminal level, and maybe all the more effectively for that. She needs only one muscular arm to turn the pages of the future; the other hangs in relaxation. She is poised to rise and act, yet remains still, concentrating on her reading. The book rests on a lectern covered with a blue cloth, symbolizing its divine content. The colors sing in splendor, pinks glazed to whiteness by the intensity of the light.

PENSIVE HEAD
The sibyl leans forward, lost in her book. She turns the page with the calm deliberation of one who "sees," one in command, touched by divine clairvoyance. She is inspired and infallible, and her stately head is undaunted by what she reads. Her role as illuminator and interpreter "to spread good tidings to all the nations" (Mark 16: 15) is evidenced by the opened book, turned outward for all to see.

145 Michelangelo, **The Last Judgment,** *west wall of Sistine Chapel, 1536–41, 44 x 48 ft (13 m 43 cm x 14 m 61 cm)*

The implicit sense of God's majesty (rather than His fatherhood) is made explicit in the most alarming *Last Judgment (145)* known to us. It is Michelangelo's final condemnation of a world

he saw as irredeemably corrupt, a verdict essentially heretical, though at that time it was thought profoundly orthodox. His judging Christ is a great, vengeful Apollo, and the power in this terrible painting comes from the artist's tragic despairs. He paints himself into the judgment, not as an integral person, but as a flayed skin, an empty envelope of dead surface, drained of his personhood by artistic pressure. The only consolation, when even the Virgin shrinks from this thunderous colossus, is that the skin belongs to St. Bartholomew, and through this martyr's promise of salvation we understand that perhaps, though flayed alive, the artist is miraculously saved.

As grandly impassive as the Erythraean Sibyl is the heroic Adam in *The Creation of Adam (146),* lifting his languid hand to his Creator, indifferent to the coming agonies of being alive.

INFLUENCES ON RAPHAEL

After the complexities of Leonardo and Michelangelo, it is a relief to find Raphael (Raffaello Sanzio, 1483–1520), a genius no less than they, but one whose daily ways were those of other men. He was born in the small town of Urbino, an artistic center (see p.100), and received his earliest training from his father. Later, his father sent him to Pietro Perugino (active 1478–1523) who, like Verrocchio and Ghirlandaio, was an artist of considerable gifts. But while Leonardo and Michelangelo quickly outgrew their teachers and show no later trace of influence, Raphael

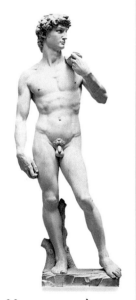

MICHELANGELO'S DAVID

Michelangelo began work on the colossal figure of David in 1501, and by 1504 the sculpture (standing 14 ft 3 in/4.34 m tall) was in place outside the Palazzo Vecchio. The choice of David was supposed to reflect the power and determination of republican Florence and was under constant attack from supporters of the usurped Medicis. In the 19th century, the statue was moved to the Accademia.

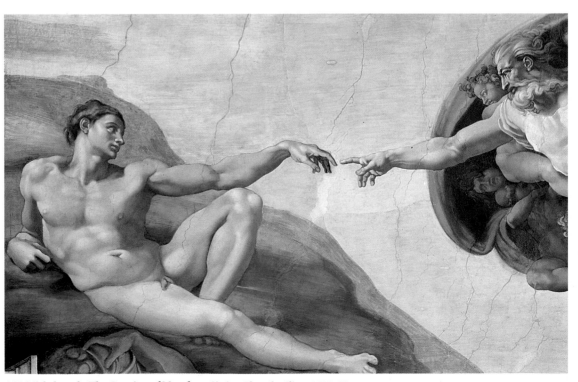

146 Michelangelo, **The Creation of Man** *from Sistine Chapel ceiling, 1511–12*

147 Pietro Perugino, **Crucifixion with the Virgin,
St. John, St. Jerome, and St. Mary Magdalene,**
c. 1485, center 22½ x 40 in (57 x 102 cm)

had a precocious talent right from the beginning
and was an innate absorber of influences.
Whatever he saw, he took possession of, always
growing by what was taught to him. An early
Raphael can look very like a Perugino. In fact,
Perugino's *Crucifixion with the Virgin, St. John,
St. Jerome, and St. Mary Magdalene (147)* was
thought to be by Raphael until evidence proved
it was given to the church of San Gimigniano in
1497, when Raphael was only 14. It is undoubtedly
a Perugino, calmly emotional, and pious rather
than passionate. A fascinating context for this
scene of quiet faith is the notorious unbelief
on the part of the artist, who was described by
Vasari as an atheist. He painted what would be
acceptable, not what he felt to be true, and this
may account for the lack of real emotive impact.

EARLY RAPHAEL

There are still echoes of the gentle Perugino in
an early Raphael like the diminutive *St. George
and the Dragon (148)*, painted when he was in
his early twenties; the little praying princess is
very Peruginesque. But there is a fire in the
knight and his intelligent horse, and a nasty
vigor in the convincing dragon that would
always be beyond Perugino's skill. Even the
horse's tail is electric, and the saint's mantle
flies wide as he speeds to the kill.

148 Raphael, **St. George and the Dragon,** *1504–06,
8½ x 11 in (22 x 28 cm)*

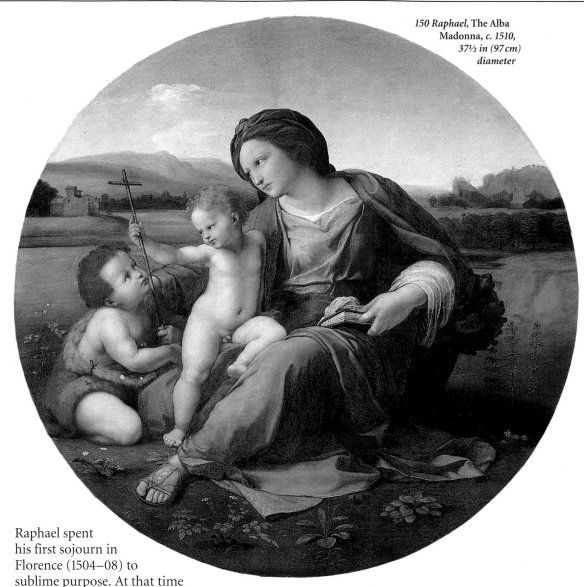

150 Raphael, The Alba Madonna, *c. 1510, 37½ in (97 cm) diameter*

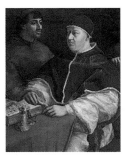

POPE LEO X

As the second son of the Medicean ruler Lorenzo the Magnificent (see p.97), Pope Leo X (1475–1521) had an easy passage to high office. He is best remembered as a patron of the arts, and he established a Greek college in Rome. He encouraged the work of artists such as Raphael (who painted this portrait). Despite his undoubted inadequacies, as the spiritual head of Christendom he was of central importance in his understanding of the human need of great art and architecture. Such worldliness undoubtedly helped provoke the Reformation (see p.169).

Raphael spent his first sojourn in Florence (1504–08) to sublime purpose. At that time Leonardo and Michelangelo were both working there, and as a result, Raphael adopted new working methods and techniques – particularly influenced by Leonardo – and his paintings took on a more vigorous graphic energy. We may think we see a hint of what he took from Leonardo in a work like the *Small Cowper Madonna (149),* with its softness of contour and perfection of balance. Both faces, the Virgin's almost smiling, almost praying, wholly wrapped up in her Child, and that of the Child, wholly at ease with His Mother, dreamily looking out at us with abstracted sweetness, have that inwardness we see in Leonardo, but made firm and unproblematic. Behind the seated figures we see a tranquil rural landscape with a church perched on a hill.

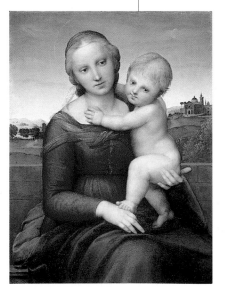

149 Raphael, Small Cowper Madonna *(detail), 1505, 17½ x 24 in (45 x 60 cm)*

RAPHAEL'S LATER WORK

Raphael returned to the subject of the Madonna and Child several times, each time in an intimate, gentle composition. *The Alba Madonna (150),* on the other hand, has a Michelangelic heroism about it; tender as always in Raphael, but also heavy; masses wonderfully composed in tondo form; a crescendo of emotion that finds its fulfillment in the watchful face of Mary. The world stretches away on either side, centered on this trinity of figures, and the movement sweeps graciously onward until it reaches the farthest fold of Mary's cloaked elbow. Then it floods back, with her bodily inclination toward the left, and the meaning is perfectly contained: love is never stationary, it is given and returned. Raphael's life was short, but while he lived he was one of those geniuses who continually evolve and develop. He had an extraordinary capacity (like, though greater than, Picasso's) to respond to every movement in the art world, and to subsume it within his own work.

THE ALBA MADONNA

Like Bellini, Raphael became a *Madonnière* – a painter of Madonnas. Depicted like Bellini's *Madonna of the Meadow* (see p.109) in an open landscape, *The Alba Madonna* is an example of the Renaissance "Madonna of Humility" tradition. However, all comparison with Bellini ends here, and it is the influence of Michelangelo that is more evident in *The Alba Madonna*, not least in its tondo format – derived from Michelangelo's *Holy Family* (c. 1503), which Raphael saw in Rome (see p.121).

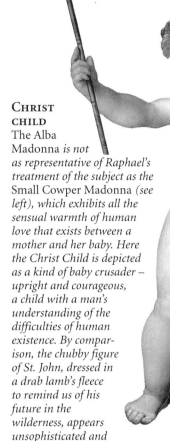

CHRIST CHILD

The Alba Madonna *is not as representative of Raphael's treatment of the subject as the* Small Cowper Madonna *(see left), which exhibits all the sensual warmth of human love that exists between a mother and her baby. Here the Christ Child is depicted as a kind of baby crusader – upright and courageous, a child with a man's understanding of the difficulties of human existence. By comparison, the chubby figure of St. John, dressed in a drab lamb's fleece to remind us of his future in the wilderness, appears unsophisticated and truly childlike.*

HEROISM

The relatively close tonal range and restrained palette of The Alba Madonna *is perfectly suited to her self-contained, gentle heroism. It is wholly unlike the rosy glow and brilliant hues of the* Small Cowper Madonna. The Alba Madonna's *whole demeanor, as well as her quietly mournful gaze, expresses dignity, spiritual strength, and solidity. She meditates on a small wooden cross that symbolizes Christ's Crucifixion.*

MADONNA'S FOOT

The military style of the sandal worn by the Madonna emphasizes her warriorlike demeanor. Like her Son, she assumes a heroic stance. The ground on which she sits is sprinkled with small flowers, some in bloom. The petals are painted delicately over the primary layer of green earth. The flowers that St. John has gathered are anemones that grow behind him. Around the picture from where he kneels are a white dandelion, what could be another anemone, a plantain, a violet, and three lilies, not yet in bloom.

UMBRIAN COUNTRYSIDE

Beyond the statuesque figure of the Madonna, in the open Umbrian landscape, is a small wood filled with odd, tightly foliaged trees. Beyond the wood, still farther into the distance, are tiny horsemen. The activities of the horsemen, too minute to make out, are reduced almost to nothingness by the giantlike form of the Madonna, her remote gaze echoing their physical distance and their essential irrelevance.

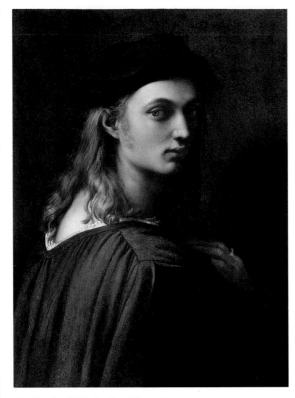

151 Raphael, **Bindo Altoviti,** *c. 1515,*
17⅓ x 23½ in (45 x 60 cm)

THE SCHOOL OF ATHENS

Raphael's fresco contains portraits of many classical philosophers. In the center stand Plato and Aristotle, the two great philosophers of antiquity. To their left Socrates is seen in argument with several young men. The old man seated on the steps is Diogenes. Other philosophical figures are identifiable, including Pythagoras, shown bottom left, explaining his proportion system on a slate, and, on the extreme right, Ptolemy, depicted contemplating a celestial globe.

Since Vasari (see p.98) described the picture commissioned by *Bindo Altoviti (151)* as "his portrait when young," historians have liked to think that this radiant youth was Raphael himself. He was indeed said to be unusually handsome, pensive, and fair, which is exactly what this portrait shows us. But it is now agreed that it is Bindo when young, and since he was at this time a mere 22 (and Raphael 33, with only five years left to him), this is not an "imagined" youth but a real boy who takes up so self-conscious a stance before the painter.

Raphael is one of the most acute of all portraitists, effortlessly cleaving through the external defenses of his sitter, yet courteously colluding with whatever image the ego would seek to have portrayed. This duality, looking beneath the surface and yet remaining wholly respectful of the surface, gives an additional layer of meaning to all his portraits. We see, and we know things that we do not see; we are helped to encounter rather than to evaluate.

Bindo Altoviti was beautiful, successful (as a banker), and rich— rather like Raphael himself. There may have been some feeling of fellowship in the work, as the noble countenance is sensitively fleshed out for us. Half the face is in shadow, as if to allow the sitter his mystery, his maturing, his private destiny. The lips are full and sensual, balanced by the

152 Raphael, The School of Athens, 1510–11, 25 ft 4 in (772 cm) wide at base

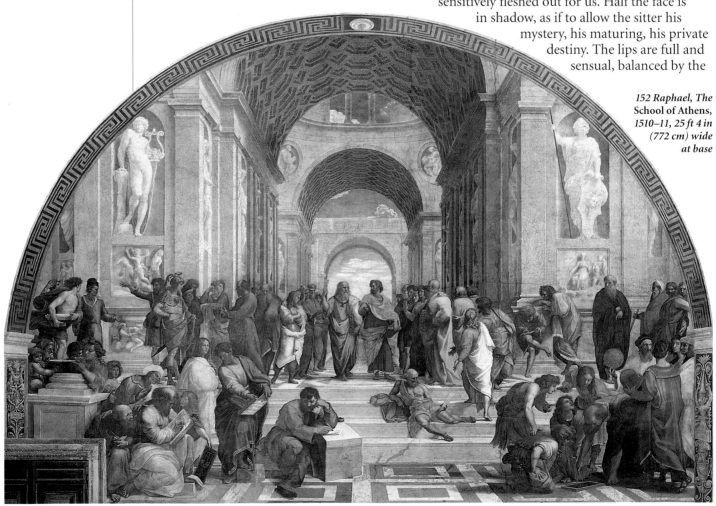

deep-set eyes with their confrontational stare, almost defiant. The ruffled shirt is half covered by the young man's locks, calculatedly casual, at odds in their dandyish profusion with the plain beret and the rich but simple doublet. He holds a darkened hand dramatically to his breast, maybe to show off the ring, maybe to indicate psychic ease.

But Raphael has not given him the real world for his setting. Bindo Aldoviti stands in a nowhere place of luminous green, outside the scope of time in his eternal youth, fearless because he is protected by art from human uncertainties.

There is an aptness in the areas of darkness in which the great doublet sleeve loses itself. For all his debonaire poise, this is a young man threatened. For the viewer who knows how short Raphael's own life was to be, the thought that this might be a self-portrait is seductively plausible. There is a sense in which every portrait is one of the self, since we never escape our own life enough to see with divine vision what is objectively there: this shows us both men, painter and banker, "when young."

Raphael is out of favor today; his work seems too perfect, too faultless for our slipshod age. Yet these great icons of human beauty can never fail to stir us: his Vatican murals can stand fearlessly beside the Sistine ceiling. *The School of Athens (152)*, for example, monumentally immortalizing the great philosophers, is unrivaled in its classic grace. Raphael's huge influence on successive artists is all the more impressive considering his short life.

THE HIGH RENAISSANCE IN VENICE

There is always a happy sureness, a sense of belonging, of knowing how things work, in Raphael, and it is this confidence that seems most to distinguish him from that other genius who died young, the Venetian Giorgione (Giorgio da Castelfranco, 1477–1510).

Giorgione achieved far less than Raphael (and his life was still shorter). Even the few works said to be by him are often contested, yet he has a hauntingly nostalgic grace found nowhere else in art. He trained in the workshop of the great Venetian painter Giovanni Bellini (see p.107), whose softness of contour and warm, glowing color continue in Giorgione's work. He does not belong, as Raphael does, to

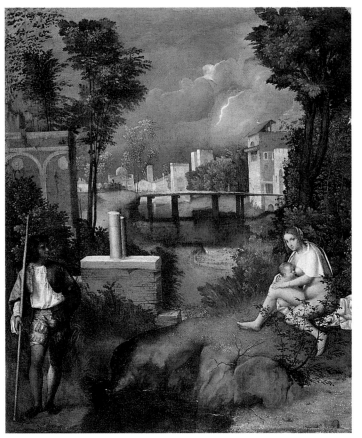

153 Giorgione, **The Tempest,** *1505–10, 28¾ x 32½ in (71 x 75 cm)*

this world, not even in the rarefied way that we find in his great successors, Titian (see p.131) and Tintoretto (see p.134). His alliance is to another spirit, yet one to which we instinctively respond, even if we do not always understand the logic of his works.

The Tempest (153) is one of the most argued-over works in existence. Its importance in relation to the development of Venetian painting lies in the predominance of landscape for its own sake. Fortunately, everyone accepts that this painting is by Giorgione, but who is this motionless soldier, brooding quietly in the storm, and who is the naked gypsy, feeding her child and apparently unaware of any company? Attempts to read the scene as a novel version of the flight into Egypt are usually foiled by the inexplicable fact of the woman's nakedness. Despite this, countless scenarios have been provided, all ingenious and all of them making some sense.

Elucidation has not been helped by scientific analysis, which reveals that the first draft of the work included a second naked woman, bathing in the stream. The "real meaning" may elude us, but perhaps that elusiveness is the meaning. We are shown the world lit up with the startling clarity of a sudden flash of lightning, and in that revelation we are able to behold mysteries that were hitherto concealed within the darkness.

> *"While we may term other works paintings, those of Raphael are living things; the flesh palpitates, the breath comes and goes, every organ lives, life pulsates everywhere."*
>
> Vasari, *Lives of the Artists*

BALDASSARE CASTIGLIONE

This portrait by Raphael is of the Renaissance diplomat and writer Baldassare Castiglione. He was employed in the service of a number of Italian dukes in the early 16th century. His treatise *Il Cortegiano*, published in 1528, described the court at Urbino and defined the correct etiquette for courtiers to learn. Another feature of the book was its popularization of Humanist philosophy (see p.82, column).

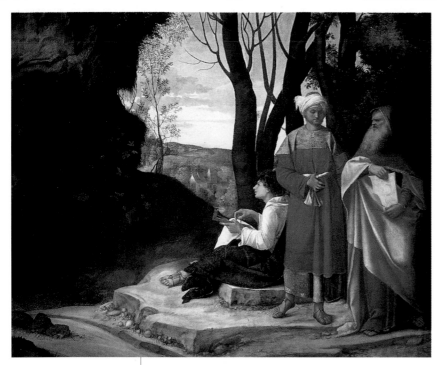

154 Giorgione (finished by Sebastiano del Piombo),
The Three Philosophers, *c. 1509, 55½ x 48 in (141 x 121 cm)*

The intensely poetic nature of the few undoubted Giorgiones brought a quality into Venetian High Renaissance art that it was never completely to lose. Even though finished by Michelangelo's friend Sebastiano del Piombo,

The Three Philosophers (154) shows the potency of this lyrical richness. The actual subject matter seems not to have mattered to the artist. He apparently began by intending a picture of the Magi (see p.98), the three eastern kings who saw the star at Christmastide and journeyed to the manger. The Magi were also believed to be astronomers, star gazers, and from this Giorgione traveled mentally to the concept of philosophical search, plotting the stars with a sextant and pondering on their meaning.

Here too are the three ages of man, with the work being embarked upon by the serious youth, held mentally and debated by the man of maturity, and stored in material form by the elderly sage, glorious in his silken raiment.

Every detail of the three has a psychological significance: the boy is dressed in springtime simplicity, and he is solitary, as is often a youthful circumstance. Who can share his dreams and hopes? The two adult men turn inward to themselves, seeming to converse, yet both as lonely as the passionate boy. They are elders, no longer fervent, but they bring to their problem a weighty earnestness.

The philosopher at the center has the look of a man of affairs as he holds his hands free for work. Beside him, the older man grasps the visible sign of his thinking, a sky chart. The three human figures occupy only a half of

BIRTH TRAYS
Like *cassoni* (see p.114), birth trays were another unusual form of Renaissance art. These colorfully painted wooden trays were used to carry gifts to new mothers and were then preserved as family heirlooms. This example, from the first half of the 15th century depicts the triumph of love. Its 12-sided shape is typical of the period.

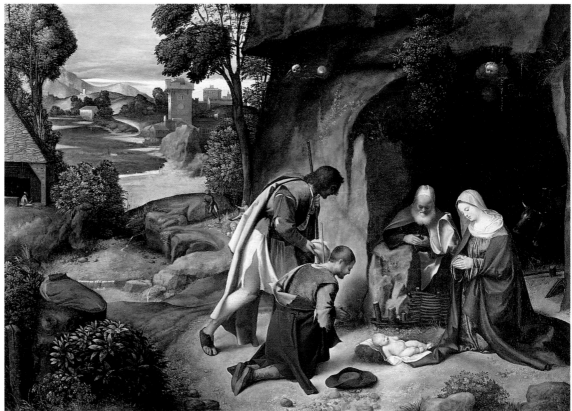

155 Giorgione, **The Adoration of the Shepherds,** *c. 1505/10, 43½ x 36 in (112 x 91 cm)*

the picture, though. The rest – the part that gives them their significance – is tree and rock. In the rock is a dark cave, and beyond it, a rich landscape burnished by the late sun.

Two possibilities are open: to venture into the unknown, the dark cave, or to move out into the familiar beauty of the countryside; to go within, into the spirit, or to go without, into the world and its rewards. Each man, alone, faces the invitation, seriously debating the wiser course, not consulting, but responsibly considering.

It is the landscape, with its autumnal ambience, that gives the work its poignancy. Scholars tells us that the old man's beard suggests to them the philosophies of Aristotle, that the middle figure wears the oriental dress reminiscent of Islamic thought, and that the sextant in the boy's motionless hand indicates the new natural philosophy that we now call science, but the information, true or not, seems irrelevant. The point is the poetry, the touch of interior gravity, the choice.

FORERUNNER OF TITIAN

A perfect example of Giorgione melting into Titian, who certainly finished some of Giorgione's paintings after his early death, is *The Adoration of the Shepherds (155)*, also called *The Allendale Nativity*. The balance of opinion now gives this solely to Giorgione, but it could equally be by Titian. In a way, the subject of the painting, or at least the focus of the artist's greatest interest, is the evening light, and this emphasis on light and landscape, first influenced by Giorgione, remained one of Titian's most enduring concerns. It unifies all it touches, and although there are certain activities taking place in the background, the overriding impression is of still- ness and silence.

The business of the normal world has come to a stop. Parents, Child, and shepherds seem lost in an eternal reverie, a prolonged sunsetting that will never move to clocktime. Even the animals are rapt in prayer, and the sense of being shown not an actual event, but a spiritual one, is very persuasive. Giorgione transports us beyond our material confines, without denying them.

TITIAN: THE "MODERN" PAINTER

Titian (Tiziano Vecellio, c. 1488–1567), who was Giorgione's successor, was destined to have one of the longest life spans in artistic history – in contrast to Giorgione and Raphael – and was one of those few very fortunate artists (Rembrandt and Matisse were two others) who changed and grew at every stage, reaching a climactic old age. The early Titian is wonderful enough; the later Titian is incomparable.

Before working with Giorgione, Titian spent time in the workshop of Giovanni Bellini (see p.107). Bellini's mastery of oil painting techniques, which had transformed Venetian painting, was of huge importance to Titian's art – and by the same token, to the direction of subsequent Western painting. It is in Titian's paintings that we find a freedom prophetic of the art of today: the actual material of the paint is valued for its inherent expressive qualities – in harmony with, but distinct from, the narrative of the paintings. Titian is perhaps the most important of all the great painters of the Renaissance. Unlike his predecessors, who were trained as engravers, designers for goldsmiths, and other crafts, he devoted all his energies to painting, and as such was a forerunner of the modern painter.

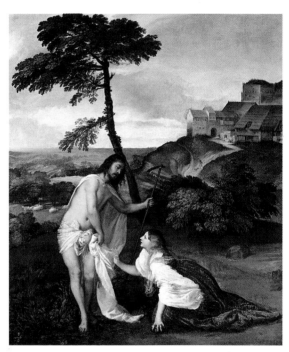

156 Titian, Christ Appearing to the Magdalen (Noli me Tangere), *c. 1512, 36 x 42¾ in (91 x 110 cm)*

Christ Appearing to the Magdalen (Noli me Tangere) (156) shows the youthful Titian delighting in the human interplay between the ardent Magdalen, all rich and spreading drapery, and the austere Christ, who withdraws from her with infinite courtesy.

Christ almost dances in resurrection freedom; she is recumbent with the heaviness of earthly involvements. A little tree tells us that newness of life has only just begun, and a great world stretches away toward the blue hills, remote, witnessing, leaving Mary Magdalene to her own choices. There is a touch of loneliness in the picture, a hint too of Giorgionesque nostalgia for a lost poetry. But fundamentally the mood has an earthly vigor.

TITIAN
SELF-PORTRAIT
This painting was completed by Titian toward the end of his life, when he was revered as an artist of great magnitude. He had revolutionized oil painting techniques, and was to be a great influence on artists such as Tintoretto and Rubens. He was ceremonially buried in Santa Maria dei Frari in Venice.

NOLI ME TANGERE
Titian's painting (see left) depicts the biblical story of Christ appearing before Mary Magdalene after His Resurrection. He forbids her to touch Him (*Noli me tangere*) but asks her to tell the disciples that He is risen. Mary mistook Him for a gardener, so He is shown holding a hoe.

RANUCCIO FARNESE

Ranuccio Farnese (1530–65) was the grandson of Pope Paul IV and belonged to one of the most influential families in Italy. This portrait was painted in 1542. By then the boy already held the privileged position of Prior of the Order of the Hospital of St. John of Jerusalem (the "Knights of Malta"), whose emblem, the Maltese Cross, is emblazoned on his cloak. Titian painted another portrait of a young aristocrat in 1542, the infant Clarissa Strozzi. Both pictures evince a warm sympathy for youth. They are full of the poignant realization of the tension between the playful world of childhood and the adult responsibilities awaiting the sitter in later life.

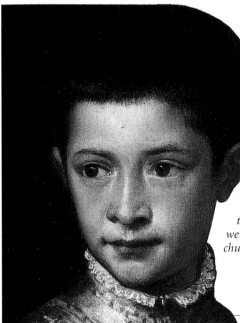

VISION OF YOUTH
At the top of the painting, above the curving swell of the satin, Titian admits the true reality of the unadorned boy, who belongs still to the realm of childhood. He has a child's fresh, unmarked skin, and his eyes are bright with reflected light. Bashfully, he does not meet our gaze, and his still-unformed mouth expresses a habitual amusement. In sharp contrast to the military paraphernalia weighing him down, we see the tender chubbiness of an untried adolescent.

MILITARY SYMBOL
The heraldic cross on Ranuccio's coat is given a metallic sheen. Thick white paint has been dragged over the graduated grays of the cross and has been applied unmixed, to create the sharpest highlights. This is the Maltese Cross, the emblem of the Knights of Malta, an order of chivalry founded in the 13th century. The order's original purpose was to administer a hospital in Jerusalem for soldiers wounded in the Holy Land while on service in the Crusades.

BOY'S TUNIC
The immediate focal point of this marvelous painting is the boy's brilliant red and gold satin tunic, contrasting with the warm, peachy flush of his cheeks. The rich cloth dazzles and shimmers in the light falling on the boy's chest, the red almost bleached out so that bright gold and silver remains, like the plumage of a bird. We are reminded of the tender vulnerability of the boy by the many small crimson slits that, in conjunction with the weapons, create an undercurrent of violence and pain.

BELT AND CODPIECE
At the bottom of the painting we see the attributes of manhood – the prominent, highlighted codpiece, closed but potent for the future: many family hopes hang upon this and his putative heirs – and the clutter of belts and sword, whose steely glint is picked out in small, dotlike strokes. Titian's portrait is built upon the contrast between the innocence of youth (Ranuccio is about 12) and the outward trappings of someone belonging to one of Italy's most powerful aristocratic families .

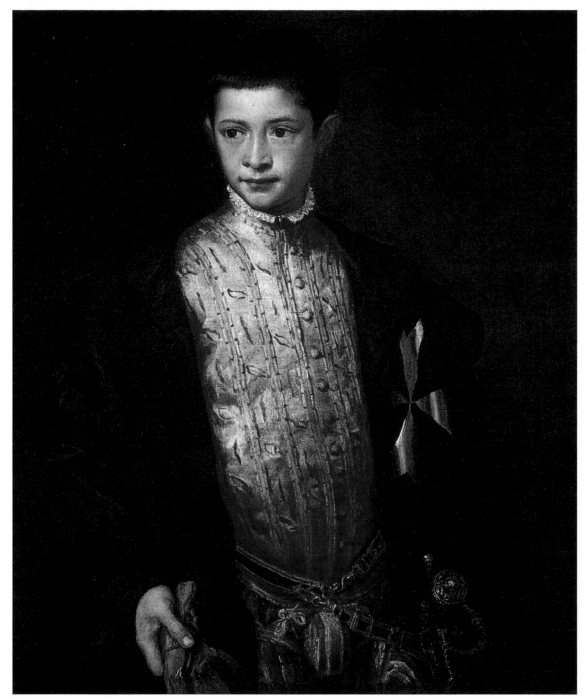

157 *Titian*, **Ranuccio Farnese**, *1542, 29 x 35 in (73 x 90 cm)*

VENUS AND OTHER MYTHS

Mythological subjects featured strongly in Titian's later work, especially in the *poesie*, a series of paintings he made for Philip II of Spain. Venus is a particularly popular figure in Renaissance art, appearing in the works of Botticelli, Giorgione, Bronzino, and Correggio as well as Titian. The Roman goddess of love and fertility, Venus is the mother of Cupid, the little god of love.

ITALIAN BANKING

The first modern bank had opened in Venice in the 12th century. However, during the Renaissance, Florentine banks became the most important in Europe, many having branches around the continent. The influential Medici family owed much of its wealth and power to its banking activities. These gold florins (above) were minted and circulated in Renaissance Florence.

TITIAN'S PORTRAITURE

This portrait *(157)* from Titian's middle years shows an artist of far greater depth of spiritual insight. Now he is not reveling in the sheer technique that turns thought into image; now he is painting from his own depths, and we feel the image arises almost spontaneously.

Ranuccio Farnese (157) portrays a very young man, splendid in his courtly attire. A silver cross gleams on one breast and light sparkles on the poignard below it. But the heraldic and warlike aspects are in shadows: what is real to the boy is the glove in his other hand, a hand visibly bare,

prepared to take on the burden of living, both unafraid and unprotected. He has not yet grown into his years, and the look of expectancy on the young face is full of an unformed innocence.

We admire the dignity that Titian has seen as appropriate, but we are also touched by the all-enveloping blackness in which Ranuccio is like a small, lighted candle.

Titian's insight is almost frightening in its realism. What he does, with superb technical skill, is show us the truth of an individual with all the attendant weakness, and yet produce a picture that is supremely beautiful.

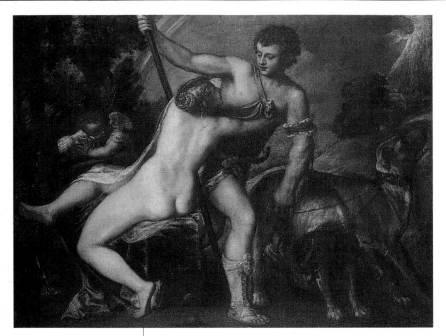

158 Titian, **Venus and Adonis,** *c. 1560,*
53½ x 42 in (135 x 106 cm)

THE LATE TITIAN

At the very end of his life, Titian painted many mythological scenes, as deeply poetic as those of the long-dead Giorgione, but with a deeper and sadder tone. Sometimes he would repeat a composition, as if seeking the total expression of some unrealized vision. One such repeated theme is that of *Venus and Adonis (158),* in which the goddess of love pleads with the young and beautiful Adonis to stay with her, knowing in prophetic insight that he will be killed while hunting. Adonis will not listen, will not – typical of inexperience – believe that he can die. He is every young man going off to war or to adventure, and Venus is every woman striving to hold him back. There is a painful irony in that she is the one being who is most desired of all men, most lovely of the gods and most loved; but the excitement of the hunt has greater charm for Adonis even than sexual bliss, and he impatiently rebuffs her. There is even a sense of older woman/ younger man, another irony, since Venus is immortal and Adonis merely thinks himself so, with tragic results.

It is the quivering color tones that make late Titian so marvelous, the soft and shimmering beauty of the flesh. Venus shows us her superb back and buttocks, beguilingly rounded, full of promise. Adonis is a hard and virile counterpart to her softness. Her coiled hair suggests her deliberateness – this is no disheveled lady of the bedchamber, and indeed they are sleeping outdoors, under a brooding sky. The great hounds, wiser than their master, sense something amiss, and even Cupid weeps with pity.

EMOTIONAL INTENSITY

So supreme an artist is Titian that it is surprising to read that Ruskin, that most insightful of Victorian critics, thought he was surpassed by Tintoretto (1518–1594). Tintoretto's original name was Jacopo Robusti, but he came to be known as *Il Tintoretto,* meaning "little dyer," after his father's profession. In a city as small as Venice, all artists knew one another, and it is no

PUTTI
Nude children, often winged, known as *putti* (plural of the Italian *putto,* meaning a little boy) appeared in many early Renaissance paintings and sculptures. Often meant to depict angels and cupids, they originally graced the art of the ancient Greeks and Romans. This bronze statue of a *putto* with a dolphin was fashioned by Verrocchio c. 1470. (see p.116).

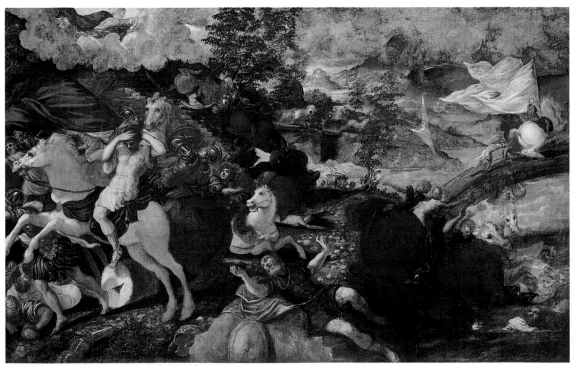

159 Tintoretto, **The Conversion of St. Paul,** *c. 1545, 7 ft 9 in x 5 ft (235 x 152 cm)*

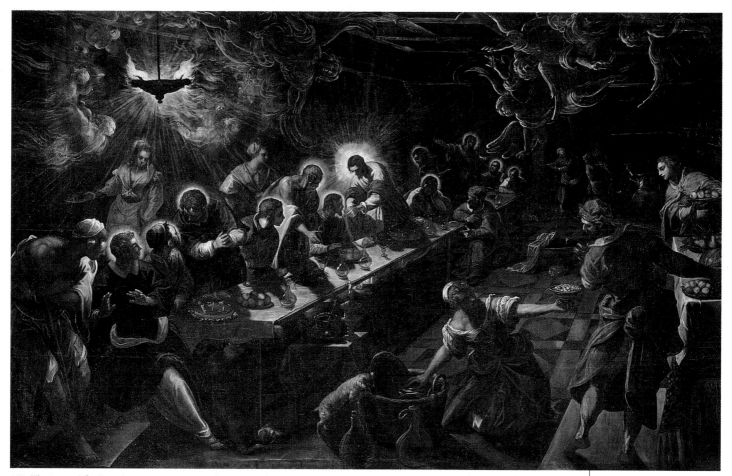

160 Tintoretto, **The Last Supper,** *1592–94, 18 ft 8 in × 12 ft (569 × 366 cm)*

surprise to learn that Tintoretto, about 30 years Titian's junior, declared his ambition was to combine Titian's color with Michelangelo's drawing. "Drawing," as Michelangelo would haughtily agree, is hardly the word to use for Venetian chromatic unities: form coalesces out of light, very softly. Tintoretto, though, was an almost "hard" Venetian, in that he painted in a fury of inspiration, dashing down his first ideas and scumbling them into a whole.

The passion of his attack makes its tempestuous presence seen: there is constant excitement and a sense of the tremendous. Only a gigantic talent could hold this trembling emotion and keep it both genuine and humble, and all the major Tintorettos do indeed affect us with their total honesty and their overwhelming emotional force. A very early work, painted when he was in his twenties, *The Conversion of St. Paul (159),* shows this extravagance of imaginative power.

Most painters show the conversion of St. Paul as dramatic, since the not-yet saint was thrown bodily from his horse and received the divine message lying terrified on his back. But none of the other works has the wild turbulence of Tintoretto's scene. The whole visible world breaks into chaotic disfunction, as the divine

erupts into our normality. On the right, a horse stampedes away with rider and streaming banners; on the left, another horse screams and rears, while its stricken rider is dazzled by the heavenly brightness above. Mountains surge, trees toss, men stagger and fall, the skies darken with ominous clouds. Paul lies in the center, overshadowed by his fallen horse. But he does not panic; he stretches out his desperate hands, passionate for salvation.

Many of his most potent images are still in their Venetian settings. *The Last Supper (160)* is still in the chancel of San Giorgio Maggiore (see right). It is an idiosyncratic version of the Last Supper, the meal commemorated every time the Eucharist (Holy Communion) is celebrated. Little is shown of the interaction between the apostles (we have to look hard to find Judas, usually a focal point). Tintoretto's one interest is in the gift of the Eucharist, and although many things are happening around this miracle, with cats, dogs, and servants included in the scene, all is insubstantial except for Christ and the food of Heaven. There is a feeling that only Christ is truly real. Angels flicker and fade in the flashes of His glory, and human presence takes on some sort of nebulous coherence only when

PALLADIAN ARCHITECTURE

The influential architect Andrea Palladio (1508–80) produced a number of buildings in Vicenza, but perhaps his most famous work is San Giorgio Maggiore in Venice. Begun in 1565, the church has the facade of a classical temple.

CHRIST AT THE SEA OF GALILEE

The contrast between Duccio's picture (see p.44) of the scene in which Christ first summons Peter and Andrew and Tintoretto's extraordinary painting could not be greater. Once again we see Christ at the Sea of Galilee, here in the middle of a violent storm. He stands on the water and calls to His amazed apostles. But as Duccio's panel painting was all certainty and calm – the moment of revelation, frozen in time and silent – Tintoretto's canvas reveals an uncertain world, filled with danger, doubt, and confusion.

THE BOAT AND FISHERMEN

The painting is largely composed of sharp, jagged shapes and wild zigzagging movement. Not least among these is the boat, whose mast is exaggeratedly curved into a thorn shape, bending almost to breaking point in the wind. The fishermen are picked out in rough, dry daubs of paint. Only two have halos: Peter (with the brighter halo), who, with all sense of personal danger lost, leaps into the water toward Christ, and another apostle, who steers the boat toward shore.

STILL POINT

Amid the violence of the storm, only the figure of Christ and the upright tree are still. All else is in turmoil. The little branch growing out of the side of the tree is flowering – a symbol of hope – and seems untroubled by the violent storm. Its gray-green leaves and tiny white petals are painted with single, thick daubs of paint.

VISIONARY FIGURE

Christ's robes are rapidly painted, with great bravura (His halo is a quick white swirl). The thick, creamy paint forming His lower robes gives them solidity, and their strange metallic pink is made by crimson glazes over the top. Tintoretto's Christ belongs to an essentially visionary world: His body lacks substance. His feet are merely outlines in white paint, with the green of the sea showing through, and His finger melts into the distant shore.

STORMY SEA

The thrashing waves echo the drama of the storm-filled sky, with its glancing, flashing light and rolling clouds. Earth colors have been added to the greens and grays of the turbulent waves, and the warm red ground shows through, linking the water to the solid earth, thereby increasing its sense of destructive might. The sharp zigzag of waves, razor-edged with thick white paint, leads our eye back and forth between Christ and the boat, and gives the impression of the earth opening up.

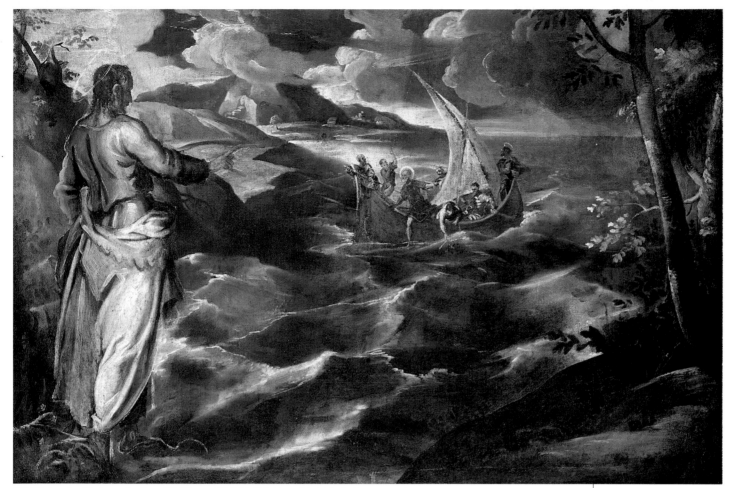

161 *Tintoretto,* Christ at the Sea of Galilee, *c. 1575/80, 5 ft 6 in x 3 ft 10 in (168 x 117 cm)*

haloed with holy brightness. There is not a moment's pretense of realism, only of underlying and sacred meaning. We either take this to heart or find it too intense.

A late Tintoretto shows *Christ at the Sea of Galilee (161)*. It is a work of immense emotional intensity. Far from presenting a frozen moment in time, it shows more than could be conveyed in a flickering instant. It is as if life could never stay still long enough to reveal what is sacred. Instead, Tintoretto paints a timeless scene of confrontation. Christ stands on the surface of a wildly tossing sea and calls His disciples. He is taut with summons, a solitary figure of majestic instancy, beckoning His divine invitation.

The apostles are a dim mass of anxious humanity, battered by the wild sea, helpless under the storm clouds. The voice of Jesus releases them from their fearful anonymity. Peter leaps joyfully into the waters, eyes fixed only on Jesus. The ugly trenches of the waves lie between servant and Master, but Tintoretto has no doubt at all that the two will meet. Violence is powerless in the presence of God, and in consequence has no authority over a seeker after God. Tintoretto shows nature as a thing almost

of torn paper, threatening and yet defanged. In an interesting touch, we are not shown the face of Christ, only His averted profile. Peter, who looks upon Him fully, can dare the leap of faith.

Even in a lovely secular work like *Summer (162)*, there is an ecstatic, springlike vitality in Tintoretto's paintings that makes the very corn "immortal wheat" in the words of the 17th-century English cleric and mystic poet Thomas Traherne. This earthly image is reminiscent of the third great Venetian artist, Veronese.

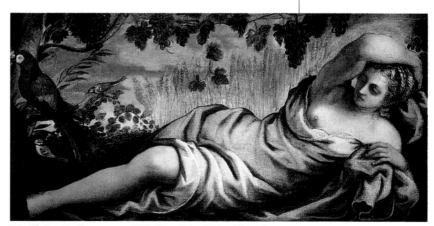

162 *Tintoretto,* Summer, *c. 1555, 76 x 42 in (194 x 106 cm)*

VERONESE'S MATERIAL WORLD

Veronese (Paolo Caliari, 1528–88) has been called the first "pure" painter, in that he is practically indifferent to the actuality of what he paints, and totally taken up with an almost abstract sensitivity to tone and hue. His works glow from within, decorative art at its noblest.

Veronese may not be as profound an artist as Titian or Tintoretto, but it is easy to underestimate him. His fascination for the way things look, their capacity for ideal beauty, raises his art to a high level. He shows not what is but what, ideally, could or should be, celebrating materiality with a magnanimous seriousness.

To take the superficial so earnestly is to raise it to another order of being. His *St. Lucy and a Donor (163)* does not really show us a martyr; he expects us to know the story of this saint and provide the context ourselves. What he does show is the glory of young womanhood, all satins and silks and sunlit beauty. Her lovely face is enraptured, slightly timid, and a closer

163 Paolo Veronese, **St. Lucy and a Donor,** *probably c. 1580,* 3 ft 9 in x 5 ft 11 in (115 x 180 cm)

inspection of the martyr's palm, held away from her, shows her usual emblem, an eye. But the allusion could not be more reticent, more present for form's sake. We see the elderly donor more as an admirer in the worldly way than as a devotee of St. Lucy's cult. The work is one of great amplitude, of confidence, and bodily delight.

The Finding of Moses (164) shows the same healthy and hopeful nature: there is an obvious and unaffected pleasure in the sheer opulence of the dress of Pharaoh's daughter and of her maidens. Everybody, including the infant Moses, is good-looking, elegant, and happy. The characters in the scene all look refreshingly uncomplicated. Trees balance the landscape to left and right. The lady looks affectionately at the attractive child. The biblical scene as such has solemn overtones, but not for Veronese. What delights him is its beautiful humanity.

It is easy to underestimate Veronese, to see him as a superb decorator producing colorful tableaux. But he carries decoration to the point where it reveals the intensity of experienced beauty and becomes powerful art in its own right. Veronese's work glows out at us with an awareness of the potential of a material world that is supremely beautiful.

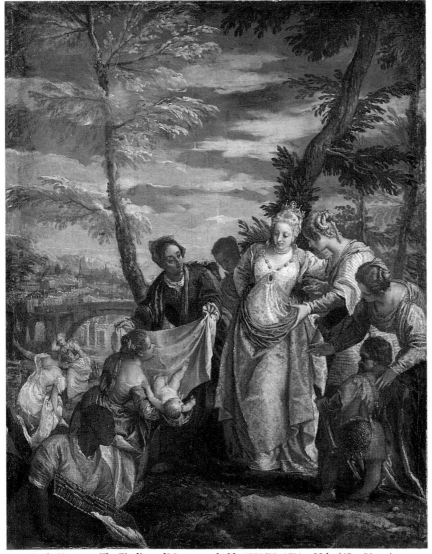

164 Paolo Veronese, **The Finding of Moses,** *probably 1570/75, 17½ x 23 in (45 x 58 cm)*

THE ITALIAN MANNERIST PERIOD

Like "Renaissance," the term "Mannerism" applies to a broad and diverse movement, and to a certain artistic standpoint, rather than any one style. It developed out of the High Renaissance, which was in decline by the early part of the 16th century and lasted roughly 60 years, between 1520 and 1580. Mannerist art was influenced by the work of such High Renaissance artists as Michelangelo and Raphael (who died in 1520).

The word "Mannerism" is derived from the Italian word *maniera*, which in the 16th century meant "style" in the sense of elegance. Because of this implication of elegance, Mannerism has long been a somewhat misleading term that has caused much confusion and disagreement among art historians. Nevertheless "style," in this sense of the word, does constitute a crucial element of Mannerism, while Mannerist painting is also often highly "mannered" in the modern sense of the word. Mannerist painting is characterized by its self-consciously sophisticated, often contrived or exaggerated elegance, its heightened or sharp color combinations, its complex and highly inventive composition, and the technical bravado and the free-flowing line favored by its painters.

EARLY MANNERIST PAINTING IN FLORENCE

The High Renaissance was exceptionally rich in minor painters, artists whose work often slid imperceptibly into Mannerism as they exaggerated their styles, intent upon creating excitement in the viewer. Even if this sounds contrived and self-conscious, there is nevertheless an emotional charge in the great Mannerists that can be highly effective.

Rosso (Giovanni Battista di Jacopo, 1494–1540) was known in France, where he emigrated, as Rosso Fiorentino, "the Florentine." He was a deeply neurotic man, and his art was almost wantonly a flouting of normal expectations. He employed bold, dissonant color contrasts, and his figures often filled the entire picture frame. *Moses and the Daughters of Jethro (165)*, for example, is a fantastic jumble of nude bodies – huge, agitated, Michelangelo-like wrestlers, with a pale, terrified, half-stripped girl standing aghast amid the carnage. Rosso is painting an idea of violence, rather than specifics, and he does so succinctly and expertly.

Pontormo (Jacopo Carucci, 1494–1556) was also an oversensitive and neurotic man. He was sometimes known to withdraw completely from the world in order to live in seclusion. Like Rosso, his art is excitable and strange, striking us with a sort of enjoyable agitation.

Pontormo and Rosso were taught by the gifted Florentine Andrea del Sarto (1486–1531), whose soft forms, gentle colors, and emotional gestures provided a counterbalance to the rigorous athleticism of Michelangelo in Rome. His smudgy sweetness was influential, moving the Classicism of the High Renaissance toward a new Mannerist expression.

THE LAURENTIAN LIBRARY
In 1523 the Medici family commissioned Michelangelo to design a library that would hold 10,000 books and manuscripts. This, the Laurentian Library, became a forerunner of Mannerist architecture. It was 1559 before Michelangelo designed the staircase, which is recognized as a masterpiece of decorative architecture inspired by classical forms.

165 **Rosso, Moses and the Daughters of Jethro,** *c. 1523, 46 × 63 in (117 × 160 cm)*

The essentially monochrome *Portrait of a Young Man (167)* is a good example of the subtle use of color in Andrea del Sarto's work – and some contemporaries rated him as one of the four best painters of his time.

Pontormo's masterpiece is his *Deposition (166)*, painted for the altarpiece of a private chapel in Florence. Its strangely luminescent quality and lucid, unearthly light were created partly to compensate for the darkness of the chapel, but also reflect the work's emotional intensity. There is an overriding sense of vulnerability and loss, and this makes the contrast between the beautifully

167 Andrea del Sarto, Portrait of a Young Man, *c. 1517, 22½ x 29 in (57 x 73 cm)*

athletic, long-limbed, classical bodies and the facial expressions of anxiety and confusion all the more pitiful. Pontormo's portrait of *Monsignor della Casa (168)* is brilliantly observed, with the prelate's long, aristocratic face giraffelike above his auburn beard. He is hemmed in by the walls of his room, rigid and defensive, challenging the onlooker with his arrogance, and yet so pleasingly decorative to view.

166 Pontormo, Deposition, *c. 1525/28, 6 ft 3 in x 10 ft 3 in (190 x 312 cm)*

168 Pontormo, Monsignor della Casa, *c. 1541/44, 31 x 40 in (79 x 102 cm)*

two of the side effects of treatments that were used in the 16th century. The allegory, by this reading, is that illicit love is attended by Fraud, who offers a honeycomb. A child representing the deceived will rushes to enjoy pleasure. The result of the ignorant embrace is syphilis. Time exposes the sickness by pulling away the blue backcloth, to reveal the truth that is hidden from Venus and Cupid.

SPIRITUALITY OF CORREGGIO

A Renaissance painter with a Mannerist mind was Correggio (Antonio Allegri, c. 1489–1534), who lived in Parma. He was one of the very great artists, intensely physical and yet steadily aware of light and its spiritual significance. Correggio was a follower of Mantegna (see p.103), and that inner solidity keeps his excesses reasonable and, still more, lovable.

A turning point in the development of Correggio's artistic identity came after a stay in Rome as a young man, where he saw the work of Michelangelo (see p.120) and Raphael

CONTEMPORARY ARTS

1542
University of Pisa founded by Cosimo de' Medici

1548
Hotel de Bourgogne, the first covered theater, opens in Paris

1553
The violin begins to develop into its modern form

1561
The English philosopher Francis Bacon is born

1578
The catacombs of Rome are discovered

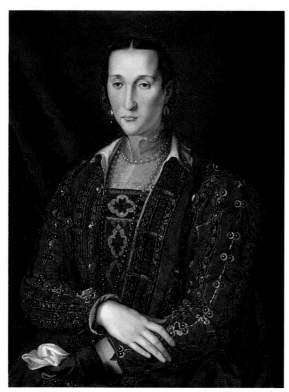

169 Agnolo Bronzino, Eleanora di Toledo, *c. 1560, 26 x 34 in (65 x 85 cm)*

BRONZINO'S CHILL VISION

Pontormo was the teacher and almost the foster-father of the strangely brilliant Agnolo Bronzino (1503–72). In Pontormo's reclusive moods Bronzino, too, was barred entrance. This may have been because Pontormo, who was deeply religious in a fanatic manner, picked up disturbing undercurrents in his protégé's work. There is a cold brilliance in Bronzino that can be very unappetizing, even when we admire his skill.

The court did not find him unattractive, however: his icy and rather bitter portraits were much admired in his day, and he became the leading Mannerist painter in Florence. His portrait of *Eleanora di Toledo (169)* shows her opulently dressed, dripping with costly pearls and grimly displeased.

Bronzino's *Allegory with Venus and Cupid (170)* used to be known as *Venus, Cupid, Folly, and Time.* It was commissioned by Cosimo I of Florence as a present for Francis I. The painting was described by Vasari as a many-sided allegory about sensual pleasure and a variety of unspecified dangers that lurk beneath the surface. Some have seen it as referring to incest, inherently perverse. But in 1986 a doctor suggested an extremely plausible explanation of the allegory, arguing that it was a reference to syphilis. The tortured figure on the left is an intricately worked illustration crammed with the clinical symptoms of the disease and one or

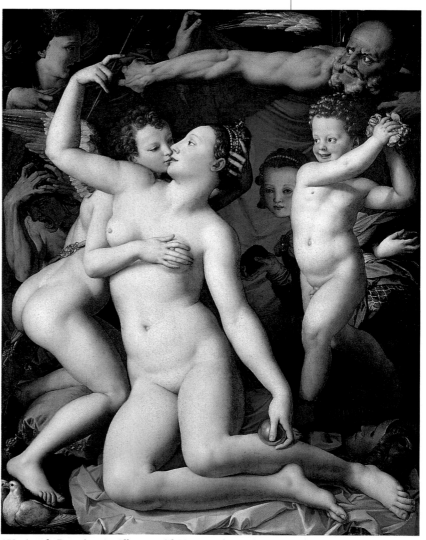

170 Agnolo Bronzino, An Allegory with Venus and Cupid, *c. 1545, 45½ x 57½ in (116 x 146 cm)*

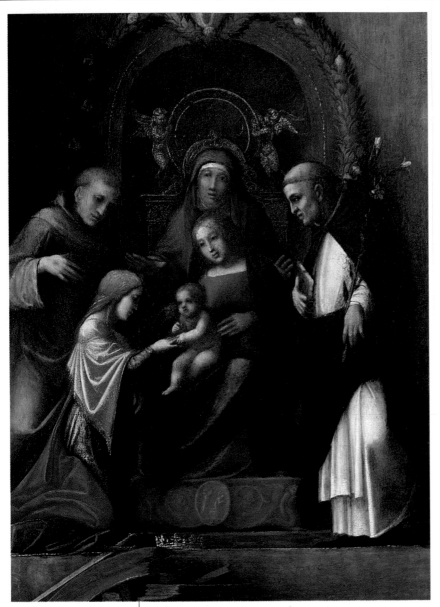

171 Correggio, The Mystic Marriage of St. Catherine, c. 1510/15, 8¼ x 11 in (21 x 28 cm)

leans forward with an expression of deep reverence. Indeed the whole painting, small but emotionally expansive, is infused with a profound awareness of the sacred.

Correggio was important as a precursor of Mannerism rather than as a Mannerist artist himself. In fact, his greatest contributions to Mannerism and the Baroque (see p.176) are his wonderful illusionistic ceiling frescoes, which are painted inside the domes of great churches in Parma.

Unfortunately, these frescoes defy reproduction. We have to stand inside Parma Cathedral, looking up into the light-filled *Assumption of the Virgin*; we have to be there in the church of San Giovanni Evangelista, tilting our heads in awe at *The Vision of St. John the Evangelist*. Only experience enables us to appreciate the skill of foreshortening and the overwhelming impression of actuality, which were to culminate in the technical wizardry of the Mannerists.

THE ELEGANCE OF PARMIGIANINO

Parmigianino (Girolamo Francesco Maria Mazzola, 1503–40) was an artist of the utmost elegance, subsuming all reality in sheer grace. *The Madonna with the Long Neck (173)* is his best-known and most typical picture. Mary is a swanlike lady, set amid a wholly improbable scene of ruins and curtains, elongated not only

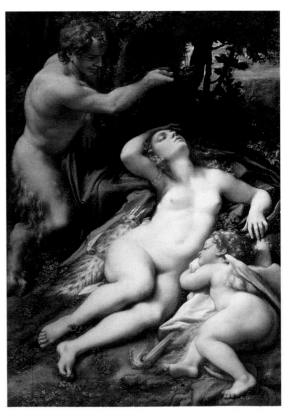

172 Correggio, Venus, Satyr, and Cupid, 1524/25, 48½ in x 6 ft 3 in (124 x 190 cm)

OTHER WORKS BY CORREGGIO

Salvator Mundi
(National Gallery of Art, Washington)

Adoration of the Shepherds
(Gemäldegalerie, Dresden)

Assumption of the Virgin (dome fresco, Parma Cathedral)

Jupiter and Io
(Kunsthistorisches Museum, Vienna)

Holy Family with the Infant St. John
(Los Angeles County Museum of Art)

(see p.124). He soon became the leading artist in Parma. His *Venus, Satyr, and Cupid (172)* has a complete sensual abandon, yet there is an innocence in its fleshliness, a feeling of living in the age before the expulsion from Eden. Each body reflects the moonlight individually and differently, the proportions subtly wrong, but thereby all the more morally reassuring.

There is precisely the same sort of fleshly sweetness in his religious pictures, such as *The Mystic Marriage of St. Catherine (171)*. The legend, that Catherine had a vision in which the Child Jesus betrothed her with a ring, is no longer thought of as literally true, yet it has a deeper meaning, one of consecration, and above all, of the vow of chastity. St Catherine kneels, oblivious to her saintly partner, who

173 **Parmigianino, The Madonna with the Long Neck,** *1534–40, 52 x 85 in (132 x 215 cm)*

GRINDING PIGMENTS

This red ochre drawing by Parmigianino shows a workshop assistant grinding pigments. During their apprenticeships, artists learned to identify, grind, and blend the pigments. In oil painting the pigments would be suspended in vegetable oils derived from linseed, walnuts, sunflower seeds, poppy seeds, or other plant sources. Using a buildup of different-colored pigments on the canvas imparted a light and liquidity that would be impossible using egg tempera.

ISABELLA D'ESTE

Recognized during the Renaissance for her exceptional talent and intellectual ability, Isabella d'Este (1474–1539) was a great patron of literature and art. She gathered a coterie of intellectuals, one of whom was Baldassare Castiglione (see p.129), to educate her, and employed the great artists of the time, including Correggio. There are portraits of her by a number of artists, notably Leonardo and Titian (shown above).

of neck but of person, with a long, elegant Child on her lap, insecurely posed but unworryingly so, since this is a world where the vulgarities of gravity do not apply. A long-legged angel, ravishingly beautiful, is only the first of a throng of similar exquisites. Everything sweeps upward, like the background pillar, as if floating heavenward and bearing us all along in its sweep.

DOSSI IN FERRARA

Dosso Dossi (c. 1490–1542), from Ferrara, is touched with the same light of fantasy as Parmigianino (see p.142). He was court painter to Lucrezia Borgia (see column, left), and there has been speculation that it is she who was the inspiration behind the magical *Circe and Her Lovers in a Landscape (174)*. It is an enchanting picture in a double sense, not least because of the possible initial misreading of Circe's body. Her left leg is modestly cloaked, but at first it can seem strangely absent, as if she strides across from another world into ours. The men magicked into animals have both pathos and humor, with a touch of cruelty congenial to the Borgia ménage. Yet Circe has a yearning face, and perhaps the strongest note in the picture is one of sadness and desire.

LOTTO IN VENICE

There is this same strain of sadness in Lorenzo Lotto (c. 1480–1556), a highly idiosyncratic painter who mingles his sadness with a disinterested human curiosity. He always gives us a slanting view, provocative and thoughtful, colored by

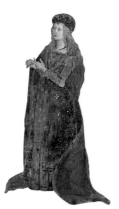

LUCREZIA BORGIA

As daughter of the Borgia Pope Alexander VI, Lucrezia (1480–1519) had her marriages arranged to further the political careers of her father and brother. As wife of the Duke of Ferrara she presided over a lively court and was patroness to a number of artists, including Dosso Dossi. Her modern reputation as a woman of easy virtue has overshadowed the real achievements of her patronage and charity.

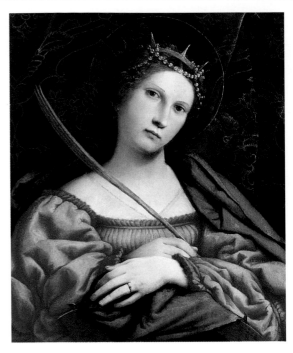

175 Lorenzo Lotto, St. Catherine, c. 1522, *20 x 22½ in (50 x 57 cm)*

Giovanni Bellini's continuing influence in Venice. Lotto is famous especially for his portraits, where his weird and original insights found splendid scope, but even in an apparent religious image, there is the same enigmatic and offbeat inventiveness. *St. Catherine (175)* tilts her charming head to one side and regards us thoughtfully. She has generously hidden from us her spiked wheel, covering it with the rich folds of her green mantle, and she rests her hands comfortably on its rotundity. The artist clearly suspects that her neck cross is essentially as much adornment as is her pearled crown, yet we believe in her totally. We may not believe in this Catherine as a saint, but that she is a real woman whom Lotto painted comes across with great clarity.

BECCAFUMI IN SIENA

Domenico Beccafumi (1485–1551) was the last great Sienese artist of the High Renaissance, just as Dossi was the last great Ferrarese. He is not an easy painter, with his sudden transitions from dark to light, his oddly proportioned figures, and his unusual acidic colors reminiscent of the Florentine Mannerist Rosso Fiorentino (see p.139). Beccafumi's figures can seem to loom up at us, disconcertingly, and his use of perspective, though sophisticated,

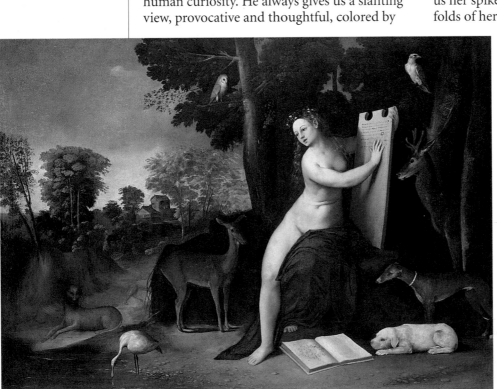

174 Dosso Dossi, Circe and Her Lovers in a Landscape, c. 1525, *53½ x 39½ in (136 x 101 cm)*

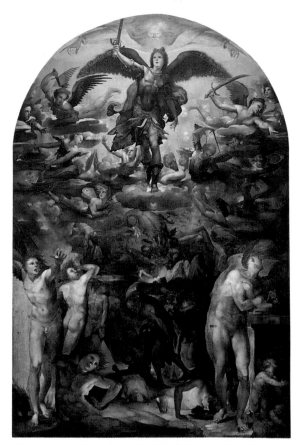

176 *Domenico Beccafumi,* **The Fall of the Rebel Angels,**
c. 1524, 7 ft 5 in × 11 ft 4 in (225 × 345 cm)

is personal to himself. *The Fall of the Rebel Angels
(176)* is a tangle of dimly lit forms, hallucinatory
in its horror, yet shot through with the memories
of Sienese graciousness (see p.43).

EL GRECO: PASSIONATE VISIONARY

The greatest Mannerist of them all is the Spanish
painter El Greco (Domenicos Theotokopoulos,
1541–1614, called "El Greco" because he was
born in Crete). His artistic roots are diverse:
he traveled between Venice, Rome, and Spain
(settling in Toledo). The Christian doctrines
of Spain made a crucial impact on his approach
to painting, and his art represents a blend of
passion and restraint, religious fervor and
Neo-Platonism, influenced by the mysticism
of the Counter-Reformation (see p.176, 187).

El Greco's elongated figures, ever straining
upward, his intense and unusual colors, his
passionate involvement in his subject, his ardor
and his energy, all combine to create a style that
is wholly distinct and individual. He is the great
fuser, and also the transfuser, setting the stamp
of his angular intensity upon all that he creates.
To the legacies of Venice, Florence, and Siena,
he added that of the Byzantine tradition, not
necessarily in form but in spirit (although he did
in fact train as an icon painter in his early years in

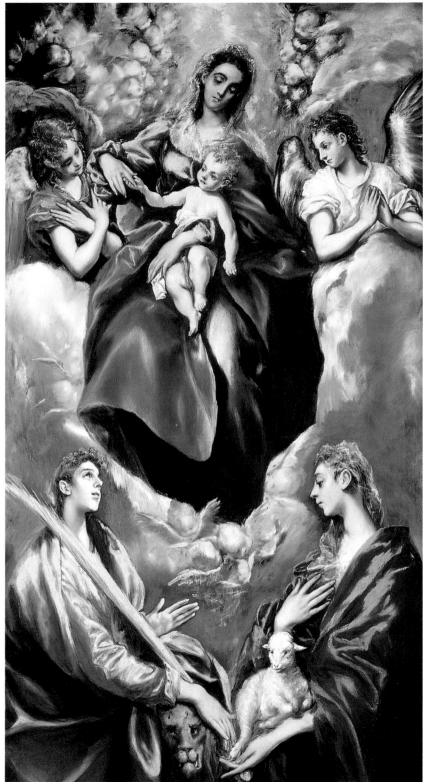

177 *El Greco,* **Madonna and Child with St. Martina and
St. Agnes,** *1597–99, 40½ × 76 in (103 × 194 cm)*

Crete). El Greco always produces icons, and it
is this interior gravity of spirit that gives his odd
distortions a sacred rightness.

The *Madonna and Child with St. Martina
and St. Agnes (177)* sweeps us up from our
natural animal level, there at the bottom with

GALILEO GALILEI

The foremost philosopher, physicist, and astronomer of the Renaissance was Galileo (1564–1642). He held an heliocentric view of the world (believing that the world revolved around the sun) and was considered a heretic by the Church. He developed a telescope (shown above) that was powerful enough to show the mountains and valleys of the moon.

In 1633 he was put under house arrest for his astronomical teachings; later he was forced to disown them publicly.

St. Martina's pensive lion and St. Agnes's lamb, balancing with unnatural poise on the branch of her arm. Martina's palm of martyrdom acts like a signal, as do the long, impossibly slender fingers of Agnes.

We are drawn irresistibly up, past the flutter of cherubic wing and the rich swirl of virginal robe, kept to the pictorial center by those strangely papery or sheetlike clouds peculiar to El Greco. Up, up, rising through the curve of Mary's cloak, we are drawn to the heart of the work, the Child and, above Him, the oval serenity of the Madonna's countenance. We are continually on the move, but never left to our own devices. We are guided and directed by El Greco, with praying figures at the corners to hold us in the right position.

UNRESOLVED QUESTIONS

Such a dramatic and insistent art can seem too obtrusive: we may long to be left to ourselves. But this psychic control is essential to El Greco, the great – in the nicest sense – manipulator. Even when we cannot really understand the picture, as in the *Laocoön (178)*, we have no doubt that something portentous is taking place and that we are diminished to the extent we cannot participate. The literal reference to the Trojan

priest and his sons is clear enough (see p.20). But who are the naked women, one of whom seems to be double-headed? Even if the extra head is indicative of the work being unfinished, it is still uncannily apposite. *The Laocoön* was overpainted after El Greco's death, and the "second head" that looks into the painting was obliterated, while the two standing frontal nudes were given loincloths. Later, these features were restored to the form that we see now.

The serpents seem oddly ineffectual, thin and meager; we wonder why these muscular males have such trouble overcoming them. And we feel that this is an allegory more than a straightforward story, that we are watching evil and temptation at work on the unprotected bodies of mankind. Even the rocks are materially unconvincing, made of the same non-substance as the high and clouded sky.

The less we understand, the more we are held enthralled by this work. It is the implicit meaning that always matters most in El Greco, that which he conveys by manner rather than by substance, gleaming with an unearthly light that we still, despite the unresolved mysteries, do not feel to be alien to us. No other of the great Mannerists carried manner to such height or with such consistency as El Greco.

OTHER WORKS BY EL GRECO

Lady in a Fur Wrap (Pollock House, Glasgow)

The Burial of Count Orgaz (Church of Santo Tome, Toledo)

The Resurrection (Prado, Madrid)

St. Bonaventura (National Gallery of Victoria, Melbourne)

St. Francis in Ecstasy (Museum of Fine Arts, Montreal)

St. Peter in Tears (Nasjonalgalleriet, Oslo)

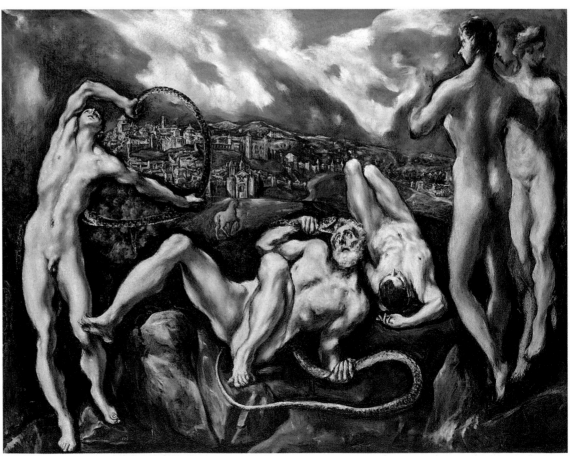

178 El Greco, Laocoön, c. 1610, 68 x 54 in (173 x 137 cm)

LAOCOÖN

El Greco's painting depicts events best known to us from Virgil's *Aeneid*, but El Greco probably knew them from the Greek writer Arctinus of Miletus. Laocoön tried to dissuade the Trojans from letting in the treacherous wooden horse (which led to the sacking of Troy). In the Arctinus version Laocoön, a priest, was killed by serpents sent by Apollo for breaking his priestly rule of celibacy (in Virgil the gods intervened openly on the Greek side).

MYSTERY WITNESSES
The figures who appear to watch the scene with indifference are a mystery. One, a woman, seems to be two-headed, with one head looking out of the painting. The figures could be Apollo and Athena, come down to witness the judgment on Laocoön.

OILED SERPENT
El Greco's wonderful circular invention of the boy wrestling with the serpent creates a powerful physical tension. We are kept in suspense as to whether the boy will end the same way as his brother lying dead on the ground. El Greco's unique and unorthodox style admits an unprecedented freedom. Around the boy's outstretched arm there is a broad band of black, which has no spatial "meaning" as such, and which emphasizes the rigidity of the arm and the desperate efforts of the boy. The line flows around the strange, stone-colored figures.

A SPANISH TROY
The allegorical horse in the middle distance trots toward the city, which is spread out under a glowering, doom-laden sky. It is a beautiful landscape, in which the vibrant red-earth ground is covered with a lattice of silvers, blues, and greens. However, this is not the ancient city of Troy, but El Greco's hometown of Toledo in Spain. El Greco painted Laocoön *during the time of the Spanish Catholic Counter-Reformátion, and his allegorical drama, of transgressing mortals and vengeful gods, set unequivocally in his own modern Spain, is an indication of the orthodoxy of the artist's religious beliefs.*

THE EPONYMOUS SUFFERER
The anguished head of Laocoön is an example of the artist's characteristic light, rapid, feathery brushwork. Where skin meets skin – in between toes, lips, nostrils – he has applied crimson or vermilion, breathing life and a suggestion of lifeblood into the deathlike steely grays of the flesh.

THE NORTHERN RENAISSANCE

Having closed the Gothic chapter with the anguished realism of Matthias Grünewald in order to concentrate on that most momentous of movements, the Italian Renaissance, we now return to the North, picking up the thread where we left off.

The 16th century heralded a new era for painting in the Netherlands and Germany. Northern artists were influenced by the great innovations in the South; many artists traveled to Italy to study; and the Renaissance concern with bringing modern science and philosophy into art was also evident in the North. There was, however, a difference of outlook between the two cultures. In Italy, change was inspired by Humanism, with its emphasis on the revival of the values of classical antiquity. In the North, change was driven by another set of preoccupations: religious reform, the return to ancient Christian values, and the revolt against the authority of the Church.

Pieter Brueghel, **The Wedding Feast,** *c. 1567–68 (detail)*

NORTHERN RENAISSANCE TIMELINE

The Renaissance in the North crystallized around the intense vision and realism of Dürer's work. Other painters in both Germany and the Netherlands followed the Northern impulse for precise observation and naturalism in the fields of landscape painting (Patinir and Brueghel) and portraiture (Holbein). As in Italy, the Northern Renaissance ended with a Mannerist phase. Mannerism was to last about a generation longer in the North than it did in Italy, where it was outmoded by 1600.

ALBRECHT DÜRER, MADONNA AND CHILD, C. 1505

Dürer's work is characterized by an intense scrutiny that enabled him to depict the innermost depths of his subjects. He sees through to the heart of his subject, whether his theme is portraiture or religious (p.153).

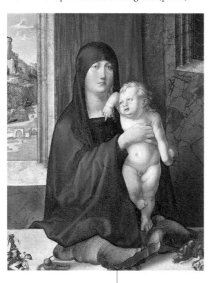

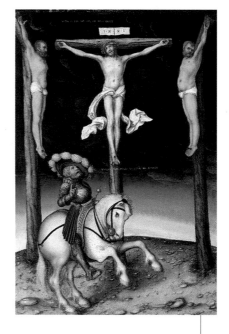

LUCAS CRANACH, CRUCIFIXION WITH THE CONVERTED CENTURION, 1536

In the course of his long career, Cranach developed two styles. Popular paintings such as nudes were sold privately to wealthy patrons, and court paintings were produced on official commission. These were either portraits or religious works. This Crucifixion, which alludes to the Gospel story of the centurion, shows Cranach tackling the task of devotional work. His sincerity is compromised by his own personal commitment to Humanism and his support for the Reformation, which questioned the value of religious imagery (p.158).

1500	1515	1530	1545

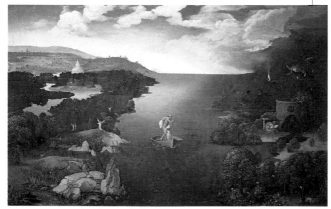

JOACHIM PATINIR, CHARON CROSSING THE STYX, 1515–24

Elements of Gothic style are visible in Patinir's work from the early Northern Renaissance. Charon, the mythical ferryman, is taking his passenger to Hades, the Greek equivalent of Hell, which is depicted as a war-torn landscape with burning buildings and tortured, despairing people in the manner of Hieronymus Bosch (see p.72). This work is, at the same time, an early foreshadowing of the Northern landscape tradition (p.166).

HANS HOLBEIN THE YOUNGER, CHRISTINA OF DENMARK, 1538

In the work of Holbein, we find the other face of portrait painting, in contrast to that of Dürer. Holbein was able to show the surface, without close inquiry into the inner life of the sitter. This distanced approach suited his work as a court and diplomatic portraitist to Henry VIII of England. Christina was not a queen, but the Duchess of Milan and a member of the Danish aristocracy. She granted Holbein an audience of only three hours in which to sketch for this powerful picture (p.160).

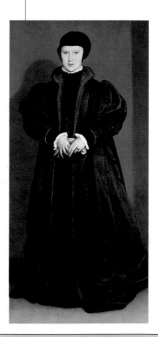

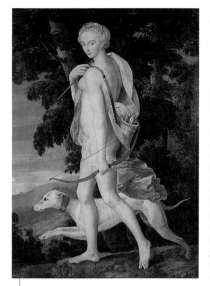

SCHOOL OF FONTAINEBLEAU, DIANA THE HUNTRESS, C. 1550

The Gothic castle at Fontainebleau outside Paris was developed by King Francis I (1514–47) as a cultural and artistic center. The king employed artists and sculptors from Italy, and Fontainebleau became an entry point through which Southern influence made its way into Northern Europe. The poets of the School of Fontainebleau treated Diana as the most important of the gods, more so even than Venus. The way Diana is painted shows well the sinuous line and decorative pose that appeared in so much Mannerist art (p.164).

JOACHIM WTEWAEL, THE JUDGMENT OF PARIS, C. 1615

Wtewael was one of the leading Mannerist painters in the Northern Netherlands. His work shows a preoccupation with elegant figure painting, in which the subjects are invariably seen in distorted poses and a characteristically acidic range of colors. This scene has the typically artificial Mannerist setting, a fantasy woodland populated with elegant creatures (p.165).

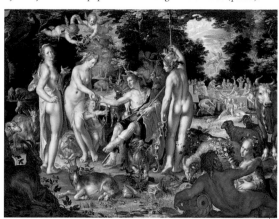

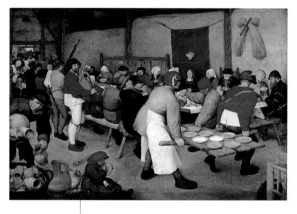

PIETER BRUEGHEL, THE WEDDING FEAST, 1567–68

This is one of a number of works in which Brueghel took as his theme the life of the contemporary peasant. For a sophisticated intellectual, it was an extraordinary achievement to enter so profoundly into the crude vitality of these scenes. Despite their rough humor, Brueghel's peasant scenes exude an almost guilty compassion for the degradation in which the peasants lived (p.168).

1560	1575	1590	1610

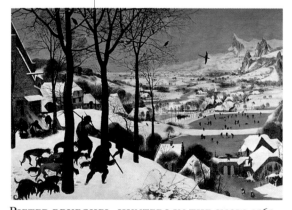

PIETER BRUEGHEL, HUNTERS IN THE SNOW, 1565

It was part of Brueghel's universality that he excelled in landscapes as well as focusing closely on human nature. In 1565 he painted a series of landscapes linked to months of the year, thus continuing the tradition of calendar illustrations seen in the "books of hours" (see p.55). In the books of hours, peasant activities were shown in alternate panels with scenes from court life. In Brueghel's series, only the peasant scenes are known, at least today. Another of this series is Gloomy Day (see p.171).

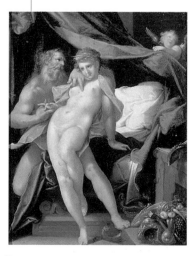

BARTHOLOMEUS SPRANGER, VULCAN AND MAIA, C. 1590

Frankly sensuous poses, attenuated figures, and a strong element of fantasy make this a quintessential work of Mannerism (p.165).

DÜRER AND GERMAN PORTRAITURE

Dürer was so great an artist, so searching and all-encompassing a thinker, that he was almost a Renaissance in his own right – and his work was admired by contemporaries in the North and South alike. The 16th century saw the emergence of a new type of patron, not the grand aristocrat but the bourgeois, eager to purchase pictures in the newly developed medium of woodcut printing. The new century also brought an interest in Humanism and science, and a market for books, many of which were illustrated with woodcuts. The accuracy and inner perception of Dürer's art represent one aspect of German portraiture; another is seen in the work of that master of the court portrait, Holbein.

OTHER WORKS BY DÜRER

Young Girl Wearing a Beret
(Staatliche Museen, Berlin-Dahlem)

A Young Man
(Palazzo Rosso, Genoa)

Virgin and Child
(Alte Pinakothek, Munich)

Salvator Mundi
(Metropolitan Museum of Art, New York)

Adam
(Prado, Madrid)

Adoration of the Trinity
(Kunsthistorisches Museum, Vienna)

Impressive though others may be, the great German artist of the Northern Renaissance is Albrecht Dürer (1471–1528). We know his life better than the lives of other artists of his time: we have, for instance, his letters and those of his friends. Dürer traveled, and found, he says, more appreciation abroad than at home. The Italian influence on his art was of a particularly Venetian strain, through the great Bellini (see p.106), who, by the time Dürer met him, was an old man. Dürer was exceptionally learned, and the only Northern artist who fully absorbed the sophisticated Italian dialogue between scientific theory and art, producing his own treatise on proportion in 1528 (see top of column, p.153). But although we know so much about his doings, it is not easy to fathom his thinking.

Dürer seems to have united a large measure of self-esteem with a deep sense of human unfulfillment. There is an undercurrent of exigency in all he does, as if work was a surrogate for happiness. He had an arranged marriage, and friends considered his wife, Agnes, to be mean and bad-tempered, though what their real marital relations were, nobody can tell. For all his apparent openness, Dürer is a reserved man, and perhaps it is this rather sad reserve that makes his work so moving.

The Germans still tended to consider the artist as a craftsman, as had been the conventional view during the Middle Ages. This was bitterly unacceptable to Dürer, whose *Self-Portrait (179)* (the second of three) shows him as slender and aristocratic, a haughty and foppish youth, ringletted and impassive. His stylish and expensive costume indicates, like the dramatic mountain view through the window (implying wider horizons), that he considers himself no mere limited provincial. What Dürer insists on above all else is his dignity, and this was a quality that he allowed to others too.

Even a small and early Dürer has this momentousness about it. His *Madonna and Child (180)*, which manifestly follows the Venetian precedent of the close-up, half-figure portrait, was once thought to be by Bellini. To Dürer, Bellini was an example of a painter who could make the ideal become actual. But Dürer can never quite believe in the ideal, passionately though he longs for it. His Madonna has a portly, Nordic handsomeness, and the Child a snub nose and massive jowls. All the same, He holds His apple

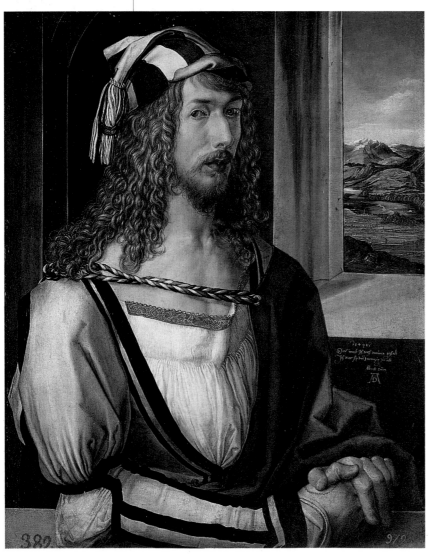

179 Albrecht Dürer, Self-Portrait, *1498, 16 x 20½ in (40 x 52 cm)*

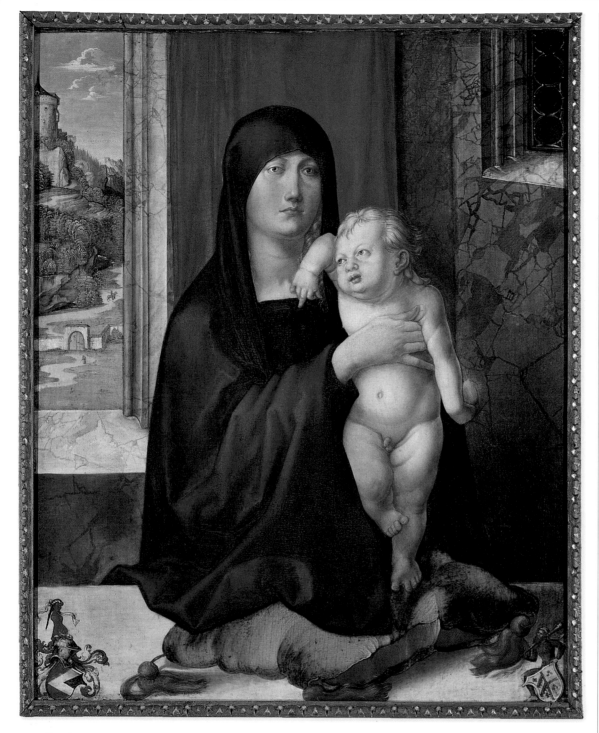

180 *Albrecht Dürer,* **Madonna and Child,** *c. 1505, 16 x 20 in (40 x 50 cm)*

DÜRER WOODCUTS
In 1498 Dürer produced his first great series of woodcuts: a set of illustrations for the Apocalypse (the book of Revelation). He would complete more than 200 woodcuts during his lifetime. The illustration above is a detail of one of these, *The Four Horsemen of the Apocalypse.* This is an allegorical representation of War, Hunger, Plague, and Death.

ART IN GERMANY AND THE LOW COUNTRIES
During the High Renaissance a number of Italian artists visited Northern Europe, but were generally critical of Northern art. Despite this, the North had a strong tradition of learning and the arts. There were many lively centers of artistic and intellectual achievement, such as Vienna, Nuremberg, and Wittenberg. Certainly by Dürer's time a Renaissance in the North was overdue.

in exactly the same position as in Dürer's great engraving of Adam and Eve, and this attitude is pregnant with significance. The Child seems to sigh, hiding behind His back the stolen fruit that brought humanity to disaster and that He is born to redeem. On one side is the richly marbled wall of the family home; on the other, the wooded and castellated world. The sad little Christ faces a choice, ease or the laborious ascent, and His remote Mother seems to give Him little help. Beautiful though the work is in color, and

fascinating in form, it is this personal emotion that always makes Dürer an artist who touches our heart, somehow putting out feelers of moral sensibility.

There is an almost obsessive quality about a great Dürer. One feels the weight of a sensibility searching into the inner truth of his subject. It is this inwardness that interests Dürer, an inner awareness that is always well contained within the outer form (he is a great portrait painter) but that lights it from within.

Having rejected the Gothic art and philosophy of Germany's past, Dürer is the first great Protestant painter, calling Martin Luther (see column, p.156) "that Christian man who has helped me out of great anxieties." These were secret anxieties, that hidden tremulousness that keeps his pride from ever becoming complacent. Although there is no reason why any Catholic artist should not have painted *The Four Apostles (181)*, nor why such an artist should not equally have chosen first John and Peter (indisputably biblical apostles), then Paul and Mark (mere disciples, not ordained by Christ in the Gospel story, though they were great preachers of the Word), it strikes a definitely Protestant note.

These four embody the four temperaments: sanguine, phlegmatic, choleric, and melancholic. Dürer had a consistent interest in medicine and its psychological concomitants, since in some way he found humankind mysterious.

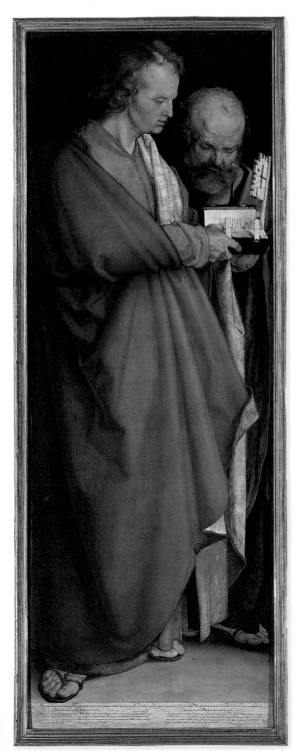

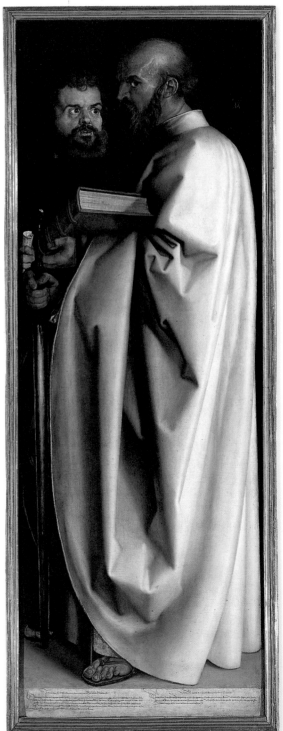

181 Albrecht Dürer, **The Four Apostles,** *1523–26, 30 x 29½ in (75 x 215 cm) (each panel)*

THE FOUR APOSTLES

Together the four apostles make a whole, just as the four temperaments meet within an individual. Dürer is depicting many things at once: the wholeness of humanity, the unity that makes a church, the need to live united without a hierarchy, the interests of various kinds of men. The painting is infinitely satisfying, full, strong, almost sculptural in its awareness of space. The four stand against a black background, heroic in their individualism and their comradeship.

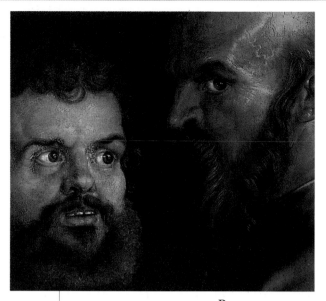

JOHN AND PETER

John is the sanguine man, hopeful and at peace, his ruddy cheeks matched by the full, flowing red of his cloak and by the auburn curls on his handsome head. As the writer of one of the Gospels, he holds a book. Peter, the phlegmatic, holds his papal keys impassively. He stands with bald head shining, face inexpressive, his body hidden behind John's impressive bulkiness. (There is surely a touch of acid wit in so diminishing the impulsive Peter, the appointed keeper of the keys.)

PAUL AND MARK

Mark is the choleric man, with angry eyes aglare. He is looking away to the right, almost as if to ward off danger. Masking him is the melancholic Paul, a tall brooder, who holds his Gospel closed and is watching us suspiciously out of the corner of his eye. Paul is visually redeemed by the amplitude of his flowing white garments, so creamy and so heavy that they fall in deep, shadowed folds. Shadows are part of melancholy, yet they have great dignity.

MONOGRAM AND YEAR

Dürer's distinctive "AD" monogram appears on virtually all his work. As if to emphasize his non-Italian, Germanic identity, he usually ignored the common practice of adding a Latin phrase to the signature. On the rare occasions when he did, he described himself as "Albertus Durer Noricus" – Albrecht Dürer of Nuremberg.

JOHN'S GOSPEL

St. John's normal attribute is a chalice, the cup used at the Last Supper and, in symbolic form, at communion. Dürer departs from tradition by using St. John's Gospel as an attribute. The open page shows the first words of a chapter, which on close inspection prove to be the German text of Luther's Bible translation, another indication of Dürer's Protestant sympathies.

Cranach was almost two painters in one – artistically schizophrenic, as it were. His most popular works are the decidedly seductive nudes with which he delighted his aristocratic patrons. These coy creatures have the rare distinction of fitting in with modern tastes, being slender, free-spirited, and even kinky. They have a sort of refined sexuality, but it is also cold and teasing: we are tempted to think that Cranach did not really care for women and may even have feared them. His *Nymph of the Spring (183)* has hung

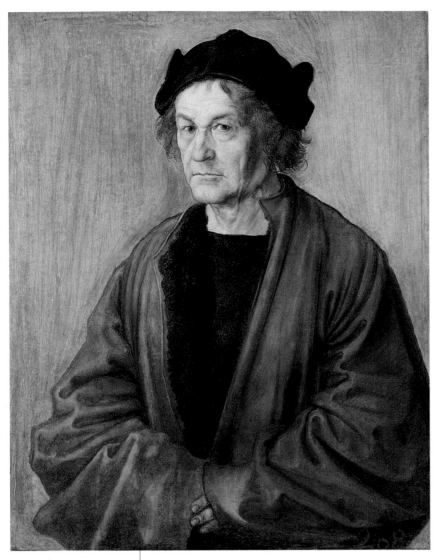

182 Albrecht Dürer, **The Painter's Father,** *1497, 16 x 20 in (40 x 50 cm)*

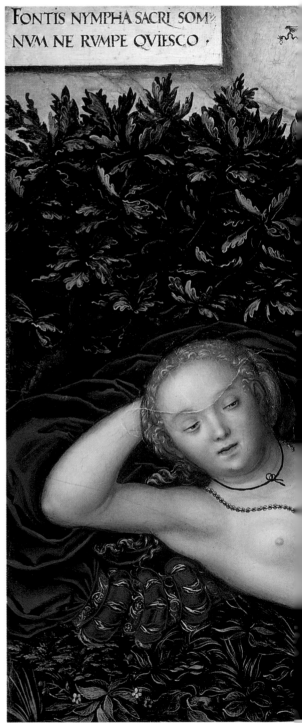

FONTIS NYMPHA SACRI SOM
NVM NE RVMPE QVIESCO ·

Dürer came from a Hungarian family of gold-smiths, his father having settled in Nuremberg in 1455. In *The Painter's Father (182)*, Dürer shows the face with respectful sensitivity. The technique is pencillike, precise, and inquiring; the description achieved has a hard brilliance. However, the rest of the picture may be incomplete, or not all Dürer's work. The rudimentary background is a far cry from the detailed one in Dürer's own *Self-Portrait* (see p.152), and the sitter's clothing is hardly more than sketched in.

THE SEDUCTIVE NUDES OF CRANACH

Lucas Cranach the Elder (1472–1553), born one year after Dürer, is as self-determined as Dürer but without his spiritual concentration. From an early stage in his career, Cranach was able to obtain copies of Dürer's woodcut prints, and his familiarity with these was to have lasting influence on his painting, with its sharp definition and brilliant color.

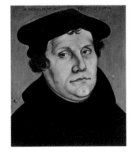

MARTIN LUTHER

This portrait of the religious reformer Martin Luther (1483–1546) is by Cranach. In 1517 Luther drafted 95 theses opposing the contemporary emphasis on ritual and denouncing the decadence of the Church. In 1521 Luther (then under house arrest) translated the New Testament into German. By 1546 much of Germany had been converted to Protestantism.

up her hunting arrows, but the presence of a pair of partridges (birds of Venus) suggests that it is the human heart that she hunts. A distinctly diaphanous wisp of silk draws attention to her loins by "covering" them, she wears her jewelry provocatively, and she is clearly only pretending to be asleep, propped up on the thick, sensual velvet of her dress. She sprawls before us, part of the landscape and in a sense its essence. A Latin inscription on the upper left reminds us that this is a nymph of a sacred fountain. She is not a secular image, despite her alluring nakedness. We are warned not to break, not to shatter her holy slumbers. Love, Cranach is telling us, is something we have to approach with delicate reverence. A meaningful landscape surrounds her. Close by is the mysterious, symbolic cave in the rock – again, an image of sacred sexual symbolism, the female hollow. Beyond that there is the world of commerce and battle, church and family, in which the sacred realities of sex are played out in actual life.

THE HOLY ROMAN EMPIRE
This was a confederation of kingdoms and principalities across Europe, though the German lands were always the chief component. The emperor was elected by the German princes together with a number of archbishops.

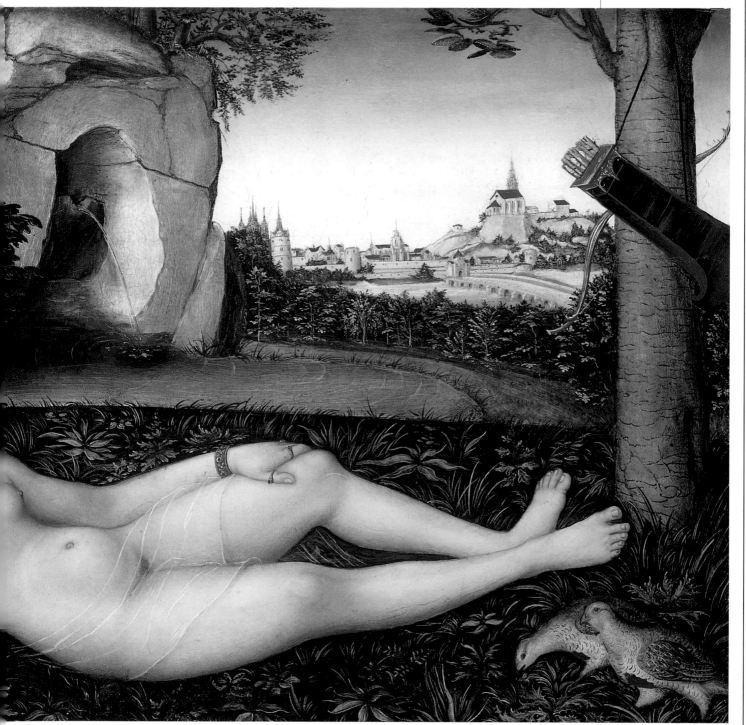

183 Lucas Cranach the Elder, **The Nymph of the Spring,** *after 1537, 29 x 19 in (73 x 48 cm)*

CRANACH'S COURT PAINTINGS

The other Cranach was also in great demand at the German courts, these being the excessively (and superficially) religious mini-courts of the Germanic states. He had a large workshop, which was busied with the production of copies of his more successful or popular pictures. His religious scenes are not always very convincing, even if the orthodoxy is impeccable: the soldier in his *Crucifixion with the Converted Centurion (185)*, a Teuton down to his monstrous feathered hat and studded armor, seems out of place beneath the Cross.

His portraits of these same Teutons, though, when the religious trappings are left aside, can be hypnotically powerful. He painted a great many court portraits, always ornately extravagant and materially decadent in mood. The fanatic precision of the dress, the elaboration of necklaces and rippling hair, and, above the grandeur, the wistful child face, make his *Princess of Saxony (184)* one of the most appealing images of the child in art.

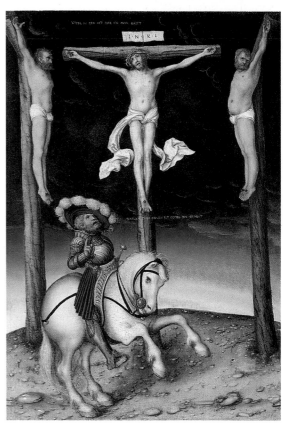

*185 **Lucas Cranach the Elder**, The Crucifixion with the Converted Centurion, 1536, 14 x 20 in (35 x 50 cm)*

She is both regal and vulnerable, a princess in her splendid attire of golden chains and her scarlet-and-white dress, and a child in her open-eyed and wondering innocence. Cranach perplexes the eye with the intermingling of her soft, waving hair with her golden chains, an apt symbol for a princess.

HANS HOLBEIN THE YOUNGER

Cranach's little girl, overdressed and over-decorated, makes an interesting contrast with Holbein's little boy *(186)*, who carries the splendor of his attire without question. The boy is, of course, not some anonymous Saxon, however noble, but the only son of the mighty King Henry VIII of England.

Hans Holbein (1497/8–1543) was educated in his father's studio in Augsburg, but early in his career he left his native Germany for Basel in Switzerland. It was in Basel that Holbein met the reformist scholar Desiderius Erasmus (see column, p.154). Erasmus provided an entrée to English court circles, where Holbein eventually received royal patronage from King Henry VIII.

The English penchant for the portrait found its complete satisfaction in Holbein's shrewd, subtle, and respectful eye, his infinitely accurate and yet ennobling hand. The small Edward was the apple of his fearsome father's eye.

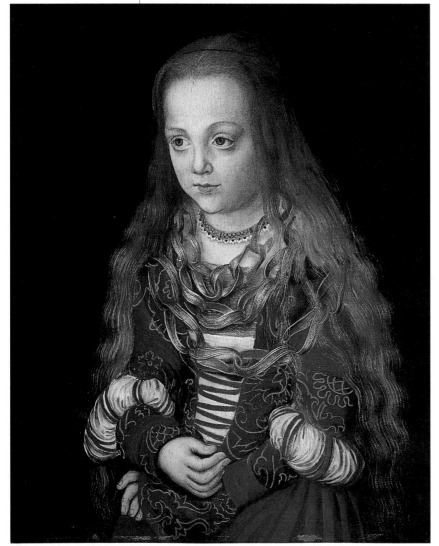

*184 **Lucas Cranach the Elder**, A Princess of Saxony, c. 1517, 13½ x 17 in (34 x 43 cm)*

186 *Hans Holbein the Younger,* **Edward VI as a Child,** *probably c. 1538, 17⅓ × 22½ in (45 × 57 cm)*

CONTEMPORARY ARTS

1512
First use of the word "masque" to denote a poetic drama

1515
The first nationalized factories for the production of tapestries are opened in France

1520
The Royal Library of France founded by King Francis at Fontainebleau

1549
Court jesters appear in Europe

FREDERICK THE WISE
Lucas Cranach spent most of his career as the court painter to Frederick the Wise, Elector of Saxony. The Electorate of Saxony was an independent state with a hereditary title (although part of the Holy Roman Empire, see p.157), which Frederick inherited in 1486. He was an intelligent, forward-thinking man who founded the University of Wittenberg and invited Luther to lecture on religious reform. He was also a great patron of artists and poets.

Holbein shows him as an apple: round, sweet, wholesome, red. It is hard to believe that Edward, who died at 15, was genuinely so bouncing a baby, but Holbein makes us credit both his health and his natural dignity. This is a princely baby, the all-important son whom Henry had sought with such savage desire in a marital history that left its mark on Europe. Holbein's intense interest in human personality, the facial characteristics that distinguish one individual from another, might seem to have little scope in dealing with a child. A child, after all, is not yet a fully achieved personality: he or she is essentially potential. Yet it is precisely this potential that Holbein shows. This face has all the soft indeterminacy of a baby, united into the hard reality of a ruler. It is the child as future king, royal child, Edward VI.

HOLBEIN AS COURT PAINTER

Holbein left the city of Basel in 1526 to go to England, where he became court painter to Henry VIII. His first visit lasted seven years, and he painted many portraits of the English aristocracy. As court painter he was employed to paint the prospective wives of the king, but only managed to complete pictures of Anne of Cleves and Christina of Denmark, above, whom Henry did not marry. He also painted a mural of Henry VIII with Queen Jane Seymour. This hung in the royal Whitehall Palace and was destroyed when the palace burned down in 1698.

OTHER WORKS BY HOLBEIN

An Englishman
(Kunstsammlung, Basel)

A Woman
(Institute of Art, Detroit)

Sir Thomas Godsalve and His Son John
(Gemäldegalerie, Dresden)

Henry VIII
(Fundaçion Thyssen-Bornemisza, Madrid)

A Merchant of the German Steelyard
(Royal Collection, Windsor Palace)

Lady Margaret Butts
(Isabella Stewart Gardner Museum, Boston)

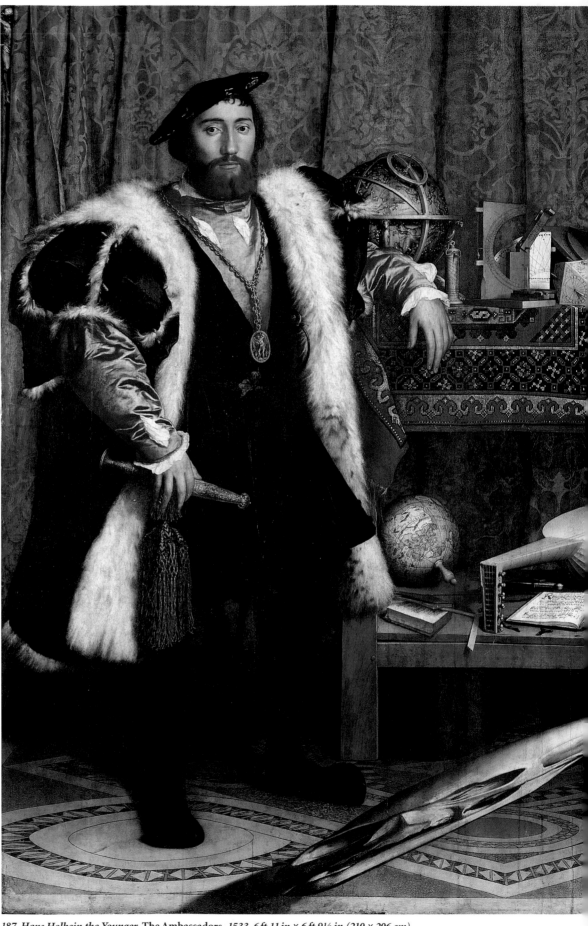

187 Hans Holbein the Younger, The Ambassadors, *1533, 6 ft 11 in x 6 ft 9½ in (210 x 206 cm)*

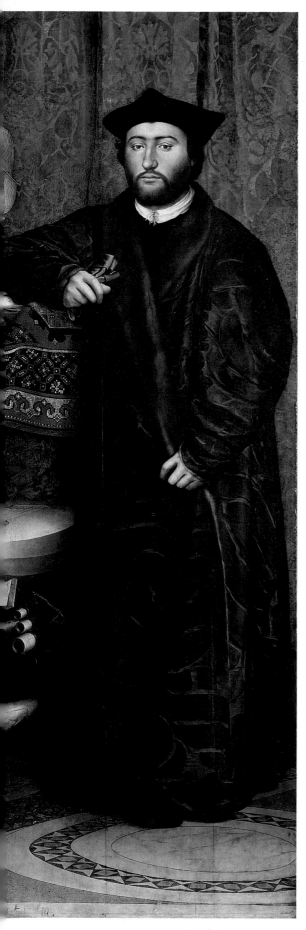

AN ELABORATE VANITAS

In his portraits of the adult rich and powerful, we see the full extent of Holbein's scope. *The Ambassadors (187,* originally named *Jean de Dinteville and Georges de Selve)* is a memorial to two extremely wealthy, educated, and powerful young men. Jean de Dinteville (on the left) was the French ambassador to England in 1533, when the portrait was painted, and was aged 29.

On the right is Georges de Selve, an eminent scholar who had recently become a bishop; he was just 25. He was not a diplomat at the time of the painting, but later became French ambassador to Venice, at that time ruled by Spain.

This picture fits into a tradition of works that show learned men with their books and instruments. Between the two Frenchmen stands a table that has an upper and a lower shelf.

Objects on the upper shelf represent the study of the heavens, while those on the lower shelf stand for the educated pursuits on earth. At the left end of the upper shelf is a celestial globe – a map of the sky – in a frame that can be used to calculate astronomical measures. Next to it is an elegant portable brass sundial. Next is a quadrant – a navigational instrument for calculating the position of a ship as it travels, by measuring the change in the apparent position of fixed stars. To the right of this is a polyhedral (multisided) sundial, and then another astronomical instrument, a torquetum, which, along with the quadrant, was used for measuring the position of heavenly bodies.

Almost unnoticed, in the top left corner of the painting, a silver crucifix is seen, representing the goal of salvation, not forgotten amid the splendor and advanced scientific knowledge.

On the lower shelf at the left is a book, which proves to have been a recent guide to arithmetic for merchants (published in 1527). Behind it is the globe, representing geographical knowledge. The try square emerging from the book probably represents the skill of mapmaking. The lute was the chief courtly instrument of the time and stands for the earthly love of music. At the end of the bent-back tip, one string can be seen to be broken, representing the sudden breakage of death. Beneath the lute, next to a pair of compasses, is a copy of a Lutheran hymn book. The flutes beside them were popular instruments for all levels of society.

To this grand image of youth in its prime, Holbein has slashed across the foreground his reminder of human mortality. We realize that this strange shape, when viewed from a certain angle, is actually a human skull that has been cunningly distorted by stretching it sideways in so-called anomorphic projection.

RENAISSANCE MINIATURES

In the 16th century, Henry VIII relaunched the 15th-century fashion for miniature paintings. Nicholas Hilliard (1547–1619) became the most successful miniature portraitist, using his skills as an artist and as a jeweler to create exquisite masterpieces. Generally, miniaturists concentrated on the head and shoulders only, and used bright colors for details. This simple miniature is of Richard Hilliard, the artist's father.

NICOLAUS KRATZER

Holbein and Nicolaus Kratzer struck up a friendship in 1527 when working together on a ceiling in Greenwich Palace. Kratzer was an astronomer and an astrologer and is said to have lent Holbein the instruments we see in *The Ambassadors.* In 1519, he was appointed "Astronomer and Deviser of the King's Horologes," and in this post he encouraged Henry VIII to popularize science and mathematics. This portrait is by Holbein and shows Kratzer working on a polyhedral sundial.

Most of Holbein's portraits are of lords and ladies, but there are a few that reveal more of his private life. One such is the haunting *Portrait of the Artist's Wife with Katherine and Philipp (188)*. Artists have always painted their families, but this is the saddest version on record. He lived very little with his wife and children in Basel (the reasons for this may have been political, religious, or financial), but this tragic little trio has all the withering marks of the unloved.

The dim-eyed wife presses down on the children, plain, pale little beings, all unhappy and all ailing. Holbein, that superb manipulator of the human face, cannot have meant to reveal their wretchedness and expose his neglect with such drastic effect. It is as if his art is stronger than his will, and for once Holbein is without defenses.

We might describe him as an un-Germanic German, since he left for Switzerland when he was still a teenager and then worked in England for Henry VIII. While Dürer and those influenced by Dürer (which includes practically all German

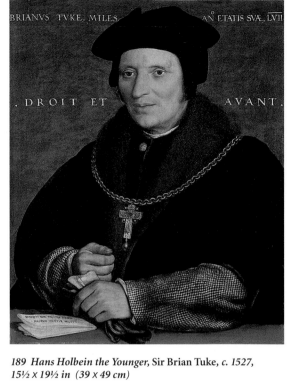

189 Hans Holbein the Younger, Sir Brian Tuke, c. 1527, 15½ x 19½ in (39 x 49 cm)

Renaissance artists except Holbein) had an intense interest in the personal self of the sitter, Holbein was essentially discreet. A court painter *par excellence*, he always maintains a dignified distance. We see the sitter's exterior, what he or she looked like, but we never pass into the inner sanctuary. The sole exception, which is what makes it so extraordinarily interesting, is this painting of his wife and children. Here his courtly shield is down, perhaps because of the artist's personal sense of guilt. He was not a good husband or father, and while he can carry off any other portrait with superb technical aplomb, he catches his breath and opens the inner door when he paints the family that he abandoned and neglected.

A much more characteristic Holbein is *Sir Brian Tuke (189)*, with his clever, sensitive face, his air of unflinching probity, the tenseness of his half-smile and his clenched hand. A folded piece of paper on the table quotes a biblical passage in which Job appeals to God for rest from anxiety. We would know, without having sufficient knowledge to recall that Tuke served Henry VIII, that here was a man who was noble but imperiled – though in fact, he flourished.

Holbein's work is never cold nor lacking in involvement, as we can see in *The Ambassadors*, *Christina of Denmark*, and *Sir Brian Tuke*; but he protects his sitters from psychological exposure and, indirectly, protects himself. What a contrast with Dürer, who always leaves both the sitter and himself open to the most personal scrutiny.

188 Hans Holbein the Younger, The Artist's Wife with Katherine and Philipp, c. 1528, 26 x 30½ in (65 x 77 cm)

NORTHERN MANNERISM

The Italianate influence on the Northern painters, who had been nurtured in the Gothic tradition, initially produced a sometimes uneasy mixture of styles. On the one hand, it resulted in a convincing monumentalism, seen, for example, in the art of Jan Gossaert (see below) and Lucas Cranach the Elder (see p.156). On the other hand, it encouraged the Northern Mannerist trend. This can be characterized by a rather superficial, even contrived, Italianate gloss.

(see p.156)

190 Jan Gossaert (Mabuse), **Portrait of a Merchant,** *c. 1530, 19 × 25 in (48 × 63.5 cm)*

Two Netherlandish painters straddle the divide between the Gothic and Renaissance worlds: Gossaert and Patinir (see p. 166) The first of these, Jan Gossaert (c. 1478–1532), even bridges the North/South divide, in that he worked in Italy, where he was influenced by Michelangelo and Raphael (both working there at that time), and invented an Italian-sounding name, "Mabuse," from his native town of Maubeuge in the province of Hainaut.

So here we see an artist from the Netherlands, with a heritage of van Eyckian observation (see p.64) and van-der-Weydenish sincerity (see p.67), but with a desire to be flamboyantly classical, as it were. He can be extremely moving when he finds a theme that suits his strange blend of talents and intentions. The mixture works well enough in his *Portrait of a Merchant (190)*, painted about 20 years after Grünewald's *Crucifixion (see p.76)*, despite the perceptible

clash between the spirit of Northern realism and this intense, masculine, Italianate face. The portrait stands apart from much of Northern portraiture of the time, which formed a strong and distinct tradition of its own, with a direct and realistic attitude to nature, and a resistance to the classical influences coming from Italy.

There is the same feeling of jarring, but wonderfully so, in Gossaert's *Danaë (191)*, in which a Flemish housewife, demure and expectant, sits in an Italianate classical arcade, the divine gold (for Jove came to her in this disguise) filtering down to her like thickened light.

(see p. 166)

<table>
<tr><td>

OTHER WORK BY GOSSAERT

A Man with a Rosary (National Gallery, London)

Virgin and Child (Musée Marmottan, Paris)

A Gentleman (Statens Museum for Kunst, Copenhagen)

Portrait of Anna de Bergh (McNay Art Institute, San Antonio, Texas)

A Woman as the Magdalen (Museum Mayer van der Bergh, Antwerp)

Adam and Eve (Fundaçion Thyssen Bornemiza, Madrid)

</td></tr>
</table>

191 Jan Gossaert, **Danaë,** *1527, 37½ × 45 in (95 × 115 cm)*

THE COURT OF FONTAINEBLEAU

One of the most distinguished artists at the court of Fontainebleau was Francesco Primaticcio, who between 1530 and 1560, created elegant sculptures as well as paintings such as the one shown above, *The Rape of Helen*. The style of the painting is self-consciously sensuous and elegant, placing emphasis on the female nude, which was to symbolize the secularization of art in the 16th century.

SCHOOL OF FONTAINEBLEAU

If France can be considered to be part of the "North," as it is at least in the sense of being non-Italianate, then Jean Clouet (1485/90–1540/1) and the School of Fontainebleau are notable examples of a painterly Renaissance in the North. The patronage of the French King Francis I attracted Italian artists to the royal court at Fontainebleau. Francis sought for himself the haughty, kingly image that Italian Mannerist artists created for their sitters. The Florentine artist Rosso Fiorentino (see p.139) and later Francesco Primaticcio (1504–70; see column, left), who was born in Bologna and trained at Mantua, brought their cultivated influence to the Fontainebleau Court.

Clouet, a native Frenchman and court painter to King Francis I (or it may have been François Clouet, his son) has given us the quintessential king in his *Francis I (192)*. The portrait is all majestic bulk, with any human frailties not so much hidden as frozen out of countenance. It is an icon, a diplomatic effigy, alarming in its careless assumption of superhuman stature.

The School of Fontainebleau based its practice on the elegancies of Italian visitors like Rosso, and all its practitioners (many of whom are by now anonymous) may be from the South, yet there is a languid realism that is different from Italian Mannerist chic. There is, too, a touch of the clumsy, not very Gallic, but extremely Northern.

Diana the Huntress (193), with her leaping mastiff and the enveloping forest, is a true wood nymph, innocent of the coyness of a Cranach hunting nude (see p.157) and striding out with lovely animal vigor.

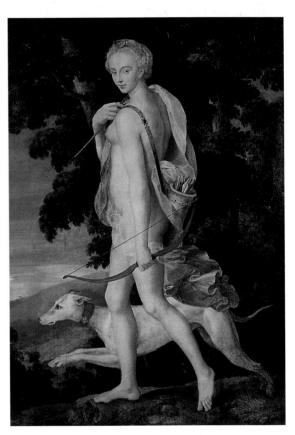

193 School of Fontainebleau, **Diana the Huntress***, c. 1550, 52 x 75 in (73 x 97 cm)*

SPREAD OF MANNERISM IN THE NORTH

This elongated, elegant, and slightly unreal form of art was not confined to Fontainebleau. Its elegance appealed to the aristocratic North in general, and there are some supreme examples outside the confines of Paris.

Joachim Wtewael (or Uytewael, 1566–1638) was one such example from the Northern Netherlands (what is known today simply as the Netherlands). He was born in Utrecht, and in his early career he traveled in Italy and France before settling down in Utrecht. He became an important exponent of the Mannerist style in his country, though he tended to ignore the advances in naturalism being achieved by his contemporaries, such as Dürer and Cranach.

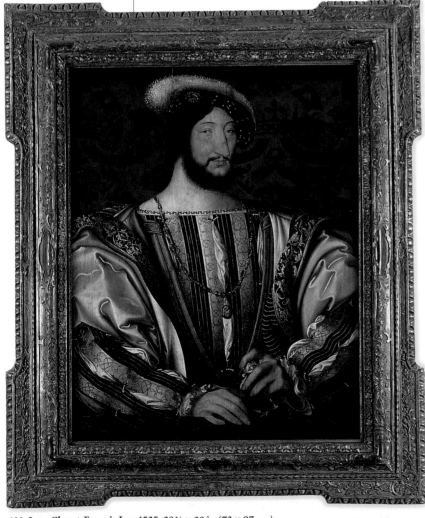

192 Jean Clouet, **Francis I***, c. 1525, 28¾ x 38 in (73 x 97 cm)*

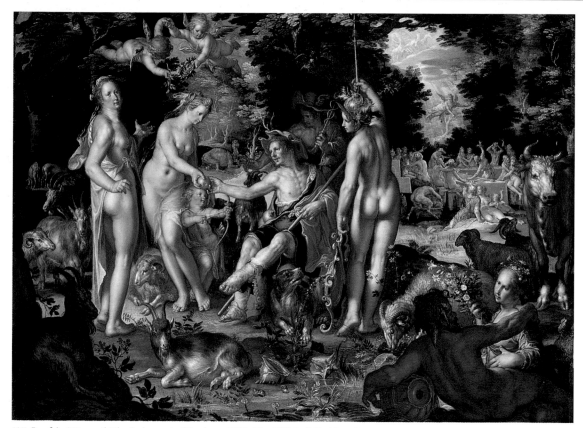

194 *Joachim Wtewael,* **The Judgment of Paris,** *c. 1615, 29 x 21½ in (75 x 55 cm)*

Wtewael's *The Judgment of Paris (194),* in which the Trojan shepherd prince Paris awards the golden apple to the goddess he considers the most beautiful, is a highly Mannerist concoction. The self-conscious poses of the three divine ladies, the suave gestures of Paris as he makes his all-important choice, even the attendant animals with their delicate horns and slender legs, recall that world of mythical romance in which Mannerism flourishes.

Another eminent painter in the Mannerist style was the Flemish artist Bartholomeus Spranger (1546–1611). Born in Antwerp, he too traveled in Italy and France when young. He worked in Vienna, then settled permanently in Prague. In 1581 Spranger became court painter to the Emperor Rudolf II, and he had much influence on the Academy of Haarlem.

Spranger's *Vulcan and Maia (195)* has an almost disturbingly erotic force. Maia is looped across the knee of the massive and saturnine Vulcan, like a living bow to which he will fit his arrow. One long, intrusive finger stabs her in the heart, and she writhes suggestively under its impact. In some ways a rather unpleasant picture, it is nevertheless strong and, in a weird way, beautiful. There is a lightness, an aristocratic innocence, about the art of Fontainebleau, which vanishes once Mannerism moves from the sunlit groves of courtly Paris to the dark,

Teutonic forests of the true North. An almost sinister quality pervades the art of Spranger and his followers, never overpowering but flavorsome, almost gamy.

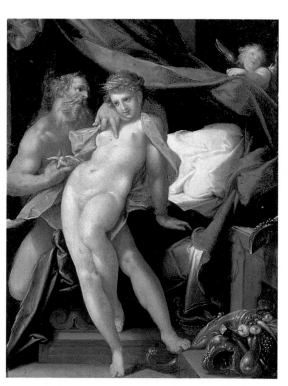

195 *Bartholomeus Spranger,* **Vulcan and Maia,** *c. 1590, 7 x 9 in (18 x 23 cm)*

NORTHERN LANDSCAPE TRADITION

Landscape painting became one of the most enduring and characteristic features of Northern painting throughout the 16th century. Before this, there had been the small cameo landscapes, spied though windows and doorways of the earlier interior scenes (see p.61). These delightful features now began to attain their rightful scale, and as they did so they became a sort of large-scale stage for all the small activities of humankind. Yet it is not until Brueghel appears that we see the truly Flemish, lyrical understanding of nature, unlocked from its servitude to human concerns and shown in all its glory.

The Flemish artist Joachim Patinir (c.1480–c.1525) is one who provided links between the Gothic world and the Renaissance. While Jan Gossaert (see p.163) had been a link between North and South, Patinir mediated between past and future. He has a Gothic imagination, a profoundly medieval sense of the world – that small ball held in the divine hand – but he has also a prophetic sense of distance and the spaciousness of true landscape. We can see Dürer in him, Dürer's prints being available to him at that time (see p.153). We also catch a glimpse of the medieval illuminated manuscripts (see p.28). *Charon Crossing the Styx (196)*, with its vision of Hell as war, shows his style well.

THE GERMAN LANDSCAPE

Albrecht Altdorfer (c.1480-1526), like his fellow German, Lucas Cranach the Elder (p.156), was, for the most part, a stay-at-home. He may well have seen some of the topographical watercolors that Dürer brought home with him after his roamings across the Alps. After Altdorfer's own trips along the Danube River, landscape was to become his passion. Altdorfer's landscapes are of a peculiarly Germanic character, bristling with wild forests and lonely, wolf-infested glades. They are fearsome, though magnificent, and they even contain the hint of irrationality overcoming sobriety. Altdorfer does maintain control, but we feel the threat.

196 Joachim Patinir, **Charon Crossing the Styx,** *1515–24, 40 x 25 in (102 x 63 cm)*

landscape to make some mysterious moral point. We can never quite comprehend the meaning of an Altdorfer work – there is always an elusive element – which is perhaps one of the reasons why he remains so consistently a source of delight and interest.

PIETER BRUEGHEL THE ELDER

The only rival to Dürer as greatest of the Northerners is a so-called peasant painter, Pieter Brueghel (1525–69). Born in Breda in the Flemish province of Brabant, he was the forefather of a whole tribe of painterly Brueghels, Jans and Pieters; but none ever takes our breath away with wonder as does Pieter the First. The "peasant" nickname is particularly unbecoming in that he was a traveled and highly cultivated man, friend of Humanists and patronized by the learned Cardinal Granvella. Despite his

197 Albrecht Altdorfer, **Christ Taking Leave of His Mother,** *perhaps 1520, 43 × 55 in (110 × 140 cm)*

Danube Landscape (198) is one of the first examples of a painting that is content to have no human beings in it at all. It stands or falls by the sheer quality of the sky, the trees, the distant river, the blue mountains. We are offered a romantic substitute for mankind, one purer and more open to the ethereal heavens. Altdorfer believes in the sacramental value of what he paints, and it is his conviction that convinces.

But he can also people his landscapes, and with remarkable effect. *Christ Taking Leave of His Mother (197)* has an extraordinary, gawky power. The vague gestures toward graciousness fall completely flat, and we see that almost comic awkwardness of the enormous feet of the supportive mourner. We also see that there is a sad dichotomy between the ruined castellations on the left, on the side of the women, and the wild encroachments of the forested world of the men on the right. There seems to be a painful absence of communication, an accepted harshness, and we come to a painful realization that this is of the essence of any saying of good-byes. This striking scene makes a rough, embarrassing, ardent picture that is quite unforgettable.

Altdorfer is an unexpected painter with many more personae in his repertoire than we might expect. Surprisingly, he has a feel for allegory, which has produced some of the most enchanting small paintings in all Northern art (there is a wonderful example in the Gemäldegalerie in Berlin). This art is landscape based but uses the

198 Albrecht Altdorfer, **Danube Landscape,** *c.1520–25, 8½ × 11¾ in (22 × 30 cm)*

travels to France and Italy around 1553, the strongest influences on his work were from Bosch (see p.72) and Patinir (see p.166). In Breughel's paintings we see a continuation of the Netherlandish tradition: from Bosch's fantastic inventions (which later, in Brueghel's hands, resided in a more gently comic nature); and from Patinir's reverent and passionate landscapes. Brueghel's paintings are supremely un-Italianate, and the classical quest for the ideal form finds no place in his art.

The only relevant application of Brueghel's nickname is that he not infrequently painted peasants, works that some think satirical but that others regard as carrying a heavy weight of compassion and affectionate concern.

The famous *Wedding Feast (199)* certainly shows us the round and stupid faces of the guests, the fat and silly bride drunk with complacency beneath her paper canopy-crown, the table agog with intent eaters. But our smile, like Brueghel's, is a painful one. She is so pathetic, the poor, plain young woman in her little hour of triumph, and if the guests are gobbling down their food, we see the food, humble plates of porridge or custard, served on a rough board in a decorated but realistic barn.

These are the poor, the downtrodden, these their wretched celebrations. The child licks with lingering gusto at her empty bowl, and the piper, who yet must play until he receives his food, stares at the porridge with the longing of the truly hungry. Only the insensitive would find *The Wedding Feast* comic. There is a very real sense in which our reactions to *The Wedding Feast* put us morally to the test. This is a wholly serious subject, the degradation of the working class, treated with disinterested humor, which we

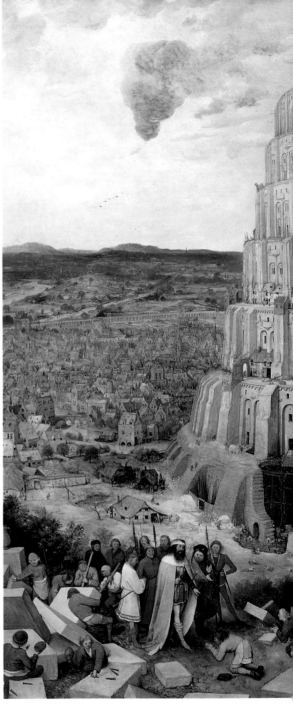

199 Pieter Brueghel, **The Wedding Feast,** *c. 1567–68, 64½ × 44½ in (163 cm × 114 cm)*

are meant to see through. Not to understand Brueghel's great concern and compassion condemns us.

The Tower of Babel (200) has a horrifying complexity, dwarfing the human figures in their authoritarian pride, reducing the most gigantic of labors to the pointless scurrying of ants. This is Babel, and it is our own local experience: the humans are both pathetic and doomed in their conceits. Brueghel was a highly educated and sophisticated painter, with a scholar's insight into myth and legend. His version of the ancient story of the Tower of Babel is far removed from

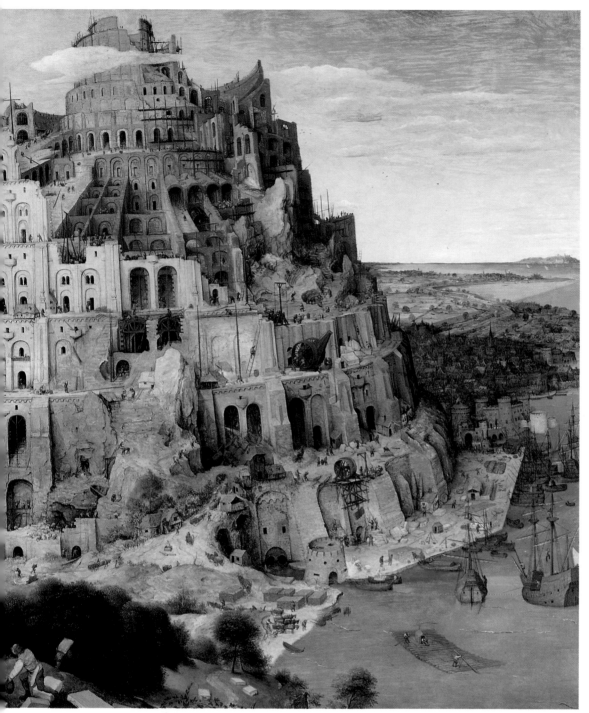

THE REFORMATION
The term "Reformation" describes the period of ecclesiastical dispute between the papacy and the various national churches of Europe throughout the 16th century. The nailing of Luther's 95 theses to the door of the Schlosskirke in Wittenberg is considered the catalyst that resulted in the reform of the Roman Catholic church and the establishment of the Protestant churches. The final agreement was that a nation should follow the religion of its sovereign. This woodcut shows rival Protestant and Catholic preachers competing for followers.

200 Pieter Brueghel, **The Tower of Babel,** *1563, 61 x 44½ in (155 x 114 cm)*

**THE TOWER
OF BABEL**
A version of the ancient story of the Tower of Babel is told in chapter 11 of the book of Genesis. The people ambitiously set out to build a tower to reach the heavens. As a punishment for their pride, God confused the people's language so they could not understand one another, and He scattered them over the face of the Earth. In art, the idea of linguistic confusion is shown in the different races of people, and the tower is seen in a chaotic and unfinished state.

a mere illustration of a biblical passage. Brueghel, in fact, never works on the surface but always in depth. Whether it is the fall of Icarus in Greek myth or the building of Babel in biblical story, it is meaning that concerns him, visual meaning.

But the great glory of Brueghel, his real claim to be ranked among the world's greatest, lies in his landscapes, in particular the set of months, à la the Limbourg brothers (see p.55), that he painted for a wealthy citizen of Antwerp. One of these is *Gloomy Day* (see p.170). Only five remain, but they have never been surpassed for

their truth, their dignity, and their mysterious spiritual power. Brueghel never forces a moral. The most reticent of painters, he merely exposes the vastness of nature that surrounds our everyday life, so that we will respond to the challenge of reality. But it is a most delicate challenge, one that makes demands on our imagination.

This is the world, Brueghel tells us, in all its diversity, majesty, mystery, and beauty. How do we respond to it? The intense pleasure that these pictures provide should not mask from us their deep moral seriousness.

GLOOMY DAY

Brueghel's innovative portrait of a landscape in the grip of winter is one of a series of paintings based on the Northern seasonal calendar. It represents the dark, cold winter months of February and March, and follows the Northern pictorial tradition (derived from illuminated manuscripts) of the labors of the months (see p.55).

MOUNTAINOUS LANDSCAPE

The wild, violent face of nature is given concrete form in the jagged mountaintops and glowering black storm clouds on the far horizon. Shown at a distance, it remains a threatening and ever-present force that dictates daily existence. The somber blacks and chilling whites provide a cool background to the red-browns and warm umbers of the peasants' habitat and assert the contrast between the wild and the domesticated. Comforting wisps of smoke trailing from chimneys are matched by the icy puffs of frozen clouds above the mountain range.

CARNIVAL TIME

Near a group of men absorbed in the February task of pollarding willows is another intimate group that provides more clues to the time of year. A man is greedily eating the Carnival fare of waffles, and the child's paper crown – common dress-up for Epiphany and Shrovetide (Carnival) processions – and lantern also denote Carnival. Our attention is first caught by the bright red and light tan of the clothing of the three figures, then led downward and along the shore, then up again, to rest finally at the horizon and thundering sky.

THE VILLAGE

From our vantage point we see the peasants' vulnerable position and their insectlike activities within this great celebration of raw nature. If we look closely, we can find touches of bawdy humor typical of Brueghel: to the left a man urinates against the wall of an inn (following his own, smaller, dictates of nature, perhaps).

FOUNDERING SHIPS

Like the village scene, this detail is not immediately apparent at first sight. The terrible catastrophe of ships crashing on the rocks is depicted as merely another incidental detail within the greater drama of the landscape. We see the irony (even if the villagers cannot) of their innocent attempts to "harness" nature by pollarding their willows, while the the destructive might of nature passes unheeded beyond them.

201 Pieter Brueghel, **Gloomy Day,** *1565, 64 x 46 in (163 x 117 cm)*

Gloomy Day (201) is about the dark days of February and March, lightened only by the Carnival festivities. Yet we sense instinctively that this painting is about far more than the end of winter. Brueghel shows us a vast, elemental universe, through which a wild river rages. Overhead, the sky is in tumult, a great, wild mass of cloud, threatening and descending. The villagers may labor, or they may play: their activities seem so small within the vast context of human reality. Lightning glints on tree trunks and village roofs. The foreground is relatively bright, which is, of course, the illusion that human activity is intended to create. Immersed in our work or play, we easily forget the threat of nature's violence and of the dark.

Hunters in the Snow (202) is both sensuously overwhelming, the very feel of the cold made visual, and emotionally expanding. The mysterious space of the valley and its mountain, its lakes, and its bare trees, its tiny inhabitants and its far-ranging birds, all lies before our view. Like the gods themselves, we look upon "the world." Every detail informs us of the season as the bonfire blazes and the hounds slink wearily home. The dazzle of white conceals the details but reveals the wholeness, with only humanity at leisure to play, and only the young at that. The grandeur of Brueghel's vision is one that he is able to share with the viewer completely.

He takes us into an awareness of what it means to live in the physical world, its mountains, valley, and rivers, its snows, its birds, its animals, its trees. No other painter has such a breadth of vision, so unencumbered by the persona. We feel this is not what Brueghel saw (and what we now see), but what actually and objectively is. This is his great and unique contribution to art.

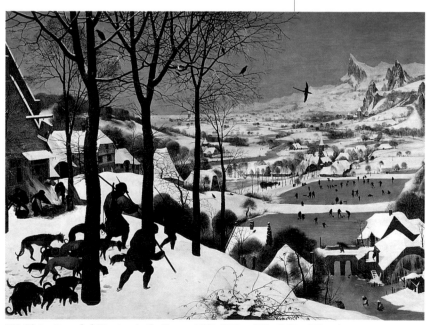

202 Pieter Brueghel, **Hunters in the Snow,** *1565, 63¾ x 46 in (162 x 117 cm)*

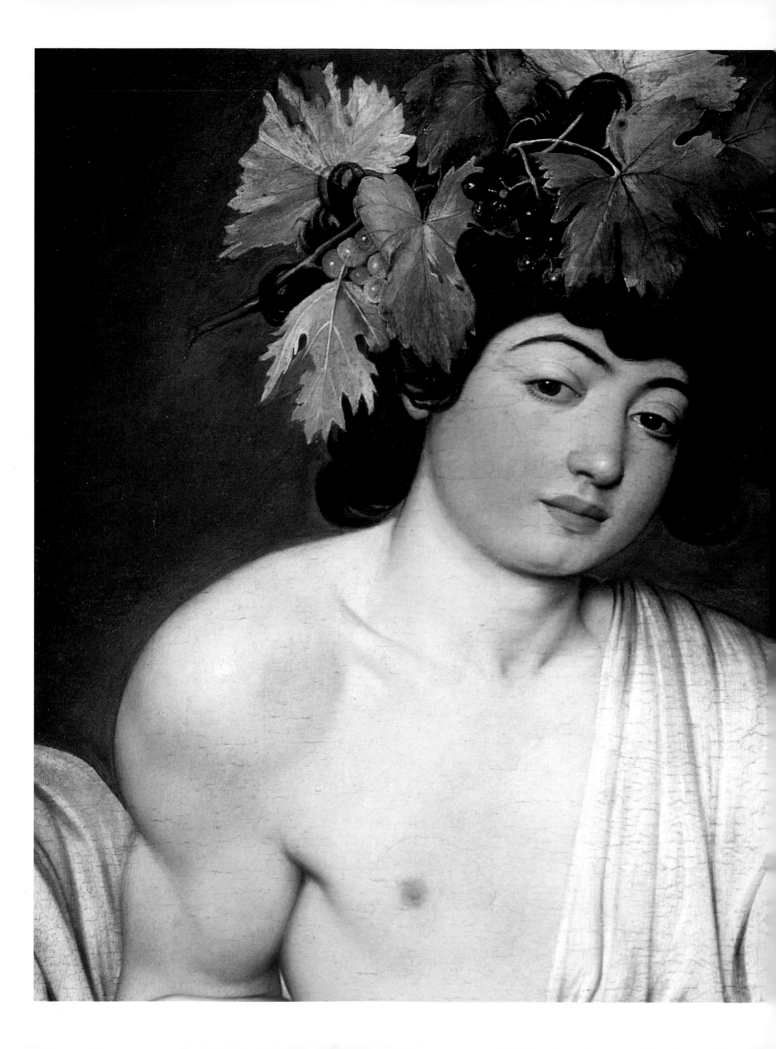

BAROQUE AND ROCOCO

Originally a Portuguese word meaning rough or irregularly shaped, "Baroque" came into use as an art term – not a complimentary one – from the world of pearl fishing. The Baroque style was a new direction in the arts that emerged in Rome at the turn of the 17th century, partly as a reaction to the artificiality of the Mannerist style of the 16th century. The new art was committed both to genuine emotion and to the imaginatively ornamental. Human drama became a vital element in Baroque paintings, typically acted out with highly expressive, theatrical gestures, lit with striking chiaroscuro and featuring rich color combinations.

The Rococo style developed as a successor to the Baroque in a wide range of arts, including architecture, music, and literature as well as painting. Its emphasis was on lightness, decoration, and stylistic elegance. The Rococo style emerged in Paris in the early 18th century, and soon spread to the rest of Europe.

Caravaggio, Bacchus, 1590s (detail)

BAROQUE AND ROCOCO TIMELINE

The Baroque period in painting corresponds roughly to the 17th century. In Italy and Spain, the Catholic church, in its campaigning, Counter-Reformation mood, put pressure on artists to seek the most convincing realism possible. In the North too, Rembrandt and Vermeer, each in their separate ways, pushed forward the limits of realism. Rococo art began with Watteau and became the ruling European style for most of the 18th century.

CARAVAGGIO, THE DEATH OF THE VIRGIN, 1605/06

Caravaggio's religious works were executed in true Counter-Reformation spirit. Nevertheless, the unprecedented realism in this work caused its rejection by the priests who had commissioned it (p.177).

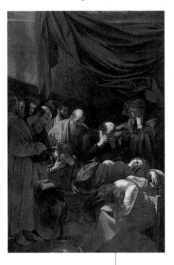

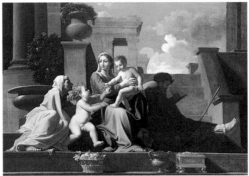

POUSSIN, THE HOLY FAMILY ON THE STEPS, 1648

Poussin's deeply classical sense of balance is revealed in every corner of this composition, particularly in the pyramidal shape of the Holy Family and the plinthlike step supporting them. Despite the classical feel, the work's emotional force and spiritual intensity place it well within the mainstream of Baroque art (as opposed to the Neoclassicism of the 18th century, p.216).

REMBRANDT, SELF-PORTRAIT, 1659

Realism was crucial to Baroque painting, and Rembrandt provides a prime example of Dutch portraiture of the Baroque period. This self-portrait shows us a face stripped of all pretensions – the artist is looking earnestly at himself and painting what he sees, producing great art from personal failure (p.202).

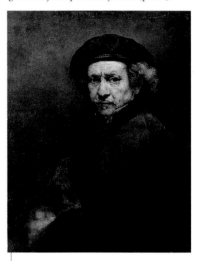

1600	1620	1640	1660	1680

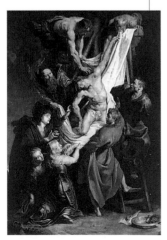

RUBENS, DESCENT FROM THE CROSS, 1612–14

Rubens, a Flemish Catholic, was one of the greatest painters of all time. His work is supremely balanced and yet passionate (p.186).

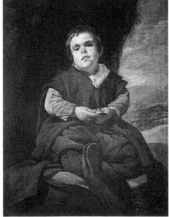

VELAZQUEZ, FRANCISCO LEZCANO, 1636–38

Velázquez was court painter at the Royal Court of Spain, immortalizing its royalty and senior court personalities, including the dwarves (jesters), whom he portrayed with his characteristic dignity (p.196).

VERMEER, KITCHEN MAID, 1656–61

Vermeer's use of light gave his paintings a silent clarity, the sensation of a moment preserved, of the recording of that precious quality of simply existing. His choice of subjects was undramatic – typically a scene of complete ordinariness (p.210).

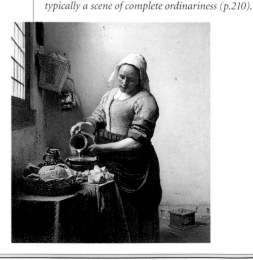

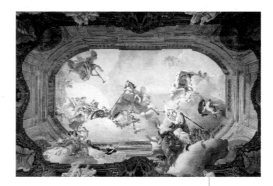

TIEPOLO, WEDDING ALLEGORY, C. 1758

The Venetian artist Tiepolo was the most celebrated and sought-after painter of his time, admired for his soaring imagination and mastery of composition. His most famous work is perhaps the fresco cycle in the Residenz at Würzburg. This magnificent ceiling fresco is in the Rezzonico Palace (now a museum) in Venice (p.232).

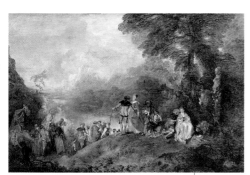

WATTEAU, "EMBARKATION FOR CYTHEREA," 1717

Rococo art began in Paris, where Watteau settled as a young man. He initiated the Rococo era and invented a new genre, known as fêtes galantes. This painting shows some of its key features: an open-air scene crowded with wistfully depicted lovers. They have just taken their vows at the shrine of Venus and are ready to leave the island. Although the fêtes galantes approach might suggest an admiration for frivolity, there is an underlying sadness in all of Watteau's works (p.224).

HOGARTH, A SCENE FROM THE BEGGAR'S OPERA, 1728/29

While Rococo fashions ruled in London, one British artist was independently building a new genre – satirical painting. Hogarth's narratives, though humorous, were profoundly moral. (p.235).

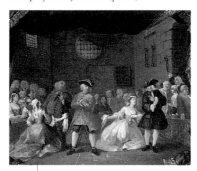

FRAGONARD, BLINDMAN'S BUFF, PROBABLY C. 1765

Fragonard, too, following Watteau and Boucher, was a Rococo painter. In this open-air scene, an innocent game takes place in a carefree atmosphere, but the players are overshadowed by the landscape (p.228).

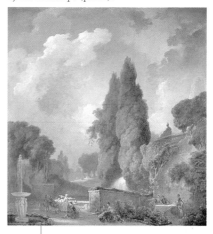

| 1700 | 1720 | 1740 | 1760 | 1780 |

CANALETTO, VENICE: THE BASIN OF SAN MARCO ON ASCENSION DAY, C. 1740

Canaletto is famous for his accurate and elaborately detailed records of city views. He painted within the Rococo tradition, and Venice is a supremely Rococo city, both fantastical and imaginative. Yet Canaletto is more interested in straightforward architecture and elegance of proportion than in fantasy. His work foreshadows the Neoclassical art that belongs to the late 18th century (p.234).

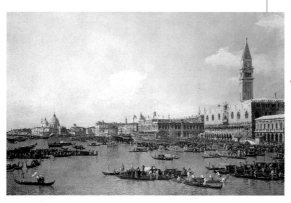

CHARDIN, STILL LIFE, C. 1760/65

Chardin was an artist of the Rococo period who would not allow the frivolous tone of the art of his time to influence him. His sober and restrained pictures often contain a moral or spiritual meaning. Sometimes it is an explicit one, contained in the action of the painting, but otherwise, as here, the message is conveyed simply in the solemn, sacramental atmosphere (p.231).

ITALY: A CATHOLIC VISION

During the Renaissance, Florence and Venice had dominated the art world, but during the Baroque period Rome became the great artistic center, visited by artists from all over Europe. Having survived the Protestant Reformation, the Catholic church emerged more vigorous than ever as a result of its own parallel process of revitalization, the Counter-Reformation. As Catholics, artists in Italy were required to endorse the authority of the Church and to make the scriptures a palpable reality to its people. The heightened emotional content and the persuasive realism of Baroque painting provided the means.

THE SCULPTURE OF BERNINI

The Italian sculptor and architect Gianlorenzo Bernini (1598–1680) was influential in the formation of Baroque style. Bernini designed the sweeping twin colonnades that surround the piazza in front of St Peter's church in Rome. He described these as "like the mother church embracing the world." Between 1645 and 1652, he completed this sculpture (above) of St. Teresa of Avila, a religious reformer, for the Cornaro family chapel. The elegance of St. Teresa's draperies and the drama of her facial expression embody the essential "realist" characteristics of Baroque sculpture.

ITALIAN ARCHITECTURE

The rebuilding of Rome in the 16th century under the pontificate of Sixtus V transformed the architectural vista of the city. The most sucessful architect of the time was Carlo Maderno (1566–1623) who designed the quintessentially early Baroque facade of St. Peter's in 1603. Francesco Borromini (1599–1667) was a contemporary of Bernini and Maderno, but his best work is seen in the smaller churches, such as San Carlo alle Quattro Fontane.

Like the Church, painting now underwent its own kind of reformation. The new style was not given the name Baroque until the 19th century, and for 200 years it was simply thought of as a form of post-Renaissance Classicism, associated especially with Raphael (see p.126). Italian artists in the 17th century moved away from the complexities of Mannerism to a new style of painting that had more in common with the grandeur of form of the High Renaissance. Pioneering this change were two artists of far-reaching importance: Caravaggio, the great proto-realist, working in Rome, and Annibale Carracci, the founder of the classical landscape tradition, in Bologna (see p.182).

CARAVAGGIO: BEAUTY IN TRUTH

The art establishment of the 19th century scorned Baroque painting, and perhaps the first and the greatest painter to be affected by this scorn was Caravaggio (Michelangelo Merisi da, 1573–1610), who moved to Rome from Milan in around 1592.

Caravaggio's early works consisted largely of genre paintings (see glossary, p.390), such as *The Lute Player (203)*: a youth so full, rich, and rosy that he has been mistaken for a girl. It is without doubt a girlish beauty, curls seductive on the low forehead, gracefully curving hands fondling the gracefully curved lute, soft lips parting in song or invitation. Perhaps some viewers found this charm frightening, with

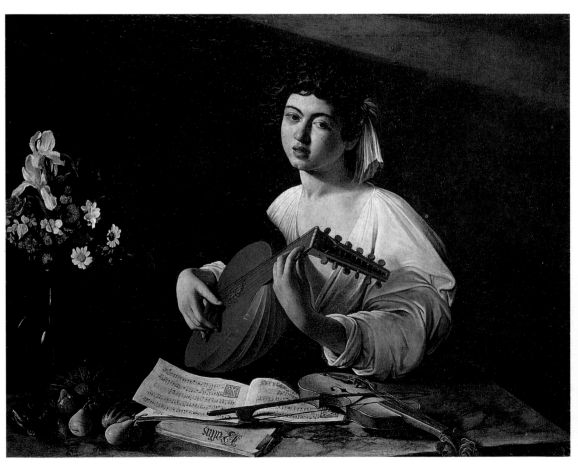

203 Caravaggio, The Lute Player, c. 1596, 47 x 37 in (120 x 94 cm)

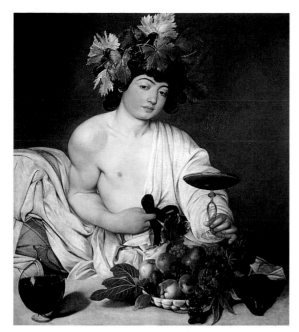

204 Caravaggio, Bacchus, *1590s, 33½ x 37 in (85 x 94 cm)*

the apostles. This woman was all they had left of their Master. Mary Magdalene is huddled in sorrow, and the men mourn in their different but equally painful manner. Mary is not shown in the customary way, ascending to Heaven in glory; we are confronted with both a human corpse and human loss. Above the body swirls a great scarlet cloth, mutely hinting at the mystery of being Mother of a divine Son: blood red for passionate love, for virtual martyrdom, for the upward movement of her soul. There is a copper bowl at the Magdalen's feet: she has been washing the body. Every realistic detail makes the work more and not less religious, one of the great sacred icons of our culture, with immense impact.

THE LIFE OF CARAVAGGIO

Caravaggio earned a reputation as a violent and irrational man and was known to the police for offenses including assaults and stabbings. In 1606, he was forced to flee Rome after killing a man, and spent the rest of his life in exile in Naples, Malta, and Sicily. He was eventually found by his enemies and disfigured in a fight for his life. He died of malaria in 1610.

its air of decadence, of pleasure up for sale: but Caravaggio does not approve or, for that matter, disapprove of this young man: he presents him with an underlying sadness, a creature whose favors will fade, like the fruit and the flowers, and whose music will end in the darkened room.

Bacchus (204) may well be the same model, but here in classical guise, the young wine god holding out the cup of pleasure. But corruption and decay are never far away: the wormhole in the apple, and the overripe pomegranate, remind us of the transience of all things. Light and darkness, good and evil, life and death: the chiaroscuro of his style plays masterfully with these fundamental realities.

OFFENDING RELIGIOUS SENSIBILITIES

Viewers may have been alarmed by the sensuality of *The Lute Player,* but what really drew condemnation was the uncompromising realism of Caravaggio's religious works. The Carmelite priests who commissioned *The Death of the Virgin (205)* rejected it, finding it indecent. There was a rumor that the model for the Virgin had been a drowned prostitute. It is certainly a shocking picture, light striking with brutal finality upon the plain and elderly face of the corpse, sprawled across the bed with two bare feet stuck out unromantically into space, and the feet are dirty. What shocks us is the sense of real death, real grief, with nothing tidied up or deodorized. If Mary was human, then she really died; the lack of faith was that of the horrified priests who rejected this masterpiece, not that of the artist. A poor, aged, worn Virgin makes perfect sense theologically, and so does the intense grief of

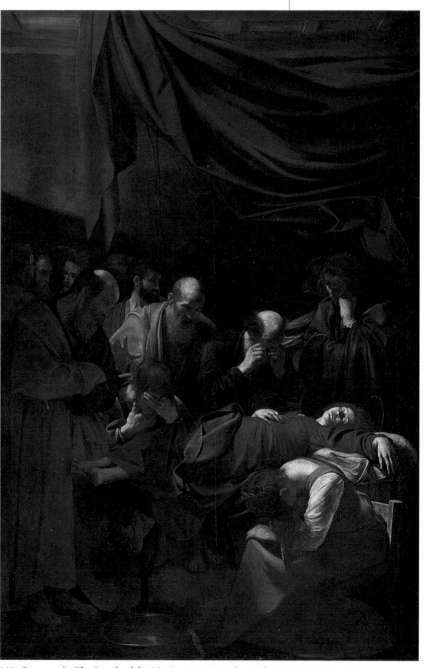

205 Caravaggio, The Death of the Virgin, *1605/06, 8 ft x 12 ft 2 in (244 x 370 cm)*

Caravaggio lived the life of an "avant-gardist" – liberated from convention, both in his art and in his life. Earlier artists had not been models of virtue, but he was astonishing in his freedom from constraint, his quarrels and rages, and even his one killing, bringing him much merited disfavor. Yet, however wild his life, down to the miserable and early death on a lonely seashore, there is nothing wild or undisciplined about his painting. It has an overwhelming truthfulness that, merely in itself, is beautiful.

It is almost impossible to overestimate the influence of Caravaggio. For the first time, as it were, an artist looked at the full reality of human existence, its highs and its lows, its glories and its sordid materiality. He accepted this and loved it into great art. If we respond to Rembrandt in his human truthfulness, it is to some extent because Caravaggio first responded as an artist to the full spectrum of real life. He was able to deal only with the simple truthfulness of his eye: equally influential was his awareness of the importance of light and dark, the chiaroscuro, which he introduced to European painting, and which was dominant for centuries to come.

PALPABLE ASTONISHMENT

The Supper at Emmaus (206) still has its power to shock, with the strangely "unspiritual" Christ, a youth with plump, pointed face and loose locks, unbearded and undramatic. Why should Christ not look like this? The unpretentious face allows the drama to be inherent in the event.

The basket of fruit, balanced on the edge of the table, spells out the significance of Christ's apparition – nothing is left of our earthly securities if death has lost its absoluteness.

Caravaggio's way of homing in on the essentials – or perhaps of bringing them up to, and through, the invisible barrier of the picture plane, into the space occupied by the viewer – made a profound impression upon his contemporaries. He told his story through every element in the work, not least light and shadow. From Jesus, light spreads outward; Caravaggio can tell his story by means of simple effects that nature itself provides. After Caravaggio, a new emphasis on reality, on natural drama, and on the infinite fluctuations of light can be seen in nearly every artist. Like Giotto, like Masaccio, Caravaggio was an art-historical hinge.

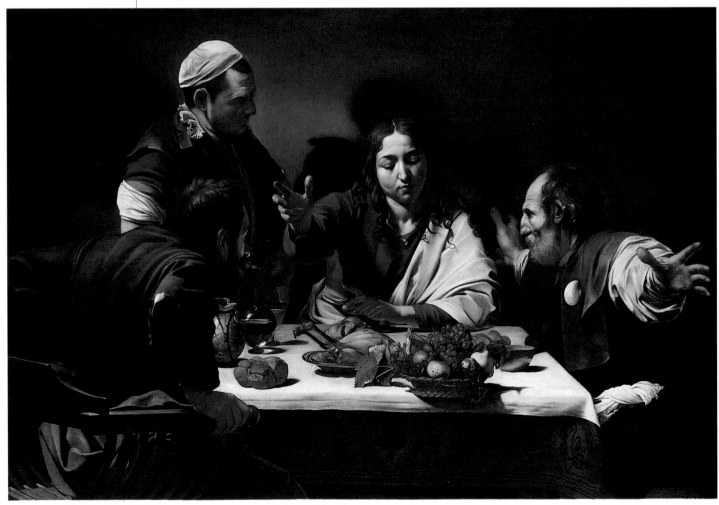

206 *Caravaggio*, **The Supper at Emmaus**, *1600–01, 77 × 55 in (195 × 140 cm)*

THE SUPPER AT EMMAUS

After His Resurrection, Jesus meets two of His disciples walking on the road from Jerusalem to Emmaus. Caravaggio shows the moment when, at supper that evening, Jesus reveals Himself to the disciples in the breaking of the bread. It is the manner in which He blesses the supper that suddenly unveils to them that this is their "dead" master, come back to them. Their astonishment is breathtakingly portrayed, while the innkeeper looks on, baffled and uncomprehending.

SUDDEN REACTION

The disciple on the right (the shell he wears is the badge of a pilgrim) makes the more dramatic gesture as he recognizes Jesus. His outstretched arms echo the Crucifixion, and one dramatically foreshortened arm appears to stretch right out of the picture toward the viewer. This contrasts with the equally sudden but more contained reaction of the other disciple, on the left, whose tattered elbow seems to protrude from the picture, but in a more restrained way.

A YOUTHFUL CHRIST

The image of Christ is that of a young man, almost a youth. Caravaggio may have been influenced by paintings by Leonardo in his unusual depiction of Christ without a beard. He is serene and remote, having transcended the agonies leading up to and during His Crucifixion, and the difficulties of mortal life. He appears, as stated in Mark's Gospel, "in another likeness." Amid the rich, dark tones and the enveloping shadows, His face is flooded in a clear light, which falls from the left (Caravaggio's customary light source). Although the innkeeper stands in the path of the light, his shadow misses Christ, falling instead onto the back wall.

STILL LIFE

The basket of fruit – subtly past its best and teetering on the edge of the table – projects into "our" space, insisting on our attention and rightful admiration. The mostly autumnal fruits are chosen for their symbolic meaning, though the Resurrection was in spring. The pomegranate symbolizes the crown of thorns, and the apples and figs man's original sin. The grapes signify the Eucharistic wine, symbolic of the blood of Christ.

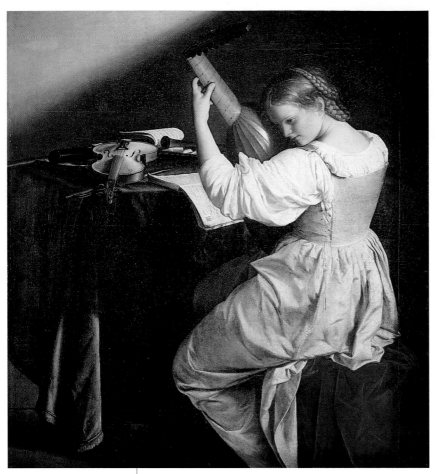

207 Orazio Gentileschi, **The Lute Player,** *probably c. 1610, 50½ x 56½ in (129 x 144 cm)*

FATHER AND DAUGHTER

We can see Caravaggio's profound influence even on a relatively unadventurous painter like Orazio Gentileschi (properly Orazio Lomi, 1563–1639). Although Gentileschi's *The Lute Player (207)* is emphatically feminine and very different from Caravaggio's lascivious boy, she too is caught by the light, held in its beams amid the slanting darkness, lovely and fresh in her innocent music making.

The innocent and rightful desire of feminist art critics to reinstate women artists in the canon has perhaps rather unbalanced our appreciation of Orazio's work. He is a splendid artist, sensitive and strong. The lute player gleams seductively out of the shadows and is totally convincing. It is only because his daughter has been wrongfully slighted (many of her works were incorrectly attributed to her father) that we pass over him to dwell on the work of his daughter, Artemisia (1593–1652/53).

She was a precociously talented painter, and almost as passionate and powerful as her father. In fact she is closer in nature to Caravaggio. Yet she is not incapable of producing a gentler image, as when she portrays herself as the allegory of painting *(208)*. Perhaps the fact that the legendary originator of the art of painting (Pittura) was a woman enabled her to make this exception. This is an unglamorized self-portrait but a delightful one, the round face of the woman intent upon her work and her gown green in the Caravaggioesque light.

Despite the unpretentious approach, the passion and intensity of her paintings make Artemisia almost unique among female artists before the 20th century. It may be – as modern historians like to speculate – because she was raped by one of her father's friends, and this left her with a special insight into violence and betrayal. Like any woman artist, she had to battle against the unexpressed absolutes of her culture, which included the belief in a "natural" inferiority of women, and this too may have fueled the fire with which she depicts *Judith Slaying Holofernes (209)*. The head of the oppressor (see p.105, column) is being visibly sawed off and palpable blood is oozing sickeningly down the mattress.

It is hard to avoid sexist generalities, to avoid saying that it is because she is a woman that she immerses us in the material practicalities of a slaughter. It is a human characteristic to be able to imagine an event in all its dimensions, which is what Artemisia does. She makes us aware of both the courageous heroism of Judith, saviour of her people, slayer of the tyrant, and of what it means to slay another human being.

WOMEN ARTISTS

Artemisia Gentileschi was one of the first important women artists whose work it is possible to attribute with certainty. As women were excluded from life classes with nude models (which formed the basis of traditional academic training), they were at a disadvantage. Other female artists, such as Rachel Ruysch (1664–1750) and Judith Leyster (1609–60), were painting during this period, and the work by Rachel Ruysch shown above is typical of the detailed flower paintings of the Baroque era.

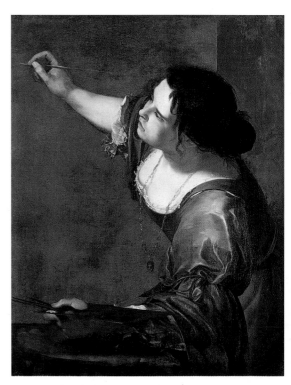

208 Artemisia Gentileschi, **Self-Portrait as the Allegory of Painting,** *1630s, 38 x 29 in (74 x 97 cm)*

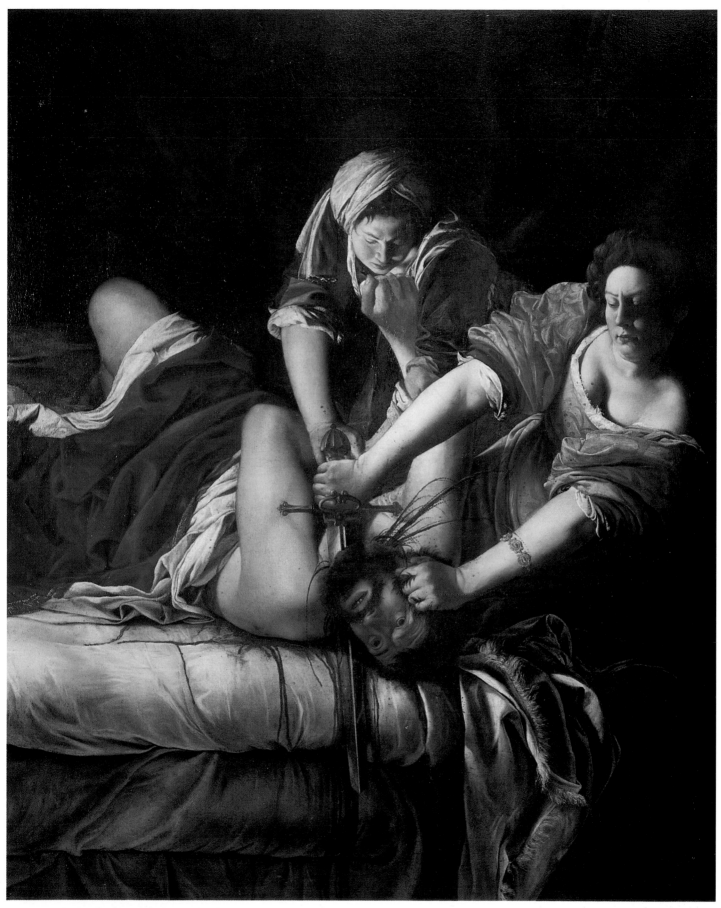

209 *Artemisia Gentileschi,* Judith Slaying Holofernes, *c. 1612–21,*
5 ft 4 in × 6 ft 7 in (163 × 200 cm)

THE CARRACCI FAMILY

The Carracci family of Bologna was also influenced by Caravaggio – as who was not – but here the influence is a subtle one. This talented family of artists comprised two brothers, Agostino (1557–1602) and Annibale (1560–1609), and their cousin Ludovico (1556–1619). They were interested less in the clash of light and shade than in that of temperaments. It was the drama they had in common with Caravaggio, but with differing emphases.

The greatest of the three was Annibale, who combined classical strength with realistic observation. Annibale united High Renaissance monumentalism with Venetian warmth and strong color, and in his paintings he achieved a form of dignified naturalism that could express the idealism, and delicacy of sentiment, that Caravaggio's revolutionary realism could not. There is unforced nobility in his painting of *Domine Quo Vadis? (210)* ("Where are you going, Lord?"), the question that St. Peter asked when he fled Rome in fear of persecution and met with a vision of Christ going the other way. No dirty feet here, and yet we are conscious of the confrontation, and that it is taking place in a real setting; idealized figures, though strong and convincing, but bare earth and unromantic trees. The touch of the ideal kept it more acceptable than the stark vision of Caravaggio, and this accessibility had an aptness in the time of the Counter-Reformation (see p.187).

210 Annibale Carracci, **Domine Quo Vadis?,** *1601–02, 22 x 30½ in (56 x 77 cm)*

THE CLASSICAL LANDSCAPE

The peaceful landscape, *The Flight into Egypt (211)*, is an example of the Carraccis' far-reaching legacy. The classical landscape tradition begins here, where harmony, classical balance, and idealism – where all is well with the world – are combined with strong mood and real personal drama. Annibale exploited the innate

211 Annibale Carraci, **The Flight into Egypt,** *c. 1603, 88½ x 47½ in (225 x 121 cm)*

expressive potential of the landscape, through nuances of light and atmosphere, so that it played as important a role as the narrative about which the painting ostensibly revolves.

Domenichino (Domenico Zampieri, 1581–1641) was a pupil of the teaching academy founded by the Carraccis in 1582. His interests lay increasingly in Classicism and landscapes as he developed, but he knew how to put these techniques to religious effect. *Landscape with Tobias Laying Hold of the Fish (212)* takes the story of the magical fish (see column, right) and sets it in a world so large, so full of potential, that the narrative is swallowed whole.

ELSHEIMER: FROM GERMANY TO ITALY

By the 17th century Northern Europe possessed a strong realist tradition of landscape and genre painting (though in the long run, Italian landscape was more influential). One of the many Northerners working in Italy at the beginning of the 17th century was the German landscape painter Adam Elsheimer (1578–1610). His paintings combine Northern clarity and an eye for the "truth" with the Southern quest for the idyllic. Another scene from the story of Tobias appears in *Tobias and the Archangel Raphael Returning with the Fish (213)*. This painting was for many years attributed to Elsheimer but is now thought to be by a later artist imitating Elsheimer's style. Tobias is depicted gingerly

212 Domenichino, **Landscape with Tobias Laying Hold of the Fish**, *perhaps c. 1617-18, 13⅜ x 17¾ in (34 x 45 cm)*

making his way homeward with his huge fish. The artist is attracted to the mysterious romance of nature, and this is a work of wonderful silence, as boy and protective spirit move through the lonely evening.

213 **After Adam Elsheimer**, Tobias and the Archangel Raphael Returning with the Fish, *mid-17th century, 11 x 7½ in (28 x 19 cm)*

CONTEMPORARY ARTS

1606
First open-air opera, in Rome

1615
Inigo Jones becomes England's chief architect

1616
Death of Shakespeare

1632
Building work begins on the Taj Mahal in India

1642
All theaters in England are closed by order of the Puritans

1661
The Royal Academy of Dance is founded in France by Louis XIV

1665
Bernini completes the high altar canopy (baldachin) for St. Peter's, Rome

1667
John Milton begins to write *Paradise Lost*

214 *Guido Reni,* **Susannah and the Elders,** *c. 1600–42,*
59 x 46 in (150 x 117 cm)

**OTHER WORKS BY
GUIDO RENI**

*Massacre of
the Innocents*
(Pinacoteca, Bologna)

St. Peter
(Kunsthistorisches
Museum, Vienna)

Charity
(Metropolitan Museum
of Art,
New York)

Bacchus and Ariadne
(Los Angeles County
Museum)

Ecce Homo
(Fitzwilliam Museum,
Cambridge, England)

*Christ Crowned
with Thorns*
(Detroit Institute
of Art)

A Sibyl
(Palais des Beaux-
Arts, Lille)

THE NEGLECTED MASTER

One former pupil of the Carracci Academy came to eclipse the Carracci family in fame, both in the city of Bologna and throughout Europe. This was Guido Reni (1575–1642), a man of reclusive temperament, whom the German poet Goethe considered a "divine" genius. Reni has had the misfortune to lose his fame over the years, as our civilization has become increasingly secular-minded and his works seem too emphatic in their piety.

The truly "Baroque" nature of his paintings brought Reni much of the contempt later expressed for Baroque art. It is an unfair judgment, and it is slowly being rectified as the wonderful pictorial emotion and the genuine seriousness of this great painter are progressively being understood again.

215 *Guido Reni,* **Deianeira Abducted by the Centaur Nessus,**
1621, 6 ft 4 in x 9 ft 8 in (194 x 295 cm)

To take one example of Reni's religious work, *Susannah and the Elders (214)* is a painting that confounds the ignorance of prejudice. The story is about a Jewish heroine who is surprised when bathing by two religious elders, who try to blackmail her into immorality. Susannah displays the opposite of surface piety: she faces her tormentors with the indignation of the innocent. She sees no reason for fear, trusting in God and her own blamelessness.

Reni is equally powerful in mythological works. *Deianeira Abducted by the Centaur Nessus (215)* is a work of thrilling majesty. Hercules is on a journey with his wife, Deianeira, when they come to a river, where the ferryman is the centaur Nessus. He takes Hercules across first, then tries to ravish Deianeira. The picture shows him ready to gallop off with her on his back. Bodies gleam in the sunlight: the man-beast hard and straining, the abducted woman vulnerable in her fleshly softness. Garments fly, clouds gather, a great equine leg is paralleled by the slender human form, the nearness underscoring the cruel unlikeness. Deianeira casts an anguished glance upward to the gods, one arm reaching out for help. On every level, visual and emotional, this is a painting that learns from Raphael and Caravaggio alike.

HUMAN DRAMA IN GUERCINO

Like Reni, Guercino (Giovanni Francesco Barbieri, 1591–1666) also fell into disrepute. Perhaps this is even less reasonable, for he is one of the great narrative painters, a draftsman of infinite ability and a superb colorist as well, especially in his earlier years. The name by which we know him was a sort of nickname and is best translated as "Squinty." It indicates a disability, but no man ever used a squint to better effect. He was influenced by the Carracci, and like the Carracci also, by Venetian painting.

Character, interaction, passions in conflict: these are things that Guercino portrays with total confidence. *Christ and the Woman Taken in Adultery (215)* makes its point mainly through the gestures of the hands, as Jesus and the accusers signal their difference of principle (see column, below right). The noble head of Christ, imperturbably calm amid the hubbub, is just sufficiently unidealized to make the incident seem credible. Guercino shows us divine love as a great force of compassion, infinitely demanding and infinitely forgiving.

Guercino is an intensely dramatic artist, playing with light and shade with dazzling skill. We are moved by meaning in his work, but also by its sheer visual beauty.

> **"***A great draftsman and a most felicitous colorist; he is a prodigy of nature, a miracle.***"**
>
> **Carracci on Guercino in a letter of 1617**

THE WOMAN TAKEN IN ADULTERY
This story is told in St. John's Gospel. Temple officials and members of the Pharisee sect try to trick Jesus into giving judgment (so that they can accuse Him of usurping authority). They bring before Him a woman who has been caught in the act of adultery, punishable in Roman law by stoning. Jesus pauses, writing with one finger in the dust, then replies, "He that is without sin among you, let him cast the first stone." At this the accusers leave the scene. Jesus finally says to the woman, "Go, and sin no more."

216 **Guercino,** **Christ and the Woman Taken in Adultery,** *c. 1621, 48 x 38½ in (122 x 98 cm)*

Flemish Baroque

In the 17th century, Flanders was the main stronghold of Catholicism in an otherwise Protestant northern Europe. It remained under Spanish rule when the Northern Netherlands won independence, and the greatest outside influences on Flemish art were Spain and the Counter-Reformation. This is clearly seen in both Rubens and van Dyck.

THE DIVISION OF THE NETHERLANDS

A truce agreement of 1609 divided the strife-torn Netherlands into two parts: the United Provinces (known to us today as the Netherlands, or Holland), which was freed from Spanish rule; and the Southern Netherlands (roughly the present-day Belgium, including Flanders), which still belonged to Spain. This division was given formal recognition by the Treaty of Münster, in 1648.

For a century, Spain had been the major military force in Europe. It had used its power to back the might of the Catholic Church in Northern Europe – precisely where Catholicism was under the strongest attack from the Protestant Reformation. In the Netherlands, when the North won its independence, Flanders remained within the Catholic fold, in an ever-closer relationship with Spain. The two Catholic countries had in common the religious idealism of the Counter-Reformation, and, linked as they were by their history, they shared similarities in their art. At the start of the 17th century, as a result of this consolidation with Spain, industry in Flanders flourished, and the arts, which were centered in Antwerp, benefited from the increasingly prosperous culture.

The greatest of the Northern Baroque painters was the Antwerp-based Peter Paul Rubens (1577–1640). He has something of Domenichino's largeness of spirit (see p.183), but greatly magnified. The wonderful mixture of Italian grandeur and Flemish lucidity and feeling for light climaxes in the paintings of Rubens. His work is infused with a kind of Catholic Humanism that admits sensuous delight along with religious sentiment, and it has an energetic, optimistic spirituality.

In 1600 Rubens went to Italy to study. He traveled widely over the next decade, notably to Spain, where he became friends with a Spanish artist who was 22 years his junior and who was of perhaps even greater stature: the incomparable Velázquez (see p.194).

Rubens wrote, "I consider the whole world to be my native land," and this confident generosity of spirit, this cosmopolitan view of the world, is manifested in his works. So expansive was his genius that he easily took the elements that he admired of the High Renaissance masters and assimilated them into his own strongly independent vision. His paintings reveal a supremely confident use of color – always rich and generous – that he learned from studying the works of the great Venetian, Titian. His figures have a massiveness of form that runs in a clear line back to Michelangelo.

RUBENS'S RELIGIOUS WORKS

Rubens spent some time in Rome and the influence of his Italian contemporary, Caravaggio (see p.176), proved to be an enduring one. This revealed itself most emphatically in Rubens's religious paintings, to which, in true Baroque form, Rubens gave popular appeal and an utterly physical presence. We cannot always tell from an artist's religious painting how personal is his faith: probably we can never tell, faith being so

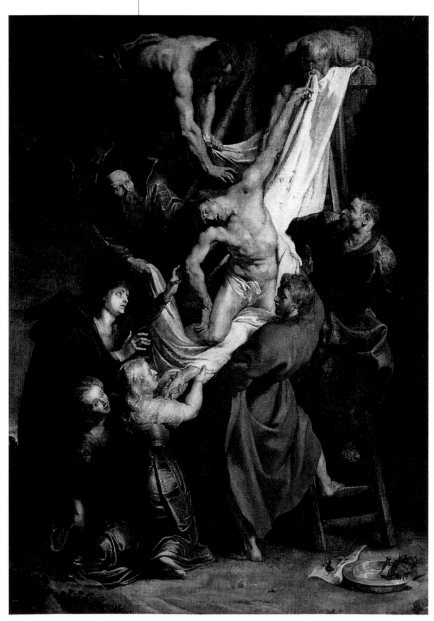

217 Peter Paul Rubens, Descent from the Cross, 1612–14, 10 ft 2 in × 13 ft 9 in (310 × 420 cm)

218 Peter Paul Rubens, **Deborah Kip, Wife of Sir Balthasar Gerbier, and Her Children,** *probably 1629/40,*
5 ft 10 in x 5 ft 5¼ in (178 x 165 cm)

integral a part of our nature. But we know that
Rubens cherished his religion and tried to live
by it. We can imagine that we see this earnestness
in his wonderfully energetic *Descent from the
Cross (217).* Here we can see Caravaggio's
influence, in the dramatic lighting and humane
realism, but also that of Michelangelo, in the
muscular, classical form of the dead Christ.

The painting still hangs in Antwerp Cathedral,
for which it was painted, a great descent indeed,
as the limp body (the only nonactive element in
the picture) drops down the whole length of the
frame. All the activity is kept central, a thick and
vital column of emotion and movement, passion
expressing itself physically, all the light kept
steady on the deadness of Christ. His weight
presses down almost unbearably, His death
making it impossible for love to reach out. The
mourners feel with despair that they have had
something of their own life taken away in the
Crucifixion of their Lord.

RUBENS AS A PORTRAITIST

But Rubens is no escapist. He never flatters the
truth into acceptability: he reveals what defects
he sees, though sitters may not have recognized
them when displayed for all to see in a portrait.

One of his great group portraits, *Deborah Kip,
Wife of Sir Balthasar Gerbier, and Her Children
(218),* shows a family that is not happy. The
three older children are grim and questioning,
the little girls looking out at us with hesitant
reserve. They are beautiful children, but they
are tense – as is the elder brother, leaning tautly
forward. The baby is unaware of tension, but
the mother seems lost in her sadness.

The father of the family was a cruel and
unprincipled man, and Rubens does not gloss
this over. Deborah Kip is gloriously dressed in
damasks and silks, but the family stands in a
setting of ominous clouds. The glow and the
beauty are observed, but with foreboding.
There is deep sentiment, but no sentimentality.

**THE COUNTER-
REFORMATION**
This was a movement that
took place within the
Catholic Church at the
time of the Protestant
Reformation (see p.169).
The Roman church found
itself in need of reform,
particularly so if it was to
win back regions that had
turned Protestant. Pope
Paul III (1468–1549,
shown above) summoned
the Council of Trent
(1545–63), which redefined
Catholic doctrines and
introduced disciplinary
reforms. New religious
orders, including the
Jesuits, were founded to
lead the counteroffensive
against the Protestants.
Later, the more rational
types of church reform
were replaced by the
paranoia of the Inquisition
(see p.197), which used
extreme measures against
Protestant "heretics."

AN AMBASSADOR'S SKILL

Rubens's vitality and tenderness – an unusual combination – could make him seem unlikely to be a success as a political artist. But his genius was immense and he was a highly successful ambassador for his country, the Spanish Netherlands, so he was used to moving in the highest political circles.

Almost all the crowned heads of Europe knew personally, and valued aesthetically, the great Rubens. He was the obvious choice for Marie de' Medici, the widowed Queen Mother of France, who needed artistic help in her state of rivalry with her own son, Louis XIII.

Louis came of age in 1614 and duly became king but, like many a parent, unfortunately, Marie was unable to accept her son as a functioning adult, and she clung tenaciously to her status. The French court came to be beset with the political problems arising from this sordid rivalry. Louis was forced to have his mother exiled to the provinces, and she was not allowed to return until 1620. She moved into the Luxembourg Palace, a splendid Baroque building on the left bank of the Seine, whose refurbishment and decoration became her main occupation for the next five years.

Her plan was to commission two cycles entailing some 48 vast canvases altogether. One was to illustrate the romance and triumph of her career, the other the events of her late husband's. Marie de' Medici had never been beautiful and was always overweight. King Henri IV had indeed been a hero, but the only cycle to come near completion was the one focusing on Marie. No other artist but Rubens could have carried this off without becoming ludicrous. The series is far from ludicrous: it is magnificent. Without eliding the truth, merely gently shading it, Rubens provides one splendid canvas after another, making a mountain of art out of a molehill of fact.

His method is splendidly exemplified in *The Apotheosis of Henri IV and the Proclamation of the Regency (219)*, which is set in terms of classical myth. Rubens's lips may have twitched as he painted this, but his artist's hand is rock steady. It is a beautiful, vibrant picture, completely integrated, one of the great narratives of art.

Facing *The Apotheosis of Henri IV* at the opposite end of the long gallery in which the cycle was originally housed was *The Queen Triumphant*, a brilliant piece of court portraiture. Other memorable successes were *The Education of the Princess, The Disembarkation at Marseilles*, and *The Birth of the Dauphin*.

If weaknesses in the cycle are looked for, they are to be found in a small minority of the paintings. *Louis XIII Comes of Age*, for instance, appears to lack conviction, and this is thought to be indicative of the lingering hostility between the officially reconciled royal figures.

219 Peter Paul Rubens, **The Apotheosis of Henri IV and the Proclamation of the Regency,** *c. 1621/25, 23 ft 10 in × 13 ft 11 in (727 × 391 cm)*

THE APOTHEOSIS OF HENRI IV

Rubens conceived the *Apotheosis of Henri IV* as the climactic work in a great cycle depicting events in the career of Marie de' Medici. It is a huge canvas, 24 feet wide and over 13 feet high (7 m by 4 m), commissioned for Marie de' Medici's palace, where it stretched across the entire end wall of the gallery in which it was hung. Its full title, *The Apotheosis of Henri IV and the Proclamation of the Regency,* explains the double nature of the composition. With great success, Rubens has depicted two separate events (both proclaimed on the same day) within one canvas: the death of the king (who was assassinated in 1610) and the regency of his widow.

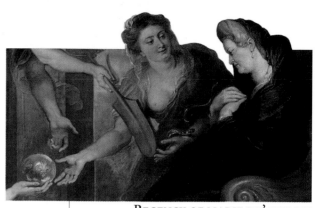

REGENCY OF MARIE DE' MEDICI
On the right-hand side, the embattled Spirit of France kneels and offers the orb to the unwilling widow (depicted in deep mourning). Above her, a figure representing the regency offers her a rudder. The French aristocracy, and the heavenly graces, plead with her to overcome her humble reluctance.

APOTHEOSIS OF HENRI IV
On the left, Henri IV is taken up to Heaven where he will be deified (the meaning of apotheosis). He is carried by Saturn (sickle in hand), the god of time and death, who delivers him to Jupiter, the supreme god of power, leaning down from Olympia to receive him. Jupiter's eagle, bearing a thunderbolt in its claws, symbolizes the ascending soul. The serpent, shot through with arrows, is an allusion to the king's assassin.

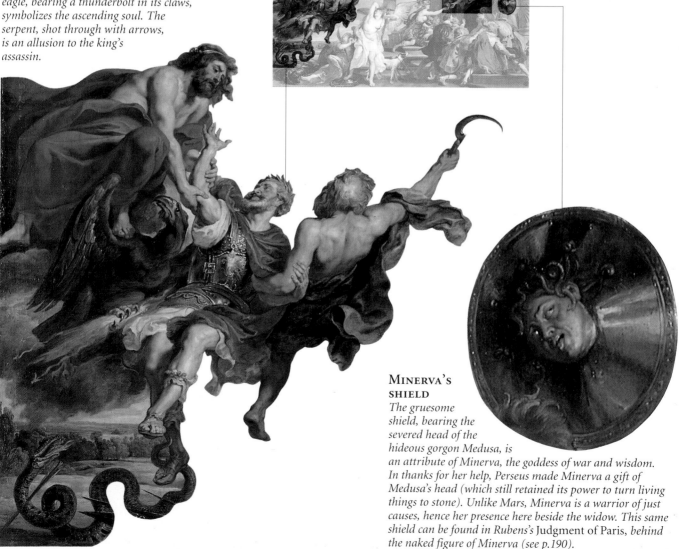

MINERVA'S SHIELD
The gruesome shield, bearing the severed head of the hideous gorgon Medusa, is an attribute of Minerva, the goddess of war and wisdom. In thanks for her help, Perseus made Minerva a gift of Medusa's head (which still retained its power to turn living things to stone). Unlike Mars, Minerva is a warrior of just causes, hence her presence here beside the widow. This same shield can be found in Rubens's Judgment of Paris, *behind the naked figure of Minerva (see p.190).*

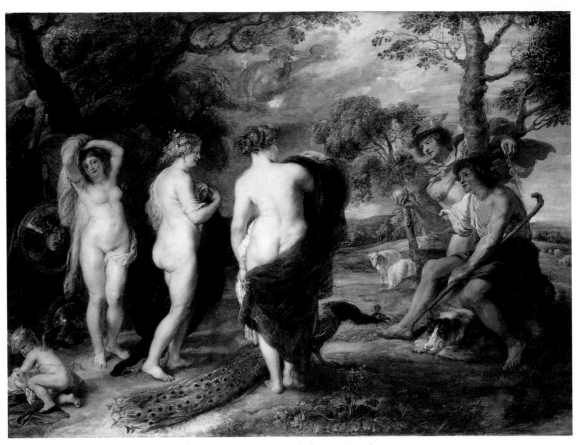

220 Peter Paul Rubens, **The Judgment of Paris**, 1635–38, 76 x 57 in (194 x 145 cm)

THE RUBENS LOOK

Rubens is unfortunate in that today's attitude toward the fat is in direct opposition to that of the 17th-century Flemings. They loved a full-bodied woman, and most of Rubens's superb nudes are too large for our taste. But he is very much more than the painter of the fair and fat.

Rubens was the most fortunate artist in history: handsome, healthy (until gout in later life), well educated, sensible, good-humored, wealthy, an innate diplomat and recognized as such by the crowned heads of Europe, twice married, both times with blissful success – so much so that he openly celebrated it in his paintings – and one of the greatest and most influential artists ever born. He used all his gifts with unselfish industry, climaxing his good fortune by being a thoroughly good man. It is typical of his happy career that at a young age he became court portraitist at Mantua in Italy (see column, p.104) and that in 1609, at 32, he became court painter to the Infanta Isabella and Archduke Albert in Brussels (see column, left).

The glory of Rubens's work is its vigor, its happy and profound consciousness of the significance of being alive and alert, of never wasting what a context offers. But as well as that, there is what one can only call a sweetness in him, shown most remarkably by the Rubens

"look." People in his paintings tend to give one another a look of wholehearted trust, an acceptance of difference and a confidence in its worth. An example is *The Judgment of Paris (220).* Paris looks at the naked goddesses with a lovely reverence – the Rubens "look." It is returned by

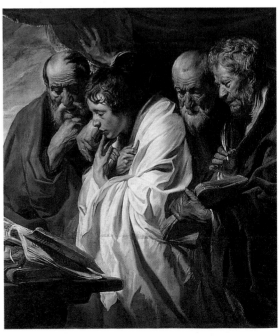

221 Jacob Jordaens, **The Four Evangelists**, c. 1625, 46¼ x 52½ in (118 x 134 cm)

VAN DYCK'S GRAND ELEGANCE

The closest to Rubens in gift, and at times in style, in the North, was Anthony van Dyck (1599–1641). In his youth, Rubens had a very aristocratic elegance that reminds us of van Dyck. An example from his early twenties is his regal-looking portrait of *Marchesa Brigida Spinola Doria (222)*, in which the face, gentle in its self-assurance, proclaims the work of Rubens.

Van Dyck can manage just as much grandeur, skillfully deploying all his arts to make his own *Marchesa (223)*, of the great Grimaldi family, appear almost immortal in her lofty state. In his portraits, van Dyck suppresses the "earthiness" and animal vitality so forceful in Rubens's paintings, and in its place we find an elegance and psychological presence that his aristocratic subjects doubtless found pleasing. The slave who holds the parasol is humankind: the lady is on another plane – yet not quite. Somehow van Dyck manages to make us believe in his lady, with a subtlety not evident in Rubens's portrait.

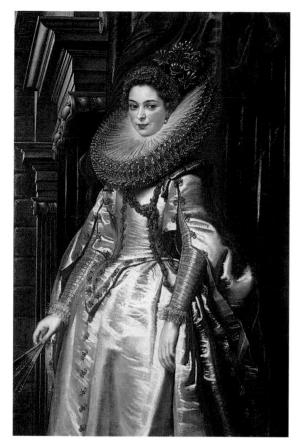

222 Peter Paul Rubens, Marchesa Brigida Spinola Doria, 1606, 38¾ x 60 in (99 x 152 cm)

Venus, innocently amazed at her victory. It has been remarked that her surprise is justified; that Juno, with her back arched above her furs, is the true winner. (The third goddess, Minerva, seems to look on with amused curiosity.) The legend takes on a special significance, quite apart from preceding the Trojan war. What interests this supremely balanced painter is the encounter between what could have been a vulgar youth and an unclad queen. Rubens lends the scene dignity and graciousness.

JORDAENS – RUBENS'S SUCCESSOR

Rubens ran a workshop in Antwerp, with a large stable of assistants. One artist who is known to have worked with him in Antwerp is Jacob Jordaens (1593–1678), who gained a great deal from his association with Rubens and flourished over the years, producing coarse-grained but vital works. Jordaens's *The Four Evangelists (221)* is painted with vigor: the thick brushwork is very different from Rubens's technique.

Jordaens worked best as a painter of genre works and typically chose modest subjects; but after Rubens's death in 1640, it was he who filled the post of Antwerp's leading artist, perpetuating Rubens's influence and producing a great many public works over his long career.

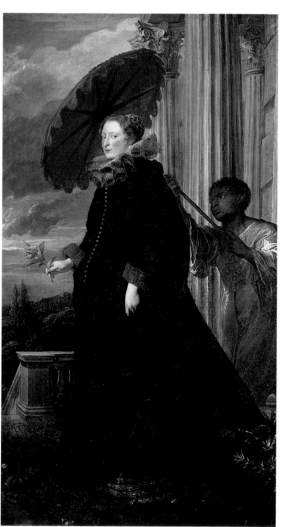

223 Anthony van Dyck, Marchesa Elena Grimaldi, 1623, 52 x 95 in (133 x 241 cm)

224 *Anthony van Dyck,* Charles I of England Out Hunting, *c. 1635–38, 6 ft 9½ in x 8 ft 8½ in (207 x 266 cm)*

Portrait painting was a lucrative business, and van Dyck really excelled at it. Like Rubens (in whose Antwerp workshop he briefly worked), he traveled extensively, enjoying an illustrious career before settling in 1632 in England. It was at the court of Charles I, that doomed monarch, that his gifts flourished, influencing generations of portrait painters in England and throughout the rest of Europe. The diminutive king starred in many of van Dyck's paintings, in a variety of symbolic roles, sometimes in armor, and sometimes on horseback. One portrait in the Louvre, *Charles I of England Out Hunting (224)*, is the greatest piece of public relations ever created. By sheer force of genius, van Dyck presents us with an icon of the heroic, of the grave scholar king who yet loves the chase. Noble tree, noble seat, noble monarch: van Dyck integrates the three into a most memorable image. Charles knighted him, and we feel he deserved it.

Spanish Baroque

Painting in 17th-century Spain was profoundly influenced by the Church, at least partly because of the religious zeal of the Spanish Hapsburg dynasty. King Philip II and his two successors, Philip III and IV, maintained religious orthodoxy by means of the dreaded Spanish Inquisition, a council for the persecution of all forms of "heresy," including Protestantism. Spanish Baroque art was largely devotional in nature, though the period can boast a little court painting and some mythological, genre, and still-life work.

Despite the tense atmosphere of religious conformity presided over by the Hapsburg regime, Caravaggio's liberating influence (see p.176) is fairly widespread in Spanish painting in the early part of the 17th century. Caravaggio's rich contrasts and dark palette were well suited to the Spanish tradition, in which a tendency toward grim and graphic realism was already well established, especially in religious sculpture (see column, p.198).

"Caravaggism" found an early exponent in Jusepe de Ribera (1591–1652), who painted with dark colors and, often, disturbingly sinister undercurrents. Ribera went to Italy – first to Rome, where he absorbed Caravaggio's influence, then to Spanish-ruled Naples. He remained in Italy for the rest of his life and enjoyed great success. There is more piety, and sensual pleasure, in Ribera's religious paintings than in those of Caravaggio and, equally, a deeper level of pain and suffering. There is a terrifying degree of pain in this mythological work *(225)*, in which Apollo punishes Marsyas by skinning him alive. Marysas, who was a skilled flautist, had challenged Apollo to a music contest, but had lost. As victor, Apollo was allowed to choose the punishment.

Ribera found his models among urchins and beggars, and portrayed them as they really were. His beggar-boys, even his philosophers, confront us with all their physical imperfections: rotting teeth, deformed limbs, dirty skin, and aged flesh, breathing a harsh and unprecedented social realism into 17th-century painting.

Spain in the 17th Century

From the reign of Philip II (1556–98) onward, the Hapsburg monarchy had to struggle to keep control over Spain's vast empire. At the beginning of the 17th century, the country was in economic decline due to the number of wars it had to fund. It was also weakened by the loss of land to France under the Treaty of the Pyrenees in 1659, and by several serious outbreaks of the plague. At the same time, Spain experienced an intellectual and artistic renaissance.

Don Quixote

Miguel de Cervantes (1547–1616) was the most successful Spanish novelist of the 17th century. His most famous work, *Don Quixote*, was written while he was in prison in Seville. The novel is a satire on the current fashion for chivalry but also portrays the theory of the human ideal and the frailty of man. The two characters represent the many fluctuating features of insanity, and the detailed descriptions of the Spanish countryside give the book a powerful resonance.

By 1605 the book was in print in Madrid; this illustration (above) shows the popular 1608 edition.

225 Jusepe de Ribera, **The Flaying of Marsyas,** *7ft 8in x 6ft (234 x 183 cm)*

VELAZQUEZ: SPANISH GENIUS

When Diego Velázquez (1599–1660) first made his bid for painterly glory (just out of his teens), he was influenced by Caravaggio (see p.176). There is the same sureness of form and control of light, but beyond this, all real comparison ends. Velázquez was unique, one of the very greatest of painters, and he developed a vision of human reality that owed little to outside influence.

The only image of royalty comparable to the van Dyck portraits of the Stuart King Charles I (see p.192) is that given by Velázquez of the Hapsburgs, whom he served as court painter; but, again, the comparison is a superficial one. Velázquez did not merely glorify his king and court, though he did that as a matter of course; he was also oddly intent on rising in social status. In time he did win his way to a mild friendship with Philip IV. The king was a poor politician (see column, left), but his saving grace was that he did appreciate the genius fate had sent him as court painter and rewarded him accordingly.

The sheer beauty of Velázquez's court paintings, official statements in an age without photography of what the monarch and entourage looked like, undoes all attempts at labeling. *Las Meninas (226)* ("the maids of honor") is now hung in the proudest place, behind bulletproof glass – visibly the greatest treasure of its great museum, the Prado, Madrid.

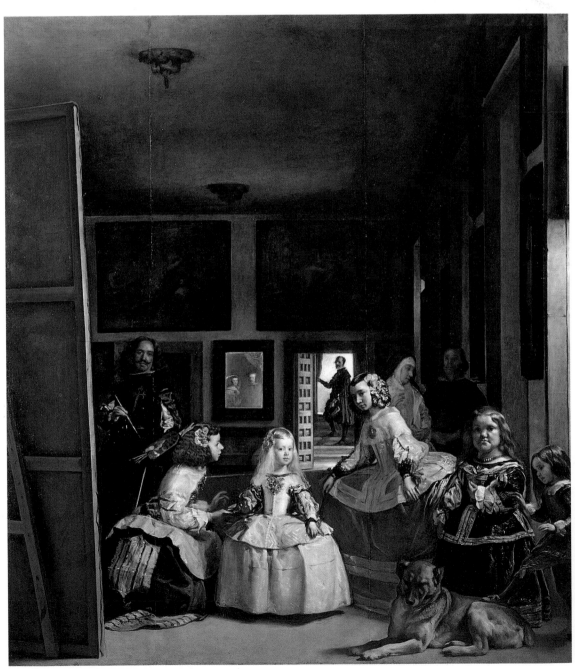

226 Diego Velázquez, Las Meninas, 1656, 9 ft ½ in x 10 ft 5 in (276 x 320 cm)

LAS MENINAS

At one level, this picture is easy to read: at the center is the little princess, the Infanta Margarita Teresa, with her maids clustered around her, her tutors, page, and dwarf in attendance, and her gigantic dog. From the dog we work our way up by stages to the distant reflection of the king and queen. Here is the whole world of the inner court, presented obliquely, in reverse order of importance. Painted for the king's private summer quarters, this work is both a portrait of his young daughter and a sophisticated, innovative tribute to the king himself. It portrays a single moment, each figure responding to the entrance of the king.

MINIATURE PORTRAITS
In the rear mirror, our attention drawn to it by the silhouetted courtier, we see a reflection of the king and queen. Whether it actually reflects them, or the painting Velázquez is working on, nobody knows for certain. Secure in their position, the royal pair can easily afford to become a mere reflection behind their child. Even as pale shadows, they can dominate, surely the subtlest of compliments.

SELF-PORTRAIT
The painter, Velázquez himself, stands at the far left, intent upon a canvas looming impressively upward, while the large copies of Rubens's paintings behind him are diminished (there is irony here) by the shadows. The red cross on Velázquez's chest signifies his subsequent knighthood and was added to the painting two or three years later.

COURT LIFE
There is a sense of life as actively lived, life held still for a passing moment – not a moment of special significance, however; merely one of the thousands passing every hour, and this one lives on. The figures of the Infanta's entourage appear and recede in a vast cave of shadows. All have been identified as historical personages except for the man standing quietly on the right.

DETAIL OF SLEEVE
Viewed at close quarters, the fluid, seemingly hasty brushmarks, have an abstract, almost arbitrary quality. But as the viewer steps back to take in the whole scene, these patches miraculously assume the solid structure of the child's arm enclosed within the gauzy fabric of her sleeve.

Earlier in his career, Velázquez had contributed to the grand projects inaugurated by Philip IV. These included a splendid new palace, the Buen Retiro, built in 1631–35, in whose many rooms some 800 paintings were hung. Its principal ceremonial room, known as the Hall of Realms, contained 27 paintings by Spanish artists, including Velázquez's *Surrender of Breda*, along with a number of works by Zurbarán (see p.197). The king's next project was the Torre de la Parada, a hunting lodge on the grounds of the Pardo Palace. Velázquez, despite the king's increasing interest in foreign artists, contributed portraits of the young crown prince Balthasar Carlos and two of the court dwarves, one of whom, *Francisco Lezcano (228)*, is shown here.

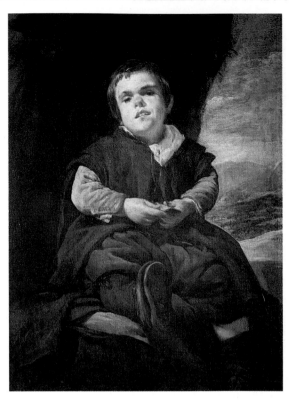

228 Diego Velázquez, Francisco Lezcano, 1636–38, 32½ × 42 in (83 × 107 cm)

Velázquez's use of paint intrigued his royal friends. They pointed out to one another, quite intelligently, that his pictures had to be viewed at a distance, when the rough and apparently glancing dabs of color would suddenly, miraculously, integrate themselves into the image. Lace, gold, the glitter of light jewels, the rosy flush of a young cheek, the weary droop of an aged head: Velázquez could catch them all and hold them for us to see. He could do this with a religious image: no *Christ on the Cross (227)* has a more mournful human dignity than his.

He could teach us that the court dwarf *(228)*, who often served as a jester (see column, left) and a figure of fun, had the same tragic dignity and unalienable humanity as the dying Jesus.

He could take a theme from mythology and show us that paganism, too, is a religion and so draws its force from the movements of the human spirit. *The Forge of Vulcan (229)* is a masterpiece of contrasts between two kinds of being. On the one hand, there is the luminous, epicene, and effeminate youth, visitant from another world, blandly confident of his ability to make himself understood. On the other, there is the team of blacksmiths, male to their core, wiry and astonished – and yet at the same time clearly unimpressed. The two worlds meet with mutual incomprehension and with mutual disinterest, yet Velázquez laughs so low in his chest that the joke may go unheard.

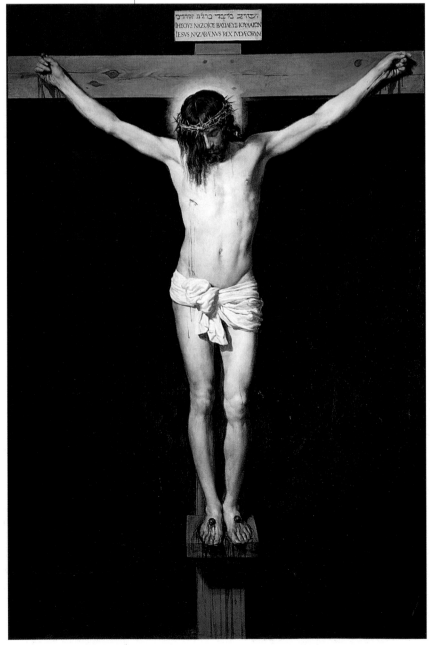

227 Diego Velázquez, Christ on the Cross, 1631–32, 5 ft 6½ in × 8 ft 1 in (169 × 250 cm)

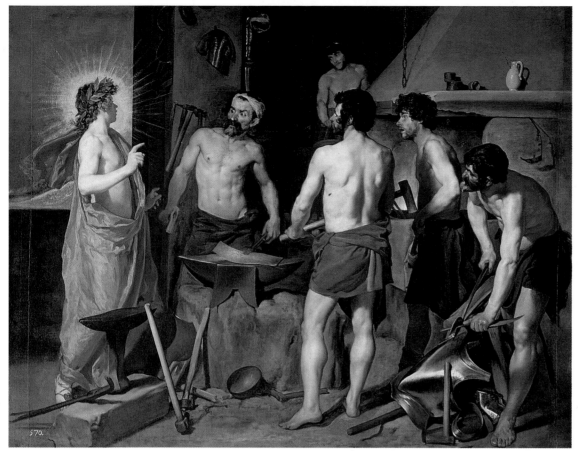

229 *Diego Velázquez,* **The Forge of Vulcan,** *1630, 9 ft 6 in × 7 ft 4 in (290 × 223 cm)*

ZURBARAN: A SACRAMENTAL CALM

Francisco Zurbarán (1598–1664) was a contemporary of Velázquez and worked in Velázquez's native town of Seville. The two were largely unlike in style, except that Zurbarán's paintings display that pleasing solidity of form and plasticity of paint found in Velázquez's early work (see p.196). It is in still life that we find Zurbarán at his finest. *Still Life with Oranges (230)* has a sacramental monumentality, a modest certainty of the value of things, the fruit laid out on an altar, the flower silent beside the humble mug, three images bathed in sunlight and conveying an indescribable sense of the sacred.

THE SPANISH
INQUISITION

Introduced in the 15th century by King Ferdinand and Queen Isabella, this became a terrifying ordeal for all Protestants, Jews, and Islamics. Dominican monks were given the task of seeking out heretics (anyone who did not openly support the Catholic faith). The monks instituted a type of trial known as the auto-da-fé (act of faith), which ended either in "recantation" or a public burning of the "heretic" at the stake. This illustration shows a heretic being led away to her death.

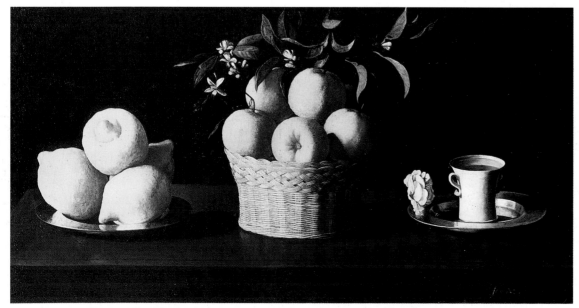

230 *Francisco Zurbarán,* **Still Life with Oranges,** *1633, 42 × 23 ½ in (110 × 63 in)*

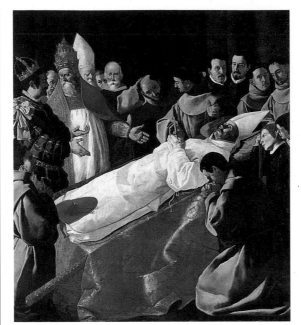

231 Francisco Zurbarán, **The Lying-in-state of St. Bonaventura**, *c. 1629, 7 ft 5 in x 8 ft 2 in (225 x 250 cm)*

The Lying-in-state of St. Bonaventura (231) has the same weight of lucid significance, of "event" that is uneventful. The work hovers between time and eternity, intent upon the unseen that gives the seen its meaning. The human actors in the drama (and we might say that the dead saint is the most vital of these) are spotlighted against profound darkness. The mystery of our journey from birth to death becomes almost tangible.

MURILLO: A FORGOTTEN MASTER

The next great 17th-century Spanish master after Velázquez and Zurbarán is another artist who lived in Seville, Bartolomé Esteban Murillo (1617–82). Sadly, Murillo is easy to misjudge; at his weakest, which is not all that infrequent, he has a softness that can only be called sentimental. The mistake is to take the weak Murillo as the only Murillo. It is true that he is never as strong or as deep as Velázquez or Zurbarán, but he has his own gentle strengths and depths. Murillo can make us catch our breath with his unworldly but convincing images.

Because of our modern desire to face life whole, with all its cruelty, Murillo is often accused of being too idealistic, too anodyne. Our desire for realism runs contrary to Murillo's personal world of family love and understanding. Some of our surprise may come from the realization, unexpected, that sweetness can be made to work. *The Holy Family (232)*, with its tenderly involved St. Joseph and the absence of anything resembling heavy symbolism, has a charm that increases the longer the picture is looked at. The small mongrel and the cosseted child are both painted with the insight of love.

But we can perhaps best appreciate the genuine if not monumental gifts of this artist in one of his rare secular works. *Two Women at a Window (233)* is a splendid image, reticent, creamily beautiful, certain of its own understanding of the two figures. One of them is almost certainly a duenna – an older woman employed by the family to be both a governess and a chaperon. She is laughing, but we are not shown her laughter: only her creased-up cheeks, flushed with mirth. Her twinkling eyes assure us that what makes the young woman smile to herself, unaffected, makes the older woman crinkle up with sardonic glee. She sees more, and understands with sharper wit, than the pretty child, and Murillo shows us this with the most delicate understatement.

In this wonderful picture, the great strong vertical of the shutter, and the equally strong horizontal of the window ledge, frame the two women. The girl, who is the emotional center of the picture, looks out at life with ironic detachment, but Murillo, and the older woman, know that her practical options are severely circumscribed.

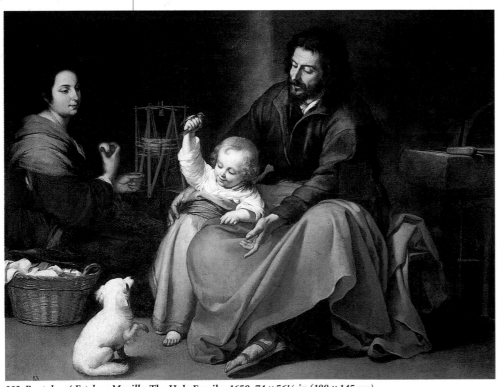

232 Bartolomé Esteban Murillo, **The Holy Family**, *1650, 74 x 56½ in (188 x 145 cm)*

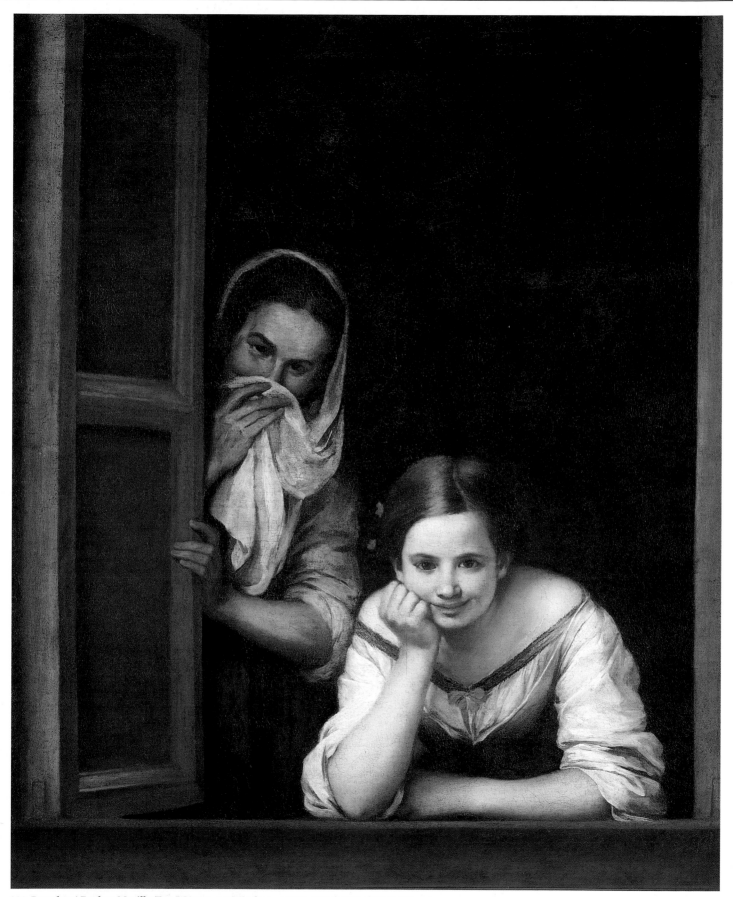

233 Bartolomé Esteban Murillo, Two Women at a Window, *c. 1670, 41¾ x 50 in (106 x 127 cm)*

A Dutch Protestant Vision

The United Provinces of the Northern Netherlands claimed their independence in 1579, but it took 30 years of armed conflict to drive the Spanish from their soil. A treaty was signed in 1648, and this Protestant region, with its Reformation affinities and Northern realist heritage, now evolved its own tradition. Life was lived out in a dramatic atmosphere, first of revolution and later of the fight to defend the hard-won freedom. A new order began, based on social justice and spiritual austerity. Churches were stripped bare for Calvinist worship, and in painting, there was renewed emphasis on realism and simple, everyday things.

It can be difficult to realize that Rubens (1577–1642, see p.186) and Rembrandt (van Rijn, 1606–1669) were contemporaries, their lives overlapping for the first half of the 17th century. Both lived in the Low Countries, though Rubens was based at Antwerp in Flanders, and Rembrandt at Amsterdam in the North, in the country that was known then as the United Provinces, and today is called "the Netherlands" or, more conversationally, "Holland".

Rubens seems to belong to an older age, more classical and international. Rembrandt is emphatically a Dutchman, and his vision comes primarily from himself and not from antiquity. Both are magnificent, but it is Rembrandt to whom we feel closest, perhaps because of his fascination for the self-portrait, which makes us able to "read" him at every stage of his emotional life. The human face fascinated him from the beginning, a fortunate circumstance that brought him many lucrative commissions. However, it is never the externals that intrigue Rembrandt, whether in his own face or that of others. It is the inner workings of the mind, an obsession that eventually lost him his successful position and the respect of his peers. Yet in Rembrandt's paintings, the two worlds of inner and outer are not in opposition. It is precisely through the body, so wonderfully conjured up in the medium of paint, that Rembrandt unveils to us the nature of the sitter, even the passing moods, as well as the deep-seated attitudes.

Rembrandt was a miller's son; in other words, he came from a middle-class background. This was significant of his times, for alongside the independence struggle, Dutch society was changing and the middle class was growing. As it grew it created a strong new demand for realistic paintings, such as serious institutional portraits and images of working life. Rembrandt was one of those born painters who started young

The United Provinces

This name was first used in 1579, when the Protestant states of the Northern Netherlands declared independence from Spanish rule. Warfare raged until the truce of 1609 (see p.186). It took 39 years for Spain and the other Catholic powers to recognize the new Protestant state and finally sign the Treaty of Münster (in 1648). Holland was the richest of the United Provinces, and its name has come to be used for the whole country, though the official name today is the Netherlands.

The Blinding of Samson

The story of Samson is told in the Old Testament book of Judges. Samson's enemies, the Philistines, seeking a chance to kill him, enlist Delilah to seduce him. She succeeds in getting him to give away the secret of his enormous strength (his hair), and while he is asleep, she lets them cut off his hair. As a consequence, his strength deserts him, leaving him helpless. The Philistines put out Samson's eyes and imprison him. Eventually he manages to exact revenge by pulling down the pillars supporting the roof of the house in which he is being held.

and was recognized almost at once. His earliest work, with its love for melodrama and keen interest in the humanity of his models, is essentially merely a hint at what is to come. His painting of a biblical story, *The Blinding of Samson (234)*, is superbly done; we flinch involuntarily from the sinister, silhouetted shape of the sword about to jab into a defenseless eye, and we tremble to see the tumultuous violence that is raging within the dark and claustrophobic spaces of the cave. Samson writhes in anguish, Delilah flits away, half gloating, half horrified, and the pressure builds so high that it threatens to topple over into farce. We can see the same "overweight" of story in the early self-portraits, too.

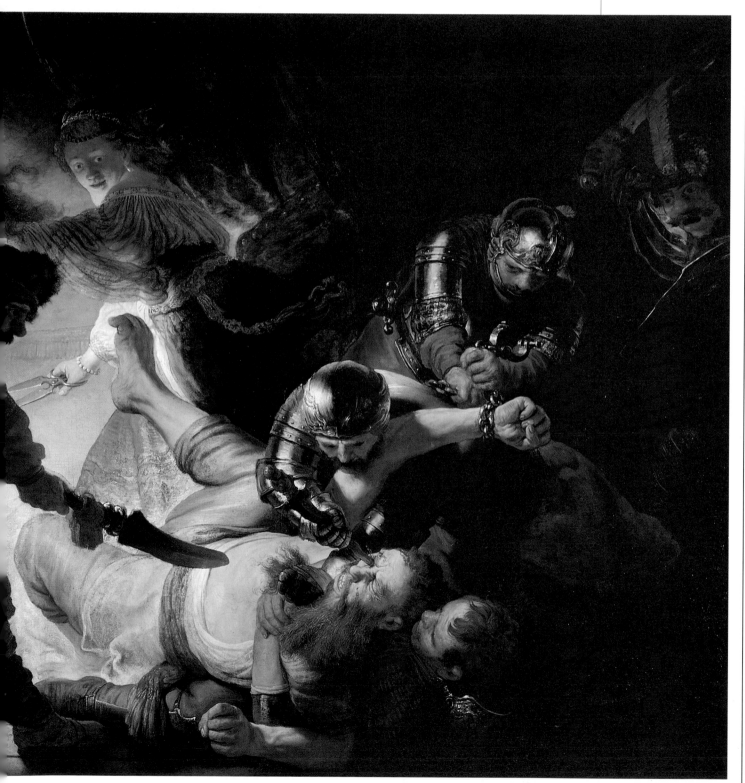

234 Rembrandt, The Blinding of Samson, *1636, 9 ft 10 in × 7 ft 9 in (300 × 236 cm)*

The *Self-Portrait at the Age of About 21 Years (235)*, dark and secretive, shows Rembrandt in early adulthood, perhaps deliberately acting the part of the "artist." In his midlife self-portraits he is more reflective, obviously successful, and quietly confident, gazing dispassionately out at us. A late work *(236)*, ten years before his death in relative poverty, shows a face stripped of all pretensions, looking earnestly, not at us, but at himself, judging himself not unkindly but with disinterested truthfulness. It is one of the most moving confessions of personal inadequacy ever made, great art won from personal failure.

PORTRAIT INTERPRETATION

Rembrandt is essentially a master story teller. Sometimes, even in the portraits, he simply puts into our grasp the materials of the "story" and trusts us to enter into it by ourselves. *Portrait of a Lady with an Ostrich-Feather Fan (237)* haunts us with its tranquil sadness, its bravery and

235 Rembrandt, **Self-portrait at the Age of About 21 Years,** *c. 1627, 6¼ x 8 in (16 x 20 cm)*

wisdom. Where do we see all this? Why should we be certain that the unknown lady has a history of sorrow and of exceptional joy? Rembrandt merely puts her before us, with light lingering as if with love on the once-beautiful face, the acceptant hands, the great, free sweep of the feather. Sometimes, though, he plays out

236 Rembrandt, **Self-portrait,** *1659, 26¼ x 33 in (66 x 83 cm)*

237 Rembrandt, **Portrait of a Lady with an Ostrich-Feather Fan,** *c. 1660, 32½ x 39 in (83 x 100 cm)*

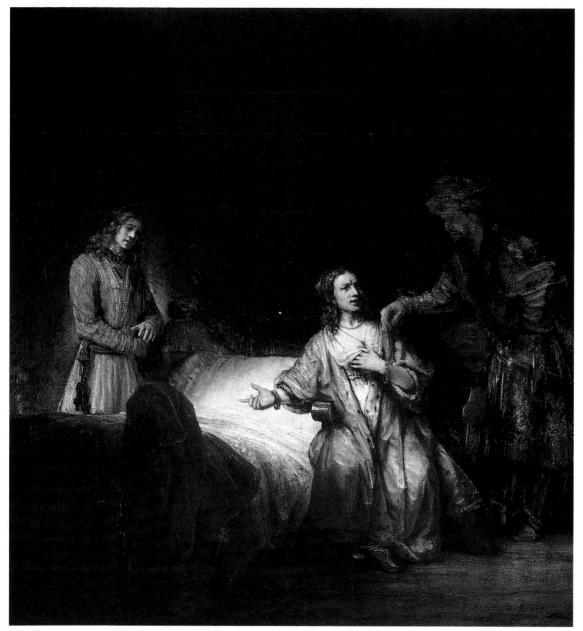

238 **Rembrandt,** Joseph Accused by Potiphar's Wife, *1655, 38½ x 41¾ in (97 x 105 cm)*

the story for us, counting upon our educated knowledge of the context. *Joseph Accused by Potiphar's Wife (238)* is an incident from the book of Genesis that has intrigued many artists. Old Potiphar, his young wife, and a handsome young Jewish slave: the outcome is as might be expected, except that Joseph is one of the heroes, and he repulses his master's wife and her advances. Woman scorned that she is, the wife accuses Joseph of attempted rape.

Rembrandt makes no distinction here between virtuous and vicious: all merit his compassion. Central is the wife, shifty of eye, false of gesture, clearly not really expecting to be believed. Sad in the shadows, Potiphar listens, and as clearly, does not believe. He knows his wife, and knows his servant. Chivalry ties his hands. The miracle

is that Rembrandt makes us see all this marital interplay, and the sorrow of it, neither party able to be truthful with each other, yet hating the falseness. Ignored amid the passionate privacies of husband and wife, Joseph waits for his public disgrace. He is wholly unassertive, unaggressive, and – most movingly – unself-pitying. He too understands that Potiphar cannot afford to ignore his wife's histrionics, and in a sense, it is only Joseph, the victim, who is capable of accepting the situation. Without a single overt sign, Rembrandt makes us aware that Joseph commits his cause to God, and rests in peace. The wife is isolated in her finery, concerned only with herself. Even the hand meant to gesticulate toward her rapist is not directed at him, but at his red cape hanging over her bed. Her other hand

NEW DISCOVERIES

Rembrandt's *The Jewish Bride* was recently cleaned and unveiled in its new condition at the Rijksmuseum, Amsterdam in 1993. During the cleaning process restorers subjected it to analysis by X-ray, microscope, and infra red spectroscopy. They discovered that the artist had originally depicted a more erotic pose with the woman sitting on the man's lap, which was then a symbol of sexual intimacy. Rembrandt's changes gave infinitely deeper meaning to this celebration of married love.

presses painfully to her breast. She is suffering, not only from her sexual rejection by a younger man, but from her own awareness of her life. Rembrandt involves us in her personality, just as he does in the unbelieving husband, who reaches out, not to her, but to her chair, the material realm where these two have their only contact. Joseph is lost in the gloomy vastness of the chamber, yet a faint nimbus (an emanation of light) enhaloes him.

Rembrandt has allowed light and color to tell us the meaning of the event and make it move us with its inextricable human complexity and its profound sadness, redeemed only by blind faith in an unseen Providence.

JEWISH BRIDE?

Perhaps the greatest and most profound of all Rembrandt's works is the mysteriously entitled "*Jewish Bride*" (239). This is our title, since Rembrandt left the work unnamed, and it is a suitable title because no viewer can help but be stirred by the picture's sense of the sacred, and the biblical garb suggests that the couple are

Jewish. Who these two people are we shall probably never know, but they are clearly married. Both are past their first youth; they are plain in looks and rather careworn, though splendidly attired in oriental garb.

The husband enfolds his wife with an embrace of heartbreaking tenderness. One hand is on her shoulder and the other on the gift of his love, the golden chain that hangs on her breast. This chain is gold, it is his gift; it is still a chain. It is this aspect of love, that it binds, that its wonder is inseparable from its weight, that seems to preoccupy the woman. She is weighing up the responsibilities of loving and being loved, of receiving and of giving. It is not by chance that her other hand rests upon her womb, since children are the ultimate responsibility of married love.

Love binds, love weighs, love is the most serious experience that we can ever know in our life. It is Rembrandt's awareness of this profound truth, and the glorious visual beauty with which he makes it accessible to us, that makes the "*Jewish Bride*" so unforgettable.

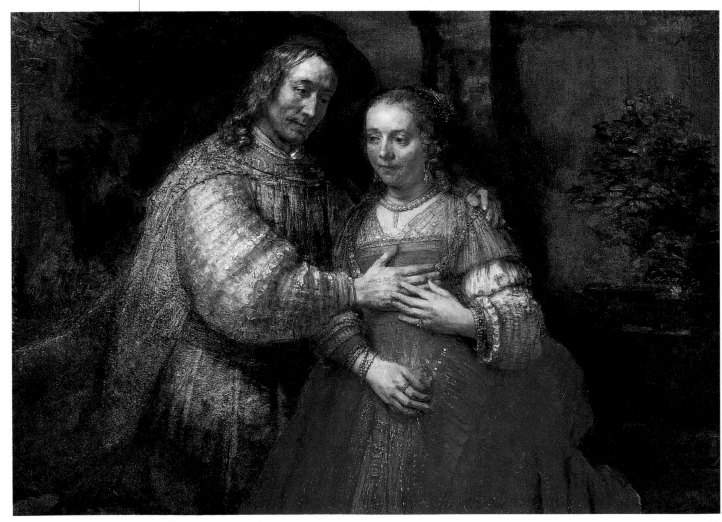

239 Rembrandt, "The Jewish Bride", 1665–67, 66 x 48 in (168 x 122 cm)

"THE JEWISH BRIDE"

"The Jewish Bride" is one of Rembrandt's late works, and one of his most beautiful. Its superb harmony, of red and gold and warm browns, is built around the most profound and compassionate insight into human relationships. It received its current title only in the 19th century, a title that implies that this could be an imaginary portrayal of one of the celebrated biblical marriages: Tobias and Sarah, for instance, or Isaac and Rebekah. But the couple's dress and jewelry, together with the powerful sense of two distinct, living personalities, suggests rather that it is a portrait of an unknown couple.

CARING EMBRACE
This is surely one of the most tender of all paintings. Few depictions of mortal love reveal such depth with such subtlety. His hand lies flat across her bosom, symbolically as well as physically tender. Her hand rests on his, with the gentlest pressure, both acknowledging and returning his caress but again delicately, as though the full significance of their union lies deeper within.

AUTHENTIC EXPRESSION
Despite the opulence and beauty of the wedding costumes, the overwhelming impact of this great painting lies in its simple emotional authenticity. The groom is a little care worn, his hair is thinning, and there are lines around his mouth and eyes. He makes no grand displays of devotion, and there is no sense of male victory but rather a quiet certainty as he inclines his head toward her, lost in thought almost as though listening to her thoughts. They do not formally address us as witnesses to their betrothal, and the intimacy is such that we feel we are intruding upon a very private moment.

SHIMMERING SLEEVE
The great billowing sleeve swells out like soft golden armor. The paint is heavily built up, and Rembrandt has used short, staccato brushstrokes to re-create the many little pleats and folds that shimmer in the light. Touches of thick white paint provide the brightest points. Thick, encrusted paint glints and shimmers across the surface of the canvas, and one senses that their costumes are stiff and heavy, expensively brocaded. The bride's jewelry is picked out in dots and blobs of paint, again highlighted with white.

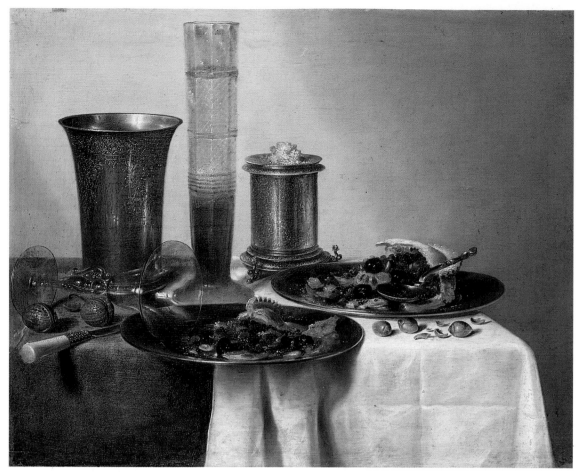

240 *William Heda,* Still Life, *1637, 21½ x 17¾ in (55 x 45 cm)*

THE DUTCH STILL-LIFE TRADITION

Humankind, fashioned from earth and spirit, and forever struggling toward the goal of integration, fascinated Rembrandt; still life did not greatly attract him, yet in his own milieu we find some wonderful examples of this genre.

A still life may be said to make a statement, while Rembrandt asks a question. And yet there is infinite curiosity in a work like Heda's (Willem Claesz, 1597–1680). His *Still Life (240)* of a tablecloth, silvery in the light, gleaming with goblets and glasses and wide plates and littered with the remnants of a meal, is painted with the utmost dignity and respect.

De Heem (Jan Davidsz, 1606–1683/84) paints a *Vase of Flowers (241)* as time defied, nature held eternally in a radiant present for our delectation; it is the other pole of the genre. Heda is silent, and de Heem sings aloud with pleasure: both enhance for us the meaning of the ordinary, achieving the same effect, in their own smaller fashion, as does Rembrandt. One might suspect that something in the Dutch temperament responds to the quietness of a still life. It demands from the artist the ability to discard the heights and lows of drama; which suggests, does it not, the flatness of the Dutch landscape?

RADIANT TRANSPARENCY

One of the glories of a great still life is that it is as great in the parts as it is in the whole. This is the aftermath of a meal, but the uneaten nut is a whole world in itself, the fallen glass has a radiant transparency, and we can pick out every detail of the scene with increasing pleasure. Notice how the light gleams on the edge of the knife blade, how the tankard changes in tone when we see it through the bell-shaped end of the glass. Heda shows refraction changing the outline of the tankard and the play of light.

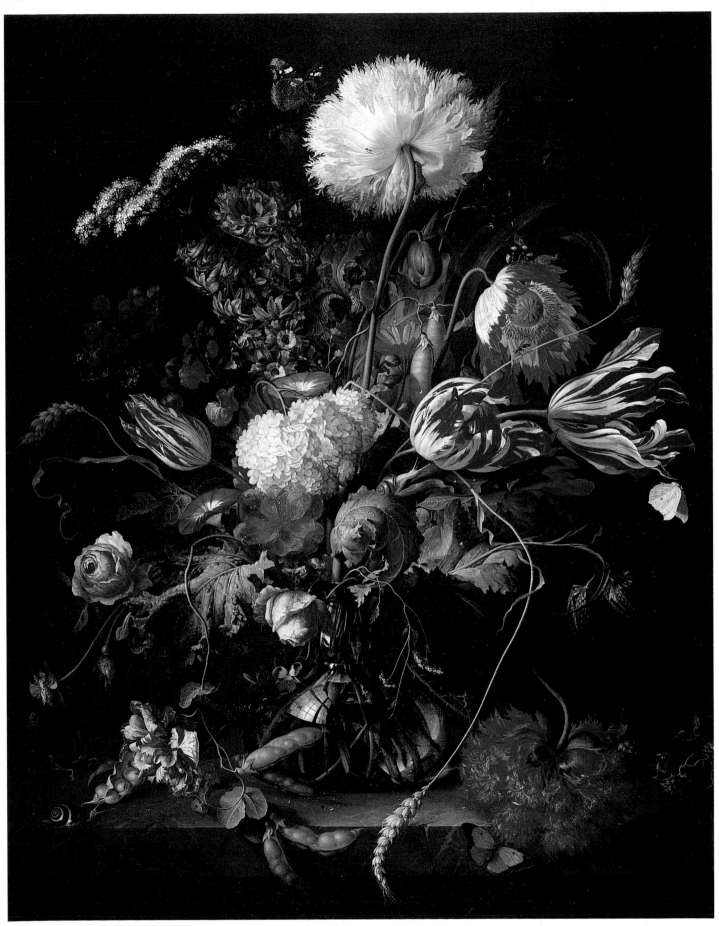

241 *Jan de Heem,* Vase of Flowers, *c. 1645, 22½ × 27 in (57 × 68 cm)*

OTHER WORKS BY VERMEER

The Little Street (Rijksmuseum, Amsterdam)

A Lady with Her Maid (The Frick Collection, New York)

Interior with an Astronomer (Louvre, Paris)

Interior with a Music Lesson (The Royal Collection, Windsor Castle)

Head of a Girl with a Pearl Earring (Maurits-huis, The Hague)

Interior with a Girl at a Window (Gemäldegalerie, Dresden)

THE SILENCE OF VERMEER

There is something about the reverent awareness of the still life painter that reminds one of the great solitary of 17th-century Holland, Jan Vermeer (1632–75). He was not literally solitary, having 11 children and a powerful family of in-laws, but none of the hubbub that must have filled his small house is ever evident in his miraculous paintings, far less any suggestion of family.

Vermeer does not need brightness in his paintings. *Woman Holding a Balance (242)*, for example, has the shutters almost closed, with light stealing obliquely around the edges. It catches the downy fur on the lady's jacket, the decorated linen that falls gracefully around her tilted head, the pearls gleaming on the shadowed table. It glances off a finger here and a necklace there, but it insists only on its silence. Silence "expresses" the purity of what exists: pure because it exists. This picture has some symbolism in that the lady is testing her empty balance, and the picture behind her shows the *Last Judgment* (see right).

But the meaning is equally in the "balance" that we experience in the actual painting: darkness and light are held in dynamic equilibrium, and in fact the picture as a whole displays a variety of balances – warm human flesh against the silky and furry garment, the unstable human hand against the frozen certainties of metal.

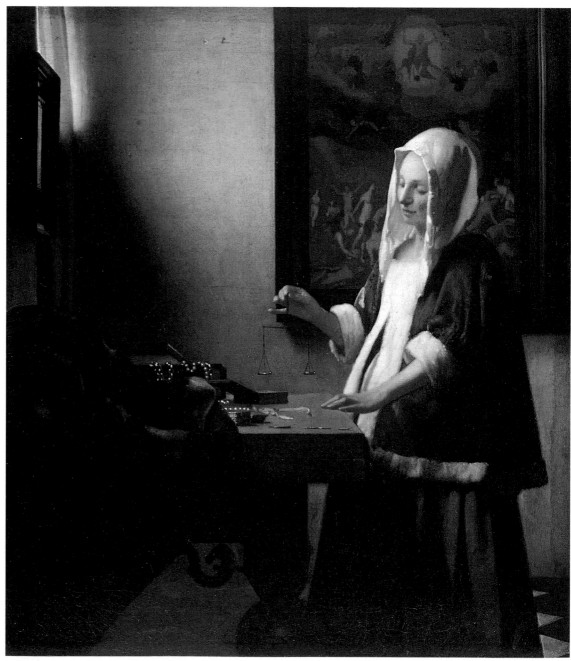

242 Jan Vermeer, **Woman Holding a Balance,** *c. 1664, 15 x 16¾ in (38 x 42 cm)*

WOMAN HOLDING A BALANCE

This painting is also known as *Woman Weighing Gold*. It is a solemn, allegorical work, in which a young woman stands before the symbols of her material wealth, weighing them for their value, whilst behind her, in the painting on the wall, the figure of Christ can be seen "weighing" souls. The young woman is clearly pregnant, and it is significant that the two strongest accents of warm orange/gold do not emanate from her jewels or her gold but from the small window, high up in the wall, from which the light falls directly onto her stomach. It is tempting to read deeper meaning into this, as comparisons with annunciation paintings (see for example pp.50, 63, 86, and 92) unavoidably spring to mind.

MOOD OF CONTEMPLATION
Her knowing expression, with gently tilted head and almost closed eyes, shows her to be more than just idly enjoying her treasures. Rather, she is at a moment when she contemplates the meaning of value itself. She is dressed richly but simply, her head covered by a plain white hood that is "beaded" with drops of light. On the wall opposite her is a mirror, suggestive of her quiet self-contemplation.

JUDGMENT DAY
The painting on the wall is a version of the Last Judgment *possibly by the 16th-century Flemish altarpiece painter Jean Bellagambe (c. 1480–c. 1535). The air of serenity and contentment in the quiet room contrasts with the pitiful chaos of the damned, who are painted as flat, dim silhouettes behind the intensely vital, living form of the woman.*

A SIMPLE BALANCE
The woman will weigh her gold and pearls on a delicate brass balance with a gesture of infinite grace. The balance is rendered so finely that in parts it is barely visible, and touches of glimmering light shine on the empty pans. This is appropriate since we are again reminded of the other, final weighing depicted behind her.

FAMILY VALUABLES
A rich blue tablecloth has been pushed back, and scattered over the table top, spilling out of jewelry boxes, is her collection of pearls and gold. Each little orb consists of a single droplet of light, made from individual touches of paint that are jewel like in themselves. The flat coins, or gold weights, are given a sense of roundness by just the slightest highlight.

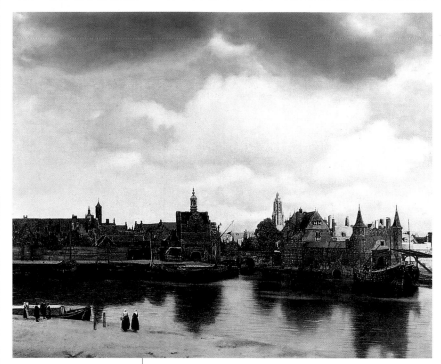

243 Jan Vermeer, View of Delft, 1658, 46 x 39 in (117 x 100 cm)

CAMERA OBSCURA

The camera obscura (Latin, "dark chamber") was a device used to create an accurate reproduction of a panoramic view or an interior. A pinhole would be made in one side of the box, allowing light to enter. The rays would cross as they passed through the hole and would then fan out, creating an upside-down reduced image on the wall. The artist could then paint a scene with accurate perspective. Vermeer is thought to have used a cubicle-type camera obscura to paint his interiors. A portable camera obscura known as the tent-type (shown above) was also popular.

We come to believe that Vermeer's pictures have a reality – not like everyday reality, but greater, less fragile. It is his unique triumph to concentrate with absolute – or so it seems – optical fidelity on the minutiae of material things. Every texture has its complete integrity in painterly form. He elides, of course, but we are unaware of it, and this sense of total truth, offered to us through a reverence for what is bodily present, effortlessly acquires a sense of the spiritual.

TRANSCENDING THE CITY

The French writer Marcel Proust, who centred his whole literary work upon the recovery, alive and powerful, of memory, thought *View of Delft (243)* the greatest work ever painted. On one level, it appears so unassuming: a topographical setting-out of the appearance of this Dutch city. Vermeer is not inventing, only describing. But he takes the bare facts of the city and its approaches and, without manipulation, renders them transcendent.

That city shining out at us across the water is both Delft and the heavenly Jerusalem, the city of peace. It offers profound variety, not in extravagance but in its simple mixture of roofs and towers, of churches and houses, of sunlit areas and swathes of lovely shadow. Overhead, the sky arches, the rain clouds lift and disperse, the lofty area of blue almost visibly grows.

The tiny figures on the near quayside are vital: they are us, not in the holy city yet, still sundered and yearning, but with great hope.

Boats are moored and no obstacle presents itself. It is the utter ordinariness of the scene that is so piercingly evocative of the Paradise world. Even when Vermeer paints a *Kitchen Maid (244)* he bathes the kitchen in a quiet radiance. She is merely pouring out milk, but there is a sense of luminous stillness, of time gently slowed, of body translucent with soul, of secular holiness. The simplicities of her yellow bodice and her blue working apron gleam out at us, not beautiful in themselves, but beautiful because light makes all it shines on share its own brightness. Her plain, broad, peasant face is lost in absorption with her task, rather as we think Vermeer must have been as he painted her. He is one of the artists who is immediately accessible, which makes his years of neglect all the more astonishing.

HALS'S BRAVADO

Frans Hals (c.1582/83–1666) also knew neglect, but his case is not the same as Vermeer's. We can sympathize with the bewilderment, for example, of the wealthy Coymans family at seeing the finery of young *Willem Coymans (245)* depicted by a rash dribble of paint, with rough slashes pleating his linen sleeve and a rather brutal sensuality lightly informing his face. Willem himself, however, may well have liked his portrait very much indeed (Hals's patrons tended to be delighted with his versions of them).

Willem has a daredevil gallantry, a look of dissipated splendour that any young man might find highly appealing to his self-esteem. Hals does not delve deep into personality like Rembrandt (see p.200) or contemplate all sitters under the noble light of Vermeer (see p.208).

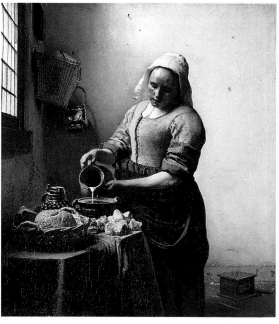

244 Vermeer, Kitchen Maid, 1656–61, 17¾ x 16 in (45 x 40 cm)

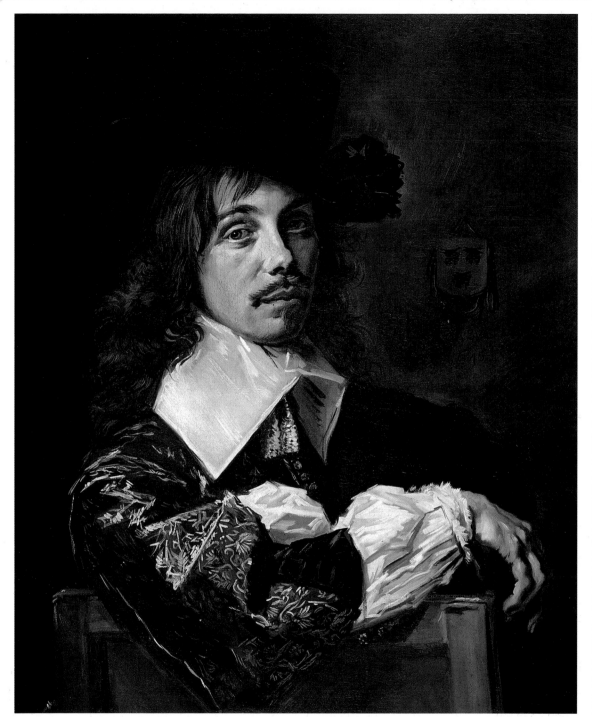

245 Frans Hals, **Portrait of Willem Coymans,** *1645, 25 × 30½ in (63 × 77 cm)*

He first made his reputation with a series of portraits, ranging from the celebrated *Laughing Cavalier* to a variety of low-life sketches of gypsies and drunkards, which were all painted in the years 1620–25 and were all delightful renderings of the nuances of expression in the sitters' smiling or leering faces. Hals' family came from Antwerp in Flanders and moved to Haarlem, in the Protestant North, when he was just a child. One is tempted to imagine what he would have produced had he stayed in the Catholic South, where his inclination towards extravagant display would certainly have found a wider field of expression than that of portraiture. Hals paints what he sees, with a sort of daredevil carelessness. He leaps upon the tightrope of pictorial art, rarely stumbling, but astonishing us with his emphatic facility. He achieves "the mostest with the leastest", to adapt the words of an American general.

Much of the work of Hals appeals to us because of its light, virtuoso quality, but in his impoverished old age he rose to a gravity that puts the stamp of greatness on his work.

**ALLA PRIMA
TECHNIQUE**
Until the 17th century most artists who used oils underpainted their surfaces first, to achieve a consistent surface. Frans Hals was one of the pioneers of the *alla prima* (Italian for "at first") technique in which the paint is applied directly to the ground without underpainting. The effect of this technique is clearly visible in the broad brushstrokes and spontaneous textural qualities of much of Frans Hals's work. With the development of better pigments in the 19th century, the technique became more popular.

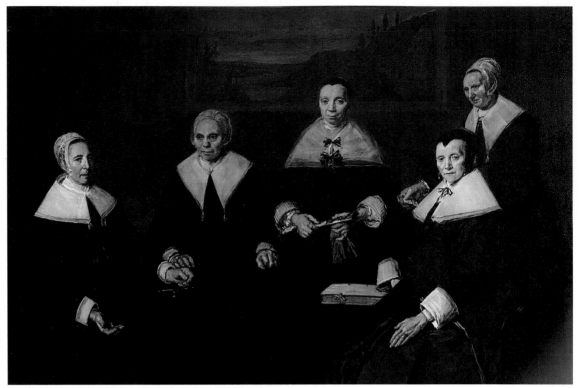

246 Frans Hals, The Women Regents of the Haarlem Almshouse, *1664, 8 ft 2 in x 5 ft 7 in (250 x 170 cm)*

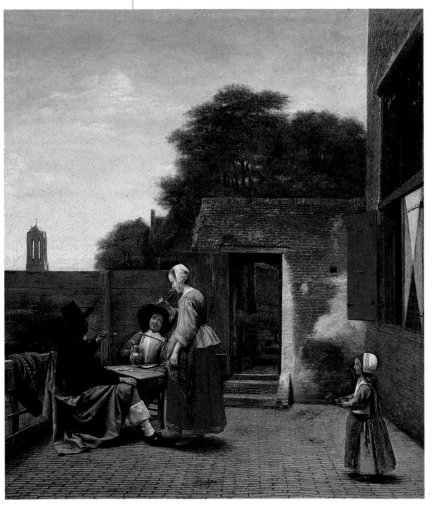

247 Pieter de Hooch, A Dutch Courtyard, *c. 1660, 23 x 27 in (58 x 68 cm)*

His *Women Regents of the Haarlem Almhouse (246)*, painted shortly before the artist's own almshouse death, is a totally serious picture. He has forgotten the ego that spurred him on to witty bravura. Here he shows us not merely the outward look of these tired and elderly women, but something of their individual personalities, and something of their corporate attitude to the responsibilities of their office.

DUTCH GENRE PAINTING

Pieter de Hooch (1629–84) has the uneasy distinction of making us aware of how great is Vermeer. De Hooch is a semi-Vermeer – all the ingredients but lacking the magic. It is as if some of Frans Hals' worldly confidence had seeped into the work, making it parochial.

Yet of course, it is the celebration of the parochial that gives de Hooch his charm, a very real charm, inadequate only in comparison with the very greatest of his contemporaries. *A Dutch Courtyard (247)* has an enchanting immediacy, with its occupants "snapped" as if by a camera. The sense of reality is seductive; at any moment the girl, we feel, will go inside through the open door, and we will go with her. The illusion is of a merely temporary pause in activity, of daylight and weather, of work and play.

This feeling of time held still and on the point of moving forward is also the beauty of *The Skittle Players Outside an Inn (248)* by Jan Steen (1626–79). Much of his work has a coarse vitality,

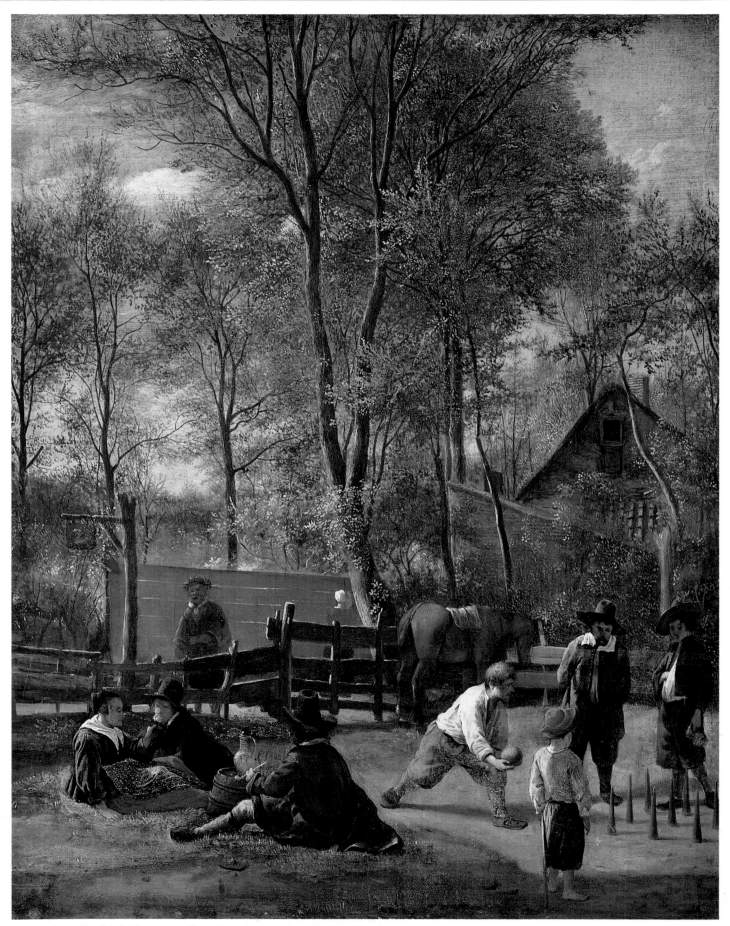

248 *Jan Steen*, **The Skittle Players Outside an Inn**, *c. 1652, 10½ x 13 in (27 x 33 cm)*

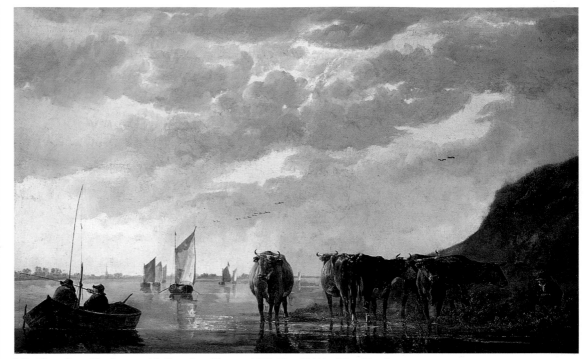

249 Albert Cuyp, **Herdsman with Cows by a River,** *c. 1650, 29 x 17 ¾ in (73 x 45 cm)*

with peasants junketing and a general air of happy vulgarity. But this painting is marvelous, evocative of an evening in early summer, with the viewer made privy to a moment of calm enjoyment. Calm enjoyment is also the constant theme of Albert Cuyp (1620–91), the enjoyment being mostly on the part of cows, which are washed in a heavenly golden radiance, inhabiting a natural paradise on our behalf *(249)*. The herd stands peacefully in the stillwaters, the ships move past them slowly into the light. It is essentially a communication of serenity. Sunlight and its bovine enjoyers do not seem the stuff of great art, and this is one of the enchantments of the Baroque. It makes its beauty out of the ordinary with great gusto. Often the focus is on the land or sea, flat fields becoming as spaciously beautiful as the romantic mountains of earlier or later art.

Jacob van Ruisdael (1628/9–82), can take a *Forest Scene (250)*, a tangle of trees and glimpsed water, a great dead horizontal of stricken branch and root, dark skies forming and humankind departing, and without tidying it up or making a moral, give us a moving depiction of the tangle of our complex and vulnerable lives. He has a greater weight than any other Dutch landscape artist. There is almost a sense of a tragic dimension, but never one without hope. His uncle, Salomon van Ruisdael (c.1600–70), works the same magic with river scenes.

Pieter Saenredam (1597–1665), focusing on another aspect of the workaday, takes us into the great spaces of church interiors, like

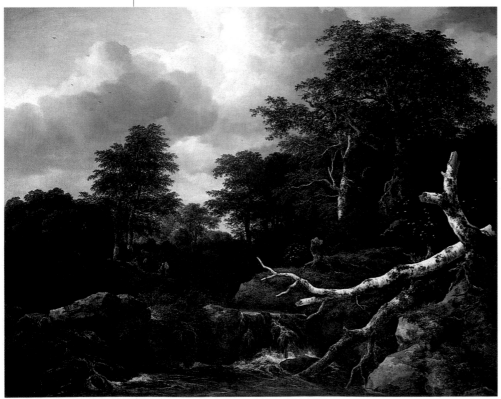

250 Jacob van Ruisdael, **Forest Scene,** *c. 1660/65, 51½ x 41 in (130 x 105 cm)*

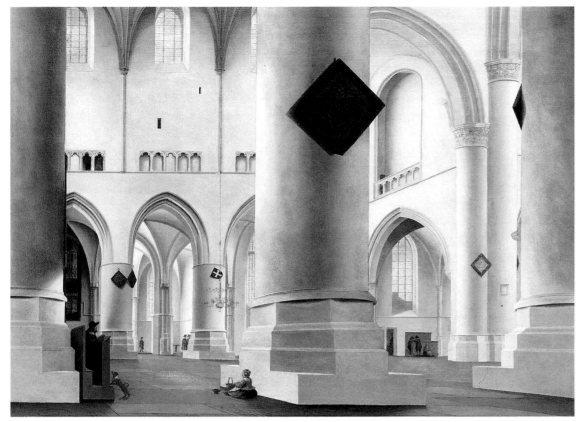

251 Pieter Saenredam, **The Grote Kerk, Haarlem,** *1636–37, 32¼ x 23½ in (82 x 60 cm)*

The Grote Kerk, Haarlem (251). The play of light on these silent architectural masses has an almost Vermeerish profundity, a strange immediacy. It would be easy to get carried away into speculation about the meaning of "interiors," which these pictures seem to be about, and so it is useful to remember that Saenredam, who specializes in church interiors, somehow also manages to get the same "inner" quality when he paints church exteriors.

The Dutch seemed to have an insatiable love for the actualities of their surroundings: their Calvinism, however tolerantly held, makes the idea of explicitly religious painting unappealing, and we can feel a great weight of quasi-religious significance being quietly removed, to rest upon landscape, still life, and portraiture. There was still room for the so-called "history" painting genre, but the most popular narrative painting was that of Gerard Dou (1613–75).

Dou's works were small, exquisitely finished, and technically perfect. Although this praise sounds rather mechanical, there is no doubt that, at his best, Dou well deserved his reputation. These small, jewel like pictures still delight and allure: it may be for the sheer contrast between their tiny size and their intensity of focus. Dou had been Rembrandt's pupil, but he seems to have taken little of the master's spirit. The cluttered but brilliant cave interior of *The*

Hermit (252) has Dou's own technical intricacy but nothing of Rembrandt's spiritual intensity, and they remain essentially genre works.

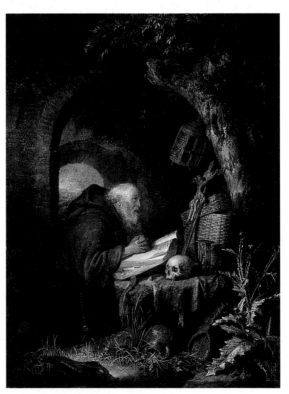

252 Gerard Dou, **The Hermit,** *1670, 13½ x 18 in (34 x 46 cm)*

France: a Return to Classicism

Dutch painters loved landscape, and they acquired great skill in its depiction, but the great names in landscape painting in the 17th century were French. Foremost among these were Nicolas Poussin and Claude Lorrain, who both lived for years in Italy and were strongly influenced by Italy's natural Classicism, however dissimilar they were in other ways.

PIERRE PUGET

Recognized as the greatest French Baroque sculptor, Pierre Puget (1620–94) originally trained as a ship's sculptor in Marseilles. His earliest work is on the portals of the town hall in Toulon, completed in 1656. He created his most famous work, the *Milo of Crotona*, for Louis XIV's palace at Versailles. The sculpture shown above, *The Assumption of the Virgin*, is now in Marseilles.

The lure of Rome, the heartland of the Baroque style, was strong in the first half of the 17th century, so much so that the French painting tradition, which was classical at heart, was considerably weakened by the exodus of artists. Among these was Nicolas Poussin (1594– 1665), who enjoyed considerable fame in Rome and painted many important works there. It took the persuasive powers of Louis XIII and his chief minister, Cardinal Richelieu (see p.223), to entice Poussin back from Rome in 1640.

The king had made previous attempts to rejuvenate the French tradition in painting, but he had met with little real success. A tradition still existed, and was even growing, in France, and it was both delicate in palette and dignified in approach. But the French School did not develop until Poussin's arrival from Rome. His art drew on Carracci's legacy of Venetian harmony and ideal beauty (see p.182). In Italy, he had studied the High Renaissance masters, together with antique sculpture, and he was also influenced by the arch-classicist Domenichino (see p.183), who was 13 years his senior and who ran a successful workshop in Rome.

Poussin's art represents a rejection of the emotional aspects of Italian Baroque, but at the same time sacrifices none of the Baroque's spiritual intensity and richness – which distinguishes him from Neoclassical art (see p.256).

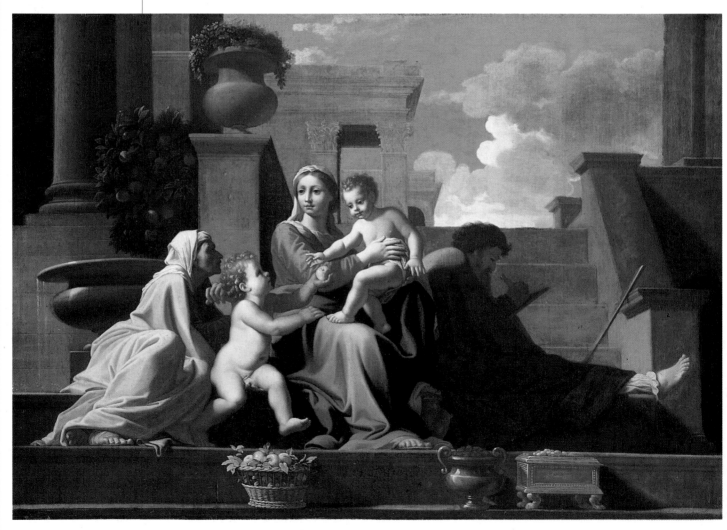

253 Nicolas Poussin, **The Holy Family on the Steps,** *1648, 38½ x 27 in (98 x 68 cm)*

In a sense, his aims in painting have more in common with those of the Renaissance artists (see pp.79–138). Poussin brought to the Baroque an austere, restrained Classicism, combined with a clear, glowing light.

He is an artist of the utmost intelligence, achieving total integration of every element within his pictures. But it is a visual intelligence, a massive understanding of beauty, so that what could be daunting in its orderliness is radiant with supreme grace. This great painterly intellect moves us rather than convinces us. In the words that John Donne, the 17th-century English poet, used to describe his beloved, it could be said of Poussin that his "body thought." It is this wonderful incarnation of vision in actuality that makes Poussin supreme.

AUSTERE BEAUTY

The Holy Family on the Steps (253) might seem, at first viewing, not a landscape work at all. This is, broadly, quite correct: the concentration is upon the five human figures in the center. But they form a great equilateral triangle, based upon the long, low step that acts as a plinth and a barrier. Mary is a sacred plinth herself, a holy barrier that holds Jesus up for us to see but is His earthly safeguard. So protected, the naked Child leans down to His nude cousin, little John the Baptist, who is untended by his own mother, St. Elizabeth, all of whose longing attention is fixed upon Mary's Child.

Balancing her, humbly seated in shadow, sits St. Joseph, whose elegant feet emerge into astonishingly clear light. Three objects line the lower margin: a basket of fruit, symbolic of the world's fertility that will spring from this family – a fertility of grace. Near Joseph, as if under his care, are two containers – a classical vase, reminiscent of the Greeks, and a box, which recalls the eastern kings and their costly gifts.

Material riches lie at the base, then, and from here the painting soars up, the eye being led by balustrade and pillar, to the porticos that open on infinity and the endless sky. The Holy Family is clearly not sitting on the steps of a real building: this is more an idealized version of an entrance, though it lacks symmetry. The glories of this world are asymmetrical; only the perfect balance of the Holy Family has the beauty of pure rationality. The center is an apple offered to the Holy Child by our representative, John.

The fruit of the fall is here redeemed, and the discreet orange trees indicate that redemption has now happened. There is fruit galore, fruit for us all. Mary holds Jesus almost as if he is living fruit, and at once we pick up eucharistic resonances. In Poussin there is always subtlety

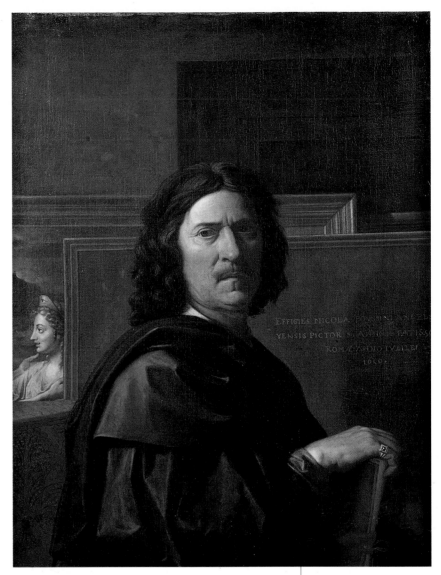

254 Nicolas Poussin, Self-Portrait, 1650,
29 x 38 in (73 x 97 cm)

upon subtlety, but at no time is it either forced subtlety or mere conceptual cleverness. He takes his concepts into his own depths, and there he finds their proper form. This painting is of an ascent, powered by the insistent verticals and made credible by the exquisite placement of continual stepping-stones of horizontals.

The austere *Self-Portrait* in the Louvre *(254)* makes no concessions to vanity. Poussin looks out gravely, with his fleshy nose and secretive eyes, and his lips shut with that firmness so obvious in all his work. He encompasses himself with canvases that are also geometrical intensifiers. His background, he implies, is one of severe order. Yet the only actual picture we see – a young woman being embraced – has a romantic charm. The other rectangles of canvas, as well as the door, are blank, and all the frames are blank. While seeming to expose himself, Poussin is actually preserving his secrecy.

NICOLAS POUSSIN
Poussin aimed to achieve a unity of mood in each picture by developing his theory of modes. According to this theory, the subject and the emotional situation of the painting dictate the appropriate treatment. Poussin also used a miniature stage set to practice composition and lighting for his paintings.

**OTHER WORKS BY
POUSSIN**

*The Crossing of
the Red Sea*
(National Gallery of
Victoria, Melbourne)

*Venus Presenting Arns
to Aeneas*
(Art Gallery of
Ontario, Toronto)

The Nurture of Jupiter
(Dulwich Picture
Gallery, London)

*The Triumph
of Neptune*
(Philadelphia
Museum of Art)

Apollo and Daphne
(Alte Pinakothek,
Munich)

Acis and Galatea
(National Gallery of
Ireland, Dublin)

SHEPHERDS AND ARCADIA

To educated people in the 17th century the name Arcadia readily evoked the pastoral tradition, that easygoing genre of poetry that had developed in parallel with epic writing since the time of the classical Greeks. The tradition stems from the carefree, open-air life that was supposedly enjoyed by shepherds and shepherdesses, who spent all summer guarding their flocks. Consequently they had plenty of time in which to play their flutes and compose love poems, which they might sing to one another, perhaps in a contest.

Best remembered of the pastoral poets were Theocritus in Sicily and Virgil in Italy, whose *Eclogues* are the best remembered of all. Arcadia is mentioned in the *Eclogues*, and occasionally in literature since the Renaissance.

The phrase "*et in Arcadia ego*" cannot be traced to any known source in the classics. It means either "I, the one who is dead, was once in Arcadia too," or "I, Death, am in Arcadia too." The Italian painter Guercino (see p.185) made a painting with this same theme in 1620.

Poussin himself produced two paintings on the "Death in Arcadia" theme. The first (the Chatsworth version) was painted between 1630 and 1632. In it, a group of shepherds discovers with shock that a tomb, with its disturbing message, exists in their idyllic countryside.

They are shown leaning forward in a tense attitude, confronting the fearsome discovery. In the version shown here (the Louvre version, *255*), originally entitled *Happiness Subdued by Death* and painted in 1638–40, the shepherds form a more relaxed group around the tomb. Instead of reacting dramatically they seem to be pondering the meaning of the inscription. Each of the four shepherds is expressing his or her own personal emotional response. Without overemphasis, Poussin makes us clearly aware of those vulnerable humans in all their individuality.

Poussin's Arcadia is a silent place; even the shepherds seem to be communicating by gesture rather than by word. They seem to have found, to their bewilderment, their first evidence of death. It is evidence, too, that their beautiful country has a history, has been lived in and died in, and yet this history has been completely forgotten. They puzzle out the inscription on the tomb with wonder and fear.

What gives this picture its force, of course, is its relevance to our own personal histories. We pass a milestone in human maturity when we come to an emotional understanding of death and of our own relative insignificance in the context of human history. Countless generations lived before us and will live after us. In all the magnificence of their youthful beauty, the shepherds must accept this.

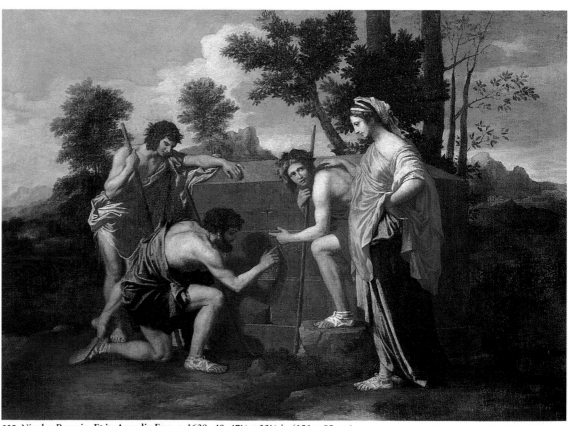

255 Nicolas Poussin, Et in Arcadia Ego, *c. 1638–40, 47½ x 33½ in (121 x 85 cm)*

ET IN ARCADIA EGO

Historically, Arcadia was the central plateau of the mountainous region of southern Greece and was inhabited by shepherds and hunters. But Arcadia was also an earthly paradise, a pastoral idyll celebrated by poets and artists as early as the 3rd century BC. It was the home of romantic love, ruled over by Pan, the rustic god of "all things": flocks and herds, woods and fields. Its native shepherds and shepherdesses shared their simple paradise with nymphs, satyrs, centaurs, and the bacchantes.

SILENT COMMUNICATION
The shepherds and shepherdess respond in different ways to the discovery of death. Some are content to ponder its significance, while others question and decipher. All, however, are silent, revealing their sadness or curiosity through individual gestures and expressions. One young shepherd looks up at the young woman beside him with an especially urgent communication, as though struck with sudden realization of his own immortality.

LANDSCAPE
Although this is one of Poussin's mature works, his treatment of the landscape is not as stylistically developed as is his treatment of form and color throughout the rest of the painting. The line of trees and foliage serves primarily to enclose the scene and act as a backdrop to the main focus of attention, which centers on the discovery of a tomb.

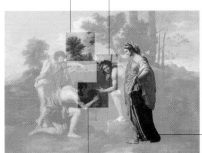

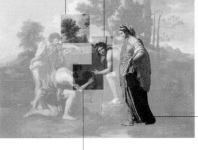

"I TOO WAS ONCE IN ARCADIA"
The inscription is the central focal point of the whole work. All our attention is directed to it, reinforced by the puzzled gestures of the shepherds as they run their fingers over the tomb as though hoping to discover its mysterious identity. The painting takes on the nature of an elegy as they quietly and solemnly contemplate the significance of the words (see left).

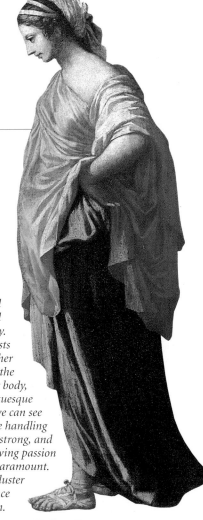

CLASSICAL FORM
Poussin has not portrayed the simple and carefree shepherds and shepherdesses supposed to inhabit Arcadia, but instead classically formed, sober and dignified figures from antiquity. The young woman manifests the classical ideal, with her smooth brow and fine nose, the proportions of her head to her body, and above all, her noble, statuesque bearing. In her figure, we can see Poussin's distinctive late handling of color. It is sharp, strong, and clear, and the artist's growing passion for order and clarity is paramount. The four figures form a tight cluster around the tomb, the balance equally distributed among them.

The Funeral of Phocion (256) shows Poussin's landscape art at its most profound. There is a story in this painting, one of those classic tales of great moral meaning that were so dear to him. Phocion was an Athenian general who argued for peace at a time when the majority was for war with Macedon. His enemies used Athens's democratic system to have him condemned.

Poussin shows this victim of judicial murder being carried to his burial by a mere two faithful slaves. They carry him through a world teeming with antique activity. Behind them the great city can be seen, with its temple, its domed capitol proclaiming Athenian order, its inhabitants peacefully busy at their rightful occupations.

Yet all this outward stability is made into a lie by the sad pair in the foreground, moving disconsolately through the wholly civilized terrain on their uncivilized task. Justice has been flouted, cruelty and envy have triumphed: the great pacific state apparatus grinds on with massive and unreal dignity. The eye is entranced by the sheer intelligibility and interest of the scene, by the nobility of the concept and the beauty of its execution. It is as intense as any poetry, yet the poetry is always epic. Poussin can daunt, but he is worth all our effort.

Claude's pastoral idylls

Claude (Claude Gellée, 1600–82), whose Frenchness was marked by adding "Lorrain" to his name, was a fellow inhabitant of Rome with Poussin. Claude too is a very great artist, but not an intellectual. Where Poussin thought out a work, Claude used his intuition. One understood the classic world, the other entered it by imagination: both visions are wonderful.

Claude is forever making us free of the classical paradise-that-never-was (or at least, not literally) so that it is subliminally the essence of his work. He sees the landscape of the Roman Campagna (a low-lying plain surrounding Rome) as bathed in a golden light, a place in harmony with the nymphs or else with the heroes of the Bible. We feel it is much the same for Claude whether we gaze across the wooded hills with Paris and the three goddesses he must assess to find the most beautiful in *The Judgment of Paris (257)*, or with the biblical Isaac and Rebekah, who have come to celebrate their marriage in *Landscape with the Marriage of Isaac and Rebekah (258)*. The "subject" is not what the title indicates. Paris and Isaac and Rebekah are excuses, pretexts for his venture into the lovely lost world of pastoral poetry.

Other works by lorrain

The Finding of Moses
(Prado, Madrid)

*Landscape with
the Shepherds*
(City Art Gallery,
Birmingham, UK)

*Apollo and the Muses
on Mount Helion*
(Museum of Fine Arts,
Boston)

The Expulsion of Hagar
(Alte Pinakothek,
Munich)

Landscape at Sunset
(Louvre, Paris)

*The Sermon
on the Mount*
(Eaton Hall, Chester)

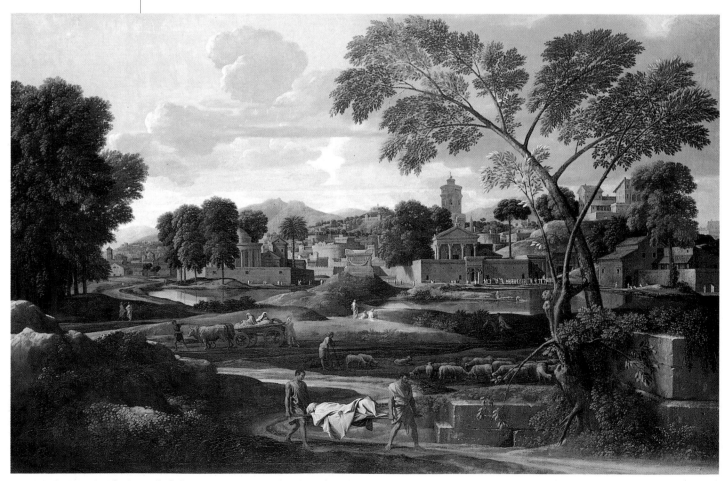

256 **Nicolas Poussin**, **The Funeral of Phocion**, 1648, 28 x 18½ in (71 x 47 cm)

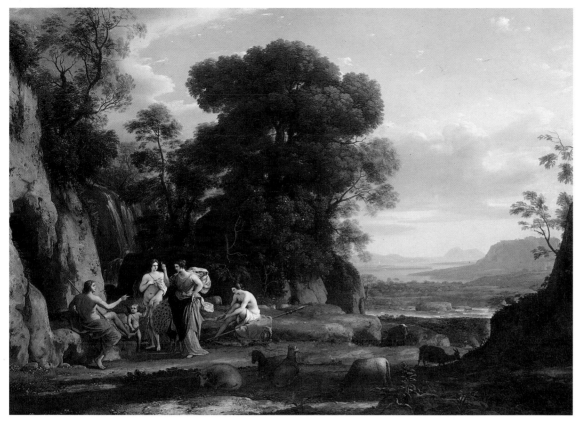

257 *Claude Lorrain,* **The Judgment of Paris,** *1645/46, 59 x 44 in (150 x 112 cm)*

THE JUDGMENT OF PARIS

At the wedding of the Greek hero Peleus to his bride Thetis, all the gods are invited except Eris, goddess of Strife. In revenge she throws down a golden apple inscribed "to the fairest," insisting that Paris, son of the king of Troy, must award the apple to one of three goddesses: Minerva, Venus, or Juno. Venus promises Paris the love of any woman he chooses and describes Helen, wife of the king of Sparta. Paris accordingly awards the apple to Venus, then abducts Helen and carries her back to Troy. This act provokes the Trojan war – in which Paris is fatally wounded.

Both landscapes are made glorious by their trees, by the amazing sense they provide of immense spaciousness. The eye roams untrammeled to the distant hills and follows the curves of the shining waters. It is not a real landscape, but its power to arouse emotion is real.

To the modern eye, *The Marriage of Isaac and Rebekah* might seem to work better than *The Judgment of Paris* if only because Claude's great weakness is thought to be his painting of the human figure. In *The Marriage* the tiny human forms dancing and feasting in the glade are as removed from us in space as they are in time. We stand on a height looking down, and although in the Bible this marriage was an important event for the continuance of the "seed of Abraham," it is the landscape that matters here, that dwarfs the human celebrants into relative insignificance. Claude clearly recognized this by his very title. Yet the landscape, so shadowed, so immemorial, does not fight the theme of marriage; it reinforces it.

In *The Judgment of Paris* we are much closer to the drama. The four actors (five if we include the infant Cupid, who clings to his mother) are fairly large and also fairly individualized. The painting captures a moment at the start of the judgment. Juno, as queen, is the first of the three goddesses to speak, putting her case as the most beautiful to Paris. He is perching rather insecurely on his rock, almost dislodged by the vigor of her approaches. Minerva, as befits a wise woman, abstracts herself from the scene and in so doing becomes its appropriate but unwitting center. It is on her white body, as she leans forward to tie her sandal, that Claude's golden light so lovingly lingers.

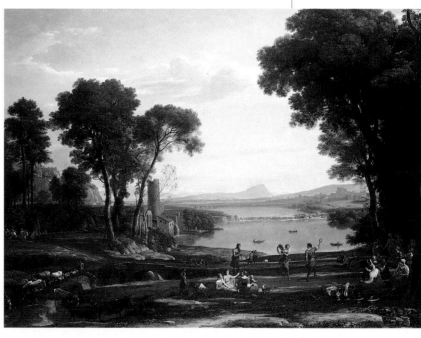

258 *Claude Lorrain,* **Landscape with the Marriage of Isaac and Rebekah,** *1648, 77½ x 58¾ in (197 x 149 cm)*

221

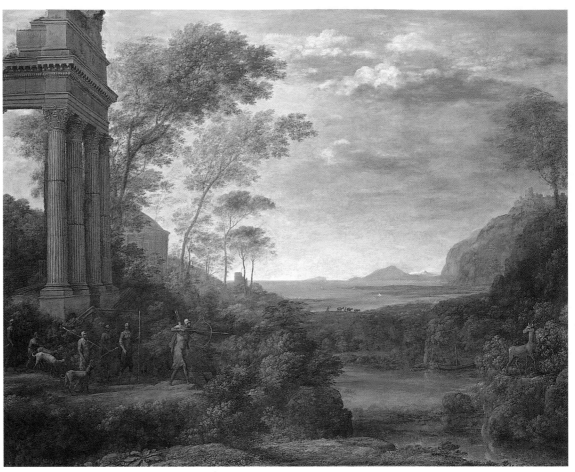

259 Claude Lorrain, Landscape with Ascanius Shooting the Stag of Silvia, *1682, 59 x 47 in (150 x 120 cm)*

Very occasionally theme matters in Claude, as in his last painting, *Landscape with Ascanius Shooting the Stag of Silvia (259)*. Here again is the whole lovely expanse of nature, but this time it is all affected by the dreadful certainty that murder is to be done and the balance of the Italian pre-Roman peace destroyed. Claude homes in on the tension of the one moment when Ascanius would still be able, if he chose, to hold back the arrow. The world waits in fear, and stag and man are locked in puzzled questioning. We need not know the legend to guess what will happen. We have indeed destroyed our sacred stag and brought down upon ourselves the end of peace. All the tragedy of the daily newspaper is implicit in this great painting.

THE ART OF THE EVERYDAY

Poussin, sublime by nature, said that those who painted "mean subjects" did so because of "the weakness of their talents." This obviously has no reference to Claude, but it might indicate why the le Nain brothers and Georges de la Tour were relatively unappreciated. The le Nains took for their subject the humble lives of the peasants. *Landscape with Peasants (260)*, by Louis le Nain (1593–1648) has, in fact, a lovely sweep of dullish scenery that seduces by its resolute lack of excitement. Peasants stand or sit, quiet amid the quietness, unaffected as is the painter by any need to become "interesting."

260 Louis Le Nain, Landscape with Peasants, *c. 1640, 22½ x 18½ in (57 x 47 cm)*

LIGHT AND DARKNESS

Georges de la Tour (1593–1652) did not exactly choose "mean subjects," but he painted with a light-and-shade duality that relates to the Caravaggesque tradition (see p.177), and he did so in a manner that verges on the simplistic. His forms are sparse, his design bare. He was a provincial painter, and his unusual freedom from accustomed conventions might well have seemed inadequate or "mean" to a classicist. *The Repentant Magdalen (261)* concentrates with semibrutal fierceness on the legendary period that the Magdalen, who had been a sinner, spent in lamenting her past. But it seems rather to be the picture of abstract thought. The Magdalen is shown as lost in profound musing, her hand caressing the skull, a "vanitas" motif, which is repeated in its mirrored reflection. The candle – the only source of light – is masked by the dome of bare bone, and the Magdalen does not so much repent as muse. With great daring, the major part of the picture is more darkness, with the young woman looming up out of the shadow like a second Lazarus. It is a work hard to forget, yet its power is difficult to explain. Vulgar? Or spiritually intense?

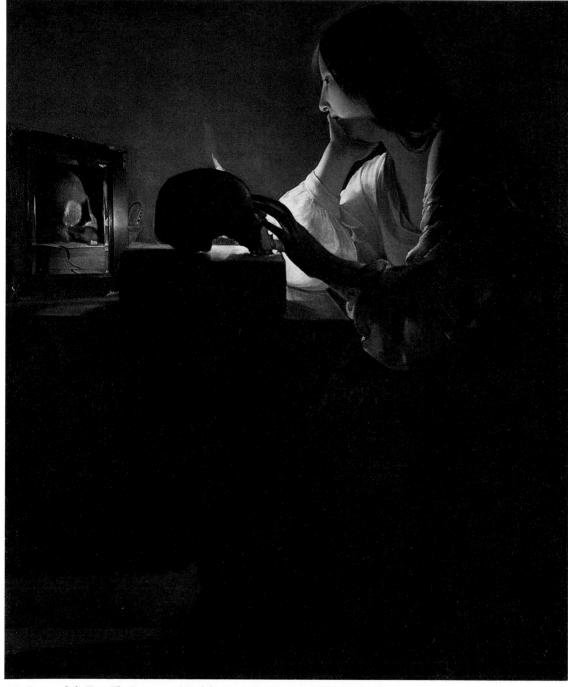

261 Georges de la Tour, **The Repentant Magdalen,** *c. 1635, 36½ x 44 in (93 x 113 cm)*

THE PHILOSOPHY OF DESCARTES

Regarded as the founder of modern philosophy, Descartes (1596–1650) was a French philosopher and mathematician. His *Discourse on Method*, published in 1637, explains the basis of his theory of dualism – "I think therefore I am." He argued that reason reigns supreme and that it is vital to systemize knowledge. The idea of God is so complex that no man could have invented it and so God must have planted the idea into man's mind.

CARDINAL RICHELIEU

Under Louis XIII, France was a weak country, with the Protestant population forming a state within a state. Richelieu (1585–1642) became minister of state in 1624, and his first task was to reduce the power of the Huguenots. He was to remain a vital pioneering force in France until the ascendency of Louis XIV, and he survived many plots against his life. He died leaving Louis XIV in a position of absolute power over a stronger and more unified country.

Rococo

With Antoine Watteau we move into the Rococo era. This style evolved in France and became a dominant influence in 18th-century art throughout most of Europe. The word was not a flattering term (few art labels ever have been); it was coined in the early 19th century, deriving from the French word rocaille. *This was the name of a style of interior decoration that made use of shell patterns and other ornamental stonework. Rococo art was thought of as thin, lightweight, not the serious art of the past.*

The Rococo style emerged in the early 18th century as an exaggeratedly decorative variation of the Baroque. Perhaps, at first, only the French took it seriously; its first great champion was Jean Antoine Watteau (1684–1721). There is an underlying sadness in his pictures that gives a painful note to all his airs and graces, a wistfulness that belongs more to the 17th than the 18th century. Watteau was born in Flanders and lived most of his short life in exile in France. His work evinces a poignant sense of never belonging, of having no lasting stake in the world, that is

FETES GALANTES
Watteau arrived in Paris in 1702 and soon made a reputation as the inventor of a new artistic genre known as *fêtes galantes*. The name means "a feast of courtship" and was coined by members of the French Academy in 1717. It applies to any open-air scene with a mixed company, such as musicians, actors, and flirtatious lovers, all enjoying themselves outdoors. Many of Watteau's contemporaries favored the genre, using it to portray the manners and fashions of the aristocracy.

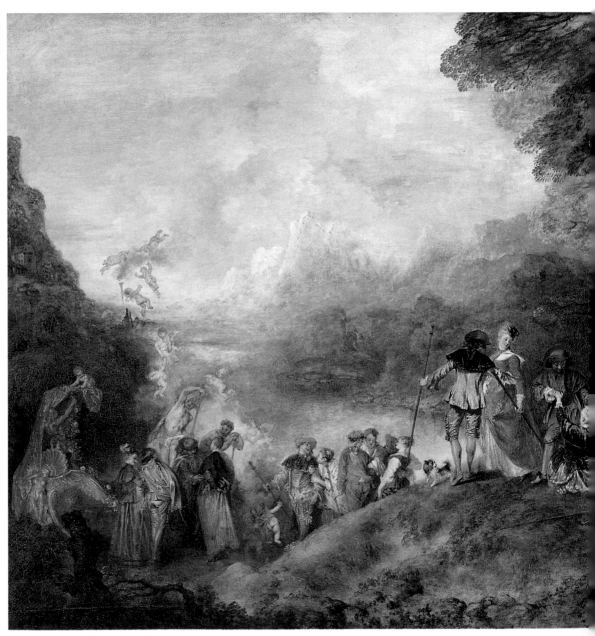

262 *Jean Antoine Watteau, "Embarkation for Cytherea," 1717, 76 x 50½ in (194 x 129 cm)*

specific to Watteau's own circumstances but has a moving relevance to us all. His training and early artistic development took place outside the confines of Paris, which is lucky for us, since the Parisian art world was becoming increasingly academic. He studied in Luxembourg under Claude Audran. Here he was fully able to absorb Rubens's great *Life of Marie de' Medici* cycle (see p.188), and we can see something of the sensual dynamism of Rubens – only in miniature form – in Watteau's delicate paintings.

LOVE AND PATHOS

Watteau was the inventor of a new art genre (though few ever could make his poetic use of it): *fêtes galantes*, in which lovers sang and danced and flirted, always on the edge of loss.

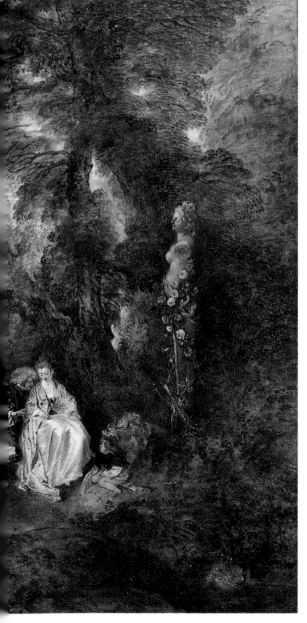

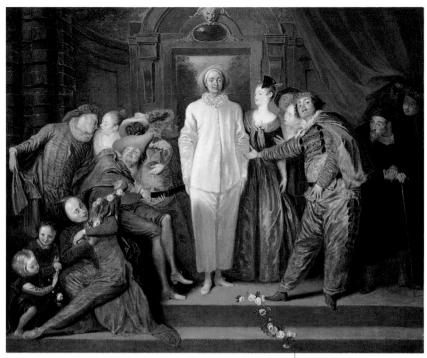

263 Jean Antoine Watteau, Italian Comedians, *probably 1720, 30 x 25 in (76 x 63 cm)*

This example, "*Embarkation for Cytherea*" (262), is in fact misnamed, but has been so immemorially. It shows lovers leaving, not embarking for, the fabled isle of lovers, where they have made their vows to the shadowy Venus who is hidden in the undergrowth. The act of taking vows has made them into inseparable pairs, but they leave with reluctance. Never again will love be so accessible and so certain: in leaving the seclusion of Venus and her bower they set all at risk and jeopardize their happiness. Watteau has no need to make this explicit. His pairs of lovers are satiated with fulfillment, yet move sadly and slowly. Love does not bring joy.

Watteau's other famous theme differs only at the literal level: his many scenes featuring the troupes of actors, Italian or French, who entertained the court. These two nationalities had different approaches to drama, but both traditions were based on the theme of love and its disappointments. *Italian Comedians* (263) has its jester and its gaily posturing actors, its pretty ladies, and its flirtations. But at the center is the strange, tragic figure of Pierrot, taller than anyone else, starkly visible in his silken whites, motionless and heraldic.

There is even a blasphemous echo of Pilate presenting Christ to the mockery of the people, and it is impossible to say that Watteau did not explicitly intend this echo. No crown of thorns, but a crown of flowers lies neglected and rejected on the steps. All gleams, and there is laughter, but we are strangely chilled.

COMMEDIA DELL'ARTE

The Italian commedia dell'arte began as an antiliterary form of theater based on improvisation, with juggling and acrobatics. It had a set of stock characters, the foremost of which were a rich, foolish old man and his clever servant Harlequin. Two others were Columbine and Pierrot, the latter being the embodiment of out-spoken simplicity. With its antiestablishment character it was banned by the French nobility in 1687. In 1716 the Italian actors were recalled by the Duc d'Orléans, Louis XV's Regent from 1713 to 1723. Scripts were eventually written for the commedia dell'arte; these had a delicate verbal style, and often an erotic undercurrent.

DIANA BATHING

Diana (known as Artemis to the Greeks) has several identities: as chastity, and more commonly, as the huntress, in which guise she appears in this painting. To the Romans, she had three personifications: Diana for the earth, Hecate for the underworld, and Luna for the moon – which explains the crescent moon she wears in her hair.

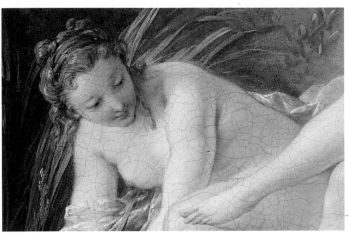

PEARLS

This detail reveals how the surface of the painting is covered in a network of fine cracks. The smooth, uninterrupted finish of Diana's perfect skin seems all the more delicate. Pearls suggest the moon, both in their gentle gleam and their lovely rotundity, and these are Diana's only ornaments. She needs nothing else, suggests Boucher; her godhood is apparent.

ATTENDANT NYMPH

Boucher has chosen to depict Diana after the hunt; to have shown her in active pursuit of game would not have suited his temperament at all. Instead, we are presented with what is essentially a boudoir scene, a fine young lady seated on her expensive silks and pampered by her handmaiden – except that this happens to be the goddess Diana, attended by a reverent nymph who dries her feet, as she rests in a secluded woodland glade.

DIANA'S HOUNDS

Diana as the Huntress is shown with hunting dogs, arrows, and quiver. One of the dogs, alerted by a noise in the undergrowth, lifts its head and sniffs the air. This is an allusion, perhaps, to the doomed mortal Actaeon, who, according to legend, accidentally stumbles upon the scene and, as punishment for beholding the naked goddess, is turned into a stag and devoured by his own dogs.

SPOILS OF THE HUNT

A rabbit and two doves have been strung onto Diana's dainty bow. Diana was often depicted in opposition to Venus, the goddess of love. Here, Venus's attribute of a pair of doves – symbols of love and lust – has been vanquished by chastity. The birds' earthy, vital nature contrasts sharply with Diana's unearthly, pure skin.

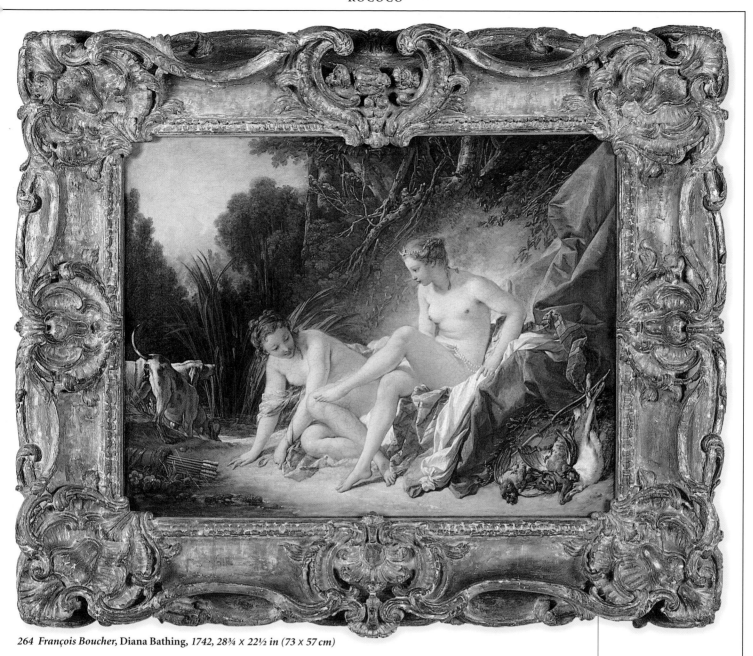

264 *François Boucher,* Diana Bathing, *1742, 28¾ x 22½ in (73 x 57 cm)*

BOUCHER'S SOLID STYLE

After Watteau came François Boucher (1703–70), a fuller and more solid painter, less magical but more robust. This contrast may be the outward reflection of the fact that he was in relatively better health than Watteau, whose constitution was frail. Boucher demonstrates the Rococo fear of the solemn, and his art – more than that of Watteau – reveals the truly Rococo spirit of decoration.

Yet, despite this ornamental spirit, Boucher's entrancing ladies, who are usually shown sweetly displaying to us their naked charms, are not trivial. At his best, Boucher succeeds in making us share in his worship of the female body, its vulnerable roundness, and its essential innocence. There is far more to Boucher than appears at first viewing. He is a great celebrator,

and a work like his masterpiece, *Diana Bathing (264)*, celebrates not only the firmly rounded goddess and her eager companion, but the civilized terrain of parkland as well. This is a cultured landscape, in which the savagery of nature has been tamed.

At the start of the 20th century Boucher was held in very low esteem, seen merely as a decorator and an artist of charm but little substance. His work, in fact, is very out of key with contemporary attitudes, especially feminism. Strangely, however, he has been creeping up in critical esteem as the spirit of his work – which is genuinely reverential – becomes more apparent to the discerning eye. Creative beauty in all its forms moved him emotionally, and his eye dwells as lovingly on the dogs and the riverbank as it does on the nymphs.

MADAME DE POMPADOUR

As official mistress of the French King Louis XV, Madame de Pompadour was a powerful figure in French artistic life. She was a great patron of the arts, commissioning a number of painters and poets, and had a huge influence on the king's policies. She also founded the military school and the porcelain factory at Sèvres.

OTHER WORKS BY FRAGONARD

The Meal on the Grass
(Museé de Picardie,
Amiens)

The Good Mother
(Museum of
Fine Arts, Boston)

A Boy as Pierrot
(Wallace Collection,
London)

The Useless Resistance
(National Museum,
Stockholm)

Bathers
(Louvre, Paris)

Washerwoman
(St. Louis Art Museum)

The New Model
(Musée Jacquemart
André, Paris)

Boucher never ogles, but – and in this respect he is akin to Rubens – he lifts his hat and sweeps low the plumes. *Venus Consoling Love (265)* floats deliciously onto the canvas, one naked goddess and three naked children. They have an eerie similarity, all four, to the fatly feathered pair of nesting birds among the reeds. Nothing here is real or meant to be. But the sense of pleasure in ideal beauty is very real, and makes the work into much more than a triviality.

BEFORE THE REVOLUTION

Fragonard (Jean-Honoré, 1732–1806) followed Boucher. He came from the town of Grasse in southeastern France, which was and is the center of the French perfume industry. Fragonard was a rapid and spontaneous painter. He was as skilled as his teacher Boucher in sharing his pleasure in young women and their bodies, but more alert to their emotions.

Fragonard had a keen and endearing sense of human folly, especially when set in the expanses of the natural world. In his *Blindman's Buff (266)*, a children's game is merrily being played by adults. Despite the light, bright and airy atmosphere there is a sense of foreboding in the painting. The gathering clouds that dominate

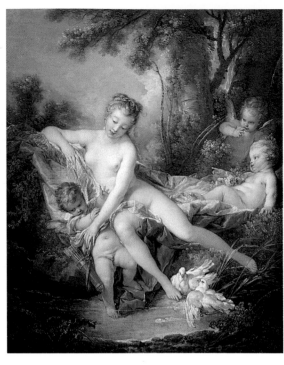

265 *François Boucher,* Venus Consoling Love, *1751, 33 x 42 in (84 x 107 cm)*

half the canvas suggest to us, yet surely not explicitly to the painter, that the French Revolution was to come before his death. The revolution had very unfortunate consequences for Fragonard, as it ruined his patrons and deprived him of commissions. After 1793, despite previous success, he lived in obscurity for the rest of his life.

A Young Girl Reading (267) is aglow with the softest of umbers, the rich color darkening and paling as it follows the girl's youthful contours. Her back is supported by a sort of maternal abundance of rosy pillow, but there is an almost horizontal element in the board under her arm except where her charming sleeve has overlapped its rigid outline. She is intent upon her book, as unprotected as any Boucher nymph.

The sweetness of *A Young Girl Reading*, its almost Renoirish charm (see p.298), should not blind us to its strength and solidity. There is a geometrical framework to the softness of the adolescent reader: a strong, vertical swathe of yellow-brown wall, and the gleaming horizontal bar of the armrest. It is this ability to transcend decoration that distinguishes Fragonard. Look at the girl's neck and bosom: delicious frills and ribbons, and the crinkling descent of the silks, yet there is the firm basis of a real, plump, human body. As in *Blindman's Buff*, the literal theme of this picture is held in an unstated context of solemnity. Like Boucher, Fragonard is more profound than he seems, and his genuine sensitivity is becoming increasingly apparent.

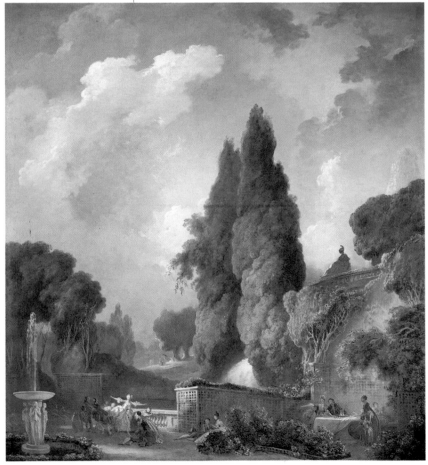

266 *Jean-Honoré Fragonard,* Blindman's Buff, *probably c. 1765, 6 ft 6 in x 7 ft 1 in (198 x 216 cm)*

267 Jean-Honoré Fragonard, A Young Girl Reading, c. 1776, 26 × 32 in (65 × 81 cm)

CHARDIN: WEIGHT AND SOBRIETY IN A ROCOCO ERA

Jean-Baptiste-Siméon Chardin (1699–1779), who is so unlike the pleasure-loving Fragonard, taught the young Fragonard before he found a more congenial mentor in Boucher.

Chardin is categorized as "Rococo" only by date, as it were. Despite his charming choice of subjects, frequently painting small children and young servants, he did not have it in him to create other than from his depth. *The Attentive Nurse (268)* simply shows a young nursemaid preparing the supper egg. She stands in the kitchen engrossed in her task, a colored column of lovely rectitude. The table is laid as for a sacrament: the bread and the goblet take on a sacred significance, and the great white water pitcher has baptismal import.

None of the mysterious significance contained in *The Attentive Nurse* is overt. It is simply that the scene has overtones. The whites here – the cloth, eggs, pitcher, and towel – are so pure; and the pinky oranges in the petticoat and the bread, picked up and intensified in the floor and bowl,

SÈVRES PORCELAIN

In the early part of the 18th century, hard-paste porcelain became highly fashionable. In 1738 Robert and Gilles Debois from Chantilly offered their porcelain-making services to the French royal household. They were paid 10,000 louis and given part of the castle at Vincennes to set up the factory. The company moved to Sèvres in 1753, and Louis XV and Madame de Pompadour began to commission work.

Sèvres porcelain is identifiable by the richness of the colors and the quality and opulence of the gilt decoration. The three most popular colors were *bleu de roi* (dark blue), *bleu céleste* (light blue, illustrated above), and *rose Pompadour* (pink).

OTHER WORKS BY CHARDIN

Still Life with the Ingredients of Lunch (Musée des Beaux Arts, Carcassone)

Vase of Flowers (National Gallery, Edinburgh)

Girl with a Shuttlecock (Uffizi, Florence)

The Governess (National Gallery of Canada, Ottawa)

Soap Bubbles (National Gallery of Art, Washington D.C.)

Woman Working on a Tapestry (National Museum, Stockholm)

268 Jean-Baptiste-Siméon Chardin, **The Attentive Nurse,** *probably 1738, 14½ × 18 in (37 × 46 cm)*

269 *Jean-Baptiste-Siméon Chardin,* **Still Life with Game,**
c. 1760/65, 23½ x 20 in (60 x 50 cm)

are so ruddy with the goodness of health, that
we feel unable to accept the work at face value.
Often in Chardin there are underlying moral
messages or implications, as we see in *The
House of Cards (269)* (life's instability and the
child's ignorance of it) or *Soap Bubbles* (not
illustrated – the uselessness, the vanity in the
biblical sense, of most human activities). But,
paradoxically, the more explicit the moral, the
less its effect.

It is the implicit moralities, like the sacramental
overtones of the nurse with her egg, or the
similar message contained in one of the great
still lifes *(269)* (from one of the greatest of all
the still-life painters) that most move us. The
slaughtered bird and hares, all small and harmless
creatures, lie in solemn state on their altar of the
kitchen ledge. A dusky shadow glimmers on the
wall, and the slab seems lit from within. Chardin
is paying homage to a ritual sacrifice, offered
on our behalf. And not only the animals: the
vegetable world, too, is one of sacrifice, and
Chardin duly bows his head before it.

Chardin never ventured upon what his age
would have considered a major theme: his work
is essentially domestic, quiet, undramatic. It is
his treatment that makes his themes major.

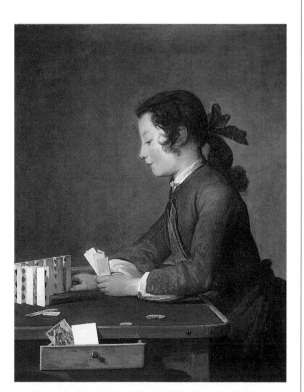

270 *Jean-Baptiste-Siméon Chardin,* **The House of Cards,**
c. 1735, 26¼ x 32¼ in (66 x 82 cm)

ROCOCO
ARCHITECTURE
The most complete
examples of Rococo
architecture are to be
found in southern
Germany and in
Austria. The palaces
of the princes, and the
Catholic churches, are
often good examples. A
fine Rococo building in
Bavaria (Germany) is
the *Residenz* (bishop's
palace) in Würzburg,
designed by Balthasar
Neumann and built in
1719–44. It contains
the famous *Kaisersaal*
(Imperial Room), with
ceiling frescoes by
Tiepolo (see p.232).

LOUIS XIV FURNITURE
During the reign of Louis
XIV great developments
occurred in French
furniture making. One
of the most successful
furniture designers was
André Charles Boulle
(1642–1732), who became
director of works at
Versailles. Boulle employed
a vast army of workers
to create his distinctive
masterpieces, using
extremely high-quality
materials such as silver,
ivory, and tortoiseshell for
the inlays. Another feature
of Boulle furniture was the
heavy bronze-gilt mounts
(illustrated above).

TIEPOLO AND ITALIAN ROCOCO

The Italians also had their great Rococo artists, especially in Venice, where the sway and sparkle of the omnipresent waters make a fitting setting. Giambattista Tiepolo (1696–1770) is the quintessential master of this style; all the decorative vitality and glowing color of the Venetian tradition finds its culmination in him. His exuberance is held under masterly control; he has a natural gaiety that is supremely imaginative and capable of flights of visual wit that have never been excelled.

Tiepolo's greatest work was done mostly in fresco. In these vast, soaring compositions the sheer extent of space to be covered draws his stupendous best. There is, therefore, a pleasing congruity in his often being commissioned to paint ceilings. This he did with enormous panache and skill, something we may miss if we see his work in a museum, where it has been removed from above our heads and pallidly hung upon a wall.

But the great ceiling at the Museo ca Rezzonico in Venice *(271)* still remains in place, arching superbly over our heads and worth any amount of neck craning. It was painted to celebrate the marriage of two Venetian princely houses, the families of Ludovico Rezzonico and Faustina Savorgnan, which Tiepolo does in a delightful allegory. Ludovico, the bridegroom, leans expectantly forward, the lion of St. Mark at his side, holding aloft the banner that shows the two coats of arms united into one. Apollo, the sun god, surges forward in his chariot, bringing the modest bride. Fame blows her trumpet, goddesses, putti, and birds rejoice, and in the distance the goddess of fertility, half concealed, contemplates the face of the child that will be conceived. The mirror of the future is still blank, but the glory Tiepolo has created makes it impossible to believe that there can be anything ahead but glory.

Tiepolo borrowed the motif of Apollo's chariot and horses from the ceiling of the Kaisersaal at the bishop's palace in Würzburg (see p.231), his masterpiece of 1750–53. Tiepolo brings the same radiant conviction to mythological subjects too. The theme of the painting that is currently entitled *Queen Zenobia Addressing Her Soldiers (272)* has been the subject of much speculation. It is now known to have been commissioned by the Zenobio family of Venice

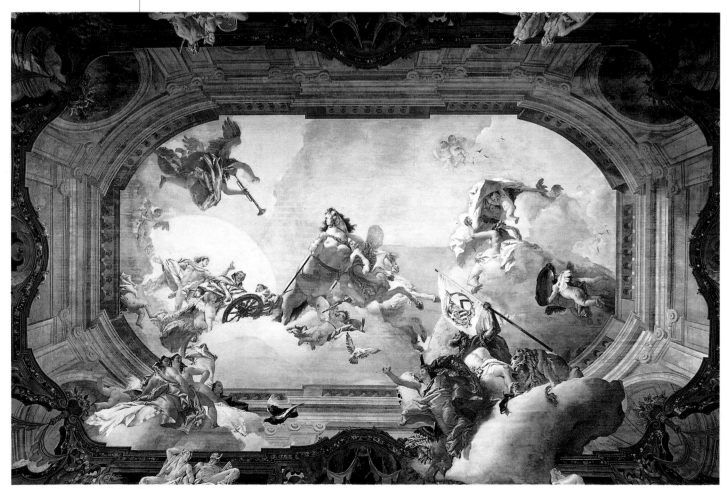

271 Giambattista Tiepolo, **Allegory of the Marriage of Rezzonico to Savorgnan,** *1758*

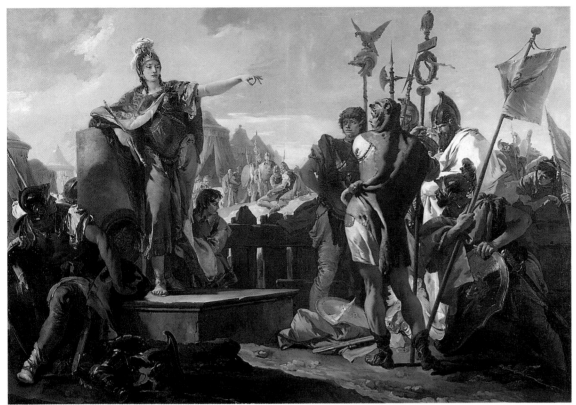

272 *Giambattista Tiepolo,* Queen Zenobia Addressing Her Soldiers, *c. 1730, 12 ft x 8 ft 7 in (366 x 262 cm)*

TIEPOLO DRAWINGS
While it is for his paintings that Tiepolo is most famous, the many sketches he left behind have a considerable reputation of their own. Tiepolo would tirelessly sketch out the characters, and then they would be transferred to his ceiling masterpieces. This sketch (shown above) illustrates Tiepolo's ability to use chiaroscuro (depiction of light and shade) and his grasp of perspective. The woman is believed to be Truth, a mythical personification who appears in several of Tiepolo's paintings.

and that the helmeted female figure is Queen Zenobia. She was an extremely powerful, 3rd-century ruler of Palmyra, but we do not need to know the story behind the painting to appreciate its power. What Tiepolo shows us with brilliant force is the confrontation of male and female, but, in 18th-century terms, reversed. It is the woman who dominates, the men who listen submissively. The woman is all-powerful and dynamic, while the men, despite their masculine bulk, await her commands passively. It is a sparkling and witty work, yet wholly serious.

LATE ROCOCO IN VENICE

The Rococo, dying out in the rest of Europe as it became increasingly regarded as frivolous, still found great painters in Venice. The best Venetian art shows the real strength of Rococo, its wonderful energy. Francesco Guardi (1712– 93), with his lyrical capriccios (imaginary landscape arrangements, half real and half surreal) is one of the last of this school. The most famous of a family of painters, his art is loose and impressionistic, airy and delightful. We may not totally believe in his architecture, but we accept its fantasy on its own terms. If he shows us

A Seaport and Classical Ruins in Italy (273), we take uncomplicated pleasure in its cloudy grandeur, a fitting site for the imagination to play in. What charms us in Guardi is his ability both to convince intellectually (we believe we are seeing a real place) and to enchant us romantically (we also feel that this is a poetic creation). Poetry that convinces us is the most enduring.

273 *Francesco Guardi,* A Seaport and Classical Ruins in Italy, *1730s, 70 x 48 in (178 x 122 cm)*

BELLOTTO

Canaletto's nephew
Bernardo Bellotto
(1721–80) caused much
confusion in the 18th
century by calling
himself Canaletto. He
trained with his uncle
in Venice but left in
1747 for the courts of
northern Europe,
particularly Dresden
and Warsaw. His work
was considered so
reliable that architects
rebuilding Warsaw
after World War II
copied buildings
and details from
his pictures.

PORTRAITS OF CITIES

An early exponent of a new stylistic current
leading to a renewed Classicism – but an artist
who was still very much a part of the Rococo
world – was the Venetian landscape painter
Canaletto (Antonio Canale, 1697–1768). He
was born only one year after Tiepolo (see p.232)
and several years before Guardi (see p.233) –
both quintessential Rococo artists – yet his art
can be seen as rigorously Neoclassical.

Canaletto adopted the city portrait as his
chosen subject early in his career and stuck to it,
becoming famous in his lifetime for his accurate
and elaborately detailed records of city views.
Since many of Canaletto's paintings are of his
birthplace, Venice itself, a fantastical and
imaginative city, they may indeed have a
Rococo exterior, but the spirit is pure sobriety.

A splendid example of Canaletto's feeling
for texture, for slate and stone and wood, with
distant water and high sky, is seen in this behind-
the-scenes view of Venice, sloppy and untidy,
yet all held in the context of the loveliest of
cities. *The Stonemason's Yard (274)* even sounds
unromantic, yet Canaletto has seen the yard as
a wonderful setting for the interplay of light and
shadow, declivity and height.

*Venice: The Basin of San Marco on Ascension
Day (275)* is bathed in the hard light of a classical
sun. Its verticals are severe and perfectly balanced,
and its architectural masses are unmistakably
solid; yet Canaletto paints with such love and
appreciation of his city that the result is beguiling.
There is no atmospheric poetry here, except for
the lyrical quality of the sky.

275 **Canaletto,** Venice: The Basin of San Marco on Ascension Day, *probably c. 1740, 72 × 48 in (183 × 122 cm)*

Canaletto was especially admired by English
visitors to Venice, who responded immediately
to his rationality. He went to England in 1745
and lived there for ten years, producing many
views of London, though these were unappreciated.

His nephew, Bernardo Bellotto (see column,
left), sometimes also known, confusingly, as
Canaletto, imitated his more famous uncle. The
two are hard to distinguish, and one could argue
(to my view, falsely) that to see a Canaletto is
to see a Bellotto. Yet Bellotto is a more detailed
painter, a great master of extent, in which the
air seems crystal clear and we possess the view
like a god. This divine amplitude characterizes
both uncle and nephew, so characteristic of
them both that the confusion of their identities
is almost inevitable.

HOGARTH: FOUNDER OF AN ENGLISH TRADITION

The British taste for art was less visual than factual.
British patrons liked portraits of themselves, as
well as landscape views of their homes and estates
and of foreign cities they visited. Ironically, William
Hogarth (1697–1764), Britain's first major artist,
though a truthful and vigorous portrait painter,
made his name in the unusual genre of pictorial
satire, which was also congenial to his countrymen,

274 **Canaletto,** The Stonemason's Yard, *c. late 1720s, 64 × 49 in (163 × 125 cm)*

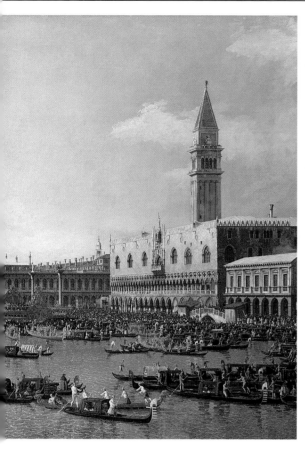

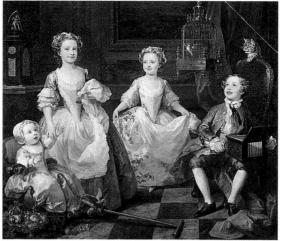

276 *William Hogarth,* The Graham Children, *1742,*
6 ft x 5 ft 4 in (183 x 163 cm)

HOGARTH
ENGRAVINGS

William Hogarth (1697–1764) trained as an engraver and popularized the use of a sequence of anecdotal pictures to portray social and moral issues. He saw himself as the defender of the common man and the upholder of sensible British values in the face of French fashions and mannerisms. The engraving shown above is of *Gin Lane*, a fictitious street in which the dire consequences of gin drinking are clearly demonstrated. The work was completed by Hogarth in 1751 and is one of a pair, the other illustrating the noble qualities of British beer. Engravings such as these sold for one shilling and were popular across the social spectrum.

The Graham Children (276) can bear comparison with the works of the great Velázquez (see p.194) in its sense of immediacy, of sharing with us a particular moment in time. The painting shows four children who, with their cat and their caged bird, sparkle happily out at us. Only after a time do we glimpse the deeper implications of this scene: the cat, electric with desire, is after the bird, and its lively chirping, which the children take to be a response to their own music, is in reality a frantic cry for their protection. Only the baby sees what the cat is up to, and as a baby, does not understand. Hogarth is showing us innocence threatened, and the shadow falls on the laughing children too.

and which Hogarth took to new heights, creating an entirely new art form. Hogarth was a lively and dogmatic man, and greatly opposed to the "Italianate" Rococo styles that were popular in London at this time. He was a decided nationalist and, finding the English art scene to be hopelessly provincial, contributed to the development of Britain's earliest art institutions. He was all for building a truly British tradition, one that did not take its lead from the continent but instead reflected the British way of life.

In his portraiture, Hogarth broke new ground in depicting the rising English middle class in ways that had previously been reserved for nobility, and his keen sense of human absurdity drew him irresistibly to satire as a suitable and lucrative means for social and judicial commentary. He tends to see his subject as if it were a piece of theater.

A Scene from the Beggar's Opera (277) istaken from the great satirical play by John Gay, written in 1728. Captain Macheath, the highwayman, stands grandly in the center, while his two lady-loves plead with their villainous, hypocritical fathers. Hogarth gets the utmost enjoyment out of the twofold satire, of good and bad not being what they seem, and of a man in love with two women who gets himself in a tangle. This is the witty Hogarth, but he also has a deeper side.

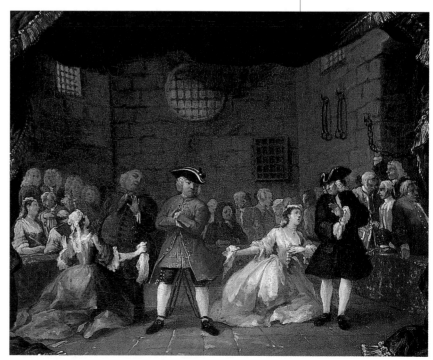

277 *William Hogarth,* A Scene from the Beggar's Opera, *1728/29,*
24 x 20¼ in (61 x 51 cm)

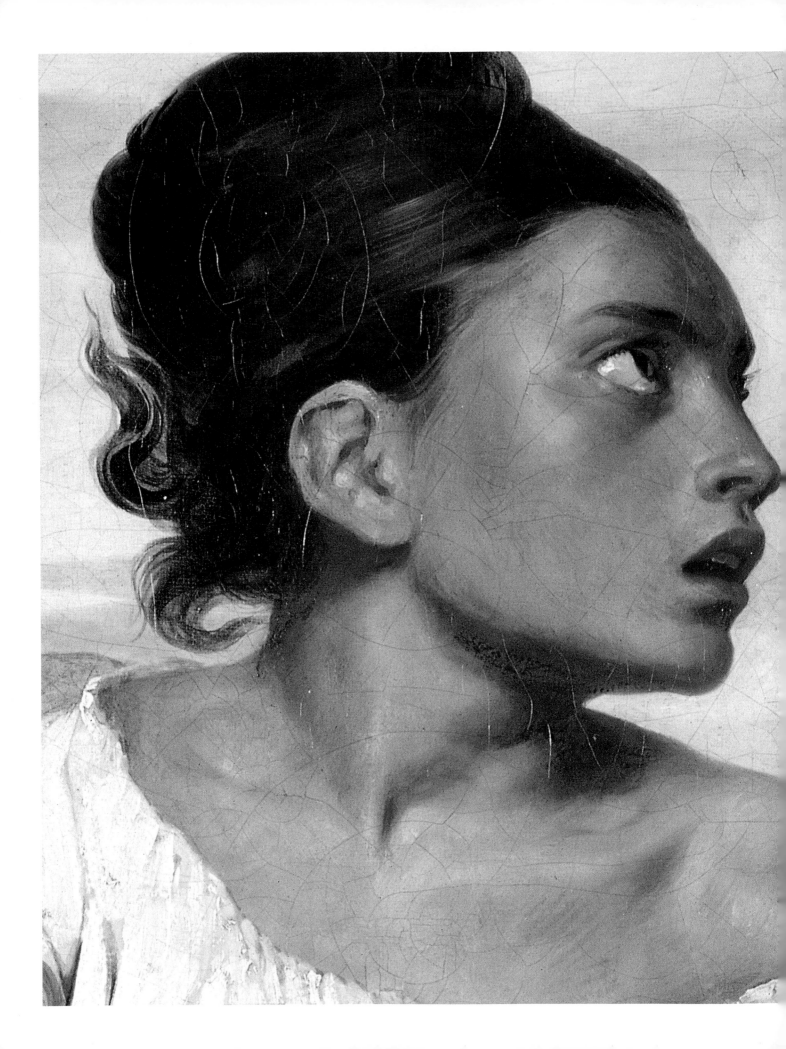

NEOCLASSICISM AND ROMANTICISM

Neoclassicism was born out of a rejection of the Rococo and late Baroque styles, around the middle of the 18th century. Neoclassical artists wanted a style that could convey serious moral ideas such as justice, honor, and patriotism. They yearned to re-create the simple, dignified style of the art of classical Greece and Rome. Some succeeded, but the movement suffered from its spirit of academic narrowness.

Romanticism began in the same era, but it was an approach that had to do with the modern rather than the antique, and it was about wildness and expression rather than control. Romantic artists had no fixed laws relating to beauty or the proprieties of subject matter. Instead, Romanticism was a creative outlook, a way of life.

A vast gulf existed between these two outlooks, and the debate between them was long and at times bitter; but in the end, Romanticism emerged as the dominant artistic movement of the first half of the 19th century.

Eugène Delacroix, **An Orphan Girl in the Graveyard,** *1824 (detail)*

NEOCLASSICISM AND ROMANTICISM TIMELINE

Neoclassicism began in the middle of the 18th century (well before the Rococo style finally went out of use) and was in decline by the early 19th century. Likewise, early traces of Romanticism in painting are found in the 1740s; for instance, in Gainsborough. Romantic painting became a recognized movement by the 1780s, continuing into the mid-19th century.

JOHN SINGLETON COPLEY, THE COPLEY FAMILY, 1776–77
Copley's portrait of his own family is an example of the effects of European Neoclassical influence (chiefly that of Reynolds) on an artist arriving from the New World. When living in America, Copley had been known for his unvarnished but convincing realism. In England, in response to the prevailing fashion, he idealized and made his figures elegant, but in the event all too often diminishing his original insight (p.246).

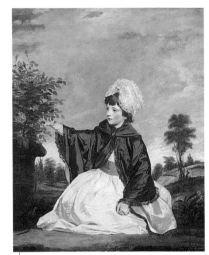

SIR JOSHUA REYNOLDS, LADY CAROLINE HOWARD, 1778
Reynolds was England's leading academic painter and possibly the best portraitist. He is an eclectic painter, leaning heavily to the classic, which gives dignity to his pictures of contemporary aristocrats. Here he gives an atmosphere of grandeur, almost heroism, to a simple portrait of a child (p.244).

GEORGE STUBBS, MARES AND FOALS, 1762
By specializing, George Stubbs attained a degree of distinction that guaranteed him lasting fame. He dedicated himself to the horse, and this is one of his many horse pictures that leave humans out altogether. It gives a glimpse of these wild creatures as superior beings to whom the landscape truly belongs (p.247).

1740	1750	1760	1770	1780	1790

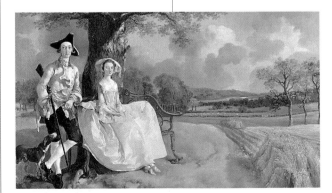

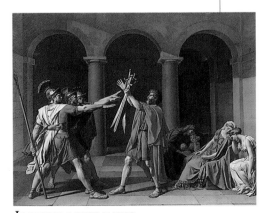

THOMAS GAINSBOROUGH, MR. AND MRS. ANDREWS, 1749
This unforgettable portrait haunts us with its startlingly original treatment. The poses and facial expressions are individual and convincing, and yet paradoxically the two figures are made to look like dolls or porcelain figures. They are positioned in the corner of the composition, allowing two-thirds of the painting to be devoted to landscape. Nature is an important element in all of Gainsborough's portraits, and he had a profound influence on the English landscape painters of the 19th century, notably Constable (p.240).

JACQUES-LOUIS DAVID, THE OATH OF THE HORATII, 1784–85
This was the first really famous image from the Neoclassical school. David was on the side of the Revolution when it came in 1789, and this subject evoked revolutionary patriotism. The composition is carefully orchestrated: for instance, the exaggerated weakness and softness of the women on the right contrast with the rigid, heroic pose of the three young men on the left (p.253).

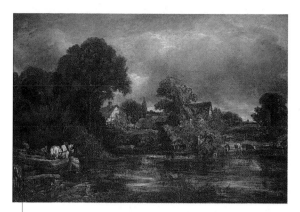

JOHN CONSTABLE, THE WHITE HORSE, 1819

This is one of the Suffolk scenes that have become part of the canon of great paintings in the English landscape tradition. Constable's work has a unique freshness. There is a brilliant use of broken color, with an immediacy and convincing truth. With his robust, work-a-day scenes from the country-side near his home, Constable breached classical rules on what constituted the "correct" sort of landscape to paint (p.270).

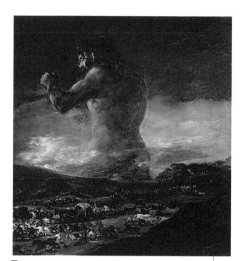

FRANCISCO GOYA, COLOSSUS, 1810–12

Goya was influenced, when first at the Spanish royal court, by the Neoclassicist Anton Raphael Mengs, but over the years of his career he moved more and more in the direction of Romanticism. He is an artist of the very greatest stature and exercised considerable influence on the development of Romanticism throughout Europe. The Colossus is an example of Goya's ability to realize an image that seems to come from our inner consciousness, powerful but with no single, unambiguous message (p.252).

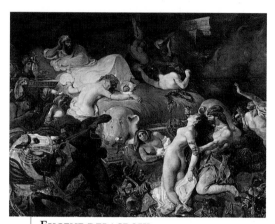

EUGENE DELACROIX, DEATH OF SARDANAPALUS, 1827

Delacroix's Romanticism has a solid underpinning of the classic. Rubens and Géricault encouraged him to see the emotional effect of strong color. This painting shows the energy and exoticism of his work, but he always retained a certain detachment and inner control (p.261).

1800	1810	1820	1830	1840	1850

JEAN-AUGUSTE INGRES, THE BATHER, 1808

Ingres became the "high priest" of Neoclassicism in France. He had a special preference for the backs and necks of his nudes, often making them into prominent features of his paintings and frequently distorting or elongating them in order to suit the needs of his highly sophisticated compositions. This was typical of the Neoclassical painters, for whom control over subject matter was central to their whole approach to art. Ingres's distortions went even further than in this example, but they were nearly always achieved in such a way as to make anatomical "falsehoods" seem as plausible as reality itself (p.256).

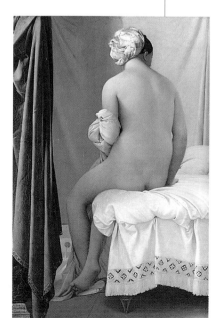

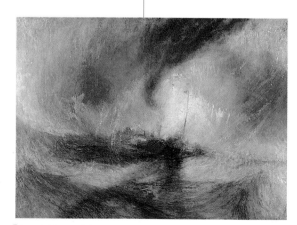

J.M.W. TURNER, STEAMBOAT IN A SNOWSTORM, 1842

In Turner's seascapes we see the emotive power of Romantic art at its most intense. Yet, like all truly great artists, Turner retains control over what is happening in this painting. Here he shows a ship in mortal danger in a storm at sea. No matter how imaginative or extreme the subject, he is still aware of perspective and its imperatives (p.265).

THE BRITISH SCHOOL

In British painting of the 18th century, there was a mixture of both the Romantic and the Neoclassical tendencies. On one hand, there was the marvelous lyricism of Thomas Gainsborough, always including the natural environment in his portraits, many of which hovered on the edge of being landscapes. On the other hand, there was the educated, classical approach of Sir Joshua Reynolds, appealing to the ideals of polite society of his time – which was known, then as well as today, as the Age of Reason.

One of the artists who led English painting into its great period was Thomas Gainsborough (1727–88). He called himself "a wild goose at best," and it was this ravishing originality, within the bounds of gentlemanly appeal, that made him so popular. A supreme portrait painter, his great love was the landscape, and his finest works give us both. His achievements in landscape painting paved the way for Constable's radically naturalistic approach to landscape, and for the English Romantic tradition (see p.264). Gainsborough's landscapes are reminiscent of Watteau's *fêtes galantes* (see p.224): whimsical, idyllic scenes, peopled with delicate creatures. In Gainsborough, however, these are transformed into large-scale lyrical landscapes, refreshing in their truth to nature. The most famous of Gainsborough's early portraits is the unconventional *Mr. and Mrs. Andrews (278)*. The young newlyweds pose in their ancestral fields, she in the height of fashion, scowling over her silks, he casual and somehow adolescent.

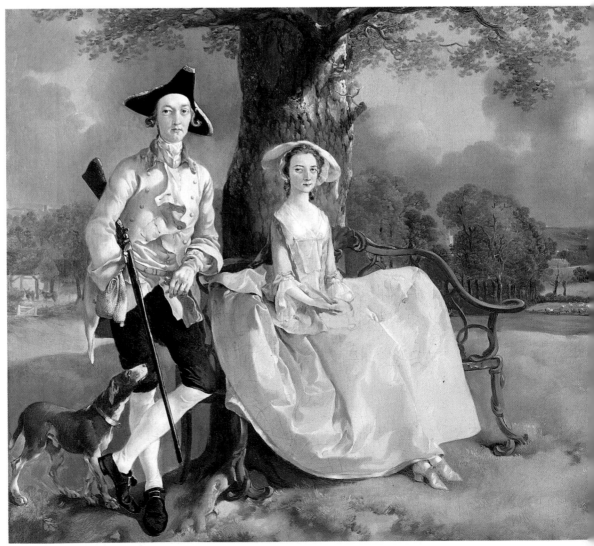

278 *Thomas Gainsborough*, Mr. and Mrs. Andrews, *c. 1749, 47 x 28 in (120 x 71 cm)*

A NEW STYLE OF PORTRAIT

The Andrews portrait takes its verve from its paradoxically real and unreal portrayal of the sitters, who appear doll-like and yet are nonetheless totally convincing, and from its strikingly original composition. Its originality lies in the positioning of its subjects off-center, flanked by an unidealized, genuinely 18th-century English landscape of farmland with its cornfield, sturdy oak tree, and changeable sky.

Their position emphasizes their status as landowners. They appear to be surveying the landscape around them, a landscape that plays an important part in its own right, no longer merely as a decorative, fanciful backdrop (as had been the custom for such outdoor portraits). The portrait is not finished. Mrs. Andrews is believed to have made the rather odd request that she be painted holding a pheasant, which probably accounts for the blank patch in her lap. Gainsborough clearly finds the couple comic, yet he paints with an admirably straight face.

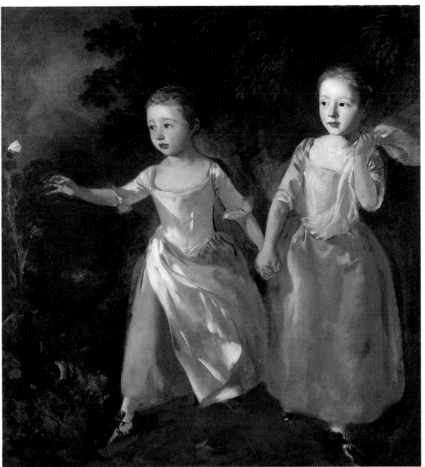

279 **Thomas Gainsborough,** The Painter's Daughters Chasing a Butterfly, *late 1750s, 41 x 45 in (105 x 115 cm)*

PATHOS AND CELEBRATION

As Gainsborough matured, his sensibility became more delicate, more "finely tuned," as did his confidence in his ability to catch a likeness. His lyrical landscape backgrounds, lightly sketched, became more idealized (though never unbelievable) and were executed with increasing freedom. Gainsborough is very sensitive to the pathos of beauty or heroism, graces that time will transform, and there can be a heartbreaking pensiveness in some of his portraits.

There is pathos, for example, in his repeated portraits of his two daughters, Molly (Mary) and Margaret, plain girls whom he dearly loved and whose future was to be unhappy – both were psychologically fragile. Our foreknowledge of their unhappiness to come seems sublimely shared in his enchanting picture of them in their childhood: *The Painter's Daughters Chasing a Butterfly (279).* Only the young chase the butterfly: the adult knows sadly that it is hard to catch, and may die as a result. For children, the chase itself is sheer pleasure without misgivings, and Gainsborough subtly expresses, at one and the same time, the happiness of innocence and the sadness of maturity.

OTHER WORKS BY GAINSBOROUGH

Captain Thomas Matthew (Museum of Fine Arts, Boston)

John Smith, Clerk to the Drapers' Company (Queensland Art Gallery, Brisbane)

Crossing the Ford (Christchurch Mansion, Ipswich)

Mrs. Susannah Gardiner (Tate Gallery, London)

Mrs. George Drummond (Montreal Museum of Fine Arts)

Lady in a Blue Dress (Philadelphia Museum of Art)

A Lady (Bridgestone Museum of Art, Tokyo)

George III (Royal Collection, Windsor Castle)

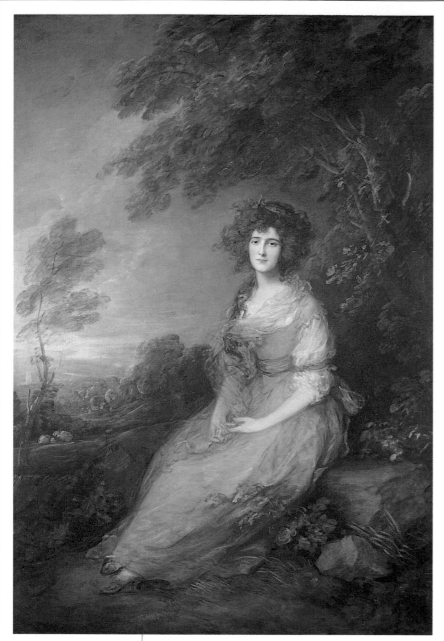

280 Thomas Gainsborough, **Mrs. Richard Brinsley Sheridan,** *1785/86, 5 ft ½ in × 7 ft 3 in (154 × 220 cm)*

Gainsborough was one of the great "independents" and his influence on portraiture was only limited. However, his landscapes were important as models for the young John Constable (see p.268), who wrote, "I fancy I see Gainsborough in every hedge and hollow tree."

RAMSAY THE CATALYST

Perhaps the greatest portrait painter in 18th-century Britain is the unfairly forgotten Scot, Allan Ramsay (1713–84). The English writer Horace Walpole, one of the shrewdest men of his age, remarked that "Reynolds seldom succeeds in women," whereas "Ramsay is formed to paint them." A great Ramsay is usually treasured by the family that originally commissioned it, and he has fallen from critical view for far too long.

This portrait, *Mrs. Allan Ramsay (281),* is of Ramsay's second wife, Margaret Lindsay (1726–82). The first Mrs. Ramsay, Anne Bayne, had died in childbirth, thereby forever destroying Ramsay's confidence in the invulnerability of love. His second wife is very lovely, sweet, and fresh, but he paints her with a touching anxiety, a haunting fear that her beloved life may fade away as inevitably as the flowers at her side.

Ramsay's delicate style introduced a blend of Baroque Italian Classicism, with French Rococo charm, into English painting. His personality – contrasting so noticeably with that of Hogarth, the pragmatic social commentator – gave rise to change, and crystallized the active ingredients for this great period in British painting.

THE PLAYWRIGHT'S WIFE

Pathos is again inherent in this portrait of *Mrs. Richard Brinsley Sheridan (280).* She had a tempestuous marriage with the great playwright Sheridan, and she was renowned for her singing voice and her unearthly beauty. Her loneliness and her elusive charm are conveyed to us in her portrait. Only the grave and lovely face is solid: all else is thin, diaphanous, unstable. Her mood is echoed by the wistful melancholy of the setting sun.

Full-length portraits, particularly of ladies placed in a natural setting, were a special tradition in 18th-century English and French painting; they were noticed on the continent, and copied, by Goya, among others (see p.248).

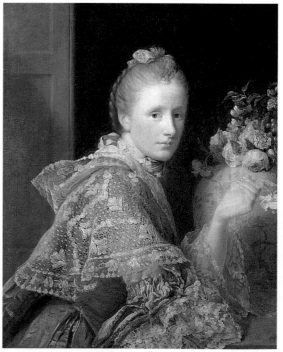

281 Allan Ramsay, **Margaret Lindsay, Mrs. Allan Ramsay,** *early 1760s, 22 × 27 in (55 × 68 cm)*

Mrs. Richard Brinsley Sheridan

The incompatible natures of the subject of this portrait and her husband (see column, p.242) meant that the former spent much of her time in the country, where she was happiest, while her wayward spouse stayed in London. She was an appropriate subject for Gainsborough's new, Romantic approach to portraiture, where all elements combine to express the gently melancholic mood of the sitter.

FACE
She is depicted as truly belonging in this environment, and her hair, caught by the wind, is treated in the same way as the leaves on the tree. Her plaintive expression (the focal point of the painting) and whole demeanor seem to express the wish she made to her husband to "take me out of the whirl of the world, place me in the quiet and simple scenes of life that I was born for." Her wistful mood is echoed by the setting sun.

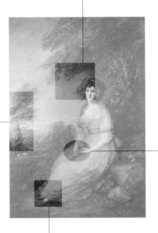

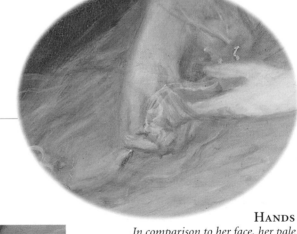

DISTANT TREE
A solitary tree in the distance has been superimposed over the sky. Its trunk is a few simple arabesques, and the fluffy clumps of foliage are all painted in the same direction. Pink underpainting is visible in the sky, which echoes the pinks and blues of her costume.

HANDS
In comparison to her face, her pale arms are relatively flatly painted, with virtually no modeling or shading. Her hands seem to lose themselves in the folds of her dress and scarf. The transparent scarf is composed of a network of fluid squiggles weaving in and out of her fingers. It unifies the figure into one single romantic gesture as it twists and tumbles down from around her shoulders and across her chest, falling through her arms and onto her knees and feet.

RHYTHM OF COLOR AND FORM
The lightly suggested feet are subordinate to the major rhythms of the composition. Gainsborough has worked largely wet-in-wet, with loosely woven layers of washes, a technique that produces softness of definition. At the speed of a glance, he has zigzagged his brush down the expanse of her dress to her feet. Our eye moves automatically to the distant tree and then up and down through the foliage behind her, where her diagonal pose begins the circular rhythm anew.

RAEBURN: BRILLIANT PORTRAITIST

Raeburn, a fellow Scot, was clearly influenced by Ramsay, and at his peak is practically his equal. One would love to know whether it was the Rev. Walker himself or Raeburn who hit upon the wonderful pose of the skater *(282)*. This extraordinary image, with the dark outline of a minister in his somber black, intent upon balancing his movement across the ice, has the superb background of mist and mountains. The man is so solid, the world so nebulous. He fixes his gaze adamantly upon the unseen and skates his way forward. We can see the muscles in play as his skates score the ice, and yet where he is going, and why this image is appropriate, baffles us still.

REYNOLDS'S GRAND MANNER

Joshua Reynolds (1723–92), who was knighted for his great success as a portrait painter, is less sensitive than Gainsborough but more balanced. Unlike the latter, who had little formal education and preferred the company of actors and musicians to scholars, Reynolds was decidedly

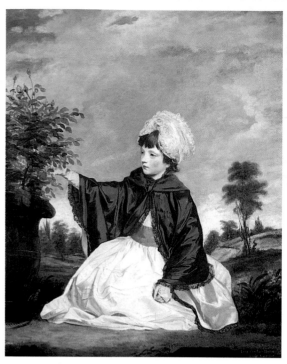

283 Sir Joshua Reynolds, Lady Caroline Howard, 1778, 44½ x 56 in (113 x 143 cm)

an intellectual. From early on in his training, Reynolds had immersed himself in the art of the Renaissance, and he shared an interest in antiquity with the Italian and French Neoclassical artists. These influences led to his revival of the "Grand Manner," set in a modern context (see column, left). He was, without question, considered the leading portrait artist in Britain in his day, although, like Gainsborough, his passion lay outside the field of portraiture.

History painting was for Reynolds the highest form of art, and he contrived to instill Classicism and heroism into his portraits of the English ruling class. The threat to Reynolds's standing in England – especially from Gainsborough's popularity – did not arise until fairly late in the day, and Reynolds's influence on English art endured for many years. He became the first president of the Royal Academy on its foundation in 1768, and his enormous influence formed the basis for academic painting (see column, left).

Reynolds was an influential theorist whose lectures at the Royal Academy still make useful reading, and he encapsulates the aristocratic dignity of his age. He can hover alarmingly on the edge of the sentimental, especially in his idealization of childhood, but when he catches youthful freshness, he is very appealing. Here is one of the best examples of his portraiture: *Lady Caroline Howard (283)*, with her rosebush and her general air of simplicity, has a pensiveness that does not make extravagant claims, but lets us enjoy this quiet and rosy child.

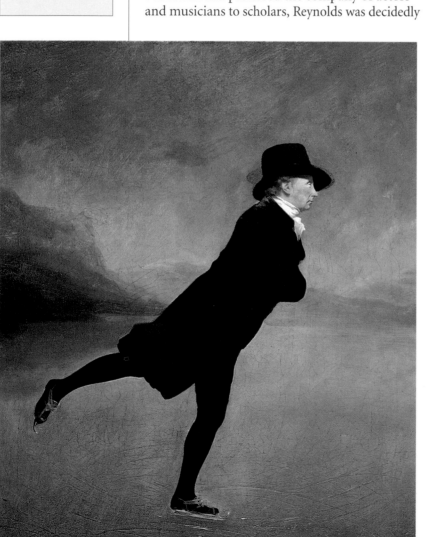

282 Sir Henry Raeburn, The Rev. Robert Walker Skating, mid-1790s, 24 x 29 in (60 x 73 cm)

AMERICA AND ENGLAND:
A SHARED LANGUAGE

If the forgotten Ramsay (see p.242) is arguably the greatest portrait painter of the time, then the equally overlooked American artist Gilbert Stuart (1755–1828), 42 years his junior, may be the most original. Stuart, as his name suggests, was of Scottish ancestry. He arrived in London at the age of 20 and trained under a fellow American, the hugely successful history painter Benjamin West (see right).

Stuart was also a great success in London. His work was so acclaimed that at a later stage it was even confused with that of Gainsborough. This is a double-edged compliment: he has his own style, which is almost recklessly truthful. His time may be too early to speak of a specifically American style, but there is a homespun brilliance in his work that we do not find in European artists.

There is superb observation in his *Mrs. Richard Yates (284)*: what other artist would have dared show her vestigial mustache? The gradations of facial color, too, and the alertness to the light glancing and dulling on her dress and cap, are all prophetic of the Impressionists (see p.294). After running into serious financial problems, Stuart returned to live in America permanently in 1793. He is probably known mainly because he painted George Washington, but despite his popularity he is not at his best as a public artist. It is the sheer domesticity of Mrs. Richard Yates, a merchant's wife, that calls out his reserves of sensitive observation.

285 Benjamin West, Self-Portrait, c. 1770, 25⅛ x 30¼ in (64 x 77 cm)

284 Gilbert Stuart, Mrs. Richard Yates, 1793/94, 25 x 30¼ in (63 x 77 cm)

HISTORY PAINTING: A POPULAR GENRE

A more famous, though less interesting artist than Gilbert Stuart is Benjamin West (1738–1820), whose enormous reputation as a history painter was gained in England rather than his native America.

West's style relied very much on accuracy of detail and historical fact, and he was influenced by Neoclassical artists such as Anton Mengs (see p.248) when he was in Rome in 1760. West's great historical dramas, which so impressed his contemporaries, leave us rather unmoved. They seem to be generated from the mind rather than the heart.

But the heart is always involved in painting a self-portrait, and here we see him at his best *(285)*. There is wishful thinking, perhaps, in this self-portrait – that of a quiet, elegant gentleman, dressed in the fashionable severity of urban style, contemplating us with aristocratic serenity. West's sketch seems an adjunct to his portrait and is in fact placed on the perimeter. Half his face and his body are deeply shadowed, with all this suggests of a divided and secretive persona.

ANGELICA KAUFFMAN

Angelica Kauffman was a friend of Joshua Reynolds and fellow member of the Royal Academy. She began as a fashionable portraitist, then became more interested in historical subjects. In the 1770s she painted a series of decorative murals for the architect Robert Adam. In 1781 she remarried and moved to Rome. This piece of Neoclassical Meissen ware (fine porcelain) is decorated with a portrait of Angelica Kauffman.

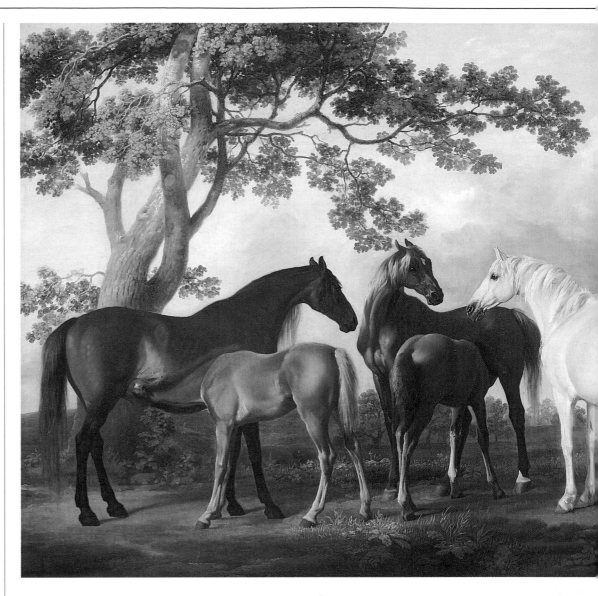

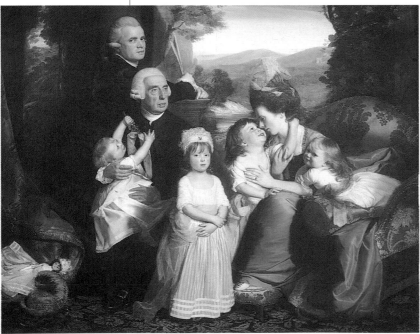

286 John Singleton Copley, The Copley Family, *1776–77, 9 ft 7 in × 6 ft 1 in (292 × 185 cm)*

COPLEY: AN UNFULFILLED TALENT

If Britain gave West the opportunity he needed, it both rewarded and damaged John Singleton Copley (1738–1815). His American works show a realism and a truthfulness that are marvelously alive. Moving to England involved him in the elegance of Neoclassicism and gave him the influence of Reynolds's Grand Manner; but, for Copley, this was not a fruitful involvement.

The change is evident in *The Copley Family (286)*. In this painting, which was carefully worked up from preliminary studies, his father-in-law's face and hands and the glorious doll in the left-hand corner are examples of his early style. Here it is thrillingly convincing. For the remainder of the picture, Copley idealizes and abstracts, and the whole, though impressive, is somehow derivative: we have seen this kind of Grand Manner portraiture before in the work of Reynolds, Gainsborough, and West, for example. It remains a fascinating work, as much for its weakness as its strength. One of the weaknesses

if he himself were an honorary member of the species. Stubbs did not totally disdain to paint humans, who, after all, were the source of his equestrian commissions. But *Mares and Foals (287)* is one of his many pictures that has no human component. There is certainly no sentimentality either, yet these stately mothers and children, trustfully grouped together with artless poetry, evince a tender vision of nature at its most inspiring.

The horses group themselves with classic elegance against an archetypal English landscape. Stubbs is profoundly moved by their beauty, and he communicates to us his own secret conviction that it is they to whom the landscape truly belongs. Thick-limbed humanity, with its clumsy trapping of clothes and its intrusive apparatus for living, is so inferior to these bare, gleaming creatures of the wild that yet honor us with their comradeship.

HORSE PAINTINGS

George Stubbs's (1724–1806) horse paintings are a testimony to the 18th-century gentleman's passionate interest in improved stock breeding techniques. The formal discipline of Stubbs' composition is Neoclassical in spirit, but the artist's romantic perception of the horse is demonstrated by his move toward Romanticism in his later years. The implied and described violence in paintings, such as *A Horse Frightened by a Lion*, appeal strongly to our emotions.

287 George Stubbs, Mares and Foals, *1762, 75 x 39 in (190 x 100 cm)*

that is paradoxically a strength comes from our uncertainty as to where this family group is located. Are they inside – as is suggested by the brocaded sofa and the gilt-edged curtain, not to mention the expensive carpet? Or are they assembled outside – as seems to be indicated by the backdrop, with its distant hills and intrusive foliage? The two settings are cleverly linked. The carpet is patterned with leaves and there is a flower motif on the sofa.

GREAT EQUESTRIAN PAINTING

The one great Anglo-Saxon master of the century, George Stubbs (1724–1806), was, like Gainsborough, a lover of the portrait and the countryside, but all his passion is concentrated on the horse. Stubbs does not merely look at horses: in his time he dissected them (literally), meditated upon them, and entered into every aspect of this noble but nonhuman being, as

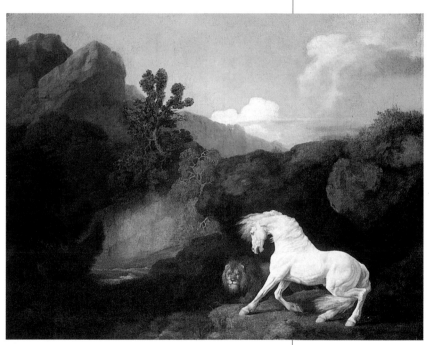

288 George Stubbs, A Horse Frightened by a Lion, *1770, 49 x 37 in (125 x 94 cm)*

Idyllic though it is, Stubbs does not cheat. The sky is darkening with storm clouds, and shadows already fall around the mares and foals. Only the very center of the meadow, where they actually stand, is still sunlit.

Stubbs was equally sensitive to the vulnerability of animal life. *A Horse Frightened by a Lion (288)* comes straight from a Freudian nightmare. Blown by the wind, under some heavenly spotlight that gleams with eerie fierceness on its terrified body, a white horse halts in abrupt horror as a leonine head looks out at it from the darkness. It is a frozen tableau of fear. He leaves its outcome to our imagination.

OTHER WORKS BY STUBBS

Otho with Larkin Up (Tate Gallery, London)

Repose After Shooting (Yale Center for British Art, New Haven, Connecticut)

Portrait of Lady Laetitia Lade (Royal Collection, Windsor Castle)

Returning from the Hunt (Museum of Art, San Antonio, Texas)

GOYA

The greatest artist of the 18th century, without any qualification, was a Spaniard – Francisco Goya. He was a man of irrepressible originality and determination. After initially being influenced by the German-born Neoclassical artist Anton Mengs, he developed in his own way and painted, above all, with a truly Spanish vision.

THE EARLY YEARS
This photograph shows the humble interior of Francisco Goya's birthplace. He was one of five children and was born (in March 1746) into a poor family in Fuendetodos, near Saragossa in northern Spain. Goya's first commission, at the age of 16 years, was to decorate a reliquary cabinet in the local church. It was not until he was 24 years old that he would depart for Italy in search of success at the academies.

JOHANN JOACHIM WINCKELMANN
Johann Winckelmann's (1717–68) doctrines on art theory were highly influential during the Neoclassical period. He developed a fervent love of classical antiquity and ancient art and wrote several treatises on the philosophy of art. He believed that classical art had "noble simplicity and grandeur" and argued that artists should apply ethical and aesthetic honesty to their work. One of Winckelmann's most ardent supporters and followers, who applied these doctrines to his own art, was Anton Mengs.

Anton Raphael Mengs (1728–79) was a founder of Neoclassicism, in association with Johann Winckelmann (see column, left). He is more significant to us today, however, for his extremely influential style of Neoclassical portraiture. Perhaps even more importantly, he was also the court painter to King Charles III of Spain. The king was a committed antiquarian and social reformer, and he had a natural preference for Mengs's serious, dignified, and pragmatic approach, which is admirably demonstrated in Mengs's *Self-Portrait (289)*. It was Mengs who invited Goya to Madrid – in 1771.

GOYA: A SPANISH GENIUS

The influence of Mengs can be seen in the early work of Francisco Goya (1746–1828), particularly in his first portraits. Beyond that Goya fits into no category: his career spanned some 60 years, undergoing several metamorphoses, changing, and maturing in new ways right up to the mid-1820s. Goya seems to have worked solely from the center of his own genius. With the hindsight of history we can see that his essentially personal

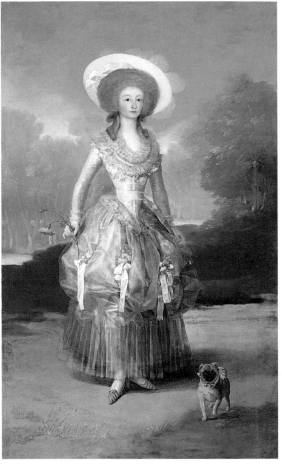

290 Francisco Goya, Marquesa de Pontejos, *c. 1786, 50 x 83 in (127 x 210 cm)*

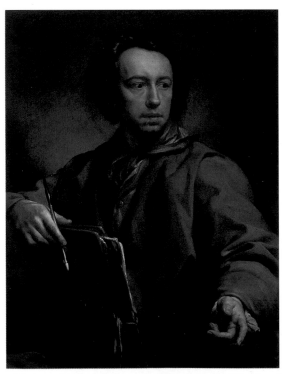

289 Anton Mengs, Self-Portrait, *1744, 22 x 29 in (55 x 73 cm)*

vision of the modern world places him as an early Romantic (see p.259). His art was more in tune with the Baroque mixture of classical form and emotive personal expression – he cited Velázquez, Rembrandt, and Nature as his masters – than with the disciplined idealism of the Neoclassicists.

Goya possessed two outstanding gifts. He could pierce through the external facade of any sitter, to unmask the interior truth, a gift dangerous for any but the prudent. But he coupled it with a marvelous decorative sense, as is clear from his disarming portrait of the *Marquesa de Pontejos (290)*. His work has such sheer beauty that even those almost pilloried in his portraits seem not to have grasped what had happened, being overwhelmed by wonder of the paint.

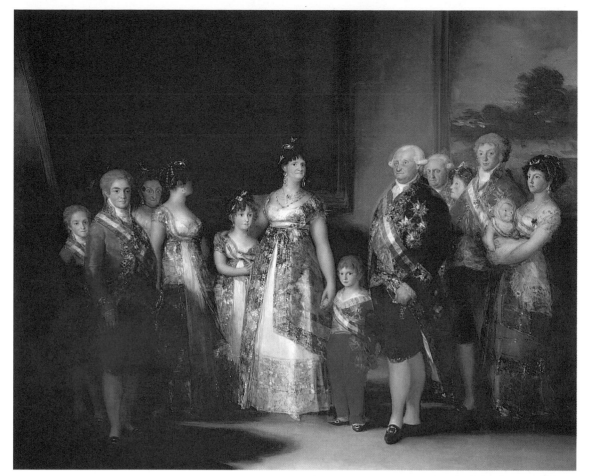

291 Francisco Goya, **The Family of King Charles IV,** *1800,*
11 ft ½ in × 9 ft 2 in (336 × 280 cm)

AN AMBITIOUS FAMILY PORTRAIT

The Family of King Charles IV (291), a portrait
of the ruling Borbón family, who were haughtily
remote from their countryfolk, shows the sitters
for what they are: vain and pompous. Yet they
continued to patronize Goya throughout his
career. The portrait is breathtaking in its cruel
insight and its beauty. The royals are spread out
like a frieze, heavy, dull-faced, and self-satisfied,
squashed together with little elegance and no
style. We wince for them, we pity the poor,
stupid king and his vixenish queen, and sigh
over the impenetrable crassness of their stumpy
heir. Then we look again, at the dazzle of attire,
the silks and laces, the infinite delicacy with
which decoration, ribbons, jewels, and sashes
are found to be glittering, gleaming, blazing out
at us with undiminished glamour.

In every portrait, Goya puts his finger on the
living pulse of the sitter. He does so with such
intensity of power that we positively need the
decorative qualities to offset the impact. When
we look at his *Thérèse Louise de Sureda (292),*
our eyes dwell with continual fascination on the
chair with its wonderfully inconsistent canary
shade, and on the dress, which is a gleaming

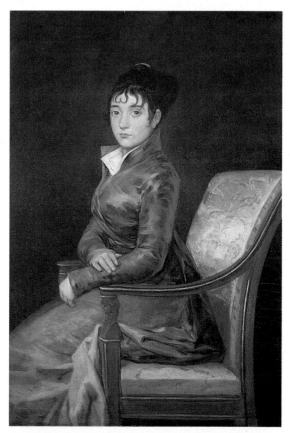

292 Francisco Goya, **Thérèse Louise de Sureda,** *c. 1803/04,*
31 × 47 in (81 × 120 cm)

THE ROYAL FAMILY

In 1779 Goya was
appointed to the position
of first court painter under
King Charles IV of Spain,
who came to the throne
in 1778. Court life under
Charles IV was extravagant
and self-indulgent, and full
of personal intrigues. This
miniature of the royal
family in profile (above)
was painted on silk by an
unknown artist. It is of
interest because of the
way it shows the close
resemblance between
family members.

TAPESTRY CARTOONS

Goya worked at various
times between 1774 and
1794 at the Royal Tapestry
Factory, painting cartoons
– the paintings from which
the weavers copied their
tapestries. Many of the
cartoons have been lost,
but 63 of Goya's are
known today, either in their
original form as cartoons
or as the finished tapestries.
This photograph shows a
tapestry of Goya's cartoon
The Vintage on the loom.
Weavers worked the
tapestry from the back,
studying the cartoon
through the threads.

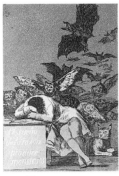

THE CAPRICES

Between 1797 and 1799 Goya produced a series of 80 satirical prints, known as the *Caprices*. Goya's friend Leandro Fernández de Moratín told Goya of some caricatures he had seen in England, and of how effectively they had ridiculed the establishment. This is an example of Goya's *Caprices* (above), entitled *The Sleep of Reason*. It was first sketched in 1797 and printed in 1798. In Spain such overt political criticism was not tolerated, and the *Caprices* were threatened with a ban by the Inquisition.

NAPOLEON'S INVASION OF SPAIN

In December 1807 Napoleon Bonaparte (1769–1821) marched 130,000 French troops into northern Spain. By the spring of 1808, he had effectively taken control of Madrid, and by June he had deposed King Ferdinand VII, appointing his (Napoleon's) own brother Joseph as king of Spain. As a result a guerilla war began between the people of Spain and the French occupying forces. This culminated in the resistance uprising of May 2, 1808, and the execution of Spanish insurgents by French soldiers at various sites across Madrid on the following day.

blue-black shot through with red and green – because the color makes it possible, through its seductions, for us to accept the force of the sitter's implacable gaze. Doña Teresa was a friend of Goya's in that her husband (also a painter) was one of Goya's drinking companions. But she was a "friend" mainly in the sense that Goya knew her and, we suspect, disliked her. She is well rounded, a compact bundle of womanhood, but she is tense and angry. She will not submit to the painter, challenging him with her glare and her uprightness, carefully coiffured but not for the warmth of love's embraces. There can be no comparable portrayal of a woman at once so attractive and so hostile.

Goya made his living by working for royalty and the establishment, and his political views appear confused: they may necessarily have been ambiguous. But it is impossible not to believe that he had an inborn hatred of tyranny. His art suggests a vehement independence, and perhaps his greatest painting is his version of a French war crime, the shooting of hostages after the Spanish people rose against Napoleon Bonaparte's rule in 1808. *The Third of May 1808 (293)* was painted six years after the event it portrays. This is only partly a patriotic picture, if it is that at all. It is not the French that Goya condemns but our communal cruelty. It is humankind that holds the rifles, but humankind at its most utterly conscienceless. The victims, too, are Everyman, the huddled mass of the poor who have no defender.

Goya manages to make us feel that we are both executioners and executed, as if the dual potential for good or evil that we all possess were animated before us. Intensity of fear, pain, and loss on one side, and the extremity of brutality on the other: which fate is the worse? Who is really destroyed in this terrible painting, the depersonalized French or the individualized Spanish? Behind the dying rises a hillock, bright with light; the soldiers stand in a shadowy and sinister no-man's-land. Meanwhile, in the central background, the city endures.

This is a very dark painting, psychologically, but the really dark works were to be painted later, in Goya's sick old age, when he was deaf and lonely, a prey to the irrational fears that are subliminally present in all his work, giving it a secret bite. He used these fears to create images of our darkest imaginings – not just his own, or they would fail to produce their terrible effect. Goya's last works have a ghastly sanity in their insanity, as if all demarcations had gone, and we had all fallen through into the abyss.

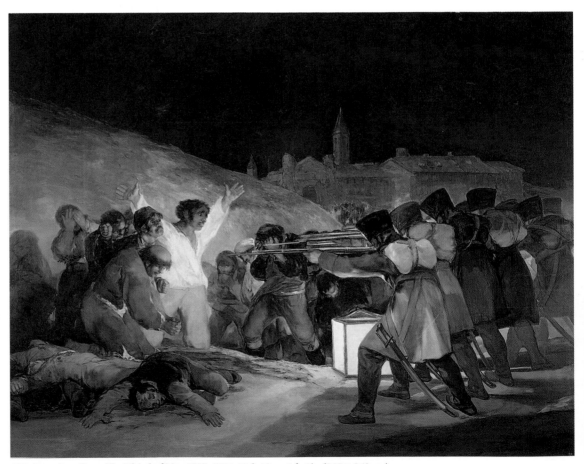

293 **Francisco Goya**, **The Third of May 1808**, *1814, 11 ft 4 in × 8 ft 6 in (345 × 260 cm)*

THE THIRD OF MAY 1808

The Third of May 1808 is one of a pair of paintings focusing on the brutal suppression and subsequent mass executions of Spanish civilians who had risen against French troops on the May 2, 1808. Only when King Ferdinand VII was finally restored to power in 1813 did Goya quickly send him a petition asking to commemorate the "most notable and heroic actions or scenes of our glorious insurrection against the tyrant of Europe."

FIRING SQUAD
The soldiers are depicted as faceless automatons. Their bodies are locked together, like some form of destructive insect. They stand unfeasibly close to their victims, emphasizing the brutal and tragically ludicrous nature of the scene, and crudely mirror David's great Neoclassical painting, The Oath of the Horatii *(see p.253). But while David's soldiers represent unity of will, Goya's represent only the mindless anonymity of the war machine.*

CHRIST FIGURE
Our attention is immediately drawn to the man kneeling with outstretched arms, evoking the Crucifixion, about to be shot almost at point-blank range. However, his heroic gesture cannot detract from the overwhelming despair and mortal terror that is depicted all around him, and we know his white shirt, brightly lit by the soldiers' lamp, will shortly be splattered with red.

"GLORIOUS INSURRECTION"
Despite his declared intention to immortalize the "heroic actions" of his countrymen, Goya has instead produced an image of a slaughterhouse. A dead man, lying facedown in a pool of blood, thrusts disturbingly into the foreground. He has been crudely foreshortened and appears twisted and mangled. His outflung arms suggest a supplication, mutely (and perhaps more eloquently) echoing the courageous, dramatic gesture of the next victim, who will shortly join the pile of corpses in the foreground.

GOYA'S DEATH

By 1825 Goya's health had deteriorated. He spent his remaining years in exile at Bordeaux in France. In 1826 he made the long, hard journey to revisit Madrid, after which his eyesight became so weak that he had to paint with the aid of a magnifying glass. Goya died on the night of April 15, 1828, in Bordeaux, and remained buried there until 1901, when his body was moved to Madrid. Later, in 1929, it was exhumed again and moved to a tomb in the Hermitage of San Antonia de la Florida. This painting of the original Bordeaux tomb is by Goya's old friend Antonio Brugada.

OTHER WORKS BY GOYA

Don Manuela Silvela
(Prado, Madrid)

The Marqués de Castro Fuerte
(Museum of Fine Arts, Montreal)

The Duke of Osuna
(Frick Collection, New York)

The Duke of Wellington
(National Gallery of New Zealand, Wellington)

Isabel de Porcel
(National Gallery, London)

Young Woman with a Letter
(Musée Lille)

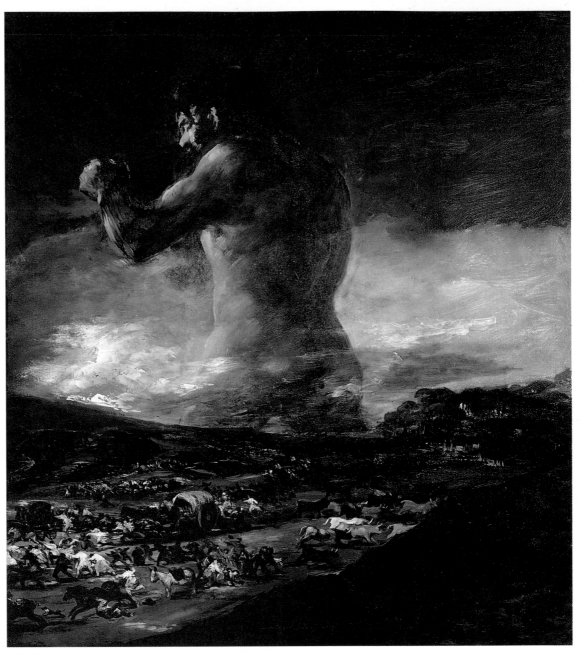

294 Francisco Goya, The Colossus, 1810–12, 41 x 45 in (105 x 115 cm)

The Colossus (294) has a subtitle, *Panic.* It shows all humanity in flight, streaming away like ants from unimaginable horror – an analogy for the monstrous destruction of war, one of the bloodiest in Spain's history (see column, p.250). Goya has visualized this dread for us, given it concrete form: a huge, hostile presence fills the sky, not yet looking down at the terrified masses below, merely flexing his muscles. Existence is not what we had thought: here are different rules and we do not know what they are. What we are contemplating is our common nightmare.

Goya gives this fear an awesomely convincing form. He is painting his own dreads, but his genius reveals them to be our own. They may in fact be more our own than we realize.

The colossus is actually looking away from the fleeing people: are we perhaps seeing more of a threat in this mysterious form than is literally there? He can even be seen as a protective colossus, the native genius of Spain, arising in might to challenge Napoleon. Yet somehow this benign interpretation does not spring readily to mind.

There is a darkness in Goya, an anger, a wildness, that represents something within our hearts, repress it though we may. It is precisely this irrational fury of the imagination, prefiguring the Romantics – poets such as Shelley, Keats, and Byron, or composers such as Schumann or Berlioz – that gives Goya the edge over his contemporary, the great French Neoclassical artist Jacques-Louis David.

THE NEOCLASSICAL SCHOOL

Neoclassicism clearly proved to be a popular philosophy among artists in the middle of the 18th century. It manifested itself in a variety of national schools, in varying degrees of intensity. In England, it was found in a modified form, in the work of Reynolds and his followers. In Italy it was important, for Rome was the world center for Neoclassical thought, attracting such personalities as the first "true" Neoclassicist, Anton Mengs. But Neoclassicism did not really become established as a coherent movement in the arts until it emerged in quintessential form in the late 18th century, in France.

In the middle of the 18th century, as in the middle of the 17th (see p.216), artists turned to Classicism in reaction against the frivolity of art of the previous generation. The 18th-century Neoclassicist philosophy was reformist in character, calling for a revival of ancient standards of seriousness, morality, and idealism. It was taken up readily by artists and writers who found themselves in the midst of social and political upheaval.

With the French Revolution (see column, p.255) breaking out in 1789, its potential for use in propaganda was not wasted. Jacques-Louis David's (1748–1826) style is nobly classical, the whole image so integrated that each section supports the other and there is a fine concentration of significance. The first great Neoclassical painting, painted in 1784-85, *The Oath of the Horatii (295)* is theatrical, but it is honestly so.

THE OATH OF THE HORATII

An argument between the peoples of Rome and Alba threatened to lead to war, and so it was decided that each side (the Horatii and the Curatii) would send three men to fight for their city. After the battle only one man, Horatius, remained alive. He discovered that his sister had been betrothed to one of the enemy Curatii. In revenge he slew his sister and was found guilty of murder, but he managed to get a reprieve from the death sentence. In art, the three brothers are usually shown swearing a sacrificial oath in front of their father.

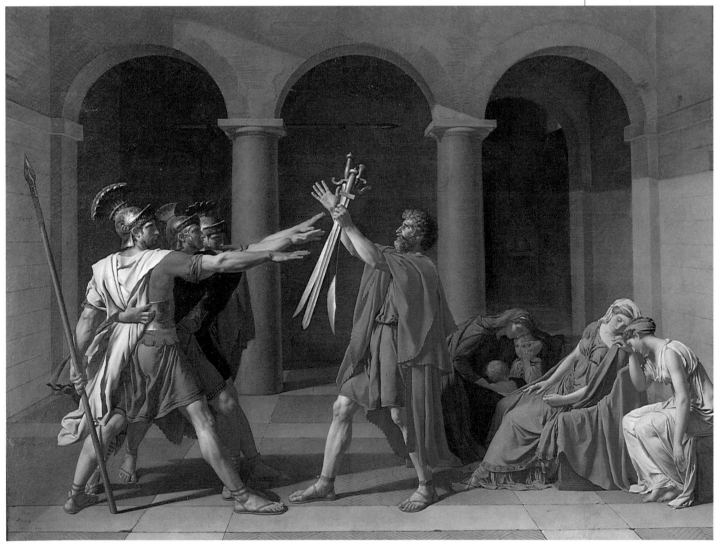

295 Jacques-Louis David, The Oath of the Horatii, 1784–85, 14 ft × 11 ft (427 × 335 cm)

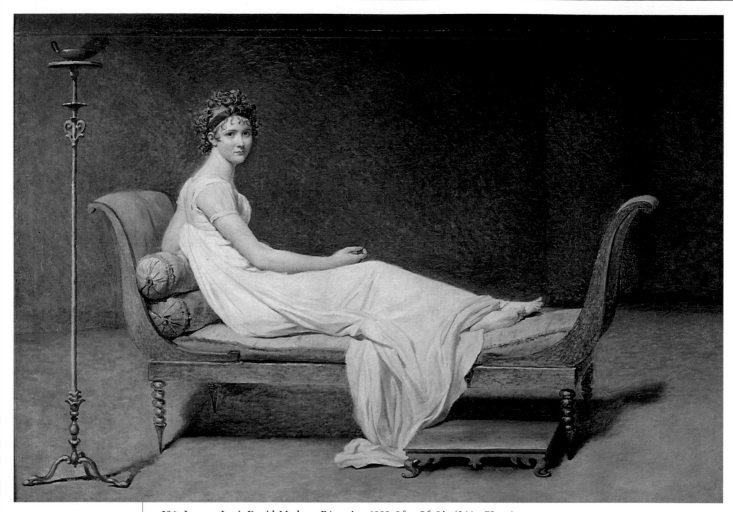

296 Jacques-Louis David, Madame Récamier, 1800, 8 ft × 5 ft 9 in (244 × 75 cm)

All elements in the painting are geared toward
facilitating our understanding of the drama:
three brave Romans are vowing their lives away
for their country. The uprightness of their intent
is shown in the straightness of their outstretched
arms as they receive swords from their father.
Great symmetrical arches stabilize their act of
taking the vow, setting it in a noble context. The
austerity and clarity of the colors emphasize the
selflessness and totality of their fervor.

The men are hard, concentrated, active; across
the room huddle the women, soft, distracted,
passive. The contrast between them is absolute,
and it is in this uncompromising climate of
absolutes that David feels most at home.
When David painted *The Oath of the Horatii*,
the Revolution was not far away, and the picture
contains a clear reference to this.

Probably the works of David that are most
compatible with present-day sensibilities are his
portraits. Here we have no need to set him in
his historical setting before we can respond fully:
he is wonderful in the sheer conciseness of his
vision. There are no superfluities, yet the bareness
has a confident rightness about it.

Madame Récamier (296) is the epitome of
Neoclassical charm. We see that she knows she
has charm and that she is almost consciously
watching its effect upon the painter. Everything
on and about her is sophisticatedly simple: she
scorns, we feel, the vulgarity of devices, but she
is all one living device, forcing us to accept her
at her own valuation. David sees that she is
lovely, and makes us see it as well: she reclines
because she is sure of the power of her charm,
secure behind the ivory chill of her pose. But he
seeks to know her at a level below the conscious,
and in that lies the forcefulness of the image.

A MARTYR OF THE REVOLUTION

The absoluteness of *The Oath of the Horatii* (see
p.253), intrinsically overstated but subjectively
real, is what makes *The Death of Marat (297)*,
a revolutionary icon. David was very involved
in the Revolution, debating in the assembly with
a furious excitement, and was intellectually swept
away, along with many others. Marat, whom he
here idealizes as a modern saint, was assassinated
by the royalist Charlotte Corday, who prepared
for her act with fasting and prayer.

The real Marat was a politician of particularly hideous appearance who was obliged to take frequent baths because of a severe skin infection. David shows him fair and martyred, struck down amid his labors for the common good. But the literal truth is unimportant here. David painted the truth he wanted to believe, a deliberate act of propaganda, and the sheer wanting, the passionate faith in the revolution and its sanctifying power, gives the work a gigantic force. If we forget Marat himself and generalize, here is an image of death in its purity. Everything conspires to recall the Christian martyrs – the dark background lightens to the right, as if heavenly glory awaited the dying saint. Yet this is brilliant legerdemain because at no point does David cheat by using Christian imagery: it is all done by subtle reminiscence.

THE FRENCH REVOLUTION

In 18th-century France the poorest people were forced to assume the burden of the highest taxes while the aristocracy and clergy were exempted from payment. On July 14, 1789, the masses (known as *sans-culottes*, illustrated above) attacked the Bastille (the royal prison) hoping to find a stock of weapons. It was against this background that on August 4, 1789, the Constituent Assembly voted to abolish the *ancien régime* (feudal society). In 1791 the royal family tried to flee Paris but were captured, and the trial and execution of Louis XVI took place in January 1793.

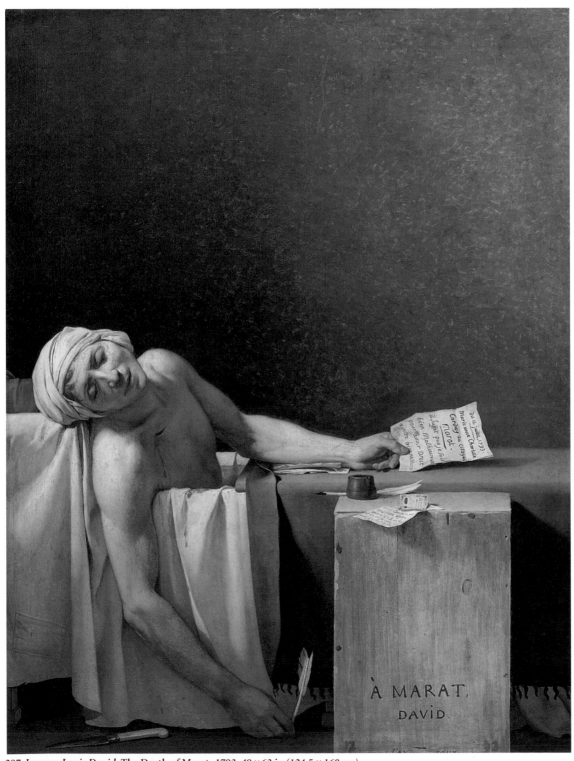

297 Jacques-Louis David, The Death of Marat, *1793, 49 x 63 in (124.5 x 160 cm)*

MAXIMILLIAN DE ROBESPIERRE

A leading radical in the National Assembly and an early member of the Jacobin Club, Robespierre (1758–94) derived his ideas from the doctrines of Rousseau. On June 8, 1794, Robespierre held "The Fête of the Supreme Beings," which was stage-managed by Jacques-Louis David. This new religious group was based on the disestablishment of the church and the worship of nature as a deity.

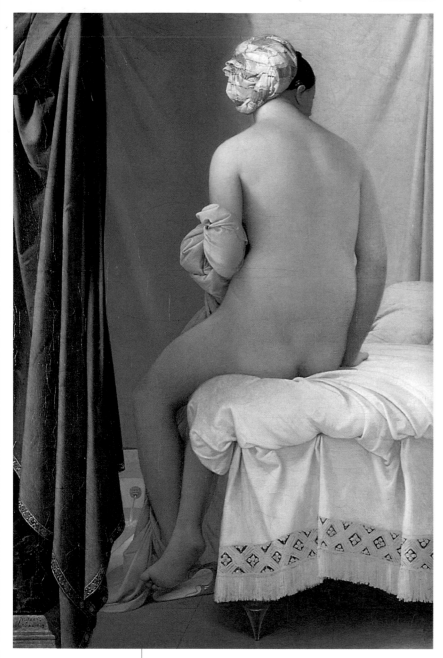

felt it ought to be, with additional vertebrae to provide the perfect elongation. *La Grande Odalisque (299)* is a superb example of this. A great curve of naked back sweeps from the line of her neck, outlining her backbone and ending in the voluptuous fullness of her buttock. She is like a glassy stream, breaking into a waterfall at the barrier of the jeweled fly-whisk, with the tumult of hand, legs, and feet flowing to the edge of the canvas.

Parmigianino, the Italian Mannerist painter, did much the same, lengthening the beautiful neck of his Madonnas (see p.142). But the Mannerists intended to excite by their use of forms; Ingres does not. His intention is to get us to accept his forms as actual, as classically perfect, and in their weird beauty they come close to it. *The Bather* (also known as *The Valpinçon Bather, 298)* is an example of this. It is a heavily sensual picture, the naked back exposed amid the contrived setting of a great sway of olive green drapery and the wonderful pillowy whites of a bed's edge.

298 Jean-Auguste Ingres, The Bather, 1808, 38 x 57½ in (97 x 146 cm)

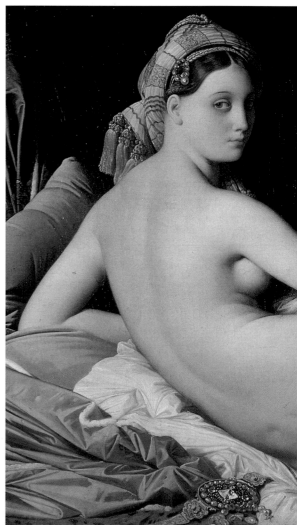

NEOCLASSICISM'S GREATEST HEIGHTS

Ingres (Jean-Auguste Dominique, 1780–1867) studied under Jacques-Louis David, who was 32 years his senior, but eventually he emerged as the leading exponent of Neoclassicism in France. Ingres was greatly influenced by David, especially in his earlier works. Like David, Ingres was a strange man, almost fanatic in his meticulousness, so dedicated to the ideal that he could not accept the real if it fell below his aspirations.

Ingres was a passionate admirer of Raphael, the supreme classicist, and it almost seems that his whole art is a yearning for that earlier certainty represented by Raphael. He is renowned for painting the female back, not as it is, but as he

She has been given the name *The Bather* in an attempt to make sense of her position and her cap, but Ingres hardly needs the trappings. It is that heavy, dimpled back he needs, too long in its luscious curvature, obsessing the artist and affecting the viewer through the force of his emotion. The same impossible curve distinguishes his Thetis. *Thetis Entreating Jupiter (300)*, in which the male is as impossibly broad as the female is supple, is a comic picture, quite unintentionally, because of this body fixation.

Ingres believed that "drawing is the probity of art," and his linear grace carries him magnificently through most hazards. But Thetis is stretching out an arm with elastic bones, a dislocated limb that halts us in our gaze and alerts us to the comely deformations the artist is trying to persuade us to accept. Ingres obviously feels that Jupiter has an iconic majesty, which has an odd truth to it, but the clamlike beauty at his knees undoes whatever faith we have managed for Jupiter. The picture fails, but so gloriously, so alarmingly, that it fascinates still.

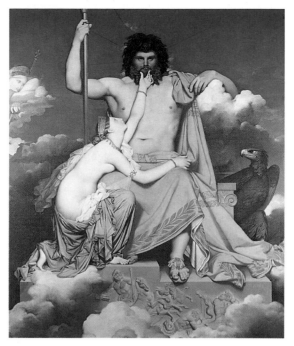

300 *Jean-Auguste Ingres,* **Thetis Entreating Jupiter**, *1811, 8 ft 5 in x 11 ft 6 in (257 x 350 cm)*

THETIS AND JUPITER

The legend of Thetis entreating Jupiter is told in the *Iliad*. Thetis, the mother of Achilles, is sent by her son to Jupiter with a petition concerning his quarrel with Agamemnon. In paintings the scene usually depicts Jupiter, scepter in hand, enthroned on Mount Olympus. Thetis kneels before him and is seen imploring with the god to intervene in her son's fate.

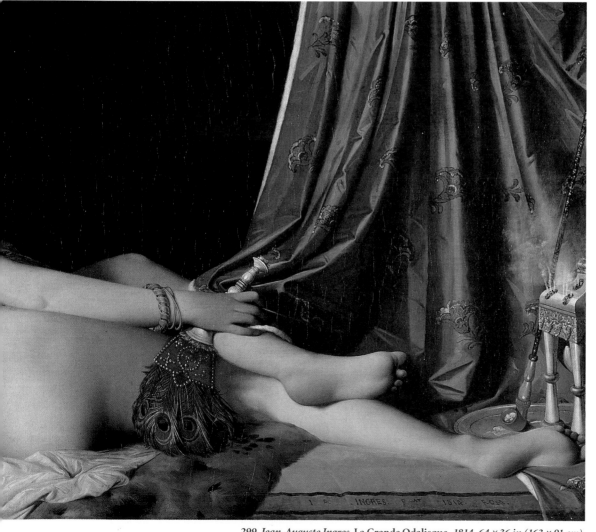

299 *Jean-Auguste Ingres,* **La Grande Odalisque**, *1814, 64 x 36 in (163 x 91 cm)*

CONTEMPOARAY ARTS

1764
Mozart composes his first symphony at the age of 8 years

1792
Mary Wollstonecraft writes *A Vindication of the Rights of Women*

1804
The English Watercolour Society is founded

1813
Jane Austen writes *Pride and Prejudice*

1818
The Prado Museum is founded in Madrid

1826
The U.S. Academy of Design is founded

1837
Dickens's *The Pickwick Papers* is serialized

1862
Victor Hugo writes *Les Misérables*

MARIE ANTOINETTE

After marrying the Dauphin in 1770, Marie Antoinette (1755–93) became queen of France on the coronation of her husband Louis XVI in 1774. Unfortunately, the miseries of France became identified with her extravagances. As a feminist, Marie Antoinette supported female artists, including Vigée-Lebrun, and was involved in the march on Versailles in 1789. After the execution of her husband in 1793, she was placed under arrest and eventually guillotined.

THE FRENCH SALON

The Salon of 1667 was the first official art exhibition held in France and was limited to members of the Royal Academy. The term *Salon* derived from the Salon d'Apollon, in the Louvre, where the annual exhibitions were first held. Until the 19th century the limited number of artists who were allowed to show at these salon exhibitions had a monopoly on publicity and sales of art. This painting, *L'Innocence*, is by Adolph-William Bouguereau (1825–1905), who was one of the key supporters of the 19th-century salon.

301 Elisabeth Vigée-Lebrun, **Countess Golovine,** *c. 1797–1800, 26½ x 33 in (67 x 83 cm)*

ROYALIST IN REVOLUTIONARY TIMES

(Marie) Elisabeth (Louise) Vigée-Lebrun (1755–1842) was a clear-minded supporter of the monarchy. She fits uncomfortably within the revolutionary climate that so excited David. She understood Neoclassicism but transcended its formalities, delighting in the freedoms of the Baroque, with its strong, contrasting colors. A charming woman, she made friends with Marie Antoinette and had an instinct for the socially acceptable. At times, her insight can take her beyond this, as in her fine portrait of the

Countess Golovine (301). It is impossible not to warm to the completely feminine frankness of this Russian aristocrat, her ingenuous gesture with her scarlet cape and the seductive simplicity with which her rosy face smiles out at us beneath the carefully disheveled black curls. This is a strong woman, for all her charm, and Vigée-Lebrun must have recognized an equal. At the outbreak of the Revolution, Vigée-Lebrun went into exile in Italy. She went to London in 1802, where she painted several important portraits, returning to Paris in 1805.

THE GREAT FRENCH ROMANTICS

If applied to the arts today, the word Romantic suggests a certain theatricality and sentimental idealism. Its original meaning, however, had very different associations. While Neoclassicism was associated with the culture of antiquity, the Romantic was associated with the modern world. Romanticism admitted the "irregular": the wild and uncontrolled aspects of nature (both animal and human, both beautiful and ugly). The necessary strategy for such expression was inevitably incompatible with the dogma of Neoclassicism and its established boundaries of beauty and subject matter.

JEAN-JACQUES ROUSSEAU

Jean-Jacques Rousseau, (1712–78) the political philosopher and author, had a great influence on the Neoclassical period. It was not until 1750 that he made his name as a writer with his *Discourse on the Sciences and the Arts*, which argued that there was a schism between the demands of contemporary society and the true nature of human beings. His argument for "Liberty, Equality, and Fraternity" became the battle cry of the French Revolution.

The pastoral idyll suggested by some of the country scenes of Gainsborough (see p.240) was fast disappearing under the Industrial Revolution, while in France, revolution of a more violent kind brought irrevocable change to the social order. The grandeur and idealism of Neoclassicism were at odds with the realities and hardships of an increasingly industrial society. Prefigured by Goya (see p.252), Romanticism stands for an outlook, an approach, a sensibility toward modern life. France was its true home, and that of its earliest innovators, Théodore Géricault (1791–1824) and Eugène Delacroix (1798–1863).

If Ingres (see p.256) was the great Neoclassicist, these were the great Romantics. Their art was diametrically opposed to his, and in the bitter debate between the two schools, theirs proved the stronger. Ingres was concerned mainly with the control of form and with outward perfection as a metaphor for inner worth. The Romantics were far more interested in the expression of emotion – through dramatic color, freedom of gesture, and by their choice of exotic and emotive subject matter. *The Raft of the Medusa (302)* was enormously important as a symbol of Romanticism in art.

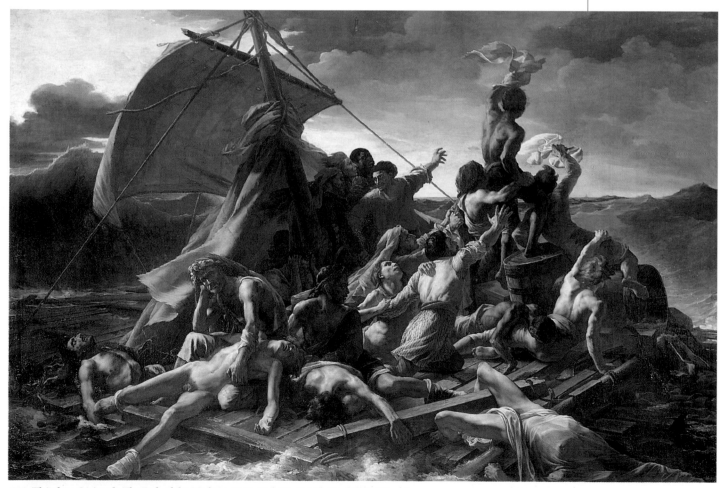

302 Théodore Géricault, **The Raft of the Medusa**, *1819, 23 ft 6 in × 16 ft 1 in (717 × 491 cm)*

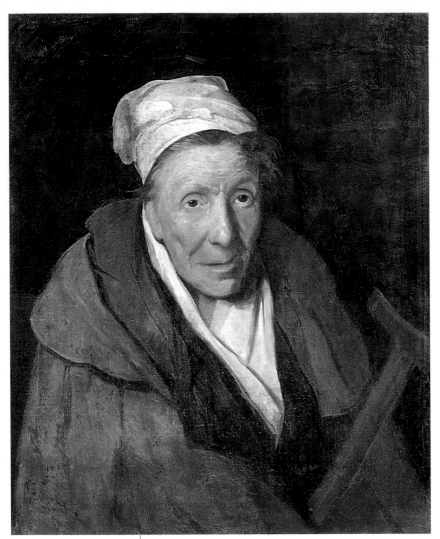

too trivial, too joyous, for such a scene. There is no space for the viewer in which to escape the terrible impact of that rough triangle of raft. It juts out at us, a blow in the solar plexus.

Disappointed with the painting's tepid reception in France, Géricault took it to England, where he stayed for a few years, deeply impressed by Constable (see p.268).

Géricault's life was short but intense. He sought after the real with a hungry passion, but it was to make the real transcendent that he sought. There is a hypnotic power in his portraits of the insane, such as *Woman with the Gambling Mania (303)*. These tragic and haunted faces had some personal resonance for him. He is not regarding their sufferings objectively; there is a moving intensity of reaction. He makes us feel that the potential for these various imbalances are endemic to us all. It is our own possible future that we contemplate.

DELACROIX: THE GREAT ROMANTIC

Géricault had a preoccupation with death and the morbid that is absent in his contemporary, Delacroix, whose characteristic is a sense of the romantic fullness of being alive. After Géricault's death in 1824, Delacroix was regarded as the sole leader of the Romantic movement, but his art was very much his own, and soon transcended Géricault's early influence. Like Géricault, Delacroix received a classical training (in fact they first met as students of the Neoclassicist Pierre-Narcisse Guérin) but, despite much

303 Théodore Géricault, Woman with the Gambling Mania, c. 1822, 26 x 30½ in (65 x 77 cm)

GÉRICAULT'S RAFT

The raft carried survivors from a French naval ship, *La Méduse*, which sank en route to West Africa in 1816. The captain and senior officers took to the lifeboats and left a makeshift raft for the 150 passengers and crew. During 13 days adrift on the Atlantic, all but 15 died. Géricault's choice of this grim subject for a gigantic canvas went against traditional artistic rules. It also implied criticism of the government, for the appointment of this unseamanlike captain had been an act of political favoritism.

This radical work was accepted, but grudgingly, by the artistic establishment: the gold medal it won at the Paris Salon of 1819 was merely a way of denying Gericault the controversy he sought. Géricault forces us, almost physically, to accept the reality of human suffering and death. It is death in the most terrible conditions, anguished, tortured, long-drawn-out, without nobility or privacy. The drama is all in the physical details. It is as if Géricault eschews the use of color as

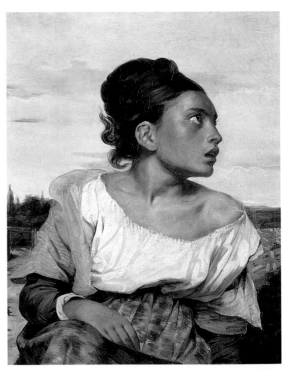

304 Eugène Delacroix, An Orphan Girl in the Graveyard, 1824, 21½ x 26 in (54 x 65 cm)

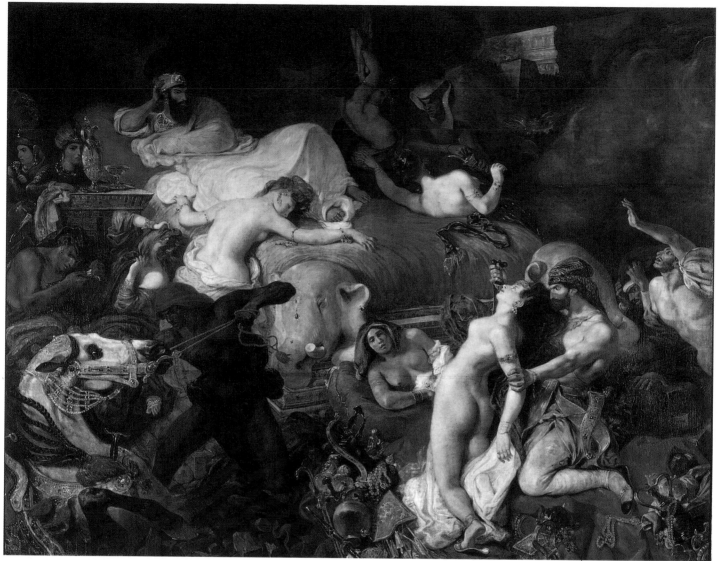

305 Eugène Delacroix, **The Death of Sardanapalus,** *1827, 16 ft 3 in × 12 ft 10 in (496 × 391 cm)*

criticism from the salons, he went on to develop a uniquely animated and expressive style, greatly influenced by Rubens (see p.186), employing a characteristically vivid palette that places him as one of the great colorists. He has an almost Rubensian energy, a wild and sometimes reckless vitality that is the exact visual equivalent of Byronism. Like Byron (see column, p.262) he can be histrionic at times, but generally he exults with the vigor of the truly great and carries the viewer uncritically away.

Delacroix is an extremely active artist. When he paints *An Orphan Girl in the Graveyard (304),* she is not a tearful or passive orphan, but a vibrant young beauty, avid for life, alarmed and alerted by the nearness of death, but slack-mouthed and bare-shouldered as she looks away from the graves toward rescue. Her eyeballs have the gleam of a frightened horse, but the tenseness of her neck muscles is completely healthy. She is not a victim, despite her label.

The Death of Sardanapalus (305) shows Delacroix at his most brilliantly unpleasant – appropriately, for Sardanapalus was an Assyrian dictator. The gorge rises to see female slaves treated as chattels just like the horses and jewels. If sadomasochism is to be glorified, this is its glorification. Only Delacroix, with his almost innocent delight in movement and color, could even attempt to carry it off.

Like Géricault, Delacroix exulted in horses, especially those from the exotic wastes of Arabia or Africa. But he did not share the younger Romantics' interest in contemporary, local reality. When he deals with modern events he distances himself by setting them in a far away, exotic location. Such detachment sets him apart from the Romantic movement as such, though not from the Romantic attraction to the exotic. It also reveals his concern that art should still strive to attain the timelessness and seeming universality of the great art of the past.

OTHER WORKS BY DELACROIX

The Assassination of the Bishop of Liège (Louvre, Paris)

Education of the Virgin (National Museum of Western Art, Tokyo)

Hercules and Alcestis (Phillips Collection, Washington, DC)

Odalisque (Musée des Beaux Arts, Dijon)

Death of Valentino (Kunsthalle, Bremen)

The Lion Hunt (Art Institute of Chicago)

Death of Ophelia (Neue Pinakothek, Munich)

TRAVEL JOURNALS

In the mid-19th century it became popular for artists to go on tours of distant countries. In 1832 Delacroix traveled to North Africa and filled seven notebooks with drawings and watercolor sketches like these studies (shown above) of the walls around Meknès. The experiences of his six-month tour of Morocco and Algeria fueled his imagination for the next 30 years.

Delacroix spent time in Tangiers and Morocco, and he remained in tune with this romantic world all his life. He felt a temptation to the violent, the extreme, and exorcised it in his paintings of the Near East, rather than of his own periodically turbulent country. Here, in a wild swoop of motion and a rolling swirl of color, he can show *Arabs Skirmishing in the Mountains (306)*. He claimed to have seen these attacks and even taken part, but their truest origin is in his imaginative bonding with the warriors. He is himself in all parts of the picture, in the frenzy of the horses, the maneuvers of the fighters, their pain and anger, their courage and despair. He is at one with the landscape, wild and high, desolate, infertile, yet fiercely loved.

The citadel on the cliffs, though, remains, above the smoke and the fury, and that, too, has a personal meaning. Delacroix never loses himself in his greatest works but, with instinctive tact, leaves always a place for detachment. There is an inner stability that keeps the work from bluster, however near the edge it may go.

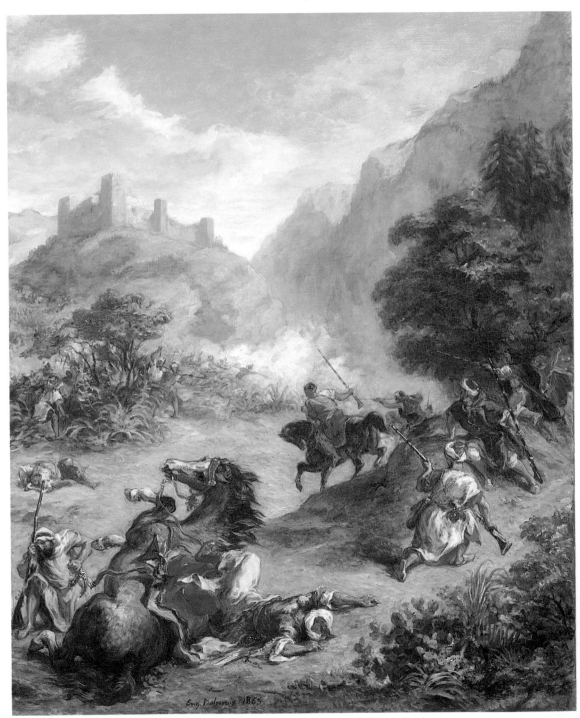

306 Eugène Delacroix, **Arabs Skirmishing in the Mountains,** *1863, 30 x 36½ in (75 x 92 cm)*

ARABS SKIRMISHING IN THE MOUNTAINS

Delacroix produced this painting a few months before his death in 1863. It has been suggested that it depicts a battle between the Moroccan sultan's tax collectors and local rebels, and Delacroix may have come into contact with such incidents when he traveled to Meknès with the Moroccan foreign minister in 1832. (An entry in his diary of 1832 suggests this.) Historical details are, however, irrelevant to the real subject of the painting, which is a Romantic celebration of drama, color, and light, and of the exotic. It is primarily a storyteller's painting, reinvented 31 years after Delacroix's Moroccan journey, and whatever its connection with real events, it exists as a purely fictitious scene.

DISTANT ACTION
The gunmen fighting in the distance are picked out largely by their headdresses and guns, within the brilliant cloud of dust, or possibly heat haze. The livid, broken surface of the horse's flank (below), which provides a sharp focal point for the foreground, gradually gives way to a broader, more relaxed application of paint as the action recedes, culminating in the ghostly fortress on the mountain.

DISTINCTIVE BRUSHWORK
Delacroix's distinctive broken brushwork recalls the flamelike motion of El Greco's (see p.145) and contrasts utterly with his Neoclassical contemporary, Ingres (see p.256). The action of the narrative is imitated in the actual paint surface, through a kind of visual onomatopoeia. It is alive with writhing, swirling brushmarks, and there are no straight lines or flat, uninterrupted surfaces; the vegetation waves, and even the men's rifles seem animated.

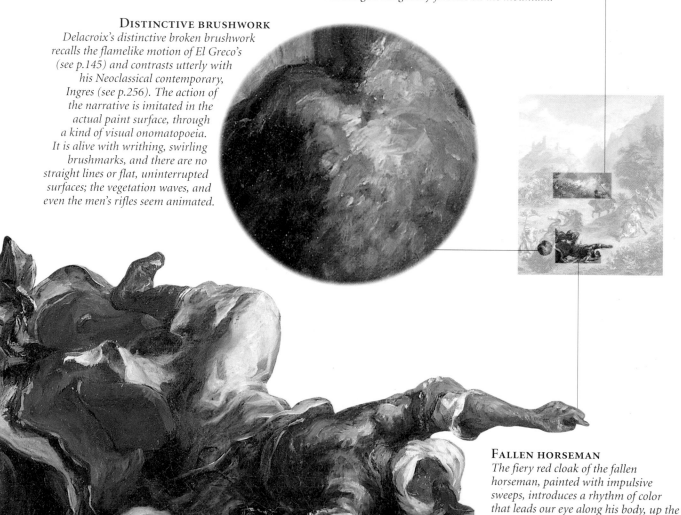

FALLEN HORSEMAN
The fiery red cloak of the fallen horseman, painted with impulsive sweeps, introduces a rhythm of color that leads our eye along his body, up the path described by vegetation to the line of kneeling riflemen, where the direction is reinforced by the emphatic diagonals of their rifles. The sweeping movement then continues on, led by the galloping horseman, into the more distant action.

ROMANTIC LANDSCAPES

In their landscape paintings the Romantics gave free rein to their daring and their imagination. Art lovers in the 19th century may have lamented the lost rational serenity of the 17th-century master Claude Lorrain (see p.220), but many of them also saw that Turner was his equal. Turner's revelations of atmosphere and light answered the need for a new artistic language. Constable surprised the world with a new awareness of, and a new openness to, nature as it actually is, without idealized or stylized form.

JOHANN WOLFGANG VON GOETHE

Germany's greatest poet, Goethe (1749–1832) pioneered Romanticism in German literature in the 1770s. He believed that great art must simulate the creative force of nature. In his later life he also studied various sciences, including optics. Goethe's writings on art included a book on the theory of color, which opposed Newton's discovery that there were seven colors in the spectrum and argued that there were only six in natural daylight conditions.

The French were by no means the only Romantics: Germany was the original "land of the Goths." A touch of that heavy symbolism that so often characterizes German art is seen in Caspar David Friedrich (1774–1840). It is primarily the countryside that Friedrich sees as a symbol, a mute praise of its unseen and unseeable Creator. Germanic mysticism has never been very exportable, and Friedrich is only today being seen as a powerful, significant artist. Religious art without an explicit religion is not easy to paint, but Friedrich succeeds.

Monk by the Shore (307) has a daring simplicity. Three great bands stretch across it – sky, sea, land – with the one vertical note of the human being, who gathers the muteness of nature into himself and gives it a voice. "Monk" comes from the Greek for "alone," and it is this loneliness that Friedrich shares with us. In the sense of this picture, we are all monks and we all stand on the shore of the unknown.

THE ENGLISH ROMANTIC TRADITION

True Romanticism – in the sense of the broad movement that was bound up with the demise of Neoclassicism – necessarily belongs to France. On the other hand, speaking strictly chronologically, a Romantic tradition had emerged earlier in England than it did in France; in a way it had been there all along, in the form of a particularly English sensibility toward the landscape – exemplified in the paintings of Gainsborough (see p.240). This early sensibility reached its full Romantic expression in the works of England's two great landscape painters: Turner and Constable.

TURNER'S LANDSCAPES

Turner (Joseph Mallord William, 1775–1851) disturbed those who met him by conforming little to the accepted idea of a great artist. He remained an unrepentant Cockney, not overscrupulous about cleanliness or correct pronunciation, but passionately intent on the things that mattered to him. He was recognized as great from the beginning, and his career was a source of baffled but resoundingly affirmative reactions throughout his life. If his pourings and soakings of paint were beyond comprehension, they bore the certain stamp of genius.

We associate Turner with color, but his early work is dark, the actuality of the scene being an overriding concern, and beyond this, its inherent drama. In midcareer, it is light itself that has begun to fascinate him. Place never loses its necessity, but it is as a focus for the light, as a precious receptacle, that it matters.

He was friendly with a group of English watercolorists who were at that time developing an art that was very much based on the atmosphere of a place, as well as its topographical fact. This new art form was called the "picturesque." Turner's early training was as a watercolorist, and he would eventually come to realize water-color's special potential for freedom of expression in his oil paintings, creating a completely unprecedented new language.

Mortlake Terrace (308) is without obvious drama. There is an early summer evening, the Thames flowing gently by, pleasure boats venturing out, tall trees lining the terrace and swaying lightly in the breeze. Shadows fall across the short grass, a few bystanders watch, a small dog leaps onto the parapet. Nothing really happens, yet the drama is as vibrant as ever. It is light that

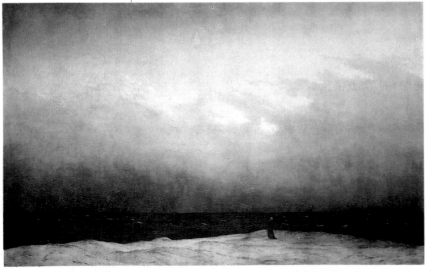

307 Caspar David Friedrich, Monk by the Shore, 1810, 67 x 43 in (170 x 110 cm)

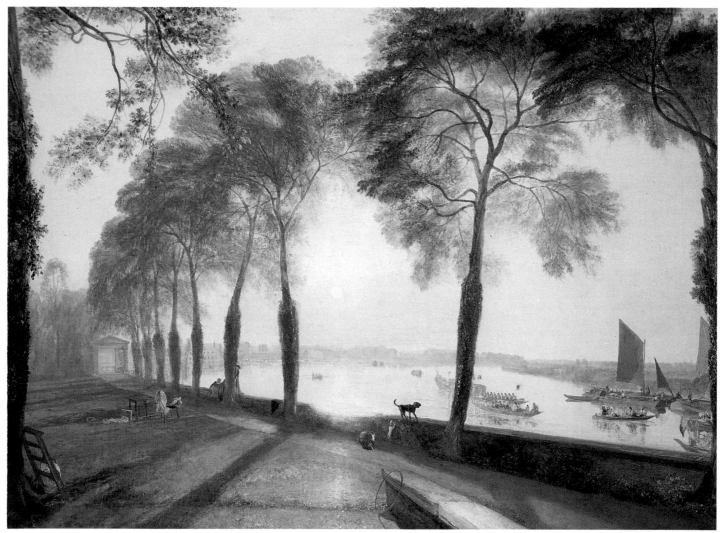

308 *J.M.W. Turner*, Mortlake Terrace, *c. 1826, 48 x 36½ in (122 x 92 cm)*

is the artist's preoccupation; all is a pretext for his enamored rendering of this delicacy of sunlight. Light quivers in the air, it bleaches the far hills, it makes the trees translucent, it throws a dark, diagonal patterning on the dull turf that takes on an entranced quality; light hides the world, and reveals it.

The Napoleonic wars ended in 1815, and the continent became accessible once more. Turner began his long series of travels in European countries. Particularly important were his trips to Italy: in 1819 he spent three months in Rome and then visited Naples, Florence, and Venice. He revisited Italy in 1829, 1833, 1840, and 1844. His understanding of the mechanics of light was greatly enhanced by the time he spent in Italy, especially Venice, and this is what marked the beginning of his last and greatest phase.

Steamboat in a Snowstorm (309) shows Turner at his most impassioned. We are presented with a whirlwind of frenetic energy, an almost tactile communication of what it means to be in a storm at sea, and a snowstorm at that. The opacity of the driven snow, the dense clouds

309 *J.M.W. Turner*, Steamboat in a Snowstorm, *1842, 48 x 36 in (122 x 91 cm)*

TURNER'S TECHNIQUE
This caricature by Richard Doyle, entitled *Turner Painting One of His Pictures,* was painted for the *Almanack of the Month* in 1846. It makes the point that Turner's love of chrome yellow, which he had used consistently since the 1820s, was still considered shocking by the public. Turner's use of luminous yellows, blues, and pinks was his most characteristic feature.

swirling from the smokestacks, the furious commotion of the water – all combine with almost frightening realism. And yet, take away the title, change the century, and we would think we were looking at an abstract.

This is the greatness of Turner, an almost reckless appreciation of natural wildness, controlled solely by the power of the artist's understanding. In controlling the scene, Turner seems to control nature itself, a godlike quality, and he communicates this orderliness to us. The viewer experiences the wildness, and yet is able to hold it in perspective. There can be few things more exhilarating than to encounter the full force of a great Turner.

EXHILARATION OF LIGHT

In Turner's work from this time until his old age, light has conquered so completely that all dissolves in its radiance. In these pictures, the Romantic glorification and love of nature's drama are shown to the fullest. It is here that the deeply poetic nature of Romantic painting first finds supreme visual form. As his rival John Constable (see p.268) put it, late Turners are as though "painted with tinted steam."

Approach to Venice (310) needs its title, since we are presented with a haze of colored nothingness, through which there loom the bright accents of what we make out to be boats and a far-off steeple. The water is golden with light, but so is the sky: where does one end and the other start? There is no perspectival depth, just space, height, clouds, dazzle, glory.

The impression given is of immense exhilaration, almost ecstatic in its power; the natural is allied with the spiritual. Turner has torn the world into paper shreds and thrown them up to the sun: there they catch fire and he paints them for us, crying "Alleluia!"

Not until the 20th century, with Pollock, Rothko, and de Kooning (see pp.368–372) was there such a daring disregard for realism. Yet Turner knew precisely what he was aiming at. The clouds of glory, the lakes of light, the stone and mortar transformed into citadels of Heaven: these are not inventions. Few people have not seen the extravagances of glory that the sun produces with casual ease morning after morning. It was Turner's special gift to know that these extremes of light and color demand from the artist an extremity of technique.

310 J.M.W. Turner, Approach to Venice, *c. 1843, 37 x 24½ in (94 x 62 cm)*

APPROACH TO VENICE

Turner visited Venice several times. He painted *Approach to Venice* on what was probably his last visit there. As a late work it exceeds, stylistically, his earlier paintings of Venice, pushing further his daring with Romantic atmospherics and departing from the topographic reality of the Venetian sea- and townscape even more than before.

DISTANT CITY

The mysterious and unnamed procession of barges moves silently through water that, more than anything, resembles liquid gold, toward the shimmering, floating city of Venice. The distant city seems to be dissolving, no more on firm ground than the barges themselves, and takes on the quality of a mirage. Indeed, when this painting was exhibited in London, a critic for the weekly magazine The Spectator *wrote: "beautiful as it is in color, it is but a vision of enchantment."*

DARKENING SKY

Turner has created a canopy of orange and blue over the setting sun. These are the strongest touches of color in the painting and suggest that the colors of the sunset have not yet reached their peak of intensity before they finally disappear. Over a smooth (and now heavily cracked) surface, these "abbreviated" clouds have been quickly and lightly rendered, and Turner has created a wonderful sense of transition as the sky moves rapidly from day to night.

MOONLIGHT ON THE WATER

Beyond the ostensible subject matter of Approach to Venice, *with its important-looking barges sailing toward Venice, is the real subject of the painting: the duel between sunset and moonrise. To the right of the canvas, the sun is setting in a spread of diffused, pale lemon light. To the left, casting its cooler reflection down the length of the picture, is the ascending full moon. When Turner first exhibited this painting, he accompanied it with these lines from a poem by Byron:*

> *"The moon is up, and yet
> it is not night,
> The sun as yet disputes
> the day with her."*

LAYERED SURFACE

Turner habitually prepared his canvases with a thick layer of white oil ground, which would largely obliterate the "tooth" of the canvas. Over this smooth surface he would apply thin, pale washes of those colors that were to be used full strength later. This resulted in a fresh, glowing surface over which he built up subsequent layers. To the barge on the left he has added thick, crusted paint, which, having a jeweled effect, catches natural light falling onto the picture and provides areas of focus. Conversely, the shadows of the dark barge on the right have been applied with thin washes of black so that they appear to sink within the surface.

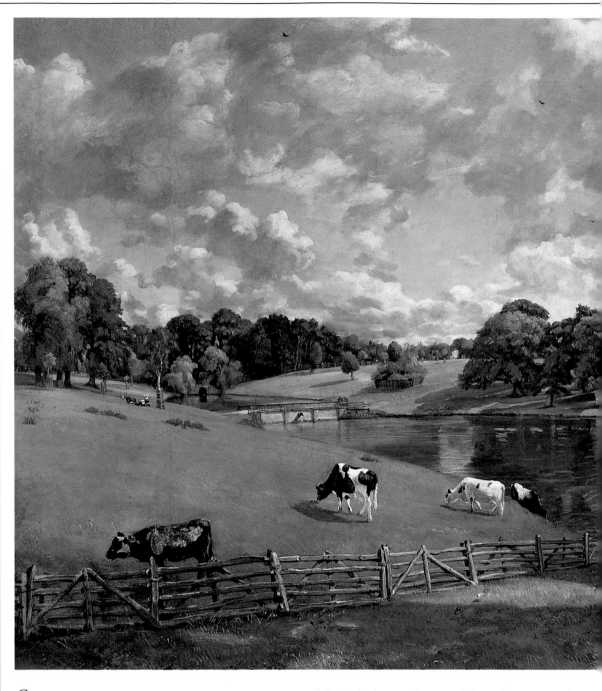

CONSTABLE – POETRY IN REALITY

Turner's Romanticism, though full of drama, is not melodramatic, and indeed "Romantic" does not preclude the humble and ordinary, as we have already seen in Turner's treatment of a quiet sunset at Mortlake (see p.265).

Constable (1776–1837) is as intense as Turner and, in his less obvious manner, fully as daring, but he always reveres the factuality of what he paints. Since he sees those facts as purely poetic, there is no loss of intensity. Turner loved the grandiose and the magnificent. Venice was his natural habitat. Constable loved the ordinary, and his love and natural dwelling place was the flat land of his beloved Suffolk. He is the natural heir to Gainsborough's lyricism (see p.240), but

while Gainsborough was still largely concerned with extracting the beautiful and harmonious in the natural landscape, Constable saw the long meadows and winding canals, the old bridges, and the slimy posts by the rivers as being inherently as lovely as anything the heart of man could desire. All his youth and all his hope of Heaven were intimately connected with these rural simplicities, already under threat from industry as he began his arduous and none too successful career as an artist.

Turner lived unmarried; Constable needed the solace of a wife to share his loneliness. Even shared, this loneliness is always discernible. The sun may shine and the trees wave in the breeze, but a Constable landscape carries a deep sense

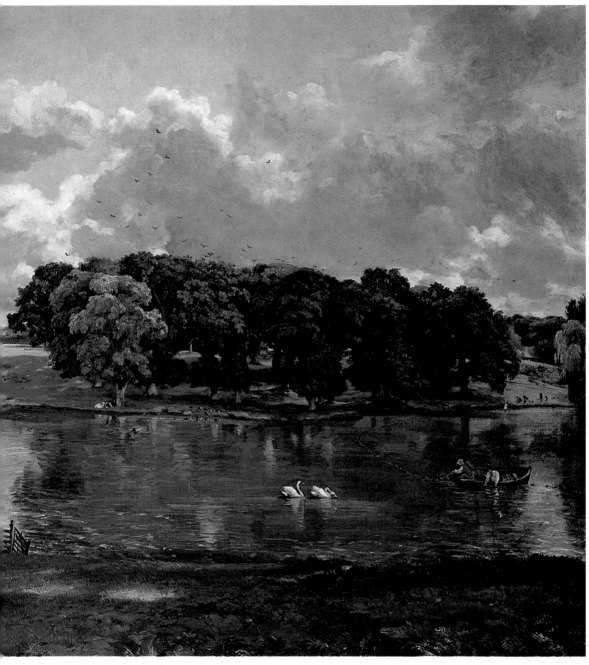

JOHN RUSKIN

The art critic John Ruskin (1819–1900) took it upon himself to rescue Turner from obscurity. In 1843 he wrote his treatise *Modern Painters* in defense of Turner. He then developed it into a series of volumes concerning artistic tastes and ethics. Ruskin belonged to the Romantic school in his conception of the artist as inspired prophet and teacher. His personal life, however, was deeply unhappy, and he died a lonely Christian socialist, fighting against the onslaught of the Industrial Revolution.

311 John Constable, Wivenhoe Park, Essex, *1816, 40 x 22 in (102 x 56 cm)*

of loss and yearning. After the early death of his beloved wife, this yearning becomes even more apparent. Yet it is a resigned yearning and an acceptance of life as it is, and of the consolation given by the beauty of the material world, our nearest image of lost Eden.

The intensity of Constable's poetry was not obvious to himself: he believed that he was the most throughgoing of realists. Even an early work, though, like *Wivenhoe Park, Essex (311),* despite its conscientious fulfillment of the owner of the park's desire to illustrate every aspect of his property (which Constable found "a great difficulty") is still a work of imaginative ardor. The reality of all he portrays is evident: there fish the Wivenhoe tenants, on the fish-stocked lake; there wander the dairy cows, belonging to the farm; there, tiny in the distance, is the family in the trap; there in the background is the stately home. Yet all this is bathed in a silvery sunlight, so that the waters shimmer and the shadows beneath the great, spreading trees entice the viewer toward their shade.

Over the earth and water towers a pale and clouded sky, hinting at rain to come, the blissful rain that every estate needs. Peace and silence, contentment and prosperity are all imagined and realized in the actual details, so that Wivenhoe Park is both real and ideal, both in our world and removed from it.

OTHER WORKS BY CONSTABLE

Hampstead Heath
(Fitzwilliam Museum, Cambridge, England)

View at Epsom
(Tate Gallery, London)

Naworth Castle
(National Gallery of Victoria, Melbourne)

Coast at Brighton, Stormy Weather
(Yale Center for British Art, New Haven, Connecticut)

View of Salisbury
(Louvre, Paris)

The Watermill
(National Museum, Stockholm)

Wooded Landscape
(Art Gallery of Ontario, Toronto)

SONGS OF INNOCENCE

As a child, the English poet William Blake (1757–1827) saw visions from which he drew lifelong inspiration. One of William Blake's most significant inventions was the printed book in which the illustrations were completely integrated with the text, both being printed from a single metal plate.

The two mediums of poetry and engraving came together triumphantly in 1789 when he published his *Songs of Innocence*. This illustration shows the original title page. The fictional world of *Songs of Innocence* is Christian and pastoral, with the innocence of childhood celebrated as a spiritual force. Five years later, Blake wrote the antithesis of this idyll, the *Songs of Experience*. In his last years Blake produced some of his finest engravings, illustrating, among others, the book of Job.

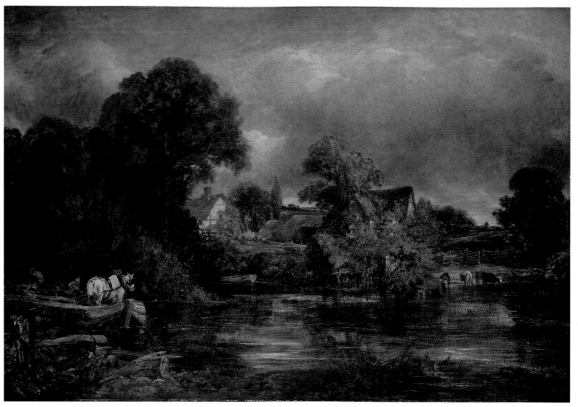

312 John Constable, **The White Horse,** *probably 1819, 74 x 51 in (188 x 130 cm)*

THE UNTRADITIONAL CONSTABLE

"Constable's England" has become so familiar to us that it is difficult to understand the impression his paintings made on his contemporaries. His work has come to shape our conceptions of the beautiful in the English landscape, but his contemporaries were accustomed to a very different kind of representation of the natural landscape. There were set formulas, strictly adhered to, concerning the correct way to create distance, harmony, and mood. Constable's naturalistic, vivid greens, for instance, totally upended these formulas, which were based on the use of warm browns in the foreground and pale blues in the far distance – and his depiction of the random or "unbeautiful" aspects of the landscape was counter to accepted standards of composition and to the conventions of appropriate subject matter.

When Delacroix (see p.260) visited England in 1825, he was enormously impressed with Constable's animated brushwork and the optical freshness that resulted from his use of broken color to create tone. On his return, Delacroix is believed to have reworked his large *Massacre at Chios*, enlivening the surface of the painting to make it echo its emotive subject.

It was his great "six-foot" canvases that Constable valued most, but modern taste finds even greater beauty in the studies and sketches with which he prepared for them. The wild passion of a Constable study has a marvelous vigor that the sedate control of the finished works may lack. *White Horse (312)* is such a magnificent picture, with the white streak of the horse uniting both sides of the river, the greenery almost palpable, the sense of actuality so piercing, that it is almost a shock to find that his oil sketches, such as *Dedham from Langham (313),* can be even more immediate and evocative, even more vital.

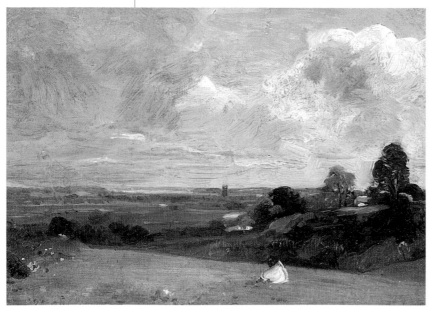

313 John Constable, **Dedham from Langham,** *c. 1813, 7½ x 5¼ in (19 x 13.5 cm)*

PREPARATORY SKETCHES

Constable adopted a systematic approach to painting from nature, making oil sketches on the spot, then later working them up into larger works. *Dedham from Langham* was one of a number of preliminary sketches of the same scene. Constable said of it, "Nature is never seen, in this climate at least, to greater perfection than at about nine o'clock in the morning of July and August when the sun has gained sufficient strength to give splendor to the landscape 'still gemmed with the morning dew.' "

ENGLISH MYSTICISM

Romanticism provided an outlet for the spiritual expression and individuality that Neoclassicism, with its emphasis on the ideal and on stoic heroism, largely denied.

Both William Blake and Samuel Palmer worked primarily as watercolorists rather than as oil painters, yet both have the peculiarly English quality of nostalgic realism that is so pronounced in Constable. Both were poets, Blake (1757–1827) literally so (see column, p.270) and Palmer temperamentally, and there is a haunting awareness of time and its passing in their works.

Blake's *Job and His Daughters (314)* is a clumsy, archaic vision that is nevertheless extremely powerful. Blake later went on to illustrate the book of Job. His strange, visionary art found a more sympathetic response after his death, and he achieved cult status among the Pre-Raphaelites of the 19th century (see p.276). Blake's wood engravings contained the crucial element of mystery and innocence that his followers also admired in the paintings of the German primitives and of the 18th-century Romantic group, the Nazarenes.

Samuel Palmer (1805–81) was an avid follower of Blake, nearly 50 years younger than him and influenced particularly by his few landscape works, which had been commissioned as illustrations

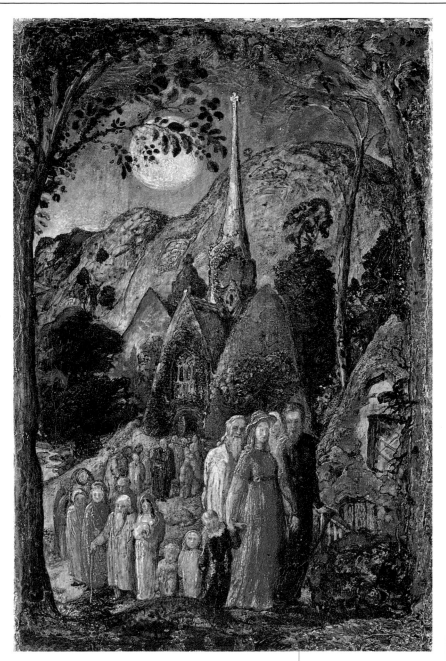

315 Samuel Palmer, **Coming from Evening Church,** *1830, 8 x 12 in (20 x 30 cm)*

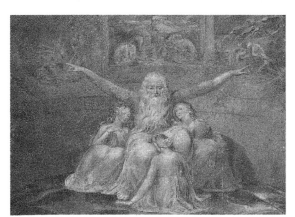

314 William Blake, **Job and His Daughters,** *1799–1800, 15 x 10½ in (38 x 27 cm)*

for a school edition of Virgil's *Eclogues* (see p.218). Palmer's *Coming from Evening Church (315)* is just as naively independent of styles and schools as Blake's art and has much the same spiritual innocence. Palmer developed a way of working with mixed media – such as Indian ink, watercolor, and gouache – that resulted in an intense luminosity, reminiscent of the medieval illuminated manuscripts (see pp.28-34).

Constable was an artist in the largest sense, as Blake and Palmer were not, but his influence continued in their work – in their particularly English strain of deeply personal love of the land, and in their awareness of its mystical importance to our spiritual well-being.

THE ANCIENTS

In 1826 Samuel Palmer (1805–81) moved to Shoreham in England and founded a group of artists known as the Ancients. The name of the group was derived from their passion for the medieval world and their concentration on pastoral subjects with a mystical outlook. Palmer's work was largely forgotten until the Neo-Romantics rediscovered him during World War II.

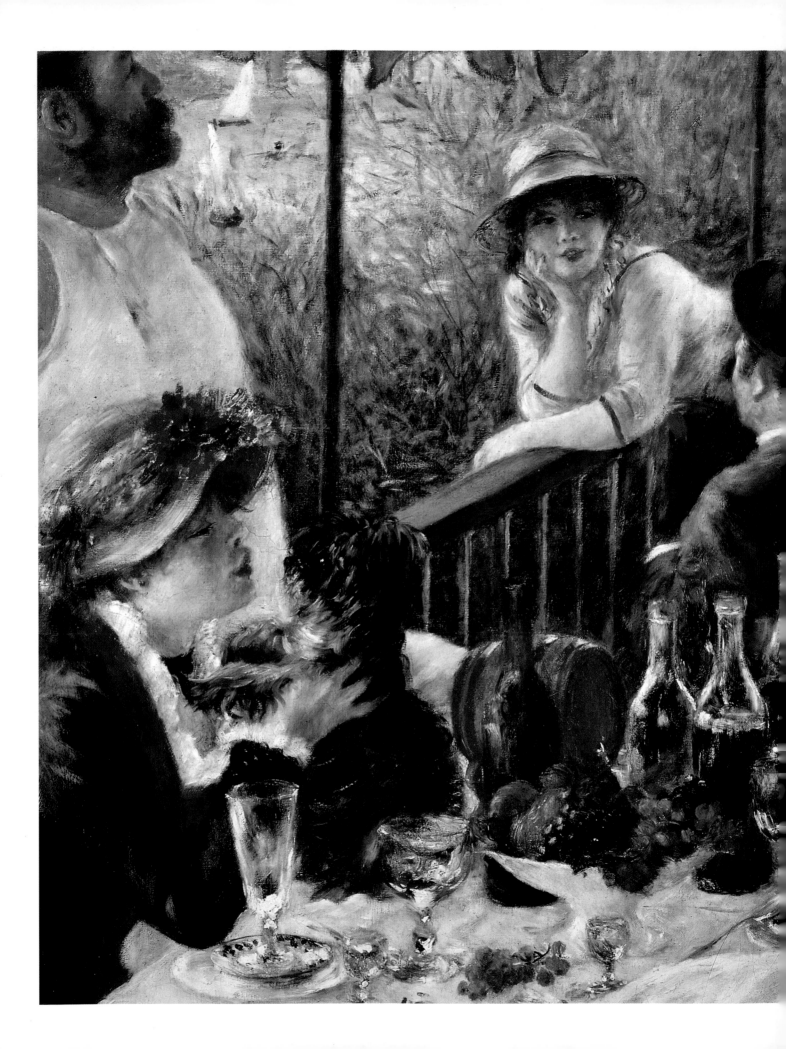

THE AGE OF IMPRESSIONISM

In the middle of the 19th century, painters began to look at reality with a new alertness. Academic conventions had become so solidified and entrenched that artists such as Gustave Courbet could see no point in them. He painted peasant life as it truly was, thereby shocking and alienating the art world establishment.

The label for this reaction was Realism, but the next generation of artists ultimately found it too material a vision. Like the Realists they rejected idealized and emotional themes – but they sought to go much further. Studio painting in itself seemed unnatural to them when the real world was "out there." So it was there that they painted, outside, seeking to capture the fleeting effects of light and to give the real impression of a passing moment.
They were known as Impressionists, and their most characteristic figures were Claude Monet and Auguste Renoir, who captured the poetry of the here and now.

Auguste Renoir, The Boating Party Lunch, *1881 (detail)*

AGE OF IMPRESSIONISM TIMELINE

Realism as a style was based upon a new attitude to social truth; it accepted the sordid conditions of real life. Impressionism was not social but personal, less "life" than "experience." If we want historical dates, it lasted from the first Impressionist exhibition of 1874 to the last in 1886, but artists escape these neat time boxes, and Impressionists reach back to the Realists and forward to the Post-Impressionists.

JEAN-FRANCOIS MILLET, THE GLEANERS, 1857

The village of Barbizon was the home of a group of artists who shared a common desire for a greater naturalism in landscape painting than that provided by Romanticism or academic painting. Millet shared this desire, painting peasants with a strong sense of their dignity, imbued with compassion for their laborious lifestyle (p.281).

SIR JOHN EVERETT MILLAIS, OPHELIA, 1851–52

The Pre-Raphaelites were a group of English artists who rejected the studio conventions of their day and harked back to medieval simplicities. Ophelia is a fine example of their weird amalgam of specific detail and Romantic theme (p.276).

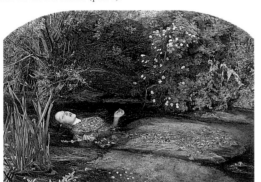

CAMILLE COROT, VILLE D'AVRAY, C. 1867–70

Corot's long career began in the 1820s, during the Romantic era, and this painting is an example of his late work. It shows his deeply poetic response to the timeless qualities of classical landscapes, that nostalgic world of the lost paradise from which we are all inevitably barred. He taught the Barbizon painters how to see this world and make it real, and the Impressionists learned from him too (p.280).

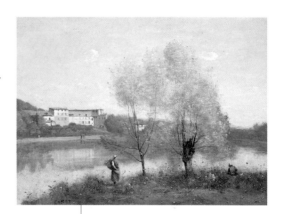

1850	1860	1870

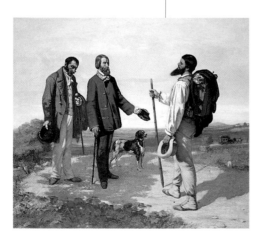

GUSTAVE COURBET, BONJOUR MONSIEUR COURBET, 1854

Courbet, like the Pre-Raphaelites, believed in the importance of the specific, but far more flamboyantly. He himself was the center of his art, and we see him here splendidly confident. It is not theories that make his paintings work, but sheer artistic power (p.283).

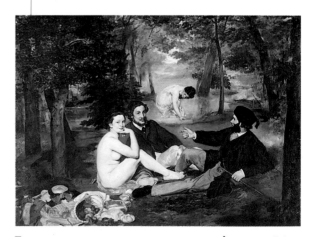

EDOUARD MANET, LE DEJEUNER SUR L'HERBE, 1863

Manet painted with a naked truth that stripped away the social pretenses of his time. It was not the subject of his work that was startling (a picnic in the woods was a well-established theme), but its alarming realism, its refusal to pretend, to hide in an antique guise. He was not specifically an Impressionist, but his artistic discoveries were an enormous influence on Impressionism (p.284).

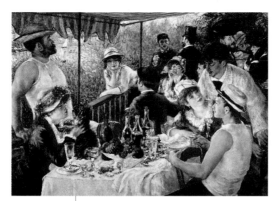

AUGUSTE RENOIR, THE BOATING PARTY LUNCH, 1881

While other Impressionists were fascinated with the ever-changing patterns of nature, Renoir was more interested in people. He took simple pleasure in whatever met his good-humored attention and aimed to give the impression, the sensation, of his subject matter. This painting shows Renoir's skill in capturing delightful scenes of modern life and recording how the Parisians spent their leisure time. He also shows relationships between people – such as that of the pair on the right (p.298).

ALFRED SISLEY, MEADOW, 1875

Sisley came from an English family living in France, and can be considered the one true Impressionist. He never developed beyond it. His landscapes are not as robust as Monet's, but are subtle, lyrical, and peaceful. The place shown here is unimportant, but Sisley catches the quality of light and the changing shadows perfectly (p.301).

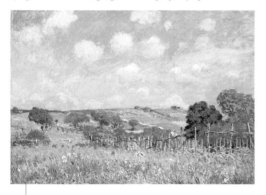

EDGAR DEGAS, FOUR DANCERS, C. 1899

Degas often exhibited with the Impressionists, although he studied the Old Masters throughout his life and was a superb draftsman. This late work is a good example of how he could seize upon the unbalance of an actual scene in the real world, and make art from what he had found. He learned this from photography and the strange magic of the Japanese printmakers (p.292).

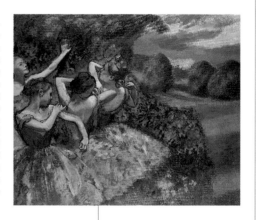

1880 1890 1900

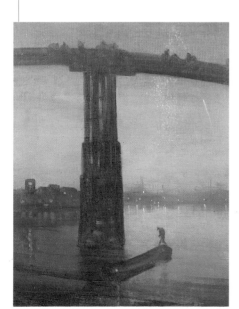

JAMES WHISTLER, NOCTURNE IN BLUE AND GOLD: OLD BATTERSEA BRIDGE, 1872–75

American by birth, Whistler moved to Europe and lived first in Paris, then London. Nocturne in Blue and Gold reveals his debt to the Impressionists. He had looked at them, but also, and more significantly, at the Japanese, in their use of a nonrealistic, seemingly two-dimensional composition, and the skillful choice of a few highly significant details. Whistler was interested in the Realist and Impressionist movements, but took from them what he needed to create a decorative style that was his alone (p.302).

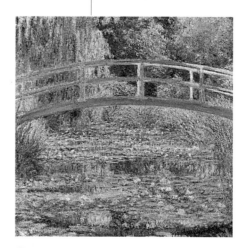

CLAUDE MONET, THE WATERLILY POND, 1899

A quintessential work of Impressionism, this is one of Monet's numerous waterlily studies, some of which border on the abstract with their floating shapes and surface reflections (p.296).

THE PRE-RAPHAELITES

Toward the middle of the 19th century, a small group of young artists in England reacted vigorously against what they felt was "the frivolous art of the day": this reaction became known as the Pre-Raphaelite movement. Their ambition was to bring English art (such as it was) back to a greater "truth to nature." They deeply admired the simplicities of the early 15th century, and they felt this admiration made them a brotherhood.

While contemporary critics and art historians worshiped Raphael (see p.125) as the great master of the Renaissance, these young students rebelled against what they saw as Raphael's theatricality and the Victorian hypocrisy and pomp of the academic art tradition. The friends decided to form a secret society, the Pre-Raphaelite Brotherhood, in deference to the sincerities of the early Renaissance before Raphael developed his grand manner. The Pre-Raphaelites adopted a high moral stance that embraced a sometimes unwieldy combination of symbolism and

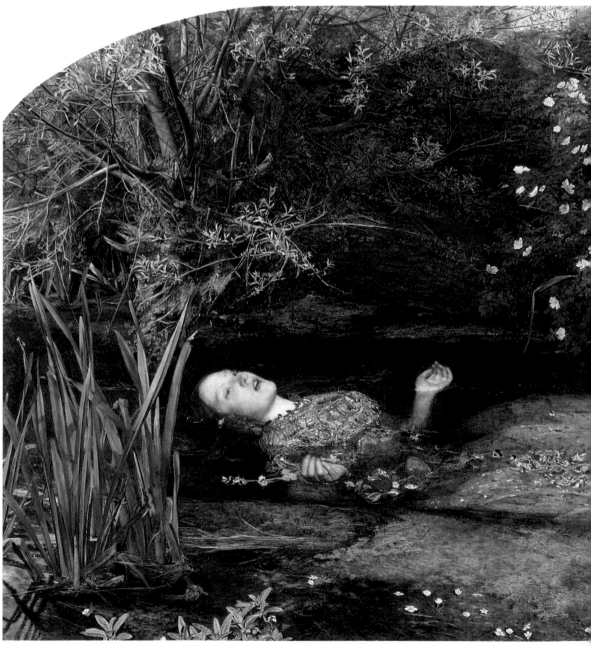

316 Sir John Everett Millais, Ophelia, *1851-52, 44 x 30 in (112 x 75 cm)*

realism. They painted only serious – usually religious or romantic – subjects, and their style was clear and sharply focused. It entailed a unique insistence on painting everything from direct observation.

The group initially caused outrage when the existence of their secret brotherhood became known after their first works were exhibited in 1849. They also offended with their heavily religious and realist themes that were so unlike the popular historical paintings. However, the Royal Academy continued to exhibit Pre-Raphaelite paintings, and after 1852 their popularity burgeoned. Their work, though certainly detailed and for the most part laboriously truthful, became progressively old-worldish, and this decision to live

317 **William Holman Hunt,** On English Coasts, *1852, 23 x 17 in (58 x 43 cm)*

in the past, while deploying the judgments of the present, makes the work of an artist such as John Everett Millais (1829–96) appear disturbingly unintegrated. His *Ophelia (316),* Hamlet's drowned lover, was modeled with painstaking attention on a real body in water, surrounded by a ravishing array of genuine wildflowers (see column, p.276). Millais spent four months painting the background vegetation on the same spot in Surrey, England. He then returned to London to paint his model, Elizabeth Siddal, posing in a bath full of water, so determined was he to capture the image authentically. The result is oddly dislocated, as if the setting, woman, and flowers did not belong together, each keeping its own truth and ignoring that of the others.

LUMINOUS COLOR
William Holman Hunt (1827–1910), a fellow art student and friend of Millais, was more alerted to the theatricalities of his age, and *On English Coasts (317)* is a political allegory on the theme of strayed and unprotected sheep. Yet the weirdly acidic colors, even though honestly come by, strike unpleasantly on the eye. We are constrained into belief, but against our will: the bright yellow is so garishly bright, and so are the aggressive greens of the sea.

The Pre-Raphaelites achieved such intense luminosity in their work by painting pure colors onto a canvas that had been prepared with white paint, sometimes reapplied fresh before each day's work, so as to give the hues added brilliance.

CHARLES DICKENS
The English author Charles Dickens (1812–70) is considered one of the greatest novelists of the 19th century. His early life was one of poverty and hard work, but he managed to educate himself and find a job as a journalist for the *Morning Herald.* His first printed book, *Sketches By Boz,* was published in 1836, and from this date onwards he became a prolific writer and completed many serialized novels, including *Hard Times,* published in 1865 (illustrated above). Dickens also found ready listeners for his criticism of Millais's *Christ in the House of His Parents.* He objected to the imagery and style of the Pre-Raphaelites' work, calling it "mean, odious, repulsive and revolting."

DANTE GABRIEL ROSSETTI
Rossetti (1828–82) was born into an intellectual and creative Italian family but spent most of his life in London. Throughout the 1840s his poetry and painting prospered, and he completed many symbolic historical paintings. He met Elizabeth Siddal in 1850; he married her in 1860 after a troubled courtship. His wife, however, was weak and died only two years later, leaving Rossetti a broken man. For her burial Rossetti insisted on placing his complete poetry manuscripts in her coffin, which he then retrieved in 1869 by exhuming her body. He fell into depression and in 1872 attempted suicide but did not die. He lingered on in a alcoholic and drug-induced haze until his death in 1882.

LITERARY INFLUENCES

Dante Gabriel Rossetti (1828–82), the third founding member of the Pre-Raphaelites, became the recognized leader and even formed a second grouping of the brotherhood in 1857, after Millais and Hunt had gone their separate ways. Rossetti came from an artistic and versatile Italian family, and it was perhaps the confidence engendered by this background, and his dynamic personality, rather than his artistic talent, that earned him his prominent position.

Rossetti was a poet as well as a painter, and in common with the other Pre-Raphaelites, his art was a fusion of artistic invention and authentic renderings of literary sources. The brotherhood drew heavily from Shakespeare, Dante, and contemporary poets such as Robert Browning and Alfred Lord Tennyson – Rossetti in particular was greatly attracted to Tennyson's reworkings of the Arthurian legends. He specialized in soulful maidens of extraordinary looks for his romantic themes, using his beautiful but neurotic wife Elizabeth Siddal as his model. Her striking face, with its long-nosed, languid expression, appears in many pictures. After Elizabeth's

318 Rossetti, The Day Dream, *1880, 36½ x 63 in (92 x 160 cm)*

319 Edward Burne-Jones, The Golden Stairs, *1876–80, 46 x 106 in (117 x 270 cm)*

death, Rossetti's model was William Morris's wife Janey (a Siddal look-alike). She is the one we see in *The Day Dream (318).*

Edward Burne-Jones (1833–98), who was a great influence on the French Symbolists (see p.321), was a friend of Rossetti and Morris. He places his introspective, medievalized heroines in *The Golden Stairs (319)* in a dreamlike never-neverland that comes close to his own unworldly convictions. This romanticized world may cloy, but there are many who feel at home in the serious play of the Pre-Raphaelites and have no difficulty in responding to their themes.

REALISM IN FRANCE

Neither a Romantic nor a Realist, it was Camille Corot who, early in the 19th century, showed that these two approaches were not necessarily in opposition. He united great truth with great lyricism, but it was his astonishing truthfulness that ultimately made the greater impact. Honoré Daumier began to look at the social realities of his day with a boldness he had learned from Corot, and so did the Barbizon School of painters. This Realism, now fully deserving its capital R, came to its full maturity in the astonishing work of Gustave Courbet.

After the emotional extremes of the Romantics (see p.259), it comes almost as a relief to enter the gentler world of Corot's imagination (Jean-Baptiste-Camille, 1796–1875). Corot's style was far removed from the heroics of the Romantics. He saw the world, both natural and manmade, with an innocent truthfulness that greatly influenced the Barbizon School of artists, as well as practically every painter of landscape in the latter half of the 19th century.

In 1825 Corot went to Italy, a journey that influenced his approach to painting for the rest of his life; subsequently, it affected the whole development of modern landscape painting. It was in Italy that Corot first experienced the benefits of painting *en plein air* (see column, right), and his authentic depiction of light and nuance set a new precedent in French landscape painting.

He came to place great importance on the Italian practice of making sketches *in situ*, valuing these for their spontaneity, truthfulness, and atmosphere. He was deeply responsive to the timeless serenity of the classical landscape; its quietness found a response within, and his Italian landscapes express this profound and lovely silence.

A View near Volterra (320) was not painted on the spot: Corot saw this view as he traveled in this strange region of Italy, and some years later, referring to his original sketch, he painted it both as what he remembered and for what it meant to him. The truth then is emotional rather than factual, but it is truth nonetheless: the quiet rocks and sunlit foliage bear within them a sense of the antique. Many generations have lived on the sites of the ancient Etruscans

PAINTING EN PLEIN AIR

The French landscape painter Charles Daubigny (1808–79) was one of the earliest exponents of *plein air* (open air) painting and was to have a significant influence on the later Impressionist painters. The invention of metal paint tubes allowed long-term storage of oil paints, making trips into the countryside feasible using the new portable easels. Many of the Impressionists settled and painted in the riverside communities along the banks of the Seine River. This illustration shows Camille Corot (1796–1875) painting *en plein air* under an umbrella.

320 **Camille Corot, A View near Volterra, 1838, 37½ x 27½ in (95 x 70 cm)**

OTHER WORKS BY COROT

Morning near Beauvais (Museum of Fine Arts, Boston)

La Rochelle (Cincinnati Art Museum)

In the Dunes (Rijksmuseum, The Hague)

Souvenir of Palluel (National Gallery, London)

The Ferryman (Louvre, Paris)

Landscape at Orleans (Bridgestone Museum of Art, Tokyo)

Canal in Holland (Philadelphia Museum of Art)

The Happy Island (Museum of Fine Arts, Montreal)

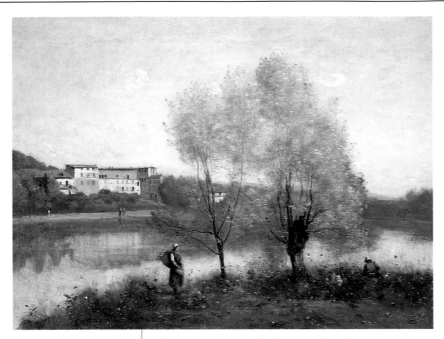

321 *Camille Corot,* Ville d'Avray, *c. 1867–70,*
26 x 19½ in (60 x 40 cm)

DAUMIER CARTOONS
Honoré-Victorin Daumier
(1808–79) was a great
caricaturist and is regarded
as one of the most
successful satirists of all
time. His work ranges
from the early anti-
government drawings
of 1831 to the more gentle
humor of his later
cartoons. The example
shown above was drawn
in 1865 during the heyday
of the Impressionist
movement and has a
punchline that reads
"One landscape artist
copies nature, the second
copies the first." With this
comment Daumier
is ridiculing all the
inferior artists who copy
landscape paintings;
simultaneously he is
making a general comment
on the dishonesty of many
artists of the time.

(see p.18), and their presence still lives on
subliminally. Corot paints the place and its
feel, evoking our own memories to unite with
his. The place is dreamlike, yet fundamental in
its solidity. No artist ever made mere substance
so spiritual as did Corot.

Corot can be so unassuming that his true
greatness is missed. He never dramatizes or
exaggerates, never strikes any kind of attitude.
Few painters have ever had such a mastery of
tone, of the imperceptible gradations by which
one color melts into another. His landscapes
are often small but perfect, with a simplicity so
profound as to be totally satisfying. He may not
have beautified his undramatic countrysides, but
the excitement is in the veracity of his vision.

Corot's early and less critically successful
landscapes paved the way for Impressionism. In
his later years, he would modify his art, painting
again and again an entrancing forest glade,
dappled and peaceful. This is the fashionable
Corot, and this too is lovely, but it is a declension
from the unique magic of his disregarded early
work. A typical and lovely example of late Corot
is *Ville d'Avray (321)*: feathery trees, pale sky,
pure white of the distant houses, silvery water,
and young people bright amid all the flowers
and grasses. The one abiding component is a
contemplative stillness that Corot never lost.

DAUMIER THE SATIRIST

We do not know what Corot thought of the
French painters Daumier and Millet, but he
gave financial help to Daumier in his blind
old age, and to Millet's widow. Honoré Daumier

(1808–79) was greatly influenced by Corot's
work – though the caustic wit and the overtly
sociopolitical content of Daumier's caricatures
and lithographs (see column, left) would appear
to have little in common with the serenity of
Corot's art. Though he was acknowledged as
one of the most important cartoonists of the
19th century during his lifetime, it is only since
his death that Daumier's qualities as a serious
painter have been recognized. His directness of
vision and lack of sentimentality in the way he
painted actual experiences make his works
some of the most powerful examples of Realism.

While Corot was comfortably well off and
never had to earn his living, Daumier struggled
throughout his career as a satirist to support
himself, suffering censorship and imprisonment
because of the subversive nature of his art. He
was a committed Republican with an intense
political passion for the poor, drawing such
strong caricatures that his own contemporaries
found it hard to take him seriously as a fine artist.
He gave Corot his painting *Advice to a Young
Artist (322)* in gratitude for an act of generosity
by Corot that released Daumier from financial
worry in his final years. Two men are alone in
the studio, the unmade bed the only sharp color.
The young man is tense, the older man intent,
perhaps marking time while he finds the encouraging
yet sincere words to offer as advice. The stress is
wholly on personal interaction, with the entire
context conjured up out of just a few props.

322 *Honoré Daumier,* Advice to a Young Artist, *probably*
after 1860, 12 x 16 in (33 x 41 cm)

MILLET AND THE BARBIZON SCHOOL

In the 1830s a group of landscape artists moved out of Paris to the small village of Barbizon on the outskirts of the Forest of Fontainebleau, where they were often joined by Corot. He was a great influence on the group, but they were also affected by Constable's landscapes (see p.268) in their desire for a greater naturalism and a truthful depiction of the countryside.

Jean-François Millet (1814–75) settled in Barbizon in 1849 and was soon associated with the school. Although in later life he turned to painting pure landscape, he is more famous for his peasant pictures, the truth of which arises from his own personal experience as the son of a farm laborer. Some now think these paintings sentimental, but they were considered radical in their day for their social realism. Millet was a sad and laborious painter, apt to see life as very dark – the temperamental opposite of Corot, with his luminous world of serenity and light – but people clearly responded to his art, although

they were still baffled by Daumier's. Millet's style was simplified, diluted, yet powerful, imbuing the ordinary with a strong sense of dignity and a monumental weight.

Millet's most famous work is probably *The Gleaners (323)*. We see three peasant women at work in a golden field: two of them are bowed in measured toil, assiduously gathering the scraps left behind by the harvesters, while the third binds together her pathetic sheath. Millet makes inescapable the realization that it is hard, back-breaking work. The women's faces are not only darkened by the sun, but seen as almost brutish, with thick, heavy features. Yet, beasts of burden though they are, he regards them with reverence. We feel awed at their massive power and the sheer beauty of the classical frieze they create silhouetted against the meadow. This is a setting of great natural loveliness: golden corn, peaceful sky, the rhythmic movement of distant laborers. The background is a pastoral idyll; the foreground a pastoral reality.

MILLET'S SKETCHES
Jean-François Millet (1814–75) was the most famous painter of rural life in 19th-century France. Although renowned as a painter, some of Millet's best works are his drawings, which invest the ordinary with depth and dignity. Millet is known to have said that he aimed "to make the trivial serve to express the sublime." Millet was admired by many artists, including van Gogh (see p.316).

323 Jean-François Millet, **The Gleaners,** *1857, 44 × 33 in (111 × 83 cm)*

THE PARIS COMMUNE
In July 1870 the French declared war on Prussia. After only two months the French leader Napoleon III was forced to surrender and an angry, humiliated mob declared the Third French Republic. Patriotic radicals in Paris sought to republicanize the country and elect a municipal council, the Commune. Barricades were established by the Communards and the State French troops had to retake the city by force. By the end of the conflict, 20,000 Parisians had been killed and the Communards had shot many high-ranking hostages. This illustration shows a female gas bomber defending the barricades.

THE PAINTER'S STUDIO
Dissatisfied with the space allotted to him at the Universal Exhibition of 1855, Gustave Courbet decided to establish his own pavilion, called *Le Realismé*, to show his works. One of the paintings exhibited was *The Painter's Studio*, which proved that secular art could now convey the deep serious-ness previously expected only from religious paintings. There were many interpretations of the painting, including a theory that it was a covert denouncement of Napoleon III. Courbet, however, stated that it shows "all the people who serve my cause, sustain me in my ideal, and support my activity."

COURBET, THE GREAT REALIST

The Pre-Raphaelites' (see p.276) concept of Realism was a fundamentally different one, their work often displaying a superficial, outward impression of nature and expressing sentiments quite removed from reality. The greatest Realist, in a much truer sense, was the brash, anti-intellectual, and largely self-taught artist Gustave Courbet (1819–98). He was by nature prone to rhetorical flourishes and was not as down-to-earth as he himself thought, but he had no tincture of the dreamy hankering after the past that characterizes the Pre-Raphaelites. Courbet's defiantly nonconformist stance and his commit-ment to concrete reality was an important influence on a subsequent generation of artists.

Courbet lived by his belief that artists should paint only "real and existing things," striding resolutely into the future and taking, he generally felt, possession of it. He was impressed by Caravaggio's robust expression (see p.176) and by the Dutch masters Hals (p.210) and Rembrandt (p.200). Their influences can also be traced in Courbet's own admirers. His landscapes are always vital with a savage sort of power, and he prided himself on this uninhibited zest. The son of a rural bourgeois landowner, he was by nature a rough, coarse, and passionate man, and he sublimated these qualities in his art. He called himself "a socialist, a democrat, and a Republican, and above all a realist, that is to say a sincere lover of genuine truth."

Courbet's work has a heavy realism that is unflinching in its restless scrutiny. All his qualities, including an indefinable something that eludes the viewer, are present in his masterpiece, *The Painter's Studio (324)*. This is an intensely personal work, yet it keeps its secrets: nobody has ever quite discovered what is meant by its full title – *A Real Allegory Summing Up Seven Years of My Artistic and Moral Life*. Courbet claimed to have assembled, imaginatively, in this one canvas, all the significant influences of his life, some generalized and some apparently

324 Courbet, The Painter's Studio, *1855, 19 ft 17 in x 11 ft 10 in (597 x 361 cm)*

personified. The people are of all kinds and conditions, all totally authentic, all centered on the artist himself, who paints a ravishing landscape while a nude model presses herself affectionately against his chair. These visitors are all guests whom he seems to have invited for a purpose. Courbet actually described this strange allegory in a letter to his friend, the novelist Jules Champfleury, writing that the figures on the left were those who "live on death," while the figures on the right "live on life."

Although the portraits on the right are identifiable – Champfleury himself is depicted among the onlookers, along with other elegant Parisian friends of Courbet, such as the journalist and socialist Pierre Proudhon and the poet Charles Baudelaire (see p.286) – the characters on the left, veiled in semidarkness, could represent people from Courbet's past or previous influences in his life: there may even be a disguised portrait of the Emperor Napoleon III. We may smile at this naive self-importance, yet we are also

325 *Gustave Courbet*, **Bonjour Monsieur Courbet**, *1854, 59 x 51 in (150 x 130 cm)*

impressed. Courbet had every right to see himself as a major painter who understood materiality so profoundly as to make it appear to become more than it really was.

THE OMNISCIENT ARTIST

Courbet's vanity is not rare in those with creative talent, but few have put their weakness to such effective use. *Bonjour Monsieur Courbet (325)* shows the painter as he saw himself, very handsome and virile, detached from the softness of civilized living, striding forth along a country lane. Courbet's devoted patron, Alfred Bruyas, and his servant, bow reverentially to the artist as if he is their superior, and it is clear that Courbet heartily agrees. There is an innocent conceit in the tilt of the artist's noble head, in the condescension of his affable smile. The dusty path, the bordering weeds and grasses, the dog – every detail of this wholly ordinary part of France is grasped completely in its truth and left undramatized. We are drawn into what Courbet saw and smelled and heard, not through any dramatic overemphasis but from his enormous painterly conviction.

This self-image of the artist existing above and beyond the mediocrities of "bourgeois" civilization was to find full expression in the works and lives of the next generation of painters, particularly Manet and Degas, who benefited from Courbet's artistic advances and laid the foundations of "modern" expression.

OTHER WORKS BY COURBET

Hunters in the Snow
(Musée des Beaux Arts, Besançon, France)

Reflection of a Gypsy
(National Museum of Western Art, Tokyo)

Landscape
(National Museum, Stockholm)

Girls on the Banks of the Seine
(Petit Palais, Paris)

The Waterfall
(National Gallery of Canada, Ottawa)

Woman with a Parrot
(Metropolitan Museum of Art, New York)

The Grotto of the Loue
(Kunsthalle, Hamburg)

THE INFLUENCE OF MANET & DEGAS

Courbet's richness of color and insistence on his own personal vision were immensely influential on other artists, teaching them to believe only what they could see with their own eyes. Manet abandoned the conventional practice of subtle blending and polished "finish," using instead bold colors to explore the harsh, realistic contrasts created by sunlight. Degas, influenced by photography and the simplicities of Japanese prints, adapted his skills as a draftsman to create startlingly new compositions with his figures.

THE NEW PARIS

When Napoleon III became emperor in 1851, he set about making Paris the new center of Europe. Napoleon employed the architect Baron Haussmann (shown above) to redesign and rebuild central Paris, using a new network of interconnecting tree-lined boulevards. During the rebuilding he also created new parks, squares, and municipal buildings. Haussmann's ruthless plans displaced over 350,000 people and led to more social problems, including increased visibility of prostitutes on the wide-open boulevards.

SALON DES REFUSES

The "salon of the rejected" was formed after the official 1863 Salon turned down more than 4,000 paintings. The alternative salon was ordered by the Emperor Napoleon III, and many artists, including Manet, Cézanne, and Whistler were happy to find a place to show their rejected works. When the Salon des Refusés opened in May 1863, over 7,000 people visited on the first day, but the exhibition received very little critical acclaim. The Salon des Refusés inspired other artists to develop their own salons and increased the influence of art dealers. This illustration shows a contemporary cartoon parodying the jury system of the Salon.

326 Edouard Manet, Le Déjeuner sur l'Herbe, 1863, 8 ft 8 in x 6 ft 10 in (265 x 206 cm)

Edouard Manet (1832–83) took Courbet's realism one step further, so blurring the boundary between objectivity and subjectivity that painting has never recovered from his quiet revolution. After Impressionism, art can never return to a dependence upon a world that exists "out there" apart from the individual artist. Yet it was a quiet revolution only in that Manet was a reticent, gentlemanly artist who desired nothing better than conventional success at the Paris Salons

(see column, p.284). Temperamentally Courbet's opposite, with his very fashion-conscious, witty, and urbane attitude, Manet was the archetypal *flâneur* (see column, right) and was well liked. To the end he could not understand why his work was so reviled by the Parisian art world and seen as an offense. Fortunately a private income enabled him to pursue his course without undue financial distress, but one cannot imagine even a starving Manet ever compromising.

"THE FATHER OF MODERN ART"

In the past Manet has been included in the all-embracing term of Impressionism, but his art is Realist rather than Impressionist. It was Manet's attitude that influenced the group of younger painters who subsequently became known as the Impressionists. They were also affected by his radical use of strong flat color, broken brush-work, harsh natural lighting, and the generally "raw," fresh appearance of his paintings.

Manet was an extremely cultured and sophisticated man from a well-to-do bourgeois background, yet he painted with a simplicity that is startling. His painting *Le Déjeuner sur l'Herbe (326)* is the work of an educated artist. The central group is based upon a print that is itself based upon a work by Raphael – nothing Pre-Raphaelite about Manet – and a picnic in the woods was a well-established artistic subject.

What shocked the critics and the public was the startling modernity of it all: the naked woman had a timeless body, but her face and attitude were unmistakably contemporary. One wonders whether the scandal would have been less if the men too had been unclothed. Manet made his subject seem so startlingly likely, a scene that might greet the eye of anyone taking a stroll in the woods.

Ironically, it was the very power of this painting that made it a popular failure, coupled with Manet's highly idiosyncratic use of perspective. The girl bathing in the brook is neither in the picture, nor out of it. Her proportions are "wrong" in relation to the others, so that the three picnickers are enclosed within what seem like two distinct styles of painting: the stooping bather seems flattened and too remote, while the superb still life of carelessly spilled clothes and fruit looks overpoweringly real.

In the center, Victorine Meurent, Manet's favorite model, looks out unabashed and shamelessly at the very intruder each viewer fears might be himself or herself. That classical nymphs should feel at ease with their bodies had long been accepted, but in portraying a modern, fleshly woman realistically, Manet stripped away the social pretenses of his time.

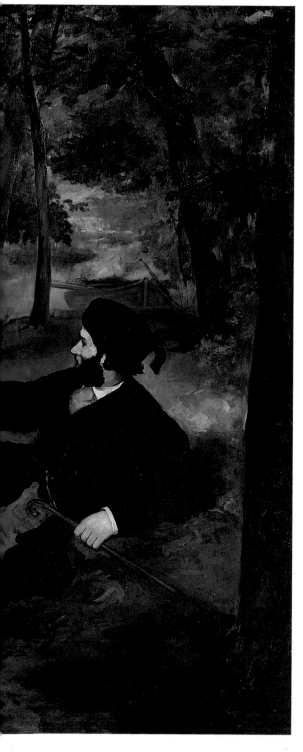

While Courbet sought to shock, Manet considered such a deliberate intention ill-bred and was suprised at the reaction to this work. Yet we can also sympathize with any incomprehension on the viewer's part: Manet is still not an easy artist. What we find so amazing is the blindness shown by his contemporaries to the great beauty of his art. The strong yet soft image of a young body set against the bosky magic of the woods – this is so entrancing that it remains a mystery why so few could actually "see" what was portrayed.

PARISIAN AVANT-GARDE

Manet was a close friend of the innovative French poet Charles Baudelaire (1821–67), whose essay *The Painter of Modern Life* – challenging artists to capture the great spectacle of life in the modern city – was an enduring influence on Manet's work. In each of Manet's paintings we can perceive a constant challenge to his contemporaries to see, as he did, the grandeur, beauty, and tragedy of modern life; urging artists to look at the world around them, instead of to the past, for their inspiration. He painted philosophers in the guise of modern beggars, street entertainers, prostitutes, courtesans, and people on the edges of society, as well as those situated comfortably within it. He was particularly sensitive to urban alienation and the constantly changing and evolving nature of cities. As such, Manet's contribution to modern "expression," and to the history of modern art, is profound. For all this, his art still maintained firm links with the past – particularly Velázquez (see p.194), Goya (p.248), and the Dutch masters (p.200) – learning from them in a modern context. These links were finally broken by the Impressionists in their entirely new approach to visualizing the physical world around them.

It could seem that Manet's main interest was the figure, but in fact it was the material world as actually seen, as experienced at one fleeting moment, in sunlight or shadows, and created anew. His still lifes are particularly moving. In *Still Life With Melon and Peaches (327)*, the light gleams upon the incandescent white of the tablecloth. Its texture is firmly distinguished from the soft white of the rose that lies on it. The picture not only plays with white but runs through an exhilarating gamut of luminous greens and yellows. The strong black of the bottle and the table, mixed from many colors, creates a dramatic contrast with the bright hues, while Manet's dexterous brushstrokes give life and vitality to these blocks of strong color. He shows us a world at its most vulnerable and yet its most lovely.

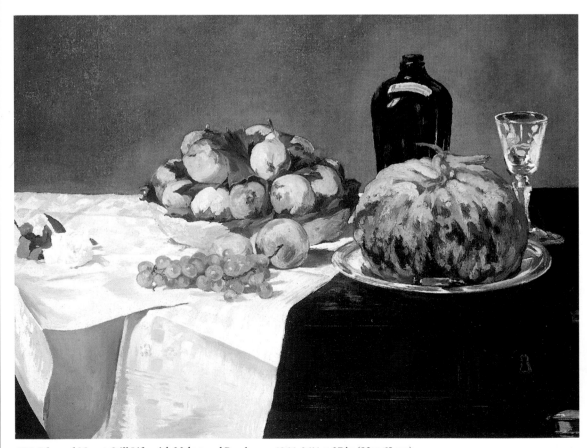

327 Edouard Manet, **Still Life with Melon and Peaches,** *c. 1866, 36½ x 27 in (92 x 69 cm)*

328 *Edouard Manet,* Gare Saint-Lazare, *1873, 45 x 37 in (115 x 94 cm)*

OTHER WORKS BY MANET

The Suicide
(Bührle Foundation,
Zürich)

Portrait of Armand Brun
(Bridgestone Museum
of Art, Tokyo)

Olympia
(Musée d'Orsay, Paris)

The Spanish Singer
(Metropolitan Museum
of Art, New York)

The Waitress
(National Gallery,
London)

House at Rueil
(National Gallery of
Victoria, Melbourne)

Philosopher with a Hat
(Art Institute
of Chicago)

The Artist's Wife
(Nasjonalgalleriet, Oslo)

CONTEMPORARY THEMES

Yet the human figure remains central to Manet's work. Victorine Meurent, that insouciant young beauty, continued to be his favorite model. Ten years after *Le Déjeuner sur l'Herbe*, Meurent is still undaunted, still self-contained and at ease with her body in *Gare Saint-Lazare (328).* This work takes the theme of a train station (which might seem mundane to the modern mind) and treats it with a compelling sense of adventure, yet also with an offbeat humor.

Always responsive to avant-garde developments, Manet was in turn influenced by the younger group of Impressionists and in particular by Monet (see p.294), with whom he became good friends. Although he never became an Impressionist, *Gare Saint-Lazare* reflects Manet's growing interest in their art and marks an important progression in his own artistic methods: Manet made his initial studies for the painting inside his studio using posed models and then worked *en plein air* on site to finish the picture.

Meurent is at the far left in *Gare Saint-Lazare,* unsymmetrical, as is usual in real life. Under a gorgeous confection of a hat, her mass of red hair streams down unrepentantly and she is dressed with a flourish of Parisian chic. Little crinkles of lace froth around her sensual throat,

a velvet band draws our attention to the neat triangle above her trim body, and she holds on her lap a book, emphatically unread, and a winsome puppy, dozing above her frilly cuffs. She enchants us with her unconcerned air. Equally unconventionally, the other character in the picture shows us only her spacious back, large swathes of starched white and a huge blue sash on which light and shade flicker and fade; the little girl is as expensively dressed as her companion, but posed to appear unaware of our presence; her whole attention is on the station, always an intriguing place for children. Manet keeps the focus of our attention on this little girl by obscuring from us what she sees, beyond a blur of smoke and the dimly lit atmosphere of the station.

It is the young girl's rapt, childish excitement, her sense of wonder at the modern world before her, that is the theme of this painting, and her attitude is made all the more evident in the boredom of the adult beside her who waits casually, passing the time away, concerned mainly with herself. Manet keeps our attention wholly where he wants it to be: on the dull, swirly background, the intense and particularized personalities, and

HOMAGE TO DELACROIX

This painting by Fantin-Latour (see p.289), completed in 1864, shows a gathering of the artistic and literary avant-garde and is entitled *Homage to Delacroix.* The painting shows Fantin-Latour, Baudelaire, Manet, and Whistler, among others, grouped around a portrait of their artistic hero, Delacroix. In spite of his association with progressive artists, Fantin-Latour was a traditionalist, and produced meticulous portraits and lithographs in his later years.

THE BAR AT THE FOLIES-BERGERE

In his review of Manet's last great work, *The Bar at the Folies-Bergère*, the French art critic Paul Alexis described the barmaid as "standing at her counter, a beautiful girl, truly alive, truly modern." A dedicated urbanite to the very end, Manet re-created the fashionable world he knew and loved best, in all its splendor, and its failures.

TRAPEZE ACT
It can come as a surprise to discover, tucked away in an upper corner, above the white glare of the electric lights, the bizarre presence of a pair of legs in little green boots. This is in fact the reflection of a trapeze act. The Folies-Bergère was a Parisian music hall that pioneered "variety" entertainment; its promenades were frequented by prostitutes.

THE "CUSTOMER"
Manet was accused of ignorance of the laws of perspective, for we see the reflection of a customer who seems to be conversing with the barmaid, but his bodily presence is missing – which we would expect to see, considering his position in reflection. Manet's critics failed to see the subtlety of his invention: we, the viewers, are in the position that the "customer" would rightly occupy, and so we take his place.

SUZON
The Bar at the Folies-Bergère *was painted in the year before Manet's death, when he was already seriously ill. There is an un-mistakable sadness beneath the bored expression of the barmaid, Suzon, who, though surrounded by gay electric lights (a new, very modern feature of the Folies-Bergère), is remote and distracted. As with much of Manet's work, the superficial gaiety of the busy Paris night life is offset by a sense of private alienation.*

MANET'S FRIENDS
Apart from the utterly solid figure of Suzon and her bar laden with refreshments, the rest of the painting is a mere reflection. Wisps of blue-gray paint, trailed over the surface of the canvas, evoke the smoky atmosphere and indicate the flatness of the mirror's surface. Cameo portraits of Manet's friends (Méry Laurent and Jeanne Demarsy) can be picked out in the blur of the teeming audience.

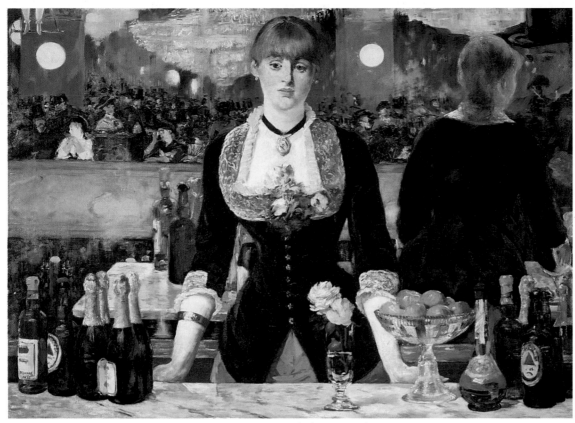

329 **Edouard Manet,** The Bar at the Folies-Bergère, *1882, 51 x 38 in (130 x 97 cm)*

ANTONIN PROUST

Manet and Proust were schoolboys and students together and were to remain lifelong friends. In 1850 Manet and Proust joined Thomas Couture's art academy in Paris and there developed their animosity toward the art establishment. Proust's *Souvenirs de Manet,* published in 1897, is the source usually quoted for some of Manet's earliest sayings. It celebrates their unfailing friendship and expounds the glories of Manet's genius. Manet died in April 1883 after six months of constant pain. Proust was a main speaker at his funeral, which was also attended by many famous artists including Monet, Renoir, Pissarro, and Sisley.

the vague impressions of a foreground. It is this new sensitivity to the fleeting, mobile reality of time that Manet gave to other artists, and which was so important to the progress of the Impressionist movement.

THE FINAL MASTERPIECE

This sense of the small, fleeting moment held perpetually still is supremely conveyed in *The Bar at the Folies-Bergère (329)*. Manet also plays with the deceptiveness of space: there are reflections that reflect falsely, and it is hard to locate ourselves in the work. The barmaid looks out with the sad dignity of the exploited, as much a comestible as the wine in the bottles or the fruit in the bowl. Like the exquisite vase of flowers on the bar, she seems to have been plucked and set before the viewer. Manet died relatively young, and knowing this, we find his late flower studies to be among his most poignant works. There we find fragile flowers, so lovely yet so mortal, contrasted with their vases, also lovely but capable of indefinite existence. There are deep emotions in Manet, but never on the surface.

It is impossible to overestimate the haunting beauty with which Manet embraces every detail of this last great canvas, his valediction to the world of high art, and it is fitting that this final work is a scene from modern Parisian life.

FANTIN-LATOUR –
A PAINTER OF STILL LIFES

Manet had a particularly wide circle of friends and artists, including Monet, Renoir, Cézanne, and Bazille, an early Impressionist painter who died in 1870 in the Franco-Prussian war (see column, p.286). There were other artists who were friends with the Impressionists, but who never quite crossed over into the fleetingness of their world. Henri Fantin-Latour (1836–1904), for example, who was especially famous for the exuberant beauty of his flower arrangements, always remained a Realist, painting his flowers with the objectivity achieved from prolonged contemplation. *Flowers and Fruit (330)*, with its meticulous detail, shows little awareness of the way Manet, Monet, or Renoir would dissolve the blooms into iridescence. His group portrait *Homage to Delacroix* (see column, p.287) reveals Fantin-Latour's friendship with some of the most advanced artists of the day, yet the dark, brooding colors and the substantial feel of each figure confirm his preference for consistent, realistic images.

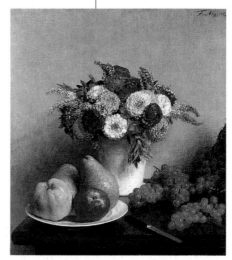

330 **Henri Fantin-Latour,** Flowers and Fruit, *1865, 22½ x 25½ in (57 x 64 cm)*

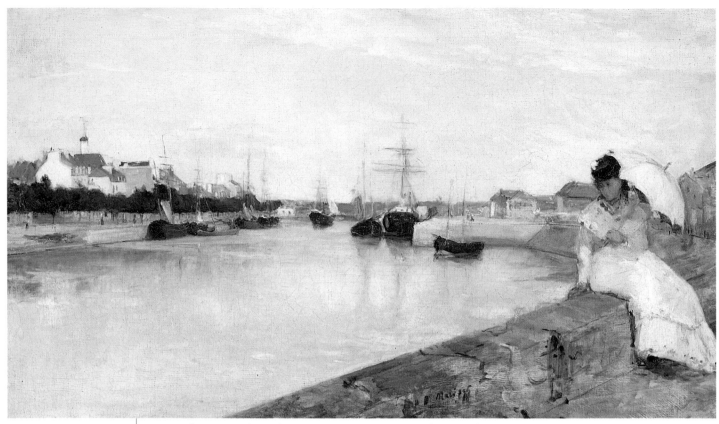

331 Berthe Morisot, **The Harbor at Lorient,** *1869, 29 x 17½ in (73 x 44 cm)*

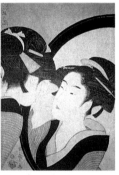

BERTHE MORISOT

The Morisot family was part of Manet's social circle, and his brother (Eugène Manet) eventually married the beautiful Berthe (1841–95). Morisot learned from Manet how to catch the passing hour and make it stay still for her, how to render the exquisite delicacy of light without hardening it into what it is not. During her early years she was taught by Corot and was also in contact with Charles-François Daubigny, an artist of the Barbizon School (see p.281). She was influenced by their honesty in capturing the true, changeable atmosphere of the landscape as it truly appeared before their own eyes.

Morisot enjoyed an intense, mutually respectful relationship with Manet. This influence was offset by her affiliation with the Impressionist group, with whom she exhibited regularly (while Manet remained aloof). Her eventual adoption of a lighter Impressionist palette was itself of considerable influence on Manet's late works. Morisot is not a strong painter in the Manet sense, but only a strong woman could have forced this work through: women's art was universally derided at that time. *The Harbor at Lorient (331)* is one of her finest paintings, a truly Impressionist work, in which the landscape is not subordinate to the figure and all is painted with the same care and the same ease. Great areas of contrasting blue

shimmer as still water reflects unstill sky, powerfully geometric diagonals anchoring the picture, and the wonderful freshness of the morning as a girl sits on the embankment, a blithely blurred image under her pink parasol. The world hovers at the corner of the eye, delightful and unobtrusive.

MARY CASSATT

The other important woman Impressionist, Mary Cassatt (1845–1926), was as upper-class as Morisot, but her family lived in Pittsburgh, Pennsylvania, not in Paris. It was after she came to France in 1868 to paint and exhibit with the Impressionist group that she became modestly well known. Her art has an amplitude, a solidity very different from Morisot's, and gender is one of the few things they have in common.

Cassatt's grave dignity is never over emphatic. Her *Girl Sewing (332)* is made beautiful by the sheer variousness of the soft light. It pinkens the path behind the young woman, glows red in the flowers, and plays with a cascading grace over her simple frock. We are held by her attitude of childlike endeavor, lips set in concentration, and by the sheer brilliance with which her physical presence is captured. Cassatt was also an accomplished and gifted printmaker, and the widespread influence of Japanese prints is especially evident in her prints and drawings.

332 Mary Cassatt, Girl Sewing,
1880–82, 25 x 36½ in (63 x 92 cm)

Cassatt's art shows her interest in physicality. This is very understandable since it was Degas, not Manet, who was Cassatt's mentor. Degas (Hilaire-Germain-Edgar, 1834–1917), a cynic in later life and a misogynist at every age, was condescendingly surprised at Cassatt. He admitted her power, quite against his will. Yet this power of draftsmanship, and the ability to make a body palpably real, is very much his own.

DEGAS AS DRAFTSMAN

Degas is a far greater painter than Cassatt, and his graphic powers have never been excelled: his genius for line combined with a rich color sense to produce work that will always ravish the viewer. Like Manet, he was separate from the Impressionist group (though unlike Manet, he did exhibit with them). He was skeptical of studying nature for its own sake and was instead drawn to Classicism.

Degas remained remote from life as much through his wealthy upbringing as his temperament. That his temperament was that of a voyeur seems certain: he looked on, not only from a distance, but from a height. This was so instinctive to him that it rarely offends us. Such a curiosity is shown in *Madame René de Gas (333)*, painted when he visited a branch of the family in New

PARIS OPERA HOUSE
The new Paris Opera House, designed by Jean Garnier, opened in January 1875, and Degas was a frequent visitor. He had held a season ticket to the old opera house, where he studied ballet classes. With the opening of the new opera house, his interest in ballet grew and became a major subject of his work in the late 1870s.

EDGAR DEGAS
In 1861 Degas met Manet while copying a Velázquez in the Louvre and was introduced by him to the circle of young Impressionists. Degas's main protégée was Mary Cassatt, who he had met in Paris in 1874 and who he asked to exhibit at the fourth Impressionist exhibition of 1879. Degas often worked in pastel, especially in the 1880s, when his sight began to fail and he chose to work using stronger colors and more simplified compositions. For the last 20 years of his life he lived alone, almost blind, as a recluse. He devoted much of his time to modeling sculptures (which would be cast after his death).

333 Edgar Degas, Madame René de Gas, 1872/73, 36½ x 29 in (92 x 73 cm)

DEGAS'S DANCERS

Over half of Degas's paintings depict the young ballerinas who performed between the main acts at the Paris Opera (see p.291). Although Degas painted the dancers in intimate behind-the-scenes situations, he viewed them with a cool detachment. Only one of Degas's ballet sculptures was exhibited (in 1881), and at the time it was considered unusually realistic because Degas dressed the sculpture in real clothes. This illustration shows a bronze sculpture of a young dancer, based on a number of pencil sketches.

DEGAS AND HORSE RACING

In the mid-19th century, horse racing became extremely popular in Parisian society. Both Manet and Degas were part of the well-bred racing fraternity and attended many of the races at Longchamp in the Bois de Boulogne. Degas preferred to depict the moments before the race began, such as those in the painting illustrated above. He produced over 300 works of art on the racecourse theme.

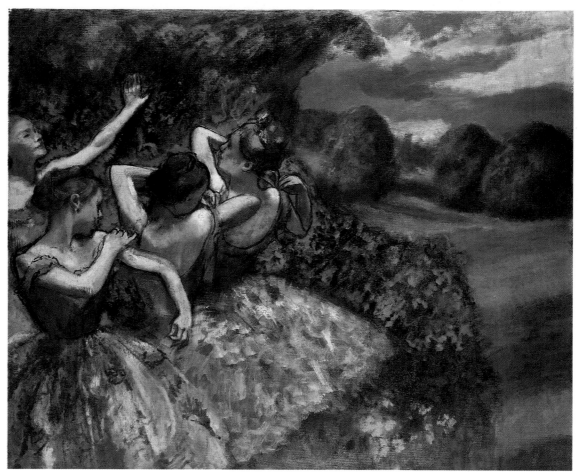

334 Edgar Degas, **Four Dancers,** *c.1899, 71 x 59½ in (180 x 151 cm)*

Orleans. His brother René had married a woman who went blind; Edgar Degas at least did not need to fear that the intensity of his stare would disturb her. He shows her gazing blankly, plump and well dressed, and we sense what her darkened world is like. The picture is strangely indistinct except for the face, where she is truly "herself." For the rest, she exists in cloudy spaciousness, her skirts spreading widely around her, the couch a sketchy background, nothing on the wall except light. The tight constraint of her hairstyle, unbecomingly scraped back, gives a certain pathos. Degas is sensitive to her situation, yet full of admiration: "My poor Estelle... is blind. She endures this in an amazing way; she is seldom helped around the house."

There is a tragic irony in the fact that Degas himself was to suffer from poor eyesight and eventually became unable to paint at all. His later work, mostly painted in the more direct medium of pastel, has a wild, instinctive rightness, as if his hand "knew" what his eye could barely see. *Four Dancers (334)* is not in pastel, but the oil is used with a pastellike freedom. He makes no attempt at obvious design. The dancers move out of the painting backward so that we just glimpse them as they move away. This unbalanced composition, learned from photography (see column, p.293) and Japanese prints, shows Degas's understanding of perspective. The viewer is intrigued, forced to accept the painter's logic rather than that of convention. The colors, too, are vivid, insistent, glaringly bright, and this is part of Degas's theme: the stage is at all times artificially lit and our distance from it makes the colors become both loud and blurred, creating an impression of distance and glamorous dazzle.

UNIDEALIZED NUDES

For one who so openly professed contempt for women, Degas was strangely fascinated by the female nude. But he also brutally demystifies it: the women he depicts are wholly unideal and lacking in individuality. Instead, his interest is in form, the figure reduced to an animating agent. He loved, he said, to paint as if "through the keyhole," catching his subjects when they thought themselves unobserved. The pastel painting *Girl Drying Herself (335)* is typical. We see only the back of this young woman as she stands with gawky tension upon her clothes. It is the rosy gleam of the light that provides romance and the hollow and swell of her muscles as she dries herself with animal vigor.

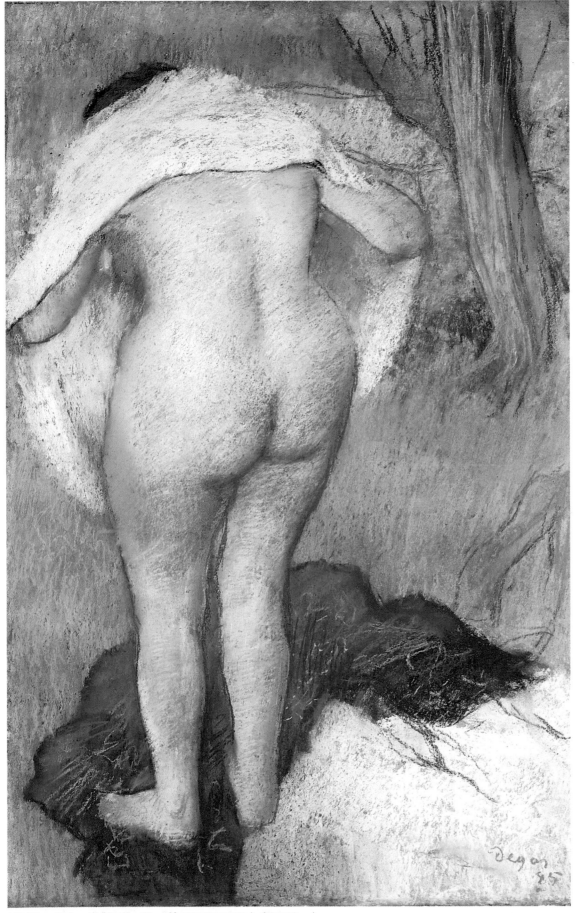

335 Edgar Degas, Girl Drying Herself, 1885, 20 x 31½ in (50 x 82 cm)

DEGAS AND PHOTOGRAPHY

By the time of the Impressionists, technical advances had led to the development of the "snapshot" camera. The availability of instant unposed photography, with blurrings and accidental cropping off of figures, created a sense of spontaneity that the Impressionists also sought to achieve. Edgar Degas was inspired by the pioneering photographer Eadweard Muybridge, whose freeze-frame photographs of humans and animals in motion revolutionized the depiction of movement in art. This illustration shows the type of camera used by Degas.

OTHER WORKS BY DEGAS

Dancers in Pink
(Museum of Fine Arts, Boston)

Woman Arranging Her Hair
(Ordrupgaard-Samlingen, Copenhagen)

Dancers in the Foyer
(Art Institute of Chicago)

The Repetition
(Burrell Collection, Glasgow)

Jockeys
(National Gallery of Canada, Ottawa)

After the Bath
(Bridgestone Museum of Art, Tokyo)

The Rehearsal of a Ballet
(Musée d'Orsay)

Nursemaids
(Norton-Simon Museum, Pasadena)

THE GREAT IMPRESSIONISTS

Impressionism was officially "born" in 1874, when the term was applied to a diverse collection of artists who exhibited at the Salon des Refusés that year. Many of the works had a comparatively coarse, unfinished appearance, which gave a strong sense of immediacy that incensed the critics. Although these artists were all individualistic, with disparate ideas and attitudes, they were united in their desire to achieve a greater naturalism in art, and their work revealed a startling new freshness and luminosity.

Critics found the independent exhibitors an easy target, especially the younger artists, Monet, Renoir, Morisot, and Sisley. These artists established a pictorial style that continued to the end of the decade and, after their first shows, consciously adopted the "Impressionist" label (see column). Cézanne, Pissarro, Degas, Gauguin – even some mainstream Salon painters – also exhibited at the Impressionist shows. Degas, though he had little stylistic affiliation with the Impressionists, wanted to support an alternative salon that would undermine the monopoly of the official Salons and provide a public arena for an innovative kind of painting, based on real life.

Degas's concentration on formal line rather than on the effects of color make him quite different from his contemporaries, Monet and Renoir. Claude Monet (1840–1926), in particular, is the quintessential Impressionist, and as such his world is exhilaratingly beautiful. Monet's style, like that of the other Impressionists, was characterized by a light, colorful palette, and he often applied unmixed paints directly onto a canvas prepared with a pure white coating. This bright surface enhanced the luminosity of each color and increased the broken, disharmonious appearance of the picture.

What fascinates Monet in *Woman with a Parasol (336)* (also called *Madame Monet and Her Son*) is not the identities of the models, but the way the light and breeze are held upon the canvas for our perpetual delectation. One summer's day a young woman stood on a small rise in the ground, grass and flowers hiding all sight of her feet. She seems to have floated here, borne along by her dappled sunshade, radiant in the sheer brightness of the hour. Her dress is alive with reflected hues, gleaming gold or blue or palest pink. The colors never settle down, any more than do her pleats and folds, which swirl against the glitter of the clouds and the intense blue sky. Monet saw this, held it still, and made it pictorially accessible to our eyes. We look up over the variegated grass with its luminous shadows, and we are dazzled.

THE SERIES PAINTINGS

Monet's contemporaries were used to controlling the motionless images they painted in their studios, so that their work corresponded not with what was actually seen in real life – which was never still – but with what was thought to be seen. Monet took away these comforting labels of certainty. He did this most alarmingly in his great series paintings, where he surveyed the same subject in different weather conditions at different times of day or seasons. As the

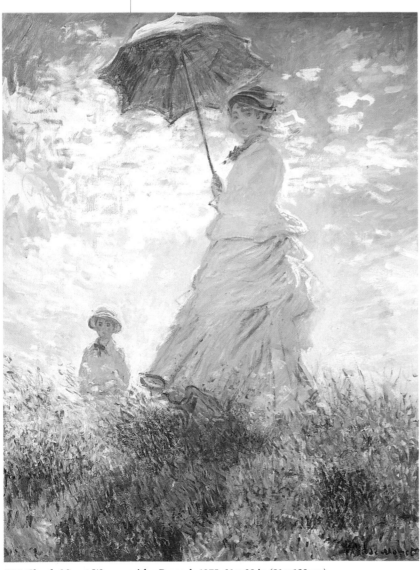

336 Claude Monet, Woman with a Parasol, *1875, 31 x 39 in (81 x 100 cm)*

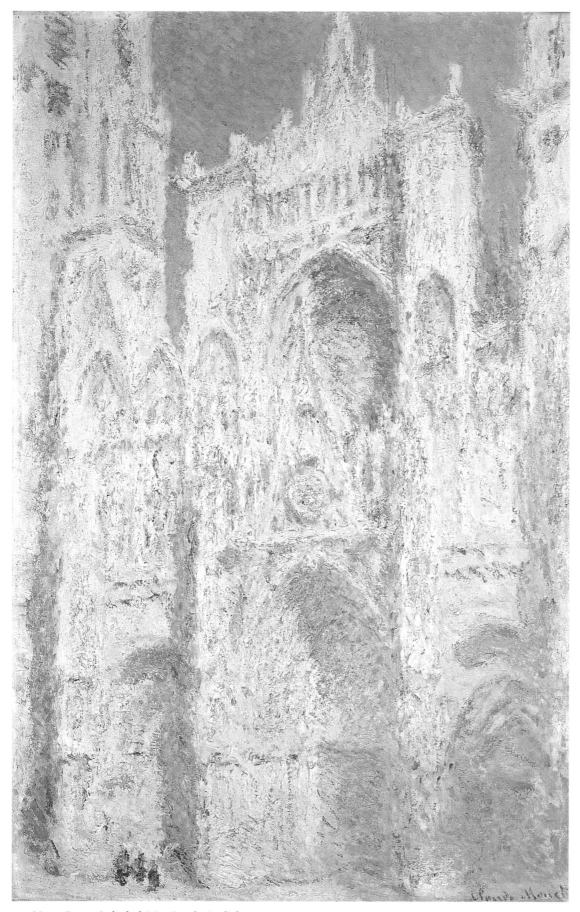

*337 Monet, **Rouen Cathedral, West Façade, Sunlight,** 1894,
26 x 39¼ in (66 x 100 cm)*

Rouen Cathedral,
The Portal Seen from the
Front (Harmony in Brown)

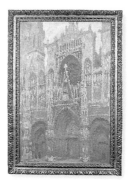

Rouen Cathedral,
The Portal, Gray Weather
(Harmony in Gray)

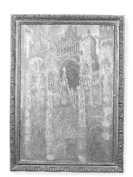

Rouen Cathedral,
Morning Sun
(Harmony in Blue)

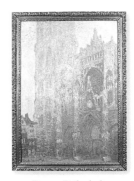

Rouen Cathedral,
The Portal and the Saint-
Romain Tower, Morning
Effect (Harmony in White)

MONET AT ARGENTEUIL

The suburb of Argenteuil, only a 15-minute train journey from Paris, was a popular destination for excursions. Monet lived in the town from 1871–78 and produced 170 paintings. Following the example of the earliest *en plein air* painter, Charles-Francois Daubigny, Monet had a studio boat built (replica illustrated above). The boat had a cabin and a shaded open deck so Monet could work outside. Monet never sailed far in the boat and tended to moor on quiet stretches of the Seine.

During his time at Argenteuil, the town hosted many international sailing regattas, providing inspiration for much of Monet's work.

OTHER WORKS BY MONET

Vétheuil
(National Gallery of Victoria, Melbourne)

Heavy Sea at Trouville
(National Museum of Western Art, Tokyo)

The Artist's Garden at Giverny
(Bührle Foundation, Zurich)

The Beach at Pourville
(Museé Marmottan, Paris)

La Grenouillère
(Metropolitan Museum of Art, New York)

Field of Poppies near Giverny
(Museum of Fine Arts, Boston)

The Japanese Bridge
(Neue Pinakothek, Munich)

enveloping light changes, so do the forms that had hitherto been thought constant and permanent. Monet used his brilliant palette to capture the optical effects created by natural light across a landscape or a townscape, paying little attention to the incidental details and using highly visible, sketchy, "undiscriminating" brushwork to capture the scene quickly.

Rouen Cathedral had seemed an unchangeable reality, but as Monet painted that identical west front with its spires and entrance arches – always from the same viewpoint – he saw how it was constantly transformed by the light: now richly ruddy, the thick, crusty paint echoing the rough stonework, the welcoming gates very visible, the great picture window a mystery of dark appeal; then pale, shimmery, fluid, and shifting, almost without detail in the richness of the glare. He usually worked on several canvases at once, softening the stonework in dull weather with a harmonious palette of gray and heightening

it with white and cobalt blue when the sun was at its most brilliant. *Rouen Cathedral, West Façade, Sunlight (337)* makes its statement solely through this light. It was this sensitivity to the changing, transforming light – in the strictest sense, creative light – that was Monet's greatest gift as a painter. This, of course, was for him the great fascination of the series paintings, and he explored this fascination to the utmost.

Monet extended his pleasure to the mechanics of water gardens during the final years of his life, working directly with nature: at last he had the time and the money to create his own garden and paint it. Some of his final waterlily murals, painted on enormous canvases, are almost abstract, with their floating shapes and surface reflections, but *The Waterlily Pond (338)* is held firmly in the world of actuality by the Japanese bridge that curves across the center. Even here, without that unifying curve, we might read this riot of greens, blues, and golds as an abstraction.

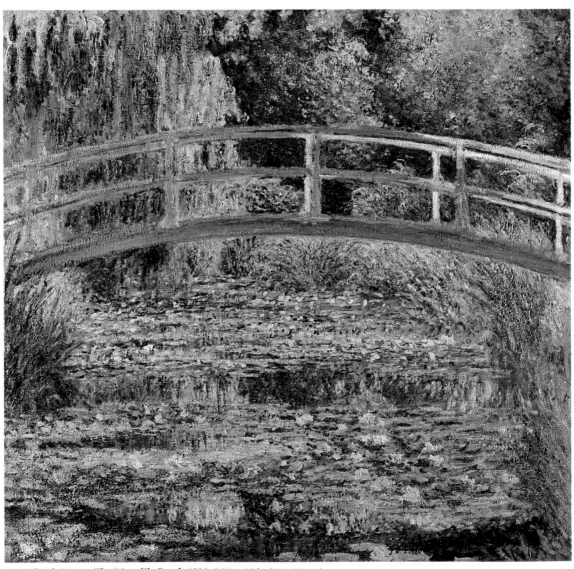

338 Claude Monet, **The Waterlily Pond**, *1899, 36½ x 35 in (92 x 90 cm)*

THE WATERLILY POND

Monet moved to a house at Giverny in northwest France in 1883 and lived there for the rest of his life. His garden was his main source of inspiration during his remaining years, and in 1893 he increased its area by purchasing an adjoining site that contained a pond. Here he created his celebrated water garden. This is one of 18 paintings belonging to Monet's late series, in which the arched, Japanese-style bridge that he had constructed over his waterlily pond forms the central motif.

VERTICAL BRUSHWORK
This version of the waterlily pond reveals the garden in full summer, with dense, bright green foliage. Beyond the tense, arching curve of the bridge, the foliage is a soft mass of confusion: greens, blues, pinks, and purples merge in and out of one another, and definition is almost nonexistent. However, the vertical rhythm of the brushwork prevents the foliage from melting into incoherence, and it helps maintain the strong formal structure, repeating the verticals of the bridge and the sides of the canvas.

THE JAPANESE BRIDGE
In this detail we can see Monet's characteristic "dry" paint surface. A heavily loaded brush was dragged over the canvas where previous applications were allowed to dry first. The result is a richly textured, encrusted surface, built up over time, which attracts light falling onto the canvas. The thick crust of paint imitates the solid structure of the bridge, standing out in sharp definition against the amorphous vegetation and transient light.

HORIZONTAL BRUSHWORK
The vertical rhythms of the foliage are continued into the deep shadows and bright reflections in the water. However, the unified downward movements of this brushwork are counterbalanced by bold horizontal brushstrokes, running from side to side across the canvas, which describe the receding bands of waterlilies stretched across the pond. These bands of color are applied with thick sculptural paint over the top of the reflections and shadows in the water, "anchoring" them by asserting the flatness of the water's surface. This continuous crisscross interplay of brushwork maintains a lively tension between the painting's two-dimensional abstract properties and its illusion of three-dimensional space.

MONET'S SIGNATURE
The effect of The Waterlily Pond *is an overwhelming sense of life, blocking out the sky and pushing in from all directions, almost vulgar in its lushness. Within the gloom of a deep shadow, not immediately visible amid such vibrancy, Monet's signature and the date of the painting can be found. The signature has been added in red, which has also been used to pick out individual flowers.*

339 *Auguste Renoir,* **The Boating Party Lunch**, *1881, 69 x 51 in (175 x 130 cm)*

CONTEMPORARY LIFE

Auguste Renoir (1841–1919) and Monet worked closely together during the late 1860s, painting similar scenes of popular river resorts and views of a bustling Paris. Renoir was by nature more solid than Monet, and while Monet fixed his attentions on the ever-changing patterns of nature, Renoir was particularly entranced by people and often painted friends and lovers. His early work has a quivering brightness that is gloriously satisfying and fully responsive to what he is painting, as well as to the effects of the light.

Renoir seems to have had the enviable ability to see anything as potentially of interest. More than any of the Impressionists, he found beauty and charm in the modern sights of Paris. He does not go deep into the substance of what he sees but seizes upon its appearance, grasping its generalities, which then enables the spectator to respond with immediate pleasure. "Pleasure" may be decried by the puritanical instinct within us all, but it is surely the necessary enhancer that

life needs. It also signifies a change from Realism: the Impressionists' paintings have none of the labored toil of Millet's peasants, for example. Instead they depict delightful, intimate scenes of the French middle class at leisure in the country or at cafés and concerts in Paris. Renoir always took a simple pleasure in whatever met his good-humored attention, but he refused to let what he saw dominate what he wanted to paint. Again he deliberately sets out to give the impression, the sensation of something, its generalities, its glancing life. Maybe, ideally, everything is worthy of attentive scrutiny, but in practice there is no time. We remember only what takes our immediate notice as we move along.

In *The Boating Party Lunch (339)*, a group of Renoir's friends are enjoying that supreme delight of the working man and woman, a day out. Renoir shows us interrelationships: notice the young man intent upon the girl at the right chatting, while the girl at the left is occupied with her puppy. But notice too the loneliness, however relaxed, that can be part of anyone's

experience at a lunch party. The man behind the girl and her dog is lost in a world of his own, yet we cannot but believe that his reverie is a happy one. The delightful debris of the meal, the charm of the young people, the hazy brightness of the world outside the awning – all communicates an earthly vision of paradise.

RENOIR'S PORTRAITS

One of Renoir's early portraits, *A Girl with a Watering Can (340)*, has all the tender charm of its subject, delicately unemphasized, not sentimentalized, but clearly relished. Renoir stoops down to the child's height so that we look at her world from her own altitude. This, he hints, is the world that the little one sees – not the actual garden that adults see today, but the nostalgic garden that they remember from their childhood. The child is sweetly aware of her central importance. Solid little girl though she is, she presents herself with the fragile charm of the flowers. Her sturdy little feet in their sensible boots are somehow planted in the garden, and the lace of her dress has a floral rightness; she also is decorative. With the greatest skill, Renoir shows the child, not amid the actual flowers and lawns, but on the path. It leads away, out of the picture, into the unknown future when she will no longer be part of the garden but an onlooker, an adult, who will enjoy only her memories of the present now depicted.

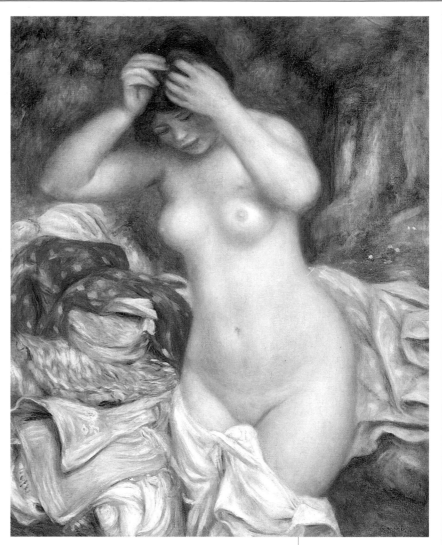

341 Auguste Renoir, Bather Arranging Her Hair, *1893, 29 x 36½ in (74 x 92 cm)*

RENOIR'S LATE STYLE

Although he may seem a happy hedonist, Renoir was in fact a serious artist. At one stage he changed his whole style, feeling that he had gone as far as he could with Impressionism and was in danger of becoming superficial. His late style is firmer, with a cleaner edge to his figures, and the last works have a classical solidity. In *Bather Arranging Her Hair (341)*, he has preserved the solid feel of the bodily form and irradiated it with luminous color. The girl's lovely body is set out amid the disarray of her many-colored garments: her corset, her hat, the white material draped around that round and rosy flesh. Renoir persuades us that the girl herself does the stripping and the presenting, and we feel she loves her body, as she should. He gazes worshipfully, not at her, the person, but at her body, the outer her, and he delights in painting her soft, glowing skin. Her bright but concentrated expression hints that the distinction would not mean much to her; she is an innocent country beauty.

340 Auguste Renoir, A Girl with a Watering Can, *1876, 29 x 39 in (73 x 100 cm)*

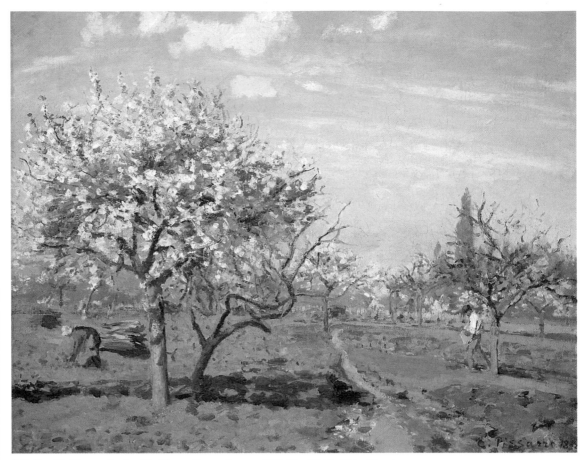

342 *Camille Pissaro,* Orchard in Bloom, Louveciennes, *1872, 22 x 17½ in (55 x 45 cm)*

CAMILLE PISSARRO

Camille Pissarro is seen as
the patriarchal figurehead
of the Impressionist
movement and is the only
artist to have had work
shown at all eight of the
Impressionist exhibitions.
During the Franco-Prussian
war (see p.286), Pissarro
joined Monet in England
and was influenced by the
English landscape tradition
of Turner and Constable.
In 1872 he returned and
settled in Pontoise, where
he became a friend and
mentor of Cézanne.
Pissarro's art centers on
the people who work the
soil, and he is renowned
for his paintings of
peasant girls going about
their daily chores.

CAMILLE PISSARRO

Camille Pissarro (1830–1903) was the patriarch
of the Impressionists, not only because he was
slightly older, but because of his benign and
generous character. After meeting Corot in 1857,
Pissarro was encouraged to abandon his formal
training to paint in the open air and, despite his
age, he became one of the most receptive of the
Impressionists to new ideas. He was a passionate
champion of progress, sometimes to the detriment
of his own individual expression. He was the
only artist to have shown work at all eight
Impressionist exhibitions.

Pissarro was a dedicated painter and
enormously prolific. He tended to stray in and
out of pure Impressionism as the spirit took him,
unconcerned with the rigors of style. He was
the outsider of the group, perhaps, a man of
mixed blood (Portuguese, Jewish, and Creole),
and he was instinctively reponsive to the
underlying architecture of nature. His paintings,
with their almost naive simplicity and unpolished
surface, influenced Gauguin (see p.322), van
Gogh (p.316), and Cézanne (p.310), who called
himself the "pupil of Pissarro."

Orchard in Bloom, Louveciennes (342) is a work
with bones under the painterly flesh: the path
that we notice in the foreground leads us with
a real sense of distance through the flowering
brightness of impressionistic trees. There is a

343 *Camille Pissarro,* Peasant Girl with
a Straw Hat, *1881, 24 x 29 in (60 x 73 cm)*

sunlit gentleness peculiar to this balanced, wise artist with his sense of freedom and restrained exhilaration. *Peasant Girl with a Straw Hat (343)* has a beautiful simplicity, a fullness of form not contradicted but given significance by the haze of the background. Pissarro himself was a very good human being, and even without knowing this, we do seem to find a lovely wholesomeness in his people and places. The girl is supremely unpretentious, unconcerned with herself, her whole being – sun-reddened nose and all – illuminated by the strong, bright light of day.

In his fifties, Pissarro became fascinated by the Neo-Impressionists and their great interest in the science of optics. He experimented with the Divisionist techniques of Seurat (see p.314) with, for Pissarro, a relative unsuccess. The work was not appreciated by the public either, and he converted back to the spontaneity of true Impressionism. He was a major Impressionist – Cézanne considered him their leader – though he has been somewhat overshadowed by Monet and his other great "pupils."

ALFRED SISLEY

Alfred Sisley (1839–99) was something of an outsider because his family, though permanently resident in France, was English. Sisley, however, has been called the most consistent of the Impressionists. All the others, even Monet in his late, great semi-abstractions, moved on from, or at least through, Impressionism. Sisley, once he saw the meaning of the movement, stayed with it. While other Impressionists sought their inspiration in Paris, he preferred, like Pissarro, to live in the countryside and paint rural scenes.

Sisley's art was not as robust as Monet's, but his paintings are some of the most subtly beautiful of the Impressionists, and they are heavenly in their peaceful celebration of nature. *Meadow (344)* lies quietly under the sun, vibrant with variety and chromatic glory. It is a scene that is easy to look at, a strip of field and a humble fence, yet Sisley has seen that it is alive all over with the intensity of being. The miracle is that the intensity is so completely without tension; Sisley seems to dream in paint.

ALFRED SISLEY
As an artist Alfred Sisley is known to have felt like an outsider from the main group of Impressionist painters. However, many of his landscapes are considered among the most lyrical and harmonious works of Impressionism. Born of English parents, he moved to France and joined the studio of Charles Gleyre in 1862, where he met Renoir and became close friends with Monet.

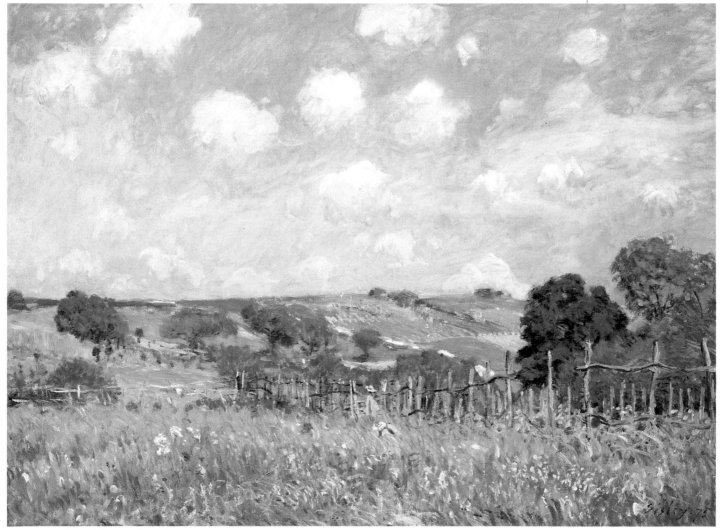

344 Alfred Sisley, Meadow, *1875, 29 x 22 in (73 x 55 cm)*

AMERICAN VISION

Impressionism became a worldwide movement, as international as the Gothic style of ages past, and artists as far away as Japan and Australia began to paint modern-day subjects in the open air. American artists such as James Whistler, Thomas Eakins, and Winslow Homer traveled to Europe to study painting. Skillfully, they took from Realism and Impressionism what each of them personally needed.

> *"Art should stand alone, and appeal to the artistic sense of eye or ear, without confounding this with emotions entirely foreign to it."*
>
> James Whistler

James Abbott McNeill Whistler (1834–1903), though he lived in London by choice, was an American. A flamboyant character, he was one of the most well-known and colorful figures of the European art world in the 19th century.

In 1855 Whistler left America and traveled to Paris to train as an artist. He entered the studio of Charles Gleyre, an advocate of Realism, and became, for a time, an enthusiastic follower of Gustave Courbet (see p.282). He was a dandy and a wit, very much at home as a Parisian *flâneur* like his two contemporaries, Manet and Degas. When his early work received more success in England, he left Paris in 1859 and moved to London, where he began to paint a favorite and enduring subject, the Thames.

AN AMERICAN ENGLISHMAN

Whistler hovered on the brink of Impressionism during the 1860s and at one stage came close to painting mere "sensation." But it was Japanese prints that influenced his style, and he was one of the first artists to understand and absorb the lessons of Japanese art, rather than imitate it. He translated the two-dimensional qualities, cool tones, and significant details of *Japonisme* into a highly individual treatment of color harmony and tone on a flat, decorative surface.

Nocturne in Blue and Gold: Old Battersea Bridge (345) shows Whistler's interest in harmonious arrangements of color and pattern. Its musical title gives emphasis to the sparse notes of color that blaze on a dimly seen background, suggesting that we are given only an impression of what is seen, not its actuality; his elongated bridge is far more reminiscent of the stylistic imagery of *Japonisme* than of the real Old Battersea Bridge. Yet despite its apparent vagueness, the painting has genuine power. This is how London would have looked in the days of smoking chimneys. We catch a sense of mystery, even glamour, the last perhaps an index of Whistler's American nature: the transatlantic traveler, as we know from the novels of Henry James (see column, p.305), finds London far more romantic than the average Londoner.

Whistler is at his best when he plays with shapes and colors and it is their intrinsic interaction that delights him, rather than the play of light itself. *The White Girl (346)* is a great piece of decorative art. Jo Heffernan, his mistress, pleasingly occupies the center of the picture. There is a marvelous subtlety in the different whites – the thick hanging of the patterned curtain; the soft whiteness of her dress; the rose she holds in her hand – while her dark, beautiful face in its rough cascade of auburn hair is sadly enigmatic.

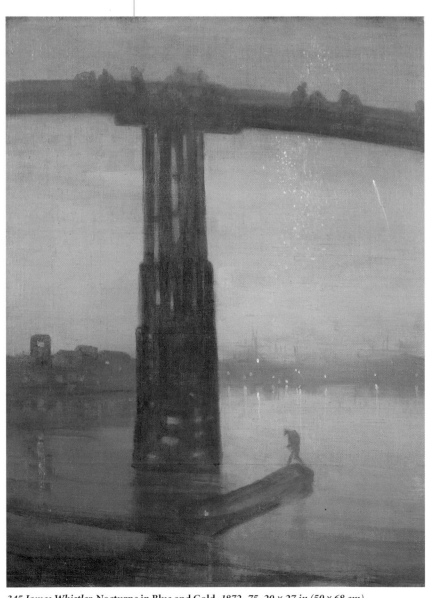

*345 James Whistler, **Nocturne in Blue and Gold,** 1872–75, 20 x 27 in (50 x 68 cm)*

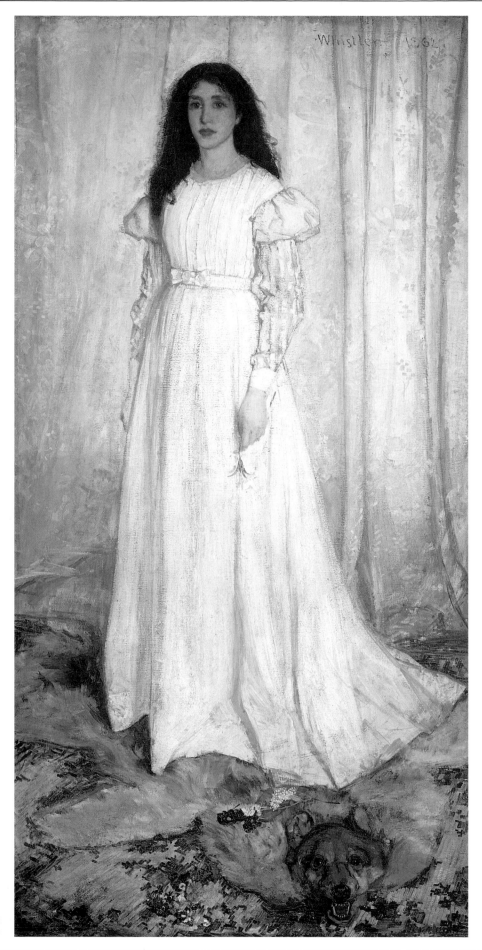

346 James Whistler,
The White Girl,
1862, 42½ x 84 in
(108 x 213 cm)

OSCAR WILDE

The playwright, novelist, poet, and wit Oscar Wilde (1854–1900) was one of Whistler's closer friends. While traveling to the United States on a lecture tour in 1882, Wilde is reported to have said, when asked if he had anything to declare, "Only my genius." He married in 1884, and in 1891 wrote the novel *The Picture of Dorian Gray*, in which the main character was apparently based on his male lover, the poet John Gray. His most famous work, however, was *The Importance of Being Earnest*, written for the theater in 1895. Wilde's brief but brilliant career ended in ruin when he was sentenced to two years in prison for homosexual practices.

OTHER WORKS BY WHISTLER

Old Westminster
(Museum of Fine Arts, Boston)

Gray and Green: the Silver Sea
(Art Institute of Chicago)

Nocturne: River Scene
(Glasgow University)

Three Figures: Pink and Gray
(Tate Gallery, London)

A Woman
(National Museum of Western Art, Tokyo)

Self-Portrait
(Detroit Institute of Art)

Man with a Pipe
(Museé d'Orsay, Paris)

347 Winslow Homer, Breezing Up, 1876, 38 x 24½ in (97 x 62 cm)

WINSLOW HOMER

Winslow Homer (1836–1910) was only lightly touched by Impressionism. He visited Paris in 1867, and was also impressed by Manet's broad tonal contrasts, but he explored light and color within a firm construction of clear outlines. Whistler's art seems a rejection of all that Homer represents, with his emphasis on clarity and objective, convincing solidity. Homer's watercolors have an incandescent brightness, his oils are beautifully solid, and he is better described by Realism than Impressionism.

Breezing Up (347) has a spectacular vividness. The sea (Homer's favorite subject) frisks and sways almost palpably under the keel of the small boat, the three boys and the fisherman brought before us by the slightest of touches.

AMERICA AND HER LEADERS

In the late 19th century the US was undergoing economic and social changes that would have repercussions across the whole world. Between 1880 and 1900 the population of the country doubled with the arrival of nine million immigrants. The country was also emerging from a period of economic depression and was stimulated by industrialization, the growth of the railroads, and the discovery of more silver and gold in the West. The election in 1880 produced a compromise president, James Garfield (1831–81), shown above, but interparty strife led to his assassination by a disappointed and deranged office seeker on July 2, 1881.

348 Thomas Eakins, The Biglin Brothers Racing, c. 1873, 36 x 24 in (91 x 60 cm)

This is one particular day when the wind begins to rise at sea with all the emotions fresh at hand for the painter. The sun shines and the air of excitement runs all along the horizon, ending with the filling – and balancing – sails that punctuate the far right of the picture.

THOMAS EAKINS

If Homer is a supreme watercolorist, then Thomas Eakins (1844–1916) is a supreme oil painter of the American Realist tradition. *Breezing Up* is wonderful, but it seems just that slight shade less convincing than *The Biglin Brothers Racing (348)*, one of Eakins's greatest works. Eakins persuades us that we too would have seen this, had we stood in Philadelphia one summer's morning to watch the racers exercise.

349 John Singer Sargent, Mrs. Adrian Iselin, 1888, 37 × 61 in (93 × 154 cm)

We would not have seen this scene, of course: the Biglin brothers would have vanished from sight before we had time to notice how the sunlight catches doublet and oar, or how the distant riverbank is as dim and dense as foliage. Eakins has held the image and created a work of such atmosphere that when we look at the painting the moment seems full and long – not at all like a snapshot. In the light of this comparison, Homer's glimpsed sailors begin to seem far more impressionistic than at first sight.

SARGENT THE SOCIETY PAINTER

John Singer Sargent (1856–1925) is essentially known as a society painter and, except for his marvelous watercolors of nature, he painted almost only high society. Often there was a great swagger of fashionable dress, but *Mrs. Adrian Iselin (349)* is too elite for such embellishments. She glitters before us in austere black with the domineering haughtiness of a grande dame. For those who think Sargent pandered to his sitters, he has faithfully depicted her large and ugly ear. At his best, Sargent could be as ruthless as Goya, and with something of his technical brilliance.

HENRY JAMES
In the work of the American writer Henry James (1843–1916), we see a change of subject matter as the author moved through three creative phases. In the first phase, which produced one of his most famous novels, *The Bostonians* (1886), James was concerned with the impact of American life on the more established European societies. In 1876 James moved to England and devoted his novels to the issues of English society. His novel *The Ambassadors* unites Anglo-American attitudes in his last period of creativity. Although an American, he was very much an Anglophile and became a British citizen during World War I.

JOHN SINGER SARGENT
The outstanding portrait painter of his time, John Singer Sargent (1856–1925) was an American citizen with a French education who came to work in England in 1885. His move to England was prompted by the scandal surrounding his exhibit at the 1884 Paris Salon. The painting, *Madame X*, was considered provocatively erotic by the judges and was also obviously the portrait of a real woman, Madame Gautreau. Her mother begged Sargent to remove the picture, but he fled to England. In his later years he was made official British war artist of World War I.

POST-IMPRESSIONISM

Art history loves labels, and Post-Impressionism is the label for the diverse art that immediately followed Impressionism (this label roughly covers the period between 1886 and 1910). The Impressionists had destroyed forever an artistic belief in the objective truth of nature. Painters now understood that what we see depends on how we see, and even more when we see: the "objective view" is in fact subject to both perception and time. We live in an essentially fleeting and uncontrollable world, and it is the glory of art to wrestle with this concept.

The greatest of all wrestlers was Paul Cézanne, who understood, as no artist before him ever had, the personal need of the artist to respond to what he saw and make a visual and enduring image of its wayward and multi-dimensional beauty. Another Post-Impressionist giant, Georges Seurat, sought a more scientific analysis of color in his painting, though his art transcended his theories. Other artists chose to portray the world, not just by its physical, outward appearance, but by its inner, less tangible realities, exploring new symbolic associations with color and line.

Paul Gauguin, **Riders on the Beach,** *1902* **(detail)**

POST-IMPRESSIONISM TIMELINE

Post-Impressionism is the name given to a group of painters in the last two decades of the 19th century. They have very little in common except their starting point – the Impressionists. Paul Cézanne, Paul Gauguin, and Vincent van Gogh are all geniuses of a high order, but the movement we call Post-Impressionism also embraces, in its capacious sweep, small groups like the Nabis.

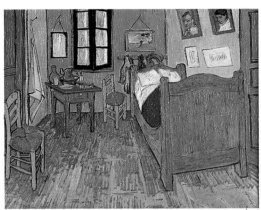

VINCENT VAN GOGH, THE ARTIST'S BEDROOM, 1889

Van Gogh used color to convey emotion more than to represent objects: this painting carries a poignant message of loneliness, hinted at by the extra chair, waiting for an eagerly expected companion – Gauguin. This room is in the house at Arles that van Gogh shared with Gauguin from October to December 1888. He painted this scene in 1888 and made two copies of it in 1889 (this is one of them), when he was in the asylum at St. Rémy (p.316).

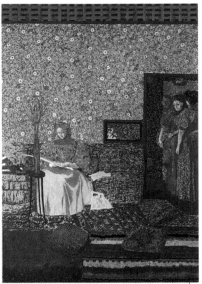

EDOUARD VUILLARD, THE READER, 1896

To the Nabi artists, it was important to show beauty in simple scenes, such as this superbly decorative painting with its assemblage of patterned fabrics (p.328).

1885	1890	1895

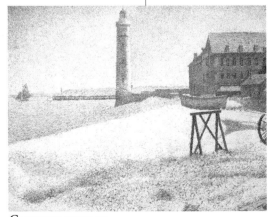

GEORGES SEURAT, THE LIGHTHOUSE AT HONFLEUR, 1886

Seurat was that rare thing, both scientist and artist. He was enthralled by the newly emerging science of optics and developed a style of painting called Pointillism, which used innumerable dots of color. The eye combines these as we do in real life, but his vision was of a world supremely pure and controlled, painfully different from actuality (p.315).

HENRI DE TOULOUSE-LAUTREC, RUE DES MOULINS, 1894

The witty, searching art of Lautrec often depicted nightclub and drinking scenes or portrayed the denizens of Parisian lowlife. Here, two prostitutes are shown lining up for a medical examination, and the sadness and shame of their position in society are held up to our gaze. Lautrec was influenced by the Japanese and their complete freedom from conventional notions of composition; the center of attention was often off-center. His style was perfectly suited to poster art, to which he brought great new zest and life. In all his work there is a fluidity and passion that captures the vitality of city life (p.320).

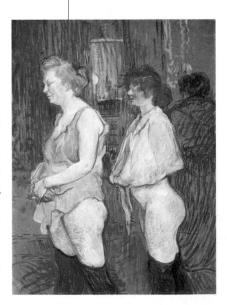

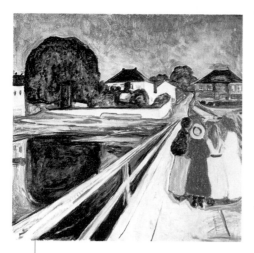

EDVARD MUNCH, FOUR GIRLS ON A BRIDGE, 1889-1900

Munch was a strange man who experienced overwhelmingly gloomy emotions. It was to express the intensity of these emotions that his art was directed. Personally he found the pain of life too much to bear, but artistically he struggled to express this pain and make beauty out of it. Symbolism struck a deep chord within him: with its high color and formal simplicity, it offered him a refuge from his fears. This Nordic gloom lived on to influence Expressionism, which dominated Germanic art after World War I (p.325).

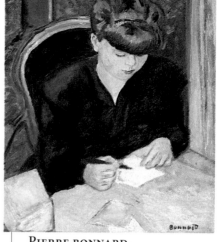

PIERRE BONNARD, THE LETTER, C. 1906

Bonnard was a leading member of the Nabis, who in some ways were a transitional movement between Post-Impressionism and the art of the 20th century. Bonnard was interested in oriental philosophy and mysticism. He was influenced by Japanese art, imitating the graphic simplicity of Japanese woodcuts. The Letter is a typical example of his many paintings of everyday life. The model is one who frequently appears in Bonnard's pictures, his lover and, later, wife, Marthe. She is portrayed with a wonderful concision, and Bonnard takes an uncomplicated pleasure in the patterns into which the image falls (p.326).

PAUL CEZANNE, LE CHATEAU NOIR, 1900/04

At all stages of his career and with all types of subject, Cézanne was a supreme master. This picture is a fine example of the Post-Impressionist tension between reality and invention. We are forced to read it not only as a wooded landscape with a château, but equally as a flat plane, upon which colors of different chromatic and tonal values have been arranged (p.312).

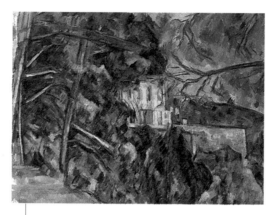

1900 **1905** **1910**

PAUL GAUGUIN, NEVERMORE, 1897

The English title Nevermore, appearing in the corner of this painting, is the name of a poem, "The Raven" by Edgar Allan Poe, which was a favorite of the French Symbolists. However, the painting is not exactly an illustration of the poem. What Gauguin hoped to create was an image of "a certain long lost barbaric luxury," and for him the girl is the main feature in the painting, and the bird is reduced to a toylike caricature. Gauguin strove to show the capacity of art to escape from rationality and naturalism, in order to describe more accurately the inner workings of the heart and mind (p.324).

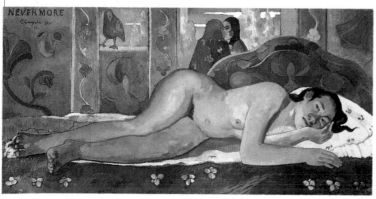

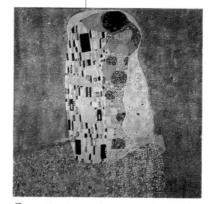

GUSTAV KLIMT, THE KISS, 1907/08

Gustav Klimt came from a family of artists and craftsmen; his father was a gold engraver. As one of Austria's most prominent artists, he helped found two radical groups, the Vienna Secession and the Vienna Workshop. The Kiss is a gloriously decorative work, a fusion of two figures into one, with a suggestion of anxiety in the tense grip of the hands and the averted face of the girl (p.325).

POST-IMPRESSIONIST ARTISTS

Like the Renaissance, Impressionism made an irreversible difference, the viewer naturally senses that all art since that time has been "after Impressionism." The artists who rejected Impressionism toward the end of the 19th century painted not only what they observed, but what they felt, finally setting painting free to deal with emotions as well as material reality. They experimented with new subjects and techniques, moving art closer to abstraction and winning tremendous freedom for the next generation of artists.

Post-Impressionism was never a movement – the term was unknown to the artists involved during their own lifetimes (see column, p.311). It encompasses a group of artists with diverse styles and ideals who became dissatisfied with the limitations of Impressionism and departed from it in various directions. Never again could it be so taken for granted that painting has a direct relation to the exterior world.

CEZANNE'S EARLY WORK

Paul Cézanne (1839–1906) is certainly as great an artist as any that ever lived, up there with Titian, Michelangelo, and Rembrandt. Like Manet and Degas, and also Morisot and Cassatt, he came from a wealthy family – his was in Aix-en-Provence, France. His banker father seems to have been an uncultivated man, of whom his highly nervous and inhibited son was afraid. Despite parental displeasure, Cézanne persevered with his passionate desire to become an artist. His early paintings display little of the majesty of his late work, though today they are rightfully awarded the respect that he never received for them.

His early years were difficult and his career was, from the beginning, dogged with repeated failure and rejection. In 1862 he was introduced to the famed circle of artists who met at the Café Guerbois in Paris, which included Manet, Degas, and Pissarro (see p.300), but his awkward manners and defensive shyness prevented him from becoming an intimate of the group. However, Pissarro was to play an important part in Cézanne's later development.

One of the most important works of his early years is the portrait of his formidable father. *The Artist's Father (350)* is one of Cézanne's "palette-knife pictures," painted in short sessions between 1865 and 1866. Their realistic content and solid style reveal Cézanne's admiration for Gustave Courbet (see p.282). Here we see a craggy, unyielding man of business, a solid mass of manhood, bodily succinct from the top of his black beret to the tips of his heavy shoes. The uncompromising verticals of the massive chair are echoed by the door, and the edges of the

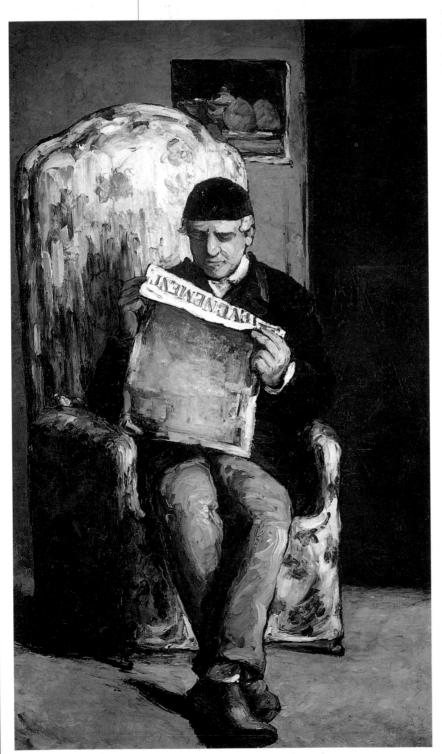

350 Paul Cézanne, The Artist's Father, 1866, 47 x 78 in (119 x 199 cm)

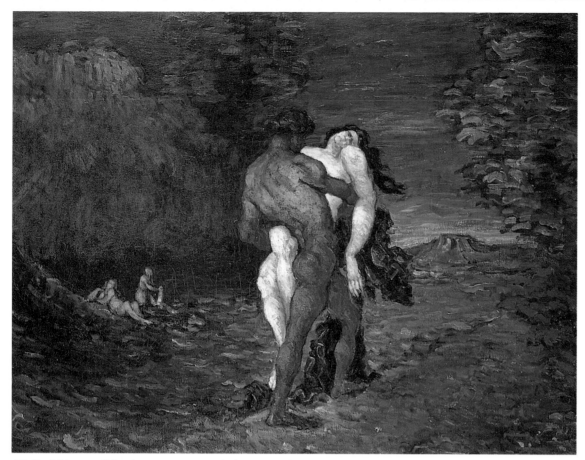

351 Paul Cézanne, **Abduction,** *c. 1867, 46 x 35 in (117 x 90 cm)*

ROGER FRY
The term
Post-Impressionism was
coined by the English
art critic Roger Fry
(1866–1934) to describe
the group of artists who
came immediately after
the Impressionists. These
artists were centered in
Paris and chose to reject
the Impressionists'
concentration on the
external, fleeting
appearances of their
world. Fry was curator
of the Metropolitan
Museum of Art in New
York between 1906 and
1910 and introduced the
Post-Impressionists to
Great Britain by exhibitions
that he arranged at the
Grafton Galleries in 1910
and 1912. Artists he
displayed included
Gauguin, Cézanne,
and van Gogh.

small still life by Cézanne on the wall just
behind: everything corresponds to the absolute
verticals of the edges of the canvas itself, further
accentuating the air of certainty about the
portrait. Thick hands hold a newspaper – though
Cézanne has replaced his father's conservative
newspaper with the liberal *L'Evénement,* which
published articles by his childhood friend Emile
Zola (see p.286). His father devours the paper,
sitting tensely upright in the elongated armchair.
Yet it is a curiously tender portrait too. Cézanne
seems to see his father as somehow unfulfilled:
for all his size he does not fully occupy the chair,
and neither does he see the still life on the wall
behind him, which we recognize as being one
of his son's. We do not see his eyes – only the
ironical mouth and his great frame, partly
hidden behind the paper.

MYSTERY OF NATURE

Cézanne was in his twenties when he painted
The Artist's Father. Wonderful though it is, with
its blacks and grays and umbers, it does not fully
indicate the profundity of his developing genius.
Yet even in this early work, Cézanne's grasp
of form and solid pictorial structures, which
came to dominate his mature style, are already
essential components. His overriding concern

with form and structure set him apart from
the Impressionists from the start, and he was
to maintain this solitary position, carving out
his unique pictorial language.

Abduction, rape, and murder: these are
themes that tormented Cézanne. *Abduction
(351),* an early work full of dark miseries, is
impressive largely for its turgid force, held barely
under his control. These figure paintings are the
most difficult to enter into, they are sinister,
with passion in turmoil just beneath the surface.

Cézanne's late studies of the human body are
most rewarding, his figures often depicted as
bathers merging with the landscape in a sunlit
lightness. This became a favorite theme for
Cézanne, and he made a whole series of pictures
on the subject. This mature work is dictated by
an objectivity that is profoundly moving for all
its seeming emotional detachment.

It was before nature that Cézanne was seized
with a sense of the mystery of the world to a
depth never expressed by another artist. He saw
that nothing exists in isolation – an obvious
insight, yet one that only he could make us see.
Things have color and they have weight, and the
color and mass of each affects the weight of the
other. It was to understand these rules that
Cézanne dedicated his life.

**OTHER WORKS BY
CEZANNE**

Basket of Apples
(Art Institute of
Chicago)

Mont Sainte Victoire
(Courtauld Institute,
London)

Still Life of Fruit
(Barnes Foundation,
Marion, Penn.)

The Card Players
(Metropolitan Museum
of Art, New York)

Poplars
(Musée d'Orsay, Paris)

Self-Portrait
(Bridgestone Museum
of Art, Tokyo)

L'Estaque
(Bührle Foundation,
Zurich)

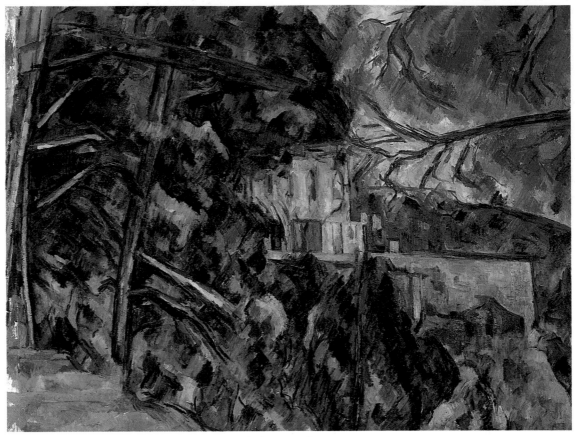

352 Paul Cézanne, Le Château Noir, *1900/04, 38 x 29 in (97 x 74 cm)*

STRUCTURE AND SOLIDITY

From 1872, under Pissarro's influence, Cézanne
painted the rich Impressionist effects of light
on different surfaces and even exhibited at the
first Impressionist show. But he maintained his
concern for solidity and structure throughout,
and abandoned Impressionism in 1877. In *Le
Château Noir (352)*, Cézanne does not respond
to the flickering light as an Impressionist might;
he draws that flicker from deep within the
substance of every structure in the painting.
Each form has a true solidity, an absolute of
internal power that is never diminished for
the sake of another part of the composition.

It is the tension between actuality and illusion,
description and abstraction, reality and invention,
that makes Cézanne's most unassuming subjects
so profoundly satisfying and exciting, and which
provided a legacy for a revolution of form that
led the way for modern art.

The special attraction of still life to Cézanne
was the ability, to some extent, to control the
structure. He brooded over his apples, pitchers,
tables, and curtains, arranging them with infinite
variety. *Still Life with Apples and Peaches (353)*
glows with a romantic energy, as hugely present
as Mont Sainte-Victoire (see column). Here too
is a mountain, and here too sanctity and victory:
the fruits lie on the table with an active power
that is not just seen but experienced. The pitcher
bulges, not with any contents, but with its own
weight of being. The curtain swags gloriously,
while the great waterfall of the napkin absorbs
and radiates light onto the table on which all
this life is supported.

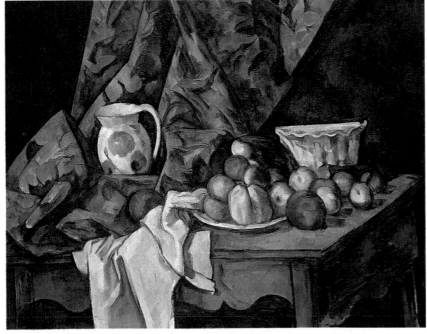

353 Paul Cézanne, Still Life with Apples and Peaches, *c. 1905, 40 x 32 in (100 x 81 cm)*

LE CHATEAU NOIR

The château in this painting gets its name from rumors about its owner, rather than from its appearance. It was built in the 18th century by an industrialist from Marseilles, who manufactured lampblack paint (derived from soot)and also used it to decorate the interior walls and furniture of the château. As a result, he was associated with black magic among the local people, who believed that the château was also home to the devil.

PATCH OF SKY
The deep blue of this patch of sky, visible through the trees, is painted with no concessions to illusory depth. The strong blue of the sky "jumps" forward, over the quieter colors of the surrounding foliage, insisting that we read the picture not only as a wooded landscape with a château, but equally as a flat plane upon which colors of differing chromatic and tonal values have been arranged.

BROKEN LINE
Again, Cézanne emphasises the physical, plastic reality of the painting. The jagged lines describing the overhanging branches are fragmented, beginning and ending in midair. They are valued as much for their formal role in maintaining the strong vertical, horizontal, and diagonal balance of the composition as for their descriptive function: Cubism's debt to Cézanne is paramount (see p.346). The impossibly rich, deep blues and greens of the sky, applied right up to and overlapping the branches, fight for dominance, creating a continuous tension between decorative flatness and spatial depth.

BRUSHWORK
This detail shows us Cézanne's characteristic diagonal brushwork and the way in which he counterbalances the disjunctures created by his abstract treatment of space (see above) with a unifying application of paint. Cézanne thus realizes his belief that a painting should be both structurally convincing and formally independent. The slanting, generally equal-sized brushmarks range across the surface of the canvas and, as such, must do the job of describing form through relative values of color alone, in a process that Cézanne called modulation.

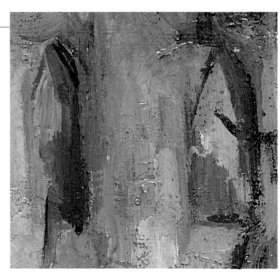

THE CHATEAU
The slender, Gothic-arched windows of the château reveal nothing but the intense blue of the sky. The complementary relationship of the yellow building and the blue windows emphatically affirms the color harmony of the work, and its ambiguity between "solid" sky and "ephemeral" stone. The building seems impressively permanent, yet also a shallow facade through which the blue hills and sky are visible. It is an intensely blue painting, made even bluer by the intervals of yellow ochre, and united by the more neutral greens.

SEURAT AND DIVISIONISM

It is possible, though perhaps improbable, that Georges-Pierre Seurat (1859–91), had he lived longer, might have been in the league of Cézanne. Like the great Masaccio at the beginning of the Renaissance (see p.82), like Giorgione (p.129) and Watteau (p.224), he died tragically young – yet after just a few years of painting he left us some marvelous work. He believed that art should be based on a system and developed Impressionism toward a rigorous formula. He invented a method he called optical painting – also known as Divisionism, Neo-Impressionism, or Pointillism – in which dots of color laid beside one another blend together in the viewer's eye. He believed that these dots of intense color, placed schematically in precise patterns, could imitate the resonant effects of light falling onto various colors more accurately than the more random, intuitive practice of the Impressionists. Seurat's systematic approach was based on his study of the new theory of color science. As a theory it sounds daunting, and in the hands of imitators it does daunt, being a theory that is more poetic than literal in its truth. A silent and secretive young man, Seurat perhaps needed this theory psychologically, and he made wonderful use of it in his paintings.

Seurat differed from the Impressionists in more than just his scientific approach. He was influenced by Ingres (see p.256) and the great Renaissance artists, and his work has a gravity that relates more to the classical tradition than to the casual intimacy and transience of Impressionism. And though, like the Impressionists, Seurat worked on small studies in the open air so that he could faithfully record the effects of light on the landscape, his large compositions were produced entirely in the studio according to his own strict laws of painting. To the themes already well mapped out by the Impressionists, such as city life, seascapes, and

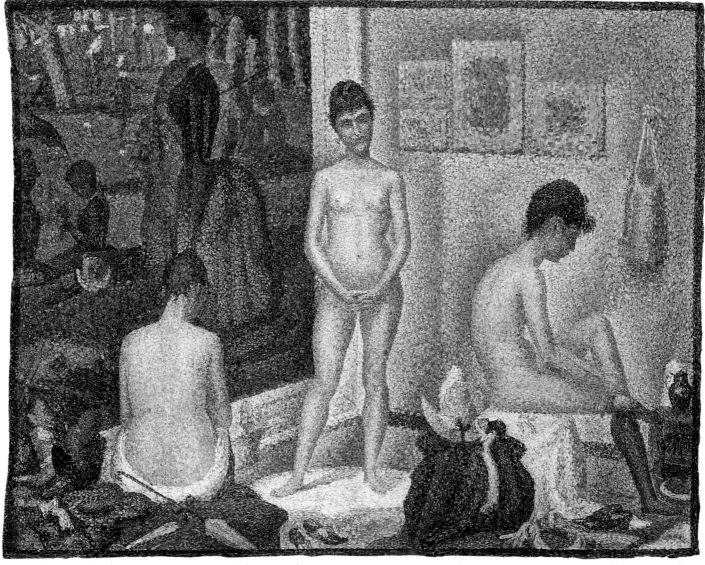

354 Georges Seurat, Les Poseuses, *1888, 19½ x 15½ in (49 x 39 cm)*

355 *Georges Seurat,* **The Lighthouse at Honfleur,** *1886, 32 x 26½ in (82 x 68 cm)*

POINTILLISM

This triple magnification of the canvas taken from Seurat's *La Grande Jatte* shows minute dots of color. This use of small, even touches of pure color, which react together optically when seen from a distance, is called Pointillism. If certain colors are placed side by side in close proximity, they enhance one another and give the painting an iridescence and depth. The term Pointillism was first used by the critic Félix Fénéon to describe Seurat's *La Grande Jatte* in 1886.

entertainment, Seurat added a sense of mystery and even monumentality, as well as a controlled geometry. In *Les Poseuses (354),* there is a sense of exquisite rightness, of flesh in all its individuality still beautifully conforming to a pattern. These images of a classical female nude are nymphlike in their delicacy, but with an austerity that is unique to Seurat.

Art replacing nature

Les Poseuses was painted in Seurat's studio in artificial light, and the large landscape serving as a backdrop to it is *Sunday Afternoon on the Island of the Grande Jatte,* a summer scene he painted between 1884 and 1886 of strollers at a favorite Parisian retreat.

La Grande Jatte is important, both within Seurat's limited oeuvre and historically. This was the painting that he hung at the last Impressionist show in 1886, despite the reluctance of the other, older exhibitors. Seurat represented a new generation of painters who heralded the disintegration of the Impressionist ideal, and whether the older painters liked it or not, a new order was rapidly being established. Pissarro alone fought for Seurat's right to exhibit with them and saw his color theory as the progressive step

Impressionism needed. Pissarro briefly adopted Divisionism himself, but found it too inhibiting and soon abandoned it.

Seurat's landscapes also heroically subdue nature to the "dot" of his color theory, and they have an interior quiet that prevails magnificently over natural confusion. Seurat organized what he saw, but he did so with the tact of genius. We realize that no landscape ever really looked so clean, so uncluttered, and so integrated, but he makes us suspend our disbelief.

Everything in the landscape painting *The Lighthouse at Honfleur (355)* is arranged with such formal perfection that removing any one element would destroy the balance. Pale, magical, severe, it absolutely needs the wooden structure in the foreground. This geometric form of sharp angles allows Seurat to move spaciously back into the far glimmer of the sea, rhyming all the other horizontals and verticals delicately with it: one upright like the lighthouse tower, redeployed by the boathouse; one flat like the boat, echoed by the top bar of the sawing frame. The sun bleaches the whole scene, so that color, too, rhymes and is compatible. This is how life ought to be, he tells us, and nature is replaced by art.

OTHER WORKS BY SEURAT

Beach at Gravelines (Courtauld Institute, London)

The Circus (Musée d'Orsay, Paris)

Woman with an Umbrella (Buhrle Foundation, Zürich)

View of the Seine (Metropolitan Museum of Art, New York)

La Grande Jatte (Art Institute of Chicago)

The Beach at Honfleur (Walters Art Gallery, Baltimore)

VAN GOGH

Seurat was one kind of genius, contained and silent. The other kind we find in a Dutch-born painter, Vincent van Gogh (1853–90), whose turbulent, seeking life everyone knows. The sad tale of van Gogh cutting off his ear is now part of common genius mythology. The unhappiness documented in a flood of letters to his brother, Theo, is transformed in his art into a passionate search for stability, truth, life itself. He has the rare power, something like that of Rembrandt (see p.200), to take the ugly, even the terrible, and make it beautiful by sheer passion.

Van Gogh's formative years as a painter reveal his confusion and restlessness. He worked in various jobs in search of a meaningful existence. At 20 he left Holland for England, then lived for a short time in Belgium as a missionary, and in 1886, aged 33, he left for Paris. Through Theo's work as an art dealer (see column, p.317), he met other artists – Degas (p.291), Pissarro (p.300), Seurat (p.314), Lautrec (p.320) – and learned about Impressionist techniques. He arrived at his artistic vocation by a slow and tortuous route, but it wasn't until he had fully absorbed the influences of Impressionism and *Japonisme* (see column, p.290) and made his own experiments with color (see column, p.317) that he discovered his true genius.

VAN GOGH AT ARLES

In 1888, leaving Theo in Paris, he went to Arles, in Provence, where, in the last two years of his life, he produced his most remarkable works. *The Artist's Bedroom (356)* has the utmost power and poignancy (this is a copy he painted to comfort himself while in the asylum at St. Rémy; see column, p.318). Two pillows and chairs hint at his eager anticipation of Gauguin's arrival (see p.322). It was his dream that Arles would become a center for painters, but Gauguin's reluctant visit ended in disaster.

356 Vincent van Gogh, The Artist's Bedroom, *1889, 35 x 28 in (90 x 71 cm)*

357 *Vincent van Gogh,* Farmhouse in Provence, *1888, 24 x 18 in (61 x 46 cm)*

Farmhouse in Provence and *La Mousmé* were painted in the year van Gogh moved to Arles. If Seurat subdued nature to reflect his intellect, van Gogh heightened it to echo his emotions. *Farmhouse in Provence (357)* has a terrible, life-threatening fertility about it. Wheat surges about the farm on all sides; the flaming ears of grain almost overwhelm the small figure who wades through them. The wall suddenly comes to an end, devoured by the encroaching army of ripening wheat, red flowers, and vegetation.

The farm has a beleaguered air, taking some trees into its protection; elsewhere, out in the field, trees are stunted and sparse. Farm buildings huddle together while the sky maintains an utter neutrality. Nature always comes to van Gogh in this threatening manner, yet he never gives in: he wrestles with it, capturing its wildness on his canvas. The sheer attention he has given to every blade of wheat gives him a moral ascendancy over such power.

La Mousmé (358) is of "a Japanese girl – provincial in this case – 12 to 14 years old," as van Gogh explained to Theo. He labored on this work, lured by the simplicity and tautness he so admired in Japanese art, and he presents this dull-faced adolescent solely in terms of decorative masses. Her dress is built up of curving stripes above and solid red dots on blue below.

The chair sweeps round her in schematic arches; hands and face are an opaque pinky brown, seemingly boneless hands dangle from her sleeves, and her face is doll-like. Her body curves flatly against a background of mottled green. So much

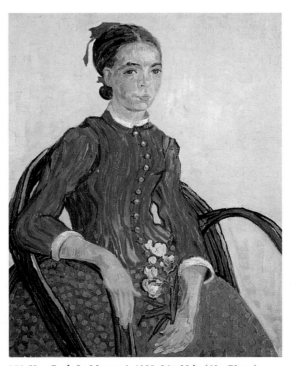

358 *Van Gogh,* La Mousmé, *1888, 24 x 29 in (60 x 73 cm)*

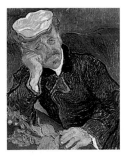

THE DECLINE

The clear signs of van Gogh's mental instability appeared while he and Gauguin were sharing the Yellow House in Arles in 1888. One evening he threatened Gauguin, lost control and cut off his own right earlobe. He presented it to a local prostitute. He was then taken to the hospital suffering from loss of blood and hallucinations. By May 1889, van Gogh had left Arles and had voluntarily committed himself to the asylum in St. Rémy. During two years in the asylum, van Gogh produced over 200 paintings. In 1890 Pissarro persuaded him to move to Auvers, where he was placed in the hands of Dr. Gachet (shown above). However, within a couple of months van Gogh fell ill, and in July 1890 he committed suicide.

OTHER WORKS BY VAN GOGH

The Farmhouse
(Rijksmuseum,
Amsterdam)

Sunflowers
(National Gallery,
London)

*Portrait of
Dr. Paul Gachet*
(Musée d'Orsay, Paris)

*Windmills at
Montmartre*
(Bridgestone Museum
of Art, Tokyo)

Two Peasants
(Buhrle Foundation,
Zurich)

Bed of Irises
(National Gallery of
Canada, Ottawa)

Hospital at St. Rémy
(Hammer Collection,
Los Angeles)

about *La Mousmé* is pathetic. She looks out at us so warily that we too feel slightly uncomfortable. Her eyes are alive, brown, and hurt, as if she knows that life will not treat her well. Van Gogh directs on the child such a force of passionate attention, such a totality of respect, such confidence in the power of vision to raise him up from the hell of existence, that the picture is an awesome success. Qualities like beauty or grace become irrelevant. To make us see through his eyes is the triumph of the painter, and van Gogh triumphs often.

VAN GOGH'S SELF-PORTRAITS

Few artists have been as interested in the self-portrait as van Gogh. *Self-Portrait (359)* is overpowering in its purity and realism: this is the real face of the artist, with a rough, red beard, unhappy mouth, and hooded eyes. His is an identity barely held in existence under the pressure of the whirling blue chaos. His face may be solid enough, but his clothes lose their identity as the lines swirl and jostle and deconstruct, showing us just how he felt as a mentally tormented and suffering individual.

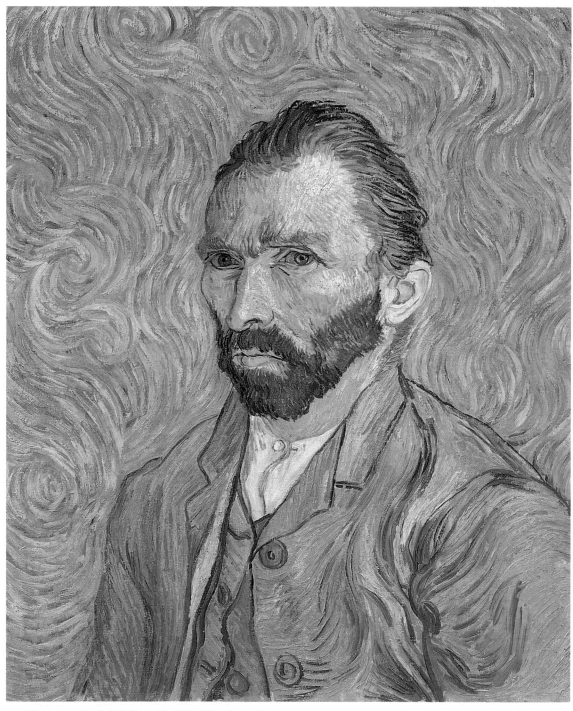

*359 Vincent van Gogh, **Self-Portrait**, 1889, 21½ x 26 in (54 x 65 cm)*

SELF-PORTRAIT

In May 1889, after his violent breakdown in Arles, van Gogh entered the asylum at St. Rémy. With his brother Theo's financial assistance, van Gogh was able to have his own bedroom, and also a studio where – whenever his condition and the asylum authorities allowed – he could continue to paint. It was at the asylum, just six weeks after another severe breakdown, that van Gogh painted this very beautiful self-portrait in September 1889. It is one of two self-portraits van Gogh painted that month, both of which are notable for their calm and dignified portrayal and their sense of fortitude, despite the misery of his situation. The skillful use of contrasting colors, the sensitive draftsmanship, and the sense of mature control all point to a superior mind, however disturbed the artist's feelings.

THE EYE
Perhaps the strongest note of color in the painting is the surprisingly vivid patch of green under the eye. It acts as a focal point, drawing our attention to van Gogh's steady and penetrating gaze. The structure of the eye is emphatically "level"; a straight, dark, horizontal line defines his heavy brow, and every detail of the eye is clearly delineated. But while the set features show resoluteness, at the same time the acid greens in the face, clashing against the reds of the hair and beard, suggest passion held under restraint.

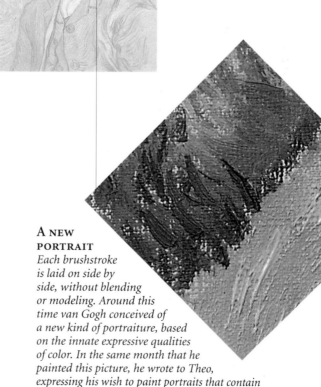

SWIRLING BACKGROUND
Within the overall cool harmonies of silver-gray, silver-green, and blues, van Gogh's head glows like a flame. Here is a painting of great contrasts. Everything outside the vivid head is subdued. The disturbed background hints at the precariousness of his own stability, symbolized by his neat vest and his shirt buttoned to the neck, and by his pose, suggestive of stillness and calm. The background can be distinguished from the figure only by the texture of the swirling brushstrokes, which are otherwise virtually identical in color to the body.

A NEW PORTRAIT
Each brushstroke is laid on side by side, without blending or modeling. Around this time van Gogh conceived of a new kind of portraiture, based on the innate expressive qualities of color. In the same month that he painted this picture, he wrote to Theo, expressing his wish to paint portraits that contain the vibrancy of life that he found in Delacroix's paintings "by a wedding of two complementary colors, their mingling and their opposition, the mysterious vibrations of kindred tones."

TOULOUSE-LAUTREC

Toulouse-Lautrec came from an aristocratic family but was physically deformed as a result of inbreeding and a childhood accident. This self-parodying photograph shows Lautrec dressed as a samurai warrior.

TOULOUSE-LAUTREC'S PARIS

If van Gogh escaped from his overwhelming burdens by committing suicide, Henri de Toulouse-Lautrec (1864–1901) escaped into the sordid nightlife of Paris. Only there, submerged within a raucous and raunchy crowd, could he forget that he was a scion of one of the noblest families in France – with an unfortunate disability. A model once said he had "a genius for distortion," but his genius, though acid, was not embittered or dark. His deformity set him free, paradoxically, from the need to accept any normal responsibilities, and though he killed himself with his excesses, he also created a witty, wiry art that still attracts. His paintings and prints reveal the strong attraction to Japanese art that he shared with van Gogh, he employed typically oblique Japanese perspectives with an off-center focus, and his art is characterized by a self-assured

361 Henri de Toulouse-Lautrec, Rue des Moulins, 1894, 24 x 33 in (61 x 83 cm)

simplicity of line, dramatic color, and flat shape. Lautrec's art was well suited to poster design and, aided by newly perfected techniques for printing posters, he revolutionized the discipline, breathing a new vibrancy and immediacy into it. In all his work there is a fluidity and passion that captures the vitality of city life.

Quadrille at the Moulin Rouge (360) has a rough energy that contrasts with the controlled vigor of the artist's line. There is life here, but no joy. However, there is also no self-pity, and though the life he shows us is horrible, it is at least lived with determination. Gabrielle, a dancer at the Moulin Rouge nightclub and one of Lautrec's favorite models, faces us with an almost comic expression of tipsy intentness as she stands aggressively in the center of the hall.

Lautrec does not often go deep, but when he does, he can appall. The two prostitutes in *Rue des Moulins (361)* are not seeking business (this he paints with a very wry laugh). They are lining up for the obligatory medical examination for licensed prostitutes, and their raddled faces are painfully pathetic. The first is aged of body, with loose, wrinkled thighs and fallen bosom. The other appears slightly younger, and although her body is less ravaged, her face is cruelly worn. Even the background of this picture is a lurid red. Vice is killing them both, despite the state medical intrusions. Lautrec does not glorify his whores; his world is one of harsh reality.

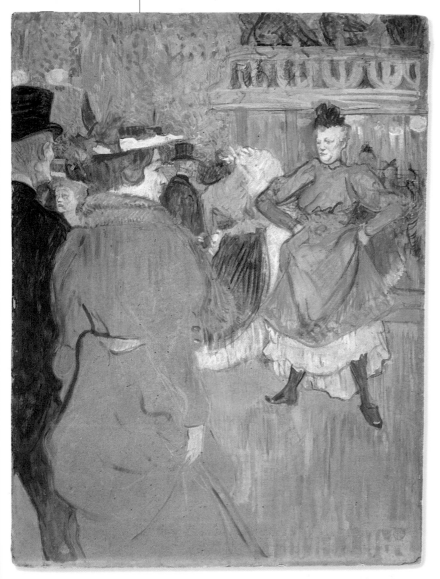

360 Henri de Toulouse-Lautrec, Quadrille at the Moulin Rouge, 1892, 24 x 31 in (60 x 80 cm)

THE INFLUENCE OF SYMBOLISM

Symbolism began as a literary movement that championed the imagination as the most important source of creativity. It soon filtered into the visual arts as another reaction to the limited, representational world of Realism and Impressionism. Inspired by the Symbolist poetry of the French poets Stéphane Mallarmé, Paul Verlaine, and Arthur Rimbaud, the Symbolist painters used emotive colors and stylized images to float their visions and moods into the viewer's consciousness, sometimes painting exotic, dream-like scenes.

Though it was toward the end of his career that Symbolism became artistically significant, it is still fair to regard Gustave Moreau (1826–98) as a precursor of Symbolist ideals and a patriarchal figure. In age he was much closer to Realism (his dates are almost contemporary with those of Manet, see p.285, or Courbet, p.282), but he ignored both Realism and Impressionism to pursue his own, distinctively individual style.

There could sometimes be a lurid and rather sickly strain in Symbolist work: the story of Salome, for example, with all its Freudian implications of woman destroying man, crops up continually. Moreau's *Salome (362)* is one of the more playful versions of this deadly myth, and we can enjoy its intense light and color without thinking too much of its sinister

STEPHANE MALLARME

Stéphane Mallarmé (1842–98) was a leading Symbolist poet and friend of many of the Symbolist artists. The basic principles of the artistic movement were to express ideas through color and line and to concentrate on mystical or fantastical images. This illustration shows an etching of Mallarmé, completed by Gauguin, with a raven in the background. The raven is believed to be a direct reference to Edgar Allen Poe's influential Symbolist poem *The Raven*, which was published in 1875. In 1886 the French poet Jean Moréas published the *Symbolist's Manifesto*, which was inspired by Mallarmé's poetry.

363 *Odilon Redon,* **Anemones and Lilacs in a Blue Vase,** *after 1912, 23½ x 29 in (60 x 74 cm)*

implications. Many of Moreau's other pictures are populated with strange beasts and mystic figures, and this escape from the world of reality, coupled with his idiosyncratic temperament, made him a significant figure among the other Symbolists.

REDON'S FLOWER PAINTINGS

Odilon Redon (1840–1916) is another escapee into a land of dreams. He did not have a major gift, but the pleasure of his art is pure and deep. He used color in a completely personal and inhibited way, but it was his themes, so elusive and fantastical, that made him a quintessential Symbolist. Like Moreau, he had a haunting imagination, but his exquisite bunches of flowers are his greatest achievement. *Anemones and Lilacs in a Blue Vase (363)* is typical of the soft, delicate imagery he could produce using iridescent pastels. These are radiant flowers, picked and preserved and glowing eternally for the viewer.

362 *Gustave Moreau,* **Salome,** *1876, 40½ x 56 in (103 x 143 cm)*

PAUL SERUSIER

The painter and art theorist Paul Sérusier (1863–1927) had a great influence on the Symbolist and Nabis movements (see p.326). The painting shown above is of the *Bois d'Amour* at Pont-Aven, where Sérusier painted while being advised on color by his friend Gauguin. The painting is also known as *The Talisman* because the younger painting generation saw it as the symbol of new artistic freedom and possibilities. Sérusier published his treatise on art in 1921.

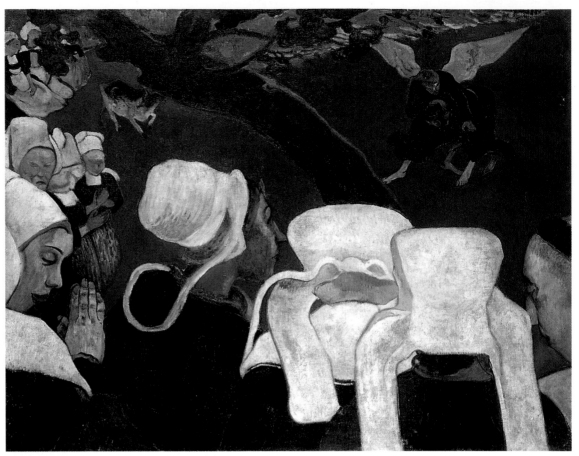

364 **Paul Gauguin,** The Vision After the Sermon, *1888, 36½ x 29 in (92 x 73 cm)*

CLOISONNISM

Emil Bernard's *Buckwheat Harvest* (shown above) is a good example of the technique known as Cloisonnism (*cloison* is French for partition). This style of painting is associated with the Pont-Aven school and is characterized by dark outlines enclosing areas of bright, flat color, similar to the effect achieved by stained glass. Gauguin and Bernard (1868–1941) worked together at Pont-Aven between 1888 and 1891, and Bernard is believed to have had a stimulating effect on Gauguin's work.

A UNIQUE VISION

Paul Gauguin (1848–1903) is best known for the art he painted after he fled to the South Seas to escape Europe and his family, but essentially he drew the inspiration for his work from within himself. Though he took to painting as a professional quite late, his early development as an amateur was influenced by the Impressionists, especially Pissarro (see p.300), whose systematic, broken brushwork Gauguin adopted. Gauguin was introduced to the Impressionists as a rich Parisian stockbroker and began to buy their art; he even exhibited his own work at some of their shows from 1879. Yet when he finally became a full-time artist in 1883, he was already feeling the constraints of the Parisian art scene.

Gauguin sought to be untrammeled by any conventions in his art. The Impressionists were influenced by nature; Gauguin was influenced by his own version of nature. He found freedom and quiet at Pont-Aven, Brittany, where he soon became the major figure in the Pont-Aven group of artists (see column, left). It was in this isolated region that he developed the distinctive symbolic and primitive elements of his art.

Inspired by medieval stained glass and folk art, he began to paint simplified shapes heavily outlined in black. The Breton peasants, with their simple faith and archaic lifestyles, also appealed to him and became a recurrent theme.

The Vision After the Sermon (364) was painted two years before he left for Tahiti, but it is as primitive as anything Tahitian. Gauguin blended reality with the inner experience of a vision and heightened it with symbolic color. He offered the painting to the local Breton church, but the priest was suspicious and thought he was being mocked. Only today does the spiritual power of the painting become vitally clear.

LAST YEARS IN FRANCE

Gauguin had long since abandoned his Dutch wife and children, and in 1888 he agreed to visit van Gogh in Arles. It seems fitting that the two were friends, though perhaps "friend" is not the right word: both were solitary men, desperately seeking healing companionship. It was the breakdown of their shaky relationship that drove van Gogh, the more fragile, to the hysterical mutilation of his own ear. Gauguin spent his remaining two years in France moving around restlessly, and left in April 1891 for Tahiti, where he spent much of the rest of his life.

VISION AFTER THE SERMON

Gauguin depicts a sermon that has just been preached
on the subject of Jacob wrestling with the angel, an Old
Testament story. Probably religion had an exotic fascination
for Gauguin, though he could only see its mysteries from
without. He imagines Jacob at dawn, struggling to overcome
his superhuman opponent and make him reveal his name.
Gauguin felt he was up against the superhuman, and he
too wrestled with his demon-angel to find his real identity.

PRAYING PRIEST
*There is no literal contest
here, as we can guess from
the downcast eyes of the
women and the priest: it
is in their imaginations
that life and death meet
in battle. Their tightly
grouped heads are
magnified so that we feel
like part of the crowd; we
have to peer over the tops
of their heads to see the
vision. Much of the
painting is conceived as
completely flat planes of
color; only the curving
forms of the women's
headdresses are painted
in a three-dimensional
style – the white folds have
a heavy, sculptural feel.*

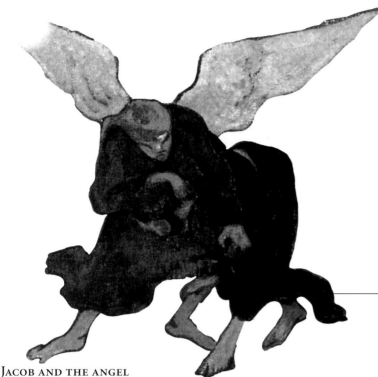

JACOB AND THE ANGEL
*Gauguin's compact image was inspired by a study of wrestlers by the
Japanese master Katsushika Hokusai, whose illustrations influenced
many of Gauguin's contemporaries (see also column, p.290). The struggle
takes place in an airless, shadowless space of saturated red in which the
combatants seem to float, out of proportion to the world around them.
Gauguin truly realized his desire to tackle a devotional work in a new way.*

THE TWO HALVES OF THE CANVAS
*Gauguin makes his composition all absolutes and opposites: brilliant
reds screaming against blazing whites; hordes of women and one
sole male (the priest, in the lower right-hand corner), violence and
meditation, enveloping garments and bare faces. A great tree trunk*
*slices the picture diagonally into two separate halves, with the real world
on the left, containing the simple Breton women and a straying cow
that paws the red earth, and the visionary world on the right, where
the angel and the man wrestle. The man won, however, as Gauguin
expected his viewers to remember.*

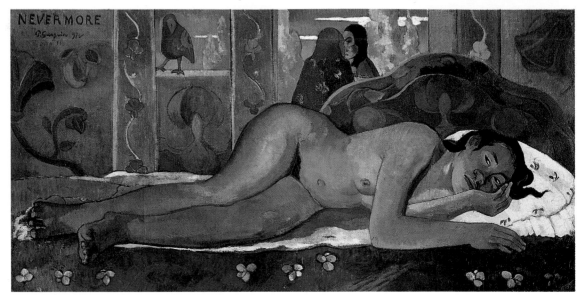

366 Paul Gauguin, Nevermore, *1897, 45 x 24 in (115 x 60 cm)*

GAUGUIN AND TAHITI

Gauguin arrived in Tahiti in 1891. Disappointed by the appearance of the main town of Papeete, he moved to a more remote part of the island. Initially his art concentrated on the influence of Western culture on native life, but in his later works he chose to emphasize the rapidly disappearing primitivism of the island. This wood carving was produced by Gauguin in 1892. The model for the sculpture is believed to be Teha'amana, Gauguin's 13-year-old mistress. Gauguin left the island in 1893, but after encountering several problems in Paris he returned to Tahiti in 1897. In 1901 he traveled to the remote Marquesa Islands, where he died in 1903.

Gauguin escaped to the South Seas in search of a primitive lifestyle where his art could flourish. Despite his disgust at the entrenched colonial society he found there (see column), he painted the Polynesian people as images of his heavenly state of total freedom. Gauguin impresses his own version of nature upon us, creating stylized, flattened shapes and using intense, exotic colors with what seems like reckless abandon, but which are carefully calculated for the greatest effect. In *Riders on the Beach (365)* he paints the sands pink not, we feel, because he actually

"saw" any pinkness there, but because only pink sands could express his feelings. Yellow would have been too intrusively real: it is not a logical scene but a magical one, and the peace and joy are symbolic, not literal. It is a painting of an idyllic state of life, gentle and radiant people effortlessly in control of their horses, freedom on every side, intoxicating seascape, wide, clouded skies, man and woman in perfect amity.

SINISTER UNDERCURRENTS

Although Gauguin transformed the Polynesian women into goddess figures – obeying no rules but those of his imagination – he also knew well the sad depravations of their real lives, and produced some dark and disturbing images in response to what he saw.

The young girl depicted in *Nevermore (366)*, painted after he had lived in the South Seas for several years, shows how he had come to terms with the haunted otherness of the interior life the women led. The girl is spread out before us, her golden body a sinister green as she ponders the mystery of her existence. A sightless raven, painted as a decorative detail, perches outside her window as a symbolic "bird of death" (inspired by the poem "The Raven" by Edgar Allan Poe, a favorite of the Symbolists).

Two women speak urgently together while the girl lies isolated and afraid on her splendid yellow pillow. The semi-abstract patternings we can see in paintings such as this are expressions of internal, psychological rhythms rather than outward events. Gauguin's skill lies in refusing to explain this complex mystery, even though he suggests there may be an answer. However long we contemplate *Nevermore*, it retains and in fact deepens its mystery before us.

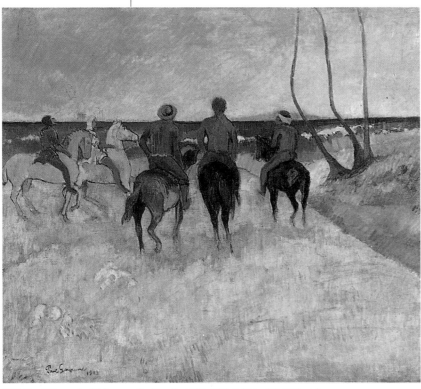

365 Paul Gauguin, Riders on the Beach, *1902, 36½ x 29 in (92 x 73 cm)*

MUNCH'S INTENSE EMOTIONALISM

Symbolist painting was not restricted to France alone. The Norwegian artist Edvard Munch (1863–1944) was a gloomy man, perpetually haunted by illness, madness and death, who used all his psychic weakness to create electrifying art.

Munch began painting in Oslo, where the predominant style was social realism, and it was only when he went to Paris in 1888 that he began to experiment. Van Gogh's swirling, emotive brushwork is detectable in Munch's more disturbing paintings, but he was also attracted to the work of Gauguin and the Symbolist painters, and he became close friends with the Symbolist poet Stéphane Mallarmé (see column, p.321).

He began to use the Symbolists' stylized forms, decorative patterning, and highly charged colors to express his own anxieties and pessimism. A precursor of Northern Expressionism (see p.340), he was one of those great artists whose main intention was to make an emotional statement, and who subdued all the elements of a picture to that end.

Munch can paint what seems an innocuous image. There are many versions of *Four Girls on a Bridge (367)*, a theme which clearly stirred something deep within him, and each work has a sinister undertone. The girls are all young and slender, passively leaning toward or away from the water. We feel uneasily that the water must represent something: time? Their coming sexual power? They are on the "bridge," the dark, heavy shapes of the future at the far side of the bridge looming ahead. Yet to spell out the full meaning is to diminish it. Munch is a Symbolist whose ideas work at a subliminal level.

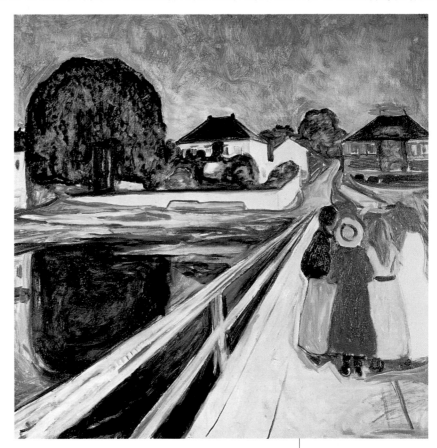

367 Edvard Munch, **Four Girls on a Bridge,** *1899–1900, 49½ x 53½ in (126 x 136 cm)*

The greater his unhappiness, the more overtly autobiographical his art became. In the 1890's he produced a series of paintings called the *Frieze of Life* which he described as "a poem of life, love, and death." In 1908 he suffered from a severe mental illness, and though he never left Norway again, his undisputed originality made a great impact on the next generation of artists.

GUSTAV KLIMT

Just as Munch can be associated with both Symbolism and Expressionism, so the art of the Austrian painter Gustav Klimt (1862–1918) is a curious and elegant synthesis of Symbolism and Art Nouveau (see column, p.327). The Austrians responded enthusiastically to the decorative artifice of Art Nouveau, and Klimt is almost artifice incarnate. He painted large ornamental friezes of allegorical scenes, and produced fashionable portraits, uniting the stylized shapes and unnatural colors of Symbolism with his own essentially harmonious concept of beauty. *The Kiss (368)* is a fascinating icon of the loss of self that lovers experience. Only the faces and hands of this couple are visible; all the rest is a great swirl of gold, studded with colored rectangles as if to express visually the emotional and physical explosion of erotic love.

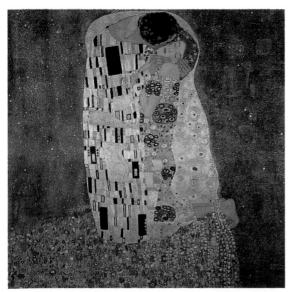

368 Gustav Klimt, **The Kiss,** *1907/08, 71 x 71 in (180 x 180 cm)*

CONTEMPORARY ARTS

1880
Rodin produces *The Thinker*

1886
The Statue of Liberty is dedicated to the American people

1889
The French begin the construction of the Eiffel Tower

1890
Oscar Wilde publishes *The Picture of Dorian Gray*

1895
Tchaikovsky's *Swan Lake* is performed in St. Petersburg

1900
Puccini's opera *Tosca* is performed in Rome

1901
The first Nobel prizes are awarded

THE NABIS

Two French artists straddle the gap between Post-Impressionism and the moderns: Pierre Bonnard and Edouard Vuillard. Difficult to place artistically, they are thought of as Intimists, and leaders of a group known as the Nabis. Both painters lived well into the 20th century, yet, with their love of the gentle domesticities of life that was such a feature of the work of the Nabis, neither seems truly to belong to the world of modern art.

Inspired by Sérusier's painting *The Talisman* (see column, p.321), Pierre Bonnard (1867–1947) and Edouard Vuillard (1868–1940) formed a group known as the Nabis (Hebrew for seers or prophets) in 1892. The decorative was the keynote to their art: as their associate Maurice Denis (see column, p.329) wrote, "A picture, before being a warhorse, a nude, or some anecdote, is essentially a surface covered with colors arranged in a certain order." Disillusioned with Paris and Impressionism, the Nabis admired Gauguin and Japanese art and embraced many aspects of oriental mysticism, endeavoring to express the spiritual in their work.

THE JAPANESE NABI

Bonnard fell the deepest under the oriental influence, being known to his friends as "the Japanese Nabi." It was the graphic concision of Japanese woodcuts, with their lovely purity of line and color, that appealed so strongly to him. As Bonnard's art matured, the colors he used became much richer and deeper, so that the whole meaning is revealed in the color.

The Letter (369) has a Japanese-like simplicity, the young woman so intent upon her writing and the tilt of her head suggesting the depth of her concentration. But that bent head is wonderfully feminine, with its glowing clumps of chestnut brown, the elegance of the small comb, the neat little nose, snub and flirtatious, and the expressive curves of her mouth. Bonnard is concerned with this woman less as a personality than as an enchantment – a very Japanese trait. He has walled her in deliciously for his own delight, with a gorgeous rim of crimson seatback, an interestingly variegated wall, and on the open, free side, a box and an envelope of entrancing hues. The green box is the palest color in the painting, directing our eyes upward toward the deep, rich blues of her modest dress and her downturned head. Bonnard makes no great statement about life or about this particular living creature. He looks at her instead with the most delicate and uncomplicated pleasure.

Bonnard, like Japanese artists, was interested in painting everyday life, in freezing the intimacies of a personal scene. Many of his paintings show images of the same model. This was Marthe, a sadly neurotic woman whom he eventually married, and who separated him from all his friends, yet who seems to have provided him with endless visual interest.

Fortunately, Marthe always loved to be painted, especially while in the bath, and many of his major paintings show her fully submerged in the water. There is an almost ecstatic brightness in the sensuous shades of her body and the water in *The Bath (370)*, and it has too often been thought that Bonnard's art is just a last dying effulgence of Impressionism. But he goes further, daringly and powerfully. Bonnard is not

*369 Pierre Bonnard, **The Letter**, c. 1906, 19 x 22 in (48 x 55 cm)*

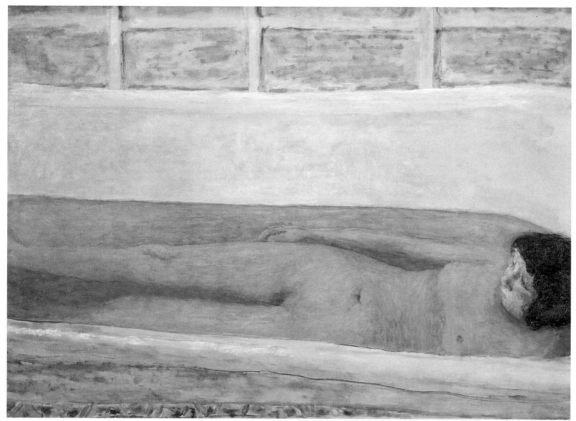

370 Pierre Bonnard, **The Bath,** *1925, 47 x 34 in (120 x 86 cm)*

ART NOUVEAU
In the 1890s a new
decorative art movement
known as Art Nouveau
developed, inspired by
naturalistic, organic forms.
The movement was
developed by sculptors,
jewelry makers, potters,
and, most importantly,
poster artists. The roots
of the movement were in
England, but French artists,
such as Bonnard and
Vuillard, were also
influenced by the swirling
shapes and bright colors
of the new style. This
illustration shows a brooch
designed in 1904 by Paco
Durrio, a Spaniard who
worked in France. It
perfectly encapsulates the
spirit of Art Nouveau – a
sensuous subject and
a fluid form.

interested in the atmospheric nuances of light,
as the Impressionists were, but rather in rhythm,
shape, texture, color, and the endless decorative
possibilities of the visual world.

CEZANNE'S INFLUENCE

The Nabis all shared an admiration for Cézanne
(p.310), certainly the dominant influence on all
early 20th-century artists. Maurice Denis's work
Homage to Cézanne (see column, p.329) shows
Bonnard and Vuillard clearly visible among
several artists as they gather around one of
Cézanne's paintings. When Bonnard paints a
landscape he shows us not only what we can
see but what the landscape feels like: he makes
a leap into otherness, into sensation.

Stairs in the Artist's Garden (371) was painted
near the end of his life, and it is an extraordinary
picture, like all his great variations on the theme
of the garden. The stairs lead up the center and
then vanish as the grandeur of the blossoms
overwhelms us. Exuberant colors mass to the
left; huge fountains of springtime green erupt
to the right. Ahead is a sunburst of bright
bushes, piercingly golden and incandescently
red, and there are more flowers overhead, allowing
the intense blues of the skies to act as a backdrop.
It is theatrical, a stage set, and the stage is set
not for a play but for life. Bonnard wants to stir us
into accepting the wonder of being alive. We are
liberated from our factual limitations into this
radiant freedom. Taking Cézanne's chromatic
majesty a step further, he etherealizes the
weightiness that Cézanne felt essential,
and is a great enough artist to succeed at this.

371 Pierre Bonnard, **Stairs in the Artist's Garden,** *1942/44, 29 x 25 in (73 x 63 cm)*

Vuillard's early paintings, as a member of the Nabis group, were highly influenced by the Japanese sketches that he had seen at the Ecole des Beaux Arts in 1890. The role of drawing, and particularly of silhouette, in achieving simplification of form was crucial to much of Vuillard's work. The sketch illustrated above was produced by Vuillard in 1890 using Indian ink and a Japanese brush. The artist was also closely involved with the theater and was employed by the theater mogul of Paris, Coquelin Cadet, to capture backstage scenes in the traditional Japanese style.

OTHER WORKS BY VUILLARD

In Bed
(Musée d'Orsay, Paris)

Girl in an Interior
(Tate Gallery, London)

Woman Before a Mirror
(Bridgestone Museum of Art, Tokyo)

Portrait of Madame Bonnard
(National Gallery of Victoria, Melbourne)

Woman Seated on a Sofa
(Art Institute of Chicago)

The Dining Room
(Neue Pinakothek, Munich)

The Lady in Green
(Glasgow Art Gallery)

VUILLARD'S INTIMATE ART

By comparison, Bonnard's friend Vuillard may seem modest. His art is certainly more delicate, and he is interested less in coloristic fireworks than in the gentle, muted subtleties of textures and patterned cloth. His mother, with whom he gladly lived for much of his life, was a dressmaker, and he spent much of his time among women as they worked away in small rooms, absorbed and talkative. The happy, unforced charm of his art never cloys, never becomes obvious, and always remains tender and alive. His works are for the most part very small, as humbly befits their theme.

372 Edouard Vuillard, **The Reader,** *1896, 5 ft 1 in × 7 ft (155 × 213 cm)*

373 Edouard Vuillard, **Vase of Flowers on a Mantelpiece,** *c.1900, 12 x 14½ in (30 x 36 cm)*

Vuillard's lifelong exposure to dress materials through his mother's work, as well as the textile designs of his uncle, was clearly a formative influence on his art. *The Reader (372)* is one of a series of panels that he painted for a friend's library, and for this reason it was atypically large. Here we see how the furnishings of a room, its wallpapers, carpets, and upholstery, can nearly submerge the human presence there. We almost tremble for the reader, so bravely intent upon her book amid the jungle of the interior, and perhaps the women watching her from the doorway tremble too. Yet Vuillard cannot but paint from love, and the threat of so many clamoring designs is diffused, held at bay by the warm charm of his color.

SMALL-SCALE INTERIORS

Vase of Flowers on a Mantelpiece (373) is exquisitely modest by comparison. We cannot see the whole mantelpiece, merely a section of it; nor can we see the entirety of the armchair beneath, merely part of the curve of its back, with the pattern of its upholstery. Vuillard stops short of painting the fire too, though the pink roses in a vase suggest that this is not the season for fires. But neither is it the season for emptiness: the mirror reflects a small, dimly lit, furnished room, and the genius of Vuillard is to keep us engrossed as we try to read what we half see. The one unmistakable area of clarity is the vase of flowers itself, one large rose surrounded by its clustering companions. It is a picture in which

nothing seems to happen, yet which is perpetually a fascinating scene. We are drawn, irresistibly, into the encompassing warmth of Vuillard's own love of the ordinary.

WALTER SICKERT

The English painter Walter Sickert (1860–1942) was not one of the Nabis, but was influenced by this group, particularly Bonnard and Vuillard, and he was important as a link between English and French art at the end of the 19th century. Although he was a pupil and studio assistant of Whistler (see p.302) in the 1880s and worked with Degas (p.291) in Paris in 1883, Sickert's paintings also show an intimism comparable to the Nabis' work, and a shared interest in unusual compositions.

Some of Sickert's paintings are Victorian England's equivalent of the Nabis' quiet images of bourgeois French culture. But Sickert also painted dark, and sometimes sinister, images of the underworld. *La Hollandaise (374)* demands no knowledge of art history to announce this woman's profession. Poor, unidealized creature that she is, she nevertheless has the whore's appeal. Sickert paints her with an economy that is almost cruel, obliterating the features of her face to expose her naked body and scraping the paint thinly across her flesh: Sickert is clearly as interested in what she is as with how she looks, and he conveys both brilliantly.

374 W. Sickert, **La Hollandaise,** *1906, 16 x 20 in (40 x 50 cm)*

HOMAGE TO CEZANNE

This painting was completed by Maurice Denis (1870–1943) in 1900 to commemorate Cézanne's first one-man exhibition, held in 1895. The painting shows a group of artists, including Redon (to the left of the composition), Vollard (behind the easel), and many of the Nabis gathered around a Cézanne still life that was once owned by Gauguin. Cézanne and the Nabis were linked by Vollard, who had begun to deal in the Nabis' paintings and was also having great success in selling much of Cézanne's work.

CAMDEN TOWN MURDER SERIES

In September 1907 Emily Dimmock, a well-known north London prostitute, was found dead with her throat cut in her lodgings in Camden Town. The body was found by her lover when he returned from his night shift. A commercial artist, Robert Wood, was accused of her murder but was acquitted after a long and exciting trial. Sickert, who is known to have followed the trial reports, adopted the name *Camden Town Murder* as a general designation for several series of etchings, paintings, and drawings. Each painting in the series features a naked woman and a clothed man who personify the tragedy of poverty and deprivation.

THE 20TH CENTURY

It has been calculated that there are more artists practicing today than were alive in the whole Renaissance, all three centuries of it. But we are no longer following one storyline: we are in a new situation, where there is no mainstream. The stream has flowed into the sea and all we can do now is trace some of the main currents.

Twentieth century art is almost indefinable, and ironically we can consider that to be its definition. This makes sense, because we live in a world that is in a constant state of flux. Not only is science changing the outward forms of life, but we are beginning to discover the strange centrality of our subconscious desires and fears. All this is completely new and unsettling, and art naturally reflects it.

The story of painting now loses its way temporarily. It enters upon an encounter with the unknown and the uncertain. Only the passage of time can reveal which artists in our contemporary world will last, and which will not.

Wassily Kandinsky, Improvisation 31 (Sea Battle), *1913 (detail)*

20TH-CENTURY TIMELINE

We have dates in the 20th century, and pictures to attach to them, but there is no longer a coherent time sequence. This can be irritating to the tidy-minded, but it is in fact exciting in its adventurous freedom. With so many dynamic artists, covering a broad spectrum of intention and experience, there is only space to touch briefly on those who seem, to many, to be part of the story, and not just footnotes.

PABLO PICASSO, LES DEMOISELLES D'AVIGNON, 1907

This picture is the one work that can be considered essential to the art of the 20th century. From its bizarre malformations and hideous energy have flowed a torrent of creative and innovative power. It startled Georges Braque, and it startles us still: it is a supreme and repulsive masterpiece (p.347).

WASSILY KANDINSKY, IMPROVISATION 31 (SEA BATTLE), 1913

It seems to be agreed that Kandinsky was the first totally abstract artist of the modern period. His art matured to an almost formal geometry, but initially, as here, it had a wild and wonderful connection with the real world, with shapes that are symbols of an imaginary sea battle (p.354).

PAUL KLEE, DEATH AND FIRE, 1940

Klee is a great colorist and an endlessly creative painter, both enchanting and profound. Only he can depict death and fire with a smile and a sacred tremor. This is characteristic of his unique approach, both to the matter and the manner of painting (p.358).

1900	1910	1920	1930	1940

HENRI MATISSE, THE CONVERSATION, 1909

Equal with Picasso (if not indeed greater), Matisse is the great master of our century. He is a skillful simplifier of form and a marvelous manipulator of color, though he never uses these talents for their own sake, but always to create a design that at every point has a meaning (p.337).

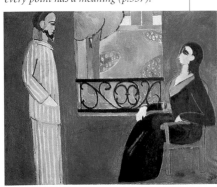

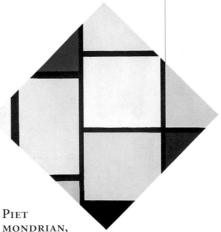

PIET MONDRIAN, DIAMOND PAINTING IN RED, YELLOW, AND BLUE, C. 1921/25

Mondrian is the great purist of art. He limited himself to a few basic colors, arranged in solemn squares. His art is profound, expressing in this bare form a noble conception of life (p.360).

SALVADOR DALI, THE PERSISTENCE OF MEMORY, 1931

Some artists are greatly gifted, but have little to express. This is not entirely true of Dali, but it can be said that what he wanted to express was his own self-importance. Sometimes his experience coincides with our own, which is why this picture of melting watches – time going into a flux – is so unforgettable (p.364).

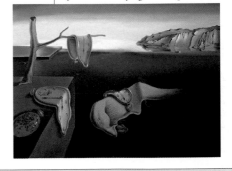

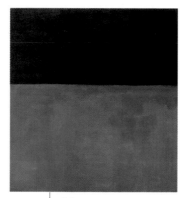

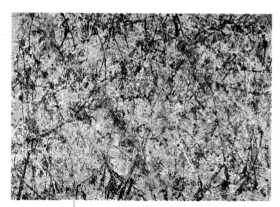

JACKSON POLLOCK, NUMBER 1, 1950 (LAVENDER MIST), 1950

Picasso and Matisse dominated the first half of our century. In the second half, the major figure is probably Jackson Pollock. Whether for good or ill, he "liberated" artists from the palette and the brush, from design and intention. He splattered his paint, swirling it out from its cans as he danced on the horizontal canvas. It was an innovation of genius and surprisingly personal to Pollock himself (p.369).

MARK ROTHKO, UNTITLED (BLACK AND GRAY), 1969

For some decades, Rothko has held his position as one of the great spiritual artists of our time. His mature work is always of the same format: there is a large canvas in which two rectangles of color hover before us. We sense deep emotion, but though the critics have spoken about "the veil of the temple" and other mystical metaphors, no explanation is completely convincing (p.370).

LUCIAN FREUD, STANDING BY THE RAGS, 1988–89

Although it is stretching a point to speak of a School of London, it is still true that a group of figurative artists is at work there. Lucian Freud is perhaps the most significant, a ruthless and clinical observer of humanity who dissects his subject on the canvas with memorable power. Such vulnerability would be unbearable to contemplate were there the slightest touch of criticism or even of distancing. It is himself Freud dissects, and us with him. Here he shows us a nude standing against a background of paint rags from his studio. He makes everything that could be made of both these subjects, and of the many contrasts between them (p.386).

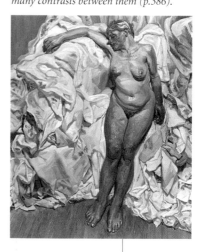

1950	1960	1970	1980	1990

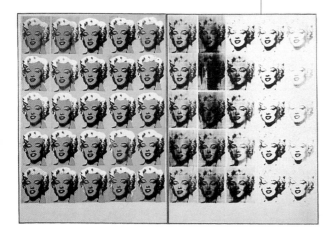

ANDY WARHOL, MARILYN DIPTYCH, 1962

There are still two vociferous attitudes toward Warhol. Is he a genius or a mountebank? Perhaps looking at the Marilyn Diptych we may feel that he is both: an artist who capitalized on his natural vulgarity and laziness, and used them to create icons for our times. One weakness – obsessive interest in the movie stars – is here set to work. He makes a subtle comment on the reality of this interest while conveying its fascination (p.380).

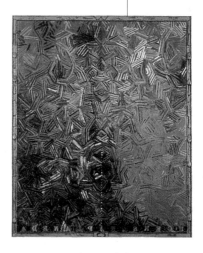

JASPER JOHNS, DANCERS ON A PLANE; MERCE CUNNINGHAM, 1980

Jasper Johns is a difficult artist, and none of his works is simple or easily comprehensible. There is always a concept controlling what he creates. Yet these creations are so supremely beautiful that they can be enjoyed even without full understanding. There is a reason behind every mark in Dancers on a Plane, and if we learn to love it we may want to investigate these secret complexities. But it is the love that matters (p.381).

AFRICAN INFLUENCES

Many of the Fauvists were inspired by African art and had their own collections of masks and statues. The fashion for tribal art had been started by Gauguin, and the African influence can be seen in several of the paintings Matisse completed around 1906. This Kwele mask, shown above, closely resembles a famous piece once owned by André Derain. The whitened face suggests that it may have been part of the ancestors cult in central Africa.

FAUVISM

*B*etween 1901 and 1906, several comprehensive exhibitions were held in Paris, making the work of Vincent van Gogh, Paul Gauguin, and Paul Cézanne widely accessible for the first time. For the painters who saw the achievements of these great artists, the effect was one of liberation, and they began to experiment with radical new styles. Fauvism was the first movement of this modern period, in which color ruled supreme.

375 *Maurice de Vlaminck,* **The River,** *c. 1910, 28¾ x 23½ in (73 x 60 cm)*

Fauvism was a short-lived movement, lasting only as long as its originator, Henri Matisse (1869–1954), fought to find the artistic freedom he needed. Matisse had to make color serve his art, much as Gauguin needed to paint the sand pink to express an emotion (see p.324). The Fauvists believed absolutely in color as an emotional force. With Matisse and his friends, Maurice de Vlaminck (1876–1958) and André

376 *André Derain,* **Charing Cross Bridge,** *1906,*
39 x 32 in (100 x 80 cm)

Derain (1880–1954), color lost its descriptive qualities and became luminous, creating light rather than imitating it. They astonished viewers at the 1905 Salon d'Automne: the art critic Louis Vauxcelles saw their bold paintings surrounding a conventional sculpture of a young boy, and remarked that it was like a Donatello *"parmi les fauves"* (among the wild beasts). The painterly freedom of the Fauves and their expressive use of color gave splendid proof of their intelligent study of van Gogh's art (see pp. 316-18). But their art seemed brasher than anything seen before.

VLAMINCK AND DERAIN

During its brief flourishing, Fauvism had some notable adherents, including Rouault (p.341), Dufy (p.339), and Braque (p.350). Vlaminck had a touch of wild-beastishness, at least in the dark vigor of his internal moods: even if *The River (375)* looks at peace, we feel a storm is coming. A self-professed "primitive," he ignored the wealth of art in the Louvre, preferring to collect the African masks that became so important to early 20th-century art (see column, p.334).

Derain also showed a primitive wildness in his Fauve period – *Charing Cross Bridge (376)* bestrides a strangely tropical London – though as he aged he quenched his fire to a classic calm. He shared a studio with Vlaminck for a while, and *The River* and *Charing Cross Bridge* seem to share a vibrant power. Both reveal an unself-conscious use of color and shape, a delight in the sheer patterning of things. This may not be profound art, but it does give visual pleasure.

CONTEMPORARY
ARTS
1902
Chekov writes
The Three Sisters
· *1907*
Stravinsky composes
his first symphony
1908
Constantin Brancusi
completes his
sculpture *The Kiss*
1916
Frank Lloyd Wright
designs the Imperial
Hotel in Tokyo
1922
James Joyce writes
Ulysses
· *1927*
The first "talkie,"
The Jazz Singer,
is produced
1928
Eugene O'Neill wins
the Nobel prize
for literature
1931
The Empire State
Building is completed
in New York City

MATISSE, MASTER OF COLOR

The art of our century has been dominated by two men: Henri Matisse and Pablo Picasso. They are artists of classical greatness, and their visionary forays into new art have changed our understanding of the world. Matisse was the elder of the two, but he was a slower and more methodical man by temperament, and it was Picasso who initially made the greater splash. Matisse, like Raphael (see p.124), was a born leader and taught and encouraged other painters, while Picasso, like Michelangelo (see p.120), inhibited them with his power: he was a natural czar. Each demands his own separate space, and we start with Matisse.

" *Instinct must be thwarted just as one prunes the branches of a tree so that it will grow better.* "
Henri Matisse

THE GREEN STRIPE
Matisse painted this unusual portrait of his wife in 1905. The green stripe down the center of Amélie Matisse's face acts as an artificial shadow line and divides the face into two distinct sides. Instead of dividing the face in the conventional portraiture style, with a light and a dark side, Matisse divides the face chromatically, with a cool and a warm side. The natural light is translated directly into colors, and the highly visible brushstrokes add to the sense of artistic drama.

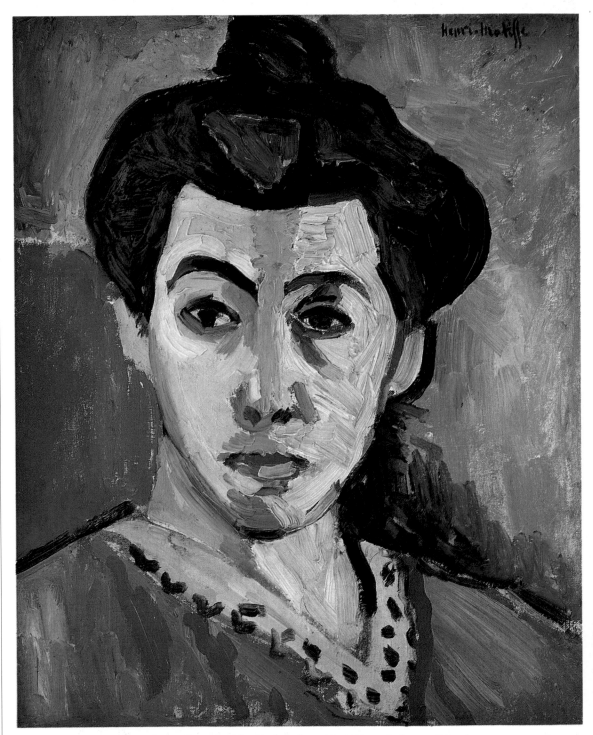

377 Henri Matisse, Madame Matisse, Portrait with a Green Stripe, 1905, 12¾ x 16 in (32.5 x 40.5 cm)

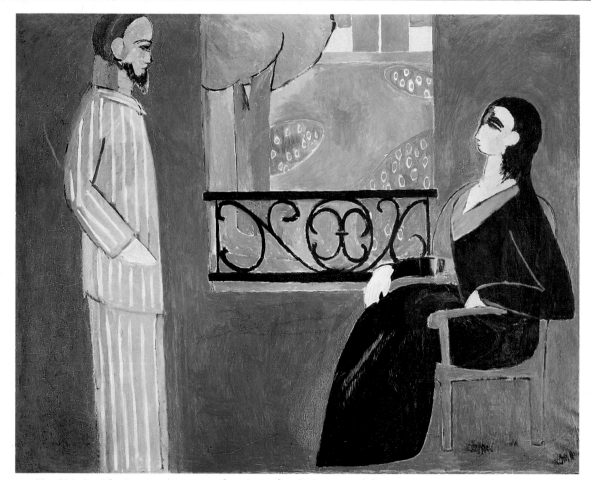

378 *Henri Matisse,* The Conversation, *1909, 7 ft 1½ in x 5 ft 9¾in (217 x 177 cm)*

AFRICAN TRAVELS

In January 1912 Matisse set off on the first of two trips to Morocco. His appetite for African primitive art had been whetted by a visit to Tangiers in 1906, and he was eager to go back to capture the wonderful light and vitality of Africa. When Matisse arrived in Morocco, it had been raining for two weeks and the rain was to continue for some time. These unusual climatic conditions left the landscape green and verdant, which in turn affected Matisse's paintings. This photograph shows a piece of traditional Moroccan textile owned by Matisse.

Matisse's art has an astonishing force and lives by innate right in a paradise world into which Matisse draws all his viewers. He gravitated to the beautiful and produced some of the most powerful beauty ever painted. He was a man of anxious temperament, just as Picasso (see p.346), who saw him as his only rival, was a man of peasant fears, carefully concealed. Both artists, in their own fashion, dealt with these disturbances through the sublimation of painting: Picasso destroyed his fear of women in his art, while Matisse coaxed his nervous tension into serenity. He spoke of his art as being like "a good armchair" – a ludicrously inept comparison for such a brilliant man – but his art was a respite, a reprieve, a comfort to him.

Matisse initially became famous as the "King of the Fauves" (see p.334), an inappropriate name for this gentlemanly intellectual: there was no wildness in him, though there was much passion. He is an awesomely controlled artist, and his spirit, his mind, always had the upper hand over the "beast" of Fauvism.

In his green stripe portrait of his wife *(377)*, he has used color alone to describe the image. Her oval face is bisected with a slash of green and her coiffure, purpled and top-knotted, juts against a frame of three jostling colors. Her right side repeats the vividness of the intrusive green; on her left, the mauve and orange echo the colors of her dress. This is Matisse's version of the dress, his creative essay in harmony.

THE EXPERIMENTAL YEARS

Matisse's Fauvist years were superseded by an experimental period, as he abandoned three-dimensional effects in favor of dramatically simplified areas of pure color, flat shape, and strong pattern. The intellectual splendor of this dazzlingly beautiful art appealed to the Russians, and many great Matisses are now in Russia. One is *The Conversation (378)*, in which husband and wife converse. But the conversation is voiceless. They are implacably opposed: the man – a self-portrait – is dominating and upright, while the woman leans back sulkily in her chair. She is imprisoned in it, shut in on all sides. The chair's arms hem her in, and yet the chair itself is almost indistinguishable from the background: she is stuck in the prison of her whole context. The open window offers escape; she is held back by an iron railing. He towers above, as dynamic as she is passive, every line of his striped pajamas undeviatingly upright, a wholly directed man.

HENRI MATISSE

Matisse's artistic career was long and varied, covering many different styles of painting from Impressionism to near Abstraction. Early on in his career Matisse was viewed as a Fauvist (see p.334), and his celebration of bright colors reached its peak in 1917, when he began to spend time on the French Riviera at Nice and Vence. Here he concentrated on reflecting the sensual color of his surroundings and completed some of his most exciting paintings. In 1941 Matisse was diagnosed as having duodenal cancer and was permanently confined to a wheelchair. It was in this condition that he completed the magnificent Chapel of the Rosary in Vence.

OTHER WORKS BY MATISSE

Woman with a Red Chair
(Baltimore Museum of Art)

The Pink Studio
(Pushkin Museum, Moscow)

Odalisque
(Bridgestone Museum of Art, Tokyo)

Two Models Resting
(Philadelphia Museum of Art)

Woman with a Violin
(The Orangerie, Paris)

The Snail
(Tate Gallery, London)

Oceania, the Sea
(Musées Royaux des Beaux Arts, Brussels)

379 Henri Matisse, Odalisque with Raised Arms, *1923, 19¾ x 25 in (50 x 65 cm)*

His neck thickens to keep his outline straight and firm, an arrow of concentrated energy. The picture cannot contain him and his head continues beyond it, into the outside world. He is greater than it all, and the sole "word" of this inimical conversation is written in the scroll of the rail: *Non*. Does he say no to her selfish passivity? Does she say no to his intensity of life? They deny each other forever.

SUPREME DECORATION

But denial is essentially antipathetic to Matisse. He was a great celebrator, and to many his most characteristic pictures are the wonderful odalisques he painted in Nice (he loved Nice for the sheer quality of its warm, southern light). Though such a theme was not appreciated at the time, it is impossible for us to look at *Odalisque with Raised Arms (379)* and feel that Matisse is

exploiting her. The woman herself is unaware of him, lost in private reverie as she surrenders to the sunlight. The splendid opulence of her chair, her diaphanous skirt, and the intricately decorated panels on either side all unite in a majestic whole that celebrates the glory of creation. It is not her abstract beauty that attracts Matisse, but her concrete reality. He reveals a world of supreme decoration: for example, the small black patches of underarm hair on the odalisque serve as witty quotation marks around the globes of her breasts and the rose pink center of each nipple.

SCULPTING IN PAPER

Picasso and Matisse were active to the end of their lives, but while Picasso was preoccupied with his aging sexuality, Matisse moved into a period of selfless invention. In this last phase, too weak to stand at an easel, he created his papercuts, carving in colored paper, scissoring

381 Raoul Dufy, Regatta at Cowes, *1934, 39 x 32¼ in (190 x 82 cm)*

out shapes, and collaging them into sometimes vast pictures. These works, daringly brilliant, are the nearest he ever came to abstraction. *Beasts of the Sea (380)* gives a wonderful underwater feeling of fish, sea cucumbers, sea horses, and water-weeds, the liquid liberty of the submarine world where most of us can never go. Its geometric rightness and chromatic radiance sum up the two great gifts of this artist, and it is easy to see why he is the greatest colorist of the 20th century. He understood how elements worked together, how colors and shapes could come to life most startlingly when set in context. Everything of Matisse's works together superbly.

DUFY'S JOYOUS ART

One painter who truly found his artistic self through Matisse and the Fauves was another Frenchman, Raoul Dufy (1877–1953). He is still hard to categorize, one of the important painters about whom the critics have not yet entirely made up their minds. His art seems too light of heart and airy, unconcerned with any conventions that would persuade the doubter of his seriousness. He is in fact utterly serious, but serious about joy, about the need to be free and disinterested, with no personal stake in life. His painting *Regatta at Cowes (381)* leaps with glorious unconcern across the canvas, so superbly organized that it almost seems artless. If some later artists have tried to imitate Dufy's apparent incoherence, none has had his profound purity that makes everything cohere. This kind of art either comes naturally, or fails.

380 Henri Matisse, Beasts of the Sea, *1950, 5 ft ½ in x 9 ft 8 in (154 x 295.5cm)*

BEASTS OF THE SEA

Matisse chose to challenge the traditional beliefs of the artistic establishment by turning to the use of bright, colorful collage. His first use of scissors and paper was in 1931, but it was purely as a design approach for his larger paintings. However, when he became ill, he turned to collage as an art in itself. In 1950, when he was over 80 years old, he cut one of his most beautiful collages in memory of the South Seas, which he had visited 20 years earlier. *Beasts of the Sea* includes symbols of aquatic life on the ocean bed, on the surface of the water, of the island itself, and of the sky above. By playing the bright colors against one another, Matisse achieved tonal resonances that would have a great influence on the color painters of the 1960s.

EXPRESSIONISM

In the north of Europe, the Fauves' celebration of color was pushed to new emotional and psychological depths. Expressionism, as it was generally known, developed almost simultaneously in different countries starting in about 1905. Characterized by heightened, symbolic colors and exaggerated imagery, it was German Expressionism in particular that tended to dwell on the darker, sinister aspects of the human psyche.

EXPRESSIONISM

The term "Expressionism" can be used to describe various art forms, but, in its broadest sense, it is used to describe any art that raises sub-jective feelings above objective observations. The paintings aim to reflect the artist's state of mind rather than the reality of the external world. The German Expressionist movement began in 1905 with artists such as Kirchner and Nolde, who favored the Fauvist style of bright colors but also added stronger linear effects and harsher outlines.

DIE BRÜCKE

In 1905 a group of German Expressionist artists came together in Dresden and took the name Die Brücke (The Bridge). The name was chosen by Karl Schmidt-Rottluff to indicate their faith in the art of the future, toward which their work would serve as a bridge. In practice they were not a cohesive group, and their art became an angst-ridden type of Expressionism. The achievement that had the most lasting value was their revival of graphic arts – in particular, the woodcut using bold and simplified forms.

382 Georges Rouault, Prostitute at Her Mirror, *1906, 23½ x 27½ in (60 x 70 cm)*

Although Expressionism developed a distinctly German character, the Frenchman Georges Rouault (1871–1958) links the decorative effects of Fauvism in France with the symbolic color of German Expressionism. Rouault trained with Matisse at Moreau's academy and exhibited with the Fauves (see p.335), but his palette of colors and profound subject matter place him as an early, if isolated, Expressionist. His work has been described as "Fauvism with dark glasses."

Rouault was a deeply religious man, and some consider him the greatest religious artist of the 20th century. He began his career apprenticed to a stained-glass worker, and his love of harsh, binding outlines containing a radiance of color gives poignancy to his paintings of whores and fools. He himself does not judge them, though the terrible compassion with which he shows his wretched figures makes a powerful impression: *Prostitute at Her Mirror (382)* is a savage indictment of human cruelty. She is a travesty of femininity, although poverty drives her to primp miserably before her mirror in the hope of getting work. Yet the picture does not depress, but holds hope of redemption. Strangely enough, this work is for Rouault – if not exactly a religious picture – at least a profoundly moral one. She is a sad female version of his tortured Christs, a figure mocked and scorned, held in disrepute.

THE BRIDGE TO THE FUTURE

Die Brücke (The Bridge) was the first of two Expressionist movements that emerged in Germany in the early decades of the 20th century. It was formed in Dresden in 1905.

The artists of Die Brücke drew inspiration from van Gogh (see p.316), Gauguin (p.322), and primitive art. Munch was also a strong influence, having exhibited his art in Berlin from 1892 (p.325). Ernst Ludwig Kirchner (1880–1938), the leading spirit of Die Brücke, wanted German art to be a bridge to the future. He insisted that the group, which included Erich Heckel (1883–1970) and Karl Schmidt-Rottluff (1884–1976), "express inner convictions… with sincerity and spontaneity."

Even at their wildest, the Fauves had retained a sense of harmony and design, but Die Brücke abandoned such restraint. They used images of the modern city to convey a hostile, alienating world, with distorted figures and colors. Kirchner does just this in *Berlin Street Scene (383)*, where the shrill colors and jagged hysteria of his own vision flash forth uneasily. There is a powerful sense of violence, contained with difficulty, in much of their art. Emil Nolde (1867–1956), briefly associated with Die Brücke, was a more profound Expressionist who worked

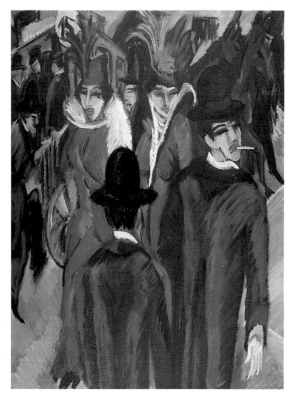

383 Ernst Ludwig Kirchner, **Berlin Street Scene,** 1913, 37½ × 47½ in (95 × 121 cm)

in isolation for much of his career. His interest in primitive art and sensual color led him to paint some remarkable pictures with dynamic energy, simple rhythms, and visual tension. He could even illuminate the marshes of his native Germany with dramatic clashes of stunning color. Yet *Early Evening (384)* is not mere drama: light glimmers over the distance with an exhilarating sense of space.

DEGENERATE ART
With the rise of Hitler and the Nazi party in the 1930s, many contemporary artists were discredited and forced to flee Germany or go into concentration camps. The term "degenerate art" was coined by the authorities to describe any art that did not support the Nazi Aryan ideology. The first degenerate art exhibition opened in Munich in 1937, with paintings by van Gogh, Picasso, and Matisse torn from their frames and hung randomly among the work of asylum inmates. The exhibition was so successful that it went on a propaganda tour throughout Germany and drew millions of visitors. Many artists were deeply affected by being labeled "degenerate," and Ernst Ludwig Kirchner actually committed suicide as a result in 1938.

384 Emil Nolde, **Early Evening,** 1916, 39½ × 29 in (101 × 74 cm)

WORLD WAR I

World War I broke out in 1914 following the assassination of Archduke Ferdinand (heir to the throne of Austria-Hungary) in Sarejevo by nationalists. This single event ignited localized problems that spread into an international conflict. Within months, all of Europe and parts of North Africa were in conflict. Austria-Hungary declared war on Serbia (believing the Serbians had devised the Sarejevo plot), and Austria's ally Germany declared war on Russia and France, then immediately invaded Belgium. In response, Britain declared war on Germany, and the stage was set for five years of incessant fighting and for the death of 10 million people. By April 1917 the allies included Britain, France, Russia, Japan, Italy, and the US. Many artists were influenced by the war, particularly Max Beckmann, who was deeply affected by his work as a medical orderly on the front lines.

OTHER WORKS BY BECKMANN

Souvenir of Chicago
(Fogg Art Museum, Cambridge, Mass.)

Two Women
(Museum Ludwig, Cologne)

The Dream
(Staatsgalerie Moderner Kunst, Munich)

Masquerade
(Art Museum, St. Louis)

Carnival
(Tate Gallery, London)

Sea Lions in the Circus
(Kunsthalle, Hamburg)

385 Max Beckmann, Self-Portrait, 1944, 23½ x 37½ in (60 x 95 cm)

386 Egon Schiele, Nude Self-Portrait, *1910, 14¼ x 43 in (35.5 x 110 cm)*

angst that was the main theme of his work. *Self-Portrait (386),* however, is a most moving theme in itself: a pathetic and yet powerful exposure of Schiele's vulnerability. He is mere skin and bone, not yet fully there as a person. He has outlined his body with a glowing line of white to indicate to us both his sense of imprisonment and his limitations: notice how his arm disappears almost at the elbow – yet paradoxically it also suggests growth and potential. He is an unhappy, scrawny youth, the wild and exaggerated expanse of pubic hair perhaps indicating the center of his unhappiness. His may seem too individualistic a view, yet in his hysterical way he is expressing the fears and doubts of many young people. He is wonderful, unsettling, and strangely innocent.

Oskar Kokoschka (1886–1980) was another Austrian artist of enormous Expressionist power. He said of his art, "It was the Baroque inheritance I took over unconsciously." He rejected harmony, but insisted on vision, and his art stakes its all on this visionary intensity, which plays havoc with more staid conventions.

In 1914 he fell passionately in love with Alma Mahler, the widow of the Austrian composer Gustav Mahler. In its wild, dreamy way *Bride of the Wind (387)* commemorates the emotional storms and insecurities of that relationship with a sophisticated psychological insight: Alma, the "bride," sleeps complacently, while Kokoschka, flayed and disintegrating within the twisting brushstrokes and sinuous ribbons of color, agonizes alone in silence.

OSKAR KOKOSCHKA

Oskar Kokoschka first made a name for himself in 1909–10 with his psychological portraits, in which the sitter's soul was believed to be exposed to the world. His paintings changed radically after his traumatic experiences in World War I, and he began to paint Expressionist landscapes. In 1914 Kokoschka began an affair with Alma Mahler, Gustav Mahler's widow, which inspired one of his most powerful paintings, *Bride of the Wind.* This relationship ended in 1915, but Kokoschka could not accept the break. He is known to have made a life-size doll of his lover, which he carried around with him at all times. His obsession with Alma was brought to an abrupt end in 1922, and he smashed the doll's head after a night of heavy drinking.

Die Brücke collapsed as the inner convictions of each artist began to differ, but arguably the greatest German artist of the time was Max Beckmann (1884–1950). Working independently, he constructed his own bridge, to link the objective truthfulness of great artists of the past with his own subjective emotions. Like some other Expressionists, he served in World War I and suffered unbearable depression and hallucinations as a result. His work reflects his stress through its sheer intensity: cruel, brutal images are held still by solid colors and flat, heavy shapes to give an almost timeless quality. Such an unshakable certainty of vision meant that he was hated by the Nazis, and he ended his days in the United States, a lonely force for good. He is just discernible as a descendant of Dürer in his love of self-portraits and the blend of the clumsy and suave with which he imagines himself. In *Self-Portrait (385),* he looks out, not at himself, but at us, with a prophetic urgency.

AUSTRIAN EXPRESSIONISM

The Austrian Expressionist painter Egon Schiele (1890–1918) died when he was only 28, and we do not really know whether he would have developed beyond the self-pitying adolescent

387 Oskar Kokoschka, Bride of the Wind, *1914, 7 ft 3 in x 5 ft 11¼ (221 x 181 cm)*

ARTISTIC EMIGRES

As the center of artistic interest, Paris attracted many foreign painters in the early 20th century, and within a few years of one another three Jewish émigrés, Chaim Soutine, Marc Chagall, and Amedeo Modigliani, had all arrived in the city. Though they became friends and gained inspiration from the recent innovations in art, they were all highly original artists and their paintings stand alone, defying categorization and imitation.

LA RUCHE
During this period many artists in Paris lived in an unusual building known as La Ruche (The Beehive). The building acquired its name from the row of small studios and the buzzing creative atmosphere. It was originally built for the 1900 World's Fair, but was then torn down and rebuilt in the Dantzig Passage area of Paris to shelter artists. The first floor contained sculpture studios, and painters, such as Chagall, Soutine, Léger, and Modigliani, all took studios on the second and third floors.

The three painters that we look at here were all born outside France, and they remained outsiders to the Parisian art scene for more than merely cultural reasons (Soutine and Chagall were both Russian and Modigliani was Italian). These painters shared the isolation of being "other," never truly belonging to any group or adhering to a single manifesto.

A PASSIONATE EXPRESSIONIST

Chaim Soutine (1894–1943) came to Paris in 1913. He was the only painter in the city who was in the least like Georges Rouault (see p.341), and as a Parisian Expressionist, he belonged to

the "School of Paris." Soutine's style of applying thickly encrusted paint was quite different from Rouault's, but his wild, chaotic spirit, sorrowful and vehement, is like that of the Frenchman. Just as Rouault, despite his Fauvist connections, is seen as inherently Expressionist, so Soutine was a natural, though unique, Expressionist.

Soutine's religion was the earth. He painted the sacredness of the country with a passion that makes his art hard to read. *Landscape at Ceret (388)* is so dense that it could be abstract, and it does take enormous liberties with the earthly facets, but when we do "read" it, hill and tree and road take on a new significance for us.

*388 Chaim Soutine, **Landscape at Ceret**, c.1920–21, 33 x 22 in (84 x 56 cm)*

DREAMS OF THE HEART

Marc Chagall (1887–1985) arrived in Paris in 1914 penniless, like Soutine. He combined his fantasies with sensuous color and modern art techniques he learned in France. He played with reality in a completely original and even primitive way. At heart he was a religious painter, using the word in its widest sense: he painted the dreams of the heart, not the mind, and his fantasy is never fantastic. It speaks beyond logic to the common human desire for happiness.

His early work in particular seems lit up from within by a psychic force that flows from his Jewish upbringing in Russia. *The Fiddler (389)* is a mythic figure, the celebrant of Jewish births, marriages, and deaths, but he bears this weight of the community alone, almost alienated from the common lot – notice the luminous green of the fiddler's face and how he hovers magically, unsupported in the air.

MODIGLIANI'S MANNERED ART

The third great "outsider" among the émigrés in Paris died all too soon. The Italian Amedeo Modigliani (1884–1920) destroyed himself through drink and drugs, driven desperate by his poverty and bitterly ashamed of it. Modigliani was a young man of fey beauty,

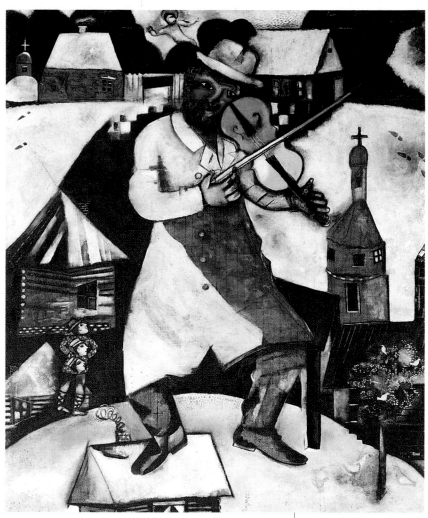

389 Marc Chagall, **The Fiddler,** *1912/13, 5 ft 2 in × 6 ft 2 in (158 × 188 cm)*

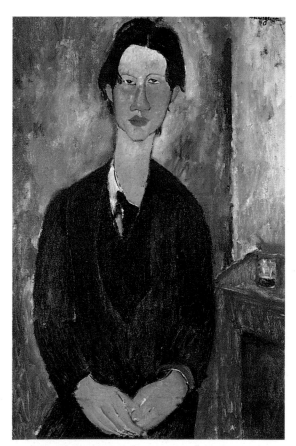

390 Amedeo Modigliani, **Chaim Soutine,** *1917, 23½ × 36 in (60 × 91 cm)*

and his work has a wonderful slow elegance that is unusual, but compelling. Through the influence of the Rumanian sculptor Constantin Brancusi, he fell under the spell of primitive sculpture, especially from Africa. He went on to develop a sophisticated, mannered style built upon graceful, decorative arabesques and simplified forms. It is hard for us to imagine why his art did not attract patrons. He is famous now for his elegant, elongated nudes, but it is his portraits that are the most extraordinary.

Chaim Soutine (390), whose own art was so offbeat, appeals to Modigliani for what he is bodily and for what he could become spiritually. Soutine rears up out of the frame like a gawky pillar. His nose is brutish in its spread, his eyes asymmetrical, his hair a shaggy mess. All this uncouthness is contrasted by his slender wrists and hands, by an impression we have of a man yearning for a homeland, set upon forming one out of his own substance if no place is provided. There is sadness here, but also determination; the thick red mouth is resolutely closed.

OTHER WORKS BY CHAGALL

The Cattle-Dealer
(Öffentliche Kunstsammlung, Basel)

The Juggler
(Art Institute of Chicago)

The Eiffel Tower
(National Gallery of Canada, Ottawa)

War
(Pompidou Center, Paris)

The Martyr
(Kunsthaus, Zurich)

The Blue Circus
(Tate Gallery, London)

Peasant Life
(Guggenheim Museum, New York)

PICASSO AND CUBISM

> **"**...The art of painting original arrangements composed of elements taken from conceived rather than perceived reality.**"**
>
> **Guillaume Apollinaire,** *The Beginnings of Cubism,* **1912**

After Cubism, the world never looked the same again: it was one of the most influential and revolutionary movements in art. The Spaniard Pablo Picasso and the Frenchman Georges Braque splintered the visual world not wantonly, but sensuously and beautifully with their new art. They provided what we could almost call a God's-eye view of reality: every aspect of the whole subject, seen simultaneously in a single dimension.

It is understandable that Pablo Picasso (1881–1973) found Spain at the turn of the century too provincial for him. Picasso's genius was fashioned on the largest lines, and for sheer invention no artist has ever bettered him– he was one of the most original and versatile of artists, with an equally powerful personality. Throughout the 20th century people have been intrigued and scandalized by Picasso's work, uncertain of its ultimate value.

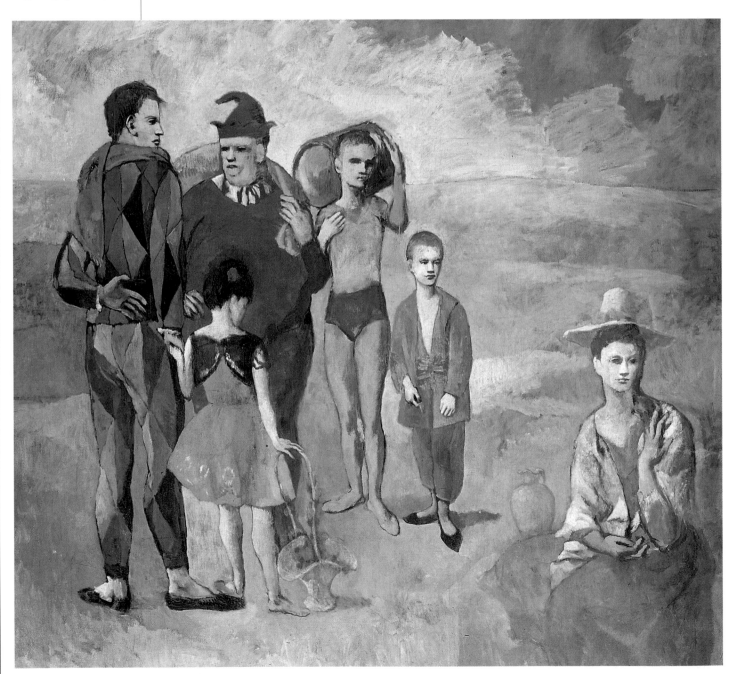

391 Pablo Picasso, **Family of Saltimbanques,** *1905, 7 ft 7 in x 7 ft (230 x 213 cm)*

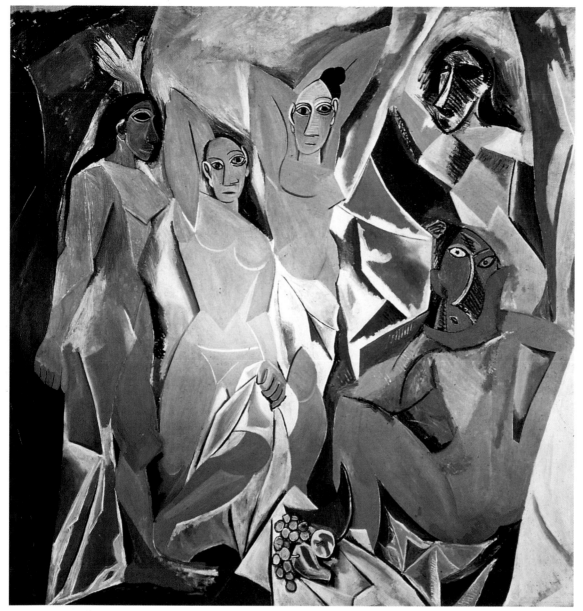

392 *Pablo Picasso,* Les Demoiselles d'Avignon, *1907, 7 ft 8 in × 8 ft (234 × 244 cm)*

THE EARLY YEARS

Picasso's Blue Period, from 1901 to 1904, sprang
from his initial years of poverty after moving to
Paris and modulated into a Rose Period as he
slowly began to emerge into prominence.
Although still only in his youth when he started
painting, Picasso had overwhelming ambition,
and his *Family of Saltimbanques (391)* was, from
the start, meant to be a major statement. It is a
very large, enigmatic work from the Rose Period,
revealing his superb graphic skill and the subtle
sense of poverty and sadness that marked those
early years. The five itinerant acrobats are strained
and solitary in the barren, featureless landscape;
the lonely girl seems not to belong to their
world, though she too is melancholy and
belongs by right of mood. There is something
portentous about the picture, some unstated

mystery. We feel that Picasso, too, does not
know the answer – only the question. Already
art is an emotional medium for Picasso, reflecting
his moods and melancholia as he seeks to find
fame as an artist.

THE FIRST CUBIST PAINTING

While still in his twenties, but finally over his
self-pitying Blue and Rose periods, Picasso
fundamentally changed cognitive reality with a
work his friends called *Les Demoiselles d'Avignon
(392)* after a notorious place of prostitution.
These demoiselles are indeed prostitutes, but
their initial viewers recoiled from their advances
with horror. This is the one inevitable image
with which a discussion of 20th-century art must
be concerned. It was the first of what would be
called the Cubist works, though the boiled pink

color of the hideous young women is far removed from later Cubism, with its infinite subtleties of gray and brown. It is almost impossible to overestimate the importance of this picture and the profound effect it had on art subsequently. The savage, inhuman heads of the figures are the direct result of Picasso's recent exposure to tribal art, but it is what he does with their heads – the wild, almost reckless freedom with which he incorporates them into his own personal vision and frees them to serve his psychic needs – that gives the picture its awesome force.

Whether he did this consciously or not we do not know, since he was a supremely macho man: *Les Demoiselles* makes visible his intense fear of women, his need to dominate and distort them. Even today when we are confronted with these ferocious and threatening viragoes, it is hard to restrain a frisson of compassionate fear.

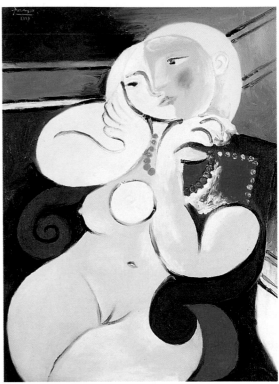

394 Pablo Picasso, Nude Woman in a Red Armchair, *1932, 38 x 51 in (97 x 130 cm)*

At first Picasso did not dare to show the painting even to his admirers, of whom there were always many. But Georges Braque (see p.350) was haunted by its savage power, and eventually he and Picasso began to work out together the implications of this new kind of art. Cubism involved seeing reality simultaneously from all angles, of meshing the object in the network of its actual context. As Cézanne had indicated, there were to be no boundary lines to truth, but a form emerging from all different aspects intuited together (see column, p.347). The results are hard to read, even though the Cubists confined themselves mostly to unpretentious and familiar objects such as bottles and glasses of wine, or musical instruments (see p.350).

BEYOND CUBISM

Picasso would have scorned any thought of limiting himself to a single style. He experimented continually, his versatility and creativity always amazing his contemporaries. Whenever he seemed to have settled in a particular mode of seeing, he changed again almost overnight.

Picasso soon became a wealthy man, and when the scandal of his early artistic methods had died down, he revived it with his subject matter. He is an even more autobiographical artist than Rembrandt or van Gogh, and it was the women in his life who provided the changing drama. Each new relationship precipitated a

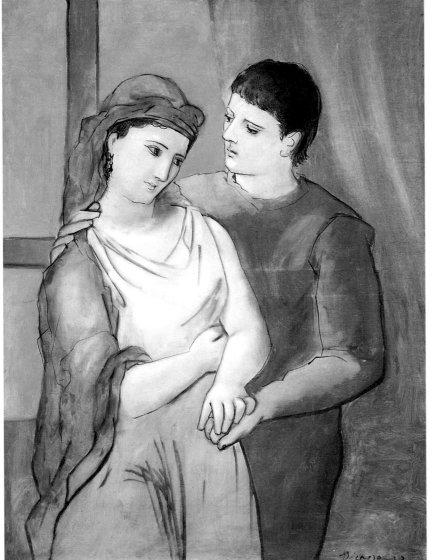

393 Pablo Picasso, The Lovers, *1923, 38 x 51 in (97 x 130 cm)*

new wave of creativity, with a new model and a new vision. *The Lovers (393)* shows him in a classical vein, soberly and simply giving substantial form to an almost theatrical drama. This was the period of his infatuation with Olga Kokhlova, the well-bred Russian ballerina whom he rashly married and whose elegant influence on him was soon to be angrily denied as their relationship faltered. There is a balletic grace in *The Lovers,* and, because he was pictorially thrifty, Picasso never completely discarded the styles as he did the women.

THE ARTIST'S PLEASURE

The mistress who inspired the most enchanting art in him was Marie-Thérèse, a large, pacific girl with whose rounded body shapes he loved to play on canvas. Picasso was so various an artist, so astonishing in his inventions that every viewer may well have a favorite period, yet (though this may be too subjective a reaction) the work inspired by Marie-Thérèse seems to come from a depth that is untouched in his other work. *Nude Woman in a Red Armchair (394)* is the last time we see Picasso relatively benign. There is something in Marie-Thérèse's willing vulnerability, in her material fecundity of shape, that Picasso finds positively reassuring.

All the Marie-Thérèse paintings – at least until the affair began to disintegrate – are remarkably satisfying: rich, gracious, almost sweet, and yet deeply challenging. Picasso toys with both the rotundity of her body and with the powerful paradox of her extreme youth (she was only 17 when they met), yet the physical satisfaction that she brought him, succoring and nurturing him, was as though this simple child was, in a sense, a mother figure to him. *Nude Woman in a Red Armchair,* with its luminous physicalities – which even the armchair seems to share as it curls and glows around her body – still expresses the dichotomy of Marie-Thérèse's double role in Picasso's treatment of her face. She is both full moon and crescent moon, full face and in profile. It is impossible not to feel the thrilling communication of the artist's pleasure. This sense of fulfillment, rare in Picasso at any stage, never reappeared after he lost interest in Marie-Thérèse and her warm charms.

PICASSO'S LATER MISTRESSES

Subsequent mistresses such as Dora Maar, an intellectual, or François Gillot, another artist – both fiercely determined women – brought out Picasso's cruelty, his determination not to be impressed. Even in his old age, when he was cared for by his second wife, Jacqueline Roque, Picasso still used her as ammunition in his battle against fate. He raged against his loss of sexual power in these final years and sought to compensate for it through the phenomenal weight of his artistic powers.

Picasso's portrait of Dora Maar, *Weeping Woman (395),* painted the same year as his great picture *Guernica,* has a terrible power. It is a deeply unattractive picture, the shrill acids of its yellows and greens fighting bitterly and unrelentingly with the weary reds, sickly whites, and sinister purples. But it is also unattractive in the sense that it conveys Picasso's venomous desire to mutilate his sitter. Dora Maar's tears were almost certainly tears caused by Picasso himself. They reveal her anguished need for respect; Picasso repays her with a vicious savagery.

Power was Picasso's special gift. He had the ability to turn even the most incidental of themes into powerful works with an often overbearing force. If we accept that all beauty has power, we can arrange artists along a line, at one end or the other. Vermeer, Claude, and Matisse would be at the beauty end, and Rembrandt and Poussin at the power end, together with Picasso.

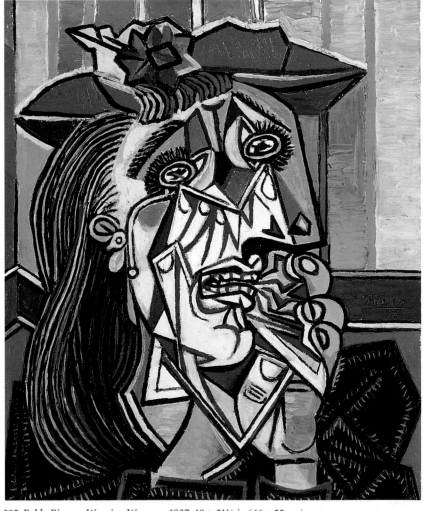

395 Pablo Picasso, Weeping Woman, *1937, 18 x 21½ in (46 x 55 cm)*

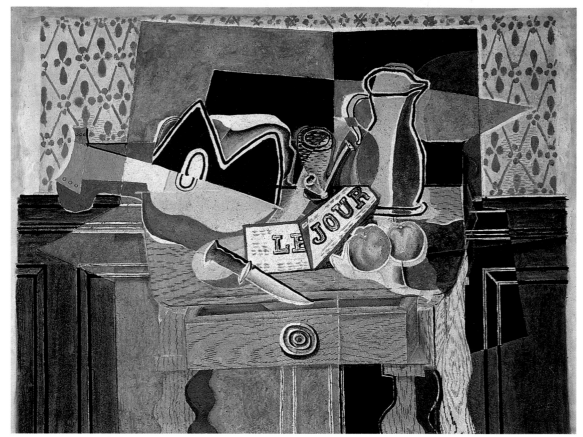

396 Georges Braque, Still Life: Le Jour, 1929, 58 x 45 in (147 x 115 cm)

GEORGES BRAQUE

Georges Braque (1882–1963) was the only artist ever to collaborate with Picasso as an equal. He admitted that they were like climbers roped together, each pulling the other up. From 1907 they worked so closely together, exploring the planes and facets of the same subject matter, that some of their work appears almost identical. Although they developed their own natural autonomy as artists, they carried Cubism to another, more brilliant level.

Their joint discovery was remarkably brief for the effect it has had. Braque never excelled in these early works, though he never fell below Picasso's standards either. His Synthetic Cubist painting (see column, p.347) of *Still Life: Le Jour (396)* is restrained in color, is hardly playful at all, and is somehow less exuberant than Picasso's Cubist work – though Braque delights in the originality of the shapes and textures. But by this time the two artists had long parted, and their innate differences are clear.

JUAN GRIS

There was a third great Cubist, the Spaniard Juan Gris (1887–1927). He died young and never moved on from the style, though he progressively brightened and clarified it. With this single-mindedness, Gris can be thought of as the one absolute Cubist. *Fantômas (397)* has a harlequinish gaiety with its shifting planes and witty celebration of newspapers, magazines, and entertainment. With its stylish sophistication, we would never think it was a Braque or Picasso.

397 Juan Gris, Fantômas, 1915, 29 x 23½ in (73 x 60 cm)

THE AGE OF MACHINERY

Interest in and appreciation of machinery was clearly in the air in the early decades of the 20th century. For a group of young Italian Futurist artists, the progress offered by machinery epitomized their increasing fascination with dynamic speed and motion. Though they translated this idea of progress into a frenetic exultation of the glory of war and the destruction of museums, their visual understanding of motion remained exciting.

The Italian Futurists, like the members of Die Brücke in Germany, aimed to free art from all its historical restraints and celebrate the new beauty of the modern age (see column, right). Umberto Boccioni (1882–1916), Gino Severini (1883–1966), and Giacomo Balla (1871–1958), who all joined Futurism in 1910, wanted to express the onrush of events in the world with pictures of motion, dynamism, and power.

In *Street Noises Invade the House (398)*, Boccioni attempts to give this sensation and succeeds remarkably well. Noise becomes something seen, something literally invasive of privacy. Boccioni said of the picture, "all life and the noises of the street rush in at the same time as the movement and the reality of the objects outside." The surging incoherence of the forms is both chaotic and ordered.

398 Umberto Boccioni, Street Noises Invade the House, 1911, 42 x 39¼ in (107 x 100 cm)

FUTURISM

The Italian avant-garde movement was founded in 1909 by the poet Marinetti. It included many painters such as Boccioni, Carra Russolo, and Severini. The aim of the movement (which included writers, architects, photographers, and musicians) was to break with academic restrictions and to celebrate the dynamism of modern technology. The name "Futurism" was first used by Marinetti in the French newspaper *Le Figaro* in February 1909, but the movement only lasted until the death of Boccioni in 1916.

THE MANIFESTO

The general manifesto announced in the newspaper *Le Figaro* was followed by several other manifestos, including that of 1910, which highlighted the violent and challenging aesthetic of Futurism. The artists who signed this manifesto believed that "universal dynamism" must be rendered as dynamic sensation. Their support of war and violence anticipated the politics of Fascism, which would arrive in Italy with Mussolini in 1919. Both Boccioni and Marinetti praised World War I as the "hygiene of civilization" and saw the growing industrialization of the world as a vital force. The artistic importance of Futurism as a modern movement, is overshadowed by the extreme right-wing politics of its members.

399 Fernand Léger, Two Women Holding Flowers, 1954, 52 x 38 in (132 x 97 cm)

400 Robert Delaunay, Homage to Blériot, 1914, 8 ft 3 in x 8 ft 2½ in (251 x 250 cm)

FRANCE AND THE MACHINE AGE

Fernand Léger (1881–1955) was initially influenced by Cubism, but after his experience of trench warfare in World War I, he converted to Socialism. Like the Futurists, he admired the harmonious union of man with modern machinery. He developed an unusual blend of abstraction and representational imagery that conveyed something of the smooth, ordered quality of machines. *Two Women Holding Flowers (399)* shows the simplicity and power of this later style, though it is still only partially realistic. The full, schematic forms of the women were meant to be easily assimilable to ordinary people, for whom Léger felt immense respect, though it is the great bright blocks of color that give his women their true interest. All the same, there is a sort of epic splendor in this art to which most people find themselves responding instinctively.

The machine age inspired not only Léger and the Futurists, but Robert Delaunay (1885–1941). *Homage to Blériot (400)* shows Delaunay's intoxication with the airplane and Blériot, the first pilot to fly the English Channel. Initially, it may seem to be an abstract picture, but it is full of visual clues. Blériot's plane whirls high above the Eiffel Tower, while figures and planes dazzle in and out of swirling multicolored circles, reminiscent of a propellor (see column, left).

TOWARD ABSTRACTION

In 1911, a new group of German artists began exhibiting their work to the public. Der Blaue Reiter was to become the high point of German Expressionism, but it also opened the way toward abstraction with its stand for free experimentation and originality. It is Wassily Kandinsky, the most influential member of the group, who is most often credited with the distinction of painting the first "abstract" picture, in 1910.

Der Blaue Reiter (The Blue Rider) was formed in 1911 and succeeded the first Expressionist movement, Die Brücke (see p.340), which dissolved in 1913. The group included Franz Marc (1880–1916), Wassily Kandinsky (1866–1944), and August Macke (1887–1914), and celebrated the art of children and primitives, but had no precise artistic program. The most active proponent of this essentially romantic and rather spiritual view of art (see column, right) was Franz Marc, a young artist who was killed in World War I. Marc saw animals as the betrayed but uncontaminated guardians of what was left of innocence and unspoiled nature.

THE BLUE RIDER

This was the name given, in 1911, to a group of Munich Expressionist artists by the two most important members, Franz Marc and Wassily Kandinsky. Two touring exhibitions of paintings were transported around Germany, with other artists, such as Macke, Klee, and Braque, also represented. This illustration shows the front cover of *Der Blaue Reiter,* published in 1912 by Marc and illustrated with a woodcut by Kandinsky.

THEOSOPHISTS

The term "theosophy" is derived from the Greek words *theos,* "God" and *sophia,* "wisdom." As a religious philosophy, theosophy can be traced back to ancient roots, but it reemerged in the late 19th century and influenced artists such as Kandinsky and Mondrian. The classic formulation of theosophical teachings is *The Secret Doctrine* written by Madame Blavatsky, an American theosophist. She argues that the "essence" of an object is more important than the attributes of the object. The new artists, like Kandinsky, believed their abstract art would lead the people to spiritual enlightenment.

401 Franz Marc, **Deer in the Forest II,** *1913/14, 39⅔ x 43½ in (100.5 x 110.5 cm)*

RUSSIAN REVOLUTION
The Russian Revolution of 1917 had its origins partly in the inability of the existing order to manage the Russian role in World War I. There were two main groups of revolutionaries: the liberals, who believed that Russia could still win the war and create a democracy; and the Bolsheviks, who thought the war was lost and wanted to transform the whole economy. The avant-garde movement was adopted by the state (though not for long) and became a major vehicle for "agitprop" (a mixture of agitation and propaganda). Artists were encouraged to design for posters and political rallies.

Like August Macke, Marc chose to express these feelings with emphatic, symbolic colors. He painted animals with a profoundly moving love: a love for what they represented and could still experience, unlike humanity. *Deer in the Forest II (401)* is made up of a dense network of shapes and lines that border on the abstract. Together they create a forest of experience through which we can see, as if emerging from the undergrowth, the small forms of the deer. The animals are utterly at peace, at home in the forest of the world. It is a stylized and luminous vision of a species that can live without the angers of the ego.

August Macke, who was also to be killed in the coming war, was another artist with a gentle, poetic temperament. He took a simple delight in the joys common to us all, which makes his senseless destruction especially painful. *Woman in a Green Jacket (402)* floats onto the canvas, blissfully detached and pacific. Of the group, he was the most sensitive to form and color, and the hues in this picture glow gently within strong shapes to create sensuous areas of light.

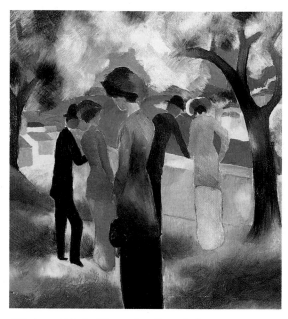

402 August Macke, **Woman in a Green Jacket,** *1913, 17 x 17⅓ in (43.5 x 44 cm)*

KANDINSKY AND ABSTRACTION

However, neither Marc nor Macke were abstract painters. It was Kandinsky who found that "interior necessity," which alone could inspire true art, was forcing him to leave behind the representational image. He was a Russian who had first trained as a lawyer. He was a brilliant and persuasive man. Then, when already in his thirties, he decided to go to Munich in 1897 to study art. By the time Der Blaue Reiter was established, he was already "abstracting" from the image, using it as a creative springboard for his pioneering art. Seeing a painting of his own, lying on its side on the easel one evening, he was struck by its beauty – a beauty beyond what he saw when he set it upright. It was the liberated color, the formal independence, that so entranced him.

Kandinsky, a determined and sensitive man, was a good prophet to receive this vision. He preached it by word and by example, and even those who were suspicious of this new freedom were frequently convinced by his paintings. *Improvisation 31 (403)* has a less generalized title, *Sea Battle*, and by taking this hint we can indeed see how he has used the image of two tall ships shooting cannonballs at each other and abstracted these specifics down into the glorious commotion of the picture. Though it does not show a sea battle, it makes us experience one, with its confusion, courage, excitement, and furious motion.

Kandinsky says all this mainly with the color, which bounces and balloons over the center of the picture, roughly curtailed at the upper corners, and ominously smudged at the bottom

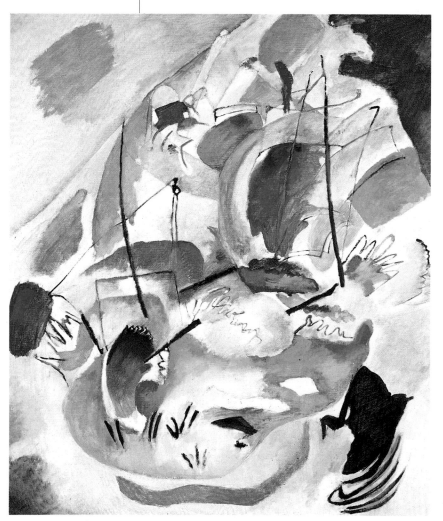

403 Wassily Kandinsky, **Improvisation 31 (Sea Battle),** *1913, 47 x 55 in (120 x 140 cm)*

right. There are also smears, of paint or of blood. The action is held tightly within two strong ascending diagonals, creating a central triangle that rises ever higher. This rising accent gives a heroic feel to the violence.

These free, wild raptures are not the only form abstraction can take, and in his later, sadder years, Kandinsky became much more severely constrained, all trace of his original inspiration lost in magnificent patternings.

Accent in Pink (404) exists solely as an object in its own right: the "pink" and the "accent" are purely visual. The only meaning to be found lies in what the experience of the picture provides, and that demands prolonged contemplation. What some find hard about abstract art is the very demanding, time-consuming labor that is implicitly required. Yet if we do not look long and with an open heart, we shall see nothing but superior wallpaper.

404 Wassily Kandinsky, **Accent in Pink,** *1926, 31¾ x 39½ in (81 x 101 cm)*

KANDINSKY AND MUSIC

Kandinsky, himself an accomplished musician, once said, "Color is the keyboard, the eyes are the harmonies, the soul is the piano with many strings. The artist is the hand that plays, touching one key or another, to cause vibrations in the soul." The concept that color and musical harmony are linked has a long history, intriguing scientists such as Sir Isaac Newton. Kandinsky used color in a highly theoretical way, associating tone with timbre (the sound's character), hue with pitch, and saturation with the volume of sound. He even claimed that when he saw color he heard music.

OTHER WORKS BY KANDINSKY

Improvisation Deluge (Lenbachaus, Munich)

In the Black Squeeze (Guggenheim Museum, New York)

Heavy Circles (Norton Simon Museum, Pasadena)

The Gray (Pompidou Center, Paris)

The Whole (National Museum of Modern Art, Tokyo)

Cossacks (Tate Gallery, London)

And Again (Kunstmuseum, Berne)

PAUL KLEE

Paul Klee was an introverted Swiss painter who spent most of his adult life in Germany until he was expelled by the Nazis in 1933. His work is impossible to clarify, except to say that it is hardly ever entirely abstract – but equally, it is never truly realistic. He had a natural sensitivity to music, the least material of the arts, and it runs through all his work, clarifying his spellbinding color and dematerializing his images.

Paul Klee (1879–1940) was one of the greatest colorists in the story of painting, and a skilled deployer of line. His gravest pictures may have an undercurrent of humor, and his powers of formal invention seem infinite. After making an early choice whether to pursue painting or music as a career, he became one of the most poetic and inventive of modern artists. He taught at the Bauhaus in Weimar and Dessau (see column, left) and then at the Düsseldorf

BAUHAUS ARCHITECTURE

The Bauhaus school of art and architecture was developed by Walter Gropius (1883–1969) around the old Weimar Academy in 1919. The early teachers at the school included artists such as Klee and Kandinsky, and a close relationship was established between the artists and local industry. Many products, including furniture and textiles, were chosen for large-scale production. In 1925 the Bauhaus moved to Dessau and established a group of large cooperative buildings (illustrated above). The Bauhaus style was impersonal, severe, and geometrical, using a strict economy of line and pure materials. Gropius left the Bauhaus group. After moving to Berlin in 1932, the Bauhaus was closed down by the Nazis. This dissolution of the group actually encouraged individuals to travel and helped disseminate Bauhaus ideas throughout the Western world.

405 *Paul Klee,* The Golden Fish, *1925/26, 27¼ x 19¾ in (69 x 50 cm)*

Academy. Until his explusion from Düsseldorf by the Nazis, Klee painted and drew on a very small scale, yet the small size of his pictures does not effect their internal greatness.

The Golden Fish (405) glides through the kingdom of its underwater freedom, all lesser fish leaving a clear space for its gleaming body. This is a magical fish with runic signs upon his body, scarlet fins, and a great pink flower of an eye. He hangs majestically in the deep, dark blue magic of the sea, which is luminous with secret images of fertility. The great fish draws the mysteriousness of his secret world into significance. We may not understand the significance, but it is there. The sea and its creatures are arranged in

406 *Paul Klee*, Diana in the Autumn Wind, *1934,*
19 x 24¾ in (48 x 63 cm)

glorious homage, belittled but also magnified by this bright presence. This quiet nobility, the brightness, the solitude, the respect: all these qualities apply to Klee himself. Whether the art world knew it or not, he was their "golden fish."

IMAGES OF DEATH AND FEAR

Klee painted with intense rapidity and sureness, and it is impossible to indicate the full breadth of his range, his unfailing magic, and his poetry. *Diana in the Autumn Wind (406)* gives a hint of his sense of movement. Leaves flying in a moist breeze are, at the same time, the Virgin goddess on the hunt, and yet also a fashionably dressed woman from Klee's social circle. The eeriness of the dying year takes shape before our eyes. And beyond all this are lovely balancing forms that exist in their own right. This work is strangely pale for Klee, yet the gentle pallor is demanded by the theme: he hints that Diana is disintegrating under the force of autumnal fruitfulness.

BOOK BURNING

At the peak of Klee's career in the early 1930s, he came under surveillance from the chamber of culture. Joseph Goebbels, the Nazi minister of propaganda, organized hundreds of book burnings in German university towns. Thousands of books were destroyed for being "nonconformist to the spirit of a new Germany," including many by Marx and Freud. Hundreds of intellectuals and artists were forced to flee the country, including Kandinsky (who fled to France), and Klee (who went to Switzerland). Other left-wing intellectuals were not so fortunate and died in concentration camps.

DER STURM

Der Sturm ("the storm") magazine and art gallery was established by Hewarth Walden (1878–1941) in Berlin to promote the German avant-garde movement. The gallery ran from 1912 to 1924 and the magazine from 1910 to 1932. *Der Sturm* became the focus of modern art in Germany and promoted the work of the Futurists and the Blaue Reiter group (see p.353). Klee's first contribution to the magazine was a reinterpretation of a Robert Delaunay painting completed in January 1913. Klee also exhibited in the show-rooms of *Der Sturm* between 1912 and 1921.

OTHER WORKS BY KLEE

Old Sound
(Öffentliche Kunstsammlung, Basel)

Garden Gate
(Kunstmuseum, Berne)

The Dancer
(Art Institute of Chicago)

Flower Terrace
(National Museum of Modern Art, Tokyo)

Fire at Evening
(Museum of Modern Art, New York)

Watchtower of Night Plants
(Staatsgalerie Moderner Kunst, Munich)

Land of Lemons
(Phillips Collection, Washington, DC)

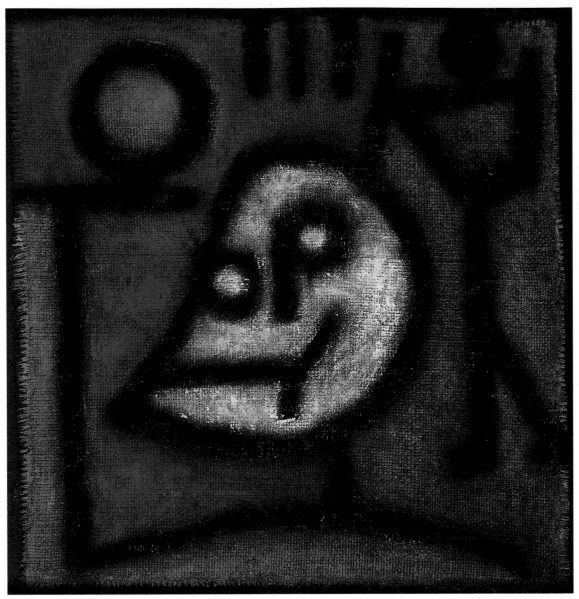

407 Paul Klee, Death and Fire, 1940, 17⅓ x 18 in (44 x 46 cm)

Klee died relatively young of a slow and wasting disease, his death horribly mimicked by the death of peace that signified World War II. His last paintings are unlike any of his others. They are larger, with the forms often enclosed by a thick black line, as if Klee were protecting them against a violent outrage. The wit is gone and there is a huge sorrow, not personal, but for foolish and willful humanity.

Death and Fire (407) is one of Klee's last paintings. A white, gleaming skull occupies the center, with the German word for death, *Tod*, forming the features of its face. A minimal man walks toward death, his breast stripped of his heart, his face featureless, his body without substance. Death is his only reality, his facial features waiting there in the grave for him. But there is fire in this picture too: the sun, not yet set, rests on the earth's rim, which is also the hand of death. The upper air is luminous with fire, presenting not an alternative to death, but a deeper understanding of it. The man walks forward bravely, into the radiance, into the light. The cool, gray-green domain of death accepts the fire and offers wry comfort.

Three mysterious black stakes jag down vertically from above, and the man strikes the skull with another. If fate forces him down into the earth, he does not go passively or reluctantly: he cooperates. Death's head is only a half-circle, but the sun that it balances in its hand is a perfect globe. The sun is what endures the longest, what rises highest, what matters most, even to death itself. Klee understood his death as a movement into the deepest reality, because, as he said, "the objective world surrounding us is not the only one possible; there are others, latent." He reveals a little of that latent otherness here.

PURE ABSTRACTION

Shapes and colors have always had their own emotional force: the designs on ancient bowls, textiles, and furnishings are abstract, as are whole pages of medieval manuscripts. But never before in Western painting had this delight in shape, in color made independent of nature, been taken seriously as a fit subject for the painter. Abstraction became the perfect vehicle for artists to explore and universalize ideas and sensations.

Several artists claimed to be the first to paint an abstract picture, rather as early photographers had wrangled over who had invented the camera. For abstract art, the distinction is most often given to Wassily Kandinsky (see p.354), but certainly another Russian artist, Kasimir Malevich, was also among the first.

RUSSIAN SUPREMATISM

Although Chagall and Soutine (see p.344) both left Russia to seek inspiration in France, the early 20th century saw an amazing renewal in Russian art. Since the far-off days of the icon painters (see pp.27–28), there had been nothing in this great country but the monotony of academic art. Now, as if unconsciously anticipating the coming revolution of 1917, one great painter after another appeared. They were not universally welcomed in their homeland, and more than one artist sought a response elsewhere, but some of the most significant painters dedicated their lives and their art to their country.

They are difficult artists. Kasimir Malevich (1878–1935), who founded what he called Suprematism (see column, right), believed in an extreme of reduction: "The object in itself is meaningless…the ideas of the conscious mind are worthless." What he wanted was a non-objective representation, "the supremacy of pure feeling." This can sound convincing until one asks what it actually means. Malevich, however, had no doubts as to what he meant, producing objects of iconic power such as his series of *White on White* paintings or *Dynamic Suprematism (408)*, in which the geometric patterns are totally abstract.

Malevich had initially been influenced by Cubism (see p.347) and primitive art (p.334), which were both based on nature, but his own movement of Suprematism enabled him to construct images that had no reference at all to reality. Great solid diagonals of color in *Dynamic Suprematism* are floating free, their severe sides denying them any connection with the real world, where there are no straight lines. This is a pure abstract painting, the artist's main theme being the internal movements of the personality. The theme has no precise form,

and Malevich had to search it out from within the visible expression of what he felt. They are wonderful works, and in their wake came other powerful Suprematist painters such as Natalia Goncharova and Liubov Popova.

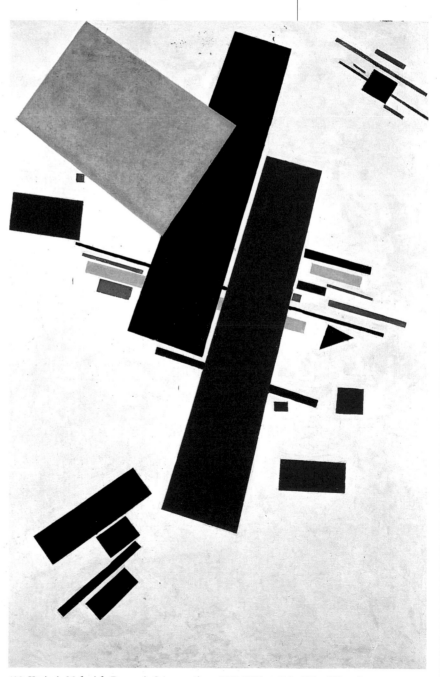

408 Kasimir Malevich, **Dynamic Suprematism,** *1916, 26½ x 40 in (67 x 102 cm)*

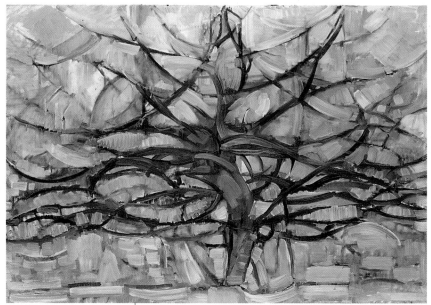

409 Piet Mondrian, The Gray Tree, 1912, 42½ x 31 in (108 x 79 cm)

MONDRIAN'S ABSTRACT PURITY

Kandinsky's late style had a geometrical tendency and Suprematist abstraction revolved largely around the square, but the real artist of geometry was the Dutchman Piet Mondrian (1872–1944). He seems to be the absolute abstract artist, yet his early landscapes and still lifes were relatively realist.

> **"** *The important task of all art is to destroy the static equilibrium by establishing a dynamic one.* **"**
>
> **Piet Mondrian in *Circle*, 1937**

NEO-PLASTICISM

Although a founding member of De Stijl ("the style") group of artists, Piet Mondrian preferred his art to be viewed as Neo-Plasticism. The first De Stijl journal, published in 1917, emphasized the importance of austere abstract clarity, and Mondrian's work certainly followed this agenda. In 1920 he published a Neo-Plasticism, pamphlet, asking artists to denaturalize art and to express the ideal of universal harmony. Mondrian restricted his paintings to primary colors, black, white, and gray, using lines to divide his canvases.

The Gray Tree (409) foreshadows the abstractions that were a halfway house to his geometrical work, yet it also has a foothold in the real world of life and death. *The Gray Tree* is realist art on the point of taking off into abstraction: take away the title and we have an abstraction; add the title and we have a gray tree. He claimed to have painted these pictures from the need to make a living, yet they have a fragile delicacy that is precious and rare. Mondrian sought an art of the utmost probity: his greatest desire was to attain personal purity, to disregard all that pleases the narrow self and enter into divine simplicities. That may sound dull, but he composed with a lyrical sureness of balance that makes his art as pure and purifying as he hoped.

Mondrian imposed rigorous constraints on himself, using only primary colors, black and white, and straight-sided forms. His theories and his art are a triumphant vindication of austerity. *Diamond Painting in Red, Yellow, and Blue (410)* appears to be devoid of three-dimensional space, but it is in fact an immensely dynamic picture. The great shapes are dense with their chromatic tension. The varying thicknesses of the black borders contain them in perfect balance. They integrate themselves continually as we watch, keeping us constantly interested. We sense that this is a vision of the way things are intended to be, but never are.

410 Piet Mondrian, Diamond Painting in Red, Yellow, and Blue, c. 1921/25, 56 x 56¼ in (142 x 143 cm)

ART OF THE FANTASTIC

Between the two World Wars, painting lost some of the raw, modern energy it began the century with and became dominated by two philosophical movements, Dada and Surrealism, which arose partly as a reaction to the senseless atrocities of World War I. But artists were also becoming introspective, concerned with their own subconscious dreams: Sigmund Freud's psychoanalytical theories were well known by this time, and painters explored their own irrationalities and fantasies in search of a new artistic freedom.

One artist who prefigured the Surrealists' idea of fantasy with his fresh, naive outlook on the world was the Frenchman Henri Rousseau (1844–1910). Like Paul Klee (see p.356), he defies all labels, and although he has been numbered among the Naïves or Primitives (two terms for untrained artists), he transcends this grouping. Known as *Le Douanier,* (customs officer) because of his lifelong job in the Parisian customs office, Rousseau is a perfect example of the kind of artist in whom the Surrealists believed: the untaught genius whose eye could see much farther than that of the trained artist.

Rousseau was an artist from an earlier era. He died in 1910, long before the Surrealist painters championed his art. Pablo Picasso (p.346), half-ironically, brought Rousseau to the attention of the art world with a dinner in his honor in 1908 – an attention to which Rousseau thought himself fully entitled. Although Rousseau's greatest wish was to paint in an academic style, and he believed that the pictures he painted were absolutely real and convincing, the art world loved his intense stylization, direct vision, and fantastical images.

Such total confidence in himself as an artist enabled Rousseau to take ordinary book and catalog illustrations and turn each one into a piece of genuine art: his jungle paintings, for instance, were not the product of any firsthand experience, and his major source for the exotic plant life that filled these strange canvases was actually the tropical plant house in Paris.

Despite some glaring disproportions, exaggerations, and banalities, Rousseau's paintings have a mysterious poetry. *Boy on the Rocks (411)* is both funny and alarming. The rocks seem to be like a series of mountain peaks, and the child effortlessly dwarfs them. His wonderful stripey garments, his peculiar mask of a face, the uncertainty as to whether he is seated on the peaks or standing above them – all come across with a sort of dreamlike force. Only a child can so bestride the world with such ease, and only a childlike artist with a simple, naive vision can understand this elevation and make us see it as dauntingly true.

METAPHYSICAL PAINTING

Giorgio de Chirico (1888–1974) was an Italian artist who originated what we now call Metaphysical painting (known as *Pittura Metafisica*), which also influenced the Surrealists' art. It was World War I and its brutalities that shocked de Chirico and his fellow Italian, Carlo Carrà (see column, p.362), into a new way of looking at reality in 1917. De Chirico painted real locations and objects within strange contexts and from unusual perspectives. The result is an uneasy assemblage of images in a peculiarly silent world.

> **"***Surrealism is destructive, but it destroys only what it considers to be shackles limiting our vision.***"**
> Salvador Dali in
> *Declaration,* 1929

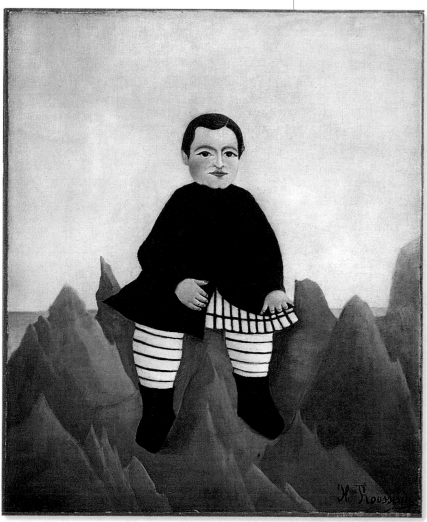

411 Henri Rousseau, Boy on the Rocks, 1895/97, 18 x 21¾ in (46 x 55 cm)

412 *Giorgio de Chirico,* **The Uncertainty of the Poet,** *1913, 37 × 41¾ in (94 × 106 cm)*

The Surrealists saw in de Chirico's paintings the importance of the mysterious world of dreams and the unconscious. They were influenced by the quality of enigma in his work, and especially by the unexpected juxtapositioning of objects, which became a distinguishing factor of much Surrealist art. De Chirico hoped to rise above the bare facts in his art, transmitting the magical experience beyond reality: he wanted his vision to be shown through reality, but not limited by it in any way.

De Chirico's theories do not really explain the power of his work, and in fact he found this art hard to sustain, so that it dwindled surprisingly soon into a brilliant but imitative classicism of a kind. While at his brief best, however, de Chirico is as magical as he hopes, and *The Uncertainty of the Poet (412)*, with its melancholy, deserted piazza, the suggestively scattered bananas, and the great bulk of the twisted, headless female bust is a genuinely unsettling picture.

FROM DADA TO SURREALISM

Max Ernst (1891–1976) is hard to categorize: he invented one new method after another during his career, including frottage (laying paper over textured surfaces, making a rubbing with graphite, and using the marks as chance starting points for an image). Untrained as an artist, Ernst originally studied philosophy. In 1919 he founded the Cologne branch of the Dada group (see column, left). Dada appeared in Paris the same year and though it lasted only until 1922, it became a precursor of Surrealism.

413 *Max Ernst,* **The Entire City,** *1934, 24 × 19¾ in (61 × 50 cm)*

*414 Joan Miró, **Woman and Bird in the Moonlight**, 1949, 26 x 32 in (66 x 81 cm)*

Dada reflected the mood of the time. It was a literary and artistic movement of young artists who, like de Chirico, were appalled and disillusioned by the atrocities of World War I. They expressed their sense of outrage by challenging established art forms with irrational and imaginative concepts in their work so that it frequently appeared nonsensical.

In 1922, Ernst settled in Paris, and he became instrumental in the evolution of Surrealism from Dada by using childhood memories to influence his subject matter. His mind was extraordinarily fertile, which attracted a group of Surrealist writers, and after Dada ended, he became an intimate with this group.

Ernst took from de Chirico the idea of unconnected objects in strange, atmospheric settings, and turned them into pictures in a more modern context, full of fear and apprehension. He is an uneven artist, but his best works have a personal sense of mythology to them. *The Entire City (413),* with its uncanny streaks of frottage and the great clear moon above with its vacant center, strikes an unhappy chord of recognition. Although we recognize the familiar floorboard pattern, Ernst makes us feel the sad likelihood that we are also receiving a preview of our future.

Surrealism began officially in 1924 with a manifesto drawn up by the Surrealist writer André Breton (1896–1966). Called "Surrealists" to stress the idea of being above or beyond reality, the group combined the irrationality of

Dada with the idea of pure, unreasoned thought through subconscious dreams and free association – a concept heavily inspired by Sigmund Freud's theories on dreams. The group took a sentence from the poet Lautréamont to explain their search for the fantastical: "Beautiful as the chance encounter of a sewing machine and an umbrella on an operating table."

MIRO AND MAGRITTE

Surrealist artists placed great value on children's drawings, the art of the insane, and untrained amateur painters whose art sprang from pure creative impulses, unrestrained by convention or aesthetic laws. Surrealism generally took the form of fantastic, absurd, or poetically loaded images. It was a potent, if inexplicable, force in the work of many artists, of whom Joan Miró (1893–1983), is perhaps the most uncanny. An introspective Spanish artist, he was one of the truly major Surrealists. His art appears far more spontaneous than that of Ernst or Dali (see p.364) in rejecting traditional images and devices in painting. *Woman and Bird in the Moonlight (414)* is a personal celebration of some deep joy. The figures tumble together with instinctive sureness, magical shapes that move in and out of recognition as if the woman and the bird could at any time exchange identities.

The Belgian René Magritte (1898–1967) was a practitioner of realist Surrealism, pressed into imaginative servitude. He began by imitating the avant-garde, but he genuinely needed a more poetic language, which was influenced

ANTONI GAUDÍ
Before Surrealism had been created at the beginning of the 20th century, the Spanish architect Antoni Gaudí (1852–1926) had already demonstrated the power of abstract forms and Surrealist fantasy in architecture. His most famous creations all encompass fluidity of form, with organic and abstract shapes, often using mosaic tiling to create arabesque decoration. The detail illustrated above is taken from the Parque Güell in Barcelona, designed by Gaudí in 1900–14 for his patron Don Basilio Güell. Several of the Surrealist artists, including Joan Miró, acknowledged drawing inspiration from Gaudí and other Catalan art.

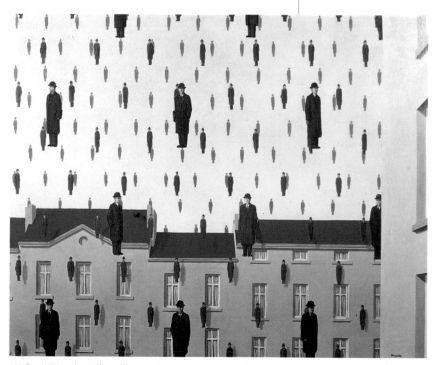

*415 René Magritte, **The Fall**, 1953, 39⅓ x 31½ in (100 x 80 cm)*

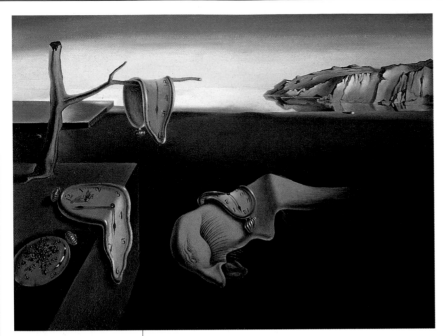

*416 Salvador Dali, **The Persistence of Memory**, 1931, 13 x 9½ in (33 x 24 cm)*

by de Chirico's Metaphysical paintings. He had a mischievous mind, and his weirdly bowler-hatted men in *The Fall (415)* drop through the sky with complete composure, expressing something of the oddity of life as we know it. His art, painted with such clarity that it appears highly realistic, typifies the Surrealist love of paradoxical visual statements, and though things may seem normal, there are anomalies everywhere. *The Fall* has a weird rightness about it, and it is in tapping our own secret understanding of sublunar peculiarity that Surrealism appeals.

DALI'S DREAM PHOTOGRAPHS

Salvador Dali (1904–89), whose graphic gifts were never affected by his mental imbalance, painted profoundly unpleasant and yet striking images of the unreality in which he felt at home. But he painted the unreality with meticulous realism, which is why they are so disturbing. He described these works as "hand-painted dream photographs," and their power lies precisely in their paradoxical condition as snapshots of things that, materially, do not exist.

It is easy, in theory, to disregard Dali, but difficult in practice. *The Persistence of Memory (416)*, with its melting watches and the distorted face (like a self-portrait) in the center, has an intensity and an applicability that we cannot shrug off. Dislike it though we may, this sense of time gone berserk, of a personal world deflated under the pressure of the contemporary, has an inescapable power. And distasteful though it is, *The Persistence of Memory* is one of the great archetypal images of our century.

DUBUFFET AND ART BRUT

Though not a Surrealist as such, Jean Dubuffet (1901–85) shared some of the Surrealists' influences, in particular children's drawings, art of the insane, and the absurd and irrational. He had a large collection of work by psychotics, which he called *Art Brut* – Raw Art.

Although he was still a young man when he trained as an artist in Paris, Dubuffet was in his forties before he began painting in earnest. On the surface, his art bears very little obvious relation to that of the Surrealists, though he painted with a Surrealist philosophy. His pictures are crude and rough, totally devoid of the illusionist trickery or persuasiveness employed by Dali and Magritte. Nor do they possess the Surrealist tendency toward enigma and mystery. Instead, his art was, as he would say, *Art Brut* – aggressively unsophisticated "outsider art."

We can be taken aback by a work such as *Nude with a Hat (417)*. It seems to have been gouged out of a primitive material context. The nude glares out at us, her big eyes, confrontational mouth, and huge, flat, egotistical hat making her a powerful and dynamic icon. Only the two small circles in the center remind us that this is a nude and these are her breasts. Dubuffet is concerned with a whole different scenario: woman as demon, as a psychic force. It is the great flat hat that matters, not her nakedness. It is this reversal of the accepted and the conventional on which Dubuffet builds his art. It is wonderful stuff, but deeply challenging.

*417 Jean Dubuffet, **Nude with a Hat**, 1946, 25 x 31½ in (64 x 80 cm)*

418 Giorgio Morandi, Still Life,
1946, 18 x 14¾ in (46 x 37.5 cm)

ISOLATION AND OBSESSION

In this period between the two world wars, Giorgio Morandi and Alberto Giacometti stood apart from their artistic contemporaries. Both painters absorbed the broad influence of Surrealism early in their careers, but soon abandoned these affiliations to pursue their own singular and intensely individual languages. Morandi was Italian, Giacometti Swiss, and like their cultural disparities, their art has little common ground. However, they share the trait of being obsessive artists, returning to the same subject again and again.

Giorgio Morandi (1890–1964) was one of the real geniuses of Italian 20th-century painting. He was an unusual man who lived a very quiet life in Bologna, and his own quiet personality is the predominant trait in his art. His early paintings are influenced by de Chirico's Metaphysical paintings, but he soon evolved his own unique vision – one that he did not deviate from for the rest of his life. He painted still lifes – often the same group of bottles, jugs, and other humble domestic ware – and they quiver on the canvas with an almost breathless reverence. *Still Life (418)* has the inner peace of visual prayer. For him, these are objects of the deepest mystery, and he has that rare artistic power of making us understand just what he experiences as he contemplates them.

THE HUMAN FORM IN SPACE

Alberto Giacometti (1901–66) spent a large proportion of his career as a sculptor and returned to painting at a relatively late stage. Like Morandi, his early paintings – especially those made in Paris, where he settled in 1922 – were essentially Surrealist, with their disturbing, aggressively ambiguous vein. He later abandoned this form of expression to work directly from life, thus severing all points of contact with the Surrealists. Giacometti spent the rest of his life engaged in one long, ongoing struggle to convey the solid presence of the human form in space. He tended to work obsessively on a series of paintings, working continuously on one particular image at a time. His tendency to wipe out every night what he had created during the day gives a poignancy to what has survived. *Jean Genet (419)*, for example, the Parisian thief-turned-writer, intrigued Giacometti in both aspects of his unique personality.

Giacometti was fascinated both by the creative Genet, the writer, and by the obsessive Genet, the thief. Something of Giacometti's double fascination is apparent in this portrait. Genet looks up almost blindly into the world of mysterious materiality. This is the world from which he was excluded, and which he yet longs to possess. All of these subtleties are present in Genet's portrait of a small, tense figure, blindly intent upon a world that eludes him. There is mastery here and menace, as well as a sense of the magical.

419 Alberto Giacometti, Jean Genet, 1955, 21¼ x 25½ in (54 x 65 cm)

PRE-WAR AMERICAN PAINTING

There have always been interesting American artists, and at least two 19th-century painters, Thomas Eakins and Winslow Homer, influenced the course of future art in the United States. During the 1920s and 1930s, Edward Hopper and Georgia O'Keeffe emerged as inspirational new painters of distinctive American traditions. Hopper's work was strongly realist, his still, precise images of desolation and isolated individuals reflecting the social mood of the times. O'Keeffe's art was more abstract, often based on enlarged plants and flowers, and infused with a kind of Surrealism she referred to as "magical realism." She may not have been a great painter, but her art was highly influential.

AMERICAN SCENE PAINTING

Edward Hopper (1882–1967) painted American landscapes and cityscapes with a disturbing truth, expressing the world around him as a chilling, alienating, and often vacuous place. Everybody in a Hopper picture appears terribly alone. Hopper soon gained a widespread reputation as the artist who gave visual form to the loneliness and boredom of life in the big city. This was something new in art, perhaps an expression of the sense of human hopelessness that characterized the Great Depression of the 1930s.

THE FEDERAL ART PROJECT

Introduced by President Franklin D. Roosevelt as part of his New Deal in 1935, the Federal Art Project aimed to alleviate the worst effects of the American Depression. At its peak, the Federal Art Project employed 5,000 people across the country to decorate public buildings and to create new art centers and galleries. Lasting until 1943, the project employed virtually all the major American artists of the period, either as teachers or practitioners.

420 Edward Hopper, Cape Cod Evening, *1939, 40 x 30¼ in (102 x 77 cm)*

366

Edward Hopper (1882–1967) has something of the lonely gravity peculiar to Thomas Eakins (see p.305), a courageous fidelity to life as he feels it to be. He also shares Winslow Homer's (p.304) power to recall the feel of things. For Hopper, this feel is insistently low-key and ruminative. He shows the modern world unflinchingly; even its gaieties are gently mournful, echoing the disillusionment that swept across the country after the start of the Great Depression in 1929 (see column, right). *Cape Cod Evening (420)* should be idyllic, and in a way it is. The couple enjoy the evening sunshine

421 Georgia O'Keeffe, Jack-in-the-Pulpit No. IV, *1930, 30 x 40 in (76 x 102 cm)*

outside their home, yet they are a couple only technically, and the enjoyment is entirely passive as both are isolated and introspective in their reveries. Their house is closed to intimacy, the door firmly shut and the windows covered. The dog is the only alert creature, but even it turns away from the house. The thick, sinister trees tap on the windowpanes, but there will be no answer.

Georgia O'Keeffe (1887–1986), like Mary Cassatt (see p.291) and Berthe Morisot (p.290), is a female artist who no story of painting can neglect: like them, she added something. She married the photographer Alfred Stieglitz in 1924, and his close-ups of vegetation and New York skyscrapers inspired her own art.

Her *Jack-in-the-Pulpit* series starts with a highly realistic image, which is abstracted and magnified until the last work shows just the "jack," the stamen. Perhaps the fourth in the *Jack-in-the-Pulpit (421)* series has the greatest impact. We are confronted by a great blaze of intense blue, haloed by a jagged outline of luminous green and centered by a radiant candle. An ardor of white flame soars upward, seemingly imprisoned and yet intimately connected with the light at the leaf's edges. The inner flame burns somehow out of sight, triumphing. Her ability to make the real become mystically unreal had few immediate imitators, but O'Keeffe has steadily influenced art for much of this century.

GEORGIA O'KEEFFE
The artist Georgia O'Keeffe (1887–1986) was one of the pioneers of Modernism in the United States. She was a member of the circle surrounding the photographer and art dealer Alfred Stieglitz (1864–1946), whom she married in 1924. O'Keeffe is best known for her close-up, quasi-photographic images of flowers, which have generally been judged to be sensuous and sexually suggestive. From the 1930s she spent every winter in New Mexico, where she was inspired by the desolate beauty of the desert landscape. After her husband's death in 1946, she moved to New Mexico permanently.

THE GREAT DEPRESSION
This term describes the economic slump which affected the United States and Europe between 1929 and 1939. In the US, the economic boom of the 1920s ended with the Wall Street crash of October 1929. By 1932 one out of every four American workers was unemployed. By 1933 the total value of world trade had fallen by more than half as countries abandoned the gold standard and stopped importing foreign goods. President Roosevelt developed the New Deal, which included many social and economic reforms. However, it was not until World War II and the ensuing growth of the arms industry that any true recovery was established.

ABSTRACT EXPRESSIONISM

However great a disaster World War II was, it did at least mean that artists such as Piet Mondrian and Max Ernst, in leaving Europe for the safety of the United States, greatly extended their artistic influence. It is impossible to estimate how much they affected American art, but the fact remains that in the 1940s and 1950s, for the first time, American artists became internationally important with their new vision and their new artistic vocabulary, known as Abstract Expressionism.

The first public exhibitions of work by the New York School of artists – who were to become known as Abstract Expressionists – were held in the mid '40s. Like many other modern movements, Abstract Expressionism does not describe any one particular style, but rather a general attitude; not all the work was abstract, nor was it all expressive. What these artists did have in common were morally loaded themes, often heavyweight and tragic, on a grand scale. In contrast to the themes of social realism and regional life that characterized American art of

JACKSON POLLOCK

It has been suggested that Pollock was influenced by Native American sand paintings, made by trickling thin lines of colored sand onto a horizontal surface. This illustration shows a Navajo sand painting called *The Whirling Log.* It was not until 1947 that Pollock began his Action paintings, influenced by Surrealist theories of "psychic automatism" (expression of the unconscious). Pollock would stick his canvas to the floor and drip paint from a can using different objects to manipulate the paint.

422 Jackson Pollock, **The Moon-Woman Cuts the Circle,** *1943, 41 x 43 in (104 x 109.5 cm)*

423 *Jackson Pollock,* Number 1, 1950 (Lavender Mist), *1950, 9 ft 10 in x 7 ft 3 in (300 x 221 cm)*

previous decades, these artists valued, above all, individuality and spontaneous improvisation. They felt ill at ease with conventional subjects and styles, which could not convey adequately their new vision. In fact, style as such almost ceased to exist with the Abstract Expressionists, and they drew their inspiration from all directions.

BREAKING THE ICE
It was Jackson Pollock (1912–56) who blazed an astonishing trail for other Abstract Expressionist painters to follow. De Kooning (see p.371) said, "He broke the ice," an enigmatic phrase suggesting that Pollock showed what art could become with his 1947 drip paintings (see column, p.368).

The Moon-Woman Cuts the Circle (422) is an early Pollock, but it shows the passionate intensity with which he pursued his personal vision. This painting is based on an American Indian myth. It connects the moon with the feminine and shows the creative, slashing power of the female psyche. It is not easy to say what we are actually looking at: a face rises before us, vibrant with power, though perhaps the image does not benefit from labored explanations. If we can respond to this art at a fairly primitive level, then we can also respond to a great abstract work such as *Lavender Mist (423)*. If we cannot, at least we can appreciate the fusion of colors and

the Expressionist feeling of urgency that is communicated. *Moon-Woman* may be a feathered harridan or a great abstract pattern; the point is that it works on both levels.

ACTION PAINTING
Pollock was the first "all-over" painter, pouring paint rather than using brushes and a palette, and abandoning all conventions of a central motif. He danced in ecstasy over canvases spread across the floor, lost in his patternings, dripping and dribbling with total control. He said, "The painting has a life of its own. I try to let it come through." He painted no image, just action, though "Action painting" seems an inadequate term for the finished result of this creative process. *Lavender Mist* is 10 ft long (nearly 3 m), a vast expanse on a heroic scale. It is alive with colored scribbles, spattered lines moving this way and that, now thickening, now trailing off to a slender skein. The eye is kept continually eager, not allowed to rest on any particular area. Pollock has put his hands into paint and placed them at the top right – an instinctive gesture reminiscent of cave painters (see p.11) who did the same. The overall tone is a pale lavender, made airy and active. In his own time Pollock was hailed as the greatest American painter, but there are already those who feel his work is not holding up in every respect.

OTHER WORKS BY POLLOCK
White Light
(Museum of Modern Art, New York)

The Deep
(Pompidou Center, Paris)

Blue Poles
(Australian National Gallery, Canberra)

No. 23
(Tate Gallery, London)

Watery Paths
(Galleria d'Arte Moderne, Rome)

Eyes In the Heat
(Guggenheim Foundation, Venice)

Untitled Composition
(Scottish National Gallery of Art, Edinburgh)

424 *Lee Krasner,* Cobalt Night, *1962, 13 ft 2 in × 7 ft 9⅓ in (401 × 237 cm)*

Lee Krasner (1908–84), married Pollock in 1944, but was not celebrated at all during Pollock's lifetime (cut short in 1956 by a fatal car crash), but it was actually she who first started covering the canvas with a passionate flurry of marks. The originality of her vision, its stiff integrity and great sense of internal cohesion, is now beginning to be recognized. *Cobalt Night (424)* at 13 ft (4 m) is even larger than *Lavender Mist* and has the same kind of heroic ambition.

MARK ROTHKO

The other giant of Abstract Expressionism is the Russian-born Mark Rothko (1903–70). Just as there are some who feel a little uneasy about the status of Pollock, and others who would fiercely defend it, so too with Rothko. Like Pollock, he was initially influenced by Surrealism and its capacity for freedom of expression, but his greatest works are his mature abstracts. These paintings are often not hung as he originally intended. He wanted dim lighting and an atmosphere of contemplation; he rarely gets it. He rejected the extreme religious connotations given to his great walls of color, saying that his work had an essentially emotional rather than mystical meaning. He insisted that the theme, the subject, was different and could only be communicated by personal involvement in an atmosphere of solitude. Yet to many it appears that all Rothkos have identical formats: oblongs of delicate color held floating in a colored setting, the edges raveled like heavenly clouds. Those who love Rothko consider him one of the most important painters of the 20th century.

Rothko's art represented an alternative Abstract Expressionism to Pollock's: he placed greater emphasis on color and gravity than on the excitement of gesture and action. Such

425 *Mark Rothko,* Untitled (Black and Gray), *1969, 6 ft 4 in × 6 ft 9⅓ in (194 × 207 cm)*

demarcations, however, can be dangerous, since the Abstract Expressionists rarely aligned themselves into such rigid camps. *Untitled (Black and Gray) (425)* was painted the year before Rothko killed himself. The chromatic luminosities of the earlier years had long been quenched by a deepening sadness, the emotion conveyed here is of deep sorrow. We must take what comfort we can in recognizing that the gray area is greater than the black and that though the black has a heavy, deadening solidity, the gray is still shot through with undershades, with potential.

ARSHILE GORKY

It may have been his soul-shattering early experiences as an Armenian refugee, and the resulting insecurities, that made Arshile Gorky (1905–48) begin his artistic career so heavily under the influence of Picasso (see p.346) that it seemed an individual style would never emerge. Born Vosdanig Manoog Adoian, Gorky emigrated to the US in 1920, moving to New York in 1925 to study and then teach art. Before he too killed himself (see column, right), Gorky did indeed find his own voice, released partly through his contact with Surrealism in America. *Waterfall (426)* shows a lovely tumble of free images, the sweetly floating flat patches of color and shapes of his maturity. Strangely, the images do truly resemble a waterfall: something in the

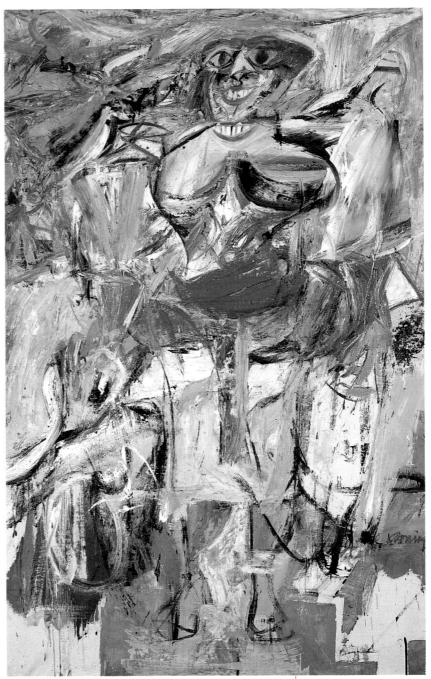

427 Willem de Kooning, Woman and Bicycle, *1952–53, 49 x 76 in (124 x 194 cm)*

surge down the canvas suggests a great sweep of water, the sunlight dazzling on hidden rocks behind. There is a springtime freshness about Gorky's work that gives his suicide an added poignancy. It is as if only in his art did he find happiness, freedom, and acceptance.

DE KOONING

Gorky was an important influence on the development of Abstract Expressionism and also on one of its most vital figures, his friend Willem de Kooning (1904–). De Kooning was born in Holland, but has lived mainly in the US.

426 Arshile Gorky, Waterfall, *1943,*
44½ x 60½ in (113 x 154 cm)

" *Imagination, no longer fettered by the laws of fear, became as one with vision. And the Act, intrinsic and absolute, was its meaning, and the bearer of its passion.* **"**

Clyfford Still

Though there were many Abstract Expressionists, the most vital seems to be de Kooning: even in Pollock's lifetime, de Kooning was hailed as his major rival. His ability to take a theme, whether landscape or portrait, and treat it with wild and wonderful freedom still impresses. His northern European background and the impulsive passion of his style, however, still bear some resemblance to Chaim Soutine (see p.344).

We are shaken with a visceral shock when we encounter de Kooning's women. *Woman and Bicycle (427)* is all teeth, eyes, and enormous bosom. She sits like a mantis, with a gleeful expectancy lighting her wedge of a face. This is a woman totally devoid of glamour, let alone charm, yet the poor giantess is dolled up in her tasteless finery, waiting for her prey. We shrink, we smile (such hideousness), we feel a little afraid. She is, above all, impressive and wickedly so. It is as much a tribute as a taunt.

At his lyrical best, de Kooning can overwhelm us with his beauty. *Door to the River (428)* balances most delicately on the cusp of abstraction. Great thick bars of color that slash and sprawl across the canvas create an unmistakable door; through

429 *Clyfford Still, 1953,*
5 ft 8½ in × 7 ft 9 in (174 × 236 cm)

the vertical bars gleams the intense blue of the distant river. This is not de Kooning delighting us with his wit, but rather drawing us right into the heart of great art. A work of art is great to the extent that to encounter it is to be changed. *Door to the River* passes this test triumphantly.

CLYFFORD STILL

With Clyfford Still (1904–80), landscape moved majestically over the cusp and into pure abstraction. Still is set apart from other artists of the New York School by the fact that for most of his career he lived and worked at a distance from the art world of New York – although he lived and taught in the great city during the height of Abstract Expressionism in the mid-1950s.

Still rejected references to the real world in his art and attempted to sever color from any links and associations. Most of his paintings are variations on a theme. He made grandiose claims for his work as being transcendent and numinous, and a painting such as *1953 (429)* does suggest why he felt able to make such claims. An objective viewer might feel he overstates his case, and yet this is a wonderful painting. The expanse of blue is dotted with black, two passionate streaks of red at the base, and great jagged slashes of color at the top. It is as if the mountains have opened to show us both the brightness and the darkness within, and it is this power to suggest a psychic significance that distinguishes Still's art.

428 **Willem de Kooning,** Door to the River, *1960, 5 ft 10 in × 6 ft 8 in (178 × 205 cm)*

430 *Franz Kline*, Ballantine, *1948–60,*
6 ft × 6 ft (183 × 183 cm)

Franz kline

If Franz Kline (1910–62) suggests urban landscapes
in his art, it is only in the sense of girders set
against the sky. It is as if the struts of a bridge or
some unsupported scaffolding had inspired him
to see the sheer majesty of pure, isolated shape.
His work resembles nothing more than oriental
calligraphy writ large. Much of it is black and
white, with all the subtle shadings and blurring
that distinguish great Chinese calligraphy. There
is a sort of passionate rightness about a work
such as *Ballantine (430)* that is immediately
convincing. This personal building of a shape
like a bridge, with an Eastern freedom of handling,
may not be especially profound, but it remains
immensely satisfying.

Barnett newman

Barnett Newman (1905–70) was one of the
most prestigious of the New York School painters.
Originally an art critic, he was an ardent supporter
of the Abstract Expressionists, explaining and
popularizing their work across America. Everyone
was surprised when he suddenly blossomed forth
as a painter himself, producing enormous "color
field" canvases: often a solid block of a single
color punctuated by what Newman called "zips."
Yellow Painting (431) is a perfect example: two
straight white lines that differ slightly in width
(though their length is identical) zip vertically
through the painting at either edge. Their pristine
whiteness makes us aware of the rich canary
yellow, that, we discover on inspection, is
bisected by another zip, this time yellow, faintly
outlined in places with a shadowy white. The
sheer size of the painting and its baffling simplicity
keep us looking. The longer we look, the more
aware we are of the strength and purity of the

yellow, and indeed of the white. This is a strangely
uplifting experience, as though color draws us
into itself while enlarging our horizons. With
these works, Newman prefigures both the
decorative panels of the Colorists (see p.375)
and the spartan canvases of the Minimalists
(see p.377).

Robert motherwell

Although his work has a monolithic simplicity,
Newman was a noted intellectual. So indeed
was Robert Motherwell (1915–91), the youngest
of the Abstract Expressionists and a philosopher
whose work exerts an enormous, though
fundamentally mysterious, moral power.

Motherwell has said that "without ethical
consciousness a painter is only a decorator."
This remark makes sense in the context of the
series that he painted as an emotional response
to the Spanish Civil War of 1936–39. These works
are elegies mourning the self-inflicted death of

431 *Barnett Newman,* Yellow Painting, *1949, 52⅜ × 5 ft 7½ in (133 cm × 171 in)*

THE SPANISH CIVIL WAR

In July 1936 General Franco organized a violent revolt against the Popular Front government in Spain to protest against the anticlerical and Socialist principles of the leaders. As a result Spain became an ideological battleground for Fascists and Socialists from all countries. Both Italy and Germany sent troops to assist Franco. Aid for the Republicans came partly from Britain and France, but mainly from the Soviet Union. The fall of Barcelona in January 1939 led to the end of the civil war and the inauguration of General Franco. The poster above was printed by a trade union as part of the Socialist campaign. Motherwell describes his work as a tribute to the Spanish people.

432 Robert Motherwell, Elegy to the Spanish Republic No. 70, 1961, 9 ft 6 in × 5 ft 9 in (290 × 175 cm)

a great civilization. Heavy swags of black, like a bull's testicles, hang down the picture space, reminding us that this is the land of bullfights that end with a noble beast slaughtered. There is a somber dignity and emotional grandeur to *Elegy to the Spanish Republic No. 70 (432),* and at first sight we may only be aware of a massive area of black against the luminous pallor of the background: yet the background shades are subtle grays and a pale blue. The solid black swings up and falls down heavily, fissured by thin and ominous dark lines. Even without the title we would know this is an elegy. Motherwell is mourning, but his grief – a very Spanish touch – has a great nobility of restraint.

PHILIP GUSTON

Philip Guston (1913–80) began painting as an Abstract Expressionist, and there are probably still some people who regard the delicate grace of those works as his best. But he underwent a conversion, suffering a revulsion against what he had come to feel was too pretty, and started what we could call a second career as the most plebeian of figurative painters.

The Painter's Table (433), painted toward the end of his life, could be described as uniquely autobiographical: there is the ashtray and still-smoking cigarette; there are the books to keep a painter's mind alert, and there is a paint box with solid squiggles of paint on the lid – a witty reminder of an earlier career as an abstract artist. But the box is closed, pressed down by one of the solid boots that became almost his trademark: life is a heavy business and we are not borne miraculously through it. Dead center is a wonderful eye, the essential requisite of the painter. Notice, though, that the eye looks through the table into infinity, the painter's task, and that the nail he has driven into the table casts a bleeding red shadow. There are mysterious shapes, too, in the picture, that tease our imaginations; why should a painter's life be fully explicable?

433 Philip Guston, The Painter's Table, 1973, 7 ft 6 in × 6 ft 5 in (229 × 196 cm)

AMERICAN COLORISTS

Abstract Expressionism, although it developed increasingly serious implications with its interior subject matter and artistic gaze, also liberated a wonderful flood of abstract art in the next generation of American painters. But to call these artists "the second generation" of Abstract Expressionists is perhaps unhelpful. They reacted against the "self-importance" and theoretical "spirituality" of painters such as Barnett Newman, seeking to free the artistic image from the obsessively metaphysical and make it a purely optical experience.

The painters that followed the Abstract Expressionist movement were less intense in their concentration, but wider and more diverse in the effects they sought. The Abstract Expressionists were profoundly serious – tragedy was essentially their theme – while the Colorists, or "Stainers," used color to express joy rather than sorrow. They stained canvases with paint or created large areas of color to communicate visually the wonder of human existence. Color has an effect on us all: it communicates meaning in its very being, irrespective of image or theme. It was this elementary power that the Colorists relied upon, bypassing the intellect to appeal to a deeper self.

HELEN FRANKENTHALER

American art has several great Colorists. One is Helen Frankenthaler (1928 –), whose method of staining the canvas with paint had such a wide influence on painting. She was influenced by Pollock's "all-over" painting (see p.369), and her innovative approach is in some ways an extension of Pollock's pouring and dripping process, though the effect is very different. She mixed thin washes and transparent stains and impregnated the bare, untreated canvas with them so that the color no longer sat on the surface of the canvas, but became the picture surface itself. *Wales (434)* shows her technique in its lovely simplicity, yet the more we look, the more subtle it is. Frankenthaler demands a place in art history as a pioneer of the staining technique, but this seems relatively unimportant compared with the end to which she put this means. Her style has been well imitated, but never with such inspired power. The eye moves over *Wales* with continual pleasure: it is a superb example of a work that has no "meaning" and yet provides profound intellectual satisfaction.

MORRIS LOUIS

When Morris Louis (1912–62) visited Frankenthaler's studio in 1954, he learned from her the technique of using stains as a means of creating, not on the canvas, but in it, making the work seem to

434 Helen Frankenthaler, Wales, 1966, 45 x 113 in (114 x 287 cm)

> **"***A bridge between Pollock and all possibilities.***"**
> Morris Louis on Helen Frankenthaler in 1953

STAIN PAINTING
From 1952 a new genre of painting known as "Stain painting" was developed by Helen Frankenthaler, who had evolved her own style of Abstract Expressionism (see pp.368-74) under the influences of Jackson Pollock and Arshile Gorky. The technique she developed involved using thinned paint to cover a whole unprimed canvas. The colors, having lost their glossy coating, float into and away from the surface creating nebulous but controllable space. At the same time, the spectator's awareness of the texture of the canvas denies the sense of extended illusion. In 1963 Frankenthaler started to use acrylic paints, which produced the same density of color saturation but were more controllable.

ACRYLIC PAINTS
The paintings of
Morris Louis mark an
important turning
point in the use of
new pigments and the
innovative exploration
of color and light.
In 1953-54 Louis began
to use a new form of
acrylic paint that
was plastic-based and
water-soluble. It was
designed to give a
revolutionary flat
surface once applied
to the canvas. Louis
reached the peak of his
creativity with this
medium between
1960 and 1962 with his
series of *Unfurleds*. The
effect on the canvas is
created by allowing the
liquid paint to flow over
the surface of a small
area of the canvas
(see right).

435 Morris Louis, Beta Kappa, *1961,*
14 ft 5 in × 8 ft 7 in (439 × 262 cm)

emerge from its own necessities. *Beta Kappa (435)* (the works are distinguished by Greek letters so that no shade of interpretation may creep into our experience of the paintings) is a late work, one of Louis's series of *Unfurleds*, where diagonal stripes across the canvas create a purely decorative effect. The painting is over 14 ft (4 m) long, yet the area in the center of the picture has been left daringly bare. We cannot take in, with just one look, the pourings down either side, so we must move between the edges, seeking an integration. Finally, we are forced to submit to the challenging nothingness of the picture, which its colored borders only make more evident.

RICHARD DIEBENKORN

Not all the great American painters live in New York. Richard Diebenkorn (1922–1994) has lived for many years in San Francisco, and his famous *Ocean Park* series is named after a suburb there. The wonderful rectangles he paints are both similar to one another and yet completely different. He has found, as Mark Rothko did (see p.370), a format that sets him free to explore the nuances of color, and it is serious play.

Stripes and diagonals divide *Ocean Park No. 64 (436)* into three sections, differently hued and sized. The absolute verticals highlight the swimming softness of the blue background and the subtle shifts and variations of paint application, so that in this work we really do recall the varying depths of the Pacific Ocean. But this is also a park, fenced in and bounded both at every edge and from within. Diebenkorn uses color so creatively that we begin to understand the world a little better.

436 Richard Diebenkorn, Ocean Park No. 64, *1973, 6 ft 8¾ in × 8 ft 3½ in (206 × 253 cm)*

MINIMALISM

If Abstract Expressionism dominated the 1940s and 1950s, Minimalism belonged to the '60s. It grew out of the restrained, spartan art of Abstract Expressionists such as Mark Rothko and Barnett Newman. A broad concept, Minimalism refers either to the paring down of visual variation within an image, or to the degree of artistic effort required to produce it. The result is an art form that is purer and more absolute than any other, stripped of incidental references and uncorrupted by subjectivity.

Ad Reinhardt (1913–67) could be said to be the quintessential Minimalist. He began as an "all-over" painter (see p.379) in the 1940s, but he matured into what he called his "ultimate" paintings in the 1950s: hard-edged, severely minimal abstract works. He darkened his palette and suppressed the contrast between adjacent colors to such an extent that after 1955 his art was restricted to the slow tonalities of deep black and almost-black colors. An inspirational teacher and outspoken theoretician, he believed passionately in reducing art to its purest form and, by extension, to its most spiritually pure state. Within the great luminous expanse of *Abstract Painting No. 5 (437)*, and its smooth, deep, blue-black surface, the artist's hand has

437 Ad Reinhardt, Abstract Painting No. 5, 1962, 5 x 5 ft (152 x 152 cm)

CONTEMPORARY ARTS

1946
Eugene O'Neill writes *The Iceman Cometh*

1949
Bertolt Brecht founds a theater company in Berlin

1953
Le Corbusier builds city of Chandigarh, India

1962
Benjamin Britten composes the *War Requiem*

1976
Christo completes his *Running Fence* sculpture across 25 miles (40 km) of Californian coastline

1982
Steven Spielberg creates the film *ET – The Extraterrestrial*

AD REINHARDT
In the 1940s Reinhardt passed through his stage of "all-over" painting into a style close to certain of the Abstract Expressionists, particularly Robert Motherwell (see p.374), with whom he jointly edited *Modern Artists in America* in 1950. During the 1950s he turned to monochromatic (usually all-black) paintings, and this reduction of his work to pure aesthetic essences reflects his fundamental belief that "Art is art. Everything else is everything else." Reinhardt's radical reduction of art to a simple chromatic abstraction was not initially accepted by the critics, but fellow artists understood his need to liberate art from the confines of contextual judgment.

"*…Non-objective, non-representational, non-figurative, non-imagist, non-expressionist, non-subjective.*"

Ad Reinhardt, describing Minimalist painting in 1962

STELLA AND MINIMALISM

The trend in minimal art developed in the 1950s in the United States. Only the most simple geometric forms were used. The impersonal nature of the genre is seen as a reaction to the high emotiveness of Abstract Expressionism. In his early work from 1958 to 1960, Frank Stella produced a kind of painting that was more abstract than any before. He confined himself to single colors, at first using black, and then aluminum paint, as in *Six Mile Bottom*, shown here. The artist chose the metallic paint because it has a quality that repels the eye, creating a more abstract appearance. Another striking aspect of Stella's work is that the structures appear to follow the shape of the canvas.

438 Frank Stella, Six Mile Bottom, 1960, 5 ft 11½ in x 9 ft 8 in (182 x 300 cm)

deliberately made itself invisible. We can see, just emerging, the faint outlines of a cross – almost as though Reinhardt himself has not painted it. This is not a Christian cross; if it is a religious icon, it is in the broadest sense, with an infinite vertical and an infinite horizontal – the unfathomable dimensions of the human spirit.

FRANK STELLA

Frank Stella (1936–) became a pivotal figure of 1960s' American art. In 1959, he produced a series of controversial pictures for the exhibition "16 Americans" at the Museum of Modern Art in New York. The works he presented were "all-over" unmodulated pictures dissected by strips of untouched canvas, creating severe geometric patterns. He consciously eliminated color, using black and then silver-colored aluminum paint to reduce the idea of illusion; even his painting process became systematic and Minimalist. His art ignores the rectangular limits of traditional canvases, reminding us that whatever connotations his paintings may evoke, they remain essentially colored objects. Often considered merely a shaped pattern, *Six Mile Bottom (438)* is a highly successful work, and one could claim that it implies a central order in worldly affairs. The geometric bareness of Stella's early work has been influential, but he developed into such a colorful, exuberant, multidimensional artist, continually experimenting and challenging, that one wonders at the stately purity of his early work. Was Stella's explosive buoyancy as yet undiscovered in 1959, or does it lurk within those strange rigidities of *Six Mile Bottom*?

440 Agnes Martin, Untitled No. 3, 1974, *6 ft x 6 ft (183 x 183 cm)*

MARTIN AND ROCKBURNE

There is never going to be universal agreement over contemporary painters, but there are some that, to this writer, are of unmistakable greatness: the Canadian Agnes Martin (1912–) is one. *Untitled No. 3 (440)* is simply a 6 ft (183 cm) square in which a fragile, almost noncolor, border encloses three great strips. The palest of pinks lies in the middle, bordered by two rectangles of watery purple or blue. The gentleness and delicate serenity of this work is exposed to our gaze without anything, as it were, seeming to happen. One has to stay with a Martin, looking as if into the waters of a lake, until the work begins to open up and flower.

With Dorothea Rockburne (1922–) there is much more to grasp and hold. She is a profoundly intellectual artist, often taking her inspiration from Old Masters, and she combines powerful austerity with a great lyrical insight. Some of her most wonderful work has been with oil and gold leaf (like the medieval illuminators) on linen prepared in a traditional way with gesso. She folds and creates geometric majesty from these simple means in *Capernaum Gate (439)*, using the utmost splendor of saturated hues and making us see her work as iconic, as something sacred.

439 Dorothea Rockburne, Capernaum Gate, *1984, 85 x 92 x 4 in (215 x 234 x 10 cm)*

ALL-OVER PAINTING
The term "all-over" painting was first used to describe the drip paintings of Jackson Pollock (see p.368). However, since then the term has been applied to any art where the overall treatment of the canvas is relatively uniform in color or pattern. Often the traditional perception of the canvas having a top, bottom, or center is no longer viable, and the painting becomes purely an experience.

POP ART

It is a moot point as to whether the most extraordinary innovation of 20th-century art was Cubism or Pop Art. Both arose from a rebellion against an accepted style: the Cubists thought Post-Impressionist artists were too tame and limited, while Pop Artists thought the Abstract Expressionists pretentious and overly intense. Pop Art brought art back to the material realities of everyday life, to popular culture (hence "pop"), in which ordinary people derived most of their visual pleasure from television, magazines, or comics.

Pop Art emerged in the mid-1950s in England, but realized its fullest potential in New York in the 1960s, where it shared, with Minimalism (see p.377), the attentions of the art world. In Pop Art, the epic was replaced with the everyday and the mass-produced awarded the same significance as the unique; the gulf between "high art" and "low art" was eroding. The media and advertising were favorite subjects for Pop Art's often witty celebrations of consumer society. Perhaps the greatest Pop artist, whose innovations have affected much subsequent art, was the American Andy Warhol (1928–87).

WARHOL'S PRINTS

Opinions, in the past, have differed wildly as to whether Warhol was a genius or a con artist extraordinaire. Having begun his career as a commercial artist, he incorporated commercial photographs into his own work, at first screen printing them himself and then handing the process over to his studio (known as "The Factory"): he devised the work, they executed it. In the *Marilyn Diptych (441)*, the image has deliberately been screen-printed without any special skill or accuracy, and the color printing on the right is, at best, approximate. Yet the

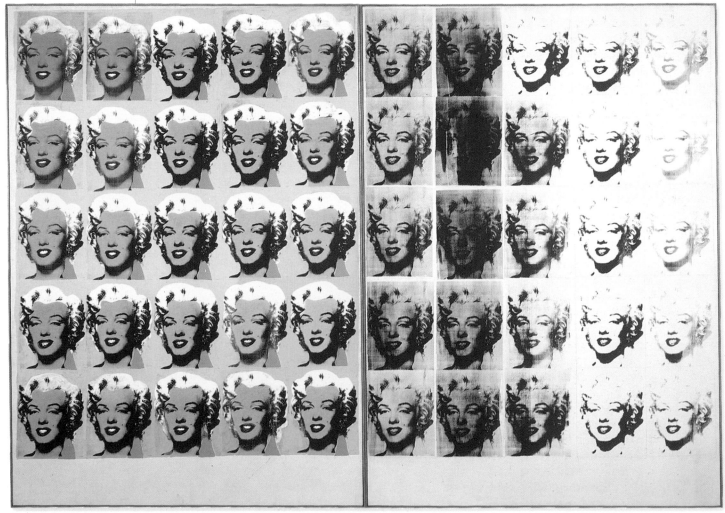

441 Andy Warhol, Marilyn Diptych, *1962, 57 x 80¾ in (145 x 205 cm) each panel*

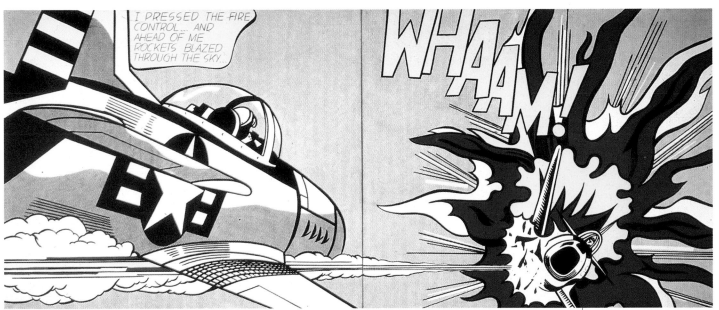

442 *Roy Lichtenstein,* Whaam, *1963, 13 ft 4 in x 5 ft 8 in (406 x 173 cm)*

Marilyn Diptych is an interesting and impressive work, rising from something deep within Warhol's psyche. He was an avid fan of the famous and understood the ephemeral nature of this fame, but he was even more interested in the idea of the American public's devotion to fame as a cultural symbol of his times. In giving herself up to the publicity machine, Monroe was destroyed as a person, and Warhol's utterly detached documentary style of portraiture echoes the impersonality and the isolation of this fame. In *Marilyn Diptych* a sea of Monroe faces, alike and yet subtly different, confront us with an iconic mask. It is an unforgettable work.

ROY LICHTENSTEIN

Ironically, Warhol's first venture into Pop Art was based on images taken from comic books, but the dealer to whom he showed his work was not interested: he had already been won over by the art of fellow American Roy Lichtenstein (1923–), another of Pop Art's major figures.

There is of course an element of nostalgia in work such as Lichtenstein's – the comic book world is that of childhood and early adolescence, with all its innocence and hopes. Lichtenstein saw the iconic dimensions of these images and re-created them on the grand scale favored by the Abstract Expressionists. His *Whaam (442)* is not an actual transcription from a comic book but an image he has taken and reduced to its essentials, to its streamlined power. *Whaam* is about violence and about how we can remove ourselves from it. The image is a narrative diptych: on one side are the powers of good, the avenging angel of the airplane; on the other, the powers of evil, the enemy destroyed

in a stylized blaze of punitive power. Lichtenstein uses simple shapes and colors and copies the dot process used in printing to restore us to the simplified world of moral black and white, and to our nostalgic childhood simplicities.

JASPER JOHNS

Dancers on a Plane; Merce Cunningham (443), is Jasper Johns's (1930–) tribute to the work of Merce Cunningham, the avant-garde American choreographer. Visually, *Dancers on a Plane* is extremely beautiful; conceptually, it is extremely

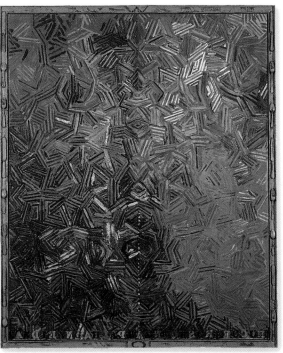

443 *Jasper Johns,* Dancers on a Plane; Merce Cunningham, *1980, 5 ft 3½ in x 6 ft 7 in (162 x 200 cm)*

complex. Johns's supreme gift is to create a demanding concept visually – he so delights the eye that he leads us into mental exploration of this concept. *Dancers on a Plane* shows the complexities of religious fulfillment (how the earthly side of life, the left side, will be divinely transformed after death, the right side) and sexual relationships, the four-dimensional nature of dance movement shown on one plane, the flat canvas, with the steps matching one another in a partnership. It is a thoroughly rewarding picture, which repays the time devoted to its contemplation. Equally, it gives pleasure on the merest glance; Johns satisfies on all levels.

ROBERT RAUSCHENBERG

The influence of Dada and Surrealism on Robert Rauschenberg (1925–) led him to a wholly new art form, using commonplace objects in unusual juxtapositions. Called "combine" paintings, they are Rauschenberg's specialty. *Canyon (445)* is one such work. He has assembled a bewildering mélange of images and techniques: oil painting combined with screen-printed photographs, newspaper text, and sheer painterly scrawl. But below this hubbub of intense life hovers the gaunt, outstretched wings of a dead bird. There is a vertiginous sense of soaring, of taking off into the canyon of the unknown. We feel that

JOHN CAGE
One of the most influential figures in 20th-century music was the composer John Cage (1912–92), who created some highly controversial pieces of "music." His most famous piece is called *4'33"* – four and a half minutes of silence, inspired by some of Robert Rauschenberg's blank paintings. Cage also produced "prepared piano" pieces by distorting the sound from the piano by placing objects on the piano strings.

445 Robert Rauschenberg, Canyon, 1959, 5 ft 10½ in × 7 ft 2½ in × 22¾ in (179 × 220 × 57.5 cm)

the canyon is not so much in the picture as below it: it is not out there, safely framed, but in here, in our own personal space. The ledge on which the bird perches juts out into the viewers' world at a diagonal, and hanging limply from it is a cushion, tightly composed into two saclike bags that seem weirdly erotic and pathetic. All the elements of the work, two-dimensional as well as three-dimensional, combine into a sense of closure, as though we were truly trapped within the high blank walls of a stone canyon. There can be an inspired lunacy in Rauschenberg that does not always come off, but when it does his images are unforgettable.

DAVID HOCKNEY

Technically, it is true to say that the Pop movement started with Richard Hamilton and David Hockney (1937–) in England. Hockney's early work made superb use of the popular magazine-style images on which much of Pop Art is based. However, when Hockney moved to California in the 1960s, he responded with such artistic depth to the sea, sun, sky, young men, and luxury that his art took on a new, increasingly naturalistic dimension. Though one might consider *A Bigger Splash (444)* a simplistic rather than a simplified view of the world, it nevertheless creates a delightful interplay between the stolid pink verticals of a Los Angeles setting and the exuberance of spray as the unseen diver enters the pool. There is no visible human presence here, just that lonely, empty chair and a bare, almost frozen world. Yet that wild white splash can only come from another human, and a great deal of Hockney's psyche is involved in the mix of lucidity and confusion of this picture.

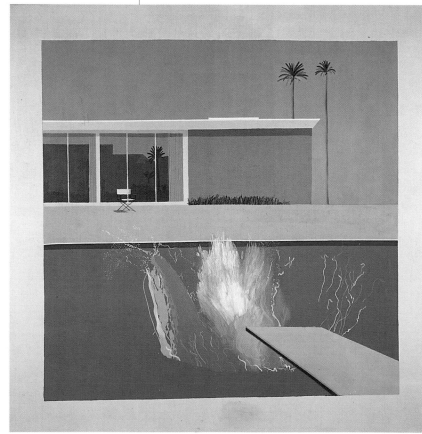

444 David Hockney, A Bigger Splash, 1967, 8 ft × 7 ft 11⅔ in (244 × 243 cm)

EUROPEAN FIGURATIVE PAINTING

*W*hile *Abstraction obsessed American artists for decades, the human figure never lost its significance in European painting. England eventually challenged American pride in the 1970s with a school of painters that included Lucian Freud and Frank Auerbach. British artists on the whole do not form "schools," and tend to work alone – which is perhaps indicative of a national tendency toward eccentricity.*

The strangely disturbing figurative art of Balthus (1908–), a Frenchman of Polish descent, has never been linked to a European school or movement. Balthus, the nickname used by Count Balthasar Klossowski de Rola since the age of 13, works in isolation with a classic majesty that can seem quite incongruous in our hectically unaristocratic age. His art is effective because this quiet sense of hierarchy comes naturally to him. Haunted by the griefs of our modern times, he chooses to deal with them obliquely, rather as Matisse did. His art is enigmatic, infused with a dignified stillness and monumentality.

BALTHUS

In the most sensitive and subtle of ways *The Game of Cards (446)* is concerned with awakening sexuality. Both young people have childlike bodies, but their facial expressions indicate that they are on the verge of entering a new world of sexual interplay. Their innocence, soon to be lost in bodily consciousness, moves Balthus, and he shares with us his emotional sympathy and his pleasure in their "game."

The Game of Cards is obviously about far more than the title suggests: the young people cannot look at one another directly without flirtatious timidity. Both reach out with one

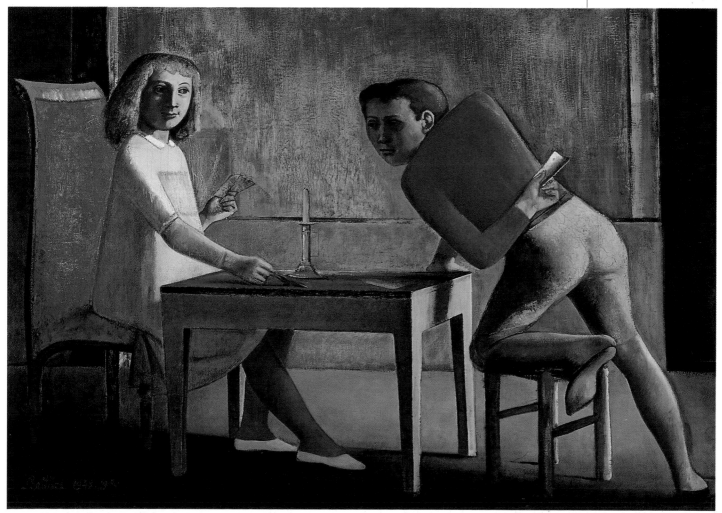

446 Balthus, The Game of Cards, 1948–50, 76 x 55 in (194 x 140 cm)

FRANCIS BACON

In 1945 British art was reawakened by the arrival of Francis Bacon. Many of Bacon's paintings were unreservedly violent, showing isolation and despair, using smudged paint and distorted human figures. Bacon proclaimed that the violence was inherent in the act of painting itself – in the struggle to remake reality on the canvas.

hand while drawing back with the other. The girl offers not only her hand but her delicate feet in her white sneakers, edged toward the boy. The boy is barricaded behind a table, determined to keep his secrets to himself (his unshod feet point away from her), and yet, as the angle of his body suggests, he is deeply attracted to her.

Everything in this picture is symbolic: the protective chair against which the girl does not lean, the low, unprotected stool that is all the young male has for support, even the mysterious brightness of the upper background and the shadows in which the activity is taking place. Is the candle at the center of the table a sacred image, a votive candle, or is it a phallic image, indicative of what is to come? It is certainly not a source of light because it is unlit. There are clear ambiguities present here, but no answer is given. Balthus does not prophesize.

FRANCIS BACON

By the 1970s a London School had emerged, though it did not share the same qualities as the Pre-war Paris or Post-war New York Schools, where the artists frequently met and shared their ideas. It included several major artists, of whom the best known is the Irishman Francis Bacon (1909–92), who moved to London in 1925.

Bacon is under reassessment: is his work a terrible indictment of the human condition, or did he wantonly create chaos for the wicked fun of it? Bacon, however, is very far from fun. His early works most certainly convey a great weight of grief and doubt, while his later paintings are overwhelmingly oppressive. Balthus's art reveals a secretive world full of obsession; Bacon's work exposes a world riddled with horror and anxiety.

Portrait of Isabel Rawsthorne Standing in a Street in Soho (447) has a deliberately long-winded title. The picture is tightly framed, with Bacon's friend entrapped like a bull in a ring, an arena. The curved wheel of a passing car suggests the horn of a bull at the same time. The woman presents an image of wary tension as she looks around quickly, her skirt aswirl with motion. The dullness of the long title adds force to her plight: a street in London's Soho – and such anxiety? Her face is hideous with brooding concentration, yet we can see that she is beautiful. She is ready to break loose from her cage.

Bacon developed a unique and inimitable technique, which included rubbing the canvas with various cloths, chosen for their different textures, to smudge and blur the paint. He also used dramatic contrasts of thin and thick paint, which he applied to the canvas with a violence akin to defacement. In this picture, Bacon has splattered wet paint in several places to indicate the role of chance, of uncertainty and risk. Not even this great coiled spring of a female can be certain of her freedom. By involving us emotionally, he shows the mark of a great painter.

LEON KOSSOFF

Two other British artists are of European-Jewish origin. Frank Auerbach (1931–) and Leon Kossoff (1926–) were both taught by the painter David Bomberg, whose art went neglected by the world until after his death (see column, p.385). Both are awesomely dedicated, working full-time in their studios, Auerbach encrusting his early work with more and more paint until it comes alive and Kossoff incessantly repainting the same familiar places and people. Both work from life; Bacon painted from memory, believing that the elusive qualities of the human presence were more honestly re-created by an equivalent painterly ambiguity.

*447 Francis Bacon, **Portrait of Isabel Rawsthorne Standing in a Street in Soho**, 1967, 58 x 78 in (147 x 198 cm)*

Kossoff is like the great Swiss sculptor and painter Alberto Giacometti (see p.365), who each night scratched out the day's work, never satisfied. For Kossoff too, painting becomes a repeated exercise, and he gains new insights through his experimentation. Then, suddenly, he understands visually and the picture is begun and finished very quickly. The sweep of his hurried paint is clearly visible as he drives himself to catch the truth before it vanishes once more. In a sense it is his own truth that he forever pursues, since the things he paints are the intimate companions of his own life.

Kossoff's aged parents are portrayed in *Two Seated Figures No. 2 (448)*, a subject that he has brooded over productively for years. Every part of their body language is intelligible to him, but he must make visual sense of it and portray this couple with fitting dignity. Unembarrassed, Kossoff paints with a keen observation: his father, a hard-working man, is now too old to be a true consort to his wife. He crouches awkwardly in his chair, seemingly unsure of himself.

Kossoff has said that his parents "obsessed" him as a subject. Here he is coming to grips with the changes in parental dominance as he has previously known it, and with the changes in the marital relationship itself. But he looks on with the steady love of the observer, admitting no grief, playing with no explicit memories. It is a marvelously reticent painting, and all the more moving for that restraint.

449 *Frank Auerbach,* The Sitting Room, *1964,*
50⅓ × 50⅓ in (128 × 128 cm)

FRANK AUERBACH

Auerbach, like Kossoff, paints only deeply loved, personal things. He tries with passion to capture their essence and always fails. But he fails gloriously. He spent nearly a year on *The Sitting Room (449)*, in the home of E.O.W., one of his few constant models, and he painted her there three times a week. Here is where they are most intimate, the model in one chair and her daughter in another, where every object has meaning for both of them. What he wants to show is not the bare sight of the room, but the sense of it seen anew each time.

Auerbach's images are built up of flat shapes of solid color, so that the depth in each picture has to be sought for. The surfaces of his early paintings are built up to the degree of a sculpted relief, the gouges and mounds of paint taking on an almost independent reality. The earthy colors in *The Sitting Room* have an emotional rightness, for this is his soul's soil, from which his art grows. He has painted and repainted endlessly, refusing to dramatize or play the illusory games of an illustrator. Suddenly the image coheres and moves forward from its obscurity. The human memory is never reliably sharp: the certainty is vital but the forms often cannot be strictly delineated.

448 *Leon Kossoff,* Two Seated Figures No. 2, *1980,*
6 ft × 8 ft (183 × 244 cm)

AUERBACH AND BOMBERG

The art dealer Henry Roland and the Beaux-Arts Gallery owner Helen Lessore both promoted figurative art in Britain during the 1950s. Many figurative art exhibitions were mounted, showing, among others, Auerbach, Bacon, and Kossoff. The latter two were pupils of David Bomberg (1890–1957) who had developed his expressive methods in the 1920s and 1930s. Between 1945 and 1953 Bomberg taught part-time at the Borough Polytechnic in London, but he was not highly regarded by the establishment, who thought his teaching techniques – allowing students to follow a highly personal, organic course – were dubious. Auerbach's portrayal of chaotic London scenes using thick impasto paint echo this eccentric philosophy.

LUCIAN FREUD

Lucian Freud, like Francis Bacon, has a serious claim to be considered as part of the story of painting. He has painted landscapes, still lifes, and portraits, but his most powerful art deals with the naked human body. He sees it in all its chromatic wonder and its astonishing vulnerability. He almost seems to paint what is underneath the skin, exposing the secret truth of his models, all of whom are people he knows well. His desire is not to create paintings that are like the subjects, but that are the subjects, so that there are two realities, one on the canvas, one walking free.

LUCIAN FREUD

Lucian Freud (1922–), grandson of the German psychoanalyst Sigmund Freud, is a resolutely realist artist, and frighteningly so. He began by painting tightly controlled, Surrealist-influenced portraits and still lifes, and rarely painted nudes before 1965–66; yet he subsequently painted some of the most powerful and original nude pictures in Western painting. Freud developed an increasingly "fleshy" style, seeking ways of conveying the physical reality of humans in a concrete world with ever greater intensity, and with an increasing interest in the wonder of skin tones. He directs a clinical eye on his subject that is chilling in its objectivity.

Standing by the Rags (450) is a recent work and a superb example of Freud at his greatest. He shows us a woman in all her raw fleshiness standing in the full exposure of the sunlight. It is almost as if Freud paints beneath the skin, with his dazzling sensitivity to the variations in her skin tone. These pinks, blues, and yellows

450 Lucian Freud, **Standing by the Rags,** *1988–89, 54⅓ x 66½ in (138 x 169 cm)*

451 *Anselm Kiefer*, **Parsifal 1**, *1973,*
7 ft 2½ in x 10 ft 8 in (225 x 320 cm)

are visually extraordinary – have we ever seen
skin like this before? The woman plunges down
toward us; the floorboards beneath her feet
provide the only perspective and are so vertiginous
that we instinctively move back, as if she would
fall out on top of us. Despite their wild disarray,
the rags are safely tucked away behind her,
barricaded by her bent arm and the weighty
flesh of her body. These rags are among some
of the most beautiful things Freud has ever
painted. They gleam with a soft luminosity, their
whiteness extending from deep shadows of gray
through all possible intermediate tones up to
a sharp pallor. The firm human flesh is played
off against the loose compression of the rag pile.
The woman is limited by the definition of her
shape; the rag pile extends indefinitely in three
directions. Every aspect of this disjuncture
delights Freud's painterly heart.

ANSELM KIEFER
Among today's German artists, many critics
would back Anselm Kiefer (1945–) for his
staying power: he is a romantic painter, an
expressionist in the German Expressionist
tradition with a deep need to give visual form to
the idea of repentance. His subject matter largely
revolves around the terrible injustices suffered
by the Jews in Germany, and it may be that the

importance of his theme obscures our judgment
here. Only time will tell. *Parsifal 1 (451)* is from
a series based on the Wagner opera. The theme
is a weighty one, and critics have seen these
works as an expression of the rough-hewn
nature of the true Germanic spirit, as well as a
meditation on the nature and growth of an indi-
vidual artist. Kiefer uses unusual techniques, so
that the overlapping strips of wallpaper, laid hor-
izontally across one another and painted black at
the edges, look like floorboards of rough wood.
This wood echoes the great forests of his native
land, and every swirl and textural mark seems to
bear some great significance for him.

GEORG BASELITZ
Those unacquainted with contemporary art may
well feel an ironic gratitude to Georg Baselitz
(1938–) because his work is immediately
recognizable. His almost invariable inversion
of his images has been criticized as a gimmick:
why, after all, are the two figures in *Adieu (452)*
upside down? The intention is in fact a serious
and aesthetic one: he wants to use the human
figure with an almost abstract freedom so that
his work is not easily understood and, as too
often happens, forgotten. As we puzzle over
the upturned figures and the strange starter's
flag of the background, we absorb something of
the artist's power and his fascination and delight
in evading familiar constructions. It is too early
to know how important an artist he is, but he is
a good example of an interesting contemporary
about whom we can make up our own minds.

THE ART OF KIEFER
Kiefer's primary choice
of subject matter at the
beginning of his career
was the portrayal of
events from German
history and mythology.
By portraying the
realities of German
atrocities, he felt he
could exorcise the past
and perhaps show that
some form of goodness
could come through
evil. Later in his career
he started to use straw,
lead, sand, and metal
to create collages, and
he even used blood as a
pigment in the *Parsifal*
series of four paintings,
created in 1973 (see
left). The one shown
here relates to the birth
and early years of the
eponymous hero of
Wagner's opera, hence
the crib. When three of
the paintings are hung
as a triptych, this
one forms the
left-hand panel.

452 *Georg Baselitz*, **Adieu**, *1982, 9 ft 10 in x 6 ft 8¾ in (300 x 205 cm)*

EPILOGUE

This is both an afterword and a foreword: hundreds and thousands of artists come after the disappearance of the "story line" into the maze of contemporary artistic experience and these same artists may of course, be the forerunners of a new story. In the present context of the end of the century, it is impossible to know which threads will lead us through the maze and which are dead ends. I can only give a very personal, subjective sample of contemporary art and single out just three artists who I hope will endure.

Robert Natkin is an established artist and a supreme colorist who has up until recently resisted being called an abstract painter. Clearly, to Natkin every part of his canvas is vital with what he calls narrative interest. A communication is being made visually: an experience is being enacted. But this event, so searching and enriching to the spirit, is carried out by means of shapes and colors, integrating into a wholeness. Natkin floats his colors on, denies them, deepens them, teases them into new complexities, always with a masterly elegance that is overwhelmingly beautiful. *Farm Street (453)* is one of a series inspired by worship at Farm Street, a Jesuit church in central London. The picture offers the viewer an entry into worship, not just the painter's, but our own. It is a humbling and uplifting work, with its wonderful luminosities. Yet Natkin offends many critics by being too beautiful, purity being suspect in these days of dilemma.

453 Robert Natkin, Farm Street, *1991, 72 x 60 in (183 x 152 cm)*

454 Joan Mitchell, Sunflowers, *1990–91, 157½ x 110¼ in (400 x 280 cm)*

The great Joan Mitchell also offends with her beauty, but she saves herself in critical circles by drawing the beauty, not just from her own vision, like Natkin, but from the seen world. Her home for many years was in Giverny, where Claude Monet had made his home and miraculous garden (see p.297). But she asserted that she never looked at the view. The "view" is in her own house, the flowers on the table or in the garden, and she paints them with enormous grace and compassion. *Sunflowers (454)* has almost the sad glory of van Gogh's version. It is a theme that Mitchell has painted many times. She has said, "If I see a sunflower drooping, I can droop with it, and draw it and feel it until its death."

MODERN RELIGIOUS ART

The Renaissance marked the high point of religious art, but since then it has almost died out. It is therefore all the more astonishing, then, that contemporary Britain should produce an artist like Albert Herbert. A profoundly educated painter who paints from his own inner experience, his own need, he creates biblical images of astonishing conviction. Here is Jonah, happily journeying within the security of his whale, and real life, represented by its goose girl and her geese, threaten and alarm him. In *Jonah and the Whale (455)*, Herbert is using biblical imagery to express powerfully and magnificently a truth about the human heart.

455 Albert Herbert, Jonah and the Whale, *c. 1988, 14 x 11 in (35 x 28 cm)*

The story of painting continues, even if the chapter we are in is still being written. It will in the end be read and appreciated, just as we appreciate the art of the past. We have the adventure of looking at contemporary art without guidelines or labels, and that is a precious part of the story.

GLOSSARY

Abstract art Art that does not represent objects or people from the observable world.

Acrylic paint A type of paint made with a synthetic acrylic resin as the medium. It dries more quickly than oil paints (see column, p.376).

Altarpiece A religious work of art placed above and behind the altar.

Annunciation A popular subject in Gothic, Renaissance and Counter-Reformation art: the moment of the announcement to the Virgin Mary by the Angel Gabriel that she shall concieve and bear a son and that he shall be called Jesus (see column, p.63).

Byzantine Esssentially Christian art produced in the Eastern Roman Empire between the 5th century AD and 1453, when Constantinople fell to the Turks.

Chiaroscuro (Italian: "light dark") The technique of suggesting three-dimensional form by varying tones of light and dark paint.

Complementary colour The true contrast of any colour. The complementary of each primary colour – red, blue, and yellow – is the combination of the other two. Red and green; blue and orange; and yellow and violet are the basic pairs. In painting, placing complementary colours next to each other makes both appear brighter.

Diptych A picture made up of two panels, usually hinged (see column, p.54).

Donor The commissioner of a painting, who in medieval and Renaissance art, is often portrayed within the painting.

En plein air (French: "in the open air") Painting out of doors.

Fetish An object, often sculpted, that was believed to be the embodiment of a spirit.

Foreshortening A technique for depicting an object at an angle to the plane of the picture by making use of perspective so that the object appears shorter and narrower as it recedes.

Fresco The wall-painting technique in which pigment, mixed with water, is applied to a layer of wet plaster. When dry, the wall and the colours are inseparable. This is known as *buon fresco* or true fresco. *Fresco secco* refers to the technique of applying paint to dry plaster.

Genre painting Paintings depicting scenes from daily life.

Grisaille A monochrome painting in shades of grey. Renaissance artists used it to imitate the look of sculptural relief.

Ground A preparatory surface of primer or paint applied to the canvas before painting.

Icon A painting on a panel depicting Christ, the Virgin Mary, or a saint in a traditional Byzantine style.

Immaculate Conception In Christian theology, the doctrine that the Virgin Mary was conceived without the stain of original sin.

Impasto A thick layer of paint.

Intimism A style adopted by a sub-group of the Nabis, in which bourgeois domestic interiors are depicted in an informal and intimate way.

Japonisme The influence of Japan on European art, in particular Impressionist and Post-Impressionist painting.

Maestà (Italian: "majesty") An altarpiece showing the Madonna and Child enthroned and surrounded by saints and angels.

Medium In paint, the vehicle (substance) that binds the pigment – for instance, in oil paint the medium is an oil (poppy oil, etc.); in tempera the medium is egg.

Odalisque A female slave or concubine.

Oil painting Painting in which oils such as linseed, walnut, or poppy are used as the medium binding the pigment.

Painterly The rendering of form by means of colour rather than outline.

Palette-knife pictures Paintings in which the paint is applied and manipulated with a palette knife.

Panel A painting on wood (see column, p.75).

Passion The sufferings of Christ between the Last Supper and His Crucifixion.

Perspective A system of depicting a three-dimensional form on a two-dimensional surface. In linear perspective, objects are depicted in diminishing size and parallel lines converge with increasing distance.

Primary colours The three colours from which all others are derived – red, yellow, and blue.

Scumbling A technique in which a thin layer of paint is unevenly applied over another layer to create a broken effect as areas of the under colour show through.

Sfumato A soft, smoky effect, created by colours and tones overlapping and blending, changing imperceptibly from light to dark (see column, p.116).

Still life A painting or drawing of inanimate objects.

Tempera Paint in which pigment is dissolved in water and mixed with gum or egg yolk.

Tondo A circular painting.

Tooth The irregular texture of a canvas, which enables paint to adhere.

INDEX

Picture Credits

Every effort has been made to trace the copyright holders, and we apologize in advance for any unintentional omissions. We would be pleased to insert the appropriate acknowledgement in any subsequent edition of this publication.

Introduction

1. Altamira cave/Ancient Art and Architecture Collection 2. Lascaux cave/Ancient Art and Architecture Collection 3. Hirmar Fotoarchiv 4. Tomb of Ramose, Thebes/Mary Jellife/Ancient Art and Architecture Collection 5. The Trustees of The British Museum, London 6. The Trustees of The British Museum, London 7. Tomb of Nefermaat, Medum/Ancient Art and Architecture Collection 8. National Archaeological Museum, Athens/Bridgeman Art Library, London 9. Palace of Knossos, Crete/Sonia Halliday Photographs 10. Museo Heraklion, Crete/Scala 11. National Archaeological Museum, Athens 12. Staatliche Antinkensammlung, Munich/Bridgeman Art Library, London 13. Antiken Museum Basel und Sammlung Ludwig/Foto Clare Niggli 14. Colorphoto Hans Hinz 15. Museo Nazionale, Athens/Scala 16. Acropolis Museum, Athens 17. Museo delle Terme, Rome/Scala 18. Archiv für Kunst und Geschichte, Berlin 19. Museo Nazionale, Naples 20. Fratelli Fabbri, Milan/Bridgeman Art Library, London 21. Museo Nazionale, Naples/Scala 22. The Vatican Museum, Vatican/Ancient Art and Architecture Collection 23. Archaeological Museum, Naples/Bridgeman Art Library, London 24. Metropolitan Museum of Art, New York/Bridgeman Art Library, London 25. Museo Nazionale, Naples/Scala 26. Museo Nazionale, Naples 27. The Trustees of the British Museum, London 28. Ancient Art and Architecture Collection 29. Courtauld Institute Galleries, London 30. Catacombe di Priscilla, Rome/Scala 31. San Vitale, Ravenna/Scala 32. Monastery of Saint Catherine, Mount Sinai/Ancient Art and Architecture Collection 33. Duomo, Monreale/Scala 34. Gallerie Statale Trat'Jakov, Moscow/Scala 35. Gallerie Statale Trat'Jakov, Moscow/ Bridgeman Art Library, London 36. Museu Nacional d'Art de Catalunya/Calveras/Sagrista 37. By permission of The British Library, London 38. The Board of Trinity College, Dublin 39. The British Library, London/Bridgeman Art Library, London 40. The Board of Trinity College, Dublin 41. By permission of The British Library, London 42. By permission of The British Library, London 43. Bibliothéque Nationale, Paris 44. City of Bayeux/Bridgeman Art Library, London 45. By Courtesy of the Board of Trustees of the V&A, Victoria and Albert Museum, London 46. Österreichische Nationalbibliothek, Vienna 47. The Trustees of The British Museum, London 48. S. Cecilia Trastevere, Rome/Scala

Gothic

49. Bibliotheque Nationale, Paris/Bridgeman Art Library, London 50. Saint Chapelle, Paris/Sonia Halliday Photographs 51. Uffizi, Florence/Scala 52. Museo dell'Opera Metropolitana, Siena/Scala 53. Museo dell'Opera Metropolitana/Scala 54. Samuel H Kress Collection, National Gallery of Art, Washington DC 55. Samuel H Kress Collection, National Gallery of Art, Washington, DC 56. Scrovegni Chapel, Padua/Scala 57. Scrovegni Chapel, Padua/Scala 58. Uffizi, Florence/Scala 59. Samuel H Kress Collection, National Gallery of Art, Washington, DC 60. Walker Art Gallery, Liverpool/Board of Trustees of the National Museums and Galleries on Merseyside 61. Courtesy of Board of Trustees The National Gallery, London 62. Palazzo Publico, Siena/Scala 63. Louvre, Paris/Bridgeman Art Library, London 64. Courtesy of Board of Trustees The National Gallery, London 65. Musée Conde, Chantilly/Giraudon/Bridgeman Art Library, London 66. Musée Conde, Chantilly/Giraudon/Bridgeman Art Library, London 67. Uffizi, Florence/Scala 68. Louvre, Paris/©Photo Ph.Sebert 69. Courtesy of Board of Trustees The National Gallery, London 70. Bibliotheque Nationale, Paris/Courtauld Institute Galleries, London 71. National Gallery of Art, Washington, DC 72. Musée des Beaux Arts, Dijon 73. Courtesy of Board of Trustees The National Gallery, London 74. Courtesy of Board of Trustees The National Gallery, London 75. Samuel H Kress Collection, National Gallery of Art, Washington, DC 76. Cathedral of St Bavo, Ghent/Giraudon/Bridgeman Art Library, London 77. Andrew W. Mellon Collection, National Gallery of Art, Washington, DC 78. Courtesy of Board of Trustees The National Gallery, London 79. Louvre, Paris/Giraudon 80. By Permission of Birmingham Museum and Art Gallery 81. Museo del Prado, Madrid 82. Andrew W. Mellon Collection, National Gallery of Art, Washington, DC 83. Uffizi, Florence/Scala 84. Andrew W. Mellon Collection, National Gallery of Art, Washington, DC 85. Courtesy of Board of Trustees The National Gallery, London 86. Andrew W. Mellon Collection, National Gallery of Art, Washington, DC 87. Museu Nacional de Arte Antiga, Lisbon/Bridgeman Art Library, London 88. Louvre, Paris/© Photo Ph.Sebert 89. Louvre, Paris/© Photo Ph.Sebert 90. Samuel H Kress Collection, National Gallery of Art, Washington, DC 91. Colmar/Bridgeman Art Library, London 92. Samuel H. Kress Collection, National Gallery of Art, Washington, DC

Italian Renaissance

93. Courtesy of Board of Trustees The National Gallery, London 94. Branacci Chapel, Florence/Scala 95. Santa Maria Novella, Florence/Scala 96. Chiesa del Carmine, Florence/Scala 97. Andrew W. Mellon Collection, National Gallery of Art, Washington, DC 98. Courtesy of Board of Trustees The National Gallery, London 99. National Gallery London 100. Samuel H. Kress Collection, National Gallery of Art, Washington, DC 101. Courtesy of Board of Trustees The National Gallery, London 102. Ashmolean Museum, Oxford 103. © Louvre, Paris/Photo Ph.Sebert 104. Museo di Marco, Florence/Scala 105. © Photo Ph. Sebert, Louvre 106. Courtesy of Board of Trustees The National Gallery, London 107. Samuel H Kress Collection, National Gallery of Art, Washington, DC 108. Courtesy of Board of Trustees The National Gallery, London 109. Uffizi, Florence/Scala 110. Uffizi, Florence/Scala 111. Andrew W. Mellon Collection, National Gallery of Art, Washington, DC 112. Samuel H. Kress Collection, National Gallery of Art, Washington, DC 113. Samuel H. Kress Collection, National Gallery of Art Washington, DC 114. Courtesy of Board of Trustees The National Gallery, London 115. San Francesco, Arezzo/Scala 116. Pinacoteca Communale Sansepolcro/Scala 117. Museo del Prado, Madrid 118. Samuel H. Kress Collection, National Gallery of Art, Washington, DC 119. The National Gallery of Ireland, Dublin 120. Photo Richard Carafetti, Widener Collection, National Gallery of Art, Washington, DC 121. Courtesy of Board of Trustees The National Gallery, London 122. Courtesy of Board of Trustees The National Gallery, London 123. Courtesy of Board of Trustees The National Gallery, London 124. Samuel H. Kress Collection, National Gallery of Art, Washington, DC 125. Widener Collection, National Gallery of Art, Washington, DC 126. Courtesy of Board of Trustees The National Gallery, London 127. Galleria Nazionale della Sicilia, Parma/Scala 128. Samuel H. Kress Collection, National Gallery of Art, Washington, DC 129. Samuel H. Kress Collection, National Gallery of Art, Washington, DC 130. Samuel H. Kress Collection, National Gallery of Art, Washington, DC 131. Samuel H. Kress Collection, National Gallery of Art, Washington, DC 132. Ailsa Mellon Bruce Fund, National Gallery of Art, Washington, DC 133. Andrew W. Mellon Collection, National Gallery of Art, Washington, DC 134. Accademia, Venice/Scala 135. Uffizi, Florence/Scala 136. Louvre, Paris/© Photo Ph.Sebert 137. Czartorisky Museum, Krakow/Scala 138. Ailsa Mellon Bruce Fund, National Gallery of Art, Washington, DC 139. Courtesy of Board of Trustees The National Gallery, London 140. Andrew W. Mellon Collection, National Gallery of Art, Washington, DC 141. Santa Maria Novella, Florence/Scala 142. Uffizi, Florence/Scala 143. Sistine Chapel, Vatican/© Nippon Television Network Corporation 1994 144. Sistine Chapel, Vatican/© Nippon Television Network Corporation 1994 145. Sistine Chapel, Vatican/Scala 146. Sistine Chapel, Vatican/© Nippon Television Network Corporation 1994 147. Andrew W. Mellon Collection, National Gallery of Art Washington DC 148. Andrew W Mellon Collection, National Gallery of Art, Washington, DC 149. Photo José Naranjo, Widener Collection, National Gallery of Art, Washington, DC 150. Andrew W. Mellon Collection, National Gallery of Art, Washington, DC 151. Samuel H. Kress Collection, National Gallery of Art, Washington, DC 152. Stanze di Raffaello, Vaticano/Scala 153. Accademia, Venice/Scala 154. Kunsthistorisches Museum, Vienna 155. Samuel H. Kress Collection, National Gallery of Art, Washington DC 156. Courtesy of Board of Trustees The National Gallery, London 157. Samuel H. Kress Collection, National Gallery of Art, Washington, DC 158. Widener Collection, National Gallery of Art, Washington, DC 159. Samuel H. Kress Collection, National Gallery of Art, Washington, DC 160. San Giorgio Maggiore, Venice/Scala 161. Samuel H. Kress Collection, National Gallery of Art, Washington, DC 162. Samuel H. Kress Collection, National Gallery of Art, Washington, DC 163. Samuel H. Kress Collection, National Gallery of Art, Washington, DC 164. Andrew W. Mellon Collection, National Gallery of Art, Washington, DC 165. Uffizi, Florence/Scala 166. Santa Felicità, Florence/Scala 167. Courtesy of Board of Trustees The National Gallery, London 168. Samuel H. Kress Collection, National Gallery of Art, Washington, DC 169. Samuel H. Kress Collection, National Gallery of Art, Washington, DC 170. Courtesy of Board of Trustees The National Gallery, London 171. Samuel H. Kress Collection, National Gallery of Art, Washington, DC 172. Louvre, Paris/© Photo Ph.Sebert 173. Uffizi, Florence/Scala 174. Samuel H. Kress Collection, National Gallery of Art, Washington, DC 175. Samuel H. Kress Collection, National Gallery of Art, Washington, DC 176. Pinacoteca Nazionale, Siena/Scala 177. Widener Collection, National Gallery of Art, Washington, DC 178. Samuel H. Kress Collection, National Gallery of Art, Washington, DC

Northern Renaissance

179. Museo del Prado, Madrid 180. Samuel H. Kress Collection, National Gallery of Art, Washington, DC 181. Blauel/Gnamm Artothek, München Alte Pinakothek 182. Courtesy of Board of Trustees The National Gallery, London 183. Gift of Clarence Y. Palitz, National Gallery of Art, Washington, DC 184. Ralph and Mary Booth Collection, National Gallery of Art, Washington, DC 185. Samuel H. Kress Collection, National Gallery of Art, Washington, DC 186. National Gallery of Art, Washington, DC 187. Courtesy of Board of Trustees The National Gallery, London 188. Kunstmuseum, Basel/Colorphoto Hans Hinz 189. Andrew W. Mellon Collection, National Gallery of Art, Washington, DC 190. Ailsa Mellon Bruce Fund, National Gallery of Art, Washington, DC 191. Joachim Blauel, Artothek/München Alte Pinakothek 192. Louvre, Paris/© Photo Ph.Sebert 193. Louvre, Paris/© Photo Ph.Sebert 194. Courtesy of Board of Trustees The National Gallery, London 195. Kunsthistorisches Museum, Vienna 196. Museo del Prado, Madrid 197. Courtesy of Board of Trustees The National Gallery, London 198. Blauel/Gnamm Artothek/München Alte Pinakothek 199. Kunsthistorisches Museum, Vienna 200. Kunsthistorisches Museum, Vienna 201. Kunsthistorisches Museum, Vienna 202. Kunsthistorisches Museum, Vienna

Baroque and Rococo

203. Hermitage, St. Petersburg/Scala 204. Uffizi, Florence/Scala 205. Louvre, Paris/RMN, Paris 206. Courtesy of Board of Trustees The National Gallery, London 207. Ailsa Mellon Bruce Fund, National Gallery of Art, Washington, DC 208. The Royal Collection, Kensington Palace, London/© Her Majesty The Queen 209. Uffizi, Florence/Scala 210. Courtesy of Board of Trustees The National Gallery, London 211. Doria Pamphili Gallery, Rome/Scala 212. Courtesy of Board of Trustees The National Gallery, London 213. Courtesy of Board of Trustees The National Gallery, London 214. Courtesy of Board of Trustees The National Gallery, London 215. Louvre, Paris/RMN 216. By Permission of Governors of Dulwich Picture Gallery 217. Antwerp Cathedral/Visual Arts Library 218. Andrew W. Mellon Fund, National Gallery of Art, Washington, DC 219. Louvre, Paris/RMN, Paris 220. Courtesy of Board of Trustees The National Gallery, London 221. Louvre, Paris/© Photo Ph. Sebert 222. Samuel H. Kress Foundation, National Gallery of Art, Washington, DC 223. Widener Collection, National Gallery of Art, Washington, DC 224. Louvre, Paris/© Photo Ph. Sebert, Louvre 225. Musée Royaux des Beaux Arts du Belgique, Brussels 226. Museo del Prado, Madrid 227. Museo del Prado, Madrid 228. Museo del Prado, Madrid 229. Museo del Prado, Madrid 230. Collection Contini

Annalee Newman insofar as her rights are concerned" National Gallery of Art, Washington, DC **432.** Visual Arts Library, London/ Museum of Modern Art, New York/© Robert Motherwell/DACS, London/VAGA New York **433.** Gift (Partial and Promised) of Mr. and Mrs. Donald M. Blinken, in Memory of Maurice H. Blinken and in honor of the 50th anniversary of the National Gallery of Art, Washington, DC **434.** Anonymous Gift, National Gallery of Art, Washington, DC **435.** Gift of Marcella Louis Brenner, National Gallery of Art, Washington, DC **436.** The Carnegie Museum of Art, The Henry L. Hillman Fund in honor of the Sarah Scaife Gallery **437.** Tate Gallery, London/The Pace Gallery **438.** Tate Gallery, London/© 1994 Frank Stella/ Artists © 1984 **439.** © Dorothea Rockburne/Artists' Rights Society (ARS), New York **440.** The Pace Gallery/Des Moines Art Center **441.** Tate Gallery, London/The Andy Warhol Foundation for the Visual Arts Inc. **442.** Tate Gallery, London/© Roy Lichtenstein/DACS 1994 **443.** Tate Gallery, London/© Jasper Johns/DACS, London/ VAGA, New York, 1994 **444.** Tate Gallery, London/Tradhart Ltd **445.** The Sonnabend Collection, New York/© Robert Rauschenberg/DACS, London/ VAGA, New York, 1994 **446.** Provenance: Fundaçion Collection Thyssen Bornemisza/ © DACS 1994 **447.** Staatliche Museen zu Berlin – Preussischer Kulturbesitz, Nationalgalerie **448.** Tate Gallery, London/ Anthony d'Offay Gallery **449.** Tate Gallery, London/ Marlborough, Fine Art, London **450.** Whitechapel Gallery, London **451.** Tate Gallery, London/Private Collection **452.** Tate Gallery, London/Derneburg **453.** Gimpel Fils, London **454.** Robert Miller Gallery, New York **455.** Courtesy of England and Co Gallery, London

ACKNOWLEDGMENTS
Dorling Kindersley would like to thank:
Colin Wiggins for reading the manuscript; Frances Smythe at the National Gallery of Art, Washington, DC; Miranda Dewar at Bridgeman Art Library; Gillian M. Walkley and David Stirling-Wylie; Julia Harris-Voss and Jo Walton; Simon Hinchcliffe, Tracy Hambleton-Miles, Tina Vaughan, Kevin Williams, Sucharda Smith, Zirrinia Austin, Samantha Fitzgerald, and Kirstie Hills.

SIDE COLUMN PICTURE CREDITS

40. *t* Giraudon; *b* © Sonia Halliday and Laura Lushington
41. *t* Photo © Woodmansterne; *b* Courtauld Institute Galleries, London
42 Giraudon/Bridgeman Art Library, London
43. © William Webb
44. Mary Evans Picture Library
46. Courtauld Institute Galleries, London
47. *t* Scala; *b* The Mansell Collection
48. *t* Bridgeman Art Library, London; *b* Scala
51. *t* Courtauld Institute Galleries, London; *b* Biblioteca Ambrosiana, Milan/Bridgeman Art Library, London
53. Courtauld Institute Galleries, London
54. Bibliotheque Nationale Paris/Bridgeman Art Library, London
55. *t* Bibliotheque Nationale, Paris/Bridgeman Art Library, London; *b* Mary Evans Picture Library
57 National Gallery of Art, Washington, DC
58. Osterreichische National-bibliothek, Vienna/Bridgeman Art Library, London
59 By Permission of The British Library, London/Bridgeman Art Library, London
60 © William Webb
61 © Michael Holford
63. Giraudon/Bridgeman Art Library, London
64. © Bibliotheque Royale Albert 1er Bruxelles
66 "Courtesy of the Board of Trustees of the V&A"
67. © Bibliotheque Royale Albert 1er Bruxelles
68. By Permission of The British Library, London /Bridgeman Art Library, London
70. *t* © DK; *b* Courtauld Institute Galleries, London/ Memling Museum, Bruges
71. *t* Staatsarchiv/Bridgeman Art Library, London; *b* © Christopher Johnston
73. Bibliotheque Nationale, Paris/Sonia Halliday Photographs
75. *t* Bridgeman Art Library, London; *b* Picture Book of Devils, Demons, and Witchcraft by Ernst and Johanna Lehnen/Dover Book Publications Inc, New York
76. Lauros/Giraudon
82. Scala
83. Museo Nazionale (Bargello), Florence/Bridgeman Art Library, London
85. Phillip Gatward © DK
87. Bargello/Scala
88. The Trustees of The British Museum, London
89. Gabinetto dei Disegni e delle Stanipe/Scala
91. Sp Alison Harris/Museo dell' Opera del Duomo
93. J. Paul Getty Museum, Malibu California/Bridgeman Art Library, London
94. Courtesy of Board of Trustees The National Gallery, London
95. Dover Publications Inc, New York
97. Uffizi/Scala
98. The Trustees of The British Museum, London
99. *t* Museo del Bargello/Scala; *b* Ashmolean Museum, Oxford
100. *t* Bridgeman Art Library,

London; *b* Pinacoteca Communale Sansepolcro/Scala
102. Sp Alison Harris/ Museo dell'Opera del Duomo
103. Scala
104 *t* Bridgeman Art Library, London; *b* Giraudon/Bridgeman Art Library, London
105. Sp Alison Harris/Palazzo Vecchio, Florence
106 © DK
107. The Trustees of The British Museum, London
108. Chiesa di Ognissanti/Scala
110 National Gallery, London/ Bridgeman Art Library, London
111. Fratelli Fabri, Milan/ Bridgeman Art Library, London
114. Courtauld Institute Galleries, London
116. Campo. S. Zanipolo, Venice/Scala
118. *t* Bulloz, Institute de France; *b* Mary Evans Picture Library
120. Sp Alison Harris/ Palazzo Vecchio, Florence
121. National Gallery of London/Bridgeman Art Library, London
124. Accademia, Firenze/Scala
125. Germanisches National Museum
126. Uffizi/Scala
129. Giraudon/Bridgeman Art Library, London
130. "By Courtesy of the Board of Trustees of the V&A"
131. Museo del Prado, Madrid
133. *t* Dover Book Publications Inc, New York, Pictorial Archives: Decorative Renaissance Woodcuts, Jost Amman; *b* The Trustees of The British Museum, London/Bridgeman Art Library, London
134. Sp Alison Harris/Palazzo Vecchio, Florence
135. San Giorgio Maggiore, Venezia/Scala
143. *t* "By Courtesy of the board of Trustees of the V&A"; *b* Ali Meyer/Bridgeman Art Library, London
144. Appartemento Borgia, Vaticano/Scala
146. Museo della Scienza, Firenze/Scala
153. Picture Book of Devils, Demons and Witchcraft by Ernst and Johanna Lehnen /Dover Publications Inc, New York
154. *t* © Wim Swann; *b* Universität Bibliothek, Basel
156. Museo Poldi Pezzoli, Milan/ Bridgeman Art Library, London
159. Museum der Stadt, Regensburg/Bridgeman Art Library, London
160. Reproduced Courtesy of the National Gallery, London
161. *t* "By Courtesy of the Board of Trustees of the V&A"; *b* Giraudon/Bridgeman Art Library, London
164. The Bowes Museum, Barnard Castle, County Durham
165. *t* "By Courtesy of the Board of Trustees of the V&A"/ Bridgeman Art Library, London; *b* Mary Evans Picture Library
166. Mary Evans Picture Library
169. Mary Evans Picture Library
171. Picture Book of Devils, Demons and Witchcraft by Ernst and Johanna Lehnen/Dover Publications Inc, New York
176. Santa Maria della Vittore, Rome/Scala
180. Museum Boymans Van

Beuningen, Rotterdam/ Bridgeman Art Library, London
182. Accademia, Venice/Scala
187. Mary Evans Picture Library
190. Mary Evans Picture Library
191. Mary Evans Picture Library
193. Index/Bridgeman Art Library, London
194. Joseph Martin/Bridgeman Art Library, London
197. Index/Bridgeman Art Library, London
203. Rembrandt Etchings/Dover Publications Inc, New York
208. Fitzwilliam Museum, University of Cambridge/Bridgeman Art Library, London
210. Science Museum, London
215. *t* Mary Evans Picture Library; *b* The Trustees of The British Museum, London
216. Giraudon/Bridgeman Art Library, London
218. Mary Evans Picture Library
222. © DK
223. *t* Mary Evans Picture Library; *b* Mary Evans Picture Library
230. Bonham's, London/ Bridgeman Art Library, London
231. "By Courtesy of the Board of Trustees of the V&A"
233. Tiepolo/Dover Publications Inc, New York
235. Engravings By Hogarth/ Dover Publications Inc, New York
240. Hanley Museum and Art Gallery, Birmingham
245 Victoria and Albert Museum/Bridgeman Art Library, London
246. Mary Evans Picture Library
248. *t* Casa Natal de Goya Fuendetodos; *b* Mary Evans Picture Library
249. *t* © DK Museo Municipal, Madrid; *b* Real Fabrica de Tapices, Madrid
250. *t* Calcografia Nacional, Madrid; *b* Mary Evans Picture Library
252. Real Academia de Bellas Ares de San Fernando, Madrid
254. Giraudon/Bridgeman Art Library, London
255. *t* Bibliotheque Nationale, Paris; *b* Mary Evans Picture Library
258. *t* Lauros-Giraudon/ Bridgeman Art Library, London; *b* Christies, London/Bridgeman Art Library, London
259. Mary Evans Picture Library
262. *t* Mary Evans Picture Library; *b* Musée Condé, Chantilly/Giraudon
264. Mary Evans Picture Library
266. National Portrait Gallery, London
268. Bridgeman Art Library, London/John Bethell
269. Mary Evans Picture Library
270. Library of Congress, Washington, DC/Bridgeman Art Library, London
277. Reproduced by courtesy of the Dickens House Museum, London
278. "By Courtesy of the Board of Trustees of the V&A"
279. Bibliotheque Nationale, Paris
280. 120 Great Lithographs of Daumier/Dover Publications Inc, New York
281. Giraudon, Paris
282. Bibliotheque Nationale, Paris
284. *t* © DK; *b* Bibliotheque Nationale, Paris

285. Bibliotheque Nationale, Paris
286. *t* Giraudon, Paris/Bridgeman Art Library, London; *b* Bibliotheque Nationale, Paris
287. Musée d'Orsay/Sp A. Harris
289. Bibliotheque Nationale, Paris
290. By Permission of The British Library/Bridgeman Art Library, London
291. *t* Edifice; *b* Bibliotheque Nationale, Paris
292. *t* Musée d'Orsay, Paris/ Sp. Ph.Sebert; *b* Musée d'Orsay, Paris/ Sp Ph.Sebert
293. Musée Francais de La Photographie Fond et Anime Depuis 1960 par Jean et André Fage/Photo Sp A.Harris
295. Musée d'Orsay/Sp Alex Saunderson
296. Sp Alex Saunderson, Replica of Monet's floating studio, built for the Société d'Economie Mixte d'Argenteuil-Bezons by the Charpentiers de Marine du Guip, en L'ile-aux-Moines (Morbihan) for Monet's 150th anniversary
300. Musée Marmottan Sp S.Price
301. Bibliotheque Nationale, Paris
303. By Courtesy of the Board of Trustees of the National Portrait Gallery, London
304. Mary Evans Picture Library
305. Mary Evans Picture Library
311. Photo: Alice Boughton/By Courtesy of the Board of Trustees of the National Portrait Gallery, London
312. Photo: Alison Harris
315. © DK
318. Musée d'Orsay, Paris/Photo Sp Ph.Sebert
320. Bibliotheque Nationale, Paris
321. *t* Private Collection; *b* Musée d'Orsay, Paris/Photo Sp Ph.Sebert
322. Collection Josefowitz
324. Musée d'Orsay, Paris/ Sp. S. Price
327. © Photo RMN
328. Bibliotheque de L'Institute de France/Sp Alison Harris
329. Photo RMN
334. Robert and Lisa Sainsbury Collection, Sainsbury Center For Visual Arts, University of East Anglia, Norwich/Photo James Austin
337. Musée Matisse, Nice
338. Explorer Archives
341. Mary Evans Picture Library
342. © Collection Viollet
353. Archiv für Kunst und Geschichte, Berlin
354. Museum of the Revolution, Moscow/Bridgeman Art Library, London
356. Archiv für Kunst und Geschichte, Berlin
362. © Collection Viollet
363. © Hurn/Magnum
364. BFI Stills, Posters and Designs
368. Horniman Museum
374. Mary Evans Picture Library
380. Hulton Deutsch Collection
382. Hulton Deutsch Collection
384. John Minilan Photo, Hulton Deutsch Collection
386. Hulton Deutsch Collection

SOCIAL
PSYCHOLOGY

FOURTH EDITION

SOCIAL PSYCHOLOGY

David G. Myers

Hope College
Holland, Michigan

McGRAW-HILL, INC.
New York St. Louis San Francisco Auckland Bogotá Caracas Lisbon London
Madrid Mexico Milan Montreal New Delhi
Paris San Juan Singapore Sydney Tokyo Toronto

SOCIAL PSYCHOLOGY

Acknowledgments appear on pages 653–656, and on this page by reference.

5 6 7 8 9 0 DOW DOW 9 0 9 8 7 6 5 4

ISBN 0-07-044292-4

This book was set in Palatino by York Graphic Services, Inc.
The editors were Jeannine Ciliotta, Christopher Rogers, and James R. Belser;
the designer was Wanda Siedlecka;
the production supervisor was Leroy A. Young
Cover photo and part opener photos by André Baranowski.
The photo editor was Elyse Rieder.
New drawings were done by Vantage Art.
R.R. Donnelley & Sons, Inc., was printer and binder.

This book is printed on acid-free paper.

Library of Congress Cataloging-in-Publication Data

Myers, David G.
 Social psychology / David G. Myers. —4th ed.
 p. cm.
 Includes bibliographical references and index.
 ISBN 0-07-044292-4
 1. Social psychology. I. Title.
HM251.M897 1993
302—dc20
 92-16358

INTERNATIONAL EDITION

When ordering this title, use ISBN 0-07-112718-6

ABOUT THE AUTHOR

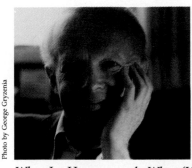

DAVID G. MYERS is the John Dirk Werkman Professor of Psychology at Michigan's Hope College, where he has taught for 25 years and been voted "Outstanding Professor" by students. Myers' love of teaching psychology is evident in his writing for the lay public. He has written for many magazines, including *Saturday Review, Psychology Today,* and *Today's Education,* and has authored or co-authored nine books, most recently, *The Pursuit of Happiness: Who Is Happy—and Why* (William Morrow, 1992).

Also an award-winning researcher, Dr. Myers received the Gordon Allport Prize from Division 9 of the American Psychological Association for his work on group polarization. His scientific articles have appeared in more than two dozen journals, including *Science, American Scientist,* and *Psychological Bulletin.* He has served his discipline as consulting editor to the *Journal of Experimental Social Psychology* and the *Journal of Personality and Social Psychology.*

In his spare time he has chaired his city's Human Relations Commission, helped found a Community Action center which assists poverty-level families, and spoken to numerous collegiate and religious groups. David and Carol Myers are parents of sons ages 26 and 22 and a 15-year-old daughter.

CONTENTS IN BRIEF

CONTENTS

PART III ■ SOCIAL RELATIONS 373

CHAPTER 14 ALTRUISM: HELPING OTHERS 503

CHAPTER 15 CONFLICT AND PEACEMAKING 543

GLOSSARY 583

PREFACE

In all of recorded history, human social behavior has been scientifically studied for just one century—our century. Considering that we have barely begun, the results are gratifying. We have amassed significant insights into belief and illusion, love and hate, conformity and independence. Much about human behavior remains a mystery, yet social psychology can now offer partial answers to many intriguing questions: Will people act differently if we can first persuade them to adopt new attitudes? If so, how can we best persuade them? What leads people sometimes to hurt and sometimes to help one another? What kindles social conflict, and how can we transform closed fists into helping hands? Answering such questions expands our self-understanding and sensitizes us to the social forces at work upon us.

When first invited to write this book I envisioned a text that would be at once solidly scientific and warmly human, factually rigorous and intellectually provocative. It would reveal social psychology as an investigative reporter might, by providing an up-to-date summary of important social phenomena, and of how scientists uncover and explain such phenomena. It would be reasonably comprehensive, yet would also stimulate students' *thinking*—their readiness to inquire, to analyze, to relate principles to everyday happenings.

How does one select material for inclusion in a "reasonably comprehensive" introduction to the discipline? I have sought to present theories and findings that are neither too esoteric for the typical undergraduate nor better suited to other courses, such as developmental and personality psychology. I have chosen instead to emphasize material that casts social psychology in the intellectual tradition of the liberal arts. By the teaching of great literature, philosophy, and science, liberal education seeks to expand our thinking and awareness and to liberate us from the confines of the present. Social psychology can contribute to these goals. Many undergraduate social psychology students are not psychology majors; virtually all will enter other professions. By focusing on humanly significant issues, one can present the fundamental content that preprofessional psychology students need in ways that are stimulating and useful to all students.

The book opens with a single chapter that introduces our methods of inquiry. The chapter also warns students how findings can seem obvious—once you know them—and how social psychologists' own values permeate the discipline. The intent is to give students just enough to prepare them for what follows.

The book then unfolds around its definition of social psychology: the scientific study of how people *think about* (Part One), *influence* (Part Two), and *relate* (Part Three) to one another.

Part One on *social thinking* examines how we view ourselves and others. For example, Chapter 3 introduces attribution theory and then looks in greater depth at three intellectually provocative concepts: the fundamental attribution error, the self-serving bias, and the benefits of self-efficacy.

Part Two explores *social influence.* By appreciating the cultural sources of our attitudes and by learning the nature of conformity, persuasion, and group influence, we can better recognize subtle social forces at work upon us.

Part Three considers the attitudinal and behavioral manifestations of both negative and positive *social relations.* It flows from prejudice to aggression, and from attraction to altruism, and concludes by exploring the dynamics of conflict and peacemaking.

Applications of social psychology are both interwoven throughout every chapter and highlighted with the applied chapter that concludes each section. For example, one such chapter, "Social Cognition and Human Well-Being," includes material on social psychology's contribution to the study of health.

This edition, like its predecessors, has a multicultural emphasis that can be seen in the thoroughly revised treatment of cultural influences in Chapter 6 and throughout the book in the inclusion of research from various cultural settings. The focus remains the same: the fundamental principles of social thinking, social influence, and social relations as revealed by careful empirical research. But these principles are more and more illustrated transnationally, thereby broadening our awareness of the whole human family.

The book is again thoroughly updated, with 600 new citations. There are fresh "Behind the Scenes" personal reflections by selected investigators. And there have been countless abbreviations of old material to accommodate these new features.

This edition is also the most painstaking revision to date. From cover to cover, the writing has been strengthened with crisper narrative and a more consistent use of the active voice. Believing with Thoreau that "Anything living is easily and naturally expressed in popular language," I have sought, paragraph by paragraph, to craft the most engaging and effective book possible. A bright new four-color design complements the text revisions and enhances the impact of the photos and figures. As before, definitions of key terms appear both in the margins and in the end-of-book Glossary.

Social Psychology, fourth edition, is accompanied by a comprehensive teaching-learning package. Martin Bolt's acclaimed *Teacher's Resource Manual* contains a wealth of classroom ideas, including dozens of ready-to-use demonstrations. For many students, the most helpful supplement to this text will be Bolt's *Study Guide,* which provides chapter objectives, chapter reviews, practice tests, and ideas and resources for papers. Ann Weber has again provided a carefully developed test-item file of over 1500 basic knowledge and application items. Computerized versions of the Test Item File are available for IBM-

compatible (5.25″ and 3.5″ disk sizes) and for Macintosh PCs. New to this edition is a set of overhead transparencies, many in full color. These acetates are taken from a number of sources, including the text.

In collaboration with Allen Funt and Philip Zimbardo, McGraw-Hill has developed *Candid Camera Classics in Social Psychology,* a videodisk (also available on videotape) that contains fifteen 3- to 5-minute clips from the original "Candid Camera" shows. Arranged to complement the text's organization, the videodisk is accompanied by an Instructor's Manual/Viewer's Guide and can enrich and stimulate classroom discussion. For more information about any of these supplements, contact your local McGraw-Hill representative.

■ IN APPRECIATION

Although only one person's name appears on this book's cover, the truth is that a whole community of scholars has invested itself in it. Although none of these people should be held responsible for what I have written—nor do any of them fully agree with everything said—their suggestions made this a better book than it could otherwise have been.

This new edition still retains many of the improvements contributed by consultants and reviewers on the first three editions. To the following esteemed colleagues I therefore remain indebted: Robert Arkin, Ohio State University; Susan Beers, Sweet Briar College; George Bishop, University of Texas at San Antonio; Martin Bolt, Calvin College; Dorothea Braginsky, Fairfield University; Russell Clark, Florida State University; Jack Croxton, State University of New York at Fredonia; Anthony Doob, University of Toronto; Philip Finney, Southeast Missouri State University; William Froming, Pacific Graduate School of Psychology; Stephen Fugita, Santa Clara University; Ranald Hansen, Oakland University; Elaine Hatfield, University of Hawaii; Bert Hodges, Gordon College; William Ickes, University of Missouri at St. Louis; Marita Inglehart, University of Michigan; Chester Insko, University of North Carolina; Edward Jones, Princeton University; Judi Jones, Georgia Southern College; Martin Kaplan, Northern Illinois University; Janice Kelly, Purdue University; Douglas Kenrick, Arizona State University; Norbert Kerr, Michigan State University; Charles Kiesler, Vanderbilt University; David McMillen, Mississippi State University; Arthur Miller, Miami University; Teru Morton, Vanderbilt University; Darren Newtson, University of Virginia; Chris O'Sullivan, Bucknell University; Paul Paulus, University of Texas at Arlington; Nicholas Reuterman, Southern Illinois University at Edwardsville; Linda Silka, University of Lowell; Royce Singleton, Jr., College of the Holy Cross; Stephen Slane, Cleveland State University; Mark Snyder, University of Minnesota; Garold Stasser, Miami University; Homer Stavely, Keene State College; Elizabeth Tanke, University of Santa Clara; William Titus, Briarcliff College; Tom Tyler, Northwestern University; Rhoda Unger, Montclair State College; Billy Van Jones, Abilene Christian College; Mary Stewart Van Leeuwen, Calvin College; Ann Weber, University of North Carolina at Asheville; Gary Wells, Iowa State University; Bernard Whitley, Ball State University; Kipling Williams, University of Toledo; and Midge Wilson, DePaul University.

This fourth edition additionally benefitted from cover-to-cover reviews, offering countless constructive suggestions by David A. Gershaw, Arizona Western College; Mary Alice Gordon, Southern Methodist University; James L. Hilton, University of Michigan; Robert Millard, Vassar College; Scott Plous, Wesleyan University; and Ann L. Weber, University of North Carolina at Asheville. I am indebted to each of these colleagues.

Hope College, Michigan, and the University of St. Andrews, Scotland, have been wonderfully supportive of these successive editions. Both the people and the environment provided by these two institutions have helped make the gestation of *Social Psychology* a pleasure. At Hope College, poet-essayist Jack Ridl helped shape the voice you will hear in these pages, and Kathy Adamski has again contributed her good cheer along with her secretarial excellence. Phyllis and Rick Vandervelde assisted the extensive recrafting of this new edition by preparing each of the successive drafts with their usual skill and efficiency. Michelle Nainys provided excellent editorial assistance and prepared the name index.

Were it not for the inspiration of Nelson Black of McGraw-Hill, it never would have occurred to me to write a textbook. Alison Meersschaert guided and encouraged the formative first edition. Editor Jeannine Ciliotta nurtured this new edition, suggesting numerous revisions and offering thousands of editorial touches along the way. And James Belser has patiently guided the process of converting each of the editions from manuscript into finished book.

To all in this supporting cast, I am indebted. Working with all these people has made the creation of this book a stimulating, gratifying experience.

DAVID G. MYERS

SOCIAL
PSYCHOLOGY

INTRODUCING SOCIAL PSYCHOLOGY

If we are interested in people, and most of us are, we can study the physical evidence of how humans live and have lived. We can also focus on a less tangible part of us—why we think, feel, and act as we do. Social psychology helps provide that focus, by asking questions that intrigue us all, questions like these:

Is What You See in Fact What You Get? To find out if preconceptions affect our judgment of others' behavior, Stanley Milgram (1992) created "cyranoids"—people who, like the character under the influence of Cyrano de Bergerac in a play of the same name, echo someone else's thoughts. Unwitting people would meet and talk with a child. The child, who had a wireless receiver in the ear, merely echoed remarks made by Milgram, who was eavesdropping from the next room. In one study, high school teachers interviewed two boys, 11 and 12 years old. The teachers were asked to probe the limits of the boys' knowledge so they could recommend them for appropriate grade placement.

The boys impressed the teachers. But did the teachers realize they were actually talking with a brilliant scholar? Milgram noted:

> The opinions teachers formed of our child cyranoids depended as much on the teacher as on the child, and the questions asked and avoided. Teachers varied in how they approached their questions, the best of them allowing the cyranoids' responses to guide their interview, the worst never seeing beyond the possibilities of an average 11-year-old.
>
> Moreover, we see how general preconceptions did not allow the teachers to get anywhere near the appropriate grade level of the cyranoid in some subjects. After all, to assign a Ph.D. to a 10th-grade class of social studies does no great honor to his Harvard degree. . . . As the source, I was hoping they would ask the cyranoid about Freud, Jung, Adler, or at least Darwin and Wittgenstein, but some teachers stuck to fractions and parts of speech.

These results make one wonder: How vulnerable are you and I to others' misjudgments? And what determines our own impressions, of ourselves and of others?

Are Ten Heads Dumber Than One? In the early 1960s, President John F. Kennedy made decisions aided by a bright and loyal group of advisers. One of their first major decisions was to approve a Central Intelligence Agency plan to invade Cuba. The group's high morale fostered a sense that the plan couldn't fail. Because no one sharply disagreed with the idea, there appeared to be consensus support for the plan. The result, however, was a fiasco. The small band of U.S.-trained and -supplied invaders, all Cubans who had fled the Castro regime, was easily captured and soon linked to the American government, causing Kennedy to wonder aloud, "How could we have been so stupid?" Reflecting on the decision making in his book *A Thousand Days*, Arthur Schlesinger, a member of Kennedy's inner circle, reproached himself "for having kept so silent in the cabinet room. I can only explain my failure to do more than raise a few timid questions by reporting that one's impulse to blow the whistle on this nonsense was simply undone by the circumstances of the discussion" (1965, p. 255).

Again, we wonder: How are we affected by our participation in groups? Broadening the question, to what extent and in what ways do other people

influence our attitudes and actions? How can we as individuals resist social pressure? And how does an individual influence a group?

To Help or to Help Oneself? As bags of cash tumbled from an armored truck on a fall day in 1987, $2 million was scattered along a Columbus, Ohio, street. Some motorists who stopped to help returned $100,000. Judging from what disappeared, many more stopped to help themselves. When similar incidents occurred several months later in San Francisco and Toronto, the results were the same: Passersby grabbed most of the money (Bowen, 1988).

Throughout this book, sources for information are cited parenthetically, then fully provided in the reference section that begins on page 587.

What situations trigger people to be helpful or greedy? For that matter, what stimulates us to like or dislike and to be friendly or antagonistic toward others?

Some common threads run through these questions: They all deal with how people view and affect one another. And that is what social psychology is all about. Social psychologists try to answer such questions by using the scientific method. They study attitudes and beliefs, conformity and independence, love and hate. To put it formally, we might say that **social psychology** is *the scientific study of how people think about, influence, and relate to one another.*

Social psychology:
The scientific study of how people think about, influence, and relate to one another.

Social psychology is still a young science. We keep reminding people of this, partly as an excuse for our incomplete answers to some of its questions. But it's true. The first social psychology experiments were not reported until the late 1800s. No book on social psychology was published before this century. Not until the 1930s did social psychology assume its current form. And it was not until World War II, when psychologists contributed imaginative studies of persuasion and soldier morale, that it began to emerge as the vibrant field it is today. In just the last two decades the number of social psychology periodicals has more than doubled. More and more, social psychologists are applying their concepts and methods to current social concerns, such as emotional well-being, health, courtroom decision making, and the quest for peace.

But what are social psychology's concepts and methods? How does the field differ from sociology and from other areas of psychology? Are social psychologists influenced by their own personal and cultural values? What are social psychology's research tactics, and how might we apply these in everyday life? In this chapter, these are our questions.

■ SOCIAL PSYCHOLOGY AND RELATED DISCIPLINES

Social psychologists are keenly interested in how people think about, influence, and relate to one another. But so are sociologists, personality psychologists, and even novelists and philosophers. How then do we distinguish social psychology? Let's briefly consider the similarities and differences between social psychology and these related fields.

SOCIAL PSYCHOLOGY AND SOCIOLOGY

People often confuse social psychology with sociology. Sociologists and social psychologists do share an interest in studying how people behave in groups.

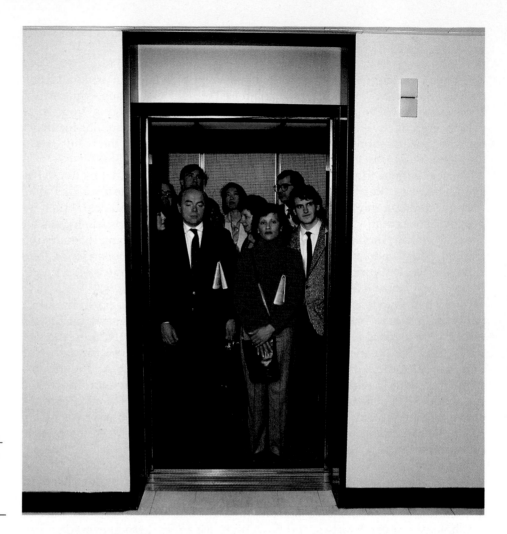

Social psychologists study individuals' behavior and thinking in social situations. For example, do people behave predictably in a crowded elevator?

But most *sociologists study groups*, from small to very large (societies), while most *social psychologists study individuals*—how a person thinks about others, is influenced by them, relates to them. Social psychologists are interested in groups, but they more often study how groups affect individual people or how an individual affects a group.

In studying close relationships, a sociologist might study trends in marriage, divorce, and cohabitation rates, while a psychologist might examine how certain individuals become attracted to one another. Or a sociologist might investigate how the racial attitudes of middle-class people as a group differ from those of lower-income people. A social psychologist is more likely to study how racial attitudes develop within the typical individual. For instance, how does labeling people as members of some group—as football players, African-Americans, sorority women, or aged—affect us? Does it lead us to overestimate both the similarity of people within the groups and the differences between the groups? (The answer, by the way, turns out to be yes.)

Although sociologists and social psychologists use some of the same research methods, social psychologists rely much more heavily upon experiments in which they *manipulate* a factor, such as the presence or absence of peer

pressure, to see what effect it has. The factors that sociologists study, such as economic class, are typically difficult or unethical to manipulate.

Social psychology also differs from social work. Social psychologists are eager to see their principles applied to such social problems as crime and marital breakdown. But their primary aim is to discern the basics of how people think about, influence, and relate to one another.

SOCIAL PSYCHOLOGY AND PERSONALITY PSYCHOLOGY

Social psychology and personality psychology both focus on the individual, so they, too, are related. Indeed, the American Psychological Association includes the two subfields in the same journals (the *Journal of Personality and Social Psychology* and the *Personality and Social Psychology Bulletin*). The difference lies in the *social* character of social psychology. Personality psychologists focus on our private internal functioning and on *differences* between individuals—for example, why some individuals are more aggressive than others. Social psychologists focus on our common humanity—on how people, in general, view and affect one another. They ask how social situations can lead *most* people to act kind or cruel, to conform or be independent, to feel liking or prejudice.

There are other differences: Social psychology has a shorter history. Many of personality psychology's heroes—deceased people like Sigmund Freud, Carl Jung, Alfred Adler, Abraham Maslow, and Carl Rogers—worked during the first two-thirds of this century. Because of its more recent history, most of social psychology's leading contributors are still active. And social psychology has fewer famous heroes—people who have invented grand theories—and many more unsung ones—creative researchers who contribute smaller-scale concepts. We will meet a sample of these people in the autobiographical "Behind the Scenes" boxes sprinkled throughout this book.

"You can never foretell what any man will do, but you can say with precision what an average number will be up to. Individuals may vary, but percentages remain constant." Sherlock Holmes, in Sir Arthur Conan Doyle's *A Study in Scarlet*, 1887

DIFFERENT LEVELS OF EXPLANATION

We study human beings from the different perspectives that we know as academic disciplines. These perspectives range from basic sciences, such as physics and chemistry, up to integrative disciplines, such as philosophy and theology. Which perspective is relevant depends on what you want to talk about. Take love, for example. A physiologist might describe love as a state of arousal. A social psychologist might examine how various characteristics and conditions—good looks, the partners' similarity, sheer repeated exposure—enhance the feeling we call love. A poet would extol the sublime experience love can sometimes be. A theologian might describe love as the God-given goal of human relationships. We needn't assume that one of these levels is *causing* the other—by supposing, for example, that a brain state causes the emotion of love or that the emotion causes the brain state. The emotional and physiological perspectives are simply two ways of looking at the same event.

One type of explanation need not compete with others. Scientific explanations needn't discredit or replace the perspectives of literature and philosophy. An evolutionary explanation of universal incest taboos (in terms of the genetic penalty offspring pay for inbreeding) does not replace a sociological explanation (which might see incest taboos as a way of preserving the family unit) or a

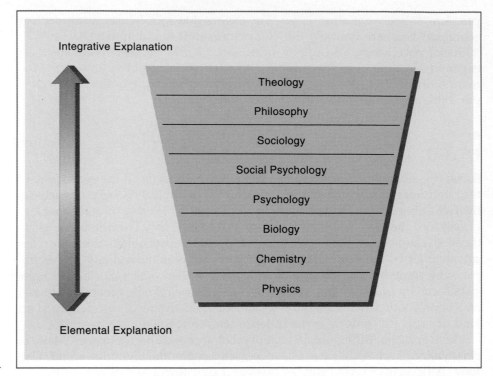

Integrative Explanation

Theology

Philosophy

Sociology

Social Psychology

Psychology

Biology

Chemistry

Physics

Elemental Explanation

FIGURE 1-1 *Partial hierarchy of disciplines. The disciplines range from basic sciences that study nature's building blocks up to integrative disciplines that study complex systems. A successful explanation of human functioning at one level need not contradict explanations at other levels.*

"Knowledge is one. Its division into subjects is a concession to human weakness."
Sir Halford John MacKinder, 1887

theological one (which might focus on moral truth). The various explanations can complement one another (Figure 1-1).

If "all truth is one," then different levels of explanation should fit together to form a whole picture, just as we can assemble different two-dimensional perspectives of an object into a three-dimensional whole image. Recognizing the complementary relationship of various explanatory levels liberates us from useless argument over whether we should view human nature scientifically or subjectively. It's not an either/or matter; the scientific and subjective perspectives are both valuable. Although this book pays particular attention to the results of scientific research, we ought not ignore the rich insights of other approaches. Sociologist Andrew Greeley (1976) explains: "Try as it might, psychology cannot explain the purpose of human existence, the meaning of human life, the ultimate destiny of the human person." Social psychologists ask some very important questions, but these are not among them. Social psychology is *one* important perspective from which we can view and understand ourselves, but it is not the only one.

■ SOCIAL PSYCHOLOGY AND HUMAN VALUES

Social psychology, I have just suggested, views human behavior from a scientific rather than a subjective perspective. In science, as in courts of law, personal opinions are inadmissible. When ideas are put on trial, evidence deter-

mines the verdict. But are social psychologists really this dispassionate? As human beings, don't our values—our personal convictions about what is desirable and how people ought to behave—seep into our work? And if they do, can social psychology really be the *scientific* study of how people think about, influence, and relate to one another?

OBVIOUS WAYS IN WHICH VALUES ENTER

Values enter the picture with our choice of research topics. It was no accident that the study of prejudice flourished during the 1940s as fascism raged in Europe; that the 1950s, a time of look-alike fashions and McCarthyist intolerance of differing views, gave us studies of conformity; that the 1960s saw increased interest in aggression as riots and rising crime rates plagued America; that the 1970s provided a wave of research on gender and sexism; that the 1980s offered a resurgence of attention to psychological aspects of the arms race; and that the 1990s began with heightened concern for how people respond to multicultural diversity. These trends reflect the social concerns of their time. Social psychology unfolds under the influence of social history.

Values may also influence the type of people attracted to various disciplines (Campbell, 1975; Moynihan, 1979). At your school, do the students attracted to the humanities, the natural sciences, and the social sciences noticeably differ? Do psychology and sociology attract people who are eager to challenge tradition, people who would rather shape the future than preserve the past?

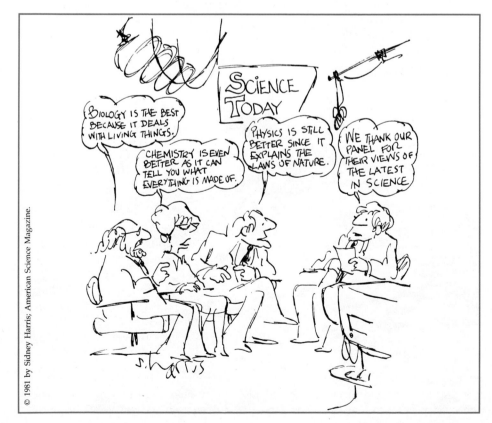

Different sciences offer different perspectives.

Finally, values obviously enter the picture as the *object* of social-psychological analysis. Social psychologists investigate how values form, why they change, and how they influence attitudes and actions. None of this, however, tells us which values are "right."

NOT-SO-OBVIOUS WAYS IN WHICH VALUES ENTER

We less often recognize the subtler ways in which value commitments masquerade as objective truth. Consider three not-so-obvious ways in which values enter social psychology and related areas.

Science Has Subjective Aspects

There has been a growing awareness among both scientists and philosophers that science is not so purely objective as we thought. Scientists do not merely read what's out there in the book of nature. Rather, they interpret nature, using their own mental categories. In our daily lives, too, we view the world through the lens of our preconceptions. Pause a moment: What do you see in Figure 1-2?

FIGURE 1-2 *What do you see?*

Can you see a Dalmatian sniffing the ground at the center of the picture? Without this expectation, most people are blind to what those who have the preconception can see. But once your mind has the preconception, it controls your interpretation of the picture—so much so that it becomes difficult *not* to see the dog. This is the way our minds work. While reading these words you have been unaware, until this moment, that you are also looking at your nose. Your mind blocks from awareness something that is there, if only you were predisposed to perceive it. This tendency to prejudge reality based on our expectations is a basic fact about the human mind.

A 1951 Princeton-Dartmouth football game demonstrated how opinions control interpretations (Hastorf & Cantril, 1954; see also Loy & Andrews, 1981). The game lived up to its billing as a grudge match; it turned out to be one of the roughest and dirtiest games in the history of either school. A Princeton All-American was gang-tackled, piled on, and finally forced out of the game with a broken nose. Fistfights erupted, and there were further injuries on both sides.

Not long afterward, two psychologists, one from each school, showed films of the game to students on each campus as part of a social psychology experiment. When the students played the role of "objective" scientist, noting each infraction as they watched and who was responsible for it, they could not set aside their loyalties. The Princeton students were much more likely than the Dartmouth students to see Princeton players as victims of illegal aggression. The Princeton students, for example, saw twice as many Dartmouth violations as the Dartmouth students saw. There *is* an objective reality out there. But, in science as in everyday life, we always view it through the lens of our beliefs and values.

Because the community of scholars at work in any given area often share a common viewpoint, their assumptions may go unchallenged. What we take for granted—the shared beliefs that European social psychologists call our **social representations** (Augoustinos & Innes, 1990; Moscovici, 1988)—are our most important but also most unexamined convictions. Sometimes, however, someone from outside the camp will call attention to these assumptions. During the 1980s, feminists and Marxists exposed some of social psychology's unexamined assumptions. Feminist critics called attention to subtle biases—for example, to the political conservatism of many scientists who favor a biological interpretation of gender differences in social behavior (Unger, 1985). Marxist critics called attention to competitive, individualist biases—for example, our assuming that conformity is bad and that individual rewards are good. Marxists and feminists, of course, make their own assumptions. In Chapter 2 we will see that our preconceptions do indeed guide our interpretations of the world around us.

Psychological Concepts Contain Hidden Values

Values also influence concepts. Consider psychologists' attempts to specify the good life. We refer to people as mature or immature, as well-adjusted or poorly adjusted, as mentally healthy or mentally ill, as if these were statements of fact, when really they disguise value judgments. The personality psychologist Abraham Maslow, for example, was known for his sensitive descriptions of "self-actualized" people—people who, with their needs for survival, safety, "belongingness," and self-esteem satisfied, go on to fulfill their human potential. Few readers notice that Maslow himself, guided by his own values, se-

"Science does not simply describe and explain nature; it is part of the interplay between nature and ourselves; it describes nature as exposed to our method of questioning."
Werner Heisenberg,
Physics and Philosophy, 1958

Social representations: Socially shared beliefs. Widely held ideas and values, including our assumptions and cultural ideologies. Our social representations help us make sense of our world.

lected the sample of self-actualized people he described. The resulting description of self-actualized personalities—as spontaneous, autonomous, mystical, and so forth—reflects Maslow's personal values. Had he begun with someone else's heroes—maybe Napoleon, Alexander the Great, and John D. Rockefeller, Sr.—the resulting description of self-actualization would have been quite different (Smith, 1978).

Psychological advice also reflects the advice giver's personal values. When mental health professionals advise us how to live our lives, when child-rearing experts tell us how to handle our children, and when some psychologists encourage us to live free of concern for others' expectations, they are giving us their personal values along with their expertise. Many people, unaware of this, defer to the "professional." Because value decisions concern us all, we should not feel intimidated by scientists and professionals. Science can help us discern how better to achieve our goals, once we have settled on them. But it does not and cannot answer questions of ultimate moral obligation, of purpose and direction, and of life's meaning.

Hidden values even seep into psychology's research-based concepts. Pretend you have taken a personality test and the psychologist, after scoring your answers, announces: "You scored high in self-esteem. You are low in anxiety. And you have exceptional ego-strength." "Ah," you think, "I suspected as much, but it feels good to know that." Now another psychologist gives you a similar test. For some peculiar reason this test asks some of the same questions. Afterward the psychologist tells you that you seem defensive, for you scored high in "repressiveness." "How could this be," you wonder. "The other psychologist said nice things about me." It could be because all these labels describe the same set of responses (a tendency to say nice things about oneself and not to acknowledge problems). Shall we call it high self-esteem or defensiveness? The label reflects the researcher's value judgment about the trait.

That value judgments are often hidden within our social-psychological language is no reason to malign social psychology. This is true of all human language. Whether we label someone engaged in guerrilla warfare a "terrorist" or a "freedom fighter" depends on our view of the cause. When "they" exalt their country and people, it's nationalism; when "we" do it, it's patriotism. Whether someone involved in an extramarital affair is practicing open marriage or adultery depends on one's personal values. Brainwashing is social influence we do not approve of. Perversions are sex acts we do not practice. Remarks about "ambitious" men and "aggressive" women, or about "cautious" boys and "timid" girls, convey a hidden message.

To repeat, values lie hidden within our definitions of mental health and self-esteem, our psychological advice for living, and our psychological labels. Throughout this book I will call your attention to additional examples of hidden values. The point of doing so will never be to show that the implicit values are necessarily bad. The point is that scientific interpretation, even at the level of labeling phenomena, is a very human activity. It is therefore quite natural and quite inevitable that prior beliefs and values will influence what social psychologists think and write.

There Is No Bridge from "Is" to "Ought"

A seductive error for those who work in the social sciences is sliding from a description of *what is* into a prescription of *what ought to be*. Philosophers call

this the **naturalistic fallacy.** The gulf between "is" and "ought," between scientific description and ethical prescription, remains as wide today as when philosopher David Hume pointed it out 200 years ago. No survey of human behavior—say, of sexual practices—logically dictates what is "right" behavior. If most people don't do something, that does not make it wrong. If most people do it, that does not make it right. There is no way we can move from objective statements of fact to prescriptive statements of what ought to be without injecting our values. Ethical decisions must in the end be made on their own merits.

In such ways, both obvious and subtle, social psychologists' personal values influence their work. We do well to remember this and also to remember that what is true of them is true of each of us. Our values and assumptions color our view of the world. Those who have known only their own culture assume its view. To discover how much our values and social representations shape what we take for granted, we need to encounter a different cultural world—as from time to time we will do throughout this book.

Naturalistic fallacy:
The error of defining what is good in terms of what is observable. For example: What's typical is normal; what's normal is good.

■ FOCUS: SOCIAL PSYCHOLOGY IN THREE WORLDS

Psychology's roots are international as well as interdisciplinary. The pioneering experimenter, Ivan Pavlov, was a Russian physiologist. Child watcher Jean Piaget was a Swiss biologist. Sigmund Freud was an Austrian physician. But it was in the United States that these and other transplanted roots flourished, thanks to abundant laboratories, sophisticated equipment, and a wealth of trained personnel. Surveying the world scene, social psychologist Fathali Moghaddam (1987, 1990) describes the United States as the psychological first world—the superpower of academic psychology, especially of social psychology. Social psychology's "professional center of gravity" is in the United States, observes Michael Bond (1988) from the Chinese University of Hong Kong. Because U.S. and Canadian social psychology are intermeshed—"indistinguishable" says Moghaddam—we could as well speak of "North American" social psychology.

The other industrialized nations form social psychology's second world. Great Britain, for example, shares with North America a strong tradition of scientific psychology. But because of its much smaller university system, Britain has only a twenty-fifth as many academic psychologists as does the United States. Likewise, the former Soviet Union has similar population to the United States but a tenth as many psychologists (Kolominsky, 1991).

European and North American social psychologists share interests in the personal and interpersonal levels of explaining social behavior, but European scholars tend to give more attention to the intergroup and societal levels as well (Doise, 1986; Hewstone, 1988). Thus European views may question U.S. individualism; conflict, they say, arises not so much from the misperceptions of individuals as from a power struggle between groups. The European political agenda stimulates their interests in social issues, such as unemployment, political ideology, and relations between different linguistic and ethnic groups.

Some European social psychologists are contributing new approaches. Their methodology supplements laboratory experiments with natural observation of behavior and social discourse.

The developing nations, such as Bangladesh, Cuba, and Nigeria, form social psychology's third world. Hampered by their limited resources, such countries have had to import their psychology from the first- and second-world nations. Yet their problems are distinctive: pressing issues related to poverty, conflict, and traditional agricultural lifestyles demand attention. In third-world societies, social psychologists seldom have the luxury of exploring the basics of human nature, nor can illiterate people answer questionnaires.

A complete social psychology would draw upon the insights of psychologists in all three worlds in describing processes of social thinking, social influence, and social relations common to all humans. As the global village continues to shrink and as we share knowledge and viewpoints, a world-based social psychology may indeed become possible.

■ BEHIND THE SCENES

After being born in Iran and educated in England, I joined hundreds of thousands of Iranians returning home after the revolution of 1978. I soon found that my new Ph.D. ill-equipped me for work in a culture that was suspicious of Western psychology and demanding that my teaching and research reflect Iranian concerns and values. Through my experiences there, and subsequently with the United Nations Development Programme, I became aware of the urgent need for a psychology that is appropriate to the poor and illiterate masses of Third World people. Believing that internationalizing psychology will benefit psychologists in all three worlds, I am now working to bridge the gap between social psychology in North America and other parts of the world and to educate psychologists for work in the Third World.

FATHALI M. MOGHADDAM, *Georgetown University*

So what do we conclude: That because science has its subjective side, we should dismiss it? Quite the contrary: The realization that human thinking always involves interpretation is precisely why we need scientific analysis. By constantly checking our beliefs against the facts, as best we know them, we counter and restrain our biases. Observation and experimentation help us clean the lens through which we see reality.

■ HOW WE DO SOCIAL PSYCHOLOGY

Unlike other scientific disciplines, social psychology has 5 billion amateur practitioners. Few of us have firsthand experience in nuclear physics, but we are the very subject matter of social psychology. As we observe people, we form ideas about how human beings think about, influence, and relate to one another. Professional social psychologists do the same, only more painstakingly, often with experiments that create miniature social dramas that pin down cause and effect.

Most of what you will learn about social-psychological research methods you will simply absorb as you read later chapters. But let us go backstage now and take a brief look at how social psychology is done. This glimpse behind the scenes will be just enough, I trust, for you to appreciate the evidence discussed throughout this book.

Social-psychological research varies by location. It can take place in the **laboratory** (a controlled situation) or in the **field** (everyday situations outside the laboratory). And it varies by method—being either **correlational** (asking whether two factors are naturally associated) or **experimental** (manipulating some factor to see its effect on another). If you want to be a critical reader of psychological research reported in newspapers and magazines, it will pay you to understand the difference between correlational and experimental research.

Field research:
Research done in natural, real-life settings outside the laboratory.

Education is correlated with future earnings. But does the Harvard education this graduate has received cause (produce) higher earnings? Or would the traits that foster success at Harvard also foster occupational success, with or without a Harvard degree?

To illustrate the advantages and disadvantages of correlational and experimental procedures, consider a practical question: Is college a good financial investment? Surely you have heard the claims about the economic benefits of going to college. Are they nothing more than a sales pitch? How might we separate fact from falsehood in assessing the impact of college upon lifetime earnings?

"College degrees boost lifetime earnings."
American Council on Education newsletter headline

CORRELATIONAL RESEARCH: DETECTING NATURAL ASSOCIATIONS

First, we might discern whether any relation—or *correlation*, as we say—exists between educational level and earnings. For example, if college is a good financial investment, then college graduates should, on average, earn more than those who don't attend. Sure enough, Figure 1-3 shows that college graduates have a whopping income advantage. So can we now agree with college recruiters that higher education is the gateway to economic success?

Before we answer yes, let's take a closer look. We know that formal education correlates with earnings; that's beyond question. But does this necessarily

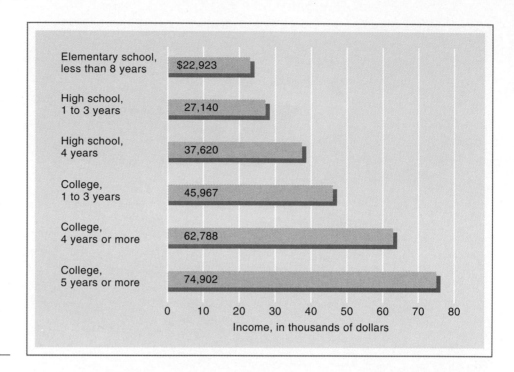

FIGURE 1-3 *Income of families, by education of head of household.*

Correlational research: The study of the naturally occurring relationships among variables.

mean that education *causes* higher incomes? Perhaps you can identify factors other than education that might explain the education-earnings correlation. (We call these factors *variables* because people will vary on them.) What about family social status? What about intellectual ability and achievement drive? Might these not already be higher in those who go to college? Perhaps the higher earnings come from some combination of these variables, and not the college degree. Or perhaps education and earnings correlate because those who have money can most easily afford college in the first place.

Correlation versus Causation

The education-earnings question illustrates the most irresistible thinking error made by both amateur and professional social psychologists. When two factors like education and earnings go together, it is terribly tempting to conclude that one is causing the other. During the 1980s, football commentators were fond of noting a correlation between yardage gained by Dallas Cowboys running back Tony Dorsett and game outcome. When Dorsett gained more than 100 yards, the Cowboys nearly always won. But they were in grave danger of losing when Dorsett gained fewer than 100 yards. The implication was nearly always that Dorsett *caused* the Cowboys' outcome. To some extent this was surely true. But so was the reverse. A Cowboy victory *caused* Dorsett to gain more than 100 yards—because when the Cowboys were winning they would give the ball to Dorsett to run out the clock on the ground (Gilovich, 1989).

Consider two examples of the correlation-causation issue in psychology. If a particular style of child-rearing correlates with the personality traits of children exposed to it, what does this tell us? If parents who often spank or even abuse their children often have unruly children, what does this tell us? With every correlation, there are three possible explanations (Figure 1-4). The effect of the

parents on the child ($x \rightarrow y$) is one. Perhaps punitive parents are more likely to have aggressive children because the parents' own example teaches such behavior. You might, however, be surprised at the strength of the evidence for children affecting their parents ($x \leftarrow y$) (Bell & Chapman, 1986). Unruly children may elicit punishment from exasperated parents. Or maybe, as explanation 3 in Figure 1-4 suggests, there is a common source (z) for both the child-rearing style and the child's traits. Perhaps the characteristics of both parent and child are rooted in shared genes. Perhaps the punitive parent and the aggressive child both mirror the influence of violent TV programs and movies watched in the home.

Consider another very real correlation—between self-esteem and academic achievement. Children with high self-esteem tend also to have high academic achievement. (As with any correlation, we can also state this the other way around: High achievers tend to have high self-esteem.) Why do you suppose this is?

Some people believe a "healthy self-concept" contributes to achievement. Thus, boosting a child's self-image may also boost the child's school achievement. Others argue that high achievement produces a favorable self-image. As a recent study of 635 Norwegian schoolchildren confirms, a string of gold stars by one's name on the spelling chart and constant praise from an admiring teacher can boost a child's self-esteem (Skaalvik & Hagtvet, 1990). But in other careful studies—one a nationwide sample of 1600 young American men, another of 715 Minnesota youngsters—self-esteem and achievement were *not* causally related (Bachman & O'Malley, 1977; Maruyama & others, 1981).

Researchers have found a modest but positive correlation between adolescents' preference for heavy metal music and their having attitudes favorable to premarital sex, pornography, satanism, and drug and alcohol use (Landers, 1988). What are the possible explanations for this correlation?

FIGURE 1-4 *When two variables correlate, any combination of three explanations is possible.*

Rather, they correlated because both were linked to intelligence and family social status. When the researchers extracted the effect of intelligence and family status, the correlation between self-esteem and achievement evaporated. Similarly, John McCarthy and Dean Hoge (1984) dispute the idea that the correlation between low self-esteem and delinquency means that low self-esteem causes delinquency; rather, their study of 1658 teenagers suggests, delinquent acts lead to lowered self-esteem.

These studies can *suggest* cause-effect relations in correlational research by pulling apart obviously related factors (like education, family status, and aptitude) to isolate the predictive power of each. Such studies can also consider the sequence of events (for example, by detecting whether changes in achievement more often precede or follow changes in self-esteem). Yet the moral of the story remains: Correlational research allows us to predict; but it cannot tell us whether changing one variable (such as education) will *cause* changes in another (such as income).

So, the great strength of correlational research is that it tends to occur in real-world settings where we can examine factors like race, sex, and education that we cannot manipulate in the laboratory. Its great disadvantage lies in ambiguous results. Knowing that two variables change together enables us to predict one when we know the other. But this does not give us cause and effect.

Survey Research

How, then, do we measure such variables as education and income? One way is by surveying representative samples of people. Survey researchers obtain a representative group by taking a **random sample**—one in which every person in the total group has an equal chance of participating. With this procedure any subgroup of people—red-haired people, for example—will tend to be represented in the survey to the extent they are represented in the total population.

Random sample:
Survey procedure in which every person in the population being studied has an equal chance of inclusion.

It is an amazing fact that whether we survey people in a city or in a whole country, 1200 randomly selected participants will enable us to be 95 percent confident of describing the entire population with an error margin of 3 percent or less. Imagine a huge jar filled with beans, 50 percent red and 50 percent white. Randomly sample 1200 of these, and you will be 95 percent certain to draw out between 47 percent and 53 percent red beans—regardless of whether the jar contains 10,000 beans or 100,000,000 beans. If we think of the red beans as supporters of one presidential candidate and white beans as supporters of the other candidate, we can understand why, since 1950, the Gallup polls taken just before U.S. national elections have diverged from election results by an average of only 1.4 percent.

Bear in mind that polls do not actually predict voting; they only *describe* public opinion as of the moment they are taken. Public opinion can shift. To evaluate surveys, we must also bear in mind four potentially biasing influences: unrepresentative samples, the order of questions, the response options, and the wording of the questions.

Unrepresentative Samples

Not only does sample size matter in a survey, but also how closely the sample represents the population under study. In 1984, columnist Ann Landers accepted a letter writer's challenge to poll her readers on the question of whether women find affection more important than sex. Her question: "Would you be

content to be held close and treated tenderly and forget about 'the act'?'' Of the more than 100,000 women who replied, 72 percent said yes. An avalanche of worldwide publicity followed. In response to critics, Landers (1985, p. 45) granted that "the sampling may not be representative of all American women. But it does provide honest—valuable—insights from a cross section of the public. This is because my column is read by people from every walk of life, approximately 70 million of them." Still, one wonders, are the 70 million readers representative of the entire population? And are the 1 in 700 readers who participated representative of the 699 in 700 who did not?

The importance of representativeness was effectively demonstrated in 1936, when a weekly news magazine, *Literary Digest,* mailed a postcard presidential poll to 10 million Americans. Among the more than 2 million returns, Alf Landon won by a landslide over Franklin D. Roosevelt. When the actual votes were counted a few days later, Landon carried only two states. The error happened because the magazine sent the poll only to people whose names it had obtained from telephone books and automobile registrations—thus omitting those who could afford neither (Cleghorn, 1980).

Sampling bias can plague even the best survey. Simultaneous political opinion polls, each supposedly having a 3 percent error margin, commonly vary

Sampling bias plagues many popular surveys. Randomly sampled mall shoppers will be representative of all mall shoppers, but not of all people.

Survey researchers must be sensitive to subtle—and not so subtle—biases.

from one another by more than 3 percent. Philip Converse and Michael Traugott (1986) attribute such discrepancies partly to the fact that some 30 percent of those sampled refuse to cooperate or are unavailable, which makes the sample obtained not a perfect random sample. For instance, when voters were surveyed by phone during the 1984 presidential race, those answering when their home was first called favored President Reagan by a slim 3 percent margin. After the interviewers persisted in callbacks until they reached everyone, President Reagan's margin increased by 13 percentage points. (Republican voters apparently were less often home.)

Order of Questions
Given a representative sample, we must also contend with other sources of bias, such as the order in which we ask questions. Asked whether "the Japanese government should be allowed to set limits on how much American industry can sell in Japan," most Americans answered no (Schuman & Ludwig, 1983). Simultaneously, two-thirds of an equivalent sample were answering yes to the same question because they were first asked whether "the American government should be allowed to set limits on how much Japanese industry can sell in the United States." Most of these people said the United States has the right to limit imports. To appear consistent, they then said that Japan should have the same right.

Response Options
Consider, too, the dramatic effects of the response options. When Joop van der Plight and his co-workers (1987) asked English voters what percentage of Britain's nuclear energy they wished came from nuclear power, the average preference was 41 percent. They asked others what percentage they wished came from (1) nuclear, (2) coal, and (3) other sources. Their average preference for nuclear power was 21 percent.

A similar effect of response option occurred when Howard Schuman and Jacqueline Scott (1987) asked Americans, "What do you think is the most important problem facing this country today—the energy shortage, the quality of public schools, legalized abortion, or pollution—or if you prefer, you may name a different problem as most important." Given these choices, 32 percent

felt that the quality of public schools was the biggest problem. Others they simply asked, "What do you think is the most important problem facing this country today?" Only 1 percent named the schools. So remember: The form of the question may guide the answer.

Wording

The precise wording of questions may also influence answers. One poll found that only 7 percent of Americans thought government programs should be cut back if they cut out "aid to the needy." Yet 39 percent would kill funds if the "needy" item was called "public welfare" (Marty, 1982). Even subtle changes in the tone of a question can have large effects (Schuman & Kalton, 1985). "Forbidding" something may be the same as "not allowing" it. But in 1940 when two comparable samples of Americans were asked, "Do you think the U.S. should forbid public speeches against democracy?" or "Do you think the U.S. should allow public speeches against democracy?" 54 percent said the United States should "forbid" such speeches and 75 percent said the United States should "not allow" them. Survey questioning is a very delicate matter. Even when people say they feel strongly about an issue, a question's form and wording may affect their answer (Krosnick & Schuman, 1988).

Response, order, and wording effects enable political manipulators to use surveys to show public support for their views—for or against nuclear power, welfare, or unrestrained speech. Consultants, advertisers, and physicians can have similar disconcerting influences upon our decisions by how they "frame" them (see Focus: "You Get What You Ask For").

■ **FOCUS:** You Get What You Ask For

How we pose an issue influences not only answers to survey questions but also important, everyday decisions. Amos Tversky and Daniel Kahneman (1981) posed the following problem to their students at Stanford University and at the University of British Columbia:

> Imagine that the U.S. is preparing for the outbreak of an unusual Asian disease, which is expected to kill 600 people. Two alternative programs to combat the disease have been proposed. Assume that the exact scientific estimate of the consequences of the programs are as follows:

Those given the following two choices favored Program A by about 3 to 1:

> If Program A is adopted, 200 people will be saved.
> If Program B is adopted, there is ⅓ probability that 600 people will be saved, and ⅔ probability that no people will be saved.

But when the same two choices were stated differently, Program B was favored by 3 to 1:

> If Program A is adopted, 400 people will die.
> If Program B is adopted, there is ⅓ probability that nobody will die, and ⅔ probability that 600 people will die.

How do you respond to the way something is framed—like those who respond more positively to ground beef described as "75 percent lean" rather than "25 percent fat"? Or like the 88 percent of college students who endorsed a condom as "effective" if it had a "95 percent success rate" in stopping the AIDS virus—though only 42 percent judged it effective, given a "5 percent failure rate" (Linville & others, 1992)? If asked, "Why did Team X win?" are you more likely to comment on their good coaching or teamwork than if asked, "Why did Team Y lose?" David Dunning and Mary Parpal (1989) have found that such variations direct people's attention and influence their response.

The moral: The way choices are worded can make a big difference.

EXPERIMENTAL RESEARCH: SEARCHING FOR CAUSE AND EFFECT

The near impossibility of discerning cause and effect among naturally correlated events prompts most social psychologists to create laboratory simulations of everyday processes whenever this is feasible and ethical. These simulations are similar to how aeronautical engineers work. They don't begin by observing how flying objects perform in a wide variety of natural environments. The variations in both atmospheric conditions and flying objects are so complex that they would find it difficult to organize and use such data to design better aircraft. Instead, they construct a simulated reality that is under their control—a wind tunnel. Now they can manipulate wind conditions and ascertain the precise effect of particular wind conditions on particular wing structures.

Control: Manipulating Variables

Independent variable:
The experimental factor that a researcher manipulates.

Like aeronautical engineers, social psychologists experiment by constructing social situations that simulate important features of our daily lives. By varying just one or two factors at a time—called **independent variables**—the experimenter pinpoints how changes in these one or two things affect us. As the wind tunnel helps the aeronautical engineer discover principles of aerodynamics, so

Does viewing violence on TV or in other media produce imitative acts, especially among children? Experiments suggest that it does.

the experiment enables the social psychologist to discover principles of social thinking, social influence, and social relations. As wind tunnel researchers aim to understand and predict the flying characteristics of complex aircraft, so social psychologists experiment to understand and predict human behavior.

Social psychologists have used the experimental method in about three-fourths of their research studies (Higbee & others, 1982). In two out of three studies the setting has been a research laboratory (Adair & others, 1985). To illustrate the laboratory experiment, consider an issue we will explore in a later chapter: television's effects on children's attitudes and behavior. Children who watch many violent television programs tend to be more aggressive than those who watch few. This suggests that children might be learning from what they see on the screen. But, as I hope you now recognize, this is a correlational finding. Figure 1-4 reminds us that there are two other cause-effect interpretations which do not implicate television as the cause of the children's aggression. (What are they?)

Social psychologists have therefore brought television viewing into the laboratory, where they control the amount of violence the children see. By exposing children to violent and nonviolent programs, researchers can observe how amount of violence affects behavior. Robert Liebert and Robert Baron (1972) showed young Ohio boys and girls a violent excerpt from a gangster television show or an excerpt from an exciting track race. The children who viewed the violence were subsequently most likely to press vigorously a special red button which supposedly would transmit a burning pain to another child. This measure of behavior we call the **dependent variable.** (Actually, there was no other child, so no one was really harmed.) Such experiments indicate that television *can* be one cause of children's aggressive behavior.

So far we have seen that the logic of experimentation is very simple: By creating and controlling a miniature reality, we can vary one factor and then another and discover how these factors, separately or in combination, affect people. Now let's go a little deeper and see how an experiment is done.

Every social-psychological experiment has two essential ingredients. One we have just considered—*control.* We manipulate one or two independent variables while trying to hold everything else constant. The other ingredient is *random assignment.*

Random Assignment: The Great Equalizer

Recall that we were reluctant to credit having gone to college with the higher incomes of college graduates, who may benefit not only from their education but also from their social backgrounds and aptitudes. A survey researcher might measure each of these likely other factors and then note the income advantage enjoyed by college graduates above and beyond what we would expect from these other factors. Such statistical gymnastics are well and good. But the researcher can never adjust for all the factors that might distinguish graduates from nonattenders. The alternative explanations for the income difference are limitless—perhaps ethnic heritage, or sociability, or good looks, or any of hundreds of other factors the researcher has never thought of.

So, for the moment, let us give free reign to our imaginations and see how all these complicating factors might be equalized in one maneuver. Suppose someone gave us the power to take a group of high school graduates and

Dependent variable: The variable being measured, so-called because it may *depend* on manipulations of the independent variable.

Experimental research: Studies which seek clues to cause-effect relationships by manipulating one or more factors (independent variables) while controlling others (holding them constant).

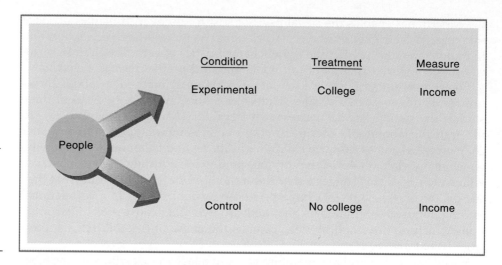

FIGURE 1-5 *Randomly assigning people either to a condition which receives the experimental treatment or to a control condition which does not gives the researcher confidence that any later difference is somehow caused by the treatment.*

Random assignment:
The process of assigning participants to the conditions of an experiment such that all persons have the same chance of being in a given condition. (Note the distinction between random *assignment* in experiments and random *sampling* in surveys. Random assignment helps us infer cause and effect. Random sampling helps us generalize to a population.)

randomly assign some to college and some to other endeavors (Figure 1-5). Each person would have an equal chance of being assigned to either the college or noncollege condition, so the people in both groups would, in every conceivable way—family status, looks, aptitude—average about the same. Random assignment would roughly equalize all these previously complicating factors. Any later income difference between these two groups could therefore not be caused by any of these factors. Rather, it would almost surely have *something* to do with the variable we manipulated. Similarly, if an experiment on malaria in Central America revealed that only people assigned to sleeping rooms with unscreened windows catch it, this would not mean that unscreened windows *cause* malaria, but it would indicate that the cause has something to do with the lack of screens.

The Ethics of Experimentation

Our college example also illustrates why some experiments are neither feasible nor ethical. Social psychologists would never manipulate people's lives in this way. In such cases we rely upon the correlational method and squeeze from it all the information we can.

In other cases, such as the issue of how television affects children, we briefly alter people's social experience and note the effects. Sometimes the experimental treatment is a harmless, perhaps even enjoyable experience to which people give their knowing consent. Sometimes, however, researchers find themselves operating in that gray area between the harmless and the risky.

Mundane realism:
Degree to which an experiment is superficially similar to everyday situations.

Social psychologists often venture into that ethical gray area when they design experiments which really engage people's thoughts and emotions. Experiments need not have what Elliot Aronson, Marilyn Brewer, and Merrill Carlsmith (1985) call **mundane realism.** That is, laboratory behavior (for example, delivering electric shocks as part of an experiment on aggression) need not be literally the same as everyday behavior. For many researchers, that sort of realism is indeed mundane—not too important. But the experiment *should* have **experimental realism**—it should absorb and involve the participants. Experimenters do not want their people consciously play-acting or ho-humming it; they want to engage real psychological processes. Forcing people

Experimental realism:
Degree to which an experiment absorbs and involves its participants.

to choose whether to give intense or mild electric shock to someone else can, for example, be a realistic measure of aggression.

Achieving experimental realism often requires deceiving people. If the person in the next room is actually not receiving the shocks, the experimenter does not want the participants to know this. That would destroy the experimental realism. Thus, about one-third of social-psychological studies (though a decreasing number) have required deception (Vitelli, 1988).

Experimenters also seek to hide their predictions lest the participants, in their eagerness to be "good subjects," merely do what's expected. In subtle ways, the experimenter's words, tone of voice, and gestures may inadvertently call forth desired responses. To minimize such **demand characteristics,** experimenters typically standardize their instructions or even write or tape-record them.

Researchers often walk a difficult tightrope in designing experiments that will be involving yet ethical. To believe that you are hurting someone, or to be subjected to strong social pressure to see if it will change your opinion or behavior, may be temporarily uncomfortable. Such experiments raise the age-old question of whether ends justify means. Do the insights gained justify deceiving and sometimes distressing people?

University ethics committees now review social-psychological research to ensure that it will treat people humanely. Ethical principles developed by the American Psychological Association (1981, 1992) and the British Psychological Society (1991) urge investigators to:

■ Tell potential participants enough about the experiment to enable them to give their **informed consent.**

■ Be truthful. Use deception only if justified by a significant purpose and if there is no alternative.

■ Protect people from harm and significant discomfort.

■ Treat information about the individual participants confidentially.

■ Fully explain the experiment afterward, including any deception. The only exception to this rule is when the feedback would be distressing, say by making people realize they have been stupid or cruel.

The experimenter should be sufficiently informative *and* considerate that people leave feeling at least as good about themselves as when they came in. Better yet, the participants should be repaid by having learned something about the nature of psychological inquiry. When treated in a courteous, non-manipulative way, few participants mind being deceived (Christensen, 1988). Indeed, say social psychology's defenders, we provoke far greater anxiety and distress by giving and returning course exams than we do in our experiments.

EXPLAINING AND PREDICTING: USING THEORIES

Although basic research often produces practical benefits, such aren't our only reason for doing social psychology. Many of us are in the profession because we have a hard time thinking of anything more fascinating than our own human existence. If, as Socrates counseled, "The unexamined life is not worth living," then simply "knowing thyself" better seems a worthy enough goal.

As we wrestle with human nature to squeeze out its secrets, we organize our

Demand characteristics: Cues in an experiment that tell the participant what behavior is expected.

Informed consent: An ethical principle requiring that research participants be told enough to enable them to choose whether they wish to participate.

"Nothing has such power to broaden the mind as the ability to investigate systematically and truly all that comes under thy observation in life."
Marcus Aurelius, *Meditations*

Theory:
An integrated set of principles that explain and predict observed events.

Hypothesis:
A testable proposition that describes a relationship that may exist between events.

ideas and findings into theories. A **theory** is an integrated set of principles that explain and predict phenomena. Some people wonder why social psychologists are so preoccupied with theories: Why don't they just gather facts? Our aeronautical engineering analogy is again useful. The engineers would soon be overwhelmed if, without any guiding principles, they tried by trial and error to create an exhaustive catalog of how different wind conditions affect different wing structures. So, they formulate broad concepts or theories about how air movements interact with wing structures and use the wind tunnel to test predictions derived from these concepts. Whether in aeronautical engineering or in social psychology, then, theories are a scientific shorthand.

In everyday conversation, "theory" often means "less than fact"—a middle rung on a confidence ladder going down from fact to theory to guess. But to any kind of scientist, facts and theories are different things, not different points on a continuum. Facts are agreed-upon statements about what we observe. Theories are *ideas* that summarize and explain facts. "Science is built up with facts, as a house is with stones," said Jules Henri Poincaré, "but a collection of facts is no more a science than a heap of stones is a house."

Theories not only summarize but also imply testable predictions, called **hypotheses.** Hypotheses serve several purposes. First, they allow us to *test* the theories on which they are based. By making specific predictions, a theory puts its money where its mouth is. Second, predictions give *direction* to research. Any scientific field will mature more rapidly if its researchers have a sense of direction. Theoretical predictions suggest new areas for research; they send investigators looking for things they might never have thought of. Third, the predictive feature of good theories can also make them very *practical* as well. What, for example, would be of greater practical value today than a theory of aggression that would predict the conditions under which to expect it and show how to control it? As Kurt Lewin, one of modern social psychology's founders, declared, "There is nothing so practical as a good theory."

Let's see how this works. Say we observe that people sometimes explode violently when in crowds. We might therefore theorize that the presence of other people makes individuals feel anonymous and lowers their inhibitions. Let's let our minds play with this anonymity idea for a moment. Perhaps we could test it by constructing a laboratory experiment similar to execution by electric chair. What if we asked individuals in groups to administer punishing shocks to a hapless victim without knowing which one of the group was actually shocking the victim? Would these individuals administer stronger shock than individuals acting alone, as our theory predicts?

We might also manipulate anonymity: Would people hiding behind masks deliver stronger shocks because they could not be identified? If the results confirm our hypothesis, they might suggest some practical applications. Perhaps police brutality could be reduced by having officers wear large name tags and drive cars identified with large numbers or by videotaping their arrests.

But how do we conclude that one theory is better than another? A good theory does all its functions well: (1) It effectively summarizes a wide range of observations. (2) And it makes clear predictions that we can use to (a) confirm or modify the theory, (b) generate new exploration, and (c) suggest practical application. When we discard theories, usually it's not because they have been proved false. Rather, like an old car, they get replaced by newer, better models.

GENERALIZING FROM LABORATORY TO LIFE

As the TV experiment illustrates, social psychology mixes everyday experience and laboratory analysis. Throughout this book we will do the same by drawing our data mostly from the laboratory and our illustrations mostly from life. Social psychology displays a healthy interplay between laboratory research and everyday life. Hunches gained from everyday experience often inspire laboratory research, which deepens our understanding of our experience. This interplay appears in the research on children's television. What people saw in everyday life suggested experiments. Network and government policymakers are now well aware of the results. So, what we see around us we can explore in experiments, the results of which we may then apply to social problems.

However, we must generalize from laboratory to life cautiously. The laboratory uncovers basic secrets of human existence, yet it is still a simplified, controlled reality. It tells us what effect to expect of variable x, all other things being equal—which in real life they never are. Moreover, as you will see, the participants in many social-psychological experiments are college students. While this may help you identify with them, college students are hardly a random sample of all humanity. Would we get similar results with people of different ages, educational levels, and cultures? This is always an open question, though experience teaches us to distinguish between the *content* of people's thinking and acting (their attitudes, for example) and the *process* by which they think and act (how attitudes affect actions and vice versa, for example). The content varies more from culture to culture than does the process: People of different cultures may hold different opinions, yet form them in similar ways. Likewise, college students in Puerto Rico report greater loneliness than do collegians on the U.S. mainland. Yet in both cultures the ingredients of loneliness are much the same—shyness, uncertain purpose in life, low self-esteem (Jones & others, 1985).

■ I KNEW IT ALL ALONG: IS SOCIAL PSYCHOLOGY SIMPLY COMMON SENSE?

But do social psychology's theories provide *new* insight into the human condition? Or do they only describe the obvious? Many of the conclusions presented in this book will probably have already occurred to you, for social psychology is all around you. Every day we observe people thinking about, influencing, and relating to one another. There is bound to be some accumulated social wisdom. For centuries, philosophers, novelists, and poets have observed and commented upon social behavior, often with keen insight. Might it therefore be said that social psychology is only common sense in different words? Social psychology faces two contradictory criticisms: One is that it is trivial because it documents the obvious; the second is that it is dangerous because its findings could be used to manipulate people. Is the first objection valid? Does social psychology simply formalize what any good amateur social psychologist already intuitively knows?

In hindsight, events seem obvious and predictable.

One problem with common sense explanations is that we invoke them *after* we know the facts. Events are far more "obvious" and predictable in hindsight than beforehand. Baruch Fischhoff and others (Slovic & Fischhoff, 1977) have demonstrated many times that when people are told the outcome of an experiment, that outcome suddenly seems unsurprising—certainly less surprising than it is to people who are simply told about the experimental procedure and the possible outcomes. People overestimate their ability to have foreseen the result. This happens especially when the result seems determined and not a mere product of chance (Hawkins & Hastie, 1990).

Likewise, in everyday life we often do not expect something to happen until it does. We *then* suddenly see clearly the forces that brought it to be and feel unsurprised. After Ronald Reagan's presidential victory over Jimmy Carter in 1980, commentators—forgetting that the election had been "too close to call" until the campaign's final few days—found the Reagan landslide unsurprising and easily understandable. When, the day before the election, Mark Leary (1982) asked people what percentage of votes they thought each candidate would receive, the average person, too, foresaw a slim Reagan victory. The day after the election Leary asked other people what result they *would have predicted* the day before the election; most indicated a Reagan vote that was closer to the final result.

Jack Powell (1988) found a similar knew-it-all-along effect after the 1984 Reagan triumph over Walter Mondale. Finding out that something had happened made it seem more inevitable. As the Danish philosopher-theologian Sören Kierkegaard put it, "Life is lived forwards, but understood backwards."

If the I-knew-it-all-along phenomenon is pervasive, you may now be feeling that you already knew about it. Indeed, almost any conceivable result of a psychological experiment can seem like common sense—*after* you know the

result. The phenomenon can be demonstrated by asking half a group to predict the outcome of some current event, such as an upcoming election. Ask the other half, a week after the outcome is known, what they would have predicted. For example, when Martin Bolt and John Brink (1991) invited Calvin College students to predict the U.S. Senate vote on controversial Supreme Court nominee Clarence Thomas, 58 percent predicted his approval. A week after his confirmation, Bolt asked other students to recall what they would have predicted. "I thought he would be approved," said 78 percent.

Or give half a group one psychological finding and the other half the opposite result. For example, tell half:

> Social psychologists have found that, whether choosing friends or falling in love, we are most attracted to people whose traits are different from our own. There seems to be wisdom in the old saying, "Opposites attract."

Tell the other half:

> Social psychologists have found that, whether choosing friends or falling in love, we are most attracted to people whose traits are similar to our own. There seems to be wisdom in the old saying, "Birds of a feather flock together."

Ask the people first to explain the result. Then ask them to say whether it is "surprising" or "not surprising." Virtually all will find whichever result they were given "not surprising."

As these examples show, we can draw upon the stockpile of ancient proverbs to make almost any result seem to make sense. Because nearly every possible outcome is conceivable, there are proverbs for various occasions. Shall we say with John Donne, "No man is an island," or with Thomas Wolfe, "Every man is an island"? If a social psychologist reports that separation intensifies romantic attraction, Joe Public responds, "You get paid for this? Everybody knows that 'absence makes the heart grow fonder.'" Should it turn out that separation weakens attraction, Judy Public may say, "My grandmother could have told you, 'Out of sight, out of mind.'" No matter what happens, there will be someone who knew it would.

Karl Teigen (1986) must have had a few chuckles when asking University of Leicester (England) students to evaluate actual proverbs and their opposites. When given the actual proverb "Fear is stronger than love," most rated it as true. But so did students who were given its reversed form, "Love is stronger than fear." Likewise, the genuine proverb "He that is fallen cannot help him who is down," was rated highly; but so, too, was "He that is fallen can help him who is down." My favorites, however, were the two highly rated proverbs: "Wise men make proverbs and fools repeat them" (authentic) and its made-up counterpart, "Fools make proverbs and wise men repeat them."

The **hindsight bias** creates a problem for many psychology students. When you read the results of experiments in your textbooks, the material often seems easy, even obvious. When you later take a multiple-choice test on which you must choose among several plausible conclusions, the task may become surprisingly difficult. "I don't know what happened," the befuddled student later moans. "I thought I knew the material." (A word to the wise: Beware of the phenomenon when studying for exams, lest you fool yourself into thinking that you know the material better than you do.)

The I-knew-it-all-along phenomenon not only can make social science findings seem like common sense, it also can have pernicious consequences. It is

"A first-rate theory predicts; a second-rate theory forbids; and a third-rate theory explains after the event."
Aleksander Isaakovich Kitaigorodskii

Hindsight bias:
The tendency to exaggerate *after* learning the outcome, one's ability to have foreseen how something turned out. Also known as the I-knew-it-all-along phenomenon.

Hindsight bias: After the Japanese attack on Pearl Harbor in December 1941, which caught the American navy totally off-guard, it seemed obvious that the U.S. military should have anticipated the possibility of attack and been better prepared.

conducive to arrogance—an overestimation of our own intellectual powers. After the invention and acceptance of the typewriter, people said it was a machine that demanded invention and that, once invented, had to be a success. But to Christopher Latham Sholes, creator of the Remington, its success was not so obvious beforehand. In an 1872 letter he confided: "My apprehension is [that] it will have its brief day and be thrown aside."

Moreover, because outcomes seem as if they should have been foreseeable, we are more likely to blame decision makers for what are in retrospect "obvious" bad choices than to praise them for good choices, which also seem "obvious." *After* the 1991 Persian Gulf War, it seemed obvious that the overwhelming air superiority of the anti-Iraq coalition would rout the Iraqi military, though that was hardly clear to most politicians and pundits beforehand. After Japan's attack on Pearl Harbor, hints of the impending attack seemed similarly obvious to Monday morning historians, who chastised the politicians and the U.S. military leadership for not having anticipated what happened.

Likewise, we sometimes chastise ourselves for "stupid mistakes"—perhaps for not having handled a situation or a person better. Looking back, we see how we should have handled it. (Recall Arthur Schlesinger's regret "for having

kept so silent" during discussions of the CIA plan to invade Cuba's Bay of Pigs.) But sometimes we are too hard on ourselves. We forget that what is obvious to us *now* was not nearly so obvious at the time. Physicians told both a patient's symptoms and the cause of death (as determined by autopsy) sometimes wonder how an incorrect diagnosis could have been made. Other physicians, given only the symptoms, don't find the diagnosis nearly so obvious (Dawson & others, 1988). (Would juries be slower to assume malpractice if they were forced to take a foresight rather than a hindsight perspective?)

So what shall we conclude—that common sense is usually wrong? Sometimes it is. Until science dethroned the common sense view, centuries of daily experience assured people that the sun revolved around the earth. But usually conventional wisdom is right—under certain conditions. So the point is not that common sense is always wrong. Rather, common sense usually is right *after the fact*; it describes events more easily than it predicts them. We therefore easily deceive ourselves into thinking that we know and knew more than we do and did.

■ SUMMING UP

SOCIAL PSYCHOLOGY AND RELATED DISCIPLINES

Social psychology is the scientific study of how people think about, influence, and relate to one another. Sociology and psychology are social psychology's parent disciplines. Social psychology tends to be more individualistic in its content and more experimental in its method than other areas of sociology. Compared to personality psychology, social psychology focuses less on differences among individuals and more on how people, in general, view and affect one another. There are many additional perspectives on human nature, each of which asks its own set of questions and provides its own set of answers. These different perspectives are complementary, not contradictory.

SOCIAL PSYCHOLOGY AND HUMAN VALUES

Social psychologists' values penetrate their work in obvious ways, such as their choice of research topics, and in subtler ways, such as their hidden assumptions when forming concepts, choosing labels, and giving advice. There is a growing awareness of the subjectivity of scientific interpretation, of values hidden in social psychology's concepts and labels, and of the gulf between scientific description of what is and ethical prescription of what ought to be. This penetration of values into science is not unique to social psychology, nor is it anything to be embarrassed about. That human thinking is seldom dispassionate is precisely (1) why we need systematic observation and experimentation if we are to check our cherished ideas against reality and (2) why social psychologists in different cultures are eager to exchange ideas and findings.

HOW WE DO SOCIAL PSYCHOLOGY

Most social psychological research is either correlational or experimental. Correlational studies, sometimes conducted with systematic survey methods, dis-

cern the relationship between variables, such as between amount of education and amount of income. Knowing two things are naturally related is valuable information, but it seldom indicates what is causing what. When possible, social psychologists prefer to conduct experiments that explore cause and effect. By constructing a miniature reality that is under their control, experimenters can vary one thing and then another and discover how these things, separately or in combination, affect behavior. We randomly assign participants to an experimental condition, which receives the experimental treatment, or to a control condition, which does not. We can then attribute any resulting difference between the two conditions to the independent variable. In creating involving experiments, social psychologists sometimes stage situations that engage people's emotions. In doing so, they are obliged to follow professional ethical guidelines, such as obtaining people's informed consent, protecting them from harm, and fully disclosing afterward any temporary deceptions.

Social psychologists organize their ideas and findings into theories. A good theory will distill an array of facts into a much shorter list of predictive principles. We can use these predictions to confirm or modify the theory, to generate new exploration, and to suggest practical application. Laboratory experiments enable social psychologists to test ideas gleaned from life experience and then to apply the principles and findings back in the real world.

I KNEW IT ALL ALONG: IS SOCIAL PSYCHOLOGY SIMPLY COMMON SENSE?

Social psychology's findings sometimes seem obvious. However, experiments reveal that outcomes are more "obvious" after the facts are known. This hindsight bias often makes people overconfident about the validity of their judgments and predictions.

■ FOR FURTHER READING

To see social psychology firsthand in its primary sources, skim, for North American social psychology, the *Journal of Personality and Social Psychology*, published by the American Psychological Association, or *Personality and Social Psychology Bulletin*.

To sample European social psychology, see the *European Journal of Social Psychology* (published by the European Association of Experimental Social Psychology) or the *British Journal of Social Psychology* (published by the British Psychological Society).

For a carefully selected sample of influential articles from the literature of social psychology, see Amy Halberstadt and Steve Ellyson's *Readings from the First Century of Social Psychology* (McGraw-Hill, 1990).

Three paperback books nicely introduce social psychology's methods:

Aron, A., & Aron, E. (1990). *The heart of social psychology,* 2nd edition. Lexington, MA: D. C. Heath. Provides a personal glimpse of what motivates social psychologists, based on extensive interviews with leading researchers.

Dane, F. C. (1988). *The common and uncommon sense of social behavior.* Belmont, CA: Brooks/Cole. An informal account of social psychology's purposes and methods, based on close analyses of a well-chosen sample of recent experiments.

Hunt, M. (1985). *Profiles of social research: The scientific study of human interactions.* New York: Russell Sage. A gifted science writer provides a behind-the-scenes tour through the wonder and excitement of social research. Depicts the human drama—the joys, struggles, and dilemmas—of doing such research.

SOCIAL THINKING

Change the way people think and things will never be the same.

STEPHEN BIKO
SOUTH AFRICAN CIVIL RIGHTS MARTYR

This book unfolds around its definition of social psychology: the scientific study of how we *think about* (Part One), *influence* (Part Two), and *relate* (Part Three) to one another.

These chapters on social thinking examine how we view ourselves and others. In varying ways, each chapter confronts an overriding question: How reasonable are our social attitudes, explanations, and beliefs? Are our impressions of ourselves and others generally accurate? How is our social thinking prone to bias and error, and how might we bring it closer to reality?

Chapter 2 looks at the amazing and sometimes rather amusing ways in which we form beliefs about our social worlds and reveals a half-dozen ways in which we are prone to err.

Chapter 3 analyzes how we explain other people's actions and our own. For example, when do we attribute people's actions to their circumstances ("She was angered by the insult") and when to their dispositions ("He is an angry, hostile person") Do we explain our own actions similarly?

Chapter 4 explores the links between attitudes and behaviors: Do our attitudes determine our behaviors? Do our behaviors determine our attitudes? Or does it work both ways?

Chapter 5 examines the implications of this research on attitudes, explanations, and beliefs for the mental health professions. For example, how do people explain their emotional and health problems? And how might psychologists and physicians diagnose people more accurately and treat them more effectively.

SOCIAL BELIEFS

When historians describe social psychology's first century, they will surely record the last 25 years as the era of social cognition. By drawing upon advances in cognitive psychology—in how people perceive, represent, and remember events—social psychologists have shed welcome light on how we form impressions, judgments, and explanations. These aspects of our social beliefs matter because they are basic to so much else: to our feelings of well-being or depression, to our opinions and reactions, to our prejudices and affections. So let's begin, in this chapter and the next, by looking at *how* we form impressions, judgments, and explanations.

Along the way we can also shed light on a centuries-old debate on human rationality. How deserving are we of our name, *homo sapiens*—wise humans? Are we, as Shakespeare's Hamlet proclaimed, "noble in reason! . . . infinite in faculty! . . . in apprehension like a god!" Or do we fit T. S. Eliot's description, "Headpiece filled with straw"?

Those impressed by our cognitive powers point to the unimaginable complexity of our brains, which outstrip the smartest computers in recognizing patterns, handling language, and processing abstract information. As cognitive scientists emphasize, our information processing is also wonderfully efficient. With such precious little time to process so much information, we specialize in mental shortcuts. Scientists marvel at the speed and ease with which we form impressions, judgments, and explanations. In many situations, our snap generalizations—"That's dangerous!"—are adaptive. They promote our survival.

Those impressed by our capacity for error point to the ways in which we form and sustain false beliefs about ourselves and the social world (recall the I-knew-it-all-along phenomenon). Through much of its history, psychology has explored the mind's facility at fabricating experiences—dreams, hallucina-

The web of illusion: Psychologists have long been fascinated by people's capacity to create illusions—sometimes to deceive or mislead themselves, sometimes to deceive or mislead others.

tions, delusions, illusions. Our capacity for creating a web of illusion fascinated Sigmund Freud. "Freud unmasked our hypocrisies, our phony ideas, our rationalization, our vanities," noted Calvin Hall (1978), "and not all the efforts of humanists and rationalists will restore the mask." More recently, brain researchers have discovered that patients whose brain hemispheres have been surgically separated will instantly fabricate—and believe—explanations of puzzling behaviors (Gazzaniga, 1985). If the patient gets up and takes a few steps after the experimenter flashes the instruction "walk" to the patient's nonverbal right hemisphere, the verbal left hemisphere will instantly invent a plausible explanation ("I felt like getting a drink").

Illusory thinking appears most strikingly, however, in the vast new literature on how we take in, store, and retrieve information. As perception researchers study visual illusions for what they reveal about our normal perceptual mechanisms, social psychologists study distortions in social thinking for what they reveal about normal information processing. These researchers want to give us a map of everyday social thinking, with the hazards clearly marked. As we examine some of these efficient thinking patterns, remember this: Demonstrations of how people create counterfeit beliefs do not prove that all beliefs are counterfeit. Still, to recognize counterfeiting, it helps to know how it's done. So let's explore how we form ideas about ourselves and others, and see where and how efficient information processing can go awry.

"People are good enough to get through life, poor enough to make predictable and consequential mistakes."
Baruch Fischhoff, 1981

■ WE OFTEN DO NOT KNOW WHY WE DO WHAT WE DO

"There is one thing, and only one in the whole universe which we know more about than we could learn from external observation," noted C. S. Lewis (1960, pp. 18–19). "That one thing is [ourselves]. We have, so to speak, inside information; we are in the know."

Indeed, some things we know best by intuition and personal experience. The *fallibility* of our self-knowledge is, however, considerably less self-evident; sometimes we *think* we know, but our inside information is wrong. This is the unavoidable conclusion of some fascinating recent research.

EXPLAINING OUR BEHAVIOR

Why did you choose your college? Why did you lash out at your roommate? Why did you fall in love with that special person? Sometimes we know. Sometimes we don't know. Asked why we have felt or acted as we have, we produce plausible answers. Yet, when causes and determinants are not obvious, our self-explanations often err. Factors that have big effects we sometimes report as innocuous, and factors that have little effect we sometimes perceive as influential.

Richard Nisbett and Stanley Schachter (1966) demonstrated this by asking Columbia University students to take a series of electric shocks of steadily increasing intensity. Beforehand, some took a fake pill which, they were told, would produce heart palpitations, breathing irregularities, and butterflies in the stomach—the very symptoms that usually accompany being shocked. Nis-

bett and Schachter anticipated people would attribute the symptoms of shock to the pill rather than to the shock. Thus they should tolerate more shock than people not given the pill. Indeed, the effect was enormous—people given the fake pill took four times as much shock.

When informed they had taken more shock than average, and asked why, their answers did not mention the pill. When pressed (and even after the experimenter explained the experiment's hypotheses in detail), they denied the pill's influence. They would usually say the pill probably did affect some people, but not them. A typical reply was, "I didn't even think about the pill."

Sometimes people think they *have* been affected by something that has had no effect. Nisbett and Timothy Wilson (1977) had University of Michigan students rate a documentary film. While some of them watched, a power saw was run just outside the room. Most people felt that this distracting noise affected their ratings. But it didn't; their ratings were similar to those of control subjects who viewed the film without distraction.

Even more thought provoking are studies in which people recorded their moods every day for two or three months (Stone & others, 1985; Weiss & Brown, 1976; Wilson & others, 1982). They also recorded factors that might affect their moods—the day of the week, the weather, the amount they slept, and so forth. At the end of each study, the people judged how much each factor had affected their moods. Remarkably (given that their attention was being drawn to their daily moods) there was little relationship between their perceptions of how important a factor was and how well the factor actually predicted their mood. In fact, their estimates of how well the weather or the day of the week had predicted their mood were no better than estimates made by strangers. These findings raise a disconcerting question: How much insight do we really have into what makes us happy or unhappy?

PREDICTING OUR BEHAVIOR

Finally, we are often poor at predicting our own behavior. Asked whether they would obey demands to deliver severe electric shocks or would hesitate to help a victim if several other people were present, people overwhelmingly deny their vulnerability to such influences. But as we will see, experiments have shown that many of us are vulnerable. Moreover, consider what Sidney Shrauger (1983) discovered when he had college students predict the likelihood of their experiencing dozens of different events during the ensuing two months (becoming romantically involved, being sick, and so forth): Their self-predictions were hardly more accurate than predictions based on the average person's experience. The surest thing we can say about your individual future is that it is hard for even you to predict. The best advice is to look at your past behavior in similar situations (Osberg & Shrauger, 1986).

THE WISDOM AND DELUSIONS OF SELF-ANALYSIS

"Know thyself," urged the ancient Greek philosopher Thales. We try. But to a striking extent, we are often wrong about what has influenced us and what we will feel and do. Our intuitive self-insights can be completely off. But let's not overstate the case. When the causes of our behavior are conspicuous and the correct explanation fits our intuition, our self-perceptions will be accurate

"You don't know your own mind."
Jonathan Swift,
Polite Conversation, 1738

"There are three things extremely hard, Steel, a Diamond, and to know one's self."
Benjamin Franklin

The works artists and scientists produce are often the result of processes they themselves cannot explain. The source of this sculptor's insight, for example, may be as much a mystery to her as it is to the observer of the finished piece.

(Gavanski & Hoffman, 1987). Peter Wright and Peter Rip (1981) found that California high school juniors *could* discern how such features of a college as its size, tuition, and distance from home influenced their reactions to it. It is when the causes of behavior are not obvious to an observer that they are not obvious to us either.

Cognitive psychologists explain that we are unaware of much that goes on in our minds. Studies of perception and memory show that our awareness is mostly of the *results* of our thinking and not of the *process*. We experience the results of our mind's unconscious workings when we set a mental clock to record the passage of time and to awaken us at an appointed hour, or when we achieve a spontaneous creative insight after a problem has unconsciously "incubated." Creative scientists and artists, for example, often cannot report the thought process that produced their insights.

Social psychologist Timothy Wilson (1985) offers the bold idea that the mental processes which control our social behavior are distinct from the mental processes through which we explain our behavior. Our rational explanations may fail to reflect the underlying attitudes that actually guide our behavior. In nine experiments, Wilson and his co-workers (1989) found that people's expressed attitudes—toward things or toward others—predicted their later behavior reasonably well, *unless* they asked the people to analyze their feelings before indicating their attitudes. For example, dating couples' happiness with their relationship was a reasonably good predictor of whether they were still dating several months later. But if before rating their happiness they first listed all the reasons they could think of why their relationship was good or bad, then their attitude reports were useless in predicting the future of the relationship! Apparently the process of dissecting the relationship drew people's attention to easily verbalized factors that actually were less important than other aspects of the relationship that were harder to verbalize. As the scientist-philosopher Pascal discerned some 300 years ago, "The heart has its reasons which reason does not know."

"Self-contemplation is a curse that makes an old confusion worse."
Theodore Roethke, *The Collected Poems of Theodore Roethke*, 1975

Murray Millar and Abraham Tesser (1985, 1989) believe that Wilson overstates our ignorance of self. Their research suggests that, yes, drawing people's attention to *reasons* diminishes the usefulness of attitude reports in predicting behaviors that are driven by *feelings*. If instead of having people analyze their romantic relationships Wilson had first asked them to get more in touch with their feelings ("How do you feel when you are with and apart from your partner?"), their attitude reports might have been *more* insightful. Other behavior domains—say, choosing which school to attend based on considerations of cost, career advancement, and so forth—seem more cognitively driven. For these, an analysis of reasons rather than feelings may be most useful. While the heart has its reasons, sometimes the mind's own reasons are decisive.

This research on the limits of our self-knowledge has two practical implications. The first is for psychological inquiry. The introspections of clients or research subjects may provide useful clues to their psychological processes, but *self-reports are often untrustworthy*. Errors in self-understanding limit the scientific usefulness of subjective personal reports.

The second implication is for our everyday lives. The sincerity with which people report and interpret their experiences is no guarantee of the validity of these reports. Personal testimonies are powerfully persuasive, but they may also convey unwitting error. Keeping this potential for error in mind can help us feel less intimidated by others and to be less gullible.

"The naked intellect is an extraordinarily inaccurate instrument."
Madeline L'Engle,
A Wind in the Door

■ OUR PRECONCEPTIONS CONTROL OUR INTERPRETATIONS AND MEMORIES

Experiments show that a significant fact about the human mind is the extent to which preconceived notions guide how we perceive, interpret, and remember information. People will grant that preconceptions matter, yet fail to realize how great the effect is. Let's look at some recent experiments. Some examine how *pre*judgments affect the way people perceive and interpret information. Others plant a judgment in people's minds *after* they have been given information to study how after-the-fact ideas bias people's *recall*.

PERCEIVING AND INTERPRETING EVENTS

The effects of prejudgments and expectations are standard fare for psychology's introductory course. Recall the Dalmatian photo in Chapter 1. Or consider this phrase:

<div align="center">
A

BIRD

IN THE

THE HAND
</div>

Did you notice anything wrong with it? There is more to perception than meets the eye. This was tragically demonstrated in 1988 when the crew of the *USS Vincennes* took an Iranian airliner to be an F-14 fighter plane and then proceeded to shoot it down. As social psychologist Richard Nisbett (1988) noted in

FIGURE 2-1 *Pro-Israeli and pro-Arab students who viewed network news descriptions of the "Beirut massacre" believed the coverage to be biased against their point of view.* (Data from Vallone, Ross, & Lepper, 1985.)

a congressional hearing on the incident, "The effects of expectations on generating and sustaining mistaken hypotheses can be dramatic."

The same is true of social perception. Because social perceptions are very much in the eye of the beholder, even a simple stimulus may strike two people quite differently. Saying Canada's Brian Mulroney is "an okay prime minister" may sound like a put-down to one of his ardent admirers and as positively biased to someone who regards him with contempt. When social information is ambiguous—subject to multiple interpretations—preconceptions matter (Hilton & von Hippel, 1990).

An experiment by Robert Vallone, Lee Ross, and Mark Lepper (1985) reveals just how powerful preconceptions can be. They showed pro-Israeli and pro-Arab students six network news segments describing the 1982 killing of civilian refugees at two camps in Lebanon. As Figure 2-1 illustrates, each group perceived the networks as hostile to its side. The phenomenon is commonplace: Presidential candidates and their supporters nearly always view the news media as unsympathetic to their cause. Sports fans perceive referees as partial to the other side. People in conflict (married couples, labor and management, opposing racial groups) see impartial mediators as biased against them.

Our shared assumptions about the world can even make contradictory evidence seem supportive. For example, Ross and Lepper assisted Charles Lord (1979) in showing Stanford University students the results of two purported new research studies. Half the students favored capital punishment and half opposed it. One study confirmed and the other disconfirmed the students' beliefs about the deterrence effect of the death penalty. Both proponents and opponents of capital punishment readily accepted evidence that confirmed their belief but were sharply critical of disconfirming evidence. Showing the two sides an *identical* body of mixed evidence had therefore not narrowed their disagreement but *increased* it. Each side perceived the evidence as supporting its belief and now believed even more strongly.

"As I am, so I see."
Ralph Waldo Emerson, *Essays*

Safe or out? Fans' perceptions of the same event often vary with their loyalties.

"Once you have a belief, it influences how you perceive all other relevant information. Once you see a country as hostile, you are likely to interpret ambiguous actions on their part as signifying their hostility."
Political scientist Robert Jervis (1985)

"The error of our eye directs our mind: What error leads must err."
Shakespeare, *Troilus and Cressida*, 1601–1602

Is this why, in politics, religion, and science, ambiguous evidence often fuels conflict? Presidential TV debates in the United States have mostly reinforced predebate opinions. By nearly a 10 to 1 margin, those who already favored one candidate or the other in the 1960, 1976, and 1980 debates perceived their candidate as having won (Kinder & Sears, 1985).

Preconceptions sway scientists too. In Chapter 1 we noted that beliefs and values penetrate science. Philosophers of science remind us that our observations are "theory-laden." There is an objective reality out there, but we view it through the spectacles of our beliefs, attitudes, and values. This is one reason our beliefs are so important; they shape our interpretation of everything else. Often, this is justifiable. Your preconceptions of the editorial standards of certain tabloid newspapers probably justify your disregarding headlines proclaiming, "Computers talk with the dead." So preconceptions can be useful: The occasional biases they create are the price we pay for their helping us filter and organize vast amounts of information efficiently.

That presuppositions affect both scientific and everyday thinking is an accepted fact. Less well known are experiments that manipulate preconceptions, with astonishing effects upon how people interpret and recall what they observe. Myron Rothbart and Pamela Birrell (1977) had University of Oregon students assess the facial expression of the man shown in Figure 2-2. Students told he was a Gestapo leader responsible for barbaric medical experiments on concentration camp inmates during World War II judged his expression as cruel. (Can you see that barely suppressed sneer?) Those told he was a leader in the anti-Nazi underground movement whose courage saved thousands of Jewish lives judged his facial expression as warm and kindly. (On second thought, look at those caring eyes and that almost smiling mouth.)

West German researcher Harald Wallbott (1988) controlled people's perceptions of emotion by manipulating the setting in which they see a face. Filmmakers call this the "Kulechov effect," after a Russian film director who would skillfully guide viewers' inferences by manipulating their assumptions.

Kulechov demonstrated the phenomenon by creating three short films that presented the face of an actor with a neutral expression after viewers had first been shown a dead woman, a dish of soup, or a girl playing—making the actor seem sad, thoughtful, or happy.

Thomas Hill, Pawel Lewicki, and their colleagues (1989) have shown how these interpretative biases become self-perpetuating. They first showed University of Tulsa students two-minute films of three men and three women, each of whom were heard "thinking out loud" while in some situation. Students in the "male sadness" condition heard each of the happy-looking men confess their inner anxiety and unhappiness and heard each of the women mentioning some minor frustration. Other students heard the *females* verbalize hidden sadness. When the students afterward rated certain male and female acquaintances on traits related to sadness, there was little effect of the filmed hints that happy-looking males (or females) may actually be harboring an inner sadness. Two weeks later the students were unexpectedly asked again to rate their friends. Now, after many fresh opportunities to notice and interpret their friends' behaviors, those who'd seen the film clips of sad men *did* perceive their male friends as sadder, while those who'd seen the film clips of sad women perceived their female friends as sadder. Supplied with the idea that cheerful-seeming men (or women) may actually be hurting inside, they had perceived their friends accordingly.

"We hear and apprehend only what we already half know." Henry David Thoreau (1817–1862)

Belief Perseverance

If a false idea biases information processing, will later discrediting it erase its effects? Imagine a baby-sitter who decides, during an evening with a crying

FIGURE 2-2 *The photo of "Kurt Walden" as shown by Myron Rothbart and Pamela Birrell. Judge for yourself: Is this man cruel or kindly?*

infant, that bottle feeding produces colicky babies: "Come to think of it, cow's milk obviously better suits calves than babies." If the infant turns out to be suffering a high fever, will the sitter nevertheless persist in believing that bottle feeding causes colic (Ross & Anderson, 1982)? To find out, Lee Ross, Craig Anderson, and their colleagues planted a falsehood in people's minds and then tried to discredit it.

Their experiments reveal that it is surprisingly difficult to demolish a falsehood, once the person conjures up a rationale for it. Each experiment first implanted a belief, either by proclaiming it was true or by inducing people to come to that conclusion after inspecting two sample cases. Then the people were asked to explain *why* it is true. Finally, the researchers totally discredited the initial information, by telling the person the truth: The information was manufactured for the experiment, and half the people in the experiment had received opposite information. Nevertheless, the new belief survived about 75 percent intact, presumably because the people still retained their invented explanations for the belief. This phenomenon, named **belief perseverance,** shows that beliefs can take on a life of their own, surviving the discrediting of the evidence that gave them birth.

For instance, Anderson, Lepper, and Ross (1980) asked people, after giving them two concrete cases to inspect, to decide whether people who take risks make good or bad fire fighters. One group considered a risk-prone person who was a successful fire fighter and a cautious person who was an unsuccessful one. The other group considered cases suggesting the opposite conclusion. After forming their theory that risk-prone people make better or worse fire fighters, the people wrote an explanation for it—for example, that risk-prone people are brave or that cautious people are careful. Once formed, each explanation could exist independently of the information that initially created the belief. Thus when that information was discredited, the people still held their

Belief perseverance:
Persistence of one's initial conceptions, as when the basis for one's belief is discredited but an explanation of why the belief might be true survives.

Do people who take risks make the best firefighters? Or the worst?

self-generated explanations and therefore continued to believe that risk-prone people really *do* make better or worse firefighters.

These experiments also show that the more we examine our theories and explain how they *might* be true, the more closed we become to information that challenges our belief. Once we consider why an accused person might be guilty, why someone of whom we have a negative first impression acts that way, or why a favored stock might rise in value, our explanations may survive challenging evidence to the contrary (Jelalian & Miller, 1984). Once we attribute our failure at the hands of an incompetent teacher to our own incompetence, our low self-image may persevere (Lepper & others, 1986).

The evidence is compelling: Our beliefs and expectations powerfully affect how we notice and interpret events. We usually benefit from our preconceptions, just as scientists benefit from creating theories that guide them in noticing and interpreting events. But the benefits sometimes entail a cost; we become prisoners of our own thought patterns. Thus the "canals" that were so often seen on Mars turned out indeed to be the product of intelligent life—an intelligence on earth's side of the telescope.

Is there any way we can restrain belief perseverance? There is a simple remedy: *Explain the opposite.* Charles Lord, Mark Lepper, and Elizabeth Preston (1984) repeated the capital punishment study described earlier and added two variations. First, they asked some of their subjects when evaluating the evidence to be *"as objective* and *unbiased* as possible."* It was to no avail; whether for or against capital punishment, those who received this plea made evaluations as biased as those who did not.

The researchers asked a third group of subjects to consider the opposite—to ask themselves "whether you would have made the same high or low evaluations had exactly the same study produced results on the *other* side of the issue." After imagining an opposite finding, these people were much less biased in their evaluations of the evidence for and against their views. In his experiments, Craig Anderson (1982; Anderson & Sechler, 1986) consistently found that explaining why an opposite theory might be true—why a cautious rather than a risk-taking person might be a better fire fighter—reduces or eliminates belief perseverance. So, to counteract belief perseverance, force yourself to explain why the opposite belief might be true.

"No one denies that new evidence can change people's beliefs. Children do eventually renounce their belief in Santa Claus. Our contention is simply that such changes generally occur slowly, and that more compelling evidence is often required to alter a belief than to create it."
Lee Ross & Mark Lepper (1980)

"Two-thirds of what we see is behind our eyes."
Chinese proverb

RECALLING EVENTS

Our beliefs control not only our perceptions and interpretations but also our memories. Do you agree or disagree with this statement?

> Memory can be likened to a storage chest in the brain into which we deposit material and from which we can withdraw it later if needed. Occasionally, something is lost from the "chest," and then we say we have forgotten.

About 85 percent of college students agree (Lamal, 1979). As a 1988 ad in *Psychology Today* put it, "Science has proven the accumulated experience of a lifetime is preserved perfectly in your mind."

Memory Construction

Actually, psychological research has proved the opposite. Many memories are not copies of experiences that remain on deposit in a memory bank. Rather, we

Memories, unlike photographs, are reconstructed when they are withdrawn from the memory bank.

construct memories at the time of withdrawal, for memory involves backward reasoning. It infers what must have been, given what we now believe or know. Like a paleontologist inferring the appearance of a dinosaur from bone fragments, we reconstruct our distant past by combining fragments of information using our current expectations (Hirt, 1990). Thus we can easily (though unconsciously) revise our memories to suit our current knowledge. When one of my sons complained, "The June issue of *Cricket* never came," and was shown where it was, he delightedly responded, "Oh good, I knew I'd gotten it."

Reconstructing Past Attitudes

Five years ago, how did you feel about nuclear power? about Ronald and Nancy Reagan? about your parents? If your attitudes have changed, do you know the extent of the change?

Experimenters have tried to answer such questions. The results have been unnerving: People whose attitudes have changed often insist that they have always felt much as they now feel. Daryl Bem and Keith McConnell (1970) took a survey among Carnegie-Mellon University students. Buried in it was a question concerning student control over the university curriculum. A week later the students agreed to write an essay opposing student control. After doing so, their attitudes shifted toward greater opposition to student control. When asked to recall how they had answered the question before writing the essay, they "remembered" holding the opinion that they *now* held and denied that the experiment had affected them. After observing Clark University students similarly denying their former attitudes, researchers D. R. Wixon and James Laird (1976) commented: "The speed, magnitude, and certainty" with which the students revised their own histories "was striking."

"A man should never be ashamed to own that he has been in the wrong, which is but saying, in other words, that he is wiser today than he was yesterday."
Jonathan Swift,
Thoughts on Various Subjects,
1711

In 1973, University of Michigan researchers interviewed a national sample of high school seniors and then reinterviewed them in 1982 (Markus, 1986). When recalling their 1973 attitudes on issues such as aid to minorities, the legalization of marijuana, and equality for women, people's reports were much closer to their 1982 attitudes than to those they actually expressed in 1973. As George Vaillant (1977, p. 197) noted after following some adults for a period of time: "It is all too common for caterpillars to become butterflies and then to maintain that in their youth they had been little butterflies. Maturation makes liars of us all."

Cathy McFarland and Michael Ross (1985) found that we even revise our recalled views of other people as our relationships with them change. They had university students rate their steady dating partners. Two months later, they rated them again. Students who were more in love than ever had a tendency to recall love at first sight. Those who had broken up were more likely to recall having recognized the partner as somewhat selfish and ill-tempered.

Diane Holmberg and John Holmes (in press) discovered the same phenomenon among 373 newlywed couples, most of whom reported being very happy. When resurveyed two years later, those whose marriages had soured recalled that things had always been bad. The results are "frightening," say Holmberg and Holmes: "Such biases can lead to a dangerous downward spiral. The worse your current view of your partner is, the worse your memories are, which only further confirms your negative attitudes."

It's not that we are totally unaware of how we used to feel, just that when memories are hazy, current feelings guide our recall. Parents of every generation bemoan the values of the next generation, partly because they misrecall their youthful values as being closer to their current values.

Reconstructing Past Behavior

Memory construction enables us to revise our own histories. Michael Ross, Cathy McFarland, and Garth Fletcher (1981) exposed some University of Waterloo students to a message convincing them of the desirability of toothbrushing. Later, in a supposedly different experiment, these students recalled brushing their teeth more often during the preceding two weeks than did students who had not heard the message. Likewise, when representative samples of Americans are asked about their cigarette smoking and their reports are projected to the nation as a whole, at least a third of the 600 billion cigarettes sold annually are unaccounted for (Hall, 1985). Noting the similarity of such findings to happenings in George Orwell's *Nineteen Eighty-Four*—where it was "necessary to remember that events happened in the desired manner"—social psychologist Anthony Greenwald (1980) surmised that we all have "totalitarian egos" that revise the past to suit our present views.

"Vanity plays lurid tricks with our memory."
Novelist Joseph Conrad, 1857–1924

Sometimes our present view is that we've improved—in which case we may misrecall our past as more *un*like the present than it actually was. This tendency resolves a puzzling pair of consistent findings: Those who participate in self-improvement programs (weight-control programs, antismoking programs, exercise programs, psychotherapy) show only modest improvement on average. Yet they often claim considerable benefit (Myers, 1992). Michael Conway and Michael Ross (1985) explain why. Having expended so much time, effort, and money on self-improvement, people may conveniently think, "I may not be perfect now, but I was worse before; this did me a lot of good." For example,

the participants in a study-skills course emerged from the experience thinking their skills had improved, especially in comparison to their now biased memories about how terrible they were before the course. But despite their belittling of their past, and their optimism about their academic future, the sad truth is that their grades did not change (Conway & Ross, 1984).

Reconstructing Our Experiences

Studies of conflicting eyewitness testimonies further illustrate our tendency to recall the past with great confidence but sometimes little accuracy. Elizabeth Loftus and John Palmer (1973) showed University of Washington students a film of a traffic accident and then asked them questions about what they had seen. People asked "How fast were the cars going when they smashed into each other?" gave higher estimates than those asked "How fast were the cars going when they hit each other?" A week later they were also asked whether they recalled seeing any broken glass. There was no broken glass. Yet people who had been asked the "smashed into" question were more than twice as likely as those asked the "hit" question to report seeing broken glass. What is more, it's difficult for untrained observers to distinguish between unreal memories (those constructed from suggestion, as with the broken glass) and memories of actual experience (Schooler & others, 1986). As such experiments show, in constructing a memory, we unconsciously use our general knowledge and beliefs to fill in the holes, thus organizing fragments from our actual past into a convincing store.

Pause to recall a scene from a favorite past experience. . . . Do you see yourself in the scene? If so, your memory must be a reconstruction, for in reality you did not see yourself.

This process affects our recall of social as well as physical events. Jack Croxton and his colleagues (1984) had students spend 15 minutes talking with someone. Those later informed that this person reported liking them recalled

Twenty years ago, how did these Latvians feel about Lenin and communism? If we asked them today, they might misrecall their former attitudes as being closer than they were to their current attitudes.

the person's behavior as relaxed, comfortable, and happy. Those informed that the person disliked them recalled the person as nervous, uncomfortable, and not so happy.

To understand why, it helps to have an idea of how our memories work. We can think of memory fragments as stored in a web of associations. To retrieve a memory, we need to activate one of the strands that leads to it, a process called **priming** (Bower, 1986). Priming is what the philosopher-psychologist William James described as the "wakening of associations."

Events may awaken or prime our associations without our realizing it. Watching a scary movie while alone at home can prime our thinking—by activating frightening memories that cause us to interpret the creaking furnace as an intruder. For many psychology students, reading about psychological disorders makes such categories accessible when interpreting their own anxieties and gloomy moods. In experiments, ideas implanted in people's minds act like preconceptions: They automatically—unintentionally, effortlessly, and without awareness—influence how people interpret and recall events (Bargh, 1989). Having recently seen words such as "adventurous" and "self-confident," people will later, in a different context, form positive impressions of an imagined mountain climber or Atlantic sailor. If, instead, their thinking is primed with such negative words as "reckless," their impressions are more negative (Higgins & others, 1977).

In Chapter 5 we will see that psychiatrists and clinical psychologists are not immune to these human tendencies. We *all* selectively notice, interpret, and recall events in ways that sustain our ideas.

Priming:
Activating particular associations in memory.

■ WE OVERESTIMATE THE ACCURACY OF OUR JUDGMENTS

We have seen how easily we can falsely explain why we do what we do. And we have seen how our beliefs control our perceptions, interpretations, and memories. Unaware of such tendencies, we may sometimes also be unaware of our mistakes in judgment.

THE OVERCONFIDENCE PHENOMENON

The intellectual conceit evident in our judgments of our past knowledge ("I knew it all along") extends to estimates of our current knowledge. Daniel Kahneman and Amos Tversky (1979) gave people factual questions and asked them to fill in the blanks, as in: "I feel 98 percent certain that the air distance between New Delhi and Beijing is more than _____ miles but less than _____ miles."

Most subjects were overconfident: About 30 percent of the time, the correct answers lay outside the range they felt 98 percent confident about. Baruch Fischhoff and his colleagues (1977) discovered the same **overconfidence phenomenon** when people rate their certainty about their answers to multiple-choice questions, such as: "Which is longer: (a) the Panama Canal, or (b) the Suez Canal?" If people 60 percent of the time answer such a question correctly, they will typically *feel* about 75 percent sure.

Overconfidence phenomenon:
The tendency to be more confident than correct—to overestimate the accuracy of one's beliefs.

To find out whether overconfidence extends to social judgments, David Dunning and his associates (1990) created a little game show. They asked Stanford University students to guess a stranger's answers to a series of questions, such as, "Would you prepare for a difficult exam alone or with others?" and "Would you rate your lecture notes as neat or messy?" Knowing the type of questions, but not the actual questions, the subjects first interviewed their target person about background, hobbies, academic interests, aspirations, astrological sign—anything they thought might be helpful. Then while the target persons answered 20 of the two-choice questions, the interviewers predicted their target's answers and rated their own confidence.

The interviewers guessed right 63 percent of the time, beating chance by 13 percent. But, on average, they *felt* 75 percent sure of their predictions. When guessing their own roommates' responses, they were 68 percent correct and 78 percent confident. Moreover, the most confident people were most likely to be *over*confident.

Do people better predict their own behavior? To find out, Robert Vallone and his colleagues (1990) had college students predict in September whether they would drop a course, declare a major, elect to live off campus next year, and so forth. Although the students felt 84 percent sure of these self-predictions, on average, they erred nearly twice as often (29 percent of the time) as they expected. Even when feeling 100 percent sure of their predictions, they erred 15 percent of the time.

Overconfidence also permeates everyday decision making. Investment experts market their services with the presumption that they can beat the stock market average (forgetting that for every stockbroker or buyer saying "Sell!" at a given price there is another saying "Buy!"). A stock's price is the balance point between these mutually confident judgments. Thus, incredible as it may seem, economist Burton Malkiel (1985) reports that mutual fund portfolios selected by investment analysts have not outperformed randomly selected stocks.

Editors' assessments of manuscripts also reveal surprising error and unreliability. In psychology, studies reveal a distressingly modest relationship between one reviewer's evaluation of a manuscript and a second reviewer's evaluation. But it's not true just of psychology. Writer Chuck Ross (1979), using a pseudonym, mailed a typewritten copy of Jerzy Kosinski's novel *Steps* to 28 major publishers and literary agencies. All rejected it, including Random House, which had published the book in 1968 and watched it win the National Book Award and sell more than 400,000 copies. The novel came closest to being accepted by Houghton Mifflin, publisher of three other Kosinski novels: "Several of us read your untitled novel here with admiration for writing and style. Jerzy Kosinski comes to mind as a point of comparison. . . . The drawback to the manuscript, as it stands, is that it doesn't add up to a satisfactory whole."

As this example hints, overconfident decision makers can wreak havoc. It was a confident Adolf Hitler who in the 1940s waged war against the rest of Europe. It was a confident Lyndon Johnson who invested U.S. weapons and soldiers in the effort to salvage democracy in South Vietnam in the 1960s. It was a confident Ronald Reagan who in 1980 believed that selling weapons in Iran would promote moderation and help liberate U.S. hostages. In 1990 it was a confident Saddam Hussein who marched his army into Kuwait.

Overconfidence is an accepted fact of psychology. The issue is what produces it. Why does experience not lead us to a more realistic self-appraisal?

"The wise know too well their weakness to assume infallibility; and he who knows most, knows best how little he knows."
Thomas Jefferson, *Writings*

Regarding the atomic bomb:
"That is the biggest fool thing we have ever done. The bomb will never go off, and I speak as an expert in explosives."
Admiral William Leahy to President Truman, 1945

Lyndon Johnson on a visit to Vietnam's Cam Ranh Bay, October 1966. Overconfidence such as President Johnson exhibited in committing American troops underlies many failed ventures.

There are several reasons (Klayman & Ha, 1987; Skov & Sherman, 1986). For one thing, people tend not to seek information that might disprove what they believe. P. C. Wason (1960) demonstrated this, as you can, by giving people a sequence of three numbers—2, 4, 6—which conformed to a rule he had in mind (the rule was simply *any three ascending numbers*). To enable the people to discover the rule, Wason invited each person to generate sets of three numbers. Each time Wason told the person whether the set did or didn't conform to his rule. When they were sure they had discovered the rule, the people were to stop and announce it.

The result? Seldom right but never in doubt: 23 of the 29 people convinced themselves of a wrong rule. They typically formed some erroneous belief about the rule (for example, counting by twos) and then searched for *confirming* evidence (for example, by testing 8, 10, 12) rather than attempting to *disconfirm* their hunches. We are eager to verify our beliefs but less inclined to seek evidence that might disprove them. We call this phenomenon **confirmation bias**.

Our preference for confirming information helps explain why our self-images are so remarkably stable. In experiments at the University of Texas at Austin, William Swann and Stephen Read (1981a,b; Swann & others, 1990) discovered that students seek, elicit, and recall feedback that confirms their beliefs about themselves. People seek as friends and spouses those who bolster their own self views—even if they think poorly of themselves (Swann & others, 1991, 1992). Swann and Read liken their findings to how someone with a domineering self-image might behave at a party. Upon arriving, the person *seeks* those guests whom she knows acknowledge her dominance. In conversation she then presents her views in ways that *elicit* the respect she expects. After the party, she has trouble recalling conversations in which her influence was minimal and more easily *recalls* her persuasiveness in the conversations that she dominated. Thus she believes her experience at the party confirms her self-image.

"When you know a thing, to hold that you know it; and when you do not know a thing, to allow that you do not know it; this is knowledge."
Confucius, *Analects*

Confirmation bias:
A tendency to search for information that confirms one's preconceptions.

The air distance between New Delhi and Beijing is 2500 miles. The Suez Canal is twice as long as the Panama Canal.

REMEDIES FOR OVERCONFIDENCE

What constructive lessons can we draw from research on overconfidence? One might be to downplay other people's dogmatic statements. Even when people seem sure that they are right, they may be wrong. So don't let cocky people intimidate you.

Two techniques have successfully reduced the overconfidence bias. One is prompt feedback on the accuracy of their judgments (Lichtenstein & Fischhoff, 1980). In everyday life, weather forecasters and those who set the odds in horse racing both receive clear, daily feedback. Experts in both groups therefore do quite well at estimating their probable accuracy (Fischhoff, 1982).

When people think about why an idea *might* be true it begins to seem true (Koehler, 1991). Thus, another way to reduce overconfidence is to get people to think of one good reason *why their judgments might be wrong,* forcing them to consider disconfirming information (Koriat & others, 1980). Managers might foster more realistic judgments by insisting that all proposals and recommendations include reasons why they might not work.

Still, we should be careful not to undermine people's self-confidence to a point where they spend too much time in self-analysis or where self-doubts begin to cripple their decisiveness. In times when their wisdom is needed, those lacking self-confidence may shrink from speaking up or making tough decisions. *Over*confidence can cost us, but realistic self-confidence is adaptive.

■ WE OFTEN IGNORE USEFUL INFORMATION

A panel of psychologists interviewed a sample of 30 engineers and 70 lawyers and summarized their impressions in thumbnail descriptions. The following description has been drawn at random from the sample of 30 engineers and 70 lawyers:

Jack is a 39-year-old man.

Question: What is the probability that Jack is a lawyer rather than an engineer?

Given no more information than this about Jack, most people surmise that the chances of his being a lawyer are 70 percent, if indeed that is the frequency (or "base rate") of lawyers in the sample from which he was drawn.

Now let's consider another example drawn from the same sample:

Twice divorced, Frank spends most of his free time hanging around the country club. His clubhouse bar conversations often center around his regrets at having tried to follow his esteemed father's footsteps. The long hours he had spent at academic drudgery would have been better invested in learning how to be less quarrelsome in his relations with other people.

Asked to guess Frank's occupation, more than 80 percent of University of Oregon students surmised he was one of the lawyers (Fischhoff & Bar-Hillel, 1984). Fair enough. But how do you suppose their estimates changed when the sample description was changed to say that 70 percent were engineers? Not in the slightest. The students took no account of the base rate of engineers and lawyers; in their minds Frank was more *representative* of lawyers, and that was all that seemed to matter.

To judge something by intuitively comparing it to our mental representation of a category is to use the **representativeness heuristic.** *Heuristics* are simple, efficient thinking strategies—implicit rules of thumb. In the case of Frank, the representativeness heuristic guided people in making snap judgments based solely on his resemblance to their image of lawyers.

Like most heuristics, representativeness usually is a reasonable guide to reality. But not always. Consider Linda, who is 31, single, outspoken, and very bright. She majored in philosophy in college. As a student she was deeply concerned with discrimination and other social issues, and she participated in antinuclear demonstrations. Based on this description, would you say it is more likely that:

a. Linda is a bank teller.

b. Linda is a bank teller and active in the feminist movement.

Most people think *b* is more likely partly because they don't understand rules of probability but also because Linda better *represents* their image of feminists. Consider: Is there a better chance that Linda is *both* a bank teller *and* a feminist than that she's a bank teller (whether feminist or not)? As Amos Tversky and Daniel Kahneman (1983) remind us, the conjunction of two events can't be more likely than either event alone.

> **Representativeness heuristic:** The strategy of judging the likelihood of things by how well they represent, or match, particular prototypes; may lead one to ignore other relevant information.

USING USELESS INFORMATION

Our willingness to ignore useful information and use useless information is also apparent in some amusing experiments. Consider the following two questions, adapted from an experiment by Henri Zukier (1982; Nisbett & others, 1981).

> Roberta is a university student who spends about three hours studying outside of classes in an average week. What would you guess her grade point average to be?

> Judith is a university student who spends about three hours studying outside of classes in an average week. Judith has four plants in the place she's living in now. On an average weekday, she goes to sleep around midnight. She has a brother and two sisters. Two months is the longest period of time she has dated one person. She describes herself as being often a cheerful person. What would you guess her grade point average to be?

The first question has but one bit of useful information. Those given it usually estimate low grades. People given the second question don't see any connection between how many plants one has and grade average. Yet when such worthless information is added to the useful information about study time, it dilutes the impact of the useful information—so much so it no longer makes much difference whether the hypothetical student is said to study 3 or 31 hours per week! In attending to the useless information, people miss the crucial bits. If people feel accountable for their judgments—if they anticipate having to defend them—do they think more rationally? Actually, report Philip Tetlock and Richard Boettger (1989), they attend to and use the useless information even more.

Thomas Gilovich (1981) noted a similar use of useless information when he asked California sportswriters and football coaches to judge the professional potential of hypothetical college football players. Their judgments were af-

fected not only by the player's ability but also by such trivia as whether the player came from the same hometown as a well-known professional player.

IGNORING BASE-RATE INFORMATION

As these experiments show, anecdotal information is persuasive. Researchers Richard Nisbett and Eugene Borgida (Nisbett & others, 1976) explored the tendency to overuse anecdotal information by showing University of Michigan students videotaped interviews of people supposedly participating in an experiment in which most subjects failed to assist a seizure victim. Learning how *most* subjects acted had little effect upon people's predictions of how the individual they observed acted. The apparent niceness of this individual was more vivid and compelling than the general truth about how most subjects really acted: "Ted seems so pleasant that I can't imagine him being unresponsive to another's plight." This illustrates the **base-rate fallacy:** Focusing upon the specific individual can push into the background useful information about the population the person came from.

There is, of course, a positive side to viewing people as individuals and not merely as statistical units. The problem arises when we formulate our beliefs about people in general from our observations of particular persons. Focusing on individuals distorts our perception of what is generally true. Our impressions of a group, for example, tend to be overly influenced by its extreme members. One man's attempt to assassinate President Reagan caused people to bemoan, "It's not safe to walk the streets anymore," and conclude, "There's a sickness in the American soul." As psychologist Gordon Allport put it, "Given a thimbleful of facts we rush to make generalizations as large as a tub."

It would be an overstatement to say that people are utterly insensitive to base-rate information. People will use base-rate data when its relevance is obvious or when it is presented *after* the case examples (Ginossar & Trope, 1987;

Base-rate fallacy:
The tendency to ignore or underuse base-rate information (information that describes most people) and instead to be influenced by distinctive features of the case being judged.

Transvestites at a gay rights demonstration. Vivid examples of a social category, being readily available in memory, may bias our impressions of a whole group.

Krosnick & others, 1990). If told that students taking a particular exam had a high failure rate, we infer the exam was difficult. This influences our judgment of the likelihood a particular student passing the exam. We also use information that applies equally to anyone in a sample, such as the frequency of apartment break-ins on a particular block, when guessing the likelihood that a particular family has suffered a break-in.

Nevertheless, the research reveals a basic principle of social thinking: People are slow to deduce particular instances from a general truth but are remarkably quick to infer general truth from a vivid instance. One University of Michigan study presented students with a vivid welfare case—a magazine article about a supposedly ne'er-do-well Puerto Rican woman who had a succession of unruly children sired by a succession of common-law husbands. This case was set against factual statistics about welfare cases—indicating that, contrary to this case, 90 percent of welfare recipients in her age bracket "are off the welfare rolls by the end of four years." Nevertheless, the facts affected people's low opinion of most welfare recipients less than did the single vivid case (Hamill & others, 1980). No wonder that after hearing and reading countless instances of rapes, robberies, and beatings, 9 out of 10 Canadians overestimate—usually by a considerable margin—the percentage of crimes that involve violence (Doob & Roberts, 1988).

"Most people reason dramatically, not quantitatively."
Oliver Wendell Holmes, Jr.

Sometimes the vivid example is a personal experience. Before buying my new Honda, I consulted the *Consumer Reports* survey of car owners and found the repair record of the Dodge Colt, which for a time I considered, to be quite good. A short while later, I mentioned my interest in the Colt to a student. "Oh no," he moaned, "don't buy a Colt. I worked in a garage last summer and serviced two Dodge Colts that kept falling apart and being brought in for one thing after another." How did I use this information—and the glowing testimonies from two friends who were Honda owners? Did I simply increment the *Consumer Reports* surveys of Colt and Honda owners by two more people each? Although I knew that, logically, that is what I should have done, it was nearly impossible to downplay my consciousness of those vivid accounts.

"Testimonials may be more compelling than mountains of facts and figures (as mountains of facts and figures in social psychology so compellingly demonstrate)."
Mark Snyder (1988)

RELYING ON THE AVAILABILITY HEURISTIC

People's individual testimonies are more compelling than general information partly because vivid information etches itself upon the mind (Reyes & others, 1980). Consider these questions:

1. Does the letter *k* appear more often as the first letter of a word or as the third letter?
2. What percent of deaths in the United States each year are due to:
 _____ accidents
 _____ cardiovascular diseases (for example, heart attacks and strokes)?

You probably judged the likelihood of these events in terms of how readily instances of them come to mind. If examples are readily *available* in our memory—as vivid examples, such as accidental deaths, tend to be—then we presume that the event is commonplace. Usually it is, so we are often well served by this cognitive rule of thumb, called the **availability heuristic.** But sometimes the rule deludes us. Vivid, easy-to-imagine events, such as diseases with easy-to-picture symptoms, may seem more likely than diseases with

Availability heuristic: An efficient but fallible rule-of-thumb that judges the likelihood of things in terms of their availability in memory. If instances of something come readily to mind, we presume it to be commonplace.

When they viewed this scene from the Aloha Airlines disaster in 1988, many people perceived the risk of flying to be far greater than it actually is.

Answer to Question 1: *The letter k is three times more likely to appear as the third letter. Yet most people judge that k appears more often at the beginning of a word. Words beginning with k are more readily available to memory, surmise Amos Tversky and Daniel Kahneman (1974), and ease of recall—availability—is our heuristic for judging the frequency of events.*

Answer to Question 2: *Cardiovascular diseases cause 10 times as many deaths as accidents: 50 percent versus 5 percent. Most people overestimate the relative frequency of vivid accidents, which are more available to memory.*

harder-to-picture symptoms (Sherman & others, 1985). Even fictional happenings in novels, television, and movies leave images which later penetrate our judgments (Gerrig & Prentice, 1991).

The availability heuristic explains why perceived risk is often so badly out of joint with the real risks of things—a matter of grave importance, given how many important decisions involve risk (Allison & others, 1992). News footage of airplane crashes is a readily available memory for most of us. This misleads people to suppose that they are more at risk traveling in a commercial airplane than in a car. In actuality, U.S. travelers during the 1980s were 26 times more likely to die in a car crash than on a commercial flight covering the same distance (National Safety Council, 1991).

Or consider this: Three jumbo jets full of passengers crashing every day for a year would not equal tobacco's deadly effects. If the deaths caused by tobacco occurred in horrible accidents, the resulting uproar would long ago have eliminated cigarettes. Because, instead, the deaths are disguised as "cancer" and "heart disease" and diffused on obituary pages, we hardly notice. Thus, rather than eliminating the hazard, the U.S. government continues to subsidize the tobacco industry's program for quietly killing its customers. The point: Dramatic events stick in our minds and we use ease of recall—the availability heuristic—when predicting the likelihood of something happening.

In their research on energy conservation, Marti Gonzales and her co-researchers (1988) showed how we can harness the availability heuristic to good ends. They trained California home energy auditors to communicate their findings to homeowners in vivid, memorable images. Rather than simply pointing out small spaces around doors where heat is lost, the auditor would say, "If you were to add up all the cracks around and under the doors of your home, you'd have the equivalent of a hole the size of a football in your living room wall." With such remarks, and by eliciting the homeowners' active commitment in helping measure cracks and state their intentions to remedy them, the trained auditors triggered a 50 percent increase in the number of customers applying for energy financing programs.

Some imagined alternatives are "phantom" products—choices that look

real but are unavailable. Computer software companies commonly announce exciting new products long before delivery. By announcing a phantom product, they hope to make existing alternatives seem less attractive, convincing buyers to defer their purchase. By imagining unavailable options—a product, a lover, a course we can't get in—we become less satisfied with our real options (Pratkanis & Farquhar, 1992).

Easily imagined events also influence our experiences of guilt, regret, frustration, and relief. If our team loses (or wins) a big game by 1 point, we can easily imagine how the game might have gone the other way, and thus we feel greater regret (or relief). Such **counterfactual thinking**—mentally simulating what might have been—occurs when we can easily picture an alternative outcome, as after doing something unusual (Kahneman & Miller, 1986; Gavanski & Wells, 1989; Landman, 1987). Thus, if we barely miss a plane or bus, we imagine making it *if only* we had left at our usual time, taken our usual route, not paused to talk. If we miss our connection by a half hour or after taking our usual route, it's harder to simulate a different outcome, so we feel less frustration.

> **Counterfactual thinking:** Imagining alternative scenarios and outcomes that might have happened, but didn't.

■ WE MISPERCEIVE CAUSATION, CORRELATION, AND PERSONAL CONTROL

Another influence on everyday thinking is our search for order in random events, a tendency that can lead us down all sorts of wrong paths.

ILLUSORY CORRELATION

It's easy to see a correlation where none exists. When we expect to see significant relationships, we easily associate random events—an **illusory correlation.** William Ward and Herbert Jenkins (1965) showed people the results of a hypothetical 50-day cloud-seeding experiment. They told their subjects which of the 50 days the clouds had been seeded and which days it rained. This information was nothing more than a random mix of results: Sometimes it rained after seeding; sometimes it didn't. People nevertheless became convinced—in conformity with their supposition about the effects of cloud seeding—that they really had observed a relationship between cloud seeding and rain.

> **Illusory correlation:** Perception of a relationship where none exists, or perception of a stronger relationship than actually exists.

Other experiments confirm that people easily misperceive random events as confirming their beliefs (Crocker, 1981; Jennings & others, 1982; Trolier & Hamilton, 1986). If we believe a correlation exists, we are more likely to notice and recall confirming instances. If we believe that premonitions correlate with events, we notice and remember the joint occurrence of the premonition and the later occurrence of that event. We seldom notice or remember all the times unusual events do not coincide. If, after we think about a friend, the friend calls us, we notice and remember this coincidence more than all the times we think of a friend without any ensuing call, or receive a call from a friend about whom we've not been thinking. Thus, we easily overestimate the frequency with which these strange things happen.

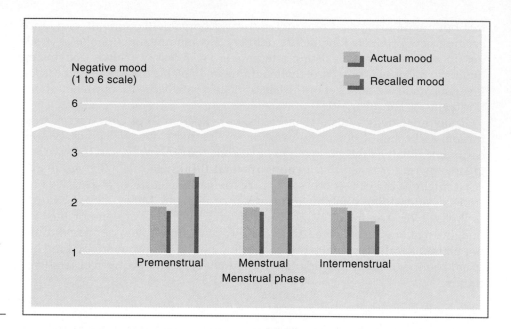

FIGURE 2-3 *Menstruation, actual mood, and perceived mood. Ontario women's daily mood reports did not vary across their menstrual cycle. Yet they perceived that their moods were generally worse just before and after menstruation and better at other times of the cycle.*

(Data from C. McFarland & others, 1989.)

One familiar example of perceived correlation is the presumption that women's moods correlate with their menstrual cycle. To find out whether they do, several researchers have had women make daily ratings of their moods. When Cathy McFarland and her colleagues (1989) did this with Ontario women, they obtained typical results. The women's self-rated negative emotions (whether they were experiencing irritability, loneliness, depression, and so forth) did not increase during their premenstrual and menstrual phases. Yet the women later *perceived* a correlation between negative mood and menstruation (Figure 2-3).

Pamela Kato and Diane Ruble (1992) say this is typical: Although many women recall mood changes over their cycle, their day-to-day experiences reveal few such changes. Moreover, cycle-related hormonal changes have no known emotional effects that would lead us to expect mood changes. So why do so many women believe they experience premenstrual tension or menstrual irritability? Because, say Kato and Ruble, their implicit theories of menstruation lead them to notice and remember the joint appearances of negative moods and the onset of menstruation, but not to notice and remember bad moods two weeks later.

Thomas Gilovich (1991) offers another familiar example of illusory correlation: "Infertile" couples who adopt a child are more likely to conceive than similar couples who do not adopt. Couples who adopt, it is popularly theorized, finally relax—and conceive. But no such theory is necessary, because it ain't so. Although researchers have found no correlation between adoption and conception, our attention is drawn to couples who have conceived after adopting (rather than to those who conceive before adopting or who don't conceive after adopting).

The difficulty we have recognizing coincidental, random events for what they are also predisposes us to perceive order in random sequences of events. During World War II, when the Germans bombed England daily, Londoners developed elaborate theories of bombing patterns. When London was later

"When a man can't explain a woman's actions, the first thing he thinks about is the condition of her uterus."
Clare Boothe Luce, *Slam the Door Softly*, 1970

"It ain't so much the things we don't know that get us in trouble. It's the things we know that ain't so."
Nineteenth-century American saying

divided up into small, geographic areas, bomb hits per area were found to have occurred randomly (Gilovich, 1991). However, because random events tend to occur in bunches—flip a coin 20 times and you will get several runs of heads and of tails—*after* the bombings, people could "see" a pattern.

Likewise, hospital staff sometimes "explain" runs of boys or girls in the sequence of births by concocting theories, such as boys being conceived under a certain phase of the moon. And basketball players and coaches perceive hot or cold shooting streaks and feed the ball accordingly—despite careful and extensive statistical analyses revealing that professional and college players are no more likely to make a basket after just making one than after just missing one (Gilovich, 1988; Tversky & Gilovich, 1989a,b). A 50 percent shooter will indeed have streaks of baskets made or missed, but no more than a coin tosser will have streaks of heads or tails.

This intense human desire to find order, even in random events, leads us to seek reasons for happenings. By attributing events to one cause or another, we order our worlds and make things seem more predictable and controllable. Again, this tendency is usually adaptive but occasionally leads us astray.

"I see men ordinarily more eager to discover a reason for things than to find out whether the things are so."
Montaigne

ILLUSION OF CONTROL

Our tendency to perceive random events as related feeds an **illusion of control**—the idea that chance events are subject to our influence. This is what keeps gamblers going, and what makes the rest of us do all sorts of unlikely things. During the 1988 summer drought, for example, retired farmer Elmer Carlson arranged a rain dance by 16 Hopis in Audubon, Iowa. The next day it rained 1 inch. "The miracles are still here, we just have to ask for them," explained Carlson (Associated Press, 1988).

Illusion of control: Perception of uncontrollable events as subject to one's control or as more controllable than they are.

"*The next dance you will see is for partly cloudy conditions with moderating temperatures.*"

The illusion of control takes many forms.

Peter Steiner

Gambling

Ellen Langer (1977) demonstrated the illusion of control with experiments on gambling. People readily believed they could beat chance. Compared to those given an assigned lottery number, people who chose their own lottery number demanded four times as much money for the sale of their ticket. When playing a game of chance against an awkward and nervous person, they bet significantly more than when playing against a dapper, confident opponent. In these and other ways, Langer consistently found people acting as if they can control chance events.

Observations of real-life gamblers confirm these experimental findings. Dice players often behave as if they can control the outcome by throwing softly for low numbers and hard for high numbers (Henslin, 1967). The gambling industry thrives on gamblers' illusions of control. Gamblers' hopes that they can beat the laws of chance sustain their gambling. Gamblers attribute wins to their skill and foresight. Losses become "near misses" or "flukes"—perhaps (for the sports gambler) a bad call by the referee or a freakish bounce of the ball (Gilovich & Douglas, 1986).

Another of Langer's studies reveals that when people experience some unusual early successes in a chance situation, they often discount later failures (Langer & Roth, 1975). People predicted the results of 30 coin tosses. Langer rigged the feedback so some people experienced mostly wins during the first 10 flips; others experienced either mostly losses or a random sequence of wins and losses. Across all 30 trials, however, each person accumulated the same total outcome: 15 wins and 15 losses. Nonetheless, those who started with an abundance of wins made inflated estimates of how many flips they had actually predicted and how many they could predict given another 100 trials. Likewise, those who experience early successes on an "ESP" task tend to recall themselves as more successful than do those who experience early failures,

The illusion of control may lead gamblers to fantasize that they can beat overwhelming odds—and to keep playing.

■ BEHIND THE SCENES

Observing people's keen desire for control even in chance situations, such as choosing lottery numbers, led me to wonder about people who typically have little control over their lives. In studying hospital patients and the elderly, I discovered that enhancing their sense of control benefited their health and well-being. People suffering the stress of crowded situations or divorce also benefited from enhanced sense of control. All this makes clear to me that perceived control is extremely important for successful functioning.

ELLEN LANGER, *Harvard University*

even when later results return overall performance to a mere chance level in both cases (Zenker & others, 1982). So whether predicting coin tosses or future events, early success leads people to see themselves as skilled and, therefore, to discount later failures.

In my home we have occasionally flipped a coin to settle trivial disputes. At one point one of my sons began arguing that he always lost coin tosses. I reminded him that each flip is a 50-50 proposition. To my dismay, he suffered several more consecutive losses. No amount of rational persuasion could then convince him that he really had a 50-50 chance on the next toss. What makes Langer's results so striking is that her subjects were not 10-year-old boys but educated Yale University students. Princeton students also display the illusion of control, as John Fleming and John Darley (1990) discovered. After reading stories of someone who rolled a desired dice outcome, the students were more likely to wager money that the person could roll the same number again.

Regression toward the Average

Tversky and Kahneman (1974) noted another way by which an illusion of control may arise: We fail to recognize the statistical phenomenon of **regression toward the average.** Because exam scores fluctuate partly by chance, most students who get extremely high scores on an exam will get lower scores on the next exam. Because their first score is at the ceiling, their second score is more likely to fall back ("regress") toward their own average than to push the ceiling even higher. (This is why a student who does consistently good work, even if never the best, will sometimes end a course at the top of the class.) Conversely, the lowest-scoring students on the first exam are likely to improve. If those who scored lowest go for tutoring after the first exam, the tutors are likely to feel effective, even if the tutoring had no effect.

Indeed, anything can seem effective, whether it actually had an effect or not. A counselor whom people visit at their most depressed point is likely to be gratified by their subsequent improvement. When things are desperate, we will try anything, and whatever we try—going to a psychotherapist, starting a new diet-exercise plan, reading a self-help book—is more likely to be followed by improvement than by further deterioration. (When we're extremely high or low, we tend to fall back toward our normal average.)

Regression toward the average:
The statistical tendency for extreme scores or extreme behavior to return toward one's average.

Sometimes we recognize that events are not likely to continue at an unusually good or bad extreme. Experience has taught us that when everything is going great, something will go wrong, and that when life is dealing us terrible blows, we can usually look forward to things getting better. Often, though, we fail to recognize this regression effect. We puzzle at why baseball's rookie-of-the-year often has a more ordinary second year—did he become overconfident? self-conscious? We forget that exceptional performance tends to regress toward normality. Imagine a volleyball coach who rewards her team with lavish praise and a light practice after their best match of the season and harasses them after an exceptionally bad match. But she fails to understand that because performance is not perfectly reliable, unusual performances tend to fall back toward the usual. She then wrongly concludes that rewards lead to poorer performance in the next game, while punishments improve performance. Parents and teachers may reach the same wrong conclusion after reacting to unusually good or bad behavior.

To simulate the consequences of using praise and punishment, Paul Schaffner (1985) invited Bowdoin College students to train an imaginary fourth-grade boy, "Harold," to come to school by 8:30 each morning. For each school day of a three-week period, a computer displayed Harold's arrival time, which was always between 8:20 and 8:40. The subjects would then select a response to Harold, ranging from strong praise to strong reprimand. As you might expect, they usually praised Harold when he arrived before 8:30 and reprimanded him when he arrived after 8:30. Because Schaffner had programmed the computer to display a random sequence of arrival times, Harold's arrival time tended to improve (to regress toward 8:30) after being reprimanded. For example, if Harold arrived at 8:39, he was almost sure to be reprimanded, and his randomly selected next-day arrival time was likely to be earlier than 8:39. Thus, *even though their reprimands were having no effect,* most subjects ended the experiment believing that their reprimands had been effective.

This experiment demonstrates Tversky and Kahneman's provocative conclusion: Nature operates in such a way that we often feel punished for rewarding others and rewarded for punishing them. In actuality, as every student of psychology knows, positive reinforcement for doing things right is usually more effective and has fewer negative side effects.

■ OUR BELIEFS MAY GENERATE THEIR OWN REALITY

There's one additional reason why our beliefs resist reality: They sometimes lead us to act in ways that produce their apparent confirmation. Our beliefs about other people can therefore become **self-fulfilling prophecies.**

In his well-known studies of "experimenter bias," Robert Rosenthal (1985) found that research subjects sometimes live up to what is expected of them. In one study experimenters asked subjects to judge the successfulness of people in various photographs. The experimenters read the same instructions to all their subjects and showed them the same photos. Nevertheless, experimenters led to expect high ratings obtained higher ratings than did those who expected their subjects to see the photographed people as failures. Even more startling—

Self-fulfilling prophecy: The tendency for one's expectations to evoke behavior that confirms the expectations.

and controversial—are reports that teachers' beliefs about their students similarly serve as self-fulfilling prophecies.

DO TEACHER EXPECTATIONS AFFECT STUDENT PERFORMANCE?

Teachers do have higher expectations for some students than for others. Perhaps you have detected this after having a brother or sister precede you in school, from having received such a label as "gifted" or "learning disabled," or from being tracked with the "high-ability" or "average-ability" students. Or perhaps the conversation in the teachers' lounge sent your reputation ahead of you, or your new teacher scrutinized your school file or discovered your family's social status. Do such teacher expectations affect student performance? It's clear that teachers' evaluations *correlate* with student achievement: Teachers think well of students who do well. That's mostly because teachers accurately perceive their students' abilities and achievements (Jussim, 1989, 1990, 1991).

But are teachers' evaluations ever a *cause* as well as a consequence of student performance? One correlational study of 4300 British schoolchildren by William Crano and Phyllis Mellon (1978) suggested yes. Not only is high performance followed by higher teacher evaluations, but the reverse is true as well.

Could we test this "teacher-expectations effect" experimentally? Pretend we gave a teacher an erroneous impression that Dana, Sally, Todd, and Manuel, four randomly selected students, are unusually capable. Will the teacher give special treatment to these four, thus eliciting superior performance from them? In a now famous experiment, Rosenthal and Lenore Jacobson (1968) reported precisely that. Randomly selected children in a San Francisco elementary school who were said (on the basis of a fictitious test) to be on the verge of a dramatic intellectual spurt did then spurt ahead in IQ score.

This dramatic result seemed to suggest that the school problems of "disadvantaged" children might merely reflect their teachers' low expectations, and the findings were soon publicized in the national media as well as in many college textbooks in psychology and education. Further analysis revealed the teacher-expectations effect to be not so powerful and reliable as this initial study had led many to believe. Some critics questioned the IQ measure and the statistical procedures (Thorndike, 1968; Elashoff & Snow, 1971). Moreover, by Rosenthal's own count, in only 39 percent of the 448 published experiments do expectations significantly affect performance (Rosenthal, 1991). Low expectations do not doom a capable child, nor do high expectations magically transform a slow learner into a valedictorian. Human nature is not so pliable.

Still, in 4 of 10 studies, teacher expectations do matter. Why? Rosenthal and other investigators report that teachers look, smile, and nod more at "high-potential students." In one study, Elisha Babad, Frank Bernieri, and Rosenthal (1991) videotaped teachers talking to, or about, unseen students for whom they held high or low expectations. A random 10-second clip of either the teacher's voice or face was enough to tell viewers—both children and adults—whether this was a good or poor student and how much the teacher liked the student. Although teachers may think they can conceal their feelings, students are acutely sensitive to teachers' facial expressions and body movements. But the expectancy effect seems not entirely due to such nonverbal messages. Teachers also may teach more to their "gifted" students, set higher goals for them, call

on them more, and give them more time to answer (Cooper, 1983; Harris & Rosenthal, 1985, 1986; Jussim, 1986).

Reading the experiments on teacher expectations makes me wonder about the effect of *students'* expectations upon their teachers. You no doubt begin many of your courses having heard "Professor Smith is interesting" and "Professor Jones is a bore." Robert Feldman and Thomas Prohaska (1979; Feldman & Theiss, 1982) found that such expectations can affect both student and teacher. Students in a learning experiment who expected to be taught by a competent teacher perceived their teacher (who was unaware of their expectations) as more competent and interesting than did students with low expectations. Furthermore, the students actually learned more. In a follow-up experiment, Feldman and Prohaska videotaped teachers and had observers later rate their performance. Teachers were judged most capable when assigned a student who nonverbally conveyed positive expectations.

To see whether such effects might also occur in actual classrooms, a research team led by David Jamieson (1987) experimented with four Ontario high school classes taught by a newly transferred teacher. During individual interviews they told students in two of the classes that both other students and the research team rated the teacher very highly. Compared to the control classes, whose expectations they did not raise, these students paid better attention during class. At the end of the teaching unit, they also got better grades and rated the teacher as clearer in her teaching. The attitudes that a class has toward its teacher are as important, it seems, as the teacher's attitude toward the students.

DO WE GET WHAT WE EXPECT FROM OTHERS?

So, the expectations of experimenters and teachers are occasionally self-fulfilling prophecies. How general is this effect? Do we get from others what we expect of them? There are times when negative expectations of someone lead us to be extra nice to that person, which induces them to be nice in return—thus *dis*confirming our expectations. But the most common finding in studies of social interaction is that, yes, we do tend to get what we expect (Miller & Turnbull, 1986).

In laboratory games, hostility nearly always begets hostility: People who *perceive* their opponents as noncooperative will readily induce them to *be* noncooperative (Kelley & Stahelski, 1970). Self-confirming beliefs abound when there is conflict. Each party's perception of the other as aggressive, resentful, and vindictive induces the other to display these behaviors in self-defense, thus creating a vicious self-perpetuating circle. Whether I expect my wife to be in a bad mood or in a warm, loving mood may affect how I relate to her, thereby inducing her to confirm my belief.

Several experiments conducted by Mark Snyder (1984) at the University of Minnesota show how, once formed, erroneous beliefs about the social world can induce others to confirm those beliefs, a phenomenon called **behavioral confirmation.** In one study, Snyder, Elizabeth Tanke, and Ellen Berscheid (1977) had men students talk on the telephone with women they thought (from having been shown a picture) were either attractive or unattractive. Analysis of just the women's comments during the conversations revealed that the women who were presumed attractive spoke more warmly than the women who were

Behavioral confirmation: A type of self-fulfilling prophecy whereby people's social expectations lead them to act in a way that causes others to confirm their expectations.

■ BEHIND THE SCENES

Our research on "when belief creates reality" suggests a reason why erroneous stereotypes stubbornly persist: Believing their stereotypes, people may treat others in ways that elicit the very behaviors they expect. Doubting their stereotypes, they may test them by selectively gathering confirming evidence. Thus, whether right or wrong, stereotypes may create and sustain their own reality.

MARK SNYDER, *University of Minnesota*

presumed unattractive. The men's erroneous beliefs had become a self-fulfilling prophecy, by leading them to act in a way that influenced the women to fulfill their stereotype that beautiful people are desirable people.

Snyder and Julie Haugen (1991) repeated this experiment, this time providing male callers with an information sheet accompanied by a photo of an obese or normal-weight woman. When asked "to check out your first impressions" of their telephone date and to "find out what she is like," the men's behavior induced the normal-weight women to talk in ways that conveyed more warmth and joy.

Expectations influence children's behavior too. After observing the amount of litter in three classrooms, Richard Miller and his colleagues (1975) had the teacher and others repeatedly tell one class that they should be neat and tidy. This persuasion increased the amount of litter placed in wastebaskets from 15 to 45 percent, but only temporarily. Another class, which also had been placing only 15 percent of its litter in wastebaskets, was repeatedly congratulated for being so neat and tidy. After eight days of hearing this, and still two weeks later, these children were fulfilling the expectation by putting more than 80 percent of their litter in wastebaskets. Repeatedly tell children they are hard working and kind (rather than lazy and mean), and they may live up to their label.

These experiments help us understand how social beliefs, such as stereotypes about handicapped people or about people of a particular race or sex, may be self-confirming. We help construct our own social realities. How others treat us reflects how we and others have treated them.

As with every phenomenon of social behavior, the tendency to confirm others' expectations has its limits. When strongly motivated to form accurate rather than rapid impressions, people will elicit more accurate information (Darley & others, 1988; Neuberg, 1989). Also, people who are forewarned about another's expectation may work to overcome it (Hilton & Darley, 1985; Swann, 1987). If Chuck knows that Jane thinks he's an airhead, he may strive to disprove her impression. If Jane knows that Chuck expects her to be aloof, she may actively refute his expectation.

William Swann and Robin Ely (1984) report a third condition under which we are less likely to confirm others' expectations: when our expectations clash with a clear self-concept. For example, Swann and Ely found that when a strongly outgoing person was interviewed by someone who expected her to be

■ FOCUS: THE SELF-FULFILLING PSYCHOLOGY OF THE STOCK MARKET

On the evening of January 6, 1981, Joseph Granville, a popular Florida investment adviser, wired his clients: "Stock prices will nose-dive; sell tomorrow." Word of Granville's advice soon spread, and January 7 became the heaviest day of trading in the previous history of the New York Stock Exchange. The Dow Jones average fell 25 points. All told, stock values lost $40 billion.

Nearly a half-century ago, John Maynard Keynes likened such stock market psychology to the beauty contests then conducted by London newspapers. To win, one had to pick the six faces out of a hundred that were, in turn, chosen most frequently by the other newspaper contestants. Thus, as Keynes wrote, "Each competitor has to pick not those faces which he himself finds prettiest, but those which he thinks likeliest to catch the fancy of the other competitors."

Investors have to pick not simply the stocks that touch their fancy but the stocks that other investors will favor. The name of the game is to predict the others' behavior. As one Wall Street fund manager explained, "You may or may not agree with Granville's view—but that's usually beside the point." If you think his advice will cause others to sell, then you want to sell quickly, before prices drop more. If you expect others to buy, you buy now to beat the rush.

The self-fulfilling psychology of the stock market worked to an extreme on Monday, October 19, 1987, when the Dow Jones average crashed 508 points, causing people to lose—on paper—about 20 percent of the value of their stock investments. Part of what happens during such slides is that the media and rumor mill focus on whatever bad news is available to explain them. Once reported, the stories further diminish people's expectations, causing declining prices to fall still lower—and vice versa with a focus on good news when stock prices are rising.

Adapted from Lohr (1981) and Rice (1988).

introverted, it was the interviewer's perceptions and not the interviewee's behavior that changed. In contrast, interviewees who were unsure of themselves were likely to live up to the interviewer's expectations. In unfamiliar situations—starting a new school or job—people often are less sure of themselves and thus more influenced by others' expectations.

Our beliefs about ourselves can also be self-fulfilling. In several experiments, Steven Sherman (1980) found that people often fulfill predictions they make of their own behavior. When Bloomington, Indiana, residents were called and asked to volunteer three hours to an American Cancer Society drive, only 4 percent agreed to do so. When a comparable group of other residents were called and asked to *predict* how they would react if they were to receive such a request, almost half predicted they would agree to help—and most of these did indeed agree to do so when they were contacted by the Cancer Society. This illustrates the self-fulfilling effects of predicting one's own behavior. Formulating a plan for how we would want to act in a given situation makes it more likely that we will really do it.

■ CONCLUSIONS

We could extend our list of principles, but surely this has been a sufficient glimpse at how people so easily come to believe what may be untrue. That

most of the participants in these experiments were intelligent people, mostly students at leading universities, amplifies the threat to our vanity. Moreover, these predictable distortions and biases occurred even when payment for right answers motivated people to think optimally. As one researcher concluded, the illusions "have a persistent quality not unlike that of perceptual illusions" (Slovic, 1972).

Research in cognitive social psychology thus mirrors the mixed review given humanity in literature, philosophy, and religion. Many research psychologists have spent lifetimes exploring the awesome capacities of the human mind (Manis, 1977). We are smart enough to have cracked our own genetic code, to have invented talking computers, to have sent people to the moon. Yet our intuition is more vulnerable to error than we suspect. With remarkable ease, we form and sustain false beliefs.

But have these experiments just been playing intellectual tricks on their hapless participants, thus making their intuitions look worse than they are? Richard Nisbett and Lee Ross (1980) contend that, if anything, laboratory procedures *over*estimate our intuitive powers. The experiments usually present people with clear evidence and warn them that their reasoning ability is being tested. Seldom does life say to us: "Here is some evidence. Now put on your intellectual Sunday best and answer these questions."

Often our everyday failings are inconsequential, but not always so. False impressions, interpretations, and beliefs can produce serious consequences. Even small biases can have profound social effects when we are making important social judgments: Why are so many people homeless? unhappy? homicidal? Does my friend love me or my money? Cognitive biases even creep into sophisticated scientific thinking. Apparently human nature has not changed in the 3000 years since the Psalmist noted that "no one can see his own errors." As Winston Churchill wryly observed, "Man will occasionally stumble over the truth, but most of the time he will pick himself up and continue on."

Lest we succumb to the cynical conclusion that *all* beliefs are absurd, I hasten to balance the picture. The elegant analyses of the imperfections of our thinking are themselves a tribute to human wisdom. (Were one to argue that *all* human thought is illusory, the assertion would be self-refuting, for it, too, would be but an illusion. It would be logically equivalent to contending "all generalizations are false, including this one.")

As medical science assumes that any given body organ serves a function, so behavioral scientists find it useful to assume that *our modes of thought and behavior are generally adaptive* (Funder, 1987; Kruglanski & Ajzen, 1983; Swann, 1984). The rules of thought that produce false beliefs and striking deficiencies in our statistical intuition usually serve us well. Frequently, the errors are a byproduct of our mental strategies for simplifying the complex information we receive.

Nobel laureate psychologist Herbert Simon (1957) was among the modern researchers who first described the bounds of human reason. Simon contends that to cope with reality, we simplify it. Consider the complexity of a chess game, which can unfold in an almost infinite variety of ways. The number of possible chess games is greater than the number of particles in the universe. How do we cope? We adopt some simplifying rules of thumb—heuristics. These heuristics sometimes lead us to defeat. But they do enable us to make

"In creating these problems, we didn't set out to fool people. All our problems fooled us, too."
Amos Tversky (1985)

■ FOCUS: How Journalists Think—Cognitive Bias in Newsmaking

"That's the way it is," concluded CBS anchorperson Walter Cronkite at the end of each newscast. And that's the journalistic ideal—to present reality the way it is. The *Wall Street Journal* reporters' manual states the ideal plainly: "A reporter must never hold inflexibly to his preconceptions, straining again and again to find proof of them where little exists, ignoring contrary evidence. . . . Events, not preconceptions, should shape all stories to the end" (Blundell, 1986, p. 25).

We might wish that it were so. But journalists are human, conclude Indiana University journalism professor Holly Stocking and New York psychologist-lawyer Paget Gross in their 1989 book, *How Do Journalists Think?* Like laypeople and scientists, journalists "construct reality." The cognitive biases considered in this chapter therefore color newsmaking, in at least six ways.

1. *Preconceptions may control interpretations.* Typically, reporters "go after an idea," which may then affect how they interpret information. Beginning with the idea that homelessness reflects a failure of mental health programs, a reporter may interpret ambiguous information accordingly while discounting other complicating factors.

2. *Confirmation bias may guide them toward sources and questions that will confirm their preconceptions.* Hoping to report the newsworthy story that a radiation leak is causing birth defects, a reporter might interview someone who accepts the idea and then someone else recommended by the first person. Believing that devastating disabilities can be overcome, a reporter might ask disabled people, "How did you overcome the obstacles you faced?" Assuming that a coach is disliked, a reporter may interview the coach's detractors and ask *how* the coach offends people.

3. *Belief perseverance may sustain preconceptions in the face of discrediting.* While "greedy" Ivan Boesky awaited sentencing on a 1987 Wall Street insider-trading scandal, he looked for volunteer work, something "a lot of white-collar crooks do to impress sentencing judges," noted a contemptuous reporter. On the other hand, a politician caught lying can, if respected, be reported as "confused" or "forgetful."

4. *Compelling anecdotes may seem more informative than base-rate information.* Like their readers, journalists may be more persuaded by vivid stories of ESP and other psychic happenings than by dispassionate research. They may be more taken by someone's apparent "cure" by a new therapy than by statistics on the therapy's success rate. After an air crash, they may describe "the frightening dangers of modern air travel," without noting its actual safety record.

5. *Events may seem correlated, when they are not.* A striking co-occurrence—say three minority athletes' problems with drugs—may lead reporters to infer a relationship between race and drug use in the absence of representative evidence.

6. *Hindsight makes for easy after-the-fact analysis.* President Carter's ill-fated attempt to rescue American hostages in Iran was "doomed from the start"; so said journalists *after* they knew it had failed. George Bush's choice of Dan Quayle as his running mate was scorned by journalists *after* the negative public reaction and Quayle's gaffes and humbling television debate with his vice presidential opponent. Decisions that turn out poorly have a way of seeming *obviously* dumb, after the fact.

Indeed, surmise Stocking and Gross, given all the information that reporters and editors must process quickly, how could they be immune to the illusory thinking tendencies that penetrate human thinking? But on the positive side, exposing these points of bias may alert journalists to ways of reducing them—by considering opposite conclusions, by seeking sources and asking questions that might counter their ideas, by seeking statistical information first and then seeking representative anecdotes, by remembering that well-meaning people make decisions without advance knowledge of their consequences.

efficient snap judgments. The availability heuristic—judging the likelihood of things by their availability in memory—enables us to estimate speedily the frequency of an event, though it may also lead us to overestimate the commonality of vivid, easily remembered occurrences.

Illusory thinking can likewise spring from useful heuristics that aid our survival. The belief in our power to control events helps maintain hope and effort. If things are sometimes subject to control and sometimes not, we will maximize our outcomes by positive thinking. Optimism pays dividends. We might even say that our beliefs are like scientific theories—sometimes in error yet useful as generalizations.

As we constantly seek to improve our theories, might we not also work to reduce error in our social thinking? In school, math teachers teach, teach, teach, until the mind is finally trained to process numerical information accurately and automatically. We assume that such ability does not come naturally; otherwise, why bother with the years of training? Research psychologist Robyn Dawes (1980)—who is dismayed that "study after study has shown [that] people have very limited abilities to process information on a conscious level, particularly social information"—suggests that we should also teach, teach, teach, how to process social information.

Richard Nisbett and Lee Ross (1980) believe that education could indeed reduce our vulnerability to certain types of error. As a beginning, they propose that we first train people to recognize likely sources of error in their own social intuition. That is my aim in this chapter.

Second, they advocate statistics courses geared to everyday problems of logic and social judgment. Given such training, people do in fact reason better about everyday events (Lehman & others, 1988; Nisbett & others, 1987).

Third, they suggest that such teaching will be most effective when richly illustrated with concrete, vivid anecdotes and examples from everyday life.

Finally, they suggest teaching memorable and useful slogans, such as: "It's an empirical question." In other words, hunches need to be checked against pertinent data. Or: "Which hat did you draw that sample out of?" In other words, vivid but unrepresentative samples are suspect. Also: "You can lie with statistics, but a well-chosen example does the job better."

Is research on pride and error *too* humbling? Are the researchers who uncover our susceptibility to error like Gregers Werle in Henrik Ibsen's play *The Wild Duck*? (Werle demolished people's illusions, leaving them without hope or meaning.) Surely we can acknowledge the hard truth of our human limits and still sympathize with the deeper message that people are more than machines. Our subjective experiences are the stuff of our humanity—our art and our music, our enjoyment of friendship and love, our mystical and religious experiences.

The cognitive and social psychologists who explore illusory thinking are not out to remake us into unfeeling, logical machines. They know that intuition and feeling not only enrich human experience but are also an important source of creative ideas. They add, however, the humbling reminder that our susceptibility to error also makes clear our need for disciplined training of the mind. Norman Cousins (1978) called this "the biggest truth of all about learning: that its purpose is to unlock the human mind and to develop it into an organ capable of thought—conceptual thought, analytical thought, sequential thought."

"The spirit of liberty is the spirit which is not too sure that it is right; the spirit of liberty is the spirit which seeks to understand the minds of other men and women; the spirit of liberty is the spirit which weighs their interests alongside its own without bias."
Learned Hand, *The Spirit of Liberty*

"Rob the average man of his life-illusion, and you rob him also of his happiness."
Henrik Ibsen, *The Wild Duck*

■ SUMMING UP

Research psychologists have for a long time explored the mind's impressive capacity for processing information. Recently, researchers in cognitive social psychology have turned their attention to the errors we typically make when processing information. Since we are generally unaware of how errors enter our thinking, an examination of "illusory thinking" can be revealing and beneficial. This chapter described six ways in which we form and sustain false beliefs—"reasons for unreason," we might call them.

WE OFTEN DO NOT KNOW WHY WE DO WHAT WE DO

First, we often do not know why we behave the way we do. When powerful influences upon our behavior are not so conspicuous that any observer could spot them, we, too, can be oblivious to what has affected us.

OUR PRECONCEPTIONS CONTROL OUR INTERPRETATIONS AND MEMORIES

Second, our preconceptions strongly influence how we interpret and remember events. In experiments, people's prejudgments have striking effects upon how they perceive and interpret information. Other experiments have planted judgments or false ideas in people's minds *after* they have been given information. As before-the-fact judgments bias our perceptions and interpretations, so after-the-fact judgments bias our recall. For example, people whose attitudes have been changed will often deny that they have been influenced; they will insist that how they feel now is how they have always felt.

WE OVERESTIMATE THE ACCURACY OF OUR JUDGMENTS

Third, we have too much faith in our judgments. This "overconfidence phenomenon" stems partly from the much greater ease with which we can imagine why we might be right than why we might be wrong. Moreover, people are much more likely to search for information that can confirm their beliefs than information that can disconfirm them.

WE OFTEN IGNORE USEFUL INFORMATION

Fourth, when given compelling anecdotes or even useless information, we often ignore useful base-rate information. This is partly due to the later ease of recall ("availability") of vivid information.

WE MISPERCEIVE CAUSATION, CORRELATION, AND PERSONAL CONTROL

Fifth, we are often swayed by illusions of correlation and personal control. It is tempting to perceive correlations where none exist ("illusory correlation") and to think we can control events which are really beyond our control (the "illusion of control").

OUR BELIEFS MAY GENERATE THEIR OWN REALITY

Sixth, erroneous beliefs take on a life of their own. Studies of experimenter bias and teacher expectations show that at least sometimes an erroneous belief that certain people are unusually capable (or incapable) can lead one to give special treatment to those people. This may elicit superior (or inferior) performance and, therefore, seem to confirm an assumption that is actually false. Similarly, in everyday social affairs we often get "behavioral confirmation" of what we expect.

CONCLUSIONS

These sources of illusory thinking, plus others discussed in Chapters 1 and 3, reveal our capacity for forming and sustaining false beliefs. These illusions are by-products of thinking strategies (heuristics) that usually serve us well, just as visual illusions are a by-product of perceptual mechanisms that help us organize sensory information. But they are errors nonetheless, errors that can warp our perceptions of reality and prejudice our judgments of others.

■ FOR FURTHER READING

Fiske, S. T., & Taylor, S. E. (1991). *Social cognition,* 2d ed. New York: McGraw-Hill. A comprehensive, state-of-the-art introduction to how we form impressions and social beliefs and how we explain people's behavior.

Gilovich, T. (1991). *How we know what isn't so: The fallibility of human reason in everyday life.* New York: Free Press. A witty yet scientific book that offers fascinating examples of disastrous reasoning in everyday life.

Goleman, D. (1985). *Vital lies, simple truths: The psychology of self-deception and shared illusions.* New York: Simon & Schuster. A psychologist-writer examines how and why we fool ourselves.

Maital, S. (1982). *Minds, markets, and money: Psychological foundations of economic behavior.* New York: Basic Books. Insightfully applies social-psychological principles to people's beliefs and behavior regarding inflation, consumption, and the stock market.

Nisbett, R., & Ross, L. (1980). *Human inference: Strategies and shortcomings of social judgment.* Englewood Cliffs, NJ: Prentice-Hall. An insightful and delightful book on the pitfalls of social reasoning by two influential social psychologists.

EXPLAINING BEHAVIOR

In September 1983, off their Pacific coast, the Soviets shot down Korean Airlines Flight 007, killing all 269 people on board. United States reaction was swift and harsh: The Soviets were condemned for slaying innocent people on an obviously off-course civilian flight.

In July 1988, the destroyer *USS Vincennes*, in battle with Iranian gunboats in the Persian Gulf, shot down Iran Airbus Flight 655, killing all 290 people on board. Now the Soviets condemned the Americans for slaying innocent people on an on-course civilian flight.

Was each country right to attribute the other's action to evil intent and to doubt the other's claim to have misidentified the aircraft as a military one? Or was each act an understandable response in the situation? Were Soviet perceptions clouded by incidents of border invasion and aircraft spying? Were U.S. perceptions clouded by the memory of air-launched missile damage to another U.S. destroyer?

As these cases illustrate, our judgments of what nations and people do depend on how we explain their behavior. Depending on our explanation, we may judge killing someone as murder, manslaughter, self-defense, or patriotism. Social psychologists therefore study how we explain what people do. What factors influence how we notice, interpret, and react to others' behavior? And to our own? This quest to understand everyday explanations is part of the larger effort to discover how we process social information—how we take in, store, and recall information about what happens around us.

■ HOW DO WE EXPLAIN OTHERS' BEHAVIOR?

The airplane tragedies illustrate a question we face daily. In trying to understand people, we wonder *why* they act that way. The human mind wants to make sense of its world. If worker productivity declines, do we assume the workers are getting lazier? Or has their equipment become less efficient? Does a young boy who hits his classmates have a hostile personality, or is he responding to relentless teasing? When a salesperson says, "That outfit really looks nice on you," does this reflect genuine feeling, or is it a sales ploy?

ATTRIBUTING CAUSALITY: TO THE PERSON OR THE SITUATION?

We endlessly analyze and discuss why things happen as they do, especially when something negative or unexpected occurs (Bohner & others, 1988; Weiner, 1985). Amy Holtzworth-Munroe and Neil Jacobson (1985, 1988) report that married people often analyze their partners' behaviors, especially their negative behaviors. Cold hostility is more likely than a warm hug to leave the partner wondering "why?" Spouses' answers correlate with their marriage satisfaction. Those who interpret their partner's negative acts as selfish and characteristic ("She's a cold, crabby person") are usually unhappily married. Those who discount their partner's negative acts ("She's frustrated because of how I acted"; "He's had a bad day") find it easier to accept and love the partner (Bradbury & Fincham, 1990; Fletcher & others, 1990).

Our conclusions about why people act as they do are profoundly important: They determine our reactions to others and our decisions regarding them. Antonia Abbey (1987, 1991) and her colleagues have repeatedly found that men are more likely than women to attribute a woman's friendliness to sexual interest. This misreading of warmth as a sexual come-on (called "misattribution") can lead to behavior the woman regards as sexual harassment (Saal & others, 1989). It also helps explain the greater sexual assertiveness exhibited by men across the world (Kenrick & Trost, 1987). Such misattributions contribute both to date rape and to the greater tendency of men in various cultures, from Boston to Bombay, to justify rape by blaming the victim's behavior (Kanekar & Nazareth, 1988; Muehlenhard, 1988; Shotland, 1989).

Attribution theory analyzes how we explain people's behavior. The variations of attribution theory share some common assumptions: that we seek to make sense of our world, that we attribute people's actions to internal or to external causes, and that we do so in fairly logical, consistent ways.

Fritz Heider (1958), attribution theory's originator, analyzed the "common-sense psychology" by which people explain everyday events. Heider concluded that people tend to attribute someone's behavior to *internal* causes (for example, the person's disposition) or *external* causes (for example, something about the person's situation). A teacher may wonder whether a child's under-achievement is due to lack of motivation and ability (a "dispositional attribution") or to physical and social circumstances (a "situational attribution"). This distinction between internal (dispositional) and external (situational) causes blurs when external situations produce internal changes (White, 1991). To say a schoolchild "is fearful" may be a short semantic leap from saying, "School frightens the child."

Attribution theory:
The theory of how people explain others' behavior—for example, by attributing it either to internal *dispositions* (enduring traits, motives, and attitudes) or to external *situations*.

To what should we attribute this student's sleepiness? To lack of sleep? to boredom? Whether we make internal or external attributions depends on whether we notice him consistently sleeping in this and other classes and whether other students react as he does.

We tend to attribute someone's behavior or the outcome of an event either to internal (dispositonal) or external (situational) causes.

"So! If it's good, it's Mister Coffee. If it's bad, it's me."

Social psychologists have discovered that we generally attribute the behavior of others to their dispositions or to the situation. Thus when Constantine Sedikides and Craig Anderson (1992) asked American students why Americans had defected to the Soviet Union, 8 in 10 attributed the behavior to a "confused," "ungrateful," or "traitorous" personality. But 9 in 10 attributed mirror-image Soviet defection to the oppressiveness of the Soviet situation.

Inferring Traits

Edward Jones and Keith Davis (1965) noted that we often *infer* that other people's intentions and dispositions *correspond* to their actions. If I observe Rick making a sarcastic comment to Linda, I am likely to infer that Rick is a hostile person. Jones and Davis's "theory of correspondent inferences" specifies the conditions under which such attributions are most likely. For example, normal or expected behavior tells us less about the person than does unusual behavior. If Rick is sarcastic in a job interview, where a person would normally be pleasant, this tells us more about Rick than if he is sarcastic about his new car just being dented in a parking lot.

The ease with which we infer traits is remarkable. In experiments at New York University, James Uleman (1989) gave students statements to remember, like, "The librarian carries the old woman's groceries across the street." The students would instantly, unintentionally, and unconsciously infer a trait. When later they were helped to recall the sentence, the most valuable clue word was not "books" (to cue librarian) or "bags" (to cue groceries) but "helpful"—the inferred trait that I suspect you, too, spontaneously attributed to the librarian.

Commonsense Attributions

As these examples suggest, attributions often are rational. In testimony to the reasonable ways in which we explain behavior, attribution theorist Harold Kelley (1973) described how we use information about "consistency," "distinctiveness," and "consensus" (Figure 3-1). When explaining why Edgar is having trouble with his XYZ5000 computer, most people appropriately use information concerning *consistency* (Does Edgar usually have trouble with his computer?), *distinctiveness* (Does Edgar have trouble with other computers, or only the XYZ?), and *consensus* (Do other people have similar problems with the XYZ?). If we learn that Edgar and Edgar alone consistently has trouble with this and other computers, we likely will attribute the troubles to Edgar, not to defects in the XYZ.

So our commonsense psychology often explains behavior logically. But Kelley also found that in everyday explanations, people often discount a contributing cause of behavior if other plausible causes are already known. If I can specify one or two reasons a student might have done poorly on an exam, I may ignore or discount other possibilities.

Information Integration

Further evidence of the reasonableness of our social judgments comes from Norman Anderson's research on information integration. Anderson (1968, 1974) and his collaborators discerned some rules by which we combine different pieces of information about a person into an overall impression. Suppose that you have an upcoming blind date with someone described as intelligent, daring, lazy, and sincere. Research on how people combine such information suggests that you would likely weight each item of information according to its importance. If you consider sincerity especially important, you will give it more weight. If you are like the participants in experiments by Solomon Asch (1946), David Hamilton and Mark Zanna (1972), and Bert Hodges (1974), you may also give extra weight to information that comes first, and you may be more sensitive to negative information.

FIGURE 3-1 *Harold Kelley's theory of attributions. Three factors—consistency, distinctiveness, and consensus—influence whether we attribute someone's behavior to internal or external causes.*

First impressions can color your interpretation of later information. Having been told that someone is "intelligent," you may then interpret the person's being "daring" as meaning courageous rather than reckless. Negative information, such as "she is dishonest," also has extra potency, perhaps because it is more unusual. Once you have interpreted and weighed each piece of information, you then use your mental algebra to integrate the different items. The result is your overall impression of your "blind" date.

WHY WE STUDY ATTRIBUTION ERRORS

So far, so good. We form impressions and explain behavior in some reasonable ways. More fascinating, though, are the intriguing errors we make. This chapter, like the one before, explains the foibles and fallacies in our social thinking. Reading these chapters may make it seem, as one student put it, that "social psychologists get their kicks out of playing tricks on people." Actually, the experiments are not designed to demonstrate "what fools these mortals be" (although some of the experiments *are* amusing). Their purpose rather is to reveal how we think about ourselves and others. As we noted in Chapter 2, other psychologists study visual illusions for the same reason—not as mind-teasing demonstrations, but for what they reveal about how the human cognitive system processes information.

If our capacity for illusion and self-deception is shocking, remember that our modes of thought are generally adaptive. Illusory thinking is often a by-product of our mind's strategies for simplifying complex information. This parallels our perceptual mechanisms, which generally give us a useful image of the world, but sometimes lead us astray.

A second reason for focusing on the biases that penetrate our thinking is that we are mostly unaware of them. My hunch is that you will find more surprises, more challenges, and more benefit in an analysis of errors and biases than you would in a string of testimonies to what you already know: the human capacity for logical thought and intellectual achievement. This is also why epics of world literature so often portray the consequences of pride and other human failings. Liberal education exposes us to fallacies in our thinking in the hope that we will become more rational, more in touch with reality. The hope is not in vain: Psychology students explain behavior less simplistically than equally able natural science students (Fletcher & others, 1986). So, remembering this overriding aim—*developing our capacity for critical thinking*—let us continue looking at how the new research on social thinking can enhance our social reasoning.

■ THE FUNDAMENTAL ATTRIBUTION ERROR

As later chapters will reveal, social psychology's most important lesson concerns how much we are affected by our social environment. At any moment, our internal state, and therefore what we say and do, depends on the situation, as well as on what we bring to the situation. In experiments, a slight difference between two situations sometimes greatly affects how people respond. I see

this when I teach classes at both 8:30 A.M. and 7:00 P.M. Silent stares greet me at 8:30; at 7:00 I have to break up a party. In each situation some individuals are more talkative than others, but the difference between the two situations exceeds the individual differences.

Attribution researchers have found that we often fail to appreciate this important lesson. When explaining someone's behavior, we underestimate the impact of the situation and overestimate the extent to which it reflects the individual's traits and attitudes. Thus, even knowing the effect of the time of day on classroom conversation, I find it terribly tempting to assume that the people in the 7:00 P.M. class are more extraverted than the "silent types" who come at 8:30 A.M.

This discounting of the part played by the situation, dubbed by Lee Ross (1977) the **fundamental attribution error,** appears in many experiments. In the first such study, Edward Jones and Victor Harris (1967) had Duke University students read debaters' speeches supporting or attacking Cuba's leader, Fidel Castro. When the position taken was said to have been chosen by the debater, the students logically enough assumed it reflected the person's own attitude. But what happened when the students were told that the debate coach had assigned the position? People write stronger statements than you'd expect from those feigning a position they don't hold (Miller & others, 1990). Thus, even knowing that the debater had been told to take a pro-Castro position did not prevent their inferring that the debater in fact had some pro-Castro leanings (Figure 3-2).

The attribution error is so irresistible that even when people know they are causing someone else's behavior, they still underestimate external influences. If subjects dictate an opinion that someone else must then express, they still tend to see the person as actually holding that opinion (Gilbert & Jones, 1986). If subjects are asked to be either self-enhancing or self-deprecating during an

Fundamental attribution error:
The tendency for observers to underestimate situational influences and overestimate dispositional influences upon others' behavior. (Also called "correspondence bias," because we so often see behavior as corresponding to a disposition.)

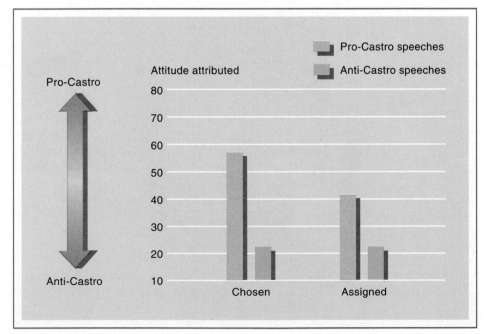

FIGURE 3-2 *The fundamental attribution error. When people read a debate speech supporting or attacking Fidel Castro, they attributed corresponding attitudes to the speech writer, even when the debate coach assigned the writer's position.*
(Data from Jones & Harris, 1967.)

interview, they are very aware of why they are acting so. But they are *un*aware of their effect on another person. If John acts modest, his naive partner Bob is likely to exhibit modesty as well. John will easily understand his own apparent modesty, but he will think that poor Bob suffers low self-esteem (Baumeister & others, 1988).

We commit the fundamental attribution error when explaining *other people's* behavior. We often explain our own behavior in terms of the situation while holding others responsible for their behavior. John might attribute his behavior to the situation ("I was angry because everything was going wrong"), but others might think, "John was hostile because he is an angry person." When referring to ourselves, we typically use verbs that describe our actions and reactions ("I get annoyed when . . ."). Referring to someone else, we more often describe what that person *is* ("He is nasty") (Fiedler & others, 1991; McGuire & McGuire, 1986; White & Younger, 1988).

DOES THE FUNDAMENTAL ATTRIBUTION ERROR OCCUR IN EVERYDAY LIFE?

If we know the checkout cashier is programmed to say, "Thank you and have a nice day," do we nevertheless automatically conclude that the cashier is a friendly, grateful person? We certainly know how to discount behavior that we attribute to ulterior motives (Fein & others, 1990). Yet consider what happened when Williams College students talked with a supposed clinical-psychology graduate student who acted either warm and friendly or aloof and critical. Researchers David Napolitan and George Goethals (1979) told half the students beforehand that her behavior would be spontaneous. They told the other

When meeting soap opera star Kate Collins, fans may be surprised to learn that she is not like her character on All My Children. *Many will have committed the fundamental attribution error by assuming she is really like the person she portrays on TV.*

half that for purposes of the experiment she had been instructed to feign friendly (or unfriendly) behavior. The effect of the information? None. If she acted friendly, they assumed she was really a friendly person; if she acted unfriendly, they assumed she was an unfriendly person. As when viewing a dummy on the ventriloquist's lap or a actor playing a "good-guy" or "bad-guy" role, we find it difficult to escape the illusion that the programmed behavior reflects an inner disposition. Perhaps this is why Leonard Nimoy, who played Mr. Spock on the original *Star Trek,* entitled his book *I Am Not Spock.*

The discounting of social constraints was further revealed in a thought-provoking experiment by Lee Ross and his collaborators (Ross & others, 1977). The experiment re-created Ross's firsthand experience of moving from graduate student to professor. His doctoral oral exam had proved a humbling experience; his apparently brilliant professors quizzed him on topics they specialized in. Six months later, *Dr.* Ross was himself an examiner, now able to ask penetrating questions on *his* favorite topics. Ross's hapless subject later confessed to feeling exactly as Ross had a half year before—dissatisfied with his ignorance and impressed with the apparent brilliance of the examiners, including the most junior of them.

In the experiment, with Teresa Amabile and Julia Steinmetz, Ross set up a simulated quiz game. He randomly assigned some Stanford University students to play the role of questioner, some to play the role of contestant, and others to observe. The researchers invited the questioners to make up difficult questions that would demonstrate their general wealth of knowledge. It's fun to imagine the questions: "Where is Bainbridge Island?" "What is the seventh book in the Old Testament?" "Which has the longer coastline, Europe or Africa?" If even these few questions have you feeling a little uninformed, then you will appreciate the results of this experiment.* Everyone had to know that the questioner would have the advantage. Yet both contestants and observers came to the erroneous conclusion that the questioners *really were* more knowledgeable than the contestants (Figure 3-3). Follow-up research shows that the misimpressions are hardly a reflection of low social intelligence. If anything, intelligent and socially competent people are *more* likely to make the attribution error (Block & Funder, 1986).

Have you ever noticed that the question-askers on TV game shows such as Jeopardy *seem more intelligent than their contestants?*

In real life, those with social power usually initiate and control conversation, which often leads underlings to overestimate their knowledge and intelligence. Medical doctors, for example, are often presumed to be experts on all sorts of questions unrelated to medicine. Similarly, students often overestimate the brilliance of their teachers. (As in the experiment, teachers are questioners on subjects of their special expertise.) When some of these students later become teachers themselves, they are usually amazed to discover that teachers are not so brilliant after all.

Attributions of responsibility are at the heart of many judicial decisions (Fincham & Jaspars, 1980). In 1988, after Colonel Oliver North was indicted on charges of theft, fraud, and conspiracy, a controversy ensued: Was North accountable for illegal activity and should he therefore be jailed? Or was North

* Bainbridge Island is across Puget Sound from Seattle. The seventh Old Testament book is Judges. Although the African continent has more than double the area of Europe, Europe's coastline is longer. (It is more convoluted, with lots of harbors and inlets, a geographical fact that contributed to its role in the history of maritime trade.)

FIGURE 3-3 *Both contestants and observers of a simulated quiz game assumed that a person who had been randomly assigned the role of questioner was actually far more knowledgeable than the contestant. Actually, the assigned roles of questioner and contestant simply made the questioner seem more knowledgeable. The failure to appreciate this illustrates the fundamental attribution error.*

(Data from Ross, Amabile, & Steinmetz, 1977.)

acting under orders in the line of duty? (In a 1991 book he maintained that even President Reagan knew of the orders he was following.) The case exemplifies many judicial controversies: The prosecution argues, "You are to blame, for you could have done otherwise"; the defendant replies, "It wasn't my fault; I was a victim of the situation" or "Under the circumstance I did no wrong."

To illustrate the fundamental attribution error, most of us need look no further than our own experience. Determined to make some new friends, Bev plasters a smile on her face and anxiously plunges into a party. Everyone else seems quite relaxed and happy as they laugh and talk with one another. Bev wonders to herself, "Why is everyone always so at ease in groups like this while I'm feeling shy and tense?" Actually, everyone else is feeling nervous, too, and making the same attributional error in assuming that Bev and the others *are* as they *appear*—confidently convivial.

WHY DO WE MAKE THE ATTRIBUTION ERROR?

So far we have seen a bias in the way we explain other people's behavior: We often ignore powerful situational determinants. Why do we tend to underestimate the situational determinants of others' behavior but not our own?

Difference in Perspective

Attribution theorists point out that we have a different perspective when observing than when acting (Jones & Nisbett, 1971; Jones, 1976). When we act, the environment commands our attention. When we watch another person act,

that *person* occupies the center of our attention. To use the perceptual analogy of figure and ground, the person is the figure that stands out from the surrounding environmental ground. So the person seems to cause whatever happens. If this is true, what might we expect if the perspectives were reversed? What if we could see ourselves as others see us and if we saw the world through their eyes? Shouldn't this eliminate or reverse the attribution error?

See if you can predict the result of a clever experiment conducted by Michael Storms (1973). If you were a subject in Storms' experiment, you might have found yourself seated facing another student with whom you were to talk for a few minutes. Beside you is a TV camera that shares your view of the other student. Facing you from alongside the other student are an observer and another TV camera. Afterward, both you and the observer judge whether your behavior was caused more by your personal characteristics or by the situation.

Question: Which of you—subject or observer—will attribute the least importance to the situation? Storms found it was the observer (another demonstration of the fundamental attribution tendency). What if we reverse points of view by having you and the observer each watch the videotape recorded from the other's perspective? (You now view yourself, while the observer views what you saw.) This reverses the attributions: The observer now attributes your behavior mostly to the situation you faced, while you now attribute it to your person. *Remembering* an experience from an observer's perspective—by "seeing" oneself from the outside—has the same effect (Frank & Gilovich, 1989).

In another experiment, people viewed a videotape of a suspect confessing during an interview by a police detective. If they viewed the confession through a camera focused on the suspect, they perceived the confession as genuine. If they viewed it through a camera focused on the detective, they perceived it as more coerced (Lassiter & Irvine, 1986). In courtrooms, most videotaped confessions focus on the confessor. As we might expect, note Dan-

The rape trial of William Kennedy Smith centered on questions of attribution. Did he rightly attribute—or wrongly misattribute—his accuser's friendliness as an invitation to sex? Should he be held responsible for his act?

iel Lassiter and Kimberley Dudley (1991), such tapes yield a nearly 100 percent conviction rate when played by prosecutors. Perhaps, then, a more impartial videotape would show both interrogator and suspect.

Time can change observers' perspectives. As the once-salient person recedes in their memory, observers often give more and more credit to the situation. Immediately after hearing someone argue an assigned position, people assume that's how the person really felt. A week later they are much more likely to credit the situational constraints (Burger, 1991). The day after the 1988 presidential election, Jerry Burger and Julie Pavelich (1991) asked Santa Clara, California, voters why the election turned out as it did. Most attributed the outcome to the candidates' personal traits and positions (Bush was likeable; Dukakis ran a poor campaign). When they asked other voters the same question a year later, only a third attributed the verdict to the candidates. More people now credited circumstances, such as the country's good mood and the robust economy.

Editorial reflections on the six presidential elections between 1964 and 1988 show the same growth in situational explanations with time, Burger and Pavelich report. Just after the 1978 election, editorial pundits focused on Ford's and Carter's campaigns and personalities. Two years later the situation loomed larger: "The shadows of Watergate . . . cleared the way for [Carter's] climb to the Presidency," noted one editorial in the *New York Times.* So one reason we underestimate situations is that we focus on the person rather than on the situation.

Seeing ourselves on television redirects our attention to ourselves. Seeing ourselves in a mirror, hearing our tape-recorded voices, having our pictures taken, filling out biographical questionnaires—such experiences similarly focus our attention inward, making us *self*-conscious instead of *situation*-conscious.

Robert Wicklund, Shelley Duval, and their collaborators have explored the effects of becoming **self-aware** (Duval & Wicklund, 1972; Wicklund, 1979, 1982). When our attention focuses upon ourselves, we attribute more responsibility to ourselves. Allan Fenigstein and Charles Carver (1978) demonstrated this by having students imagine themselves in hypothetical situations. Those made self-conscious, by thinking they were hearing their heartbeats while pondering the situation, saw themselves as more responsible for the imaginary outcome than did those who thought they were just hearing extraneous noises.

Some people are typically quite self-conscious. In experiments, people who report themselves as privately self-conscious (who agree with statements such as "I'm generally attentive to my inner feelings") behave similarly to people whose attention has been self-focused with a mirror (Carver & Scheier, 1978). Thus, people whose attention focuses on themselves—either briefly during an experiment or because they are self-conscious persons—view themselves more as observers typically do; they attribute their behavior more to internal factors and less to the situation.

Here then is one good reason for the attribution error: *We find causes where we look for them.* To see this in your own experience, consider: Would you say your social psychology instructor is a quiet or a talkative person?

My guess is you inferred that he or she is fairly outgoing. But consider further: Your attention focuses on your instructor while he or she behaves in a context that demands speaking. The instructor, on the other hand, observes his

Self-awareness:
A self-conscious state in which attention focuses on oneself. Makes people more sensitive to their own attitudes and dispositions.

Observing talk show host Arsenio Hall, people infer he must be extremely outgoing. But he attributes his outgoing behavior partly to the situation, claiming to be naturally more shy than people think he is.

or her own behavior in many different situations—in the classroom, in meetings, at home. "Me talkative?" your instructor might say. "Well, it all depends on the situation. When I'm in class or with good friends, I'm rather outgoing. But at conventions and in unfamiliar situations I feel and act rather shy."

If we are acutely aware of how our behavior varies with the situation, we should also see ourselves as more variable than other people. And that is precisely what studies in the United States, Canada, and Germany have found (Baxter & Goldberg, 1987; Kammer, 1982; Sande & others, 1988). Moreover, the less opportunity we have to observe people's behavior in context, the more we attribute to their personalities. Thomas Gilovich (1987) explored this by showing people a videotape of someone and then having them describe the person's actions to other people. The secondhand impressions were more extreme. Similarly, people's impressions of someone they have often heard about from a friend are typically more extreme than their friend's firsthand impressions. The better you know someone, the less prone you are to overgeneralized impressions (Prager & Cutler, 1990).

Cultural Differences

Cultures also influence the attribution error (Ickes, 1980; Watson, 1982). For example, our western world view predisposes us to assume that people, not situations, cause events. Jerald Jellison and Jane Green (1981) reported that among University of Southern California students internal explanations are more socially approved. "You can do it," we are assured by the pop psychology of positive-thinking western culture.

This assumes that, with the right disposition and attitude, anyone can surmount almost any problem: You get what you deserve and deserve what you get. Thus we often explain bad behavior by labeling the person as "sick," "lazy," or "sadistic." As children grow up in western culture, they increasingly explain behavior in terms of the other's personal characteristics (Rholes & oth-

"You can do anything you want to if you just set your mind to it and go to work."
J. Danforth Quayle,
U.S. vice presidential debate,
October 5, 1988

ers, 1990; Ross, 1981). As a first grader, one of my sons brought home an example. He unscrambled the words "gate the sleeve caught Tom on his" into "The gate caught Tom on his sleeve." His teacher, applying the western cultural assumptions of the curriculum materials, marked this wrong. The "right" answer located the cause within Tom: "Tom caught his sleeve on the gate."

Some languages promote external attributions. Instead of "I was late," Spanish idiom allows one to say, "The clock caused me to be late." In less individualist cultures, people less often perceive others in terms of personal dispositions (Zebrowitz-McArthur, 1988). When told of someone's actions, Hindus in India are less likely than Americans to offer dispositional explanations ("She is kind") and more likely to offer situational explanations ("Her friends were with her") (Miller, 1984). College students in Japan are less likely than American students to answer the question, "Who am I?" with psychological traits ("I am sincere," "I am confident") and more likely to declare their social identities ("I am a Keio student") (Cousins, 1989).

HOW FUNDAMENTAL IS THE FUNDAMENTAL ATTRIBUTION ERROR?

Like most provocative ideas, the presumption that we're all prone to a fundamental attribution error has its critics. Granted, say some, there is an attribution *bias.* But in any given instance, this may or may not produce an "error," just as parents who are biased to believe their child does not drink or use drugs may or may not be in error (Harvey & others, 1981). We can be biased to believe what is true. Moreover, some everyday circumstances, such as being in church or on a job interview, are like the experiments we have been considering: As actors realize better than observers, the circumstances involve clear constraints. Hence the attribution error. But in other settings—in one's room, at a park—people exhibit their individuality. In such settings, people may see their own behavior as *less* constrained than do observers (Monson & Snyder, 1977; Quattrone, 1982). So it's an overstatement to say that at all times and in all settings observers underestimate situational influences.

Nevertheless, experiments reveal that the bias occurs even when we are aware of the situational forces—when we know that an assigned debate position is not a good basis for inferring someone's real attitudes (Croxton & Morrow, 1984; Croxton & Miller, 1987; Reeder & others, 1989) or that the questioners' role in the quiz game gives them an advantage (Johnson & others, 1984). It is sobering to think that you and I can know about a social process that distorts our thinking and still be susceptible to it. Perhaps that's because it takes more mental effort to assess social effects on people's behavior than merely to attribute it to their disposition (Gilbert & others, 1988). It's as if the person thinks, "This isn't a very good basis for making a judgment, but it's easy and all I've got to go on."

The attribution error is *fundamental* because it colors our explanations in basic and important ways. Researchers in Britain, India, Australia, and the United States have found, for example, that people's attributions predict their attitudes toward the poor and unemployed (Feather, 1983; Furnham, 1982; Pandey & others, 1982; Wagstaff, 1983). Those who attribute poverty and unemployment to personal dispositions ("They're just lazy and undeserving") tend to adopt political positions unsympathetic to such people. Their views

differ from those who make external attributions ("If you or I were to have lived with the same overcrowding, poor education, and discrimination, would we be any better off?"). French investigators Jean-Leon Beauvois and Nicole Dubois (1988) report that "relatively privileged" middle-class people are more likely than less advantaged people to assume that people's behaviors have internal explanations. (Those who have made it tend to assume that you get what you deserve.)

How might we benefit from being aware of the bias? Perhaps being sensitive to it can help. Recently, I assisted with some interviews for a faculty position. One candidate was interviewed by six of us at once; each of us had the opportunity to ask two or three questions. I came away thinking, "What a stiff, awkward person he is." The second candidate I met privately over coffee, and we immediately discovered we had a close, mutual friend. As we talked, I became increasingly impressed by what a "warm, engaging, stimulating person she is." Only later did I remember the fundamental attribution error and reassess my analysis. I had attributed his stiffness and her warmth to their dispositions; in fact, I later realized, such behavior resulted partly from the formality versus informality of their interview situations. Had I viewed these interactions through their eyes, instead of my own, I might have come to different conclusions.

> "Most poor people are not lazy. . . . They catch the early bus. . . . They raise other people's children. . . . They clean the streets. No, no, they're not lazy."
> The Reverend Jesse Jackson, address to the Democratic National Convention, July 1988.

■ HOW DO WE SEE AND EXPLAIN OURSELVES?

We have considered how we explain others' behavior, paying special attention to the fundamental attribution error. Social psychologists also study how we explain *our own* behavior and how we select, interpret, and recall information about ourselves.

During the 1980s no topic in psychology was more researched than the self. In 1990 the word "self" appeared in nearly 4000 book and article summaries in *Psychological Abstracts*—more than double the proportion of 20 years earlier. This new wave of research revealed that our ideas about ourselves (our self-schemas) powerfully affect how we process social information. Our sense of self organizes our thoughts, feelings, and actions, thereby influencing how we perceive, remember, and evaluate both other people and ourselves (Markus & Wurf, 1987). The self serves as a sort of mental Dewey Decimal System for cataloguing and retrieving information. One example is the **self-reference effect:** When information is relevant to our self-conceptions, we process it more quickly and remember it better (Higgins & Bargh, 1987; Kuiper & Rogers, 1979; Reeder & others, 1987). If asked whether specific words, such as "outgoing" describe us, we later remember those words better than if asked whether they describe someone else. If asked to compare ourselves with a character in a short story, we remember that character better.

Self-reference effect: The tendency to process efficiently and remember well information related to oneself.

But as we process self-relevant information, a potent bias intrudes. We readily attribute our failures to difficult situations and just as readily take credit for our successes. This feeds what for most people is a favorable self-image, enabling them to enjoy the benefits of positive self-esteem while occasionally suffering the perils of self-righteous pride.

THE SELF-SERVING BIAS: "HOW DO I LOVE ME? LET ME COUNT THE WAYS."

It is widely believed that most of us suffer the "I'm not OK—you're OK" problem of low self-esteem. A generation ago, humanistic psychologist Carl Rogers (1958) concluded that most people he knew "despise themselves, regard themselves as worthless and unlovable." Many popularizers of humanistic psychology concur. "All of us have inferiority complexes," contends John Powell (1989). "Those who seem not to have such a complex are only pretending." Or as Groucho Marx put it: "I'd never join any club that would accept a person like me."

Actually, most of us have a good reputation with ourselves. In studies of self-esteem, even low-scoring people respond in the midrange of possible scores. (A "low" self-esteem person responds to such statements as "I have good ideas" with a qualifying adjective, such as "somewhat" or "sometimes.") Moreover, one of social psychology's most provocative yet firmly established conclusions concerns the potency of **self-serving bias.**

Self-serving bias:
The tendency to perceive oneself favorably.

Attributions for Positive and Negative Events

Time and again, experimenters have found that people readily accept credit when told they have succeeded (attributing the success to their ability and effort), yet attribute failure to such external factors as bad luck or the problem's inherent "impossibility" (Whitley & Frieze, 1985, 1986). Similarly, in explaining their victories, athletes commonly credit themselves, but attribute losses to something else: bad breaks, bad referee calls, the other team's super effort (Grove & others, 1991; Mullen & Riordan, 1988). And how much responsibility do you suppose car drivers tend to accept for their accidents? On insurance forms, drivers have described their accidents in words such as these: "An invisible car came out of nowhere, struck my car and vanished"; "As I reached an intersection, a hedge sprang up, obscuring my vision and I did not see the other car"; "A pedestrian hit me and went under my car" (*Toronto News*, 1977). Situations that combine skill and chance (for example, games, exams, job applications) are especially prone to the phenomenon: Winners can easily attribute their successes to their skill, while losers can attribute their losses to chance. When I win at Scrabble, it's because of my verbal dexterity; when I lose, it's because, "Who could get anywhere with a *Q* but no *U*?"

In experiments that require two people to cooperate to make money, most individuals blame their partner for failure (Myers & Bach, 1976). This follows a tradition established in the most ancient example of self-serving bias, Adam's excuse: "The woman whom you gave to be with me, she gave me fruit from the tree, and I ate." Thus while managers usually blame poor performance on workers' lack of ability or effort, workers are more likely to blame something external—inadequate supplies, excessive work load, difficult co-workers, ambiguous assignments (Rice, 1985).

Michael Ross and Fiore Sicoly (1979) observed a marital version of self-serving bias. They found that young married Canadians usually felt they took more responsibility for such activities as cleaning the house and caring for the children than their spouses were willing to credit them for. In a more recent survey of Americans, 91 percent of wives but only 76 percent of husbands credited the wife with doing most of the food shopping (Burros, 1988). In

Because they more easily recall what they have done than what they have not done, married people may perceive themselves as doing more of the housework than their spouses give them credit for.

another study, husbands estimated they did more of the housework than their wives did; the wives, however, estimated their efforts were more than double their husbands' (Fiebert, 1990). Every night, my wife and I pitch our laundry at the foot of our bedroom clothes hamper. In the morning, one of us puts it in. When she suggested that I take more responsibility for this, I thought, "Huh? I already do it 75 percent of the time." So I asked her how often she thought she picked up the clothes. "Oh," she replied, "about 75 percent of the time." Small wonder that divorced people usually blame their partner for the breakup and view themselves as victim rather than villain (Gray & Silver, 1990).

Likewise, in competing for prizes, scientists seldom seem to underrate their own contributions. After Frederick Banting and John Macleod received a 1923 Nobel Prize for discovering insulin, Banting claimed that Macleod, who headed the laboratory, had been more of a hindrance than a help. Macleod omitted Banting's name in speeches about the discovery (Ross, 1981).

Students also exhibit this self-serving bias. Researchers Walter Stephan, Robert Arkin, Mark Davis, and others have consistently found that after receiving an examination grade, those who do well tend to accept personal credit. They judge the exam to be a valid measure of their competence (Arkin & Maruyama, 1979; Davis & Stephan, 1980; Gilmor & Reid, 1979; Griffin & others, 1983). Those who do poorly are much more likely to criticize the exam.

Reading about these experiments, I cannot resist a satisfied "knew-it-all-along" feeling. But college professors are not immune: Mary Glenn Wiley and her co-workers (1979) asked 230 scholars who had submitted articles to sociology journals why their papers had been accepted or rejected. The scholars attributed rejections mostly to factors beyond their control (for example, bad luck in the editor's choice of critic for the paper). As you can by now imagine, they did not attribute acceptances to *good* luck but rather to controllable factors, like the quality of their articles and the effort they put into them.

The experiments dealing with students' means of explaining their good and bad performances are complemented by experiments on teachers' ways of explaining students' good and bad performances. When there is no need to feign modesty, those assigned the role of teacher tend to take credit for positive outcomes and blame failure on the student, especially when the student's performance reflects on them (Arkin & others, 1980; Davis, 1979). Teachers, it seems, are likely to think, "With my help, Maria graduated with honors. Despite all my help, Melinda flunked out."

"The need to view oneself in a favorable way following a success or failure . . . may be one of the best established, most often replicated, findings in social psychology."
Michael Ross & Garth Fletcher (1985)

Can We All Be Better Than Average?

Self-serving bias also appears when people compare themselves to others. If the sixth-century B.C. Chinese philosopher Lao-tzu was right that "at no time in the world will a man who is sane over-reach himself, over-spend himself, over-rate himself," then most of us are a little insane. For on nearly any dimension that is both *subjective* and *socially desirable,* most people see themselves as better than average. Consider:

■ Most businesspeople see themselves as more ethical than the average businessperson (Baumhart, 1968; Brenner & Molander, 1977). Ninety percent of business managers rate their performance as superior to their average peer (French, 1968). And most managers see their leadership as more encouraging of openness and innovation than do their subordinates and neutral observers (Hollander, 1985).

■ In Australia, 86 percent of people rate their job performance as above average, 1 percent as below average (Headey & Wearing, 1987).

■ Most community residents see themselves as less prejudiced and as fairer than others in their communities (Fields & Schuman, 1976; Lenihan, 1965; Messick & others, 1985; O'Gorman & Garry, 1976).

■ Most drivers—even most drivers who have been hospitalized for accidents— believe themselves to be safer and more skilled than the average driver (Svenson, 1981).

■ Most Americans perceive themselves as more intelligent than their average peer (Wylie, 1979) and as better looking (*Public Opinion,* 1984).

■ Most adults believe they give more of themselves to their aging parents than do their siblings (Lerner & others, 1991).

■ Los Angeles residents think they are healthier than most of their neighbors, and most college students believe they will outlive their actuarially predicted age of death by about 10 years (Larwood, 1978; C. R. Snyder, 1978).

Every American community, it seems, is like Garrison Keillor's fictional Lake Wobegon, where "all the women are strong, all the men are good-looking, and all the children are above average." Perhaps one reason for this optimism is that although 12 percent of Americans feel old for their age, many more—66 percent—think they are young for their age (*Public Opinion*, 1984). All of which calls to mind Freud's joke about the man who told his wife, "If one of us should die, I think I would go live in Paris."

Subjective dimensions (such as "disciplined") trigger greater self-serving bias than behavioral dimensions (such as "punctual"). Students are more likely to rate themselves superior in "moral goodness" than in "intelligence" (Allison & others, 1989; Van Lange, 1991). This is partly because subjective qualities give us so much leeway in constructing our own definitions of success (Dunning & others, 1989, 1991). Rating my "athletic ability," I ponder my basketball play, not the agonizing weeks I spent as a Little League baseball player hiding in right field. Assessing my "leadership ability," I conjure up an image of a great leader whose style is similar to mine. By defining ambiguous criteria in our own terms, each of us can see ourselves as relatively successful. In one College Entrance Examination Board survey of 829,000 high school seniors taking its Scholastic Aptitude Test, *0* percent rated themselves below average in "ability to get along with others" (a subjective, desirable trait), 60 percent rated themselves in the top 10 percent, and 25 percent saw themselves among the top 1 percent!

"*I dread to think of all the inaccuracies there would be if you wrote my biography after I'm gone.*"

Most people perceive themselves as more intelligent and better looking than their average peer.

We also support our self-image by assigning importance to the things we're good at. Over a semester, those who ace an introductory computer science course come to place a higher value on their identity as a computer-literate person in today's world. Those who do poorly are more likely to scorn the computer geeks and to exclude computer skills as pertinent to their self-image (Hill & others, 1989).

Other Self-Serving Tendencies

These tendencies toward self-serving attributions and self-congratulatory comparisons are not the only signs of favorably biased self-perceptions. In Chapter 2 we saw that most of us overestimate how desirably we would act in a given situation. We also display a "cognitive conceit" by overestimating the accuracy of our beliefs and judgments. And we misremember our own past in self-enhancing ways.

Additional streams of evidence converge to form a river:

- If an undesirable act cannot be misremembered or undone, then, as we will see in Chapter 4, we may justify it.

- The more favorably we perceive ourselves on some dimension (intelligence, persistence, sense of humor), the more we use that dimension as a basis for judging others (Lewicki, 1983).

- If a test or some other source of information—even a horoscope—flatters us, then we believe it, and we evaluate positively both the test and any evidence suggesting that the test is valid (Glick & others, 1989; Pyszczynski & others, 1985; Tesser & Paulhus, 1983).

- We tend to see ourselves as center stage; we overestimate the extent to which others' behavior is aimed at us; and we see ourselves as responsible for events in which we played only a small part (Fenigstein, 1984).

"How little we should enjoy life if we never flattered ourselves!"

La Rochefoucauld, *Maxims*, 1665

Basking in reflected glory gives our ego a boost, as when we identify publicly with "our" team's victory or success.

■ **VIEWPOINT:** THE ILLUSION OF INVULNERABILITY

In a 1943 Harvard Chapel meditation, psychologist Gordon W. Allport (1978, pp. 19–20) described the perils of unrealistic optimism:

> Recently I examined two hundred life histories written by refugees from Nazi Germany. With scarcely an exception these people had found themselves blinded by their own hopes.
>
> Not one of them would at first believe that Hitlerism could bring such a catastrophe on them.
>
> In 1932 they hoped and therefore believed that Hitler would never come to power.
>
> In 1933 they hoped and therefore believed that he could not put his threats into execution.
>
> In 1934 they hoped and therefore believed that the nightmare would soon pass.

In 1938 the Austrians were certain that Hitler could never come to Austria, because they hoped that Austrians were different from Germans.

Another example comes from a study of college undergraduates who were asked to estimate their income in five years' and in ten years' time after leaving college. The results, I regret to report, are quite fantastic. Most of them picture themselves as well-to-do, quite overlooking probabilities.

If they were headed for medicine, they estimated their income within a range which only about 5 percent of the medical profession achieves. If they were to become airplane pilots, they figured a salary above that obtained by any pilot.

Hope based on ignorance may spring eternal, but it certainly spells a fall. It is more of a vice than a virtue.

■ Judging from photos, we not only guess that attractive people have desirable personalities, we also guess that they have personalities more like our own than do unattractive people (Marks & others, 1981).

■ We like to associate ourselves with the glory of others' success. If, however, we find ourselves linked with (say, born on the same day as) some reprehensible person, we boost ourselves by softening our view of the rascal (Finch & Cialdini, 1989).

What is more, many of us have what researcher Neil Weinstein (1980, 1982) terms "an unrealistic optimism about future life events." At Rutgers University, for example, students perceive themselves as far more likely than their classmates to get a good job, draw a good salary, and own a home, and as far less likely to experience negative events, such as developing a drinking problem, having a heart attack before age 40, or being fired. In Dundee, Scotland, most late adolescents think they are much less likely than their peers to become infected by the AIDS virus (Abrams, 1991). After experiencing the 1989 earthquake, San Francisco Bay–area students did lose their optimism about being less vulnerable than their classmates to injury in a natural disaster, but within three months their illusory optimism had rebounded (Burger & Palmer, 1991).

Linda Perloff (1987) notes how illusory optimism increases our vulnerability. Believing ourselves immune to misfortune, we do not take sensible precautions. Most young Americans know that half of U.S. marriages end in divorce but persist in believing that *theirs* will not (Lehman & Nisbett, 1985). Sexually active undergraduate women who don't consistently use contraceptives perceive themselves, compared to other women at their university, as much *less* vulnerable to unwanted pregnancy (Burger & Burns, 1988). Those who cheerfully shun seat belts, deny the effects of smoking, and stumble into ill-fated relationships remind us that blind optimism, like pride, may go before a fall.

"Views of the future are so rosy that they would make Pollyanna blush."
Shelley E. Taylor,
Positive Illusions, 1989

"O God, give us grace to ac-
cept with serenity the things
that cannot be changed, cour-
age to change the things which
should be changed, and the
wisdom to distinguish the one
from the other."
Reinhold Niebuhr,
"The Serenity Prayer," 1943

False consensus effect:
The tendency to overesti-
mate the commonality of
one's opinions and one's
undesirable or unsuccessful
behaviors.

A dash of pessimism can energize students, most of whom exhibit excess
optimism about upcoming exams (Sparrell & Shrauger, 1984). Students who
are overconfident tend to underprepare. Their equally able but more anxious
peers, fearing that they are going to bomb the upcoming exam, study furiously
and get higher grades (Goodhart, 1986; Norem & Cantor, 1986; Showers &
Ruben, 1987). The moral: Success in school and beyond requires enough opti-
mism to sustain hope and enough pessimism to motivate concern.

Finally, we have a curious tendency to enhance our self-image by overesti-
mating or underestimating the extent to which others think and act as we do:
the **false consensus effect.** On matters of *opinion*, we find support for our
positions by overestimating the extent to which others agree (Marks & Miller,
1987; Mullen & Goethals, 1990). When we behave badly or fail in a task, we
reassure ourselves by thinking that such lapses are common. We guess that
others think and act as we do: "I do it, but so does everyone else." If we favor
Brian Mulroney for prime minister, cheat on our income taxes, or smoke, we

are likely to overestimate the number of other people who do likewise. Lance Shotland and Jane Craig (1988) suspect that this helps explain why males are quicker than females to perceive friendly behavior as sexually motivated: Men, having a lower threshold for sexual arousal, are likely to assume that women share similar feelings.

One might argue that false consensus occurs because we generalize from a limited sample, which includes ourselves (Dawes, 1990). But on matters of *ability* or when we behave well or successfully, a **false uniqueness effect** more often occurs (Goethals & others 1991). We serve our self-image by seeing our talents and behaviors as relatively unusual. Thus those who drink heavily but use seat belts will *over*estimate (false consensus) the number of other heavy drinkers and *under*estimate (false uniqueness) the commonality of seat belt use (Suls & others, 1988). Simply put, people see their failings as normal, their virtues as rare.

SELF-DISPARAGEMENT

Perhaps you have by now recalled times when someone was not self-praising but self-disparaging. But even put-downs can be self-serving, for often they elicit reassuring "strokes." A remark such as, "I wish I weren't so ugly," elicits at least a, "Come now. I know a couple of people who are uglier than you."

There is another reason people verbally disparage themselves and praise others. Think of the coach who, before the big game, extols the opponent's strength. Is the coach sincere? Robert Gould, Paul Brounstein, and Harold Sigall (1977) found that in a laboratory contest their University of Maryland students similarly aggrandized their anticipated opponent, but only when the assessment was made publicly. Anonymously, they credited their future opponent with much less ability.

When coaches publicly exalt their opponents, they convey an image of modesty and good sportsmanship and set the stage for a favorable evaluation no matter what the outcome. A win becomes a praiseworthy achievement, a loss

"The thief thinks everyone else is a thief."
El Salvadoran saying

False uniqueness effect: The tendency to underestimate the commonality of one's abilities and one's desirable or successful behaviors.

"Humility is often but a trick whereby pride abases itself only to exalt itself later."
La Rochefoucauld, *Maxims*, 1665

"Congratulations! I understand you're everybody's favorite."

By praising our competitors, we soften the blow of possible defeat and glorify the victories we may achieve.

attributable to the opponent's "great defense." Modesty, said the seventeenth-century philosopher Francis Bacon, is but one of the "arts of ostentation."

Self-Handicapping

Sometimes people sabotage their chances for success by presenting themselves as shy, ill, or handicapped by past traumas. Far from being deliberately self-destructive, such behaviors typically have a self-protective aim (Arkin & others, 1986; Baumeister & Scher, 1988; Rhodewalt, 1987): "I'm not a failure—I'm okay except for this problem that handicaps me."

Can people handicap themselves with self-defeating behavior? Recall that we eagerly protect our self-images by attributing failures to external factors rather than to ourselves. Can you see why, *fearing failure*, people might handicap themselves by partying half the night before a job interview, getting a headache the day of a big date, or by playing video games instead of studying before a big exam? When self-image is tied up with performance, it can be more self-deflating to try hard and fail than to have a ready excuse. If we fail while working under a handicap, we can cling to a sense of competence; if we succeed under such conditions, it can only boost our self-image.

This analysis of **self-handicapping,** proposed by Steven Berglas and Edward Jones (1978), has been confirmed. One experiment was said to concern "drugs and intellectual performance." Imagine yourself in the position of their Duke University subjects. You guess answers to some difficult aptitude questions and then are told, "Yours was one of the best scores seen to date!" Feeling incredibly lucky, you are then offered a choice between two drugs before answering more of these items. One drug will aid intellectual performance, and the other will inhibit it. Which drug do you want? Most students wanted the drug that would supposedly disrupt their thinking and thus provide a handy excuse for anticipated poorer performance.

Researchers have documented other ways in which people self-handicap. Fearing failure, people will:

- Reduce their preparation for important individual athletic events (Rhodewalt & others, 1984)
- Not try as hard as they could during a tough ego-involving task (Hormuth, 1986; Pyszczynski & Greenberg, 1983)
- Give their opponent an advantage (Shepperd & Arkin, 1991)
- Report feeling depressed (Baumgardner, 1991)
- Perform poorly at the beginning of a task in order not to create unreachable expectations (Baumgardner & Brownlee, 1987)

After losing to some younger rivals, tennis great Martina Navratilova confessed that she was "afraid to play my best. . . . I was scared to find out if they could beat me when I'm playing my best because if they can, then I am finished" (Frankel & Snyder, 1987).

WHY THE SELF-SERVING BIAS?

The self-serving bias has been explained in three ways: as an effort to *present* a positive image, as a by-product of how we *process information*, or as *motivated* by our desire to protect and enhance our self-esteem.

Self-handicapping: Protecting one's self-image by creating a handy excuse for failure.

"With no attempt there can be no failure; with no failure no humiliation."
William James, *Principles of Psychology*, 1890

Self-Presentation

Self-presentation refers to our wanting to present a good image both to an external audience (other people) and to an internal audience (ourselves). Thus we work at managing the impressions we create. Intentionally or not, we deceive, excuse, justify, or apologize as necessary to shore up our self-esteem and verify our self-image (Schlenker & Weigold, 1992).

No wonder, say self-presentation researchers, that people will self-handicap when failure might make them look bad (Arkin & Baumgardner, 1985). No wonder people express more modesty when their self-flattery is vulnerable to being debunked or when experts will be scrutinizing their self-evaluations (Arkin & others, 1980; Riess & others, 1981; Weary & others, 1982). Professor Smith will express less confidence in the significance of her work when presenting it to professional colleagues than when presenting to students.

Presenting oneself in ways that create a good impression is a very delicate matter. People want to be seen as able but also as modest and honest (Carlston & Shovar, 1983). Modesty creates a good impression, and unsolicited boasting creates a bad impression (Forsyth & others, 1981; Holtgraves & Srull, 1989; Schlenker & Leary, 1982). Thus people often display *less* self-esteem than they privately feel (Miller & Schlenker, 1985). When explaining an important success, they are doubly likely to acknowledge others' help if their explanation is public (Baumeister & Ilko, 1991). But when we have obviously done extremely well, false disclaimers ("I did well, but it's no big deal") may come across as feigned humility. Self-handicapping, too, can make a bad impression (Smith & Strube, 1991). To make good impressions—as modest yet competent—requires social skill.

Self-presentation:
The act of expressing oneself and behaving in ways designed to create a favorable impression or an impression that corresponds to one's ideals. (Self-presentation is a prime example of "impression management.")

"I would like to thank my family, my children, my friends, and everyone I have ever met in my entire life."
Maureen Stapleton, publicly sharing credit for her Academy Award, 1982

In cultures that value self-restraint, like that of Japan, people often present modesty.

The tendency to self-present modesty is especially great in cultures that value self-restraint, such as China and Japan (Markus & Kitayama, 1991; Wu & Tseng, 1985). But the self-serving bias is hardly restricted to North America. Self-serving perceptions have been noted among Dutch high school and university students, Belgian basketball players, Hindus in India, Japanese drivers, Australian students and workers, Chinese students, and French people of all ages (Chan, 1987; Codol, 1976; de Vries & van Knippenberg, 1987; Feather, 1983; Hagiwara, 1983; Jain, 1990; Liebrand & others, 1986; Lefebvre, 1979; Murphy-Berman & Sharma, 1986; and Ruzzene & Noller, 1986, respectively).

Information Processing

Why do people across the world perceive (if not always present) themselves in self-enhancing ways? One explanation sees the self-serving bias as simply a by-product of how we process and remember information about ourselves.

Recall the study by Michael Ross and Fiore Sicoly (1979) in which married people gave themselves more credit for household work than their spouses. Might this not be due, as Ross and Sicoly believe, to our greater recall for what we've actively done and our lesser recall for what we've not done or merely observed others doing? I can easily picture myself picking up the laundry, but I have difficulty picturing myself absentmindedly overlooking it.

Self-Esteem Motivation

But are the biased perceptions simply a perceptual error, an unemotional bent in how we process information? Or are self-serving *motives* also involved? A third view presumes that we are motivated to protect and enhance our self-esteem (Tice, 1991).

It's now clear from research that we have multiple motives. Questing for self-knowledge, we're eager to *assess* our competence (Brown, 1990). Questing for self-confirmation, we're eager to *verify* our self-conceptions (Sanitioso & others, 1990; Swann, 1990). Questing for self-affirmation, we're especially motivated to *enhance* our self-image.

Experiments confirm that a motivational engine powers our cognitive machinery (Kunda, 1990). The feelings we have after success and failure motivate self-serving explanations, especially if we are ego-involved (Burger, 1986; Pyszczynski & Greenberg, 1987; Steele, 1988). The more physiologically aroused we are after a failure, the more likely we are to excuse the failure with self-protective attributions (Brown & Rogers, 1991). We are not just cool information-processing machines.

Abraham Tesser (1988) at the University of Georgia reports that a "self-esteem maintenance" motive predicts a variety of interesting findings, even friction among brothers and sisters. Do you have a sibling of the same sex who is close to you in age? If so, people probably compared the two of you as you grew up. Tesser presumes that people's perceiving one of you as more capable than the other will motivate the less able one to act in ways that maintain his or her self-esteem. (Tesser thinks the threat to self-esteem is greatest for an older child with a highly capable younger sibling.) Men with a brother of differing ability typically recall not getting along well with him; men with a brother of similar ability are more likely to recall very little friction. Among friends and married partners, too, shared interests are healthy but identical career goals may produce tension or jealousy (Clark & Bennett, 1992).

Among sibling relationships, the threat to self-esteem is greatest for an older child with a highly capable younger brother or sister.

REFLECTIONS ON THE SELF-SERVING BIAS

No doubt many readers are finding all this either depressing or contrary to their own occasional feelings of inadequacy. To be sure, those of us who exhibit the self-serving bias—that includes most of us—may still feel inferior to specific individuals, especially those who are a step or two higher on the ladder of success, attractiveness, or skill. And not everyone operates with a self-serving bias. Some people *do* suffer from low self-esteem. Do such people hunger for esteem and therefore often exhibit self-serving bias? Is self-serving bias just a cover-up? This is what some theorists, such as Erich Fromm, have proposed (Shrauger, 1975).

And it's true: When feeling good about ourselves, we are less defensive (Epstein & Feist, 1988). We are also less thin-skinned and judgmental—less likely to praise those who like us and berate those who don't (Baumgardner & others, 1989). In experiments, people whose self-esteem is temporarily bruised— say, by being told they did miserably on an intelligence test—are more likely to disparage others. More generally, people who are down on themselves tend also to be down on others (Wills, 1981). And those whose ego has recently been wounded are more prone to self-serving explanations of success or failure than are those whose ego has recently received a boost (McCarrey & others, 1982). So, when feeling unaffirmed, people may offer self-affirming boasts, excuses, and put-downs of others. Mockery says as much about the mocker as the one mocked.

"Narcissism, like selfishness, is an overcompensation for the basic lack of self-love."
Erich Fromm, *Escape from Freedom,* 1941

■ BEHIND THE SCENES

In my high school and college days I was, for fun and profit, a guitarist in a rock group. Two observations from that period influenced my later research. First, the performance was as important as the music. I came to see that the same is true in everyday social interactions: What matters is not just what people are like on the inside, but how they present themselves to others. I became curious about how people manage information to create desired impressions, and this curiosity led to a research program that has kept me busy for 20 years.

Second, most musicians I met seemed convinced that their group was special because of its exceptional instrumental artistry, singing talent, song-writing skill, stage presence, or managerial direction. Also, rock band members typically over-estimated their contributions to a group success and underestimated their contributions to failure. I admit to similar feelings about my own group and my contributions to it. I saw many good bands disintegrate from the problems caused by these self-glorifying tendencies. My later research revealed that self-serving bias is common in groups and identified the conditions that foster it.

BARRY SCHLENKER, *University of Florida*

Nevertheless, those who score highest on self-esteem tests (who say nice things about themselves) also say nice things about themselves when explaining their successes and failures (Ickes & Layden, 1978; Levine & Uleman, 1979; Schlenker & others, 1990), when describing their own traits (Roth & others, 1986), when evaluating their group (Brown & others, 1988), and when comparing themselves to others (Brown, 1986). Threats to self-esteem provoke self-serving defensiveness; yet in questionnaire studies, the trait of high self-esteem goes hand in hand with self-serving perceptions.

The Self-Serving Bias as Adaptive

Without the self-serving bias, and its accompanying excuses, people with low self-esteem are more vulnerable to anxiety and depression (Snyder & Higgins, 1988). As we will see in Chapter 5, although most people excuse their failures on laboratory tasks or perceive themselves as being more in control than they are, depressed people's self-appraisals are more accurate: Sadder but wiser.

And consider: Thanks to our reluctance to share negative impressions, most of us have difficulty gauging how strangers and casual acquaintances are really perceiving us (DePaulo & others, 1987; Kenny & Albright, 1987). Mildly depressed people are less prone to illusions; they generally see themselves *as* other people see them (Lewinsohn & others, 1980). This prompts the unsettling thought that Pascal may have been right: "I lay it down as a fact that, if all men knew what others say of them, there would not be four friends in the world."

"No one speaks of us in our presence as in our absence."
Pascal, *Pensées*, 1670

As the new research on depression suggests, there may be some practical wisdom in self-serving perceptions. Cheaters give a more convincing display of honesty if they believe in their honesty. Belief in our superiority can also motivate us to achieve and can sustain a sense of hope in difficult times.

Self-Serving Bias as Maladaptive

The self-serving bias is not always adaptive. People who blame others for their social difficulties are often unhappier than people who can acknowledge their mistakes (Newman & Langer, 1981; Peterson & others, 1981; C. A. Anderson & others, 1983). Research by Barry Schlenker (1976; Schlenker & Miller, 1977a, 1977b) at the University of Florida has also shown how self-serving perceptions can poison a group. In nine experiments Schlenker had people work together on some task. He then falsely informed them that their group had done either well or poorly. In every one of these studies the members of successful groups claimed more responsibility for their group's performance than did members of groups that supposedly failed at the task. Most presented themselves as contributing more than the others in their group when the group did well; few said they contributed less.

Such self-deception can lead individual group members to expect greater-than-average rewards when their organization does well and less-than-average blame when it does not. If most individuals in a group believe they are underpaid and underappreciated relative to their contributions, disharmony and envy are likely. College presidents and academic deans will readily recognize the phenomenon. Most college faculty members—94 percent in one survey at the University of Nebraska (Cross, 1977), 90 percent in a survey of the faculties of 24 institutions (Blackburn & others, 1980)—rate themselves as superior to their average colleague. It is therefore inevitable that when merit salary raises are announced and half receive an average raise or less, many will feel themselves victims of injustice.

Biased self-assessments also distort managerial judgment. When groups are comparable, most people consider their own group superior (Codol, 1976; Taylor & Doria, 1981; Zander, 1969). Thus, most corporation presidents predict more growth for their own firms than for their competition (Larwood & Whittaker, 1977). And most production managers overpredict their production (Kidd & Morgan, 1969). As Laurie Larwood and William Whittaker (1977) noted, such overoptimism can produce disastrous consequences. If those who deal in the stock market or in real estate perceive their business intuition to be superior to that of their competitors, they may be in for severe disappointment. Even the seventeenth-century economist Adam Smith, a defender of human economic rationality, foresaw that people would overestimate their chances of gain. This "absurd presumption in their own good fortune," he said, arises from "the overweening conceit which the greater part of men have of their own abilities" (Spiegel, 1971, p. 243). Falsely imagining that we could have predicted the present (the hindsight bias) reinforces overoptimism about our ability to predict the future (Johnson & Sherman, 1990).

That people see and present themselves with a favorable bias is hardly new— the tragic flaw portrayed in ancient Greek drama was *hubris,* or pride. Like the subjects of our experiments, the Greek tragic figures were not self-consciously evil; they merely thought too highly of themselves. In literature, the pitfalls of pride are portrayed again and again. In religion, pride has long been first among the "seven deadly sins."

If pride is akin to the self-serving bias, then what is humility? Is it self-contempt? Or can we be self-affirming and self-accepting without a self-serving bias? To paraphrase the English scholar-writer C. S. Lewis, humility

"Victory finds a hundred fathers but defeat is an orphan."
Count Galeazzo Ciano,
The Ciano Diaries, 1938

"Hubris is back in town."
W. C. Fields

Self-serving pride in group settings can become especially dangerous.

"Then we're in agreement. There's nothing rotten here in Denmark. Something is rotten everywhere else."

surely is not handsome people trying to believe they are ugly and clever people trying to believe they are fools. *False modesty* can actually be a cover for pride in one's better-than-average humility. (Perhaps some readers have by now congratulated themselves on being unusually free of self-serving bias.) True humility—a third alternative to self-serving bias and depressive realism—is more like self-forgetfulness than false modesty. It leaves people free to rejoice in their special talents and, with the same honesty, to recognize those of others.

■ SELF-EFFICACY

We have seen two potent biases recently uncovered by social psychologists: a tendency to ignore situational forces when explaining others' behavior (the fundamental attribution error) and a tendency to perceive and present ourselves favorably (the self-serving bias). The first can dispose us to misunderstand others' problems (for example, by assuming that unemployed people are necessarily lazy or incompetent). The second can fuel conflict among people and nations when all see themselves as more moral and deserving than others.

Studies of the fundamental attribution error and the self-serving bias reveal some deep truths about human nature. But as Pascal taught 300 years ago, no

■ VIEWPOINT: To Feel Better—Increase Success or Decrease Pretensions

In his pioneering 1890 text, *Principles of Psychology*, the philosopher-psychologist William James offered a formula for self-esteem:

> Our self-feeling in this world depends entirely on . . . a fraction of which our pretentions are the denominator and the numerator our success: Thus,
>
> $$\text{Self-esteem} = \frac{\text{Success}}{\text{Pretentions}}.$$
>
> Such a fraction may be increased as well by diminishing

the denominator as by increasing the numerator. To give up pretensions is as blessed a relief as to get them gratified; and where disappointment is incessant and the struggle unending, this is what men will always do. The history of evangelical theology, with its conviction of sin, its self-despair, and its abandonment of salvation by works, is the deepest of possible examples, but we meet others in every walk of life. . . . How pleasant is the day when we give up striving to be young—or slender! Thank God! we say, those illusions are gone. Everything added to the Self is a burden as well as a pride.

single truths are ever sufficient, because the world is not simple. Indeed, there is an important complement to these truths. High self-esteem—a sense of self-worth—is adaptive. Compared to those with low self-esteem, people with high self-esteem are happier, less neurotic, less troubled by ulcers and insomnia, less prone to drug and alcohol addictions (Brockner & Hulton, 1978; Brown, 1991).

Additional research on such topics as locus of control, learned helplessness, and intrinsic motivation confirms the benefits of seeing oneself as competent and effective. Albert Bandura (1986) merges much of this research into a concept called **self-efficacy,** a scholarly version of the wisdom behind the "power of positive thinking." An optimistic yet realistic belief in our own possibilities

"Half the truth is often a great lie."
Benjamin Franklin, *Poor Richard's Almanac*, 1758

Self-efficacy:
A sense that one is competent and effective. Distinguished from self-esteem, a sense of one's self-worth. A bombardier might feel high self-efficacy and low self-esteem.

The fundamental attribution error, coupled with the self-serving bias, could lead us to make assumptions about this family and its situation that bear no relation to the facts. Unless we happen to know these people, we cannot make statements about the cause of their misfortune.

■ BEHIND THE SCENES

Our research on self-efficacy was an unanticipated result of our discovery that people who overcame phobias through mastery experiences, say by learning to deal with snakes, become more confident and venturesome in other areas of their life. The specific treatment, it seemed, had strengthened people's general sense of efficacy in managing events in their lives. From this realization came our further studies of how perceived self-efficacy affects various behaviors, from stress reactions to achievement strivings to career pursuits.

ALBERT BANDURA, *Stanford University*

pays dividends. People with strong feelings of self-efficacy are more persistent, less anxious and depressed, and more academically successful (Gecas, 1989; Maddux, 1991; Scheier & Carver, 1991).

LOCUS OF CONTROL

Which do you more strongly believe?

In the long run people get the respect they deserve in this world.	or	Unfortunately, people's worth often passes unrecognized no matter how hard they try.
What happens to me is my own doing.	or	Sometimes I feel that I don't have enough control over the direction my life is taking.
The average person can have an influence in government decisions.	or	This world is run by the few people in power, and there is not much the little guy can do about it.

Do your answers to such questions (from Rotter, 1973) indicate that you believe you control your own destiny ("internal locus of control") or that chance or outside forces determine your fate ("external locus of control")? Those who see themselves as internally controlled are more likely to do well in school, successfully stop smoking, wear seat belts, practice birth control, deal with marital problems directly, make lots of money, and delay instant gratification in order to achieve long-term goals (e.g., Findley & Cooper, 1983; Lefcourt, 1982; Miller & others, 1986).

How competent and effective we feel also depends on how we explain negative events. Perhaps you have known students who blame poor grades on things beyond their control—their feelings of stupidity or their "poor" teachers, texts, or tests. If such students are coached to adopt a more hopeful attitude—to believe that effort, good study habits, and self-discipline can make a difference—their grades tend to go up (Noel & others, 1987; Peterson & Barrett, 1987).

Successful people are more likely to see setbacks as a fluke or to think "I need a new approach." New life insurance sales representatives who view failures as controllable ("It's difficult, but with persistence I'll get better") sell more policies. They are half as likely as their more pessimistic colleagues to quit during their first year (Seligman & Schulman, 1986). Among college swimming team members, those with an optimistic explanatory style are more likely than pessimists to perform beyond expectations (Seligman & others, 1990).

LEARNED HELPLESSNESS VERSUS SELF-DETERMINATION

The benefits of a sense of personal efficacy also appear in animal research. Dogs that learn a sense of helplessness (by being taught they cannot escape shocks) will later fail to take the initiative in another situation when they *could* escape the punishment. Dogs that learn personal control (by allowing them to escape their first shocks successfully) adapt easily to a new situation. Researcher Martin Seligman (1975, 1991) notes similarities in human situations; depressed or oppressed people, for example, become passive because they believe their efforts have no effect. Helpless dogs and depressed people both suffer paralysis of the will, passive resignation, even motionless apathy.

Here is a clue to how institutions—whether malevolent, like concentration camps, or benevolent, like hospitals—can dehumanize people. In hospitals, "good patients" don't ring bells, don't ask questions, don't try to control what's happening (Taylor, 1979). Such passivity may be good for hospital efficiency, but it is bad for people. Feelings of efficacy, of an ability to control one's life, enhance health and survival. Losing control over what you do and what others do to you can make unpleasant events profoundly stressful (Pomerleau & Rodin, 1986). Several diseases are associated with feelings of helplessness and diminished choice. So is the rapidity of decline and death in concentration camps and nursing homes. Hospital patients who are trained to believe in their ability to control stress require fewer pain relievers and sedatives, and nurses see them as exhibiting less anxiety (Langer & others, 1975).

Ellen Langer and Judith Rodin (1976) showed the importance of personal control by treating elderly patients in a high-rated Connecticut nursing home in one of two ways. With one group the benevolent care-givers stressed "our responsibility to make this a home you can be proud of and happy in." They treated these patients as passive recipients of the normal well-intentioned, sympathetic care. Three weeks later, most were rated by themselves, by interviewers, and by nurses as further debilitated. Langer and Rodin's other treatment promoted personal control. It stressed opportunities for choice, the possibilities for influencing nursing-home policy, and the person's responsibility "to make of your life whatever you want." These patients were given small decisions to make and responsibilities to fulfill. Over the ensuing three weeks, 93 percent of this group showed improved alertness, activity, and happiness.

The experience of the first group must have been similar to that of James MacKay (1980), an 87-year-old psychologist:

> I became a nonperson last summer. My wife had an arthritic knee which put her in a walker, and I chose that moment to break my leg. We went to a nursing home. It was all nursing and no home. The doctor and the head nurse made all decisions; we were merely animate objects. Thank heavens it was only two weeks. . . . The top

man of the nursing home was very well trained and very compassionate; I considered it the best home in town. But we were nonpersons from the time we entered until we left.

The research findings suggest that systems of governing or managing people that promote self-efficacy will also promote health and happiness (Deci & Ryan, 1987). Prisoners given some control over their environments—by being able to move chairs, control TV sets, and switch the lights—experience less stress, exhibit fewer health problems, and commit less vandalism (Ruback & others, 1986; Wener & others, 1987). Workers given leeway, in carrying out tasks and participating in decision making, experience improved morale (Miller & Monge, 1986). Institutionalized residents allowed choice in such matters as what to eat for breakfast, when to go to a movie, whether to sleep late or get up early, may live longer and certainly are happier (Timko & Moos, 1989).

COLLECTIVE EFFICACY

"If my mind can conceive it and my heart can believe it, I know I can achieve it. Down with dope! Up with hope! I am somebody!"
Jesse Jackson, civil rights march on Washington, 1983

Although it is commonly thought that hopelessness breeds militant social action, the truth is that it more often breeds apathy. Compared to apathetic people, protesting members of aggrieved groups generally have more self-pride and a stronger belief in their ability to influence events (Caplan, 1970; Forward & Williams, 1970; Lipset, 1966). In many countries, university students (not the most severely disadvantaged members of the society) spearhead political activism. Bandura (1982) writes:

Collective action requires enough pessimism to breed concern, and enough self-efficacy to believe in people power.

"*This gives my confidence a real boost.*"

Confidence and feelings of self-efficacy are rooted in our successes.

People who have a sense of collective efficacy will mobilize their efforts and resources to cope with external obstacles to the changes they seek. But those convinced of their inefficacy will cease trying even though changes are attainable through concerted effort. . . . As a society, we enjoy the benefits left by those before us who collectively resisted inhumanities and worked for social reforms that permit a better life. Our own collective efficacy will, in turn, shape how future generations will live their lives.

REFLECTIONS ON SELF-EFFICACY

Although this psychological research and comment on self-efficacy is new, the emphasis on taking charge of one's life and realizing one's potential is not. The you-can-do-it theme of Horatio Alger's rags-to-riches books is an enduring American idea. We find it in Norman Vincent Peale's 1950s best-seller, *The Power of Positive Thinking* ("If you think in positive terms you will get positive results. That is the simple fact."). We find it in self-help books and videos that urge people to succeed through positive mental attitudes.

Research on self-efficacy gives us greater confidence in traditional virtues such as perseverance and hope. Yet Bandura (1989) believes that self-efficacy grows not primarily by self-persuasion ("I think I can, I think I can") or by puffing people up like hot-air balloons ("You're terrific. You are somebody. You are beautiful."). He notes that "No amount of reiteration that I can fly will persuade me that I have the efficacy to get myself airborne." Self-efficacy in-

"Argue for your limitations, and sure enough they're yours."
Richard Bach, *Illusions: Adventures of a Reluctant Messiah*, 1977

stead results from undertaking challenging yet realistic tasks and succeeding. After mastering the physical skills needed to repel a sexual assault, women feel less vulnerable, less anxious, and more in control (Ozer & Bandura, 1990). Students who experience academic success develop higher appraisals of their academic ability, which in turn often stimulates them to work harder and achieve more (Felson, 1984). To do one's best and achieve is to feel more confident and empowered.

Still, let us remember the point at which we began our consideration of self-efficacy: Any truth, separated from its complementary truth, is but a half-truth. The truth embodied in the concept of self-efficacy may encourage us not to resign ourselves to bad situations, to persist despite initial failures, to exert effort without being overly distracted by self-doubts. But lest the pendulum swing too far toward *this* truth, Bandura reminds us, we had best remember that self-efficacy is not the whole story. If positive thinking can accomplish *anything*, then if we are unhappily married, poor, or depressed, we have only ourselves to blame. For shame! If only we had tried harder, been more disciplined, less stupid. Failing to appreciate that difficulties sometimes reflect the oppressive power of social situations can tempt us to blame people for their problems and failures, or even to blame ourselves too harshly for our own.

"Poised somewhere between sinful vanity and self-destructive submissiveness is a golden mean of self-esteem appropriate to the human condition."
Sanford Lyman, *The Seven Deadly Sins: Society and Evil, 1977*

■ SUMMING UP

HOW DO WE EXPLAIN OTHERS' BEHAVIOR?

Attribution researchers study how we explain people's behavior. When will we attribute someone's behavior to a person's disposition and when to the situation? By and large we make reasonable attributions. However, we are consistently prone to two errors: the fundamental attribution error and self-serving bias.

THE FUNDAMENTAL ATTRIBUTION ERROR

When explaining people's behavior, we often commit the *fundamental attribution error*. We attribute their behavior so much to their inner traits and attitudes that we discount situational constraints, even when these are obvious. We make this attribution error partly because when we watch someone act, that *person* is the focus of our attention. When *we* act, our attention is usually on what we are reacting to. Thus we are more sensitive to the situational influences upon ourselves. With time, however, our perspectives, and our explanations, often change.

HOW DO WE SEE AND EXPLAIN OURSELVES?

When perceiving ourselves, we are prone to the *self-serving bias*. This is a tendency to blame the situation for our failures while taking credit for our successes, to see ourselves as generally "better than average," and in at least a dozen other ways to protect and enhance our self-image. Even self-disparaging and self-handicapping behaviors can protect or enhance our self-image.

Three explanations explain the self-serving bias. One is that we seek to *present* a positive image. The other two suggest that we genuinely perceive ourselves in self-enhancing ways. Biased self-perceptions may stem from how we *process information* (if good things more often happen to us than bad things, it is logical to blame unusual circumstances for the occasional bad outcomes). Or they may stem from a self-esteem *motivation*. Evidence confirms that we are motivated to see ourselves favorably.

SELF-EFFICACY

Research on these attribution errors is complemented by other research showing the benefits of the *self-efficacy* that comes from succeeding at challenging tasks. People who believe in their own competence, effectiveness, and control cope better and achieve more. Groups that feel collective efficacy often are activist.

■ FOR FURTHER READING

Bandura, A. (1986). *Social foundations of thought and action: A social-cognitive theory.* Englewood Cliffs, NJ: Prentice-Hall. Bandura describes research on self-efficacy in the context of his theory of personality and social behavior.

Jones, E. E. (1991). *Interpersonal perception.* New York: Freeman (Scientific American Books). A leading researcher explores how we perceive and explain people's behavior, including our own.

Seligman, M. (1991). *Learned optimism.* New York: Knopf. Describes research on learned helplessness and optimism, showing why optimism is important and how to gain it.

Taylor, S. E. (1989). *Positive illusions.* New York: Basic Books. The ancient wisdom to ''know thyself'' notwithstanding, mental health may instead reflect the art of being well deceived. Or so social psychologist Taylor suggests in this captivating summary of research on the benefits of positive, if self-serving, thinking.

BEHAVIOR AND ATTITUDES

Among the anti-Iraq coalition soldiers captured during the Persian Gulf war were several who, on videotapes played back home, expressed remorse for their actions and sympathy for their captors. "I think this war is crazy and should never have happened," declared U.S. Marine officer Guy Hunter, Jr., his blackened left eye nearly closed. "I think our leaders and our people have wrongly attacked the peaceful people of Iraq," said Navy Lt. Jeffrey Zaun, his face swollen and flecked with dried blood. Outside Iraq, people wondered: Did the prisoners' statements—to any extent—reflect genuine attitudes? Or were they brutally coerced into making the statements? More generally, how reliably do people's actions mirror their attitudes?

When people question someone's attitude, they refer to beliefs and feelings about a person or event and the resulting support or opposition. Taken together, favorable or unfavorable *evaluative reactions*—whether exhibited in beliefs, feelings, or inclinations to act—define a person's **attitude** toward something (Zanna & Rempel, 1988). Attitudes are an efficient way to size up the world. When we have to respond quickly to something, how we *feel* about it can guide how we react (Breckler & Wiggins, 1989; Sanbonmatsu & Fazio, 1990).

Attitude:
A favorable or unfavorable evaluative reaction toward something or someone, exhibited in one's beliefs, feelings, or intended behavior.

We assume that the different ways we exhibit an attitude relate—that, for example, a person who *believes* a particular ethnic group is lazy and aggressive may *feel* dislike for such people and therefore *intend to act* in a discriminatory manner. When assessing attitudes, we tap one of these three dimensions. You can remember them as the ABCs of attitudes: *a*ffect (feelings), *b*ehavior (intention), and *c*ognition (thoughts).

The study of attitudes is close to social psychology's heart, and historically was one of its first concerns. So we continue our look at social thinking by asking, how strongly do our attitudes affect our actions?

■ DO ATTITUDES DETERMINE BEHAVIOR?

"The ancestor of every action is a thought."
Ralph Waldo Emerson, Essays, First Series, 1841

"Thought is the child of Action."
Benjamin Disraeli, *Vivian Grey*, 1826

Asking whether attitudes determine behavior asks a basic question about human nature: What is the relationship between what we *are* (on the inside) and what we *do* (on the outside)? Philosophers, theologians, and educators have long speculated about the connection between thought and action, character and conduct, private word and public deed. The prevailing assumption, which underlies most teaching, counseling, and child rearing, has been that our private beliefs and feelings determine our public behavior. So, if we want to alter the way people act, we need to change their hearts and minds.

ARE WE ALL HYPOCRITES?

In the beginning, social psychologists agreed that to know people's attitudes is to predict their actions. But in 1964, Leon Festinger concluded the evidence did not show that changing attitudes changes behavior. Festinger believed the attitude-behavior relation works the other way around, with our behavior as the horse and our attitudes as the cart. As Robert Abelson (1972) put it, we are "very well trained and very good at finding reasons for what we do, but not very good at doing what we find reasons for."

PACIFIC CHIVALRY.

Encouragement to Chinese Immigration.

This Thomas Nast cartoon from the end of the last century points up the disjunction between attitudes, such as chivalry, and behavior. The attitudes we express often do not predict our behavior in real situations.

A further blow to the supposed potency of attitudes came in 1969, when social psychologist Allan Wicker reviewed several dozen research studies covering a wide variety of people, attitudes, and behaviors and offered a shocking conclusion: People's expressed attitudes predicted little of the variation in their behaviors. For instance, students' attitudes toward cheating bore little relation to the likelihood of their actually cheating. People's attitudes toward the church were but modestly linked with church attendance on any given Sunday. Self-described racial attitudes predicted little of the variation in behavior that occurred when people faced an actual interracial situation.

This was dramatically apparent during the early 1930s, when many Americans were expressing intense prejudice against Asians. To discern the extent of such prejudice, Richard LaPiere (1934) wrote 251 restaurants and hotels, asking, "Will you accept members of the Chinese race as guests in your establishment?" Among the 128 who replied, 92 percent said no. Only one said yes. But LaPiere and a "personable and charming" young Chinese couple had traveled the country six months previously and actually received courteous treatment at all but one of these establishments. Faced with a specific couple that defied their stereotypes, the proprietors laid aside their negative attitudes and behaved warmly.

If people don't play the same game that they talk, it's little wonder that attempts to change behavior by changing attitudes often fail. Warnings about the dangers of smoking only minimally affect those who already smoke. Increasing the public's awareness of the desensitizing and brutalizing effects of a prolonged diet of television violence has stimulated many people to voice a desire for less violent programming—yet they still watch media murder as much as ever. Appeals for safe driving habits have had far less effect on accident rates than have lower speed limits and divided highways (Etzioni, 1972).

"Between the idea
And the reality
Between the motion
And the Act
Falls the Shadow"
T. S. Eliot, *The Hollow Men*, 1925

While Wicker and others were describing the impotence of attitudes, some personality psychologists were saying that personality traits also fail to predict behavior (Mischel, 1968). If we want to know how helpful people are going to be, we usually won't learn much by giving them tests of self-esteem, anxiety, or defensiveness. If the situation makes clear-cut demands, we're better off knowing how most people react. Likewise, many psychotherapists began to argue that talking therapies, such as psychoanalysis, seldom "cure" people's problems. So instead of analyzing personality defects, they sought to change the problem behavior.

All in all, the developing picture of what controls our behavior emphasized external social influences and played down internal factors, such as attitudes and personality. The emerging image was of little billiard balls that have different stripes and colors, to be sure, but that are all buffeted by outside forces. In short, the original thesis that attitudes determine actions was countered during the 1960s by the antithesis that attitudes determine virtually nothing. Thesis. Antithesis. Is there a synthesis? The surprising finding that what people say often differs from what they do sent social psychologists scurrying to find out why. Surely, we reasoned, convictions and feelings must sometimes make a difference.

Indeed. In fact, what I am about to explain now seems so obvious that I wonder why most social psychologists (myself included) were not thinking this way before the early 1970s. I must remind myself that the truth is obvious only once it is known.

"It may be desirable to abandon the attitude concept."
Allan Wicker (1971)

WHEN DO ATTITUDES PREDICT BEHAVIOR?

We so often act contrary to our expressed attitudes because, as Figure 4-1 suggests, our behavior and our expressed attitudes are both subject to other influences. One social psychologist counted 40 separate factors that complicate their relationship (Triandis, 1982; see also Kraus, 1991). If we could just neutralize the other influences—make all other things equal—might attitudes accurately predict behaviors? Let's see.

Minimizing Social Influences on Expressed Attitudes

Unlike a physician measuring heart rate, social psychologists never get a direct reading on attitudes. Rather, we measure *expressed* attitudes. Like other behaviors, expressions are subject to outside influences. This was vividly demonstrated when the U. S. House of Representatives once overwhelmingly passed a salary increase for itself in an off-the-record vote, then moments later overwhelmingly defeated the same bill on a roll-call vote. Fear of criticism had distorted the true sentiment on the roll-call vote. We sometimes say what we think others want to hear.

Bogus pipeline:
A false procedure that fools people into disclosing their attitudes. Participants are first convinced that a new machine can use their psychological responses to measure their private attitudes. Then they are asked to predict the machine's reading, thus revealing their attitudes.

Knowing that people don't wear their hearts on their sleeves, social psychologists have longed for a "pipeline to the heart." Edward Jones and Harold Sigall (1971) therefore devised a **bogus pipeline** method for measuring attitudes. In one experiment, conducted with Richard Page, Sigall (1971) had University of Rochester students hold a locked wheel which if unlocked could turn a pointer to the left, indicating disagreement, or to the right, indicating agreement. When electrodes were attached to their arms, the fake machine supposedly measured tiny muscular responses said to gauge their tendency to turn

Other influences

Behavior

Attitude

Expressed attitude

Other influences

FIGURE 4-1 *Our expressed attitudes imperfectly predict our behavior, because both are subject to other influences.*

the wheel left (disagree) or right (agree). To demonstrate this amazing new machine, the researcher asked the students some questions. After a few moments of impressive flashing lights and whirring sounds, a meter on the machine announced the student's attitude—which was nothing more than an attitude the student had earlier expressed as part of a now-forgotten survey. The procedure convinced everyone.

Once the students were convinced, the attitude meter was hidden and they were asked questions concerning their attitudes toward African-Americans and requested to guess what the meter revealed. How do you suppose these White collegians responded? Compared to other students who responded through a typical questionnaire, those responding by the bogus pipeline admitted more negative belief. It was as if they were thinking, "I'd better tell the truth or the experimenter will think I'm out of touch with myself."

An example: those responding to the paper-and-pencil scale rated African-Americans as being more sensitive than other Americans; those responding through the bogus pipeline reversed these judgments. Displays of positive ra-

cial attitudes were socially approved among sophisticated collegians of 1970, but the bogus pipeline cut through the feigned attitudes—a finding that has led other researchers to use the technique when asking people about their drug and alcohol use (Roese & Jamieson, 1991). Studies such as this offer one reason for a weak attitude-behavior link: People sometimes distort their real attitudes when expressing them.

Minimizing Other Influences on Behavior

Social influences color not just expressed attitudes but other behaviors as well. As Chapters 6 to 9 will illustrate again and again, social influences can be enormous—enormous enough to induce people to violate their deepest convictions. Before Jesus's crucifixion, his disciple Peter denies knowing him. Presidential aides may go along with actions they know are wrong. Politicians may say what they believe voters want to hear. Prisoners of war may lie to placate their captors.

"Do I contradict myself? Very well then I contradict myself. (I am large, I contain multitudes.)"
Walt Whitman, *Song of Myself*, 1855

On any occasion it's not only our inner attitudes that guide us but also the situation we face. Would *averaging* many occasions enable us to detect more clearly the impact of our attitudes? Predicting people's behavior is like predicting a baseball player's hitting. The outcome of any particular time at bat is nearly impossible to predict, because it is affected not only by the batter but also by what the pitcher throws and by chance factors. When we consider many times at bat, we neutralize these complicating factors. Knowing the players, we can predict their approximate batting *averages*.

To use a comparable example from research, people's general attitude toward religion poorly predicts whether they will go to church next Sunday (because the weather, the preacher, how one is feeling, and so forth also influence church attendance). But religious attitudes predict quite well the total quantity of religious behaviors over time (Fishbein & Ajzen, 1974; Kahle & Berman, 1979). The moral: The effects of an attitude on behavior become more apparent when we look at a person's long-term or average behavior rather than at isolated acts.

Examining Attitudes Specific to the Behavior

Other conditions further improve the predictive accuracy of attitudes. As Icek Ajzen and Martin Fishbein (1977; Ajzen, 1982) point out, when the measured attitude is general—say, an attitude toward Asians—and the behavior is very specific—say, a decision whether to help the particular Asian couple in LaPiere's study—we should not expect a close correspondence between words and actions. Indeed, report Fishbein and Ajzen, in 26 out of 27 such research studies, attitudes did not predict behavior. But attitudes *did* predict behavior in all 26 studies they could find in which the measured attitude was directly pertinent to the situation. Thus attitudes toward the general concept of "health fitness" poorly predict specific exercise and dietary practices. Whether people jog is more likely to depend on their opinions about the costs and benefits of *jogging*. Likewise, attitudes toward contraception strongly predict contraceptive use (Morrison, 1989). And attitudes toward recycling (but not general proenvironmental attitudes) predict participation in recycling (Oskamp, 1991). To change health habits through persuasion, we should alter people's attitudes toward *specific* practices (Olson & Zanna, 1981; Ajzen & Timko, 1986).

So far we have seen two conditions under which our attitudes will predict

our behavior: (1) when we minimize other influences upon our attitude statements and our behavior and (2) when the attitude is specifically relevant to the observed behavior. There is a third condition: An attitude predicts behavior better when the attitude is potent.

Maximizing Attitude Potency

Our attitudes often lie dormant when we act automatically, without pausing to consider them. We act out familiar scripts, without pausing to reflect on what we're doing. We respond to people we meet in the hall with an automatic "Hi." We answer the restaurant cashier's question, "How was your meal?" by saying, "Fine," even if we found it tasteless. Such mindless action is adaptive. It frees our minds to work on other things. As the philosopher Alfred North Whitehead argued, "Civilization advances by extending the number of operations which we can perform without thinking about them."

Bringing Attitudes to Mind

In novel situations our behavior is less automatic; when there is no script, we think before we act. If they are prompted to think about their attitudes before acting, will people be truer to themselves? Mark Snyder and William Swann (1976) wanted to find out. So two weeks after 120 of their University of Minnesota students indicated their attitudes toward affirmative-action employment policies, Snyder and Swann invited them to act as jurors in a sex-discrimination court case. Only if they first induced the students to remember their attitudes— by giving them "a few minutes to organize your thoughts and views on the affirmative-action issue"—did attitudes predict verdicts. Similarly, people who take a few moments to review their past behavior express attitudes that better predict their future behavior (Zanna & others, 1981). Our attitudes guide our behavior *if* they come to mind. Attitudes that don't come readily to mind are passed over when opportunities to act on them arise (Kallgren & Wood, 1986; Krosnick, 1989).

"Thinking is easy, acting difficult, and to put one's thoughts into action, the most difficult thing in the world."
Goethe

Self-conscious people are usually in tune with their own attitudes (Miller & Grush, 1986). This suggests another way experimenters can induce people to focus on their inner convictions: Make people self-conscious, perhaps by having them act in front of a mirror (Carver & Scheier, 1981). Perhaps you can recall suddenly being acutely aware of yourself upon entering a room having a large mirror. Making people self-aware in this way promotes consistency between words and deeds (Gibbons, 1978; Froming & others, 1982).

Edward Diener and Mark Wallbom (1976) noted that nearly all college students *say* that cheating is morally wrong. But will they follow the advice of Shakespear's Polonius, "To thine own self be true"? Diener and Wallbom set University of Washington students to work on an anagram-solving task (said to predict IQ) and told them to stop when a bell in the room sounded. Left alone, 71 percent cheated by working past the bell. Among other students, made self-aware by working in front of a mirror while hearing their tape-recorded voices, only 7 percent cheated. It makes one wonder: Would eye-level mirrors in stores decrease shoplifting by making people more conscious of their attitudes against stealing?

"Without doubt it is a delightful harmony when doing and saying go together."
Montaigne, *Essays*

Although the attitudes we espouse are most potent when brought to mind, other attitudes we're not so proud of operate mostly without our awareness. Here are some examples.

Mirrors and cameras discourage shoplifting by making people more self-aware, and therefore promoting consistency between words and deeds.

Social scientists despise ethnic prejudice. Yet, reports Anthony Greenwald (1990), in their own articles those with unambiguous Jewish names cite 6 percent more authors with Jewish names than do Anglo-Saxon-named authors. And Anglo-Saxon–named authors cite 7 percent more authors with Anglo-Saxon names than do Jewish-named authors. Such prejudice operates unconsciously, without the person's being aware that a latent attitude is active, and thus without awakening other attitudes that would counter it.

Unconscious attitudes can also influence spontaneous behavior. Like other preconceptions (pages 40–45), attitudes influence how we *perceive* and *interpret* events and, therefore, how we react (Fazio, 1990). At a basketball game, fans' attitudes toward the two teams influence their perceptions of who is fouling whom, and thus their spontaneous reactions to referees' calls. Such attitudes spontaneously guide behavior if they are accessible and the situation activates them.

The Potency of Attitudes Forged through Experience

Finally, we sometimes acquire attitudes in a manner that makes them potent, sometimes not. An extensive series of experiments by Russell Fazio and Mark Zanna (1981) shows that when attitudes arise from experience, they are far more likely to endure and to guide actions. They conducted one of their studies with the unwitting help of Cornell University. A housing shortage forced the university to assign some first-year students to several weeks on cots in dormitory lounges, while others basked in the relative luxury of permanent rooms. When questioned by Dennis Regan and Fazio (1977), students in both groups espoused equally negative attitudes about the housing situation and how the

administration was dealing with it. But given opportunities to act upon their attitudes—to sign a petition and solicit other signatures, to join a committee forming to investigate the situation, to write a letter—only those whose attitudes grew from direct experience with the temporary housing acted upon their attitudes. Moreover, compared to attitudes formed passively, those forged in the fire of experience are more thoughtful, more certain, more stable, more resistant to attack, and better remembered (Sherman & others, 1983; Watts, 1967; Wu & Shaffer, 1988).

Some Conclusions

To summarize, our attitudes predict our actions *if* other influences are minimized; *if* the attitude is specific to the action; and *if*—as we act—the attitude is potent, because something reminds us of it, because the situation activates an unconscious attitude that subtly guides how we perceive and react to events, or because we gained it in a manner that makes it strong.

Do these conditions seem obvious? It may be tempting to think we "knew them all along." But remember: They were not obvious to researchers in 1970. Nor were they obvious to the German university students who were unable to guess the outcomes of published studies on attitude-behavior consistency (Six & Krahe, 1984).

So it is now plain that, depending on the circumstances, the relationship between attitude statements and behavior can range from no relationship to a strong one (Kraus, 1991). La Rochefoucauld, the seventeenth-century French writer, was correct: "It is easier to preach virtue than to practice it." Yet we can breathe a sigh of relief that our attitudes are, after all, *one* determinant of our actions. To return to our philosophical question, there *is* a connection between what we are and what we do, even if that connection is looser than most of us would have guessed.

Now we turn to the more startling idea that our behavior determines our attitudes. It's true that we sometimes stand up for what we believe, but it's also true that we come to believe in what we stand up for. If social psychology has taught us anything during the last 25 years, it is that *we are likely not only to think ourselves into a way of acting but also to act ourselves into a way of thinking* (Figure 4-2).

Attitude

Action

FIGURE 4-2 *Attitudes and actions generate one another, like chickens and eggs.*

Social-psychological theories inspired much of the research that underlies this conclusion. Instead of beginning with these theories, I think it more interesting to first present the wide-ranging evidence that behavior affects attitudes. Now you can play theorist as you read. Speculate *why* actions affect attitudes, and then compare your ideas with the explanations proposed by social psychologists.

■ DOES BEHAVIOR DETERMINE ATTITUDES?

"In doing we learn."
George Herbert, *Jacula Prudentum*

How do we learn to bicycle, type, play a musical instrument, or swim? To learn it, we must do it. We can read books on bicycling, but we cannot *know* bicycling until we have done it. But is this effect of action limited to knowing physical skills? Consider the following incidents, each based on actual happenings:

■ Sarah is hypnotized and told to take off her shoes when a book drops on the floor. Fifteen minutes later a book drops, and Sarah quietly slips out of her loafers. "Sarah," asks the hypnotist, "why did you take off your shoes?" "Well . . . my feet are hot and tired," Sarah replies. "It has been a long day." The act produces the idea.

■ George has electrodes temporarily implanted in the brain region that controls his head movements. When neurosurgeon José Delgado (1973) stimulates the electrode by remote control, George always turns his head. Unaware of the remote stimulation, he offers a reasonable explanation for it: "I'm looking for my slipper," "I heard a noise," "I'm restless," or "I was looking under the bed."

■ Carol's severe seizures were relieved by surgically separating her two brain hemispheres. Now, in an experiment, psychologist Michael Gazzaniga (1985) flashes a picture of a nude woman to the left half of Carol's field of vision and thus to the nonverbal right side of her brain. A sheepish smile spreads over her face, and she begins chuckling. Asked why, she invents— and apparently believes—a plausible explanation: "Oh—that funny machine." Frank, another split-brain patient, has the word "smile" flashed to his nonverbal right hemisphere. He obliges and forces a smile. Asked why, he explains, "This experiment is very funny."

Such illustrations hint at a wide-ranging effect of what we do on what we "know." Indeed, the mental aftereffects of our behavior appear in a rich variety of experimental and social situations. The following examples will illustrate the power of self-persuasion—of attitudes following behavior.

ROLE PLAYING

The word "role" is borrowed from the theater and, as in the theater, refers to prescribed actions—actions expected of those who occupy a particular social position. When stepping into a new social role, we must perform its actions, even if we feel phony. But our sense of phoniness seldom lasts.

Think about a time when you stepped into some new role—perhaps your

Percent promanagement attitudes

Supervisor
Stewards

FIGURE 4-3 *Workers promoted to the role of union steward or of company supervisor developed attitudes compatible with their new role.* (Data from Lieberman, 1956.)

first days on a job, or at college, or in a sorority or fraternity. That first week on campus, for example, you may have been supersensitive to the new social prescriptions and tried valiantly to meet them and to root out your high school behavior. At such times we feel artificial. We self-consciously observe our new speech and actions, because they aren't natural to us. Then one day an amazing thing happens: We notice that our insincere sorority enthusiasm or our pseudo-intellectual patter no longer feels forced. The role has begun to fit as comfortably as our old jeans and T-shirt.

In one study, researchers observed industrial workers who were promoted to supervisor (a company position) or shop steward (a union position). The new roles demanded new behavior. And, sure enough, the men soon developed new attitudes (Figure 4-3). The supervisors became more sympathetic to the management's positions, the stewards to the union's (Lieberman, 1956). This hints at the importance of vocational role. The career you choose will affect not only what you do on the job but also your attitudes. Teachers, police officers, soldiers, and managers usually internalize their roles, with significant effects on their attitudes. The U.S. Marines "make a man out of you" not just by indoctrination but by having you act like a marine.

The effect of behavior on attitude appears even in the theater. Self-conscious acting may diminish as the actor becomes absorbed into the role and experiences genuine emotion. In William Golding's novel *Lord of the Flies*, a group of shipwrecked English boys become uncivilized and exhibit brutal behavior. When a movie version of the book was made, the youngsters who acted it out became the creatures prescribed by their roles. The director, Peter Brook (1964),

"No man, for any considerable period, can wear one face to himself and another to the multitude without finally getting bewildered as to which may be true."
Nathaniel Hawthorne, 1850

"My whole personality changed during the time I was doing the part."
Ian Charleson on his role as serene and devout Olympic hero Eric Liddell in Chariots of Fire

Before long, these Austin, Texas, police cadets will be internalizing attitudes appropriate to their new role.

reported: "Many of their off-screen relationships completely paralleled the story, and one of our main problems was to encourage them to be uninhibited within the shots but disciplined in between them" (p. 163). Jonathan Winters has remarked that a hazard for stand-up comics like himself is that "you get to believing your own stuff." After several years of constructing fantastic characters, Winters underwent therapy to treat a confused personal identity (Elliott, 1986).

SAYING BECOMES BELIEVING

There is abundant evidence that most people adapt what they say to please their listeners. Social psychologist Philip Tetlock (1981b) has found that the policy statements of American presidents tend to be simplistic during the political campaign (for example, "To bring down the deficit we need major cuts in government spending"). After the election their statements become more complex—until the next campaign. Similarly, we are quicker to tell people good news than bad, and we adjust our message toward our listener's position (Manis & others, 1974; Tesser & others, 1972; Tetlock, 1983). In one experiment, faculty members writing supposedly candid letters of recommendation to graduate schools were more glowing in their comments when the students reserved their right to inspect the letters (Ceci & Peters, 1984). We shade our views this way or that, depending on our audience.

Thomas Jefferson recognized this effect in 1785: "He who permits himself to tell a lie once finds it much easier to do it a second and third time, till at length it becomes habitual; he tells lies without attending to it, and truths without the world's believing him. This falsehood of the tongue leads to that of the heart, and in time depraves all its good dispositions." Experiments bear out this point. People induced to give spoken or written witness to something about which they have real doubts will often feel bad about their deceit. Nevertheless, they begin to believe what they are saying, *provided* they weren't bribed or coerced into doing so. When there is no compelling external explanation for one's words, saying becomes believing (Klaas, 1978). Sometimes, though, there is a compelling justification, especially in cultures that value controlling one's feelings. One cross-cultural study asked people to consider a father's best response to his daughter's introducing her fiance from another race. Although the father privately thought he "would never allow them to marry," 2 percent of Americans and 44 percent of Japanese felt he should tell them he "was in favor of their marriage" (Iwao, 1988).

Working in the North American culture, which values sincerity, Tory Higgins and his colleagues (Higgins & Rholes, 1978; Higgins & McCann, 1984) confirmed that "saying becomes believing." They had university students read

"I had thought I was humoring [my captors] by parroting their clichés and buzz words without personally believing in them. . . . In trying to convince them I convinced myself."
Kidnap victim Patricia Campbell Hearst, *Every Secret Thing*, 1982

"*Good God! He's giving the white-collar voters' speech to the blue collars.*"

© 1984: The New Yorker and Joseph Farris.

Impression management: In expressing our thoughts to others, we sometimes tailor our words to what we think the others will want to hear.

■ **VIEWPOINT: ACTING ONESELF INTO BELIEF—SAYING IS BELIEVING**

University of Oregon psychologist Ray Hyman (1981) described how acting the role of a palm reader convinced him that palmistry worked.

> I started reading palms when I was in my teens as a way to supplement my income from doing magic and mental shows. When I started I did not believe in palmistry. But I knew that to "sell" it I had to act as if I did. After a few years I became a firm believer in palmistry. One day the late Stanley Jaks, who was a professional mentalist and a man I respected, tactfully suggested that it would make an interesting experiment if I deliberately gave readings opposite to what the lines indicated. I tried this out with a few clients. To my surprise and horror my readings were just as successful as ever. Ever since then I have been interested in the powerful forces that convince us, [palm] reader and client alike, that something is so when it really isn't. (p. 86)

a personality description of someone and then summarize it for someone else who was known to like or dislike this person. The students not only gave a more positive description when the recipient liked the person but also then liked the person more themselves. And when asked to recall what they had read, they remembered the description as being more positive than it was. In short, it seems that we are prone to adjust our messages to our listeners, and having done so, to believe the altered message.

THE FOOT-IN-THE-DOOR PHENOMENON

Most of us can recall times when, after agreeing to help out with a project or an organization, we ended up more involved than we ever intended, vowing that in the future we would say no to such requests. How does this happen? Experiments suggest that if you want people to do a big favor for you, one technique is to get them to do a small favor first. In the best-known demonstration of this **foot-in-the-door** principle, researchers posing as safety-drive volunteers asked Californians to permit the installation of a large, poorly lettered "Drive Carefully" sign in their front yards. Only 17 percent consented. Others were first approached with a small request: Would they display a 3-inch "Be a safe driver" sign? Nearly all readily agreed. When approached two weeks later to allow the large, ugly sign in their front yards, 76 percent consented (Freedman & Fraser, 1966).

Although the effects are seldom so dramatic, many other researchers have confirmed these findings (Beaman & others, 1983; Dillard & others, 1984). Several studies have tried to elicit altruistic acts. Consider four examples:

Foot-in-the-door phenomenon:
The tendency for people who have first agreed to a small request to comply later with a larger request.

- Patricia Pliner and her collaborators (1974) found 46 percent of Toronto suburbanites willing to give to the Cancer Society when approached directly. Others, asked a day ahead to wear a lapel pin publicizing the drive (which all agreed to do), were nearly twice as likely to donate when the Cancer Society came calling.

"You will easily find folk to do favors if you cultivate those who have done them."
Publilius Syrus, 42 B.C.

- Among the residents of one middle-class Israeli city, 53 percent gave to a collection for the mentally handicapped when approached by canvassers working for Joseph Schwarzwald and his colleagues (1983). Two weeks earlier, other residents had been approached to sign a petition supporting a

recreation center for the handicapped; among these, 92 percent now gave.

■ Anthony Greenwald and his co-researchers (1987) approached a sample of registered voters the day before the 1984 U.S. presidential election and asked them a small question: "Do you expect that you will vote or not?" All said yes. Compared to other voters not asked their intentions, they were 41 percent more likely to vote.

■ Angela Lipsitz and others (1989) report that ending blood-drive reminder calls with, "We'll count on seeing you then, OK? [pause for response]," increased the show-up rate from 62 to 81 percent.

Note that in these experiments the initial compliance—signing a petition, wearing a lapel pin, stating one's intention—was voluntary. We will see again and again that when people commit themselves to public behaviors *and* perceive these acts to be their own doing, they come to believe more strongly in what they have done.

Robert Cialdini and his collaborators (1978) demonstrated the effects of commitment by experimenting with the **low-ball technique**, a tactic used by some car dealers. After the customer agrees to buy a new car because of its great price and begins completing the sales forms, the salesperson removes the price advantage by charging for options the customer thought were included or by checking with a boss who disallows the deal because, "We'd be losing money." Folklore has it that more customers stick with their purchase, even at the higher price, than would have agreed if the salesperson revealed the full price at the outset. Cialdini and his collaborators found that this technique indeed works. When they invited introductory psychology students to participate in an experiment at 7:00 A.M., only 24 percent showed up. But if the students first agreed to participate without knowing the time and only then were asked to participate at 7:00 A.M., 53 percent came.

Marketing researchers and salespeople have found that the principle works even when we are aware of a profit motive (Cialdini, 1988). A harmless initial commitment—returning a card for more information and a gift, agreeing to listen to an investment possibility—often moves us toward a larger commitment. The day after I wrote this sentence, a life insurance salesperson came to my office and offered to do a thorough analysis of my family's financial situation. He did not ask whether I wished to buy his life insurance, or even whether I wished to try his free service. His question was instead a small

Low-ball technique:
A tactic for getting people to agree to something. People who agree to an initial request will often still comply when the requester ups the ante. People who receive only the costly request are less likely to comply with it.

The low-ball sales tactic.

Born Loser reprinted by permission of USF, Inc.

foot-in-the-door, one carefully calculated to elicit agreement: Did I think people should have such information about their financial situation? I could only answer yes, and before I realized what was happening, I had agreed to the analysis. But I'm learning. Just the other evening a paid fund-raiser came to my door, first soliciting a petition signature supporting environmental cleanup, then welcoming my contribution to what I'd signed my support of. (I sign, but resisting manipulation, don't give.)

Salespeople may exploit the power of small commitments when trying to bind people to purchase agreements. Many states now have laws that allow customers of door-to-door salespeople a few days to cancel their purchases. To combat the effect of these laws, many companies use what the sales-training program of one encyclopedia company calls "a very important psychological aid in preventing customers from backing out of their contracts" (Cialdini, 1988, p. 78). They simply have the customer, rather than the salesperson, fill out the agreement. Having written it themselves, people usually live up to their commitment.

This process of step-by-step commitment, of spiraling action and attitude, contributed to the escalation of the U.S. involvement in the Vietnam war. After making and defending difficult decisions, political and military leaders seemed blind to information incompatible with their acts. They noticed and remembered comments that harmonized with their actions but ignored or dismissed information that undermined their assumptions. As Ralph White (1971) put it, "There was a tendency, when actions were out of line with ideas, for decision-makers to align their ideas with their actions."

The foot-in-the-door phenomenon is well worth being aware of so we won't be naively vulnerable to it. Someone trying to seduce us, financially, politically, or sexually, usually will try to create a momentum of compliance. Before agreeing to the small request, we need to think about what will follow.

EVIL ACTS AND EVIL ACTORS

The action-attitude sequence occurs not just with shading the truth but with more immoral acts as well. Evil sometimes results from gradually escalating

■ BEHIND THE SCENES

All my life I've been a patsy. For as long as I can recall, I've been an easy mark for the pitches of peddlers, fund-raisers, and operators of one sort or another. Being a sucker contributes to my interest in the study of compliance: Just what are the factors that cause one person to say yes to another person? To help answer this question, I conduct laboratory experiments. I also spent three years infiltrating the world of compliance professionals. By becoming a trainee in various sales, fund-raising, and advertising organizations, I discovered how they exploit the weapons of influence and how we can spot these weapons at work.

ROBERT B. CIALDINI, *Arizona State University*

commitments. A trifling evil act can make a less trifling evil act easier. To paraphrase another of La Rochefoucauld's *Maxims* (1665), it is not as difficult to find a person who has never succumbed to a given temptation as to find a person who has succumbed only once. Consider some examples.

Cruel acts corrode the consciences of those who perform them. Harming an innocent victim—by uttering hurtful comments or delivering electric shocks—typically leads aggressors to disparage their victims, thus helping them justify the behavior (Berscheid & others, 1968; Davis & Jones, 1960; Glass, 1964). In all the studies that have established this, people justify an action especially when coaxed, not coerced, into it. When we agree to do a deed, we take more responsibility for it.

In everyday life, oppressors usually disparage their victims. We tend not only to hurt those we dislike but to dislike those we hurt. In times of war, soldiers denigrate their victims: In World War II American soldiers called their enemies "the Japs." In the 1960s American soldiers dehumanized the Vietnamese people as "gooks." This is another instance of the spiraling action and attitude: The more one commits atrocities, the easier it becomes. The same holds for prejudice. If one group holds another in slavery, it is likely to perceive the slaves as having traits that justify their oppression. Actions and attitudes feed one another, sometimes to the point of moral numbness.

These observations suggest that evil acts not only reflect the self, they shape the self. Situations that elicit evil acts therefore gnaw at the moral sensitivity of the actor. Conscience mutates. Here is an interrogation of one man who testified that he was but a small cog in the Nazi machine:

> **Q:** Did you kill people in the camp?
> **A:** Yes.
> **Q:** Did you poison them with gas?
> **A:** Yes.
> **Q:** Did you bury them alive?
> **A:** It sometimes happened. . . .
> **Q:** Did you personally help kill people?
> **A:** Absolutely not, I was only paymaster in the camp.
> **Q:** What did you think of what was going on?
> **A:** It was bad at first but we got used to it.
> **Q:** Do you know the Russians will hang you?
> **A:** [*Bursting into tears*] Why should they? *What have I done?* (Arendt, 1971, p. 262)

"Our self-definitions are not constructed in our heads; they are forged by our deeds."
Robert McAfee Brown, *Creative Dislocation—The Movement of Grace*

Fortunately, the principle works in the other direction as well: Moral action affects the actor in positive ways. When children resist temptation, they internalize the conscientious act if the deterrent is strong enough to elicit the desired behavior yet mild enough to leave them with a sense of choice. In a dramatic experiment, Jonathan Freedman (1965) introduced elementary school children to an enticing battery-controlled robot but instructed them not to play with it while he was out of the room. Freedman used a severe threat with half the children and a mild threat with the others. Both were sufficient to deter the children.

Several weeks later a different researcher, with no apparent relation to the earlier events, left each child to play in the same room with the same toys. Of the 18 children who had been given the severe threat, 14 now freely played

For these El Salvaradoran soldiers, as for us all, actions feed attitudes.

with the robot; but two-thirds of those who had been given the mild deterrent still resisted playing with it. Having made the conscious choice not to play with the toy, the mildly deterred children apparently internalized their decision, and this new attitude controlled their subsequent action. So, moral action, especially when chosen rather than coerced, affects moral thinking.

INTERRACIAL BEHAVIOR AND RACIAL ATTITUDES

If moral action feeds moral attitudes, will positive interracial behavior reduce racial prejudice? This was part of social scientists' testimony before the Supreme Court's 1954 decision to desegregate schools. Their argument ran like this: If we wait for the heart to change—through preaching and teaching—we will wait a long time for racial justice. But if we legislate moral action, we can, under the right conditions, indirectly affect heartfelt attitudes. Although this idea runs counter to the presumption that "you can't legislate morality," attitude change has, in fact, followed on the heels of desegregation. Consider:

■ Since the Supreme Court decision, the percentage of White Americans favoring integrated schools has more than doubled, and now includes nearly everyone.

■ In the 10 years after the Civil Rights Act of 1964, the percentage of White Americans who described their neighborhoods, friends, co-workers, or fellow students as all White declined by about 20 percent for each of these

measures. During the same period, the percentage of White Americans who said that Blacks should be allowed to live in any neighborhood increased from 65 percent to 87 percent (ISR Newsletter, 1975).

■ More uniform national standards against discrimination were followed by decreasing differences in racial attitudes among people of differing religion, class, and geographic regions. As Americans came to act more alike, they came to think more alike (Greeley & Sheatsley, 1971; Taylor & others, 1978).

Experiments confirm that positive behavior toward someone fosters liking for that person. Doing a favor for an experimenter or another subject, or tutoring a student, usually increases liking of the person helped (Blanchard & Cook, 1976). In 1793, Benjamin Franklin tested the idea that doing a favor engenders liking. As clerk of the Pennsylvania General Assembly, he was disturbed by opposition from another important legislator. So Franklin set out to win him over:

"We do not love people so much for the good they have done us, as for the good we have done them."
Leo Tolstoy, *War and Peace*, 1867–1869

> I did not . . . aim at gaining his favour by paying any servile respect to him but, after some time, took this other method. Having heard that he had in his library a certain very scarce and curious book I wrote a note to him expressing my desire of perusing that book and requesting he would do me the favour of lending it to me for a few days. He sent it immediately and I return'd it in about a week, expressing strongly my sense of the favour. When we next met in the House he spoke to me (which he had never done before), and with great civility; and he ever after manifested a readiness to serve me on all occasions, so that we became great friends and our friendship continued to his death. (Rozenzweig, 1972, p. 769)

SOCIAL MOVEMENTS

The effect of a society's behavior on its racial attitudes suggests the possibility, and the danger, of employing the same idea for political socialization on a mass scale. In Nazi Germany participation in mass meetings, wearing uniforms, demonstrating, and especially the public greeting "Heil Hitler" established for many a profound inconsistency between behavior and belief. Historian Richard Grunberger (1971) reports:

> The "German greeting" was a powerful conditioning device. Having once decided to intone it as an outward token of conformity, many experienced schizophrenic discomfort at the contradiction between their words and their feelings. Prevented from saying what they believed, they tried to establish their psychic equilibrium by consciously making themselves believe what they said. (p. 27)

The practice is not limited to totalitarian regimes. North American political rituals—the daily flag salute by schoolchildren, singing the national anthem—use public conformity to build a private belief in patriotism. I recall participating in air-raid drills in my elementary school not far from the Boeing Company in Seattle. After we repeatedly acted as if we were the objects of Soviet attack, many of us came to fear the Soviets. Observers noted how the civil rights marches of the 1960s strengthened the demonstrators' commitments. Their actions expressed an idea whose time had come and drove that idea more deeply into their hearts. The 1980s move toward inclusive language (by referring, say, to "human nature" rather than "man's nature") has similarly strengthened inclusive attitudes.

"One does what one is; one becomes what one does."
Robert Musil, *Kleine Prosa*, 1930

Our political rituals, like this daily flag salute by schoolchildren, use public conformity to build private conviction.

BRAINWASHING

Many people assume that the most dramatic influence comes through *brainwashing*, a term coined to describe what happened to American prisoners of war (POWs) during the 1950s Korean war. Actually, the Chinese "thought-control" program was not nearly as irresistible as this term suggests. But it was disconcerting that hundreds of prisoners cooperated with their captors, that 21 chose to remain after being granted permission to return to America, and that many of those who did return came home believing "although communism won't work in America, I think it's a good thing for Asia" (Segal, 1954).

Edgar Schein (1956) interviewed many of the POWs during their journey home and reported that the captors' methods included a gradual escalation of demands. The Chinese always started with trivial requests and gradually worked up to more significant ones. "Thus after a prisoner had once been 'trained' to speak or write out trivia, statements on more important issues were demanded." Moreover, they always expected active participation, be it just copying something or participating in group discussions, writing self-criticism, or uttering public confessions. Once a prisoner had spoken or written a statement, he felt an inner need to make his beliefs consistent with his public acts. This often drove prisoners to persuade themselves of what they had done. The "start-small-and-build" tactic was an effective application of the foot-in-the-door technique, as it continues to be today in the socialization of terrorists and torturers (Chapter 7).

"You can use small commitments to manipulate a person's self-image; you can use them to turn citizens into 'public servants,' prospects into 'customers,' prisoners into 'collaborators.'"

Robert Cialdini, *Influence*, 1988

REFLECTIONS ON THE EVIDENCE

From these observations—of the effects of role playing, the foot-in-the-door experience, moral and immoral acts, interracial behavior, social movements,

and brainwashing—there is a powerful practical lesson: If we want to change ourselves in some important way, it's best not to wait for insight or inspiration. Sometimes we need to act—to begin writing that paper, to make those phone calls, to see that person—even if we don't feel like acting. Jacques Barzun (1975) recognized the energizing power of action when he advised aspiring writers to engage in the act of writing even if passive contemplation had left them feeling uncertain about their ideas:

> If you are too modest about yourself or too plain indifferent about the possible reader and yet are required to write, then you have to pretend. Make believe that you want to bring somebody around to your opinion; in other words, adopt a thesis and start expounding it. . . . With a slight effort of the kind at the start—a challenge to utterance—you will find your pretense disappearing and a real concern creeping in. The subject will have taken hold of you as it does in the work of all habitual writers. (pp. 173–174)

This attitudes-follow-behavior phenomenon is not irrational or magical, for that which prompts us to act may also prompt us to think. Writing an essay, or role-playing an opposing view, forces us to consider arguments we might have ignored. What is more, we remember information best when we have actively explained it in our own terms. In one experiment, Gordon Bower and Mark Masling (1979) gave Stanford students a list of bizarre correlations like this one: "As the number of fire hydrants in an area decreases the crime rate increases." Students who simply studied or were given explanations for these correlations recalled only about 40 percent of them when tested later. But students who invented their own explanations recalled 73 percent of the correlations.

The memorability of self-produced information is one reason we are most affected by information we have reformulated in our own terms (Greenwald, 1968; Petty & others, 1981). As one student wrote me, "It wasn't until I tried to verbalize my beliefs that I really understood them." As a teacher and a writer, I must therefore remind myself not always to lay out finished results. It is better to stimulate students to think through the implications of a theory, to make them active listeners and readers. Even taking notes deepens the impression. The philosopher-psychologist William James (1899) made the same point 90 years ago: "No reception without *reaction*, no impression without correlative expression—this is the great maxim which the teacher ought never to forget."

"If we wish to conquer undesirable emotional tendencies in ourselves we must . . . cold-bloodedly go through the outward motions of those contrary dispositions we prefer to cultivate."
William James, "What Is an Emotion?" 1884

■ WHY DO ACTIONS AFFECT ATTITUDES?

We have seen that several streams of evidence merge to form a river: the effect of actions on attitudes. Do these observations contain any clues to *why* action affects attitude? Social psychology's detectives suspect three possible sources. **Self-presentation theory** assumes that for strategic reasons we express attitudes that make us *appear* consistent. **Cognitive dissonance theory** assumes that to reduce discomfort, we justify our actions to ourselves. **Self-perception theory** assumes that our actions are self-revealing (when uncertain about our feelings or beliefs, we look to our behavior, much as anyone else would). Let's examine each.

SELF-PRESENTATION: IMPRESSION MANAGEMENT

The first explanation began as a simple idea: Who among us does not care what people think? We spend countless dollars on clothes, diets, cosmetics, even plastic surgery—all because we worry about what others think of us. To make a good impression is often to gain social and material rewards, to feel better about ourselves, even to become more secure in our social identities (Leary & Kowalski, 1990).

Indeed, no one wants to look foolishly inconsistent. To avoid seeming so, we express attitudes that match our actions. To *appear* consistent, we may even feign attitudes we don't really believe in. Even if it means displaying a little insincerity or hypocrisy, it can pay to manage the impression one is making. Or so *self-presentation theory* suggests.

We have seen that people do engage in "impression management." They will adjust what they say to please rather than offend. Sometimes it may take a bogus pipeline to cut through the pretense. Moreover, people take longer to deliver news of failure (for example, signaling wrong answers on an IQ-type test) than news of success; but this effect occurs only if the bearers of the news are identifiable and therefore concerned about making a bad impression (Bond & Anderson, 1987).

For some people, making a good impression is a way of life. By continually monitoring their own behavior and noting how others react, they adjust their

People spend billions trying to manage the impression they make on others. Such concern leads us to present ourselves and our attitudes in ways that evoke favorable reactions.

© 1987, The New Yorker Magazine, Inc.

"My not wearing a hairpiece indicates to others that I'm comfortable with myself."

Self-presentation theory assumes that our behavior aims to create desired impressions.

social performance when it's not having the desired effect. Those who score high on a scale of **self-monitoring** tendency (who, for example, agree that "I tend to be what people expect me to be") act like social chameleons—they adjust their behavior in response to external situations (Snyder, 1987). Having attuned their behavior to the situation, they are more likely to espouse an attitude they don't really hold (Zanna & Olson, 1982). Being conscious of others, they are less likely to act on their own attitudes. For high self-monitors, attitudes therefore serve a social adjustment function; they help these people adapt to new jobs, roles, and relationships (Snyder & DeBono, 1989; Snyder & Copeland, 1989).

Those who score low in self-monitoring care less about what others think. They are more internally guided and thus more likely to talk and act as they feel and believe (McCann & Hancock, 1983). Most of us fall somewhere between the high self-monitoring extreme of the con artist and the low self-monitoring extreme of stubborn insensitivity to others.

Does our eagerness to *appear* consistent explain why expressed attitudes shift toward consistency with behavior? To some extent, yes—people exhibit a much smaller attitude change when a bogus pipeline inhibits trying to make a good impression (Paulhus, 1982; Tedeschi & others, 1987). Moreover, self-presentation involves not just impressing others but expressing our ideals and identity and establishing a reputation that reflects them. We want to have people know us as we really are (Baumeister, 1982, 1985; Schlenker, 1986, 1987).

Self-monitoring:
Being attuned to the way one presents oneself in social situations and adjusting one's performance to create the desired impression.

"Public opinion is always more tyrannical towards those who obviously fear it than towards those who feel indifferent to it." Bertrand Russell, *The Conquest of Happiness*, 1930

But there is more to the attitude changes we have reviewed than self-presentation, for we express changed attitudes even to someone who doesn't know how we have behaved. (There is no need to present a consistent attitude when talking to someone who is unaware of our behavior.) In fact, we sometimes internalize our self-presentations as genuine attitude changes. To explain how this happens, consider two other theories.

SELF-JUSTIFICATION: COGNITIVE DISSONANCE

Cognitive dissonance:
Tension that arises when one is simultaneously aware of two inconsistent cognitions. For example, dissonance may occur when we realize that we have, with little justification, acted contrary to our attitudes or made a decision favoring one alternative despite reasons favoring another.

One theory is that our attitudes change because we are motivated to rationalize our behavior. Such is the implication of Leon Festinger's (1957) **cognitive dissonance theory**. The theory is simple, but its range of application is enormous. It assumes we feel tension ("dissonance") when two thoughts or beliefs ("cognitions") are psychologically inconsistent—when we recognize that they don't fit together. Festinger argued that we adjust our thinking to reduce this tension. For example, Steven Sherman and Larry Gorkin (1980) aroused dissonance in their Indiana University students by giving them the following riddle:

> A father and his son are out driving. They are involved in an accident. The father is killed, and the son is in critical condition. The son is rushed to the hospital and prepared for the operation. The doctor comes in, sees the patient, and exclaims, "I can't operate, it's my son!" How could this be?

Although virtually all the students had previously said they strongly favored sexual equality and other feminist ideals, most failed to solve the riddle (by identifying the doctor as the son's mother). Believing "I am nonsexist," yet now realizing that "I perceived this riddle with sexist assumptions," evoked dissonance. When later the students judged a case of alleged sex discrimination, how do you suppose those who had failed to solve the riddle reacted? They reacted with exceptionally strong support for the female complainant, reducing their dissonance and reaffirming their nonsexist self-image.

"A foolish consistency is the hobgoblin of little minds."
Ralph Waldo Emerson, "Self-Reliance," 1841

Dissonance theory pertains mostly to discrepancies between behavior and attitudes. We are aware of both. Thus if we sense an inconsistency, we feel pressure for change. That helps explain why, in a British survey, half of cigarette smokers disagreed with the near-consensus among nonsmokers that smoking is "really as dangerous as people say" (Eiser & others, 1979). So if we can persuade others to adopt a *new* attitude, their behavior should change

■ BEHIND THE SCENES

Following a 1934 earthquake in India, there were rumors outside the disaster zone of worse disasters to follow. It occurred to me that these rumors might be "anxiety-justifying"—cognitions that would justify their lingering fears. From that germ of an idea, my theory of dissonance reduction—making your view of the world fit with how you feel or what you've done—developed.

LEON FESTINGER, 1920–1989

accordingly; that's common sense. Or if we can induce a person to behave differently, their attitude should change (that's the self-persuasion effect we have been reviewing). But cognitive dissonance theory offers several surprising predictions. Perhaps you can figure them out.

Insufficient Justification

Imagine you are a subject in a famous experiment conducted by Festinger and J. Merrill Carlsmith (1959). For an hour, you are required to perform dull tasks, such as turning wooden knobs again and again. After you finish, the experimenter explains that the study concerns how expectations affect performance. The next subject, waiting outside, must be led to expect an interesting experiment. The experimenter explains that the assistant who usually creates this expectation couldn't make this session: "Could you fill in and do this?" It's for science and you are being paid, so you agree to tell the next subject (who is actually the experimenter's real assistant) what a delightful experience you had just had. "Really?" responds the supposed subject. "A friend of mine was in this experiment a week ago, and she said it was boring." "Oh, no," you respond, "it's really very interesting. You get good exercise while turning some knobs. I'm sure you'll enjoy it." Finally, someone else who is studying how people react to experiments has you complete a questionnaire that asks how much you actually enjoyed your knob-turning experience.

Now for the prediction: Under which condition are you most likely to believe your little lie and say the experiment was indeed interesting? When paid $1 for doing so, as some of the subjects were? Or when paid a generous $20, as others were? Contrary to the common notion that big rewards produce big effects, Festinger and Carlsmith reasoned that those paid just $1 would be most likely to adjust their attitudes to their actions. Having **insufficient justification** for their action, they would experience more discomfort (dissonance) and thus be more motivated to believe in what they had done. Those paid $20 had sufficient justification for what they did and hence should have experienced less dissonance. As Figure 4-4 shows, the results fit this intriguing prediction.*

In dozens of later experiments, the attitudes-follow-behavior effect was strongest when people felt some choice and when their action had foreseeable consequences. If you agree for a measly $1.50 to help a researcher by writing an essay supporting something you don't believe in—say, a tuition increase—you may begin to feel somewhat greater sympathy with the policy. This is especially so if something makes you face the inconsistency or if you think important people will actually read an essay with your name on it (Leippe & Elkin, 1987). Feeling responsible for statements you have made, you will now believe them more strongly. Pretense has become reality.

Earlier we noted the insufficient justification principle working with punishments. Children were more likely to internalize a request not to play with an

Insufficient justification effect:
Reduction of dissonance by internally justifying one's behavior when external justification is "insufficient."

* There is a seldom-reported final aspect of this 1950s experiment. Imagine yourself finally back with the experimenter, who is truthfully explaining the whole study. Not only do you learn that you've been duped, but the experimenter asks for the $20 back. Do you comply? Festinger and Carlsmith note that all their Stanford student subjects willingly reached into their pockets and gave back the money. This is a foretaste of some quite amazing observations on compliance and conformity discussed in Chapter 7. As we will see, when the social situation makes clear demands, people usually respond accordingly.

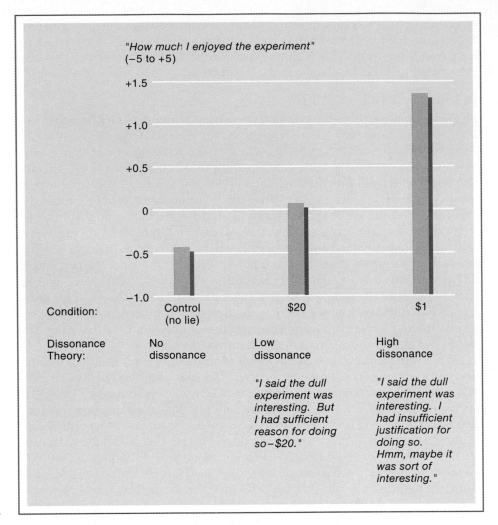

"How much I enjoyed the experiment"
(−5 to +5)

Condition:	Control (no lie)	$20	$1
Dissonance Theory:	No dissonance	Low dissonance	High dissonance

"I said the dull experiment was interesting. But I had sufficient reason for doing so—$20."

"I said the dull experiment was interesting. I had insufficient justification for doing so. Hmm, maybe it was sort of interesting."

FIGURE 4-4 *Insufficient justification: Dissonance theory predicts that when our actions are not fully explained by external rewards or coercion, we will experience dissonance, which we can reduce by believing in what we have done.*
(Data from Festinger & Carlsmith, 1959.)

attractive toy if given a mild threat that insufficiently justified their compliance. When a parent says, "Clean up your room, Johnny, or I'll knock your block off," Johnny won't need to internally justify cleaning his room. The severe threat is a sufficient justification.

Note that cognitive dissonance theory focuses on what *induces* a desired action, rather than the relative effectiveness of rewards and punishments administered *after* the act. It aims to have Johnny say, "I am cleaning up my room because I want a clean room," rather than, "I am cleaning up my room because my parents will kill me if I don't." People are more likely to support rules if they share responsibility for them. Dorm residents who share responsibility for enforcing dorm rules, for example, are less tolerant of rule breakers than are residents who have no control over their enforcement (Triplet & others, 1988).

These implications of dissonance theory have led some to view it as an integration of humanistic and scientific perspectives. Authoritarian management will be effective, the theory predicts, only with the authority present, because people are unlikely to internalize behavior they don't choose. As Bree, a formerly enslaved talking horse in C. S. Lewis's *The Horse and His Boy* (1974),

observes: "One of the worst results of being a slave and being forced to do things is that when there is no one to force you any more you find you have almost lost the power of forcing yourself" (p. 193). Dissonance theory insists that encouragement and inducement should be enough to elicit the desired action. But it suggests that managers, teachers, and parents should use only enough incentive to elicit the desired behavior. The principle: We accept responsibility for our behavior if we have chosen it without obvious pressure and incentives.

Dissonance after Decisions

The emphasis on perceived choice and responsibility implies that *decisions* produce dissonance. When faced with an important decision—what college to attend, whom to date, which job to accept—we are sometimes torn between two equally attractive alternatives. Perhaps you can recall a time when, having committed yourself, you become painfully aware of dissonant cognitions—the desirable features of what you had rejected and the undesirable features of what you had chosen. If you decided to live on campus, you may have realized you were forgoing the spaciousness and freedom of an apartment in favor of cramped, noisy dorm quarters. If you elected to live off campus, you may have realized that your decision meant physical separation from campus and friends and having to cook for yourself.

After making important decisions, we usually reduce dissonance by upgrading the chosen alternative and denigrating the option we passed over. In the first published dissonance experiment (1956), Jack Brehm had University of Minnesota women rate eight products, such as a toaster, a radio, and a hair dryer. Brehm then showed the women two objects they had rated closely and told them they could have whichever they chose. Later, when rerating the eight objects, the women increased their evaluations of the item they had chosen and decreased their evaluations of the rejected item. It seems that when we've made our choice, the grass does *not* then grow greener on the other side of the fence.

With simple decisions, this deciding-becomes-believing effect can occur very quickly. Robert Knox and James Inkster (1968) found that racetrack bettors who had just put down their money on a horse felt more optimistic about their bet than did those who were about to bet. In the few moments that intervened between standing in line and walking away from the betting window, nothing had changed—except the decision and the person's feelings about it. Contestants in carnival games of chance feel more confident of winning right after agreeing to play than right before. And voters indicate more esteem and confidence in a candidate just after voting than just before (Younger & others, 1977). There may sometimes be but a slight difference between the two options, as I can recall in helping make faculty tenure decisions. The competence of one faculty member who barely makes it and that of another who barely loses seem not very different—until after you make and announce the decision.

All these experiments and examples suggest that, once made, decisions grow their own legs of support—self-justifying reasons why the commitment was wise. Often, these new legs are strong enough that when one leg is pulled away—perhaps the original one—the decision does not collapse. Alison decides to take a trip home if it can be done for an airfare under $400. It can, so she makes her reservation and begins to think of additional reasons why she is

"Every time you make a choice you are turning the central part of you, the part of you that chooses, into something a little different from what it was before."
C. S. Lewis, *Mere Christianity*, 1943

glad she is going. When she goes to buy the tickets, however, she learns there has been a fare increase to $475. No matter, she is now determined to go. As when being low-balled by a car dealer, it never occurs to people, reports Robert Cialdini (1984, p. 103), "that those additional reasons might never have existed had the choice not been made in the first place."

SELF-PERCEPTION

Although dissonance theory has inspired much research, an even simpler theory explains its phenomena. Consider how we make inferences about other people's attitudes. We see how a person acts in a particular situation, and then we attribute the behavior either to the person's traits and attitudes or to environmental forces. If we see Mr. and Mrs. Wong coercing their little Susie into saying, "I'm sorry," we attribute Susie's reluctant behavior to the situation, not to her personal regret. If we see Susie apologizing with no apparent inducement, we attribute the apology to Susie herself.

Self-perception theory (proposed by Daryl Bem, 1972) assumes that we make similar inferences when we observe our own behavior. When our attitudes are weak or ambiguous, we are in the position of someone observing us from the outside. As we discern people's attitudes by looking closely at their actions when they are free to act as they please, so do we discern our own attitudes. Hearing myself talk informs me of my attitudes; seeing my actions provides clues to how strong my beliefs are, especially if my behavior is not easily attributable to external constraints. The acts we freely commit are self-revealing.

William James proposed a similar explanation for emotion a century ago. We infer our emotions, he suggested, by observing our bodies and our behaviors. A stimulus such as a growling bear confronts a woman in the forest. She tenses, her heartbeat increases, adrenaline flows, and she runs away. Observing all this, she then experiences fear. At a college where I am to lecture, I awake before dawn and am unable to get back to sleep. Noting my wakefulness, I conclude that I must be anxious.

You may be skeptical of the self-perception effect. I was when I first heard it. However, experiments on the effects of facial expressions suggest a way for you to experience it. When James Laird (1974, 1984; Duclos & others, 1989) induced college students to frown while attaching electrodes to their faces—"contract these muscles," "pull your brows together"—they reported feeling angry. It's more fun to try out Laird's other finding: Those induced to make a smiling face felt happier and found cartoons more humorous.

We have all experienced this phenomenon. We're feeling crabby, but then the phone rings or someone comes to the door and elicits from us warm, polite behavior. "How's everything?" "Just fine, thanks. How are things with you?" "Oh, not bad. . . ." If our feelings are not intense, this warm behavior may change our whole attitude. It's tough to smile and feel grouchy. When Miss America parades her smile, she may, after all, be helping herself feel happy. Going through the motions can trigger the emotions.

Even your gait can affect how you feel. When you get up from reading this chapter, walk for a minute taking short, shuffling steps, with eyes downcast. It's a great way to feel depressed. "Sit all day in a moping posture, sigh, and reply to everything with a dismal voice, and your melancholy lingers," noted

Self-perception theory: The theory that when unsure of our attitudes, we infer them much as would someone observing us—by looking at our behavior and the circumstances under which it occurs.

"Self-knowledge is best learned, not by contemplation, but action."
Goethe

"I can watch myself and my actions, just like an outsider."
Anne Frank, *The Diary of a Young Girl*

According to German psychologist Fritz Strack and colleagues (1988), people find cartoons funnier while holding a pen with their teeth (using a smiling muscle) than while holding it with their lips (using muscles incompatible with smiling).

William James (1890, p. 463). Want to feel better? Walk for a minute taking long strides with your arms swinging and your eyes straight ahead. Can you, like the Skidmore College participants in an experiment by Sara Snodgrass (1986), feel the difference?

 If our expressions influence our feelings, then would imitating others' expressions help us know what they are feeling? An experiment by Katherine Burns Vaughan and John Lanzetta (1981) suggests it would. They asked Dartmouth College students to observe someone receiving electric shock. They told some of the observers to make a pained expression whenever the shock came on. If, as Freud and others supposed, expressing an emotion allows us to discharge it, then the pained expression should be inwardly calming (Cacioppo & others, 1992). Actually, compared to other students who did not act out the expressions, these grimacing students perspired *more* and had a faster heart rate whenever they saw the person shocked. Acting out the person's emotion apparently enabled the observers to feel more empathy. The implication: To sense how other people are feeling, let your own face mirror their expressions.

"The free expression by outward signs of emotion intensifies it. On the other hand, the repression as far as possible, of all outward signs softens our emotions."
Charles Darwin, *The Expression of the Emotions in Man and Animals,* 1897

"*I don't sing because I am happy. I am happy because I sing.*"

Actually, you hardly need try. Observing others' faces, postures, and voices, we naturally and unconsciously mimic their moment-to-moment reactions (Hatfield & others, 1992). We synchronize our movements, postures, and tones of voice with theirs. Doing so helps us tune in to what they're feeling. It also makes for "emotional contagion," helping explain why it's fun to be around happy people and depressing to be around depressed people (Chapter 5).

Our facial expressions also influence our attitudes. In a clever experiment, Gary Wells and Richard Petty (1980) had University of Alberta students "test headphone sets" by making either vertical or horizontal head movements while listening to a radio editorial. Who most agreed with the editorial? Those who had been nodding their heads up and down. Why? Wells and Petty surmised that positive thoughts are compatible with vertical nodding and incompatible with horizontal motion. Try it yourself when listening to someone: Do you feel more agreeable when nodding rather than shaking your head?

Overjustification and Intrinsic Motivation

Recall the insufficient justification effect—the *smallest* incentive that will get people to do something is usually the most effective in getting them to like the

activity and keep on doing it. Cognitive dissonance theory offers one explanation for this: When external inducements are not enough to justify our behavior, we *justify it internally*.

Self-perception theory offers another explanation: People explain their behavior by noting the conditions under which it occurs. Imagine hearing someone proclaim the wisdom of a tuition increase after being paid $20 to do so. Surely the statement would seem less sincere than if you thought the person was expressing those opinions for no pay. Perhaps we make similar inferences when observing ourselves.

Natural mimicry and emotional contagion. People in sync—like these volunteers videotaped during an Oregon State University study by Frank Bernieri and his colleagues—feel more emotional rapport with each other.

Self-perception theory goes even a step farther. Contrary to the notion that rewards always increase motivation, it suggests that unnecessary rewards sometimes have a hidden cost. Rewarding people for doing what they already enjoy may lead them to attribute their doing it to the reward, thus undermining their self-perception that they do it because they like it. Experiments by Edward Deci and Richard Ryan (1991) at the University of Rochester, by Mark Lepper and David Greene (1979) at Stanford, and by Ann Boggiano and her colleagues (1985, 1987) at the University of Colorado confirm this **overjustification effect.** Pay people for playing with puzzles, and they will later play with the puzzles less than those who play without being paid; promise children a reward for doing what they intrinsically enjoy (for example, playing with magic markers) and you will turn their play into work (Figure 4-5).

A folktale illustrates the overjustification effect. An old man lived alone on a street where boys played noisily every afternoon. The din annoyed him, so one day he called the boys to his door. He told them he loved the cheerful sound of children's voices and promised them each 50 cents if they would return the next day. Next afternoon the youngsters raced back and played more lustily than ever. The old man paid them and promised another reward the next day. Again they returned, whooping it up, and the man again paid them; this time 25 cents. The following day they got only 15 cents, and the man explained that his meager resources were being exhausted. "Please, though, would you come to play for 10 cents tomorrow?" The disappointed boys told the man they would not be back. It wasn't worth the effort, they said, to play all afternoon at his house for only 10 cents.

As self-perception theory implies, an *unanticipated* reward does *not* diminish intrinsic interest, because people can still attribute their action to their own motivation (Bradley & Mannell, 1984). (It's like the heroine who, having fallen in love with the woodcutter, now learns that he's really a prince.) And if compliments for a good job make us feel more competent and successful, this can actually *increase* our intrinsic motivation. The overjustification effect occurs

Overjustification effect: The result of bribing people to do what they already like doing; they may then see their action as externally controlled rather than intrinsically appealing.

FIGURE 4-5 *When people do something they enjoy, without reward or coercion, they attribute their behavior to their love of the activity. External rewards undermine intrinsic motivation by leading people to attribute their behavior to the incentive.*

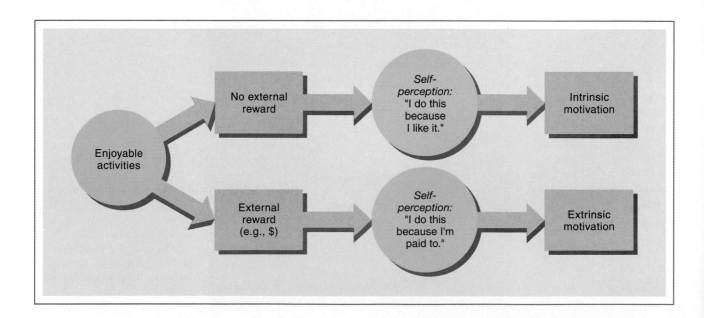

when someone offers an unnecessary reward beforehand in an obvious effort to control behavior. What matters is what a reward implies: Rewards and praise that *inform* people of their achievements (that make them feel, "I'm very good at this") *boost* intrinsic motivation. Rewards that seek to *control* people and lead them to believe it was the reward that caused their effort ("I did it for the money") *diminish* the intrinsic appeal of an enjoyable task (Rosenfeld & others, 1980; Sansone, 1986).

How then can we cultivate people's enjoyment of tasks that are not intrinsically appealing? Young Maria may find her first piano lessons frustrating. Tommy may not have an intrinsic love of fifth-grade science. Sandra may not look forward to making those first sales calls. In such cases, the parent, teacher, or manager should probably use some incentives to coax the desired behavior (Boggiano & Ruble, 1985; Workman & Williams, 1980). After the person complies, suggest an intrinsic reason for doing so: "I knew you'd share your toys because you're a generous person" (Cialdini & others, 1992).

If we provide students with *just enough* justification to perform a learning task and use rewards and labels to help them feel competent, we may enhance their enjoyment and their eagerness to pursue the subject on their own. When there is too much justification—as happens in classrooms where teachers dictate behavior and use rewards to control the children—child-driven learning may diminish (Deci & Ryan, 1985, 1991). My younger son eagerly consumed six or eight library books a week—until our library started a reading club which promised a party to those who read ten books in three months. Three weeks later he began checking out only one or two books during our weekly visit. Why? "Because you only need to read ten books, you know."

COMPARING THE THEORIES

We have seen one explanation of why our actions *seem* to affect our attitudes (self-presentation theory). And we have seen two explanations of why our

actions *genuinely* affect our attitudes: (1) the dissonance-theory assumption that we justify our behavior to reduce our internal discomfort and (2) the self-perception-theory assumption that we observe our behavior and make reasonable inferences about our attitudes, as we do when observing other people.

The last two explanations seem to contradict one another. Which is right? It's difficult to find a definitive test. In most instances they make the same predictions, and we can bend each theory to accommodate most of the findings we have considered (Greenwald, 1975). Daryl Bem (1972), the self-perception theorist, even suggested it boils down to a matter of loyalties and esthetics. This illustrates the subjectivity of scientific theorizing (see Chapter 1). Neither dissonance theory nor self-perception theory has been handed to us by nature. Both are products of human imagination—creative attempts to simplify and explain what we've observed.

It is not unusual in science to find that a principle, such as "attitudes follow behavior," is predictable from more than one theory. Physicist Richard Feynman (1967) marveled that "one of the amazing characteristics of nature" is the "wide range of beautiful ways" in which we can describe it: "I do not understand the reason why it is that the correct laws of physics seem to be expressible in such a tremendous variety of ways" (pp. 53–55). Like different roads leading to the same place, different sets of assumptions can lead to the same principle. If anything, this *strengthens* our confidence in the principle. It becomes credible not only because of the data supporting it but also because it rests on more than one theoretical pillar.

Dissonance as Arousal

Can we say that one of our theories is better? On one key point, strong support has emerged for dissonance theory. Recall that dissonance is, by definition, an aroused state of uncomfortable tension. To reduce this tension, we supposedly change our attitudes. Self-perception theory says nothing about tension being aroused when our actions and attitudes are not in harmony. It assumes merely that when our attitudes are weak to begin with, we will use our behavior and its circumstances as a clue to those attitudes (like the person who said, "How do I know how I feel until I hear what I say?").

Are conditions that supposedly produce dissonance (for example, making decisions or acting contrary to one's attitudes) actually *arousing?* Clearly yes, providing that the behavior has unwanted consequences for which the person feels responsible (Cooper & Fazio, 1984; Scher & Cooper, 1989). If in the privacy of your closet you say something you don't believe, dissonance will be minimal. But it will be much greater if there are unpleasant results—if someone hears and believes you, if the negative effects are irrevocable rather than something you can take back, and if the person harmed is someone you like. If, moreover, you feel responsible for these consequences—if you can't easily excuse your act because you freely agreed to it and if you could foresee its consequences—then dissonance will be aroused (Figure 4-6). Moreover, the arousal will be detectable as increased perspiration and heart rate (Cacioppo & Petty, 1986; Croyle & Cooper, 1983; Losch & Cacioppo, 1990).

There is a reason why "volunteering" to say or do undesirable things is arousing, suggests Claude Steele (1988). Such acts are embarrassing. They

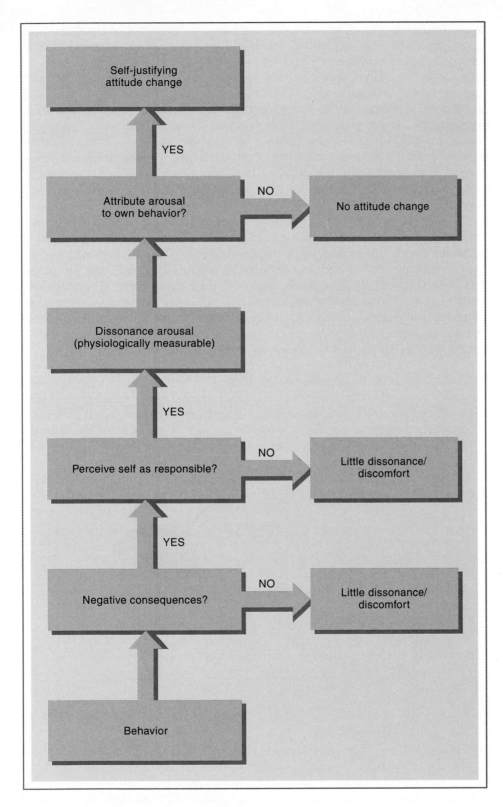

FIGURE 4-6 *A revised version of dissonance theory: the sequence that leads from behavior to attitude change.*

make us feel foolish. They threaten our sense of personal competence and goodness. Justifying our actions and decisions is therefore self-protective; it affirms our sense of integrity and self-worth.

So what do you suppose happens if, after committing a self-contradictory act, we offer people some other way to reaffirm their sense of self-worth, such as by doing a good deed? In several experiments Steele found that, with their self-concepts secure, people felt much less need to justify their acts. Ergo, says Steele, people are aroused by undesirable dissonant behaviors because such acts threaten their positive self-concepts. Had the Chinese in Korea used threats of torture to gain compliance, the POWs would have had less need to justify their acts to themselves. You don't need to feel guilty about, or to justify, forced acts.

So dissonance conditions do indeed arouse tension, especially when they threaten self-worth. But is this arousal necessary for the attitudes-follow-behavior effect? Steele and his colleagues (1981) believe the answer is yes. When drinking alcohol reduces dissonance-produced arousal, the attitudes-follow-behavior effect disappears. In one of their experiments, they induced University of Washington students to write an essay favoring a big tuition increase. The students reduced their resulting dissonance by softening their antituition attitudes—*unless* after writing the unpleasant essay, they drank alcohol, supposedly as part of a beer- or vodka-tasting experiment.

Self-Perceiving When Not Self-Contradicting

So dissonance procedures are arousing, and arousal leads to self-persuasion after acting contrary to one's attitudes. (Indeed, the boost provided by taking an amphetamine that one *thinks* is merely a placebo accentuates the attitude change.) But dissonance theory cannot explain all the findings. When people

People rarely internalize coerced behavior.

"No, Hoskins, you're not going to do it just because I'm telling you to do it. You're going to do it because you believe in it."

© 1988, The New Yorker Magazine, Inc.

■ BEHIND THE SCENES

I have always been fascinated by cognitive dissonance theory's portrayal of people as rationalizers. The idea seems to capture something profoundly important—our relentless interest in explaining ourselves. Yet Festinger's idea about *why* we rationalize seems wrong. My research convinces me that the real goal of rationalization is not consistency but a sense of self-adequacy. We find that people can easily tolerate inconsistency—if they are allowed to affirm their overall worth. Thus it is the war for global self-worth, not the battle against specific inconsistencies, that causes our rationalizations.

CLAUDE STEELE, *Stanford University*

argue a position that is in line with their opinion, although a step or two beyond it, procedures that usually eliminate arousal do not eliminate attitude change (Fazio & others, 1977, 1979). Dissonance theory also does not explain the overjustification effect, since being paid to do what you like to do should not arouse great tension. And what about situations where the action really does not contradict any attitude—when, for example, people are induced to smile or grimace. Here, too, there should be no dissonance. For these cases, self-perception theory has a ready explanation.

In short, it appears that dissonance theory successfully explains what happens when we act contrary to clearly defined attitudes: We feel tension, so we adjust our attitudes to reduce it. Dissonance theory, then, explains attitude *change*. In situations where our attitudes are not well formed, self-perception theory explains attitude *formation*. As we act and reflect, we develop a more readily accessible attitude to guide our future behavior (Fazio, 1987).

■ SUMMING UP

DO ATTITUDES DETERMINE BEHAVIOR?

How do our inner attitudes relate to our external actions? Social psychologists agree that attitudes and actions have a reciprocal relationship, each feeding the other. Popular wisdom stresses the impact of attitudes on action. Surprisingly, our attitudes—usually assessed as our feelings toward some object or person—often poorly predict our actions. Moreover, changing people's attitudes typically fails to produce much change in their behavior. These findings sent social psychologists scurrying to find out why we so often fail to play the game we talk. The answer: Our attitude expressions and our behaviors are each subject to many influences. Our attitudes *will* predict our behavior (1) if these "other influences" are minimized, (2) if the attitude corresponds very closely to the predicted behavior (as in voting studies), and (3) if the attitude is potent (be-

cause something reminds us of it, because the situation subtly activates it, or because we acquired it in a manner that makes it strong). Thus there *is* a connection between what we think and feel and what we do, even if that connection in many situations is looser than we'd like to believe.

DOES BEHAVIOR DETERMINE ATTITUDES?

The attitude-action relation also works in the reverse direction: We are likely not only to think ourselves into action but also to act ourselves into a way of thinking. When we act, we amplify the idea underlying what we have done, especially when we feel responsible for it. Many streams of evidence converge on this principle. The actions prescribed by social roles mold the attitudes of the role players. Research on the foot-in-the door phenomenon reveals that committing a small act (for example, agreeing to do a small favor) later makes people more willing to do a larger one. Actions also affect our moral attitudes: That which we have done we tend to justify as right. Similarly, our racial and political behaviors help shape our social consciousness: We not only stand up for what we believe, we also believe in what we have stood up for.

WHY DO ACTIONS AFFECT ATTITUDES?

Three competing theories explain *why* our actions affect our attitude reports. *Self-presentation theory* assumes that people, especially those who self-monitor their behavior hoping to create a good impression, will adapt their attitude reports to *appear* consistent with their actions. The available evidence confirms that people do adjust their attitude statements out of concern for what other people will think but also shows that some genuine attitude change occurs.

Two theories propose that our actions trigger genuine attitude change. *Dissonance theory* explains this attitude change by assuming that we feel tension after acting contrary to our attitudes or making a difficult decision. To reduce this arousal, we internally justify our behavior. Dissonance theory further proposes that the less external justification we have for an undesirable action, the more we feel responsible for it, and thus the more dissonance arises and attitudes change.

Self-perception theory assumes that when our attitudes are weak, we simply observe our behavior and its circumstances and infer our attitudes. One interesting implication of self-perception theory is the "overjustification effect": Rewarding people to do what they like doing anyway can turn their pleasure into drudgery (if the reward leads them to attribute their behavior to the reward). Evidence supports predictions from both theories, suggesting that each describes what happens under certain conditions.

■ FOR FURTHER READING

Cialdini, R. B. (1988). *Influence: Science and practice* (2d ed.). Glenview, IL: Scott, Foresman/Little, Brown. An engrossing summary of six "weapons of influence" revealed by social-psychological research and exploited in everyday

situations. See, especially, Chapter 3, "Commitment and Consistency: Hobgoblins of the Mind."

Snyder, M. (1987). *Public appearances/Private realities: The psychology of self-monitoring.* New York: Freeman. Describes (1) how people vary in their eagerness to create a good impression in each situation versus being true to themselves whatever the situation and (2) how this "self-monitoring" tendency affects their attitude-behavior consistency, their friendships and romantic relationships, and their jobs and careers.

Zimbardo, P. G., & Leippe, M. R. (1991). *The psychology of attitude change and social influence.* New York: McGraw-Hill. A basic introduction to attitudes, including how they influence, and are influenced by, our actions.

SOCIAL COGNITION AND HUMAN WELL-BEING

If you are a typical college student, you may occasionally feel mildly depressed, dissatisfied with your life, discouraged about the future, sad, lacking appetite and energy, unable to concentrate, perhaps even wondering if life is worth it. Maybe you think disappointing grades have jeopardized your career goals. Perhaps the breakup of a relationship has left you in despair. And maybe your self-focused brooding at such times only worsens your feelings. For some 5 percent of men and twice that many women, life's downtimes are not just temporary blue moods but one or more major depressive episodes that last for weeks without any obvious cause.

Among the many thriving areas of applied social psychology is one that applies research on social cognition (described in Chapters 2 to 4) to such problems as depression. This bridge-building research between social psychology and **clinical psychology** seeks answers to three important questions: (1) As laypeople or as professional psychologists, how can we improve our judgments and predictions about others? (2) How do the ways in which we think about ourselves and others feed such problems as depression, loneliness, anxiety, and even physical illness? (3) How can these maladaptive thought patterns be reversed? In this chapter we explore some answers by examining social psychology's contribution to improving clinical *judgment and prediction*, to the *understanding of disorders*, such as depression, and to their *treatment*.

Clinical psychology:
The study, assessment, and treatment of people with psychological difficulties.

■ MAKING CLINICAL JUDGMENTS

Clinical psychologists struggle to make accurate judgments, recommendations, and predictions in any number of real situations: Is Susan suicidal? Should John be committed to a mental hospital? If released, will Tom be a homicide risk?

But psychologists are not the only ones who analyze people. All of us, all the time, are forming impressions of others and analyzing their behavior. Why did she act that way toward me? Is he as weird as he looks? If I criticize her, how will she take it? Employers and personnel managers scrutinize people during interviews. They select certain questions, notice particular things, and file some things away in memory. The net result is their impression and their intuitive prediction of how competent and reliable the person is likely to be.

Such judgments illustrate principles introduced in Chapter 2. By alerting mental health workers, interviewers, and others to how people form both impressions and *mis*impressions, they help avert misjudgments and perhaps fatal mistakes. Let's begin by identifying some of the ways in which personality judgments go astray.

"To free a man of error is to give, not to take away. Knowledge that a thing is false is a truth."
Arthur Schopenhauer, 1788–1860

AMATEUR PSYCHOLOGIZING

Judging Others

Several tendencies distort our social judgments. For example, sometimes we miss what has influenced our judgments of others. Richard Nisbett and Nancy Bellows (1977) had University of Michigan students rate a female job applicant. In her folder, some of the students read that the woman (1) was physically

attractive, (2) had an excellent academic record, (3) had spilled coffee during her interview, (4) had been in a car accident, and/or (5) would later be introduced to them. When later they were asked how much each of the five factors had influenced their ratings, the students were surprisingly ignorant of how much each factor had swayed them. For example, the students expressed more liking for interviewees who spilled coffee yet denied that the coffee spilling had influenced them.

Our social judgments may also be clouded by implicit personality theories: "Salespeople are extroverted," "Show people are egocentric," "Scholars are reclusive." Once formed, theories and stereotypes may perpetuate themselves. Chapter 11 will show how easily we slip into overestimating the uniformity of people we group within a particular category (football players, racial minorities, and so forth).

Judging Ourselves

We also form impressions of ourselves. Consider the **Barnum effect**—named in honor of circus entrepreneur P. T. Barnum, who said, "There's a sucker born every minute," and remarked that a good circus had a "little something for everybody." How well does the following description fit you?

> You have a strong need for other people to like you and for them to admire you. You have a tendency to be critical of yourself. You have a great deal of unused energy which you have not turned to your advantage. While you have some personality weaknesses, you are generally able to compensate for them. Your sexual adjustment has presented some problems for you. Disciplined and controlled on the outside, you tend to be worrisome and insecure inside. At times you have serious doubts as to whether you have made the right decision or done the right thing. You prefer a certain amount of change and variety and become dissatisfied when hemmed in by restrictions and limitations. You pride yourself on being an independent thinker and do not accept other opinions without satisfactory proof. You have found it unwise to be too frank in revealing yourself to others. At times you are extroverted, affable, sociable, while at other times you are introverted, wary, and reserved. Some of your aspirations tend to be pretty unrealistic. (Forer, 1949)

Barnum effect:
The tendency to accept as valid favorable descriptions of one's personality that are generally true of everyone, such as those found in astrology books and horoscopes.

By exploiting the Barnum effect, this palm reader at a Winnipeg folk festival may impress, even astonish, his client.

In many experiments, researchers have shown people descriptions like this one, constructed from a horoscope book. When told the description is true of most individuals, people usually say it fits so-so. When told the description is designed specifically for them on the basis of psychological tests or astrological data, they will say the description is very accurate (McKelvie, 1990). In fact, given a choice between a fake description and an actual test-based description of themselves, people usually judge the fake as equally or more accurate (Dickson & Kelly, 1985; Standing & Keays, 1986).

That helps explain why people as prominent as Nancy and Ronald Reagan take astrologers' opinions seriously, despite overwhelming evidence that astrology doesn't work (birth dates don't correlate with traits; astrologers can't beat chance when trying to identify someone of a given birth date from a lineup of personality descriptions; and people can't recognize their own horoscope in a set of horoscopes—Carlson, 1985).

People are more likely to accept false results that supposedly come from projective tests (like the Rorschach inkblots) than from an objective personality test. And having accepted the phony results, they express increased confidence in psychological testing and the clinician's skill. Richard Petty and Timothy Brock (1979) found that people also live up to their psychological profile. They told some Ohio State University students, "You are an open-minded person. You have the ability to see both sides of an issue." These students later wrote a fairly balanced assessment of two issues. Students told, "You are not a wishy-washy person. . . . You can take a strong stand on one side and defend it," wrote one-sided assessments of the issues.

Graphologists—people who make predictions from handwriting samples—similarly fail to surpass chance when trying to guess people's occupations, based on their handwriting.
(Neter & Ben-Shakhar, 1989)

FIGURE 5-1 *"If it's positive, it sounds like me (and my best friend)." Subjects judged that favorable paragraphs were not especially accurate descriptions of their casual acquaintances. They perceived such paragraphs as more accurate descriptions of their good friends and even better descriptions of themselves.*
(From Johnson & others, 1985.)

Finally, people see these Barnum descriptions as more true of themselves than of people in general, especially when the description is positive. Within reason, the more favorable a description, the more people believe it and the more they perceive it as unique to themselves (Ruzzene & Noller, 1986; Schlenker & others, 1979; Shavit & Shouval, 1980). Joel Johnson and his colleagues (1985) report that this self-serving bias can occur without deception. His subjects saw negative statements as no more applicable to themselves than to anyone else. But as Figure 5-1 shows, they judged paragraphs built of positive descriptions ("finds it easy to be open and demonstrative") to be much more true of them than of casual acquaintances.

PROFESSIONAL PSYCHOLOGIZING

Professional clinical judgment is also social judgment, subject to its principles (Leary & Maddux, 1987). The findings of social psychology experiments thus raise some disconcerting questions for psychiatry and clinical psychology. Regardless of whether a particular diagnosis has any validity, the recipient often stands in awe of the clinician and believes it. The Barnum effect suggests a recipe for impressing clients: Give people a subjective test; make them think that its interpretation is unique to them; and then, drawing upon things true of most people, tell them something that is positive, though somewhat ambiguous. This approach should increase clients' faith in your clinical skills, even if what they have been told has no diagnostic validity. Professional judgment is also vulnerable to illusory correlations, overconfidence bred by hindsight, and self-confirming diagnoses.

Illusory Correlations

Consider the following court transcript in which a seemingly confident psychologist (PSY) is being questioned by an attorney (ATT):

ATT: You asked the defendant to draw a human figure?

PSY: Yes.

ATT: And this is the figure he drew for you? What does it indicate to you about his personality?

PSY: You will note this is a rear view of a male. This is very rare, statistically. It indicates hiding guilt feelings, or turning away from reality.

ATT: And this drawing of a female figure, does it indicate anything to you; and, if so, what?

PSY: It indicates hostility toward women on the part of the subject. The pose, the hands on the hips, the hard-looking face, the stern expression.

ATT: Anything else?

PSY: The size of the ears indicates a paranoid outlook, or hallucinations. Also, the absence of feet indicates feelings of insecurity. (Jeffery, 1964)

The assumption here, as in so many clinical judgments, is that test results reveal something important. Do they? There is a simple way to decide. Have one clinician administer and interpret the test. Have another clinician assess the same person's symptoms. And repeat this process over many people. The proof is in the pudding: Are test outcomes indeed correlated with reported symptoms? Some tests are indeed predictive. With other tests, such as the Draw-a-Person test above, the correlation is far weaker than its users suppose.

Why, then, do clinicians continue to express confidence in such uninformative tests?

Pioneering experiments by Loren Chapman and Jean Chapman (1969, 1971) help us see why. They invited both college students and professional clinicians to study patients' test performances and diagnoses. If the students or clinicians expected a particular association, they generally were able to perceive it, regardless of whether the data were supportive. For example, clinicians who believed that suspicious people draw peculiar eyes on the Draw-a-Person test perceived such a relationship—even when shown cases in which suspicious people drew peculiar eyes *less* often than nonsuspicious people. To believe is to see. Believing that a relationship existed between two things, they were more likely to notice confirming than disconfirming instances.

In fairness to clinicians, illusory thinking also occurs among political analysts, historians, sportscasters, personnel directors, stockbrokers, and many other professionals, including the research psychologists who point them out. As a researcher I have often been blind to the shortcomings of my theoretical analyses. I so eagerly presume that my idea of truth is *the* truth that no matter how hard I try, I cannot see my own error. This is evident in the editorial review process that precedes any research publication. During the last 25 years I have read dozens of reviews of my own manuscripts and have been a reviewer for dozens of others. My experience is that it is far easier to spot someone else's sloppy thinking than to perceive my own.

"No one can see his own errors."
Psalms 19:12

Hindsight and Overconfidence

If someone we know commits suicide, how do we react? One common reaction is to think that we, or those close to the person, should have been able to

Illusory thinking is human—and therefore an aspect of most professions. Because random data contain more streaks than people expect, sportscasters may overinterpret "slumps" and coincidences.

Hindsight: When babysitter Laurie Dann shot and killed several schoolchildren in Winnetka, Illinois, in 1988, many psychologists said experts "should have known" she might do this based on her psychological history.

predict and therefore to prevent the suicide. In hindsight, we can see the suicidal signs and the pleas for help: "We should have known." Indeed, in one experiment those who were given a summary of a case and told the person committed suicide were more likely to say they "would have expected" the suicide than were those given the same case information without the suicide being mentioned (Goggin & Range, 1985). Moreover, if they were told of the suicide, their reactions to the victim's family were more negative. After a tragedy, an I-should-have-known-it-all-along phenomenon can leave family, friends, and therapists feeling guilty. When a client becomes violent, a therapist may, in retrospect, seem negligent for not having foreseen the danger and taken appropriate measures. Perhaps if this phenomenon was more widely understood, people could be more accepting of themselves and others in such times.

Hindsight bias also afflicts professionals' judgments, as Hal Arkes and his colleagues (1988) discovered when they asked neuropsychologists to diagnose a man described as suffering a tremor and deteriorating memory. For each of three groups, one of three possible diagnoses was said to be correct. Given a supposed diagnosis, nearly half the neuropsychologists thought they, too, would have made the same diagnosis. Arkes found a way to minimize hindsight bias: Ask the professionals to give a reason why one of the other diagnoses *might* have been correct.

David Rosenhan (1973) and seven of his Stanford University associates provided a striking example of potential error in after-the-fact explanations. To test mental health workers' clinical insights, they each made an appointment with a different mental hospital admissions office and complained of "hearing voices." Apart from giving false names and vocations, they reported their life histories and emotional states honestly and exhibited no further symptoms. Most got diagnosed as schizophrenic and remained hospitalized for two to three weeks. The clinicians then searched for early incidents in the pseudopatients' life histories and hospital behavior that "confirmed" and "explained"

"Undergraduate psychology can, and I believe should, seek to liberate the student from ignorance, but also from the arrogance of believing we know more about ourselves and others than we really do."
David L. Cole (1982)

the diagnosis. Rosenhan tells of one pseudo-patient who truthfully explained to the interviewer that he

> had a close relationship with his mother but was rather remote from his father during his early childhood. During adolescence and beyond, however, his father became a close friend, while his relationship with his mother cooled. His present relationship with his wife was characteristically close and warm. Apart from occasional angry exchanges, friction was minimal. The children had rarely been spanked.

The interviewer, "knowing" the person suffered from schizophrenia, explained the problem this way:

> This white 39-year-old male . . . manifests a long history of considerable ambivalence in close relationships, which begins in early childhood. A warm relationship with his mother cools during his adolescence. A distant relationship to his father is described as becoming very intense. Affective stability is absent. His attempts to control emotionality with his wife and children are punctuated by angry outbursts and, in the case of the children, spankings. And while he says that he has several good friends, one senses considerable ambivalence embedded in those relationships also.

Rosenhan later told some mental hospital staff members (who had heard about his controversial experiment but doubted such mistakes could occur in their hospital) that during the next three months one or more pseudo-patients would seek admission to their hospital. After the three months, he asked the staff to guess which of the 193 patients admitted during that time were really pseudo-patients. Of the 193 new patients, 41 were accused by at least one staff member of being normal. Actually, there were none.

Self-Confirming Diagnoses

So far we've seen that mental health workers sometimes perceive illusory correlations and that hindsight explanations are often questionable. A third problem with clinical judgment is that people may also supply information that fulfills clinician's expectations. In a clever series of experiments at the University of Minnesota, Mark Snyder (1984), in collaboration with William Swann and others, gave interviewers some hypotheses to test concerning individuals' traits. To get a feel for their experiments, imagine yourself on a blind date with someone who has been told that you are an uninhibited, outgoing person. To see whether this is true, your date slips questions into the conversation, such as, "Have you ever done anything crazy in front of other people?" As you answer such questions, will your date meet a different "you" than if you were probed for instances when you were shy and retiring?

Snyder and Swann found that people often test for a trait by looking for information that will confirm it. If they are trying to find out if someone is an extrovert, they often solicit extroversion ("What would you do if you wanted to liven things up at a party?"). Testing for introversion, they are more likely to ask, "What factors make it hard for you to really open up to people?" Such questioning led those being tested for extroversion to behave more sociably and those being tested for introversion to appear more shy and reserved.

At Indiana University, Russell Fazio and his colleagues (1981) reproduced this finding and also discovered that those asked the "extroverted questions" later perceived themselves as actually more outgoing than those asked the introverted question. Moreover, they really became noticeably more outgoing.

An accomplice of the experimenter later met each subject in a waiting room and 70 percent of the time correctly guessed from the subject's outgoingness which condition the subject had come from. When given the structured list of questions to choose from, even experienced psychotherapists prefer the extroverted questions when testing for extroversion and unwittingly trigger extroverted behavior among their interviewees (Dallas & Baron, 1985; Snyder & Thomsen, 1988). Here, then, is more evidence that our beliefs may generate their own confirmation.

In later experiments, Snyder and his colleagues (1982) tried to get people to search for behaviors that would *disconfirm* the trait they were testing. In one experiment, they told the interviewers "it is relevant and informative to find out ways in which the person . . . may not be like the stereotype." In another experiment Snyder (1981a) offered "$25 to the person who develops the set of questions that tell the most about . . . the interviewee." Still, people resisted choosing "introverted" questions when testing for extroversion. This illustrates the confirmation bias discussed in Chapter 2: When testing our beliefs, we seek information that will verify them before we seek disconfirming information.

These provocative findings prompted follow-up studies that revealed their limits. When ordinary people or psychotherapists are invited to make up *their own* questions to test for extroversion, they are less likely to display the confirmation bias (Dallas & Baron, 1985; Trope & others, 1984). Many of their questions seem quite appropriate for distinguishing extroverted from introverted people. Nevertheless, when interviewers have very definite ideas of their own, these ideas *will* influence the questions they ask (Lalljee & others, 1984; Leyens, 1989; Swann & Giuliano, 1987). Recall, for example, how teachers questioned the young "cyranoids" described in Chapter 1.

Thus, say researchers, though our primary goal is to ask informative questions, our questions are often slanted by a secondary desire to get a yes answer to confirm our hypotheses (Devine & others, 1990; Slowiaczek & others, 1991).

Based on Snyder's experiments, can you see why the behaviors of people undergoing psychotherapy come to fit the theories of their therapists (Whitman & others, 1963)? When a psychologist and a psychiatrist, Harold Renaud and Floyd Estess (1961), conducted life history interviews of 100 healthy, successful adult men, they were startled to discover that their subjects' childhood experiences were loaded with "traumatic events," tense relations with certain people, and bad decisions by their parents—the very factors usually used to explain psychiatric problems. When Freudian therapists go fishing for traumas in early childhood experiences, they will often find their hunches confirmed. Thus, surmises Snyder (1981a):

> The psychiatrist who believes (erroneously) that adult gay males had bad childhood relationships with their mothers may meticulously probe for recalled (or fabricated) signs of tension between their gay clients and their mothers, but neglect to so carefully interrogate their heterosexual clients about their maternal relationships. No doubt, any individual could recall some friction with his or her mother, however minor or isolated the incidents.

Clinical versus Statistical Prediction

Given these hindsight- and diagnosis-confirming tendencies, it will come as no surprise that most clinicians and interviewers express more confidence in their

"As is your sort of mind, So is your sort of search: You'll find What you desire."
Robert Browning (1812–1889)

intuitive assessments than in statistical data. Yet when researchers pit statistical prediction (as when predicting graduate school success using a formula that includes grades and aptitude scores) against intuitive prediction, the former usually wins. Statistical predictions are indeed unreliable, but human intuition—even expert intuition—is even more unreliable (Dawes & others, 1989; Faust & Ziskin, 1988; Meehl, 1954).

Three decades after demonstrating the superiority of statistical over intuitive prediction, Paul Meehl (1986) found the evidence stronger than ever:

> There is no controversy in social science which shows [so many] studies coming out so uniformly in the same direction as this one. . . . When you are pushing 90 investigations, predicting everything from the outcome of football games to the diagnosis of liver disease and when you can hardly come up with a half dozen studies showing even a weak tendency in favor of the clinician, it is time to draw a practical conclusion. . . .
>
> Surely we all know that the human brain is poor at weighing and computing. When you check out at a supermarket, you don't eyeball the heap of purchases and say to the clerk, "Well it looks to me as if it's about $17.00 worth; what do you think?"

"The effect of Meehl's work on clinical practice in the mental health area can be summed up in a single word: Zilch. He was honored, elected to the presidency of [the American Psychological Association] at a very young age in 1962, recently elected to the National Academy of Sciences, and ignored." Robyn M. Dawes (1989)

So, why do so many clinicians continue to interpret Rorschach inkblot tests and offer intuitive predictions about parolees, suicide risks, and likelihood of child abuse? Partly out of sheer ignorance, says Meehl, but also partly out of "mistaken conceptions of ethics":

> If I try to forecast something important about a college student, or a criminal, or a depressed patient by inefficient rather than efficient means, meanwhile charging this person or the taxpayer 10 times as much money as I would need to achieve greater predictive accuracy that is not a sound ethical practice. That it feels better, warmer, and cuddlier to me as predictor is a shabby excuse indeed.

Such words are shocking. Do Meehl and the other researchers underestimate our skills of intuition? To see why such findings are apparently true, consider the assessment of human potential by graduate admissions interviewers. University of Oregon researcher Robyn Dawes (1976) illustrates why statistical prediction is so often superior to an interviewer's intuition when predicting certain outcomes such as graduate school success:

> What makes us think that we can do a better job of selection by interviewing (students) for a half hour, than we can by adding together relevant (standardized) variables, such as undergraduate GPA, GRE score, and perhaps ratings of letters of recommendation. The most reasonable explanation to me lies in our overevaluation of our cognitive capacity. And it is really cognitive conceit. Consider, for example, what goes into a GPA. Because for most graduate applicants it is based on at least 3½ years of undergraduate study, it is a composite measure arising from a minimum of 28 courses and possibly, with the popularity of the quarter system, as many as 50. . . . Yet you and I, looking at a folder or interviewing someone for a half hour, are supposed to be able to form a better impression than one based on 3½ years of the cumulative evaluations of 20–40 different professors. . . . Finally, if we do wish to ignore GPA, it appears that the only reason for doing so is believing that the candidate is particularly brilliant even though his or her record may not show it. What better evidence for such brilliance can we have than a score on a carefully devised aptitude test? Do we really think we are better equipped to assess such aptitude than is the Educational Testing Service, whatever its faults?

Interviewers are prone to over-confidence in intuitive assessments based on brief conversations.

IMPLICATIONS

So when forming personal impressions, we do well to remember that we often are:

- Unaware of what influences our assessments of others
- Prone to perceive people in line with our stereotypes
- Susceptible to the Barnum effect

Also, the evidence suggests that although psychotherapy often helps troubled individuals (Smith & others, 1980; Elkin, 1986), there can be problems with clinical judgments. Professional clinicians:

- Can easily convince clients of worthless diagnoses
- Are frequently the victims of illusory correlation
- Are too readily convinced of their own after-the-fact analyses
- Often fail to appreciate how erroneous diagnoses can be self-confirming

The implications for mental health workers are more easily stated than practiced: Be mindful that clients' verbal agreement with what you say does not prove its validity. Beware of the tendency to see relationships that you expect to see or that are supported by striking examples readily available in your memory. Recognize that hindsight is seductive: It can lead you to feel overconfident and sometimes to judge yourself too harshly for not having foreseen outcomes. Guard against the tendency to ask questions that assume your preconceptions are correct; consider opposing ideas and test them too.

This chapter's research on illusory thinking has implications not only for

"'I beseech ye in the bowels of Christ, think that ye may be mistaken.' I shall like to have that written over the portals of every church, every school, and every courthouse, and, may I say, of every legislative body in the United States."
Judge Learned Hand, 1951, echoing Oliver Cromwell's 1650 plea to the Church of Scotland

mental health workers but for all psychologists. What Lewis Thomas (1978) has said of biology may as justly be said of psychology:

> The solidest piece of scientific truth I know of, the one thing about which I feel totally confident, is that we are profoundly ignorant about nature. Indeed, I regard this as the major discovery of the past 100 years of biology. . . . It is this sudden confrontation with the depth and scope of ignorance that represents the most significant contribution of 20th century science to the human intellect. We are, at last, facing up to it. In earlier times, we either pretended to understand how things worked or ignored the problem, or simply made up stories to fill the gaps.

"One thing I have learned in a long life: that all our science, measured against reality, is primitive and childlike—and yet it is the most precious thing we have."
Albert Einstein, in B. Hoffman & H. Dukes, *Albert Einstein: Creator and Rebel,* 1973

"Science is the great antidote to the poison of enthusiasm and superstition."
Adam Smith, *Wealth of Nations,* 1776

Psychology has crept only a little way across the edge of insight into our human condition. Ignorant of their ignorance, some psychologists invent theories to fill the gaps in understanding. Intuitive observation seems to support these theories, even if they are mutually contradictory. Research on illusory thinking therefore leads us to a new humility concerning the truth of our unchecked speculation. It reminds research psychologists why they must test their preconceptions before propounding them as truth. To seek the hard facts, even if they threaten cherished illusions, is the goal of every science.

I am *not* arguing that the scientific method can answer all human questions. There are questions which it cannot address and ways of knowing which it cannot capture. But science *is* one means for examining claims about nature, human nature included. Propositions that imply observable results are best evaluated by systematic observation and experiment—which is the whole point of social psychology. We also need inventive genius, or we test only trivialities. But whatever unique and enduring insights psychology can offer will be hammered out by research psychologists sorting through competing

■ VIEWPOINTS: A PHYSICIAN LOOKS AT SOCIAL PSYCHOLOGY

Reading this book helps me understand the human behaviors I observe in my work as a cancer specialist and as medical director of a large staff of physicians. A few examples:

Reviews of medical records illustrate the "I-knew-it-all-along phenomenon." Physician reviewers who assess the medical records of their colleagues often believe, in hindsight, that problems such as cancer or appendicitis should clearly have been recognized and treated much more quickly. Once you know the correct diagnosis, it's easy to look back and interpret the early symptoms accordingly.

For many physicians I have known, the intrinsic motives behind their entering the profession—to help people, to be scientifically stimulated—soon become "overjustified" by the high pay. Before long, the joy is lost. The extrinsic rewards become the reason to practice, and the physician, having lost the altruistic motives, works to increase "success," measured in income.

"Self-serving bias" is ever present. We physicians gladly accept personal credit when things go well. When they don't—when the patient is misdiagnosed or doesn't get well or dies—we attribute the failure elsewhere. We were given inadequate information or the case was ill-fated from the beginning.

I also observe many examples of "belief perseverance." Even when presented with the documented facts about, say, how AIDS is transmitted, people will strangely persist in wrongly believing that it is just a "gay" disease or that they should fear catching it from mosquito bites. It makes me wonder: How can I more effectively persuade people of what they need to know and act upon?

Indeed, as I observe medical attitudes and decision making I feel myself submerged in a giant practical laboratory of social psychology. To understand the goings-on around me, I find social psychological insights invaluable and would strongly advise premed students to study the field. (Burton F. VanderLaan, Chicago, Illinois.)

claims. Science always involves an interplay between intuition and rigorous test, between creative hunch and skepticism.

■ SOCIAL COGNITION IN PROBLEM BEHAVIORS

One of psychology's most intriguing research frontiers concerns the cognitive processes that accompany psychological disorders. What are the attributions, expectations, and other thought patterns of troubled people? In the case of depression, the most heavily researched disorder, dozens of new studies are providing some answers.

SOCIAL COGNITION AND DEPRESSION

As we all know from experience, depressed people are negative thinkers. They view life through dark-colored glasses. With seriously depressed people—those who are feeling worthless, lethargic, disinterested in friends and family, and unable to sleep or eat normally—the negative thinking becomes self-defeating. Their intensely pessimistic outlook leads them to magnify bad experiences and minimize good ones. One depressed young woman illustrates: "The real me is worthless and inadequate. I can't move forward with my work because I become frozen with doubt" (Burns, 1980, p. 29).

Distortion or Realism?

Are all depressed people unrealistically negative? To find out, Lauren Alloy and Lyn Abramson (1979) studied college students who were either not depressed or mildly depressed. They had the students observe whether their pressing a button was linked with a light coming on. Surprisingly, the depressed students were quite accurate in estimating their degree of control. It was the nondepressives, whose judgments were distorted, who exaggerated the extent of their control.

This phenomenon of **depressive realism,** nicknamed the "sadder-but-wiser effect," shows up in many ways (Alloy & others, 1990; Dobson & Franche, 1989). Shelley Taylor (1989, p. 214) explains:

> Normal people exaggerate how competent and well liked they are. Depressed people do not. Normal people remember their past behavior with a rosy glow. Depressed people [unless severely depressed] are more evenhanded in recalling their successes and failures. Normal people describe themselves primarily positively. Depressed people describe both their positive and negative qualities. Normal people take credit for successful outcomes and tend to deny responsibility for failure. Depressed people accept responsibility for both success and failure. Normal people exaggerate the control they have over what goes on around them. Depressed people are less vulnerable to the illusion of control. Normal people believe to an unrealistic degree that the future holds a bounty of good things and few bad things. Depressed people are more realistic in their perceptions of the future. In fact, on virtually every point on which normal people show enhanced self-regard, illusions of control, and unrealistic visions of the future, depressed people fail to show the same biases. "Sadder but wiser" does indeed appear to apply to depression.

Depressive realism: The tendency of mildly depressed people to make accurate rather than self-serving judgments, attributions, and predictions.

Underlying the thinking of depressed people is their attributions of responsibility. Consider: If you fail an exam and blame yourself, you may conclude that you are stupid or lazy, and feel depressed. If you attribute the failure to an unfair exam or to other circumstances beyond your control, you are more likely to feel angry. In over 100 studies involving 15,000 subjects (Sweeney & others, 1986), depressed people have been more likely than nondepressed people to exhibit a negative "attributional style" (Figure 5-2). They are more likely to attribute failure and setbacks to causes that are *stable* ("It's going to last forever"), *global* ("It's going to affect everything I do"), and *internal* ("It's all my fault"). The result of this pessimistic, overgeneralized, self-blaming thinking, say Abramson and her colleagues (1989), is a depressing sense of hopelessness.

Compared to this depressive attributional style, self-serving illusions are adaptive. If, in hindsight, this sounds obvious, how much more obvious would sound the familiar pronouncement that mental health is based on *accurate* perceptions of ourselves and the world. After amassing the available research, Shelley Taylor and Jonathan Brown (1988) say that mental health derives, rather, from "overly positive self-evaluations, exaggerated perceptions of control or mastery, and unrealistic optimism." Thanks to our positive illusions, we are happier, more productive, and less self-preoccupied than are depressed realists.

"Life is the art of being well deceived."
William Hazlitt, 1778–1830

Positive illusions can also breed the problems noted in Chapters 3, such as the false optimism that ignores real perils and the "I'm-better-than-you" attitude that underlies social conflicts and prejudice. Still, we can understand how La Rochefoucauld could surmise "that Nature, which has so wisely constructed our bodies for our welfare, gave us pride to spare us the painful knowledge of our shortcomings" (*Maxims*, 1665). Even depressed people—though especially those headed toward recovery—compensate for their negative self-concepts with positive views of certain of their traits (Pelham, 1991).

FIGURE 5-2 *Depressive attributional style. Depression is linked with a negative, pessimistic way of explaining and interpreting failures.*

Is Negative Thinking a Cause or a Result of Depression?

The cognitive accompaniments of depression raise a chicken-and-egg question: Do depressed moods cause negative thinking, or does negative thinking cause depression?

■ BEHIND THE SCENES

As graduate students we were shocked to discover that the popular and clinical lore that depressed people distort reality had never been tested. We were further surprised when our own studies revealed that nondepressed people often distort reality—in an optimistic direction. This phenomenon of depressive realism—what we call the "sadder but wiser effect"—makes us wonder: Does realism about oneself and one's world make people more vulnerable to depression? Or is realism a consequence of depression?

LAUREN ALLOY, *Temple University*
LYN ABRAMSON, *University of Wisconsin*

Depressed Moods Cause Negative Thinking

Without doubt, our moods color our thinking. To West Germans enjoying their team's World Cup soccer victory (Schwarz & others, 1987) and to Australians emerging from a heartwarming movie (Forgas & Moylan, 1987), people seem good-hearted, life seems wonderful. In a happy mood, we find the world seems friendlier, decisions come more easily, good news more readily comes to mind (Johnson & Tversky, 1983; Isen & Means, 1983; Stone & Glass, 1986). When we *feel* happy, we *think* happy and optimistic thoughts. *Currently* depressed people recall their parents as having been rejecting and punitive. But *formerly* depressed people recall their parents in the same positive terms as do never-depressed people (Lewinsohn & Rosenbaum, 1987).

Let our mood turn gloomy, and our thoughts switch onto a different track. Off come the rose-colored glasses; on come the dark glasses. Now the bad mood primes our recollections of negative events (Bower, 1987; Johnson & Magaro, 1987). Our relationships seem to sour, our self-image takes a dive, our hopes for the future dim, people's behavior seems more sinister (Brown & Taylor, 1986; Mayer & Salovey, 1987).

Imagine yourself in an experiment by Joseph Forgas and his colleagues (1984) that used hypnosis to put you in a good or bad mood and then had you watch a videotape (made the day before) of yourself talking with someone. If made to feel happy, you feel pleased with what you see, and you are able to detect many instances of your poise, interest, and social skill. If put in a bad mood, viewing the same tape seems to reveal a quite different you—one who is frequently stiff, nervous, and inarticulate (Figure 5-3). Given how your mood colors your judgments, you feel relieved at how things brighten when the experimenter switches you to a happy mood before leaving the experiment. Curiously, note Michael Ross and Garth Fletcher (1985), we don't attribute our changing perceptions to our mood shifts. Rather, the world really seems different, depending on our mood.

The effects of a depressed mood are also behavioral. The person who is withdrawn, glum, and complaining does not elicit joy and warmth in others.

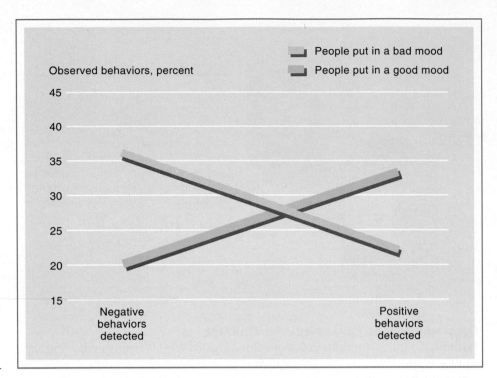

FIGURE 5-3 *A temporary good or bad mood strongly influenced people's ratings of their videotaped behavior. Those in a bad mood detected far fewer positive behaviors.*
(Forgas & others, 1984.)

Stephen Strack and James Coyne (1983) found that depressed people were realistic in thinking that others didn't appreciate their behavior. Depressed behavior can trigger hostility, anxiety, and even reciprocal depression in others. College students who have depressed roommates tend to be a little depressed themselves (Burchill & Stiles, 1988; Howes & others, 1985; Sanislow & others, 1989). Depressed people are therefore at risk for being divorced, fired, or shunned, thus magnifying their depression (Coyne & others, 1991; Gotlib & Lee, 1989; Sacco & Dunn, 1990). They may also seek out those whose unfavorable views of them verify, and further magnify, their low self-image (Swann & others, 1991).

Does Negative Thinking Cause Depression?
So being depressed has cognitive and behavioral effects. Does it also have cognitive origins? It's perfectly normal to feel depressed over a *major* loss, such as losing a job, suffering a death in the family, or being rejected or abused. But why are some people so readily depressed by *minor* stresses? The results have been mixed, because negative thinking tends to wax and wane with depression (Barnett & Gotlib, 1988; Kuiper & Higgins, 1985). But new evidence suggests that a negative attributional style contributes to depressive reactions. Colin Sacks and Daphne Bugental (1987) asked some young women to get acquainted with a stranger who sometimes acted cold and unfriendly, creating an awkward social situation. Unlike optimistic women, those with a pessimistic explanatory style—who characteristically offer stable, global, and internal attributions for bad events—reacted to the social failure by becoming more depressed. Moreover, they then behaved more antagonistically toward the next person they met. Their negative thinking had predisposed a negative (depressed) mood response which predisposed negative behavior.

Outside the laboratory, studies of children, teenagers, and adults confirm that those with the pessimistic explanatory style are more likely to become depressed when bad things happen (Alloy & Clements, 1991; Brown & Siegel, 1988; Nolen-Hoeksema & others, 1986). If you are predisposed to see negative events—money problems, bad grades, social rejections—as uncontrollable, you are more likely to get depressed.

Researcher Peter Lewinsohn and his colleagues (1985) have assembled these findings into a coherent psychological understanding of depression. In their view, the negative self-image, attributions, and expectations of a depressed person are an essential link in a vicious cycle that is triggered by negative experience—perhaps academic or vocational failure, or family conflict, or social rejection (Figure 5-4). In those vulnerable to depression, such stresses trigger brooding, self-focused, self-blaming thoughts (Pyszczynski & others, 1991; Wood & others, 1990a,b). Such ruminations create a depressed mood that drastically alters the way a person thinks and acts, which then fuels further negative experiences, self-blame, and depressed mood. Depression is therefore *both* a cause and a consequence of negative cognitions.

Martin Seligman (1988) believes that self-focus and self-blame help explain the near-epidemic levels of depression in America today. Compared to 50 years ago, rates of ''unipolar'' depression (the type most commonly experienced) have risen tenfold. Seligman believes that the decline of religion and family, plus the growth of the individualist ''you can do it'' attitude, breeds hopelessness and blame when things don't go well. Failed courses, careers, and marriages produce despair when we stand alone, with nothing and no one to fall back on. If, as a macho *Fortune* ad declared, you can ''make it on your own,'' on ''your own drive, your own guts, your own energy, your own ambition,'' then whose fault is it if you *don't* make it on your own?

These insights into the thinking style linked with depression have prompted social psychologists to study thinking patterns associated with other problems. How do those who are plagued with excessive loneliness, shyness, or substance abuse view themselves? How well do they recall their successes and

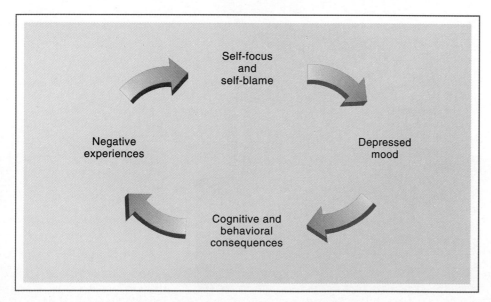

FIGURE 5-4 *The vicious cycle of depression.*

their failures? To what do they attribute their ups and downs? Is their attention focused on themselves or on others? Here are some of the emerging answers.

SOCIAL COGNITION AND LONELINESS

If depression is the common cold of psychological disorders, then loneliness is the headache. Loneliness, whether chronic or temporary, is a painful awareness that our social relationships are less numerous or meaningful than we desire. Jenny de Jong-Gierveld (1987) observed in her study of Dutch adults that unmarried and unattached people are more likely to feel lonely. This prompted her to speculate that the modern emphasis on individual fulfillment and the depreciation of marriage and family life may be "loneliness-provoking" (as well as depression-provoking).

But loneliness need not coincide with aloneness. One can feel lonely in the middle of a party. And one can be utterly alone—as I am while writing these words in the solitude of an isolated turret office at a British university 5000 miles from home—without feeling lonely. To feel lonely is to feel excluded from a group, unloved by those around you, unable to share your private concerns, or different and alienated from those in your surroundings (Beck & Young, 1978; Davis & Franzoi, 1986). Adolescents experience such feelings more commonly than do adults. When beeped by an electronic pager at various times during a week and asked to record what they were doing and how they felt, adolescents more often than adults reported feeling lonely when alone (Larson & others, 1982). Males and females feel lonely under somewhat different circumstances—males when isolated from group interaction, and

To feel lonely is to feel excluded from a group, unloved by those around you, or unable to share your private concerns.

females when deprived of close one-to-one relationships (Berg & McQuinn, 1988; Stokes & Levin, 1986).

Like depressed people, chronically lonely people seem caught in a vicious cycle of self-defeating social cognitions and social behaviors. They have some of the negative attributional style of the depressed; they blame themselves for their poor social relationships and see most things as beyond their control (Anderson & Riger, 1991; Snodgrass, 1987). Moreover, they perceive others in negative ways. When paired with a stranger of the same sex or with a first-year college roommate, lonely students are more likely to perceive the other person negatively (Jones & others, 1981; Wittenberg & Reis, 1986).

These negative views may both reflect and color the lonely person's experience. Lonely people often do find it hard to introduce themselves, make phone calls, and participate in groups (Rook, 1984; Spitzberg & Hurt, 1987). They tend to be self-conscious and low in self-esteem (Check & Melchior, 1990; Vaux, 1988). When talking with a stranger, they spend more time talking about themselves and take less interest in their conversational partners than do nonlonely people (Jones & others, 1982). After such conversations, the new acquaintances often come away with more negative impressions of the lonely people (Jones & others, 1983). Believing in their social unworthiness and feeling pessimistic about others inhibit lonely people from acting to reduce their loneliness.

SOCIAL COGNITION AND SOCIAL ANXIETY

Being interviewed for a much-wanted job, dating someone for the first time, stepping into a roomful of strangers, performing before an important audience, or—that most common of phobias—giving a speech, can make almost anyone feel anxious. Some people—especially those who are shy or easily embarrassed—feel anxious in almost any situation in which they might be evaluated. For these people, anxiety is more a trait than a temporary state.

What causes us to feel anxious in social situations? Why are some people shackled in the prison of their own shyness? Barry Schlenker and Mark Leary (1982b, 1985; Leary, 1984, 1986; Maddux & others, 1988) answer these questions by applying self-presentation theory. As you may recall from Chapters 3 and 4, self-presentation theory assumes that we are eager to present ourselves in ways that make a good impression. The implications for social anxiety are straightforward: *We feel anxious when we are motivated to impress others but doubt our ability to do so.* This simple principle helps explain a variety of research findings, each of which may ring true in your own experience. We feel most anxious when:

- Dealing with powerful, high-status people—people whose impressions matter
- In an evaluative context, as when making a first impression on the parents of one's fiance
- The interaction focuses on something central to our self-image, as when a college professor presents ideas before peers at a professional convention
- We are in novel situations, such as a first school dance or first formal dinner, where we are unsure of the social rules
- We are self-conscious (as shy people often are) and our attention is focused on ourselves and how we are coming across

When we are eager to make a good impression on important people, it is only human to feel social anxiety.

The natural tendency in all such situations is to be cautiously self-protective: to talk less; to avoid topics that reveal one's ignorance; to be guarded about oneself; to be unassertive, agreeable, and smiling.

Shyness is a form of social anxiety characterized by self-consciousness and worry about what others think (Anderson & Harvey, 1988; Asendorpf, 1987; Carver & Scheier, 1986). Self-conscious people (whose numbers include many adolescents) see incidental events as somehow relevant to themselves (Fenigstein, 1984). They overpersonalize situations, a tendency that breeds anxious concern and, in extreme cases, paranoia. Shown a videotape of someone they think is interviewing them live, they perceive the interviewer as less accepting and interested in them (Pozo & others, 1991). They also overestimate the extent to which other people are watching and evaluating them. If their hair won't comb right or they have a facial blemish, they assume everyone else notices and judges them accordingly.

To reduce social anxiety, some people turn to alcohol. Alcohol lowers anxiety as it reduces self-consciousness (Hull & Young, 1983). Thus, chronically self-conscious people are especially likely to drink following a failure. If they become alcoholics, they are more likely than those low in self-consciousness to relapse from treatment when they again experience stress or failure.

Symptoms as diverse as anxiety and alcohol abuse can also serve what Chapter 3 called a self-handicapping function. Labeling oneself as anxious, shy, depressed, or under the influence of alcohol can provide an excuse for failure (Snyder & Smith, 1986). Behind a barricade of symptoms, the person's ego stands secure. "Why don't I date? Because I'm shy, so people don't easily get to know the real me." The symptom is an unconscious strategic ploy to explain away negative outcomes.

What if we were to remove the need for such a ploy by providing people with a handy alternative explanation for their anxiety and therefore for possible failure? Would a shy person no longer need to be shy? That is precisely what Susan Brodt and Philip Zimbardo (1981) found when they brought shy

and not-shy college women to the laboratory and had them converse with a handsome male who posed as another subject. Before the conversation, the women were cooped up in a small chamber and blasted with loud noise. Some of the shy women (but not others) were told that the noise would leave them with a pounding heart, a common symptom of social anxiety. Thus when these women later talked with the man, they could attribute their pounding heart and any conversational difficulties to the noise, not to their shyness or social inadequacy. Compared to the shy women who were not given this handy explanation for their pounding hearts, these women were no longer so shy. They talked fluently once the conversation got going and asked questions of the man. In fact, unlike the other shy women (whom the man could easily spot as shy), these women were to him indistinguishable from the not-shy women.

SOCIAL COGNITION AND PHYSICAL ILLNESS ·

During the health-conscious 1980s, reports by the National Academy of Sciences and other agencies informed us that half of all deaths are linked with behavior—with consuming cigarettes, alcohol, drugs, and harmful foods; with reactions to stress; with lack of exercise and not following a doctor's orders. Efforts to study and change these behavioral contributions to illness helped create a new interdisciplinary field called **behavioral medicine.**

Health Psychology

Psychology's contribution to this interdisciplinary science is its new subfield **health psychology.** The American Psychological Association's division of health psychology, formed in 1979, mushroomed to 2900 members in its first 10 years, and includes many of the estimated 3000 psychologists now working in U.S. medical schools. Among health psychology's questions (and some tentative answers), are the following:

■ *Do characteristic emotions, and ways of responding to stressful events, predict susceptibility to heart disease, stroke, cancer, and other ailments (Figure 5-5)?*

Behavioral medicine: An interdisciplinary field that integrates and applies behavioral and medical knowledge about health and disease.

Health psychology: A subfield of psychology that provides psychology's contribution to behavioral medicine.

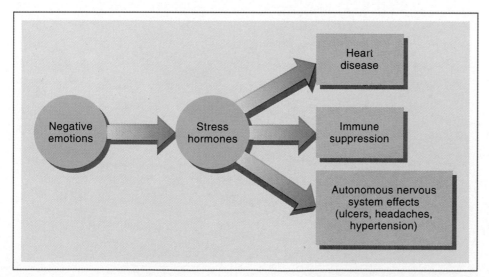

FIGURE 5-5 *Stress-caused negative emotions may have various effects on health. This is especially so for depressed or anger-prone people.*

Heart disease has been linked with a competitive, impatient, and—the aspect that matters—*anger-prone* personality (Friedman, 1991; Matthews, 1988). Under stress, reactive, anger-prone "Type A" people secrete more of the stress hormones believed to accelerate the buildup of plaque on the walls of the heart's arteries.

Sustained stress suppresses the disease-fighting immune system, leaving us more vulnerable to infections and malignancy (Cohen & Williamson, 1991; Institute of Medicine, 1989). Experiments reveal that the immune system's activity can also be influenced by conditioning.

■ *How can we control or reduce stress?*

Health psychologists are exploring the benefits of aerobic exercise (an effective antidote to mild depression and anxiety), relaxation training (to help control such tension-related ailments as headaches and high blood pressure), and supportive close relationships (which can help buffer the impact of stress).

■ *How do people decide whether they are ill, and what can be done to ensure that they seek medical help and follow a treatment regimen?*

We decide we are sick when symptoms fit one of our existing "schemas" for disease (Bishop, 1991). Does the small cyst match our idea of a malignant lump? Is the stomachache bad enough to be appendicitis? Is the pain in the chest area merely—as many heart attack victims suppose—a muscle spasm?

Patients are more willing to follow treatment instructions when they have a warm relationship with their doctor, when they help plan their treatment, and when options are framed attractively. People are more likely to elect an operation when given "a 40 percent chance of surviving" than when given "a 60 percent chance of not surviving" (Wilson & others, 1987).

Many recent studies reveal that regular aerobic exercise helps reduce and prevent anxiety and depression.

■ *What lifestyle changes would prevent illness and promote health, and how might such changes be encouraged?*

Psychologists are exploring the social influences that motivate adolescents to start smoking and have pioneered effective smoking prevention techniques (see p. 295).

New explorations of internal and external influences on body weight explain why the obese have difficulty losing weight permanently and also how they can best modify eating and exercise (Rodin, 1992).

Social psychologists have helped provide answers to all these questions. To illustrate their work, let's look more deeply at one question: How do our styles of explaining events and our feelings of control affect our vulnerability to illness?

Optimism and Health

Stories abound of patients who take a sudden turn for the worse when something makes them lose hope or who suddenly improve when hope is renewed. As cancer attacks the liver of nine-year-old Jeff, his doctors fear the worst. But Jeff remains optimistic. He is determined to grow up to be a cancer research scientist who will search for a cure. One day Jeff is elated. A specialist who has taken a long-distance interest in his case is planning to stop off while on a cross-country trip. There is so much Jeff wants to tell the doctor and to show him from the diary he has kept since he got sick. On the anticipated day, fog blankets his city. The doctor's plane is diverted to another city, from which the doctor flies on to his final destination. Hearing the news, Jeff cries quietly. The next morning, pneumonia and fever have developed, and Jeff lies listless. By evening he is in a coma. The next afternoon he dies (Visintainer & Seligman, 1983).

Understanding the links between attitudes and disease requires more than dramatic true stories such as this, however. Even if hopelessness coincides with cancer, does cancer breed hopelessness, or does hopelessness also hinder resistance to cancer? To resolve this chicken-and-egg riddle, researchers have (1) experimentally created hopelessness by subjecting organisms to uncontrollable stresses and (2) correlated the hopeless explanatory style with future illnesses.

Stress and Illness

The clearest indication of the effects of hopelessness—what Chapter 3 labeled *learned helplessness*—comes from experiments that subject animals to mild but uncontrollable electric shocks, loud noises, or crowding. Such experiences do not *cause* diseases, such as cancer, but they lower the body's resistance. Rats injected with live cancer cells more often develop and die of tumors if they also receive inescapable shocks than if they receive escapable shocks or no shocks. Moreover, compared to juvenile rats given controllable shocks, those given uncontrollable shocks are twice as likely in adulthood to develop tumors if given cancer cells and another round of shocks (Visintainer & Seligman, 1985). Animals that have learned helplessness react more passively, and blood tests reveal a weakened immune response.

It's a big leap from rats to humans. But a growing body of evidence reveals that people who undergo highly stressful experiences become more vulnerable to disease. The death of a spouse, the stress of a space flight landing, even the

Extreme stress like that caused by the death of a spouse has been associated with a weakening of the immune response and greater vulnerability to disease.

strain of an exam week have all been associated with depressed immune defenses (Jemmott & Locke, 1984). In one experiment, a temporary stress magnified the severity of symptoms experienced by volunteers who were knowingly infected with a cold virus (Dixon, 1986).

Pessimistic Explanatory Style and Illness

If uncontrollable stress affects health by generating a passive, hopeless resignation, then will people who exhibit such attitudes be more vulnerable to illness? Several studies have confirmed that a pessimistic style of explaining bad events (saying, "It's my responsibility, it's going to last, and it's going to undermine everything") makes illness more likely. Christopher Peterson and Martin Seligman (1987) studied the press quotes of 94 members of baseball's Hall of Fame and gauged how often they offered pessimistic (stable, global, internal) explanations for bad events, such as losing big games. Those who routinely did so tended to die at somewhat younger ages. Optimists—who offered stable, global, and internal explanations for *good* events—usually outlived the pessimists.

Peterson, Seligman, and George Valliant (1988) offer other findings: Harvard graduates who expressed the least pessimism when interviewed in 1946 were healthiest when restudied in 1980. Virginia Tech introductory psychology students who offered stable and global explanations for bad events suffered more colds, sore throats, and flus a year later. Michael Scheier and Charles Carver (1991) similarly report that optimists (who agree, for example, that "I usually expect the best") are less often bothered by various illnesses and recover faster from coronary bypass surgery.

Even cancer patients appear more likely to survive if their attitude is hopeful and determined rather than pessimistic and stoical (Levy & others, 1988; Pettingale & others, 1985). One study of 86 women undergoing breast cancer therapy found that those who participated in a morale-boosting weekly support group sessions survived an average of 37 months, double the 19-month average survival time among the nonparticipants (Spiegel & others, 1989). Blood tests provide a reason, by linking the pessimistic explanatory style with weaker immune defenses (Kamen & others, 1988). Compared to UCLA cancer patients in a control group, those who participated in support groups became

more upbeat, with an associated increase in immune cells (Cousins, 1989). Beliefs, it seems, can boost biology.

From their own studies, researchers Howard Tennen and Glenn Affleck (1987) agree that a positive, hopeful attributional style is generally good medicine. But they also remind us that every silver lining has a cloud. Optimists may see themselves as invulnerable and thus fail to take sensible precautions. And when things go wrong in a big way—when the optimist has a Down's syndrome child or encounters a devastating illness—adversity can be shattering. Optimism *is* good for health. But we need to remember that even optimists have a mortality rate of 100 percent.

"You are dust, and to dust you shall return."
Genesis 3:19

■ SOCIAL-PSYCHOLOGICAL APPROACHES TO TREATMENT

So far we have considered patterns of social thinking that are linked with problems in living, ranging from serious depression to everyday shyness to physical illness. Does the emerging understanding of maladaptive thought patterns suggest any guidelines for treating such difficulties? There is no single social-psychological method of therapy. But therapy is a social encounter, and social psychologists are now suggesting how their principles might be integrated into existing treatment techniques (Leary & Maddux, 1987). Building on what we have already learned, let's consider three examples (with a fourth to come in Chapter 7, "Persuasion").

INDUCING INTERNAL CHANGE THROUGH EXTERNAL BEHAVIOR

In Chapter 4, we reviewed a broad range of evidence for a simple but powerful principle: Our actions affect our attitudes. The roles we play, the things we say and do, and the decisions we make help form who we are. When we act, we amplify associated ideas, especially when we feel some responsibility for an action. Our behaviors are self-persuasive.

Consistent with the attitudes-follow-behavior principle, several psychotherapy techniques prescribe action. If we cannot directly control our feelings by sheer will power, we can influence them indirectly through our behavior. Behavior therapists try to shape behavior and, if they care about inner dispositions, assume that these will tag along after the behavior changes. Assertiveness training employs the foot-in-the-door procedure (p. 124). The individual first role-plays assertiveness in a supportive context, then gradually becomes assertive in everyday life. Rational-emotive therapy assumes that we generate our own emotions; clients receive "homework" assignments to act in new ways that will generate new emotions. Encounter groups subtly induce participants to behave in new ways in front of the group—to express anger, cry, act with high self-esteem, express positive feelings.

Experiments confirm that what we say about ourselves can affect how we feel. In one experiment, students were induced to write self-laudatory essays (Mirels & McPeek, 1977). These students, more than others who wrote essays about a current social issue, later expressed higher self-esteem when privately

rating themselves for a different experimenter. In several more experiments, Edward Jones and his associates (1981; Rhodewalt & Agustsdottir, 1986) influenced students to present themselves to an interviewer in either self-enhancing or self-deprecating ways. Again, the public displays—whether upbeat or downbeat—carried over to later private responses on a test of actual self-esteem. Saying is believing, even when we talk about ourselves. This was especially true when the students were made to feel responsible for how they presented themselves.

The importance of perceived choice is also apparent in an experiment by Pamela Mendonca and Sharon Brehm (1983). They invited one group of overweight children who were about to begin a weight-loss program to choose the treatment they preferred. Then they periodically reminded them that they had chosen their treatment. Compared to no-choice children who simultaneously experienced the same eight-week program, those who felt responsible for their treatment had lost more weight when reweighed at the end of the eight weeks and three months later.

When a sense of choice and personal responsibility is yoked with a high level of effort, the impact is even greater, report Danny Axom and Joel Cooper (1985; Axom, 1989). When they put women who wanted to lose weight through some supposedly (but not actually) therapeutic tasks, such as making perceptual judgments, those engaged in committing the most effort lost the most weight. A follow-up study of people's fear of snakes showed that an effortful commitment to change helped most when it was freely chosen. Uncoerced, effortful behavior commitments can indeed be therapeutic.

BREAKING VICIOUS CYCLES

If depression, loneliness, and social anxiety maintain themselves through a vicious cycle of negative experiences, negative thinking, and self-defeating behavior, it should be possible to break the cycle at any of several points—by changing the environment, by training the person to behave more constructively, by reversing negative thinking. And it is. Several different therapy methods can help free people from depression, and even without therapy most people eventually manage to break the cycle.

Social Skills Training

Depression, loneliness, and shyness are not just problems in someone's mind. To be around a depressed person for any length of time can be irritating and depressing. As such lonely and shy people suspect, they may indeed come across poorly in social situations. In these cases, social skills training may help. By observing and then practicing new behaviors in safe situations, the person may develop the confidence to behave more effectively in other situations.

As the person begins to enjoy the rewards of behaving more skillfully, a more positive self-perception develops. Frances Haemmerlie and Robert Montgomery (1982, 1984, 1986) demonstrated this in several heartwarming studies with shy, anxious college students. Those who seldom date and are nervous around those of the other sex infer, "I don't date much, so I must be socially inadequate, so I shouldn't try reaching out to anyone." To reverse this negative sequence, Haemmerlie and Montgomery enticed such students into pleasant interactions with people of the other sex.

Social skills training. When shy, anxious people observe, then rehearse, then try out more assertive behaviors in real life, their social skills often improve.

In one experiment, college men completed social anxiety questionnaires and then came to the laboratory on two different days. Each day they enjoyed 12-minute conversations with each of six young women. The men thought the women were also subjects. Actually, the women had been asked simply to carry on a natural, positive, friendly conversation with each of the men.

The effect of these two and a half hours of conversation was remarkable. As one subject wrote afterward, "I had never met so many girls that I could have a good conversation with. After a few girls, my confidence grew to the point where I didn't notice being nervous like I once did." Such comments were supported by a variety of measures. Unlike men in a control condition, those who experienced the conversations reported considerably less female-related anxiety when retested one week and six months later. Placed alone in a room with an attractive female stranger, they also became much more likely to start conversation. Outside the laboratory they actually began occasional dating.

Haemmerlie and Montgomery note that not only did all this occur without any counseling but it may very well have occurred *because* there was no counseling. Having behaved successfully on their own, the subjects could now perceive themselves as socially competent. Although seven months later the researchers did debrief the subjects, by that time the men had presumably enjoyed enough social success to maintain their internal attributions for success. "Nothing succeeds like success," concluded Haemmerlie (1987), "as long as there are no external factors present that the client can use as an excuse for that success!"

Attributional Style Therapy

The vicious cycles that maintain depression, loneliness, and shyness can be broken not only by training in more effective social skills and by positive experiences that alter self-perceptions but also by changing negative thought patterns. Some people have social skills, but their experiences with hypercritical friends and family have convinced them they do not. For such people it may be enough to help them reverse their negative beliefs about themselves and their futures. Among the cognitive therapies with this aim is an "attributional style therapy" proposed by social psychologists (Abramson, 1988; Försterling, 1986).

One such program taught depressed college students to change their typical attributions. Mary Anne Layden (1982) first explained the advantages of making attributions more like those of the nondepressed person (by accepting credit for successes and seeing how circumstances can make things go wrong). After assigning a variety of tasks, she helped the students see how they typically interpreted success and failure. Then came the treatment phase: Layden instructed each person to keep a diary of daily successes and failures, making special note of how they contributed to their own successes and of external reasons for their failures. When they were retested after a month of this attributional retraining and compared with an untreated control group, their self-esteem had risen and their attributional style had become more positive. And the more their attributional style improved, the more their depression lifted. By changing their social cognitions, they had changed their emotions.

MAINTAINING CHANGE THROUGH INTERNAL ATTRIBUTIONS FOR SUCCESS

Two of the principles considered so far—that internal change may follow behavior change and that changed self-perceptions and self-attributions can help break a vicious cycle—converge on a corollary principle: Once achieved, improvements are maintained best if people attribute them to factors under their own control rather than to a treatment program.

As a rule, coercive techniques trigger the most drastic and immediate behavior changes (Brehm & Smith, 1986). By making the unwanted behavior extremely costly or embarrassing and the healthier behavior extremely rewarding, a therapist may achieve quick and dramatic results. The problem, as 30 years of social-psychological research reminds us, is that coerced behavior changes tend not to endure.

To appreciate why not, consider the experience of Martha, who is concerned with her mild obesity and frustrated with her inability to do anything about it. Martha is considering several different commercial weight-control programs. Each claims it achieves the best results. She chooses one and is ordered onto a strict 1200-calorie-a-day diet. Moreover, she is required to record and report her calorie intake each day and to come in once a week and be weighed so she and her instructor can know precisely how she is doing. Confident of the program's value and not wanting to embarrass herself, Martha adheres to the program and is delighted to find the unwanted pounds gradually disappearing. "This unique program really does work!" Martha tells herself as she reaches her target weight.

Sadly, however, after graduating from the program, Martha's experience repeats that of most weight-control graduates (Wing & Jeffery, 1979): She regains the lost weight. On the street, she sees her instructor approaching. Embarrassed, she moves to the other side of the sidewalk and looks away. Alas, she is recognized by the instructor, who warmly invites her back into "the program." Admitting that the program achieved good results for her the first time, Martha grants her need of it and agrees to return, beginning a second round of yo-yo dieting.

Martha's experience typifies that of the participants in several weight-control experiments, including one by Janet Sonne and Dean Janoff (1979). Half

the participants were led, like Martha, to attribute their changed eating behavior to the program. The others were led to credit their own efforts. Both groups lost weight during the program, but those in the self-control condition had maintained the weight loss best when reweighed 11 weeks later. These people, like those in the shy-man-meets-women study described earlier, illustrate the benefits of self-efficacy. Having learned to cope successfully and believing that they did it, they now felt more confident and were more effective.

Having emphasized what changed behavior and thought patterns can accomplish, we do well to remind ourselves of their limits. Social skills training and positive thinking cannot transform us into consistent winners who are loved and admired by everyone. Furthermore, temporary depression, loneliness, and shyness are perfectly appropriate responses to profoundly sad events. It is when such feelings exist chronically and without any discernible cause that there is reason for concern and a need to change the self-defeating thoughts and behaviors.

■ SUMMING UP

To review and apply principles of social cognition discussed in previous chapters, we have considered some of social psychology's contributions to clinical understanding, treatment, and judgment.

MAKING CLINICAL JUDGMENTS

From their studies of how people form judgments and misjudgments of others, social psychologists reveal how judgments, recommendations, and predictions can be led astray. As we judge others, we are sometimes unaware of what has affected our assessments of them and inclined to perceive them in line with our stereotypes. When judging ourselves, we are susceptible to the "Barnum effect" (accepting worthless diagnoses), especially when the feedback is positive.

Psychiatrists and clinical psychologists are vulnerable to illusory thinking. As they diagnose and treat their clients, they may perceive illusory correlations. Hindsight explanations of people's difficulties are sometimes too easy. Indeed, after-the-fact explaining can breed overconfidence in clinical judgment. When interacting with clients, erroneous diagnoses are sometimes self-confirming, because interviewers tend to seek and recall information that verifies what they are looking for.

Research on the errors that so easily creep into intuitive judgments documents the need for rigorous testing of intuitive conclusions. The scientific method cannot answer all questions and is itself vulnerable to bias. Thankfully, however, it can help us sift truth from falsehood.

SOCIAL COGNITION IN PROBLEM BEHAVIORS

Social psychologists are actively exploring the attributions and expectations of depressed, lonely, socially anxious, and physically ill people. Depressed people have a negative attributional style. Compared to nondepressed people,

they engage in more self-blame, they interpret and recall events in a more negative light, and they are less hopeful about the future. Despite their more negative judgments, mildly depressed people in laboratory tests tend to be surprisingly realistic. Depressed thinking has consequences for the depressed person's behavior, which in turn helps maintain a self-defeating cycle. Much the same can be said of those who suffer chronic loneliness and states of social anxiety, such as extreme shyness. The mushrooming new field of health psychology is exploring the links among illness, stress, and a pessimistic explanatory style.

SOCIAL-PSYCHOLOGICAL APPROACHES TO TREATMENT

Among the social-psychological principles that may be usefully applied in treatment are these three: (1) Changes in external behavior can trigger internal change. (2) A self-defeating cycle of negative attitudes and behaviors can be broken by training more skillful behavior, by positive experiences that alter self-perceptions, and by changing negative thought patterns. (3) Improved states are best maintained after treatment if people attribute their improvement to internal factors under their continued control rather than to the treatment program itself.

■ FOR FURTHER READING

Abramson, L. Y. (Ed.). (1988). *Social cognition and clinical psychology: A synthesis.* New York: Guilford. Various experts explore the implications of research on social thinking for psychological health and psychotherapy.

Friedman, H. S. (1991). *The self-healing personality: Why some people achieve health and others succumb to illness.* New York: Holt. Health psychologist Friedman offers a lucid, state-of-the-art analysis of how our genes, habits, and emotions make us disease-prone or health-prone.

Peterson, C., & Bossio, L. M. (1991). *Health and optimism.* New York: Free Press. A leading researcher shows how social cognition—especially, an optimistic versus pessimistic explanatory style—influences physical well-being.

Snyder, C. R., & Forsyth, D. F. (Eds.). (1991). *Handbook of social and clinical psychology: The health perspective.* New York: Pergamon Press. Experts offer state-of-the-art summaries of social psychology's contributions to the diagnosis, understanding, and treatment of mental and physical disorder.

SOCIAL INFLUENCE

Social psychology studies not only how we think about one another—our topic in the preceding chapters—but also how we influence and relate to one another. In Chapters 6 through 10 we therefore probe social psychology's central concern: the powers of social influence.

What are these unseen social forces that push and pull us? How powerful are they? Research on social influence helps illuminate the invisible strings by which our social worlds move us about. This unit reveals these subtle powers, especially the cultural sources of attitudes and behavior (Chapter 6), the forces of social conformity (Chapter 7), the principles of persuasion (Chapter 8), the consequences of participation in groups (Chapter 9), and how all these influences operate together in everyday situations. In Chapter 10, we take a close look at the social influences at work in a specific setting—the courtroom.

Seeing these influences, we may better understand why people feel and act as they do. And we may ourselves become less vulnerable to unwanted manipulation and more adept at pulling our own strings.

CULTURAL INFLUENCES

In many important ways we humans—members of one species, one great family with common ancestors—are all alike. We share not only a common biology but common behavior tendencies. We perceive the world, feel thirst, and develop grammar through identical mechanisms.

Our social behavior, too, is characteristically human: We all know how to read frowns and smiles. We all feel a liking for people whose attitudes and attributes are similar to our own. We join groups, conform, and form status hierarchies. We show favoritism to our own groups and, when confronting other groups, react with negative behaviors ranging from caution to genocide. Such commonalities define our shared human nature. To a social psychologist, we are more alike than different.

Perhaps the most important of all our similarities is our capacity to learn and adapt. Our shared biology makes possible our social diversity. It enables those in one **culture** to value promptness, welcome frankness, and accept premarital sex, while those in other cultures live by different standards. Whether we equate beauty with slimness or shapeliness depends on where and when in the world we live. Whether we define social justice as equality (all receive the same) or as equity (those who produce more receive more) depends on whether Marxism or capitalism shapes our ideology. Whether we tend to be expressive or reserved, casual or formal, hinges partly on whether we have spent our lives in an African, European, or Asian culture.

Culture:
The enduring behaviors, ideas, attitudes, and traditions shared by a large group of people and transmitted from one generation to the next.

■ CULTURE AND SOCIAL DIVERSITY

Everyone knows that the social influences of culture are enormous. Still, given how readily most of us think of our way as *the* way, cultural diversity can astonish us. Sociologist Ian Robertson (1987) notes:

All cultures have accepted ideas about appropriate behavior. Standards of dress, for example, differ for North American and Middle-Eastern women.

Americans eat oysters but not snails. The French eat snails but not locusts. The Zulus eat locusts but not fish. The Jews eat fish but not pork. The Hindus eat pork but not beef. The Russians eat beef but not snakes. The Chinese eat snakes but not people. The Jalé of New Guinea find people delicious. (p. 67)

The range of dress habits is equally great. If you were a traditional Muslim woman, you would cover your entire body, even your face, and be thought deviant if you didn't. If you were a North American woman, you would expose your face, arms, and legs, but you would cover your breasts and pelvic region, and be thought deviant if you didn't. If you were a Tasaday tribe woman in the Philippines, you would go about your daily activities naked, and be thought deviant if you didn't.

We begin our consideration of social influence with a close look at how, and how much, culture and its norms and roles shape our identities and behaviors. We'll look at social diversity across cultures. And we'll see how the same forces that create social diversity across cultures create diversity within cultures by constructing gender differences.

AFFIRMING DIVERSITY AND SEEKING UNITY

So long as we live in relatively homogeneous groups in separate regions, the diversity of human cultures mattered less. One might know from reading *National Geographic* that cultures vary, yet take for granted how "we" do things. Sailing along with a unified culture is like sailing with the wind: We hardly feel it, until we reverse direction and try to sail against it.

Now, the growing economic interdependence of nations and the linkage of world television systems confront every culture with the beliefs and lifestyles of other cultures. Moreover, thanks to migration, refugee evacuations, and modern transport, most nations today have become a diverse mix of people, forcing almost everyone to struggle with the tension between affirming diversity and seeking unity. Even island cultures as homogeneous as the British and the Japanese and continental cultures as distinctive as the French are being challenged and reshaped by the influx of new people and new ideas. Indeed, says historian Arthur Schlesinger (1991), social diversity "is the explosive problem of our times." The roll call of nations torn by ethnic tensions includes India, Yugoslavia, Ethiopia, Sri Lanka, Iraq, Lebanon, South Africa, and, to lesser degrees, Britain, Canada, and the United States. In half the 100 largest cities of the United States, for example, ethnic minorities will be the majority by the end of this decade (Jones, 1990). As we prepare to play, work, and live with people whose culture and gender differ from our own, we need to understand how each of us has come to be who we are. And accepting our differences, our societies need also to embrace unifying ideals that will hold them together. Doing so may eventually help us broaden our circles of love to encompass not only our families, neighbors, and ethnic groups but the whole human community on spaceship earth.

INDIVIDUALISM VERSUS COLLECTIVISM

A pervasive culture difference arises from social values that stress either individual control and achievement or the bonds of social solidarity. To reflect on your own orientation, consider these questions from the Individualism-Collectivism Scale, developed by C. Harry Hui (1988):

Would you agree that

> I would help if a colleague at work told me that he/she needed money to pay utility bills.
>
> Young people should take into consideration their parents' advice when making education/career plans.
>
> I am often influenced by the moods of my neighbors.

Do your answers suggest that you place a greater value on your individual goals and identity or on your social bonds?

Western industrialized cultures typically value **individualism.** They give more priority to self-reliance and personal well-being than to social identity. Western literature often celebrates rugged individuals who, rather than fulfilling others' expectations, seek their own fulfillment.

Asian and third-world cultures place a greater value on **collectivism.** They give more priority to the goals and welfare of their groups. Eastern literature often celebrates those who, despite temptations to self-indulgence, remember who they are and do their social duty. Without discounting individual differences within cultures, cross-cultural psychologists such as Harry Triandis, Richard Brislin, and C. Harry Hui (1988) have shown how a culture's individualism or collectivism affects self-concept, social relations, and child rearing.

Individualism:
Giving priority to one's own goals over group goals and defining one's identity in terms of personal attributes rather than group identifications.

Collectivism:
Giving priority to the goals of one's groups (often one's extended family or work group) and defining one's identity accordingly.

Self-Concept

Shorn of their social connections—separated from family, friends, and work group—individualists retain their identity, their sense of "me." Thus individualists feel free to leave jobs, homes, churches, and extended families in search of better opportunities for themselves. For collectivists, social networks provide one's bearings and help define who one is. Collectivists have fewer relationships, but they are deeper and more stable.

Social Relations

"The squeaky wheel gets the grease."
American saying

"The nail that stands out gets pounded down."
Japanese saying

Compared to North American students, university students in Hong Kong talk during a day with fewer people for longer periods (Wheeler & others, 1989). Employer-employee relations are marked by mutual loyalty. Valuing social solidarity, people in collectivist cultures seek to maintain harmony by showing respect and allowing others to save face. They avoid blunt honesty, stay away from touchy topics, and display a self-effacing humility (Markus & Kitayama, 1991). People do favors for one another and remember who has done favors for them. For collectivists, no one is an island. The self is not independent but *inter*dependent.

Because social identity is so important, collectivists are somewhat quicker to prejudge people by their groups. In their culture, they say, it *helps* to know people's group identities—"tell me a person's family, schooling, and employment and you tell me a lot about the person." Individualists warn against stereotyping and prefer not to judge people by their backgrounds and affiliations. Individualists do prejudge people but often by obvious personal attributes, such as physical attractiveness (Dion & others, 1990).

Child Rearing

In individualist cultures, parents and schools teach children to be independent and to think for themselves. Children and adolescents typically decide their

In individualist cultures, children are taught independence. Collectivist cultures prefer to teach the values of communal sensitivity and to maintain the extended family.

own restaurant orders, open their own mail, choose their own boyfriends and girlfriends, and chart their own goals en route to leaving the family nest. If you live in a western culture, you probably take all this for granted. If you live in Asia, you may wince at such individualism, preferring instead to teach children the values of communal sensitivity and cooperation, to guide or decide children's choices, and to maintain the extended family by providing care for aging parents (Hui, 1990).

Communicating across Cultures

When people from different cultures interact, sensitivity to their differences helps minimize misunderstandings and awkward moments. Triandis, Brislin, and Hui (1988) advise individualists visiting collectivist cultures to avoid confrontation, to cultivate long-term relationships without expecting instant intimacy, to present oneself modestly, to attend to people's positions in their group hierarchies, and to let them know one's own social position. When visiting individualist cultures, collectivists should feel freer than usual to criticize, to get right to business, to disclose their skills and accomplishments, and to pay more attention to personal attitudes than to group memberships and positions.

Each cultural tradition offers benefits, for a price. In competitive, individualist cultures, people enjoy more personal freedom, take greater pride in their own achievements, enjoy more privacy, and feel freer to move about and choose their own lifestyles. But the price is more frequent loneliness, more divorce, more homicide, and more vulnerability to stress-related disease (Triandis & others, 1988).

■ BEHIND THE SCENES

As a Hong Kong native who has studied in North America, I am sometimes asked whether I am an individualist or a collectivist. My North American and British friends consider me a collectivist. In their eyes, I seldom contradict people and I'm rarely assertive. My decisions seem to give consideration to my family members and relatives. But my extended Chinese family sees me as an individualist. On a vacation with ten relatives, I insisted on us each going our own ways—to shop, to eat, to tour buildings as we wished. I didn't want my preference for tranquility to cut short someone's shopping trip. They, however, found less enjoyment in where they went than in experiencing things TOGETHER. Who am I? Am I both individualist and collectivist? Or neither?

C. HARRY HUI, *University of Hong Kong*

■ NORMS

American males may feel uncomfortable when Middle Eastern heads of state greet the U.S. President with a kiss on the cheek. A German student, used to a system where one seldom speaks to ''Herr Professor'' outside the lecture hall, considers it strange that at my institution most faculty office doors are open and students stop by freely. An Iranian student on her first visit to an American McDonald's restaurant fumbles around in her paper bag looking for the eating utensils until she sees the other customers eating their french fries with, of all things, their hands. In many areas of the globe your and my best manners are a serious breach of etiquette. Oxford social psychologist Michael Argyle (1988) notes that foreigners visiting Japan struggle to master the rules of the social game—when to take their shoes off, how to pour the tea, when to give and open gifts, how to act toward someone higher or lower in the social hierarchy.

Norms:
Rules for accepted and expected behavior. Norms *prescribe* ''proper'' behavior. (In a different sense of the word, norms also *describe* what most others do—what is *normal.*)

As these examples illustrate, all cultures—be they juvenile gangs, tribes, or nations—have their own accepted ideas about appropriate behavior. People often view these social expectations, or **norms,** as a negative force that imprisons us all in a blind effort to perpetuate tradition. Norms restrain and control us so successfully and so subtly that we hardly sense their existence. Like fish in the ocean, we are so immersed in our culture that we must leap out of it to understand it. There is no better way to learn the norms of our culture than to visit another culture and see that its members do things *that* way, while we do them *this* way. I tell my children that yes, Europeans eat meat with the fork facing down in the left hand, but we Americans consider it good manners to cut the meat and then transfer the fork to the right hand: ''I admit it's inefficient. But it's the way *we* do it.'' Given the growing cultural mix within most countries, many people need only visit across town or down the block to appreciate how cultural norms vary.

Standards of etiquette, such as bowing as a social greeting, illustrate norms—rules for proper social behavior.

To test the subtle influence of norms, Robert Cialdini, Carl Kallgren, and Raymond Reno (1991) noted whether people littered the ground when removing a "Drive Carefully" handbill placed under their windshield wipers in a parking garage. While walking to their car from the elevator, some of the people walked through a litter-free garage, others through a sprinkling of litter, including many of the handbills. As Figure 6-1 shows, more people littered when that was the apparent norm. (No wonder Disney World stays so litter-free. Not only is any piece of litter picked up within minutes, the litter-free environment defines an antilittering norm.) To call attention to the norm of littering or cleanliness, one of the researchers sometimes visibly dropped one

FIGURE 6-1 *Fewer subjects littered when the environment was free of litter. This effect was heightened by observing a model who littered, thus calling attention to the norm of littering or not littering.*
(From Cialdini & others, 1991.)

of the handbills as each subject approached his or her car. As the researchers expected, the effect of the environmental norm was greatest when the researcher's littering drew people's attention to the presence or absence of litter. This experiment reminded Cialdini and his colleagues of a poignant televised public service ad depicting a Native American shedding a tear over a passer-by adding litter to a trashy highway. They speculate that the ad would have been even more effective had the passer-by littered a *clean* highway, thereby calling attention to a litter-free norm.

Norms may seem arbitrary and confining. However, just as a play moves smoothly when the actors know their lines, so social behavior occurs smoothly when people know what's expected. Consider Michael Argyle's description of the five-stage sequence when a British family moves into a new home and the wife is visited by the woman next door (D. Cohen, 1980). First come the greetings, after which the visitor enters. Next, the visitor admires the house. During the third stage, the newcomer serves coffee and cookies and the women exchange information—mainly about their husbands. The fourth stage smooths any feelings ruffled during stage 3 (such as if one women said her husband was a labor union executive while the other said her husband was in management). Stage 5 is the farewells.

Argyle notes that for the social interaction to proceed smoothly, both women must recognize each of the five stages. The visitor who arrives at the house and blurts out "My man's with IBM" or the householder who immediately thrusts coffee and cookies on the visitor reveals a lack of social skill. Indeed, many awkward, embarrassing moments are caused by our unintentionally violating social norms: walking into the wrong restroom, clapping at a pause during a symphony, arriving at the party in a dress or coat and tie to find everyone else in jeans.

Norms not only grease the social machinery, but they also liberate us from preoccupation with what we are saying and doing. In unfamiliar situations, when the norms may be unclear, we monitor others' behavior and adjust our own accordingly. In familiar situations, our words and acts come effortlessly. Well-learned, ritualistic ways of interacting free us to concentrate on other matters. This helps explain why work units with clearly understood and agreed-upon norms function more effectively (Argote, 1989). When norms clash—when people with differing expectations and styles must live or work together—tensions often simmer and conflict may erupt.

■ BEHIND THE SCENES

When I was a boy, I had several friends who were shy or otherwise socially incompetent. I went into psychology partly to solve their problems; however not even social psychology in those days seemed to have any contribution to make. My own early research rapidly moved towards the study of social skills and the detailed analysis of social interaction. I hope it has helped somebody.

MICHAEL ARGYLE, *Oxford University*

"Look, everyone here loves vanilla, right? So let's start there."

Despite the enormous cultural variation in norms, we humans do hold some norms in common.

UNIVERSAL NORMS

Although norms vary by culture and gender, we humans do hold some norms in common. Best known is the taboo against incest: Parents are not to have sexual relations with their children, nor siblings with one another. Although the taboo apparently is violated more often than psychologists once believed, the norm is still universal. Every society disapproves of incest.

Roger Brown (1965) noticed another universal norm. Everywhere, people talk to higher-status people in the respectful way they often talk to strangers. And they talk to lower-status people in the more familiar, first name way they speak to friends. Patients call their physician "Dr. So and So"; the physician often replies using their first name. Students and professors typically address one another in a similar nonmutual way.

Most languages have two forms of the English pronoun "you": a respectful form and a familiar form (for example, *Sie* and *du* in German, *vous* and *tu* in French, *usted* and *tu* in Spanish). People typically use the familiar form with intimates and those they perceive as inferior (not only with close friends and family members but also in speaking to children and dogs). A German child receives a boost when strangers begin addressing the child as "Sie" instead of "du." Nouns, too, can express assumed social inequalities. Among faculty studied by Rebecca Rubin (1981), young female professors were far more likely than young male professors to have students call them by their first name. Women tennis players will empathize: Sportscasters 53 percent of the time refer to them using only their first name; with men players this happens only 8 percent of the time (*Harper's Index*, 1991).

This first aspect of Brown's universal norm—that *forms of address communicate not only social distance but also social status*—correlates with a second aspect: *Advances in intimacy are usually suggested by the higher-status person.* In Europe, where most twosomes begin a relationship with the polite, formal "you" and

In The Female Eunuch, *Germaine Greer notes how the language of affection reduces women to foods and baby animals—honey, lamb, sugar, sweetie-pie, kitten, chick.*

may eventually progress to the more intimate "you," someone obviously has to initiate the increased intimacy. Who do you suppose does so? On some congenial occasion, the elder, or richer, or more distinguished of the two may say, "Why don't we say *du* to one another?"

This norm extends beyond language to every type of advance in intimacy. It is more acceptable to borrow a pen from or put a hand on the shoulder of one's intimates and subordinates than to behave in such a casual way with strangers or superiors. Similarly, the president of my college invites faculty to his home before they invite him to theirs. In general, then, the higher-status person is the pacesetter in the progression toward intimacy.

NORMS VARY WITH CULTURE

Some norms cross cultures, but many do not. To someone from a relatively formal northern European culture, a person whose roots are in an expressive Mediterranean culture may seem "warm, charming, inefficient, and time-wasting." To the Mediterranean person, the northern European may seem "efficient, cold, and overconcerned with time" (Triandis, 1981). Latin American business executives who arrive late for a dinner engagement may be mystified by how obsessed their American counterparts are with punctuality.

Every culture has its norms—rules for accepted and expected social behavior.

"*Women kiss women good night. Men kiss women good night. But men do not kiss men good night—especially in Armonk.*"

In the Middle East men do kiss men, as startled Western soldiers learned when greeted by grateful Kuwaitis upon the liberation of their capital city during the Persian Gulf War.

Cultures also vary in their norms for **personal space,** a sort of portable bubble or buffer zone that we like to maintain between ourselves and others. As the situation changes, the bubble varies in size. With strangers we maintain a fairly large personal space, keeping a distance of 4 feet or more between us. On uncrowded buses, or in restrooms or libraries, we protect our space and respect others' space. We let friends come closer, often within 2 or 3 feet.

Individuals differ: Some people prefer more personal space than others (Smith, 1981; Sommer, 1969; Stockdale, 1978). Adults maintain more distance than children. Men keep more distance from one another than do women. For reasons unknown, cultures near the equator prefer less space and more touching and hugging. Thus the British and Scandinavians prefer more distance than the French and Arabs; Americans prefer more space than Latin Americans.

To see the effect of encroaching on another's personal space, play space invader. Stand or sit but a foot or so from a friend and strike up a conversation. Does the person fidget, look away, back off, show other signs of discomfort? These are some signs of arousal noted by researchers (Altman & Vinsel, 1978). One controversial experiment revealed that men require more time to begin urination and less time to complete the act (known symptoms of mild emotional arousal) when another man is standing at an adjacent urinal (Middlemist & others, 1976, 1977).

Personal space:
The buffer zone we like to maintain around our bodies. Its size depends on our familiarity with whomever is near us.

"Some 30 inches from my nose, the frontier of my person goes."
W. H. Auden, 1907–1973

Drawing by Mankoff; © 1988 The New Yorker Magazine, Inc.

"*You're not one of those guys who are afraid of intimacy, are you?*"

Depending partly on their culture, some people prefer more personal space than others.

NORMS VARY WITH GENDER

There are many obvious dimensions of human diversity—height, weight, hair color, to name just a few. But for people's self-concepts and social relationships, the two dimensions that matter most, and that people first attune to, are race and, especially, sex. In Chapter 11, we will look closely at how race and sex affect the way others regard and treat us. For now, let's consider **gender** variations in social norms. What behaviors are characteristic and expected of males and of females?

As you have perhaps learned in earlier psychology courses, the sexes are nearly identical in many physical traits, such as age of sitting, teething, and walking. They also are alike in many psychological traits, such as overall vocabulary, intelligence, and happiness. But the occasional differences are what capture attention and make news. Women are twice as vulnerable to anxiety disorders and depression, though only one-third as vulnerable to alcoholism and suicide. Women have a slightly better sense of smell. They more easily become rearoused immediately after orgasm. And they are much less likely to suffer hyperactivity or speech disorders as children and to display antisocial personalities as adults.

During the 1970s, many scholars worried that studies of such gender differences might reinforce stereotypes and that gender differences might be construed as women's deficits. Focusing attention on gender differences will provide "battle weapons against women" they warned (Bernard, 1976, p. 13). And

Gender:
In psychology, the characteristics, whether biologically or socially influenced, by which people define male and female. Because "sex" is a biological category, social psychologists often refer to biologically based gender differences as "sex differences."

it's true that explanations for differences usually focus on the group that's seen as different (Miller & others, 1991). In discussing the "gender gap" in American presidential voting, commentators more often wonder why women so often vote Democratic than why men so often vote Republican. People more often wonder what causes homosexuality than what causes heterosexuality (or what determines sexual orientation). People ask why Asian-Americans so often excel in math and science, not why other groups less often excel. In each case, people define the standard by one group and wonder why the other is "different." From "different" it is but a short way to "deviant" or "substandard."

Since the 1980s, scholars have felt freer to explore gender diversity (Ashmore, 1990). Some argued that gender difference research has "furthered the cause of gender equality" by reducing overblown stereotypes (Eagly, 1986) and that we can accept and value gender diversity. The two sexes, like two sides of a coin, can differ yet be equal. Let's consider, then, two dimensions of gender diversity in social norms.

Independence versus Connectedness

Individual men display outlooks and behavior varying from fierce competitiveness to caring nurturance. So do individual women. Without denying that, psychologists Nancy Chodorow (1978, 1989), Jean Baker Miller (1986), and Carol Gilligan and her colleagues (1982, 1990) contend that women more than men give priority to relationships.

The difference surfaces in childhood. Boys strive for independence; they define their identity in separation from the caregiver, usually their mother. Girls welcome interdependence; they define their identity through their social connections. Boys' play often involves group activity. Girls play occurs in smaller groups, with less aggression, more sharing, more imitation of relationships, and more intimate discussion (Lever, 1978). Shown slides or told stories, girls react with more empathy (Hunt, 1990).

Adult relationships extend this gender difference. In conversation, men more often focus on tasks, women on relationships. In groups, men contribute more task-oriented behaviors, such as giving information, and women contribute more positive social-emotional behaviors, such as giving help or showing support (Eagly, 1987). Women spend more time caring for both preschoolers and aging parents (Eagly & Crowley, 1986). They buy most birthday gifts and greeting cards (DeStefano & Colasanto, 1990; Hallmark, 1990). In most of the U.S. caregiving professions, such as social worker, teacher, and nurse, women outnumber men. Among first-year college students, 5 in 10 males and 7 in 10 females say it is *very* important to "help others who are in difficulty" (Astin & others, 1991). Women's greater social concern helps explain why, in survey after survey, American women are more likely than men to support Democratic Party candidates and to oppose military initiatives (*American Enterprise,* 1991).

When surveyed, women are far more likely to describe themselves as having **empathy,** as being able to feel what another feels—to rejoice with those who rejoice and weep with those who weep. To a lesser extent, the empathy difference extends to laboratory studies, in which women are more likely to cry or report feeling distressed at another's distress (Eisenberg & Lennon, 1983). And this helps explain why, compared to friendships with men, both men and

"In the different voice of women lies the truth of an ethic of care."
Carol Gilligan (1982, p. 173)

Empathy:
The vicarious experience of another's feelings; putting oneself in another's shoes.

Ads sell women with promises of intimacy. Marlboro sells men an image of rugged individualism.

women report friendships with women to be more intimate, enjoyable, and nurturing (Rubin, 1985; Sapadin, 1988). When they want empathy and understanding, someone to whom they can disclose their joys and hurts, both men and women usually turn to women.

Women's greater connectedness also gets expressed in their smiling. When Marianne LaFrance (1985) analyzed 9000 college yearbook photos and when Amy Halberstadt and Martha Saitta (1987) studied 1100 magazine and newspaper photos and 1300 people in shopping malls, parks, and streets, they consistently found that females were more likely to smile.

One explanation for this male-female empathy difference is that women tend to be better at reading others' emotions. In her analysis of 125 studies of men's and women's sensitivity to nonverbal cues, Judith Hall (1984) discerned that women are generally superior at decoding others' emotional messages. When shown a two-second silent film clip of the face of an upset woman, women guess more accurately whether she is angry or discussing a divorce. Women also are more skilled at expressing emotions nonverbally, reports Hall.

Whether considered feminine or human, traits such as gentleness, sensitivity, and warmth are a boon to close relationships. In a study of 108 married couples in Sydney, Australia, John Antill (1983) found that when either the

husband or wife had these traditionally feminine qualities—or better, when *both* did—marital satisfaction was higher. Both husbands and wives find marriage rewarding when their spouse is nurturant and emotionally supportive.

Social Dominance

In both modern and traditional societies around the world, from Asia to Europe, people expect men to be, and perceive them as, the more dominant and driven sex (Williams & Best, 1990a). And in essentially every society, men *are* socially dominant. They are 93 percent of the world's legislators (Harper's, 1989). They are half of all jurors but 90 percent of elected jury leaders and most of the leaders of ad hoc laboratory groups (Davis & Gilbert, 1989; Kerr & others, 1982). As is typical of those in higher-status positions, men initiate most of the inviting for dates. Iftikhar Hassan (1980) of Pakistan's National Institute of Psychology explained the traditional status of Pakistani women:

When women achieve equal status with men, will they, should they, feel as free as men to initiate formal dates?

> She knows that parents are not happy at the birth of a girl and she should not complain about parents not sending her to school as she is not expected to take up a job. She is taught to be patient, sacrificing, obedient. . . . If something goes wrong with her marriage she is the one who is to be blamed. If any one of her children do not succeed in life, she is the main cause of their failure. And in the rare circumstance that she seeks a divorce or receives a divorce her chances of second marriage are very slim because Pakistani culture is very harsh on divorced women.

Men's style of communicating undergirds their social power. As leaders in situations where roles aren't rigidly scripted, men tend to be directive, women to be democratic (Eagly & Johnson, 1990). Men tend to excel as task-focused leaders, women as social leaders who build team spirit (Eagly & Karau, 1991; Wood & Rhodes, 1991). In everyday conversation, men are more likely to act as powerful people often do—talking assertively, interrupting, touching with the hand, staring more, smiling less (Ellyson & others, 1991; Carli, 1991; Major & others, 1990). Stating the results from a female perspective, women's influence style (especially in mixed-sex groups) tends to be more indirect—less interruptive, more sensitive, more polite, less cocky.

Aware of such findings, Nancy Henley (1977) has argued that women should stop feigning smiles, averting their eyes, and tolerating interruptions and should instead look people in the eye and speak assertively. Judith Hall (1984), however, values women's less autocratic communication style and therefore objects to the idea

Salley Forth by Greg Howard, with permission of North American Syndicate

"A little further, dear."

Drawing by W. Steig; © 1989 The New Yorker Magazine, Inc.

that women should change their nonverbal style so as to appear more affectively distant and insensitive. . . . What would be sacrificed is the deeper value to self and society of a behavioral style that is adaptive, socially wise, and likely to facilitate positive interaction, understanding, and trust. . . . Whenever it is assumed that women's nonverbal behavior is undesirable, yet another myth is perpetuated: that male behavior is "normal" and that it is women's behavior that is deviant and in need of explanation. (pp. 152–153)

■ ROLES

All the world's a stage,
And all the men and women merely players:
They have their exits and their entrances;
And one man in his time plays many parts.
WILLIAM SHAKESPEARE

Role theorists assume, as did William Shakespeare, that social life is like acting on a theatrical stage, with all its scenes, masks, and scripts. Like the role of Jaques, who speaks these lines in *As You Like It*, social roles, such as parent, student, and friend, outlast those who play them. And, as Jaques says, these roles allow some freedom of interpretation to those who act them out; great performances are defined by the way the role is played. However, some aspects of any role *must* be performed. A student must at least show up for exams, turn in papers, and maintain some minimum grade point average.

When only a few norms are associated with a social category (for example, sidewalk pedestrians should keep to the right and not jaywalk), we do not

regard the position as a social role. It takes a whole cluster of norms to define a **role.** I could readily generate a long list of norms prescribing my activities as a professor or as a father. Although I may acquire my particular image by violating the least important norms (I am occasionally a couple minutes late to class), violating my role's most important norms (failing to meet my classes, abusing my children) could lead to my being fired or divorced. From studies conducted in Britain, Italy, Hong Kong, and Japan, Michael Argyle and Monika Henderson (1985) noted several cultural variations in the norms that define the role of friend (in Japan it's especially important not to embarrass a friend with public criticism). But there are also some apparently universal norms: Respect the friend's privacy, make eye contact while talking, don't divulge things said in confidence. These are among the rules of the friendship game. Break them and the game is over.

Role:
A set of norms that define how people in a given social position ought to behave.

EFFECTS OF ROLE PLAYING

In Chapter 4, we noted that we tend to absorb our roles. On a first date or on a new job, we may act the role self-consciously. As we internalize the role, self-consciousness subsides. What felt awkward now feels genuine.

"Nowhere is social psychology further apart from public consciousness," noted Philip Brickman (1978), "than in its understanding of how things become real for people." Take the case of kidnapped heiress Patricia Hearst. In 1974, while held by some young revolutionaries who called themselves the Symbionese Liberation Army (SLA), she renounced her former life, her wealthy parents, and her fiancé. Announcing that she had joined her captors, she asked that people "try to understand the changes I've gone through." Twelve days later a bank camera recorded her participation in an SLA armed holdup.

Eventually, Hearst was apprehended and, after "deprogramming," resumed her role as an heiress. Then she became a suburban Connecticut housewife and mother who now devotes much of her time to charitable causes (Johnson, 1988). If Patricia Hearst had really been a dedicated revolutionary all

Heiress Patricia Hearst as "Tanya" the revolutionary and as a suburban socialite.

along, or had she only pretended to cooperate with her captors, people could have understood her actions. What they could not understand (and what therefore helped make this one of the biggest news stories of the 1970s) was, as Brickman wrote, "that she could really be an heiress, really a revolutionary, and then perhaps really an heiress again." It's mind-blowing. Surely, this could not happen to you or me—or could it?

Yes and no. As we'll see in the last section of this chapter, our actions depend not only on the social situation but also on our dispositions. Not everyone responds in the same way to pressure. In Patricia Hearst's predicament, you and I might respond differently. Nevertheless, some social situations can move most "normal" people to behave in "abnormal" ways. This is clear from experiments that put well-intentioned people in a bad situation to see whether good or evil prevails. To a dismaying extent, evil wins. Nice guys often don't finish nice.

Roles That Dehumanize

Does prison brutality occur because the dispositions of those involved are cruel? (Former Georgia governor Lester Maddox was once asked if there was any way to improve prisons. "What we need," he replied, "is a better class of prisoner.") Could prisons be reformed by employing better people as guards and isolating sadistic prisoners? Does the person make the place violent? Or do prisons dehumanize people because the institutional roles of guard and prisoner embitter and harden even the most compassionate of people? In other words, does the place make the person violent?

"If only it were all so simple! If only there were evil people somewhere insidiously committing evil deeds, and it were necessary only to separate them from the rest of us and destroy them. But the line dividing good and evil cuts through the heart of every human being."
Aleksandr Solzhenitsyn, *The Gulag Archipelago*

Guards and prisoners in the Stanford prison simulation quickly absorbed the roles they played.

■ BEHIND THE SCENES

We've taken the message of our simulated prison study—the corrupting power of the prison situation—to prison officials, judges, lawyers, and committees of the U.S. Senate and House. That "good people" could be so vulnerable to the "evil forces" in a simulated prison environment challenges us to reevaluate assumptions about the causes of social and personal pathology. After seeing a video presentation of the prison study at a 1991 psychological conference, the vice-president of the Soviet Psychological Society told the audience that this experiment had been conducted on a wider scale—in the U.S.S.R. He said the Communist rulers assigned most people to play the roles of prisoners and the rest to be their guards in a 70-year long experiment. Now that it is officially over, he wondered whether the subjects may have learned their roles too well and would not be able to shed them even when they were free to do so.

PHILIP ZIMBARDO, *Stanford University*

The debate continues between those who say the evil resides in the individuals (reform the guards, rehabilitate the prisoners) and those who also see evil in the inherent dynamics of prison life. Personality and situational factors intertwine, so we can make a case for either. Recognizing this dilemma, Philip Zimbardo assigned similar groups of people to differing roles. In a simulated prison constructed in the basement of Stanford University's psychology department, he subjected some decent, intelligent college men to important features of the prison situation. Among this volunteer group, half, by a flip of a coin, he designated guards. He gave them uniforms, billy clubs, and whistles and instructed them to enforce certain rules. The other half, the prisoners, were locked in cells and made to wear humiliating outfits.

After little more than a day, the guards and prisoners, and even the experimenters, got caught up in the situation. The guards devised cruelly degrading routines. The prisoners broke down, rebelled, or became apathetic. And the experimenters worked overtime to maintain prison security. There developed, reported Zimbardo (1972b), a "growing confusion between reality and illusion, between role-playing and self-identity. . . . This prison which we had created . . . was absorbing us as creatures of its own reality." The simulation was planned to last two weeks. But:

> At the end of only six days we had to close down our mock prison because what we saw was frightening. It was no longer apparent to us or most of the subjects where they ended and their roles began. The majority had indeed become "prisoners" or "guards," no longer able to clearly differentiate between role-playing and self. There were dramatic changes in virtually every aspect of their behavior, thinking and feeling. In less than a week, the experience of imprisonment ended (temporarily) a lifetime of learning; human values were suspended, self-concepts were challenged, and the ugliest, most base, pathological side of human nature surfaced. We were horrified because we saw some boys ("guards") treat other boys as if they were despicable animals, taking pleasure in cruelty, while other boys ("prisoners") became servile, dehumanized robots who thought only of escape, of their own individual survival, and of their mounting hatred of the guards. (Zimbardo, 1971, p. 3)

The fundamental demonstration of this controversial simulation has nothing to do with real prisons, which differ from the simulated one. Nor does it concern the many real-life situations that may involve similarly destructive role relations. Rather, it shows how that which was unreal (an artificial role) can evolve into that which is real. Imagine playing the role of slave—not just for six days but for decades. If a few days altered the behavior of those in Zimbardo's "prison," then imagine the corrosive effects of decades of subservient behavior. The master may be even more profoundly affected, because the master's role is chosen. Frederick Douglass, a former slave, recalls his slave mistress's transformation as she absorbed her role:

> My new mistress proved to be all she appeared when I first met her at the door—a woman of the kindest heart and finest feelings. She had never had a slave under her control previously to myself, and prior to her marriage she had been dependent upon her own industry for a living. She was by trade a weaver; and by constant application to her business, she had been in a good degree preserved from the blighting and dehumanizing effects of slavery. I was utterly astonished at her goodness. I scarcely knew how to behave towards her. She was entirely unlike any other white woman I had ever seen. I could not approach her as I was accustomed to approach other white ladies. My early instruction was all out of place. The crouching servility, usually so acceptable a quality in a slave, did not answer when manifested toward her. Her favor was not gained by it; she seemed to be disturbed by it. She did not deem it impudent or unmannerly for a slave to look her in the face. The meanest slave was put fully at ease in her presence, and none left without feeling better for having seen her. Her face was made of heavenly smiles, and her voice of tranquil music.
>
> But, alas! this kind heart had but a short time to remain such. The fatal poison of irresponsible power was already in her hands, and soon commenced its infernal work. That cheerful eye, under the influence of slavery, soon became red with rage; that voice, made all of sweet accord, changed to one of harsh and horrid discord; and that angelic face gave place to that of a demon. (Douglass, 1845, pp. 57–58)

Burnout

Burnout:
Hostility, apathy, or loss of idealism resulting from the requirements of a role or from conflict between those in antagonistic roles.

Human service professionals often experience the transforming power of a new role in the **burnout** of their initial idealism. A New York City police officer explains: "You change when you become a cop—you become tough and hard and cynical. You have to condition yourself to be that way in order to survive on this job. And sometimes, without realizing it, you act that way all the time, even with your wife and kids" (Maslach & Jackson, 1979). Ward attendants in institutions for the mentally retarded often start to refer to residents with derogatory labels such as "biter," "soiler," and "brat"; and the initial idealism of social workers, like that of Frederick Douglass's slave mistress, often degenerates into an impersonal, demeaning attitude (Wills, 1978).

And the clients? They often view the staff workers as cold and callous. One young man, recovering from the amputation of his leg, went with his mother to the social security office to request information about aid for the disabled. After the caseworker accused them of trying to rip off the government, they went home and cried for three hours. Of course, not all police officers, ward attendants, and caseworkers become so insensitive. Yet the wide range of personalities who experience burnout suggests we might usefully view burnout as caused by bad situations rather than by inherently bad people.

Christina Maslach (1978, 1982) has identified how role relations between staff and clients create burnout. The norms of the caseworker role (some of

them formalized as rules and regulations) require the caseworker to ask the client very personal questions, yet restrict the caseworker's freedom to offer aid. This produces a tense relationship and induces the caseworker to keep an emotional distance. Norms dictate that the caseworker be assertive, the client passive and dependent. As a result, the caseworker may unknowingly come to view the clients as objects. Moreover, the situation dictates that clients let them know when things go wrong but not when things go right. If the casework does not bring gratifying results, to what will the professional helper likely attribute client complaints and failures? To the clients' dispositions, of course: "If they can't change after all I've done for them, then let's face it—there's something basically wrong with them."

Recall the fundamental attribution error. When professional helpers are selectively exposed to clients' problems and negative behaviors, do they attribute these problems to the clients' dispositions rather than to their situations?

High- and Low-Status Roles

In George Orwell's *Animal Farm*, the livestock overthrow their human masters and form an egalitarian society in which, "All animals are equal." As the story unfolds, the pigs—who assume the managerial role—soon evade chores and accept comforts they consider appropriate to their status. "All animals are equal," they affirm, "but some animals are more equal than others."

Lawrence Messé, Norbert Kerr, and David Sattler (1992) note that the effects of status on self-perceptions aren't limited to pigs. In many everyday and laboratory situations, people assigned a superior status come to see themselves as meriting favorable treatment or as capable of superior performance. Ronald Humphrey (1985) showed this when he set up a simulated business office. By lottery, some people became managers, others clerks. As in real offices, the managers gave orders to the clerks and did higher level work. Afterward, both clerks and managers perceived the equally able (randomly assigned) managers as *more* intelligent, assertive, and supportive—as really being more leaderlike.

Likewise, playing a *subservient* role can have demeaning effects. Ellen Langer and Ann Benevento (1978) discovered this when they had pairs of New York City women solve arithmetic problems. After solving the problems individually, the women solved more problems together, with one of the women designated "boss" and the other "assistant." When they then went back to working individually, the "bosses" now solved more problems than they had in the first round, and the "assistants" solved fewer. Similar effects of assigned status on performance have been found in experiments with elementary school children (Jemmott & Gonzalez, 1989; Musser & Graziano, 1991). Demeaning roles undermine self-efficacy.

"It is the peculiar triumph of society—and its loss—that it is able to convince those people to whom it has given inferior status of the reality of this decree."
James Baldwin, *Notes of a Native Son*, 1955

Role Reversal

Thus far we have dealt primarily with role playing's negative effects. But role playing can also be a positive force. By intentionally playing a new role, people sometimes change themselves or empathize with people whose roles differ from their own. Psychodrama, a form of psychotherapy, uses role playing for just this purpose. In George Bernard Shaw's *Pygmalion*, Eliza Doolittle, the cockney flower vendor, discovers that if she plays the role of a lady, and is viewed by others as a lady, then she in fact is a lady. What wasn't real now is.

Roles often come in pairs defined by relationships—parent and child, husband and wife, teacher and student, doctor and patient, employer and employee, police and citizen. To help each understand the other, role reversals can help. The problem with much human conversation and argument, observed La

"Great Spirit, grant that I may not criticize my neighbor until I have walked for a moon in his moccasins."
Native American prayer

Rochefoucauld, is that people pay more attention to their own utterances than to others. "Even the most charming and clever do little more than appear attentive, while in their eyes one may see a look of bewilderment as one talks, so anxious are they to return to their own ideas" (1665, No. 139). A negotiator or group leader can therefore create better communication by having the two sides reverse roles, with each arguing the other's position. Or each side can be asked to restate the other party's point (to the other's satisfaction) before replying. The next time you get into a difficult argument with a friend or parent, try to stop it in the middle and have each of you restate the other's perceptions and feelings before going on with your own. Likely, your mutual understanding will increase.

GENDER ROLES

The shaping power of cultural expectations is conspicuous in our ideas about how men and women should behave. Even in contemporary, dual-career, North American marriages, men do most of the household repairs and women arrange the child care (Biernat & Wortman, 1991). Such behavior expectations for males and females define **gender roles.**

Gender role:
A set of behavior expectations (norms) for males or females.

In an experiment with Princeton University undergraduate women, Mark Zanna and Susan Pack (1975) showed the impact of gender role expectations. The women answered a questionnaire on which they described themselves to a tall, unattached, senior man they expected to meet. Those led to believe his ideal woman was home-oriented and deferential to her husband presented themselves as more traditionally feminine than did women expecting to meet a man who liked strong, ambitious women. Moreover, given a problem-solving test, those expecting to meet the nonsexist man behaved more intelligently: They solved 18 percent more problems than those expecting to meet the man with the traditional views. This adapting of themselves to fit the man's image

Do you ever present one self to members of your own sex and a different self to members of the other sex?

■ BEHIND THE SCENES

When I began my career at Princeton in 1970, the first group of female undergraduates had just enrolled at this formerly all-male bastion. These pioneers were incredibly bright and very ambitious. Indeed, the majority intended to become doctors, lawyers, or professors! It was Susan Pack's intuition that, despite the great capabilities and high achievement motivation of her female peers, they still "acted dumb" when confronted with the typical attractive, though chauvinistic, Princeton male. Susan's undergraduate honors thesis, designed to test this notion, demonstrated that Princeton females "acted dumb" or "acted smart" depending, in part, on whether they believed an attractive Princeton male held chauvinistic or liberated attitudes about women. I wonder: would these results hold today at Princeton? At other colleges? Would males, too, act to fulfill the gender stereotypes of attractive females?

MARK ZANNA, *University of Waterloo*

Women as mechanics. With time, gender roles are becoming more flexible, and it is no longer always the woman who does the housework and the man who fixes the car.

was much less pronounced if the man was less desirable—a short, already attached freshman.

But does culture construct gender roles? Or do gender roles merely reflect behavior naturally appropriate for men and women? The variety of gender roles across cultures and over time show that culture indeed constructs our gender roles.

Gender Roles Vary with Culture

Should women do the housework? Should they be more concerned with promoting their husband's career than with their own? John Williams, Debra Best, and their collaborators (1990b) asked such questions of university students in 14 cultures. In nearly every one, women students had slightly more egalitarian views than their male peers. But the differences between the countries was far greater. Nigerian and Pakistani students, for example, had much more traditional ideas about distinct roles for men and women than did Dutch and German students.

These differing ideas about gender roles are displayed in differing behaviors. In the United States, for example, women during the 1980s accounted for 3 percent of top executives at the 1000 largest corporations, 4 percent of the Marine Corps, 97 percent of nurses, and 99 percent of secretaries (Castro, 1990; Saltzman, 1991; Williams, 1989). In countries everywhere, girls spend more time helping with housework and child care, while boys spend more time in unsupervised play (Edwards, 1991). In some countries these boy-girl roles differ sharply. In rural central India, for example, girls spend two-thirds of their time doing household work, while their brothers spend two-thirds of their time in leisure (Sarawathi & Dutta, 1988).

To some, the absence of women in top management suggests an invisible barrier—a "glass ceiling"—that restrains women's reaching the top (O'Leary & Ickovics, 1992).

Doonesbury copyright 1981 G.B. Trudeau.

In western cultures, gender roles are changing, but not this much.

Gender Roles Vary over Time

In the last half century—a thin slice of our long history—gender roles have changed dramatically. In 1938, 1 in 5 Americans approved "of a married woman earning money in business or industry if she has a husband capable of supporting her." By the end of the 1980s, 4 in 5 approved (Niemi & others, 1989)—although nearly 2 in 3 still think that for children the "ideal family situation" is "father has a job and mother stays home and cares for the children" (Gallup, 1990). In 1967, 57 percent of first-year American collegians agreed that "the activities of married women are best confined to the home and family." In 1990, 25 percent agreed (Astin & others, 1987, 1991).

Behavior changes have accompanied this attitude shift. Between 1960 and 1990, the proportion of American women in the work force increased from 1 in 3 to nearly 3 in 5. Between 1965 and 1985, American women were spending progressively less time in household tasks and men more time, raising the proportion of housework done by men from 15 to 33 percent (Robinson, 1988). But cultural variations in the extent to which men are found standing in front of the stove or bending over the laundry remain huge. Japanese husbands devote about 4 hours a week to domestic chores; their Swedish counterparts devote 18 hours a week (Juster & Stafford, 1991).

American husbands do 72 percent of the outdoor work and 91 percent of the auto maintenance, but only 19 percent of the meal preparation, 16 percent of the housecleaning, and 12 percent of the laundry (Blair & Lichter, 1991).

■ CULTURE OR BIOLOGY?

We began this chapter by affirming our biological kinship as members of one human family. In emphasizing the extent of social diversity, how norms and roles vary with culture, and how cultures change over time, remember that our primary quest in social psychology is not to catalog differences but to identify universal principles of behavior. Our aim is what cross-cultural psychologist Walter Lonner (1989) calls "a universalistic psychology—a psychology that is as valid and meaningful in Omaha and Osaka as it is in Rome and Botswana." Attitudes and behaviors will always vary with culture, but the processes by which attitudes influence behavior vary much less. People in Nigeria and Japan define gender roles differently than do those in Europe and North America, but in all cultures role expectations guide social relations. G. K. Chesterton had the idea nearly a century ago: When someone "has discovered why men in Bond Street wear black hats he will at the same moment have discovered why men in Timbuctoo wear red feathers."

To see how biology and culture work together, let's consider two more gender differences—in physical aggression and in sexual initiative.

By **aggression,** psychologists mean behavior intended to hurt. Throughout the world, hunting, fighting, and warring are primarily men's activities. In surveys, men admit to more aggression than do women. In laboratory experiments, men indeed exhibit more physical aggression, for example, by administering what they believe are hurtful electric shocks (Eagly & Steffen, 1986; Hyde, 1986). In the United States, men are arrested for violent crimes 8 times more often than women—a trend found in every society that has kept crime records (Kenrick, 1987).

There is also a gender gap in sexual attitudes and assertiveness. It's true that in their physiological and subjective responses to sexual stimuli, women and men are "more similar than different" (Griffitt, 1987). Yet Susan Hendrick and her colleagues (1985) report that many studies, including their own, reveal that women are "moderately conservative" about casual sex and men are "moderately permissive." The American Council on Education's recent survey of a quarter million first-year college students is illustrative. "If two people really like each other, it's all right for them to have sex even if they've known each other for only a very short time," agreed 66 percent of men but only 39 percent of women (Astin & others, 1991).

The gender difference in sexual attitudes carries over to behavior. "With few exceptions anywhere in the world," report cross-cultural psychologist Marshall Segall and his colleagues (1990, p. 244), "males are more likely than females to initiate sexual activity." Moreover, among people of both sexual orientations (though especially among those with a homosexual orientation) "men without women have sex more often, with more different partners, than women without men" (Baumeister, 1991, p. 151). Like their human counterparts, the males of most animals species, too, are more sexually assertive and less selective about their partners (Hinde, 1984). Not only in sexual relations, but also in courtship, self-disclosure, and touching, males tend to take more initiative (Hendrick, 1988; Kenrick 1987).

As detectives are more intrigued by crime than virtue, so psychological detectives are more intrigued by differences than similarities. In explaining

Aggression:
Physical or verbal behavior intended to hurt someone. In laboratory experiments, this might mean delivering electric shocks or saying something likely to hurt another's feelings. By this social psychological definition, one can be socially assertive without being aggressive.

"The relatively simple question of whether sex differences exist has evolved into the more theoretically interesting question of why sex differences occur."
Alice H. Eagly and Wendy Wood (1988)

gender roles, and gender differences in aggression and sexual initiative, inquiry has focused on two culprits: biology and culture.

BIOLOGY

"What do you think is the main reason men and women have different personalities, interests, and abilities?" asked the Gallup Organization (1990) in a national survey. "Is it mainly because of the way men and women are raised, or are the differences part of their biological makeup?" Among the 99 percent who answered the question (apparently without questioning its assumptions), nearly equal numbers answered "upbringing" and "biology."

There are, of course, salient biological sex differences. Men have penises; women have vaginas. Men produce sperm, women eggs. Men have the muscle mass to hunt with a spear; women can breast-feed. Are biological sex differences limited to these obvious distinctions in reproduction and physique? Or do genes, hormones, and brains differ in ways that also contribute to behavior differences? Social scientists have recently been giving increased attention to biological influences on social behavior. Consider the biosocial view of gender differences.

The Evolution of the Sexes: Doing What Comes Naturally

Since Darwin, most biologists have assumed that for millions of years organisms have competed to survive and leave descendants. Genes that increased the odds of leaving descendants became more abundant. In the snowy Arctic environment, for example, polar bear genes programming a thick coat of camouflaging fur have won the genetic competition and now predominate.

Simplified, Darwin assumed that the way organisms evolve is adaptive—otherwise they wouldn't be here. Organisms well adapted to their environ-

"I hunt and she gathers—otherwise, we couldn't make ends meet."

ment are more likely to contribute their genes to posterity. **Evolutionary psychology** studies how this process may predispose not just adaptive physical traits, such as polar bear coats, but also psychological traits and social behaviors (Buss, 1991).

Evolutionary theory offers a ready explanation for why males exert more sexual initiative. The average male produces over 8 trillion sperm in his lifetime, making sperm cheap compared to eggs. Moreover, while a female brings one fetus to term and then nurses it, a male can spread his genes by fertilizing many females. Thus females invest their reproductive opportunities carefully, looking for signs of health and resources. (Rape is said to be universally feared by women partly because it violates their ability to select a fit and supportive reproductive partner.) Meanwhile, males compete with other males for chances to send their genes into the future. Moreover, evolutionary psychology suggests, physically dominant males gained more access to females, which over generations made male aggression and dominance characteristic.

Mind you, little of this is conscious. No one stops to calculate, "How can I maximize the number of genes I leave to posterity?" Rather, say evolutionary psychologists, our natural yearnings are our genes' way of making more genes. And that, they say, helps explain not only male aggression but also the differing sexual attitudes and behaviors of females and males. Although our genes endow us with the adaptive flexibility that permits cultural influence, studies in 37 cultures worldwide reveal that men everywhere feel attracted to women whose youthful features suggest fertility and that women everywhere feel attracted to men whose wealth, power, and ambition promise resources needed to protect and nurture offspring (Buss, 1989).

Without disputing the principle of natural selection—that nature tends to select physical and behavioral traits that enhance gene survival—critics see two problems with evolutionary explanations. First, such an explanation often starts with an effect (such as the male-female difference in sexual initiative) and then works backward to conjecture an explanation for it. This approach is reminiscent of functionalism, a dominant theory in psychology during the 1920s. "Why does that behavior occur? Because it serves such and such a function." The theorist can hardly lose at this game.

The way to prevent the hindsight bias is to imagine things turning out otherwise. Let's try it. If human males were never known to have extramarital affairs, might we not see the evolutionary wisdom behind their fidelity? After all, there's more to bringing offspring to maturity than merely depositing seed in a fertile woman. Males who are loyal to their mates and offspring are more apt to ensure that their young will survive to perpetuate their genes. (This is, in fact, an evolutionary explanation for why humans, and certain other species whose young require a heavy parental investment, tend to pair off and be monogamous.) Or imagine that women were the stronger, more physically aggressive sex. "But of course!" someone might say, "all the better for protecting their young."

Evolutionary psychologists reply that their field is more and more an empirical science that tests ideas with data from animal behavior, cross-cultural observations, and hormonal and genetic studies. Also, as the evolutionary psychologist would caution us, evolutionary wisdom is *past* wisdom. It tells us what behaviors worked in the past. Whether such tendencies are still adaptive is a different question.

Evolutionary psychology: The study of how natural selection predisposes adaptive traits and behavior tendencies.

Secretariat, the greatest race-horse of modern times, sired 400 foals.

"A hen is only an egg's way of making another egg."
Samuel Butler, 1835–1901

"Sex differences in behavior may have been relevant to our ancestors gathering roots and hunting squirrels on the plains of Northern Africa, but their manifestations in modern society are less clearly 'adaptive.' Modern society is information oriented—big biceps and gushing testosterone have less direct relevance to the president of a computer firm."
Douglas Kenrick (1987)

Critics acknowledge that evolution helps explain both our commonalities and our differences (a certain amount of diversity aids survival). But they say our common evolutionary heritage does not, by itself, predict the enormous cultural variation in human marriage patterns (from one spouse to a succession of spouses to multiple wives to multiple husbands to spouse swapping). Nor does it explain cultural changes in behavior patterns over mere decades of time. The most significant trait that nature has endowed us with, it seems, is the capacity to adapt—to learn and to change. Therein lies what all agree is culture's shaping power.

Hormones

The results of architectural blueprints can be seen in physical structures, such as the sex hormones that differentiate males and females. To what extent do hormonal differences predispose psychological differences?

Infants have built-in abilities to suck, grasp, and cry. Do mothers have a corresponding built-in predisposition to respond? Advocates of the biosocial perspective, such as sociologist Alice Rossi (1978), argue that they do. Behaviors critical to survival, such as the attachment of nursing mothers to their dependent infants, tend to be innate and culturally universal. For example, an infant's crying and nursing stimulates the mother's secretion of oxytocin, the same sex hormone that causes the nipples to become erect during lovemaking. For most of human history, the physical pleasure of breast-feeding probably helped forge the mother-infant bond. Thus Rossi found it not surprising that, while many cultures expect men to be loving fathers, *all* cultures expect women to be closely attached to their young children. She would also not be surprised that in one study of more than 7000 passers-by in a Seattle shopping mall, teenage and young adult women were more than twice as likely as similar-age men to pause to look at a baby (Robinson & others, 1979).

The gender gap in aggression reflects the influence of another hormone, *testosterone*. In various animals, administering testosterone heightens aggressiveness. In humans, violent male criminals have higher-than-normal testosterone levels, as do National Football League players (Dabbs & others, 1990). Moreover, for both humans and monkeys the gender difference in aggression appears early in life (before culture has much effect) and wanes as testosterone levels decline during adulthood. No one of these lines of evidence is conclusive. Taken together, they convince most scholars that sex hormones matter. But so does culture.

BIOLOGY *AND* CULTURE

As people mature to middle age and beyond, a curious thing happens. Women become more assertive and self-confident, men more empathic and less domineering (Lowenthal & others, 1975; Pratt & others, 1990). Hormone changes are one possible explanation for the shrinking gender differences. Role demands are another. Some speculate that during courtship and early parenthood, social expectations lead both sexes to emphasize traits that enhance their roles. While courting, providing, and protecting, men play up their macho sides and forgo their needs for interdependence and nurturance (Gutmann, 1977). While courting and rearing young children, young women restrain their impulses to assert and be independent. As men and women graduate from these early adult

Only very occasionally do couples violate the male-taller norm.

roles, they supposedly express more of their restrained tendencies. Each becomes more *androgynous*—more capable of exhibiting traits associated with both traditional masculinity (such as assertiveness) and femininity (such as nurturance).

"The finest people marry the two sexes in their own person." Ralph Waldo Emerson, *Journals*, 1843

But we needn't think of biology and culture as absolute competitors. Cultural norms subtly but powerfully affect our attitudes and behavior. But they needn't do so independent of biology. What biology initiates, culture may accentuate. If their genes and hormones predispose males to be more physically aggressive than females, culture may amplify this difference by socializing males to be tough and females to be the kinder, gentler sex.

Biology and culture may also **interact.** In humans, biological traits influence how the environment reacts. People respond differently to a Sylvester Stallone than to a Woody Allen. Men, being 8 percent taller and averaging almost double the proportion of muscle mass, may likewise have different experiences than women (Kenrick, 1987). Or consider this: A very strong cultural norm dictates that males should be taller than their female mates. In one study, only 1 in 720 married couples violated this norm (Gillis & Avis, 1980). With hindsight, we can speculate a psychological explanation: Perhaps being taller (and older) helps men perpetuate their social power over women. But we can also speculate biological wisdom that might underlie the cultural norm: If people preferred partners of the same height, tall men and short women would often be without partners. As it is, biology dictates that men tend to be taller than women, and culture dictates the same for couples. So the height norm might well be biology *and* culture, hand in hand.

Interaction: The effect of one factor (such as biology) depends on another factor (such as environment).

FIGURE 6-2 *A social-role theory of gender differences in social behavior. Various influences, including childhood experiences and biological factors, bend males and females toward differing roles. The expectations and the skills and beliefs associated with these differing roles affect men's and women's behavior.*

(Adapted from Eagly, 1987, and Eagly & Wood, 1991.)

In her book *Sex Differences in Social Behavior*, Alice Eagly (1987) theorizes a process by which biology and culture interact (Figure 6-2). She believes that a variety of factors, including biological influences and childhood socialization, predisposes a sexual division of labor. In adult life the immediate causes of gender differences in social behavior are the *roles* that reflect this sexual division of labor. Men tend to be found in roles demanding social and physical power, and women in more nurturant roles. Each sex tends to exhibit the behaviors expected of those who fill such roles and to have their skills and beliefs shaped accordingly. The effects of biology and socialization may be important insofar as they influence the social roles that people play, for the roles we play influence who we become.

■ THE GREAT LESSON OF SOCIAL PSYCHOLOGY

Food for thought: If Bohr's statement is a great truth, what is its opposite?

"There are trivial truths and great truths," declared the physicist Niels Bohr. "The opposite of a trivial truth is plainly false. The opposite of a great truth is also true." Each chapter in this unit on social influence teaches a great truth: the power of the social situation. This great truth about the power of external pressures would sufficiently explain our behavior if we were passive, like tumbleweed. But unlike tumbleweed, we are not just blown here and there by the environment. We act; we react. We respond, and we get responses. We can resist the social situation and sometimes even change it. Thus each of these "social influence" chapters concludes by calling attention to the opposite of the great truth: the power of the person.

Perhaps this chapter's stress on the power of culture leaves you somewhat uncomfortable. Most of us resent any suggestion that external forces determine our behavior; we see ourselves as free beings, as the originators of our actions (well, at least of our good actions). We sense that believing in social determinism can lead to what philosopher Jean-Paul Sartre called "bad faith"—evading responsibility by blaming something or someone for one's fate.

"The words of truth are always paradoxical."
Lao-tzu, *The Simple Way*

Actually, social control (the power of the situation) and personal control (the power of the person) no more compete with one another than do biological and

cultural explanations. Social and personal explanations of our social behavior are both valid, for at any moment we are both the creatures and the creators of our social worlds. We may well be the products of our genes and environment. But it is also true that the future is coming, and it is our job to decide where it is going. Our choices today determine our environment tomorrow.

Social situations do profoundly influence individuals. But individuals also influence the social situation. The two *interact*. Asking whether external situations or inner dispositions determine behavior is like asking whether length or width determines the area of a field.

The interaction occurs in at least three ways (Snyder & Ickes, 1985). First, a given social situation often affects different people somewhat differently. Because our minds do not see reality identically, we each respond to a situation as we construe it. And some people are more sensitive and responsive to social situations than others (M. Snyder, 1983). The Japanese, for example, are more responsive to social expectations than the British (Argyle & others, 1978).

Second, interaction between persons and situations also occurs because people can choose to be part of a particular situation (Ickes & others, 1990). Given a choice, sociable people elect situations that evoke social interaction. When you chose your college, you were also choosing to expose yourself to a specific set of social influences. Ardent political liberals are unlikely to settle in Orange County, California, join the Chamber of Commerce, or read *U. S. News and World Report*. They are more likely to live in San Francisco, join Common Cause, and read the *New Republic*—in other words, to choose a social world that reinforces their inclinations.

Third, people often create their situations. Recall again that our preconceptions can be self-fulfilling: If we expect someone to be extraverted, hostile, feminine, or sexy, our actions toward the person may induce the very behavior we expect. What, after all, composes a social situation but the people in it? A liberal political environment is one created by political liberals. What takes place at the Elks Club bar is created by the patrons. The social environment is not like the weather—something that just happens to us. It is more like our homes—something we make for ourselves.

This reciprocal causation between situations and persons allows us to see people as either *reacting to* or *acting upon* their environment. Each perspective is correct, for we are both the products and the architects of our social worlds. However, is one perspective wiser? In one sense, it is wise to see ourselves as the creatures of our environments (lest we become too proud of our achievements and blame ourselves too much for our problems) and to see others as free actors (lest we become paternalistic and manipulative).

However, perhaps we would do well more often to assume the reverse—to view ourselves as free agents and to view others as influenced by their environments. We would then assume self-efficacy as we view ourselves and seek understanding and social reform as we relate to others. (If we view others as influenced by their situations, we are more likely to understand and empathize than smugly to judge unpleasant behavior as freely chosen by "immoral," "sadistic," or "lazy" persons.) Most religions encourage us to take responsibility for ourselves but to refrain from judging others. Does religion teach this because our natural inclination is to excuse our own failures while blaming others for theirs?

"If we explain poverty, or emotional disorders, or crime and delinquency, or alcoholism, or even unemployment, as resulting from personal, internal, individual defects . . . then there simply is not much we can do about prevention."
George Albee (1979)

■ SUMMING UP

CULTURE AND SOCIAL DIVERSITY

The impact of culture—the thoughts and behaviors shared and sustained by a large group of people—has become a source of tensions as most nations have become a diverse mix of peoples. With the influx of new people and new ideas and the growing interdependence and telecommunications among nations, cultural diversity confronts us all. One important culture difference arises from the valuing of individual self-reliance (as in western cultures) versus collective solidarity and group identity (as in many Asian and third-world cultures). The priority which cultures place on individualism or collectivism influences their people's self-concepts, social relations, and child rearing.

NORMS

The remarkably wide diversity of attitudes and behaviors from one culture to another indicates the extent to which we are the products of cultural norms. Norms restrain and control us, but they also lubricate the social machinery: Social behavior occurs with greater ease when everyone knows what is both expected and accepted.

Despite their distinct differences, cultures share some norms in common. One apparently universal norm concerns how people of unequal status relate to one another. The more formal way we communicate with strangers is the same way we communicate with superiors. Moreover, increased intimacy (for example, a social invitation) is usually initiated by the person with higher status.

Other norms vary across cultures. For example, cultures vary in their norms regarding eating and personal space. And norms vary within cultures. Men and women differ in their propensities toward independence or interdependence. Male norms tend to favor competition and social dominance. Female norms are more supportive of empathy and social connections.

ROLES

A role is a set of norms associated with a given social position. We tend to assimilate the roles we play. Thus our playing a destructive role can be corrupting, as illustrated in observations of students playing the role of prison guard. Parallels to these laboratory results are found in daily life, such as in the "burnout" often experienced by police officers, ward attendants, and social workers. But role playing can also be constructive. By reversing roles intentionally for a time, we can develop empathy for another.

The most heavily researched of roles, gender roles, illustrate culture's impact. Gender roles vary sharply from culture to culture and from time to time.

CULTURE OR BIOLOGY?

Biological sex differences influence behavioral differences. Evolutionary psychologists speculate how evolution might have predisposed sex differences in

aggression and sexual initiative. The evidence is clearer that hormonal sex differences help create aggressivencss in males and a mother-infant bond in females.

However, biological and cultural explanations need not be contradictory. Indeed, they interact. Biological factors operate within a cultural context, and culture builds upon a biological foundation.

THE GREAT LESSON OF SOCIAL PSYCHOLOGY

The great truth about the power of social influence is but half the truth if separated from its complementary truth: the power of the person. Persons and situations interact in at least three ways. First, individuals vary in how they interpret and react to a given situation. Second, people choose many of the situations that influence them. Third, people help create their social situations. Thus power resides both in persons and in situations. We create and are created by our social worlds.

■ FOR FURTHER READING

Bond, M. (Ed.). (1989). *The cross-cultural challenge to social psychology.* Newbury Park, CA: Sage. Social psychologists examine cultural influences on social processes and debate the necessity of cross-cultural research.

Eagly, A. H. (1987). *Sex differences in social behavior: A social-role explanation.* Hillsdale, NJ: Erlbaum. How and why are men and women alike and different in aggressiveness, altruism, influenceability, and nonverbal behavior? Eagly digests all the available research studies and cogently explains the outcomes.

Segall, M. H., Dasen, P. R., Berry, J. W., & Poortinga, Y. H. (1990). *Human behavior in global perspective.* New York: Pergamon. Cross-cultural psychologists from four different countries review what we have learned about culture's impact.

Tavris, C. (1992). *The mismeasure of women.* New York: Simon & Schuster. A wise and witty dissection of myths and misunderstandings about the biological and social differences between men and women.

Unger, R., & Crawford, M. (1992). *Women and gender.* New York: McGraw-Hill. A state-of-the-art look at how we become gendered, with special attention to women's experiences, achievements, and stresses.

CONFORMITY

It was a long-awaited May afternoon. Three thousand family members and friends had gathered for the celebration. On cue, 400 Hope College seniors rose to hear the college president declare, "I hereby confer upon each of you the degree of Bachelor of Arts, with all the rights and privileges appertaining thereto." The declaration finished, the 25 new alumni in the first row began filing forward to receive their diplomas. As they did so, the other 375 eyed one another nervously, each thinking: "Weren't we instructed to sit down now and await our turn?" But no one sat. The seconds ticked by. Half the first row now had diplomas in hand. Outwardly, the standing herd kept its cool. But inside each head thoughts were buzzing: "We could be standing here for a half hour before it is our row's turn. . . . We're blocking the view of spectators seated behind us. . . . Why doesn't someone sit down?" Still, no one sat. Now two minutes had elapsed. The graduation marshal, whose instructions at the graduation rehearsal they were ignoring, strode up to the first standing row and subtly signaled it to sit down. No one sat. So he moved to the next row and audibly ordered it to "Sit down!" Within two seconds, 375 much-relieved people were happily relaxing in their chairs.

This scene raised three sets of questions for me. First, why, given the diversity of individuals among that large group, was their behavior so uniform? Is social pressure sometimes powerful enough to obliterate individual differences? Where were the rugged individualists?

Second, 25 percent of those graduates had been my students in social psychology. Although it was the farthest thing from their minds at the moment, they knew about conformity. When studying the topic, many of them had privately assured themselves that they would never be so docile as were subjects in the famous conformity experiments. But here they were, participating in one of life's parallels to the laboratory experiments. In everyday life is courage always more easily fantasized than performed? Are we more susceptible to social influence than we realize? Does learning about social influence not liberate us from it?

Third, is conformity as bad as my description of this docile "herd" implies? Should I have been pleased at their "group solidarity" and "social sensitivity" rather than dismayed at their "mindless conformity"?

Let us take the last question first. Is conformity good or bad? This is another question that has no scientific answer. But assuming the values most of us share, we can say two things. First, conformity is at times bad (when it leads someone to drink and drive), at times good (when it inhibits people from cutting in front of us in a theater line), and at times inconsequential (when it disposes us to wear white when playing tennis).

Second, the word "conformity" does carry a negative value judgment. How would you feel if you overheard someone describing you as a "real conformist"? I suspect you would feel hurt, because western cultures don't prize the trait of submitting to peer pressure. Hence North American and European social psychologists more often give it negative labels (conformity, submission, compliance) than positive ones (communal sensitivity, responsiveness, cooperative team play). We choose labels to suit our judgments. In retrospect, I view the U.S. senators who cast unpopular votes against the Vietnam war as "independent" and "inner-directed" and those who cast unpopular votes against civil rights legislation as "eccentric" and "self-centered."

Labels both describe and evaluate—and they are inescapable. We cannot

"The race of men, while sheep in credulity, are wolves for conformity."
Carl Van Doren, *Why I Am an Unbeliever*

"Whatever crushes individuality is despotism, by whatever name it may be called."
John Stuart Mill, *On Liberty,* 1859

"Everywhere in Japan, one senses an intricate serenity that comes to a people who know exactly what to expect from each other."
Lance Morrow (1983)

Drawing by W.B. Park; © 1988 The New Yorker Magazine, Inc.

The American People Finally Speak Up

Sometimes it is difficult to avoid complying.

discuss the topics of this chapter without labels. So let us be clear on the meanings of the following labels: "conformity," "compliance," "acceptance."

When, as part of a crowd, you rise to cheer a game-winning touchdown, are you conforming? When, along with millions of others, you drink milk or coffee, are you conforming? When you and everyone else agree that men look better with combable hair than with crewcuts, are you conforming? Maybe, maybe not. The key is whether your behavior and beliefs would be the same apart from the group. Would you rise to cheer the touchdown if you were the only fan in the stands? Conformity is not just acting as other people act, it is being affected by how they act. It is acting differently from the way you would act alone. Thus Charles Kiesler and Sara Kiesler (1969) defined **conformity** as "a change in behavior or belief . . . as a result of real or imagined group pressure" (p. 2).

There are two varieties of conformity. Sometimes we conform without really believing in what we are doing. We put on the necktie or dress, though we dislike doing so. This insincere, outward conformity is **compliance.** We comply primarily to reap a reward or avoid a punishment. If our compliance is to an explicit command, we call it obedience.

Sometimes we genuinely believe in what the group has convinced us to do. We may join millions of others in drinking milk because we are convinced that milk is nutritious. This sincere, inward conformity is called **acceptance.** Acceptance sometimes follows compliance. As Chapter 4 emphasized, attitudes follow behavior. Thus, unless we feel no responsibility for our behavior, we usually become sympathetic to what we have stood up for.

Conformity:
A change in behavior or belief as a result of real or imagined group pressure.

Compliance:
Conformity that involves publicly acting in accord with social pressure while privately disagreeing.

Acceptance:
Conformity that involves both acting and believing in accord with social pressure.

■ CLASSIC STUDIES

Researchers who study conformity construct miniature social worlds—laboratory microcultures that simplify and simulate important features of

Drawing by Booth; © 1977 The New Yorker Magazine, Inc.

Authorities may impose public compliance, but private acceptance is another matter.

everyday social influence. Let's begin our review of conformity research by examining three noted sets of experiments. Each provides a method for studying conformity and some startling findings.

SHERIF'S STUDIES OF NORM FORMATION

The first of the three classics provides a bridge between the focus in Chapter 6 on culture's power to create and perpetuate arbitrary norms and this chapter's focus on conformity. Muzafer Sherif (1937) wondered whether it was possible to observe the emergence of a social norm in the laboratory. Like biologists seeking to isolate a virus so they can then experiment with it, Sherif wanted to isolate and then experiment with the social phenomenon of norm formation.

As a participant in one of Sherif's experiments, you might find yourself seated in a dark room. Fifteen feet in front of you a pinpoint of light appears.

At first, nothing happens. Then for a few seconds it moves erratically and finally disappears. Now you must guess how far it moved. The dark room gives you no way to judge distance, so you offer an uncertain "6 inches." The experimenter repeats the procedure. This time you say "10 inches." With further repetitions, your estimates continue to average about 8 inches.

The next day you return, joined by two others who the day before had the same experience. When the light goes off for the first time, the other two people offer their best guesses from the day before. "One inch" says one. "Two inches," says the other. A bit taken aback, you nevertheless say, "6 inches." With successive repetitions of this group experience, both on this day and for the next two days, will your responses change? The Columbia University men whom Sherif tested changed their estimates markedly. As Figure 7-1 illustrates, a group norm typically emerged. (The norm was false. Why? The light never moved! Sherif had taken advantage of a perceptual illusion called the **autokinetic phenomenon.**)

Sherif and others have used this technique to answer questions about people's suggestibility. When people were retested alone a year later, would their estimates again diverge or would they continue to follow the group norm?

The autokinetic phenomenon: Self (*auto*) motion (*kinetic*). The apparent movement of a stationary point of light in the dark. Perhaps you have experienced this when thinking you have spotted a moving satellite in the sky, only to realize later that it was merely an isolated star.

FIGURE 7-1 *A sample group from Sherif's study of norm formation. Three individuals converge as they give repeated estimates of the apparent movement of a point of light.* (Data from Sherif & Sherif, 1969, p. 209.)

Remarkedly, they continued to support the group norm (Rohrer & others, 1954). (Does this suggest compliance or acceptance?)

Struck by culture's seeming power to perpetuate false beliefs, Robert Jacobs and Donald Campbell (1961) studied the transmission of false beliefs in their Northwestern University laboratory. Using the autokinetic phenomenon, they had a **confederate** give an inflated estimate of how far the light moved. The confederate then left the experiment and was replaced by another real subject who was in turn replaced by a still newer member. The inflated illusion persisted for five generations. These people had become "unwitting conspirators in perpetuating a cultural fraud." The lesson of these experiments: Because others influence us, our views of reality are not ours alone.

In everyday life the results of suggestibility are sometimes amusing. In late March 1954, Seattle newspapers reported damage to car windshields in a city 80 miles to the north. On the morning of April 14, similar windshield damage was reported 65 miles away and later that day only 45 miles away. By nightfall, the windshield-pitting agent had reached Seattle. Before the end of April 15, the Seattle police department had received complaints of damage to more than 3000 windshields (Medalia & Larsen, 1958). That evening the mayor of Seattle called on President Eisenhower for help.

I was an 11-year-old Seattleite at the time. I recall searching our windshield, frightened by the explanation that a Pacific H-bomb test was raining fallout on Seattle. However, on April 16 the newspapers hinted that the real culprit might be mass suggestibility. After April 17 there were no more complaints. Later analysis of the pitted windshields concluded that the cause was ordinary road damage. Why did we notice this only after April 14? Given the suggestion, we had looked carefully *at* our windshields instead of *through* them.

In real life suggestibility is not always so amusing. Hijackings, UFO sightings, and even suicides tend to come in waves. Sociologist David Phillips and

Confederate:
An accomplice of the experimenter.

"Why doth one man's yawning make another yawn?"
Robert Burton, *Anatomy of Melancholy,* 1621

UFO sightings come in waves. Given the suggestion that ambiguous objects are UFOs, people perceive more UFOs.

his colleagues (1985, 1989) report that known suicides, and fatal auto accidents and private airplane crashes (which sometimes disguise suicides), increase after well-publicized suicides. Following Marilyn Monroe's August 6, 1962, suicide, there were 200 more August suicides in the United States than normal. Moreover, the increase happens only in areas where the suicide story is publicized. The more publicity, the greater the increase in later fatalities.

A copycat suicide phenomenon has also occurred in Germany (Jonas, 1991). In both Germany and the United States, suicide rates rise slightly following fictional suicides on soap operas, and, ironically, even after serious dramas that focus on the suicide problem (Gould & Shaffer, 1986; Hafner & Schmidtke, 1989; Phillips, 1982). Phillips reports that teenagers are most susceptible, which would help explain the clusters of teen suicides that occasionally occur in some communities.

ASCH'S STUDIES OF GROUP PRESSURE

Participants in the autokinetic experiments faced an ambiguous reality. Consider a less ambiguous perceptual problem, such as faced by a young boy named Solomon Asch. While attending the traditional Jewish seder at Passover, recalls Asch,

> I asked my uncle, who was sitting next to me, why the door was being opened. He replied, "The prophet Elijah visits this evening every Jewish home and takes a sip of wine from the cup reserved for him."
>
> I was amazed at this news and repeated, "Does he really come? Does he really take a sip?"
>
> My uncle said, "If you watch very closely, when the door is opened you will see—you watch the cup—you will see that the wine will go down a little."
>
> And that's what happened. My eyes were riveted upon the cup of wine. I was determined to see whether there would be a change. And to me it seemed—it was tantalizing, and of course, it was hard to be absolutely sure—that indeed something was happening at the rim of the cup, and the wine did go down a little. (Quoted by Aron & Aron, 1989, p. 27)

Years later, social psychologist Asch re-created his boyhood experience in his laboratory. Imagine yourself as one of Asch's volunteer subjects. You are seated sixth in a row of seven people. After explaining that you will be taking part in a study of perceptual judgments, the experimenter asks you to say which of the three lines in Figure 7-2 matches the standard line. You can easily see that it's line 2. So it's no surprise when the five people responding before you all say "line 2."

The next comparison proves as easy, and you settle in to endure a boring experiment. But the third trial startles you. Although the correct answer seems just as clear-cut, the first person gives a seemingly wrong answer. When the second person gives the same answer, you sit up in your chair and stare at the cards. The third person agrees with the first two. Your jaw drops; you start to perspire. "What is this?" you ask yourself. "Are they blind? Or am I?" The fourth and fifth people agree with the others. Then the experimenter looks at you. Now you are experiencing an "epistemological nightmare": "How am I to know what is true? Is it what my peers tell me or what my eyes tell me?"

Dozens of college students experienced this conflict during Asch's experiments. Those in a control condition who answered alone were correct more

"He who sees the truth, let him proclaim it, without asking who is for it or who is against it."
Henry George, *The Irish Land Question,* 1881

Comparison lines

FIGURE 7-2 *Sample comparison from Solomon Asch's conformity procedure. The participants judged which of three comparison lines matched the standard.*

Ethical note: *Professional ethics usually dictate explaining the experiment afterward (see Chapter 1). Pretend you were an experimenter who had just finished a session with a conforming participant. Could you explain the deception without making the person feel gullible and dumb?*

than 99 percent of the time. Asch wondered: If several others ("confederates" coached by the experimenter) gave identical wrong answers, would people declare what they would otherwise have denied? Although some people never conformed, most did so at least once. All told, 37 percent of the responses were conforming. Of course, that means 63 percent of the time people did not conform. Despite the independence shown by many of his subjects, Asch's (1955) feelings about the conformity were as clear as the correct answers to his questions: "That reasonably intelligent and well-meaning young people are willing to call white black is a matter of concern. It raises questions about our ways of education and about the values that guide our conduct."

Asch's procedure became the standard for hundreds of later experiments. These experiments lack what Chapter 1 called the "mundane realism" of everyday conformity, but they do have "experimental realism." People get emotionally involved in the experience. However, the procedure is expensive and difficult to control because it requires a troupe of confederates who must act with near-perfect consistency from subject to subject. Richard Crutchfield (1955) remedied this by automating Asch's experiment. Five participants— each a real subject—sat in adjacent booths and viewed questions projected on the wall across the room. Each booth had a panel of lights and switches that allowed the subjects to declare their judgments and to see how others responded. After a few warm-up trials, all subjects found themselves responding last after seeing the purported responses of the other four.

The technique lets the researcher present a variety of questions. Crutchfield tested military officers by presenting a circle and a star side by side (Figure 7-3). The area of the circle was one-third greater. But when each officer thought the others had judged the star to be larger, 46 percent of them denied their senses and voted with the group. Tested privately, the officers each rejected the statement, "I doubt whether I would make a good leader." Of course—these *are* leaders. Yet, believing the other officers all accepted the statement, almost 40 percent concurred.

"It is too easy to go over to the majority."
Seneca, *Epistulae ad Lucilium*

In one of Asch's conformity experiments (top), the subject, no. 6, experienced uneasiness and conflict (bottom) after hearing the five people who answered a question before him all give the wrong answer.

FIGURE 7-3 *Richard Crutchfield's conformity-testing procedure. People sit in adjacent booths and answer questions presented on the wall in front of them after witnessing others' purported answers.*

Even ideologically objectionable positions got approval when the group approved. Not long before the 1960s free-speech movement surfaced at the University of California, Berkeley, Crutchfield and his colleagues found 58 percent of the students willing to go along with the group and agree that "free speech being a privilege rather than a right, it is proper for a society to suspend free speech when it feels itself threatened" (Krech & others, 1962).

The Sherif, Asch, and Crutchfield results are startling because in none of them is there any open, obvious pressure to conform—there are no rewards for "team play," no punishments for individuality. One wonders: If people are this compliant in response to such minimal pressure, how much more compliant will they be if they are directly coerced? Could someone force the average North American to perform cruel acts like those of the Nazis in Germany? I would have guessed not: North Americans' democratic and individualistic values would make them resist such pressure. Besides, the easy verbal pronouncements of these experiments are a giant step away from actually harming someone; you and I would never yield to coercion to hurt another. Or would we? Stanley Milgram wondered.

MILGRAM'S OBEDIENCE EXPERIMENTS

Milgram's (1965, 1974) experiments on what happens when the demands of authority clash with the demands of conscience have become the most famous and controversial experiments in all social psychology. "Perhaps more than any other empirical contributions in the history of social science," notes Lee Ross (1988), "they have become part of our society's shared intellectual legacy—that small body of historical incidents, biblical parables, and classic literature that serious thinkers feel free to draw on when they debate about human nature or contemplate human history."

Here is the scene: Two men come to Yale University's psychology laboratory to participate in a study of learning and memory. A stern experimenter in a gray technician's coat explains that this is a pioneering study of the effect of punishment on learning. The experiment requires one of them to teach a list of word pairs to the other and to punish errors by delivering shocks of increasing intensity. To designate the roles, they draw slips out of a hat. One of the men, a mild-mannered, 47-year-old accountant who is the experimenter's confederate, pretends that his slip says "learner" and is ushered into an adjacent room. The "teacher" (who has come in response to a newspaper ad) takes a mild sample shock and then looks on as the experimenter straps the learner into a chair and attaches an electrode to his wrist.

Teacher and experimenter then return to the main room where the teacher takes his place before a "shock generator" with switches ranging from 15 to 450 volts in 15-volt increments. The switches are labeled "Slight Shock," "Very Strong Shock," "Danger: Severe Shock," and so forth. Under the 435 and 450 volt switches appear "XXX." The experimenter tells the teacher to "move one level higher on the shock generator" each time the learner gives a wrong answer. With each flick of a switch, lights flash, relay switches click, and an electric buzz sounds.

If the subject complies with the experimenter's requests, he hears the learner grunt at 75, 90, and 105 volts. At 120 volts the learner shouts that the shocks are painful. And at 150 volts he cries out, "Experimenter, get me out of here! I

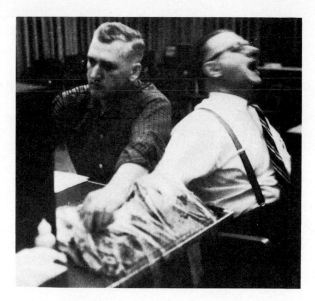

An obedient subject in the "touch" condition forces the victim's hand onto the shock plate. Usually, however, "teachers" were more merciful to victims who were next to them.

won't be in the experiment anymore! I refuse to go on!" By 270 volts his protests have become screams of agony, and he continues to insist he be let out. At 300 and 315 volts he screams his refusal to answer. After 330 volts he falls silent. In answer to the teacher's inquiries and pleas to end the experiment, the experimenter states that the nonresponses should be treated as wrong answers. To keep the subject going, he uses four verbal prods:

Prod 1: Please continue (*or* Please go on).
Prod 2: The experiment requires that you continue.
Prod 3: It is absolutely essential that you continue.
Prod 4: You have no other choice; you *must* go on.

How far would you go? Milgram described the experiment to 110 psychiatrists, college students, and middle-class adults. People in all three groups guessed that they would disobey by about 135 volts; none expected to go beyond 300 volts. Recognizing that self-estimates may reflect self-serving bias, Milgram asked them how far they thought *other* people would go. Virtually no one expected anyone to proceed to XXX on the shock panel. (The psychiatrists guessed about one in a thousand.)

But when Milgram conducted the experiment with 40 men—a vocational mix of 20- to 50-year-olds—25 of them (63 percent) went clear to 450 volts. In fact, all who reached 450 volts complied with a command to *continue* the procedure until, after two further trials, the experimenter called a halt.

Given this disturbing result, Milgram next made the learner's protests even more compelling. As the learner was strapped into the chair, the teacher heard him mention his "slight heart condition" and heard the experimenter's reassurance that "although the shocks may be painful, they cause no permanent tissue damage." The learner's anguished protests (see "Focus: The Learner's Schedule") were to little avail; of 40 new men in this experiment, 26 (65 percent) fully complied with the experimenter's demands (Figure 7-4).

The obedience of his subjects disturbed Milgram. The procedures he used

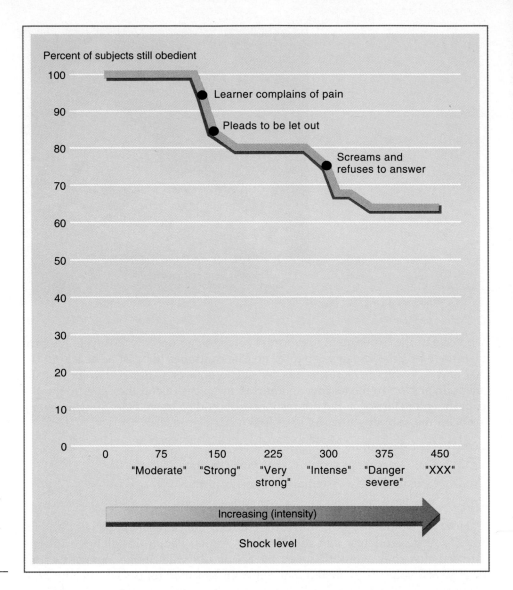

FIGURE 7-4 *The Milgram obedience experiment. Percentage of subjects complying despite the learner's cries of protest and failure to respond.* (From Milgram, 1965.)

"If a system of death camps were set up in the United States of the sort we had in Nazi Germany, one would be able to find sufficient personnel for those camps in any medium-sized American town." Stanley Milgram on *60 Minutes,* 1979

disturbed many social psychologists (Miller, 1986). The "learner" in these experiments actually received no shock (he disengaged himself from the electric chair and turned on a tape recorder that delivered the protests). Nevertheless, some critics said that Milgram did to his subjects what they did to their victims: He stressed them against their will. Indeed, many of the "teachers" did experience agony. They sweated, trembled, stuttered, bit their lips, groaned, or even broke into uncontrollable nervous laughter. A *New York Times* reviewer complained that the cruelty inflicted by the experiments "upon their unwitting subjects is surpassed only by the cruelty that they elicit from them" (Marcus, 1974). Critics also argued that the participants' self-concepts may have been altered. One participant's wife told him, "You can call yourself Eichmann" (referring to Nazi death camp administrator Adolf Eichmann).

In his own defense, Milgram pointed first to the lessons his nearly two dozen experiments taught us and second to the support he received from the

participants after the deception was revealed and the experiment explained. When surveyed afterward, 84 percent said they were glad to have participated; only 1 percent regretted volunteering. A year later, a psychiatrist interviewed 40 of those who had suffered most and concluded that, despite the temporary stress, none was harmed.

WHAT BREEDS OBEDIENCE?

Milgram did more than reveal the extent to which people will obey an authority; he also examined the conditions that breed obedience. In further experiments, he varied the social conditions and got compliance ranging from 0 to 93 percent fully obedient. The determining factors were these four: The victim's emotional distance, the authority's closeness and legitimacy, whether or not the authority is institutionalized, and the liberating effects of group influence.

Emotional Distance of the Victim

Milgram's subjects acted with least compassion when the "learners" could not be seen (and could not see them). When the victim was remote and the teachers heard no complaints, nearly all obeyed calmly to the end. When the learner

■ FOCUS: The Learner's Schedule of Protests in Milgram's "Heart Disturbance" Experiments

75 volts	Ugh!
90 volts	Ugh!
105 volts	Ugh! (*Louder*)
120 volts	Ugh! Hey this really hurts.
135 volts	Ugh!!
150 volts	Ugh!!! Experimenter! That's all. Get me out of here. I told you I had heart trouble. My heart's starting to bother me now. Get me out of here, please. My heart's starting to bother me. I refuse to go on. Let me out.
165 volts	Ugh! Let me out! (*Shouting*)
180 volts	Ugh! I can't stand the pain. Let me out of here! (*Shouting*)
195 volts	Ugh! Let me out of here. Let me out of here. My heart's bothering me. Let me out of here! You have no right to keep me here! Let me out! Let me out of here! Let me out! Let me out of here! My heart's bothering me. Let me out! Let me out!
210 volts	Ugh! Experimenter! Get me out of here. I've had enough. I won't be in the experiment any more.

225 volts	Ugh!
240 volts	Ugh!
255 volts	Ugh! Get me out of here.
270 volts	(*Agonized scream*) Let me out of here. Let me out of here. Let me out of here. Let me out. Do you hear? Let me out of here.
285 volts	(*Agonized scream*)
300 volts	(*Agonized scream*) I absolutely refuse to answer any more. Get me out of here. You can't hold me here. Get me out. Get me out of here.
315 volts	(*Intensely agonized scream*) I told you I refuse to answer. I'm no longer part of this experiment.
330 volts	(*Intense and prolonged agonized scream*) Let me out of here. Let me out of here. My heart's bothering me. Let me out. I tell you. (*Hysterically*) Let me out of here. Let me out of here. You have no right to hold me here. Let me out! Let me out! Let me out of here! Let me out! Let me out!

(From *Obedience to Authority* by Stanley Milgram. New York: Harper & Row, 1974, pp. 56–57.)

■ VIEWPOINT: PERSONALIZING THE VICTIMS

Innocent victims trigger more compassion if personalized. In a week when a soon-forgotten earthquake in Iran kills 3000 people, a lone boy dies in a well shaft in Italy, and the whole world grieves. The projected death statistics of a nuclear war are impersonal to the point of being incomprehensible. So international law professor Roger Fisher proposed a way to personalize the victims:

> It so happens that a young man, usually a navy officer, accompanies the President wherever he goes. This young man has a black attaché case which contains the codes that are needed to fire nuclear weapons.

> I can see the President at a staff meeting considering nuclear war as an abstract question. He might conclude, "On SIOP Plan One, the decision is affirmative. Communicate the Alpha line XYZ." Such jargon keeps what is involved at a distance.

My suggestion, then, is quite simple. Put that needed code number in a little capsule and implant that capsule right next to the heart of a volunteer. The volunteer will carry with him a big, heavy butcher knife as he accompanies the President. If ever the President wants to fire nuclear weapons, the only way he can do so is by first, with his own hands, killing one human being.

"George," the President would say, "I'm sorry, but tens of millions must die." The President then would have to look at someone and realize what death is—what an *innocent* death is. Blood on the White House carpet: it's reality brought home.

When I suggested this to friends in the Pentagon, they said, "My God, that's terrible. Having to kill someone would distort the President's judgment. He might never push the button."

Adapted from "Preventing Nuclear War" by Roger Fisher, *Bulletin of the Atomic Scientists*, March 1981, pp. 11–17.

was in the same room, "only" 40 percent obeyed to 450 volts. Full compliance dropped to 30 percent when teachers were required to force the learner's hand into contact with a shock plate.

In everyday life, too, it is easiest to abuse someone who is distant or depersonalized. People will be unresponsive even to great tragedies. Executioners depersonalize those being executed by placing hoods over their heads. The ethics of war allow one to bomb a helpless village from 40,000 feet but not to shoot an equally helpless villager. Even in combat with an enemy they can see, many soldiers either do not fire or do not aim. Such disobedience is rare among those given orders to kill with the more distant artillery or aircraft weapons (Padgett, 1989).

On the positive side, people act most compassionately toward those who are personalized. This is why appeals for the unborn or the hungry are nearly always personalized with a compelling photograph or description. In his 1790 *Theory of Moral Sentiments*, Scottish economist Adam Smith imagined that "the great empire of China, with all its myriads of inhabitants, was suddenly swallowed up by an earthquake." Your average European, he guessed, would on hearing the news "express very strongly his sorrow for the misfortune of that unhappy people, would make many melancholy reflections upon the precariousness of human life . . . and when all this fine philosophy was over [would resume] his business or his pleasure . . . as if no such accident had happened."

Imagine you had the power to prevent either a tidal wave that would kill 25,000 people in Pakistan, a crash that would kill 250 people at your local airport, or a car accident that would kill an acquaintance. Which would you prevent?

Closeness and Legitimacy of the Authority

The physical presence of the experimenter also affected obedience. When Milgram gave the commands by telephone, full obedience dropped to 21 percent (although many lied and said they were obeying). Other studies confirm that

when the one making the request is physically close, compliance increases. Given a light touch on the arm, people are more likely to lend a dime, sign a petition, or sample a new pizza (Kleinke, 1977; Willis & Hamm, 1980; Smith & others, 1982).

However, the authority must be perceived as legitimate. In another twist on the basic experiment, the experimenter received a rigged telephone call that required him to leave the laboratory. He said that since the equipment recorded data automatically, the teacher should just go ahead. After the experimenter left, another subject who had been assigned a clerical role (actually a second confederate) assumed command. The clerk "decided" that the shock should be increased one level for each wrong answer and instructed the teacher accordingly. Now 80 percent of the teachers refused to comply fully. The confederate, feigning disgust at this defiance, then came and sat down in front of the shock generator and tried to take over the teacher's role. At this point most of the defiant participants protested. Some tried to unplug the generator. One large man lifted the zealous shocker from his chair and threw him across the room. This rebellion against an illegitimate authority contrasted sharply with the deferential politeness usually shown the experimenter.

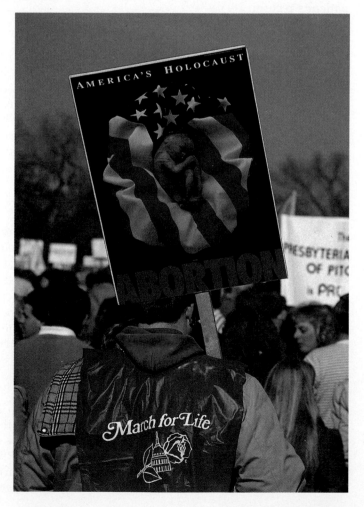

To reduce emotional distance from the unborn, and to increase emotional concern for them, right-to-life advocates offer vivid fetal images.

It also contrasts with the behavior of hospital nurses who in one study were called by an unknown physician and ordered to administer an obvious overdose of a drug (Hofling & others, 1966). The researchers told one group of nurses and nursing students about the experiment and asked how they would react. Nearly all said they would not have given the medication as ordered. One explained that she would have replied, "I'm sorry, sir, but I am not authorized to give any medication without a written order, especially one so large over the usual dose and one that I'm unfamiliar with. If it were possible, I would be glad to do it, but this is against hospital policy and my own ethical standards." Nevertheless, when 22 other nurses were actually given the phoned-in overdose order, all but one obeyed without delay (until being intercepted on their way to the patient). Although not all nurses are so compliant (Rank & Jacobson, 1977), these nurses were following a familiar script: Doctor (a legitimate authority) orders; nurse obeys.

Compliance with legitimate authority was also apparent in the strange case of the "rectal ear ache" (Cohen & Davis, 1981, cited by Cialdini, 1988). A doctor ordered ear drops given to a patient suffering infection in the right ear. On the prescription, the doctor abbreviated "place in right ear" as "place in *R ear*." Reading the order, the compliant nurse put the required drops in the compliant patient's rectum.

Institutional Authority

If the prestige of the authority is this important, then perhaps the institutional prestige of Yale University legitimized the commands. In postexperimental interviews, many participants volunteered that had it not been for Yale's reputation, they would not have obeyed. To see whether this was true, Milgram moved the experiment to Bridgeport, Connecticut. He set himself up in a modest commercial building as the "Research Associates of Bridgeport." When the usual "heart disturbance" experiment was run with the same personnel, what percentage of the men do you suppose fully obeyed? Though reduced, the rate remained remarkably high—48 percent.

The Liberating Effects of Group Influence

These classic experiments give us a negative view of conformity. Can conformity be constructive? Perhaps you can recall a time you felt justifiably angry at an unfair teacher, or with someone's offensive behavior, but you hesitated to object. Then one or two others objected, and you followed their example. Milgram captured this liberating effect of conformity by placing the teacher with two confederates who were to help conduct the procedure. During the experiment, both defied the experimenter, who then ordered the real subject to continue alone. Did he? No. Ninety percent liberated themselves by conforming to the defiant confederates.

REFLECTIONS ON THE CLASSIC STUDIES

"If the commander-in-chief tells this lieutenant colonel to go stand in the corner and sit on his head, I will do so."
Oliver North, 1987

The common response to Milgram's results is to note their counterparts in recent history: the "I was only following orders" defenses of Adolf Eichmann; of Lieutenant William Calley, who directed the unprovoked slaughter of hundreds of Vietnamese villagers in My Lai; and of the participants in various government scandals. Soldiers are trained to obey superiors. In the United

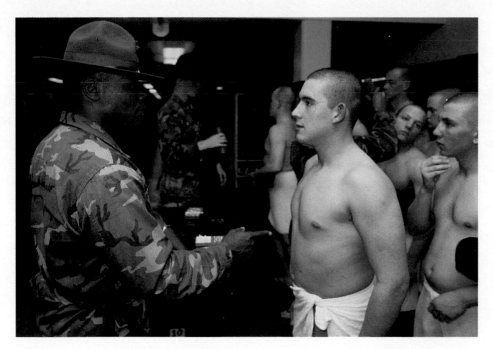

In the military, soldiers are trained to obey orders, not to question nor to think about them. Those who give orders are seen as having legitimate authority.

States, the military acknowledges that even Marines should disobey *inappropriate* orders, but the military does not train soldiers to recognize an illegal or immoral order (Staub, 1989). Thus one participant in the My Lai massacre recalled:

> [Lieutenant Calley] told me to start shooting. So I started shooting, I poured about four clips into the group. . . . They were begging and saying, "No, no." And the mothers were hugging their children and. . . . Well, we kept right on firing. They was waving their arms and begging. (Wallace, 1969)

The obedience experiments differ from the other conformity experiments in the strength of the social pressure: Compliance is explicitly commanded. Without the coercion, people did not act cruelly. Yet both the Asch and Milgram experiments share certain commonalities. They show how compliance can take precedence over moral sense. They succeeded in pressuring people to go against their own conscience. They did more than teach us an academic lesson; they sensitized us to moral conflicts in our own lives. And they illustrated and affirmed certain social psychological principles discussed in earlier chapters. Let us recall some of these.

Behavior and Attitudes

In Chapter 4 we noted that attitudes fail to determine behavior when external influences override inner convictions. These experiments are a vivid illustration. When responding alone, Asch's subjects nearly always gave the correct answer. It was another matter when they stood alone against a group. In the obedience experiments, a powerful social pressure (the experimenter's commands) overcame a weaker one (the remote victim's pleas). Torn between the pleas of the victim and the orders of the experimenter, between the desire to avoid doing harm and the desire to be a good subject, a surprising number chose to obey. As Milgram explained,

■ BEHIND THE SCENES

While working for Solomon E. Asch, I wondered whether his conformity experiments could be made more humanly significant. First, I imagined an experiment similar to Asch's except that the group induced the person to deliver shocks to a protesting victim. But a control was needed to see how much shock a person would give in the absence of group pressure. Someone, presumably the experimenter, would have to instruct the subject to give the shocks. But now a new question arose: Just how far would a person go when ordered to administer such shocks? In my mind, the issue had shifted to the willingness of people to comply with destructive orders. It was an exciting moment for me. I realized that this simple question was both humanly important and capable of being precisely answered.

The laboratory procedure gave scientific expression to a more general concern about authority, a concern forced upon members of my generation, in particular upon Jews such as myself, by the atrocities of World War II. The impact of the Holocaust on my own psyche energized my interest in obedience and shaped the particular form in which it was examined. (Abridged from the original for this book and from Milgram, 1977, with permission of Alexandra Milgram.)

STANLEY MILGRAM (1933–1984), *City University of New York*

Some subjects were totally convinced of the wrongness of what they were doing [yet] felt that—within themselves, at least—they had been on the side of the angels. What they failed to realize is that subjective feelings are largely irrelevant to the moral issue at hand so long as they are not transformed into action. Political control is effected through action. . . . Tyrannies are perpetuated by difficult men who do not possess the courage to act out their beliefs. Time and again in the experiment people disvalued what they were doing but could not muster the inner resources to translate their values into action. (Milgram, 1974, p. 10)

Why were the participants unable to disengage themselves? How had they become trapped? Imagine yourself as the teacher in yet another version of Milgram's experiment, one he never conducted. Assume that when the learner gives the first wrong answer, the experimenter asks you to zap him with 330 volts. After flicking the switch, you hear the learner scream, complain of a heart disturbance, and plead for mercy. Do you continue?

I think not. Recall the step-by-step entrapment of the foot-in-the-door phenomenon (Chapter 4) as we compare this hypothetical experiment to what Milgram's subjects experienced. Their first commitment was mild—15 volts—and it elicited no protest. You, too, would agree to do that much. By the time they delivered 75 volts and heard the learner's first groan, they already had complied five times. On the next trial the experimenter asked them to commit an act only slightly more extreme than what they had already repeatedly committed. By the time they delivered 330 volts, after 22 acts of compliance, the subjects had reduced some of their dissonance. They were therefore in a different psychological state from that of someone beginning the experiment at that

point. As Chapter 4 emphasized, external behavior and internal disposition can feed one another, sometimes in an escalating spiral. Thus, reported Milgram (1974, p. 10):

> Many subjects harshly devalue the victim *as a consequence* of acting against him. Such comments as "He was so stupid and stubborn he deserved to get shocked," were common. Once having acted against the victim, these subjects found it necessary to view him as an unworthy individual, whose punishment was made inevitable by his own deficiencies of intellect and character.

During the early 1970s, the military junta then in power in Greece used this "blame-the-victim" process to train torturers (Haritos-Fatouros, 1988; Staub, 1989). In Greece, as in the training of SS officers in Nazi Germany, the military selected future torturers based on their respect for and submission to authority. But such tendencies alone do not a torturer make. Thus they would first assign the trainee to guard prisoners, then to participate in arrest squads, then to hit prisoners, then to observe torture, and only then to practice it. Step by step, an obedient but otherwise decent person evolved into an agent of cruelty. Compliance bred acceptance.

From his study of human genocide across the world, Ervin Staub (1989) shows where this process can lead. Too often, criticism produces contempt, which licenses cruelty, which, when justified, leads to brutality, then killing, then systematic killing. Evolving attitudes both follow and justify actions. Staub's disturbing conclusion: "Human beings have the capacity to come to experience killing other people as nothing extraordinary" (p. 13).

"Men's actions are too strong for them. Show me a man who has acted and who has not been the victim and slave of his action."
Ralph Waldo Emerson, *Representative Men: Goethe,* 1850

The Power of the Situation

The most important lesson of Chapter 6—that culture is a powerful shaper of lives—and this chapter's most important lesson—that situational forces are similarly powerful—reveal the strength of the social context. To feel this for

■ BEHIND THE SCENES

After many years spent studying what makes children and adults helpful, I turned to studying what makes people unhelpful, destructive, even into perpetrators of torture and genocide. What cultural characteristics, what social conditions, what personal needs and motives, lead human beings to destroy other human beings? And how might we create more caring societies and persons? I believe that my intense concern about kindness and cruelty springs from my own experience. As a young Jewish child in Budapest I survived the Holocaust, the destruction of most European Jews by Nazi Germany and its allies. My life was saved by a Christian woman who repeatedly endangered her life to help me and my family, and by Raoul Wallenberg, the Swede who came to Budapest and with courage, brilliance, and complete commitment saved the lives of tens of thousands of Jews destined for the gas chambers. These two heroes were not passive bystanders, and my work is one of the ways for me not to be one.

ERVIN STAUB, *University of Massachusetts*

When violating even minor social norms, such as dressing inappropriately, most people realize the strength of social constraints.

yourself, imagine violating some minor norms: standing up in the middle of a class; singing out loud in a restaurant; greeting some distinguished senior professors by their first names; wearing shorts to church; playing golf in a suit; munching Cracker Jacks at a piano recital. In trying to break with social constraints, we suddenly realize how strong they are.

Some of Milgram's own students learned this lesson when he and John Sabini (1983) asked their help in studying the effects of violating a simple social norm: asking riders on the New York City subway system for their seats. To their surprise, 56 percent gave up their seats, even when no justification was given. The students' own reactions to making the request were as interesting: Most found it extremely difficult. Often, the words got stuck in their throat, and they had to withdraw. Once having made a request and gotten a seat, they sometimes justified their norm violation by pretending to be sick. Such is the power of the unspoken rules governing our public behavior.

There is also a lesson here about evil. Evil sometimes results from a few bad apples. That's the image of evil symbolized by depraved killers in suspense novels and horror movies. In real life we think of Hitler's extermination of Jews, of Saddam Hussein's extermination of Kurds, of Pol Pot's extermination of Cambodians. But evil also results from social forces—from the heat, humidity, and disease that help make a whole barrel of apples go bad. As these experiments show, situations can induce ordinary people to agree to false-

hoods or capitulate to cruelty. Like the seductive power of the ring in J. R. R. Tolkien's *Lord of the Rings*, evil situations have enormous corrupting power.

This is especially true when, as happens often in complex societies, the most terrible evil evolves from a sequence of small evils. German civil servants surprised Nazi leaders with their willingness to handle the paperwork of the Holocaust. They were not killing Jews, of course; they were merely pushing paper (Silver & Geller, 1978). When fragmented, evil becomes easier. Milgram studied this compartmentalization of evil by involving yet another 40 men more indirectly. Rather than trigger the shock, they had only to administer the learning test; 37 of the 40 fully complied.

So it is in our everyday lives: The drift toward evil usually comes in small increments, without any conscious intent to do evil. Procrastination involves a similar unintended drift, toward self-harm (Sabini & Silver, 1982). A student knows the deadline for a term paper weeks ahead. Each diversion from work on the paper—a video game here, a TV program there—seems harmless enough. Yet gradually the student veers toward not doing the paper without ever consciously deciding not to do it.

"Killing organizations produce those who are killed, and those who kill."
John Darley (1992)

The Fundamental Attribution Error

Why do the results of these classic experiments so often startle people? Isn't it because we expect people to act in accord with their dispositions? It doesn't surprise us when a surly person is nasty, but we expect those with pleasant dispositions to be kind. Bad people do bad things; good people do good things.

When you read about Milgram's experiments, what impressions did you form of the subjects? Most people attribute negative qualities to them. When told about one or two of the obedient subjects, people judge them to be aggressive, cold, and unappealing—even after learning that their behavior was typical (A. G. Miller & others, 1973). Cruelty, we presume, is inflicted by the cruel at heart.

Günter Bierbrauer (1979) tried to eliminate this underestimation of social forces (the fundamental attribution error). He had university students observe a vivid reenactment of the experiment, or play the role of obedient teacher themselves. Regardless, they still predicted that their friends would, in a repeat of Milgram's experiment, be only minimally compliant. Bierbrauer concluded that although social scientists accumulate evidence that our behavior is a product of our social history and current environment, most people continue to believe that people's inner qualities reveal themselves—that only good people do good and that only evil people do evil.

It is tempting to assume that Eichmann and the Auschwitz camp commanders were uncivilized monsters. But after a hard day's work, the Auschwitz commanders would relax by listening to Beethoven and Schubert. Eichmann himself was outwardly indistinguishable from common people with ordinary jobs (Arendt, 1963). Milgram's conclusion makes it harder to attribute the Holocaust to unique character traits in the German people: "The most fundamental lesson of our study," he noted, is that "ordinary people, simply doing their jobs, and without any particular hostility on their part, can become agents in a terrible destructive process" (Milgram, 1974, p. 6). As Mister Rogers often reminds his preschool television audience, "Good people sometimes do bad things." Perhaps then, we should be more wary of political leaders whose genial dispositions lull us into supposing that they would never do evil.

"Eichmann did not hate Jews, and that made it worse, to have no feelings. To make Eichmann appear a monster renders him less dangerous than he was. If you kill a monster you can go to bed and sleep, for there aren't many of them. But if Eichmann was normality, then this is a far more dangerous situation."
Hannah Arendt, *Eichmann in Jerusalem*, 1963

"The assaulting quality of the Milgram experiment is really a valuable attack on the denial and indifference of all of us. Whatever upset follows facing the truth, we must eventually face up to the fact that so many of us are, in fact, available to be genociders or their assistants."
Israel W. Charny (1982), Executive Director, International Conference on the Holocaust and Genocide

The classic conformity experiments answered some questions but raised others: (1) Sometimes people conform; sometimes they do not. When do they? (2) Why do people conform? Why don't they ignore the group and "to their own selves be true?" (3) Is there a type of person who is likely to conform? Let's take these questions one at a time.

■ WHEN DO PEOPLE CONFORM?

Social psychologists wondered: If even Asch's noncoercive, unambiguous situation could elicit a conformity rate of 37 percent, would other settings produce even more? Researchers soon discovered that conformity did grow if the judgments were difficult or if the subjects felt incompetent. The more insecure we are about our judgments, the more influenced we are by others.

Researchers have also found that the nature of the group has an important influence. Conformity is highest when the group has three or more people and is cohesive, unanimous, and high in status. Conformity is also highest when the response is public and made without prior commitment.

GROUP SIZE

In laboratory experiments a group need not be large to have a large effect. Asch and other researchers found that three to five people will elicit much more conformity than just one or two. Increasing the number of people beyond five yields diminishing returns (Rosenberg, 1961; Gerard & others, 1968). In a field experiment, Milgram, Leonard Bickman, and Lawrence Berkowitz (1969) had 1, 2, 3, 5, 10, or 15 people pause on a busy New York City sidewalk and look up.

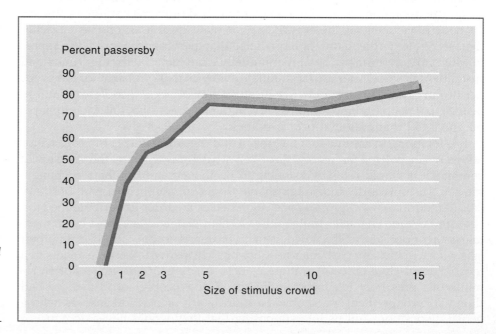

FIGURE 7-5 *Group size and conformity. The percentage of passers-by who imitated a group looking upward increased as group size increased to five persons.*
(Data from Milgram, Bickman, & Berkowitz, 1969.)

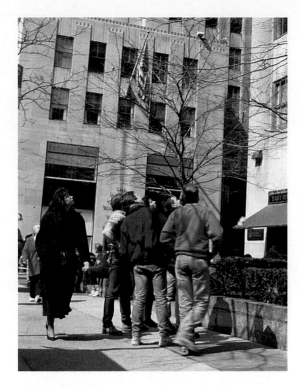

When a unanimous group of five or more persons acts together, their influence is hard to resist.

As Figure 7-5 shows, the percentage of passers-by who also looked up increased as the number looking up increased from one to five persons.

Bibb Latané (1981) accounts for the diminishing returns of increases in group size with his "social impact theory." It proposes that social influence increases with the immediacy and size of the group. But as the number of influencing persons increases, the increments in social impact decrease: The second person has less effect than the first, and person n has less effect than person $(n - 1)$.

The way the group is "packaged" also makes a difference. Researcher David Wilder (1977) gave University of Wisconsin students a jury case. Before giving their own judgments, the students watched videotapes of four confederates giving their judgments. When presented as two independent groups of two people, the participants conformed more than when the four confederates presented their judgments as a single group. Similarly, two groups of three people elicited more conformity than one group of six, and three groups of two people elicited even more. Evidently, the agreement of several small groups makes a position more credible.

UNANIMITY

Imagine yourself in a conformity experiment where all but one of the people responding before you give the same wrong answer. Would the example of this one nonconforming confederate be as liberating as it was for the subjects in Milgram's obedience experiment? Several experiments reveal that someone who punctures a group's unanimity deflates its social power (Allen & Levine, 1969; Asch, 1955; Morris & Miller, 1975). As Figure 7-6 illustrates, subjects will

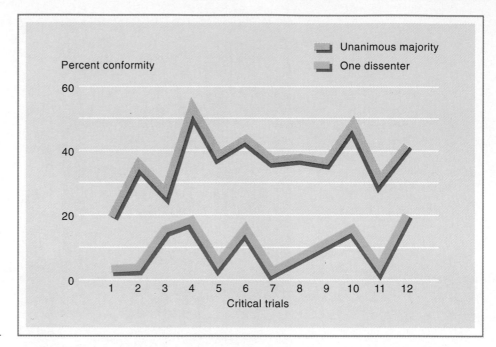

FIGURE 7-6 *The effect of unanimity on conformity. When someone giving correct answers punctures the group's unanimity, subjects conform only one-fourth as often.*
(From Asch, 1955.)

"My opinion, my conviction, gains infinitely in strength and success, the moment a second mind has adopted it."
Novalis, *Fragment*

nearly always voice their convictions if just one other person has also done so. The subjects in such experiments often later say they felt warm toward and close to their nonconforming ally, but deny that the ally influenced them: "I would have answered just the same if he weren't there."

It's difficult to be a minority of one; few juries are hung because of one dissenting juror. These experiments teach the practical lesson that it is easier to stand up for something if you can find someone else to stand up with you. Many religious groups recognize this. Following the example of Jesus, who sent his disciples out in pairs, the Mormons send two missionaries into a neighborhood together. The support of the one comrade greatly increases a person's social courage.

Observing someone else's dissent—even when it is wrong—can increase our own independence. Charlan Nemeth and Cynthia Chiles (1988) discovered this after having people observe a lone individual in a group of four misjudge blue stimuli as green. Although the dissenter was wrong, observing him enabled the observers later to exhibit their own form of independence. In a follow-up experiment, 76 percent of the time they correctly labeled red slides "red" even when everyone else was calling them "orange." Lacking this model of courage, 70 percent of the time observers went along with the group in calling red "orange."

COHESION

A minority opinion from someone outside the groups we identify with—from someone at another college or of a different religion—sways us less than the same minority opinion from someone within our group (Clark & Maass, 1988, 1989). A heterosexual arguing for gay rights would more effectively sway het-

erosexuals than would a homosexual. The more **cohesive** a group is, the more power it gains over its members. In college sororities, for example, friends tend to share binge-eating tendencies, especially as they grow closer (Crandall, 1988).

In experiments, too, group members who feel attracted to the group are more responsive to its influence (Berkowitz, 1954; Lott & Lott, 1961; Sakurai, 1975). They do not like disagreeing with group members. Fearing rejection by people they like, they allow them a certain power. In his *Essay Concerning Human Understanding*, the seventeenth-century philosopher John Locke recognized the cohesiveness factor: "Nor is there one in ten thousand who is stiff and insensible enough to bear up under the constant dislike and condemnation of his own club."

Cohesiveness:
A "we feeling"—the extent to which members of a group are bound together, such as by attraction for one another.

STATUS

As you might suspect, higher-status people tend to have more impact (Driskell & Mullen, 1990). Studies of jaywalking behavior, conducted with the unwitting aid of nearly 24,000 pedestrians, reveal that the baseline jaywalking rate of 25 percent decreases to 17 percent in the presence of a nonjaywalking confederate and increases to 44 percent in the presence of another jaywalker (Mullen & others, 1990). The nonjaywalker does best in discouraging jaywalking when he or she is well dressed (although, strangely, jaywalking confederates do not trigger more jaywalking when well dressed). Clothes seem to "make the person" in Australia too. Michael Walker, Susan Harriman, and Stuart Costello

It's difficult to stand alone as a minority of one. Doing so sometimes makes a hero, as was the lone dissenting jury member played by Henry Fonda in the movie classic 12 Angry Men.

(1980) found that Sydney pedestrians were more compliant when approached by a well-dressed survey taker than one who was poorly dressed.

Milgram (1974) reports that in his obedience experiments people of lower status accepted the experimenter's commands more readily than people of higher status. After delivering 450 volts, one subject, a 37-year-old welder, turned to the experimenter and deferentially asked, "Where do we go from here, Professor?" (p. 46). Another subject, a divinity school professor who disobeyed at 150 volts, said: "I don't understand why the experiment is placed above this person's life," and plied the experimenter with questions about "the ethics of this thing" (p. 48).

PUBLIC RESPONSE

"If you worry about missing the boat—remember the Titanic."
Anonymous

One of the first questions researchers sought to answer was this: Would people conform more in their public responses than in their private opinions? Or would they sway more in their private opinions but be unwilling to conform publicly, lest they appear wishy-washy? The answer is now clear: In experiments, people conform more when they must respond publicly before others than when they write their answer privately. Asch's subjects, after hearing others respond, were less influenced by group pressure if they could write an answer that only the experimenter would see. It is much easier to stand up for what we believe in the privacy of the voting booth than before a group.

NO PRIOR COMMITMENT

In 1980, Genuine Risk became the second filly to win the Kentucky Derby. In her next race, the Preakness, she came off the last turn gaining on the leader, Codex, a colt. As they came out of the turn neck and neck, Codex moved sideways toward Genuine Risk, causing her to hesitate and giving him a narrow victory. Had Codex brushed Genuine Risk? Had his jockey even whipped Genuine Risk in the face? The race referees huddled. After a brief deliberation

Did Codex brush against Genuine Risk? Once race referees had publicly announced their decision, no amount of argument or evidence could budge them.

MANKOFF

"All right! Have it your own way. It was a ball."

Drawing by Mankoff; © 1980 The New Yorker Magazine, Inc.

Prior commitment: Once they commit themselves to a position, people seldom yield to social pressure. Real umpires and referees rarely reverse their initial judgments.

they judged that no foul had occurred and confirmed Codex as the winner. The decision caused an uproar. On the televised instant replays, it appeared that Codex had indeed brushed Genuine Risk, the sentimental favorite. A protest was filed. The officials reconsidered their decision, but they did not change it.

Did their commitments immediately after the race affect officials' openness toward reaching a different decision later? We will never know. However, we can put people through a laboratory version of this event—with and without the immediate commitment—and observe whether the commitment makes a difference. Again, imagine yourself in an Asch-type experiment. The experimenter displays the lines and asks you to respond first. After you have given your judgment and then heard everyone else disagree, the experimenter offers you an opportunity to reconsider. In the face of group pressure, do you now back down?

In experiments, people almost never do (Deutsch & Gerard, 1955); once having made a public commitment, they stick to it. At most, they will change their judgments in later situations (Saltzstein & Sandberg, 1979). So we may expect that judges of diving contests, for example, will seldom change their ratings of a dive after seeing the other judges' ratings, although they might adjust their ratings of later dives.

Prior commitments restrain persuasion too. In experiments on decision making by simulated juries, hung verdicts are more likely in cases when jurors are polled by a show of hands rather than by secret ballot (Kerr & MacCoun, 1985). Making a public commitment makes people hesitant to back down. Smart persuaders know this. They ask questions that prompt us to make statements for, rather than against, what they are marketing. Textbook salespeople are more likely to ask professors what they do *not* like about their competitors'

On the other hand: "Those who never retract their opinions love themselves more than they love truth."
Joubert, *Pensées*

books than what they *do* like about them. Religious evangelists invite people "to get up out of your seat," knowing that people are more likely to hold to their new faith if they make a public commitment to it.

Public commitment may reduce conformity not only because people are more accepting of what they have made a commitment to but also because they hate to appear indecisive. Compared to people whose attitudes are stable, those whose attitudes change seem less reliable (Allgeier and others, 1979). People who "wander, waver, waffle, and wiggle," as President Ford said contemptuously of candidate Jimmy Carter in 1976, lose respect.

■ WHY CONFORM?

Here I was, an American attending my first lecture during an extended visit at a German university. As the lecturer finished, I lifted my hands to join in the clapping. But rather than clap, the other people began rapping the tables with their knuckles. What did this mean? Did they disapprove of the speech? Surely, not everyone would be so openly rude to a visiting dignitary. Nor did their faces express displeasure. No, I decided, this must be a German ovation. Whereupon, I added my knuckles to the chorus.

What prompted this conformity? Why had I not clapped even while the others rapped? There are two possibilities: A person may bow to the group to be accepted and avoid rejection or to obtain important information. Morton Deutsch and Harold Gerard (1955) named these two possibilities **normative** social influence and **informational** social influence.

Normative conformity is "going along with the crowd" to avoid rejection, to stay in people's good graces, or to gain their approval. In the laboratory and in everyday life, groups often reject those who consistently deviate (Miller & Anderson, 1979; Schachter, 1951). Can you recall such an experience? As most of us know, social rejection is painful; when we deviate from group norms, we often pay an emotional price. Darrin Lehman and Alan Reifman (1987) believe that explains why in 1984–1985 games involving the Los Angeles Lakers, National Basketball Association referees called fewer fouls on star players when they were playing at home (2.4 fouls per game) than when they were playing away (3.1 fouls per game). (The refs called nonstar players for the same number of fouls at home and away.)

Sometimes the high price of deviation compels people to support what they do not believe in. Fearing they would be court-martialed for disobedience, some of the soldiers at My Lai participated in the massacre. Normative influence commonly leads to compliance. This is especially true for people seeking to climb a group's status ladder (Hollander, 1958). As John F. Kennedy (1956) recalled, "'The way to get along,' I was told when I entered Congress, 'is to go along'" (p. 4).

Informational influence, on the other hand, leads people to acceptance. When reality is ambiguous, as it was for subjects in the autokinetic situation, other people can be a valuable source of information. The subject may reason, "I can't tell how far the light is moving. But this guy seems to know." Others' responses may also affect how we interpret ambiguous stimuli. People who witness others agreeing that "free speech should be limited" may infer a differ-

Normative influence: Conformity based on a person's desire to fulfill others' expectations, often to gain acceptance.

Informational influence: Conformity that results from accepting evidence about reality provided by other people.

"Do as most do and men will speak well of thee."
Thomas Fuller, *Gnomologia*

ent meaning to the statement than those who witness others disagreeing (Allen & Wilder, 1980). In short, concern for social image produces normative influence. The desire to be correct produces informational influence.

In day-to-day life, normative and informational influence often occur together. I was not about to be the only person in the room clapping (normative influence), yet the others' behavior also showed me how to express my appreciation (informational influence).

Some of the experiments on "when people conform" have isolated either normative or informational influence. Conformity is greater when people respond before a group; this surely reflects normative influence (because subjects receive the same information whether they respond publicly or privately). What is more, the larger the group, the greater the difference between public and private responding (Insko & others, 1985). On the other hand, conformity is greater when participants feel incompetent, when the task is difficult, or when the subjects care about being right. So, why do we conform? For two main reasons: Because we want to be liked and approved or because we want to be right.

■ WHO CONFORMS?

Are some people generally more susceptible (or, should I say, more *open*) to social influence? Among your friends, can you identify some who are "conformists" and others who are "independent"? I suspect that most of us can. Researchers are exploring several areas in their search for the conformer. Let us look briefly at three: gender, personality, and culture.

GENDER

Among Americans tested in group-pressure situations during the last 30 years, there has been a slight tendency for women to conform more than men. Alice Eagly and Linda Carli (1981; also Becker, 1986) discerned this by statistically combining results from the dozens of available studies. However, newer conformity experiments and those conducted by women seldom find females more conforming.

Is labeling this small gender effect a "conformity difference" a negative judgment on the women "conformers"? Remember, our label for the phenomenon is something we choose. Perhaps we should instead call the difference a "greater people orientation." (Recall from Chapter 6 that women are somewhat more empathic and socially sensitive.) Perhaps we should say that women are slightly more flexible, more open and responsive to their social environment, more concerned with interpersonal relations. Such language carries quite different connotations from saying that women are more conforming.

To say that women are slightly more influenceable because they are more concerned with interpersonal relations attributes the difference to personality. Eagly and Wendy Wood (1985) believe that gender differences in conformity may instead be a product of men's and women's typical social roles. Male-female differences are not just a gender difference but also (or instead) status differences. In everyday life, men tend to occupy positions of greater status

Although Milgram's subjects (1974) were nearly all males— some 1000 in all—40 female subjects did experience the "heart-disturbance" obedience procedure. Milgram assumed that women were generally more compliant yet also more empathic and less aggressive. Thus, what he found was no difference: 65 percent were fully compliant.

■ BEHIND THE SCENES

I began my work on gender and social influence in the early 1970s. Like many feminist activists of the day, I initially assumed that, despite negative cultural stereotypes about women, the behavior of women and men is substantially equivalent. Over the years, my views have evolved considerably in response to research on sex differences and gender stereotypes. I have found that women and men do behave somewhat differently, especially in relatively unstructured situations in which gender roles become important. Although most of these differences are gender-stereotypic, feminists should not assume that these differences reflect unfavorably on women. Women's tendencies to be more attuned to other people's concerns and to treat others more democratically are assets in many situations, and people recognize these desirable qualities of women's behavior. In fact, my recent research on gender stereotypes (Eagly & others, 1991) shows that, if we take both negative and positive qualities into account, the stereotype of women is currently more favorable than the stereotype of men.

ALICE EAGLY, *Purdue University*

and power, so we often see men exerting influence and women accepting influence. This explains why people *perceive* a much greater gender difference in everyday conformity than has been found in experiments that assign men and women identical roles.

PERSONALITY

The history of social-psychological thinking about the relationship between personality traits and social behavior parallels the history of thinking about attitudes and behavior (Sherman & Fazio, 1983). During the 1950s and early 1960s psychologists studied how people's actions expressed their inner motives and dispositions. People who described themselves as needing social approval, for example, were more conforming (Snyder & Ickes, 1985). During the late 1960s and 1970s, efforts to link personal characteristics with social behaviors, such as conformity, found only weak connections (Mischel, 1968). In contrast to the demonstrable power of situational factors, such as group unanimity versus nonunanimity, personality scores hardly predicted individuals' behavior. If you wanted to know how conforming or aggressive or helpful someone was going to be, it seemed you were better off knowing the details of the situation than the person's scores on a battery of psychological tests. As Milgram (1974) concluded: "I am certain that there is a complex personality basis to obedience and disobedience. But I know we have not found it" (p. 205).

Reflecting on his prison simulation (p. 194) and other experiments, Philip Zimbardo argued that the ultimate message

is to say what it is we have to do to break through your egocentricism, to say you're not different, anything any human being has ever done cannot be alien to you, you can't divorce it! We must break through this "we-they" idea that our dispositional

orientation promotes and understand that the situational forces operating on a person at any given moment could be so powerful as to override everything prior—values, history, biology, family, church. (Bruck, 1976)

During the 1980s, the idea that personal dispositions make little difference prompted personality researchers to pinpoint the circumstances under which traits *do* predict behavior. Their research affirms a principle that we met in Chapter 4: While internal factors (attitudes, personality traits) seldom precisely predict a specific action, they better predict a person's behavior in general across many situations (Epstein, 1980; Rushton & others, 1983). An analogy may help: Just as your response to a single test item is hard to predict, so is your behavior in a single situation. And just as your total score across the many items of a test is more predictable, so your total conformity (or outgoingness or aggressiveness) across many situations is more predictable.

Personality also predicts behavior better when researchers study a variety of individuals, when the trait is specific to a situation (such as "speech anxiety" rather than anxiety in general), and when social influences are weak. Like many other laboratory studies, Milgram's obedience experiments created "strong" situations; their clear-cut demands made it difficult for personality differences to operate. Still, Milgram's subjects differed widely in how obedient they were, and there is good reason to suspect that some of his subjects'

"Wait! Wait! Listen to me! . . . We don't HAVE to be just sheep!"

A group's unanimity versus nonunanimity affects conformity more than does individual personality.

hostility, respect for authority, and concern for meeting expectations affected their obedience (Blass, 1990, 1991). In the Nazi extermination camps, too, some guards displayed kindness, while others chose to use live infants as air-tossed shooting targets or to hurl them into the fire alive. Personality matters.

In "weaker" situations—as when two strangers sit in a waiting room with no cues to guide their behavior—individual personalities are even freer to shine (Ickes & others, 1982; Monson & others, 1982). If we compare two similar personalities in very different situations, the situational effect will overwhelm the personality difference. If we compare a group of Charles Manson types with a group of Mother Theresa types in a smattering of everyday situations, the personality effect will look much stronger.

David Funder and Randall Colvin (1991) of the University of California, Riverside, confirmed that behavioral styles persist across situations. They video-taped pairs of students while they got acquainted in casual conversation, then videotaped them again a few weeks later while casually chatting with a new acquaintance and while participating in a debate. Those who spoke loudly or were energetic, outgoing, or relaxed in one situation usually behaved much the same way in the other situations.

It is interesting to note how the pendulum of professional opinion swings. Without discounting the undeniable power of social forces, the pendulum is now swinging back toward an appreciation of individual personality. Like the attitude researchers we considered earlier, personality researchers are clarifying and reaffirming the connection between who we are and what we do. Thanks to their efforts, virtually every social psychologist today would agree with theorist Kurt Lewin's (1936) dictum: "Every psychological event depends upon the state of the person and at the same time on the environment, although their relative importance is different in different cases" (p. 12).

CULTURE

Does cultural background help predict how conforming people will be? Indeed it does. James Whittaker and Robert Meade (1967) repeated Asch's conformity experiment in several countries and found similar conformity rates in most—31 percent in Lebanon, 32 percent in Hong Kong, 34 percent in Brazil—but 51 percent among the Bantu of Zimbabwe, a tribe with strong sanctions for non-conformity. When Milgram (1961) used a different conformity procedure to compare Norwegian and French students, he consistently found the Norwegian students to be the more conforming. However, cultures may change. Replications of Asch's experiment with university students in Britain, Canada, and the United States sometimes trigger less conformity than Asch observed two or three decades earlier (Lalancette & Standing, 1990; Larsen, 1974, 1990; Nicholson & others, 1985; Perrin & Spencer, 1981).

When researchers in Germany, Italy, South Africa, Australia, Austria, Spain, and Jordan repeated the obedience experiments, how do you think the results compared to those with American subjects? The obedience rates were similar, or even higher—85 percent in Munich (Mantell, 1971; Meeus & Raaijmakers, 1986; Milgram, 1974).

In a study of "administrative obedience" in the Netherlands, Wim Meeus and Quinten Raaijmakers (1986) ordered Dutch adults who had volunteered for an experiment to disrupt a job applicant who was taking an employment

Conformity experiments suggest that people in a collectivist culture, such as the Bantu of Zimbabwe, tend to be more responsive to social norms.

test, causing the applicant to fail the test and supposedly remain unemployed. In the guise of an experiment on the effects of stress, the subjects had to trigger 15 derogatory computer messages that caused the applicant to become progressively more upset. As the applicant's tension turned to irritation and finally to despair, the subjects found the procedure unfair and their task disagreeable. Yet by shifting responsibility to the experimenter, 90 percent fully complied.

So, conformity and obedience are universal phenomena, yet they vary by culture (Bond, 1988; Triandis & others, 1988). Euro-American cultures teach individualism: You are responsible for yourself. Follow your own conscience. Be true to yourself. Define your unique gifts. Meet your own needs. Respect one another's privacy. Asian and other nonwestern cultures are more likely to teach collectivism: Your family or clan is responsible for its individual members, whose actions therefore reflect shame or honor upon it. So bring honor to your group. Be true to your traditions. Show respect for elders and superiors. Cultivate harmony, and do not criticize another publicly. Be loyal to family, company, nation. Live communally, without assuming that you have a private self separate from your social context.

"I don't want to get adjusted to this world."
Woody Guthrie

A cross-cultural comparison of individualism in 12-year-olds shows the effect of these cultural assumptions (Garbarino & Bronfenbrenner, 1976; Shouval & others, 1975). An international team of researchers assessed conformity to conventional standards by having children predict their behavior in a variety of situations. As Figure 7-7 shows, children from more individualistic western nations were considerably more likely to admit to disobedient, mischievous tendencies than were children from more collectivist countries, such as the former U.S.S.R., where both home and school emphasized "obedience and propriety." The children in the collectivist countries described themselves as more compliant with adult expectations and less likely to join their peers in defying adult expectations.

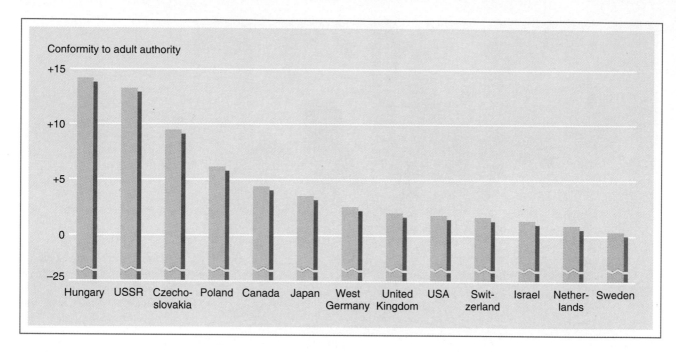

FIGURE 7-7 *Conformity of 12-year-olds to moral standards of adult authorities.*
(Data from Garbarino & Bronfenbrenner, 1976.)

FIGURE 7-8 *Repeated surveys of mothers in Muncie, Indiana, 54 years apart, and of American and German adults, illustrate the growth of individualistic values during this century.*
(Data from Alwin, 1990, and Remley, 1988.)

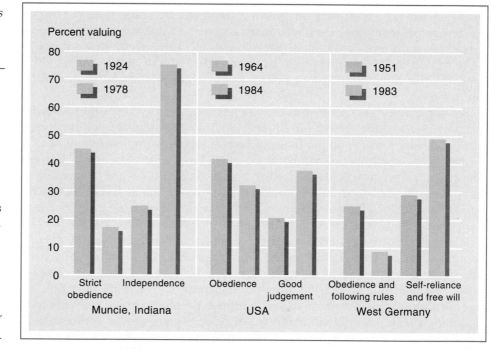

Euro-American individualism has intensified during this century. In Italy, England, Germany, and the United States, today's parents prize independence and self-reliance; 40 years ago and more they were more likely to value obedience (Figure 7-8). The downside of this individualism has been an accompanying rise in depression. When facing failure or loss, the self-reliant individual has nowhere to turn for hope. If a *Fortune* ad was right in proclaiming the

American Dream—that you can "make it on your own," on "your own drive, your own guts, your own energy, your own ambition"—then whose fault is it if you *don't* make it on your own?

■ RESISTING SOCIAL PRESSURE

This chapter, like Chapter 6, emphasizes the power of social forces. It is therefore fitting that we conclude by again reminding ourselves of the power of the person. We are not just billiard balls; we act in response to the forces that push upon us. Knowing that someone is trying to coerce us may even prompt us to react in the *opposite* direction.

"To do just the opposite is also a form of imitation."
Lichtenberg, *Aphorisma,* 1764–1799

REACTANCE

Individuals value their sense of freedom and self-efficacy (Baer & others, 1980). So when social pressure becomes so blatant that it threatens their sense of freedom, they often rebel. Think of Romeo and Juliet, whose love was intensified by their families' opposition. Or think of children asserting their freedom and independence by doing the opposite of what their parents ask. Savvy parents therefore offer their children choices instead of commands: "It's time to clean up: Do you want a bath or a shower?"

The theory of psychological **reactance**—that people do indeed act to protect their sense of freedom—is supported by experiments showing that attempts to restrict a person's freedom often produce a "boomerang effect" (Brehm & Brehm, 1981). Suppose someone stops you on the street and asks you to sign a petition that advocates something you mildly support. While considering the petition, you are told that someone else believes "people absolutely should not be allowed to distribute or sign such petitions." Reactance theory predicts that such blatant attempts to limit freedom will actually increase the likelihood of your signing. When Madeline Heilman (1976) staged this experiment on the streets of New York City, that is precisely what she found. Clinical psychologists sometimes use the reactance principle by ordering resistant clients to enact the to-be-eliminated behavior (Brehm, 1986; Seltzer, 1983). By resisting the therapist, the clients get better.

Reactance:
A motive to protect or restore one's sense of freedom. Reactance arises when someone threatens our freedom of action.

Calvin and Hobbes by Bill Watterson; copyright © 1987 by Universal Press Syndicate. All rights reserved.

Reactance may also contribute to underage drinking. In the United States, where alcohol sales are illegal to persons under age 21, a survey of 3375 students on a cross section of 56 campuses revealed a 25 percent rate of abstinence among students of legal drinking age but only a 19 percent abstinence rate among students under 21. The researchers, Ruth Engs and David Hanson (1989), also found that 15 percent of the legal-age students and 24 percent of the underage students were heavy drinkers. They suspect this reflects a reactance against the restriction. It probably also reflects peer influence. With alcohol use, as with drugs, peers influence attitudes, provide the substance, and provide a context for its use. This helps explain why college students, living in a peer culture that often supports alcohol use, drink more alcohol than their noncollege peers (Atwell, 1986).

Reactance can escalate into social rebellion. Like obedience, rebellion can be produced and observed in experiments. William Gamson, Bruce Fireman, and Steven Rytina (1982) posed as members of a commercial research firm. They recruited people from towns near the University of Michigan to come to a hotel conference room for "a group discussion of community standards." Once there, the people learned that the discussions were to be videotaped on behalf of a large oil company seeking to win a legal case against a local station manager who had spoken out against high gas prices. In the first discussion, virtually everyone sided with the station manager. Hoping to convince the court that people in the local community were on its side, the "company representative" then began to tell more and more group members to defend the company. In the end, he told everyone to attack the station manager and asked them to sign an affidavit giving the company permission to edit the tapes and use them in court. By leaving the room from time to time, the experimenter gave the group members repeated opportunities to interpret and react to the injustice.

In a world of extreme conformity, like that imagined in the futuristic novel and movie The Handmaid's Tale, *some people would surely feel compelled to reassert their uniqueness.*

Most rebelled, objecting to and resisting the demand that they misrepresent their opinions to help the oil company. Some groups even mobilized themselves to stop the whole effort. They made plans to go to a newspaper, the Better Business Bureau, a lawyer, or the court.

By brewing small social rebellions, the researchers saw how a revolt is born. They found that successful resistance often begins very quickly. The more a group complies with unjust demands, the more trouble it later has breaking free. And someone must be willing to seed the process by expressing the reservations the others are feeling.

These demonstrations of reactance reassure us that people are not puppets. Sociologist Peter Berger (1963) expressed the point vividly:

> We see the puppets dancing in their miniature stage, moving up and down as the strings pull them around, following the prescribed course of their various little parts. We learn to understand the logic of this theater and we find ourselves in its motions. We locate ourselves in society and thus recognize our own position as we hang from its subtle strings. For a moment we see ourselves as puppets indeed. But then we grasp a decisive difference between the puppet theater and our own drama. Unlike the puppets, we have the possibility of stopping in our movements, looking up and perceiving the machinery by which we have been moved. In this act lies the first step towards freedom. (p. 176)

ASSERTING UNIQUENESS

Imagine a world of complete conformity where there were no differences among people. Would such a world be a happy place? If nonconformity can create discomfort, can sameness create comfort?

People feel uncomfortable when they appear too different from others. But, at least in western cultures, they also feel uncomfortable when they appear exactly like everyone else. As experiments by C. R. Snyder and Howard Fromkin (1980; see also Duval, 1976) have shown, people feel better when they see themselves as unique. Moreover, they act in ways that will assert their individuality. In one experiment, Snyder (1980) led Purdue University students to believe that their "10 most important attitudes" were either distinct from or nearly identical to the attitudes of 10,000 other students. When they then participated in a conformity experiment, those deprived of their feeling of uniqueness were most likely to assert their individuality by nonconformity. In another experiment, people who heard others express attitudes identical to their own altered their positions to maintain their sense of uniqueness.

Seeing oneself as unique also appears in people's "spontaneous self-concepts." William McGuire and his Yale University colleagues (McGuire & Padawer-Singer, 1978; McGuire & others, 1979) report that when children are invited to "tell us about yourself," they are most likely to mention their distinctive attributes. Foreign-born children are more likely than others to mention their birthplace. Redheads are more likely than black- and brown-haired children to volunteer their hair color. Light and heavy children are the most likely to refer to their body weight. Minority children are the most likely to mention their race. Likewise we become more keenly aware of our gender when we are with people of the other sex (Cota & Dion, 1986).

The principle, says McGuire, is that "one is conscious of oneself insofar as, and in the ways that, one is different." Thus, "If I am a Black woman in a group

"When I'm in America, I have no doubt I'm a Jew, but I have strong doubts about whether I'm really an American. And when I get to Israel, I know I'm an American, but I have strong doubts about whether I'm a Jew."
Leslie Fiedler, *Fiedler on the Roof,* 1991

of White women, I tend to think of myself as a Black; if I move to a group of Black men, my blackness loses salience and I become more conscious of being a woman" (McGuire & others, 1978). This insight helps us understand why any minority group tends to be conscious of its distinctiveness and how the surrounding culture relates to it. The majority group, being less conscious of race, may see the minority group as "hypersensitive." Living for a year in Scotland, where my American accent marks me as a foreigner, I am conscious of my national identity and sensitive to how others react to it.

So it seems that while we do not like being greatly deviant, we are, ironically, all alike in wanting to feel distinctive and noticing how we are distinctive. But as research on self-serving bias (Chapter 3) makes clear, it is not just any kind of distinctiveness we seek, but distinctiveness in the right direction. Our quest is not merely to be different from the average, but *better* than average.

Finally, a comment on the experimental method used in conformity research: Conformity situations in the laboratory differ from those in everyday life. How often are we asked to judge lines or administer shock? As combustion is similar for a burning match and a forest fire, so we assume that the psychological processes engaged in the laboratory and everyday life are similar (Milgram, 1974). We must be careful in generalizing from the simplicity of a burning match to the complexity of a forest fire. Yet, as controlled experiments on burning matches can give us insights into combustion that we cannot gain by observing forest fires, so can the social-psychological experiment offer insights into behavior not readily revealed in everyday life. The experimental situation is unique, but so is every social situation. By testing with a variety of unique tasks, and by repeating experiments in different times and places, researchers probe for the common principles that lie beneath the surface diversity.

■ SUMMING UP

Conformity—changing one's behavior or belief as a result of group pressure—comes in two forms. *Compliance* is outwardly going along with the group while inwardly disagreeing. *Acceptance* is believing as well as acting in accord with social pressure. Both types have been explored in laboratory experiments that ask: (1) To what extent do people conform? (2) When do people conform? (3) Why do people conform? (4) Who conforms most?

CLASSIC STUDIES

Three classic sets of experiments illustrate how researchers have studied conformity and how conforming people can be. Muzafer Sherif observed that others' judgments influenced people's estimates of the illusory movement of a point of light. Norms for "proper" answers emerged and survived over both long periods of time and succeeding generations of subjects. This laboratory suggestibility parallels suggestibility in real life.

Solomon Asch used a task that was as clear-cut as Sherif's was ambiguous. Asch had people listen to others' judgments of which of three comparison lines was equal to a standard line and then make the same judgment themselves.

When the others unanimously gave a wrong answer, the subjects conformed 37 percent of the time.

Sherif's procedure elicited acceptance; Stanley Milgram's obedience experiments, on the other hand, elicited an extreme form of compliance. Under optimum conditions—a legitimate, close-at-hand commander, a remote victim, and no one else to exemplify disobedience—65 percent of his adult male subjects fully obeyed instructions to deliver what were supposedly traumatizing electric shocks to a screaming innocent victim in an adjacent room.

These classic experiments expose the potency of social forces and the ease with which compliance breeds acceptance. Evil is not just the product of bad people in a nice world but also of powerful situations that induce people to conform to falsehoods or capitulate to cruelty.

WHEN DO PEOPLE CONFORM?

Using conformity testing procedures such as these, experimenters explored the circumstances that produce conformity. Conformity is affected by the characteristics of the group: People conform most when faced with the unanimous reports of three or more attractive, high-status people. People also conform most when their responses are public (in the presence of the group) and made without prior commitment.

WHY CONFORM?

Experiments reveal two reasons people conform at all. *Normative influence* results from a person's desire for acceptance. *Informational influence* results from others' providing evidence about reality. For example, the tendency to conform more when responding publicly reflects normative influence, and the tendency to conform more on difficult decision-making tasks reflects informational influence.

WHO CONFORMS?

This question has produced fewer definitive answers. In experiments, females have, on the average, been slightly more conforming than males. (If this sounds negative it's because labels such as "conformity" evaluate as well as describe behavior. Call the trait "openness" or "communal sensitivity," and it takes on a more positive connotation.) Global personality scores are poor predictors of specific acts of conformity but better predict average tendencies to conformity (and other social behaviors). Trait effects are strongest in "weak" situations where social forces do not overwhelm individual differences. Although conformity and obedience are universal, culture socializes people to be more or less socially responsive.

RESISTING SOCIAL PRESSURE

The chapter's emphasis on the power of social pressure must be joined by a complementary emphasis on the power of the person. We are not puppets. When social coercion becomes blatant, people often experience *reactance*—a motivation to defy the coercion to maintain their sense of freedom. When

group members experience reactance simultaneously, the result may be rebellion.

We are not comfortable being too different from a group, but neither do we want to appear the same as everyone else. Thus, we act in ways that preserve our sense of uniqueness and individuality. In a group, we are most conscious of how we differ from the others.

▪ FOR FURTHER READING

Kelman, H. C., & Hamilton, V. L. (1989). *Crimes of obedience: Toward a social psychology of authority and responsibility.* New Haven, CT: Yale University Press. Social psychologist Kelman and sociologist Hamilton analyze crimes ordered by authority (Nazi war crimes, the My Lai massacre, Watergate, the Iran-Contra affair). They show ''how responsibility may be 'lost' where it is most essential to retain it: in the military and bureaucratic hierarchies of the modern world.''

Milgram, S. (1974). *Obedience to authority.* New York: Harper & Row. The complete but simply written account of the experiments that, in the words of Milgram's biographer, now belong ''to the self-understanding of literate people in our age.''

Miller, A. G. (1986). *The obedience experiments: A case study of controversy in social science.* New York: Praeger. A skillful review of the nearly two dozen obedience experiments conducted by Stanley Milgram and of the ensuing replications, critiques, and controversies. As one reviewer notes, this is a book that ''any serious student of social psychology would profit from reading.''

Staub, E. (1989). *The roots of evil: The origins of genocide and other group violence.* New York: Cambridge University Press. Why do human beings kill and brutalize other human beings? This book powerfully analyzes the social psychological roots of human torture and slaughter as practiced in Turkey, Nazi Germany, Argentina, Cambodia, Russia, and Greece.

PERSUASION

Our social behavior is influenced not only by our cultural experience and our current situation but also by our attitudes. Those who wish to influence behavior therefore seek to change attitudes.

Consider Joseph Goebbels, Nazi Germany's minister of "popular enlightenment" and propaganda. Given control of publications, radio programs, motion pictures, and the arts, he undertook to persuade Germans to accept Nazi ideology. Julius Streicher, another member of the Nazi group, published *Der Stürmer*, a weekly anti-Semitic (anti-Jewish) newspaper with a circulation of 500,000 and the only paper read cover to cover by his intimate friend, Adolf Hitler. Streicher also published anti-Semitic children's books and along with Goebbels spoke at the mass rallies that became a part of the Nazi propaganda machine. How effective were Goebbels, Streicher, and other Nazi propagandists? Did they, as the Allies alleged at Streicher's Nuremberg trial, "inject poison into the minds of millions and millions" (Bytwerk, 1976)? Most Germans were not persuaded to feel raging hatred for the Jews. But some were. Others became sympathetic to anti-Semitic measures. And most of the rest became either sufficiently uncertain or sufficiently intimidated to allow the Holocaust to happen.

Powerful persuasive forces are also at work today in modern North America. In the wake of publicized research on the physical and social consequences of marijuana use, adolescent attitudes have changed rapidly. Among the 16,000 U.S. high school seniors surveyed annually by the University of Michigan, the proportion who believe there is "great risk" to regular marijuana use has doubled—from 35 percent in 1978 to 79 percent in 1991 (Johnston & others, 1992). Simultaneously, support for the legalization of marijuana dropped sharply among the quarter million new college students surveyed annually by UCLA—from 50 percent to 21 percent (Astin & others, 1987, 1991). Behavior changed too. Marijuana use within the month preceding the survey dropped from 37 percent of high school seniors to 14 percent. Canadian teens underwent similar attitude and marijuana-use changes (Smart & Adlaf, 1989). Thanks to health promotion campaigns, American cigarette smoking rates have plunged dramatically since 1954, from 45 to 28 percent (Gallup, 1989). And the number of alcohol abstainers has increased since 1978 from 29 to 43 percent (Gallup & Newport, 1990).

But some persuasive efforts flop. One massive governmental experiment to persuade people to use seat belts had no discernible effect (7 carefully designed cable TV messages were broadcast 943 times during prime time to 6400 households). Psychologist Paul Slovic (1985) thought he and his colleagues might do better. Their hunch was that only 10 percent of the people use seat belts because most people perceive themselves to be invulnerable. Although it's true that only 1 trip in 100,000 produces an injury, 50,000 trips taken in an average lifetime means that for many people the feeling of safety eventually turns out to be an "illusion of invulnerability."

With the support of the National Traffic Safety Administration, Slovic and his colleagues produced 12 TV messages designed to persuade people of the risks of driving without seat belts. After pretesting with hundreds of people, several thousand people at a "screening house" evaluated six polished messages. The three best messages were repeatedly presented to yet another group of people. Alas, the messages had no effect on their seat-belt use. Because each safe trip reinforces nonuse of seat belts, concluded Slovic, "There seems to be

The odds are that marijuana
won't ruin your life.
And that Russian roulette won't kill you.

Partnership for a Drug-Free America.

A picture is worth a thousand words.

no form of educational campaign or message that will persuade more than a small percentage of American motorists to voluntarily wear seat belts."

As these examples show, efforts to persuade are sometimes diabolical, sometimes salutary; sometimes effective, sometimes futile. Persuasion is neither inherently good nor bad. It is usually the content of the message that elicits judgments of good or bad. The bad we call "propaganda." The good we call "education." True education is more factually based and less coercive than mere propaganda. Yet generally we call it "education" when we believe it, "propaganda" when we don't (Lumsden & others, 1980).

Our opinions have to come from somewhere. As long as we have opinions, persuasion—whether it be education or propaganda—is inevitable. Indeed, persuasion is everywhere—at the heart of politics, marketing, courtship, parenting, negotiation, evangelism, and courtroom decision making. Social psychologists therefore seek to understand what makes a message effective: What factors influence us to change? And how, as persuaders, can we most effectively "educate" others?

Imagine that you are a marketing or advertising executive, one of those responsible for some of the $100+ billion spent annually just in the United States on ads promoting products and services (Wachtel, 1989). Or imagine that you are a preacher, trying to increase love and charity among your parishioners. Or imagine that you want to promote energy conservation, to encourage breast feeding, or to campaign for a political candidate. What could you do to make yourself, and your message, persuasive? Or, if you are wary of being manipulated by such appeals, what tactics should you be alert to?

To answer such questions, social psychologists usually study persuasion the way some geologists study erosion—by observing the effects of various factors

"To swallow and follow, whether old doctrine or new propaganda, is a weakness still dominating the human mind."
Charlotte Perkins Gilman,
Human Work, 1904

Computer ads take the central route to persuasion, by offering cogent information that aims to stimulate favorable cognitive responses.

in brief controlled experiments. The effects are small and are most potent with attitudes that don't touch our values (Johnson & Eagly, 1989). Yet they enable us to understand how, given enough time, such factors could produce big effects.

■ TWO ROUTES TO PERSUASION

In choosing tactics, you must first decide: Should you focus mostly on building strong, central arguments? Or should you make your message appealing by associating it with favorable peripheral cues? Persuasion researchers Richard Petty and John Cacioppo (1986) and Alice Eagly and Shelly Chaiken (1992) report that people who are able and motivated to think through an issue are best persuaded through a **central route** to persuasion—one that marshals systematic arguments to stimulate favorable thinking. Computer ads, for example, seldom feature Hollywood stars or great athletes; instead they offer their analytical customers competitive features and prices.

Central route persuasion: Persuasion that occurs when interested people focus on the arguments and respond with favorable thoughts.

Some people are more analytical than others, report Petty and Cacioppo. They like to think about issues and mentally elaborate them. Such people rely not just on the cogency of the arguments but on their own cognitive responses

to persuasive appeals, as well. It's not so much the arguments that are persuasive, as what they get people thinking. And when people think deeply rather than superficially, any changed attitude will likely persist (Verplanken, 1991).

On issues that don't and won't engage people's thinking, a **peripheral route**—one that provides cues that trigger acceptance without much thinking—works better. Instead of providing product information, cigarette ads merely associate the product with images of beauty and pleasure. Even analytical people sometimes form tentative opinions using simple heuristics (Chaiken, 1987). Residents of my community recently voted on a complicated issue involving the legal ownership of our local hospital. I didn't have the time or interest to study this question myself (I had this book to write). But I noted that referendum supporters were all people I either liked or regarded as experts. So I used a simple heuristic—friends and experts can be trusted—and voted accordingly. We all make snap judgments using other rule-of-thumb heuristics: If a speaker is articulate and appealing, has apparently good motives, and has several arguments (or better, if the different arguments come from different sources), we take the easy peripheral route and accept the message without much thought (Figure 8-1).

Peripheral route persuasion: Persuasion that occurs when people are influenced by incidental cues, such as a speaker's attractiveness.

■ THE ELEMENTS OF PERSUASION

Social psychologists have explored four ingredients of persuasion, some central to the message, others more peripheral. These are: (1) the communicator, (2) the message, (3) how the message is communicated, and (4) the audience. In other words, *who* says *what* by *what means* to *whom*?

FIGURE 8-1 *The central and peripheral routes to persuasion. Computer ads typically take the central route, by assuming their audience wants to systematically compare features and prices. Soft-drink ads usually take the peripheral route, by merely associating their product with glamour, pleasure, and good moods.*

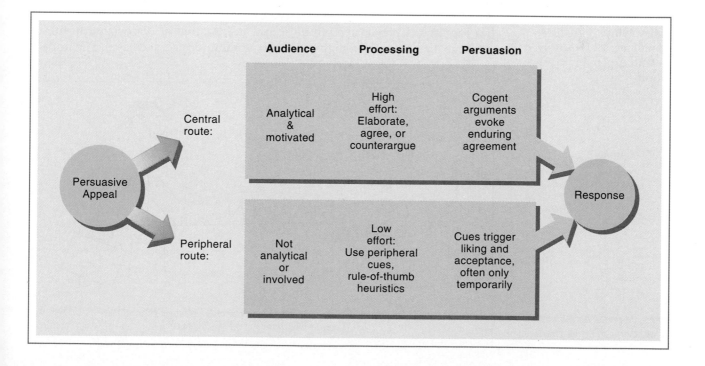

WHO SAYS? THE EFFECT OF THE COMMUNICATOR

Imagine the following scene: I. M. Wright, a middle-aged American, is watching the evening news. In the first segment, a small group of radicals is shown burning an American flag. As they do, one shouts through a bullhorn that whenever any government becomes oppressive, "it is the Right of the People to alter or to abolish it. . . . It is their right, it is their duty, to throw off such government!" Angered, Mr. Wright mutters to his wife, "It's sickening to hear them spouting that Communist line." In the next segment, a presidential candidate speaking before an antitax rally declares, "Thrift should be the guiding principle in our government expenditure. It should be made clear to all government workers that corruption and waste are very great crimes." An obviously pleased Mr. Wright relaxes and smiles: "Now that's the kind of good sense we need. That's my kinda guy."

Now switch the scene. Imagine Mr. Wright hearing the same revolutionary line at a July 4 oration of the Declaration of Independence (from which the line comes) and hearing a Communist speaker read the thrift quote from *Quotations from Chairman Mao Tsetung* (from which they come). Would he now react differently?

Social psychologists have found that who is saying something makes a big difference. In one experiment, when the Socialist and Liberal leaders in the Dutch parliament argued identical positions using the same words, each was most effective with members of his own party (Wiegman, 1985). Obviously, it's not just the message that matters, but a peripheral cue—who says it. But precisely what is it that makes one communicator more persuasive than another?

Credibility

All of us, I suspect, would find a statement about the benefits of exercise more believable if it came from the National Academy of Sciences rather than the *National Enquirer*. These source **credibility** effects diminish after a month or so. If a message is persuasive but its source is forgotten or dissociated from the message, the impact of a high-credibility communicator decreases. The impact

Credibility:
Believability. A credible communicator is perceived as both expert and trustworthy.

"If I seem excited, Mr. Bolling, it's only because I know that I can make you a very rich man."

© 1987, The New Yorker Magazine, Inc.

Effective persuaders know how to convey a message effectively.

of a low-credibility communicator may correspondingly *increase* over time (if people remember the message better than the reason for discounting it) (Cook & Flay, 1978; Gruder & others, 1978; Pratkanis & others, 1988). This delayed persuasion, after people forget the source or its connection with the message, is called the **sleeper effect**.

Perceived Expertise

Credible communicators are both *expert* and *trustworthy*. How does one become "expert"? One way is to begin by saying things the audience agrees with, which makes you seem smart. Another is to be introduced as someone who is *knowledgeable* on the topic. A message about toothbrushing from "Dr. James Rundle of the Canadian Dental Association" is much more convincing than the same message from "Jim Rundle, a local high school student who did a project with some of his classmates on dental hygiene" (Olson & Cal, 1984). After more than a decade studying high school marijuana use, the University of Michigan researchers (Bachman & others, 1988) concluded that scare messages from unreliable sources did not affect marijuana use during the 1960s and 1970s. But from a credible source, scientific reports of the biological and psychological results of long-term marijuana use "can play an important role in reducing . . . drug use."

Another way to appear credible is to *speak confidently*. Bonnie Erickson and her collaborators (1978) had University of North Carolina students evaluate courtroom testimony given in the straightforward manner said to be characteristic of "men's speech" or in the more hesitant manner of "women's speech." For example:

> **QUESTION:** Approximately how long did you stay there before the ambulance arrived?
>
> **ANSWER:** [*Straightforward*] Twenty minutes. Long enough to help get Mrs. David straightened out.
>
> [*Hesitating*] Oh, it seems like it was about uh, twenty minutes. Just long enough to help my friend Mrs. David, you know, get straightened out.

The students found the straightforward witnesses much more competent and credible.

Perceived Trustworthiness

Speech style also affects a speaker's apparent trustworthiness. Gordon Hemsley and Anthony Doob (1978) found that if, while testifying, videotaped witnesses looked their questioner straight in the eye instead of gazing downward, they impressed people as more believable.

Norman Miller and his colleagues (1976) at the University of Southern California found that both trustworthiness and credibility increase when people talk fast. People in the Los Angeles area who listened to tape-recorded messages on topics such as "the dangers of coffee drinking" rated fast speakers (about 190 words per minute) as more objective, intelligent, and knowledgeable than slow speakers (about 110 words per minute). They also found the more rapid speakers more persuasive.

But is it speed alone that makes rapid speakers more persuasive? Or is it something that accompanies rapid speech, like higher intensity or pitch? Marketing researcher James MacLachlan (1979; MacLachlan & Siegel, 1980) elec-

Sleeper effect: A delayed impact of a message; occurs when we remember the message but forget a reason for discounting it.

"Believe an expert."
Virgil, *Aeneid*

tronically compressed radio and television commercials without altering the speaker's pitch, inflection, and intensity. (He deleted small segments, about a fiftieth of a second in length, from all parts of the speech.) Speed itself was a factor. When the commercials were speeded up by 25 percent, listeners comprehended as well, rated the speakers as more knowledgeable, intelligent, and sincere, and found the messages more interesting. In fact, the normal 140- to 150-word-per-minute speech rate can be almost doubled before comprehension begins to drop abruptly (Foulke & Sticht, 1969). John F. Kennedy, an exceptionally effective public speaker, sometimes spoke in bursts approaching 300 words per minute. Although fast speech doesn't leave listeners time to elaborate favorable thoughts, it also cuts short any unfavorable thoughts (Smith & Shaffer, 1991).

Trustworthiness is also higher if the audience believes the communicator is not trying to persuade them. In an experimental version of what later became the "hidden-camera" method of television advertising, Elaine Hatfield and Leon Festinger (Walster & Festinger, 1962) had some Stanford University undergraduates eavesdrop on graduate students' conversations. (What they actually heard was a tape recording.) When the conversational topic was relevant to the eavesdroppers (having to do with campus regulations), supposedly unsuspecting speakers were more influential than speakers said to be aware that someone was listening. After all, if people don't know someone's listening, why would they be less than fully honest?

People also perceive those who argue a position that is against their own self-interest as more sincere. Alice Eagly, Wendy Wood, and Shelly Chaiken (1978) presented University of Massachusetts students with a speech attacking a company's pollution of a river. When they said the speech was given by a political candidate with a business background or to an audience of company supporters, it seemed unbiased and was persuasive. When the same antibusiness speech was supposedly given to environmentalists by a proenvironment politician, listeners could attribute the politician's arguments to personal bias or to the audience.

As if aware of this study, candidate Jimmy Carter in 1976 announced his support of amnesty for Vietnam draft resisters before, of all places, the American Legion convention. It was like advocating lower wages to a convention of labor leaders, but it did help convince the larger public of his sincerity. Being willing to suffer for one's beliefs—which many great leaders have done—has a similar effect (Knight & Weiss, 1980).

These experiments all point to the importance of attribution: To what do we attribute a speaker's position—to the speaker's bias and selfish motives or to the evidence? Wood and Eagly (1981) report that when a speaker argues an *unexpected* position, we are more likely to attribute the message to compelling evidence and thus to find it persuasive. Arguments for generous compensation in a personal-injury case are most persuasive when they come from a stingy, Scrooge-type person. Arguments for stingy compensation are most persuasive when they come from a normally warm, generous person (Wachtler & Counselman, 1981). We could therefore expect that an Arab-Israeli peace treaty would be most trusted by the Israelis if it were negotiated by a hardline Israeli president.

Some television ads are obviously constructed to make the communicator appear both expert and trustworthy. Drug companies peddle pain relievers

Attractive communicators, such as Magic Johnson speaking out on AIDS, often trigger peripheral route persuasion. We associate their message or product with our good feelings toward the communicator, and we approve and believe.

using a white-coated speaker, who declares confidently that most doctors recommend their ingredient (the ingredient, of course, is aspirin). Given such peripheral cues, people who don't care to analyze the evidence may reflexively infer the product's value. Other ads seem not to use the credibility principle. Is Bill Cosby really a trustworthy expert on Jell-O desserts? And are you and I more likely to drink Gatorade because Michael Jordan recommends it?

Attractiveness

Most people deny that endorsements by star athletes and entertainers affect them. Everyone knows that stars are seldom knowledgeable about the products. Besides, we know the intent is to persuade us; we don't just accidentally eavesdrop on Cosby lapping Jell-O. Such ads are based on another characteristic of an effective communicator: attractiveness. We may think we are not influenced by how attractive or likeable the person is, but researchers have found otherwise. Our liking of them may open us to their arguments (central route persuasion) or may serve simply to trigger positive associations when we later see the product (peripheral route persuasion).

Attractiveness varies in several ways. *Physical appeal* is one. Arguments, especially emotional ones, are often more influential when they come from beautiful people (Chaiken, 1979; Dion & Stein, 1978; Pallak & others, 1983). *Similarity* is another. As Chapter 13 will emphasize, we tend to like people who are like us. We also are influenced by them. For example, Theodore Dembroski, Thomas Lasater, and Albert Ramirez (1978) gave African-American junior high students a taped appeal for proper dental care. When a dentist assessed the cleanliness of their teeth the next day, those who heard the appeal from an African-American dentist had cleaner teeth than those who heard the same appeal from a Caucasian dentist. As a general rule, people are better able to hear and respond to a message that comes from someone in their group (Mackie & others 1990; Wilder, 1990).

Attractiveness: Having qualities which appeal to an audience. An appealing communicator (often someone similar to the audience) is most persuasive on matters of subjective preference.

Is similarity more important than credibility? Sometimes yes, sometimes no. Timothy Brock (1965) found paint store customers more influenced by the testimony of an ordinary person who had recently bought the same amount of paint they planned to buy than by an expert who had recently purchased 20 times as much. But recall that a leading dentist (a dissimilar but expert source) was more persuasive than a student (a similar but inexpert source) when discussing dental hygiene.

Seemingly contradictory findings such as this bring out the detective in the scientist. They suggest that an undiscovered factor is at work—that similarity is more important given factor X and credibility is more important given not-X. But what is factor X? George Goethals and Erick Nelson (1973) discovered that it is whether the topic is one of *subjective preference* or *objective reality*. When the choice concerns matters of personal value, taste, or way of life, similar communicators will be most influential. But on judgments of fact—Does Seattle have more rainfall than London?—confirmation of belief by a *dissimilar* person does more to boost confidence. A dissimilar person provides a more independent judgment. So, similar communicators are more effective on matters of value and preference than on judgments of fact.

WHAT IS SAID? THE CONTENT OF THE MESSAGE

It matters not only who says a thing, but *what* that person says. If you were to help organize an appeal to get people to vote for school taxes, or to stop smoking, or to give money to world hunger relief, you might grapple with several practical questions. Common sense can be made to argue on either side of these questions:

- Is a carefully reasoned message or one that arouses emotion more persuasive?
- How discrepant (different) should the message be from the audience's existing opinions: Will you get more opinion change by advocating a position only slightly discrepant from the listeners' existing opinions? Or by advocating an extreme point of view?
- Should the message express your side only, or should it acknowledge and attempt to refute opposing views?
- If people present both sides, say in successive talks at a community meeting, is there an advantage to going first or last?
- Let's take these questions one at a time.

Reason versus Emotion

"*The truth is always the strongest argument.*"
Sophocles, *Phaedra*

"*Opinion is ultimately determined by the feelings and not by the intellect.*"
Herbert Spencer, *Social Statics, 1851*

Suppose you were campaigning in support of world hunger relief. Would it be best to itemize your arguments and cite an array of impressive statistics? Or would you be more effective with an emotional approach, say by presenting the compelling story of one starving child? Of course, an argument need not be unreasonable to arouse emotion. Still, which is more influential—reason or emotion? Was Shakespeare's Lysander right when he said, "The will of man is by his reason sway'd"? Or was Lord Chesterfield's advice wiser: "Address yourself generally to the senses, to the heart, and to the weaknesses of mankind, but rarely to their reason"?

The answer: It depends on the audience. Well-educated or analytical people are more responsive to rational appeals than are less educated or less analytical people (Cacioppo & others, 1983; Hovland & others, 1949). Involved audiences travel the central route; they are more responsive to reasoned arguments. Audiences that care little travel the peripheral route; they are more affected by how much they like the communicator (Chaiken, 1980; Petty & others, 1981). To judge from interviews before the 1980 U.S. presidential election, many voters were uninvolved. Their voting preferences were more predictable from emotional reactions to the candidates (for example, whether Ronald Reagan ever made them feel happy) than from their beliefs about the candidates' traits and likely behaviors (Abelson & others, 1982). In 1988, too, many people who agreed more with Michael Dukakis nevertheless *liked* George Bush more and therefore voted for Bush.

Advertising research, as in one study of the persuasiveness of 168 television commercials (Agres, 1987), reveals that the most effective ads invoke both reasons ("You'll get whiter whites with Detergent X") and emotions ("Choosy mothers choose Jif").

The Effect of Good Feelings

Messages also become more persuasive through association with good feelings. Irving Janis and his colleagues (1965; Dabbs & Janis, 1965) found that Yale students were more convinced by persuasive messages if they were allowed to enjoy peanuts and Pepsi while reading them (Figure 8-2). Similarly, Mark Galizio and Clyde Hendrick (1972) found Kent State University students more persuaded by folk-song lyrics accompanied by pleasant guitar music than by unaccompanied lyrics. Those who like conducting business over sumptuous lunches with soft background music can celebrate these results.

Good feelings enhance persuasion partly by enhancing positive thinking (Petty & others, 1991). As we noted in Chapter 5, in a good mood, people view

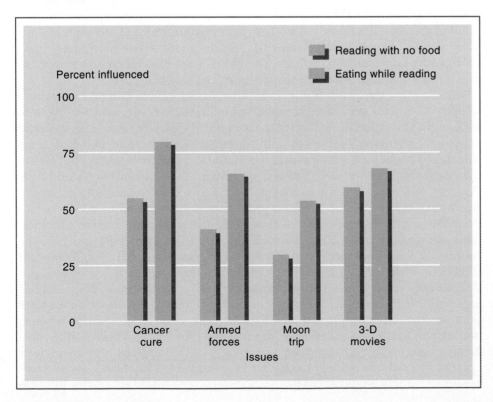

FIGURE 8-2 *People who snacked as they read were more persuaded than those who read without snacking.*
(Data from Janis, Kaye, & Kirschner, 1965.)

the world through rose-colored glasses. They also make faster, more impulsive decisions; they rely less on systematic thinking, more on heuristic cues (Schwarz & others, 1991). Because unhappy people ruminate more before reacting, they are less easily swayed by weak arguments. Thus, if you can't make a strong case, it's a smart idea to put your audience in a good mood and hope they'll feel good about your message without thinking too much about it.

The Effect of Arousing Fear

Messages also can be effective by evoking negative emotions. In trying to convince people to cut down on smoking, brush their teeth more often, get a tetanus shot, or drive carefully, a fear-arousing message can be potent (Muller & Johnson, 1990). Showing cigarette smokers the horrible things that sometimes happen to people who smoke too much adds to persuasiveness. But how much fear should be aroused? Should you evoke just a little fear, lest people become so frightened that they tune out your painful message? Or should you try to scare the daylights out of them? Experiments by Howard Leventhal (1970) and his collaborators at the University of Wisconsin and by Ronald Rogers and his collaborators at the University of Alabama (Robberson & Rogers, 1988) show that, often, the more frightened people are, the more they respond.

The effectiveness of fear-arousing communications is being applied in ads discouraging smoking, risky sexual behaviors, and drinking and driving. Dawn Wilson and her colleagues (1987, 1988) had doctors send a letter to their patients who smoked. Of those who received a positively framed message (explaining that by quitting they would live longer), 8 percent tried to quit smoking. Of those who received a fear-framed message (explaining that by continuing to smoke they would likely die sooner), 30 percent tried to quit. Similarly, researcher Claude Levy-Leboyer (1988) found that attitudes toward alcohol and drinking habits among French youth were more effectively changed by fear-arousing pictures. This finding led the French government to incorporate fear-arousing information into its TV spots.

But playing on fear won't always make a message more potent. If you don't tell people how to avoid the danger, frightening messages can be too much to cope with (Leventhal, 1970; Rogers & Mewborn, 1976). Such messages are more effective if you lead people not only to fear the severity and likelihood of a threatened event (say, a lung cancer death due to cigarette smoking) but also to believe there is an effective protective strategy they can follow (Maddux & Rogers, 1983). Many ads aimed at reducing sexual risks aim both to arouse fear—"AIDS kills"—and to offer a protective strategy: abstain or wear a condom. During the 1980s, fear of AIDS indeed persuaded many men to alter their behavior. One study of 5000 gay men found that between 1984 and 1986 the number saying they were celibate or monogamous rose from 14 to 39 percent (Fineberg, 1988).

Political propaganda often exploits fears. Streicher's *Der Stürmer* aroused fear with hundreds upon hundreds of unsubstantiated anecdotes about Jews who were said to have ground rats to make hash, seduced non-Jewish women, and cheated families out of their life savings. Streicher's appeals, like most Nazi propaganda, were emotional, not logical. The appeals also gave clear, specific instructions on how to combat "the danger": They listed Jewish businesses so readers would avoid them, encouraged readers to submit for publica-

Campaign attack ads exploit the persuasive power of fear-arousing messages.

tion the names of Germans who patronized Jewish shops and professionals, and directed readers to compile lists of Jews in their area (Bytwerk & Brooks, 1980). This was vivid propaganda, hard to forget. The negative campaign ads that dominated the 1988 U.S. presidential campaign also played on fears—fears of a possible "President Quayle" should George Bush die in office, fears of "soft-on-crime" candidate Dukakis cultivated with TV ads alluding to a Massachusetts convict who, while out on a prison furlough, committed a heinous crime.

The potency of fear-arousing information is also apparent in recent research. Vividly imagined diseases seem a more likely threat than hard-to-picture diseases (Sherman & others, 1985). That little fact helps explain why health warnings like those on cigarette ads are so ineffective—"a yawnful concentration of legal jargon," say Timothy Brock and Laura Brannon (1991)—and hardly make a dent in the ad's visual impact. Making the warnings more vivid—with color photos of lung cancer surgery—makes them more effective in changing attitudes and intentions. When it comes to persuasion, a dramatic picture can indeed be worth a thousand words.

"If those who have studied the art of writing are in accord on any one point, it is on this: the surest way to arouse and hold the attention of the reader is by being specific, definite, and concrete."
William Strunk and E. B. White,
The Elements of Style, 1979

Discrepancy

Picture the following scene: Wanda arrives home on spring vacation and hopes to convert her portly, middle-aged father to her new "health-fitness lifestyle." She runs 5 miles a day. Her father says his idea of exercise is "pushing the button on my garage door opener and turning pages of the *Wall Street Journal.*" Wanda thinks: "Would I be more likely to get Dad off his duff by urging him to try a modest exercise program, say a daily walk, or by trying to get him involved in something strenuous, say a program of calisthenics and running? Maybe if I asked him to take up a rigorous exercise program he would compromise and at least take up something worthwhile. But then again maybe he'd think I'm crazy and do nothing."

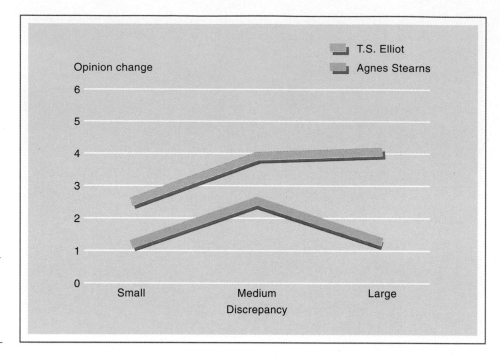

FIGURE 8-3 *Discrepancy interacts with communicator credibility. Only a highly credible communicator maintains effectiveness when arguing an extreme position.*

(Data from Aronson, Turner, & Carlsmith, 1963.)

Like Wanda, social psychologists can reason either way. Disagreement produces discomfort, and discomfort prompts people to change their opinions (recall from Chapter 4 the effects of dissonance). So perhaps wider disagreement will produce more change. But then again, a communicator who proclaims a discomfiting message may get discredited. One study found that people who disagree with conclusions drawn by a newscaster rate the newscaster as more biased, inaccurate, and untrustworthy. People are more open to conclusions within their range of acceptability (Zanna & others, 1976; Zanna, in press). So perhaps wider disagreement will produce *less* change.

Given these considerations, Elliot Aronson, Judith Turner, and Merrill Carlsmith (1963) reasoned that only a *credible source*—someone hard to discount—would elicit considerable opinion change when advocating a position *greatly discrepant* from the recipient's. Sure enough, when T. S. Eliot was said to have highly praised a disliked poem, people changed their opinion more than when he gave it faint praise. But when "Agnes Stearns, a student at Mississippi State Teachers College," evaluated a disliked poem, faint praise was as persuasive as high praise. Thus, as Figure 8-3 shows, discrepancy and credibility *interact:* The effect of a large versus small discrepancy depends on whether or not the communicator is credible.

So the answer to Wanda's question—"Should I argue an extreme position?"—is, "It depends." Is Wanda in her adoring father's eyes a highly prestigious, authoritative source? If so, Wanda should push for a complete fitness program. If not, Wanda would be wise to make a more modest appeal.

The answer also depends on how involved her father is in the issue. Those who are deeply involved in an issue tend to accept only a narrow range of views. To involved people, a moderately discrepant message may seem foolishly radical, especially if the message argues an opposing view rather than being a more extreme view of what they already agree with (Pallak & others,

1972; Petty & Cacioppo, 1979; Rhine & Severance, 1970). If Wanda's father has not yet thought or cared much about exercise, she can profitably take a more extreme position than if he is strongly committed to not exercising.

One-Sided versus Two-Sided Appeals

Persuaders face another practical issue: how to deal with opposing arguments. Once again, common sense offers no clear answer. Acknowledging the opposing arguments might confuse the audience and weaken the case. On the other hand, a message might seem fairer, more disarming, if it recognizes the opposition's arguments.

After Germany's defeat in World War II, the U.S. Army did not want soldiers to relax and think that the still ongoing war with Japan now would be easy. So social psychologist Carl Hovland and his colleagues (1949) in the Army's Information and Education Division designed two radio broadcasts arguing that the war in the Pacific would last at least two more years. One broadcast was one-sided; it did not acknowledge the existence of contradictory arguments, such as the advantage of fighting only one enemy instead of two. The other broadcast was two-sided; it mentioned and responded to the opposing arguments. As Figure 8-4 illustrates, the effectiveness of the message depended on the listener. A one-sided appeal was most effective with those who already agreed. An appeal that acknowledged opposing arguments worked better with those who disagreed.

Later experiments revealed that if people are (or will be) aware of opposing arguments, a two-sided presentation is more persuasive and enduring (Jones & Brehm, 1970; Lumsdaine & Janis, 1953). Apparently, a one-sided message stimulates an informed audience to think of counterarguments and to view the communicator as biased. Thus, a political candidate speaking to a politically informed group would indeed be wise to respond to the opposition.

"Opponents fancy they refute us when they repeat their own opinion and pay no attention to ours."
Goethe, *Maxims and Reflections*, early nineteenth century

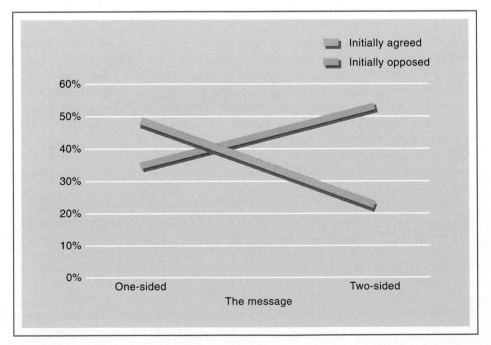

FIGURE 8-4 *The interaction of initial opinion with one-versus two-sidedness. After Germany's defeat in World War II, American soldiers skeptical of a message suggesting Japan's strength were more persuaded by a two-sided communication. Soldiers initially agreeing with the message were strengthened more by a one-sided message.* (Data from Hovland, Lumsdaine, & Sheffield, 1949.)

Primacy versus Recency

Imagine yourself a consultant to a prominent politician who must soon debate another prominent politician regarding a proposed nuclear arms limitation treaty. Three weeks before the vote, each politician is to appear on the nightly news and present a prepared statement. By the flip of a coin, your side receives the choice of whether to speak first or last. Knowing that you are a former social psychology student, everyone looks to you for advice.

You mentally scan your old books and lecture notes. Would first be best? People's preconceptions control their interpretations. Moreover, a belief, once formed, is difficult to discredit (Chapter 2). So going first could give people ideas that would favorably bias how they would perceive and interpret the second speech. Besides, people may pay most attention to what comes first. But then again, people remember recent things best. Might it really be more effective to speak last?

Primacy effect:
Other things being equal, information presented first usually has the most influence.

Your first line of reasoning predicts what is most common, a **primacy effect:** Information presented early is most persuasive. First impressions *are* important. For example, can you feel a difference between these two descriptions?

■ John is intelligent, industrious, impulsive, critical, stubborn, and envious.
■ John is envious, stubborn, critical, impulsive, industrious, and intelligent.

When Solomon Asch (1946) gave these sentences to college students in New York City, those who read the adjectives in the intelligent-to-envious order rated the person more positively than did those given the envious-to-intelligent order. Evidently, the earlier information colored their interpretation of the later information, producing the primacy effect. A similar effect occurs in experiments where people succeed on a guessing task 50 percent of the time and fail 50 percent of the time. People perceive those whose successes come early as more able than those whose successes come mostly after early failures (Jones & others, 1968; Langer & Roth, 1975; McAndrew, 1981).

Does this mean that primacy is also the rule in persuasion? Norman Miller and Donald Campbell (1959) gave Northwestern University students a condensed transcript from an actual civil trial. They placed the plaintiff's testimony and arguments in one block, those for the defense in another. The students read both blocks. When they returned a week later to declare their opinions, most sided with the information they had read first. Gary Wells, Lawrence Wrightsman, and Peter Miene (1985) found a similar effect when they varied the timing of a defense attorney's opening statement in the transcript of an actual criminal case. The defense statement was more effective if presented before the prosecution's presentation of the evidence, rather than after (as some experts advise).

Recency effect:
Information presented last sometimes has the most influence. Recency effects are less common than primacy effects.

What about the opposite possibility? Will our better memory for recent information ever create a **recency effect**? We know from our experience (as well as from memory experiments) that today's events can temporarily outweigh significant past events. To test this, Miller and Campbell gave another group of students one block of testimony to read. A week later the researchers had them read the second block and then immediately state their opinions. Now the results were just the reverse—a recency effect. Apparently the first block of arguments, being a week old, had largely faded from memory. Forgetting creates the recency effect (1) when enough time separates the two messages *and*

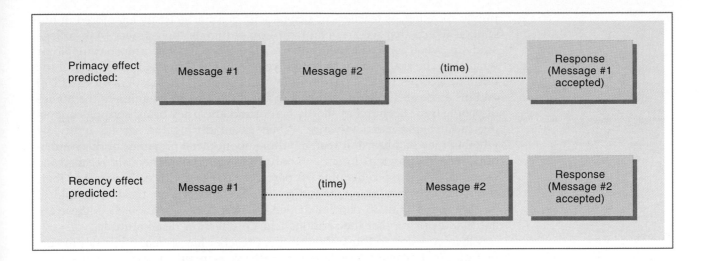

(2) when the audience commits itself soon after the second message. When the two messages are back to back, followed by a time gap, a primacy effect usually occurs (Figure 8-5). So, what advice would you give to the political debater?

HOW IS IT SAID? THE CHANNEL OF COMMUNICATION

Active Experience or Passive Reception?

In Chapter 4 we noted that our actions shape who we are. When we act, we amplify the idea behind what we've done, especially when we feel responsible. We also noted that attitudes rooted in our own experience—rather than learned secondhand—are more likely to endure and to affect our behavior. Compared to attitudes formed passively, experience-based attitudes are more confident, more stable, and less vulnerable to attack.

Commonsense psychology nevertheless places faith in the power of written words. How do we try to get people out to a campus event? We post notices. How do we get drivers to slow down and keep their eyes on the road? We put "Drive Carefully" messages on billboards. How do we discourage students from dropping trash on campus? We litter campus bulletin boards and mailboxes with antilitter messages.

Are people so easily persuaded? Consider two well-intentioned efforts. At Scripps College in California, a week-long antilitter campaign urged students to "Keep Scripps' campus beautiful," "Let's clean up our trash," and so forth. Such slogans were placed in students' mailboxes each morning and displayed on prominent posters across the campus. The day before the campaign began, social psychologist Raymond Paloutzian (1979) placed litter near a trash can along a well-traveled sidewalk. Then he stepped back to record the behavior of 180 passersby. No one picked up anything. On the last day of the campaign he repeated the test with 180 more passersby. Did the pedestrians now race one another in their zeal to comply with the appeals? Hardly. Only 2 of the 180 picked up the trash.

Are spoken appeals more persuasive? Not necessarily. Those of us who do

FIGURE 8-5 *Primacy effect versus recency effect. When two persuasive messages are back to back and the audience then responds at some later time, the first message has the advantage (primacy effect). When the two messages are separated in time and the audience responds soon after the second message, the second message has the advantage (recency effect).*

Channel of communication: The way the message is delivered—whether face to face, in writing, on film, or in some other way.

public speaking, as teachers or persuaders, become so easily enamored of our spoken words that we are tempted to overestimate their power. Ask college students what aspect of their college experience has been most valuable or what they remember from their first year, and few, I am sad to say, recall the brilliant lectures that we faculty remember giving. Thomas Crawford (1974) and his associates tested the impact of the spoken word by going to the homes of people from 12 churches shortly before and after they heard sermons opposing racial bigotry and injustice. When asked during the second interview whether they had heard or read anything about racial prejudice or discrimination since the previous interview, only 10 percent spontaneously recalled the sermons. When the remaining 90 percent were asked directly whether their clergy had ''talked about prejudice or discrimination in the last couple of weeks,'' more than 30 percent denied hearing such a sermon. It is therefore hardly surprising that the sermons had no effect on racial attitudes.

When you stop to think about it, the preacher has so many hurdles to surmount, it's a wonder that preaching affects as many people as it does. As Figure 8-6 shows, persuasive speakers must deliver a message that not only gets attention but is also understandable, convincing, memorable, and compelling. A carefully thought-out appeal must consider each of these steps in the persuasion process.

Passively received appeals, however, are not always futile. My drugstore sells two brands of aspirin, one heavily advertised and one unadvertised. Apart from slight differences in how fast each tablet crumbles in your mouth, any pharmacist will tell you the two brands are identical. Aspirin is aspirin. Our bodies cannot tell the difference between them. But our pocketbooks can. The advertised brand sells for three times the price of the unadvertised brand. And sell it does, to millions of people.

With such power, can the media help a wealthy political candidate buy an election? Joseph Grush (1980) analyzed candidate expenditures in all the 1976 Democratic presidential primaries and found that those who spent the most in any election usually got the most votes. As Grush noted, the effect of this exposure was often to make an unfamiliar candidate into a familiar one. (This parallels laboratory experiments in which mere exposure to unfamiliar stimuli breeds liking—see Chapter 13.) Their message, too, may gain with repetition. People rated trivial statements, like ''Mercury has a higher boiling point than

FIGURE 8-6 *To elicit action, a persuasive message must clear several hurdles. What is crucial is not so much remembering the message itself as remembering one's own thoughts in response.*
(Adapted from McGuire, 1978.)

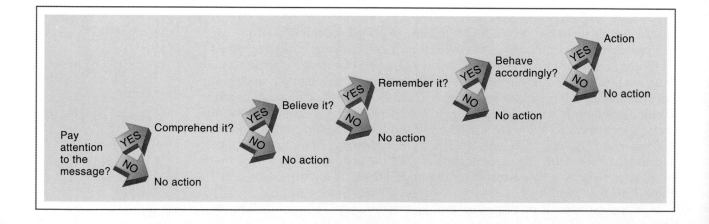

copper," as more truthful if they had read and rated them a week before. Mere repetition can make things believable. Researcher Hal Arkes (1990) views such findings as "scary." As political manipulators know, demagoguery can triumph over reason, believable lies can displace hard truths, echoed clichés can cover complex realities.

Would the media be as potent with familiar candidates and important issues? Probably not. Researchers have time and again found little effect of political advertising on voters' attitudes in the general presidential election (although, of course, even a small effect could swing a close election) (Kinder & Sears, 1985; McGuire, 1986).

Because passively received appeals are sometimes effective and sometimes not, can we specify in advance the topics on which a persuasive appeal will be successful? There is a simple rule: Persuasion decreases as the significance and familiarity of the issue increases. On minor issues, such as which brand of aspirin to buy, it's easy to demonstrate the media's power. On more familiar and important issues, such as racial attitudes in racially tense cities, persuading people is like trying to push a piano uphill. It is not impossible, but one shove won't do it.

Personal versus Media Influence

Persuasion studies demonstrate that the major influence upon important beliefs and attitudes is not the media but our contact with people. Two field experiments illustrate the strength of personal influence. Some years ago, Samuel Eldersveld and Richard Dodge (1954) studied political persuasion in Ann Arbor, Michigan. They divided citizens intending not to vote for a revision of the city charter into three groups. Of those exposed only to what they saw and heard in the mass media, 19 percent voted for the revision on election day. Of a second group who received four mailings in support of the revision, 45 percent voted for it. Of those in a third group who were visited personally and given the appeal face to face, 75 percent cast their votes for it.

In another field experiment, a research team led by John Farquhar and Nathan Maccoby (1977; Maccoby & Alexander, 1980; Maccoby, 1980) tried to reduce the frequency of heart disease among middle-aged adults in three small California cities. To check the relative effectiveness of personal and media influence, they interviewed and medically examined some 1200 people before the project began and at the end of each of the following three years. Residents of Tracy, California, received no persuasive appeals other than those occurring in their regular media. In Gilroy, California, a two-year multimedia campaign used TV, radio, newspapers, and direct mail to teach people about coronary risk and what they could do to reduce it. In Watsonville, California, this media campaign was supplemented by personal contacts with two-thirds of those whose blood pressure, weight, and age put them in a high-risk group. Using behavior-modification principles, the researchers helped people set specific goals and reinforced their successes.

As Figure 8-7 shows, after one, two, and three years the high-risk people in Tracy (the control town) were about as much at risk as before. High-risk people in Gilroy, which was deluged with media appeals, improved their health habits and were now somewhat less at risk. Those in Watsonville, who also received the personal contacts, changed most.

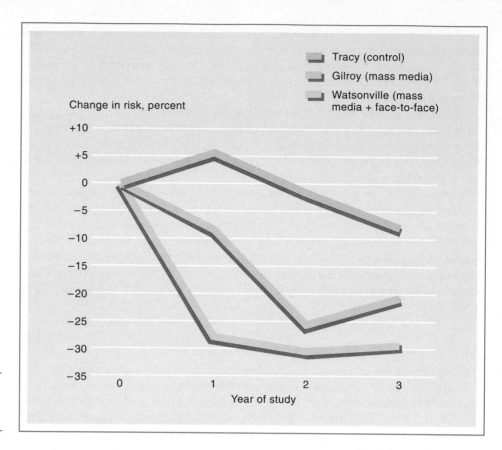

FIGURE 8-7 *Percentage change from baseline (0) in coronary risk after one, two, or three years of health education.* (Data from Maccoby, 1980.)

I suspect college students will have little trouble recognizing in their own experience the potency of personal influence. In retrospect, most say they learned more from their friends and fellow students than from their contact with books or professors. Educational researchers have confirmed the students' intuition: Out-of-class personal relationships powerfully influence how students mature during college (Astin, 1972; Wilson & others, 1975).

Although face-to-face influence is usually greater than media influence, we should not underestimate the media's power. Those who personally influence our opinions must get their ideas somewhere, and often their sources are the media. Elihu Katz (1957) observed that much of the media's effects operate in a **two-step flow of communication**—from media to opinion leaders to the rank and file. If I want to evaluate computer equipment, I defer to the opinions of my son, who gets many of his ideas from the printed page.

The two-step flow model is an oversimplification. The media also communicate directly with mass audiences. But the model does remind us that media influences penetrate the culture in subtle ways. Even if the media had little direct effect upon people's attitudes, they could still have a big indirect effect. Those rare children who grow up without watching television do not grow up beyond television's influence. Unless they live as hermits, they will join in TV-imitative play on the school ground. They will ask their parents for the TV-related toys their friends have. They will beg or demand to watch their friend's favorite programs. Parents can just say no, but they cannot switch off television's influence.

Two-step flow of communication:

The process in which media influence often occurs through opinion leaders, who in turn influence others.

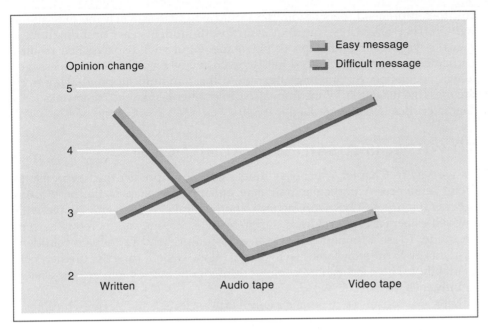

FIGURE 8-8 *Easy-to-understand messages are most persuasive when videotaped. Difficult messages are most persuasive when written. Thus the difficulty of the message interacts with the medium to determine persuasiveness.* (Data from Chaiken & Eagly, 1978.)

Lumping together all media from mass mailings to television is another oversimplification. Studies comparing different media find that the more life-like the medium, the more persuasive its message. Thus the order of persuasiveness seems to be: live, videotaped, audiotaped, and written. But to add to the complexity, messages are best *comprehended* and *recalled* when written. Comprehension is one of the first steps in the persuasion process (recall Figure 8-6). Shelly Chaiken and Alice Eagly (1978) reasoned that if a message is diffi-

■ BEHIND THE SCENES

My interest in studying persuasion was spurred when my graduate school advisor, Alice Eagly, pointed me to William McGuire's analysis of media effects. McGuire reasoned that different factors might affect someone's *comprehending* a persuasive argument and their *yielding* to it. This took me back to my preteen experience watching John F. Kennedy demolish (or so I thought) Richard Nixon during their presidential debates. Yet, I later learned, the perception that Kennedy "won" may have run stronger among people who *viewed* the debates than among people who only *heard* them or *read* them. Had my verdict been influenced more than I'd imagined by my hero's attractive appearance and bearing?

My master's thesis research (Figure 8-8) confirmed that the medium of communication indeed matters. Moreover, this led to the idea that people sometimes process messages *heuristically*, basing judgments on extrinsic factors such as the communicator's likability or attractiveness. I like to take credit for this idea, but it's high time I thanked Alice Eagly, Bill McGuire, and President Kennedy for their input.

SHELLY CHAIKEN, *New York University*

cult to comprehend, persuasion, too, could be greatest when the message is written. They gave University of Massachusetts students easy or difficult messages in writing, on audiotape, or videotape. Figure 8-8 displays their results: Difficult messages were indeed most persuasive when written, easy messages when videotaped. By drawing attention to the communicator and away from the message itself, the TV medium also draws attention to the communicator's characteristics (Chaiken & Eagly, 1983).

TO WHOM IS IT SAID? THE AUDIENCE

As we saw in Chapter 7, people's traits often don't predict their response to social influence. A particular trait may enhance one step in the persuasion process (Figure 8-6) but work against another. Take self-esteem. People with low self-esteem are often slow to comprehend a message and therefore hard to persuade. Those with high self-esteem may comprehend yet remain confident of their own opinions; thus self-esteem alone won't directly predict persuadability. The conclusion: People with moderate self-esteem are the easiest to influence (Rhodes & Wood, 1992).

Let's also consider two other audience factors: its age and its thoughtfulness.

How Old Are They?

People today tend to have different social and political attitudes depending on their age. There are two explanations for the difference. One is a *life-cycle explanation:* Attitudes change (for example, become more conservative) as people grow older. The other is a *generational explanation:* The attitudes older people adopted when they were young persist largely unchanged; because these attitudes are different from those now being adopted by young people today, a generation gap develops.

The evidence supports the generational explanation. In surveying and resurveying groups of younger and older people over several years, it is almost always found that the attitudes of older people change less than do those of young people. As David Sears (1979, 1986) puts it, researchers have "almost invariably found generational rather than life cycle effects."

The point is not that older adults are inflexible; most people in their fifties and sixties have more liberal sexual and racial attitudes than they had in their thirties and forties (Glenn, 1980, 1981). And personal experiences with institutions color our attitudes, whether we're young or old (Tyler & Schuller, 1991). The point is that the teens and early twenties are important formative years (Krosnick & Alwin, 1989), and the attitudes formed then tend to be stable thereafter. (If you are an 18- to 25-year-old, you may therefore want to choose carefully your own social influences—the groups you join, the books you read, the roles you adopt.)

Experiences during adolescence and early adulthood are formative partly because they make deep and lasting impressions. When Howard Schuman and Jacqueline Scott (1989) asked people to name the one or two most important national or world events over the last half century, most recalled events from their teens or early twenties. For those who experienced the Great Depression or World War II as 16- to 24-year-olds, those events overshadowed the Civil Rights movement and the Kennedy assassination of the early sixties, the Vietnam war and moon landing of the late sixties, and the women's movement of

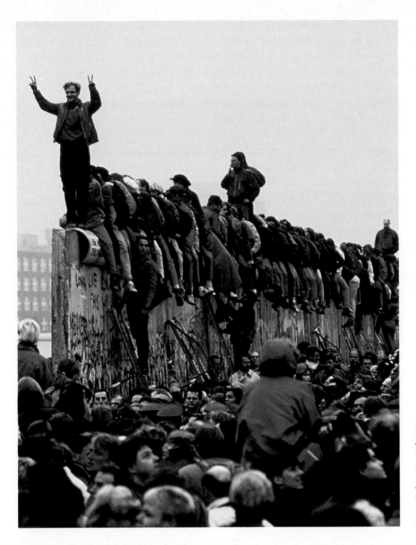

For today's young adults, the fall of the Berlin wall in December 1989 and the democratization of Eastern Europe that followed in its wake will live as a significant moment in world history.

the seventies, each of which imprinted themselves on the minds of those who experienced them as 16- to 24-year-olds. For today's young adults, we may expect that memories of the Persian Gulf war, or of the fall of the Berlin Wall and the democratization of eastern Europe and the Soviet Union will be indelible turning points in world history.

What Are They Thinking?

In central route persuasion, what's crucial is not the message itself but what responses it evokes in a person's mind. Our minds are not sponges that soak up whatever messages pour over them. If the message summons favorable thoughts, it persuades us. If it provokes us to think of contrary arguments, we remain unpersuaded.

Forewarned Is Forearmed—If You Care Enough to Counterargue

What circumstances breed counterarguing? One is a low-credibility communicator with a disagreeable message (Perloff & Brock, 1980). Another is a *forewarning* that someone is going to try to persuade you. If you had to tell your

parents that you wanted to drop out of school, you would anticipate their trying to persuade you to stay. So, you might develop a list of arguments to counter every conceivable argument they might make. Jonathan Freedman and David Sears (1965) demonstrated the difficulty of trying to persuade someone under such circumstances. They forewarned one of two large groups of California high school seniors that they were going to hear a talk: "Why Teenagers Should Not Be Allowed to Drive." Those forewarned did not budge; those not forewarned did.

Sneak attacks on attitudes are especially useful with involved people. Given several minutes' forewarning, such people will prepare defenses (Petty & Cacioppo, 1977, 1979). But when people regard an issue as trivial, even blatant propaganda can be effective. Would you bother to construct counterarguments for two brands of toothpaste? Similarly, when someone slips a premise into a casual conversation—"Why was Sue hostile to Mark?"—people often accept the premise (that Sue was, in fact, hostile) (Swann, Giuliano, & Wegner, 1982).

Distraction Disarms Counterarguing

Verbal persuasion also increases by distracting people with something that attracts their attention just enough to inhibit counterarguing (Festinger & Maccoby, 1964; Keating & Brock, 1974; Osterhouse & Brock, 1970). Political ads often use this technique. The words promote the candidate, and the visual images keep us occupied so we don't analyze the words. Distraction is especially effective when the message is simple (Harkins & Petty, 1981; Regan & Cheng, 1973).

This research on how persuasion becomes more effective as counterarguing decreases makes me wonder: Are fast talkers more persuasive partly because they leave us less time to counterargue? Are easy messages less persuasive when written because readers pace themselves and can therefore stop to counterargue? And does television shape important attitudes more through its subtle or hidden messages (for example, concerning gender roles) than through its explicit persuasive appeals? After all, if we don't notice a message, we cannot argue against it.

Uninvolved Audiences Use Peripheral Cues

As we noted earlier, there are two routes to persuasion—the central route of systematic thinking and the peripheral route of heuristic cues. Like the road through town, the central route has starts and stops as the mind analyzes arguments and formulates responses. Like the freeway around town, the peripheral route zips people to their destination. Analytical people—those with a high "need for cognition"—prefer central routes. Image-conscious people who care less about whether they're right or wrong than what sort of impression they are making are quicker to respond to such peripheral cues as the communicator's attractiveness and the pleasantness of the surroundings (Snyder, 1991). But the issue matters too. All of us struggle actively with issues that involve us while making snap judgments about things that matter little (Johnson & Eagly, 1990). As we mentally elaborate upon an important issue, the strength of the arguments and the tenor of our own thoughts determine our attitudes (Figure 8-9).

This basically simple theory—that what you think in response to a message is crucial *if* you are motivated and able to think about it—helps us understand

several findings. For example, we more readily believe expert communicators—because when we trust the source we think favorable thoughts and are less likely to counterargue. When we mistrust the source, we are more likely mentally to defend our preconceptions by refuting the disagreeable message.

The theory has also generated many predictions, most of which have been confirmed by Petty, Cacioppo, and others (Axsom & others, 1987; Harkins & Petty, 1987; Leippe & Elkin, 1987). Many experiments have explored ways to stimulate people's thinking—by using *rhetorical questions,* by presenting *multiple speakers* (for example, having three speakers each give one argument instead of one speaker giving three), by making people *feel responsible* for evaluating or passing along the message, by using *relaxed* rather than standing postures, by *repeating* the message, and by getting people's *undistracted attention.* Their consistent finding: Each of these techniques for stimulating thinking makes strong messages more persuasive and (because of counterarguing) weak messages less persuasive.

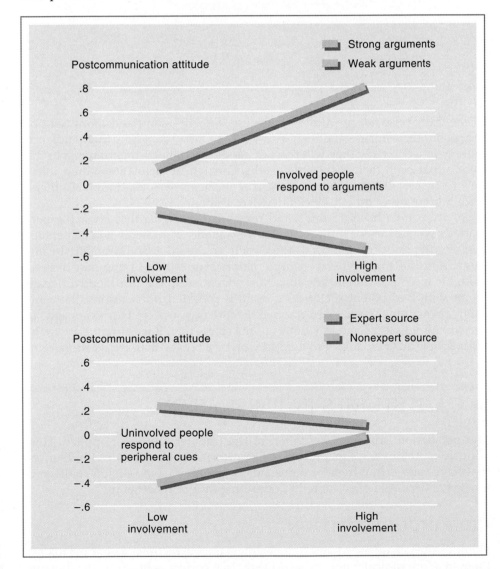

FIGURE 8-9 *Central versus peripheral routes to attitude change. When college students were given a persuasive message advocating a departmental exam before graduation, they found weak arguments unpersuasive but strong arguments convincing (top panel). The source made little difference. When the same message was uninvolving, advocating that the exam policy begin in 10 years, the quality of the arguments made little difference, but now the expertise of the source mattered (bottom panel).* (From Petty, Cacioppo, & Goldman, 1981.)

■ **BEHIND THE SCENES**

We spent many hours during graduate school trying to convince each other of our personal views. After these marathon debates, it seemed that the vulnerability of our attitudes depended on the merits of our arguments. We therefore were surprised what happened when, for a class project, we gained admittance to an introductory "cult" meeting. The cult leaders achieved success less by relying on arguments than by using peripheral cues such as source attractiveness, social approval, and the trappings of credibility. We left the meeting convinced that there were multiple routes by which attitudes change. Some people, in some situations, respond more to a central (argument-based) route; others, in other situations, respond more to peripheral cues. That basic idea is the core of our theory of persuasion.

RICHARD PETTY
and JOHN CACIOPPO, *Ohio State University*

The theory also has practical implications. Effective communicators care not only about their images and their messages but also about how their audience is likely to react. How they will react depends not only on their interest in the issue but also on their dispositions—their analytical inclinations, their tolerance for uncertainty, their need to be true to themselves (Cacioppo & others, 1986; Sorrentino & others, 1988; Snyder & DeBono, 1987).

So, are people likely to think and remember thoughts that favor the persuader's point of view? If the answer is yes, quality arguments will be persuasive. During the closing days of the closely contested 1980 presidential campaign, Ronald Reagan effectively used rhetorical questions to stimulate desired thoughts in voters' minds. His summary statement in the presidential debate began with two potent rhetorical questions repeated often during the campaign's remaining week: "Are you better off than you were four years ago? Is it easier for you to go and buy things in the stores than it was four years ago?" Most people answered no, and Reagan won by a bigger-than-expected margin.

■ CASE STUDIES IN PERSUASION

The persuasion principles described in this chapter are being applied, consciously or not, in ways that reveal their power. Consider the social influences that have caused hundreds of thousands of people to join religious cults and that have benefited even more in counseling and psychotherapy.

CULT INDOCTRINATION

Hare Krishna chanters, Moonies, Jonestown suicide victims—what persuades them to adopt radically new beliefs? Do their experiences illustrate the dynam-

ics of human persuasion? Bear two things in mind: First, this is hindsight analysis. It uses persuasion principles as categories for explaining, after the fact, a fascinating social phenomenon.

Second, explaining *why* people believe something says nothing about the *truth* of their beliefs. That is a logically separate issue. A psychology of religion that could tell us *why* a theist believes in God and an atheist disbelieves would not tell us who is right. Explaining either belief does not explain it away. So when someone tries to discount your beliefs by saying, "You just believe that because . . . ," you might recall the reply of Archbishop William Temple. After giving an address at Oxford, a questioner opened the discussion with a challenge: "Well, of course, Archbishop, the point is that you believe what you believe because of the way you were brought up." To which the Archbishop replied: "That is as it may be. But the fact remains that you believe I believe what I believe because of the way I was brought up, because of the way you were brought up."

In recent decades, two troubling and mystifying **cults** have gained much publicity: Sun Myung Moon's Unification Church and Jim Jones' Peoples Temple. The Reverend Moon's mixture of Christianity, anticommunism, and glorification of Moon himself as a new messiah attracted a worldwide following. In response to Moon's declaration, "What I wish must be your wish," many committed themselves and their incomes to the Unification Church. How were they persuaded to do so?

In 1978 in Guyana, 911 followers of the Reverend Jones, who had followed him there from San Francisco, shocked the world when they died by following his order to down a strawberry drink laced with tranquilizers, painkillers, and a lethal dose of cyanide. How could such a thing happen? What persuaded these people to give such total allegiance that they committed suicide on order? In hindsight, it looks as if the attitude-change principles have been at work.

> *In one survey of over 1000 San Francisco–area high school students, 54 percent reported having had at least one contact with a cult recruiter.*
> Philip G. Zimbardo & Cynthia F. Hartley (1985)

Cult:
A group typically characterized by (1) the distinctive ritual of its devotion to a god or a person, (2) isolation from the surrounding "evil" culture, and (3) a living, charismatic leader.

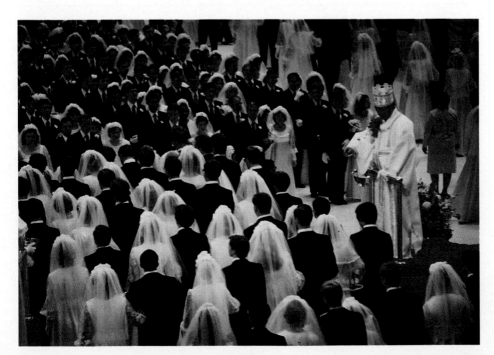

What persuades cult followers, such as these participants in weddings arranged by Sun Myung Moon, to give such fervent, unquestioning allegiance?

Attitudes Follow Behavior

Compliance Breeds Acceptance

As Chapter 4 showed over and again, people usually internalize commitments made voluntarily, publicly, and repeatedly. Cult leaders seem to know this. New converts soon learn that membership is no trivial matter. They are quickly made active members of the team, not mere spectators. Rituals within the cult community, and public canvassing and fund-raising, strengthen the initiates' identities as members. As those in social-psychological experiments come to believe in what they bear witness to (Aronson & Mills, 1959; Gerard & Mathewson, 1966), cult initiates become committed advocates. And the greater the personal commitment, the more the need to justify it.

The Foot-in-the-Door Phenomenon

How are we induced to make commitments? Seldom by an abrupt, conscious decision. One does not just decide, "I'm through with mainstream religion. I'm gonna find a cult." Nor do cult recruiters approach people on the street with, "Hi. I'm a Moonie. Care to join us?"

Rather, the recruitment strategy exploits the foot-in-the-door principle. Unification Church recruiters would invite people to a dinner and then to a weekend of warm fellowship and discussions of philosophies of life. At the weekend retreat, they encouraged the attenders to join in songs, activities, and discussion. Once the recruiters identified potential converts, they urged them to sign up for longer training retreats. Eventually the activities became more arduous—soliciting contributions and attempting to convert others.

Jim Jones used this foot-in-the-door technique with his Peoples Temple members. At first, monetary offerings were voluntary. He next inaugurated a required 10-percent-of-income contribution, which soon increased to 25 per-

Hundreds of thousands of Americans in recent years have been recruited by members of some 2500 religious cults, but seldom through an abrupt decision.

"You go on home without me, Irene. I'm going to join this man's cult."

Who says?	What?	How?	To whom?
Communicator	**Message content**	**Channel**	**Audience**
Credibility expertise trustworthiness Attractiveness	Reason vs. emotion Discrepancy One-sided vs. two-sided Primacy vs. recency	Active vs. passive Personal vs. media	Analytical or image-conscious age

cent. Finally, he ordered members to turn over to him everything they owned. Workloads also became progressively more demanding. Grace Stoen recalls:

> Nothing was ever done drastically. That's how Jim Jones got away with so much. You slowly gave up things and slowly had to put up with more, but it was always done very gradually. It was amazing, because you would sit up sometimes and say, wow, I really have given up a lot. I really am putting up with a lot. But he did it so slowly that you figured, I've made it this far, what the hell is the difference? (Conway & Siegelman, 1979, p. 236)

FIGURE 8-10 *Variables known to affect the impact of persuasive communications. In real life, these variables may interact; the effect of one may depend on the level of another.*

Persuasive Elements

We can also analyze cult persuasion using the factors discussed in this chapter (and summarized in Figure 8-10).

The Communicator

Successful cults have a charismatic leader—someone who attracts and directs the support of the members. As in experiments on persuasion, a credible communicator is someone the audience perceives as expert and trustworthy—for example, as "Father" Moon.

Jim Jones reportedly used "psychic readings" to establish his credibility. Newcomers were asked to identify themselves as they entered the church before services. Then one of his aides would call the person's home and say, "Hi. We're doing a survey, and we'd like to ask you some questions." Later, one ex-member recalls, Jones would call out the person's name and say:

> Have you ever seen me before? Well, you live in such and such a place, your phone number is such and such, and in your living room you've got this, that, and the other, and on your sofa you've got such and such a pillow. . . . Now do you remember me ever being in your house? (Conway & Siegelman, 1979, p. 234)

Trust is another aspect of credibility. Cult researcher Margaret Singer (1979) noted that middle-class Caucasian youths are more vulnerable because they are more trusting. They lack the "street smarts" of lower-class youths (who know how to resist a hustle) and the wariness of upper-class youths (who have been warned of kidnappers since childhood). Many cult members have been recruited by friends or relatives, people they trust (Stark & Bainbridge, 1980).

The Message

To lonely or depressed people, the vivid, emotional messages and the warmth and acceptance with which the group showers them can be strikingly appeal-

"Listen — just take one of our brochures and see what we're all about. ... In the meantime, you may wish to ask yourself, 'Am I a happy cow?'"

Some persuasive techniques are particularly difficult to resist.

ing: Trust the master, join the family; we have the answer, the "one way." The message echoes through channels as varied as lectures, small-group discussions, and direct social pressure.

The Audience

Recruits are often young—people under 25 and still at that comparatively open age before attitudes and values stabilize. Some, such as the followers of Jim Jones, are less educated people who like the simplicity of the message and find it difficult to counterargue. More are well-educated and middle-class people who, taken by the ideals, overlook the contradictions in those who profess selflessness and practice greed, who pretend concern and behave indifferently.

Potential converts often are at a turning point in their lives or facing a personal crisis. They have needs; the cult offers them an answer (Singer, 1979; Lofland & Stark, 1965). Times of social and economic upheaval are therefore especially conducive to an ayatollah or a "father" who can make apparent simple sense out of the confusion (O'Dea, 1968; Sales, 1972).

Group Effects

Cults illustrate the next chapter's theme: the power of a group to shape members' views and behavior. Members are usually separated from their previous social support systems and isolated with other cultists. There may then occur what Rodney Stark and William Bainbridge (1980) call a "social implosion": External ties weaken until the group socially collapses inward, each person engaging only with other group members. Cut off from families and former

friends, they lose access to counterarguments. The group now defines reality. Because the cult frowns on disagreements—or in the case of the Peoples Temple punishes them—the apparent consensus helps eliminate any lingering doubts.

Contrary to the idea that cults turn hapless people into mindless robots, these techniques—binding behavioral commitments, persuasion, and group isolation—do not have unlimited power. The Unification Church successfully recruits fewer than 1 in 10 people who attend its workshops (Ennis & Verrilli, 1989). As Jim Jones made his demands more extreme, he increasingly had to control people with intimidation. He used threats of harm to those who fled the community, beatings for noncompliance, and drugs to neutralize disagreeable members. By the end, he was as much an arm twister as a mind bender.

Moreover, cult influence techniques are in some ways similar to techniques used by groups more familiar to us. Fraternity and sorority members, for example, have reported that the initial "love bombing" of potential cult recruits is not unlike their own "rush" period, during which members lavish prospective pledges with attention and make them feel special. During the pledge period, new members are somewhat isolated, cut off from old friends who did not pledge. They spend time studying the history and rules of their new group. They suffer and commit time on its behalf. And they are expected to comply with all its demands. Not surprisingly, the result is usually a committed new member.

Much the same is true of some therapeutic communities for recovering drug and alcohol abusers. Like religious cults, zealous self-help groups form a cohesive "social cocoon," have intense beliefs, and exert a profound influence on members' behavior (Galanter, 1989, 1990). Terrorist organizations exploit some

Fraternities, sororities, and self-help groups, like the one pictured here, harness some of the same group-building processes used by religious cults—but in these cases, the goal is to free the individual.

of these principles in recruiting and indoctrinating members (McCauley & Segal, 1987).

I chose the examples of fraternities, sororities, and self-help groups not to disparage them but to illustrate two concluding observations. First, if we attribute cult indoctrination to the leader's mystical force or to the followers' peculiar weaknesses, we may delude ourselves into thinking we are immune to social control techniques. In truth, as the fraternity and sorority example suggests, our own groups—and countless salespeople, political leaders, and other persuaders—successfully use many of these tactics on us. Second, that Jim Jones abused the power of persuasion does not mean that the power is itself intrinsically bad. Nuclear power enables us to light up homes or wipe out cities. Sexual power enables us to express and celebrate committed love or exploit people for selfish gratification. Persuasive power enables us to enlighten or deceive. That these powers can be harnessed for evil purposes should alert us to guard against their immoral use. But the powers themselves are neither inherently evil nor inherently good; how we use them determines whether their effect is destructive or constructive.

PERSUASION IN COUNSELING AND PSYCHOTHERAPY

One constructive use of persuasion powers is in counseling and psychotherapy, which social-counseling psychologist Stanley Strong views "as a branch of applied social psychology" (1978, p. 101). Like Strong, psychiatrist Jerome Frank (1974, 1982) recognized years ago that it takes persuasion to change clients' self-defeating attitudes and behaviors. Frank noted that the psychotherapy setting, like cults and zealous self-help groups, provides (1) a supportive, confiding social relationship, (2) an offer of expertise and hope for demoralized people, (3) a special rationale or myth that explains one's difficulties and offers a new perspective, and (4) a set of rituals and learning experiences that promises a new sense of peace and happiness.

By the 1990s, psychologists more and more accepted the idea that social influence—one person affecting another—is at the heart of therapy. Having noted in Chapter 5 the therapeutic value of changing maladaptive behaviors and attributions, let's look now at verbal persuasion. Strong (1991) offers a prototypical example: A thirtyish woman comes to a therapist complaining of depression. The therapist gently probes her feelings and her situation. She explains her helplessness and her husband's demands. Although admiring her devotion, the therapist helps her see how she takes responsibility for his problems. She protests. But the therapist persists. In time, she grants that her husband may not be as fragile as she presumed. She begins to see how she can respect both her husband and herself. And with the therapist she plans strategies for each new week. At the end of a long stream of reciprocal influences between therapist and client, she emerges no longer depressed and with new ways of behaving.

Early analyses of social influence in psychotherapy focused on how therapists establish credible expertise and trustworthiness and how their credibility enhances their influence (Strong, 1968). More recent analyses have focused less on the therapist than on how the interaction affects the client's thinking (Cacioppo & others, 1991; McNeill & Stoltenberg, 1991; Neimeyer & others,

1991). Peripheral cues, such as therapist credibility, may open the door for ideas which the therapist can now get the client to think about. But the central route to persuasion provides the most enduring attitude and behavior change. Therapists should therefore aim not to elicit a client's superficial agreement with their expert judgment but to change the client's own thinking.

Fortunately, most clients entering therapy are motivated to take the central route, thinking deeply about their problems under the therapist's guidance. The therapist's task is to offer arguments and raise questions calculated to elicit favorable thoughts. The cogency of the therapist's insights matters less than the thoughts they evoke in the client. The therapist needs to put things in ways that a client can hear and understand, that will prompt agreement rather than counterargument, and that allow time and space for the client to reflect. Questions such as, "How do you respond to what I just said?" can stimulate the client's thinking.

Martin Heesacker (1989) illustrates with the case of Dave, a 35-year-old male graduate student. Having seen what Dave denied—an underlying substance abuse problem—the counselor drew on his knowledge of Dave, an intellectual person who liked hard evidence, in persuading him to accept the diagnosis and join a treatment-support group. The counselor said, "OK, if my diagnosis is wrong, I'll be glad to change it. But let's go through a list of the characteristics of a substance abuser to check out my accuracy." The counselor then went through each criterion slowly, giving Dave to think about each point. As he finished, Dave sat back and exclaimed, "I don't believe it: I'm a damned alcoholic."

In an experiment, John Ernst and Heesacker (1991) showed the effectiveness of escorting participants in an assertion training workshop through the central route to persuasion. Some participants experienced the typical assertiveness workshop by learning and rehearsing concepts of assertiveness. Others learned the same concepts but also volunteered a time when they hurt themselves by being unassertive. Then they heard arguments that, from pretesting, Ernst and Heesacker knew were likely to trigger favorable thoughts (for example, "By failing to assert yourself, you train others to mistreat you"). At the workshop's end, Ernst and Heesacker asked the people to stop and reflect on how they now felt about all they had learned. Compared to those in the first group, those who went through the thought-evoking workshop left the experience with more favorable attitudes and intentions regarding assertiveness. Moreover, their roommates noticed greater assertiveness during the ensuing two weeks.

In his 1620 *Pensées*, the philosopher Pascal foresaw this principle: "People are usually more convinced by reasons they discover themselves than by those found by others." It's a principle worth remembering in our own lives.

■ RESISTING PERSUASION: ATTITUDE INOCULATION

This exposure to persuasive influences has perhaps made you wonder if it is possible to *resist* unwanted persuasion. Of course it is. If, because of an aura of credibility, the repairperson's uniform and doctor's title have intimidated us

into unquestioning agreement, we can rethink our habitual responses to authority. We can seek more information before committing time or money. We can question what we don't understand.

STRENGTHENING PERSONAL COMMITMENT

Chapter 7 presented another way to resist: Before encountering others' judgments, make a public commitment to your position. Having stood up for your convictions, you become less susceptible (or should we say less "open"?) to what others have to say.

Challenging Beliefs

How might we stimulate people to commit themselves? From his experiments, Charles Kiesler (1971) offers one possible way: Mildly attack their position. Kiesler found that when committed people were attacked strongly enough to cause them to react, but not so strongly as to overwhelm them, they became even more committed. Kiesler explains:

> When you attack a committed person and your attack is of inadequate strength, you drive him to even more extreme behaviors in defense of his previous commitment. His commitment escalates, in a sense, because the number of acts consistent with his belief increases. (p. 88)

Perhaps you can recall a time when this happened in an argument, as those involved escalated their rhetoric, committing themselves to increasingly extreme positions.

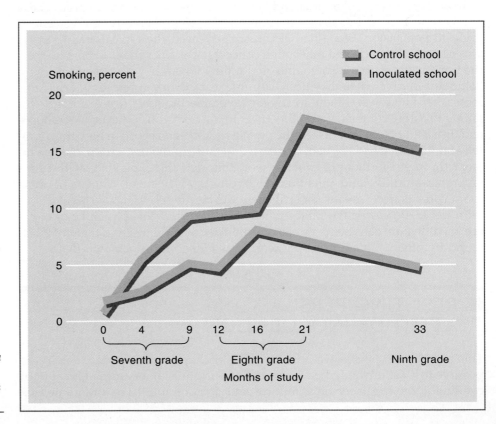

FIGURE 8-11 *The percentage of cigarette smokers at an "inoculated" junior high school was much less than at a matched control school using a more typical smoking education program.*
(Data from McAlister & others, 1980; Telch & others, 1981.)

Developing Counterarguments

There is a second reason a mild attack might build resistance. Like inoculations against disease, weak arguments prompt counterarguments, which are then available for a stronger attack. William McGuire (1964) documented this in a series of experiments. McGuire wondered: Could we inoculate people against persuasion much as we inoculate them against a virus? Is there such a thing as **attitude inoculation**? Could we take people raised in a "germ-free ideological environment"—people who hold some unquestioned belief—and stimulate their mental defenses? And would subjecting them to a small "dose" of belief-threatening material inoculate them against later persuasion?

That is what McGuire did. First, he found some cultural truisms, such as, "It's a good idea to brush your teeth after every meal if at all possible." He then showed that people were vulnerable to a massive, credible assault upon these truisms (for example, prestigious authorities were said to have discovered that too much toothbrushing can damage one's gums). If, however, before having their belief attacked, they were "immunized" by first receiving a small challenge to their belief, *and* if they read or wrote an essay in refutation of this mild attack, then they were better able to resist the powerful attack.

CASE STUDIES: LARGE-SCALE INOCULATION PROGRAMS

Inoculating Children against Peer Pressure to Smoke

In a clear demonstration of how laboratory research findings can lead to practical application, a research team led by Alfred McAlister (1980) had high school students "inoculate" seventh graders against peer pressures to smoke. The seventh graders were taught to respond to advertisements implying that liberated women smoke by saying, "She's not really liberated if she is hooked on tobacco." They also acted in role plays in which, after being called "chicken" for not taking a cigarette, they answered with statements like, "I'd be a real chicken if I smoked just to impress you." After several such sessions during the seventh and eighth grades, the inoculated students were half as likely to begin smoking as uninoculated students at another junior high school that had an identical parental smoking rate (Figure 8-11).

Other research teams have confirmed that education-inoculation procedures can indeed greatly reduce the teenage smoking rate (Evans & others, 1984; Flay & others, 1985). Most newer efforts emphasize strategies for resisting social pressure. One study exposed sixth to eighth graders to antismoking films or to information about smoking, together with role plays of student-generated ways of refusing a cigarette (Hirschman & Leventhal, 1989). A year and a half later 31 percent of those who watched the antismoking films had taken up smoking, but only 19 percent had done so among those who role-played refusing. Another study involved the entire seventh-grade class in a diverse sample of 30 junior high schools. It warned students about pressures to smoke and use drugs and offered them strategies for resisting (Ellickson & Bell, 1990). Among nonusers of marijuana, the training curbed initiation by a third; among users, it reduced usage by half.

Antismoking and drug education programs apply other persuasion principles too. They use attractive peers to communicate information. They trigger

Inoculation:
Exposing people to weak attacks upon their attitudes so that when stronger attacks come, they will have refutations available.

"The SLA . . . read me news items they clipped from the newspapers almost every day. Some of their stories were indisputable, sometimes I did not know what to believe. It was all very confusing. I realized that my life prior to my kidnapping had indeed been very sheltered; I had taken little or no interest in foreign affairs, politics, or economics."
Patricia Campbell Hearst, *Every Secret Thing*, 1982

the students' own cognitive processing ("Here's something you might want to think about"). They get the students to make a public commitment (by making a rational decision about smoking and then announcing it, along with their reasoning, to their classmates). Some of these smoking-prevention programs require only 2 to 6 one-hour class sessions, using prepared printed materials or videotapes. Today any school district or teacher wishing to use the social-psychological approach to smoking prevention can do so easily, inexpensively, and with the hope of significant reductions in future smoking rates and associated health costs.

Inoculating Children against the Influence of Advertising

Researchers have also now studied how to immunize young children so they can more effectively analyze and evaluate television commercials. This research is prompted partly by studies showing that children, especially those under 8 years, (1) have trouble distinguishing commercials from programs and fail to grasp their persuasive intent, (2) trust television advertising rather indiscriminately, and (3) desire and badger their parents for advertised products (Adler & others, 1980; S. Feshbach, 1980; Palmer & Dorr, 1980). Children, it seems, are an advertiser's dream: gullible, vulnerable, an easy sell. Moreover, half the 20,000 ads the typical child sees in a year are for low-nutrition, often sugary foods.

A debated question: What is the cumulative effect on children's materialism of watching some 350,000 commercials during their growing-up years?

Armed with such data, citizen's groups have given the advertisers of such products a chewing out (Moody, 1980): "When a sophisticated advertiser spends millions to sell unsophisticated, trusting children an unhealthy product, this can only be called exploitation. No wonder the consumption of dairy products has declined since the start of television, while soft-drink consumption has almost doubled." On the other side are the commercial interests, who claim that such ads allow parents to teach their children consumer skills and, more important, finance children's television programs. In the United States, the Federal Trade Commission has been in the middle, pushed by research findings and political pressures while trying to decide whether to place new constraints on TV ads aimed at young children.

Meanwhile, researchers have wondered whether children can be taught to resist deceptive ads. In one such effort, a team of investigators led by Norma Feshbach (1980; S. Cohen, 1980) gave small groups of Los Angeles–area elementary school children three half-hour lessons in analyzing commercials. The children were inoculated by viewing ads and discussing them. For example, after viewing a toy ad, they were immediately given the toy and challenged to make it do what they had just seen in the commercial. Such experiences helped breed a more realistic understanding of commercials.

SOME IMPLICATIONS

This inoculation research also has some provocative implications. The best way to build resistance to brainwashing may not be, as some senators thought after the Korean war, to introduce more courses on patriotism and Americanism. William McGuire advised that teachers use inoculation techniques: Challenge the concepts and principles of democracy and explain alternatives such as communism and constitutional monarchy, and so help students to develop defenses.

Children, especially those under eight, are easily persuaded by ads for junk foods.

For the same reason, religious educators should be wary of creating a "germ-free ideological environment" in their churches and schools. An attack refuted is more likely to solidify one's position than to undermine it, particularly if the threatening material can be examined with like-minded others. Cults apply this principle by forewarning members of how families and friends will attack the cult's beliefs. When the expected challenge comes, the member is armed with counterarguments.

Another implication is that, for the persuader, an ineffective appeal can be worse than none. Why? Those who reject one appeal are inoculated against further appeals. Consider an experiment in which Susan Darley and Joel Cooper (1972) invited students to write essays advocating a strict dress code. Because this was against the students' own positions and the essays were to be published, all chose *not* to write the essay—even those offered money to do so. After turning down the money, they became even more extreme and confident in their anti-dress-code opinions. Having now made an overt decision against

■ BEHIND THE SCENES

I confess to having felt like Mr. Clean when doing this immunization work because I was studying how to help people resist being manipulated. Then, after our research was published, an advertising executive called and said, "Very interesting, Professor: I was delighted to read about it." Somewhat righteously, I replied, "Very nice of you to say that Mr. Executive, but I'm really on the other side. You're trying to persuade people, and I'm trying to make them more resistant." "Oh, don't underrate yourself, Professor," he said. "We can use what you're doing to diminish the effect of our competitors' ads." And sure enough, it has become almost standard for advertisers to mention other brands and deflate their claims.

WILLIAM McGUIRE, *Yale University*

the dress code, they became even more resistant to it. Those who have rejected initial appeals to quit smoking may become immune to further appeals. Thus, ineffective persuasion, by stimulating the listener's defenses, may be counterproductive. Rebuffed appeals "harden the heart" against later appeals.

Inoculation research has a personal implication too. Do you want to build your resistance to persuasion without becoming closed to valid messages? Be an active listener and a critical thinker. Force yourself to counterargue. After hearing a political speech, discuss it with others. In other words, don't just listen; react. If the message cannot withstand careful analysis, so much the worse for it. If it can, its effect on you will be the more enduring for your having done the analytical work.

■ SUMMING UP

TWO ROUTES TO PERSUASION

Sometimes persuasion occurs as people focus on arguments and respond with favorable thoughts. Such systematic, or "central route," persuasion occurs when people are naturally analytical or involved in the issue. When issues don't engage people's systematic thinking, persuasion may occur through a faster "peripheral route" as people use heuristics or incidental cues to make snap judgments. Central route persuasion, being more thoughtful and less superficial, is more durable and more likely than peripheral route persuasion to influence behavior.

THE ELEMENTS OF PERSUASION

What makes persuasion effective? Researchers have explored four factors: the communicator, the message, the channel, and the audience.

Who Says? The Effect of the Communicator

Credible communicators are perceived as trustworthy experts. People who speak unhesitatingly, who talk fast, and who look listeners straight in the eye seem more credible. So also are people who are overheard without their knowledge or who argue against their own self-interest. An attractive communicator—for example, someone who is appealing or similar to the audience— also is effective on matters of taste and personal values.

What Is Said? The Content of the Message

Emotional factors can play a role. Associating a message with the good feelings one has while eating, drinking, or listening to music makes it more convincing. People often make snappier, less reflective judgments while in good moods. Some types of messages that arouse fear can also be effective, perhaps because they are vivid and memorable. For example, ads to encourage AIDS prevention both arouse fear and suggest preventive strategies.

How discrepant should a message be from the audience's existing opinions? That depends on the communicator's credibility. Highly credible people elicit the greatest changes in opinion when they argue an extreme position; less credible people are more successful when they advocate positions closer to those of the audience.

Is a message most persuasive when it presents only its position or when it introduces the opposing side as well? This depends on the listeners. When the audience already agrees with the message, is unaware of opposing arguments, and is unlikely later to consider the opposition, then a one-sided appeal is most effective (although perhaps not most ethical). With more sophisticated audiences or with those not already agreeing, two-sided messages are most successful.

Given two sides of an issue, do the arguments presented first or second have the advantage? The common finding is a primacy effect: Information presented early is most potent, especially when it affects one's interpretation of the later information. However, if a time gap separates the two sides, the effect of the early information diminishes; if a decision is also made right after hearing the second side, which is therefore still fresh in the mind, the result will likely be a recency effect.

How Is It Said? The Channel of Communication

Another important consideration is *how* the message is communicated. Attitudes developed from experience are usually stronger than those shaped by appeals passively received. Nevertheless, although not as potent as face-to-face personal influence, the mass media can be effective when the issue is minor (such as which brand of aspirin to buy) or unfamiliar (such as deciding between two otherwise unknown political candidates). Some of the media's effect may, however, be transmitted in two steps: directly to opinion leaders and then on to others through their personal influence.

To Whom Is It Said? The Audience

Finally, it matters *who* receives the message. Traits such as self-esteem bear no simple relation to persuadability, apparently because a trait that enables one to receive and comprehend a message will often work against yielding to it. More

crucial is what the audience thinks while receiving a message. Do they think agreeing thoughts? Do they counterargue? Forewarning an audience that a disagreeable message is coming reduces persuasion by stimulating counterarguments. On the other hand, distracting people while they hear a disagreeable message can increase persuasion by interfering with their counterarguing. Highly involved or analytically minded people are more likely to be affected by the quality of the arguments than by such peripheral cues as the communicator's attractiveness.

The age of the audience also makes a difference. Researchers who have resurveyed people over time find that young people's attitudes are less stable. Apparently, we form most of our basic attitudes and values when young and then carry them through adulthood. As succeeding generations form new attitudes, generation gaps result.

CASE STUDIES IN PERSUASION

Cult Indoctrination

The successes of religious cults, such as the Unification Church and the Peoples Temple, provide an opportunity to see powerful persuasion processes at work. It appears that their success has resulted partly by their eliciting behavior commitments (as described in Chapter 4), by applying principles of effective persuasion (this chapter), and by isolating members in like-minded groups (to be discussed in Chapter 9).

Persuasion in Counseling and Psychotherapy

Mental health workers also are recognizing that changing clients' attitudes and behaviors requires persuasion. Therapists, aided by their image as expert, trustworthy communicators, aim to stimulate healthier thinking by offering cogent arguments and raising questions.

RESISTING PERSUASION: ATTITUDE INOCULATION

How do people resist persuasion? A prior public commitment to one's own position, stimulated perhaps by a mild attack on the position, breeds resistance to later persuasion. A mild attack can also serve as an inoculation, stimulating one's attitudinal defenses to develop counterarguments that will then be available if and when a strong attack comes. This implies, paradoxically, that one way to strengthen existing attitudes is to challenge them, though not so strongly as to overwhelm them.

■ FOR FURTHER READING

Cialdini, R. B. (1988). *Influence: Science and practice.* Glenview, IL: Scott, Foresman. An entertaining and informative description of how and why people agree to things. Cialdini explains how skillful car salespeople, Tupperware dealers, realtors, and cult recruiters exploit the "weapons of influence."

Eagly, A. H., & Chaiken, S. (1993). *The psychology of attitudes.* San Diego: Harcourt Brace Jovanovich. A comprehensive summary of what we've learned

from a half century of research and theorizing on attitudes and how they change.

Pratkanis, A. R., & Aronson, E. (1992). *Age of propaganda: The everyday use and abuse of persuasion.* New York: Freeman. Two social psychologists explain how persuasion principles can be used (for example, to promote environmentally conscious behaviors) and abused (to exploit gullible people).

Zimbardo, P. G., & Leippe, M. R. (1991). *The psychology of attitude change and social influence.* New York: McGraw-Hill. A basic and skillful introduction to the study of persuasion and behavior change.

GROUP INFLUENCE

Our world contains not only 5.4 billion individuals, but also 200 nation-states, 4 million local communities, 20 million economic organizations, and hundreds of millions of other formal and informal groups—couples on dates, families, churches, housemates in bull sessions. How do these groups influence individuals? Consider some concrete examples of the group influences studied by social psychologists:

■ *Social facilitation:* Tawna is nearing the end of her daily jog. Her mind prods her to keep going; her body begs her to walk it in. She compromises and slogs home. The next day conditions are identical, except that a friend runs with her. Tawna runs her route two minutes faster. She wonders: "Did I run better merely because Gail was with me?"

■ *Social loafing:* In a team tug-of-war, will eight people on a side exert as much force as the sum of their best efforts in individual tugs-of-war? Nearly a century ago, French engineer Max Ringelmann (reported by Kravitz & Martin, 1986) found that the collective effort of such teams was but half the sum of the individual efforts. Were the participants coasting on the group's effort? If so, does such loafing also occur in group-graded work groups or on team projects?

■ *Deindividuation:* Preparing for battle, warriors in some tribal cultures depersonalize themselves with body and face paints or special masks. After the battle, some cultures kill, torture, or mutilate any remaining enemies; other cultures take prisoners alive. Robert Watson (1973) scrutinized anthropological files and discovered that the cultures with depersonalized warriors were also the cultures that were brutal to the enemy. Do groups in modern cultures depersonalize people? If so, how, and with what results?

■ *Group polarization:* Educational researchers have detected a curious "accentuation phenomenon." Initial attitude differences among students in different colleges grow as they progress through college. Likewise, attitude differences between those who do and don't belong to a fraternity or a sorority are modest at the first year level and more pronounced in the senior year. Does this phenomenon occur because group interaction among like-minded people accentuates their initial leanings? If so, why?

■ *Groupthink:* The executives of a soft-drink company enthusiastically discuss plans for their new asparagus-flavored soda pop. The group leader invites no contrary opinions and those who harbor doubts hesitate to puncture their group's enthusiasm. Thus the group deludes itself that all endorse the product and overestimates its probable success. When the product hits the market, dismal sales stun the executives. In real social situations, do group influences often work against optimal decisions? If so, what group forces hamper good decision making and how can we avoid them?

■ *Minority influence:* The 1957 movie *12 Angry Men* opens at a murder trial as 12 wary jurors file into the jury room. It is a hot day. The jurors are tired, close to agreement, and eager for a quick verdict convicting a teenage boy of killing his father with a knife. But one maverick, played by Henry Fonda, refuses to vote guilty. As the heated deliberation proceeds, all the jurors, one by one, change their verdicts until consensus is reached: "Not guilty." In real trials, a lone individual seldom sways the entire group. Yet, history is made by minorities that sway majorities. What helps make a minority—or an effective leader—persuasive?

We will examine these six intriguing phenomena of group influence one at a time. But first things first: What is a group and why do groups exist?

■ WHAT IS A GROUP?

The answer to the question seems self-evident—until several people compare their definitions. Are Tawna and her jogging partner a group? Are the passengers on an airplane a group? Is a group a set of people who identify with one another, who sense they belong to one another? Is a group people who share common goals and rely on one another? Does a group form when individuals become organized? When their relationships with one another continue over time? These are among the characteristics various social psychologists have used to define a group (McGrath, 1984).

Group dynamics expert Marvin Shaw (1981) argues that all groups have one thing in common: Their members interact. He therefore defines a **group** as two or more people who interact and influence one another. Moreover, notes Australian social psychologist John Turner (1987), groups perceive themselves as "us" in contrast to "them." So Tawna and her jogging companion are indeed a group. And certainly the fraternity and sorority members and corporate decision makers would be members of groups. Groups may exist for a number of reasons—to meet a need to belong, to provide information, to supply rewards, to accomplish goals.

By Shaw's definition, the passengers on a routine airplane flight would *not* be a group. Although physically together, they are more a collection of individuals than a true, interacting group. But the distinction between simple collective behavior among unrelated individuals on a plane and the more influential group behavior among interacting individuals sometimes blurs. People who are merely in one another's presence do sometimes influence one another. Moreover, they may perceive themselves as, say, "us" fans in contrast with "them" who root for the other team.

In this chapter we consider three examples of such collective influence: *social facilitation, social loafing,* and *deindividuation.* These three phenomena occur in situations that involve minimal interaction (sometimes called "minimal group situations"). We consider them here because the phenomena are elements of people's behavior while interacting. Then we will consider three examples of social influence in interacting groups: *group polarization, groupthink,* and *minority influence.*

Group:
Two or more people who, for longer than a few moments, interact with and influence one another and perceive one another as "us."

■ SOCIAL FACILITATION

Let's begin with social psychology's most elementary question: Are we affected by the mere presence of another person? "Mere presence" means people are not competing, do not reward or punish, and in fact do nothing except be present as a passive audience or as **coactors.** Would the mere presence of others affect a person's jogging, eating, typing, or exam performance? The search for the answer makes a scientific mystery story.

Coactors:
A group of people working simultaneously and individually on a noncompetitive task.

THE PRESENCE OF OTHERS

A century ago, Norman Triplett (1898), a psychologist interested in bicycle racing, noticed that cyclists' times were faster when racing together than when racing alone against the clock. Before he peddled his hunch (that the presence of others boosts performance), Triplett conducted one of social psychology's early laboratory experiments. Children told to wind string on a fishing reel as rapidly as possible wound faster when they worked with coactors than when they worked alone.

Subsequent experiments in the early decades of this century found that the presence of others also improves the speed with which people do simple multiplication problems and cross out designated letters, and it improves the accuracy with which people perform simple motor tasks, such as keeping a metal stick in contact with a dime-sized disk on a moving turntable (F. H. Allport, 1920; Dashiell, 1930; Travis, 1925). This **social-facilitation** effect, as it came to be called, also occurs with animals. In the presence of others of their species, ants excavate more sand and chickens eat more grain (Bayer, 1929; Chen, 1937).

Other studies conducted about the same time revealed that on other tasks the presence of others hindered performance. In the presence of others, cockroaches, parakeets, and green finches learn mazes more slowly (Allee & Masure, 1936; Gates & Allee, 1933; Klopfer, 1958). This disruptive effect also occurs with people. The presence of others diminishes efficiency at learning nonsense syllables, completing a maze, and performing complex multiplication problems (Dashiell, 1930; Pessin, 1933; Pessin & Husband, 1933).

Saying that the presence of others sometimes facilitates performance and sometimes hinders it is about as satisfying as a weather forecast predicting that it might be sunny but then again it might rain. By 1940, research activity in this area had stopped. It lay dormant for 25 years until awakened by the touch of the new idea.

Social facilitation:
(1) Original meaning—the tendency of people to perform simple or well-learned tasks better when others are present.
(2) Current meaning—the strengthening of dominant (prevalent, likely) responses due to the presence of others.

The presence of others, whether in competition or not, boosts well-learned performance.

Social psychologist Robert Zajonc (pronounced *Zy-ence*, rhymes with *science*) wondered whether these seemingly contradictory findings could be reconciled. As often happens at creative moments in science, Zajonc (1965) used one field of research to illuminate another. In this case the illumination came from a well-established principle in experimental psychology: Arousal enhances whatever response tendency is dominant. Increased arousal enhances performance on easy tasks for which the most likely—"dominant"—response is the correct one. People solve easy anagrams, such as *akec*, fastest when they are anxious. On complex tasks (for which the correct answer is not dominant), increased arousal promotes *incorrect* responding. On harder anagrams people do worse when anxious.

Could this principle solve the mystery of social facilitation? It seemed reasonable to assume that others' presence will arouse or energize people. (Most of us can recall feeling more tense or excited when before an audience.) If social arousal facilitates dominant responses, it should boost performance on easy tasks and hurt performance on difficult tasks. Now the confusing results made sense. Winding fishing reels, doing simple multiplication problems, and eating were all easy tasks for which the responses were well learned or naturally dominant. And sure enough, having others around boosted performance. On the other hand, learning new material, doing a maze, or solving complex math problems were more difficult tasks for which the correct responses were initially less probable. And sure enough, the presence of others increased the number of *incorrect* responses on these tasks. The same general rule—*arousal facilitates dominant responses*—seemed to work in both cases. Suddenly, what had looked like contradictory results no longer seemed contradictory.

Zajonc's solution, so simple and elegant, left other social psychologists thinking what Thomas H. Huxley thought after first reading Darwin's *Origin of Species:* "How extremely stupid not to have thought of that!" It seemed obvious—once Zajonc had pointed it out. Perhaps, however, the pieces appeared to merge so neatly only because we viewed them through the spectacles of hindsight. Would the solution survive direct experimental tests?

After almost 300 studies conducted with the help of more than 25,000 volunteer subjects, it has survived (Bond & Titus, 1983; Guerin, 1986). Several experiments in which Zajonc and his associates manufactured an arbitrary dominant response confirmed that an audience enhanced this response. In one, Zajonc and Stephen Sales (1966) asked people to pronounce various nonsense words between 1 and 16 times. Then they told the people that the same words would appear on a screen, one at a time. Each time, they were to guess which had appeared. When the people were actually shown only random black lines for a hundredth of a second, they "saw" mostly the words they had pronounced most frequently. These words had become the dominant responses. People who took the same test in the presence of two others were even more likely to guess the dominant words (Figure 9-1).

In various ways, later experiments confirmed that social arousal facilitates dominant responses, whether right or wrong. Peter Hunt and Joseph Hillery (1973) found that in the presence of others, University of Akron students took less time to learn a simple maze and more time to learn a complex one (just as the cockroaches do). And James Michaels and his collaborators (1982) found that good pool players in the Virginia Polytechnic Institute student union (who had made 71 percent of their shots while being unobtrusively observed) did

"Mere social contact begets . . . a stimulation of the animal spirits that heightens the efficiency of each individual workman."
Karl Marx, *Das Kapital*, 1867

"Discovery consists of seeing what everybody has seen and thinking what nobody has thought."
Albert Axent-Gyorgyi, *The Scientist Speculates*

FIGURE 9-1 *Social facilitation of dominant responses. People responded with dominant words (practiced 16 times) more frequently and subordinate words (practiced but once) less frequently when observers were present.*
(Data from Zajonc & Sales, 1966.)

even better (80 percent) when four observers came up to watch them play. Poor shooters (who had previously averaged 36 percent) did even worse (25 percent) when closely observed.

CROWDING: THE PRESENCE OF MANY OTHERS

So, people do respond to the presence of others. But does the presence of observers really arouse people? In times of stress, a comrade can be comforting. However, researchers have found that with others present, people perspire more, breathe faster, tense their muscles more, and have higher blood pressure and a faster heart rate (Geen & Gange, 1983; Moore & Baron, 1983).

The effect of other people increases with their number (Jackson & Latane, 1981; Knowles, 1983). Sometimes the arousal and self-conscious attention created by a very large number of people interfere with well-learned, automatic behaviors, such as speaking. Stutterers tend to stutter more in front of larger audiences than when speaking to just one or two people (Mullen, 1986). College basketball players become slightly *less* accurate in their free-throw shooting when highly aroused by a packed fieldhouse (Sokoll & Mynatt, 1984). In baseball's World Series, home teams have won 60 percent of the first two games but only 40 percent of the final games (Baumeister & Steinhilber, 1984; Heaton & Sigall, 1989, 1991). The arousal created by playing before the home fans helps to a point—home teams win two-thirds of college basketball games (Hirt & Kimble, 1981). But under the pressure of a World Series final game, the home team players sometimes choke, producing twice as many fielding errors in final games as in games 1 and 2.

Being *in* a crowd also intensifies positive or negative reactions. When they sit very close, friendly people are liked even more, and *un*friendly people are

*dis*liked even more (Schiffenbauer & Schiavo, 1976; Storms & Thomas, 1977). In experiments with Columbia University students and with Ontario Science Center visitors, Jonathan Freedman and his co-workers (1979; 1980) had an accomplice listen to a humorous tape or watch a movie with other subjects. When all sat close together, the accomplice could more readily induce them to laugh and clap. As theater directors and sports fans know, and as researchers have confirmed (Aiello & others, 1983; Worchel & Brown, 1984), a "good house" is a full house.

Perhaps you've noticed that a class of 35 students feels more warm and lively in a room that seats just 35 than when spread around a room that seats 100. This occurs partly because when others are close by, we are more likely to notice and join in their laughter or clapping. But crowding also enhances arousal, as Gary Evans (1979) found. He tested 10-person groups of University of Massachusetts students, either in a room 20 by 30 feet or in one 8 by 12 feet. Compared to those in the large room, those densely packed had higher pulse rates and blood pressure (indicating arousal). Though their performance on simple tasks did not suffer, on difficult tasks they made more errors. In their study of university students in India, Dinesh Nagar and Janak Pandey (1987) also found that crowding hampered performance only on complex tasks, such as solving difficult anagrams.

For a skilled athlete such as Michael Jordan, the arousal created by a crowd enhances well-learned, automatic behaviors.

WHY ARE WE AROUSED IN THE PRESENCE OF OTHERS?

To this point we have seen that what you do well, you will be energized to do best in front of others (unless you become hyperaroused and self-conscious). What you find difficult may seem impossible in the same circumstances. What is it about other people that causes arousal? Is it their mere presence? There is evidence to support three possible factors, each of which may play a role.

Evaluation Apprehension

Evaluation apprehension: Concern for how others are evaluating us.

Nickolas Cottrell surmised that observers make us apprehensive because we wonder how they are evaluating us. To test whether **evaluation apprehension** exists, Cottrell and his associates (1968) repeated Zajonc and Sales's nonsense-syllable study at Kent State University and added a third condition. In this "mere presence" condition they blindfolded observers, supposedly in preparation for a perception experiment. In contrast to the effect of the watching audience, the mere presence of these blindfolded people did *not* boost well-practiced responses. Other experiments confirmed Cottrell's conclusion: The enhancement of dominant responses is strongest when people think they are being evaluated. In one experiment, joggers on a University of California at Santa Barbara jogging path sped up as they came upon a woman seated on the grass—*if* she was facing them rather than sitting with her back turned (Worringham & Messick, 1983).

Evaluation apprehension also helps explain:

- Why people perform best when their coactor is slightly superior (Seta, 1982)
- Why arousal may lessen when a high-status group is diluted by the addition of people whose opinions we don't much care about (Seta & Seta, 1992)
- Why people who worry most about others' evaluations are the ones most affected by their presence (Gastorf & others, 1980; Geen & Gange, 1983)

FIGURE 9-2 *In the "open-office plan" people work in the presence of others. How might this affect worker efficiency?* (Photo courtesy of Herman Miller Inc.)

■ Why social-facilitation effects are greatest when the others are unfamiliar and hard to keep an eye on (Guerin & Innes, 1982)

The self-consciousness we feel when being evaluated can also interfere with behaviors that we perform best automatically—without thinking about how we're doing them (Mullen & Baumeister, 1987). If self-conscious basketball players analyze their body movements while shooting critical free throws, they are more likely to miss.

Driven by Distraction

Glenn Sanders, Robert Baron, and Danny Moore (1978; Baron, 1986) carry evaluation apprehension a step farther. They theorize that when people wonder how coactors are doing or how an audience is reacting, they get distracted. This *conflict* between paying attention to others and paying attention to the task overloads the cognitive system, causing arousal. Evidence that people are indeed "driven by distraction" comes from experiments that produce social facilitation not just by the presence of another person but even by a nonhuman distraction, such as bursts of light (Sanders, 1981a, 1981b).

Mere Presence

Zajonc, however, believes that the mere presence of others produces some arousal even without evaluation apprehension or conflict. For example, people's color preferences are stronger when they make judgments with others present (Goldman, 1967). On such a task, there is no "good" or "right" answer for others to evaluate and thus no reason to be concerned with their reactions.

That response facilitation effects also occur with animals, which probably are not consciously worrying about how other animals are evaluating them, hints at an innate social arousal mechanism common to much of the zoological world. I think that Tawana, our jogger, would agree. Most joggers feel energized when jogging with someone else, even one who neither competes nor evaluates.

This is a good time to remind ourselves of the purpose of a theory. As we noted in Chapter 1, a good theory is a scientific shorthand: It simplifies and summarizes a variety of observations. Social-facilitation theory does this well. It is a simple summary of many research findings. A good theory also offers clear predictions that (1) help confirm or modify the theory, (2) guide new exploration, and (3) suggest practical application. Social-facilitation theory has definitely generated the first two types of prediction: (1) The basics of the theory (that the presence of others is arousing and that this social arousal enhances dominant responses) have been confirmed, and (2) the theory has brought new life to a long dormant field of research. Does it also suggest (3) some practical applications?

Application is properly the last research phase. In their study of social facilitation, researchers have yet to work much on this. That gives us the opportunity to speculate on what some applications might be. For example, as Figure 9-2 illustrates, many new office buildings are replacing private offices with large, open areas divided by low partitions. Might the resulting awareness of others' presence help energize the performance of well-learned tasks but disrupt creative thinking on complex tasks? Can you think of other possible applications?

■ SOCIAL LOAFING

Social facilitation usually occurs when people work toward individual goals and when their efforts, whether winding fishing reels or solving math problems, can be individually evaluated. These situations parallel some everyday work situations, but not those where people cooperatively pool their efforts toward a *common* goal and where individuals are *not* accountable for their efforts. A team tug-of-war provides one such example. Organizational fundraising provides another. People on a work crew or a class group project where all get the same grade are another. On such "additive tasks"—tasks where the group's achievement depends on the sum of the individual efforts—will team spirit boost productivity? Will bricklayers lay bricks faster when working as a team than when working alone? One way to attack such questions is with laboratory simulations.

MANY HANDS MAKE LIGHT WORK

Contrary to the common notion that "in unity there is strength," the tug-of-war experiment suggests that group members may actually be *less* motivated when performing additive tasks. Maybe, though, the group's poor performance stemmed from poor coordination—people pulling in slightly different directions at slightly different times. A group of Massachusetts researchers led by Alan Ingham (1974) cleverly eliminated this problem by making individuals think others were pulling with them, when in fact they were pulling alone. Blindfolded participants assigned the first position in the apparatus shown in Figure 9-3 and told to "pull as hard as you can" pulled 18 percent harder when they knew they were pulling alone than when they believed that behind them two to five people were also pulling.

At Ohio State University, researchers Bibb Latané, Kipling Williams, and Stephen Harkins (1979; Harkins & others, 1980) kept their ears open for other ways to investigate this phenomenon, which they labeled **social loafing.** They observed that the noise produced by six people shouting or clapping "as loud as you can" was less than three times that produced by one person alone. However, like the tug-of-war task, noisemaking is vulnerable to group inefficiency. So Latané and his merry prankster associates followed Ingham's example by leading participants to believe others were shouting or clapping with them, when in fact they were doing so alone.

Their method was to blindfold six people, seat them in a semicircle, and have them put on headphones, over which they were blasted with the sound of people shouting or clapping. People could not hear their own shouting or clapping, much less that of others. On various trials they were instructed to shout or clap either alone or along with the group. Other people told about the experiment guessed the subjects would shout louder when with others, because they would be less embarrassed (Harkins, 1981). The actual result? Once again, social loafing: When the participants believed five others were also either shouting or clapping, they produced one-third less noise than when they thought themselves alone. (Curiously, those who clapped both alone and in groups did not view themselves as loafing; they perceived themselves clapping

Social loafing:
The tendency for people to exert less effort when they pool their efforts toward a common goal than when they are individually accountable.

FIGURE 9-3 *The rope-pulling apparatus. People in the first position pulled less hard when they thought people behind them were also pulling.*
(Data from Ingham, Levinger, Graves, & Peckham, 1974. Photo by Alan G. Ingham.)

equally in both situations. This parallels what happens when students work on group projects yielding a shared grade. Williams reports that all agree that loafing occurs—by others. No one admits to doing the loafing.) This effect occurs even when the subjects are high school cheerleaders who believe themselves to be cheering together or alone (Hardy & Latané, 1986).

John Sweeney (1973), a political scientist interested in the policy implications of social loafing, obtained similar results in an experiment at the University of Texas. He found that students pumped exercise bicycles more energetically (as measured by electrical output) when they knew they were being individually monitored than when they thought their output was being pooled with that of other riders. In the group condition, people were tempted to **free-ride** on the group effort.

In this and some four dozen other studies (Figure 9-4), we see a twist on one of the psychological forces that makes for social facilitation: evaluation apprehension. In the social-loafing experiments, individuals believe they are evaluated only when they act alone. The group situation (rope pulling, shouting, and so forth) *decreases* evaluation apprehension; when people are not accountable and cannot evaluate their own efforts, responsibility is diffused across all group members (Harkins & Jackson, 1985; Kerr & Bruun, 1981). By contrast, the social-facilitation experiments *increased* people's exposure to evaluation. When made the center of attention, people self-consciously monitor their behavior (Mullen & Baumeister, 1987). So the principle is the same: When being observed *increases* evaluation concerns, social facilitation occurs; when being lost in a crowd *decreases* evaluation concerns, social loafing occurs.

To motivate group members, one strategy is to make performance individually identifiable. Some football coaches do this by individually filming and evaluating each player. The Ohio State researchers had group members wear individual microphones while engaged in group shouting (Williams & others, 1981). Whether in a group or not, people exert more effort when their outputs

Free riders:
People who benefit from the group but give little in return.

FIGURE 9-4 *A statistical digest of 49 studies, involving more than 4000 participants, revealed that effort decreases (loafing increases) as the size of the group increases. Each dot represents the aggregate data from one of these studies.*
(From Williams, Jackson, & Karau, 1992.)

were individually identifiable: University swim team members swim faster in intrasquad relay races when someone monitors and announces their individual times (Williams & others, 1989).

SOCIAL LOAFING IN EVERYDAY LIVING

How widespread is social loafing? In the laboratory, the phenomenon occurs not only among people who are pulling ropes, cycling, shouting, and clapping but also among those who are pumping water or air, evaluating poems or editorials, producing ideas, typing, and detecting signals. Do these results generalize to everyday worker productivity?

On their collective farms under communism, Russian peasants worked one field one day, another field the next, with little direct responsibility for any given plot. For their own use, they were given small private plots. In one analysis, the private plots occupied 1 percent of the agricultural land, yet produced 27 percent of the Soviet farm output (H. Smith, 1976). In Hungary, private plots accounted for only 13 percent of the farmland but produced one-third of the output (Spivak, 1979). In China, where farmers are now allowed to sell food grown in excess of that owed to the state, food production increased 8 percent each year after 1978—2½ times the rate in the preceding 26 years (Church, 1986). In the early 1990s, long lines of frustrated people outside sparsely stocked, state-run Russian food stores persuaded government leaders to begin moving toward private ownership with profit incentives.

In North America, workers who do not pay dues or volunteer time to their union or professional association nevertheless are usually happy to accept its benefits. So, too, are public television viewers who don't respond to their sta-

tion's fund drives. This hints at another possible explanation of social loafing. When rewards are divided equally, regardless of how much one contributes to the group, any individual gets more reward per unit of effort by free riding on the group. So people may be motivated to slack off when their efforts are not individually monitored and rewarded.

In a pickle factory, for example, the key job is picking the right-size, dill-pickle halves off the conveyor belt and stuffing them in jars. Unfortunately, workers are tempted to stuff any size pickle in, because their output is not identifiable (the jars go into a common hopper before reaching the quality-control section). Williams, Harkins, and Latané (1981) note that research on social loafing suggests "making individual production identifiable, and raises the question: 'How many pickles could a pickle packer pack if pickle packers were only paid for properly packed pickles?'"

But surely collective effort does not always lead to slacking off. Sometimes the goal is so compelling and maximum output from everyone is so essential that team spirit maintains or intensifies effort. In an Olympic crew race, will the individual rowers in an eight-person crew pull their oars with less effort than those in a one- or two-person crew?

My hunch is that they do not. Experiments show that people in groups loaf less when the task is *challenging, appealing,* or *involving* (Brickner & others, 1986; Jackson & Williams, 1985). On challenging tasks, people may perceive their efforts as indispensable (Harkins & Petty, 1982; Kerr, 1983; Kerr & Bruun, 1983). When people see others in their group as unreliable or as unable to contribute much, they work harder (Vancouver & others, 1991; Williams & Karau, 1991). Adding incentives or challenging a group to strive for certain standards also promotes collective effort (Harkins & Szymanski, 1989; Shepperd & Wright, 1989).

Latané notes that Israel's communal kibbutz farms have actually outproduced Israel's noncollective farms (Leon, 1969), and Williams (1981) and Loren Davis and his associates (1984) report that groups of friends loaf much less

Given a sufficiently involving task—as in this tug-of-war at the Garnock Highland Games in Scotland—social loafing by group members may not occur.

than do groups of strangers. Perhaps cohesiveness somehow intensifies effort. If so, will social loafing not occur in group-centered cultures? To find out, Latané and his co-researchers (Gabrenya & others, 1985) headed for Asia where they repeated their sound production experiments in Japan, Thailand, Taiwan, India, and Malaysia. Their findings? Social loafing was evident in all these countries too. In collectivist China, however, social loafing was notably absent (Early, 1989). And as we noted in Chapter 6, loyalty to family and work groups runs strong in collectivist cultures. In Japanese corporate culture, and within families of Asian immigrants, if less so in momentary laboratory groups, team spirit fuels achievement.

Some of these findings parallel those from studies of everyday work groups. When groups are given challenging objectives, when they are rewarded for group success, and when there is a spirit of commitment to the "team," group members work hard (Hackman, 1986). So, while social loafing is a common occurrence when group members work collectively and without individual accountability, many hands need not always make light work.

■ DEINDIVIDUATION

In 1991 an eyewitness videotaped four Los Angeles police officers hitting unarmed Rodney King more than 50 times—fracturing his skull in nine places with their nightsticks and leaving him brain damaged and missing teeth—while 23 other officers watched passively. Replays of the tape shocked the nation into a prolonged discussion of police brutality and group violence. People wondered: Where was the officers' humanity? What had happened to standards of professional conduct? What evil force could unleash such behavior?

DOING TOGETHER WHAT WE WOULD NOT DO ALONE

Experiments on social facilitation show that groups can arouse people. Social-loafing experiments reveal that groups can diffuse responsibility. When arousal and diffused responsibility combine, normal inhibitions may diminish. The result may be acts ranging from a mild lessening of restraint (throwing food in the dining hall, snarling at a referee, screaming during a rock concert) to impulsive self-gratification (group vandalism, orgies, thefts) to destructive social explosions (police brutality, riots, lynchings). In a 1967 incident, 200 University of Oklahoma students gathered to watch a disturbed fellow student threatening to jump from a tower. They began to chant "Jump. Jump. . . ." The student jumped to his death (UPI, 1967).

These unrestrained behaviors have something in common: They are somehow provoked by the power of a group. It is harder to imagine a single rock fan screaming deliriously at a private rock concert, a single Oklahoma student trying to coax someone to suicide, or even a single police officer beating a defenseless motorist. In certain kinds of group situations people are more likely to abandon normal restraints, to lose their sense of individual responsibility, to become what Leon Festinger, Albert Pepitone, and Theodore Newcomb (1952) labeled **deindividuated.** What circumstances elicit this psychological state?

Deindividuation:
Loss of self-awareness and evaluation apprehension; occurs in group situations that foster anonymity and draw attention away from the individual.

The beating of Rodney King by Los Angeles police officers makes us wonder: How do group situations release people from normal restraints?

Group Size

A group has the power not only to arouse its members but also to render them unidentifiable. The snarling crowd hides the snarling basketball fan. A lynch mob enables its members to believe they will not be prosecuted; they perceive the action as the *group's*. Rioters, made faceless by the mob, are freed to loot. In an analysis of 21 instances in which crowds were present as someone threatened to jump from a building or bridge, Leon Mann (1981) found that when the crowd was small and exposed by daylight, people usually did not try to bait the person. But when a large crowd or the cover of night gave people anonymity, the crowd usually baited and jeered. Brian Mullen (1986) reports a similar effect of lynch mobs: The bigger the mob, the more its members lose self-awareness and become willing to commit atrocities, such as burning, lacerating, or dismembering the victim. In each of these examples, from sports crowds to lynch mobs, evaluation apprehension plummets. And because "everyone is doing it," all can attribute their behavior to the situation rather than to their own choices.

Philip Zimbardo (1970) speculated that the mere immensity of crowded cities produces anonymity and thus norms that permit vandalism. He once purchased two 10-year-old cars and left them with the hoods up and license plates removed, one on a street near the old Bronx campus of New York University and one near the Stanford University campus in Palo Alto, a much smaller city. In New York the first auto strippers arrived within 10 minutes, taking the battery and radiator. After 3 days and 23 incidents of theft and vandalism by neatly dressed White people, the car was reduced to a battered, useless hulk of metal. By contrast, the only person observed to touch the Palo Alto car in over a week was a passerby who lowered the hood when it began to rain.

"A mob is a society of bodies voluntarily bereaving themselves of reason."
Ralph Waldo Emerson, "Compensation," *Essays, First Series,* 1841

Physical Anonymity

How can we be sure that the crucial difference between the Bronx and Palo Alto is greater anonymity in the Bronx? We can't. But we can experiment with

FIGURE 9-5 *Anonymous, although obviously poised, women delivered more shock to helpless victims than did identifiable women.*

anonymity to see if it actually lessens inhibitions. In one such experiment, Zimbardo (1970) dressed New York University women in identical white coats and hoods, rather like Ku Klux Klan members (Figure 9-5). Asked to deliver electric shocks to a woman, they pressed the shock button twice as long as did women who were visible and wearing large name tags.

A research team led by Ed Diener (1976) cleverly demonstrated the effect both of being in a group *and* of being physically anonymous. At Halloween, they observed 1352 Seattle children trick-or-treating. As the children, either alone or in groups, approached 1 of 27 homes scattered throughout the city, an experimenter greeted them warmly, invited them to "take *one* of the candies," and then left the room. Hidden observers noted that, compared to solo children, those in groups were more than twice as likely to take extra candy. Also, compared to children who had been asked their names and where they lived, those left anonymous were also more than twice as likely to transgress. The transgression rate thus varied dramatically with the situation. As Figure 9-6 shows, when group immersion was combined with anonymity, the deindividuated children usually stole extra candy.

These experiments make me wonder about the effect of wearing uniforms. For his prison simulation, Zimbardo dressed the guards and prisoners in depersonalizing common outfits (Chapter 6). Did this contribute to their depraved behavior? Recall, too, Robert Watson's discovery that warriors wearing depersonalizing masks or face paints treat their victims more brutally. The uniformed Los Angeles police officers who beat Rodney King were aroused by their apprehension of him, enjoying one another's camaraderie, and unaware that outsiders would view their actions. Thus, forgetting their normal standards, they were swept away by their worst impulses.

Does becoming physically anonymous *always* unleash our worst impulses? Fortunately, no. For one thing, the situations in which some of these experiments took place had clear antisocial cues. Robert Johnson and Leslie Downing

(1979) point out that the Klan-like outfits worn by Zimbardo's subjects may have encouraged hostility. In an experiment at the University of Georgia, they had women put on nurses' uniforms before deciding how much shock someone should receive. When those wearing the nurses' uniforms were made anonymous, they became *less* aggressive in administering shock than when their names and personal identities were stressed. Evidently being anonymous makes one less self-conscious and more responsive to cues present in the situation, whether negative (Klan uniforms) or positive (nurses' uniforms). Given altruistic cues, deindividuated people even give more money (Spivey & Prentice-Dunn, 1990).

This helps explain why wearing black uniforms—which are traditionally associated with evil and death, as worn by medieval executioners, Darth Vader, and Ninja warriors—have an effect opposite to that of wearing a nurse's uniform. Mark Frank and Thomas Gilovich (1988) report that, led by the Los Angeles Raiders and the Philadelphia Flyers, black-uniformed teams consistently ranked near the top of the National Football and Hockey Leagues in penalties assessed between 1970 and 1986. Follow-up laboratory research suggests that just putting on a black jersey can trigger wearers to behave more aggressively.

Even if anonymity does unleash our impulses, as well as make us more responsive to social cues, we must remember that not all our impulses are sinister. Consider the heartwarming outcome of an experiment conducted by Swarthmore College researchers Kenneth Gergen, Mary Gergen, and William Barton (1973). Imagine that, as a subject in this experiment, you are ushered into a totally darkened chamber, where you spend the next hour (unless you

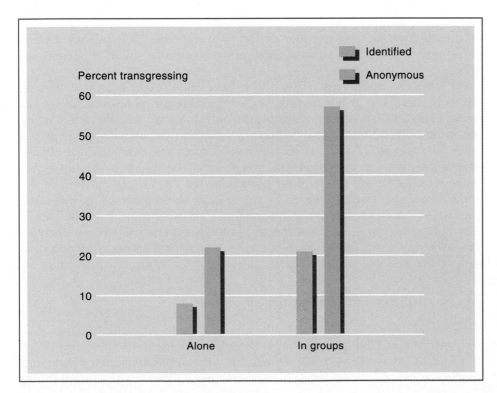

FIGURE 9-6 *Children were more likely to transgress by taking extra Halloween candy when trick-or-treating in a group, when anonymous, and, especially, when deindividuated by the combination of group immersion and anonymity.* (Data from Diener & others, 1976.)

choose to leave) with seven strangers of both sexes. You are told, "There are no rules as to what you should do together. At the end of the time period you will be escorted from the room alone, and will subsequently depart from the experimental site alone. There will be no opportunity to [formally] meet the other participants."

Control participants, who spent the hour in a lighted room with more conventional expectations, chose simply to sit and talk. By contrast, the experience of being anonymous in the dark room with unclear expectations "unleashed" intimacy and affection. People in the dark talked less, but they talked more about "important" things. Ninety percent purposefully touched someone; 50 percent hugged another. Few disliked the anonymity; most deeply enjoyed it and volunteered to return without pay. Anonymity had "freed up" intimacy and playfulness.

"The use of self-control is like the use of brakes on a train. It is useful when you find yourself going in the wrong direction, but merely harmful when the direction is right."
Bertrand Russell, *Marriage and Morals*

Arousing and Distracting Activities

Aggressive outbursts by large groups are often preceded by minor actions that arouse and divert people's attention. Group shouting, chanting, clapping, or dancing serve both to hype people up and to reduce self-consciousness. One Moonie observer recalls how the "choo-choo" chant helped deindividuate:

> All the brothers and sisters joined hands and chanted with increasing intensity, choo-choo-choo, Choo-choo-choo, CHOO-CHOO-CHOO! YEA! YEA! POWW!!! The act made us a group, as though in some strange way we had all experienced something important together. The power of the choo-choo frightened me, but it made me feel more comfortable and there was something very relaxing about building up the energy and releasing it. (quoted by Zimbardo & others, 1977, p. 186)

In William Golding's (1962) *Lord of the Flies,* a group of marooned boys gradually descend into savagery. The boys sometimes preceded savage acts with group activities, such as dancing in a circle and chanting, *"Kill the beast! Cut his throat! Spill his blood!"* In so doing, the group became "a single organism" (p. 182).

Ed Diener's experiments (1976, 1979) have shown that such activities as throwing rocks and group singing can set the stage for more disinhibited behavior. There is a self-reinforcing pleasure in doing an impulsive act while observing others doing it also. When we see others act as we are acting, we think they feel as we do, and so feel reinforced in our own feelings (Orive, 1984). Moreover, impulsive group action absorbs our attention. When we yell at the referee, we are not thinking about our values; we are reacting to the immediate situation. Later, when we stop to think about what we have done or said, we sometimes feel chagrined. Sometimes. At other times we seek deindividuating group experiences—dances, worship experiences, group encounters—where we can enjoy intense positive feelings and a sense of closeness with others.

"Attending a service in the Gothic cathedral, we have the sensation of being enclosed and steeped in an integral universe, and of losing a prickly sense of self in the community of worshippers."
Yi-Fu Tuan (1982, p. 127)

DIMINISHED SELF-AWARENESS

Group experiences that diminish self-consciousness tend to disconnect behavior from attitudes. Experiments by Ed Diener (1980) and Steven Prentice-Dunn and Ronald Rogers (1980, 1989) reveal that unself-conscious, deindividuated people are less restrained, less self-regulated, more likely to act without think-

As in Lord of the Flies, *group shouting, chanting, clapping, or dancing both hype people up and reduce their self-consciousness, turning them into a "single organism."*

ing about their own values, more responsive to the situation. These findings complement and reinforce the experiments on *self-awareness* considered in Chapters 3 and 4. Self-awareness is the other side of the coin from deindividuation. Those made self-aware, say by acting in front of a mirror or TV camera, exhibit *increased* self-control, and their actions more clearly reflect their attitudes. People made self-aware are less likely to cheat (Beaman & others, 1979; Diener & Wallbom, 1976). So are those who generally have a strong sense of themselves as distinct and independent (Nadler & others, 1982). People who are self-conscious, or who are made so, exhibit greater consistency between their words outside a situation and their deeds in it.

Circumstances that diminish self-awareness (as alcohol consumption does—Hull & others, 1983) therefore increase deindividuation. And deindividuation decreases in circumstances that increase self-awareness: mirrors and cameras, small towns, bright lights, large name tags, undistracted quiet, individual clothes and houses (Ickes & others, 1978). When a teenager leaves for a party, a parent's parting advice could well be: "Have fun, and remember who you are." In other words, enjoy the group, but be self-aware; don't become deindividuated.

■ GROUP POLARIZATION

Which effects—good or bad—does group interaction more often have? Police brutality and mob violence demonstrate its destructive potential. Yet support-group leaders, management consultants, and educational theorists proclaim its

benefits. And social and religious movements and collectivist cultures urge their members to strengthen their identities by fellowship with like-minded others.

Recent research helps clarify our understanding of such effects. From studies of people in small groups, a principle emerges that helps explain both destructive and constructive outcomes: Group discussion often strengthens members' initial inclinations, good or bad. The unfolding of this research on group polarization illustrates the process of inquiry—how an interesting discovery often leads researchers to hasty and erroneous conclusions, which are ultimately replaced with better conclusions and new ideas for research. This is one scientific mystery I can discuss firsthand, having been one of the detectives.

THE STORY BEGINS: "RISKY SHIFT"

A research literature of more than 300 studies began with a surprising finding by James Stoner (1961), then an MIT graduate student. For his master's thesis in industrial management, Stoner decided to compare risk taking by individuals and groups. He wanted to test the commonly held belief that groups are more cautious than individuals. Stoner's procedure, followed in dozens of later experiments, posed decision dilemmas faced by fictional characters. The participant's task was to advise the character how much risk to take. Put yourself in the participant's shoes: What advice would you give the character in this situation?

> Henry is a writer who is said to have considerable creative talent but who so far has been earning a comfortable living by writing cheap westerns. Recently he has come up with an idea for a potentially significant novel. If it could be written and accepted, it might have considerable literary impact and be a big boost to his career. On the other hand, if he cannot work out his idea or if the novel is a flop, he will have expended considerable time and energy without remuneration.
>
> Imagine that you are advising Henry. Please check the *lowest* probability that you would consider acceptable for Henry to attempt to write the novel.
>
> Henry should attempt to write the novel if the chances that the novel will be a success are at least:
>
> _____ 1 in 10
>
> _____ 2 in 10
>
> _____ 3 in 10
>
> _____ 4 in 10
>
> _____ 5 in 10
>
> _____ 6 in 10
>
> _____ 7 in 10
>
> _____ 8 in 10
>
> _____ 9 in 10
>
> _____ 10 in 10 (Place a check here if you think Henry should attempt the novel only if it is certain that the novel will be a success.)

After making your decision, guess what the average reader of this book would advise.

Having marked their advice on a dozen items similar to this one, five or so individuals would then gather in a group to discuss and reach agreement on

each item. How do you think the group decisions compared to the average decision before the discussions? Would the groups be likely to take greater risks? Would they be more cautious? About the same?

Much to everyone's amazement, the decisions chosen by the group were usually *riskier*. Dubbed the risky shift phenomenon, this finding set off a wave of investigation into group risk taking. The studies revealed that this effect occurs not only when a group decides by consensus; after a brief discussion, individuals, too, will alter their decisions. What is more, researchers successfully repeated Stoner's finding with people of varying ages and occupations in a dozen different nations.

Opinions did converge during discussion. However, it was curious that the point toward which they converged was usually a lower (riskier) number than their initial average. Here was a delightful puzzle. The risky shift effect, while not huge, was nevertheless reliable, unexpected, and without any immediately obvious explanation. What group influences produce such an effect? And how widespread is the effect? Do discussions in juries, business committees, and military organizations also promote risk taking?

After about five years of speculation and research on groups being more prone to take risks, we became aware that the risky shift was not as universal as we first thought. We could write decision dilemmas that did *not* yield a reliable risky shift, or on which people became more *cautious* after discussion. One of these featured "Roger," a young married man with two school-age children and a secure but low-paying job. Roger can afford life's necessities but few of its luxuries. He hears that the stock of a relatively unknown company may soon triple in value if its new product is favorably received or decline considerably if it does not sell. Roger has no savings; so in order to invest in the company, he is considering selling his life insurance policy.

Is there a general principle that will predict both the tendency to give riskier advice after discussing Henry's situation and more cautious advice after discussing Roger's? Yes. If you are like most people, you would likely advise Henry to take greater risk than Roger, even before talking with others. It turns out there is a strong tendency for discussion to accentuate these initial leanings.

We began to realize that this group phenomenon was not, as originally assumed, a consistent shift to risk, but rather a tendency for group discussion to *enhance* the individuals' initial leanings. This idea led investigators to propose a **group polarization** phenomenon: Discussion typically strengthens the average inclination of group members.

Group polarization:
Group-produced enhancement of members' preexisting tendencies; a strengthening of the members' *average* tendency, not a split within the group.

DO GROUPS INTENSIFY OPINIONS?

Experiments on Group Polarization

This new view of the changes induced by group discussion prompted experimenters to have people discuss statements that most of them favored or most of them opposed. Would talking in groups enhance their initial inclinations as it did with the decision dilemmas? That's what the group polarization hypothesis predicts (Figure 9-7).

Group polarization has been confirmed in dozens of studies. Serge Moscovici and Marisa Zavalloni (1969) observed that discussion enhanced French students' initially positive attitude toward their premier and negative attitude toward Americans. Likewise, Mititoshi Isozaki (1984) found that Japanese uni-

FIGURE 9-7 *The group-polarization hypothesis predicts that discussion will strengthen an attitude shared by group members. If people initially tend to favor risk on a life dilemma question, they tend to favor it even more after discussion. If they tend to oppose risk, they tend to oppose it even more after discussion.*

versity students gave more pronounced judgments of "guilty" after discussing a traffic case. And Glen Whyte (1992) reports that group decision making exacerbates the "too much invested to quit" phenomenon that has cost many businesses huge sums of money. When Canadian business students imagined themselves having to decide whether to invest more money in the hope of preventing losses in various failing projects (for example, whether to make a high-risk loan to protect an earlier investment), they exhibited the typical effect: 72 percent reinvested money they would seldom have invested if they were considering the new investment on its own merits. When making the same decision as groups, 94 percent opted for reinvestment.

Another research strategy has been to pick issues on which opinions are divided and then isolate people who hold the same view. Does discussion with like-minded people strengthen shared views? Does it magnify the attitude gap that separates the two sides?

George Bishop and I wondered. So we set up groups of relatively prejudiced and unprejudiced high school students and asked them to respond—before and after discussion—to issues involving racial attitudes, such as property rights versus open housing (Myers & Bishop, 1970). We found that the discussions among like-minded students did indeed increase the initial gap between the two groups (Figure 9-8). Such polarization helps explain another repeated finding: that groups compete more against one another, and cooperate less, than do individuals interacting with individuals (Schopler & others, 1991).

Naturally Occurring Group Polarization

There is lots of evidence that in everyday life people associate mostly with others whose attitudes are similar to their own (Chapter 13). To illustrate, look at your own circle of friends. So, does group interaction in everyday situations intensify shared attitudes? In natural situations it's hard to disentangle cause and effect. But the laboratory phenomenon does have real-life parallels.

One such parallel is what education researchers call the "accentuation phenomenon": Initial differences among college-student groups are accentuated with time in college. If the students at college X are initially more intellectual than the students at college Y, that difference is likely to expand as they progress through college. Likewise, compared to fraternity and sorority members, independents tend to have more liberal political attitudes, a difference that grows with time in college (Pascarella & Terenzini, 1991). Researchers believe this results partly from group members reinforcing shared inclinations (Chickering & McCormick, 1973; Feldman & Newcomb 1969; Wilson & others, 1975).

Polarization also occurs in communities. During community conflicts, like-minded people increasingly associate with one another, thus amplifying shared tendencies. Gang delinquency emerges from a process of mutual reinforcement within neighborhood gangs, whose members have a common socioeconomic and ethnic background (Cartwright, 1975). From their analysis of terrorist organizations around the world, Clark McCauley and Mary Segal (1987) note that terrorism does not erupt suddenly. Rather, it arises among people whose shared grievances bring them together. As they interact in isolation from moderating influences, they become progressively more extreme. The result is violent acts which the individuals, apart from the group, might never have contemplated.

In two recent trials, South African courts reduced sentences after learning how social-psychological phenomena, including deindividuation and group polarization, led crowd members to commit murderous acts (Colman, 1991). Would you agree that courts should consider social-psychological phenomena as possible extenuating circumstances when determining guilt and pronouncing sentence?

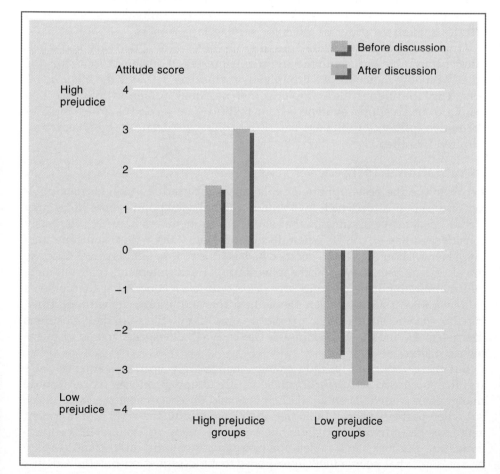

FIGURE 9-8 *Discussion increased polarization between homogeneous groups of high- and low-prejudice high school students.*
(Data from Myers & Bishop, 1970.)

■ **FOCUS**: GROUP POLARIZATION

Shakespeare portrayed the polarizing power of the like-minded group in this dialogue of Julius Caesar's followers:

> ANTONY: Kind souls, what weep you when you but behold/Our Caesar's vesture wounded? Look you here./Here is himself, marr'd, as you see, with traitors.
> FIRST CITIZEN: O piteous spectacle!
> SECOND CITIZEN: O noble Caesar!
> THIRD CITIZEN: O woeful day!
> FOURTH CITIZEN: O traitors, villains!
> FIRST CITIZEN: O most bloody sight!
> SECOND CITIZEN: We will be revenged!
> ALL: Revenge! About! Seek! Burn! Fire! Kill! Slay! Let not a traitor live!

From *Julius Caesar* by William Shakespeare, act 3, scene 2, lines 199–209.

EXPLAINING GROUP POLARIZATION

Why do groups adopt stances more exaggerated than the average opinions of their individual members? Researchers hoped that solving the mystery of group polarization might provide insights into social influence. Solving small puzzles sometimes provides clues for solving larger ones.

Among several proposed theories of group polarization, two survived scientific scrutiny. One deals with the arguments presented during a discussion, the other with how members of a group view themselves vis-à-vis the other members. The first idea is an example of informational influence (influence that results from accepting evidence about reality). The second is an example of normative influence (influence based on a person's desire to be accepted or admired by others).

Informational Influence

According to the best-supported explanation, group discussion elicits a pooling of ideas, most of which favor the dominant viewpoint. These ideas may include persuasive arguments that some group members had not previously considered (Stasser, 1991). When discussing Henry the writer, someone may say, "Henry should go for it, because he has little to lose—if his novel flops, he can always go back to writing cheap westerns." Such statements often entangle information about the person's *arguments* with cues concerning the person's *position* on the issue. But when people hear relevant arguments without learning the specific stands other people assume, they still shift their positions (Burnstein & Vinokur, 1977; Hinsz & Davis, 1984). *Arguments*, in and of themselves, matter.

But there's more to attitude change than merely hearing someone else's arguments. *Active verbal participation* in discussion produces more attitude change than passive listening. Participants and observers hear the same ideas, but when participants put them into their own words, the verbal commitment magnifies the impact. This illustrates a point made in Chapter 8: People's minds are not just blank tablets for persuaders to write on. In central route persuasion, what people *think* in response to a message is crucial. Indeed, just

thinking about an issue for a couple of minutes can make opinions more emphatic (Millar & Tesser, 1986). Even just *expecting* to discuss an issue with an equally expert person of an opposing view can motivate people to marshal their arguments and thus to adopt a more extreme position (Fitzpatrick & Eagly, 1981).

Normative Influence

A second explanation of polarization involves comparison with others. As Leon Festinger (1954) argued in his influential theory of **social comparison,** it is human nature to want to evaluate our opinions and abilities, something we can do by comparing our views with others'. We are most persuaded by people in groups we identify with (Abrams & others, 1990; Hogg & others, 1990). Moreover, wanting people to like us, we may express stronger opinions after discovering that others share our views.

Perhaps you can recall a time when you and others were guarded and reserved in a group, until someone broke the ice and said, "Well, to be perfectly honest, I think . . ." Soon you were all surprised to discover strong support for your views. Sometimes when a professor asks if anyone has any questions, no one will respond, leading each student to infer that he or she is the only one confused. All believe that fear of embarrassment explains their own silence but that everyone else's silence means they understand the material.

Dale Miller and Cathy McFarland (1987) bottled this familiar phenomenon in a laboratory experiment. They asked people to read an incomprehensible article and to seek help if they ran into "any really serious problems in understanding the paper." Although none of the subjects sought help, they presumed *other* subjects would not be similarly restrained by fear of embarrassment. They wrongly inferred that people who didn't seek help didn't need any. To overcome such **pluralistic ignorance,** someone must break the ice and enable others to reveal and reinforce their shared but secret reactions.

When people are asked (as you were earlier) to predict how others would respond to items, such as the "Henry" dilemma, they typically exhibit pluralistic ignorance: They don't realize how much others support the socially preferred tendency (in this case, writing the novel). A typical person will advise writing the novel even if its chance of success is only 4 in 10 but estimate that most other people would require 5 or 6 in 10. When the discussion begins, people discover they are not outshining the others as they had supposed. In fact, some of the others are ahead of them, having taken an even stronger position for writing the novel. No longer restrained by a misperceived group norm, they are liberated to voice their preferences more strongly.

This social comparison theory prompted experiments that exposed people to others' positions without exposing them to others' arguments. This is roughly the experience we have when reading the results of an opinion poll. When people learn others' positions—without discussion—will they adjust their responses to maintain a socially favorable position? When people have not already made a prior commitment to a particular response, seeing others' responses does indeed stimulate a small polarization (Goethals & Zanna, 1979; Sanders & Baron, 1977). (See Figure 9-9 for an example.) Polarization from mere social comparison is usually less than that produced by a lively discussion. Still, it's surprising that, instead of simply conforming to the group average, people often go it one better. Are people "one-upping" the observed norm

Social comparison:
Evaluating one's opinions and abilities by comparing oneself to others.

Pluralistic ignorance:
A false impression of how other people are thinking, feeling, or responding.

This finding is reminiscent of the self-serving bias (Chapter 3): People tend to view themselves as better-than-average embodiments of socially desirable traits and attitudes.

FIGURE 9-9 *On "risky" dilemma items (such as the case of Henry), mere exposure to others' judgments enhanced individuals' risk-prone tendencies. On "cautious" dilemma items (such as the case of Roger), exposure to others' judgments enhanced their cautiousness.*
(Data from Myers, 1978.)

to differentiate themselves from the group? Is this another example of our need to feel unique (Chapter 7)?

Group polarization research illustrates the complexity of social-psychological inquiry. Much as we like our explanations to be simple, one explanation of a phenomenon seldom accounts for all the data. Because people are complex, more than one factor frequently influences a phenomenon. In group discussions, persuasive arguments predominate on issues that have a factual element ("Is she guilty of the crime?"). Social comparison sways responses on value-laden judgments ("How long a sentence should she serve?") (Kaplan, 1989). On the many issues that have both factual and value-laden aspects, the two factors work together. Discovering that others share one's feelings (social comparison) unleashes arguments (informational influence) supporting what everyone secretly favors.

■ GROUPTHINK

Do the social-psychological phenomena we have been considering in these first nine chapters occur in sophisticated groups like corporate boards or the President's Cabinet? Is there likely to be self-justification? Self-serving bias? A cohesive "we feeling" provoking conformity and rejection of dissent? Public commitment producing resistance to change? Group polarization? Social psychologist Irving Janis (1971, 1982a) wondered whether such phenomena might help explain good and bad group decisions made by recent American presi-

dents and their advisers. To find out, he analyzed the decision-making procedures that led to several major fiascos:

■ **Pearl Harbor:** In the weeks preceding the December 1941, Pearl Harbor attack that put the United States into World War II, military commanders in Hawaii received a steady stream of information about Japan's preparations for attack on the United States—somewhere in the Pacific. Then military intelligence lost radio contact with Japanese aircraft carriers, which had begun moving straight for Hawaii. Air reconnaissance could have spotted the carriers or at least provided a few minutes' warning. But complacent commanders decided against such precautions. The result: No alert was sounded until the attack on virtually defenseless ships and airfields was underway.

■ **The Bay of Pigs invasion:** In 1961 President John Kennedy and his advisers tried to overthrow Fidel Castro by invading Cuba with 1400 CIA-trained Cuban exiles. Nearly all the invaders were soon killed or captured, the United States was humiliated, and Cuba allied itself even closer to the U.S.S.R. "How could we have been so stupid?" he asked after learning the outcome.

■ **The Vietnamese war:** From 1964 to 1967 President Lyndon Johnson and his "Tuesday lunch group" of policy advisers escalated the war in Vietnam on the assumption that U.S. aerial bombardment, defoliation, and search and destroy missions would bring North Vietnam to the peace table with the appreciative support of the South Vietnamese populace. They continued the escalation despite warnings from government intelligence experts and nearly all U.S. allies. The resulting disaster cost 46,500 American and more than 1 million Vietnamese lives, drove the President from office, and created huge budget deficits that helped fuel inflation in the 1970s.

Janis believes these blunders were bred by the tendency of decision-making groups to suppress dissent in the interests of group harmony, a phenomenon he calls **groupthink.** In work groups, a cohesive camaraderie boosts productivity (Evans & Dion, 1991). But when making decisions, close-knit groups may pay a price. The soil from which groupthink sprouts includes an amiable, cohesive group; relative isolation of the group from dissenting viewpoints; and a directive leader who signals what decision he or she favors. When planning the ill-fated Bay of Pigs invasion, the newly elected President Kennedy and his advisers enjoyed a strong esprit de corps. Arguments critical of the plan were suppressed or excluded, and the President himself soon endorsed the invasion.

Groupthink:
"The mode of thinking that persons engage in when concurrence-seeking becomes so dominant in a cohesive ingroup that it tends to override realistic appraisal of alternative courses of action."
Irving Janis (1971)

SYMPTOMS OF GROUPTHINK

From historical records and the memoirs of participants and observers, Janis identified eight groupthink symptoms. These symptoms are a collective form of dissonance reduction that surface as group members try to maintain their positive group feeling in the face of a threat (Turner & others, 1992). The first two symptoms lead group members to *overestimate their group's might and right*.

■ **An illusion of invulnerability:** The groups Janis studied all developed an excessive optimism that blinded them to warnings of danger. Told that his

forces had lost radio contact with the Japanese carriers, Admiral Kimmel, the chief naval officer at Pearl Harbor, joked that maybe they were about to round Honolulu's Diamond Head. Kimmel's laughing at the idea dismissed the very possibility of its being true.

■ **Unquestioned belief in the group's morality:** Group members assume the inherent morality of their group and ignore ethical and moral issues. The Kennedy group knew that adviser Arthur Schlesinger, Jr., and Senator J. William Fulbright had moral reservations about invading a small, neighboring country. But the group never entertained or discussed these moral qualms.

Group members also become *close-minded:*

■ **Rationalization:** The groups discounted challenges by collectively justifying their decisions. President Johnson's Tuesday lunch group spent far more time rationalizing (explaining and justifying) than reflecting upon and re-thinking prior decisions to escalate. Each initiative became an action to defend and justify.

■ **Stereotyped view of opponent:** Participants in these groupthink tanks consider their enemies too evil to negotiate with or too weak and unintelligent to defend themselves against the planned initiative. The Kennedy group convinced itself that Castro's military was so weak and his popular support so shallow that a single brigade could easily overturn his regime.

Finally, the group suffers from *pressures toward uniformity:*

■ **Conformity pressure:** Group members rebuffed those who raised doubts about the group's assumption and plans, at times not by argument but by personal sarcasm. Once, when President Johnson's assistant Bill Moyers arrived at a meeting, the President derided him with, "Well, here comes Mr. Stop-the-Bombing." To avoid disapproval, most people fall into line when faced with such ridicule.

■ **Self-censorship:** Since disagreements were often discomforting and the groups seemed in consensus, members withheld or discounted their misgivings. In the months following the Bay of Pigs invasion, Arthur Schlesinger (1965, p. 255) reproached himself "for having kept so silent during those crucial discussions in the Cabinet Room, though my feelings of guilt were tempered by the knowledge that a course of objection would have accomplished little save to gain me a name as a nuisance."

People "are never so likely to settle a question rightly as when they discuss it freely."
John Stuart Mill, *On Liberty,* 1859

■ **Illusion of unanimity:** Self-censorship and pressure not to puncture the consensus create an illusion of unanimity. What is more, the apparent consensus confirms the group's decision. This appearance of consensus was evident in the three fiascos and in other fiascos before and since. Albert Speer (1971), an adviser to Adolf Hitler, describes the atmosphere around Hitler as one where pressure to conform suppressed all deviation. The absence of dissent created an illusion of unanimity:

In normal circumstances people who turn their backs on reality are soon set straight by the mockery and criticism of those around them, which makes them aware they have lost credibility. In the Third Reich there were no such correctives, especially for those who belonged to the upper stratum. On the contrary, every self-deception was multiplied as in a hall of distorting mirrors, becoming a repeatedly confirmed pic-

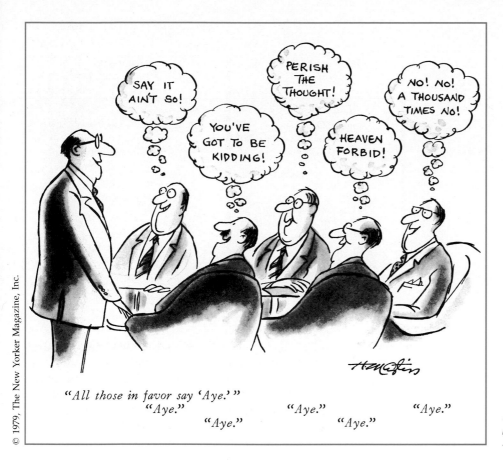

Self-censorship contributes to an illusion of unanimity.

ture of a fantastical dream world which no longer bore any relationship to the grim outside world. In those mirrors I could see nothing but my own face reproduced many times over. No external factors disturbed the uniformity of hundreds of unchanging faces, all mine. (p. 379)

■ **Mindguards:** Some members protect the group from information that would dispute the effectiveness or morality of its decisions. Before the Bay of Pigs invasion, Robert Kennedy took Schlesinger aside and told him, "Don't push it any further." Secretary of State Dean Rusk withheld diplomatic and intelligence experts' warnings against the invasion. They thus served as the President's "mindguards," protecting him from disagreeable facts rather than physical harm.

GROUPTHINK IN ACTION

Groupthink symptoms cause several problems in making decisions, which involve a failure to seek and discuss contrary information and alternative possibilities (Figure 9-10). When a leader promotes an idea and when a group insulates itself from dissenting views, beware of groupthink (McCauley, 1989).

This failure was tragically evident in the decision process by which NASA decided to launch the space shuttle *Challenger* on its fateful mission in January 1986 (Esser & Lindoerfer, 1989). Engineers at Morton Thiokol, which makes the

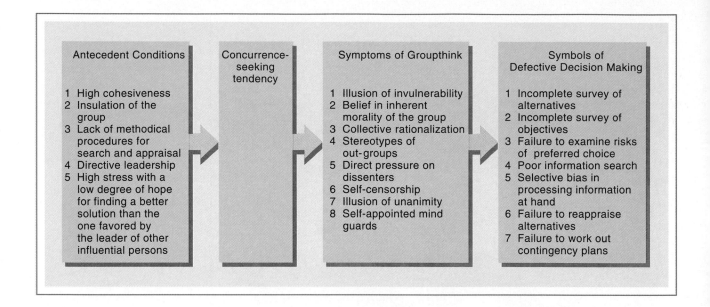

Antecedent Conditions	Concurrence-seeking tendency	Symptoms of Groupthink	Symbols of Defective Decision Making
1 High cohesiveness 2 Insulation of the group 3 Lack of methodical procedures for search and appraisal 4 Directive leadership 5 High stress with a low degree of hope for finding a better solution than the one favored by the leader of other influential persons		1 Illusion of invulnerability 2 Belief in inherent morality of the group 3 Collective rationalization 4 Stereotypes of out-groups 5 Direct pressure on dissenters 6 Self-censorship 7 Illusion of unanimity 8 Self-appointed mind guards	1 Incomplete survey of alternatives 2 Incomplete survey of objectives 3 Failure to examine risks of preferred choice 4 Poor information search 5 Selective bias in processing information at hand 6 Failure to reappraise alternatives 7 Failure to work out contingency plans

FIGURE 9-10 *Theoretical analysis of groupthink.* (Data from Janis & Mann, 1977, p. 132.)

shuttle's rocket boosters, and at Rockwell International, which manufactures the orbiter, opposed the launch because of dangers posed to equipment by the subfreezing temperatures. The Thiokol engineers feared the cold would make the rubber seals between the rocket's four segments too brittle to contain the superhot gases. Several months before the doomed mission, the company's top expert had warned in a memo that it was a "jump ball" whether the seal would hold and that if it failed, "the result would be a catastrophe of the highest order" (Magnuson, 1986).

In a telephone discussion the night before the launch, the engineers argued their case with their uncertain managers and with NASA officials, who were eager to proceed with the already delayed launch. One Thiokol official later testified: "We got ourselves into the thought process that we were trying to find some way to prove to them [the booster] wouldn't work. We couldn't prove absolutely that it wouldn't work." The result was an *illusion of invulnerability.*

Conformity pressures also operated. One NASA official complained, "My God, Thiokol, when do you want me to launch, next April?" The top Thiokol executive declared, "We have to make a management decision," and then asked his engineering vice president to "take off his engineering hat and put on his management hat."

To create an *illusion of unanimity,* this executive then proceeded to poll only the management officials and ignore the engineers. The go-ahead decision now made, one of the engineers belatedly pleaded with a NASA official to reconsider: "If anything happened to this launch," he said prophetically, "I sure wouldn't want to be the person that had to stand in front of a board of inquiry to explain why I launched."

Thanks, finally, to *mindguarding,* the top NASA executive who made the final decision never learned about the engineers' concerns, nor about the reservations of the Rockwell officials. Protected from disagreeable information, he confidently gave the go-ahead to launch the *Challenger* on its tragic flight.

"There was a serious flaw in the decision-making process." Report of the Presidential Commission on the Space Shuttle *Challenger* Accident, 1986

PREVENTING GROUPTHINK

Does this bleak analysis imply that group decision making is inherently defective? To pose the question with contradictory proverbs, do too many cooks always spoil the broth? Or are two or more heads sometimes better than one?

Janis also analyzed two highly successful group decisions: the Truman administration's formulation of the Marshall Plan for getting Europe back on its feet after World War II and the Kennedy administration's handling of the U.S.S.R.'s attempts to install missile bases in Cuba in 1962. Janis's recommendations for preventing groupthink (see "Focus: 10 Prescriptions for Leadership") incorporate many of the effective group procedures used by both the Marshall Plan and the missile-crisis groups.

Experiments confirm that under some conditions two heads *are* better than one. Patrick Laughlin and his colleagues (1980, 1991) have shown this with various intellective tasks. Consider one of their analogy problems:

Assertion is to *disproved* as *action* is to

a. *hindered*

b. *opposed*

c. *illegal*

d. *precipitate*

e. *thwarted*

Most college students miss this question when answering alone, but answer correctly after discussion. (See the marginal note on p. 334 for the answer.) Moreover, Laughlin finds that if but two members of a six-person group are

■ FOCUS: 10 Prescriptions for Leadership that Prevents Groupthink

1. Tell group members about groupthink, its causes and consequences.

2. Be impartial; do not endorse any position.

3. Ask everyone to evaluate critically; encourage objections and doubts.

4. Assign one or more members the role of "devil's advocate."

5. From time to time subdivide the group. Have the subgroups meet separately, and then come together to air differences.

6. When the issue concerns relations with a rival group, take time to survey all warning signals and identify various possible actions by the rival.

7. After reaching a preliminary decision, call a "second-chance" meeting, asking each member to express remaining doubts.

8. Invite outside experts to attend meetings on a staggered basis; ask them to challenge the group's views.

9. Encourage group members to air the group's deliberations with trusted associates and report their reactions.

10. Have independent groups work simultaneously on the same question.

Adapted from "Counteracting the Adverse Effects of Concurrence-Seeking in Policy-Planning Groups: Theory and Research Perspectives," by I. L. Janis. In H. Brandstätter & others (Eds.), *Group Decision Making*. New York: Academic Press, 1982, pp. 477–501.

initially correct, two-thirds of the time they convince all the others. If but one person is correct, this "minority of one" almost three-fourths of the time fails to convince the group. Dell Warnick and Glenn Sanders (1980) and Verlin Hinsz (1990) confirmed that several heads can be better than one when they studied the accuracy of eyewitnesses' reports of a videotaped crime or job interview. Groups of eyewitnesses gave accounts that were much more accurate than those provided by the average isolated individual. Several heads critiquing each other can also constrain some forms of cognitive bias (Wright & others, 1990).

But contrary to the popular idea that brainstorming in small groups generates more creative ideas than do the same people working alone, researchers agree it isn't so (Diehl & Stroebe, 1991; Mullen & others, 1991; Paulus & others, 1992). People *feel* more productive when generating ideas in groups (partly because people disproportionately credit themselves for the ideas that come out). But time and again researchers have found that people working alone will generate *more* good ideas than will the same people in a group.

GROUPTHINK ILLUSTRATES GROUP INFLUENCE PRINCIPLES

The answer to the question on page 333 is thwarted.

The symptoms of groupthink illustrate self-justification, self-serving bias, and conformity. Ivan Steiner (1982) believes the hypothesized groupthink processes also coincide with previous research on group influence. For example, researchers have noted that problem-solving groups have a strong tendency to converge on a single solution. Convergence (which Janis calls "concurrence seeking") appears in the group polarization experiments: A group's average position may polarize, but its members also converge. Groups "strain toward uniformity" (Nemeth & Staw, 1989).

Experiments on group problem-solving document self-censorship and biased discussion. Once a margin of support for one alternative develops, better ideas have little chance of acceptance. Likewise, reports Steiner, accounts of

■ BEHIND THE SCENES

The idea of *groupthink* hit me while reading Arthur Schlesinger's account of how the Kennedy administration decided to invade the Bay of Pigs. At first, I was puzzled: How could bright, shrewd people like John F. Kennedy and his advisers be taken in by the CIA's stupid, patchwork plan? I began to wonder whether some kind of psychological contagion had interfered, such as social conformity or the concurrence-seeking that I had observed in cohesive small groups. Further study (initially aided by my daughter Charlotte's work on a high school term paper) convinced me that subtle group processes had hampered their carefully appraising the risks and debating the issues. When I then analyzed other U.S. foreign policy fiascos and the Watergate coverup, I found the same detrimental group processes at work.

IRVING JANIS (1918–1990)

mob lynchings reveal that once a lynching was suggested, misgivings, if not immediately expressed, got drowned out. In group polarization experiments, arguments that surface in group discussion are more one-sided than those volunteered by individuals privately. This one-sidedness helps group discussion accentuate natural tendencies toward overconfidence (page 49) (Dunning & Ross, 1988).

Steiner believes cohesiveness by itself does not breed groupthink. Highly cohesive groups (say, a secure married couple) provide their members with freedom to disagree. Steiner argues that the prime determinant of groupthink is instead *desire for cohesion*. Group members are likely to suppress disagreeable thoughts when striving to build or maintain good group feeling or when looking to the group for acceptance and approval.

■ MINORITY INFLUENCE

Each chapter in this social influence unit concludes with a reminder of our power as individuals. We have seen that while cultural situations mold us, we also help create and choose these situations; that while pressures to conform sometimes overwhelm our better judgment, blatant pressure can motivate us to assert our individuality and freedom; and that while persuasive forces are indeed powerful, we can resist persuasion by making public commitments and by anticipating persuasive appeals. This chapter has emphasized group influences on the individual. We conclude it with a look at how individuals can influence their groups.

At the beginning of most social movements, a small minority will sometimes sway, and then even become, the majority. "All history," wrote Ralph Waldo Emerson, "is a record of the power of minorities, and of minorities of one." Think of Copernicus and Galileo, of Martin Luther, of the suffragettes. Technological history is also made by innovative minorities. As Robert Fulton developed his steamboat—"Fulton's Folly"—he endured constant derision: "Never did a single encouraging remark, a bright hope, a warm wish, cross my path" (Cantril & Bumstead, 1960).

What makes a minority persuasive? What might Arthur Schlesinger have done to get the Kennedy group to consider his misgivings about the Bay of Pigs invasion? Experiments by Serge Moscovici in Paris have identified several determinants of minority influence: consistency, self-confidence, defection.

CONSISTENCY

More influential than a minority that wavers is a minority that unswervingly sticks to its position. Moscovici and his associates (1969, 1985) have found that if a minority consistently judges blue slides as green, members of the majority will occasionally agree. But if the minority wavers, saying "blue" to one-third of the blue slides and "green" to the rest, virtually no one in the majority will ever agree with "green."

Still debated is the nature of this influence (Clark & Maass, 1990; Levine & Russo, 1987). Moscovici believes that a minority's following the majority usually reflects mere public compliance, but a majority's following a minority

"If the single man plant himself indomitably on his instincts, and there abide, the huge world will come round to him."
Ralph Waldo Emerson, *Nature, Address, and Lectures: The American Scholar,* 1849

Consistency, vision, self-confidence, optimism, and the ability to communicate with others define charismatic leaders, such as Boris Yeltsin, who in 1991 successfully ignited the Russian people's defiance of a coup attempt by old-line Communist leaders.

usually reflects genuine acceptance—really recalling the blue slide as greenish. A minority influences us by making us think more deeply; a majority can also influence by intimidating us or by giving us a rule of thumb for deciding truth ("All those smart cookies can't be wrong") (Burnstein & Kitayama, 1989; Mackie, 1987). Minority influence is therefore more likely to take the thought-filled central route to persuasion (Chapter 8).

Experiments show—and experience confirms—that nonconformity, especially persistent nonconformity, is often painful (Levine, 1989). If you set out to be Emerson's minority of one, prepare yourself for ridicule—especially when you argue an issue that's personally relevant to the majority and when the group is wanting to settle an issue (Kruglanski & Webster, 1991; Trost & others, 1992). People may attribute your dissent to psychological peculiarities, such as your presumed dogmatism (Papastamou & Mugny, 1990). When Charlan Nemeth (1979) planted a minority of two within a simulated jury and had them oppose the majority's opinions, the duo was inevitably disliked. Nevertheless, the majority acknowledged that the persistence of the two did more than anything else to make them rethink their positions. In so doing, a minority may stimulate creative thinking on problem-solving tasks (Mucchi-Faina & others, 1991; Nemeth, 1992). With dissent from within one's own group, people take in more information, think about it in new ways, and often make better decisions. Believing that one need not win friends to influence people, Nemeth quotes Oscar Wilde: "We dislike arguments of any kind; they are always vulgar, and often convincing."

SELF-CONFIDENCE

Consistency and persistence convey self-confidence. Furthermore, Nemeth and Joel Wachtler (1974) reported that any behavior by a minority that conveys self-confidence—for example, taking the head seat at the table—tends to raise self-doubts among the majority. By being firm and forceful, the minority's apparent self-assurance may prompt the majority to reconsider its position.

DEFECTIONS FROM THE MAJORITY

A persistent minority punctures any illusion of unanimity. When a minority consistently doubts the majority wisdom, members of the majority who might otherwise have self-censored their own doubts feel freer to express them and may even switch to the minority position. In research with University of Pittsburgh students, John Levine (1989) found that a minority person who had defected from the majority was more persuasive than a consistent minority voice. In her jury-simulation experiments, Nemeth found that once defections begin, others often soon follow, initiating a snowball effect. As President Carter slipped in the polls in the months preceding the 1980 election, some of his former supporters began to yearn for another alternative and called for an "open" Democratic National Convention. Speculating from the experiments, we might surmise that observing these defections aroused doubts among the President's remaining supporters.

Are these factors that strengthen minority influence unique to minorities? Sharon Wolf and Bibb Latané (1985; Wolf, 1987) believe not. They argue that the same social forces work for both majorities and minorities. If consistency, self-confidence, and defections from the other side strengthen the minority, such variables strengthen a majority also. The social impact of any position— whether held by a majority or a minority—depends on the strength, immedi-

■ BEHIND THE SCENES

As a female raised Roman Catholic in the 1940s and 1950s, I was acutely aware of my minority status, and the expectations people had of me, as I struggled to achieve in both athletic and intellectual endeavors. However, this also made me aware of the contributions one can make by viewing things as an outsider. This perspective, heightened by my exposure to the conflict and violence of the late 1960s in Chicago, made me eager to understand the influence processes that enable social control and social change. I focused on the ways in which minorities exercised influence, but my ultimate concern is how social influence can improve social conditions by enlightening and educating us.

My heroes always stood up and told the truth as they saw it. Often they were vilified, though history would come to treat them more kindly. In 1968 at the University of Chicago, I saw colleagues tell the truth as they saw it and end up bloodied. In the midst of this conflict over ideas and values, I experienced one of the most intellectually and morally invigorating periods of my life. The next year, while a visiting professor in England and France, I had the good fortune of working with Henri Tajfel and Serge Moscovici. The three of us were "outsiders"—I an American Roman Catholic female in Europe, they having survived World War II as Eastern European Jews. Sensitivity to the value and the struggles of the minority perspective came to dominate our work. While studying jury deliberations, I discovered that, even when wrong, minority views can stimulate productive thinking. This helped me see why Senator William Fulbright was wise to say that we should "welcome and not fear the voices of dissent."

CHARLAN JEANNE NEMETH, *University of California, Berkeley*

acy, and number of those who support it. Minorities have less influence than majorities simply because they are smaller.

However, Anne Maass and Russell Clark (1984, 1986) agree with Moscovici that minorities are more likely to convert people to *accepting* their views. Nemeth (1986) also believes that the stress of being in the minority differs from the more relaxed reflection of the majority. And from their analyses of how groups evolve over time, John Levine and Richard Moreland (1985) conclude that new recruits to a group exert a different type of minority influence than do longtime members. Newcomers exert influence through the attention they receive and the group awareness they trigger in the old-timers. Established members feel freer to dissent and to exert leadership.

There is a delightful irony in this new emphasis on how individuals can influence the group. Until recently, the idea that the minority could sway the majority was itself a minority view in social psychology. Nevertheless, by arguing consistently and forcefully, Moscovici, Nemeth, and others have convinced the majority of group influence researchers that minority influence is a phenomenon worthy of study.

IS LEADERSHIP MINORITY INFLUENCE?

Leadership:
The process by which certain group members motivate and guide the group.

One example of the power of individuals is **leadership,** the process by which certain individuals mobilize and guide groups. Some leaders are formally appointed or elected; others emerge informally as the group interacts. What makes for good leadership often depends on the situation—the best person to lead the engineering team may not make the best leader of the sales force. Some people excel at *task leadership*—at organizing work, setting standards, and focusing on goal attainment. Others excel at *social leadership*—at building teamwork, mediating conflicts, and being supportive.

Task leaders often have a directive style—one that can work well if the leader is bright enough to give good orders (Fiedler, 1987). Being goal-oriented, such leaders also keep the group's attention and effort focused on its mission. Experiments show that the combination of specific, challenging goals and periodic progress reports helps motivate high achievement (Locke & Latham, 1990).

Women more often than men have a democratic leadership style (Eagly & Johnson, 1990).

Social leaders often have a democratic style—one that delegates authority and welcomes input from team members. Many experiments reveal that such leadership is good for morale. Group members usually feel more satisfied when they participate in making decisions (Spector, 1986; Vanderslice & others, 1987). Given control over their tasks, workers also become more motivated to achieve (Burger, 1987). People who value good group feeling and take pride in achievement therefore thrive under democratic leadership.

Democratic leadership can be seen in the move by many businesses toward "participative management," a management style common in Sweden and Japan (Naylor, 1990; Sundstrom & others, 1990). Ironically, a major influence on this "Japanese-style" management was M.I.T. social psychologist Kurt Lewin. In laboratory and factory experiments, Lewin and his students demonstrated the benefits of inviting workers to participate in decision making. Shortly before World War II, Lewin visited Japan and explained his findings to industrial and academic leaders (Nisbett & Ross, 1991). In due time, his influence circled back to North America.

When they are able to participate in decision making, workers usually feel more satisfied and motivated.

The once-popular "great person" theory of leadership—that all great leaders share certain traits—has fallen into disrepute. Effective leadership styles, we now know, vary with the situations. Recently, however, social psychologists have again wondered if there might be qualities that mark a good leader in many situations (Mumford, 1986). British social psychologists Peter Smith and Monir Tayeb (1989) report that studies done in India, Taiwan, and Iran have found that the most effective supervisors in coal mines, banks, and government offices score high on tests of *both* task and social leadership. They are actively concerned for how work is progressing *and* sensitive to the needs of their subordinates.

Studies also reveal that many effective leaders of laboratory groups, work teams, and large corporations exhibit behaviors that promote minority influence. They engender trust by consistently sticking to their goals. And they often exude a self-confident charisma that kindles the allegiance of their followers (Bennis, 1984; House & Singh, 1987). Charismatic leaders typically have a compelling *vision* of some desired state of affairs, an ability to *communicate* this to others in clear and simple language, and enough optimism and faith in their group to *inspire* others to follow.

To be sure, groups also influence their leaders. Sometimes those at the front of the herd have simply sensed where it is already heading. Political candidates know how to read the opinion polls. A leader who deviates too radically from the group's standards may be rejected. Smart leaders usually remain with the majority and spend their influence prudently. Nevertheless, effective individual leaders can sometimes exhibit a type of minority influence by mobilizing and guiding their group's energies.

■ SUMMING UP

We spend much of our lives in groups—with family members, friends, fellow believers, and coworkers. What influences do such groups have upon their individual members? This chapter examined six phenomena of group influence.

SOCIAL FACILITATION

Social psychology's most elementary issue concerns the mere presence of others. Some early experiments on this question found that performance improved with observers or coactors present. Others found that the presence of others can hurt one's performance. Robert Zajonc reconciled these findings by applying a well-known principle from experimental psychology: Arousal facilitates dominant responses. Because the presence of others is arousing, the presence of observers or coactors boosts performance on easy tasks (for which the correct response is dominant) and hinders performance on difficult tasks (for which incorrect responses are dominant).

But why are we aroused by others' presence? Experiments suggest that the arousal stems partly from "evaluation apprehension" and partly from a conflict between paying attention to others and concentrating on the task. Other experiments, including some with animals, suggest that the presence of others can be somewhat arousing even when we are not evaluated or distracted.

SOCIAL LOAFING

Social-facilitation researchers study people's performance on tasks where they can be individually evaluated. However, in many work situations people pool their efforts and work toward a common goal without individual accountability. Studies show that group members often work less hard when performing such "additive tasks." This finding parallels everyday situations with diffused responsibility, tempting individual group members to free-ride on the group's effort.

DEINDIVIDUATION

When high levels of social arousal combine with diffused responsibility, people may abandon their normal restraints and lose their sense of individuality. Such "deindividuation" is especially likely when, after being aroused and distracted, people feel anonymity while in a large group or wearing indistinct garb. The result is diminished self-awareness and self-restraint and increased responsiveness to the immediate situation, be it negative or positive.

GROUP POLARIZATION

Potentially positive and negative results also arise from group discussion. While trying to understand the curious finding that group discussion enhanced risk taking, investigators discovered that discussion actually tends to strengthen whatever is the initially dominant point of view, whether risky or cautious, whether for or against a position on some attitudinal issue. In everyday situations, too, group interaction tends to intensify opinions.

The group polarization phenomenon provided a window through which researchers could observe group influence. Experiments confirmed two group influences: informational and normative. The information gleaned from a discussion mostly favors the initially preferred alternative, thus reinforcing people's support for it. Moreover, people may go farther out on the limb when, after comparing their positions, they discover surprising support for their initial inclinations.

GROUPTHINK

Analysis of the decisions that led to several international fiascos indicates that a group's desire for harmony can override its realistic appraisal of contrary views. This is especially true when group members strongly desire unity, when they are isolated from opposing ideas, and when the leader signals what he or she wants from the group. Symptomatic of this overriding concern for harmony, labeled "groupthink," are (1) an illusion of invulnerability, (2) rationalization, (3) unquestioned belief in the group's morality, (4) stereotyped views of the opposition, (5) pressure to conform, (6) self-censorship of misgivings, (7) an illusion of unanimity, and (8) "mindguards" who protect the group from unpleasant information.

However, both in experiments and in actual history, groups sometimes decide wisely. The circumstances for such suggest remedies for groupthink. By seeking information from all sides and improving its evaluation of possible alternatives, a group can benefit from its members' combined insights.

MINORITY INFLUENCE

We looked finally at how individuals can influence their groups. If minority viewpoints were always impotent, history would be static. In experiments, a minority is most influential when consistent and persistent in its views, when its actions convey self-confidence, and when it begins to elicit some defections from the majority. Even if such factors do not persuade the majority to adopt the minority's views, they will likely increase the majority's self-doubts and prompt it to consider other alternatives, often leading to better, more creative decisions.

Through their task and social leadership, formal and informal group leaders exert disproportionate influence. Those who consistently press toward their goals and exude a self-confident charisma often engender trust and inspire others to follow.

■ FOR FURTHER READING

Janis, I. L. (1982). *Groupthink: Psychological studies of policy decisions and fiascos.* Boston: Houghton Mifflin. An informative and captivating analysis of the group decision processes that led to several historical fiascoes, from the failure to anticipate the Pearl Harbor attack to the Watergate cover-up.

Janis, I. L. (1989). *Crucial decisions: Leadership in policy making and crisis management.* New York: Free Press. Janis draws upon social-psychological research and his close study of policymakers' mistakes in formulating guidelines for better executive and managerial decisions. Includes a profile of 20 effective leadership practices.

Paulus, P. B. (Ed.). (1989). *The psychology of group influence* (2d ed.). Hillsdale, NJ: Erlbaum. Experts provide state-of-the-art reviews of recent research on group influence. Includes further information on many of the topics discussed in this chapter.

SOCIAL PSYCHOLOGY IN COURT

The media loved it. William Kennedy Smith had been drinking with his uncle, Senator Ted Kennedy, when he met a woman and took her during the middle of the night to the grounds of his family estate in Palm Beach, Florida. There, on the lawn, he had intercourse with her. Was this consenting sex, as Smith insisted? Or was it rape, as the woman alleged and the prosecutor concurred?

The December, 1991, trial raised issues of interest to social psychologists:

■ Apart from Kennedy and the woman, there were no eyewitnesses to the alleged crime. How important and effective is eyewitness testimony in persuading jurors? How accurate and trustworthy are eyewitness recollections?

■ Smith was a handsome medical student and a member of a wealthy, famous family. Do personal characteristics, such as a defendant's attractiveness and status, influence jurors' judgments?

■ During the trial, the prosecutor asked Smith several questions, such as "Are you some kind of sex machine?," which the judge disallowed. Will jurors ignore suggestive questions and follow the judge's instructions to ignore inadmissible evidence?

■ The jury was composed of four women and two men, all of whom were White and married, and three of whom—like the Kennedy/Smith clan— were Roman Catholic. Do jurors' characteristics bias their verdicts? Can trial lawyers use the jury selection process to stack a jury in their favor?

■ The six-member jury deliberated 77 minutes before concurring on acquittal. During deliberations, how do jurors influence one another? Does a minority often sway the majority? Do six-member juries reach the same verdicts as twelve-member juries? Do juries deliberate differently when they aren't required to reach unanimity?

Such questions fascinate lawyers, judges, and defendants. And they are questions to which social psychology can suggest answers, as some 100 American law schools have recognized by hiring one or more professors of "law and social science" (Melton & others, 1987).

We can think of a courtroom as a miniature social world, one that magnifies everyday social processes with major consequences for those involved. Here, as elsewhere, people think about and influence one another. There is, then, a long list of topics pertinent to both social psychology and law. For example:

■ How do a culture's norms influence its legal decisions? How, say, do cultural ideas about women's and men's roles in child rearing influence whether judges in divorce cases award child custody to the mother or father?

■ What legal procedures strike people as fair? How important are perceptions of the judge's or mediator's neutrality and honesty? (Quite important, reports Tom Tyler, 1988, 1989.) Most English-speaking countries have an adversarial justice system that asks attorneys not to seek truth but to "zealously" represent their side. Most other countries have a nonadversarial system in which the court takes a more active role. Which procedure— adversarial or nonadversarial—do people in English-speaking and non-English-speaking countries regard as fairer? (In both North America and Europe, most people regard the adversarial system as fairer, report Allan Lind & others, 1976, 1978).

■ In cases of civil liability, why do clients and their attorneys spend such enormous sums on legal fees before reaching settlements? Is it partly be-

cause cognitive bias leads defendants to overestimate their own case and therefore to reject reasonable settlement offers? (Jeffrey Rachlinski's 1990 analysis of civil cases reveals the answer is yes.)

In criminal cases, psychological factors may influence decisions involving arrest, interrogation, prosecution, plea bargaining, sentencing, and parole. Of criminal cases disposed of in U.S. district courts, 4 in 5 never come to trial (U.S. Department of Justice, 1980). Much of the trial lawyer's work therefore "is not persuasion in the courtroom but bargaining in the conference room" (Saks & Hastie, 1978, pp. 119–120). Even in the conference room, decisions are made based on speculation about what a jury or judge might do.

So, whether a case reaches a jury verdict or not, the social dynamics of the courtroom matter. Let's therefore consider two sets of factors that have been heavily researched: (1) features of the courtroom drama that can influence jurors' judgments of a defendant and (2) characteristics of both the jurors and their deliberations.

■ JUDGING THE EVIDENCE

As the courtroom drama unfolds, jurors hear testimony, form impressions of the defendant, listen to instructions from the judge, and render a verdict. Let's take these steps one at a time. Research on jurors' reactions explores two questions: First, when and how much do biases erode fair judgments? Second, what reforms could reduce bias?

EYEWITNESS TESTIMONY

How Persuasive Is Eyewitness Testimony?

In Chapter 2 we noted that anecdotes and personal testimonies, being vivid and concrete, can be powerfully persuasive, often more so than information that is logically compelling but abstract. There's no better way to end an argument than to say, "I saw it with my own eyes!" Seeing is believing.

At the University of Washington, Elizabeth Loftus (1974, 1979) found that those who had "seen" were indeed believed, even when their testimony was shown to be useless. When students were presented with a hypothetical robbery-murder case with circumstantial evidence but no eyewitness testimony, only 18 percent voted for conviction. Other students received the same information but with the addition of a single eyewitness. Now, knowing that someone had declared, "That's the one!" 72 percent voted for conviction. For a third group, the defense attorney discredited this testimony (the witness had 20/400 vision and was not wearing glasses). Did this discrediting reduce the effect of the testimony? Hardly—68 percent still voted for conviction.

Follow-up experiments found that, although discrediting reduces the number of guilty votes, a discredited eyewitness is more convincing than no eyewitness at all (Whitley, 1987). Unless contradicted by another eyewitness (Leippe, 1985), a vivid eyewitness account is difficult to erase from jurors' minds. That helps explain why, compared to criminal cases lacking eyewitness testimony, those that have eyewitness testimony are more likely to produce convictions (Visher, 1987).

Ah, but can't jurors spot erroneous testimony? To find out, Gary Wells, R. C. L. Lindsay, and their colleagues staged hundreds of eyewitnessed thefts of a University of Alberta calculator. Afterward, they asked each eyewitness to identify the culprit from a photo lineup. Other people, acting as jurors, observed the eyewitnesses being questioned and then evaluated their testimony. Are incorrect eyewitnesses believed less often than those who are accurate? As it happened, both correct and incorrect eyewitnesses were believed 80 percent of the time (Wells & others, 1979). This led the researchers to speculate "that human observers have absolutely no ability to discern eyewitnesses who have mistakenly identified an innocent person" (Wells & others, 1980).

In a follow-up experiment, Lindsay, Wells, and Carolyn Rumpel (1981) staged the theft under conditions that sometimes allowed witnesses a good, long look at the thief and sometimes didn't. The jurors believed the witnesses more when conditions were good. But even when conditions were so poor that two-thirds of the witnesses had actually misidentified an innocent person, 62 percent of the jurors still usually believed the witnesses.

In yet another experiment, Wells and Michael Leippe (1981) found that jurors were more skeptical of eyewitnesses whose memory for trivial details had been tested in cross-examination. However, the cross-examination did most to discredit the *accurate* witnesses, whose memories of trivial details actually were poorer. Jurors are impressed by recall of such details (Bell & Loftus, 1988, 1989). They think a witness who can remember that there were three pictures hanging in the room must have "really been paying attention." Actually, as other researchers have also found (Cutler & others, 1987), those who pay attention to details are *less* likely to pay attention to the culprit's face.

How Accurate Are Eyewitnesses?

Is eyewitness testimony, in fact, often inaccurate? Stories abound of innocent people who have wasted years in prison because of the testimony of eyewit-

Eyewitness recall of detail is sometimes impressive. When John Yuille and Judith Cutshall (1986) studied accounts of a midafternoon murder on a busy Burnaby, British Columbia, street, they found that eyewitnesses' recall for detail was 80 percent accurate.

"As it turned out, my battery of lawyers was no match for their battery of eyewitnesses."

© 1984, The New Yorker Magazine, Inc.

■ BEHIND THE SCENES

When I first began to conduct eyewitness identification experiments I was shocked at the high rate of false identifications. Surely, I thought, actual testimony from mistaken eyewitnesses would be less confident and persuasive than testimony from accurate eyewitnesses. In fact, however, subsequent studies revealed that eyewitnesses who made false identifications of an innocent person were just as certain about their accuracy and just as likely to be believed by people who observed their testimony as were the eyewitnesses who had accurately identified the culprit. After several replications of this finding, my excitement grew because it became clear that a centuries-old assumption of the criminal justice system was unsupported by empirical data. One fascinating aspect of social psychology is that innumerable other assumptions of the justice system still remain untested. Social psychologists are in a strong position to test these assumptions.

GARY L. WELLS, *Iowa State University*

nesses who were sincere, but sincerely wrong (Brandon & Davies, 1973). In the United States alone, eyewitnesses accuse some 75,000 people a year of crimes (Goldstein & others, 1989). So even dozens of such cases would not prove that eyewitness accounts are unreliable. To assess the accuracy of eyewitness recollections (or psychics' predictions), we need to learn their overall rates of "hits" and "misses." One way to gather such information is to stage crimes comparable to those in everyday life and then solicit eyewitness reports.

This has now been done many times, sometimes with disconcerting results. For example, at the California State University, Hayward, 141 students witnessed an "assault" on a professor. Seven weeks later, when Robert Buckhout (1974) asked them to identify the assailant from a group of six photographs, 60 percent chose an innocent person. It's not surprising that eyewitnesses to actual crimes sometimes disagree about what they saw.

Of course, some witnesses are more confident than others. And Wells and his colleagues report that it's the confident witnesses jurors find most believable. So it is disconcerting that unless conditions are very favorable, as when the culprit is very distinctive-looking, witness certainty relates minimally to accuracy (Bothwell & others, 1987; Brigham, 1990; Wells & Murray, 1984). Incorrect witnesses are virtually as self-assured as correct witnesses. Although two to four eyewitnesses questioned together are somewhat more accurate, they are also more confident, even when wrong (Stephenson & others, 1983, 1986). And when different statements by the same witness are compared, self-assured statements are nearly as likely to be wrong as less confident statements (Smith & others, 1989).

This repeated finding would surely come as a surprise to members of the 1972 U.S. Supreme Court. In a judgment that established the U.S. judiciary system position regarding eyewitness identifications, the Court declared that among the factors to be considered in determining accuracy is "the level of certainty demonstrated by the witness" (Wells & Murray, 1983). We now know that, in fact, mistaken eyewitnesses are no less willing to testify, hardly less confident, and no less persuasive than accurate eyewitnesses.

"Certitude is not the test of certainty."
Oliver Wendell Holmes, *Collected Legal Papers*

Sources of Error: How Memories Are Constructed

Errors sneak into our perceptions and our memories because our minds are not videotape machines. Rather, we construct our memories, based partly on what we perceived at the time and partly on our expectations, beliefs, and current knowledge (Figures 10-1 and 10-2).

Suggestive Questions Elizabeth Loftus and her associates (1978) provided a dramatic demonstration of memory construction. They showed University of Washington students 30 slides depicting successive stages of an automobile-pedestrian accident. One critical slide showed a red Datsun stopped at a stop

FIGURE 10-1 *Sometimes believing is seeing. Cultural expectations affect perceiving, remembering, and reporting. In a 1947 experiment on rumor transmission, Gordon Allport and Leo Postman showed people this picture of a White man holding a razor blade and then had them tell a second person about it, who then told a third person, and so on. After six tellings, the razor blade in the White man's hand usually shifted to the Black man's.*

(From "Eyewitness Testimony" by Robert Buckhout. Copyright © 1974 by Scientific American, Inc. All rights reserved.)

FIGURE 10-2 *Expectations affect perception. Is the drawing on the far right a face or figure?*

(From Fisher, 1968, adapted by Loftus, 1979. Drawing by Anne Canevari Green.)

FIGURE 10-3 *When shown one of these two pictures and then asked a question suggesting the sign from the other photo, most people later "remembered" seeing the sign they had never actually seen.*
(From Loftus, Miller, & Burns, 1978. Photos courtesy of Elizabeth Loftus.)

sign or a yield sign. Afterward they asked half the students, among other questions, "Did another car pass the red Datsun while it was stopped at the stop sign?" They asked the other half the same question but with the words "stop sign" replaced by "yield sign." Later, when shown both slides in Figure 10-3 and asked which one they had previously seen, those earlier asked the question consistent with what they had seen were 75 percent correct. Those previously asked the misleading question were only 41 percent correct; more often than not, they denied seeing what they had actually seen and instead "remembered" the picture they had never seen!

In other experiments, Loftus (1979) found that after suggestive questions witnesses may believe that a red light was actually green or that a robber had a mustache when he didn't. When questioning eyewitnesses, police and attor-

■ FOCUS ON: MISTAKEN IDENTITY

Fifty years ago, Yale law professor Edwin Borchard (1932) documented 65 convictions of people whose innocence was ultimately established beyond a doubt. Most resulted from mistaken identifications of the cul-prit by eyewitnesses. Borchard observed that in several of the cases the convicted prisoner, later proved innocent, was saved from hanging or electrocution by a hairbreadth. Only by rare good fortune were some of the sentences of hanging and electrocution commuted to life imprisonment, so the error could still be corrected. How many wrongfully convicted persons have actually been executed it is impossible to say.

Eyewitness misidentification put Randall Ayers, shown here with his sisters on his first day of freedom in 8 years, behind bars for a rape he didn't commit. The actual culprit—who strikingly resembles Ayers—confessed to the rape when arrested for the murders of two women. Jurors later admitted being bothered by the absence of supporting evidence and by Ayers being an inch shorter than the victim, although the attacker was supposedly an inch or two taller. Nevertheless, the eyewitnesses' repeated and confident identification of Ayers was persuasive.

neys commonly ask questions framed by their own understanding of what happened. So it is troubling to discover how easily witnesses incorporate misleading information into their memories, especially when they believe the questioner is well informed (Smith & Ellsworth, 1987). When the eyewitnesses are children, jurors and attorneys appreciate that recall may reflect suggestion (Leippe & Romanczyk, 1989; Leippe & others, 1988). Although information that children recall on their own is not notably error-prone, they are indeed more susceptible to misleading questions (Ceci & others, 1987).

Retelling Retelling events commits people to their recollections, whether accurate or not. An accurate retelling helps people later resist misleading suggestions (Bregman & McAllister, 1982). At other times, the more we retell a story, the more we convince ourselves of a falsehood. Wells, Ferguson, and Lindsay (1981) demonstrated this by having eyewitnesses to a staged theft rehearse their answers to questions before taking the witness stand. Doing so increased the confidence of those who were wrong, and thus made jurors who heard their false testimony more likely to convict the innocent person.

In Chapter 4 we noted that we often adjust what we say to please our listeners and, having done so, come to believe the altered message. Imagine you witness an argument that erupts into a fight in which one person injures the other. Afterward, the injured party sues the other, and before the trial a smooth lawyer for one of the two parties interviews you. Might you slightly adjust your testimony, giving a version of the fight that supports this lawyer's client? If you did so, might your later recollections in court be similarly slanted?

Blair Sheppard and Neil Vidmar (1980) report that the answer to both questions is yes. At the University of Western Ontario, they had some students serve as witnesses to a fight and others as lawyers and judges. When interviewed by lawyers for the defendant rather than the plaintiff, the witnesses later gave the judge testimony that was more favorable to the defendant. In a follow-up experiment, Vidmar and Nancy Lair (1983) noted that witnesses did not omit important facts from their testimony; they just changed their tone of voice and choice of words depending on whether they thought they were a witness for the defendant or the plaintiff. Even this was enough to bias the impressions of those who heard the testimony. So it's not only suggestive questions that can distort eyewitness recollections, but also their own retellings, which may be subtly adjusted to suit their audience.

Reducing Error

Given these error-prone tendencies, what constructive steps can be taken to increase the accuracy of eyewitnesses and jurors? Experts have several ideas.

Train Police Interviewers

When Ronald Fisher and his co-workers (1987) examined tape-recorded interviews of eyewitnesses conducted by experienced Florida police detectives, they found a typical pattern. Following an open-ended beginning ("Tell me what you recall"), the detectives would occasionally interrupt with follow-up questions before asking a series of questions eliciting terse answers ("How tall was he?"). Fisher and Edward Geiselman say interviews should begin by allowing eyewitnesses to offer their own unprompted recollections.

The recollections will be most complete if the interviewer uses memory-jogging questions, such as by first guiding people to reconstruct the setting. Have them visualize the scene and what they were thinking and feeling at the time. Even showing pictures of the setting—of, say, the store checkout lane with a clerk standing where she was robbed—can promote accurate recall (Cutler & Penrod, 1988). After giving witnesses ample, uninterrupted time to report everything that comes to mind, the interviewer jogs their memory with evocative questions ("Was there anything unusual about the voice? Was there anything unusual about the person's appearance or clothing?"). When Fisher and his colleagues (1989) trained detectives to question in this way, the information they elicited from eyewitnesses increased 50 percent.

However, interviewers must be careful to keep questions free of hidden assumptions. Loftus and Guido Zanni (1975) found that questions such as, "Did you see the broken headlight?" triggered twice as many "memories" of nonexistent events as did questions without the hidden assumption: "Did you see a broken headlight?" Likewise, flooding eyewitnesses' minds with an array of mugshots reduces their accuracy in later identifying the culprit (Brigham & Cairns, 1988).

"While the rules of evidence and other safeguards provide protection in the courtroom, they are absent in the backroom of the precinct station." Ernest Hilgard & Elizabeth Loftus (1979)

Minimize False Lineup Identifications

The case of Ron Shatford illustrates how the composition of a police lineup can promote misidentification (Doob & Kirshenbaum, 1973). After a suburban Toronto department store robbery, the cashier involved could only recall that the culprit was not wearing a tie and was "very neatly dressed and rather good looking." When police put the good-looking Shatford in a lineup with 11 unat-

"*That's* him! *That's* the one! ... I'd recognize that silly little hat *anywhere!*"

Lineup fairness? From the suspect's perspective a lineup is fair, note John Brigham, David Ready, and Stacy Spier (1990), when "the other lineup members are reasonably similar in general appearance to the suspect."

tractive men, all of whom wore ties, the cashier readily identified him as the culprit. Only after he had served 15 months of a long sentence did another person confess, allowing Shatford to be retried and found not guilty. As this case illustrates, many eyewitnesses will identify the lineup member who *most resembles* the culprit.

Gary Wells (1984) reports that one way to reduce such misidentifications is to give eyewitnesses a lineup that contains no suspects and screen out those who make false identifications. The remaining witnesses are less likely to make false identifications at the actual lineup. Mistakes can also be reduced by having witnesses simply make individual yes/no judgments in response to a *sequence* of people (Cutler & Penrod, 1988; Lindsay & Wells, 1985). (If witnesses view a group of photos simultaneously, they are more likely to choose whoever most resembles the culprit.)

Police can also minimize false identifications with instructions acknowledging that the offender may not be in the lineup (Malpass & Devine, 1984). Compared to lineups of several suspects, a lineup composed of one suspect and several people known to be innocent further reduces misidentifications (Wells & Turtle, 1986). Lineups containing innocent people enable police to disregard eyewitnesses who make errors; with all-suspect lineups, there is no opportunity to weed out those who are guessing.

Such procedures make police lineups more like good experiments. They contain a control group (a no-suspect lineup or a lineup in which mock witnesses try to guess the suspect based merely on a general description). They have an experimenter who is blind to the hypotheses (an officer who doesn't know which person is the suspect). And questions are worded so they don't subtly demand a particular response (the procedure doesn't imply the culprit *is* in the lineup). Using these social-psychological insights, Canada's Law Reform Commission has recommended new eyewitness identification procedures to reduce the likelihood of future Ron Shatfords (Wells & Luus, 1990).

Educate Jurors

Do jurors evaluate eyewitness testimony critically? Do they intuitively understand how the circumstances of a lineup determine its reliability? Do they know whether to take an eyewitness's self-confidence into account? Do they realize how memory can be influenced by earlier misleading questions, by stress at the time of the incident, by the interval until being questioned, by whether the suspect is the same or a different race, by whether recall of other details is sharp or hazy? Studies in Canada, Britain, and the United States reveal that jurors discount most of these factors known to influence eyewitness testimony (Cutler & others, 1988; Noon & Hollin, 1987; Wells & Turtle, 1987).

To educate jurors, experts are now frequently asked (usually by defense attorneys) to testify about eyewitness testimony. Their aim is to offer jurors the sort of information you have been reading, to help them critically evaluate the testimony of both prosecution and defense witnesses. They explain that:

- Eyewitnesses often perceive events selectively.
- Discussions about the events can alter or add to their memories.
- Research using staged crimes has shown witnesses often choose a wrong person from a lineup.
- Eyewitnesses are especially prone to error when trying to identify someone of another race (Chapter 11).
- Jurors should disregard the confidence with which an eyewitness offers testimony.

Table 10-1, drawn from a survey of 63 experts on eyewitness testimony, lists the most agreed-upon phenomena.

TABLE 10-1 *Influences upon Eyewitness Testimony*

PHENOMENON	RELIABLE ENOUGH?*
1. *Question wording.* An eyewitness's testimony about an event can be affected by how the questions put to that eyewitness are worded.	97
2. *Lineup instructions.* Police instructions can affect an eyewitness's willingness to make an identification and/or the likelihood that he or she will identify a particular person.	95
3. *Postevent information.* Eyewitness testimony about an event often reflects not only what they actually saw but information they obtained later on.	87
4. *Accuracy versus confidence.* An eyewitness's confidence is not a good predictor of his or her identification accuracy.	87
5. *Attitudes and expectations.* An eyewitness's perception and memory for an event may be affected by his or her attitudes and expectations.	85

*Percentage of eyewitness experts agreeing, ''This phenomenon is reliable enough for psychologists to present it in courtroom testimony.''

From S. M. Kassin, P. C. Ellsworth, & V. L. Smith, 1989.

Experiments (Loftus, 1980; Maass & others, 1985; Wells & others, 1980) show that such information can prompt jurors to analyze eyewitness reports more skeptically and discuss them more fully. Taught the conditions under which eyewitness accounts *are* trustworthy, jurors become more likely to trust such testimony (Cutler & others, 1989; Wells, 1986).

THE DEFENDANT'S CHARACTERISTICS

According to the famed trial lawyer, Clarence Darrow (1933), jurors seldom convict a person they like or acquit one they dislike. Thus, he argued, the main work of the trial lawyer is to make a jury like the defendant. Was he right? Is jurors' liking or disliking the defendant crucial? And is it true, as Darrow also said, that "facts regarding the crime are relatively unimportant"?

Darrow overstated the case. One study of more than 3500 criminal cases and some 4000 civil cases found that 4 times in 5 the judge agreed with the jury's decision (Kalven & Zeisel, 1966). Although both may have been wrong, the evidence usually is clear enough that jurors can set aside their biases, focus on the evidence, and agree on a verdict (Saks & Hastie, 1978; Visher, 1987). Darrow was too cynical: Facts do matter.

Nevertheless, when making arguable social judgments—would this defendant commit such an offense? intentionally?—facts are not all that matter. As we noted in Chapter 8, communicators are more persuasive if they seem credible and attractive. Jurors can't help forming impressions of the defendant's credibility and attractiveness. Can they put these preconceptions aside and decide the case based on the facts alone? To judge from the more lenient treatment often received by high-status defendants (McGillis, 1979), it seems that some cultural bias lingers. But actual cases vary in so many ways—in the type of crime, in the status, age, sex, and race of the defendant—that it's hard to isolate the factors that influence jurors. Experimenters have therefore controlled such factors by giving mock jurors the same basic facts of a case while varying, say, the defendant's attractiveness or similarity to the jurors.

Physical Attractiveness

As we will see in Chapter 13, there is a physical attractiveness stereotype: Beautiful people seem like good people. Michael Efran (1974) wondered whether this stereotype would bias students' judgments of someone accused of cheating. He asked some of his University of Toronto students whether attractiveness should affect presumption of guilt. Their answer: "No, it shouldn't." But did it? Yes. When Efran gave other students a description of the case with a photograph of either an attractive or an unattractive defendant, they judged the most attractive as least guilty and recommended that person for least punishment.

Other experimenters have confirmed that when the evidence is meager or ambiguous, justice is not blind to a defendant's looks (Cash, 1981; Stewart, 1980, 1983). Diane Berry and Leslie Zebrowitz-McArthur (1988) discovered this when they asked people to judge the guilt of baby-faced and mature-faced defendants. Baby-faced adults (people with large, round eyes and small chins) seemed more naive and were found guilty more often of crimes of negligence and less often of intentional criminal acts. If convicted, unattractive people also

And so I ask the jury . . . is that the face of a mass murderer?

Other things being equal, people often judge physically appealing defendants more leniently.

strike people as more dangerous, especially if they are sexual offenders (Esses & Webster, 1988).

To see if these findings extend to the real world, Chris Downs and Phillip Lyons (1991) asked police escorts to rate the physical attractiveness of 1742 defendants appearing before 40 Texas judges in misdemeanor cases. Whether the misdemeanor was serious (such as forgery), moderate (such as harassment), or minor (such as public intoxication), the judges set greater bails and fines for less attractive defendants (Figure 10-4). What explains this dramatic effect? Are unattractive people also lower in status? Are they indeed more likely to flee or to commit crime, as the judges perhaps suppose? Or are judges simply ignoring the Roman statesman Cicero's advice: "The final good and the supreme duty of the wise man is to resist appearance."

Similarity to the Jurors

If Clarence Darrow was even partially right in his declaration that one's liking for a defendant colors one's judgments, then other factors that influence liking should also matter. Among such influences is the principle, noted in Chapter 8, that likeness (similarity) leads to liking. When people pretend they are jurors, they are indeed more sympathetic to a defendant who shares their attitudes, religion, race, or (in cases of sexual assault) gender (Selby & others, 1977; Towson & Zanna, 1983; Ugwuegbu, 1979).

Some examples: When Paul Amato (1979) had Australian students read evidence concerning a left- or right-wing person accused of a politically motivated burglary, they judged the defendant less guilty if his or her political views were similar to their own. When Cookie Stephan and Walter Stephan (1986) had English-speaking people judge someone accused of assault, they were more likely to think the person not guilty if the defendant's testimony was in

Imagine that Rodney King had been White and that the officers who mercilessly clubbed him had been Black. After viewing the beating on video, would the jury (which had no Black members) have acquitted the officers, as they did the actual White officers?

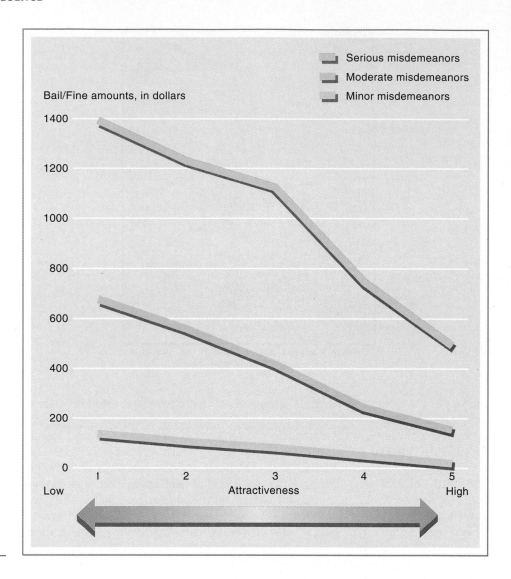

FIGURE 10-4 *Attractiveness and legal judgments. Texas Gulf Coast judges set higher bails and fines for less attractive defendants.*
(Data from Downs & Lyons, 1991).

English, rather than translated from Spanish or Thai. It seems we are more sympathetic toward a defendant with whom we can identify. If we think *we* wouldn't have committed that criminal act, we may assume that someone like us would also have been unlikely to do it.

Ideally, jurors should leave such biases outside the courtroom door and begin a trial with blank minds. So implies the Sixth Amendment to the U.S. Constitution: "The accused shall enjoy the right to a speedy and public trial by impartial jury." In its concern for objectivity, the judicial system is similar to science: Both scientists and judges and jurors are to sift the evidence, free of bias. Both the courts and science have rules about what evidence is relevant. Both keep careful records and assume that others given the same evidence would decide similarly.

When the evidence is clear and jurors focus on it (as when they reread and debate the meaning of testimony), their biases are indeed minimal (Kaplan & Schersching, 1980). The quality of the evidence matters more than the preju-

dices of the jurors. To minimize juror bias in cases where the evidence is ambiguous, Daniel McGillis (1979) suggests warning jurors about sources of bias during orientation sessions.

THE JUDGE'S INSTRUCTIONS

Judges, too, instruct jurors to ignore biasing information. All of us can recall courtroom dramas in which an attorney exclaimed, "Your honor, I object!" whereupon the judge sustained the objection and ordered the jury to ignore the other attorney's suggestive question or the witness's remark. For example, nearly all states in the United States now have "rape shield" statutes that prohibit or limit testimony concerning the victim's prior sexual activity. Such testimony, though irrelevant to the case at hand, tends to make jurors more sympathetic to the accused rapist's claim that the woman consented to sexual relations (Borgida, 1981; Cann & others, 1979).

If such reliable, illegal, or prejudicial testimony is nevertheless slipped in by the defense or blurted out by a witness, will jurors follow a judge's instruction to ignore it? And is it enough for the judge to remind jurors that "the issue is not whether you like or dislike the defendant but whether the defendant committed the offense"?

"Surely not guilty. Next case."

© 1988, The New Yorker Magazine, Inc.

Very possibly not. Several experimenters report that it is hard for jurors to ignore inadmissible evidence, such as the defendant's previous convictions. In one study, Stanley Sue, Ronald Smith, and Cathy Caldwell (1973) gave University of Washington students a description of a grocery store robbery-murder and a summary of the prosecution's case and the defense's case. When the prosecution's case was weak, no one judged the defendant guilty. When a tape recording of an incriminating phone call made by the defendant was added to the weak case, about one-third judged the person guilty. The judge's instructing jurors that the tape was not legal evidence and they should ignore it did nothing to erase the effect of the damaging testimony.

Indeed, Sharon Wolf and David Montgomery (1977) found that a judge's order to ignore testimony—"It must play no role in your consideration of the case. You have no choice but to disregard it"—can even boomerang, adding to the testimony's impact. Perhaps such statements create **reactance** in the jurors. Or perhaps they sensitize jurors to the inadmissible testimony, like what happens when I warn you *not* to look at your nose as you finish this sentence. Judges can more easily strike inadmissible testimony from the court records than from the jurors' minds. As trial lawyers sometimes say, "You can't unring a bell."

Pretrial publicity is also hard for jurors to ignore. Geoffrey Kramer and his colleagues (1990) confirmed this when they exposed nearly 800 mock jurors (most from actual jury rolls) to incriminating news reports about a man accused of robbing a supermarket. Jurors viewed a videotaped reenactment of the trial and then either did or did not hear the judge's instructions to disre-

Reactance:
The desire to assert one's sense of freedom (see p. 253).

Even when pretrial publicity colors people's judgments, they usually deny it—which makes it difficult to screen out potentially biased jurors.

"*The jury will disregard the witness's last remarks.*"

It is not easy for jurors to erase inadmissible testimony from memory.

gard the pretrial publicity. The effect of the judicial admonition was nil. Moreover, people whose opinions are biased by such publicity typically deny its effect on them, and their denial makes it hard to eliminate biased jurors (Moran & Cutler, 1991).

Nevertheless, judges do influence jurors. Judges come to trials with their own opinions, which they subtly communicate to jurors. One analysis of municipal court judges' behavior during videotaped trials revealed that their pretrial opinions of the case influenced their nonverbal behaviors—the tone of their instructions, their head nods, their smiles, their frowns—which in turn related to the jury's later verdict (Blanck & others, 1985).

To minimize the effects of inadmissible testimony, judges can *forewarn* jurors that certain types of evidence, such as a rape victim's sexual history, are irrelevant. Once jurors form impressions based on such evidence, a judge's admonitions have much less effect (Borgida & White, 1980; Kassin & Wrightsman, 1979). Thus, reports Vicki Smith (1991), a pretrial training session pays dividends. Teaching jurors legal procedures and standards of proof improves their understanding of the trial procedure and their willingness to withhold judgment until after they have processed all the trial information.

Better yet, judges could cut inadmissible testimony before the jurors hear it—by videotaping testimonies and removing the inadmissible parts. Live and videotaped testimony have much the same impact, as do live and videotaped lineups (Cutler & others, 1989; Miller & Fontes, 1979). Perhaps, then, courtrooms of the future will have life-size television monitors. Critics object that the procedure prevents jurors from observing how the defendant and others react to the witness. Proponents argue that videotaping not only enables the judge to edit out inadmissible testimony but also speeds up the trial and allows witnesses to talk about crucial events before memories fade.

OTHER ISSUES

We have considered three courtroom factors—eyewitness testimony, the defendant's characteristics, and the judge's instructions. Researchers are also studying the influence of many other factors. For example, at Michigan State University, Norbert Kerr and his colleagues (1978, 1981, 1982) have studied these issues: Does a severe potential punishment (for example, a death penalty) make jurors less willing to convict? Do experienced jurors' judgments differ from those of novice jurors? Are defendants judged more harshly when the *victim* is attractive or has suffered greatly? Kerr's research suggests that the answer to all three questions is yes.

Experiments by Mark Alicke and Teresa Davis (1989) and Michael Enzle and Wendy Hawkins (1992) show that even when the aggressor was unaware of the victim's characteristics, they can affect judgments of blame and punishment. This is especially so when the victim comes to the encounter armed for violence, as in the 1984 case of the "subway vigilante" Bernhard Goetz. On a New York subway four teens asked Goetz for $5. The frightened Goetz pulled out a loaded gun and shot each of them, leaving one partially paralyzed. When Goetz was charged with homicide, there was an outcry of public support for him based partly on the disclosure that the youths had extensive criminal records and that three of them were carrying concealed, sharpened screwdrivers. Although Goetz didn't know any of this, he was acquitted of the homicide charge and convicted only of illegal firearm possession.

When subway vigilante Bernhard Goetz shot four teens who approached him and asked for $5, he was unaware that they had criminal records and were carrying sharpened screwdrivers. But when these facts were made public, there was an outcry of support for Goetz.

■ BEHIND THE SCENES

While I was a new University of Illinois graduate student, my advisor, James Davis, began studying how a group's size affects its decisions. Coincidentally, the Supreme Court had just guessed that jury size wouldn't much matter. So Jim, with my help, decided to experiment with jury size. As I eavesdropped on the mock juries I became fascinated by the jurors' insightful arguments, their mix of amazing recollections and memory fabrications, their prejudices, their attempts to persuade or coerce, and their occasional courage in standing alone. Here brought to life before me were so many of the psychological processes I had been studying! Although our student jurors understood they were only simulating a real trial, they really cared about reaching a fair verdict. Ever since listening in on those first jury deliberations, I've been hooked on studying juror behavior.

NORBERT KERR, *Michigan State University*

■ THE JURY

These courtroom influences upon "the average juror" are worth pondering. But no juror is the average juror; each carries into the courthouse individual attitudes and personalities. And when deliberating, they influence one another. A key question is, How are their verdicts influenced by their individual dispositions and by their working together as a group?

THE JURORS AS INDIVIDUALS

Juror Comprehension

To gain insight into juror comprehension, Nancy Pennington and Reid Hastie (1990, 1992) have sampled the ongoing thoughts of mock jurors, drawn from courthouse jury pools, while viewing reenactments of actual trials. In making their decisions, jurors first construct a story that makes sense of all the evidence. After observing one murder trial, some jurors concluded that a quarrel made the defendant angry, triggering him to get a knife, search for the decedent, and stab him to death. Others surmised that the frightened defendant picked up a knife which he used to defend himself when he later encountered the decedent. When the jurors begin deliberating, it surprises many that others have constructed stories different from their own. This implies—and research confirms—that jurors are persuaded when attorneys present evidence in the order of a narrative story. In felony cases—where the national conviction rate is 80 percent—the prosecution case more often than the defense case follows a story structure.

Next the jurors must grasp the essentials of the judge's instructions concerning the available verdict categories. For a judge's instructions to be effective, jurors must first understand them. Study after study has found that many

people do not understand the standard legalese of judicial instructions. Depending on the type of case, a jury may be told that the standard of proof is a "preponderance of the evidence," "clear and convincing evidence," or "beyond a reasonable doubt." Such statements may have one meaning for the legal community and different meanings in the minds of jurors (Kagehiro, 1990). In one study of Nevada criminal instructions, viewers of videotaped instructions could answer only 15 percent of 89 questions posed to them about what they had heard (Elwork & others, 1982). Jurors may be further confused if the criteria change as a jury moves from the trial phase that determines guilt or innocence into the penalty phase (Luginbuhl, 1992). In North Carolina, for example, jurors are to convict only if there is "proof beyond a reasonable doubt." But a "preponderance of the evidence" is sufficient when judging whether mitigating circumstances, such as an abusive childhood, should preclude a death sentence.

Finally, jurors must compare their explanatory story with the verdict categories. When using the judge's definition of, say, justifiable self-defense, jurors must decide whether "pinned against a wall" matches their understanding of the required circumstance "unable to escape." Often, though, a judge's abstract, jargon-filled definition of verdict categories loses in the competition with the jurors' own images ("mental prototypes") of these crimes. Vicki Smith (1991) reports that, regardless of the judge's definition, if a defendant's actions matches jurors' images of "vandalism," "assault," or "robbery," they likely will find the person guilty.

Jurors also struggle with lawyers' statistical arguments. Imagine that a suspected bank robber's blood matched blood left at the scene. Told that only 1 in 100 people share the actual culprit's blood type, some people will agree with the prosecuting attorney, "There's a 99 percent chance this is the robber." But, replies the defense attorney, in this city of 100,000 people, 100 people have that blood type. "So there's only a 1 in 100 chance the suspect is the robber." Faced with such a clever defense attorney, 3 in 5 people will discount the relevance of the blood-type evidence, report William Thompson and Edward Schumann (1987). Actually, both attorneys are wrong. The evidence *is* relevant, because few of the other 100 people can reasonably be considered suspects. Likewise, the prosecuting attorney's argument ignores the fact that the defendant was charged partly because his blood type matched.

Understanding how jurors misconstrue judicial instructions and statistical information is a first step toward better decisions. The next step is devising and testing clearer, more effective ways to present information—a task on which several social psychologists are currently at work. For example, when a judge quantifies the required standard of proof (as, say, 51, 71, or 91 percent certainty) jurors understand and respond appropriately (Kagehiro, 1990).

Jury Selection

Given the variations among individual jurors, can trial lawyers use the jury selection processes to stack a jury in their favor? Legal folklore suggests sometimes they can. One president of the Association of Trial Lawyers of America boldly proclaimed, "Trial attorneys are acutely attuned to the nuances of human behavior, which enables them to detect the minutest traces of bias or inability to reach an appropriate decision" (Bigam, 1977).

Mindful that people's assessments of others are error-prone (Chapter 5), social psychologists doubt that attorneys come equipped with fine-tuned social Geiger counters. In several celebrated trials, survey researchers therefore used "scientific jury selection" to help attorneys weed out those likely to be unsympathetic. One famous trial involved two of President Nixon's former cabinet members, conservatives John Mitchell and Maurice Stans. A survey revealed that from the defense's viewpoint the worst possible juror was "a liberal, Jewish, Democrat who reads the *New York Times* or the *Post,* listens to Walter Cronkite, is interested in political affairs, and is well-informed about Watergate" (Zeisel & Diamond, 1976). In the first nine trials relying on such methods, the defense won seven (Wrightsman, 1978; Hans & Vidmar, 1981).

Many trial attorneys have now used scientific jury selection to identify questions they can use to exclude people biased against their client. Most report satisfaction with the results (Gayoso & others, 1991). Most jurors, when asked by a judge to "raise your hand if you've read anything about this case that would prejudice you," don't directly acknowledge their preconceptions. It takes further questioning to reveal them. For example, if the judge allows an attorney to check prospective jurors' attitudes toward drugs, the attorney can often guess their verdicts in a drug-trafficking case (Moran & others, 1990). Likewise, people who acknowledge they "don't put much faith in the testimony of psychiatrists" are less likely to accept an insanity defense (Cutler & others, 1991).

Despite the excitement—and ethical concern—about scientific jury selection, experiments reveal that attitudes and personal characteristics don't always predict verdicts. There are "no magic questions to be asked of prospective jurors, not even a guarantee that a particular survey will detect useful attitude-behavior or personality-behavior relationships," caution Steven Penrod and Brian Cutler (1987). Researchers Michael Saks and Reid Hastie (1978)

Using either their intuition or scientific jury selection, can trial lawyers select people likely to favor their client? The evidence matters more; when the evidence is ambiguous, attorneys can sometimes predict a juror's leanings from certain other attitudes the juror has.

agree: "The studies are unanimous in showing that evidence is a substantially more potent determinant of jurors' verdicts than the individual characteristics of jurors" (p. 68). In courtrooms, jurors' public pledge of fairness and the judge's instruction to "be fair" strongly commit most jurors to the norm of fairness.

In experiments, it's when the evidence is made ambiguous that jurors' personalities and general attitudes have an effect. Still, variations in the situation, especially in the evidence, have even more effect. Saks and Hastie believe that "what this implies about human behavior, on juries or off, is that while we are unique individuals, our differences are vastly overshadowed by our similarities. Moreover, the range of situations we are likely to encounter is far more varied than the range of human beings who will encounter them" (p. 69).

"Death-Qualified" Jurors

"The kind of juror who would be unperturbed by the prospect of sending a man to his death . . . is the kind of juror who would too readily ignore the presumption of the defendant's innocence, accept the prosecution's version of the facts, and return a verdict of guilty."
Witherspoon v. Illinois, 1968

A *close* case can, however, be decided by *who* gets selected for the jury. In criminal cases, people who do not oppose the death penalty—and who therefore are eligible to serve when a death sentence is possible—are more prone to favor the prosecution, to feel that courts coddle criminals, and to oppose protecting the constitutional rights of defendants (Bersoff, 1987). Simply put, those who favor the death penalty are more concerned with crime control and less concerned with due process of law. When a court dismisses potential jurors who have moral scruples against the death penalty, it constructs a jury that is more likely to vote guilty. The research record is "unified," reports Phoebe Ellsworth (1985, p. 46): "Defendants in capital-punishment cases do assume the extra handicap of juries predisposed to find them guilty." What is more, conviction-prone jurors tend also to be more authoritarian—more rigid, punitive, closed to mitigating circumstances and contemptuous of those with lower status (Gerbasi & others, 1977; Luginbuhl & Middendorf, 1988; Moran & Comfort, 1982, 1986; Werner & others, 1982).

Because the legal system operates on tradition and precedent, such research findings only slowly alter judicial practice. In 1986, the U.S. Supreme Court in a split decision overturned a lower-court ruling that "death-qualified" jurors are indeed a biased sample. Ellsworth (1989) believes the Court in this case disregarded the compelling and consistent evidence partly because of its "ideological commitment to capital punishment" and partly because of the havoc that would result if the convictions of thousands of people on death row had to be reconsidered.

THE JURY AS A GROUP

Imagine a jury that, having finished a trial, has entered the jury room to begin its deliberations. Researchers Harry Kalven and Hans Zeisel (1966) reported that chances are about 2 in 3 that the jurors will initially *not* agree on a verdict. Yet, after discussion, the odds reach almost 95 percent that they will emerge with a consensus. Obviously, group influence has occurred.

In the United States alone, 300,000 times a year small groups sampled from the 3 million people called for jury duty convene to seek a group decision (Kagehiro, 1990). Are they subject to the social influences that mold other decision groups—to patterns of majority and minority influence, to group polar-

ization, to groupthink? Let's start with a simple question: If we knew the jurors' initial leanings, could we predict their verdict?

The law prohibits observation of actual juries. So researchers simulate the jury process by presenting a case to "mock juries" and having them deliberate like a real jury would. In a series of such studies at the University of Illinois, James Davis, Robert Holt, Norbert Kerr, and Garold Stasser tested various mathematical schemes for predicting group decisions, including decisions by mock juries (Davis & others, 1975, 1977, 1989; Kerr & others, 1976). Will some mathematical combination of people's initial decisions predict their final group decision? Davis and his colleagues found that the scheme which predicts best varies according to the nature of the case. But in several experiments, a "two-thirds-majority" scheme fared best: The group verdict was usually the alternative favored by at least two-thirds of the jurors at the outset. Without such a majority, a hung jury was likely.

Likewise, in Kalven and Zeisel's survey of juries, 9 in 10 reached the verdict favored by the majority on the first ballot. Although you or I might fantasize about someday being the courageous lone juror who sways the majority, the fact is it seldom happens.

Minority Influence

Minority influence:
See pages 335–339.

Seldom, yet sometimes, what was initially a minority prevails. In the Mitchell-Stans trial the four jurors who favored acquittal persisted and eventually prevailed. From the research on minority influence we know that jurors in the minority will be most persuasive when they are consistent, persistent, and self-confident, especially if they can begin to trigger some defections from the majority.

Ironically, the most influential minority juror in the Mitchell-Stans trial, Andrew Choa, was a well-educated *New York Times* reader—someone who did not fit the survey profile of a juror sympathetic to the defense. But Choa was also a dedicated supporter of Richard Nixon and a bank vice president who ingratiated himself with the other jurors through various favors, such as taking them to movies in his bank's private auditorium (Zeisel & Diamond, 1976). Choa also illustrates a common finding from jury experiments: High-status male jurors tend to be most influential (Gerbasi & others, 1977).

Group Polarization

Group polarization:
See pages 321–328.

Jury deliberation shifts people's opinions in other intriguing ways as well. In experiments, deliberation often magnifies initial sentiments. For example, Robert Bray and Audrey Noble (1978) had University of Kentucky students listen to a 30-minute tape of a murder trial. Then, assuming the defendant was found guilty, they recommended a prison sentence. Groups of high authoritarians initially recommended strong punishments (56 years) and after deliberation were even more punitive (68 years). The low-authoritarian groups were initially more lenient (38 years) and after deliberation became more so (29 years).

Confirmation that group polarization can occur in juries comes from an ambitious study in which Reid Hastie, Steven Penrod, and Nancy Pennington (1983) put together 69 twelve-person juries from Massachusetts citizens on jury duty. Each jury was shown a reenactment of an actual murder case, with roles played by an experienced judge and actual attorneys. Then they were given

FIGURE 10-5 *Group polarization in juries. In highly realistic simulations of a murder trial, 828 Massachusetts jurors stated their initial verdict preferences, then deliberated the case for periods ranging from three hours to five days. Deliberation strengthened initial tendencies, which favored the prosecution.*
(From Hastie & others, 1983.)

unlimited time to deliberate the case in a jury room. As Figure 10-5 shows, the evidence was incriminating: Four out of five jurors voted guilty before deliberation, but felt unsure enough that a weak verdict of manslaughter was their most popular preference. After deliberation, nearly all agreed the accused was guilty, and most now preferred a stronger verdict—second-degree murder. Through deliberation, their initial leanings had grown stronger.

Leniency

In many experiments, one other curious effect of deliberation has surfaced: Especially when the evidence is not highly incriminating, as it was in the experiment just described, jurors often become more lenient after deliberating (MacCoun & Kerr, 1988). This qualifies the "two-thirds-majority-rules" finding, for if even a bare majority initially favors *acquittal*, it usually will prevail (Stasser & others, 1981). Moreover, a minority that favors acquittal stands a better chance of prevailing than one that favors conviction (Tindale & others, 1990).

Once again, a survey of actual juries confirms the laboratory results. Kalven and Zeisel (1966) report that in those cases where the majority does not prevail, it usually shifts to acquittal (as in the Mitchell-Stans trial). When a judge disagrees with the jury's decision, it is usually because the jury acquits someone the judge would have convicted.

Might "informational influence" (stemming from others' persuasive arguments) account for the increased leniency? The "innocent-unless-proved-guilty" and "proof-beyond-a-reasonable-doubt" rules put the burden of proof

"It is better that ten guilty persons escape than one innocent suffer."
William Blackstone (1769)

on those who favor conviction. Perhaps this makes evidence of the defendant's innocence more persuasive than evidence for conviction. Or perhaps "normative influence" creates the leniency effect, as jurors who view themselves as fair-minded confront other jurors who are even more concerned with protecting a possibly innocent defendant.

Are 12 Heads Better Than 1?

In Chapter 9 we saw that on thought problems where there is an objective right answer, group judgments surpass those by most individuals. Does the same hold true in juries? When deliberating, jurors not only exert normative pressure by trying to shift others' judgments by the sheer weight of their own, but they also share information, thus enlarging one another's knowledge of the case. So, does informational influence produce superior collective judgment?

The evidence, though meager, is encouraging. Groups recall information from a trial better than do their individual members (Vollrath & others, 1989). Moreover, some of the biases that contaminate individual judgments have much less effect after the jurors deliberate (Kaplan & Scherching, 1980). Deliberation not only cancels out certain biases but also draws jurors' attention away from their own prejudgments and to the evidence.

Are 6 Heads as Good as 12?

In keeping with their British heritage, juries in the United States and Canada have traditionally been composed of 12 people whose task is to reach consensus—a unanimous verdict. However, in several cases appealed during the early 1970s, the U.S. Supreme Court declared that in civil cases and state criminal cases not potentially involving a death penalty, courts could use six-person juries. Moreover, the Court affirmed a state's right to allow less than unanimous verdicts, even upholding one Louisiana conviction based on a 9 to 3 vote

Experimental simulations of jury decision making, often using videotaped reenactments of trials, enables researchers to test theories about actual jury decision making.

(Tanke & Tanke, 1979). There is no reason to suppose, argued the Court, that smaller juries, or juries not required to reach consensus, will deliberate or decide differently from the traditional jury.

The Court's assumptions triggered an avalanche of criticism from both legal scholars and social psychologists (Saks, 1974). Some criticisms were matters of simple statistics. For example, if 10 percent of a community's total jury pool is African-American, then 72 percent of 12-member juries but only 57 percent of 6-member juries may be expected to have at least one African-American person. So smaller juries are less likely to reflect a community's diversity. And if, in a given case, one-sixth of the jurors initially favor acquittal, that would be a single individual in a 6-member jury and 2 people in a 12-member jury. The Court assumed that, psychologically, the two situations would be identical. But as you may recall from our discussion of conformity, resisting group pressure is far more difficult for a minority of one than for a minority of two. Not surprisingly, then, 12-person juries are more likely than 6-person juries to have hung verdicts (Kerr & MacCoun, 1985).

Other criticisms were based on experiments by Michael Saks (1977), Charlan Nemeth (1977), and James Davis and others (1975). In these mock jury experiments, the overall distribution of verdicts from small or nonunanimous juries did not differ much from the verdicts pronounced by unanimous 12-member juries (although verdicts from the smaller juries were slightly more unpredictable). There are, however, greater effects on deliberation. A smaller jury has the advantage of greater and more evenly balanced participation per juror but the disadvantage of eliciting less total deliberation. Moreover, once they realize that the necessary majority has been achieved, juries not required to reach consensus seem to discuss minority views rather superficially (Davis & others, 1975; Foss, 1981; Hastie & others, 1983; Kerr & others, 1976).

In 1978, after some of these studies were reported, the Supreme Court rejected Georgia's 5-member juries (although it still retains the 6-member jury). Announcing the Court's decision, Justice Harry Blackmun drew upon both the logical and the experimental data to argue that 5-person juries would be less representative, less reliable, less accurate (Grofman, 1980). Ironically, many of these data actually involved comparisons of 6- versus 12-member juries, and thus also argued against the 6-member jury. But having made and defended a public commitment to the 6-member jury, the Court was not convinced that the same arguments applied (Tanke & Tanke, 1979).

"We have considered [the social science studies] carefully because they provide the only basis, besides judicial hunch, for a decision about whether smaller and smaller juries will be able to fulfill the purposes and functions of the Sixth Amendment."
Justice Harry Blackmun (Ballew v. Georgia, 1978)

SIMULATED JURIES AND REAL JURIES

Perhaps while reading this chapter, you have wondered what some critics (Vidmar, 1979; Tapp, 1980) have wondered: Isn't there an enormous gulf between college students discussing a hypothetical case and real jurors deliberating a real person's fate? Indeed there is. It is one thing to ponder a pretend decision given minimal information and quite another to agonize over the complexities and profound consequences of an actual case. So Reid Hastie, Martin Kaplan, James Davis, Eugene Borgida, and others have asked their participants, who sometimes are drawn from actual juror pools, to view enactments of actual trials. The enactments are so realistic that sometimes participants forget a trial they are watching on television is not real but staged (Thompson & others, 1981).

The U.S. Supreme Court (1986) debated the usefulness of jury research in its decision regarding the use of "death-qualified" jurors in capital punishment cases. The dissenting judges argued that a defendant's constitutional "right to a fair trial and an impartial jury whose composition is not biased toward the prosecution" is violated when jurors include only those who accept the death penalty. Their argument, they said, was based chiefly on "the essential unanimity of the results obtained by researchers using diverse subjects and varied methodologies." The majority of the judges, however, declared their "serious doubts about the value of these studies in predicting the behavior of actual jurors." The dissenting judges replied that it is the courts themselves that have not allowed experiments with actual juries; thus "defendants claiming prejudice from death qualification should not be denied recourse to the only available means of proving their case."

Researchers also defend the laboratory simulations, by noting that the laboratory offers a practical, inexpensive method for studying important issues under controlled conditions (Bray & Kerr, 1982; Dillehay & Nietzel, 1980). What is more, as researchers have begun testing them in more realistic situations, findings from the laboratory studies have often held up quite well. No one contends that the simplified world of the jury experiment mirrors the complex world of the real courtroom. Rather, the experiments help us formulate theories that help us interpret the complex world.

Come to think of it, are these jury simulations any different from social psychology's other experiments, all of which create simplified versions of complex realities? By varying just one or two factors at a time in this simulated reality, the experimenter pinpoints how changes in one or two aspects can affect us. And that is the essence of social psychology's experimental method.

■ SUMMING UP

In hundreds of recent experiments, courtroom procedures have been on trial. Social psychologists have conducted these experiments believing that the courtroom offers a natural context for studying how people form judgments and that social psychology's principles and methods can shed new light on important judicial issues.

JUDGING THE EVIDENCE

During a trial, jurors hear testimony, form impressions of the defendant, and listen to the judge's instructions. At each of these stages, subtle factors may influence their judgments.

Eyewitness Testimony

Experiments reveal that both witnesses and jurors readily succumb to an illusion that a given witness's mental-recording equipment functions free of significant error. But as witnesses construct and rehearse memories of what they have observed, errors creep in. Research suggests ways to lessen such error, both in eyewitness reports and in jurors' use of such reports.

The Defendant's Characteristics

The facts of a case are usually compelling enough that jurors can lay aside their biases and render a fair judgment. When the evidence is ambiguous, jurors are more likely to interpret it with their preconceived biases and to feel sympathetic to a defendant who is attractive or similar to themselves.

The Judge's Instructions

When jurors are exposed to damaging pretrial publicity or to inadmissible evidence, will they follow a judge's instruction to ignore it? In simulated trials, the judge's orders were sometimes followed, but often, especially when the judge's admonition came *after* the impression was made, they were not.

THE JURY

What matters is what happens not only in the courtroom but also within and among the jurors themselves.

The Jurors as Individuals

In forming their judgments, jurors (1) construct a story that explains the evidence, (2) consider the judge's instructions, and (3) compare their understandings with the possible verdicts. In a close case, the jurors' own characteristics can influence their verdicts. For example, jurors who favor capital punishment or who are highly authoritarian appear more likely to convict certain types of defendants. Thus lawyers, sometimes with the aid of survey researchers, seek to identify and eliminate potential jurors likely to be unsympathetic to their side. Nevertheless, what matters most is not the jurors' personalities and general attitudes but rather the situation that they must react to.

The Jury as a Group

Juries are groups, groups that are swayed by the same influences that bear upon other types of groups—patterns of majority and minority influence, group polarization, information exchange. Researchers have also examined and questioned the assumptions underlying several recent U.S. Supreme Court decisions permitting smaller juries and nonunanimous juries.

Simulated Juries and Real Juries

Simulated juries are not real juries, so we must be cautious in generalizing these findings to actual courtrooms. Yet, like all experiments in social psychology, laboratory jury experiments help us formulate theories and principles that we can use to interpret the more complex world of everyday life.

■ FOR FURTHER READING

Hans, V. P., & Vidmar, N. (1986). *Judging the jury*. New York: Plenum. A graceful review of the history of the jury, of two decades of jury research, of important court decisions, and of highly publicized trials. Examines issues involved in insanity, rape, and death penalty cases.

Kassin, S. M., & Wrightsman, L. S. (1988). *The American jury on trial: Psychological perspectives.* New York: Hemisphere. An easy-to-read and authoritative review of the entire process of trial by jury, from jury selection to verdict.

Loftus, E., & Ketcham, K. (1991). *Witness for the defense: The accused, the eyewitness, and the expert who puts memory on trial.* New York: St. Martin's. Memory researcher and frequent expert witness Elizabeth Loftus shows how memory construction can produce persuasive but flawed eyewitness reports by adults and children.

SOCIAL RELATIONS

Having explored how we think about (Part I) and influence (Part II) one another, we come finally to social psychology's third facet—how we relate to one another. Our feelings and actions toward people are sometimes negative, sometimes positive. Chapter 11, "Prejudice," and 12, "Aggression," examine the unpleasant aspects of human relations: Why do we dislike, even despise, one another? Why and when do we hurt one another? Then in Chapters 13, "Attraction," and 14, "Altruism," we explore the more pleasant aspects: Why do we like or love particular people? When will we offer help to friends or strangers? Lastly in Chapter 15, "Conflict and Peacemaking," we consider how social conflicts develop and how they can often be justly and amicably resolved.

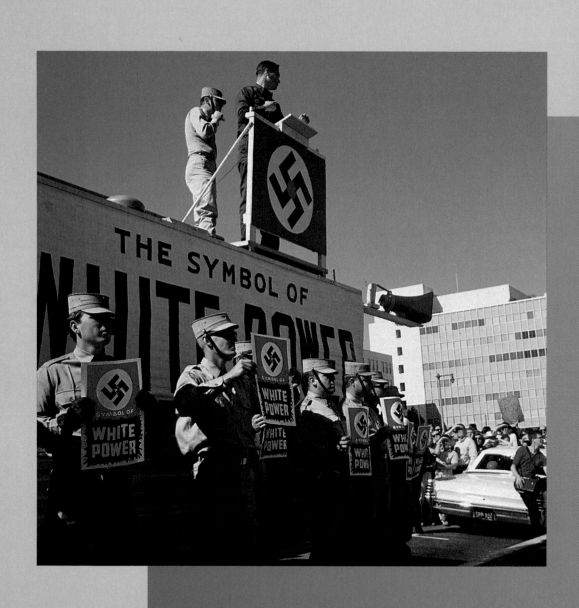

PREJUDICE: DISLIKING OTHERS

Prejudice comes in so many forms—prejudices against AIDS victims, against "northeastern liberals" or "southern rednecks," against Arab "terrorists" or Christian "fundamentalists," against people who are short, or fat, or homely. Consider a few actual occurrences:

In 1961 Charlayne Hunter, now PBS newscaster Charlayne Hunter-Gault, needed a federal judge to compel the University of Georgia to admit her. A week after she enrolled, state officials asked the court whether they also were compelled to allow her to eat on campus (Menand, 1991).

A group of homosexual students at the University of Illinois announced that the motto for one spring day would be: "If you are gay, wear blue jeans today." When the day dawned, many students who usually wore jeans woke up with an urge to dress up in a skirt or slacks. The homosexual group had made its point—that attitudes toward homosexuals are such that many would rather give up their usual clothes lest anyone suspect (*RCAgenda*, 1979).

Prejudice against girls and women is sometimes subtle, sometimes devastating. Nowhere in the modern world are female infants left on a hillside to die of exposure, as was the occasional practice in ancient Greece. Yet in many developing countries, girls' death rates exceed boys'. During the 1976–1977 Bangladesh famine, preschool girls were more malnourished than boys (Bairagi, 1987). In South Korea, where would-be parents often test to learn the sex of their fetus, male births exceed female births by 14 percent. Under China's one-child policy, unmarried males now greatly exceed the number of unmarried females (*Time*, 1990).

Yoshio, one of a group of Japanese university students visiting an American college, matter-of-factly reveals to his Japanese peers that he is a Burakumin, one of Japan's "ghetto people" whose ancestors had an occupation regarded as polluting. Their response: Hands come to the mouth and brows furrow, revealing their shock and astonishment. Though physically indistinguishable from other Japanese, the Burakumin have for generations been segregated in Japan's slums, considered eligible only for the most menial occupations and unfit for intermarriage with other Japanese. So, how could this obviously bright, attractive, ambitious student be a Burakumin?

■ WHAT IS PREJUDICE?

Prejudice:
An unjustifiable negative attitude toward a group and its individual members.

Prejudice, stereotyping, discrimination, racism, sexism: The terms often overlap. Before seeking to understand prejudice, let's clarify the terms. Each of the situations just described involved a negative evaluation of some group. And that is the essence of **prejudice:** an unjustifiable negative attitude toward a group and its individual members. Prejudice is *prejudgment;* it biases us against a person based solely on the person's identification with a particular group.

Prejudice is an attitude. As we saw in Chapter 4, an attitude is a distinct combination of feelings, inclinations to act, and beliefs. This combination we called the ABC of attitudes: *a*ffect (feelings), *b*ehavior tendency (inclination to act), and *c*ognition (beliefs). A prejudiced person might therefore *dislike* the Burakumin and *behave* in a discriminatory manner, *believing* them ignorant and dangerous.

Stereotype:
A belief about the personal attributes of a group of people. Stereotypes can be overgeneralized, inaccurate, and resistant to new information.

The negative evaluations that mark prejudice can stem from emotional associations, from the need to justify behavior, or from negative beliefs, called **stereotypes** (Stroebe & Insko, 1989; Zanna & others, 1990). To stereotype is to

generalize. To simplify the world, we generalize all the time: The British are reserved; Americans are outgoing. Professors are absentminded. Women who assume the title of "Ms." are more assertive and ambitious than those who call themselves "Miss" or "Mrs." (Dion, 1987; Dion & Cota, 1991; Dion & Schuller, 1991). Such generalizations can have a germ of truth. As we saw in Chapter 6, cultures do in fact differ.

The problem with stereotypes arises when they are *overgeneralized* or just plain wrong. Pretend you told me I was about to meet Mike, an avid organic gardener. I might form an image of someone in bib overalls sporting a neatly trimmed beard and driving a van displaying a "Ban Handguns" bumper sticker. Certainly I would not expect someone to pull up in a Cadillac and emerge wearing a three-piece blue suit with a National Rifle Association lapel button. My stereotype of organic gardeners may contain a kernel of truth, just as people's beliefs about the employment rates, crime rates, and single-parent birthrates of different racial groups sometimes mirror actual census statistics (McCauley & Stitt, 1978). Yet it is likely an overgeneralization. There may be some conservatively dressed, Cadillac-driving organic gardeners. But were I to meet one, I might shrug it off by telling myself, "Every rule has its exceptions."

Prejudice is a negative *attitude;* **discrimination** is negative *behavior.* Discriminatory behavior often, but not always, has its source in prejudicial attitudes. As Chapter 4 emphasized, attitudes and behavior are often loosely linked, partly because our behavior reflects more than our inner convictions. Prejudiced attitudes need not breed hostile acts, nor does all oppression spring from prejudice. **Racism** and **sexism** are institutional practices that discriminate, even when there is no prejudicial intent.

Imagine a state police force that set a height requirement of 5 feet, 10 inches, for all its officers. If this requirement were irrelevant to on-the-job effectiveness and tended to exclude Hispanics, Asians, and women, someone might label the requirement racist and sexist. Note that we could make this allegation even if no one intended discrimination. Similarly, if word-of-mouth hiring practices in an all-White business have the effect of excluding non-White employees, the practice could be called racist—even if the open-minded employer intended no discrimination. This chapter explores the roots and fruits of prejudiced attitudes, leaving it to sociologists and political scientists to explore racism and sexism in their institutional forms.

Discrimination: Unjustifiable negative behavior toward a group or its members.

Racism: (1) Individual's prejudicial attitudes and discriminatory behavior toward people of a given race, or (2) institutional practices (even if not motivated by prejudice) that subordinate people of a given race.

Sexism: (1) Individuals' prejudicial attitudes and discriminatory behavior toward people of a given sex, or (2) institutional practices (even if not motivated by prejudice) that subordinate people of a given sex.

■ HOW PERVASIVE IS PREJUDICE?

Is prejudice inevitable? Can we eradicate it? As a case example, let's look at racial and gender prejudice in a heavily studied country, the United States.

RACIAL PREJUDICE

In the context of the world, every race is a minority. Non-Hispanic Whites, for example, are but one-fifth of the world's people and will be but one-eighth within another half century. Thanks to mobility and migration during the past two centuries, the world's races now intermingle, with relations that are sometimes hostile, sometimes amiable.

Is Racial Prejudice Becoming Extinct?

To judge from what Americans tell survey takers, racial prejudice toward African-Americans has plummeted since the early 1940s. In 1942, most Americans agreed, "There should be separate sections for Negroes on streetcars and buses" (Hyman & Sheatsley, 1956); today, the question would seem bizarre. In 1942, fewer than a third of all Whites (only 1 in 50 in the south) supported school integration; by 1980, support for it was 90 percent. Considering what a thin slice of history is covered by the years since 1942, or even since slavery was practiced, the changes are dramatic.

African-Americans' attitudes also have changed since the 1940s, when Kenneth Clark and Mamie Clark (1947) demonstrated that many held anti-Black prejudices. In making its historic 1954 decision declaring segregated schools unconstitutional, the Supreme Court found it noteworthy that when the Clarks gave African-American children a choice between Black dolls and White dolls, most chose the White. In studies from the 1950s through the 1970s, Black children were increasingly likely to prefer Black dolls. And adult Blacks came to view Blacks and Whites as similar in traits such as intelligence, laziness, and dependability (Jackman & Senter, 1981; Smedley & Bayton, 1978).

Psychologists capitalize Black and White to emphasize that these are race labels, not literal color labels for persons of African and European ancestry.

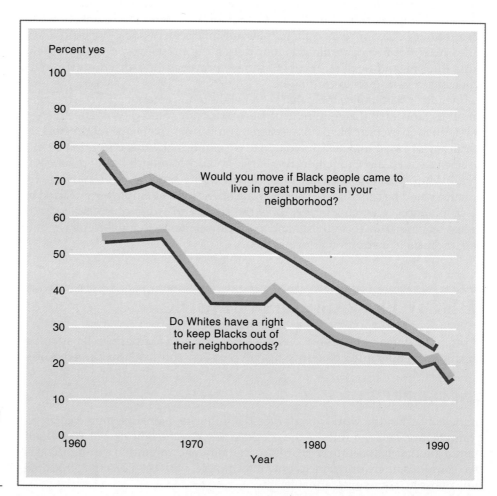

FIGURE 11-1 *Expressed racial attitudes of White Americans from 1963 to 1990.*

(Data from Gallup & Hugick, 1990; Niemi & others, 1989; Smith, 1990)

Although prejudice most often surfaces in people's feelings about intimate racial contacts, the number of interracial couples continues to increase.

So, shall we conclude that racial prejudice is extinct in the United States? No. Although no longer fashionable, racial prejudice still exists, surfacing when a person thinks it is safe to express it.

Prejudice appears in the residue of White Americans who, as Figure 11-1 shows, openly dislike African-Americans. During the late 1980s and into the 1990s, "hate crimes"—slurs, vandalism, physical violence—victimized a growing number of African-Americans and gay men and lesbians (Goleman, 1990; Herek, 1990; Levine, 1990). In other cultures, open ethnic hostilities are common, as Israel's Palestinians and Jews, Northern Ireland's Protestants and Catholics, and Yugoslavia's Serbs and Croatians know well.

Questions concerning intimate interracial contacts still detect prejudice. "I would probably feel uncomfortable dancing with a Black person in a public place," detects more racial feeling than, "I would probably feel uncomfortable riding a bus with a Black person." In one survey, only 3 percent of Whites said they wouldn't want their child to attend an integrated school, but 57 percent acknowledged they would be unhappy if their child *married* a Black person (*Life*, 1988). This phenomenon of *greatest prejudice in the most intimate social realms* seems universal. In India, people who accept the prejudices of the caste system typically allow someone from a lower caste into their home but would not consider marrying such a person (Sharma, 1981).

In 1990, there were 211,000 Black-White married couples in the United States, triple the number in 1970.

Subtle Forms of Prejudice

Recall from Chapter 4 that when White students indicate racial attitudes while hooked up to a supposed lie detector, they admit to prejudice. Other researchers have invited people to evaluate someone's behavior, that someone being either White or Black. Birt Duncan (1976) had White students at the University of California, Irvine, observe a videotape of one man lightly shoving another during a brief argument. When a White shoved a Black man, only 13 percent of the observers rated the act as "violent behavior." They more often interpreted the shove as "playing around" or "dramatizing." Not so when a Black shoved

FIGURE 11-2 *Does anger trigger latent prejudice? When White students administered electric shock, supposedly as part of a "behavior-modification experiment," they behaved less aggressively toward an agreeable Black victim than toward a White victim. But when the victim insulted the subjects, they responded with more aggression if the victim was Black.*

(Data from Rogers & Prentice-Dunn, 1981.)

Race sensitivity leads to exaggerated reactions to isolated minority persons—both overpraising their accomplishments and overcriticizing their mistakes (Fiske, 1989; Hass & others, 1991).

a White man: Then, 73 percent said the act was "violent." (Likewise, if an interviewer is male rather than female, people more quickly interpret the interviewer's unwillingness to hire a woman to operate heavy equipment as "sexist"—Baron & others, 1991.)

Many experiments have assessed people's *behavior* toward Blacks and Whites. As we will see in Chapter 14, Whites are equally helpful to any person in need—except when the needy person is remote (say, a wrong-number caller who needs a message relayed). Likewise, when asked to use electric shocks to "teach" a task, White people give no more (if anything less) shock to a Black than a White person—except when they are angered or when the recipient can't retaliate or know who did it (Crosby & others, 1980; Rogers & Prentice-Dunn, 1981) (Figure 11-2). Discriminatory behavior surfaces not when a behavior would *look* prejudicial but when it can hide behind the screen of some other motive.

Finally, attitude researchers report that prejudicial attitudes persist in subtle forms (Dovidio & others, 1992). In the United States, some Whites accept school busing but not when it involves racial mixing. In France, Britain, Germany, and the Netherlands, too, subtle prejudice (exaggerating ethnic differences, feeling less admiration and affection for minorities, rejecting minorities for supposedly nonracial reasons) is replacing blatant prejudice (Pettigrew & Meertens, 1991).

Critics reply that opposition to busing and to affirmative action hiring policies often reflects a valuing of individual choice and self-reliance rather than subtle racial prejudice (Roth, 1990; Sniderman & others, 1991). "Subtle prejudice," they say, may be nothing more than political conservatism. Or, as other researchers believe, do conservative values support prejudice? The debate continues.

This much is agreed upon: Even as blatant prejudice subsides, automatic, emotional reactions linger. Patricia Devine and her colleagues (1989, 1991) report that those low and high in prejudice often have similar automatic reactions. They differ because the low-prejudice person consciously suppresses prejudicial thoughts and feelings. It's like consciously breaking a bad habit, says Devine. Thomas Pettigrew (1987, p. 20) illustrates: "Many [people] have confessed to me . . . that even though in their minds they no longer feel prejudice toward Blacks, they still feel squeamish when they shake hands with a Black. These feelings are left over from what they learned in their families as children." Thus prejudice operates partly as an unconscious emotional response (Greenwald, 1990). As in the experiments with the shoves, shocks, and wrong phone numbers, unconscious prejudice appears mostly when people react to someone for the first time, with their conscious attention focused on something other than the person's race.

To summarize, the good news: During the past four decades, open prejudice against Black Americans has nearly vanished. White racial attitudes are far more egalitarian than a generation ago. The bad news pertains to all people of color, including Native Americans and Hispanics (Trimble, 1988; Ramirez, 1988): Though now camouflaged by a more pleasant exterior, resentments and partiality still lurk beneath the surface. And what is true in the United States is true everywhere: In a world still torn by ethnic tensions, old hatreds die slowly.

PREJUDICE AGAINST WOMEN

How pervasive is prejudice against women? In Chapter 6, we examined gender-role norms—people's ideas about how women and men *ought* to behave. Here we first consider gender *stereotypes*—people's beliefs about how women and men *do* behave.

Gender Stereotypes

From research on stereotypes, two conclusions are indisputable: Strong gender stereotypes exist, and, as often happens, members of the stereotyped group accept the stereotypes. Men and women agree that you *can* judge the book by its sexual cover. Analyzing responses from a University of Michigan survey, Mary Jackman and Mary Senter (1981) found that gender stereotypes were much stronger than racial stereotypes. For example, only 22 percent of men thought the two sexes equally "emotional." Of the remaining 78 percent, those who believed females were more emotional outnumbered those who thought males were by 15 to 1. And what did the women believe? To within 1 percentage point, their responses were identical.

Consider, too, a study by Natalie Porter, Florence Geis, and Joyce Jennings Walstedt (1983). They showed students pictures of "a group of graduate students working as a team on a research project" (Figure 11-3). Then they gave them a test of "first impressions," asking them to guess who contributed most to the group. When the group was either all male or all female, the students overwhelmingly chose the person at the head of the table. When the group was mixed sex, a man occupying the head position was again overwhelmingly chosen. But a woman occupying that position was usually ignored. Each of the men in Figure 11-3 received more of the leadership choices than all three women combined! This stereotype of men as leaders was true not only of

"All the pursuits of men are the pursuits of women also, and in all of them a woman is only a lesser man."
Plato, *The Republic*

FIGURE 11-3 *Which one of these people would you guess is the group's strongest contributor? Shown this picture, college students usually guessed one of the two men. Those shown photos of same-sex groups most commonly guessed the person at the head of the table.*

women as well as men but also of feminists as well as nonfeminists. How pervasive are gender stereotypes? Quite pervasive.

Remember that stereotypes are generalizations about a group of people and may be true, false, or overgeneralized from a kernel of truth. In Chapter 6 we noted that the average man and woman do differ somewhat in social connectedness, empathy, social power, aggressiveness, and sexual initiative. Do we then conclude that gender stereotypes are accurate? Not at all.

They are often overgeneralizations. Carol Lynn Martin (1987) surmised as much after asking visitors to the University of British Columbia to check which of several traits described themselves and to estimate what percentage of North American males and females had each trait. Males were *slightly* more likely than females to describe themselves as assertive and dominant and were slightly less likely to describe themselves as tender and compassionate. But stereotypes of these differences were greatly exaggerated: The people perceived North American males as almost twice as likely as females to be assertive and dominant and roughly half as likely to be tender and compassionate. The conclusion: Self-perceived differences between the sexes are small, as are actual behavioral differences, but stereotypes are strong.

Stereotypes (beliefs) are not prejudices (attitudes). Stereotypes may support prejudice. But then again one might believe, without prejudice, that men and women are "different yet equal." Let us therefore see how researchers probe for gender prejudice.

Gender Attitudes

Judging from what people tell survey researchers, attitudes toward women have changed as rapidly as racial attitudes. In 1937, one-third of Americans said they would vote for a qualified woman whom their party nominated for President; in 1988, 9 in 10 said they would. In 1967, 56 percent of first-year

American college students agreed, "The activities of married women are best confined to the home and family"; by 1990, only 25 percent agreed (Astin & others, 1987, 1991). In 1970, Americans were split 50-50 on whether they favored or opposed "efforts to strengthen women's status." By the end of the decade, this tenet of the women's movement was favored by better than 2 to 1 (Figure 11-4). And should there be "equal pay for women and men when they are doing the same job?" (NBC, 1977b). Yes, say both men and women—by a 16 to 1 margin, as close to absolute consensus as Americans ever get.

Alice Eagly and her associates (1991) also report that people don't respond to women with gut-level negative emotions as they do to certain other groups. If anything, their emotional evaluations of women exceed those of men, thanks largely to the common perception that women are more kind, understanding, and helpful.

There is still more good news for those who are upset by sex bias. One heavily publicized finding of prejudice against women no longer holds true. In one study, Philip Goldberg (1968) gave women students at Connecticut College several short articles, asking them to judge the value of each. Sometimes a given article was attributed to a male author (for example, John T. McKay), other times to a female author (for example, Joan T. McKay). In general, the articles received lower ratings when attributed to a female. The historic mark of oppression—self-deprecation—surfaced again. Women were prejudiced against women.

Eager to demonstrate the subtle reality of gender prejudice, I obtained Goldberg's materials and repeated the experiment for my own students' benefit. They showed no such tendency to deprecate women's work. So, Janet Swim, Eugene Borgida, Geoffrey Maruyama, and I (1989) searched the literature and corresponded with investigators to learn all we could about studies of gender

FIGURE 11-4 *Prejudice against women: an idea whose time has passed? The percentage of Americans who say that they approve of a married woman's working for money if she has a capable husband and that they would vote for a qualified woman candidate for President has steadily increased since the mid-1930s.*

(Data from Niemi & others, 1989; Tom Smith, personal correspondence.)

bias in the evaluation of men's and women's work. To our surprise, the biases that occasionally surfaced were as often against men as women. But the most common result across 104 studies involving almost 20,000 people was *no difference.* On most comparisons, judgments of someone's work were unaffected by whether the work was attributed to a female or a male.

The attention given highly publicized studies of prejudice against women's work illustrates a familiar point: Social scientists' values often penetrate their conclusions. The researchers who conducted the publicized studies did as they should in reporting their findings. However, my colleagues and I more readily accepted and reported findings supporting our preconceived biases than those opposing them.

So, is gender bias fast becoming extinct in the United States? Has the women's movement nearly completed its work? No. As with race prejudice, blatant gender prejudice is dying, but subtle bias lives. The bogus-pipeline method, for example, exposes bias. As we noted in Chapter 4, men who believe an experimenter can read their true attitudes with a sensitive lie detector express less sympathy toward women's rights. Even on paper-and-pencil questionnaires, Janet Swim and her co-researchers (1991) found a subtle sexism that parallels subtle racism. Both appear in denials of discrimination and antagonism toward efforts to promote equality.

We can also detect bias in behavior. That's what a research team led by Ian Ayres (1991) did while visiting 90 Chicago-area car dealers and using a uniform strategy to negotiate the lowest price on a new car that cost the dealer about $11,000. White males were given a final price that averaged $11,362; White females were given an average price of $11,504; Black males were given an average price of $11,783; and Black females were given an average price of $12,237.

Most women know that gender bias exists. They believe that sex discrimination affects most working women, as shown by the lower salaries for women

Question: "Misogyny" is the hatred of women. What is the corresponding word for the hatred of men?
Answer: In most dictionaries, no such word exists.

Issues of gender bias surfaced in the 1991 U.S. Senate hearings on Supreme Court nominee Clarence Thomas when law professor Anita Hill claimed that Thomas had sexually harassed her.

Drawing by Vietor; © 1981 The New Yorker Magazine, Inc.

"And just why do we always call my income the second income?"

Gender prejudice gets expressed subtly.

and for jobs such as child care worker that are filled mostly by women. Yet, curiously, Faye Crosby and her colleagues (1989) have repeatedly found that most women deny feeling personally discriminated against. Discrimination, they believe, is something *other* women face. Their employer is not villainous. They are doing better than the average woman. Hearing no complaints, managers—even in discriminatory organizations—can persuade themselves that justice prevails. Similar denials of personal disadvantage, while perceiving discrimination against one's group, occur among unemployed people, out-of-the-closet lesbians, African-Americans, and Canadian minorities (Taylor & others, 1990).

To conclude our case study of American racial and gender bias, overt prejudice against racial minorities and women is far less common today than it was four decades ago. Although stereotypes remain, blatant racial and gender prejudices have largely disappeared. Nevertheless, techniques that are sensitive to subtle prejudice still detect widespread bias. We therefore need to look carefully and closely at the problem of prejudice. What causes prejudice? Let's examine its social, cognitive, and emotional sources.

■ SOCIAL SOURCES OF PREJUDICE

Prejudice springs from several sources, because prejudice, like other attitudes, serves several functions (Herek, 1986, 1987). Prejudicial attitudes may express our sense of who we are and gain us social acceptance. They may defend our sense of self against anxiety that arises from insecurity or inner conflict. And they may promote our self-interest by supporting what brings us pleasure and opposing what doesn't. Consider first how prejudice functions to defend the self-esteem and social position of those who are high or rising on the social and economic ladder.

SOCIAL INEQUALITIES

Inequality and Prejudice

A principle to remember: Unequal status breeds prejudice. Masters view slaves as lazy, irresponsible, lacking ambition—as having just those traits that justify the slavery. Historians debate the forces that create unequal status. But once inequalities exist, prejudice helps justify the economic and social superiority of those who have wealth and power. Thus, prejudice and discrimination support each other: Discrimination breeds prejudice, and prejudice legitimizes discrimination (Pettigrew, 1980).

Examples of prejudice rationalizing unequal status abound. Until recently, prejudice was greatest in regions where slavery was practiced. Nineteenth-century European politicians and writers justified imperial expansion by describing exploited, colonized people as "inferior," "requiring protection," and a "burden" to be borne altruistically (G. W. Allport, 1958, pp. 204–205). Four decades ago, sociologist Helen Mayer Hacker (1951) noted how stereotypes of Blacks and women helped rationalize the inferior status of each: Many people thought both groups were mentally slow, emotional and primitive, and "contented" with their subordinate role. Blacks were "inferior"; women were "weak." Blacks were all right in their place; women's place was in the home.

In times of conflict, attitudes easily adjust to behavior. People often view enemies as subhuman and depersonalize them with a label. During World War II, the Japanese people became "the Japs." After the war was over, they became "the intelligent, hardworking Japanese" whom Americans came to admire. When the 1991–1992 recession heightened the sense of economic conflict with Japan, resentment of the Japanese again flared. Attitudes are amazingly adaptable.

In Chapter 4, we noted laboratory experiments revealing that cruel acts breed cruel attitudes. Harming an innocent person typically leads aggressors to disparage their victims, thus justifying their behavior. Stephen Worchel and Virginia Mathie Andreoli (1978) found that, compared to students whose task was to reward a man for right answers on a learning task, those who gave shocks for wrong answers dehumanized their subject. They were less able to recall his unique characteristics (such as name and physique) and better able to recall attributes such as race and religion that depersonalized the victim by identifying him with a group.

Gender stereotypes, too, help rationalize differing gender roles. After studying gender stereotypes worldwide, John Williams and Deborah Best (1990) noted that if women provide most of the care to young children, it is reassuring to think women are naturally nurturant. And if males run the businesses, hunt, and fight wars, it is comforting to suppose that men are aggressive, independent, and adventurous.

Or is it simply the other way around—that women's and men's traits indeed suit them for different roles? To see whether stereotypes *follow* the division of labor, Curt Hoffman and Nancy Hurst (1990) gave University of Alberta students information on two make-believe groups—the Orinthians and the Ackmians—who inhabit a distant planet. Although there were no sexes on this planet (anyone could mate with anyone else, causing both to reproduce), individuals worked either as *child raisers* in group homes or as *city workers*. Students then read about the roles and traits of 15 Orinthians and 15 Ackmians. Each individual was described with one assertive, one communal, and one

neutral trait. For example, "Dolack, an Ackmian who raises children, is outspoken, compassionate, and reliable." The only difference between the two groups was whether most of the Orinthians and few of the Ackmians were city workers or vice versa.

Despite the equivalent descriptions, the students afterward perceived each group as having traits that suited their predominant roles. As one student explained after reading sentences in which most Orinthians were child raisers: "The Orinthians are on average kind and sensitive. The Ackmians are more self-confident and forceful, therefore better suited for working in the city." Clearly, then, stereotypes do follow, and justify, the division of labor between different groups.

Racial prejudice often begins during times of conflict, as during World War II when Japanese-Americans were sent to internment camps. Today, prejudice still exists. In Japan, racially stereotypical dolls suggest views some Japanese may have of Caucasians and Blacks.

Religion and Prejudice

Those who benefit from social inequalities yet avow that "all are created equal" need to justify the way things are. And what more powerful justification than to believe God has ordained the existing social order? For all sorts of cruel deeds, noted William James, "Piety is the mask" (1902, p. 264)—the mask that sometimes portrays lovely expressions while hiding ugly motives.

In almost every country, leaders invoke religion to sanctify the present order. In a remarkable turnabout, Father George Zabelka (1980), chaplain to the aircrews that bombed Hiroshima, Nagasaki, and other civilian targets in Japan, years later came to regret that he had provided religion's blessing for these missions of devastation: "The whole structure of the secular, religious, and military society told me clearly that it was all right to 'let the Japs have it.' God was on the side of my country."

The use of religion to justify injustice helps explain a consistent pair of findings concerning Christianity, North America's dominant religion: (1) Church members express more racial prejudice than nonmembers and (2) those professing traditional Christian beliefs express more prejudice than those professing less traditional beliefs (Batson & others, 1985; Gorsuch, 1988).

Knowing the correlation between two variables—religion and prejudice—tells us nothing about their causal connection. There might be no connection at all. Perhaps people with less education are both more fundamentalist and more prejudiced. Or perhaps prejudice causes religion, by leading people to create religious ideas to support their prejudices. Or perhaps religion causes preju-

dice, by leading people to believe that because all individuals possess free will, impoverished minorities have no one but themselves to blame for any perceived lack of virtue or achievement.

If indeed religion causes prejudice, then the most religious church members should also be the most prejudiced. But three other findings consistently indicate that this plainly is not so. First, among church members, faithful church attenders are, in 24 out of 26 comparisons, *less* prejudiced than irregular attenders (Batson & Ventis, 1982). Second, Gordon Allport and Michael Ross (1967) found that those for whom religion is an end in itself (those who agree, for example, with the statement, "My religious beliefs are what really lie behind my whole approach to life") express *less* prejudice than those for whom religion is more a means to other ends (who agree, "A primary reason for my interest in religion is that my church is a congenial social activity"). And those for whom religion is an open-ended quest (not an attachment to pat answers) exhibit little prejudice (Batson & others, 1986). Third, Protestant ministers and Roman Catholic priests gave more support to the civil rights movement than did lay people (Fichter, 1968; Hadden, 1969). And in Germany, 45 percent of clergy in 1934 had aligned themselves with the Confessing Church, organized to oppose the Nazis' racist regime (Reed, 1989). So it's clear that some types of deeply religious people exhibit less prejudice than more superficially religious people.

What, then, is the relationship between religion and prejudice? The answer we get depends on *how* we ask the question. If we define religiousness as church membership or willingness to agree at least superficially with traditional beliefs, then the more religious are the more racially prejudiced—hence the Ku Klux Klan, which rationalizes bigotry with religion. However, if we assess depth of religious commitment in any of several other ways, then the very devout are less prejudiced than the nominally religious—hence the religious roots of the modern civil rights movement, among whose leaders were many ministers and priests. As Gordon Allport concluded, "The role of religion is paradoxical. It makes prejudice and it unmakes prejudice" (1958, p. 413).

"We have just enough religion to make us hate, but not enough to make us love one another."
Jonathan Swift, *Thoughts on Various Subjects*

Discrimination's Impact: The Self-Fulfilling Prophecy

Attitudes may coincide with the social order not only as a rationalization for it but also because discrimination affects its victims. "One's reputation," wrote Gordon Allport, "cannot be hammered, hammered, hammered into one's head without doing something to one's character" (1958, p. 139). In his classic book, *The Nature of Prejudice*, Allport catalogued 15 possible effects of victimization. Allport believed these reactions were reducible to two basic types—those that involve blaming oneself (withdrawal, self-hate, aggression against one's own group) and those that involve blaming external causes (fighting back, suspiciousness, increased group pride). If the net results are negative—say, higher rates of crime—people can use them to justify the discrimination that helps maintain them: "If we let those people in our nice neighborhood, property values will plummet."

Does discrimination affect its victims as this analysis supposes? We must be careful not to overstate the point, lest we feed the idea that the "victims" of prejudice are of necessity socially deficient. The soul and style of Black culture

"It is understandable that the suppressed people should develop an intense hostility towards a culture whose existence they make possible by their work, but in whose wealth they have too small a share."
Sigmund Freud, *The Future of an Illusion*, 1927

is for many a proud heritage, not just a response to victimization (Jones, 1983). Cultural differences need not imply social deficits. Nevertheless, social beliefs *can* be self-confirming.

Note the effects of discrimination in a clever pair of experiments by Carl Word, Mark Zanna, and Joel Cooper (1974). In the first experiment, Princeton University White men interviewed White and Black job applicants. When the applicant was Black, the interviewers sat farther away, ended the interview 25 percent sooner, and made 50 percent more speech errors than when the applicant was White. Imagine being interviewed by someone who sat at a distance, stammered, and ended the interview rather quickly. Would it affect your performance or your feelings about the interviewer?

To find out, the researchers conducted a second experiment in which trained interviewers treated students as the interviewers in the first experiment had treated either the White or Black applicants. When videotapes of the interviews were later rated, those treated like the Blacks in the first experiment seemed more nervous and less effective. Moreover, the interviewees could themselves sense a difference; those treated like the Blacks judged their interviewers as less adequate and less friendly. The experimenters concluded "that the 'problem' of black performance resides not entirely within the Blacks, but rather within the interaction setting itself."

The idea that victims need not be deserving of blame is gaining acceptance. Nearly 3 of 4 White Americans now *disagree* that the reason "poor Blacks have not been able to rise out of poverty [is] mainly the fault of Blacks themselves." They instead believe that "generations of slavery and discrimination have created conditions that make it difficult for Blacks to work their way out of the lower class" (Dovidio & others, 1989).

"If we foresee evil in our fellow man, we tend to provoke it; if good, we elicit it."
Gordon Allport, *The Nature of Prejudice,* 1958

INGROUP AND OUTGROUP

The social definition of who you are—your race, religion, sex, academic major— implies a definition of who you are not. The circle that includes "us" (the **ingroup**) excludes "them" (the **outgroup**). Thus, the mere experience of people's being formed into groups may promote **ingroup bias.** Ask children, "Which are better, the children in your school or the children at [another school nearby]?" Virtually all will say their own school has the better children.

In a series of experiments, British social psychologists Henri Tajfel and Michael Billig (1974; Tajfel, 1970, 1981, 1982) discovered how little it takes to provoke favoritism toward *us* and unfairness toward *them.* They found that even when the us-them distinction is trivial, people still favor their own group. In one study Tajfel and Billig had British teenagers evaluate modern abstract paintings and then told them that they and some others had favored the art of Paul Klee over that of Wassily Kandinsky. Finally, without ever meeting the other members of their group, the teens divided some money among members of both groups. In experiment after experiment, defining groups even in this trivial way produced favoritism. David Wilder (1981) summarized the typical result: "When given the opportunity to divide 15 points [worth money], subjects generally award 9 or 10 points to their own group and 5 or 6 points to the other group." This bias occurs with both sexes and with people of all ages and nationalities, though especially with people from individualist cultures

Ingroup:
"Us"—a group of people who share a sense of belonging, a feeling of common identity.

Outgroup:
"Them"—a group that people perceive as distinctively different from or apart from their ingroup.

Ingroup bias:
The tendency to favor one's own group.

(Gudykunst, 1989). (People in communal cultures identify more with all their peers and so treat everyone the same.)

We also are more prone to ingroup bias when our group is small, relative to the outgroup (Mullen, 1991). When we're part of a small group surrounded by a larger group, we are also more conscious of our group membership; when our ingroup is the majority, we think less about it. To be a foreign student, or to be a Black student on a mostly White campus or a White student on a mostly Black campus, is to feel one's social identity more keenly and to react accordingly.

Even forming conspicuous groups on *no* logical basis—say, merely by composing groups X and Y with the flip of a coin—will produce some ingroup bias (Billig & Tajfel, 1973; Brewer & Silver, 1978; Locksley & others, 1980). In Kurt Vonnegut's novel *Slapstick,* computers gave everyone a new middle name; all "Daffodil-11's" then felt unity with one another and distance from "Raspberry-13's." The self-serving bias (Chapter 3) rides again, enabling people to achieve a more positive social identity: "We" are better than "they," even when "we" and "they" are alike.

> "There is a tendency to define one's own group positively in order to evaluate oneself positively."
> John C. Turner (1984, p. 528).

Because we evaluate ourselves partly by our group memberships, seeing our own groups as superior helps us feel good about ourselves. What is more, our whole self-concept—our sense of who we are—contains not just our personal identity (our sense of our personal attributes and attitudes) but our *social identity* (Hogg & Abrams, 1988). Having a sense of "we-ness" strengthens our self concept. It *feels* good. So much so, report Charles Perdue and his associates (1990), that just pairing a nonsense syllable such as *yof* with words like "we" and "us" makes the syllable seem more pleasant than if it is associated with "they" or "them."

Because of our social identifications, we conform to our group norms. We sacrifice ourselves for team, family, nation. We disdain outgroups. The more important our social identity and the more strongly attached we feel to a group, the more we react prejudicially to threats from another group (Crocker & Luhtanen, 1990; Hinkle & others, 1992). Names such as Croatian, Ukranian, Tamil, Kurd, and Estonian represent ingroup identities for which people are prepared to die. Israeli historian and former Jerusalem deputy mayor Meron Benvenisti (1988) reports that among Jerusalem's Jews and Arabs, social identity is so central to self-concept that it constantly reminds them of who they are not. Thus, on the integrated street where he lives, his own children—to his dismay—"have not acquired a single Arab friend."

> "To kill 100,000 [Iraqi's] and to feel no pain at having done so may be dangerous to those who did the killing. It hints at an impaired humanity."
> Lance Morrow, "A Moment for the Dead," 1991

When our group has actually been successful, we can also make ourselves feel better by identifying more strongly with it. When queried after their football team's victory, college students frequently report *"we* won." When questioned after their team's defeat, students are more likely to say *"they* lost." Basking in the reflected glory of a successful ingroup is strongest among those who have just experienced an ego blow, such as learning they did poorly on a "creativity test" (Cialdini & others, 1976). We can also bask in the reflected glory of a friend's achievement—except when the friend outperforms us on something that is pertinent to our identity (Tesser & others, 1988). If you think of yourself as an outstanding psychology student, you will likely take more pleasure in a friend's excelling in mathematics than in psychology.

Ingroup bias is the favoring of one's group. Such relative favoritism could reflect (1) liking for the ingroup, (2) dislike for the outgroup, or both. If both,

loyalty to one's group should produce a devaluing of other groups. Is that true? Does ethnic pride cause prejudice? Does women's solidarity with other women cause them to like men less? Does loyalty to a particular fraternity or sorority lead its members to deprecate independents and members of other fraternities and sororities?

Experiments support both explanations. Outgroup stereotypes prosper when people feel keenly their ingroup identity, as when with fellow ingroup members (Wilder & Shapiro, 1991). At a club meeting, we may sense most strongly our differences from those in another club. Yet ingroup bias results primarily from perceiving that one's own group is good (Brewer, 1979) and to a lesser extent from a sense that other groups are bad (Rosenbaum & Holtz, 1985). So it seems that positive feelings for our own groups need not be mirrored by equally strong negative feelings for outgroups. Granted, devotion to one's own race, religion, and social group can predispose a person to devalue other races, religions, and social groups. But the sequence is not automatic.

Father, Mother, and Me,
 sister and Auntie say
All the people like us are We,
 and every one else is They.
And They live over the sea,
 While We live over the way.
But—would you believe it?—
 they look upon We
 As only a sort of They!
Rudyard Kipling, 1926 (quoted by Mullen, 1991)

CONFORMITY

Once established, prejudice is maintained largely by inertia. If prejudice is a social norm, many people will follow the path of least resistance and conform to the fashion. They will act not so much out of a need to hate as from a need to be liked and accepted.

Drawing by Ed Fisher; © 1987 The New Yorker Magazine, Inc.

"OVERWHELMING!"—NY

"Uh-oh! They seem to have loved it!"

Something favored by an "outgroup" may be cast in a negative light.

Studies by Thomas Pettigrew (1958) of Whites in South Africa and the American south revealed that during the 1950s those who conformed most to other social norms were also most prejudiced; those who were less conforming mirrored less of the surrounding prejudice. The price of nonconformity was painfully clear to the ministers of Little Rock, Arkansas, where the Supreme Court's 1954 school desegregation decision was implemented. Most ministers favored integration but usually only privately; they feared that advocating it vigorously would lose them members and contributions (Campbell & Pettigrew, 1959). Or consider the Indiana steelworkers and West Virginia coal miners of the same era. In the mills and the mines, the workers accepted integration. In the neighborhood, the norm was rigid segregation (Reitzes, 1953; Minard, 1952). Prejudice was clearly *not* a manifestation of "sick" personalities but simply of the norms that operated in a given situation.

Conformity also maintains gender prejudice. "If we have come to think that the nursery and the kitchen are the natural sphere of a woman," wrote George Bernard Shaw in an 1891 essay, "we have done so exactly as English children come to think that a cage is the natural sphere of a parrot—because they have never seen one anywhere else." Children who *have* seen women elsewhere—children of employed women—have less stereotyped views of men and women (Hoffman, 1977).

In all this, there is a message of hope. If prejudice is not deeply ingrained in personality, then as fashions change and new norms evolve, prejudice can diminish. And so it has.

INSTITUTIONAL SUPPORTS

Segregation is one way that social institutions (schools, government, the media) bolster widespread prejudice. Political leaders are another. Leaders may both reflect and reinforce prevailing attitudes. When Arkansas Governor Orville Faubus barred the doors of Central High School in Little Rock, he was doing more than representing his constituents; he was legitimating their views.

Schools, too, reinforce dominant cultural attitudes. One analysis of stories in

■ BEHIND THE SCENES

One's best ideas in social psychology often evolve from direct experience. As a White southerner, I realized when reading *The Authoritarian Personality* as an undergraduate that the book did not explain most of what I thought I knew about anti-Black prejudice in the south. I knew many people who were racially prejudiced but did not appear to be authoritarian personalities. To explain the discrepancy, I needed only to recall the times I had been expelled from the public schools of Richmond, Virginia, for opposing the traditional racial norms. These ideas led directly to my research on how societal pressures to conform shape individual attitudes and behavior.

THOMAS PETTIGREW, *University of California, Santa Cruz*

A contemporary example of institutionalized bias: the visual prominence given women's bodies and men's faces.

134 children's readers written before 1970 found that male characters outnumbered female characters 3 to 1 (Women on Words and Images, 1972). Who was portrayed as showing initiative, bravery, and competence? Note the answer in this excerpt from the classic "Dick and Jane" children's reader: Jane, sprawled out on the sidewalk, her roller skates beside her, listens as Mark explains to his mother;

> "She cannot skate," said Mark.
> "I can help her.
> I want to help her.
> Look at her, mother.
> Just look at her.
> She's just like a girl.
> She gives up."

Not until the 1970s, when changing ideas about males and females fostered new perceptions of such portrayals, was this blatant stereotyping widely noticed and changes made in the textbooks. The institutional supports for prejudice often go unnoticed. Usually, they are not deliberately, hateful attempts to oppress a group; more often, they simply reflect a culture's assumptions, as when the one "flesh"-colored crayon in the Crayola box was pinkish-white.

What contemporary examples of institutionalized biases still go unnoticed? Here is one most of us have never noticed, although it is frequently right before our eyes: By examining 1750 photographs of people in magazines and newspapers, Dane Archer and his associates (1983) discovered that about two-thirds of the average male photo, but less than half of the average female photo, is devoted to the face. As Archer widened his search, he discovered that "face-ism" is common. He found it in the periodicals of 11 other countries, in 920 portraits gathered from the artwork of six centuries, and in the amateur drawings of students at the University of California, Santa Cruz. Georgia Nigro and

her colleagues (1988) observed the face-ism phenomenon in more magazines, including *Ms.*

The visual prominence given men's faces and women's bodies both reflects and perpetuates sex bias—the researchers suspect. In research in Germany, Norbert Schwarz and Eva Kurz (1989) confirmed that people whose faces are prominent in photos seem more intelligent and ambitious. But better a whole-body depiction than none at all. When Ruth Thibodeau (1989) examined the previous 42 years of *New Yorker* cartoons, she could find only a single instance in which an African-American appeared in a cartoon unrelated to race.

Many films and television programs also embody and reinforce prevailing cultural attitudes. The muddle-headed wide-eyed Black butlers and maids in 1930s movies helped perpetuate the stereotypes they reflected. On radio and in the early years of television, the popular *Amos 'n' Andy* show provoked Americans to laugh at a portrayal of irresponsible, fun-loving Blacks. Today most of us would find such images offensive, yet we might fail to notice stereotyped portrayals of "savage" Native Americans (Trimble, 1988), fanatical Arabs (Shaheen, 1990), or bird-brained women. Women continue to be stereotyped and underrepresented: Men outnumber women 3 to 1 in primetime television and 9 to 1 as those universal sources of authority, narrators of commercials (Bretl & Cantor, 1988; Gerbner & others, 1986; Lovdal, 1989).

■ EMOTIONAL SOURCES OF PREJUDICE

Although prejudice is bred by social situations, emotional factors often add fuel to the fire: Frustration and aggression can feed prejudice, as can personality factors like status needs and authoritarian tendencies. Let's see how.

Scapegoats provide an outlet for frustrations and hostilities.

"*And now at this point in the meeting I'd like to shift the blame away from me and onto someone else.*"

Drawing by Maslin; © 1985 The New Yorker Magazine, Inc.

FRUSTRATION AND AGGRESSION: THE SCAPEGOAT THEORY

As we will see in Chapter 12, pain and frustration (the blocking of a goal) often evoke hostility. When the cause of our frustration is intimidating or vague, we often redirect our hostility. This phenomenon of "displaced aggression" may have contributed to the lynchings of African-Americans in the south after the Civil War. Between 1882 and 1930, there were more lynchings in years when cotton prices were low and economic frustration was therefore presumably high (Hepworth & West, 1988; Hovland & Sears, 1940).

Targets for this displaced aggression vary. Following their defeat in World War I and their country's subsequent economic chaos, many Germans saw Jews as villains. Long before Hitler came to power, one German leader explained: "The Jew is just convenient. . . . If there were no Jews, the anti-Semites would have to invent them" (quoted by G. W. Allport, 1958, p. 325). In earlier centuries people vented their fear and hostility on witches, whom they sometimes burned or drowned in public. Today's economic frustrations are often attributed to targets such as "lazy welfare bums" or "greedy corporations."

"Whoever is dissatisfied with himself is continually ready for revenge."
Nietzsche, *The Gay Science*, 1882–1887

A famous experiment by Neal Miller and Richard Bugelski (1948) confirmed the scapegoat theory. They asked college-age men working at a summer camp to state their attitudes toward Japanese and Mexicans. Some did so before, and then after, being forced to stay in camp to take tests rather than attend a long-awaited free evening at a local theater. Compared to a control group that did not undergo this frustration, the deprived group afterward displayed increased prejudice. Passions provoked prejudice.

One source of frustration is competition. When two groups compete for jobs, housing, or social prestige, one group's goal fulfillment can become the other group's frustration. Thus the **realistic group conflict theory** suggests that prejudice arises when groups compete for scarce resources. A corresponding ecological principle, Gause's law, states that maximum competition will exist between species with identical needs. In western Europe, for example, some people agree that "over the last five years people like yourself have been economically worse off than most [name of country's minority group]." These frustrated people express relatively high levels of blatant prejudice (Pettigrew & Meertens, 1991). Researchers have consistently detected the strongest anti-Black prejudice among Whites who are closest to Blacks on the socioeconomic ladder (Greeley & Sheatsley, 1971; Pettigrew, 1978; Tumin, 1958). When interests clash, prejudice pays, for some people. Certainly prejudice paid the White American men who, for most of this century, managed to protect their own interests by excluding women and minorities from the workplace and the career ladder.

Realistic group conflict theory:
The theory that prejudice arises from competition between groups for scarce resources.

PERSONALITY DYNAMICS

But any two people, with equal reason to feel frustrated or threatened, will often not be equally prejudiced. This suggests that prejudice serves other functions besides advancing our competitive self-interest. Sometimes, suggested Sigmund Freud, people hold to beliefs and attitudes that satisfy unconscious needs.

Need for Status

Status is relative: To perceive ourselves as having status, we need people below us. Thus one psychological benefit of prejudice, or of any status system, is the feeling of superiority it offers. Most of us can recall a time when we took secret satisfaction in another's failure—perhaps we saw a brother or sister punished or heard of a classmate's failing a test. Our own esteem derives a boost from such comparisons. So prejudice is often greater among those low or slipping on the socioeconomic ladder and among those whose positive self-image is being threatened (Lemyre & Smith, 1985; Thompson & Crocker, 1985). In one study at Northwestern University, members of lower-status sororities were more disparaging of other sororities than were members of higher-status sororities (Crocker & others, 1987). Perhaps people whose status is secure have less need to feel superior.

But other factors associated with low status could also account for prejudice. Imagine yourself as one of the Arizona State University students who took part in an experiment by Robert Cialdini and Kenneth Richardson (1980). You are walking alone across campus. Someone approaches you and asks your help with a five-minute survey. You agree. After the researcher gives you a brief "creativity test," he deflates you with the news that "you have scored relatively low on the test." The researcher then completes the survey by asking you

"By exciting emulation and comparisons of superiority, you lay the foundation of lasting mischief; you make brothers and sisters hate each other."
Samuel Johnson, quoted in James Boswell's *Life of Samuel Johnson*

In French-speaking Canada, signs in French make a statement: in this part of a predominantly English-speaking nation, a minority has majority status.

some evaluative questions about either your school or its traditional rival, the University of Arizona. Would your feelings of failure affect your ratings of either school? Compared with those in a control group whose self-esteem was not threatened, the students who experienced failure gave higher ratings to their own school, lower ratings to their rival. Apparently, boasting of one's own group and denigrating outgroups can boost one's ego.

James Meindl and Melvin Lerner (1984) found that a humiliating experience—accidentally knocking over a stack of someone's important computer cards—provoked English-speaking Canadian students to express increased hostility toward French-speaking Canadians. And Teresa Amabile and Ann Glazebrook (1982) found that Dartmouth College men who were made to feel insecure judged others' work more harshly. Thinking about your own mortality—by writing a short essay on dying and the emotions aroused by thinking about death—also provokes enough insecurity to intensify ingroup favoritism and outgroup prejudice (Greenberg & others, 1990).

All this suggests that a man who doubts his own strength and independence might, by proclaiming women to be pitifully weak and dependent, boost his masculine image. Indeed, when Joel Grube, Randy Kleinhesselink, and Kathleen Kearney (1982) had Washington State University men view young women's videotaped job interviews, men with low self-acceptance disliked strong, nontraditional women. Men with high self-acceptance preferred them.

A despised outgroup serves yet another need: the need to belong to an ingroup. As we will see in Chapter 15, the perception of a common enemy unites a group. School spirit is seldom so strong as when the game is with the arch-rival. The sense of comradeship among workers is often highest when they all feel a common antagonism toward management. To solidify the Nazi hold over Germany, Hitler used the "Jewish menace." Despised outgroups can strengthen the ingroup.

The Authoritarian Personality

The emotional needs that contribute to prejudice are said to predominate in the "authoritarian personality." In the 1940s, a group of University of California, Berkeley, researchers—two of whom had fled Nazi Germany—set out on an urgent research mission. They wanted to uncover the psychological roots of an anti-Semitism so poisonous that it caused the slaughter of millions of Jews and turned many millions of Europeans into indifferent spectators. In studies of American adults, Adorno and his colleagues (1950) discovered that hostility toward Jews often coexisted with hostility toward other minorities. Moreover, these **ethnocentric** people shared authoritarian tendencies—an intolerance for weakness, a punitive attitude, and a submissive respect for their ingroup's authorities, as reflected in their agreement with such statements as, "Obedience and respect for authority are the most important virtues children should learn."

As children, authoritarian people often were harshly disciplined. This apparently led them to repress their hostilities and impulses and to "project" them onto outgroups. The insecurity of authoritarian children seemed to predispose them toward an excessive concern with power and status and an inflexible right-wrong way of thinking that made ambiguity difficult to tolerate. Such people therefore tended to be submissive to those with power over them and aggressive or punitive toward those beneath them.

Ethnocentrism:
A belief in the superiority of one's own ethnic and cultural group, and a corresponding disdain for all other groups.

Adolf Hitler, an extreme authoritarian personality, was raised in an authoritarian home and, said his sister, given "his due measure of beatings" every day (Miller, 1990).

Scholars criticized the research on several counts: (1) Perhaps mere lack of education accounted for the simplistic prejudices of authoritarian individuals. (2) The Berkeley researchers, by focusing on right-wing authoritarianism, overlooked dogmatic authoritarianism of the left. (3) The researchers' democratic values were hardly disguised: The contemptibly "rigid" authoritarian character was strikingly similar to the "stable" character identified by psychologists in pre-Nazi Germany. Values thus determined whether such personalities were condemned for their "ethnocentrism" (American psychologists' label) or praised for their strong "group loyalty" (German psychologists' label) (Brown, 1965).

Still, the main conclusion of this ambitious research has survived: Authoritarian tendencies, sometimes reflected in ethnic tensions, surge during threatening times of economic recession and social upheaval (Sales, 1973; Doty & others, 1991). Moreover, contemporary studies of right-wing authoritarians by University of Manitoba psychologist Bob Altemeyer (1988, 1992) confirm that there *are* individuals whose fears and self-righteous hostilities surface as prejudice. Feelings of moral superiority may go hand in hand with brutality toward perceived inferiors. Although the prejudices that maintained *apartheid* in South Africa arose from social inequalities, socialization, and conformity (Louw-Potgieter, 1988), those who most strongly favored separation usually had authoritarian attitudes (van Staden, 1987). In repressive regimes across the world, people who become torturers typically have an authoritarian liking for hier-

archical chains of command and a contempt for those who are weak or resistant (Staub, 1989). Moreover, different forms of prejudice—toward Blacks, gays and lesbians, women, old people—*do* tend to coexist in the same individuals (Bierly, 1985; Snyder & Ickes, 1985). As Altemeyer concludes, right-wing authoritarians tend to be "equal opportunity bigots."

■ COGNITIVE SOURCES OF PREJUDICE

Much of the explanation of prejudice so far could have been written in the 1960s—but not what follows. This new look at prejudice supplements the established ideas by applying the new research on social thinking. The basic point is this: Stereotyped beliefs and prejudiced attitudes exist not only because of social conditioning, and not only because they serve an emotional function, enabling people to displace and project their hostilities, but also as by-products of normal thinking processes. Stereotypes spring less from malice than from the way we all simplify our complex worlds. They are like perceptual illusions, a by-product of our knack for simplifying. The cognitive approach says that to understand prejudice, we should take a closer look at how we think about the world.

CATEGORIZATION

One way we simplify our environment is to "categorize"—to organize the world by clustering objects into groups. A biologist organizes the world by classifying plants and animals. Once we organize people into categories, we can think about them more easily. If persons in a group are similar, knowing the group enables us to predict their individual behavior. Customs inspectors and airplane antihijack personnel are therefore taught "profiles" of suspicious individuals (Kraut & Poe, 1980). Such are categorization's benefits—providing useful information with a minimum amount of effort. When pressed for time (Kaplan & others, 1992), when preoccupied (Gilbert & Hixon, 1991), when tired (Bodenhausen, 1990), or when too young to appreciate diversity (Biernat, 1991), it's easy to rely on stereotypes.

However, the benefits exact a cost. We have already considered one social cost: the ingroup bias. Merely dividing people into groups can trigger discrimination. There are other costs as well. When decisions must be made quickly, we often rely on efficient but oversimplified stereotypes (Kruglanski & Freund, 1983). Moreover, ethnicity and sex are, in our current world, powerful ways of categorizing people. Imagine Tom, a 40-year-old, African-American New Orleans real estate agent. I suspect that your image of "Black male" predominates over the categories "middle-aged," "businessperson," and "southerner."

Experiments expose our spontaneous categorization of people by race. Imagine yourself hearing statements made by six different people (three Whites, three Blacks), slides of whom you see as they speak. Later you try to match a list of their statements with a numbered set of their pictures. Sometimes you forget who said what. But if you encode and retrieve information by race, you should nevertheless recall whether the statement was made by a White or a Black person. And that is precisely what the experiments confirm:

People use race categories when forming memories (Hewstone & others, 1991; Stroessner & others, 1990; Taylor & others, 1978). By itself, such categorization is not prejudice, but it does provide a foundation for prejudice.

Perceived Similarities and Differences

Picture the following objects: apples, chairs, pencils.

There is a strong tendency to see objects within a group as being more uniform than they really are. Were your apples all red? your chairs all straight-backed? your pencils all yellow? It's the same with people. Once we assign people to groups—athletes, drama majors, math professors—we are likely to exaggerate the similarities within the groups and the differences between them (S. E. Taylor, 1981; Wilder, 1978). Mere division into groups can create an **outgroup homogeneity effect**—a sense that "they" are "all alike" and different from "us" and "our" group (Allen & Wilder, 1979). Because we generally like people we think are similar to us and dislike those we perceive as different, the natural result is ingroup bias (Byrne & Wong, 1962; Rokeach & Mezei, 1966; Stein & others, 1965).

The mere fact of a group decision can lead outsiders to overestimate a group's unanimity. If a conservative wins a national election by a slim majority, observers infer "the people have turned conservative." If a liberal won by a similarly slim margin, voter attitudes would hardly have differed, but observers would now attribute a "liberal mood" to the country. Whether the decision is made by majority rule or by a designated group executive, people usually presume that it reflects the entire group's attitudes (Allison & others, 1985, 1987, 1990).

When the group is our own, we are more likely to see the diversity among its members. Many non-Europeans see the Swiss as a fairly homogeneous people. But to the people of Switzerland, the Swiss are a diverse group, encompassing French-, German-, and Italian-speaking people. White Americans readily identify "Black leaders" who supposedly can speak for Black Americans, and White reporters sometimes find it newsworthy that the "Black community is divided" on such an issue as the Persian Gulf war. Whites apparently presume their own racial group is more diverse: They do not assume there are "White leaders" who can speak for White America, nor is it newsworthy that not all Whites agree on an issue. (No newspapers headlined, "White leaders divided over Persian Gulf war.") Likewise, sorority sisters perceive the members of any other sorority as less diverse than the mix of women in their own sorority (Park & Rothbart, 1982). And business majors and engineering majors overestimate the uniformity of the other group's traits and attitudes (Judd & others, 1991). In general, the greater our familiarity with a social group, the more we see its diversity (Linville & others, 1989). The less our familiarity, the more we stereotype.

The outgroup homogeneity effect is especially potent among competing groups (Judd & Park, 1988). Moreover, the smaller the outgroup, the more people see it as unified (Mullen & Hu, 1989). So whether they are more homogeneous or not, the members of a small, competing sorority will probably seem more alike.

Perhaps you have noticed: "They"—the members of any racial group other than your own—even *look* alike. Many of us can recall embarrassing ourselves by confusing two people of another racial group, prompting the person we've

Outgroup homogeneity effect:
Perception of outgroup members as more similar to one another than are ingroup members. Thus "they are alike; we are diverse."

"Women are more like each other than men [are]."
Lord (not Lady) Chesterfield

FIGURE 11-5 *The own-race bias. White subjects more accurately recognize the faces of Whites than of Blacks; Black subjects more accurately recognize the faces of Blacks than of Whites.*
(From Devine & Malpass, 1985).

misnamed to say, "You think we all look alike." Experiments by John Brigham, June Chance, Alvin Goldstein, and Roy Malpass in the United States and by Hayden Ellis in Scotland reveal that people of other races do in fact appear to look more alike than do people of one's own race (Brigham & Williamson, 1979; Chance & Goldstein, 1981; Ellis, 1981). When White students are shown faces of a few White and a few Black individuals and then asked to pick these individuals out of a photographic lineup, they more accurately recognize the White faces than the Black.

I am White. When I first read this research I thought, of course: White people *are* more physically diverse than Blacks. But my reaction was apparently just an illustration of the phenomenon. For if my reaction were correct, Black people, too, would better recognize a White face among a lineup of Whites than a Black face in a lineup of Blacks. But in fact the opposite appears true: As Figure 11-5 illustrates, Blacks more easily recognize another Black than they do a White (Bothwell & others, 1989). And Hispanics more readily recognize another Hispanic whom they saw a couple hours earlier than they do an Anglo (Platz & Hosch, 1988).

This intriguing "own-race bias" appears to be an automatic cognitive phenomenon, for it is usually unrelated to the perceiver's racial attitudes (Brigham & Malpass, 1985). But experience may play a role. June Chance (1985) reports that White students have difficulty recognizing individual Japanese faces (although Japanese facial features are actually as varied as those of White faces). But White students become markedly better at recognizing Japanese faces if

The term "own-race bias" is a misnomer in the case of Anglo and Hispanic identifications. Both ethnic groups are classified as Caucasians.

Distinctive people—like this tourist visiting a Saturday market in Menghun, China— draw attention. Their salience may cause exaggerated perceptions of their good and bad qualities.

over several training sessions they view pairs of Japanese faces, which they must learn to differentiate. Chance's hunch is that experience enables people to become attuned to the types of faces they frequently encounter. This helps explain why Black people in White cultures are slightly better than Whites at recognizing faces from another race (Anthony & others, 1992). It also explains why to me all Cabbage Patch dolls looked alike, though they hardly looked alike to my nine-year-old daughter and her friends.

DISTINCTIVE STIMULI

Distinctive People Draw Attention

Other ways we perceive our worlds also breed stereotypes. Distinctive people and vivid or extreme occurrences often capture attention and distort judgments.

Have you ever found yourself working or socializing in a situation in which you were the only person present of your sex, race, or nationality? If so, your difference from the others probably made you more noticeable and the object of more attention. A Black in an otherwise White group, a man in an otherwise female group, or a woman in an otherwise male group seems more prominent and influential and to have exaggerated good and bad qualities (Crocker & McGraw, 1984; S. E. Taylor & others, 1979). This occurs because when someone in a group is made salient (conspicuous), we tend to see that person as causing whatever happens (Taylor & Fiske, 1978). If we are positioned to look at Joe, an average group member, Joe will seem to have a greater-than-average influence upon the group. People who capture our attention seem more responsible for what happens.

In an experiment at Harvard, Ellen Langer and Lois Imber (1980) found that students watching a videotape of a man reading paid closer attention when

they were led to think he was out of the ordinary—a cancer patient, a millionaire, or a homosexual. They detected characteristics of the man that other viewers ignored, and their evaluation of him was more extreme. Those who thought the man a cancer patient noticed his distinctive facial characteristics and bodily movements and thus perceived him as much more "different from most people" than did the other viewers. The extra attention paid to distinctive people creates an illusion that such people differ more from others than they really do. If people thought you had the IQ of a genius, they would probably notice things about you that otherwise would pass unnoticed.

However, sometimes we perceive others reacting to our distinctiveness when actually they aren't. At Dartmouth College, researchers Robert Kleck and Angelo Strenta (1980) discovered this when they led college women to feel disfigured. The women thought the purpose of the experiment was to assess how someone would react to a facial scar created with theatrical makeup on the right cheek, running from the ear to the mouth. Actually, the purpose was to see how the women themselves, when made to feel deviant, would perceive others' behavior toward them. After applying the makeup, the experimenter gave each subject a small hand mirror so she could see the authentic-looking scar. When she put the mirror down, he then applied some "moisturizer" to "keep the makeup from cracking." What the "moisturizer" really did was remove the scar.

The scene that followed was poignant. A young woman, feeling terribly self-conscious about her supposedly disfigured face, is talking with another woman who sees no such disfigurement and knows nothing of what has gone before. If you have ever felt similarly self-conscious—perhaps about a physical handicap, acne, even just "awful-looking hair"—then perhaps you can sympathize with the self-conscious woman. Compared to women led to believe their conversational partner merely thought they had an allergy, the "disfigured" women became acutely sensitive to how their partners were looking at them. They rated their partners as more tense, distant, and patronizing. But in fact, observers who later analyzed videotapes of how the partners treated "disfigured" persons could find no such differences in treatment. Self-conscious about being different, the "disfigured" women misinterpreted mannerisms and comments they would otherwise not notice.

The self-consciousness created by being a token minority— say, a man in a group of women or a woman in a group of men—can also disrupt one's normal thinking and memory processes, thereby making the token person seem inept (Lord & Saenz, 1985).

Vivid, Distinctive Cases

Our minds also use distinctive cases as a shortcut to judging groups. Are Blacks good athletes? "Well, there's Carl Lewis and Florence Griffith Joyner and Michael Jordan. Yeah, I'd say so." Note the thought processes at work here: We recall instances of a particular category and, based on those recalled, generalize. The problem, as noted in Chapter 2, is that vivid instances, though persuasive because of their greater impact on memory, are seldom representative of the larger group. Exceptional athletes, though distinctive and memorable, are not the best basis for judging the distribution of athletic talent among an entire ethnic group.

Two experiments demonstrate how distinctive cases fuel stereotypes. In one, Myron Rothbart and his colleagues (1978) had University of Oregon students view 50 slides, each of which stated the man's height. For one group of students, 10 of the men were slightly over 6 feet (up to 6 feet, 4 inches). For other students, these 10 men were well over 6 feet (up to 6 feet, 11 inches). When

asked later how many of the men were over 6 feet, those given the taller examples recalled 5 percent too many. In a follow-up experiment, students read descriptions of the actions of 50 men, 10 of whom had committed either nonviolent crimes, such as forgery, or violent crimes, such as rape. Of those shown the list with the violent crimes, most overestimated the number of criminal acts.

Because they are distinctive, we most easily remember extreme cases—and because they alone are newsworthy, they dominate our images of various groups. The attention-getting power of distinctive, extreme cases helps explain why middle-class people so greatly exaggerate the dissimilarities between themselves and the underclass. Contrary to stereotypes of "welfare queens" driving Cadillacs, people living in poverty generally share the aspirations of the middle class and would rather provide for themselves than accept public assistance (Cook & Curtin, 1987). Moreover, the less we know about a group, the more we are influenced by a vivid case or two (Quattrone & Jones, 1980). To see is to believe.

Distinctive Events Produce Illusory Correlations

Stereotypes assume a correlation between group membership and individuals' characteristics ("Italians are emotional," "Jews are shrewd," "Accountants are perfectionists"). Even under the best of conditions, our attentiveness to unusual occurrences can create **illusory correlations.** Because we are sensitive to distinctive events, the co-occurrence of two such events is especially noticeable—more noticeable than each of the times the unusual events do not occur together. Thus Rupert Brown and Amanda Smith (1989) found that British faculty members overestimated the number of (relatively rare, though noticeable) female senior faculty at their university.

David Hamilton and Robert Gifford (1976) demonstrated illusory correlation in a clever experiment. They showed students slides on which various people, members of "Group A" or "Group B," were said to have done something desirable or undesirable. For example, "John, a member of Group A, visited a sick friend in the hospital." Twice as many statements described members of Group A as Group B, but both groups did nine desirable acts for every four undesirable behaviors. Since both Group B and the undesirable acts were less frequent, their co-occurrence—for example, "Allen, a member of Group B, dented the fender of a parked car and didn't leave his name"—was an unusual combination that caught people's attention. The students therefore overestimated the frequency with which the "minority" group (B) acted undesirably and judged Group B more harshly.

Remember, Group B members actually committed undesirable acts in the same proportion as Group A members. Moreover, the students had no preexisting biases for or against Group B, and they received the information more systematically than daily experience ever offers it (Mullen & Johnson, 1990). Researchers debate the explanation for this phenomenon—that the joint occurrence of two distinctive events grabs attention (Fiedler, 1991; Hamilton & Sherman, 1989; Mullen & Johnson, 1990; Smith, 1991). But they agree that illusory correlation occurs and provides yet another source for the formation of racial stereotypes.

The mass media reflect and feed this phenomenon. When a self-described homosexual murders someone, homosexuality often gets mentioned. When a

Illusory correlation:
A false impression that two variables correlate. See Chapter 2.

heterosexual murders someone, this is a less distinctive event; the person's sexual orientation seldom gets mentioned. Likewise, when ex-mental patients like Mark Chapman and John Hinckley, Jr., shoot John Lennon and President Reagan, respectively, the person's mental history commands attention. Assassins and mental hospitalization are both relatively infrequent, making the combination especially newsworthy. Such reporting adds to the illusion of a large correlation between (1) violent tendencies and (2) homosexuality or mental hospitalization.

Unlike those who judged groups A and B, we often have preexisting biases. Further research by Hamilton with Terrence Rose (1980) reveals that our preexisting stereotypes can lead us to "see" correlations that aren't there. They had University of California, Santa Barbara, students read sentences in which various adjectives described the members of different occupational groups ("Doug, an accountant, is timid and thoughtful"). In actuality, each occupation was described equally often by each adjective; accountants, doctors, and salespeople were equally often timid, wealthy, and talkative. However, the students *thought* they had more often read descriptions of timid accountants, wealthy doctors, and talkative salespeople. Their stereotyping led them to perceive correlations that weren't there, thus helping to perpetuate the stereotypes (McArthur & Friedman, 1980). To believe is to see.

ATTRIBUTION: IS IT A JUST WORLD?

In explaining others' actions, we frequently commit the fundamental attribution error. We attribute their behavior so much to their inner dispositions that we discount important situational forces. The error occurs partly because our attention focuses on the persons themselves, not on their situations. A person's race or sex is vivid and attention-getting; the situational forces working upon that person are less visible. Slavery was often overlooked as an explanation for slave behavior; the behavior was instead attributed to the slaves' own nature. Until recently, the same was true of how we explained the perceived differences between women and men. Because gender-role constraints were hard to see, we attributed men's and women's behavior solely to their innate dispositions.

Fundamental attribution error:
See Chapter 3.

The Ultimate Attribution Error

Thomas Pettigrew (1979, 1980) argues that this fundamental attribution error becomes the **ultimate attribution error** when people explain the actions of people in groups. They grant members of their own group the benefit of the doubt: "She donated because she has a good heart; he refused because he had to under the circumstances." When explaining acts by members of other groups, people more often assume the worst: "He donated to gain favor; she refused because she's selfish." Hence, as we noted earlier in this chapter, the shove that Whites perceive as mere "horsing around" when done by another White becomes a "violent gesture" when done by a Black.

Positive behavior by outgroup members is more often dismissed. It may be seen as a "special case" ("He is certainly bright and hardworking—not at all like other Hispanics"), as due to luck or some special advantage ("She probably got admitted just because her med school had to fill its quota for women applicants"), as demanded by the situation ("Under the circumstances, what

Ultimate attribution error:
Bias characterized by granting the benefit of the doubt to members of one's own group, but not to members of other groups. Thus people attribute outgroup members' negative behavior to their dispositions but explain away positive behavior. (Also called "group-serving bias.")

could the cheap Scot do but pay the whole check?''), or as attributable to extra effort (''Jewish students get better grades because they're so compulsive''). Disadvantaged groups and groups that stress modesty (such as the Chinese) exhibit less of this *group-serving bias,* as the ultimate attribution error is also known (Hewstone & Ward, 1985; Fletcher & Ward, 1989).

Earlier we noted that blaming the victim can justify the blamer's own superior status. Blaming occurs as people attribute an outgroup's failures to its members' flawed dispositions, notes Miles Hewstone (1990): ''They fail because they're stupid; we fail because we didn't try.'' If women, Blacks, or Jews have been abused, they must somehow have brought it on themselves. When the British marched a group of German civilians around the Bergen-Belsen concentration camp at the close of World War II, one German responded: ''What terrible criminals these prisoners must have been to receive such treatment.''

The Just-World Phenomenon

In a series of experiments conducted at the Universities of Waterloo and Kentucky, Melvin Lerner and his colleagues (Lerner & Miller, 1978; Lerner, 1980) discovered that merely *observing* another person being innocently victimized is enough to make the victim seem less worthy. Imagine that you along with some others are participating in a study on the perception of emotional cues (Lerner & Simmons, 1966). One of the participants, a confederate, is selected by lottery to perform a memory task. This person receives painful shocks whenever she gives a wrong answer. You and the others note her emotional responses. After watching the victim receive these apparently painful shocks, the experimenter asks you to evaluate her. How would you respond? With compassionate sympathy? We might legitimately expect such. As Ralph Waldo

"Your Honor, we the jury blame the victim."

■ BEHIND THE SCENES

I still remember that day in 1979 when, as an Oxford graduate student, I was told by one of my advisors after a trip to the United States that "attribution theory was finished." Having hoped to integrate North American attribution theory with European theory about intergroup relations and prejudice, I was dismayed. Fortunately, my second advisor supported my exploring how people attribute motives to those in other groups. This research illustrates how the international field of social psychology benefits from both the North American and European perspectives. It also reminds me that, when rebuffed, students should seek a second opinion. If you glimpse an important phenomenon that begs to be studied, don't be easily deterred by current research fads and fashions.

MILES HEWSTONE, *University of Bristol*

Emerson wrote, "The martyr cannot be dishonored." On the contrary, the experiments revealed that when observers were powerless to alter the victim's fate, they often rejected and devalued the victim. Juvenal, the Roman satirist, anticipated these results: "The Roman mob follows after Fortune . . . and hates those who have been condemned."

Linda Carli and her colleagues (1989, 1990) report that this **just-world phenomenon** colors our impressions of rape victims. Carli had people read detailed descriptions of interactions between a man and a woman. Some read a scenario that has a happy ending: "Then he led me to the couch. He held my hand and asked me to marry him." In hindsight, people find the ending unsurprising and admire the man's and woman's character traits. Others read the same scenario with a different ending: "But then he became very rough and pushed me onto the couch. He held me down on the couch and raped me." Given this ending, people see it as more inevitable and blame the woman for behavior that seems faultless when it has a happier outcome.

Lerner (1980) believes such disparaging of hapless victims results from our need to believe, "I am a just person living in a just world, a world where people get what they deserve." From early childhood, he argues, we are taught that good is rewarded and evil punished. Hard work and virtue pay dividends; laziness and immorality do not. From this it is but a short leap to assuming that those who flourish must be good and those who suffer must deserve their fate. The classic illustration is the Old Testament story of Job, a good person who suffers terrible misfortune. Job's friends surmise that, this being a just world, Job must have done something wicked to elicit such terrible suffering.

All this suggests that people are indifferent to social injustice not because they have no concern for justice but because they *see* no injustice. What is more, believing in a just world—believing, as many people do, that rape victims must have behaved seductively (Borgida & Brekke, 1985), that battered spouses must have provoked their beatings (Summers & Feldman, 1984), that poor people don't deserve better (Furnham & Gunter, 1984), that sick people are responsible for their illness (Gruman & Sloan, 1983)—enables successful

Just-world phenomenon: The tendency of people to believe the world is just and that people therefore get what they deserve and deserve what they get.

The just-world phenomenon.

people to reassure themselves that they deserve what they have. The wealthy and healthy can see their own good fortune and others' misfortune as justly deserved. By linking good fortune with virtue and misfortune with moral failure the fortunate can feel pride in their achievements and avoid responsibility for the unfortunate.

People loathe a loser even when the loser's misfortune quite obviously stems from mere bad luck. People *know* that gambling outcomes are just good or bad luck and should not affect their evaluations of the gambler. Still, they can't resist playing Monday-morning quarterback—judging people by their results. Ignoring the fact that reasonable decisions can bring bad results, they judge losers as less competent (Baron & Hershey, 1988). Lawyers and stock market speculators may similarly judge themselves by their outcomes, becoming smug after successes and self-reproachful after failures. Talent and initiative are not unrelated to success. But the "It's-a-just-world" idea discounts the uncontrollable factors that can derail one's best efforts.

On a more hopeful note, our yearning to see and to have a just world lies waiting to be tapped. The same motive that leads us to disparage life's losers when we can do little to help can, when we finally recognize injustice, lead us to act (D. T. Miller, 1977). Once we see injustice, we are not indifferent to it.

COGNITIVE CONSEQUENCES OF STEREOTYPES

Stereotypes Are Self-Perpetuating

Prejudice is prejudgment. Prejudgments are inevitable. None of us is a dispassionate bookkeeper of social happenings, tallying evidence for and against our biases. Rather, our prejudgments guide our attention, our interpretations, and our memories (Bodenhausen, 1988; Hamilton & others, 1990).

Whenever a member of a group behaves as people expect, we duly note the fact; our prior belief is confirmed. When a member of a group behaves incon-

sistently with our expectation, we may explain away the behavior as due to special circumstances (Crocker & others, 1983). Or we may misinterpret it, leaving the prior belief intact. Recall, for example, the teachers' underestimates of the "cyranoids" in Chapter 1.

Perhaps you, too, can recall a time when, try as you might, you could not overcome someone's opinion of you, a time when no matter what you did you were misinterpreted. Such misinterpretations are likely when someone expects an unpleasant encounter with you (Wilder & Shapiro, 1989). William Ickes and his colleagues (1982) demonstrated this in an experiment with pairs of college-age men. Upon arrival, the experimenters falsely forewarned one member of each pair that the other subject was "one of the unfriendliest people I've talked to lately." The two were then introduced and left alone together for five minutes. Students in another condition were led to think the other subject was exceptionally friendly. Both groups were friendly to the new acquaintance. In fact, those who expected him to be *un*friendly went out of their way to be friendly, and their smiles and other friendly behaviors elicited a warm response. But unlike the positively biased students, those expecting an unfriendly person attributed this reciprocal friendliness to their own "kid-gloves" treatment of him. They afterward expressed more mistrust and dislike for the person and rated his behavior as less friendly. Despite their partner's actual friendliness, the negative bias induced these students to "see" hostilities lurking beneath his "forced smiles." As researcher David Hamilton (1981) quipped, "I wouldn't have seen it if I hadn't believed it!"

It would be an overstatement to say that we are absolutely blind to disconfirming facts. When Hamilton and George Bishop (1976) interviewed suburban Connecticut homeowners several times during the year following the arrival of a first Black neighbor, they found initial opposition melting. Fears that the new Black neighbors would not take care of their property or that property values would decline apparently proved groundless, partially disconfirming the negative stereotypes.

"Labels act like shrieking sirens, deafening us to all finer discriminations that we might otherwise perceive."
Gordon Allport, *The Nature of Prejudice*, 1954

■ FOCUS: Is It a Just World? Blaming the Rape Victim

The 21-year-old divorced mother had been drinking and socializing in Big Dan's Bar in New Bedford, Massachusetts. But had she invited her fate? Egged on by one another, several male patrons seized her, tore off most of her clothes, and gang-raped her on the barroom floor and then on the pool table while others in the bar applauded and cheered. In this and several other such incidents, dramatized in the 1988 movie, *The Accused*, many people condemned the victims as having "deserved it." "She had no business being in a bar," said one elderly woman. "She should have been home with her kids instead of destroying men's lives!"

This case, in both its actual and dramatized versions, illustrates our human readiness not only to credit people for their successes but to blame them for their misfortunes. In one national survey, 33 percent of British people agreed that women who have been raped are usually to blame for it (Wagstaff, 1982). In experiments, those given a description of a woman's friendly behavior with a man judge her actions as appropriate. Others, also told she gets raped by the man, judge the same behavior as inappropriate—as having invited the rape (Janoff-Bulman & others, 1985). If it's a just world, then victims can be blamed for their fates. But is the world always just?

Still, people's negative ideas about a person or a group are often hard to disconfirm (Rothbart & John, 1985). For one thing, a positive image—that one is gentle, sincere, or dependable—is easily reversed by just a few contrary behaviors. An unfavorable image—that one is deceitful, hostile, or unethical—is not so easily countered (Rothbart & Park, 1986). We can easily misinterpret someone's genuine friendliness as superficial smoothness. The resistance of negative stereotypes to disconfirming facts is sometimes alarming. In congressional testimony, California Governor Earl Warren warned of subversion by Japanese-Americans during World War II: "I take the view that this [lack of subversive activity] is the most ominous sign in our whole situation. It convinces me more than perhaps any other factor that the sabotage we are to get [is] timed just like Pearl Harbor was timed" (Daniels, 1975).

Information that is strikingly inconsistent with a stereotype can be hard to misinterpret and forget. Still, when the "exceptions" seem concentrated in a few atypical people, we can salvage the stereotype by splitting off a new category (Brewer, 1988; Johnston & Hewstone, 1992). Homeowners who have desirable Black neighbors can form a new stereotype of "professional, middle-class" Blacks. This subgroup stereotype helps maintain the larger stereotype that *most* Blacks make irresponsible neighbors. The positive image British schoolchildren form of their friendly school police officers—whom they perceive as in a special category—doesn't improve their image of police officers in general (Hewstone & others, 1992). One who believes that women are basically passive and dependent can split off a new stereotype category of "aggressive feminist" to handle women who don't fit the basic stereotype (S. E. Taylor, 1981). Similarly, people split their stereotypes of the elderly into the "grandmotherly" type, the "elder-statesman" type, and the inactive "senior-citizen" type (Brewer & Lui, 1984).

"There are no good women climbers. Women climbers either aren't good climbers or they aren't real women."
Anonymous climber (cited by Rothbart & Lewis, 1988)

Do Stereotypes Bias Our Judgments of Individuals?

There is an upbeat note on which we can conclude this chapter. People often evaluate individuals more positively than the groups they compose (Miller & Felicio, 1990). Anne Locksley, Eugene Borgida, and Nancy Brekke have found that once someone knows a person, "stereotypes may have minimal, if any, impact on judgments about that person" (Borgida & others, 1981; Locksley & others, 1980, 1982). They discovered this by giving University of Minnesota students anecdotal information about recent incidents in the life of "Nancy." In a supposed transcript of a telephone conversation, Nancy told a friend how she responded to three different situations (for example, being harassed by a seedy character while shopping). Some of the students read transcripts portraying Nancy responding assertively (telling the seedy character to leave); others read a report of passive responses (simply ignoring the character until he finally drifts away). Still other students received the same information, except that the person was named "Paul" instead of Nancy. A day later the students predicted how Nancy (or Paul) would respond to other situations.

Did knowing the person's sex have any effect on these predictions? None at all. Expectations of the person's assertiveness were influenced solely by what they had learned about that individual the day before. Even their judgments of masculinity and femininity were unaffected by knowing the person's sex. Gender stereotypes had been left on the shelf; the students evaluated Nancy and Paul as individuals.

Our friendships with those of a differing race or physical capacity often override our previous stereotypes. Sometimes, however, we salvage our stereotypes by splitting off a subgroup category that includes the people we know and like.

The explanation for this finding is implied by an important principle discussed in Chapter 2. Given (1) general (base-rate) information about a group and (2) trivial but vivid information about a particular group member, the vivid information usually overwhelms the effect of the general information. This is especially so when the person doesn't fit our image of the typical group member (Fein & Hilton, 1992; Lord & others, 1991). For example, imagine yourself being told how most people in an experiment actually behaved and then viewing a brief interview with one of the supposed subjects. Would you react like the typical viewer—by guessing the person's behavior from the interview, ignoring the base-rate information on how most people actually behaved?

Stereotypes are general beliefs about the distribution of traits in groups of people. For example, "assertiveness is found mostly in men, passiveness in women." People often believe such stereotypes, yet ignore them when given vivid, anecdotal information. Thus, many people believe "politicians are crooks" but "our Senator Jones has integrity." (No wonder Americans can have such a low opinion of politicians yet nearly always reelect their own politicians.) Similarly, the bigot who holds extreme stereotypes may claim, "One of my best friends is. . . ." Borgida, Locksley, and Brekke explain: "People may sustain general prejudices while simultaneously treating individuals with whom they frequently interact in a nonprejudicial manner."

These findings resolve a puzzling set of findings considered early in this chapter. We know that gender stereotypes (1) are strong yet (2) have little effect

on people's judgments of work attributed to a man or a woman. Now we see why. People may have strong gender stereotypes yet ignore them when judging a particular individual.

Sometimes, however, stereotypes do color our judgments of individuals. When Thomas Nelson, Monica Biernat, and Melvin Manis (1990) had students estimate the heights of individually pictured men and women, they judged the individual men as taller—even when their heights were equal, even when they were told that in this sample sex didn't predict height, and even when they were offered cash rewards for accuracy.

Given information that categorizes a person (say, told that someone they are about to meet suffers from schizophrenia), we form quick impressions of how much we like the person. Lacking such information, we take more time to examine the person's individual characteristics (Fiske & Pavelchak, 1986). Also, sometimes we make judgments, or begin interacting with someone, with little to go on but our stereotype. In such cases stereotypes can strongly bias our interpretations and memories of people (Crocker & Park, 1985; Krueger & Rothbart, 1988). For example, Charles Bond and his colleagues (1988) found that, after getting to know their patients, White psychiatric nurses equally often put Black and White patients in physical restraints. But they restrained *incoming* Black patients more often than their White counterparts. With little else to go on, stereotypes mattered.

Such bias can operate subtly. In an experiment by John Darley and Paget Gross (1983), Princeton University students viewed a videotape of a fourth-grade girl, Hannah. The tape depicted her either in a depressed urban neighborhood, supposedly the child of lower-class parents, or in an affluent suburban setting, the child of professional parents. Asked to guess Hannah's ability level in various subjects, both groups of viewers refused to use Hannah's class background to prejudge her ability level; each group rated her ability level at her grade level. Other students also viewed a second videotape, showing Hannah taking an oral achievement test in which she got some questions right and some wrong. Those who had previously been introduced to upper-class Hannah judged her answers as showing high ability and later recalled her getting most questions right; those who had met lower-class Hannah judged her ability as below grade level and recalled her missing almost half the questions. But remember: The second videotape was *identical* for both groups. So we see that when stereotypes are strong and the information about someone is ambiguous (unlike the cases of Nancy and Paul), stereotypes can *subtly* bias our judgments of individuals.

Finally, stereotypes sometimes bias our judgments of individuals by producing a contrast effect. A woman who rebukes someone cutting in front of her in a movie line ("Shouldn't you go to the end of the line?") may seem more assertive than a man who reacts similarly (Manis & others, 1988). Aided by the testimony of social psychologist Susan Fiske and her colleagues (1991), the U.S. Supreme Court saw such stereotyping at work when Price Waterhouse, one of the nation's top accounting firms, denied Ann Hopkins' promotion to partner. Among the 88 candidates for promotion, Hopkins, the only woman, was number one in the amount of business she brought in to the company and, by all accounts, was hard-driving, hardworking, and exacting. By other accounts, she needed a "course at charm school," where she could learn to "walk more femininely, talk more femininely, dress more femininely. . . ." After reflecting

on this, the Supreme Court in 1989 decided that encouraging men to be aggressive, but not women, is to act "on the basis of gender":

> We sit not to determine whether Ms. Hopkins is nice, but to decide whether the partners reacted negatively to her personality because she is a woman. . . . An employer who objects to aggressiveness in women but whose positions require this trait places women in an intolerable Catch 22: out of a job if they behave aggressively and out of a job if they don't.

Stereotypes more often bias our judgments of groups. Sometimes we judge groups as a whole. On such occasions, whether we personally know any members of the group is irrelevant. What matters—what shapes public policy—is our impression of the group as a whole. Once we come to know a particular person, we are often able to set aside stereotypes and prejudices. Yet both remain potent social forces.

Social psychologists have been more successful in explaining prejudice than in alleviating it. Because prejudice results from many interrelated factors, there is no simple remedy. Nevertheless, we can now anticipate techniques for reducing prejudice (discussed further in Chapters 13 and 15): If unequal status breeds prejudice, then we can seek to create cooperative, equal-status relationships. If prejudice often rationalizes discriminatory behavior, then we can mandate nondiscrimination. If social institutions support prejudice, then we can pull out those supports (for example, have the media model interracial harmony). If outgroups seem more unlike one's own group than they really are, then we can make efforts to personalize their members. These are some of the antidotes for the poison of prejudice.

Since the end of World War II in 1945, a number of these antidotes have been applied, and racial and gender prejudices have indeed diminished. It now remains to be seen whether, during the remaining years of this century, prog-

■ BEHIND THE SCENES

We risked a lot by having me testify on Ann Hopkins' behalf, no doubt about it. As far as we knew, no one had ever introduced the social psychology of stereotyping in a gender case before. Race discrimination cases have used social science evidence ever since the landmark 1954 *Brown vs. Board of Education* decision ending school desegregation. But gender cases had used only common sense or statistics, not social psychology, as evidence of discriminatory intent. I was a fresh assistant professor, sitting alone in my office, when attorney Sally Burns (now of New York University Law School) called me and proposed such testimony. Other people told me I was wasting my time, but I couldn't resist, as it seemed so exciting a chance. If we succeeded, we would get the latest stereotyping research out of the dusty journals and into the muddy trenches of legal debate, where it might be useful. If we failed, we might hurt the client, slander social psychology, and damage my reputation as a scientist. At the time I had no idea that the testimony would eventually make it successfully through the Supreme Court.

SUSAN T. FISKE, *University of Massachusetts*

ress will continue or whether, as could easily happen in a time of increasing population and diminishing resources, antagonisms will again erupt into open hostility.

■ SUMMING UP

HOW PERVASIVE IS PREJUDICE?

Stereotypical beliefs, prejudicial attitudes, and discriminatory behavior have long poisoned our social existence. Judging by what Americans have told survey researchers during the last four decades, prejudice against Blacks and women has plunged. Nevertheless, subtle survey questions, and indirect methods for assessing people's attitudes and behavior, still reveal strong gender stereotypes and a fair amount of disguised racial and gender bias. Prejudice, though less obvious, yet lurks.

Prejudice arises from an intricate interplay of social, emotional, and cognitive sources.

SOCIAL SOURCES OF PREJUDICE

The social situation breeds and maintains prejudice in several ways. A group that enjoys social and economic superiority will often justify its standing with prejudicial beliefs. Moreover, prejudice can lead people to treat others in ways that trigger expected behavior, thus seeming to confirm the view one holds. Experiments also reveal that an ingroup bias often arises from the mere fact of people's division into groups. Once established, prejudice continues partly through the inertia of conformity and partly through institutional supports, such as the mass media.

EMOTIONAL SOURCES OF PREJUDICE

Prejudice has emotional roots too. Frustration breeds hostility, which people sometimes vent on scapegoats and sometimes express more directly against competing groups perceived as responsible for one's frustration. By providing a feeling of social superiority, prejudice may also help cover one's feelings of inferiority. Different types of prejudice are often found together in those who have an "authoritarian" attitude.

COGNITIVE SOURCES OF PREJUDICE

A new look at prejudice has emerged. Research shows how the stereotyping that underlies prejudice is a by-product of our simplifying the world. First, clustering people into categories exaggerates the uniformity within a group and the differences between groups. Second, a distinctive individual, such as a lone minority person, has a compelling quality. Such persons make us aware of differences that would otherwise go unnoticed. Knowing little about another group, we may form a stereotype from our vivid impressions. The occurrence

of two distinctive events—say a minority person committing an unusual crime—helps create an illusory correlation between such people and such behavior. Third, attributing others' behavior to their dispositions can lead to the ultimate attribution error: assigning outgroup members' negative behavior to their natural character while explaining away their positive behaviors. Blaming the victim also results from the common presumption that because this is a just world, people get what they deserve.

Stereotypes have cognitive consequences and cognitive sources. By directing interpretations and memory, they lead us to "find" supportive evidence, even when none exists. Stereotypes are therefore resistant to change. Yet, when becoming acquainted with a person, people often ignore the group stereotype and judge the person individually. Stereotypes are more potent when judging unknown individuals and when considering whole groups.

■ FOR FURTHER READING

Altemeyer, B. (1988). *Enemies of freedom: Understanding right-wing authoritarianism.* San Francisco: Jossey-Bass. The complete report of a prize-winning analysis of why some people—notably those with self-righteous, authoritarian tendencies—belittle and brutalize socially disparaged outgroups.

Dovidio, J. F., & Gaertner, S. L. (Eds.). (1986). *Prejudice, discrimination, and racism.* Orlando, FL: Academic Press. The foremost researchers provide comprehensive summaries of recent research on prejudice, especially that involving White-Black relationships.

Katz, P. A., & Taylor, D. A. (1988). *Eliminating racism: Profiles in controversy.* New York: Plenum. Experts document the reality of prejudice against Blacks, Hispanics, Japanese Americans, Native Americans, and women and examine the fruitfulness of various remedies, such as desegregation, cooperative behavior, and affirmative action.

Taylor, D. M., & Moghaddam, F. M. (1987). *Theories of intergroup relations: International social psychological perspectives.* New York: Praeger. A skillful summary and evaluation of major theories of prejudice and group attitudes.

AGGRESSION: HURTING OTHERS

Humanity's potential for inhumanity is frightening. The *Bulletin of the Atomic Scientists* (1991) reports that the world has 50,000 nuclear warheads, each averaging 15 times more destructive power than the bomb that destroyed Hiroshima. Spending for arms and armies approaches $3 billion per *day,* or more than $200 per year for every person on earth—hundreds of millions of whom never receive $200 in one year (Figure 12-1).

Those who have trouble understanding the threat of annihilation have no difficulty understanding the threat of violent crime. Despite a temporary drop in the number of teen and young adult males, the U.S. rate of violent crime—murder, rape, robbery, and assault—continues upward (Figure 12-2). Although Woody Allen's one-time prediction that "by 1990 kidnapping will be the dominant mode of social interaction" has not been fulfilled, the odds of someone's being hit by violent crime have doubled since 1970. Reported assaults now exceed 1 million annually.

Is barbarism unique to the late twentieth century? The *Guinness Book of World Records* suggests not. Consider:

FIGURE 12-1 *World military expenditures (adjusted for inflation, with 1960 spending set at 100) have outstripped economic gains (gross national product per person).*
(From Sivard, 1991.)

Rate, per 100,000 population

FIGURE 12-2 *The U.S. violent crime rate doubled between 1970 and 1990. (Rate per 100,000 of murder, forcible rape, robbery, and aggravated assault.)*
(Data from *FBI Uniform Crime Reports*, 1971–1990.)

- *Bloodiest war:* World War II, with 55 million battle and civilian deaths, took more lives than all other wars together over the previous 500 years (Figure 12-3).
- *Bloodiest battle:* The first battle of the Somme in World War I, June 24 to November 13, 1916, which took more than 1 million lives.
- *Bloodiest civil war:* The Taiping rebellion in China about the time of the American Civil War, in which 20 to 30 million people were slaughtered.
- *Greatest mass killings:* The liquidation of 26 million Chinese in the first 16 years of Mao Tse-tung's regime (1949–1965). Stalin's purge of 1936 to 1938 killed 8 to 10 million Soviets.

Consider the fate of the Native Americans who, having welcomed Columbus ashore, were described by him as "ever sweet and gentle." Consider the Native Americans who generously saved the English from starvation after their 1620 landing in Plymouth. Except for those sold into slavery, both Native American groups were almost completely exterminated by the White invaders—a fate that eventually befell all but a fourth of the native population

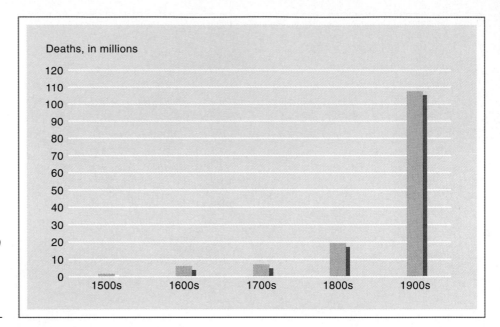

FIGURE 12-3 *Even after allowing for world population increases (from 0.5 billion in the 1500s to 2.5 billion in 1950 to 5 billion today), our century has seen the most war killings. (War death data from Sivard, 1991.)*

"Our behavior toward each other is the strangest, most unpredictable, and most unaccountable of all the phenomena with which we are obliged to live. In all of nature, there is nothing so threatening to humanity as humanity itself."
Lewis Thomas (1981)

Aggression:
Physical or verbal behavior intended to hurt someone.

(Brown, 1971). Sophistication and cultural achievements do not prevent such inhumanity. Nazi commanders at the Auschwitz camp in Poland—who exterminated up to 6000 people a day—spent their evenings relaxing to the music of Beethoven and Schubert.

Why this propensity to hurt others? Is it because we, like the mythical Minotaur, are half human, half beast? What circumstances prompt hostile outbursts? Can we control aggression? In this chapter, these are our questions. However, we first need to clarify this term, "aggression."

■ WHAT IS AGGRESSION?

"Aggression" has varied meanings. Clearly, the original Thugs, members of a criminal fraternity in northern India, were aggressing when between 1550 and 1850 they strangled more than 2 million people, claiming to do so in the service of a goddess. But when "aggressive" describes a dynamic salesperson, it takes on a different meaning. What is the difference?

Social psychologists debate how to define aggression, but they agree on this much: We should sharpen our vocabulary by distinguishing between self-assured, energetic, go-getting behavior and behavior that hurts, harms, or destroys. The former is assertiveness; the latter clearly and surely is aggression.

In Chapter 6 we defined **aggression** as physical or verbal behavior intended to hurt someone. This excludes auto accidents, dental treatments, and sidewalk collisions. It includes actions intended to hurt someone—slaps, direct insults, even gossipy "digs." Researchers typically measure aggression by having people decide how much to hurt someone, such as by having them choose how much electric shock to impose.

Our definition covers two distinct types of aggression. Animals exhibit so-

cial aggression, characterized by displays of rage, and silent aggression, as when a predator stalks its prey. Peter Marler (1974) reports that these two types of animal aggression involve separate brain regions. In humans, psychologists label the two types "hostile aggression" and "instrumental aggression." **Hostile aggression** springs from anger. Its goal is to injure. **Instrumental aggression** also aims to hurt but only as a means to some other end. In 1990, political leaders justified the Persian Gulf war not as a hostile effort to kill 100,000 Iraqis but as a means toward liberating Kuwait. Hostile aggression is "hot"; instrumental aggression is "cool."

Distinguishing between hostile and instrumental aggression is sometimes difficult. What begins as a cool, calculating act can ignite hostility. Still, social psychologists find the distinction useful. Most murders, for example, are hostile. They are impulsive, emotional outbursts—which explains why data from 110 nations show that enforcing the death penalty has not resulted in fewer homicides (Wilkes, 1987). But some murders are instrumental. Most of Chicago's 1000+ murders since 1919 by mob "hit men" were calculated to attain specific goals.

Hostile aggression:
Aggression driven by anger and performed as an end in itself.

Instrumental aggression:
Aggression that is a means to some other end.

■ THE NATURE OF AGGRESSION

In analyzing the cause of aggression, social psychologists have focused on three primary ideas: (1) There is an *inborn* aggressive drive. (2) Aggression is a natural response to *frustration.* (3) Aggressive behavior, like other social behaviors, is *learned.* Because hostile and instrumental aggression may have different causes, a combination of these explanations could well be valid.

The genocidal massacre of Native Americans by European invaders illustrates our human capacity for violence.

IS AGGRESSION INBORN?

Philosophers have long debated whether our human nature is fundamentally that of a benign, contented "noble savage" or that of a potentially explosive brute. The first view, popularly associated with the eighteenth-century philosopher Jean-Jacques Rousseau, blames society, not human nature, for social evils. The second, associated with the philosopher Thomas Hobbes (1588–1679), sees society's restrictions as necessary to restrain and control the human brute. In this century, the "brutish" view—that aggressive drive is inborn and thus inevitable—was most prominently argued by Sigmund Freud in Vienna and Konrad Lorenz in Germany.

Instinct Theory

Freud, the pioneering psychoanalyst, speculated that human aggression springs from our redirecting toward others the energy of a primitive death urge (which, loosely speaking, he called the "death instinct"). Lorenz, who studied animal behavior, saw aggression as adaptive rather than self-destructive. But both agreed that aggressive energy is instinctual. If not discharged, it supposedly builds up until it explodes or until an appropriate stimulus "releases" it, like a mouse releasing a mousetrap. Although Lorenz (1976) also argued that we have innate mechanisms for inhibiting aggression (such as making ourselves defenseless), he feared the implications of arming our "fighting instinct" without comparably arming our inhibitions.

Instinctive behavior:
An innate, unlearned behavior pattern exhibited by all members of a species.

"Some say the world will end in fire, Some say in ice. From what I've tasted of desire I hold with those who favor fire."
Robert Frost, "Fire and Ice" in *The Poetry of Robert Frost*, New York: Holt, Rinehart and Winston, 1969

Humanity has armed its capacity for destruction without comparably arming its capacity for the inhibition of aggression.

"Of course, we'll never actually <u>use</u> it against a potential enemy, but it will allow us to negotiate from a position of strength."

John Ruge

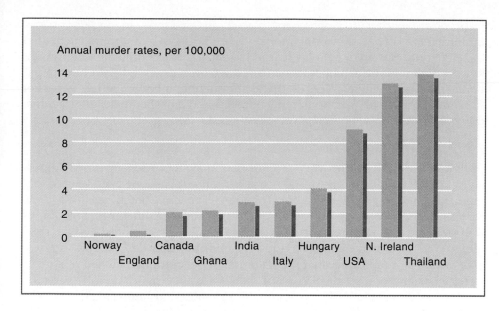

FIGURE 12-4 *Aggression varies by culture. Homicide rates during the early 1970s varied widely from country to country.*
(Data from Archer & Gartner, 1984.)

Social psychologists criticize the idea that aggressive energy instinctively wells up from within, quite apart from encounters with the environment. Among animals, aggression is more modifiable than the instinct theory suggests. Among humans, aggressiveness varies widely, from the peaceful Iroquois before the White invaders to the hostile Iroquois after the White invasion (Hornstein, 1976); from the nonviolence of Norway, where murder is rare, to the repeated killings of Northern Ireland; from the relatively gentle inhabitants of some South Sea islands to the warring South American Yanomamos, nearly half of whose surviving adult males have been involved in a killing (Chagnon, 1988) (Figure 12-4).

What is more, the use of instincts to explain social behavior fell into disrepute after sociologist Luther Bernard scanned books by 500 social scientists and in 1924 compiled a list of 5759 supposed human instincts (Barash, 1979, p. 4). What the social scientists had tried to do was *explain* social behavior by *naming* it. It's tempting to play this explaining-by-naming game: "Why do sheep stay together?" "Because of their herd instinct." "How do you know they have a herd instinct?" "Just look at them: They're always together!" Such circular explanation is, of course, no explanation at all.

Biological Influences

Although the human propensity to aggress may not qualify as an instinct, aggression *is* biologically influenced.

Neural Influences

Because aggression is a complex behavior, no one spot in the brain controls it. But in both animals and humans, researchers have found complex neural systems that facilitate aggression. When they activate these areas in the inner brain, hostility increases; when they deactivate them, hostility decreases. Docile animals can thus be provoked into rage, and raging animals into submission.

In one experiment, researchers placed an electrode in an aggression-inhibiting area of a domineering monkey's brain. Given a button that activated the electrode, one small monkey learned to push it every time the tyrant monkey got intimidating. Comparable effects have been observed with human patients. After receiving painless electrical stimulation in her amygdala (a part of the inner brain), one woman became enraged and smashed her guitar against the wall, barely missing her psychiatrist's head (Moyer, 1976).

Genetic Influences

Individuals of any species vary in their neural system's sensitivity to aggressive cues. One source of the difference is heredity. It has long been known that animals of many species can be bred for aggressiveness. Sometimes this is done for practical purposes (the breeding of fighting cocks). Sometimes, breeding is done for research. Kirsti Lagerspetz (1979), a Finnish psychologist, took normal albino mice and bred the most aggressive ones together and the least aggressive ones. After repeating the procedure for 26 generations, she had one set of fierce mice and one set of placid mice.

Aggressiveness similarly varies among primates and humans (Asher, 1987; Olweus, 1979). Our temperament—how intense and reactive we are—is partly something we bring with us into the world, influenced by our sympathetic nervous system's reactivity (Kagan, 1989). A person's temperament, observed in infancy, therefore endures (Larsen & Diener, 1987; Wilson & Matheny, 1986). Identical twins, when asked separately, are more likely than fraternal twins to agree on whether they have "a violent temper" (Rushton & others, 1986).

Biochemical Influences

Blood chemistry is another influence on neural sensitivity to aggressive stimulation. Both laboratory experiments and police data indicate that when people are provoked, alcohol diminishes restraints on aggression (Bushman & Cooper, 1990; Taylor & Leonard, 1983). The U.S. Department of Justice estimates that nearly a third of the nation's 523,000 state prisoners drank heavily before committing rapes, burglaries, and assaults (Desmond, 1987). Alcohol enhances aggressiveness by reducing people's self-awareness and their ability to consider the results of their actions (Hull & Bond, 1986; Steele & Southwick, 1985). Alcohol therefore deindividuates and disinhibits.

There are other biochemical influences too. Low blood sugar can boost aggressiveness. In males, aggressiveness is influenced by the male sex hormone, testosterone (Moyer, 1983). Although hormonal influences appear much stronger in lower animals than in humans, drugs that diminish testosterone levels in violent human males will subdue their aggressive tendencies. After age 25 testosterone and rates of violent crime both decrease. Among both male and female prisoners convicted of unprovoked violent crimes, testosterone levels tend to be higher than among those imprisoned for nonviolent crimes (Dabbs & others, 1988). And among the normal range of teen boys and adult men, those with high testosterone levels are more prone to delinquency, hard drug use, and aggressive responses to provocation (Archer, 1991; Dabbs & Morris, 1990; Olweus & others, 1988).

So, there exist important neural, genetic, and biochemical influences on aggression. But is aggression so much a part of human nature that it makes peace

Genes predispose the pit bull, like several other kinds of animals, to be aggressive.

unattainable? To counter such pessimism, the Council of Representatives of the American Psychological Association and the directors of the International Council of Psychologists have joined other organizations in unanimously endorsing a "statement on violence" developed by scientists from a dozen nations (Adams, 1991). "It is scientifically incorrect," declares the statement, to say that "war or any other violent behavior is genetically programmed into our human nature," or that "war is caused by 'instinct' or any single motivation." Thus there are, as we will see, ways to reduce human aggression.

IS AGGRESSION A RESPONSE TO FRUSTRATION?

It is a warm evening. Tired and thirsty after two hours of studying, you borrow some change from a friend and head for the nearest soft-drink machine. As the machine devours the change, you can almost taste the cold, refreshing cola. But when you push the button, nothing happens. You push it again. Then you flip the coin return button. Still nothing. Your throat is now feeling parched. Again, you hit the buttons. You slam them. And finally you shake and whack the machine. You stomp back to your studies, empty-handed and short-changed. Should your roommate beware? Are you now more likely to say or do something hurtful?

One of the first psychological theories of aggression, the popular frustration-aggression theory, answers yes. In fact, John Dollard and several of his Yale colleagues (1939) proposed that "aggression is always a consequence of frustration" and that "frustration always leads to some form of aggression" (p. 1). One cannot occur without the other.

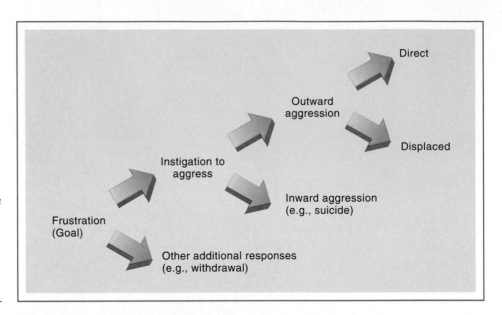

FIGURE 12-5 *The classic frustration-aggression theory. Frustration creates a motive to aggress. Fear of punishment or disapproval for aggressing against the source of frustration may cause the aggressive drive to be displaced against some other target or even redirected against oneself.*
(Based on Dollard & others, 1939, and Miller, 1941.)

Frustration:
The blocking of goal-directed behavior.

Displacement:
The redirection of aggression to a target other than the source of the frustration. Generally, the new target is a safer or more socially acceptable target.

Note that frustration-aggression theory is designed to explain hostile aggression, not instrumental aggression.

Frustration, said Dollard and his colleagues, is anything (such as the malfunctioning vending machine) that blocks our attaining a goal. Frustration grows when our motivation to achieve a goal is very strong, when we expected gratification, and when the blocking is complete.

As Figure 12-5 suggests, the aggressive energy need not explode directly against its source. We learn to inhibit direct retaliation, especially when others might disapprove or punish; instead we *displace* our hostilities to safer targets. **Displacement** occurs in the old anecdote about a man who, humiliated by his boss, berates his wife, who yells at their son, who kicks the dog, which bites the mail carrier.

Frustration-Aggression Theory Revised

Laboratory tests of the frustration-aggression theory produce mixed results: Sometimes frustration increases aggressiveness, sometimes not. For example, if the frustration is understandable—if, as in one experiment by Eugene Burnstein and Philip Worchel (1962), a confederate disrupts a group's problem solving because his hearing aid malfunctions (rather than just because he paid no attention)—then frustration leads to irritation but not aggression.

Knowing that the original theory overstated the frustration-aggression connection, Leonard Berkowitz (1978, 1989) revised it. Berkowitz theorized that frustration produces anger, an emotional readiness to aggress. Anger arises when someone who frustrates us could have chosen to act otherwise (Weiner, 1981; Averill, 1983). A frustrated person is especially likely to lash out when aggressive cues pull the cork, releasing bottled-up anger. Sometimes the cork will blow without such cues. But cues associated with aggression amplify aggression (Carlson & others, 1990).

Black clothing, often associated with aggression and death, can serve as an aggressive cue. Mark Frank and Thomas Gilovich (1988) report that, led by the Los Angeles Raiders and the Philadelphia Flyers, black-uniformed teams consistently ranked near the top of the National Football and Hockey Leagues in

penalties assessed between 1970 and 1986. In the laboratory, just putting on a black jersey can trigger the wearer to act more aggressively.

Berkowitz (1968, 1981) and others have found that the sight of a weapon—an obvious aggressive cue—also can heighten aggression. In one experiment, children who had just played with toy guns became more willing to knock down another child's blocks. In another, angered University of Wisconsin men gave more electric shocks to their tormenter when a rifle and a revolver were nearby (supposedly left over from a previous experiment) than when badminton racquets had been left behind (Berkowitz & LePage, 1967). Some experiments failed to replicate this "weapons effect," but enough have that Berkowitz is not surprised that half of all U.S. murders are committed with handguns and that handguns in homes are far more likely to kill household members than intruders. "Guns not only permit violence," he reports, "they can stimulate it as well. The finger pulls the trigger, but the trigger may also be pulling the finger."

Nor would Berkowitz be surprised that countries which ban handguns have lower murder rates. Britain, for example, has one-fourth as many people as the United States and one-sixteenth as many murders. The United States has 10,000 handgun homicides a year; Britain has about 10. Vancouver, British Columbia, and Seattle, Washington, have similar populations, climates, economies, and rates of criminal activity and assault—except that Vancouver, which carefully restricts handgun ownership, has one-fifth as many handgun murders as Seat-

The black uniforms worn by certain professional football and hockey league teams apparently serve as an aggressive cue, for such teams have exhibited higher rates of aggressive play.

tle and thus a 40 percent lower overall murder rate (Sloan & others, 1988). When Washington, D.C., adopted a law restricting handgun possession, the numbers of gun-related murders and suicides each abruptly dropped about 25 percent. No changes occurred in other methods of murder and suicide, nor did adjacent areas outside the reach of the law experience any such declines (Loftin & others, 1991).

Guns not only serve as aggression cues, they also put psychological distance between aggressor and victim. As Milgram's obedience studies taught us, remoteness from the victim facilitates cruelty. A knife attack can kill someone but is more difficult and less likely than pulling a trigger from a distance (Figure 12-6).

Is Frustration the Same as Deprivation?

Picture someone feeling extremely frustrated—economically, or sexually, or politically. My hunch is that most of you will imagine someone economically, or sexually, or politically *deprived*. But frustration is often *un*related to deprivation. The most sexually frustrated people are probably not celibate. The most economically frustrated people are probably not the impoverished residents of Jamaican shantytowns. As the 1969 National Commission on the Causes and Prevention of Violence concluded, economic advancements may even exacerbate frustration and escalate violence. Let's pause to examine this paradoxical conclusion.

Just before Detroit's 1967 riot, in which 43 people were killed and 683 structures burned, Michigan's Governor George Romney appeared on television's *Meet the Press.* He boasted about his state's leadership in civil rights legislation and about the $367 million in federal aid pumped into Detroit during the five preceding years. No sooner were his words broadcast than a large Black neighborhood in Detroit exploded into this century's worst U.S. civil disorder.

People were stunned. Why Detroit? Although things were still bad there relative to the affluence of the White populace, there were greater injustices elsewhere. The National Advisory Commission on Civil Disorders, established

FIGURE 12-6 *Weapons used to commit murder in the United States in 1990.*
(Source: *FBI Uniform Crime Reports,* 1991.)

50%	Handguns
4%	Rifles
6%	Shotguns
5%	Other guns or type unknown
18%	Cutting instruments
5%	Blunt objects
6%	Hands, feet
8%	Other weapons

to answer the question, concluded that one immediate psychological cause was the frustration of expectations fueled by the legislative and judicial civil rights victories of the 1960s. When there occurs a "revolution of rising expectations," as happened in Detroit and elsewhere, frustrations may escalate, even while conditions improve.

The principle works everywhere. The political scientist–social psychologist team of Ivo and Rosaline Feierabend (1968, 1972) applied the frustration-aggression theory in a study of political instability within 84 nations. When people in rapidly modernizing nations become urbanized and literacy improves, they become more aware of material improvements. However, since affluence usually diffuses slowly, the increasing gap between aspirations and achievements intensifies frustration. Even as deprivation diminishes, frustration and political aggression may therefore escalate. Expectation outstrips reality.

The point is not that actual deprivation and social injustice are irrelevant to social unrest; injustice can be a root cause, even if not the immediate psychological cause. The point is this: Frustration arises from the *gap* between expectations and attainments.

Does Money Alleviate Frustration?

The principle "frustration equals expectations minus attainments" helps us understand why economic satisfaction and frustration fluctuate. Consider the following rather bewildering set of facts: Fact 1: Americans at every income level, except the very top, have insisted that just 10 or 20 percent more income would make them happier (Strumpel, 1976). They believe more money would relieve their financial woes and buy more happiness. Three in four entering collegians declare that "being very well off financially" is a very important life goal (Astin & others, 1991). Fact 2: By the early 1990s, the average American was enjoying a disposable income (adjusted for inflation and taxes) double that of the mid-1950s. Moreover, Americans had more of what money buys—twice as many cars per capita, not to mention color TVs and VCRs in most homes and computers and answering machines in many. Given that most Americans believe money promotes happiness and that Americans do, in fact, have more money today than in decades past, they must be happier, right?

Wrong. Americans in recent years have been no more likely than those of the 1950s to report feeling happy and satisfied with their lives. In 1957, for example, 35 percent reported themselves "very happy." In 1991, after two decades of growing affluence, it was 31 percent (Figure 12-7). By some measures, such as rates of depression and teen suicide, modern affluence has been accompanied by greater despair.

Why are we not happier with our improving affluence? And how do yesterday's luxuries—color television, microwave ovens, stereo sound systems—become today's necessities? (One national survey revealed that two-thirds of Americans labeled a TV set, a clothes dryer, and aluminum foil as a "necessity" rather than a "luxury you could do without"—*Public Opinion*, 1984.)

The Adaptation-Level Phenomenon

Two principles developed by research psychologists help explain rising expectations and therefore continuing frustrations. The **adaptation-level phenomenon** implies that feelings of success and failure, satisfaction and dissatisfaction,

"Evils which are patiently endured when they seem inevitable become intolerable when once the idea of escape from them is suggested."
Alexis de Tocqueville, 1856

Parkinson's second law: Expenditures rise to meet income.

Adaptation-level phenomenon:
The tendency to adapt to a given level of stimulation and thus to notice and react to changes from that level.

FIGURE 12-7 *Does money buy happiness? Although buying power has doubled since the 1950s, self-reported happiness has not increased.*

(Income data from *Historical Statistics of the U.S.* and *Economic Indicators*. Happiness data cited by Niemi & others, 1989, and Tom Smith, 1990, personal communication.)

Per-person after-tax income in 1990 constant dollars

Percent describing themselves as "very happy"

— Personal income

— Very happy

are relative to prior achievements. If our current achievements fall below what we previously accomplished, we feel dissatisfied, frustrated; if they rise above that level, we feel successful, satisfied.

If we continue to achieve, however, we soon adapt to success. What formerly felt good now registers as neutral, and what formerly felt neutral now feels like deprivation. This helps explain why, despite the rapid increase in real income during the past several decades, the average American is no happier. Donald Campbell (1975) surmised that humans will never create a social paradise on earth. If we did achieve it, we would soon redefine "utopia" and once again feel sometimes pleased, sometimes deprived, sometimes neutral.

Most of us have experienced the adaptation-level phenomenon. More consumer goods, academic achievement, or social prestige provide an initial surge of pleasure. Yet, all too soon the feeling wanes. Now, we need an even higher level to give us another surge of pleasure. "Even as we contemplate our satisfaction with a given accomplishment, the satisfaction fades," noted Philip Brickman and Donald Campbell (1971), "to be replaced finally by a new indifference and a new level of striving."

A study of state lottery winners illustrates. Brickman and his colleagues, Dan Coates and Ronnie Janoff-Bulman (1978), found that at first the winners

"People are never happy for a thousand days."
Chinese proverb

Could Lucy ever experience enough "ups"? Not according to the adaptation-level phenomenon.

Many people think wealth equals well-being. But once used to a lifestyle like that of the characters on the TV series Dynasty, *people begin to feel the normal range of emotions, just like those who have adapted to a disability.*

typically felt elated: "Winning the lottery was one of the best things that ever happened to me." Yet their self-reported overall happiness did not increase. In fact, ordinary activities they had previously enjoyed, such as reading or eating a good breakfast, became less pleasurable. Winning the lottery was apparently such an emotional high that, by comparison, their ordinary pleasures paled.

Relative Deprivation

The dissatisfaction that comes with adapting to new highs is often compounded when we compare ourselves with others. Ephraim Yuchtman (1976) observed that feelings of well-being, especially among white-collar workers, depend on whether their compensation is equitable compared to others in their line of work. A salary raise for a city's police officers, while temporarily lifting their morale, may deflate that of the fire fighters.

"A house may be large or small; as long as the surrounding houses are equally small, it satisfies all social demands for a dwelling. But let a palace arise beside the little house, and it shrinks from a little house into a hut."
Karl Marx

In everyday life, when people experience an increase in affluence, status, or achievement, they raise the standards by which they evaluate their own attainments. When feeling good and climbing the ladder of success, people look up, not down (Gruder, 1977; Suls & Tesch, 1978; Wheeler & others, 1982). They attend to where they are going, often neglecting where they have come from. This "upward comparison" can cause feelings of **relative deprivation** (Williams, 1975; Wood, 1989).

Such feelings predict the reactions to perceived inequities by minority groups in the United States and Canada (Dion, 1985). Relative deprivation explains why women who make less than men working in the same occupations feel underpaid only if they compare themselves with male rather than female colleagues (Zanna & others, 1987). There are different versions of the relative deprivation principle. One emphasizes that social protest erupts not from feelings of *personal* deprivation but from the feeling that one's *group* is relatively deprived (Walker & Mann, 1987). But all versions agree that feelings of deprivation are determined not just by an objective situation but relative to some standard of comparison.

Relative deprivation: The perception that one is less well off than others to whom one compares oneself.

The term *relative deprivation* was coined by researchers studying the satisfaction felt by American soldiers in World War II (Merton & Kitt, 1950; Stouffer & others, 1949). Ironically, those in the Air Corps, where promotions were rapid and widespread, felt *more* frustrated about their own rate of promotion than those in the Military Police, for whom promotions were slow and unpredictable. The Air Corps' promotion rate was rapid, and most Air Corps personnel probably perceived themselves as better than the average Air Corps member (the self-serving bias). Thus, their aspirations likely soared higher than their achievements. The result? Frustration. And where there is frustration, aggressive tendencies often follow.

One possible source of such frustration today is the affluence depicted in television programs and commercials. Karen Hennigan and her co-workers (1982) analyzed crime rates in American cities around the time television was introduced. In 34 other cities where television ownership became widespread in 1951, the 1951 larceny theft rate (for crimes such as shoplifting and bicycle stealing) took an observable jump. In 34 other cities, where a government freeze had delayed the introduction of television until 1955, a similar jump in the theft rate occurred—in 1955. Why? Hennigan and her colleagues believe

> television caused younger and poorer persons (the major perpetrators of theft) to compare their life-styles and possessions with (a) those of wealthy television characters and (b) those portrayed in advertisements. Many of these viewers may have felt resentment and frustration over lacking the goods they could not afford, and some may have turned to crime as a way of obtaining the coveted goods and reducing any "relative deprivation."

Some Conclusions

The principles of adaptation-level and relative deprivation have a thought-provoking implication: Seeking satisfaction through material achievement requires continually expanding affluence merely to maintain satisfaction. "Poverty," said Plato, "consists not in the decrease of one's possessions, but in the increase of one's greed."

Fortunately, adaptation also can enable us to adjust downward, should we choose or be forced to simplify our lives. If our buying power shrinks, we initially feel some pain. But eventually we adapt to the new reality. In the aftermath of the 1970s gas price hikes, North Americans managed to substantially reduce their "need" for large, gas-slurping cars. Even paraplegics, the blind, and other people with severe handicaps usually show remarkable resilience. They adapt to their disability and achieve a normal or near-normal level of life satisfaction (Brickman & others, 1978; Chwalisz & others, 1988; Schulz & Decker, 1985). Victims of traumatic incidents surely must envy those who are not paralyzed, as many of us envy those who have won a state lottery. Yet, after a period of adjustment, none of these three groups differs appreciably from the others in moment-to-moment happiness. Human beings have an enormous capacity to adapt.

Finally, experiences that lower our comparison standards can renew our contentment. A research team led by Marshall Dermer (1979) put University of Wisconsin-Milwaukee women through some imaginative exercises in deprivation. After viewing depictions of how grim life was in Milwaukee in 1900, or after imagining and then writing about being burned and disfigured, the women expressed greater satisfaction with their own lives. In another experi-

"All our wants, beyond those which a very moderate income will supply, are purely imaginary."
Henry St. John,
Letter to Swift, 1719

"However great the discrepancies between men's lots, there is always a certain balance of joy and sorrow which equalizes all."
La Rochefoucauld, *Maxims*, 1665

ment, Jennifer Crocker and Lisa Gallo (1985) found that those who five times completed the sentence "I'm glad I'm not a . . ." afterward felt less depressed and more satisfied with life than did those who had completed sentences beginning "I wish I were a. . . ." For this reason, people facing personal threat often search for a silver lining by comparing downward (Gibbons & Gerrard, 1989; Taylor, 1989). Realizing that others have it worse helps people feel better about themselves. As Abraham Maslow (1972) noted:

> All you have to do is to go to a hospital and hear all the simple blessings that people never before realized *were* blessings—being able to urinate, to sleep on your side, to be able to swallow, to scratch an itch, etc. Could *exercises* in deprivation educate us faster about all our blessings? (p. 108)

IS AGGRESSION LEARNED SOCIAL BEHAVIOR?

The theories of aggression based on instinct and frustration assume that hostile urges erupt from inner emotions, which naturally "push" aggression from within. Social psychologists contend that learning also "pulls" aggression out of us.

The Rewards of Aggression

By experience and by observing others, we learn that *aggression often pays*. Through a series of successful bouts, experiments have transformed animals from docile creatures into ferocious fighters. Severe defeats, on the other hand, create submissiveness (Ginsburg & Allee, 1942; Kahn, 1951; Scott & Marston, 1953).

People, too, can learn the rewards of aggression. A child whose aggressive acts successfully intimidate other children will likely become increasingly aggressive (Patterson & others, 1967). Aggressive hockey players—the ones sent most often to the penalty box for rough play—score more goals than nonaggressive players (McCarthy & Kelly, 1978a, 1978b). Canadian teenage hockey players whose fathers applaud physically aggressive play show the most aggressive attitudes and style of play (Ennis & Zanna, 1991). In all these cases, aggression is instrumental in achieving certain rewards.

Collective violence can also pay. After the 1980 riot in Miami's Liberty City neighborhood, President Carter came to the neighborhood to assure residents personally of his concern and of forthcoming federal aid. After the 1967 Detroit riot, the Ford Motor Company accelerated its efforts to hire minority workers, prompting comedian Dick Gregory to joke, "Last summer the fire got too close to the Ford plant. Don't scorch the Mustangs, baby." After the 1985 riots in South Africa became severe, the government repealed laws forbidding mixed marriages, offered to restore Black "citizenship rights" (not including the right to vote), and eliminated the hated pass laws controlling the movement of Blacks. The point is not that people consciously plan riots for their instrumental value but that aggression sometimes has payoffs. If nothing more, it gets attention.

The same is true of terrorist acts, which enable powerless people to garner widespread attention. "Kill one, frighten ten thousand," asserts an ancient Chinese proverb. In this age of global communications, killing only a few can frighten tens of millions—as happened when the terrorist-caused deaths of 25 Americans in several incidents during 1985 struck more fear into the hearts of

travelers than the traffic-accident deaths of 46,000. Deprived of what Margaret Thatcher called "the oxygen of publicity," terrorism would surely diminish, concludes Jeffrey Rubin (1986). It's like the 1970s incidents of naked spectators "streaking" onto football fields for a few seconds of television exposure, which ended once the networks decided to ignore the incidents.

Observational Learning

Social learning theory:
The theory that we learn social behavior by observing and imitating and by being rewarded and punished.

Albert Bandura, the leading proponent of the **social learning theory** of aggression, believes that we learn aggression not only by experiencing its payoffs but also by observing others. Like many social behaviors, we acquire aggression by watching others act and noting the consequences.

Picture this scene from one of Bandura's experiments (Bandura & others, 1961). A Stanford nursery school child is put to work on an interesting art activity. An adult is in another part of the room, where there are Tinker Toys, a mallet, and a big, inflated doll. After a minute of working with the Tinker Toys, the adult gets up and for almost 10 minutes attacks the inflated doll. She pounds it with the mallet, kicks it, and throws it, all the while yelling, "Sock him in the nose. . . . Knock him down. . . . Kick him."

After observing this outburst, the child goes to a different room with many very attractive toys. But after two minutes the experimenter interrupts, saying these are her best toys and she must "save them for the other children." The frustrated child now goes into another room with various toys for aggressive and nonaggressive play, two of which are a Bobo doll and a mallet.

Seldom did children not exposed to the aggressive adult model display any aggressive play or talk. Although frustrated, they nevertheless played calmly. Those who had observed the aggressive adult were many times more likely to pick up the mallet and lash out at the doll. Watching the adult's aggressive

People learn aggression from aggressive models. The gang subculture, for example, provides its younger members with models of success based on toughness.

FIGURE 12-8 *The social learning view of aggression. The emotional arousal stemming from an aversive experience motivates aggression. Whether aggression or some other response actually occurs depends on what consequences we have learned to expect.*
(Based on Bandura, 1979.)

behavior lowered their inhibitions. Moreover, the children often reproduced the model's acts and said her words. Observing aggressive behavior had both lowered their inhibitions and taught them ways to aggress.

Bandura (1979) believes that in everyday life aggressive models appear in (1) the family, (2) the subculture, and (3) the mass media. Children of physically punitive parents tend to use similar aggression when relating to others. The parents of violent teenage boys and of abused children often themselves had parents who were physically punitive (Bandura & Walters, 1959; Strauss & Gelles, 1980). Although most abused children do not become criminals or abusive parents, 30 percent do later abuse their own children—four times the national rate (Kaufman & Zigler, 1987; Widom, 1989). Within families, violence often leads to violence.

The social environment outside the home also provides models. In communities where "macho" images are admired, aggression is readily transmitted to new generations (Cartwright, 1975; Short, 1969). The violent subculture of teenage gangs, for instance, provides its junior members with numerous aggressive models. At sporting events such as soccer games, player violence precedes most incidents of fan violence (Goldstein, 1982).

Although family or subculture may model aggression, television offers a much wider range of violent models. As we will see, viewing televised violence tends to (1) increase aggressiveness, (2) desensitize viewers to violence, and (3) shape their assumptions about social reality.

So, people learn aggressive responses both by experience and by observing aggressive models. But when will aggressive responses actually occur? Bandura (1979) contends that aggressive acts are motivated by a variety of aversive experiences—frustration, pain, insults (Figure 12—8). Such experiences arouse us emotionally. But whether we act aggressively depends upon the consequences we anticipate. Aggression is most likely when we are aroused *and* it seems safe and rewarding to aggress.

So far, we have looked at several theories of aggression. The social learning theory in particular offers a perspective from which we can examine specific influences on aggression.

■ INFLUENCES ON AGGRESSION

To a greater or lesser extent, we all know how to respond aggressively. We are each a potential aggressor. But under what conditions will we act? What will trigger or "pull" aggression out of us? Let's now look at a few influences: aversive incidents, arousal, the media, and the group.

AVERSIVE INCIDENTS

Pain

Researcher Nathan Azrin wanted to know if switching off foot shocks would reinforce two rats' positive interactions with each other. Azrin planned to turn on the shock and then, once the rats approached each other, cut off the pain. To his great surprise, the experiment proved impossible. As soon as the rats felt pain, they attacked each other, before the experimenter could switch off the shock. Azrin then dropped his initial research plans and, with colleagues Ronald Hutchinson (1983), Roger Ulrich, and Don Hake, undertook a series of studies on this pain-attack reaction.

First, they found that the greater the shock, the more violent the aggression. They also noted that the rats did not adapt to the shock. Given several thousand shocks a day, the attack response endured. What is more, rats reared in isolation reacted much the same way, suggesting an innate pain-attack reaction much like the natural frustration-aggression reaction theorized by John Dollard decades earlier.

Is this true of rats alone? The researchers found that with a wide variety of species, the cruelty the animals imposed upon each other matched zap for zap the cruelty imposed upon them. As Azrin (1967) explained, the pain-attack response occurred

> in many different strains of rats. Then we found that shock produced attack when pairs of the following species were caged together: some kinds of mice, hamsters, opossums, raccoons, marmosets, foxes, nutria, cats, snapping turtles, squirrel monkeys, ferrets, red squirrels, bantam roosters, alligators, crayfish, amphiuma (an amphibian), and several species of snakes including the boa constrictor, rattlesnake, brown rat-snake, cottonmouth, copperhead, and black snake. The shock-attack reaction was clearly present in many very different kinds of creatures. In all the species in which shock produced attack it was fast and consistent, in the same "push-button" manner as with the rats.

The animals were not choosy about their targets. They would attack animals of their own species and also those of a different species, or stuffed dolls, or even tennis balls.

Today's ethical guidelines for use of animals in research restrain investigators' use of painful stimuli.

Last, the researchers varied the source of pain. It was found that not just shocks induce attack; intense heat and "psychological pain"—for example, suddenly not rewarding hungry pigeons that have been trained to expect a grain reward after pecking at a disk—brought the same reaction. Such "psychological pain" is, of course, what we call frustration.

Consistent with social learning theory (Figure 12-8), these experiments demonstrated that in many animal species, aversive stimulation fuels aggression. Further consistent with Figure 12-8, aversive stimulation also increases the

likelihood of certain other behaviors, especially escape. Given a choice, many animals prefer to flee rather than fight. Azrin and his colleagues prevented alternative responses by restricting the animals to a small enclosure. Escape was impossible. So the animals did the next best thing—they attacked. In hindsight, we can see how pain-provoked fight and flight both have survival value, by terminating aversive stimulation.

Pain heightens aggressiveness in humans, also. Many of us can recall such a reaction after stubbing a toe or suffering a headache. Leonard Berkowitz and his associates demonstrated this by having University of Wisconsin students hold one hand in lukewarm water or painfully cold water. Those whose hands were submerged in the cold water reported feeling more irritable and more annoyed, and they were more willing to blast another person with unpleasant noise. In view of such results, Berkowitz (1983, 1989) now believes that aversive stimulation rather than frustration is the basic trigger of hostile aggression. Frustration is certainly one important type of unpleasantness. But any aversive event, whether a dashed expectation, a personal insult, or physical pain, can incite an emotional outburst. Even the torment of a depressed state can increase the likelihood of hostile aggressive behavior.

The pain-attack reaction: Upon receiving a shock or other painful effect, many animals will automatically attack whatever animal is within reach.

Heat

People have theorized for centuries about the effect of climate on human action. Hippocrates (ca. 460–377 B.C.), comparing the civilized Greece of his day to the savagery and human sacrifice in what we now know as Germany and Switzerland, believed the cause to be northern Europe's harsh climate. Later, the English attributed their "superior" culture to *England's* ideal climate. French thinkers proclaimed the same for France. Because climate remains steady while cultural traits change, the climate theory of culture obviously has limited validity.

However, temporary climate variations can affect behavior. Offensive odors, cigarette smoke, and air pollution have all been linked with aggressive behavior (Rotton & Frey, 1985). But the most-studied environmental irritant is heat. William Griffitt (1970; Griffitt & Veitch, 1971) found that compared to students who answered questionnaires in a room with a normal temperature, those who did so in an uncomfortably hot room (over 90°F) reported feeling more tired and aggressive and expressed more hostility toward a stranger. Follow-up experiments revealed that heat also triggers retaliative actions (Bell, 1980; Rule & others, 1987).

Does uncomfortable heat increase aggression in the real world as well as in the laboratory? Consider:

■ The riots occurring in 79 U.S. cities between 1967 and 1971 were more likely on hot than on cool days (Figure 12-9).

■ When the weather is hot in Houston, Texas, violent crimes are more likely (Figure 12-10). The same is true in Des Moines, Iowa (Cotton, 1981); Dayton, Ohio (Rotton & Frey, 1985); Indianapolis, Indiana (Cotton, 1986); and Dallas, Texas (Harries & Stadler, 1988).

■ Not only do hotter days have more violent crimes, so do hotter seasons of the year and hotter summers (Anderson, 1989).

I pray thee, good Mercutio, let's retire;
The day is hot, the Capulets abroad,
And, if we meet, we shall not 'scape a brawl,
For now, these hot days, is the mad blood stirring.
Shakespeare, *Romeo and Juliet*

FIGURE 12-9 *Between 1967 and 1971 the likelihood of a riot increased with temperature. (This does not mean that most riots occurred at temperatures above 90°F. Rather, on any given day above 90°F a riot was more likely than on any other given day of lower temperature.)*
(Data from Carlsmith & Anderson, 1979.)

Murders and rapes, per day

Temperature, °Fahrenheit

FIGURE 12-10 *Aversive heat and violent crime. On days between 1980 and 1982, the number of rapes and murders in Houston, Texas, was greater when the temperature reached the mid-90s.*

(From Anderson & Anderson, 1984.)

- In heat-stricken Phoenix, Arizona, drivers without air conditioning are more likely to honk at a stalled car (Kenrick & MacFarlane, 1986).

- During the 1986 to 1988 major league baseball seasons, the number of batters hit by a pitch was two-thirds greater for games played in the 90s than for games played below 80° (Reifman & others, 1991). Pitchers weren't wilder on hot days—they had no more walks and wild pitches. They just clobbered more batters.

Do these real-world findings show that heat discomfort directly fuels aggressiveness? Although this conclusion appears plausible, these *correlations* between temperature and aggression don't prove it. People certainly could be more irritable in hot, sticky weather. However, there may be other contributing factors. Maybe hot summer evenings lead people into the streets. There, other group influence factors may well take over. Judging from the laboratory experiments on aversive stimulation and from those on group aggression (see pages 452–453), my hunch is that such behavior is stimulated by *both* the heat and the group.

Attacks

Being attacked by another is especially conducive to aggression. Experiments at Kent State University by Stuart Taylor (Taylor & Pisano, 1971), at Washington State University by Harold Dengerink (Dengerink & Myers, 1977), and at Osaka University by Kennichi Ohbuchi and Toshihiro Kambara (1985) confirm that intentional attacks breed retaliatory attacks. In most of these experiments one person competes with another in a reaction-time contest. After each test trial, the winner chooses how much shock to give the loser. Actually, each subject is playing a programmed opponent, who steadily escalates the amount

"If someone hits you, you hit him back."
Defense Secretary Caspar Weinberger, justifying the U.S. bombing of Libya (quoted by Rowe, 1986)

of shock. Do the real subjects respond charitably, "turning the other cheek"? Hardly. Extracting "an eye for an eye" is the more likely response. When attacked, subjects usually retaliate in kind.

Crowding

Crowding:
A subjective feeling of not enough space per person.

Crowding—the subjective feeling of not having enough space—is stressful. Crammed in the back of a bus, trapped in slow-moving freeway traffic, or living three to a small room in a college dorm diminishes one's sense of control (Baron & others, 1976; McNeel, 1980). Might such experiences also heighten aggression?

The stress experienced by animals allowed to overpopulate a confined environment does produce heightened aggressiveness, along with abnormal sexual behavior and even an inflated death rate (Calhoun, 1962; Christian & others, 1960). But it is a rather large leap from rats in an enclosure or deer on an island to human beings in a city. Nevertheless, it's true that dense urban areas do experience higher rates of crime and emotional distress (Fleming & others, 1987; Kirmeyer, 1978). Even when they *don't* suffer higher crime rates, residents of crowded cities may *feel* more fearful. Toronto's crime rate is four times higher than Hong Kong's. Yet people from Hong Kong, which is four times more densely populated than Toronto, report feeling more fearful on their city's streets than do people from Toronto (Gifford & Peacock, 1979).

AROUSAL

So far we have seen that various aversive stimulations can arouse anger. Do other types of arousal, such as those that accompany exercise or sexual excitement, have a similar effect? Imagine that Tawna, having just finished a stimulating short run, comes home to discover that her date for the evening has called and left word that he has made other plans. Will Tawna more likely explode in fury after her run than if she discovered the same message after awakening from a nap? Or, having just exercised, will her aggressive tendencies have been exorcised? To look for an answer, let's examine some intriguing research on how we interpret and label our bodily states.

In a now famous experiment, Stanley Schachter and Jerome Singer (1962) found we can experience an aroused bodily state in different ways. They aroused University of Minnesota men by injecting adrenaline, producing feelings of body flushing, heart palpitation, and more rapid breathing. When forewarned that the drug would produce these effects, the men felt little emotion, even when waiting with either a hostile or a euphoric person. Of course; they could readily attribute their bodily sensations to the drug. Schachter and Singer led another group of men to believe the drug produced no such side effects. Then they, too, were placed in the company of a hostile or euphoric person. How did they feel and act? Angrily when with the hostile person; amused when with the person who was euphoric.

Other experiments indicate that arousal is not as emotionally undifferentiated as Schachter believed. Yet being physically stirred up does intensify just about any emotion (Reisenzein, 1983). For example, Paul Biner (1991) reports that people find radio static unpleasant, *especially* when they are aroused by bright lighting. And Dolf Zillmann (1988), Jennings Bryant, and their collabora-

FIGURE 12-11 *What emotion we experience depends on how we interpret and label our bodily states. If we attribute arousal to aggressive stimuli, we will likely experience anger.*

tors found that people who have just pumped an exercise bike or watched a film of a Beatles rock concert find it easy to misattribute their arousal to a provocation. They then retaliate with heightened aggression. While common sense might lead us to assume that Tawna's run would have drained her aggressive tensions, enabling her to accept bad news calmly, these studies show that arousal feeds emotions.

If you understand this principle—that a given state of bodily arousal feeds one emotion or another, depending on how the person interprets and labels the arousal—then you will anticipate the following outcome. Russell Geen and his co-researchers (1972) had a confederate subject administer electric shocks to some University of Missouri men while they were reading a sexually stimulating story. Either the shocks or the story alone would have aroused the men. But, while wired to physiological instruments, some saw dials showing they were experiencing strong "shock arousal" but little "sexual arousal." Others saw dials that led them to believe their arousal came from the story. Question: When their turn came to do the shocking, which group of men delivered the most shock?

Geen predicted, and found, that those led to believe they were aroused by the shocks labeled their arousal as anger (Figure 12-11). They reciprocated by giving the confederate what they believed were more and stronger shocks.

Sexual arousal and other forms of arousal, such as anger, can also amplify one another (Zillmann, 1989). Love is never so passionate as after a fight or a fright. In the laboratory, erotic stimuli are more arousing to people who have just been frightened. The arousal of a roller coaster ride may similarly spill over into romantic feeling for one's partner.

THE MEDIA

Given that excitation transfers from one realm to another, might sexual arousal amplify aggressive responses to insults and aggravations? If so, what are the social consequences of pornography (which *Webster's* defines as erotic depictions intended to excite sexual arousal)? And what are the effects of modeling violence in movies and on television?

Pornography and Sexual Violence

Repeated exposure to erotic films has several effects. It can decrease attraction for a less exciting partner (see page 479). It may also increase acceptance of extramarital sex and of women's sexual submission to men (Zillmann, 1989). Rock music video images of macho men and sexually acquiescent women can similarly color viewers' perceptions of men and women (Hansen, 1988; Hansen & Hansen 1989, 1990; St. Lawrence & Joyner, 1991). But social-psychological research has focused mostly on depictions of sexual violence.

A typical sexually violent episode finds a rapist forcing himself upon a female victim. She at first resists and tries to fight off her attacker. Gradually she becomes sexually aroused, and as she does, her resistance melts. By the end she is in ecstasy, pleading for more. We have all viewed or read nonpornographic versions of this sequence: She resists, he persists. Dashing man grabs and forcibly kisses protesting woman. Within moments, the arms that were pushing him away are clutching him tight, her resistance overwhelmed by her unleashed passion. In *Gone with the Wind*, Scarlett O'Hara is carried to bed protesting and kicking, and wakes up singing.

Social psychologists report that viewing such fictional scenes of a man overpowering and arousing a woman can (1) distort one's perceptions of how women actually respond to sexual coercion and (2) increase men's aggression against women, at least in laboratory settings.

Distorted Perceptions of Sexual Reality

Does viewing sexual violence reinforce the myth that some women would welcome sexual assault—that "'no' doesn't really mean no"? To find out, Neil Malamuth and James Check (1981) showed University of Manitoba men either two nonsexual movies or two movies depicting a man sexually overcoming a woman. A week later, when surveyed by a different experimenter, those who saw the films with mild sexual violence were more accepting of violence against women. Note that the sexual message was subtle and unlikely to elicit counterarguing. (Recall from Chapter 8 that more persuasion occurs when a disagreeable message slips in without provoking people to counterargue.)

Viewing slasher movies has much the same effect. Men shown films such as the *Texas Chainsaw Massacre* become desensitized to brutality and more likely to view rape victims unsympathetically (Linz & others, 1988, 1989). In fact, say researchers Edward Donnerstein, Daniel Linz, and Steven Penrod (1987), what better way for an evil character to enable people to react calmly to the torture and mutilation of women than to show a gradually escalating series of such films.

Aggression against Women

Evidence also accumulates that pornography may contribute to men's aggression toward women. Correlational studies suggest that possibility. John Court (1984) notes that across the world, as pornography became more widely available during the 1960s and 1970s, the rate of reported rapes sharply increased—except in countries and areas where pornography has been controlled. (The examples that counter this trend—such as Japan, where violent pornography is available but the rape rate is low—remind us that other factors are also important.) In Hawaii, the number of reported rapes rose ninefold between 1960 and

"Pornography that portrays sexual aggression as pleasurable for the victim increases the acceptance of the use of coercion in sexual relations."
Social science consensus at Surgeon General's Workshop on Pornography and Public Health (Koop, 1987)

"Pornography is the theory and rape the practice."
Robin Morgan (1980, p. 139)

1974, then dropped when restraints on pornography were temporarily imposed, then rose again when the restraints were lifted.

In another correlational study, Larry Baron and Murray Straus (1984), discovered that the sales of "soft-core" sexually explicit magazines (such as *Hustler* and *Playboy*) in each of the 50 states correlates with state rape rates. After controlling for other factors, such as the percentage of young males in each state, a positive relationship remained. Alaska ranked first in sex magazine sales and first in rape. Nevada was second on both measures.

When interviewed, Canadian and American sexual offenders commonly acknowledge pornography use. For example, William Marshall (1989) reports that Ontario rapists and child molesters use pornography much more than men who are not sexual offenders. An FBI study also reports considerable exposure to pornography among serial killers (Ressler & others, 1988). Of course, this *correlation* cannot prove that pornography is a contributing *cause* of rape. Maybe the offenders' use of pornography is merely a symptom and not a cause of their basic deviance.

Although limited to the sorts of short-term behaviors that can be studied in the laboratory, controlled experiments reveal that—to quote a consensus statement by 21 leading social scientists—"exposure to violent pornography increases punitive behavior toward women" (Koop, 1987). One of these social scientists, Edward Donnerstein (1980), had shown 120 University of Wisconsin men either a neutral, an erotic, or an aggressive-erotic (rape) film. Then, the men, supposedly as part of another experiment, "taught" a male or female

Was the use of pornography by Milwaukee mass murderer Jeffrey Dahmer (in whose apartment police found pornographic tapes) merely a symptom of his derangement, or also a contributing cause? Did the comments of Ted Bundy (shown here on the eve of his execution for a series of rape-murders) illustrate this causal effect, or was it just a handy excuse? "The most damaging kinds of pornography [involve] violence. Like an addiction, you keep on craving something that is harder, harder, something which gives you a greater sense of excitement. Until you reach a point where the pornography only goes so far, you reach that jumping off point where you begin to wonder if maybe actually doing it would give you that which is beyond just reading it or looking at it."

FIGURE 12-12 *After viewing an aggressive-erotic film, college men delivered stronger shocks than before, especially to a woman.*
(Data from Donnerstein, 1980.)

confederate some nonsense syllables by choosing how much shock to administer for incorrect answers. The men who had watched the rape film administered markedly stronger shocks—but only to female victims (Figure 12-12).

If the ethics of conducting experiments such as these trouble you, rest assured that these researchers appreciate the controversial and powerful experience they are giving participants, and they are careful to warn participants what they might be shown. Only after giving their knowing consent do people participate. Moreover, after the experiment researchers debunk any rape myths the film communicated. One hopes that such debriefing sufficiently offsets the vivid image of a supposedly euphoric rape victim. Judging from studies with University of Manitoba and Winnipeg students by James Check and Neil Malamuth (1984; Malamuth & Check, 1984), it does. Those who read erotic rape stories and were then debriefed became less accepting of the "women-enjoy-rape" myth than students who had not seen the film. Similarly, Donnerstein and Berkowitz (1981) found that Wisconsin students who viewed pornography *and* were then thoroughly debriefed were later *less* likely than other students to agree that "being roughed up is sexually stimulating to many women."

The U.S. rape rate is reportedly 4 times higher than Germany's, 13 times higher than England's, and 20 times higher than Japan's (Gelman, 1990).

Justification for this experimentation is not only scientific but also humanitarian. In 1990, some 103,000 U.S. women—one every 5 minutes—were known to have suffered the horror of forcible rape—four times the rate of 25 years earlier (FBI *Uniform Crime Reports*, 1971 to 1990). In surveys of 6200 college students nationwide and 2200 Ohio working women, Mary Koss and her colleagues (1988, 1989, 1990) found that 28 percent of the women reported an experience that meets the legal definition of rape or attempted rape (although most, having been overcome on a date or by an acquaintance, didn't label it as such). Three in four stranger rapes and nearly all acquaintance rapes went unreported to police. Thus the known rape rate *greatly* underestimates the

actual rape rate. Moreover, many more women—half in one recent survey of college women (Sandberg & others, 1985)—report having suffered some form of sexual assault while on a date, and even more have experienced verbal sexual coercion or harassment (Craig, 1990; Pryor, 1987).

Eight different surveys have asked college males whether there was any chance they would rape a woman "if you could be assured that no one would know and that you could in no way be punished" (Stille & others, 1987). A disturbing proportion—about one-third—admit to at least a slim possibility of doing so. Are these admissions of attraction to sexual aggression believable? Researcher Malamuth (1984, 1989) says yes. Compared to men who indicate no possibility of raping, those who do are more like convicted rapists in their belief in rape myths and in their being sexually aroused by rape depictions. Moreover, those who admit the possibility of raping behave more aggressively toward women in both laboratory and dating situations, especially if they have formed the sort of rape-supportive attitudes that pornography cultivates. Men who behave in sexually coercive, aggressive ways typically desire dominance, exhibit hostility toward women, and are sexually experienced (Malamuth, 1986).

Malamuth, Donnerstein, and Zillmann are among those alarmed by women's increasing risk of being raped. They caution against oversimplifying the complex causes of rape—which is no more attributable to any one cause than is cancer. Yet they conclude that viewing violence, especially sexual violence, can have antisocial effects. Just as most Germans quietly tolerated the degrading anti-Semitic images that fed the Holocaust, so most people today tolerate media images of women that feed what some call the growing "female holocaust" of sexual harassment, abuse, and rape. Susan Brownmiller (1980, 1984), author of *Against Our Will: Women and Rape*, challenges our tolerance of aggressive pornography, which she views as "propaganda against women." Liberals would not tolerate pornographic depictions of Jewish victims being abused by Gentiles or of Blacks being abused by Whites but have condoned such depictions when women are the victims of men. Brownmiller calls for an end to this double standard.

> "Society doesn't expect Jews to stop anti-Semitism, or Blacks to stop racism, or children to end child abuse."
> Katha Pollitt, "Georgie Porgie is a Bully," 1990

Rather than advocate censorship, many psychologists favor "media awareness training." Recall that pornography researchers have successfully resensitized and educated participants to women's actual responses to sexual violence. Could educators similarly promote critical viewing skills? By sensitizing people to the view of women that predominates in pornography and to issues of sexual harassment and violence, it should be possible to counter the myth that women enjoy being coerced. "Our utopian and perhaps naive hope," say Edward Donnerstein, Daniel Linz, and Steven Penrod (1987, p. 196), "is that in the end the truth revealed through good science will prevail and the public will be convinced that these images not only demean those portrayed but also those who view them."

Is the hope naive? Consider: Without prohibition, growing health consciousness and alcohol awareness has increased the number of nondrinkers in the United States from 29 percent in 1978 to 43 percent in 1990 (Gallup & Newport, 1990). Without banning cigarettes, the number of smokers has dropped from 43 percent in 1972 to 27 percent in 1989 (Gallup Organization, 1989). Without censoring racism, once-common media images of African-Americans as childlike, superstitious buffoons have nearly disappeared. As public consciousness

> "What we're trying to do is raise the level of awareness of violence against women and pornography to at least the level of awareness of racist and Ku Klux Klan literature."
> Gloria Steinem (1988)

■ BEHIND THE SCENES

Having heard opposing claims from people who seemed sure that pornography was ''good,'' ''bad,'' or ''innocuous,'' we thought that careful research could inform the debate and guide public policy. To some degree this has happened. But we learned that people with strong opinions often use scientific data selectively. If the findings support their beliefs, they try to ignore or discount the research. We have therefore been appalled at the way our findings sometimes get misrepresented and oversimplified in the mass media.

NEIL M. MALAMUTH, *University of Michigan*
ED DONNERSTEIN, *University of California, Santa Barbara*

changed, script writers, producers, and media executives decided that exploitative images of minorities were not good. More recently they have decided that drugs are not glamorous, as many films and songs from the 1960s and 1970s implied, but dangerous. Will we one day look back with embarrassment on the time when movies entertained people with scenes of exploitation, mutilation, and sexual coercion?

Television

We have seen that watching an aggressive model can unleash children's aggressive urges and teach them new ways to aggress. And we have seen that after viewing sexual violence, college men act more violently toward a woman who has angered them. Such findings cause many people concern about television's effect on viewers.

"The problem with television is that people must sit and keep their eyes glued on a screen: the average American family hasn't time for it. Therefore, the showmen are convinced that . . . television will never be a serious competitor of [radio] broadcasting."
New York Times, March 19, 1939

Consider these few facts about watching television. In 1945, the Gallup poll asked Americans, ''Do you know what television is?'' (Gallup, 1972, p. 551). Today, in America, as in much of the industrialized world, 98 percent of households have a TV set, more than have bathtubs or telephones. In the average home, the set is on seven hours a day, with a household member watching it for about four of those hours. Women watch more than men, non-Whites more than Whites, preschoolers and retired people more than those in school or working, and the less educated more than the highly educated (Nielsen, 1990). For the most part, these facts about Americans' viewing habits also characterize Europeans, Australians, and Japanese (Murray & Kippax, 1979).

During all those hours, what social behaviors are modeled? Since 1967, George Gerbner and other TV watchers (1990) at the University of Pennsylvania have been sampling U.S. network prime-time and Saturday morning entertainment programs. Their findings? Seven of ten programs contain violence (''physically compelling action that threatens to hurt or kill, or actual hurting or killing''). Prime-time programs average five violent acts per hour, Saturday

morning children's programs 25 per hour. Since 1967 the yearly rates of televised cruelty have never varied by more than 30 percent from the average for the whole period. Reflecting on his 22 years of cruelty counting, Gerbner (in press) lamented, "Humankind has had more bloodthirsty eras but none as filled with *images* of violence as the present. We are awash in a tide of violent representations the world has never seen . . . drenching every home with graphic scenes of expertly choreographed brutality."

These two facts—(1) more than 1000 hours a year of television watching per person and (2) a heavy dose of aggression in the typical television diet—arouse concern about the cumulative effects of viewing. Does prime-time crime stimulate the behavior it depicts? Or, as viewers vicariously participate in aggressive acts, do the shows drain off aggressive energy?

The latter idea, a variation on the **catharsis** hypothesis, postulates that experiencing an emotion is a way to release it. Generalized to viewing aggression, the catharsis hypothesis would maintain that watching violent drama enables people to release their pent-up hostilities. Defenders of the media cite this theory frequently and remind us that violence predates television. In an imaginary debate with one of television's critics, the medium's defender might argue, "Television played no role in the genocides of Jews and Native Americans. Television just reflects and caters to our tastes." "Agreed," responds the critic, "but it's also true that during America's TV age violent crime has increased several times faster than the population rate. Surely you don't mean the popular arts are mere passive reflections, without any power to influence public consciousness." The defender replies: "The violence epidemic results from many factors. TV may even reduce aggression by keeping people off the streets and by offering them a harmless opportunity to vent their aggression."

The debate goes on. Studies of television viewing and aggression aim to identify effects more subtle and pervasive than the occasional "copy-cat" murders that capture public attention. They ask: How does television affect viewers' *behavior*? viewers' *thinking*?

Television's Effects on Behavior
Do viewers imitate violent models? Examples abound of people reenacting television crimes. In one informal survey of 208 prison convicts, 9 of 10 admitted that by watching crime programs they learned new criminal tricks. And 4 out of 10 said they had attempted specific crimes seen on television (*TV Guide*, 1977).

Correlation of TV Viewing and Behavior Crime stories are not scientific evidence. Nor do they tell us how television affects those who have never committed violent crimes. Researchers therefore use correlational and experimental studies to examine the effects of viewing violence. One technique, commonly used with schoolchildren, asks whether their TV watching predicts their aggressiveness. To some extent it does. The more violent the content of the child's TV viewing, the more aggressive the child (Eron, 1987; Turner & others, 1986). The relationship is modest but consistently found in the United States, Europe, and Australia.

So can we conclude that a violent TV diet fuels aggression? Perhaps you are already thinking that because this is a correlational study, the cause-effect relation could also work in the opposite direction. Maybe aggressive children pre-

Catharsis:
Emotional release. The catharsis view of aggression is that aggressive drive is reduced when one "releases" aggressive energy, either by acting aggressively or by fantasizing aggression.

"One of television's great contributions is that it brought murder back into the home where it belongs. Seeing a murder on television can be good therapy. It can help work off one's antagonisms."
Alfred Hitchcock

fer aggressive programs. Or maybe some underlying third factor, such as lower intelligence, predisposes some children both to prefer aggressive programs and to act aggressively.

Researchers have developed two ways to test these alternative explanations. They test the "hidden-third-factor" explanation by statistically pulling out the influence of some of these possible factors. For example, British researcher William Belson (1978; Muson, 1978) studied 1565 London boys. Compared to those who watched little violence, those who watched a great deal (especially realistic rather than cartoon violence) admitted to 50 percent more violent acts during the preceding six months (for example, "I busted the telephone in a telephone box"). Belson also examined 22 likely third factors, such as family size. The heavy and light viewers still differed after equating them with respect to potential third factors. So Belson surmised that the heavy viewers were indeed more violent *because* of their TV exposure.

Similarly, Leonard Eron and Rowell Huesmann (1980, 1985) found that violence viewing among 875 eight-year-olds correlated with aggressiveness even after statistically pulling out several obvious possible third factors. Moreover, when they restudied these individuals as 19-year-olds, they discovered that violence viewing at age 8 modestly predicted aggressiveness at age 19, but that aggressiveness at age 8 did *not* predict the viewing of violence at age 19. Thus aggression followed viewing, not the reverse. They confirmed these findings in follow-up studies of 758 Chicago-area and 220 Finnish youngsters (Huesmann & others, 1984). What is more, when Eron and Huesmann (1984) examined the later criminal conviction records of their initial sample of 8-year-olds, they found that at age 30, those men who as children had watched a great deal of violent television were more likely to have been convicted of a serious crime (Figure 12-13).

Even murder rates increase when and where television comes. In Canada and the United States, the homicide rate doubled between 1957 and 1974 as violent television spread. In census regions where television came later, the homicide rate jumped later too. In White South Africa, where television was not introduced until 1975, a similar near doubling of the homicide rate did not begin until after 1975 (Centerwall, 1989). And in a closely studied rural Canadian town where television came late, playground aggression doubled soon after (Williams, 1986).

Notice that these studies illustrate how researchers are now using correlational findings to *suggest* cause and effect. Yet, an infinite number of possible third factors could be creating a merely coincidental relation between viewing violence and aggression. Fortunately, however, the experimental method can control these extraneous factors. If we randomly assign some children to watch a violent film and others a nonviolent film, any later aggression difference between the two groups will be due to the only factor that distinguishes them: what they watched.

TV Viewing Experiments The pioneering experiments by Albert Bandura and Richard Walters (1963) sometimes had young children view the adult pounding the inflated doll on film instead of observing it live—with much the same effect. Then Leonard Berkowitz and Russell Geen (1966) found that angered college students who viewed a violent film acted more aggressively than did similarly angered students who viewed nonaggressive films. These laboratory

"I rarely turn down an invitation to speak to a PTA meeting or other civic groups in order to warn parents and other caretakers that they must control their children's viewing habits."
Leonard Eron (1985)

Seriousness of criminal acts by age 30

Frequency of TV viewing at age 8

FIGURE 12-13 *Children's television viewing and later criminal activity. Violence viewing at age 8 was a predictor of a serious criminal offense by age 30.*
(Data from Eron & Huesmann, 1984.)

experiments, coupled with growing public concern, were sufficient to prompt the U.S. Surgeon General to commission 50 new research studies during the early 1970s. By and large, these studies confirmed that viewing violence amplifies aggression.

In a later series of experiments, research teams led by Ross Parke (1977) in the United States and Jacques Leyens (1975) in Belgium showed institutionalized American and Belgian delinquent boys a series of either aggressive or nonaggressive commercial films. Their consistent finding: "Exposure to movie violence . . . led to an increase in viewer aggression." Compared to the week preceding the film series, physical attacks increased sharply in cottages where boys were viewing violent films.

The Convergence of Evidence Television research has involved a variety of methods and participants. One ambitious researcher, Susan Hearold (1986), assembled results from 230 correlational and experimental studies involving more than 100,000 people. Her conclusion: Viewing antisocial portrayals is indeed associated with antisocial behavior. The effect is not overwhelming and is, in fact, at times so modest that some critics doubt it exists (Freedman, 1988; McGuire, 1986). Moreover, the aggression provoked in these experiments is not assault and battery; it's more on the scale of a shove in the lunch line, a cruel comment, a threatening gesture.

Nevertheless, the convergence of evidence is striking. Experimental studies point most clearly to cause and effect, but they are sometimes remote from real life (for example, pushing a hurt button). Moreover, the experiments can but hint at the cumulative effects of witnessing more than 100,000 violent episodes and some 20,000 murders, as the average American child does before becoming

"Then shall we simply allow our children to listen to any story anyone happens to make up, and so receive into their minds ideas often the very opposite of those we shall think they ought to have when they are grown up?"
Plato, *The Republic*

"Consider this a divorce!" bellows Arnold Schwarzenegger just before he blows his wife away in Total Recall.

the average American teenager (Murray & Lonnborg, 1989). Uncontrolled influences complicate the correlational studies, but such studies do tap the cumulative effects of real-life viewing.

Why Does TV Viewing Affect Behavior? The conclusion drawn by the Surgeon General and by these researchers is *not* that television and pornography are primary causes of social violence, any more than cyclamates are a primary cause of cancer. However, television is *a* cause. Even if it is just one ingredient in a complex recipe for violence, it is one that, like cyclamates, is potentially controllable. Given the convergence of correlational and experimental evidence, researchers have explored *why* viewing violence has this effect.

Consider three possibilities (Geen & Thomas, 1986). One is that it's not the violent content per se that causes social violence, but the *arousal* produced by the exciting action (Mueller & others, 1983; Zillmann, 1989). As we noted earlier, arousal tends to spill over: One type of arousal energizes other behaviors.

Other research shows that viewing violence *disinhibits*. Viewing others performing an antisocial act can loosen our own restraints. In Bandura's experiment, the adult's punching the Bobo doll seemed to legitimate such outbursts and to lower the children's own inhibitions. Viewing violence primes the viewer for aggressive behavior by activating violence-related thoughts (Berkowitz, 1984; Bushman & Geen, 1990; Josephson, 1987).

Media portrayals also evoke *imitation*. The children in Bandura's experiments reenacted the specific behaviors they had witnessed. The commercial television industry is hard-pressed to dispute that television leads viewers to imitate what they have seen. Its advertisers model consumption. Television's critics agree—and are troubled that on TV programs acts of assault outnumber affectionate acts 4 to 1 and that, in other ways as well, television models an unreal world (Table 12-1). TV cops fire their guns in almost every episode;

actual Chicago police officers fire their guns an average of once every 27 years (Radecki, 1989).

If the ways of relating and problem solving modeled on television do trigger imitation, especially among young viewers, then modeling **prosocial behavior** should be socially beneficial. Chapter 14 contains good news: Television's subtle influence can indeed teach children positive lessons in behavior.

Prosocial behavior: Positive, constructive, helpful social behavior; the opposite of antisocial behavior.

Television's Effects on Thinking

We have focused on television's effect on behavior. Researchers have also examined the cognitive effects of viewing violence: Does prolonged viewing desensitize us to cruelty? Does it distort perceptions of reality?

Take some emotion-arousing stimulus, say an obscene word, and repeat it over and over. What happens? From introductory psychology you may recall that the emotional response will "extinguish." After witnessing thousands of acts of cruelty, there is good reason to expect a similar emotional numbing. Perhaps the most common response might well become, "Doesn't bother me at all." Such a response is precisely what Victor Cline and his colleagues (1973) observed when they measured the physiological arousal of 121 Utah boys who watched a brutal boxing match. Compared to boys who watched little television, those who watched habitually were minimally aroused; their responses to the beating were more a shrug than a concern.

Of course, these boys might differ in ways other than television viewing. But in experiments on the effects of viewing sexual violence, similar desensitization—a sort of psychic numbness—occurs among young men who view slasher films. Moreover, experiments by Ronald Drabman and Margaret Thomas (1974, 1975, 1976) confirmed that such viewing breeds a more blasé reaction when later viewing the film of a brawl or when actually observing two children fighting.

Does viewing television's fictional world also mold our conceptions of the real world? George Gerbner and his University of Pennsylvania associates

"All television is educational. The question is, what is it teaching?" Nicholas Johnson, Former Commissioner, Federal Communications Commission, 1978

TABLE 12-1 *America's Television World versus the Real World*
How closely does prime-time network television drama mirror the world around us? Compare the percentages of people and behaviors on TV dramas with those in the real world. Television may reflect culture's mythology, but it distorts the reality.

ITEM VIEWED	SEEN ON TELEVISION	IN THE REAL WORLD
Female	25%	51%
Blue collar	25%	67%
Characters involved in violence	> 50/week	< 1/year
Implied sexual intercourse: partners not married	85%	Unknown
Beverages consumed: percentage alcoholic	45%	16%

From an analysis of more than 25,000 television characters since 1969 by George Gerbner & others (1986). TV sex data from Fernandez-Collado & others (1978). Alcohol data from NCTV (1988). Percentage of sex that occurs among unmarried partners is unknown but is surely a fraction of that depicted on TV, given that most adults are married, that frequency of intercourse is higher among the married than among singles, and that extramarital sex is much rarer than commonly believed (Greeley, 1991).

"Those of us who have been active over more than 15 years in studying [television] cannot fail to be impressed with the significance of this medium for the emerging consciousness of the developing child."
Jerome Singer and Dorothy Singer (1988)

(1979, in press) suspect this is television's most potent effect. Their surveys of both adolescents and adults show that heavy viewers (four hours a day or more) are more likely than light viewers (two hours or less) to exaggerate the frequency of violence in the world around them and to fear being personally assaulted. Similarly, a national survey of American 7- to 11-year-old children found that heavy viewers were more likely than light viewers to admit fears "that somebody bad might get into your house" or that "when you go outside, somebody might hurt you" (Peterson & Zill, 1981). Adults better dissociate television crime from the events in their own neighborhood. Those who watch crime dramas (more than those who don't) see New York as a dangerous place. They even believe that their own city could be dangerous. But they are not more afraid of their own neighborhood (Heath & Petraitis, 1987; Tyler & Cook, 1984).

Researchers are also investigating other positive and negative effects of television. Perhaps, though, television's biggest effect occurs indirectly, as it each year replaces in people's lives a thousand or more hours of other activities. If, like most others, you have spent a thousand-plus hours per year watching TV, think how you might have used that time if there were no television. What difference would that have made in who you are today?

GROUP AGGRESSION

We have considered what provokes *individuals* to aggress. If frustrations, insults, and aggressive models heighten the aggressive tendencies of isolated people, then such factors are likely to prompt the same reaction in groups. As a riot begins, aggressive acts often spread rapidly after the "trigger" example of one antagonistic person. Seeing looters freely helping themselves to VCRs or steaks, normally law-abiding bystanders may drop their moral inhibitions and imitate.

"The worst barbarity of war is that it forces men collectively to commit acts against which individually they would revolt with their whole being."
Ellen Key, *War, Peace, and the Future*, 1916

Groups can amplify aggressive reactions partly by diffusing responsibility. Decisions to attack in war typically are made by strategists remote from the front lines. The strategists have a buffer between themselves and the actual violence: They give orders. Others carry them out. Does such distancing make it easier to recommend aggression?

Jacquelin Gaebelein and Anthony Mander (1978) simulated this situation in the laboratory. They asked their University of North Carolina at Greensboro students to *shock* someone or to *advise* someone how much shock to administer. When the recipient provoked the front-line subjects, they and the advisers independently favored approximately the same amount of shock. But when the recipient was innocent of any provocation, as are most victims of mass aggression, the front-line subjects gave less shock than recommended by the advisers, who felt less directly responsible for any hurt.

Diffusion of responsibility increases not only with distance but with numbers. (Recall from Chapter 9 the phenomenon of deindividuation.) When Brian Mullen (1986) analyzed information from 60 lynchings that occurred between 1899 and 1946, he made an interesting discovery: The greater the number of people in a lynch mob, the more vicious the murder and mutilation.

Such situations also involve group interaction. Groups magnify aggressive tendencies, much as they polarize other tendencies. Consider gang wars, and what Scandinavians call "mobbing"—schoolchildren repeatedly harassing or

(Dan Perkins/THIS MODERN WORLD)

People who watch many hours of television see the world as a dangerous place.

attacking an insecure, weak schoolmate. Mobbing occurs as a group activity. One bully alone is less likely to taunt or attack a victim (Lagerspetz & others, 1982).

Experiments by Israeli social psychologists Yoram Jaffe and Yoel Yinon (1983) confirm that groups can polarize aggressive tendencies. In one, university men angered by a supposed fellow subject retaliated with decisions to give much stronger shocks when in groups than when alone. In another experiment (Jaffe & others, 1981), unskilled workers decided, either alone or in groups, how much punishing shock to give someone for incorrect answers on an ESP task. As Figure 12-14 shows, individuals gave progressively more of the assumed shock as the experiment proceeded, and group decision making magnified this individual tendency. So, when circumstances provoke an individual's aggressive reaction, the addition of group interaction will often amplify it.

■ REDUCING AGGRESSION

We have examined instinct, frustration-aggression, and social learning theories of aggression, and we have scrutinized influences on aggression. How, then, can we reduce aggression? Do theory and research suggest ways to control aggression?

Shock intensity

Phase of experiment

FIGURE 12-14 *When individuals chose how much shock to administer as punishment for wrong answers, they escalated the shock level as the experiment proceeded. Group decision making further polarized this tendency.*
(Data from Jaffe & others, 1981.)

CATHARSIS

"Youngsters should be taught to vent their anger." So advised Ann Landers (1969). If a person "bottles up his rage, we have to find an outlet. We have to give him an opportunity of letting off steam." So asserted the prominent psychiatrist Fritz Perls (1973). Both statements assume the "hydraulic model"—that, like dammed-up water, accumulated aggressive energy, whether derived from instinctual impulses or from frustrations, needs a release.

The concept of catharsis is usually credited to Aristotle. Although Aristotle actually said nothing about aggression, he did argue that we can purge emotions by experiencing them and that viewing the classic tragedies therefore enabled a catharsis ("purgation") of pity and fear. To have an emotion excited, he believed, is to have that emotion released (Butcher, 1951). The catharsis hypothesis has been extended to include the emotional release supposedly obtained not only by observing drama but also through recalling and reliving past events, through expressing emotions, and through various actions. In such ways, we supposedly "blow off a little steam."

Assuming that aggressive action or fantasy drains pent-up aggression, thus reducing the aggressive urge, some therapists and group leaders encourage people to ventilate suppressed aggression by acting it out—by whopping one another with foam bats or beating a bed with a tennis racket while screaming. Some psychologists advise parents to encourage children's release of emotional tension through aggressive play. Many Americans have bought the idea, as reflected in their nearly 2-to-1 agreement with the statement, "Sexual materials provide an outlet for bottled-up impulses" (Niemi & others, 1989). But

then the same national surveys reveal that most Americans also agree, "Sexual materials lead people to commit rape." So, is the catharsis approach valid or not?

If viewing erotica provides an outlet for sexual impulses, then people should afterward experience diminished sexual desire and men should be less likely to view and treat women as sexual objects. But experiments show the opposite is true (Kelley & others, 1989; McKenzie-Mohr & Zanna, 1990). The near consensus among social psychologists is that catharsis does not occur as Freud, Lorenz, and their followers supposed (Geen & Quanty, 1977). For example, Robert Arms and his associates report that Canadian and American spectators of football, wrestling, and hockey exhibit *more* hostility after viewing the event than before (Arms & others, 1979; Goldstein & Arms, 1971; Russell, 1983). Not even war seems to purge aggressive feelings. After a war, a nation's murder rate tends to jump (Archer & Gartner, 1976).

In laboratory tests of the catharsis hypothesis, Jack Hokanson and his colleagues (1961, 1962a,b, 1966) found that when Florida State University students were allowed to counterattack someone who had provoked them, their arousal (as measured by their blood pressures) did more quickly return to normal. But this calming effect of retaliation occurs only in specific circumstances—when the target is one's actual tormentor, not a substitute. Moreover, the retaliation must be justifiable and the target nonintimidating, so the person does not afterward feel guilty or anxious.

Does such aggressing reduce later aggression? Experiments dealing with aggression's *short-run* consequences give mixed results. Sometimes people who aggress do become less aggressive. But this may occur when experiments produce *inhibition* rather than catharsis. The aggressor may have been inhibited by thinking, "If I overdo it, I could get into trouble" or "The poor guy has suffered enough."

Some therapists, assuming a catharsis effect, encourage people to ventilate their pent-up aggression. Experiments suggest that any calming effect is short-lived, and may in the long run reduce inhibitions against aggression.

In other experiments, aggressing has led to heightened aggression. Ebbe Ebbesen and his co-researchers (1975) interviewed 100 engineers and technicians shortly after they were angered by layoff notices. Some were asked questions that gave them an opportunity to express hostility against their employer or supervisor—for example, "What instances can you think of where the company has not been fair with you?" Afterward, they answered a questionnaire assessing attitudes toward the company and the supervisor. Did the previous opportunity to "vent" or "drain off" their hostility reduce it? To the contrary, their hostility increased. Expressing hostility bred more hostility.

Sound familiar? Recall from Chapter 4 that cruel acts beget cruel attitudes. Furthermore, as we noted in analyzing Stanley Milgram's obedience experiments, little aggressive acts can breed their own justification. Derogating the victim makes us feel more hostility, facilitating further aggression. Even if retaliation sometimes (in the short run) reduces tension, in the long run it reduces inhibitions. We can speculate that this will be true especially when, as often happens, the force of the aggressive outburst is an overreaction to the provocation. Moreover, when people discover that retaliation is tension-reducing, this reinforcement may increase the likelihood of future retaliation. So in the long run, aggression is more likely to breed aggression than reduce it.

Should we therefore bottle up anger and aggressive urges? Silent sulking is hardly more effective, because it allows us to continue reciting our grievances as we conduct conversations in our head. Fortunately, there are other, nonaggressive ways to express our feelings and to inform others how their behavior affects us. Stating, "I'm angry," or "When you talk like that I feel irritated," communicates our feelings in a way that leads the other person to make amends rather than further escalate the aggression. It is possible to be assertive without being aggressive.

A SOCIAL LEARNING APPROACH

If aggressive behavior is learned rather than instinctive, then there is hope for its control. Let us briefly review factors that influence aggression and speculate how to counteract them.

Aversive experiences such as frustrated expectations and personal attacks create a readiness to aggress. So it is wise to refrain from planting false, unreachable expectations in people's minds. Anticipated rewards and costs control instrumental aggression. This suggests that we should reward cooperative, nonaggressive behavior. In experiments, children become less aggressive when their aggressive behavior is ignored rather than rewarded with attention and when their nonaggressive behavior is reinforced (Hamblin & others, 1969). Punishing the aggressor is less consistently effective. Under ideal conditions—when the punishment is strong, prompt, and sure; when it is combined with reward for the desired behavior; and when the potential aggressor is not angry—threatened punishment deters aggression (R. A. Baron, 1977). This was evident in 1969 when the Montreal police force went on a 16-hour strike. Widespread looting and destruction erupted—until the police returned.

The side effects of punishment, particularly physical punishment, can backfire. Punishment is aversive stimulation; it models the behavior it seeks to prevent. And it is coercive (recall that we seldom internalize actions coerced

with strong external justifications). These are reasons violent teenagers and child-abusing parents so often come from homes where discipline took the form of harsh physical punishment.

Observing aggressive models can lower inhibitions and elicit imitation. This suggests new ways to reduce brutal, dehumanizing portrayals in films and on television, steps comparable to those already taken to reduce racist and sexist portrayals. It also suggests inoculating children against the effects of media violence. Despairing that the TV networks would ever "face the facts and change their programming," Eron and Huesmann (1984) taught 170 Oak Park, Illinois, children that television portrays the world unrealistically, that aggression is less common and effective than TV suggests, and that aggressive behavior is undesirable. (Drawing upon attitude research, Eron and Huesmann encouraged children to draw these inferences themselves and to attribute their expressed criticisms of television to their own convictions.) When restudied two years later, these children were less influenced by TV violence than were untrained children.

Aggression is also elicited by aggressive stimuli. This suggests reducing the availability of weapons such as handguns. Jamaica in 1974 implemented a sweeping anticrime program that included strict gun control and censorship of gun scenes from television and movies (Diener & Crandall, 1979). In the following year, robberies dropped 25 percent, nonfatal shootings 37 percent. In Sweden, the toy industry has discontinued the sale of war toys. The Swedish Information Service (1980) states the national attitude: "Playing at war means learning to settle disputes by violent means."

Arousal can be "steered" into hostility or other emotions depending on the context. Thus, we can try to redirect a person's anger. This often works with children, whose anger can sometimes be converted to intense laughter. Once laughter occurs, it is likely to breed a happier emotion. Similarly, mild sexual arousal and empathy are incompatible with anger. All these incompatible responses diminish aggression.

Robert A. Baron (1976) illustrated this at an intersection near Purdue University. He instructed a driver to hesitate 15 seconds in front of another car after the light changed to green. In response to this mild frustration, 90 percent of the drivers did what we might expect: They honked (a mildly aggressive act). If, while the light was red, a female pedestrian crossed between two cars, disappearing by the time the light changed to green, the honking rate was still close to 90 percent. However, when this procedure was repeated with the pedestrian on crutches (evoking empathy), or dressed in a revealing outfit (evoking mild sexual arousal), or wearing an outlandish clown mask (evoking humor), the honking rate dropped to about 50 percent.

Experiments by Norma Feshbach and Seymour Feshbach (1981) confirm that aggression is incompatible with empathy. They put some Los Angeles elementary school children through a 10-week program that trained them to recognize others' feelings, to assume their perspective, and to share their emotions. Compared to other children in control groups, those who received this empathy training became significantly less aggressive in their school behavior.

Suggestions such as these can help us minimize aggression. But given the complexity of aggression's causes and the difficulty of controlling them, who can feel the optimism expressed by Andrew Carnegie's forecast that in the

twentieth century, "To kill a man will be considered as disgusting as we in this day consider it disgusting to eat one." Since Carnegie uttered those words in 1900, some 200 million human beings have been killed. It is a sad irony that although today we understand human aggression better than ever before, humanity's inhumanity is hardly diminished.

■ SUMMING UP

WHAT IS AGGRESSION?

Aggression manifests itself in two forms: *hostile aggression*, which springs from emotions such as anger and intending to injure, and *instrumental aggression*, which is a means to some other end.

THE NATURE OF AGGRESSION

There are three broad theories of aggression. The *instinct* view is most commonly associated with Sigmund Freud and Konrad Lorenz. It contends that, if not discharged, aggressive energy will accumulate from within, like water accumulating behind a dam. Although the available evidence offers little support for the instinct view, aggression *is* biologically influenced by heredity, blood chemistry, and the brain.

According to the second view, *frustration* causes anger. Given aggressive cues, this anger may provoke aggression. Frustration stems not from deprivation per se but from the gap between expectations and achievements. Expectations are driven higher by past achievements and by social comparison.

The *social learning* view presents aggression as learned behavior. By experience and by observing others' success, we learn that aggression sometimes pays. Thus when aroused by an aversive experience and when it seems safe and rewarding to aggress, we will likely do so.

INFLUENCES ON AGGRESSION

Aversive experiences include not only frustrations but also discomfort, pain, and personal attacks, both physical and verbal. Arousal from almost any source, even physical exercise or sexual stimulation, can be steered by the environment into anger.

American television portrays considerable violence. Laboratory studies reveal that viewing violent models increases aggressive behavior. So it is no wonder that researchers are now studying the impact of television. Correlational and experimental studies converge on the conclusion that viewing violence (1) breeds a modest increase in aggressive behavior and (2) desensitizes viewers to aggression and alters their perceptions of reality. These two findings parallel the results of research on the effects of viewing pornography.

Much aggression is committed by groups. Circumstances that provoke individuals may also provoke groups. By diffusing responsibility and polarizing actions, group situations amplify aggressive reactions.

REDUCING AGGRESSION

How can we minimize aggression? Contrary to the catharsis hypothesis, aggression more often breeds than reduces aggression. The social learning approach suggests controlling aggression by counteracting the factors that provoke it—by reducing aversive stimulation, by rewarding and modeling nonaggression, and by eliciting reactions incompatible with aggression.

■ FOR FURTHER READING

Archer, S., & Gartner, R. (1984). *Violence and crime in cross-national perspective.* New Haven: Yale University Press. Examines homicide tendencies worldwide, asking how urbanization, the death penalty, and wars influence murder rates.

Groebel, J., & Hinde, R. (Eds.). (1988). *Aggression and war: Their biological and social bases.* New York: Cambridge University Press. Prominent aggression researchers summarize current understandings of the biological, psychological, and cultural sources of aggression.

ATTRACTION: LIKING AND LOVING OTHERS

In the beginning there was attraction—the attraction between a particular man and a particular woman to which we each owe our existence. Our lifelong dependence on one another puts relationships at the core of our existence. Asked, "What is it that makes your life meaningful?" or "What is necessary for your happiness?" most people mention—before anything else—satisfying close relationships with friends, family, or romantic partners (Berscheid, 1985; Berscheid & Peplau, 1983).

"I cannot tell how my ankles bend, nor whence the cause of my faintest wish, Nor the cause of the friendship I emit, nor the cause of the friendship I take again."
Walt Whitman, *Song of Myself,* 1855

What predisposes one person to like, or to love, another? Few questions about human nature arouse greater interest. The ways that people's affections flourish and fade form the stuff and fluff of soap operas, popular music, novels, and much of our everyday conversation. Long before I knew there was such a field as social psychology, I had memorized Dale Carnegie's recipe for *how to win friends and influence people.* So much has been written about liking and loving that almost every conceivable explanation—and its opposite—has been already proposed. Does absence make the heart grow fonder? Or is someone who is out of sight also out of mind? Is it likes that attract? Or opposites?

More than 2000 years ago science gave us an almost exact estimate of the earth's circumference, but it was not until our lifetime that liking and loving became the objects of vigorous scientific scrutiny. When they did, the very idea of scientifically analyzing such "subjective" phenomena was greeted with scorn. When the National Science Foundation awarded an $84,000 grant for research on love, Wisconsin Senator William Proxmire was irate:

> I object to this not only because no one—not even the National Science Foundation—can argue that falling in love is a science; not only because I'm sure that even if they spend $84 million or $84 billion they wouldn't get an answer that anyone would believe. I'm also against it because I don't want the answer.
>
> I believe that 200 million other Americans want to leave some things in life a mystery, and right at the top of things we don't want to know is why a man falls in love with a woman and vice versa. . . .
>
> So National Science Foundation—get out of the love racket. Leave that to Elizabeth Barrett Browning and Irving Berlin! (Harris, 1978)

The press had a field day with Proxmire's comments. In the *New York Times,* James Reston (1975) acknowledged that love has unfathomable depths of mystery. Yet, he argued, "If the sociologists and psychologists can get even a suggestion of the answer to our pattern of romantic love, marriage, disillusion, divorce—and the children left behind—it could be the best investment of federal money since Jefferson made the Louisiana Purchase."

Levels of explanation: See Chapter 1.

Social-psychological analyses of friendship and intimate love are not meant to compete with Elizabeth Barrett Browning and Irving Berlin. The social psychologist and the poet deal with love at different levels. The social psychologist examines who attracts whom. The poet describes love as a sometimes sublime experience.

■ A SIMPLE THEORY OF ATTRACTION

Asked why they are friends with someone or why they were attracted to their partner, most people can readily answer. "I like Carol because she's warm, witty, and well-read." What such explanations leave out—and what social

psychologists believe most important—is ourselves. Attraction involves the one who is attracted as well as the attractor. Thus a more psychologically accurate answer might be, "I like Carol because of how I feel when I'm with her." We are attracted to those *we* find it satisfying and gratifying to be with. Attraction is in the eye (and brain) of the beholder.

The point can be expressed as a simple psychological principle: Those who reward us, or whom we associate with rewards, we like. This **reward** principle is elaborated in two allied theories. One is the **minimax** principle: Minimize costs, maximize rewards. This implies that if a relationship gives us more rewards than costs, we will like it and will wish to continue. This will be especially true if the relationship is more profitable than alternative relationships (Burgess & Huston, 1979; Kelley, 1979; Rusbult, 1980). Minimax: Minimize boredom, conflicts, expenses; maximize self-esteem, pleasure, security. Some 300 years ago La Rochefoucauld (1665) conjectured similarly: "Friendship is a scheme for the mutual exchange of personal advantages and favors whereby self-esteem may profit."

If both partners in a friendship pursue their personal desires willy-nilly, the friendship will likely die. Therefore, our society teaches us to exchange rewards by a rule that Elaine Hatfield, William Walster, and Ellen Berscheid (1978) call **equity:** What you and your friend get out of a relationship should be proportional to what you each put into it. If two people receive equal outcomes, they should contribute equally; otherwise their relationship will feel unfair to one or the other. If both feel their outcomes correspond to the assets and efforts each contributes, then both perceive equity.

Reward theory of attraction:
The theory that we like those whose behavior is rewarding to us or whom we associate with rewarding events.

Minimax:
Minimize costs, maximize rewards.

Equity:
A condition in which the outcomes people receive from a relationship are proportional to what they contribute to it. Note: Equitable outcomes needn't always be equal outcomes.

True friendships involve equitable give and take in the long term, without keeping score in the short term.

Strangers and casual acquaintances maintain equity by exchanging benefits: You lend me your class notes; later, I'll lend you mine. I invite you to my party; you invite me to yours. Those in love (or those who have roomed together for some time—Berg, 1984) do not feel so bound to trade identical benefits: notes for notes, parties for parties. They feel freer to maintain equity by exchanging a variety of benefits ("When you drop by to lend me your notes, why don't you stay for dinner?") and eventually to stop keeping track of who owes whom.

Is it crass to suppose that friendship and love are rooted in an equitable exchange of rewards? Do we sometimes give in response to a loved one's need, without expecting a reciprocal benefit? Indeed, those involved in an equitable *long-term* relationship are unconcerned with *short-term* equity. Margaret Clark and Judson Mills (1979; Clark, 1984, 1986; Mills & Clark, in press) argue that people even take pains to *avoid* calculating any exchange benefits. When we help a good friend, we do not want instant repayment. If someone has us for dinner, we wait before reciprocating, lest the person attribute the motive for our return invitation to be merely paying off a social debt. True friends tune into one another's needs even when reciprocation is impossible (Clark & others, 1986, 1989). One clue that an acquaintance is becoming such a friend is the person's sharing when sharing is unexpected (Miller & others, 1989). Happily married people tend *not* to keep score of how much they are giving and getting (Buunk & Van Yperen, 1991).

In experiments with University of Maryland students, Clark and Mills confirmed that not being calculating is a mark of friendship. Tit-for-tat exchanges boosted people's liking when the relationship was relatively formal but *diminished* liking when the two sought friendship. Clark and Mills surmise that marriage contracts in which each partner specifies what is expected from the other are more likely to undermine than enhance the couple's love. Only when the other's positive behavior is voluntary can we attribute it to love.

We not only like people who are rewarding to be with; we also, according to the second version of the reward principle, like those we *associate* with good feelings. According to theorists Donn Byrne and Gerald Clore (1970), and to Albert Lott and Bernice Lott (1974), social conditioning creates positive feelings toward those linked to rewarding events. When, after a strenuous week, we relax in front of a fire, enjoying good food, drink, and music, we will likely feel a special warmth toward those around us. We are less likely to take a liking to someone we meet while suffering a splitting headache.

Pawel Lewicki (1985) tested this liking-by-association theory. In one experiment, University of Warsaw, Poland, students were virtually 50-50 in choosing which of two pictured women (A or B in Figure 13-1) looked friendlier. Other

© Mell Lazarus. By permission of Mell Lazarus and Creators Syndicate.

Our liking and disliking of people is influenced by the events with which they are associated.

| Experimenter | Person A | Person B |

students, having interacted with a warm, friendly experimenter, by a 6 to 1 margin chose the photo of woman A, who resembled the friendly experimenter. In a follow-up study, the experimenter acted *unfriendly* toward half the subjects. When these subjects later had to turn in their data to one of two women, they nearly always *avoided* the one who resembled the experimenter. (Perhaps you can recall a time when you reacted positively or negatively to someone who reminded you of someone else.)

Other experiments confirm this phenomenon of liking—and disliking—by association. In one, college students who evaluated strangers in a pleasant room liked them better than those who evaluated them in an uncomfortably hot room (Griffitt, 1970). In another experiment, people evaluated photographs of other people while in either an elegant, sumptuously furnished, softly lit room or in a shabby, dirty, stark room (Maslow & Mintz, 1956). Again, the warm feelings evoked by the elegant surroundings transferred to the people being rated. Elaine Hatfield and William Walster (1978) find a practical tip in these research studies: "Romantic dinners, trips to the theatre, evenings at home together, and vacations never stop being important. . . . If your relationship is to survive, it's important that you *both* continue to associate your relationship with good things."

This simple theory of attraction—we like those who reward us and those we associate with rewards—is helpful. But as with most sweeping generalizations, it leaves many questions unanswered. What, precisely, *is* rewarding? Of course, the answer will vary from person to person and situation to situation. But is it usually more rewarding to be with someone who differs from us or someone who is similar to us? to be lavishly flattered or constructively criticized? In your experience, what factors have fostered your close friendships?

With so many possibilities, we must consider specific influences on attraction. For most people, what factors nurture liking and loving? Let's start with those that help a friendship begin and then consider those that sustain and deepen a relationship. In your experience, what factors have fostered your close friendships?

FIGURE 13-1 *Liking by association. After interacting with a friendly experimenter, people preferred someone who looked like her (A) to one who didn't (B). After interacting with an unfriendly experimenter, people avoided the woman who resembled her (Lewicki, 1985).*

■ LIKING: WHO LIKES WHOM?

Friendships arise under the influence of seemingly accidental or trivial factors: mere geographical proximity or superficial physical attributes can attract people to one another. So can similarity and the warm reactions of others.

PROXIMITY

Proximity:

Geographical nearness. Proximity (more precisely, "functional distance") powerfully predicts liking.

One of the most powerful predictors of whether any two people are friends is their sheer **proximity** to one another. Proximity can also breed hostility; most assaults and murders involve people living in close proximity. (Guns purchased for self-defense are much more likely to be turned on family members than against intruders.) But fortunately far more often, proximity kindles liking. Though it may seem trivial to those pondering the mysterious origins of romantic love, sociologists have found that most people marry someone who lives in the same neighborhood, or works at the same job, or sits in the same class (Bossard, 1932; Burr, 1973; Clarke, 1952; Katz & Hill, 1958). Look around. If you choose to marry, it will likely be to someone who has lived or worked or studied within walking distance.

Leon Festinger, Stanley Schachter, and Kurt Back (1950) discovered that proximity leads to liking when they observed the formation of friendships in MIT married student apartments (Figure 13-2). Because people were assigned apartments essentially at random, without any prior friendships, the researchers could assess the importance of proximity. And important it was. Asked to name their three closest friends within the entire complex of buildings, two-thirds of those named lived in the same building, and two-thirds of these lived on the same floor. The person most frequently chosen? One who lived next door.

Interaction

Actually, it is not geographical distance that is critical but rather "functional distance"—how often people's paths cross. People frequently become friends with those who use the same entrances, parking lots, and recreation areas. At one California naval training center, workers most enjoyed talking to co-workers whom they most often ran into (Monge & Kirste, 1980). At the college where I teach, the men and women students once lived on opposite sides of the campus. They understandably bemoaned the dearth of cross-sex friendships.

FIGURE 13-2 *Diagram of a married student apartment building at MIT. Had you desired to make friends after moving into one of these buildings, which apartments should you have preferred? Experimenters found that residents of apartments 1 and 5, who were functionally close to several of the upper apartments as well as to the lower apartments, had the best opportunities to form friendships.*

The architecture of collegiality. Steelcase, Inc., the world's largest maker of office furniture, designed its $111 million Grand Rapids, Michigan research center to encourage "planned and spontaneous communication." All enter together through a single entrance. Top management is in the building's middle, not its top. Psychologists helped design the building so employees would run into one another unexpectedly or spontaneously interact in one of 11 break areas stocked with coffee and equipped with marker boards. The building's design thus spurs both creativity and friendship formation.

Now that they occupy different areas of the same dormitories and share common sidewalks, lounges, and laundry facilities, cross-sex friendships are far more frequent. So, if you're new in town and want to make friends, try to get an apartment near the mailboxes, an office desk near the coffee pot, a parking spot near the main buildings. Such is the architecture of friendship.

Further evidence that what's crucial in forming friendships is the opportunity for interaction comes from a clever study with University of North Carolina students. Chester Insko and Midge Wilson (1977) sat three students in a triangle facing one another and then had persons A and B converse about themselves while C observed. Thus, for example, B and C were equally near A and observed the same behavior from A. But who most likes A? Usually person B, with whom person A had talked. Interacting with another stimulates liking. It does so by enabling people to explore their similarities, to sense one another's liking, and to perceive themselves as a social unit (Arkin & Burger, 1980). Likewise, randomly assigned college roommates, who of course can hardly avoid frequent interaction, are far more likely to become good friends than enemies (Newcomb, 1961).

But why does proximity breed liking? One factor is the availability of people nearby; obviously, there are fewer opportunities to get to know someone who attends a different school or lives in another town. But there is more to it than that; most people like their roommates, or those one door away, better than those two doors away. After all, those just a few doors away, or even a floor below, hardly live at an inconvenient distance. Moreover, those close by are potential enemies as well as friends. So why does proximity encourage affection more often than animosity?

Anticipation of Interaction

Already we have noted one answer: Proximity enables people to discover commonalities and exchange rewards. What is more, merely *anticipating* interaction boosts liking. John Darley and Ellen Berscheid (1967) discovered this when

"When I'm not near the one I love, I love the one I'm near."
E. Y. Harburg, *Finian's Rainbow,* London: Chappell Music, 1947

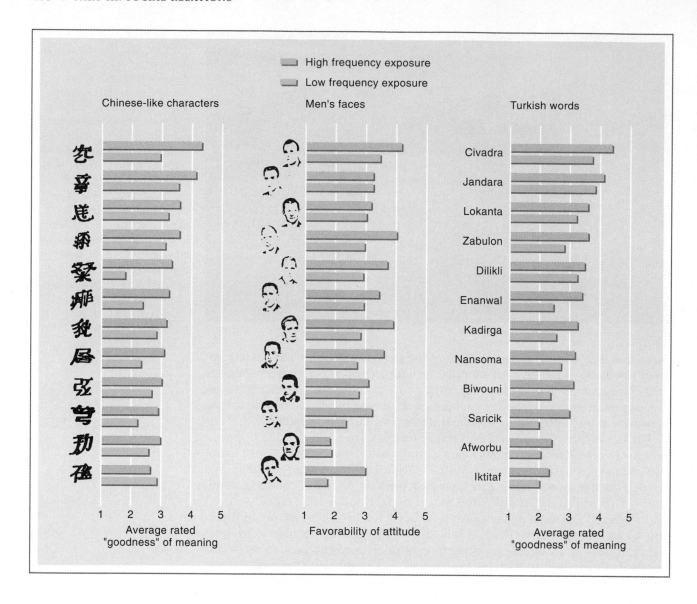

FIGURE 13-3 *The mere-exposure effect. Stimuli are rated more positively after being shown repeatedly.* (From Zajonc, 1968).

they gave University of Minnesota women ambiguous information about two other women, one of whom they expected to converse with intimately. Asked how much they liked each one, the women preferred the person they expected to meet. Expecting to date someone similarly boosts liking (Berscheid & others, 1976).

Does this occur because the anticipation of interacting with someone creates a feeling that the two of you are a group? (Recall from Chapter 11 the "ingroup bias.") Or does anticipating interaction stimulate us to perceive the other person as pleasant and compatible, maximizing the chance of a rewarding relationship (Knight & Vallacher, 1981; Kunda, 1990; Miller & Marks, 1982)? Likely, it is both. But even if it isn't, this much seems clear: The phenomenon is adaptive. Our lives are filled with relationships with people whom we may not have chosen but with whom we need to have continuing interactions—dormmates, grandparents, teachers, classmates, co-workers. Liking such people is surely

conducive to better relationships with them, which in turn makes for happier, more productive living.

Mere Exposure

Proximity also leads to liking for another reason: More than 200 experiments reveal that, contrary to the old proverb about familiarity breeding contempt, familiarity breeds fondness (Bornstein, 1989). Mere repeated exposure to all sorts of novel stimuli—nonsense syllables, Chinese characters, musical selections, faces—boosts people's ratings of them. Do the supposed Turkish words *nansoma, saricik,* and *afworbu* mean something better or something worse than the words *iktitaf, biwojni,* and *kadirga*? University of Michigan students tested by Robert Zajonc (1968, 1970) preferred whichever of these words they had seen most frequently. The more times they had seen a meaningless word or Chinese ideograph, the more likely they were to say it meant something good (Figure 13-3). Among the letters of the alphabet, people of differing nationalities, languages, and ages prefer the letters appearing in their own name and those that frequently appear in their own language (Hoorens & others, 1990; Nuttin, 1987). French students rate capital *W*, the least frequent letter in French, as their least favorite letter.

Many residents of Grand Rapids, Michigan, were not pleased when presented with their new downtown landmark, a huge metal sculpture created by the artist Alexander Calder. Their reaction? "An abomination," "an embarrassment," "a waste of money." Other people were neutral; few seemed enthusiastic. But within a decade, the sculpture had become an object of civic pride: Its picture adorned bank checks, city posters, and tourist literature. When completed in 1889, the Eiffel Tower in Paris was mocked as grotesque. Today it is the beloved symbol of Paris (Harrison, 1977). Such changes make one wonder about people's initial reactions to new things. Do visitors to the Louvre in Paris really adore the *Mona Lisa*, or are they simply delighted to find a familiar face? It might be both: To know her is to like her.

Mere-exposure effect: The tendency for novel stimuli to be liked more or rated more positively after the rater has been repeatedly exposed to them.

Mere repeated exposure can increase acceptance of various stimuli, from Chinese ideographs to politicians.

But, you may object that one really has to get to know some people in order to *dis*like them, or that some stimuli lose their appeal when *over*exposed. A new song that grows on you can, after the hundredth hearing, become wearisome. To be sure, the "exposure-breeds-liking" principle must be qualified. First, repetitions not only have a diminishing positive effect but can sometimes eventually have a negative effect (Suedfeld & others, 1975). This negative effect seems especially likely when people's initial reactions to the stimulus are already negative, rather than neutral or positive (Grush, 1976). Second, positive responses lessen when repetitions are incessant rather than distributed among other experiences (Harrison, 1977). Third, with boredom-prone people or boring stimuli, repeated exposures fail to boost liking (Bornstein & others, 1990). Finally, the exposure effect, like many other influences on us, is modest; because it is but one of many influences, it won't by itself overcome strong feelings from other sources.

Still, as a generalization, the principle seems indisputable. Zajonc and his co-workers, William Kunst-Wilson and Richard Moreland, report that exposure leads to liking even when people don't know that they have been exposed (Kunst-Wilson & Zajonc, 1980; Moreland & Zajonc, 1977; Wilson, 1979). In one experiment, women students listened in one ear through headphones to a prose passage. They also repeated the words out loud and compared them to a written version to check for errors. Meanwhile, brief, novel melodies played in their other ear. This procedure focused the women's attention upon the verbal material and away from the tunes. Later, when they heard the tunes interspersed among similar ones not previously played, they did not recognize them. Nevertheless, they *liked best* the tunes they had previously heard. In another experiment, people were shown a series of geometric figures, one at a time, each for a millisecond—long enough to perceive but a flash of light. Although later they were unable to recognize the figures they had been shown, they nevertheless *liked* them best.

Note that in both experiments conscious judgments about the stimuli were a far less reliable clue to what people had heard or seen than were instant feelings. You, too, can probably recall immediately liking or disliking something or someone without consciously knowing why. Zajonc (1980) argues that emotions are often more instantaneous, more primitive than thought. Fearful or prejudicial feelings are not always expressions of stereotyped beliefs; sometimes the beliefs arise later as justifications for intuitive feelings.

What causes this familiarity-liking relationship? Some believe it stems from a natural "neophobia," the adaptive tendency to be wary of unfamiliar things until we learn they are not dangerous. Animals, too, prefer familiar over unfamiliar stimuli (Hill, 1978) and approach new situations with extreme caution.

Whatever the explanation, the phenomenon colors our evaluations of others. Familiar people we like more (Swap, 1977). We even like ourselves better when we are the way we're used to seeing ourselves. In a delightful experiment, Theodore Mita, Marshall Dermer, and Jeffrey Knight (1977) photographed women students at the University of Wisconsin-Milwaukee and later showed each one her actual picture along with a mirror image of it. Asked which picture they liked better, most preferred the mirror image—the image they were used to seeing. (No wonder our photographs never look quite right.) When close friends of the subjects were shown the same two pictures, they preferred the true picture—the image *they* were used to seeing.

"'Tis strange—but true; for truth is always strange— Stranger than fiction."
Lord Byron, *Don Juan*

Advertisers and politicians exploit the mere exposure phenomenon. When people don't have strong feelings about a product or a candidate, repetition alone can boost sales or votes (McCullough & Ostrom, 1974; Winter, 1973). If candidates are relatively unknown, as often happens in congressional and presidential primaries and in local elections, those with the most media exposure usually win (Patterson, 1980; Schaffner & others, 1981). Joseph Grush and his colleagues (1978) exhaustively analyzed the 1972 U.S. congressional primaries. They found that overwhelmingly the winners were either incumbents or big spenders—a phenomenon repeated in the 1988 U.S. congressional elections, in which 98 percent of House incumbents won reelection bids. Even in presidential debates, the lesser-known challenger has more to gain than does the already familiar incumbent. As one political campaign handbook put it, "Repetition breeds familiarity and familiarity breeds trust" (Meyer, 1966).

The respected Washington state Supreme Court Chief Justice Keith Callow learned this lesson after his 1990 loss to a nominal opponent, self-described "blue-collar attorney" Charles Johnson. Johnson, an unknown attorney who handled minor criminal cases and divorces, filed for the seat on the principle that judges "need to be challenged." Neither man campaigned, and the media ignored the race. On election day the two candidates' names appeared without any identification—just one name next to the other. The result: a 53 percent to 47 percent Johnson victory. "There are a lot more Johnsons out there than Callows," offered the ousted judge afterward to a stunned legal community. Indeed, a Seattle newspaper counted 27 Charlie Johnsons in Seattle alone. There was Charles Johnson, the King County judge. And down in Tacoma there was television anchorman Charles Johnson, whose broadcasts were seen on statewide cable TV. Forced to choose between two unknown names, many voters apparently preferred the comfortable, familiar name of Charlie Johnson.

PHYSICAL ATTRACTIVENESS

What do (or did) you look for in a potential date? Sincerity? Good looks? Character? Conversational ability? Sophisticated, intelligent people are unconcerned with such superficial qualities as good looks; they know "beauty is only skin deep" and "you can't judge a book by its cover." At least they know that's how they *ought* to feel. As Cicero counseled, "The final good and the supreme duty of the wise man is to resist appearance."

The belief that looks matter little may be another instance of our denying real influences upon us (Chapter 2), for there is now a file drawer full of research studies showing that appearance *does* matter. The consistency and pervasiveness of this effect is startling, even disconcerting. Good looks are a great asset.

"We should look to the mind, and not to the outward appearances."
Aesop, *Fables*

"Personal beauty is a greater recommendation than any letter of introduction."
Aristotle, *Diogenes Laertius*

Dating

Like it or not, the fact is that a young woman's physical attractiveness is a moderately good predictor of how frequently she dates. A young man's attractiveness is slightly less a predictor of how frequently he dates (Berscheid & others, 1971; Krebs & Adinolfi, 1975; Reis & others, 1980, 1982; Walster & others, 1966). Does this imply, as many have surmised, that women are better at following Cicero's advice? Or does it merely reflect the fact that men more often do the inviting? If women were to indicate their preferences among vari-

ous men, would looks be as important to them as to men? Philosopher Bertrand Russell (1930, p. 139) thought not: "On the whole women tend to love men for their character while men tend to love women for their appearance."

To see whether indeed men are more influenced by looks, researchers provide men and women students with various pieces of information about someone of the other sex, including a picture of the person. Or they briefly introduce a man and a woman and later ask each about their interest in dating the other. In such experiments, men do put somewhat more value on opposite-sex physical attractiveness than do women (Feingold, 1990, 1991). Perhaps sensing this, women more than men worry about their appearance and constitute 90 percent of cosmetic surgery patients (Dion & others, 1990). But women, too, respond to a man's looks.

In one ambitious study, Elaine Hatfield and her co-workers (1966) matched 752 University of Minnesota first-year students for a "Welcome Week" computer dance. The researchers gave each individual personality and aptitude tests but then matched the couples randomly. On the night of the dance, the couples danced and talked for two and one-half hours and then took a brief intermission to evaluate their dates. How well did the personality and aptitude tests predict attraction? Was someone who was high in self-esteem, or low in anxiety, or different from the partner in outgoingness liked better? The researchers examined a long list of possibilities, but so far as they could determine, only one thing mattered: how physically attractive the person was. The more attractive a woman was, as rated by the experimenters and, especially, as rated by her date, the more he liked her and wanted to date her again. And the more attractive the man was, the more she liked him and wanted to date him again. Pretty pleases.

So, after a brief date, physically attractive people are liked best. Similar effects of attractiveness—whether self-described or pictured on videotape—are found in responses to commercial dating services, such as the lonely hearts ads in a singles magazine (Lynn & Shurgot, 1984; Riggio & Woll, 1984; Woll, 1986). But not everyone can end up paired with someone stunningly attractive. So how do people pair off?

The Matching Phenomenon

Judging from research by Bernard Murstein (1986) and others, they pair off with people who are about as attractive as they are. Several studies have found a strong correspondence between the attractiveness of husbands and wives, of dating partners, and even of those within particular fraternities (Feingold, 1988). People tend to select as friends and especially to marry those who are a "good match" not only to their level of intelligence but also to their level of attractiveness.

Matching phenomenon:
The tendency for men and women to choose as partners those who are a "good match" in attractiveness and other traits.

Experiments confirm this **matching phenomenon.** When choosing whom to approach, knowing the other is free to say yes or no, people usually approach someone whose attractiveness roughly matches their own (Berscheid & others, 1971; Huston, 1973; Stroebe & others, 1971). Good physical matches may also be conducive to good relationships, as Gregory White (1980) found in a study of UCLA dating couples. Those who were most similar in physical attractiveness were most likely, nine months later, to have fallen more deeply in love. So, who might we expect to be most closely matched for attractiveness—married

Beauty, Brains And Breeding—Single white female, 33, 5'5", 110, blond Manhattan executive seeks partner for boating, skiing, tennis and lifelong romance. Please be sincere, educated, successful, 30-40 male.

Blue-Eyed Beauty—26, health care professional, seeking a hard-to-find, fit, ambitious, single professional man, 28-32, who enjoys the finer things in life. Note/photo. POB 32H. Scarsdale, NY 10583.

Sensational-Looking Blond—Executive, 47, green eyes, great figure, sexy and playful, with style and class, seeks special man with brains, substance and sophisticated life style, for romance, caring and love.

Gorgeous, Elegant, Intelligent—Cindy Crawford look-alike - Ivy grad, wildly successful, sensational figure, honest, caring, sensuous - seeks professional male counterpart, 40-55. Photo a must. 2834

Stunning, Head-Turning, Scintillating—Tall, smiling brunette - seeks erudite, cultured, divorced, solvent professional, 39-52. 2818

Wall Street Exec—42, 6'2", 180, brown hair, blue eyes. Very fit. Enjoys travel, reading, sports. Would like to share a glass of fine wine with a woman, 30-50, who has a stunning figure and a pleasant personality. Photo plea

CEO, WORLD TRAVELLER, GQ TYPE, 39, 6', dark complexioned, green eyed, well built. Also generous, kind and witty. Seeking stunning, sophisticated and worldly counterpart (25-35) over 5'3" for com-

Seeking European Beauty—Corporate president, Manhattanite, 39, 6', GQ type, well-built, green-eyed world traveler, witty and passionate. Seeks worldly and refined, stunning counterpart, 25-35, slim and fit, 5'3" plus, for committed relationship. Photo for reply - will exchange. 2557

Handsome Attorney—63, 5'10", successful, humorous, desires very pretty, intelligent professional lady, medium height, clean-cut, slim, about 50, for significant relationship. Phone/bio and clear, updated photo a must. 4067

UNIVERSITY ADMINISTRATOR/PROF. Sensitive, caring, cultured and adventurous. Divorced black male in mid-40s, 5'9", slender. Loves the arts, exploring NYC as well as quiet times and the outdoors. Seeking intellectual, assertive, attractive slender/trim woman mid-30s to mid-40s. Race, children unimportant. EXT 8706.

couples or couples casually dating? White found, as have other researchers, that married couples are better matched.

Perhaps this research prompts you to think of happy couples who are not similarly attractive. In such cases, the less attractive person often has compensating qualities. Each partner brings assets to the social marketplace, and the value of the respective assets creates an equitable match. Personal advertisements exhibit this exchange of assets (Koestner & Wheeler, 1988). Men typically offer status and seek attractiveness; women more often do the reverse: "Attractive, bright woman, 38, slender, seeks warm, professional male." The social-exchange process helps explain why beautiful young women often marry men whose social status exceeds their own (Elder, 1969). Prince Charles was not the handsomest man Lady Diana Spencer ever set eyes on, but he certainly was extremely rich, powerful, and prestigious.

Some scholars fear that, by *describing* the romantic marketplace in this way, researchers may *foster* a calculating, self-serving approach to relationships: If your mate gains weight or becomes wrinkled or if you achieve fame and fortune, why not dump the mate for one of better value? "It should be no surprise if a marketplace orientation to dating and mating had a hand in driving divorce rates up," warn Michael and Lise Wallach (1983, p. 25). "Such an orientation would make it only natural, after all, to stay on the lookout for some better deal . . . a chance to trade upward."

The social marketplace. Personal ads seeking companionship exemplify the value people place on physical attractiveness and other compensating assets.

"Love is often nothing but a favorable exchange between two people who get the most of what they can expect, considering their value on the personality market."
Erich Fromm, *The Sane Society,* 1955

The Physical-Attractiveness Stereotype

Do the benefits of being good-looking spring entirely from sexual attractiveness? Clearly not. Much as adults are biased toward attractive adults, young children are biased toward attractive children (Dion, 1973; Dion & Berscheid, 1974; Langlois & Stephan, 1981). To judge from how long they gaze at someone, even babies prefer attractive faces (Langlois & others, 1987). Adults show a similar bias when judging children. Margaret Clifford and Elaine Hatfield (Clifford & Walster, 1973) showed Missouri fifth-grade teachers identical information about a boy or girl but with the photograph of an attractive or unattractive child attached. The teachers perceived the attractive child as more intelli-

gent and successful in school. Think of yourself as a playground supervisor having to discipline an unruly child. Might you, like the University of Minnesota women studied by Karen Dion (1972), give less benefit of the doubt to an unattractive child? The sad truth is that, until shown otherwise, most of us assume what we might call a "Bart Simpson effect"—that homely children are less able and socially competent than their beautiful peers.

What is more, we assume that beautiful people, even if of the same sex, possess certain desirable traits. Other things being equal, we guess beautiful people are happier, more sociable, and more successful, though not more honest or concerned for others (Eagly & others, 1991; Hatfield & Sprecher, 1986). Not only does a smile make a face more attractive (Reis & others, 1990), but an attractive face makes a smile seem more self-confident and the person seem higher in status (Forgas, 1987; Kalick, 1988).

Physical-attractiveness stereotype:

The presumption that physically attractive people possess other socially desirable traits as well: What is beautiful is good.

Added together, the findings define a **physical-attractiveness stereotype:** What is beautiful is good. Children learn the stereotype quite early. Snow White and Cinderella are beautiful—and kind. The witch and the stepsisters are ugly—and wicked. As one kindergarten girl put it when asked what it means to be pretty, "It's like to be a princess. Everybody loves you" (Dion, 1979).

If physical attractiveness is this important, then permanently changing people's attractiveness should change the way others react to them. But is it ethical to alter someone's looks? In the United States, such manipulations are performed millions of times a year by plastic surgeons and orthodontists. With teeth and nose straightened, hair replaced and dyed, and face lifted, can a self-dissatisfied person find happiness?

"Even virtue is fairer in a fair body."
Virgil, *Aeneid*

To examine the effect of such alterations, Michael Kalick (1977) had Harvard students rate their impressions of eight women based on profile photographs taken before or after cosmetic surgery. Not only did they judge the women as more physically attractive after the surgery, but also as kinder, more sensitive, more sexually warm and responsive, more likable, and so on. Likewise, Karen Korabik (1981) found that University of Guelph (Ontario) students rated girls as more intelligent, better-adjusted, and so forth after they had completed orthodontic treatment. Amazingly, ratings were based on before and after pictures taken with mouths closed and teeth not showing. (Orthodontic treatment affects facial structure as well as teeth, and the raters were apparently responding to these subtle facial changes.) Ellen Berscheid (1981) notes that although such cosmetic improvements can boost self-image, they can also be temporarily disturbing:

> Most of us—at least those of us who have *not* experienced swift alterations of our physical appearance—can continue to believe that our physical attractiveness level plays a minor role in how we are treated by others. It is harder, however, for those who have actually experienced swift changes in appearance to continue to deny and to minimize the influence of physical attractiveness in their own lives—and the fact of it may be disturbing, even when the changes are for the better.

To say that attractiveness is important, other things being equal, is not to say that physical appearance always outranks other qualities. Attractiveness probably most affects first impressions. But first impressions are important—and are becoming more so as society becomes increasingly mobile and urbanized and contacts with people become more fleeting (Berscheid, 1981).

Moreover, though interviewers may deny it, attractiveness and grooming affect first impressions in job interviews (Cash & Janda, 1984; Mack & Rainey, 1990; Marvelle & Green, 1980). This helps explain why attractive people have more prestigious jobs, make more money, and describe themselves as happier (Umberson & Hughes, 1987). Patricia Roszell and her colleagues (1990) looked at the attractiveness of a national sample of Canadians whom interviewers had rated on a 1 (homely) to 5 (strikingly attractive) scale. They found that for each additional scale unit of rated attractiveness, people earned, on average, an additional $1988. Irene Hanson Frieze and her associates (1991) did the same analysis with 737 MBA graduates after rating them on a similar 1 to 5 scale using student picture book photos. For each additional scale unit of rated attractiveness, men earned an added $2600 and women earned an added $2150.

Is the Stereotype Accurate?

Do beautiful people indeed have desirable traits? Or was Leo Tolstoy correct when he wrote that it's "a strange illusion . . . to suppose that beauty is goodness"? There is a trace of truth to the stereotype. Attractive children and young adults tend to have slightly higher self-esteem and fewer psychological disorders (Hatfield & Sprecher, 1986; Maruyama & Miller, 1981). They are more assertive, although they are also believed to be more egotistical (Jackson & Huston, 1975). They are neither more nor less academically capable (contrary to the negative stereotype that "beauty times brains equals a constant") (Sparacino & Hansell, 1979). However, they are somewhat more socially polished. William Goldman and Philip Lewis (1977) demonstrated this by having 60 University of Georgia men call and talk for five minutes with each of three women students. Although the telephone partners were unseen, the men and women rated those who happened to be most attractive as somewhat more socially skillful and likable.

Surely these small average differences between attractive and unattractive people result from self-fulfilling prophecies. Attractive people are valued and favored, so many develop more social self-confidence. (You may recall from Chapter 2 an experiment in which men evoked a warm response from unseen women who they *thought* were attractive.) By this analysis, what's crucial to your social skill is not how you look but how people treat you and how you feel about yourself—whether you accept yourself, like yourself, feel comfortable with yourself.

Sara Kiesler and Roberta Baral (1970) led several dozen Yale men to feel either good about themselves—by leading them to think they were scoring high on a test of intelligence and creativity—or bad about themselves. During a break in the testing the experimenter and subject went for coffee and sat down next to a supposed female acquaintance of the experimenter's. The woman, actually a confederate, was groomed either as her very attractive self or very sloppily, with her hair tied back severely and grotesque eye glasses. When the experimenter excused himself to make a phone call, the confederate observed how warm and romantic the man was. Did he talk to her? compliment her? buy her coffee? ask her out? Men who were feeling good about themselves behaved most romantically toward the attractive confederate. Those whose self-esteem had been lowered exhibited more interest in the plain woman.

■ BEHIND THE SCENES

I vividly remember the afternoon I began to appreciate the far-reaching implications of physical attractiveness. Graduate student Karen Dion (now a professor at the University of Toronto) learned that some researchers at our Institute of Child Development had collected popularity ratings from nursery school children and taken a photo of each child. Although teachers and caregivers of children had persuaded us that "all children are beautiful" and no physical-attractiveness discriminations could be made, Dion suggested we instruct some people to rate each child's looks and correlate these with popularity. After doing so, we realized our long shot had hit home: Attractive children were popular children. Indeed, the effect was far more potent than we and others had assumed, with a host of implications that investigators are still tracing.

ELLEN BERSCHEID, *University of Minnesota*

Despite all the advantages of being beautiful, attraction researchers Elaine Hatfield and Susan Sprecher (1986) report there is also an ugly truth about beauty. Exceptionally attractive people may suffer unwelcome sexual advances from those of the other sex and resentment from those of their own sex. They may be unsure whether others are responding to their inner qualities or just to their looks, which in time are destined to fade. Others may regard them as vain and sexually unfaithful. Moreover, if they can coast on their looks, they may be less motivated to develop themselves in other ways. Ellen Berscheid wonders whether we might still be lighting our houses with candles if Charles Steinmetz, the homely and exceptionally short genius of electricity, had instead been subjected to the social enticements experienced by a Mel Gibson or Rob Lowe.

Who Is Attractive?

I have described attractiveness as if it were an objective quality like height, which some people have more of, some less. Strictly speaking, attractiveness is whatever the people of any given place and time find attractive. This, of course, varies. The beauty standards by which Miss Universe is judged hardly apply to the whole planet. Among African-Americans, the definition of beauty has varied (Neal & Wilson, 1989). Historically there has been a strong preference for fine features (exemplified by Michael Jackson's cosmetic surgery on his nose) and light skin (exemplified when Vanessa Williams became the first Black woman named Miss America). But the "Black is beautiful" movement of the 1960s and 1970s questioned and weakened White standards of attractiveness. Even in a given place and time, people (fortunately) disagree about who's attractive and who's not (Morse & Gruzen, 1976).

But there is also some agreement. Generally, "attractive" facial and bodily features do not deviate too drastically from the average (Beck & others, 1976; Graziano & others, 1978; Symons, 1981). People perceive noses, legs, or statures that are not unusually large or small as relatively attractive. Judith Langlois

and Lori Roggman (1990) showed this by digitizing the faces of up to 32 college students and using a computer to average them. Students judged the composite faces as more appealing than 96 percent of the individual faces. So in some respects, perfectly average is strikingly attractive.

What makes for an attractive face depends somewhat on one's sex. Consistent with men's historically having greater social power (Chapter 6), people judge women more attractive if they have "baby-faced" features, such as large eyes, that suggest nondominance (Cunningham, 1986; Keating, 1985). Men seem more attractive when their faces—and their behaviors—suggest maturity and dominance (Sadalla & others, 1987). Curiously, among homosexuals these preferences tend to reverse: Many gay males prefer baby-faced males, and lesbians seem not to show the usual preference for baby-faced females. With this exception, reports Michael Cunningham (1991), people across the world show remarkable agreement about the features of an ideal male face and female face when judging any ethnic group.

The Evolutionary View

Psychologists working from an evolutionary perspective explain these gender differences in terms of reproductive strategy (Buss, 1988; Kenrick & Trost, 1987, 1989). They assume that evolution predisposes men to favor female features that imply youth and health—and therefore good reproductive potential. And they assume women favor male traits signifying an ability to provide and protect resources. David Buss (1987) invites us to consider a world where this was not so, a world where "males expressed no preference for physical appearance cues that correlate with female reproductive capability." These males would sometimes mate with women who are no longer fertile and so "would become no one's ancestors." Thus, if a preference for women who appear young and fertile has even a slight genetic basis, then over time such preferences "would necessarily evolve."

Assume that males who prefer fertile-seeming females leave more offspring than males who prefer infertile-seeming females. That, Buss (1989) believes, would explain why the males he studied in 37 cultures—from Australia to Zambia—do indeed prefer female characteristics that signify reproductive ca-

Standards of beauty differ from culture to culture. Yet some people—especially those with youthful features that suggest health and fertility—are considered attractive throughout most of the world.

"I'LL TELL YOU WHY WE'RE BECOMING EXTINCT. BECAUSE WE'RE SOLITARY CREATURES, EVEN DURING THE <u>MATING</u> SEASON — THAT'S WHY WE'RE BECOMING EXTINCT."

pacity. Douglas Kenrick and Richard Keefe (1992) believe it also explains why older males across the world prefer younger females. And Thomas Alley and Michael Cunningham (1991) believe it explains why in some respects it's not perfectly average that's most attractive but bodily features such as smooth skin that suggest better-than-average health and fertility.

By the same evolutionary mechanisms, women are said to prefer men whose traits and resources suggest a maximum potential contribution to their offspring. Thus, status, ambition, and dominance cues are more important to women than to men. This explains why physically attractive females tend to marry high-status males and why men compete with such determination to achieve fame and fortune. Or so evolutionary psychology contends.

Attractiveness Is Relative

What's attractive to you also depends on what you have adapted to. Douglas Kenrick and Sara Gutierres (1980) had male confederates interrupt Montana State University men in their dormitory rooms and explain, "We have a friend coming to town this week and we want to fix him up with a date, but we can't decide whether to fix him up with her or not, so we decided to conduct a survey. . . . We want you to give us your vote on how attractive you think she is . . . on a scale of 1 to 7." Shown a picture of an average young woman, those who had just been watching three beautiful women on television's *Charlie's Angels* rated her less attractive than those who hadn't.

Laboratory experiments confirm this "contrast effect." To men who have

"Love is only a dirty trick played on us to achieve a continuation of the species."
Novelist W. Somerset Maugham, 1874–1965

recently been gazing at centerfolds, average women—or even their own wives—seem less attractive (Kenrick & others, 1989). Viewing pornographic films simulating passionate sex similarly decreases dissatisfaction with one's own partner (Zillmann, 1989). Being sexually aroused may temporarily make a person of the other sex seem more attractive. But the residual effect of exposure to perfect "10s," or of unrealistic sexual depictions, is to make one's own partner seem less appealing—more like a "5" than an "8." It works the same way with our self-perceptions. After viewing a superattractive person of the same sex, people *feel* less attractive than after viewing a homely person (Brown & others, 1992).

We can conclude our discussion of attractiveness on a heartwarming note. Not only do we perceive attractive people as likable, but we also perceive likable people as attractive. Perhaps you can recall individuals who, as you grew to like them, became more attractive, their physical imperfections no longer so noticeable. Alan Gross and Christine Crofton (1977) had University of Missouri–St. Louis students view someone's photograph after reading a favorable or unfavorable description of the person's personality. When portrayed as warm, helpful, and considerate, people *looked* more attractive. Discovering someone's similarities to us also makes the person seem more attractive (Beaman & Klentz, 1983; Klentz & others, 1987). Moreover, love sees loveliness: The more in love a woman is with a man, the more physically attractive she finds him (Price & others, 1974). And the more in love people are, the *less* attractive they find all others of the opposite sex (Johnson & Rusbult, 1989; Simpson & others, 1990). "The grass may be greener on the other side," note Rowland Miller and Jeffry Simpson (1990), "but happy gardeners are less likely to notice." To paraphrase Benjamin Franklin, when Jill's in love, she finds Jack more handsome than his friends.

SIMILARITY VERSUS COMPLEMENTARITY

From our discussion so far, one might surmise Leo Tolstoy was entirely correct: "Love depends . . . on frequent meetings, and on the style in which the hair is done up, and on the color and cut of the dress." However, as people get to know one another, other factors influence whether an acquaintanceship will develop into a friendship. Thus, men's initial liking for one another after the first week of living in the same boardinghouse does *not* predict very well their ultimate liking four months later (Nisbett & Smith, 1989). Their similarity, however, does.

Do Birds of a Feather Flock Together?

Of this much we may be sure: Birds who flock together are of a feather. Friends, engaged couples, and spouses are far more likely than people randomly paired to share common attitudes, beliefs, and values. Furthermore, among married couples, the greater the similarity between husband and wife, the happier they are, the less likely they are to divorce, and the more unchanging are their personalities (Byrne, 1971; Caspi & Herbener, 1990). Such correlational findings are intriguing. But cause and effect remain an enigma. Does similarity lead to liking? Does liking lead to similarity? Or do attitude similarity and liking both spring from some third factor, such as common cultural background?

"Do I love you because you are beautiful, or are you beautiful because I love you?"
Prince Charming, in Rogers & Hammerstein's *Cinderella*

"Can two walk together except they be agreed?"
Amos 3:3

Likeness Begets Liking

To discern cause and effect, we experiment. Imagine that at a campus party Laura gets involved in a long discussion of politics, religion, and personal likes and dislikes with Les and Larry. She and Les discover they agree on almost everything, she and Larry on few things. Afterward, she reflects: "Les is really intelligent. And he's so likable. I hope we meet again." In experiments, Donn Byrne (1971) and his colleagues captured the essence of Laura's experience. Over and over again they found that the more similar someone's attitudes are to your own, the more likable you will find the person. This "likeness-leads-to-liking" relationship holds true not only for college students but also for children and the elderly, people of various occupations, and those in various nations. What matters is not only the number of similar attitudes expressed by the other person (Kaplan & Anderson, 1973) but the proportion: We like better someone who shares our opinions on 4 of 6 topics than one who agrees on 8 of 16 (Byrne & Nelson, 1965).

This "agreement" effect has been tested in real-life situations by noting who comes to like whom (Lapidus & others, 1985; Neimeyer & Mitchell, 1988). At the University of Michigan, Theodore Newcomb (1961) studied two groups of 17 unacquainted male transfer students. After 13 weeks of living together in a boardinghouse, those whose agreement was initially highest were most likely to have formed close friendships. One group of friends was composed of five liberal arts students, each a political liberal with strong intellectual interests. Another was made up of three conservative veterans who were all enrolled in the engineering college. Similarity breeds content.

Because the men living in the boardinghouse spent much of their time out of

"And they are friends who have come to regard the same things as good and the same things as evil, they who are friends of the same people, and they who are the enemies of the same people. . . . We like those who resemble us, and are engaged in the same pursuits."
Aristotle, *Rhetoric*

"Actually, Lou, I think it was more than just my being in the right place at the right time. I think it was my being the right race, the right religion, the right sex, the right socioeconomic group, having the right accent, the right clothes, going to the right schools . . ."

Drawing by Miller; © 1992 The New Yorker Magazine, Inc.

the house, it took a while for likes to attract. William Griffitt and Russell Veitch (1974) compressed the getting-to-know-you process by confining 13 unacquainted men in a fallout shelter. (The men were paid volunteers.) Knowing the men's opinions on various issues, the researchers could predict with better-than-chance accuracy whom each man would most like and most dislike. As in the boardinghouse, the men liked best those most like themselves.

Like all generalizations, the similarity-attraction principle needs qualification. First, when made to feel like a faceless member of a homogeneous crowd, we like to associate with people who restore our feeling of being special (Snyder & Fromkin, 1980). Second, similarity sometimes divides people—when they are competing for scarce payoffs, such as jobs or grades in a curve-graded class. Third, the *type* of similarity makes a difference. Similarity matters more on important issues; we like people who share our ideals (Wetzel & Insko, 1982). And while we *like* best those who share our preferred activities, we *respect* most those who share our attitudes (Lydon & others, 1988). Finally, similarity is relative: Merely being from the same country is enough to breed mutual warmth when one is a foreign student or tourist. In the Scottish town where I resided while writing this, Americans who had little in common in the United States often greeted one another like old friends.

Nevertheless, similar attitudes are a potent source of attraction. Birds of a feather *do* flock together. Surely you have noticed this upon discovering a special someone who shares your ideas, values, and desires, a soul mate who likes the same music, the same activities, even the same foods you do.

Liking Begets Perceived Likeness

As we noted earlier, it works the other way around as well: Those who flock together perceive themselves to be of a feather. Voters overestimate the extent to which their candidates share their views (Judd & others, 1983). Men who feel romantically inclined toward a woman overestimate the similarity of her ideas and interests to their own (Gold & others, 1984). Even the attraction that arises from mere exposure to photographs of certain faces is enough to trigger the perception that those likable people are similar to oneself (Moreland & Zajonc, 1982). As Figure 13-4 suggests, such perceptions may then reinforce one's lik-

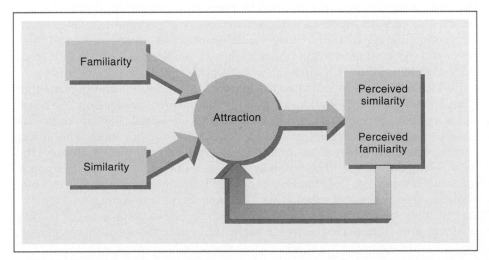

FIGURE 13-4 *The interplay among familiarity, similarity, attraction, and perceived familiarity and similarity. Experiments reveal that (1) familiarity and similarity lead to liking and that (2) liking leads to perceived familiarity and similarity, which in turn (3) reinforces liking.*

ing for a person. Strangers made to think they are similar (whether they are or not) will talk as intimately as friends, which may in turn lead to their actually becoming friends (Piner & Berg, 1988).

Dissimilarity Breeds Dislike

We have a bias—the "false consensus bias"—toward assuming that others do share our attitudes. When we discover that someone's attitudes are dissimilar, we may dislike the person. Iowa Democrats surveyed in one study were not so much fond of other Democrats as they were disdainful of Republicans (Rosenbaum, 1986). The extent to which people perceive those of another race as similar or dissimilar therefore helps determine racial attitudes. When people perceived Jews or Native Americans as a lower species of life, genocide was not far behind. Wherever one group of people regards another as "other"—as creatures who speak differently, live differently, think differently—the potential for oppression is high. Opposites attack.

In fact, except for intimate relationships, such as dating, the perception of like minds seems more important for attraction than like skins. Most Whites express more liking for, and willingness to work with, a similarly minded Black than a dissimilarly minded White (Insko & others, 1983; Rokeach, 1968). Yet "cultural racism" persists, argues James Jones (1988), because cultural differences are a fact of life. Black culture tends to be present-oriented, expressive, spiritual, and emotionally driven. White culture tends to be more future-oriented, individualistic, materialistic, and achievement-driven, and it judges people accordingly. Rather than trying to eliminate such differences, says Jones, we might better appreciate what they "contribute to the cultural fabric of a multicultural society." There are situations in which expressiveness is advantageous and situations in which future orientation is advantageous. Each culture has much to learn from the other. And in countries where migration and different birthrates make for growing diversity, a major challenge is educating people to respect and enjoy those who are different.

In the United States during the 1980s, the ethnic minority population grew from 12 to 20 percent. Canada and the European countries are experiencing similar diversification.

Do Opposites Attract?

But are we not also attracted to people who are in some ways *different* from ourselves, different in ways that complement our own characteristics? Researchers have explored this question by comparing not only the attitudes and beliefs of friends and spouses but also their age, religion, race, smoking behavior, economic level, education, height, intelligence, and appearance. In all these ways and more, similarity still prevails (Buss, 1985; Kandel, 1978). Smart birds flock together. So do rich birds, Protestant birds, tall birds, pretty birds.

Still we resist: Are we not attracted to people whose needs and personalities complement our own? Would a gratifying relationship develop from the meeting of a sadist and a masochist? Even the *Reader's Digest* tells us that "opposites attract. . . . Socializers pair with loners, novelty-lovers with those who dislike change, free spenders with scrimpers, risk-takers with the very cautious" (Jacoby, 1986). Sociologist Robert Winch (1958) reasoned that the needs of someone who is outgoing and domineering would naturally complement those of someone who is shy and submissive. The logic seems compelling, and most of us can think of couples who view their differences as complementary: "My husband and I are perfect for each other. I'm Aquarius—a decisive person.

■ BEHIND THE SCENES

As a Yale graduate student I was invited to write a book on prejudice. Wanting to take readers past the individual blame aspect of prejudice, I entitled the volume *Prejudice and Racism*, and explained how race problems are embedded in society. Prejudice is ultimately not a race problem but a culture problem. European- and African-heritage cultures differ, and their differences are the soil from which springs cultural racism—the intolerance of those whose culture differs. In today's world of ethnic mixing, we must learn to accept our cultural diversity even as we seek unifying ideals.

JAMES JONES, *University of Delaware*

He's Libra—can't make decisions. But he's always happy to go along with arrangements I make."

Given the idea's persuasiveness, the inability of researchers to confirm it is astonishing. For example, most people feel attracted to expressive, outgoing people (Friedman & others, 1988). Would this be especially so when one is down in the dumps? Do depressed people seek those whose gaiety will cheer them up? To the contrary, it is happy people who most prefer the company of happy people (Locke & Horowitz, 1990; Rosenblatt & Greenberg, 1988, 1991; Wenzlaff & Prohaska, 1989). When you're feeling blue, another's bubbly personality is not appealing. The contrast effect that makes average people feel homely in the company of beautiful people also makes sad people more conscious of their misery in the company of cheerful people.

Some **complementarity** may evolve as a relationship progresses (even a relationship between two identical twins). Yet people seem, if anything, slightly more prone to marry those whose needs and personalities are *similar* (Berscheid & Walster, 1978; Buss, 1984; D. Fishbein & Thelen, 1981a, 1981b; Nias, 1979). Perhaps we shall yet discover some ways (other than heterosexuality) in which differences commonly breed liking. But researcher David Buss (1985) doubts it: "The tendency of opposites to marry, or mate . . . has never been reliably demonstrated, with the single exception of sex." So it seems that the "opposites-attract" rule, if it's ever true, is of minuscule importance compared to the powerful tendency of likes to attract.

Complementarity:
The supposed tendency, in a relationship between two people, for each to complete what is missing in the other. The questionable complementarity hypothesis proposes that people attract those whose needs are different, in ways that complement their own.

LIKING THOSE WHO LIKE US

With hindsight, the reward principle explains our conclusions so far:

- *Proximity* is rewarding. It costs less time and effort to receive friendship's benefits with someone who lives or works close by.
- We like *attractive* people because we perceive that they offer other desirable traits and because we benefit by associating with them.
- If others have *similar* opinions, we feel rewarded because we presume that

they like us in return (Condon & Crano, 1988). Moreover, those who share our views help validate them. We especially like people if we have successfully converted them to our way of thinking (Lombardo & others, 1972; Riordan, 1980; Sigall, 1970).

If we like those whose behavior is rewarding, then we ought to adore those who like and admire us. The best friendships should be mutual admiration societies. Do we in fact like those who like us? Let's examine the evidence.

It's true that we like those who we think like us. And it is also true that we presume those we like also like us (Curry & Emerson, 1970). But maybe they don't. In the University of Minnesota Welcome Week dating experiment, how much a man liked his date was unrelated to how much she liked him. With such a disconcerting finding—do we wrongly imagine that our friends like us?—David Kenny and William Nasby (1980) refined the research method. They analyzed various dyads to see how person A felt about person B, relative to how other people felt about B and relative to how A felt about other people. Sure enough, one person's relative liking for another predicted the other's relative liking in return. Liking was mutual.

But does one person's liking another *cause* the other to return the appreciation? People's reports of how they fell in love suggest yes (Aron & others, 1989). Discovering that an appealing someone really likes you seems to awaken romantic feelings. And experiments confirm it. Those told that certain others like or admire them feel a reciprocal affection (Berscheid & Walster, 1978). Ellen Berscheid and her colleagues (1969) even found that University of Minnesota students liked better another student who said eight positive things about them than one who said seven positive things and one negative thing. We are sensitive to the slightest hint of criticism. Writer Larry L. King speaks for many in noting, "I have discovered over the years that good reviews strangely fail to make the author feel as good as bad reviews make him feel bad." Whether we are judging ourselves or others, negative information carries more weight because, being less usual, it grabs more attention (Yzerbyt & Leyens, 1991). People's votes are more influenced by their impressions of presidential candidates' weaknesses than by their impressions of strengths (Klein, 1991), a phenomenon that has not been lost on those who design negative campaign tactics.

Believing that another likes or dislikes you can be self-fulfilling. Rebecca Curtis and Kim Miller (1986) discovered this with Adelphi University students. They led some to believe that someone they had briefly met either liked or disliked them. When later conversing with this person, those who felt liked disclosed more about themselves, disagreed less, and exhibited a warmer attitude and tone of voice—and therefore elicited more warmth in return from the naive conversational partner.

This principle—that we like and treat warmly those we perceive as liking us—was recognized long before social psychologists confirmed it. Observers from the ancient philosopher Hecato ("If you wish to be loved, love") to Ralph Waldo Emerson ("The only way to have a friend is to be one") to Dale Carnegie ("Dole out praise lavishly") anticipated the findings. What they did not anticipate was the precise conditions under which the principle works.

Attribution

As we've seen, flattery *will* get you somewhere. But not everywhere. If praise clearly violates what we know is true—if someone says, "Your hair looks

great," when we haven't washed it in days—we may lose respect for the flatterer and wonder whether the compliment springs from ulterior motives (Shrauger, 1975). For such reasons, we often believe criticism to be more sincere than praise (Coleman & others, 1987).

Laboratory experiments reveal something we've noted in previous chapters: Our reactions depend on our attributions. Do we attribute the other's flattery to some **ingratiating** selfish motive? Is the person trying to con us—to get us to buy something, to acquiesce sexually, to do a favor? If so, both the flatterer and the praise lose appeal (E. E. Jones, 1964; Lowe & Goldstein, 1970). But if there is no apparent ulterior motive, then we warmly receive both flattery and flatterer.

How we explain our own actions also matters. Clive Seligman, Russell Fazio, and Mark Zanna (1980) paid undergraduate dating couples to indicate "why you go out with your girl friend/boy friend." They asked some to rank seven intrinsic reasons, such as "I go with _____ because we always have a good time together" and "because we share the same interests and concerns." Others ranked possible extrinsic reasons: "because my friends think more highly of me since I began seeing her/him" and "because she/he knows a lot of important people." Asked later to respond to a "Love Scale," those whose attention had been drawn to possible extrinsic reasons for their relationship expressed less love for their partner and saw marriage as a less likely possibility than did those made aware of possible intrinsic reasons. (Sensitive to ethical concerns, the researchers debriefed all the participants afterward and confirmed that the experiment had no long-term effects on the participants' relationships.)

Ingratiation:
The use of strategies, such as flattery, by which people seek to gain another's favor.

Self-Esteem and Attraction

The reward principle also implies that another's approval should be especially rewarding after one has been deprived of approval, much as eating is most powerfully rewarding when we are extremely hungry. To test this idea, Elaine Hatfield (Walster, 1965) gave some Stanford University women either very favorable or very unfavorable analyses of their personalities, affirming some and wounding others. Then she asked them to evaluate several people, including an attractive male confederate who just before the experiment had struck up a warm conversation with each subject and had asked each for a date. (Not one turned him down.) After the affirmation or criticism, which women do you suppose most liked the man? It was those whose self-esteem had been temporarily shattered and who were presumably hungry for social approval. This helps explain why people sometimes fall in love quickly on the rebound, after an ego-bruising rejection.

After this experiment Dr. Hatfield spent almost an hour explaining the experiment and talking with each woman. She reports that in the end, none remained disturbed by the temporary ego blow or the broken date.

Gaining Another's Esteem

If approval after disapproval is powerfully rewarding, then would we most like someone who liked us after initially disliking us *or* someone who liked us from the start? Dick is in a small discussion class with his roommate's cousin, Jan. After the first week of classes, Dick learns via his "pipeline" that Jan thinks him rather dull, shallow, and socially awkward. However, as the semester progresses, he learns that Jan's opinion of him is steadily rising; gradually she comes to view him as bright, thoughtful, and charming. Will Dick now like Jan as much as he would have had she thought well of him from the beginning? If Dick is simply counting the number of approving comments he receives, then

the answer will be no: he would like Jan better had she consistently offered affirmative comments. But if after her initial disapproval, Jan's rewards become more potent, Dick then might like her just as much as if she had been consistently affirming.

To see which is most often true, Elliot Aronson and Darwyn Linder (1965) captured the essence of Dick's experience in a controlled experiment. They "allowed" 80 University of Minnesota women to overhear a sequence of evaluations of themselves by another woman. Some women heard consistently positive things about themselves, some consistently negative. Still others heard evaluations that changed either from negative to positive (like Jan's evaluations of Dick) or from positive to negative. In this and other experiments, the target person is liked as much or even more when the subject experienced a *gain* in the other's esteem, especially when the gain occurs gradually and reverses the earlier criticism (Aronson & Mettee, 1974; Clore & others, 1975). Perhaps Jan's nice words have more credibility coming after her not-so-nice words. Or perhaps after being withheld, they are especially gratifying.

Aronson speculates that constantly approving a loved one can lose value. When the complimentary husband says for the five-hundredth time, "Gee, honey, you look great," the words carry far less impact than were he now to say, "Gee, honey, you don't look good in that dress." A loved one you've doted upon is hard to reward but easy to hurt. This suggests that an open, honest relationship—one where people enjoy one another's esteem and acceptance yet are candid about their negative feelings—is more likely to offer continuing rewards than one dulled by the suppression of unpleasant emotions, one in which people try only, as Dale Carnegie advised, to "lavish praise." Aronson (1988) put it this way:

> As a relationship ripens toward greater intimacy, what becomes increasingly important is authenticity—our ability to give up trying to make a good impression and begin to reveal things about ourselves that are honest even if unsavory. In addition, we must be willing to communicate a wide range of feelings to our friends under appropriate circumstances and in ways that reflect our caring. Thus . . . if two people are genuinely fond of each other, they will have a more satisfying and exciting relationship over a longer period of time if they are able to express both positive and negative feelings than if they are completely "nice" to each other at all times. (p. 323)

They may also help one another become more socially competent. In most social interactions, we self-censor our negative feelings. Such feelings may still leak through nonverbally, but less sensitive people may never receive these subtle messages. Thus, note William Swann and his colleagues (1991), they may live deaf to corrective feedback that fails to penetrate the facade of kind words. Living in a world of pleasant illusion, they continue to act in ways that alienate their would-be friends. A true friend is one who loves and accepts us, but with enough honesty to let us in on bad news.

"Hatred which is entirely conquered by love passes into love, and love on that account is greater than if it had not been preceded by hatred."
Baruch Spinoza, *Ethics*

"It takes your enemy and your friend, working together, to hurt you to the heart; the enemy to slander you and the friend to get the news to you."
Mark Twain, *Pudd'nhead Wilson's New Calender*, 1911

■ LOVING

What is this thing called "love"? Loving is more complex than liking and thus more difficult to measure, more perplexing to study. People yearn for it, live

for it, die for it. Yet only in the last few years has loving—despite Senator Proxmire's scorn—become a serious topic in social psychology.

Most attraction researchers have studied what is most easily studied—responses during brief encounters between strangers. Such first impressions can color our later perceptions of the person. What is more, initial influences on our liking of another—proximity, attractiveness, similarity, being liked—also influence our long-term, close relationships. The impressions that dating couples quickly form of each other therefore provide a clue to their long-term future (Berg, 1984; Berg & McQuinn, 1986). Indeed, if romances in the United States flourished *randomly,* without regard to proximity and similarity, then most Catholics (being a minority) would marry Protestants, most Blacks would marry Whites, and college graduates would be as apt to marry high school dropouts as fellow graduates.

So first impressions are important. Nevertheless, loving is not merely an intensification of initial liking. Social psychologists are therefore shifting their attention from the mild attraction experienced during first encounters to the study of enduring, close relationships.

One line of investigation has compared the nature of love in various close relationships—same-sex friendships, parent-child relationships, and spouses or lovers (Davis, 1985; Maxwell, 1985; Sternberg & Grajek, 1984). These investigations reveal elements that are common to all loving relationships: mutual understanding, giving and receiving support, valuing and enjoying being with the loved one. Although such ingredients of love apply equally to love between best friends or between husband and wife, they are spiced differently depending on the relationship. Passionate love, especially in its initial phase, is distinguished by physical affection, an expectation of exclusiveness, and an intense fascination with the loved one.

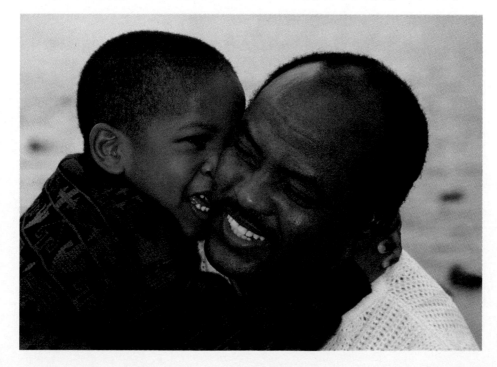

Children too experience the emotional intensity that defines passionate love.

Lest we think that passionate love occurs only between romantic lovers, Phillip Shaver and his co-workers (1988) note that year-old infants typically display a passionate attachment to their parents. Much like young adult lovers, they welcome physical affection, are distressed when separated, express intense affection when reunited, and take great pleasure in parental attention and approval. John Carlson and Elaine Hatfield (1992) report that five-year-olds, too, often display passionate love, by acknowledging that there is a child of the other sex whom they can't stop thinking about, whom they want to be near, and whom they like to touch and be touched by. However, love researchers focus their attention not on these rudimentary passions but on adolescent and adult romantic loving.

PASSIONATE LOVE

The first step in scientifically studying romantic love, as in studying any variable, is to decide how to define and measure it. We have ways to measure aggression, altruism, prejudice, and liking—but how do we measure love? Elizabeth Barrett Browning asked a similar question: "How do I love thee? Let me count the ways." Social scientists have counted various ways. Psychologist Robert Sternberg (1988) views love as a triangle, whose three sides (of varying lengths) are passion, intimacy, and commitment (Figure 13-5). Drawing from ancient philosophy and literature, sociologist John Alan Lee (1988) and psychologists Clyde Hendrick and Susan Hendrick (1993) identify three primary love styles—*eros* (passion), *ludus* (game playing), and *storge* (friendship)—which, like the primary colors, combine to form secondary love styles, such as mania (a compound of eros and ludus). Pioneering love researcher Zick Rubin

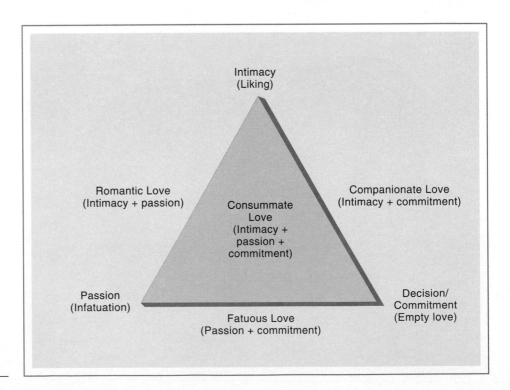

FIGURE 13-5 *Robert Sternberg's (1988) conception of combinations of three basic components of love.*

■ **BEHIND THE SCENES**

When I was an undergraduate, I studied learning and motivation in rats. By the time I entered Stanford, I had become less interested in rats and more interested in the very human phenomena of passionate love and emotions. Learning theory didn't do a very good job of explaining these powerful experiences. My fellow graduate students, who were mostly hard scientists interested in constructing mathematical models of rat learning, warned me to avoid such topics. They dismissed love and emotions as taboo, impossibly difficult to study, and trivial, though common sense argued for their significance. Luckily, I've always followed my own passions and have been able to spend my time studying those subjects I had always wondered about: passionate love, emotions, and the place of physical attractiveness in personal encounters.

ELAINE HATFIELD, *University of Hawaii*

(1970, 1973) discerned somewhat different factors. To tap each, he wrote questionnaire items:

1. *Attachment* (for example, "If I were lonely, my first thought would be to seek _____ out.")

2. *Caring* (for example, "If _____ were feeling bad, my first duty would be to cheer him [her] up.")

3. *Intimacy* (for example, "I feel that I can confide in _____ about virtually everything.")

Rubin gave his Love Scale to hundreds of dating couples at the University of Michigan. He later invited to the laboratory couples whose scores suggested their relationship was either weak or strong. While each couple awaited the session, observers behind a one-way mirror clocked the time they maintained eye contact. The "weak-love" couples looked at one another less than the "strong-love" couples, who gave themselves away by gazing into one another's eyes.

Passionate love is emotional, exciting, intense. Hatfield (1988) defines it as *"a state of intense longing for union with another"* (p. 193). If reciprocated, one feels fulfilled and joyous; if not, one feels empty or despairing. Like other forms of emotional excitement, passionate love involves a mix of elation and gloom, tingling exhilaration and dejected misery.

As this definition implies, people can feel passionate love toward someone who evokes pain, anxiety, and jealousy. Why? Romantic love sometimes seems not to follow the sensible principle that we like those who reward us and dislike those who cause us pain. Douglas Kenrick and Robert Cialdini (1977) propose one possible answer: While the loved one may cause pain and anxiety, the loved one also alleviates those emotions. The lover triggers jealousy when with someone else, yet also offers ecstatic relief upon returning. Loving those associated with the termination of negative feelings actually illustrates the re-

Passionate love:
A state of intense longing for union with another. Passionate lovers are absorbed in one another, feel ecstatic at attaining their partner's love, and are disconsolate on losing it.

"Passionate love is in many ways an altered state of consciousness. . . . In many states today, there are laws that a person must not be in an intoxicated condition when marrying. . . . But passionate love is a kind of intoxication."

Roy Baumeister, *Meanings of Life*, 1991

ward principle. Perhaps you can recall a "lover's quarrel" that was almost justified by the intense pleasure of making up.

A Theory of Passionate Love

Hatfield has a different explanation of passionate love, one that applies a theory of emotion we considered in Chapter 12. There, we saw that a given state of arousal can be steered into any of several emotions, depending on how we attribute the arousal. An emotion involves both body and mind, both arousal and how we interpret and label the arousal. Imagine yourself with pounding heart and trembling hands: Are you experiencing fear, anxiety, joy? Physiologically, one emotion is quite similar to another. You may therefore experience the arousal as joy if you are in a euphoric situation, anger if your environment is hostile, and passionate love if the situation is romantic. In this view, passionate love is the psychological experience of being biologically aroused by someone we find attractive.

If indeed passion is a revved-up state that's labeled "love," then whatever revs one up should intensify feelings of love. In several experiments, college men aroused sexually by reading or viewing erotic materials had a heightened response to a woman (for example, by scoring much higher on Rubin's Love Scale when describing their girlfriend) (Carducci & others, 1978; Dermer & Pyszczynski, 1978; Stephan & others, 1971). Proponents of the **two-factor theory of emotion** argue that when the revved-up men respond to a woman, they easily misattribute some of their arousal to her.

Two-factor theory of emotion:
Arousal × label = emotion.

According to this theory, being aroused by *any* source should intensify one's passionate feelings—providing one's mind is free to attribute some of the arousal to a romantic stimulus. Donald Dutton and Arthur Aron (1974, 1989) invited University of British Columbia men to participate in a learning experiment. After meeting their attractive female partner, some were frightened with the news that they would be suffering some "quite painful" electric shocks. Before the experiment was to begin, the researcher gave a brief questionnaire "to get some information on your present feelings and reactions, since these often influence performance on the learning task." Asked how much they would like to date and kiss their female partner, the aroused (frightened) men expressed more intense attraction toward the woman.

Likewise, after Gregory White and his co-researchers (1981; White & Kight, 1984) aroused college men—by having them run in place, listen to a Steve Martin comedy routine, or hear a grisly tape of human mutilation—the men responded more intensely to a confederate female. They expressed greater liking for an attractive woman and greater disliking for an unattractive woman. And Brett Cohen and his co-researchers (1989) report that couples exhibit more attraction (by touching and talking) when leaving a movie theater than when entering—*if* they have just watched an arousing thriller rather than an unemotional movie.

Does this phenomenon occur outside the laboratory? Dutton and Aron (1974) had an attractive young woman approach individual young men as they crossed a narrow, wobbly 450-foot-long suspension walkway hanging 230 feet above British Columbia's rocky Capilano River. The woman asked each man to help her fill out a class questionnaire. When he had finished, she scribbled her name and phone number and invited him to call if he wanted to hear more about the project. Most accepted the phone number, and half who did so called. By contrast, men approached by the woman on a low, solid bridge, and

men approached on the high bridge by a *male* interviewer, rarely called. Once again, physical arousal accentuated romantic responses. Adrenaline made the heart grow fonder.

But does it usually? Social psychologists debate this (Furst & others, 1980; Kenrick & others, 1979). The two-factor theory of romantic love predicts that arousal will most intensify love when its source is ambiguous, leaving us free to misattribute the arousal to passion. But sometimes the source of our arousal is *un*ambiguous; we know all too well why we're feeling anxious, irritated, or frightened. Ruminating on the problem can therefore leave us *less* open to romantic love. At other times, as when we are elated or stirred by a happening that doesn't gnaw at our minds, our arousal can be steered into passion. Our actual arousal—say, the elevated heart rate that lingers several minutes after exercising—outlasts our *feeling* aroused (Cacioppo & others, 1987). This lingering but unperceived arousal means that we need less stimulation to raise our responses back up to the threshold for feeling aroused. The lingering arousal fuels the new emotion. Even when we know that something like exercise has previously aroused us, the arousal adds fuel to any other fire currently burning (Allen & others, 1989).

"The 'adrenaline' associated with a wide variety of highs can spill over and make passion more passionate. (Sort of a 'Better loving through chemistry' phenomenon.)"
Elaine Hatfield and Richard Rapson (1987)

Variations in Love

Time and Culture
There is always a temptation (the false consensus effect) to assume that others share our feelings and ideas. We assume, for example, that love is a precondition for marriage. But this assumption is not shared in cultures that practice arranged marriages. Moreover, until recently in North America, marital choices, especially those by women, were strongly influenced by considerations of economic security, family background, and professional status. But by

The arranged marriages which have long been a feature of Indian culture may have emotional as well as practical advantages: In one study done in Jaipur, India, in love-based marriages romantic love declined with years of marriage; in arranged marriages, love increased over time.

FIGURE 13-6 *Passionate love: now, but not always, an essential precondition for marriage in North America. As college women have become freer of economic dependence on men, they have also become more likely to regard love as a prerequisite for marriage.*
(From Simpson & others, 1986.)

the mid-1980s, as Figure 13-6 indicates, almost 9 in 10 young adults surveyed indicated that love is essential for marriage. Thus cultures vary in the importance placed upon romantic love. In western cultures today, love generally precedes marriage; in others, it more often follows marriage.

Personality

Within any given place and time, individuals also vary in their approach to heterosexual relationships. Some seek a succession of short involvements; others value the intimacy of an exclusive and enduring relationship. In a series of studies, Mark Snyder and his colleagues (1985, 1988; Snyder & Simpson, 1985) identified a personality difference linked with these two approaches to romance. In Chapter 4 we noted that some people—those high in "self-monitoring"—skillfully monitor their own behavior to create the desired effect in any given situation. Others—those low in self-monitoring—are more internally guided, more likely to report that they act the same way regardless of the situation.

Which type of person—someone high or low in self-monitoring—would you guess to be more affected by a prospect's physical appearance? to be more willing to end a relationship in favor of a new partner and therefore to date more people for shorter periods of time? to be more sexually promiscuous?

Snyder and Simpson report that in each case the answer is the person high in self-monitoring. Such people are skilled in managing first impressions but tend to be less committed to deep and enduring relationships. Low self-monitors, being less externally focused, are more committed and display more concern for people's inner qualities. When perusing folders to examine poten-

tial dates or employees, they place a higher premium on personal attributes than on appearance. And given a choice between someone who shares their attitudes or their preferred activities, low self-monitors (unlike high self-monitors) feel drawn to those with kindred attitudes (Jamieson & others, 1987).

Gender

Do males and females differ in how they experience passionate love? Studies of men and women falling in and out of love reveal some surprises. Most people, including the writer of the following letter to a newspaper advice columnist, suppose that women fall in love more readily:

> Dear Dr. Brothers:
> Do you think it's effeminate for a 19-year-old guy to fall in love so hard it's like the whole world's turned around? I think I'm really crazy because this has happened several times now and love just seems to hit me on the head from nowhere. . . . My father says this is the way girls fall in love and that it doesn't happen this way with guys—at least it's not supposed to. I can't change how I am in this way but it kind of worries me.—P.T. (quoted by Dion & Dion, 1985)

P.T. would be reassured by the repeated finding that it is actually *men* who tend to fall more readily in love (Dion & Dion, 1985; Peplau & Gordon, 1985). Men also seem to fall out of love more slowly and are less likely than women to break up a premarital romance. However, women in love are typically as emotionally involved as their partners, or more so. They are more likely to report feeling euphoric and "giddy and carefree," as if they were "floating on a cloud." Women are also somewhat more likely than men to focus on the intimacy of the friendship and on their concern for their partner. Men are more likely than women to think about the playful and physical aspects of the relationship.

"Hmmm... what shall I wear today...?"

A high self-monitoring person.

COMPANIONATE LOVE

"When two people are under the influence of the most violent, most insane, most delusive, and most transient of passions, they are required to swear that they will remain in that excited, abnormal, and exhausting condition continuously until death do them part."
George Bernard Shaw

Companionate love:
The affection we feel for those with whom our lives are deeply intertwined.

"To marry a woman you love and who loves you is to lay a wager with her as to who will stop loving the other first."
Alfred Capus, *Notes et Pensées*, 1926

Although passionate love burns hot, it inevitably simmers down. Much as we develop tolerance for drug-induced highs, so the passionate high we feel for a romantic partner is fated to become more lukewarm. The longer a relationship endures, the fewer its emotional ups and downs (Berscheid & others, 1989). The high of romance may be sustained for a few months, even a couple of years. But as we noted in Chapter 12's discussion of adaptation level, no high lasts forever. If a close relationship is to endure, it settles to a steadier but still warm afterglow that Hatfield calls **companionate love.**

Unlike the wild emotions of passionate love, companionate love is lower key; it's a deep, affectionate attachment. And it is just as real. Even if one develops tolerance for a drug, withdrawal can be painful. So it is with close relationships. Mutually dependent couples who no longer feel the flame of passionate love will often, upon divorce or death, discover that they have lost more than they expected. Having focused on what was not working, they failed to notice all the things that did work, including hundreds of interdependent activities (Carlson & Hatfield, 1992).

The cooling of passionate love over time and the growing importance of other factors, such as shared values, can be seen in the feelings of those who enter arranged versus love-based marriages in India. Usha Gupta and Pushpa Singh (1982) asked 50 couples in Jaipur, India, to complete Zick Rubin's Love Scale. They found that those who married out of love reported diminishing feelings of love if they had been married more than five years. By contrast, those in arranged marriages reported *more* love if they were not newlyweds (Figure 13-7).

The cooling of intense romantic love often triggers a period of disillusion, especially among those who regard such love as essential both for a marriage (recall Figure 13-5) and for its continuation. Jeffry Simpson, Bruce Campbell, and Ellen Berscheid (1986) suspect "the sharp rise in the divorce rate in the past two decades is linked, at least in part, to the growing importance of intense positive emotional experiences (e.g., romantic love) in people's lives, experiences that may be particularly difficult to sustain over time." Compared to North Americans, Asians tend to be less focused on personal feelings, such as passion, and more concerned with the practical aspects of social attachments (Dion & Dion, 1988). Thus, they may be less vulnerable to disillusionment. Asians are also less prone to the self-focused individualism that in the long run can undermine a relationship and lead to divorce (Dion & Dion, 1991; Triandis & others, 1988).

The decline in intense mutual fascination may be natural and adaptive for species survival. The result of passionate love is frequently children, whose survival is aided by the parents' waning obsession with one another (Kenrick & Trost, 1987). Nevertheless, for those married more than 20 years, some of the lost romantic feeling is often renewed as the family nest empties and the parents are once again free to focus their attention on one another (Hatfield & Sprecher, 1986). "No man or woman really knows what love is until they have been married a quarter of a century," said Mark Twain. If the relationship has been intimate and mutually rewarding, companionate love probably still thrives. But what is "intimacy"? And what is "mutually rewarding"?

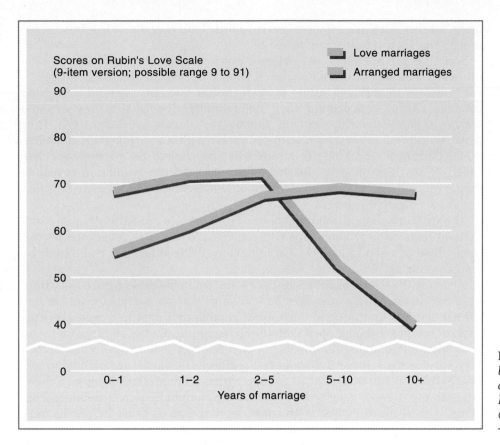

FIGURE 13-7 *Romantic love between partners in arranged or love marriages in Jaipur, India.*
(Data from Gupta & Singh, 1982).

Self-Disclosure

Deep, companionate relationships are intimate. They enable us to be known as we truly are and feel accepted. This delicious experience we enjoy in a good marriage or a close friendship—a relationship where trust displaces anxiety and where we are therefore free to open ourselves without fear of losing the other's affection (Holmes & Rempel, 1989). Such relationships are characterized by what the late Sidney Jourard called **self-disclosure,** or what Dalmas Taylor (1979) and Irwin Altman (Altman & Taylor, 1973) have called "social penetration." As such a relationship grows, those involved reveal more and more of themselves to one another; their knowledge of one another penetrates to deeper and deeper levels until it reaches an appropriate depth. Lacking such opportunities for intimacy causes us to experience the pain of loneliness (Berg & Peplau, 1982; Solano & others, 1982).

Experiments have probed both the *causes* and the *effects* of self-disclosure. Researchers have wondered: When are people most willing to disclose intimate information concerning "what you like and don't like about yourself" or "what you're most ashamed and most proud of"? And what effects do such revelations have upon those who reveal and receive them?

The most reliable finding is the **disclosure reciprocity** effect: Disclosure begets disclosure (Berg, 1987; Miller, 1990; Reis & Shaver, 1988). We reveal more to those who have been open with us. But intimacy is seldom instant; far more

Self-disclosure:
Revealing intimate aspects of oneself to others.

Disclosure reciprocity:
The tendency for one person's intimacy of self-disclosure to match that of a conversational partner.

often, it progresses like a dance: I reveal a little, you reveal a little—but not too much. You then reveal more, as do I.

Some people are especially skilled "openers"—people who readily elicit intimate disclosures from others, even from those who normally don't reveal very much of themselves (Miller & others, 1983). Such people tend to be good listeners. During conversation they maintain attentive facial expressions and appear to be comfortably enjoying themselves (Purvis & others, 1984). They may also express interest by uttering supportive phrases while their conversational partner is speaking. They are what psychologist Carl Rogers (1980) called "growth-promoting" listeners—people who are *genuine* in revealing their own feelings, who are *accepting* of others' feelings, and who are *empathic*, sensitive, reflective listeners.

The partner's disposition matters too. Some people are naturally more intimate in their close relationships (Prager 1986). And nearly everyone reveals more when in a good mood (M. Cunningham, 1988). When in a bad mood, we tend to clam up.

What are the effects of such self-disclosure? Jourard (1964) argued that dropping our masks, letting ourselves be known as we are, nurtures love. He presumed that it is gratifying to open up to another and then to receive the trust another implies by being open with us. For example, having an intimate friend with whom we can discuss threats to our self-image seems to help us comfortably survive such stresses (Swann & Predmore, 1985). A true friendship is a special relationship that helps us to cope with our other relationships. "When I am with my friend," reflected the Roman playwright Seneca, "methinks I am alone, and as much at liberty to speak anything as to think it." At its best, marriage is such a friendship, sealed by commitment.

Although intimacy is rewarding, the results of many experiments caution us not to presume that self-disclosure will automatically kindle love. It's just not that simple. It's true that we like best those to whom we've disclosed ourselves

"What is a Friend? I will tell you. It is a person with whom you dare to be yourself."
Frank Crane, *A Definition of Friendship*

■ FOCUS: Endless Love? Emotions Were Bottled Up

SEATTLE, WASH. (UPI)—Ten years ago a man wrote a love poem to his wife, slipped it into a bottle with an envelope and dropped it into the Pacific Ocean halfway between Seattle and Hawaii.

Chris Willie, an employee of the National Wildlife Federation, found the bottle recently while jogging on a beach in Guam. After replacing the envelope—the 10-cent stamp was a bit behind the times—he dutifully mailed the letter to Seattle.

When it was returned with "no longer at this address," Willie sent it to the *Seattle Times*.

The printed note was unabashed, old-fashioned romanticism.

"If, by the time this letter reaches you, I am old and gray, I know that our love will be as fresh as it is today.

"It may take a week or it may take years for this note to find you. Whatever the case may be, it shall have traveled by a strange and unpredictable messenger—the sea.

"If this should never reach you, it will still be written in my heart that I will go to extreme means to prove my love for you. Your husband, Bob."

The woman to whom the letter was addressed was reached by phone and the note was read to her. She burst out laughing—and the more she heard the harder she laughed.

"We're divorced," she said, slamming down the phone.

Milwaukee Journal, August 27, 1981, p. 1.

Close friendships are marked by self-disclosure—the intimate, mutual sharing of life's ups and downs.

(R. L. Archer & others, 1980). But we are not always fond of those who most intimately reveal themselves to us (Archer & Burleson, 1980; Archer & others, 1980). Someone who early in an acquaintanceship rushes to tell us intimate details may come across as indiscreet, immature, even unstable (Dion & Dion, 1978; Miell & others, 1979). Usually, though, people prefer an open, self-disclosing person to one who holds back. This is especially so when the disclosure is appropriate to the conversation. We feel pleased when a normally reserved person says that something about us "made me feel like opening up" and share confidential information (Archer & Cook, 1986; D. Taylor & others, 1981). It's gratifying to be singled out for another's disclosure.

Intimate self-disclosure is one of companionate love's delights. Dating and married couples who most reveal themselves to one another express most satisfaction with their relationship and are more likely to endure in it (Berg & McQuinn, 1986; Hendrick & others, 1988; Sprecher, 1987). In a recent Gallup national marriage survey, 75 percent of those who prayed with their spouse (and 57 percent of those who didn't) reported their marriage as very happy (Greeley, 1991). Among believers, shared prayer from the heart is a humbling, intimate, soulful exposure. Those who pray together also more often say they discuss their marriage together, respect their spouse, and rate their spouse as a skilled lover.

Researchers have also found that women are often more willing to disclose their fears and weaknesses than are men (Cunningham, 1981). As Kate Millett (1975) put it, "Women express, men repress." Nevertheless, men today, particularly men with egalitarian gender-role attitudes, seem increasingly willing to reveal intimate feelings and to enjoy the satisfactions that accompany a relationship of mutual trust and self-disclosure.

That Certain Someone, Inc.
INTRODUCTION SERVICE
● MEMBERSHIP
● STRICT CONFIDENTIALITY
● COMPUTERIZED
● ALL INQUIRIES
 GUARANTEED

"My preference is for someone who's afraid of closeness, like me."

Equity

Earlier, we noted an equity rule at work in the matching phenomenon: People usually bring equal assets to romantic relationships: Often they are matched for attractiveness, status, and so forth. If they are mismatched in one area, such as attractiveness, they tend to be compensatingly mismatched in some other area, such as status. But in total assets, they are an equitable match. No one says, and few even think, "I'll trade you my good looks for your big income." But especially in relationships that last, equity is the rule.

Those in a relationship that is equitable are more content (Fletcher & others, 1987; Hatfield & others, 1985; Van Yperen & Buunk, 1990). Those who perceive their relationship as inequitable feel discomfort: The one who has the better deal may feel guilty and the one who senses a raw deal may feel strong irritation. (Given the self-serving bias, the person who is "overbenefited" is less sensitive to the inequity.) Robert Schafer and Patricia Keith (1980) surveyed several hundred married couples of all ages, noting those who felt their marriage was somewhat unfair because one spouse contributed too little to the cooking, housekeeping, parenting, or providing. Inequity took its toll: Those who perceived inequity also felt more distressed and depressed.

Ending or Sustaining a Close Relationship

What do people do when they perceive a relationship is inequitable? Comparing their seemingly unsatisfying partner with the support and affection they imagine is available elsewhere, some will exit the relationship. Among dating couples, the closer and longer the relationship and the fewer the available

alternatives, the more painful the breakup (Simpson, 1987). Surprisingly, Roy Baumeister and Sara Wotman (1992) report that months or years later people recall more pain over spurning someone's love than over having been spurned. Their distress arises from guilt over hurting someone, from upset over the heartbroken lover's persistence, or from uncertainty over how to respond. Among married couples, breakup has additional costs: shocked parents and friends, restricted parental rights, guilt over broken vows. Still, each year millions of couples are willing to pay such costs to extricate themselves from what they perceive as the greater costs of continuing a painful, unrewarding relationship. Sociologists and demographers report that divorce is least likely among those who marry after age 20, date for a long while before marrying, are well educated, enjoy a stable income, live in a small town or on a farm, do not cohabit or become pregnant before marrying, and are actively religious (Myers, 1992).

When relationships suffer, there are alternatives to exiting through divorce. Caryl Rusbult and her colleagues (1986, 1987) have explored three other ways of coping with a failing relationship. Some people exhibit *loyalty*—passively but optimistically waiting for conditions to improve. The problems are too painful to speak of and the risks of separation are too great, so the loyal partner grits teeth and perseveres, hoping the good old days will return. Others (especially men) display *neglect*, by passively allowing the relationship to deteriorate. When painful dissatisfactions are ignored, an insidious emotional uncoupling ensues as the partners begin redefining their lives without each other. Still others, however, will *voice* their concerns and take active steps to improve the relationship.

Study after study reveals that unhappy couples disagree, command, criticize, and put down. Happy couples more often agree, approve, assent, and laugh (Noller & Fitzpatrick, 1990). So would unhappy relationships brighten if the partners agreed to *act* more as happy couples do—by complaining and criticizing less? by affirming and agreeing more? by setting times aside to voice their concerns? by praying or playing together daily? As attitudes trail behaviors, do affections trail actions?

Joan Kellerman, James Lewis, and James Laird (1989) wondered. They knew that among couples passionately in love, eye gazing is typically prolonged and mutual (Rubin, 1973). Would intimate eye gazing similarly stir feelings between those not in love? To find out, they asked unacquainted male-female pairs to gaze intently for two minutes either at one another's hands or in one another's eyes. When they separated, the eye gazers reported a tingle of attraction and affection toward each other. Simulating love had begun to stir it.

By enacting and expressing love, researcher Robert Sternberg (1988) believes the passion of initial romance can evolve into enduring love:

> "Living happily ever after" need not be a myth, but if it is to be a reality, the happiness must be based upon different configurations of mutual feelings at various times in a relationship. Couples who expect their passion to last forever, or their intimacy to remain unchallenged, are in for disappointment. . . . We must constantly work at understanding, building, and rebuilding our loving relationships. Relationships are constructions, and they decay over time if they are not maintained and improved. We cannot expect a relationship simply to take care of itself, any more than we can expect that of a building. Rather, we must take responsibility for making our relationships the best they can be.

Given the psychological ingredients of marital happiness—kindred minds, social and sexual intimacy, equitable giving and receiving of emotional and material resources—it becomes possible to contest the French saying, "Love makes the time pass and time makes love pass." But it takes effort to stem love's decay. It takes effort to carve out time each day to talk over the day's happenings. It takes effort to forego nagging and bickering and instead to disclose and hear one another's hurts, concerns, and dreams. It takes time to make a relationship into "a classless utopia of social equality" (Sarnoff & Sarnoff, 1989), in which both partners freely give and receive, share decision making, and enjoy life together.

■ SUMMING UP

A SIMPLE THEORY OF ATTRACTION

Who likes whom, and why? Few of social psychology's questions have more perennial interest. We can explain several influences upon our attractions to one another with the aid of a simple principle: We like people whose behavior we find rewarding or who have been associated with rewarding events.

LIKING: WHO LIKES WHOM

This chapter examined four powerful influences upon liking. The best predictor of whether any two people are friends is their sheer *proximity* to one another. Proximity is conducive to interaction, which enables us to discover similarities and to feel one another's liking. Liking also receives a boost from the mere anticipation of interacting with someone. Finally, proximity repeatedly exposes us to others, and mere repeated exposure often triggers liking.

A second determinant of our initial attraction to another is the person's *physical attractiveness*. Both in laboratory studies and in field experiments involving blind dates, college students tend to prefer attractive people. In everyday life, however, people tend actually to prefer and marry someone whose attractiveness roughly matches their own (or someone who, if less attractive, has other compensating qualities). Positive attributions about attractive people are so wide-ranging that many researchers believe there exists a strong physical-attractiveness stereotype—an assumption that what is beautiful is good. But attractiveness is relative—not only relative to our culture's definition of attractiveness but also relative to whom we're comparing a person to and relative to how much we like the person.

As an acquaintance progresses, two other factors further help determine whether acquaintanceship becomes friendship. One's liking for another is greatly aided by *similarity* of attitudes, beliefs, and values. A wide variety of laboratory and field experiments consistently reveal that likeness leads to liking. Researchers so far have been unable to discover needs and traits for which people seek out those different from themselves. Opposites rarely attract.

We are also likely to develop friendships with people who *like us*. The tendency to be fond of those who like and admire us is especially strong when (1)

we do not attribute the others' flattery to ingratiating motives, (2) we have recently been deprived of approval, and (3) the others' praise reverses earlier criticism.

LOVING

Occasionally, an acquaintance develops not just into friendship but into *passionate love*. Such love is often a bewildering confusion of ecstasy and anxiety, elation and pain. Advocates of the reward principle argue that we can love someone who causes us pain because the loved one also alleviates the pain. Advocates of the two-factor theory of emotion argue that in a romantic context arousal from any source, even painful experiences, can be steered into passion.

In the best of relationships, the initial romantic high settles to a steadier, more affectionate relationship called *companionate love*. One delight of companionate love is intimate self-disclosure, a state achieved gradually as each partner reveals more and more. Companionate love is most likely to endure when both partners feel it to be equitable, in that both receive from the relationship in proportion to what they contribute to it.

■ FOR FURTHER READING

Hatfield, E., & Rapson, R. L. (1993). *Love, sex, and intimacy.* New York: Harper-Collins. Love experts Hatfield and Rapson offer a down-to-earth tour of the ups and downs and ins and outs of love.

Hendrick, C., & Hendrick, S. S. (1993). *Romantic Love.* Newbury Park, CA: Sage. A literate summary of the roots, the history, and the meaning of different types of love.

Hendrick, S. S., & Hendrick, C. (1992). *Liking, loving and relating.* Pacific Grove, CA: Brooks/Cole. A brief, authoritative overview of what psychologists have learned about the types and stages of close personal relationships.

Marsh, P. (Ed.). (1988). *Eye to eye: How people interact.* Topsfield, MA: Salem House Publishers. A popular, lavishly illustrated book, authored by a team of predominantly British psychologists. Its 31 chapters explore nonverbal communication, family relations, love, jealousy, marriage, and breaking up.

Pennebaker, J. (1990). *Opening up: The healing power of confiding in others.* New York: William Morrow. Researcher James Pennebaker explains why disclosing oneself to others is good for both body and soul.

Sternberg, R. (with C. Whitney). (1991). *Love the way you want it: Using your head in matters of the heart.* New York: Bantam. A leading love researcher discusses why relationships fail and how we can help them succeed.

ALTRUISM: HELPING OTHERS

The half-starved, brutalized body of 16-year-old Sylvia Likens was discovered on October 26, 1965, in Indianapolis, Indiana. Since that July, she had boarded with Gertrude Braniszewski. Aided by her three teenage children and two neighborhood boys, Braniszewski had beaten, burned, and branded the youngster. Sylvia had not accepted her degradation passively. She had fought back. Many neighbors heard her screams. Kate Millett (1979) reports:

> They heard it for weeks on end. Judy Duke observed Sylvia's beatings and even described them to her mother once in the kitchen over the dinner dishes; the verdict was that the child deserved punishment. Mrs. Vermillion, living next door, her house a mere fourteen feet from Sylvia's basement window, must have heard the child's suffering almost to madness week after week, before another sound, the sound of a coal shovel scraping the floor, made her trouble herself with the notion of calling the police. And stopped short of doing it. Just as Sylvia stopped short, the shovel no longer moving, signaling, crying out finally for help. . . .
>
> And so Mrs. Vermillion put down the phone, grumbled one more time to her husband . . . and slumped back into moral lassitude again. (pp. 22–23)

Why had Sylvia's neighbors not come to her aid? Were they callous? indifferent? apathetic? Were they, as Millett surmises, "vegetable minds"? If so, there are many such minds. Consider:

> On March 13, 1964, Kitty Genovese is set upon by a knife-wielding rapist as she returns to her Queens, New York, apartment house at 3:00 A.M. Her screams of terror and pleas for help—"Oh my God, he stabbed me! Please help me! Please help me!"—arouse 38 of her neighbors. Many of them come to their windows and watch while, for 35 minutes, she struggles to escape her attacker. Not until her attacker departs does anyone so much as call the police. Soon after, she dies.
>
> Andrew Mormille is knifed in the stomach as he rides the subway home. After his attackers leave the car, 11 other riders watch the young man bleed to death.
>
> An 18-year-old switchboard operator, working alone, is sexually assaulted. She momentarily escapes and runs naked and bleeding to the street and screams for help. Forty pedestrians watch as the rapist tries to drag her back inside. Fortunately, two police officers happen by and arrest the assailant.
>
> Eleanor Bradley trips and breaks her leg while shopping. Dazed and in pain, she pleads for help. For 40 minutes the stream of shoppers simply parts and flows around her. Finally, a cab driver helps her to a doctor (Darley & Latané, 1968).

What is shocking is not that in these cases some people failed to help but that in each of these groups (of 38, 11, 40, and 100s) almost 100 percent of those involved failed to respond. Why? In the same or similar situations, would you, would I, react as they did? Or would we be heroes, like these people:

> Hearing the rumble of an approaching New York subway train, Everett Sanderson leapt down onto the tracks and raced toward the approaching headlights to rescue Michelle De Jesus, a four-year-old who had fallen from the platform. Three seconds before the train would have run her over, Sanderson flung Michelle into the crowd above. As the train roared in, he himself failed in his first effort to jump back to the platform. At the last instant, bystanders pulled him to safety (Young, 1977).
>
> It was 2:00 on a midsummer's afternoon in 1983 when Joe Delaney, a Kansas City Chiefs football player, saw people standing around a huge water-filled hole. Three boys had waded in, unaware that a short way out the bottom dropped off. Suddenly they were in over their heads and thrashing and screaming for help. As Joe alone dashed for the pond, a little boy asked, "Can you swim?" "I can't swim good," Joe

answered, "but I've got to save those kids. If I don't come up, get somebody." One boy struggled back to safety. Later the other two—and Joe Delaney—were hauled out by rescuers, dead (Deford, 1983).

On a hillside in Jerusalem, 800 trees form a simple line, the Avenue of the Righteous. Beneath each tree is a plaque with the name of a European Christian who, during the Nazi Holocaust, gave refuge to one or more Jews. These "righteous Gentiles" knew that if the refugees were discovered, Nazi policy dictated that both host and refugee would suffer a common fate. Many did (Hellman, 1980; Wiesel, 1985).

Less dramatic acts of comforting, caring, and helping abound: Without asking anything in return, people offer directions, donate money, give blood. Why, and when, will people perform such acts? And what can be done to lessen indifference and increase altruism? These are this chapter's primary questions.

Altruism is selfishness in reverse. An altruistic person is concerned and helpful even when no benefits are offered or expected in return. Jesus' parable of the Good Samaritan provides the classic illustration of altruism:

> A man was going down from Jerusalem to Jericho, and fell into the hands of robbers, who stripped him, beat him, and went away, leaving him half dead. Now by chance a priest was going down that road; and when he saw him, he passed by on the other side. So likewise a Levite, when he came to the place and saw him, passed by on the other side. But a Samaritan while traveling came near him; and when he saw him, he was moved with pity. He went to him and bandaged his wounds, having poured oil and wine on them. Then he put him on his own animal, brought him to an inn, and took care of him. The next day he took out two denarii, gave them to the innkeeper, and said, "Take care of him; and when I come back, I will repay you whatever more you spend" (Luke 10:30–35.)

The Samaritan illustrates altruism in a pure form. Filled with compassion, he gives a total stranger time, energy, and money while expecting neither repayment nor appreciation.

Altruism:
Concern and help for others that asks nothing in return; devotion to others without conscious regard for one's self-interests.

∎ WHY DO WE HELP?

To study altruistic acts, social psychologists examine the conditions under which people perform such deeds. But before looking at what the experiments reveal, let's consider what motivates altruism.

SOCIAL EXCHANGE: THE BENEFITS AND COSTS OF HELPING

One explanation for altruism comes from **social-exchange theory:** Human interactions are guided by a "social economics." We exchange not only material goods and money but also *social* goods—love, services, information, status (Foa & Foa, 1975). In doing so, we use a "minimax" strategy—minimize costs, maximize rewards. Social-exchange theory does not contend that we consciously record costs and rewards, only that such considerations predict our behavior. If we walk by an empty car with its lights on, we may briefly pause to try the driver's door; if it is locked, we seldom make the more costly effort of

Social-exchange theory:
The theory that human interactions are transactions that aim to maximize one's rewards and minimize one's costs.

searching for the owner. We are more likely to give telephone change to a classmate (someone who can later reciprocate or whose esteem we covet) than to a stranger.

How might this cost-benefit theory explain a decision to donate blood? Suppose your campus is having a blood drive and someone asks you to participate. Might you not weigh the *costs* of donating (needle prick, time, fatigue) versus those of not donating (guilt, disapproval)? Might you not also weigh the *benefits* of donating (feeling good about helping someone, free refreshments) versus those of not donating (saving the time, discomfort, and anxiety)? According to social-exchange theory—and to studies of Wisconsin blood donors by Jane Allyn Piliavin, Dorcas Evans, and Peter Callero (1982)—such subtle calculations precede decisions to help or not.

"Men do not value a good deed unless it brings a reward."
Ovid, *Epistulae ex Ponto*

Altruism as Disguised Self-Interest

Rewards that motivate helping may be external or internal. When businesses donate money to improve their corporate images or when someone offers another a ride hoping to receive appreciation or friendship, the reward is external. We give to get. Thus we are most eager to help someone attractive to us, someone whose approval we desire (Krebs, 1970; Unger, 1979).

The benefits of helping also include internal self-rewards. Near someone in distress, we typically respond with empathy. A woman's scream outside your window arouses and distresses you. If you cannot reduce your arousal by interpreting the scream as a playful shriek, then you may investigate or give aid, thereby reducing your distress (Piliavin & Piliavin, 1973). Indeed, Dennis Krebs (1975) found that Harvard University men whose physiological responses and self-reports revealed the most distress in response to another's distress also gave the most help to the person. As Everett Sanderson remarked after saving the child who fell from the subway platform, "If I hadn't tried to save that little girl, if I had just stood there like the others, I would have died inside. I would have been no good to myself from then on." Altruistic acts also increase our sense of self-worth. Nearly all blood donors in Jane Piliavin's research agreed that giving blood "makes you feel good about yourself" and "gives you a feeling of self-satisfaction."

Perhaps you object that the cost-benefit business is demeaning, because it takes the selflessness out of altruism. In defense of the theory, however, is it not a credit to humanity that we can derive pleasure from helping others? that much of our behavior is not antisocial but "prosocial"? that we can find fulfillment in the giving of love? How much worse if we gained pleasure only by serving ourselves.

"True," some readers may reply. "Still, doesn't social-exchange theory imply that a helpful act is never truly altruistic, that we merely *call* it 'altruistic' when its rewards are inconspicuous? If we help the screaming woman to gain social approval, relieve our distress, or boost our self image, is it really altruistic?" This is reminiscent of B. F. Skinner's (1971) analysis of altruism. We credit people for their good deeds, said Skinner, only when we don't know why they do them. (In the language of attribution theory, we attribute their behavior to their inner dispositions only when we lack external explanations.) When the external causes are conspicuous, we credit the causes, not the person.

There is, however, a weakness in social-exchange theory: It easily degenerates into explaining-by-naming. If someone volunteers for the Big Sister tutor

What motivates these hospital volunteers to come and hold sick babies? Do they help because the benefits (being thanked and admired, feeling good about themselves) outweigh the costs? Or is such altruism sometimes genuinely selfless?

program, it is tempting to "explain" her compassionate action by the satisfaction it brings her. But such after-the-fact naming of rewards creates a circular explanation: "Why did she volunteer?" "Because of the inner rewards." "How do you know there are inner rewards?" "Why else would she have volunteered?" Because of such circularity, the philosophical doctrine of psychological **egoism**—the idea that self-interest motivates all behavior—has fallen into disrepute.

To escape the circularity, we must define the rewards and costs independently of the altruistic behavior. If social approval motivates helping, then in experiments we should find that when approval follows helping, helping increases. And it does (Staub, 1978). Moreover, the cost-benefit analysis says something else. It suggests that the passive bystanders who observed the switchboard operator being dragged by the rapist may not have been apathetic. They may actually have been greatly distressed, yet paralyzed by their awareness of the potential costs of intervening.

Empathy as a Source of Genuine Altruism

Are life-saving heroes, everyday blood donors, and Peace Corps volunteers *ever* motivated by genuine altruism, by an ultimate goal of selfless concern for another? Or is their ultimate goal always some form of self-benefit, such as relief from distress or avoidance of guilt?

Abraham Lincoln illustrated the philosophical issue in his conversation with a fellow passenger in a horse-drawn coach. After Lincoln argued that selfishness prompts all good deeds, he noticed a sow making a terrible noise. Her piglets had gotten into a pond and were in danger of drowning. Lincoln called

Egoism:
The motivation (supposedly underlying all behavior) to increase one's own welfare. The opposite of *altruism*, which aims to increase another's welfare.

"Are you all right, Mister? Is there anything I can do?"

"Young man, you're the only one who bothered to stop! I'm a millionaire and I'm going to give you five thousand dollars!"

Drawing by Tobey; © 1972 The New Yorker Magazine, Inc.

We never know what benefits may come from helping someone in distress.

the coach to a halt, jumped out, ran back, and lifted the little pigs to safety. Upon his return, his companion remarked, "Now, Abe, where does selfishness come in on this little episode?" "Why, bless your soul, Ed, that was the very essence of selfishness. I should have had no peace of mind all day had I gone and left that suffering old sow worrying over those pigs. I did it to get peace of mind, don't you see?" (F. C. Sharp, cited by Batson & others, 1986). Until recently, psychologists would have sided with Lincoln and denied the possibility of genuine altruism.

Psychologist Daniel Batson (1991), however, theorizes that our willingness to help is influenced by both self-serving *and* selfless considerations (Figure 14-1). Feeling distress over someone's suffering motivates us to relieve our troubled state, either by escaping the distressing situation (like the priest and Levite) or by helping (like the Samaritan). But especially when we feel attached to someone, report Batson and his colleagues, we also feel *empathy*. Loving parents suffer when their children suffer and rejoice over their children's joys—an empathy lacking in child abusers and other perpetrators of cruelty (Miller & Eisenberg, 1988).

When feeling empathy we focus not so much on our own distress as on the sufferer. Genuine sympathy and compassion motivate us to help the person for his or her own sake. Such empathy comes naturally. Even day-old infants cry more when they hear another infant cry (Hoffman, 1981). In hospital nurseries, one baby's crying sometimes evokes a chorus of crying.

Often distress and empathy together motivate responses to a crisis. In 1983, people watched on television as an Australian bushfire wiped out hundreds of

homes near Melbourne. Afterward, Paul Amato (1986) studied donations of money and goods. He found that those who felt angry or indifferent gave less than those who felt either distressed (shocked and sickened) or empathic (sympathetic and worried for the victims).

To separate egoistic distress reduction from altruistic empathy, Batson's research group conducted studies that aroused feelings of empathy. Then the researchers noted whether the aroused people would reduce their own distress by escaping the situation or whether they would go out of their way to aid the person. The results were consistent: Their empathy aroused, they usually helped; seldom did they "pass by on the other side."

In one of these experiments, Batson and his associates (1981) had University of Kansas women observe a young woman suffering while she supposedly received electric shocks. During a pause in the experiment, the obviously upset victim explained to the experimenter that a childhood fall against an electric fence left her acutely sensitive to shocks. In sympathy, the experimenter suggested that perhaps the observer (the actual subject in this experiment) might trade places and take the remaining shocks for her. Previously, half of these actual subjects had been led to believe the suffering person was a kindred spirit on matters of values and interests (thus arousing their empathy). Some also were led to believe that their part in the experiment was completed, so that in any case they were done observing the woman's suffering. Nevertheless, their empathy aroused, virtually all these student observers willingly offered to substitute for the victim.

Is this pure altruism? Mark Schaller and Robert Cialdini (1988) doubt it. Feeling empathy for a sufferer makes one sad, they note. In one of their experiments they led people to believe that their sadness was going to be relieved by a different sort of mood-boosting experience—listening to a comedy tape. Under such conditions, people who felt empathy were not especially helpful. Schaller and Cialdini concluded that if we feel empathy but know that something else will make us feel better, we aren't so likely to help.

Other findings suggest that genuine altruism may, however, exist. For example, empathy produces helping only when people believe the other will receive the needed help (Dovidio & others, 1990). Moreover, people whose empathy is aroused will help even when they believe no one will know about their helping. Their concern continues until someone *has* helped (Fultz & oth-

FIGURE 14-1 *Egoistic and altruistic routes to helping. Viewing another's distress can evoke a mixture of self-focused distress and other-focused empathy. Researchers agree that distress triggers egoistic motives. But they debate whether empathy can trigger a pure altruistic motive.*
(Adapted from Batson, Fultz, & Schoenrade, 1987.)

	Emotion	Motive	Behavior
Other's distress	Distress (upset, anxious, disturbed)	Egoistic motivation to reduce own distress	Behavior (possibly helping) to achieve reduction of own distress
	Empathy (sympathy and compassion for other)	Altruistic motivation to reduce other's distress	Behavior (helping) to achieve reduction of other's distress

ers, 1986). And people will sometimes persist in wanting to help a suffering person even when they believe their distressed mood has been temporarily frozen by a "mood-fixing" drug (Schroeder & others, 1988).

To summarize, everyone agrees that some helpful acts are either obviously egoistic (done to gain rewards or avoid punishment) or subtly egoistic (done to relieve inner distress). Is there a third type of helpfulness—a true altruism that aims simply to increase another's welfare (producing happiness for oneself merely as a by-product)? Is empathy-based helping a source of such altruism? Cialdini (1991) and his colleagues Mark Schaller and Jim Fultz still doubt it. They note that no experiment rules out all possible egoistic explanations for helpfulness. Batson (1991) and others (Dovidio, 1991; Staub, 1991; Wallach & Wallach, 1983) believe that sometimes people *do* focus on others' welfare, not on their own.

During the Vietnam war 63 soldiers received Medals of Honor for using their bodies to shield their buddies from exploding devices (Hunt, 1990). Most were in close-knit combat groups. Most threw themselves on live hand grenades. In doing so, 59 made the ultimate sacrifice. Unlike other altruists, such as the 50,000 Gentiles now believed to have rescued 200,000 Jews from the Nazis, these soldiers had no time to reflect upon the shame of cowardice or the eternal rewards of self-sacrifice. Yet something drove them to act. With energy and creativity, today's social psychologists explore and debate what that something is.

SOCIAL NORMS

Often we help others not because we have consciously calculated that such behavior is in our self-interest but simply because something tells us we *ought* to. We ought to help a new neighbor move in. We ought to turn off a parked car's lights. We ought to return the wallet we found. We ought to protect our

Medals for heroism, such as this firefighter is receiving, extol selfless, life-risking altruism toward strangers.

■ BEHIND THE SCENES

Attempting to answer the question of altruism versus egoism—of whether we humans are capable of genuine caring for each other or only of caring for ourselves—has been like coming home for me. It's the kind of question about human nature that I often asked, first in college studying philosophy and later in seminary studying theology. When Jay Coke and I began studying people's emotional reactions to witnessing others in need, I realized that we were approaching a long-standing philosophical and theological puzzle. I was excited to think that if we could ascertain whether people's concerned reactions were genuine, and not simply a subtle form of selfishness, then we could shed new light on a basic issue regarding human nature.

C. DANIEL BATSON, *University of Kansas*

combat buddies from harm. Norms (as you may recall from Chapter 6) are social expectations. They *prescribe* proper behavior, the *oughts* of our lives. Researchers studying helping behavior have identified two social norms that motivate altruism.

The Reciprocity Norm

Sociologist Alvin Gouldner (1960) contended that one universal moral code is a **norm of reciprocity:** To those who help us, we should return help, not harm. Gouldner believed this norm is as universal as the incest taboo. We "invest" in others and expect dividends. Politicians know that the one who gives a favor can later expect a favor in return. The reciprocity norm even applies with marriage. Sometimes one may give more than one receives. But in the long run, one expects the exchange to balance out. In all such interactions, to receive without giving in return violates the reciprocity norm. Those who do so can expect rejection.

The reciprocity norm applies most strongly to interactions with equals. Those who do not see themselves as inferior or as dependent especially feel the need to reciprocate. If they cannot reciprocate, they may feel threatened and demeaned by accepting aid. Thus, compared to low self-esteem people, they are more reluctant to seek help (Nadler & Fisher, 1986). With people who clearly are dependent and unable to reciprocate—children, the severely impoverished and disabled, and others perceived as unable to return as much as they receive—another social norm motivates our helping.

Reciprocity norm:
An expectation that people will help, not hurt, those who have helped them.

"There is no duty more indispensable than that of returning a kindness."
Cicero

The Social-Responsibility Norm

The reciprocity norm reminds us to balance giving and receiving in social relations. However, if only a reciprocity norm existed, the Samaritan would not have been the Good Samaritan. In the parable, Jesus obviously had something more humanitarian in mind, something explicit in another of his teachings: "If you love those who love you [the reciprocity norm], what right have you to claim any credit? . . . I say to you, Love your enemies" (Matthew 5:46, 44).

In 1988, when 18-month-old Jessica McClure fell 22 feet into an abandoned well, it took 2½ days for the people of Midland, Texas to free her. Motivated by social responsibility, these people worked around the clock to save Baby Jessica.

Social-responsibility norm: An expectation that people will help those dependent upon them.

The belief that people should help those who need help, without regard to future exchanges, is the **norm of social responsibility** (Berkowitz, 1972b; Schwartz, 1975). The norm motivates people to retrieve a dropped book for a person on crutches. In India, a relatively collectivist culture, people support the social-responsibility norm more strongly than in the individualist west (Miller & others, 1990). They voice an obligation to help even when the need is not life-threatening or the needy person is outside their family circle.

Experiments show that even when helpers remain anonymous and have no expectation of any reward, they often help needy people (Shotland & Stebbins, 1983). However, they usually apply the social-responsibility norm selectively to those whose need appears not to be due to their own negligence. The norm seems to be: Give people what they deserve. If they are victims of circumstance, like natural disaster, then by all means be generous. If they seem to have created their own problems, by laziness or lack of foresight, then they should get what they deserve. Responses are thus closely tied to *attributions*. If we attribute the need to an uncontrollable predicament, we help. If we attribute the need to the person's choices, fairness does not require us to help; we say it's the person's own fault (Weiner, 1980).

Imagine yourself as one of the University of Wisconsin students in a study by Richard Barnes, William Ickes, and Robert Kidd (1979). You receive a call from a "Tony Freeman" who explains that he is in your introductory psychology class. He says that he needs help for the upcoming exam and that he has gotten your name from the class roster. "I don't know. I just don't seem to take good notes in there," Tony explains. "I know I can, but sometimes I just don't feel like it, so most of the notes I have aren't very good to study with." How sympathetic would you feel toward Tony? What sacrifice would you make to lend him your notes? If you are like the students in this experiment, you would probably be much less inclined to help than if Tony had just explained that his troubles were beyond his control. So, when people need our help, we feel the social-responsibility norm—unless we blame them for their problem.

EVOLUTIONARY PSYCHOLOGY

The third explanation of altruism comes from evolutionary theory. As you may recall from Chapters 6 and 13, evolutionary psychology contends that the essence of life is gene survival. Our genes drive us in ways that maximize their chance of survival. When we die, they usually live on.

As suggested by the title of Richard Dawkins' (1976) popular book *The Selfish Gene*, evolutionary psychology offers a humbling human image—one that psychologist Donald Campbell (1975a,b) has called a biological reaffirmation of a deep, self-serving "original sin." Genes that would predispose people to selflessly promote strangers' welfare would not survive in the evolutionary competition. Genetic selfishness should, however, predispose two specific types of selfless or even self-sacrificial altruism: kin protection and reciprocity.

"Fallen heroes do not have children. If self-sacrifice results in fewer descendants, the genes that allow heroes to be created can be expected to disappear gradually from the population."
E. O. Wilson (1978, pp. 152–153)

Kin Protection

Our genes dispose us to care for relatives in whom they reside. Thus one form of self-sacrifice that *would* increase gene survival is devotion to one's children. Parents who put their children's welfare ahead of their own are more likely to pass their genes on to posterity than parents who neglect their children. As David Barash (1979, p. 153) said, "Genes help themselves by being nice to themselves, even if they are enclosed in different bodies." Although evolution favors altruism toward one's children, children have less at stake in the survival of their parents' genes. Thus, parents are generally more devoted to their children than their children are to them.

Other relatives share genes in proportion to their biological closeness. You share one-half your genes with your brothers and sisters, one-eighth with your cousins. That led the evolutionary biologist J. B. S. Haldane to jest that while he would not give up his life for his brother, he would sacrifice himself for *three* brothers—or for nine cousins. Haldane would not have been surprised that, compared to fraternal twins, genetically identical twins are noticeably more mutually supportive (Segal, 1984).

The point is not that we calculate genetic relatedness before helping but that nature programs us to care about close kin. The Carnegie medal for heroism is never awarded for saving a relative. That we expect. What we do not expect (and therefore honor) is the altruism of those who, like our subway hero Everett Sanderson, risk themselves to save a stranger.

We also share common genes with many others. Blue-eyed people share particular genes with other blue-eyed people. But how do we detect the people in which copies of our genes occur most abundantly? As the blue-eyes example suggests, one clue lies in physical similarities (Rushton & others, 1984). Also, in evolutionary history one's genes were shared more with neighbors than with foreigners. Are we therefore biologically biased to act more altruistically toward those similar to us and those who live near us? In the aftermath of natural disasters, the order of who gets helped would not surprise an evolutionary psychologist: family members first, friends and neighbors second, strangers last (Form & Nosow, 1985).

Some evolutionary psychologists say we can also expect ethnic ingroup favoritism—the root of countless historical and contemporary conflicts (Rushton, 1991). E. O. Wilson (1978) notes that **kin selection**—favoritism toward those who share our genes—is "the enemy of civilization. If human beings are

Kin selection:
The idea that evolution has selected altruism toward one's close relatives to enhance the survival of mutually shared genes.

to a large extent guided . . . to favor their own relatives and tribe, only a limited amount of global harmony is possible" (p. 167).

Reciprocity

Genetic self-interest also predicts reciprocity. An organism helps another, biologist Robert Trivers argues, because it expects help in return (the giver expects later to be the getter) (Binham, 1980). Failure to reciprocate gets punished: The cheat, the turncoat, and the traitor are universally despised.

Reciprocity works best in small, isolated groups, groups in which one will often see the people for whom one does favors. If a vampire bat has gone a day or two without food—it can't go much more than 60 hours without starving to death—it asks a well-fed nestmate to regurgitate food for a meal (Wilkinson, 1990). The donor bat does so willingly, losing fewer hours till starvation than the recipient gains. But such favors occur only among familiar nestmates who share in the give and take. Those who always take and never give, and those who have no relationship with the donor bat, go hungry.

For similar reasons, reciprocity is stronger in the remote Cook Islands of the South Pacific than in New York City (Barash, 1979, p. 160). Small schools, towns, churches, work teams, and dorms are all conducive to a community spirit in which people care for each other. Compared to people in small-town or rural environments, those in big cities are less willing to relay a phone message, less likely to mail "lost" letters, less cooperative with survey interviewers, less helpful to a lost child, and less willing to do small favors (Steblay, 1987).

These volunteers in Woodstock, New York, exhibit the neighborly spirit of small communities, in which people care for one another and for their common good.

TABLE 14-1 *Comparing Theories of Altruism*

| | | HOW IS ALTRUISM EXPLAINED? | |
THEORY	LEVEL OF EXPLANATION	MUTUAL "ALTRUISM"	INTRINSIC ALTRUISM
Social norms	Sociological	Reciprocity norm	Social responsibility norm
Social exchange	Psychological	External rewards for helping	Distress → inner rewards for helping
Evolutionary	Biological	Reciprocity	Kin selection

If individual self-interest inevitably wins in genetic competition, then why does nonreciprocal altruism toward strangers occur? What causes a Mother Teresa to act as she does? soldiers to throw themselves on grenades?

Donald Campbell's (1975) answer is that human societies evolved ethical and religious rules that serve as brakes on the biological bias toward self-interest. Commandments, such as "Love your neighbor," admonish us to balance self-concern with concern for the group, and so contribute to the survival of the group. Richard Dawkins (1976) offered a similar conclusion: "Let us try to *teach* generosity and altruism, because we are born selfish. Let us understand what our selfish genes are up to, because we may then at least have the chance to upset their designs, something no other species has ever aspired to" (p. 3).

COMPARING AND EVALUATING THEORIES OF ALTRUISM

By now you have perhaps noticed similarities among the social-exchange, social norm, and evolutionary views of altruism. The parallels are indeed striking. As Table 14-1 shows, each proposes two types of prosocial behavior: a tit-for-tat reciprocal exchange and a more unconditional helpfulness. They do so at three complementary levels of explanation. If the evolutionary view is correct, then our genetic predispositions *should* manifest themselves in psychological and sociological phenomena.

Each theory appeals to logic. Yet each is vulnerable to charges of being speculative and after the fact. When we start with a known effect (the give and take of everyday life) and explain it by conjecturing a social-exchange process, a "reciprocity norm," or an evolutionary origin, we might be merely explaining-by-naming. The argument that a behavior occurs because of its survival function is hard to disprove. With hindsight, it's easy to think it had to be that way. If we can explain *any* conceivable behavior after the fact as the result of a social exchange, a norm, or natural selection, then we cannot falsify the theories. Each theory's task is therefore to generate predictions that enable us to test it.

An effective theory also provides a coherent scheme for summarizing a variety of observations. On this criterion, the three altruism theories get higher marks. Each offers us a broad perspective from which we can understand both enduring commitments of time or monies and spontaneous help, such as that studied in the experiments described below.

■ WHEN WILL WE HELP?

Social psychologists were curious and concerned about bystanders' lack of involvement during such events as the Kitty Genovese rape-murder. So they undertook experiments to identify when people will help in an emergency. (Not until a decade and more later did concern also focus on causes of sexual violence—Cherry 1991.)

More recently, they have broadened the question to ask: When will people help in nonemergencies—by such deeds as giving money, donating blood, or contributing time? Let's examine these experiments by looking first at the *circumstances* that enhance helpfulness and then at the characteristics of the *people* who help.

SITUATIONAL INFLUENCES: NUMBER OF BYSTANDERS

Bystander passivity during emergencies prompted social commentators to lament today's "alienation," "apathy," "indifference," and "unconscious sadistic impulses." These explanations attribute the nonintervention to the bystanders' dispositions. This allows us to reassure ourselves that as caring people, we *would* have helped. But why were the bystanders such dehumanized characters?

Two social psychologists, Bibb Latané and John Darley (1970), were not convinced that the bystanders were dehumanized. So Latané and Darley staged ingenious emergencies and found that a single situational factor—the presence of other bystanders—greatly decreased intervention. By 1980 some four dozen experiments compared help given by bystanders who perceived themselves to be either alone or with others. In about 90 percent of these comparisons, involving nearly 6000 people, lone bystanders were more likely to help (Latané & Nida, 1981).

Sometimes, the victim was actually less likely to get help when many people were around. When Latané, James Dabbs (1975), and 145 collaborators "accidentally" dropped coins or pencils during 1497 elevator rides, they were

■ BEHIND THE SCENES

Shocked by the Kitty Genovese murder, Bibb Latané and I met over dinner and began to analyze the bystanders' reactions. Being social psychologists, we thought not about the personality flaws of the "apathetic" individuals, but rather about how anyone in that situation might react as did these people. By the time we finished our dinner, we had formulated several factors that together could lead to the surprising result: no one helping. Then we set about conducting experiments that isolated each factor and demonstrated its importance in an emergency situation.

JOHN M. DARLEY, *Princeton University*

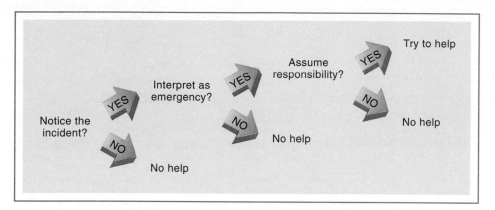

FIGURE 14-2 *Latané and Darley's decision tree. Only one path up the tree leads to helping. At each fork of the path, the presence of other bystanders may divert a person down a branch toward not helping.*
(Adapted from Darley & Latané, 1968.)

helped 40 percent of the time when one other person was on the elevator and less than 20 percent of the time when there were six passengers. Why? Latané and Darley surmised that as the number of bystanders increases, any given bystander is less likely to *notice* the incident, less likely to *interpret* the incident as a problem or emergency, and less likely to *assume responsibility* for taking action (Figure 14-2).

Noticing

Twenty minutes after Eleanor Bradley has fallen and broken her leg on a crowded city sidewalk, you come along. Your eyes are on the backs of the pedestrians in front of you (it is bad manners to stare at those you pass) and your private thoughts are on the day's events. Would you therefore be less likely to notice the injured woman than if the sidewalk were virtually deserted?

To test this conjecture, Latané and Darley (1968) had Columbia University men fill out a questionnaire in a room, either by themselves or with two strangers. While they were working (and being observed through a one-way mirror), there was a staged emergency: Smoke poured into the room through a wall vent. *Solitary* students, who often glanced idly about the room while working, noticed the smoke almost immediately—usually in less than five seconds. Those in *groups* kept their eyes on their work. It typically took them about 20 seconds to *notice* the smoke.

Interpreting

Once we notice an ambiguous event, we must interpret it. Put yourself in the room filling with smoke. Though worried, you don't want to embarrass yourself by getting flustered. You glance at the others. They look calm, indifferent. Assuming everything must be okay, you shrug it off and go back to work. Then one of the others notices the smoke and, noting your apparent unconcern, reacts similarly. This is yet another example of informational influence (Chapter 7). Each person uses others' behavior as clues to reality.

So it happened in the actual experiment. When those working alone noticed the smoke, they usually hesitated a moment, then got up, walked over to the vent, felt, sniffed, and waved at the smoke, hesitated again, and then went to report it. In dramatic contrast, those in groups of three did not move. Among the 24 men in 8 groups, only one person reported the smoke within the first

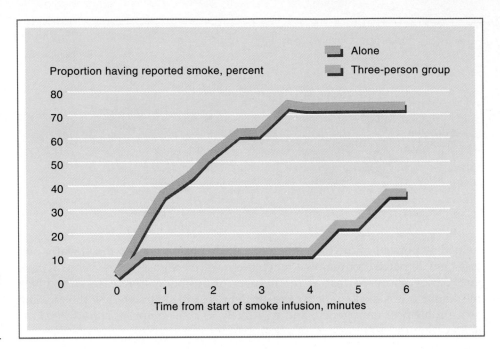

FIGURE 14-3 *The smoke-filled room experiment. Smoke pouring into the testing room was much more likely to be reported by individuals working alone than by three-person groups.* (Data from Latané & Darley, 1968.)

four minutes (Figure 14-3). By the end of the six-minute experiment, the smoke was so thick it was obscuring the men's vision and they were rubbing their eyes and coughing. Still, in only three of the eight groups did even a single person leave to report the problem.

Equally interesting, the group's passivity affected its members' interpretations. What caused the smoke? "A leak in the air conditioning," "Chemistry labs in the building," "Steam pipes," "Truth gas." They offered many explanations. Not one said, "Fire." The group members, in serving as nonresponsive models, influenced each other's interpretation.

This experimental dilemma parallels dilemmas each of us face. Are the shrieks outside merely playful antics or the desperate screams of someone being assaulted? Is the boys' scuffling a friendly tussle or a vicious fight? Is the woman slumped in the doorway sleeping, or is she seriously ill, perhaps in a diabetic coma?

Bystander effect:
The finding that a person is less likely to provide help when there are other bystanders.

Unlike the smoke-filled-room experiment, however, each of these everyday situations involves danger to another person rather than to oneself. To see if the same **bystander effect** occurs in such situations, Latané and Judith Rodin (1969) staged an experiment around a woman in distress. A female researcher set Columbia University men to work on a questionnaire and then left through a curtained doorway to work in an adjacent office. Four minutes later she could be heard (from a high-fidelity tape recorder) climbing on a chair to reach some papers. This was followed by a scream and a loud crash as the chair collapsed and she fell to the floor. "Oh, my God, my foot . . . I . . . I . . . can't move it," she sobbed. "Oh . . . my ankle . . . I . . . can't get this . . . thing . . . off me." Only after two minutes of moaning did she manage to make it out her office door.

Seventy percent of those alone when they overheard the "accident" came into the room or called out to offer help. Among pairs of strangers confronting

the emergency, only 40 percent of the time did either person offer help. Those who did nothing apparently interpreted the situation as a nonemergency. "A mild sprain," said some. "I didn't want to embarrass her," explained others. This again demonstrates the bystander effect: As the number of people known to be aware of an emergency increases, any given person becomes *less* likely to help. For the victim, there is therefore no safety in numbers.

People's interpretations also affect their reactions to street crimes. In staging physical fights between a man and a woman, Lance Shotland and Margaret Straw (1976) found that bystanders intervened 65 percent of the time when the woman shouted, "Get away from me; I don't know you," but only 19 percent of the time when she shouted, "Get away from me; I don't know why I ever married you." In the second situation, people perceived an intervener as more threatened and the woman as less threatened. Spouse abuse, it seems, just doesn't trigger as much concern as stranger abuse.

Harold Takooshian and Herzel Bodinger (1982) suspected that interpretations could also affect bystanders' reactions to burglaries. When they staged hundreds of car burglaries in 18 cities (using a coat hanger to gain access to a valuable object, such as a TV set or fur coat), they were astonished. Fewer than 1 in 10 passers-by so much as questioned their activity. Many people noticed and even stopped to stare, snicker, or offer help. Some apparently interpreted the "burglar" as the car's owner.

Assuming Responsibility

But misinterpretation was not the only factor. Even when a shabby 14-year-old was the "burglar," when someone simultaneously broke into two adjacent cars, or when onlookers saw a different person breaking into the car than had just gotten out of it, Takooshian and Bodinger report there still was virtually no intervention by New Yorkers. And what about those times when it is obvious an emergency is occurring? Those who watched Kitty Genovese being attacked and heard her pleas for help correctly interpreted what was happening. But the

Our interpretations of social situations—is this a man locked out of his car or a burglar?—affects whether we respond with concern or indifference.

lights and silhouetted figures in neighboring windows told them that others were also watching. This diffused the responsibility for action.

Few of us have observed a murder. But all of us have at times been slower to react to a need when others were present. To explore further why bystanders inhibit action, Darley and Latané (1968) simulated the Genovese drama. They placed people in separate rooms from which the subjects would hear a victim crying for help. To create this situation, Darley and Latané asked some New York University students to discuss over a laboratory intercom their problems with university life. They told the students that to guarantee their anonymity, no one would be visible, nor would the experimenter eavesdrop. During the ensuing discussion, the participants heard one person, when the experimenter turned his microphone on, lapse into an epileptic seizure. With increasing intensity and speech difficulty, he pleaded for someone to help.

Of those led to believe they were the only listener, 85 percent left their room to seek help. Of those who believed four others also overheard the victim, only 31 percent went for help. Were those who didn't respond apathetic and indifferent? When the experimenter entered the room to end the experiment, she did not find them so. Most immediately expressed concern. Many had trembling hands and sweating palms. They believed an emergency had occurred but were undecided whether to act.

After the smoke-filled room, the woman-in-distress, and the seizure experiments, Latané and Darley asked the participants whether the others' presence had influenced them. We know the other bystanders had a dramatic effect. Yet the participants almost invariably denied the influence. The typical reply? "I was aware of the others, but I would have reacted just the same if they weren't there." This response reinforces a point stressed in Chapter 2: We often do not know why we do what we do. And that, of course, is why experiments such as these are revealing. A survey of uninvolved bystanders following a real emergency would have left the bystander effect hidden.

Further experiments revealed situations in which others' presence sometimes does *not* inhibit people from offering help. Irving Piliavin and his colleagues (1969) staged an emergency in a laboratory on wheels, the unwitting subjects being 4450 riders of New York's subway. On each of 103 occasions, a confederate entered a subway car and stood in the center next to a pole. After the train pulled out of the station, he staggered, then collapsed. When the victim carried a cane, one or more bystanders almost always promptly offered help. Even when the victim carried a bottle and smelled of liquor, he was often promptly offered aid—aid that was especially prompt when several male bystanders were close by. Why? Did the presence of other passengers provide a sense of security to those who helped? Was it because the situation was unambiguous? (The passengers couldn't help noticing and realizing what was happening.)

To test this latter possibility, Linda Solomon, Henry Solomon, and Ronald Stone (1978) conducted experiments in which New Yorkers either saw and heard someone's distress, as in the subway experiment, or only heard it, as in the woman-in-distress experiment (leaving the situation more open to interpretation). When the emergencies were unambiguous, those in groups were only slightly less likely to help than were those alone. However, when the emergencies were somewhat ambiguous, the subjects in groups were far less

likely to help than were solitary bystanders. New Yorkers, like other urbanites, are seldom alone in public places, which helps explain why city people often are less helpful than country people. "Compassion fatigue" and "sensory overload" from encountering so many people in need further restrain helping in large cities.

In the subway experiment, the passengers sat face-to-face, allowing them to see the alarm on one another's faces. To explore the effect of this, Darley, Allan Teger, and Lawrence Lewis (1973) had people working either face-to-face or back-to-back when they heard a crash in the adjacent room as several metal screens fell on a workman. Unlike those working alone, who almost always offered help, pairs working back-to-back seldom offered help. A person working face-to-face with a partner could notice the other's startle and know that the other had observed the event as well. Apparently, this led both people to interpret the situation as an emergency and to feel some responsibility to act, for these pairs were virtually as likely to give aid as were those working alone. Being designated the leader of a group has much the same effect, for leaders are as likely to aid someone in distress as are those working alone (Baumeister & others, 1988). The same is true of those of who feel especially competent to give aid, such as doctors or registered nurses who see an accident (Cramer & others, 1988).

Finally, all the experiments we have considered involved groups of strangers. Imagine yourself facing any of these emergencies with a group of friends. Would your acquaintance with the other bystanders make a difference? Experiments conducted in two Israeli cities and at the University of Illinois at Chicago reveal that the answer is yes (Rutkowski & others, 1983; Yinon & others, 1982). Cohesive groups are *less* inhibited about helping than are solitary individuals. To summarize: The presence of other bystanders inhibits helping *if* the emergency is *ambiguous* and the other bystanders are *strangers* who *cannot easily read one another's reactions.*

This seems a good place to raise again the issue of research ethics. Is it right to force hundreds of subway riders to witness someone's apparent collapse? Were the researchers in the seizure experiment ethical when they forced people to decide whether to abort the discussion to report the problem? Would you object to being in such a study? Note that it would have been impossible to get your "informed consent"; doing so would have destroyed the cover for the experiment.

In defense of the researchers, they were always careful to debrief their laboratory participants. After explaining the seizure experiment, probably the most stressful, the experimenter gave the participants a questionnaire. One hundred percent said the deception was justified and that they would be willing to take part in similar experiments in the future. None of the participants reported feeling angry at the experimenter. Other researchers similarly report that the overwhelming majority of subjects in such experiments say afterward that their participation was both instructive and ethically justified (Schwartz & Gottlieb, 1981). In the field experiments, an accomplice assisted the victim if no one else did, thus reassuring bystanders that the problem was being dealt with.

Also, remember that the social psychologist has a twofold ethical obligation: to protect the participants and to enhance human welfare by discovering influences upon human behavior. Such discoveries can alert us to unwanted influ-

ences and show us how we might exert positive influences. The ethical principle thus seems to be: After protecting participants' welfare, social psychologists fulfill their responsibility to society by doing such research.

SITUATIONAL INFLUENCES: HELPING WHEN SOMEONE ELSE DOES

If aggressive models can heighten aggression (Chapter 12) and if unresponsive models can heighten nonresponding, then will helpful models promote helping? Imagine hearing a crash followed by sobs and moans. If another bystander's reaction implied, "Uh oh. This is an emergency! I've got to do something," would this stimulate others to help?

The evidence is clear: Prosocial models do promote altruism. James Bryan and Mary Ann Test (1967) found that Los Angeles drivers were more likely to offer help to a female driver with a flat tire if a quarter mile earlier they witnessed someone helping another woman change a tire. In another experiment, Bryan and Test observed that New Jersey Christmas shoppers were more likely to drop money in a Salvation Army kettle if they had just seen someone else do the same. And in a study with British adults, Philippe Rushton and Anne Campbell (1977) found people usually unwilling to donate blood, unless they were approached after observing a confederate consent to donating.

Sometimes models contradict in practice what they preach. Parents may advise their children, "Do as I say, not as I do." Experiments show that children learn moral judgments both from what they hear preached and what they see practiced (Rice & Grusec, 1975; Rushton, 1975). When exposed to hypocrites, they imitate: They do what the model does and say what the model says.

However, not all models are emulated. The example set by a *disliked* model can boomerang. Imagine being one of the several hundred Madison, Wisconsin, residents who found an addressed envelope with several personal documents showing. Wrapped around the documents was a note from someone who had found the envelope but dropped it. In the note, this first finder identified himself as a White South African who was "very disappointed with how self-centered and childish Americans are." The note added, "You have much to learn from the honest way we keep our Negroes down," and "I must say, it has been annoying to have to get involved with whole problem of returning these things" (Schwartz & Ames, 1977). Under these conditions—having a repulsive model who disliked helping—fully three-fourths of the second finders mailed the envelopes. It seemed that the typical subject felt, "If he's against helping, I'm for it." When the model was disliked, yet expressed *enjoyment* of helping, only about half the second finders mailed the envelope: "I'm not sure I want to go along with what a jerk like that does."

SITUATIONAL INFLUENCES: TIME PRESSURES

Darley and Batson (1973) discerned another determinant of helping in the Good Samaritan parable. The priest and the Levite were both busy, important people, probably hurrying to their duties. The lowly Samaritan surely was less pressed for time. To see whether people in a hurry would behave as the priest and Levite did, Darley and Batson cleverly staged the situation described in the parable.

"We are, in truth, more than half what we are by imitation. The great point is, to choose good models and to study them with care."
Lord Chesterfield, *Letters*, January 18, 1750

Prosocial modeling. People who have just witnessed someone being altruistic are more likely to do likewise.

After collecting their thoughts prior to recording a brief extemporaneous talk (which, for half the participants, was on the Good Samaritan parable), Princeton Theological Seminary students were directed to a recording studio in an adjacent building. En route, they passed a man sitting slumped in a doorway, head down, coughing and groaning. Some of the students had been sent off nonchalantly: "It will be a few minutes before they're ready for you, but you might as well head on over." Of these, almost two-thirds stopped to offer help. Others were told, "Oh, you're late. They were expecting you a few minutes ago . . . so you'd better hurry." Of these, only 10 percent offered help.

Reflecting on these findings, Darley and Batson remarked:

> A person not in a hurry may stop and offer help to a person in distress. A person in a hurry is likely to keep going. Ironically, he is likely to keep going even if he is hurrying to speak on the parable of the Good Samaritan, thus inadvertently confirming the point of the parable. (Indeed, on several occasions, a seminary student going to give his talk on the parable of the Good Samaritan literally stepped over the victim as he hurried on his way!)

This is one of the most ironically humorous scenes ever noted in a social psychology experiment: A contemporary "priest" passing by a slumped, groaning victim while pondering the parable of the Good Samaritan.

Are we being unfair to the seminary students, who were, after all, hurrying to *help* the experimenter? Perhaps they keenly felt the social-responsibility norm but found it pulling them two ways—toward the experimenter and toward the victim. In another enactment of the Good Samaritan situation, Batson and his associates (1978) directed 40 University of Kansas students to an experiment in another building. Half were told they were late; half knew they had plenty of time. Half thought their participation was vitally important to the

experimenter; half thought it was not essential. The results: Those who, like the White Rabbit in *Alice's Adventures in Wonderland,* were late for a very important date seldom stopped to help. They had a pressing social obligation elsewhere. Those on their way to an unimportant appointment usually stopped to help.

Can we conclude that those who were rushed were callous? Did the seminarians notice the victim's distress and then consciously choose to ignore it? No. In their hurry, they never fully grasped the situation. Harried, preoccupied, rushing to meet a deadline, they simply did not take time to tune into the person in need.

PERSONAL INFLUENCES: FEELINGS

We have considered external influences on the decision to help—number of bystanders, modeling, hurrying, and characteristics of the person in need. We also need to consider internal factors, such as the helper's emotional state or personal traits.

Guilt

Throughout recorded history, guilt has been a painful emotion, so painful that cultures have institutionalized ways to relieve it: animal and human sacrifices, offerings of grain and money, penitent behavior, confession, denial. In ancient Israel, the sins of the people were periodically laid on a ''scapegoat'' animal that was then led into the wilderness to carry away the people's guilt (de Vaux, 1965).

To examine the consequences of guilt, social psychologists have induced people to transgress: to lie, to deliver shock, to knock over a table loaded with alphabetized cards, to break a machine, to cheat. Afterward, the guilt-laden participants may be offered a way to relieve their guilt: by confessing, by disparaging the one harmed, or by doing a good deed to offset the bad one. The results are remarkably consistent: People will do whatever can be done to expunge the guilt and restore their self-image.

Picture yourself as a participant in one such experiment conducted with Mississippi State University students by David McMillen and James Austin (1971). You and another student, each seeking to earn credit toward a course requirement, arrive for the experiment. Soon after, a confederate enters, portraying himself as a previous subject looking for a book he had lost. He strikes up a conversation in which he mentions that the experiment involves taking a multiple-choice test, for which most of the correct answers are ''B.'' After the accomplice departs, the experimenter arrives, explains the experiment and then asks, ''Has either of you been in this experiment before or heard anything about it?''

Would you lie? The behavior of those who have gone before you in this experiment—100 percent of whom told the little lie—suggests that you would. After you have taken the test (without receiving any feedback on it), the experimenter says: ''You are free to leave. However, if you have some spare time, I could use your help in scoring some questionnaires.'' Assuming you have told the lie, do you think you would now be more willing to volunteer some time? Judging from the results, the answer again is yes. On average, those who had not been induced to lie volunteered only two minutes of time. Those who had lied were apparently eager to redeem their self-image; on average they offered

a whopping 63 minutes. One moral of this experiment was well expressed by a seven-year-old girl, who, in one of our own experiments, wrote, "Don't Lie or youl Live with gilt." And if you suffer guilt, you will feel a need to relieve it.

Our eagerness to do good after doing bad reflects both our need to reduce *private* guilt and restore our shaken self-image and our desire to reclaim a positive *public* image. We are more likely to redeem ourselves with helpful behavior when other people know about our misdeeds (Carlsmith & Gross, 1969). Alternatively, publicly confessing a misdeed can elicit sympathy and forgiveness (Weiner & others, 1991). But even when our guilt is private, we act to reduce it. Dennis Regan and his associates (1972) demonstrated this in a New York shopping center. They led women to think they had broken a camera. A few moments later a confederate, carrying a shopping bag with candy spilling out, crossed paths with each woman. Compared to women not put on the guilt trip—only 15 percent of whom bothered to alert the confederate to the spillage—nearly four times as many of the guilt-laden women did so. The guilt-laden women had no need to redeem themselves in the confederate's eyes. So their helpfulness is best explained as a way of relieving their private guilt feelings. Other ways of relieving guilt—as by confession—similarly reduce helping (Carlsmith & others, 1968).

"Open confession is good for the soul."
Old Scottish proverb

Negative Mood

If guilt increases helping, do other negative feelings do the same? If, depressed by a bad grade, you saw someone spill papers on the sidewalk, would you be more likely than usual to help? Or less likely?

At first glance, the results are confusing. Putting people in a negative mood (by having them read or think about something sad) sometimes increases altruism, sometimes decreases it. Such an apparent contradiction excites the scientist's detective spirit. If we look closely, we find order amid the confusion. First, the studies in which negative mood decreased helping usually involved children (Isen & others, 1973; Kenrick & others, 1979; Moore & others, 1973); those that found increased helping usually studied adults (Aderman & Berkowitz, 1970; Apsler, 1975; Cialdini & others, 1973; Cialdini & Kenrick, 1976). Why do you suppose a negative mood affects children and adults differently?

Robert Cialdini, Douglas Kenrick, and Donald Baumann (1981; Baumann & others, 1981) surmise that for adults, altruism is self-gratifying. It carries its own inner rewards. Blood donors feel better about themselves for having donated. Students who've helped pick up dropped materials feel better about themselves after helping (Williamson & Clark, 1989). Thus, when an adult is in a guilty, a sad, or an otherwise negative mood, a helpful deed (or any other mood-improving experience) helps neutralize the bad feelings.

This implies (and experiments confirm) that a negative mood won't boost helping if a person first receives some other mood boost (finds money or listens to a humorous tape) (Cialdini & others, 1973; Cunningham & others, 1980; Kidd & Berkowitz, 1976). Likewise, if people believe a drug has temporarily fixed their mood state, then a negative mood does not affect willingness to help (Manucia & others, 1984). To repeat: *If* being helpful is a way to improve mood, a sad adult is helpful.

Why doesn't this work with children? Cialdini, Kenrick, and Baumann argue that altruism is not similarly rewarding for children. When reading stories, young children view unhelpful characters as happier than helpful ones; as

As children mature, and become capable of seeing and feeling things from another's perspective, their empathy and altruism grow.

children grow older, their views reverse (Perry & others, 1986). Although young children exhibit empathy, they do not take much pleasure in being helpful; such behavior is a product of *socialization*—or so Cialdini and his colleagues believed.

To test their belief, they had children in early elementary school, late elementary school, and high school reminisce about sad or neutral experiences prior to a chance to donate prize coupons privately to other children (Cialdini & Kenrick, 1976). When sad, the youngest children donated slightly less, the middle groups donated slightly more, and the teenage group donated significantly more. Only the teenagers seemed to find generosity a self-gratifying technique for cheering themselves up.

As the researchers note, these results are consistent with Donald Campbell's evolutionary view. We are born selfish; thus we must socially indoctrinate altruism. Such results are also consistent with the view that altruism naturally grows with age as the child comes to see things from another person's point of view (Bar-Tal, 1982; Rushton, 1976; Underwood & Moore, 1982). Perhaps some combination of these ideas (altruism as socialized, altruism as natural) is closest to the truth.

Exceptions to the Feel Bad–Do Good Effect

So among well-socialized adults should we always expect the "feel bad–do good" phenomenon? No. In the previous chapter, we saw that one negative mood, anger, produces anything but compassion. Another exception to the

phenomenon is depression, which is characterized by brooding self-concern unaccompanied by social concern (Carlson & Miller, 1987; Wood & others, 1990). Yet another exception is profound grief. People who suffer the loss of a spouse or a child, whether through death or separation, often undergo a period of intense self-preoccupation, a state that makes it difficult to be self-giving (Aderman & Berkowitz, 1983; Gibbons & Wicklund, 1982).

In a powerfully involving laboratory simulation of self-focused grief, William Thompson, Claudia Cowan, and David Rosenhan (1980) had Stanford University students privately listen to a taped description of a person (whom they were to imagine was their best friend of the other sex) dying of cancer. The experiment focused some subjects' attention on their own worry and grief:

> He (she) could die and you would lose him, never be able to talk to him again. Or worse, he could die slowly. You would know every minute could be your last time together. For months you would have to be cheerful for him while you were sad. You would have to watch him die in pieces, until the last piece finally went, and you would be alone.

For others, it focused their attention on the friend:

> He spends his time lying in bed, waiting those interminable hours, just waiting and hoping for something to happen. Anything. He tells you that it's not knowing that is the hardest.

The researchers report that regardless of which tape the participants heard, they were profoundly moved and sobered by the experience, yet not the least regretful of participating (although some participants in a control condition who listened to a boring tape were regretful). Did their mood affect their helpfulness? When immediately thereafter they were given a chance to anonymously help a graduate student with her research, 25 percent of those whose attention had been self-focused did so. Of those whose attention was other-focused, 83 percent helped. The two groups were equally touched. But only the other-focused participants found helping someone especially rewarding. In short, the feel bad–do good effect occurs with people whose attention is on others, people for whom altruism is therefore rewarding (Barnett & others, 1980; McMillen & others, 1977). So unless they are self-preoccupied, sad people are sensitive, helpful people.

Positive Mood

Are happy people unhelpful? Quite the contrary. There are few more consistent findings in the entire literature of psychology: Happy people are helpful people. This effect occurs with both children and adults, regardless of whether the good mood comes from ego-boosting success, thinking happy thoughts, or any of several other positive experiences (Salovey & others, 1991). One woman recalled her experience after falling in love:

> At the office, I could hardly keep from shouting out how deliriously happy I felt. The work was easy; things that had annoyed me on previous occasions were taken in stride. And I had strong impulses to help others; I wanted to share my joy. When Mary's typewriter broke down, I virtually sprang to my feet to assist. Mary! My former "enemy"! (Tennov, 1979, p. 22)

In experiments the one helped may be someone seeking a donation, an experimenter seeking help with paperwork, a woman who drops papers. Alice

"It's curious how, when you're in love, you yearn to go about doing acts of kindness to everybody."
P. G. Wodehouse, *The Mating Season*, 1949

Isen, Margaret Clark, and Mark Schwartz (1976) had a confederate who had supposedly spent her last dime on a wrong number then call people who, 0 to 20 minutes earlier, had received a free sample of stationery. As Figure 14-4 shows, their willingness to relay the phone message rose slightly during the first four or five minutes afterward, perhaps as the gift "sank in" or as they became less distracted. Then, as the good mood wore off, helpfulness dropped.

If sad people are sometimes extra helpful, how can it be that happy people are also helpful? Experiments reveal several factors are at work (Carlson & others, 1988). Helping softens a bad mood and sustains a good mood. A positive mood is, in turn, conducive to positive thoughts and positive self-esteem, which predispose us to positive behavior (Berkowitz, 1987; Cunningham & others, 1990; Isen & others, 1978). In a good mood—after being given a gift or while feeling the warm glow of success—people are more likely to have positive thoughts and to have positive associations with being helpful. Positive thinkers are likely to be positive actors.

Recall from Chapter 5 the effect of depressed versus happy moods on cognition.

PERSONAL INFLUENCES: PERSONALITY TRAITS

We have seen that mood and guilt dramatically affect altruism. Are there similar dramatic effects from enduring personality traits? Surely some traits must distinguish the Mother Teresa types.

"There are . . . reasons why personality should be rather unimportant in determining people's reactions to the emergency. For one thing, the situational forces affecting a person's decision are so strong."
Bibb Latané and John Darley (1970, p. 115)

For many years social psychologists were unable to discover a single personality trait that predicted altruistic behavior with anything close to the predictive power of the situation, guilt, and mood factors. Modest relationships were found between helping and certain personality variables, such as need for social approval. But by and large, the personality tests were unable to identify the helpers. So, the prevailing conclusion in 1980 was that the situation could powerfully affect willingness to help and that personality made little difference. If that has a familiar ring, it could be from a similar conclusion by conformity researchers (Chapter 7): Conformity, too, seemed more influenced by the situation than by measurable personality traits. Perhaps, though, you recall from Chapter 2 that who we are does affect what we do. Attitude and trait measures seldom predict a *specific* act, which is what most experiments on altruism measure, in contrast to the lifelong altruism of a Mother Teresa. But they better predict average behavior across many situations.

Personality researchers have responded to the challenge, first by demonstrating individual differences in helpfulness and showing that these differences persist over time and are noticed by one's peers (Hampson, 1984; Rushton & others, 1981). Second, researchers are gathering clues to the network of traits that predispose a person to helpfulness. Preliminary indications are that those high in emotionality, empathy, and self-efficacy are most likely to be concerned and helpful (Bierhoff & others, 1991; Eisenberg & others, 1991; Tice & Baumeister, 1985). Third, personality influences how people react to particular situations (Carlo & others, 1991; Romer & others, 1986; Wilson & Petruska, 1984). High self-monitoring people, being highly attuned to people's expectations, are especially helpful *if* they think helpfulness will be socially rewarded (White & Gerstein, 1987). Others' opinions matter less to internally guided, low self-monitoring people.

This interaction of person and situation also appears in the 172 studies that have compared the helpfulness of nearly 50,000 male and female subjects. After

Helping, percent

FIGURE 14-4 *Percentage of those willing to relay a phone message 0 to 20 minutes after receiving a free sample. Of control subjects who did not receive a gift, only 10 percent helped.*
(Data from Isen & others, 1976.)

analyzing these results, Alice Eagly and Maureen Crowley (1986) report that when faced with potentially dangerous situations in which strangers need help (such as with a flat tire or a fall in a subway), men more often help. (Eagly and Crowley also report that among 6767 individuals who have received the Carnegie medal for heroism in saving human life, 90 percent have been men.) But in safer situations, such as volunteering to help with an experiment or spend time with retarded children, women are slightly more likely to help. Thus, the gender difference interacts with (depends on) the situation. Eagly and Crowley suspect that if researchers were to study caring behavior in long-term, close relationships, rather than in short-term encounters with strangers, they would discover that women are significantly more helpful.

PERSONAL INFLUENCES: RELIGIOSITY

With Nazi submarines sinking ships faster than the Allied forces could replace them, the troop ship *SS Dorchester*, steamed out of New York harbor with 904 men headed for Greenland (Elliott, 1989). Among those leaving anxious families behind were four chaplains, Methodist preacher George Fox, Rabbi Alexander Goode, Catholic priest John Washington, and Reformed Church minister Clark Poling. Some 150 miles from their destination, *U-456* caught the *Dorchester* in its cross hairs. Within moments of the torpedo's impact, stunned men were pouring out from their bunks as the ship began listing. With power cut off, the escort vessels, unaware of the unfolding tragedy, pushed on in the darkness. On board, chaos reigned as panicky men came up from the hold without life jackets and leapt into overcrowded lifeboats.

As the four chaplains arrived on the steeply sloping deck they began guiding the men to their boat stations. They opened a storage locker, distributed life

FIGURE 14-5 *Religion and long-term altruism. Those whom George Gallup (1984) classifies as "highly spiritually committed" are more likely to report working among the needy.*

jackets, and coaxed the men over the side. In the icy, oil-smeared water, Pvt. William Bednar heard the chaplains preaching courage and found the strength to swim out from under the ship until he reached a life raft. Still on board, Grady Clark watched in awe as the chaplains handed out the last life jacket and then, with ultimate selflessness, gave away their own. As Clark slipped into the waters he saw the chaplains standing—their arms linked—praying, in Latin, Hebrew, and English. Other men, now serene, joined them in a huddle as the *Dorchester* slid beneath the sea.

Does the heroic example of the four chaplains rightly suggest that faith somehow promotes courage and caring? Most altruism studies explore spontaneous helping acts. Confronted with a minor emergency, people who report their beliefs or involvements as highly religious are not noticeably more responsive (Batson & others, 1985). Now, some researchers have also begun exploring planned helping—the sort of sustained helping provided by AIDS volunteers, Big Brother and Big Sister helpers, and supporters of campus service organizations (Amato, 1990; Clary & Snyder, 1991; Snyder & Omoto, 1991). It is when making intentional choices about long-term altruism that religiosity predicts altruism.

At Earlham College, Peter Benson and his colleagues (1980) found that religiously committed students volunteered more hours as tutors, relief workers, and campaigners for social justice than did religiously uncommitted students. Among the 12 percent of Americans whom George Gallup (1984) classified as "highly spiritually committed," 46 percent said they were presently working among the poor, the infirm, or the elderly—many more than the 22 percent among those "highly uncommitted" (Figure 14-5). In a follow-up Gallup survey (Colasanto, 1989), charitable and social service volunteering was reported by 28 percent of those who rated religion "not very important" in their lives and by 50 percent of those who rated it "very important."

Moreover, Sam Levenson's jest, "When it comes to giving, some people stop at nothing," is seldom true of church and synagogue members. In a 1987 Gallup survey, Americans who said they never attended church or synagogue reported giving away 1.1 percent of their incomes (Hodgkinson & others, 1990). Weekly attenders were two and a half times as generous. This 24 percent of the population gave 48 percent of all charitable contributions. The other three-quarters of Americans give the remaining half. A follow-up 1990 Gallup survey for Independent Sector confirmed this pattern: Nonattenders reported giving 0.8 percent of their household income (Hodgkinson & Weitzman, 1990). Those attending religious services once or twice a month gave twice as much, 1.5 percent. Weekly attenders gave twice again as much, 3.8 percent. The desire for social and personal rewards may help motivate such generosity (Batson & others, 1989). Nevertheless, the religious influence on planned helping is significant.

"Religion is the mother of philanthropy."
Emerson Andrew, *Attitudes Toward Giving*, 1953

■ WHOM DO WE HELP?

When considering the social-responsibility norm, we noted the tendency to help those most in need, those most deserving. In the subway experiment, the "victim" was helped more promptly when carrying a cane than when carrying a liquor bottle. Grocery store shoppers are more willing to give change to a woman who wants to buy milk than to one who wants to buy cookie dough (Bickman & Kamzan, 1973).

GENDER

If, indeed, perception of another's need strongly determines one's willingness to help, will women, if perceived as less competent and more dependent, *receive* more help than men? In the United States, this is indeed the case. Alice Eagly and Maureen Crowley (1986) located 35 studies that compared help received by male or female victims. (Virtually all the studies involved short-term encounters with strangers in need—the very situations in which people expect males to be chivalrous, note Eagly and Crowley.)

When the potential helpers were males, female victims were more likely to receive aid than male victims in 4 out of 5 studies. When the potential helpers were females, female and male victims were equally likely to receive aid. Several experiments have found that women with disabled cars (for example, with a flat tire) get many more offers of help than do men (Penner & others, 1973; Pomazal & Clore, 1973; West & others, 1975). Similarly, solo female hitchhikers receive far more offers of help than do solo males or couples (Pomazal & Clore, 1973; M. Snyder & others, 1974).

Of course, men's chivalry toward lone women may be motivated by something other than altruism. Some of the helpful men may reason that the cost of helping is minimal (at least in terms of risk to one's safety), but the potential benefits are maximal. So it won't come as a great surprise to learn that men more frequently help attractive than less attractive women (Mims & others, 1975; Stroufe & others, 1977; West & Brown, 1975).

Women not only receive more offers of help in certain situations, they also

seek more help. They are twice as likely to seek medical and psychiatric help. They are the majority of callers to radio counseling programs and clients of college counseling centers. They more often welcome help from friends. Arie Nadler (1991), a Tel Aviv University expert on help seeking, attributes this to the gender differences in independence versus interdependence (Chapter 6).

SIMILARITY

Because similarity is conducive to liking (Chapter 13) and liking is conducive to helping, we are also biased toward those *similar* to us. The similarity bias applies to both dress and beliefs. Tim Emswiller and his fellow researchers (1971) had confederates, dressed either conservatively or in counterculture garb, approach "straight" and "hip" Purdue University students seeking a dime for a phone call. Fewer than half the students did the favor for those dressed differently from themselves. Two-thirds did so for those dressed similarly. Similarly, Scottish shoppers were less willing to make change for someone if the person wore a T-shirt with a pro-gay slogan (Gray & others, 1991). On election day, 1972, Stuart Karabenick, Richard Lerner, and Michael Beecher (1973) had Nixon and McGovern workers "accidentally" drop campaign leaflets near voting pools. The workers were helped by fewer than half the passersby who preferred the other candidate but by more than two-thirds of those whose preference was the same.

Does the similarity bias extend to race? During the 1970s, researchers explored this question with confusing results: Some studies found a same-race bias (Benson & others, 1976; Clark, 1974; Franklin, 1974; Gaertner, 1973; Gaertner & Bickman, 1971; Sissons, 1981). Others found no bias (Gaertner, 1975; Lerner & Frank, 1974; Wilson & Donnerstein, 1979; Wispe & Freshley, 1971). And still others—especially those involving face-to-face situations—found a bias toward helping those of a different race (Dutton, 1971, 1973; Dutton & Lake, 1973; Katz & others, 1975). Is there a general rule that resolves these seemingly contradictory findings?

Few people want to appear prejudiced. Thus one possibility is that people favor their own race but keep this bias secret to preserve a positive image. If so, the same-race bias should appear only when failure to help someone of another race can be attributed to factors other than race. This is what happened in experiments by Samuel Gaertner and John Dovidio (1977, 1986). For example, University of Delaware White women were less willing to help a Black than a White "woman in distress" *if* their responsibility could be diffused among the bystanders ("I didn't help the Black woman because there were others who could"). When there were no other bystanders, the women were equally helpful to the Black and the White women. The rule seems to be: When norms for appropriate behavior are well defined, Whites don't discriminate; when norms are ambiguous or conflicting, racial similarity may bias responses.

■ HOW CAN WE INCREASE HELPING?

As social scientists, our goal is to understand human behavior, thus also suggesting ways to improve it. We therefore wonder how we might apply insights from research on altruism to increase altruism.

What made this woman agree to give blood?

UNDOING THE RESTRAINTS ON HELPING

One way to promote altruism is to reverse those factors that inhibit it. Given that hurried, preoccupied people are less likely to help, can we think of ways to encourage them to slow down and turn their attention outward? If the presence of others diminishes each bystander's sense of responsibility, how can we enhance responsibility?

Reduce Ambiguity, Increase Responsibility

If Latané and Darley's decision tree (Figure 14-2) describes the dilemmas bystanders face, then assisting people to interpret an incident correctly and to assume responsibility should increase their involvement. Leonard Bickman and his colleagues (1975, 1977, 1979) tested this presumption in a series of experiments on crime reporting. In each, supermarket or bookstore shoppers witnessed a shoplifting. Some witnesses had seen signs that attempted both to sensitize them to shoplifting and to inform them how to report it. But the signs had little effect. Other witnesses heard a bystander interpret the incident: "Say, look at her. She's shoplifting. She put that into her purse." (The bystander then left to look for a lost child.) Still others heard this person add, "We saw it. We should report it. It's our responsibility." Both face-to-face comments substantially boosted reporting of the crime.

The potency of personal influence is no longer in doubt. Robert Foss (1978) surveyed several hundred blood donors and found that neophyte donors, unlike veterans, were usually there at someone's personal invitation. Leonard Jason and his collaborators (1984) confirmed that personal appeals for blood donation are much more effective than posters and media announcements—*if* the personal appeals come from friends. Nonverbal appeals can also be effec-

tive when they are personalized. Mark Snyder and his co-workers (1974) found that hitchhikers doubled the number of ride offers by looking drivers straight in the eye. A personal approach makes one feel less anonymous, more responsible.

Henry Solomon and Linda Solomon (1978; Solomon & others, 1981) confirmed the benefits of reducing anonymity. They found that bystanders who had identified themselves to one another—by name, age, and so forth—were more likely to offer aid to a sick person than were anonymous bystanders. Similarly, when a female experimenter caught the eye of another shopper and gave her a warm smile prior to stepping on an elevator, that shopper was far more likely than other shoppers to offer help when the experimenter later said, ''Damn. I've left my glasses. Can anyone tell me what floor the umbrellas are on?'' Even a trivial momentary conversation with someone—''Excuse me, aren't you Suzie Spear's sister?'' ''No, I'm not''—dramatically increased the person's later helpfulness.

Helpfulness also increases when one expects later to meet the victim and other witnesses again. Using a laboratory intercom system, Jody Gottlieb and Charles Carver (1980) led University of Miami students to believe they were discussing problems of college living with other students. (Actually, the other discussants were tape-recorded.) When one of the supposed fellow discussants had a choking fit and cried out for help, she was helped most quickly by subjects who believed they would soon be meeting the discussants face-to-face. In short, anything that personalizes bystanders—a personal request, eye contact, stating one's name, anticipation of interaction—increases willingness to help.

Personal treatment probably makes bystanders more self-aware and therefore more attuned to their own altruistic ideals. Recall (from Chapters 4 and 9) that people made self-aware by acting in front of a mirror or TV camera exhibit increased consistency between attitudes and actions. By contrast, ''deindividuated'' people are less responsible. Thus, circumstances promoting self-awareness—name tags, being watched and evaluated, undistracted quiet—should also increase helping. Shelley Duval, Virginia Duval, and Robert Neely (1979) confirmed this. They showed University of Southern California women their own image on a TV screen or had them complete a biographical questionnaire just before giving them a chance to contribute time and money to people in need. Those made self-aware contributed more. Similarly, pedestrians who have just had their picture taken by someone became more likely to help another pedestrian pick up dropped envelopes (Hoover & others, 1983). To be self-aware, yet not self-preoccupied, makes people more likely to put their ideals into practice.

Guilt and Concern for Self-Image

Earlier we noted that people who feel guilty will act to reduce guilt and restore their self-worth. Can heightening people's awareness of their transgressions therefore increase desire to help? A Reed College research team led by Richard Katzev (1978) wondered. So when visitors to the Portland Art Museum disobeyed a ''Please do not touch'' sign, experimenters reprimanded some of them: ''Please don't touch the objects. If everyone touches them, they will deteriorate.'' Likewise, when visitors to the Portland Zoo fed unauthorized food to the bears, some of them were admonished with, ''Hey, don't feed unauthor-

ized food to the animals. Don't you know it could hurt them?" In both cases, 58 percent of the now guilt-laden subjects shortly thereafter offered help to another experimenter who had "accidentally" dropped something. Of those not reprimanded, only one-third helped.

People also care about their public image. When Robert Cialdini and his colleagues (1975) asked some of their Arizona State University students to chaperon delinquent children on a zoo trip, only 32 percent agreed to do so. With other students the questioner first made a very large request—that the students commit two years as volunteer counselors to delinquent children. After getting the **door-in-the-face** in response to this request (all refused), the questioner then counteroffered with the chaperoning request, saying, in effect, "OK, if you won't do that, would you do just this much?" With this technique, nearly twice as many—56 percent—agreed to help.

Cialdini and David Schroeder (1976) offer another practical way to trigger concern for self-image: Ask for a contribution so small that it's hard to say no without feeling like a Scrooge. When they had a solicitor approach suburbanites and say, "I'm collecting money for the American Cancer Society," 29 percent contributed an average of $1.44 each. When the solicitor added, "Even a penny will help," 50 percent contributed, averaging $1.54 each. When James Weyant (1984) repeated this experiment, he found similar results: The "even a penny will help" boosted the number contributing from 39 to 57 percent. And when 6000 people were solicited by mail for the American Cancer Society, those asked for small amounts were more likely to give—and gave no less on average—than those asked for larger amounts (Weyant & Smith, 1987). When approaching previous donors, bigger requests (within reason) do elicit bigger donations (Doob & McLaughlin, 1989). But with door-to-door solicitation, there is more success with requests for small contributions, which are difficult to turn down and still allow an altruistic self-image.

Labeling people as helpful can also strengthen a helpful self-image. After they had made a charitable contribution, Robert Kraut (1973) told some Connecticut women, "You are a generous person." Two weeks later, these women were more willing than those not so labeled to contribute to a different charity. Likewise, Angelo Strenta and William DeJong (1981) told some students a personality test revealed that "you are a kind, thoughtful person." These students were later more likely than others to be kind and thoughtful toward a confederate who dropped a stack of computer cards.

> **Door-in-the-face technique:** A strategy for gaining a concession. After someone first turns down a large request (the door-in-the-face), the same requester counteroffers with a more reasonable request.

SOCIALIZING ALTRUISM

If we can learn altruism, then how might we teach it? Here are three ways.

Teaching Moral Inclusion

Rescuers of Jews in Nazi Europe, leaders of the American antislavery movement in the 1840s and 1850s, and medical missionaries share at least one thing in common: They include people who differ from them within the human circle to which their moral values and rules of justice apply. These people are *morally inclusive.*

Moral exclusion—omitting certain people from one's circle of moral concern—has the opposite effect. It justifies all sorts of harm, from discrimination to genocide (Opotow, 1990; Staub, 1990; Tyler & Lind, 1990). Exploitation or

> **Moral exclusion:** The perception of certain individuals or groups as outside the boundary within which one applies moral values and rules of fairness. Moral *inclusion* is regarding others as within one's circle of moral concern.

cruelty becomes acceptable, even appropriate, toward those we regard as undeserving or as nonpersons. The Nazis excluded Jews from their moral community; so does anyone who participates in enslavement, death squads, or torture.

A first step toward socializing altruism is therefore to counter the natural ingroup bias favoring kin and tribe by broadening the range of people whose well-being concerns us. Daniel Batson (1983) notes how religious teachings do this. They extend the reach of kin-linked altruism by urging "brotherly and sisterly" love toward all our fellow "children of God" in the whole human "family." If everyone is part of our family, then everyone has a moral claim on us. The boundaries between "we" and "they" fade. Nurturing children to have a secure sense of self also helps, by enabling them to accept social diversity without feeling threatened (Deutsch, 1990).

Modeling Altruism

Earlier we learned that when we see unresponsive bystanders, we, too, are unlikely to help. If we see someone helping, we are more likely to offer assistance. A similar modeling effect occurred within the families of European Christians who risked their lives to rescue Jews in the 1930s and 1940s and of the civil rights activists of the late 1950s. In both cases these exceptional altruists had warm and close relationships with at least one parent who was, similarly, a strong "moralist" or committed to humanitarian causes (London, 1970; Oliner & Oliner, 1988; Rosenhan, 1970). Their family—and often their friends and church—had taught them the norm of helping and caring for others. This "prosocial value orientation" led them to include people from other groups in their circle of moral concern and to feel responsible for others' welfare (Staub, 1989, 1991, 1992). People reared by extremely punitive parents, as were many

Morally inclusive people, like these volunteer French medical teams working in Mexico City after the 1985 earthquake, act with concern for those who are different or distant from themselves. Their circle of concern includes the world, not just their own families or neighborhoods.

delinquents, chronic criminals, and Nazi mass murderers, show much less of the empathy and principled caring that typified altruistic rescuers long after the Nazi era.

Modeling also helps increase blood donations, as Irwin Sarason and his colleagues (1991) discovered after soliciting nearly 10,000 students at 66 high schools across America. The researchers compared two groups of students. One group experienced the procedure that blood centers believed most effective in recruiting students. A second group viewed a slide show that included 38 photos of high school blood drive scenes. Those exposed to the modeling were 17 percent more likely to donate.

Do television's positive models promote helping, much as its aggressive portrayals promote aggression? Television's prosocial models have actually had even greater effects than its antisocial models. Susan Hearold (1986) statistically combined 108 comparisons of prosocial programs with neutral programs or no program. She found that, on average, "If the viewer watched prosocial programs instead of neutral programs, he would [at least temporarily] be elevated from the 50th to the 74th percentile in prosocial behavior—typically altruism."

In one such study, researchers Lynette Friedrich and Aletha Stein (1973; Stein & Friedrich, 1972) showed preschool children *Mister Rogers' Neighborhood* episodes each day for four weeks as part of their nursery school program. (*Mister Rogers* is an educational program designed to enhance young children's social and emotional development.) During this viewing period, children from less educated homes became more cooperative, helpful, and likely to state their feelings. In a follow-up study, kindergartners who viewed four *Mister Rogers* programs were able to state its prosocial content, both on a test and in puppet play (Friedrich & Stein, 1975; also Coates & others, 1976).

"Children can learn to be altruistic, friendly and self-controlled by looking at television programs depicting such behavior patterns."
National Institute of Mental Health, Television and Behavior, 1982

Attributing Helpful Behavior to Altruistic Motives

Another clue to socializing altruism comes from research on the overjustification effect: When the justification for an act is more than sufficient, the person may attribute the act to the extrinsic justification rather than to an inner motive. Rewarding people for doing what they would do anyway therefore undermines intrinsic motivation. We can state the principle positively: By providing people with just enough justification to prompt a good deed (weaning them from bribes and threats when possible), we may increase their pleasure in doing such deeds on their own.

Overjustification effect: See Chapter 4.

Daniel Batson and his associates (1978, 1979) put the overjustification phenomenon to work. In several experiments they found that University of Kansas students felt most altruistic after agreeing to help someone without payment or implied social pressure. When pay had been offered or social pressures were present, people felt less altruistic after helping. In another experiment, the researchers led students to attribute a helpful act to compliance ("I guess we really don't have a choice") or to compassion ("The guy really needs help"). Later, when the students were asked to volunteer their time to a local service agency, 25 percent of those who had been led to perceive their previous helpfulness as mere compliance now volunteered; of those led to see themselves as compassionate, 60 percent volunteered. The moral? Simple: When people wonder, "Why am I helping?" it's best if the circumstances enable them to answer, "Because help was needed, and I am a caring, giving, helpful person."

Anything beyond that may undermine altruistic feelings. Batson and his co-workers (1987) discovered this when they asked people to describe a "situation in which you voluntarily helped someone at considerable cost to yourself" and then to reflect on "why you helped" by writing out the pertinent reasons. Compared to those who did not analyze their reasons for helping, those who did ended up feeling less selflessly altruistic.

As you may recall from Chapter 4, rewards undermine intrinsic motivation when they function as controlling bribes. An unanticipated compliment, however, can boost intrinsic motivation, by making people feel competent and worthy. When Joe is coerced with, "If you quit being chicken and give blood, we'll win the fraternity prize for most donations," he'll likely not attribute his donation to altruism. When Jocelyn is rewarded with, "That's terrific that you'd choose to take an hour out of such a busy week to give blood," she's more likely to walk away with an altruistic self-image—and thus to contribute again (Piliavin & others, 1982; Thomas & Batson, 1981; Thomas & others, 1981).

Indeed, many people begin giving blood because of incentives and social pressures but with repeated donations become more and more self-motivated (Callero & Piliavin, 1983). Goodness, like evil, often evolves in small steps. The Gentiles who saved Jews often began with a small commitment—to hide someone for a day or two. Having taken that step, they began to see themselves differently, as people who help, and then they became more intensely involved (Goleman, 1985).

Learning about Altruism

Researchers have found another way to boost altruism, one that provides a happy conclusion to our chapter. Some social psychologists worry that as people become more aware of social psychology's findings, their behavior may change, thus invalidating the findings (Gergen, 1983). Will learning about the factors that inhibit altruism reduce their influence? Sometimes, such "enlightenment" is not our problem but one of our goals.

Experiments with University of Montana students by Arthur Beaman and his colleagues (1978) reveal that once people understand why bystanders inhibit helping, they become more likely to help in group situations. The researchers used a lecture to inform some students how bystander refusal can affect both one's interpretation of an emergency and one's feelings of responsibility. Other students heard either a different lecture or no lecture at all. Two weeks later, as part of a different experiment in a different location, the participants found themselves walking (with an unresponsive confederate) past someone slumped over or past a person sprawled beneath a bicycle. Of those who had not heard the helping lecture, a fourth paused to offer help; twice as many of those "enlightened" did so. Having read this chapter, you, too, have perhaps changed. For as you come to understand what influences people's responses—whether hostile, indifferent, or caring—your attitudes, and perhaps your behavior, may never again be the same.

Coincidentally, shortly before I wrote the last paragraph, a former student, now living in Washington, D.C., stopped by. She mentioned that she recently found herself part of a stream of pedestrians striding past a man lying unconscious on the sidewalk. "It took my mind back to our social psych class and the accounts of why people fail to help in such situations. Then I thought, well, if

I just walk by, too, who's going to help him?" So she made a call to an emergency help number and waited with the victim—and other bystanders who now joined her—until help arrived.

Another student, happening upon a drunk man beating up a street person near midnight in a Vienna subway station, flowed by with the crowd.

> Finally, I was convinced enough of the truth we learned in social psychology to go back and pull the drunk off the street person. Suddenly he was very mad at me and chased me through the subway until police came, arrested him, and got an ambulance for the victim. It was pretty exciting and made me feel good. But the coolest part was how a little insight into social-psychological aspects of our own behavior can help us overcome the power of the situation and change our predicted actions.

■ SUMMING UP

WHY DO WE HELP?

Three theories explain altruistic behavior. The *social-exchange theory* assumes that helping, like other social behaviors, is motivated by people's desire to minimize their costs and maximize their rewards—rewards either external (for example, social approval) or internal (for example, reducing distress, increasing self-satisfaction). Other psychologists believe that a genuine altruistic concern for another's welfare also motivates people.

Social norms also mandate helping. The *reciprocity norm* stimulates us to return help, not harm, to those who have helped us. The *social-responsibility norm* beckons us to help needy, deserving people, even if they cannot reciprocate.

Evolutionary psychology assumes two types of altruism: devotion to one's kin and reciprocity. However, most evolutionary psychologists believe that the genes of selfish individuals are more likely to survive than the genes of self-sacrificing individuals and that society must therefore teach altruism.

These three theories complement one another. Each uses psychological, sociological, or biological concepts to account for two types of altruism: (1) an "altruism" of reciprocal exchange—when you scratch my back, I'm more likely to scratch yours—and (2) an unconditional altruism. Yet each theory is vulnerable to charges of being speculative and of inventing explanations, explanations that more clearly describe than predict altruism.

WHEN WILL WE HELP?

Several situational influences work either to inhibit or to encourage altruism. As the number of bystanders at an emergency increases, any given bystander is (1) less likely to notice the incident, (2) less likely to interpret it as an emergency, and (3) less likely to assume responsibility. This is especially true when the situation is ambiguous or when the bystanders cannot easily detect one another's alarm.

When are people most likely to help? (1) After observing someone else helping and (2) when not hurried. Personal influences such as moods also matter. After transgressing, one often becomes more willing to offer help, apparently

hoping to relieve guilt or to restore one's self-image. Sad people also tend to be helpful, especially when such behavior is a way to feel better. However, this feel bad–do good effect is not found in young children, thus suggesting that the inner rewards of helping are a product of later socialization. Finally, there is a striking feel good–do good effect: Happy people are helpful people.

In contrast to altruism's potent situational and mood determinants, personality test scores have served as only modest as predictors of helping. However, new evidence indicates that some people are consistently more helpful than others and that the effect of personality or gender may depend on the situation. Religiosity predicts long-term altruism, as reflected in volunteerism and charitable contributions.

WHOM DO WE HELP?

We are most likely to help those judged to both need and deserve it and those similar to us. In crisis or short-term needs situations, women receive more offers of help than men, especially from men.

HOW CAN WE INCREASE HELPING?

Research suggests that we can enhance helpfulness in two ways. First, reverse those factors that inhibit helping. We can take steps to reduce the ambiguity of an emergency situation or to increase feelings of responsibility (by reducing feelings of anonymity or increasing self-awareness). We can even use reprimands or the door-in-the face technique to evoke guilt feelings or a concern for self-image.

Second, we can teach altruism. Research into television's portrayals of prosocial models shows the medium's power to teach positive behavior. Children who view helpful behavior tend to act helpfully.

If we want to coax altruistic behavior from people, we had best remember the overjustification effect: When we coerce good deeds, with either excessive rewards or threats, people's intrinsic love of the activity often diminishes. If we provide people with enough justification for them to decide to do good, but not much more, they will attribute their behavior to their own altruistic motivation and henceforth be more willing to help.

■ FOR FURTHER READING

Clark, M. S. (Ed.). (1991). *Prosocial behavior.* Newbury Park, CA: Sage. Prominent researchers discuss their research on the causes and effects of helping.

Gilkey, L. (1966). *Shantung compound.* New York: Harper & Row. A first-person account of human nature laid bare among 1800 westerners crowded into a Japanese internment camp during World War II. Self-centeredness prevailed but was interspersed by incidents of selfless altruism.

Hunt, M. (1990). *The compassionate beast: What science is discovering about the humane side of humankind.* New York: William Morrow. Drawing on exten-

sive interviews with leading researchers, Hunt offers a personalized and provocative tour through the new altruism research.

Kohn, A. (1990). *The brighter side of human nature: Altruism and empathy in everyday life*. New York: Basic Books. A journalist's synopsis of the roots and fruits of helping.

Oliner, S. P., & Oliner, P. M. (1988). *The altruistic personality: Rescuers of Jews in Nazi Europe*. New York: The Free Press. From interviews with over 400 European rescuers and nonrescuers, the Oliners explore the moral and social roots of heroic behavior.

CONFLICT AND PEACEMAKING

■ CONFLICT

SOCIAL DILEMMAS
The Prisoner's Dilemma / The Tragedy of the Commons / Resolving social dilemmas
COMPETITION
PERCEIVED INJUSTICE
MISPERCEPTION
Mirror-image perceptions / Shifting perceptions

■ PEACEMAKING

CONTACT
Does desegregation improve racial attitudes? / When does desegregation improve racial attitudes?
COOPERATION
Common external threats / Superordinate goals / Cooperative learning
COMMUNICATION
Bargaining / Mediation / Arbitration
CONCILIATION
GRIT / Applications in the real world / The enduring commitment to coercion

"We . . . are not the creators of tension. We merely bring to the surface the hidden tension that is already alive. We bring it out in the open, where it can be seen and dealt with."
Martin Luther King, Jr.

Conflict varies. It is at times minimal, at times immense; at times hidden, at times open; at times destructive, at times constructive. Despite such variation, this much is sure: Any time people, or groups, are so bound together that their actions affect one another, conflict is natural and inevitable. Conflict may sometimes be suppressed. But unless the two parties have identical needs and desires, their wishes will sometimes clash. Conflict happens between individuals, between groups, between nations. Consider these examples.

Between individuals: George and his roommate are hardly speaking. Apart from a few snide allusions to "the lousy socks on the floor" and "that loud, distracting music," each has settled into a quiet smolder. The longer silence prevails, the more George assumes his roommate feels hostile and the more hostile George feels in return. Where will it lead? Will they split? Or will they reach a new understanding that restores their former friendship?

Between groups: Workers at the Acme Manufacturing Company are out on strike. Disgruntled over low pay and minimal benefits, they insist they won't return without a significant boost in pay and benefits. The company's reply: "Given your high absenteeism and low productivity, we can't afford to meet your demands." Where will it end? Will the strike force the company into bankruptcy and the workers out of their jobs? Or might it be possible to recast the current employer-employee relationship, enabling higher productivity and profits for the company and higher wages for the workers?

Between nations: There is a speech that has been spoken in many languages by the leaders of many countries. It goes like this: "The intentions of our country are entirely peaceful. Yet, we are also aware of the world's unrest, and of the threat posed by other nations, with their new weapons. Thus we would be remiss not to take adequate steps to increase our ability to defend against attack. By so doing, we shall protect our way of life and preserve the peace" (L. F. Richardson, 1969). Almost every nation claims concern only for peace but, mistrusting other nations, arms itself in self-defense. The result: a world in which developing countries have 8 soldiers for every doctor, a world with 51,000 nuclear weapons stockpiled (Sivard, 1991).

The biggest threats to human well-being, such as overpopulation, arise as people rationally pursue their individual self-interest, to their collective detriment.

A relationship or an organization without conflict is probably apathetic. Conflict signifies involvement, commitment, and caring. If understood, if recognized, it can stimulate renewed and improved human relations. Without conflict, people seldom face and resolve their problems.

Let's clarify our terms. **Conflict** is a perceived incompatibility of actions or goals. Whether their perceptions are accurate or inaccurate, people in conflict sense that one side's gain is the other's loss. "I'd like the music off." "I'd like it on." "We want more pay." "We can't give it to you." "We want peace and security." "So do we, but you threaten us."

Peace, in its most positive sense, is more than the suppression of open conflict, more than a tense, fragile, surface calmness. Peace is the outcome of a creatively managed conflict, one in which the parties reconcile their perceived differences and reach genuine accord. "We got our increased pay. You got your increased profit. Now we're helping each other achieve our aspirations."

But what kindles conflict? Social-psychological studies have identified several ingredients. What's striking (and what simplifies our task) is that these ingredients are common to all levels of social conflict, whether interpersonal or more complex intergroup or international conflicts.

Conflict:
A perceived incompatibility of actions or goals.

■ CONFLICT

As we examine the ingredients of conflict, bear in mind that social psychology provides but one perspective on significant social conflicts. For example, international conflicts also spring from differing histories, ideologies, and economics—all of which political scientists carefully study. Let's first identify some common types of social conflict.

SOCIAL DILEMMAS

Several of the problems that most threaten our human future—nuclear arms, the greenhouse effect, pollution, overpopulation, natural resource depletion— arise as various parties pursue their self-interest but do so, ironically, to their collective detriment. Anyone can think: "It would cost me lots to buy expensive pollution controls. Besides, by itself my pollution is trivial." Many others reason similarly, and the result is befouled air and water.

In some societies individuals benefit by having many children who, they assume, can assist with the family tasks and provide security in the parents' old age. But when most families have many children, the result is the collective devastation of overpopulation. Thus, choices that are individually rewarding become collectively punishing when others choose the same. We therefore have an urgent dilemma: How can we reconcile the well-being of individual parties—their right to pursue freely their personal interests—with the well-being of the community?

To isolate and illustrate this dilemma, social psychologists have used laboratory games that expose the heart of many social conflicts. By showing us how well-meaning people become trapped in mutually destructive behavior, they illuminate some fascinating, yet troubling, paradoxes of human existence. Consider two examples: the Prisoner's Dilemma and the Tragedy of the Commons.

The Prisoner's Dilemma

One dilemma derives from an anecdote concerning two suspects questioned separately by a prosecuting attorney (Rapoport, 1960). They are jointly guilty; however, the prosecutor has only enough evidence to convict them of a lesser offense. So the prosecutor offers each a chance to confess privately, explaining that if one confesses and the other doesn't, the confessor will be granted immunity and the confession will be used to convict the other of a maximum offense. If both confess, each will receive a moderate sentence for the lesser offense. If neither confesses, each will receive a light sentence. The matrix of Figure 15-1 summarizes the choices. Faced with such a dilemma, would you confess?

Many would, despite the fact that mutual confession elicits more severe sentences than mutual nonconfession. Note from the matrix that no matter what the other prisoner decides, each is better off confessing. If the other confesses, one then gets a moderate sentence instead of a severe one. If the other does not confess, one goes free. Of course, each prisoner reasons the same way. Hence, the social trap.

In some 2000 studies (Dawes, 1991), university students have faced variations of the Prisoner's Dilemma with the outcomes being not prison terms but chips, money, or course points. As Figure 15-2 illustrates, on any given decision, a person is better off defecting (because such behavior exploits the other's cooperation or protects against exploitation by the other). However—and here's the rub—by not cooperating, both parties end up far worse off than if they trusted each other and gained a joint profit. This dilemma often traps each one in a maddening predicament in which both realize they *could* mutually profit but, mistrusting one another, become "locked in" to not cooperating.

In such dilemmas, the unbridled pursuit of self-interest can be detrimental to all. This was the case during the cold war between the United States and the Soviet Union after 1945. A disinterested observer from another planet would

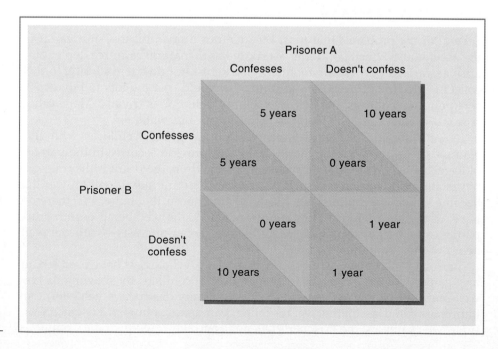

FIGURE 15-1 *The Prisoner's Dilemma. In each box, the number above the diagonal is prisoner A's outcome. Thus, if both prisoners confess, both get five years. If neither confesses, each gets a year. If one confesses, that prisoner is set free in exchange for evidence used to convict the other of a crime bringing a 10-year sentence. If you were one of the prisoners, would you confess?*

FIGURE 15-2 *Laboratory version of the Prisoner's Dilemma. The numbers represent some reward, such as money. In each box, the number above the diagonal lines is the outcome for person A.*

likely note that the military policy of "mutually assured destruction" is, as its acronym implies, MAD. As Dwight D. Eisenhower lamented:

> Every gun that is made, every warship launched, every rocket fired signifies, in the final sense, a theft from those who hunger and are not fed, those who are cold and are not clothed. This world in arms is not spending money alone. It is spending the sweat of its laborers, the genius of its scientists, the hopes of its children. . . . This is not a way of life, at all, in any true sense. Under the cloud of threatening war, it is humanity hanging from a cross of iron.

It may occasionally be true that maintaining a balance of terror helps prevent war, which might occur if one nation believed it could easily exploit another's weaknesses. But neither the historical record (Lebow & Stein, 1987) nor the psychological evidence we will consider supports the idea that threatening an enemy with big sticks, such as nuclear weapons, deters war. More wars were fought during the heavily armed 1980s than in any previous decade in history (Sivard, 1991). Moreover, the people of all nations would surely be more secure if there were no weapons threat and if military spending were available for productive rather than destructive purposes.

It's easy to say all this, but the dilemma faced by national leaders—and by college students in laboratory simulations of the arms race dilemma—is that one-sided disarmament makes one vulnerable to attack or blackmail. In the laboratory, those who adopt an unconditionally cooperative strategy often get exploited (Oskamp, 1971; Reychler, 1979; Shure & others, 1965). So, alas, the arms expenditures continue.

"When multiplied by 2, a national policy of Peace Through Strength leads inevitably to an arms race."
George Levinger (1987)

The Tragedy of the Commons

Unlike conflicts between two nations, many other pressing social dilemmas involve many participants. The predicted greenhouse effect will stem mostly

When after eight years of war, more than a million casualties, civilian and military, and ruined economies, Iran and Iraq finally called a halt, the border over which they had fought was exactly the same as when they started.

from widespread deforestation and from the carbon dioxide emissions of countless cars, oil burners, and coal-fired power plants. Each gas-guzzling car contributes infinitesimally to the problem, and the harm each does is diffused over many people. To model such social predicaments, researchers have developed laboratory dilemmas that involve multiple people.

A metaphor for the insidious nature of social dilemmas is what ecologist Garrett Hardin (1968) called the "tragedy of the commons." He derived the name from the centrally located pasture in old English towns. However, the "commons" can be air, water, whales, cookies, or any shared and limited resource. If all use the resource in moderation, it may replenish itself as rapidly as it's harvested. The grass will grow, the whales will reproduce, and the cookie jar gets restocked.

Imagine 100 farmers surrounding a commons capable of sustaining 100 cows. When each grazes one cow, the common feeding ground is optimally used. But then someone reasons: "If I put a second cow in the pasture, I'll double my output, minus the mere 1 percent overgrazing." So this farmer adds a second cow. Then so does each of the other farmers. The inevitable result? The tragedy of the commons—a grassless mud field.

Many real predicaments parallel this story. Environmental pollution is the sum of many minor pollutions, each of which benefits the individual polluters much more than they could benefit themselves (and the environment) if they stopped their small pollution. We litter public places—dorm lounges, parks, zoos—but keep our personal spaces clean. And we deplete our natural resources, because the immediate personal benefits of, say, taking a long, hot shower outweigh the seemingly inconsequential costs. Whalers knew others would exploit the whales if they didn't and that taking a few whales would

hardly diminish the species. Therein lay the tragedy. Everybody's business (conservation) became nobody's business.

The elements of the Commons Dilemma have been isolated in laboratory games. Put yourself in the place of Arizona State University students playing Julian Edney's Nuts Game (1979). You and several others sit around a shallow bowl that initially has ten metal nuts. The experimenter explains that your goal is to accumulate as many nuts as possible. Each of you at any time may take as many as you want, and every 10 seconds the number of nuts remaining in the bowl will be doubled. Would you leave the nuts in the bowl to regenerate, thus producing a greater harvest for all?

Likely not. Unless they were given time to devise and agree upon a conservation strategy, 65 percent of Edney's groups never reached the first 10-second replenishment. Often the people knocked the bowl on the floor grabbing for their share.

Is such individualism uniquely American? Kaori Sato (1987) gave students in a more collective culture, Japan, opportunities to harvest—for actual money—trees from a simulated forest. When the students shared equally the costs of planting the forest, the result was like those in western cultures. More than half the trees were harvested before they had grown to the most profitable size.

Edney's nut bowl and Sato's forest remind me of the cookie jar in our home. What we *should* do is conserve cookies during the interval between weekly restockings, so that each day we can each munch two or three. Lacking regulation and fearing that other family members will soon deplete the resource, what we actually do is maximize our individual cookie consumption by downing one after the other. The result: Within 24 hours the cookie glut ends, the jar sits empty, and we again await its replenishment.

The Prisoner's Dilemma and Commons Dilemma games have several similar features. First, both tempt people to explain their own behavior situationally ("I had to protect myself against exploitation by my opponent") and to explain their partners' behavior dispositionally ("she was greedy," "he was

▪ BEHIND THE SCENES

I am brash enough to believe that laboratory studies of conflict can illumine our understanding of the dynamics of war, peace, and social justice. From small groups to nations, the social processes appear similar. Thus social psychologists who study conflict are in much the same position as the astronomers. We cannot conduct true experiments with large-scale social events. But we can identify the conceptual similarities between the large scale and the small, as the astronomers have between the planets and Newton's apple. By experimenting with small-scale social situations, we may thus be able to understand, predict, and influence large-scale social processes. That is why the games people play as subjects in our laboratory may advance our understanding of war, peace, and social justice.

MORTON DEUTSCH, *Columbia University*

untrustworthy"). Most never realize that their counterparts are viewing them with the same fundamental attribution error.

Second, motives often change. At first, people are eager to make some easy money, then to minimize their losses, and finally to save face and avoid defeat (Brockner & others, 1982; Teger, 1980). These shifting motives are strikingly similar to President Johnson's apparently shifting motives during the buildup of the Vietnam war. At first, his speeches described America's concern for democracy, freedom, and justice. As the conflict escalated, his expressed concern became protecting America's honor and avoiding the national humiliation of losing a war.

Non-zero-sum games: Games in which outcomes need not sum to zero. With cooperation, both can win; with competition, both can lose. (Also called *mixed-motive situations.*)

Third, most real-life conflicts, like the Prisoner's Dilemma and Commons Dilemma, are **non-zero-sum games.** The two sides' profits and losses need not add up to zero. Both can win; both can lose. Each game pits the immediate interests of individuals against the well-being of the group. Each is a diabolical social trap that shows how, even when individuals behave "rationally," harm can result. No malicious person planned for Los Angeles to be smothered in smog, nor for the horrendous destruction of the Vietnam conflict, nor for the earth's atmosphere to be warmed by a blanket of carbon dioxide.

However, we must take care not to overstate the point. Not all self-serving behavior leads to collective doom. In a plentiful commons—as in the world of the eighteenth-century capitalist economist Adam Smith—individuals who seek to maximize their own profit may also give the community what it needs: "It is not from the benevolence of the butcher, the brewer, or the baker, that we expect our dinner, but from their regard to their own interest" (Smith, 1976, p. 18).

But in those situations that are indeed social traps, how can we induce people to cooperate for their mutual betterment?

Resolving Social Dilemmas

Research with the laboratory dilemmas has revealed several methods for promoting cooperation.

Regulation

Reflecting on the Commons Dilemma, Garrett Hardin (1968) wrote: "Ruin is the destination to which all men rush, each pursuing his own best interest in a society that believes in the freedom of the commons. Freedom in a commons brings ruin to all." Consider: If taxes were entirely voluntary, how many would pay their full share?

Surely, many would not, which is why modern societies do not depend on voluntary charity to meet their needs for social and military security. We also develop laws and regulations for our common good. An International Whaling Commission sets an agreed-upon "harvest" that enables whales to regenerate. The United States and the Soviet Union mutually commit themselves to the Atmospheric Test Ban Treaty that reduces radiation in our common air. When enforced, environmental regulations equalize the burden for all; no steel company need fear that other companies will gain a competitive advantage by disregarding their environmental responsibilities.

Similarly, participants in laboratory games often seek ways to regulate their

behavior for what they know to be their common good. Players of the Nuts Game may agree to take but 1 or 2 nuts every 10 seconds, leaving the rest to regenerate, or they may elect a leader to decide each person's share (Messick & others, 1983; Samuelson & others, 1984).

So, regulating behavior is one solution to social dilemmas. But in everyday life, regulation has costs—costs of administering and enforcing the regulations, costs of diminished personal freedom. A volatile political question thus arises: At what point does a regulation's cost exceed its benefits?

Small Is Beautiful

Given the costs of regulation, are there other ways of resolving social dilemmas? One suggestion: Keep the group small. In laboratory dilemma games, people who interact with but a few others cooperate more than do those in larger groups (Dawes, 1980). In small commons, each person feels more responsible, effective, and identified with the group's success (Kerr, 1989). Although group identification occurs more readily in small groups, anything that gives people a "we feeling"—even just a few minutes of discussion or just believing that one shares similarities with others in the group—will increase cooperation (Brewer, 1987; Orbell & others, 1988).

In small rather than large groups, individuals are also more likely to take no more than their equal share of available resources (Allison & others, 1992). On the Puget Sound island where I grew up, our small neighborhood shared a communal water supply. On hot summer days when the reservoir ran low, a light came on, signaling our 15 families to conserve. Recognizing our responsibility to one another, and feeling like our conservation really mattered, each of us conserved. Never did the reservoir run dry.

In a much larger commons—say, a city—voluntary conservation is less successful. The harm one does diffuses across many others. Thus each one can rationalize away personal accountability. Some political theorists and social psychologists therefore argue that, where feasible, the commons should be divided into smaller territories (Edney, 1980). In his 1902 *Mutual Aid*, the Russian revolutionary Pyotr Kropotkin set down a vision of small communities making decisions for the benefit of all by consensus, thereby reducing the need for central government (Gould, 1988).

"For that which is common to the greatest number has the least care bestowed upon it."
Aristotle

Communication

To escape a social trap, people must communicate. In the laboratory, group communication sometimes degenerates into threats and name calling (Deutsch & Krauss, 1960). More often, communication enables groups to cooperate (Bornstein & others, 1988, 1989; Jorgenson & Papciak, 1981). Discussing the dilemma forges a group identity and enables people to commit themselves to cooperation, thereby often doubling cooperation.

Open, clear, forthright communication also reduces mistrust. Without communication, those who expect others not to cooperate usually refuse to cooperate themselves (Messé & Sivacek, 1979; Pruitt & Kimmel, 1977). One who mistrusts almost has to be uncooperative (to protect against expected exploitation). Noncooperation, in turn, feeds further mistrust ("What else could I do? It's a dog-eat-dog world"). In experiments, communication reduces mistrust, enabling people to reach agreements that lead to their common betterment.

"My own belief is that Russian and Chinese behavior is as much influenced by suspicion of our intentions as ours is by suspicion of theirs. This would mean that we have great influence on their behavior—that, by treating them as hostile, we assure their hostility."
U.S. Senator J. William Fulbright (1971)

Changing the Payoffs

Cooperation rises when experimenters change the payoff matrix to make cooperation more rewarding, exploitation less rewarding (Pruitt & Rubin, 1986; Komorita & Barth, 1985). Changing payoffs also helps resolve actual dilemmas. In some cities, freeways clog and skies fill with smog because people prefer the convenience of driving themselves directly to work. Each knows that one more car does not add noticeably to the congestion and pollution. To alter the personal cost-benefit calculations, many of these cities now give carpoolers incentives, such as freeway lanes designated for their use.

Appeals to Altruistic Norms

In Chapter 14, we noted a social-responsibility norm, and we saw how increasing people's feelings of responsibility for others boosts altruism. Can we therefore assume that appeals to altruistic motives will prompt people to act for the common good?

The evidence is mixed. On the one hand, it seems that just *knowing* about the dire consequences of noncooperation has little effect. In laboratory dilemma games, people realize that their self-serving choices are mutually destructive, yet they continue to make them (Cass & Edney, 1978; Edney & Harper, 1978). Outside the laboratory, warnings of doom and appeals to conserve have triggered little response. Shortly after taking office in 1976, President Carter declared that America's response to the energy crisis should be "the moral equivalent of war" and urged conservation. The following summer, Americans consumed more gasoline than ever before. *Knowing* the good does not necessarily lead to *doing* the good.

Still, most people do adhere to norms of social responsibility, reciprocity, equity, and keeping one's commitments (Kerr, 1992). The problem is how to tap such feelings. When permitted to communicate, participants in laboratory games frequently appeal to the social-responsibility norm: "If you defect on the rest of us, you're going to have to live with it for the rest of your life" (Dawes & others, 1977). Noting this, researcher Robyn Dawes (1980) and his associates gave people a short sermon about group benefits, exploitation, and ethics. Then the people played a dilemma game. The appeal worked: People were convinced to forgo immediate personal gain for the common good. (Recall, too, from Chapter 14, the disproportionate volunteerism and charitable contributions by people who regularly hear sermons in churches and synagogues.)

Could such appeals work in large-scale dilemmas? Michael Lynn and Andrew Oldenquist (1986) believe they could. When cooperation obviously serves the public good, one can usefully appeal to the social-responsibility norm. Basketball players will pass up a good shot to offer a teammate a better shot. Struggling for civil rights, many marchers willingly agreed, for the sake of their larger group, to suffer harassment, beatings, and jail. In wartime, people make great personal sacrifices for the good of their group. As Winston Churchill said of the Battle of Britain, the actions of the Royal Air Force pilots were altruistic for the common good: A great many people owed a great deal to those who flew into battle knowing the high probability they would not return.

To summarize, we can minimize destructive entrapment in social dilemmas by establishing rules that regulate self-serving behavior, by keeping groups small, by enabling people to communicate, by changing payoffs to make cooperation more rewarding, and by invoking altruistic norms.

"Never in the field of human conflict was so much owed by so many to so few."
Sir Winston Churchill, House of Commons, August 20, 1940

To change behavior, many cities have changed the payoff matrix. Fast carpool-only lanes increase the benefits of carpooling and the costs of driving alone.

COMPETITION

In Chapter 11 we noted that racial hostilities often arise when groups compete for jobs and housing. When interests clash, conflict erupts. This was powerfully evident in the Shantung compound, a World War II internment camp into which the invading Japanese military herded foreigners residing in China. According to one of those interned, theologian Langdon Gilkey (1966), the need to distribute the barely adequate food and floor space provoked frequent conflicts among the doctors, missionaries, lawyers, professors, businesspeople, junkies, and prostitutes. The effects of competition for space, jobs, and political power have been tragically evident in Northern Ireland, where since 1969 hostilities between the ruling Protestant majority and the Catholic minority have claimed nearly 3000 lives. (A comparable proportion of the North American population would number close to 400,000 in the United States and 40,000 in Canada.)

But does competition by itself provoke hostile conflict? Real-life situations are so complex that it is hard to be sure. If competition is indeed responsible, then it should be possible to provoke conflict in an experiment. We could randomly divide people into two groups, have the groups compete for a scarce resource, and note what happens. This is precisely what Muzafer Sherif (1966) and his colleagues did in a dramatic series of experiments with typical 11- and 12-year-old boys. The inspiration for these experiments dated back to Sherif's witnessing, as a teenager, Greek troops invading his Turkish province in 1919.

> They started killing people right and left. [That] made a great impression on me. There and then I became interested in understanding why these things were happening among human beings. . . . I wanted to learn whatever science or specialization was needed to understand this intergroup savagery. (Quoted by Aron & Aron, 1989, p. 131)

After studying the social roots of savagery, Sherif introduced these apparent essentials into several three-week summer camping experiences. In one such study, he divided 22 unacquainted Oklahoma City boys into two groups, took them to a Boy Scout camp in separate buses, and settled them in bunkhouses about a half mile apart. For most of the first week, they were unaware of the other group's existence. By cooperating in various activities—preparing meals, camping out, fixing up a swimming hole, building a rope bridge—each group soon became close-knit. They gave themselves names: "Rattlers" and "Eagles." Typifying the good feeling, a sign appeared in one cabin: "Home Sweet Home."

Group identity thus established, the stage was set for the conflict. Toward the end of the first week, the Rattlers "discovered the Eagles on 'our' baseball field." When the camp staff then proposed a tournament of competitive activities between the two groups (baseball games, tugs-of-war, cabin inspections, treasure hunts, and so forth), both groups responded enthusiastically. This was win-lose competition. The spoils (medals, knives) would all go to the tournament victor.

The result? The camp gradually degenerated into open warfare. It was like a scene from William Golding's novel *Lord of the Flies,* which depicts the social disintegration of boys marooned on an island. In Sherif's study, the conflict began with each side calling the other derogatory names during the competitive activities. Soon it escalated to dining hall "garbage wars," flag burnings, cabin ransackings, even fistfights. Asked to describe the other group, the boys said "they" were "sneaky," "smart alecks," "stinkers," while referring to their own group as "brave," "tough," "friendly."

The win-lose competition had produced intense conflict, negative images of the outgroup, and strong ingroup cohesiveness and pride. All this occurred without any cultural, physical, or economic differences between the two groups and with boys who were their communities' "cream of the crop." Sherif noted that had we visited the camp at this point, we would have concluded these "were wicked, disturbed, and vicious bunches of youngsters" (1966, p. 85). Actually, their evil behavior was triggered by an evil situation. Fortu-

Competition kindles conflict. Here, in the Sherif experiment, one group of boys raids the bunkhouse of another.

nately, as we will see, Sherif not only made strangers into enemies; he then made the enemies into friends.

PERCEIVED INJUSTICE

"That's unfair!" "What a ripoff!" "We deserve better!" Such comments typify conflicts bred by perceived injustice. But what is "justice"? According to some social-psychological theorists, people perceive justice as equity—the distribution of rewards in proportion to individuals' contributions (Walster & others, 1978). If you and I have a relationship (employer-employee, teacher-student, husband-wife, colleague-colleague), it is equitable if:

$$\frac{\text{My outcomes}}{\text{My inputs}} = \frac{\text{Your outcomes}}{\text{Your inputs}}$$

If you contribute more and benefit less than I do, you will feel exploited and irritated; I may feel exploitative and guilty. Chances are, though, that you more than I will be sensitive to the inequity (Messick & Sentis, 1979; Greenberg, 1986).

"Do unto others 20% better than you would expect them to do unto you, to correct for subjective error."
Linus Pauling (1962)

We may agree with the equity principle's definition of justice yet disagree on whether our relationship is equitable. If two people are colleagues, what will each consider a relevant input? The one who is older may favor basing pay on seniority, the other on current productivity. Given such a disagreement, whose definition is likely to prevail? More often than not, those with social power convince themselves and others that they deserve what they're getting (Mikula, 1984). Karl Marx anticipated this finding: "The ideas of the *ruling* class are in every epoch the ruling ideas: i.e., the class, which is the ruling material force of society, is at the same time its ruling intellectual force" (Walster & others, 1978, p. 220). This has been called a "golden" rule: Whoever has the gold makes the rules.

As this suggests, the exploiter can relieve guilt by valuing or devaluing inputs to justify the existing outcomes. Some men may perceive the lower pay of women as equitable, given women's "less important" inputs. As we noted in Chapter 11, those who inflict harm may even blame the victim and thus maintain their belief in a just world.

And those who are exploited? How do they react? Elaine Hatfield, William Walster, and Ellen Berscheid (1978) detected three possibilities. Exploited people can accept and justify their inferior position ("We're poor; it's what we deserve, but we're happy"). They can demand compensation, perhaps by harassing, embarrassing, even cheating their exploiter. If all else fails, they may try to restore equity by retaliating, perhaps vindictively.

An interesting implication of equity theory—an implication that has been confirmed experimentally—is that the more competent and worthy people feel (the more they value their inputs), the more likely they feel that a given outcome is insufficient and thus retaliate (Ross & others, 1971). Intense social protests generally come from those who believe themselves worthy of more than they are receiving. Since 1970, professional opportunities for women have significantly increased (page 208). Ironically, though understandably to an equity theorist, so have people's feelings that women's status is *inequitable* (Table 15-1).

TABLE 15-1 *Gallup Polls Reveal Increased Perceptions of Gender Inequality*

All things considered, who has a better life in this country— men or women?

	1975	1989
Men	32%	49%
Women	28	22
Same	31	21
No opinion	9	8

From De Stefano & Colasanto, 1990.

"Awards should be 'according to merit'; for all people agree that what is just in distribution must be according to merit in some sense, though they do not all specify the same sort of merit."

Aristotle

So long as women compared their opportunities and earnings with other women, they felt generally satisfied (Jackson, 1989; Major, 1989). Now that women are more likely to see themselves as men's equals, their sense of relative deprivation has grown. If secretarial work and truck driving have "comparable worth" (for the skills required), then they deserve comparable pay; that's equity, say advocates of gender equality (Lowe & Wittig, 1989).

Critics argue that equity is not the only conceivable definition of justice. (Pause a moment: Can you imagine any other basis for defining justice?) Edward Sampson (1975) says equity theorists wrongly assume that the economic principles which guide western, capitalist nations are universal. Some noncapitalist cultures define justice not as equity but as equality or even fulfillment of need: "From each according to his abilities, to each according to his needs" (Karl Marx). When rewards are distributed to those within one's group, people socialized under the influence of collectivist cultures, such as China and India, likewise favor need or equality more than do individualistic Americans (Hui & others, 1991; Leung & Bond, 1984; Murphy-Berman & others, 1984). Even within individualistic cultures, criteria other than equity sometimes define justice (Deutsch, 1985). In a family or an altruistic institution, the criterion may be need. In a friendship, it may be equality. In a competitive relationship, the winner may take all the reward.

Indeed, our criteria for justice do vary. Men tend to favor making rewards proportional to input, whereas women lean more toward equality. When asked to split rewards between themselves and a partner whose performance has been inferior, men tend to divide them equitably and women tend to divide them 50-50 (Major & Adams, 1983).

Conditions also matter. When social harmony is stressed, an equality norm often prevails. Roommates tend to overlook merit and distribute rewards equally (Austin, 1980). When productivity is stressed or when attention is drawn to their responsibility for outcomes, people favor equity (Greenberg, 1979, 1980).

Different reward systems have varying effects. Imagine that bonus money was made available to your work group for its efforts on some task. Under which payment system would you work hardest? *Winner takes all* (whoever performs best gets the entire bonus)? *Equity* (each paid according to contribution)? *Equality* (all paid the same)? Or *need*?

In a series of experiments, Morton Deutsch (1991) found no evidence that people work more productively when their individual earnings are tied to their

performance. The Columbia University students who participated in these experiments seemed more motivated by their own needs to excel than by the greater pay they could potentially earn in the winner-takes-all and equity conditions.

Given that positive reinforcement motivates behavior and that many people will "free-ride" on others' efforts, critics wonder how applicable Deutsch's findings are in everyday work situations. He notes that where there is cooperative ownership, accountability to immediate co-workers increases motivation and decreases the cost of supervision. Deutsch also reports that compared to competitive payment systems, cooperative systems of distributing rewards have more favorable effects on group morale, friendly feelings, and self-esteem. Moreover, those who care most about personal and group morale are more likely to prefer equal or need-based rewards. This helps explain why women are more likely than men to prefer equality or need-based rewards. Women tend to be less competitive than men and more concerned with others' feelings and with harmonious relations (Kahn & Gaeddert, 1985).

How universal, then, is the tendency to define justice as equity? And on what basis *should* rewards be distributed? Need? Equality? Merit? Some combination of these? Such questions are debated still. However, one thing is clear: One source of human conflict is our varying perceptions of what is fair.

"Solutions to the distribution problem are nontrivial. Children fight, colleagues complain, group members resign, tempers flare, and nations battle over issues of fairness. As parents, employers, teachers, and presidents know, the most frequent response to an allocation decision is 'not fair.'"
Arnold Kahn & William Gaeddert (1985)

In cooperative ventures, such as this employee-owned and operated cheese and bake shop, worker motivation is typically high.

MISPERCEPTION

Recall that conflict is a *perceived* incompatibility of actions or goals. Many conflicts contain but a small core of truly incompatible goals; the bigger problem is the misperceptions of the other's motives and goals. The Eagles and the Rattlers did indeed have some genuinely incompatible aims. But their perceptions subjectively magnified their differences (Figure 15-3).

In earlier chapters we considered several seeds of such misperception. The *self-serving bias* leads individuals and groups to accept credit for their good deeds and shuck responsibility for bad deeds, without according others the same benefit of the doubt. A tendency to *self-justify* further inclines people to deny the wrong of evil acts that cannot be shucked off. Thanks to the *fundamental attribution error,* each side sees the other's hostility as reflecting an evil disposition. One then filters the information and interprets it to fit one's *preconceptions*. Groups frequently *polarize* these self-serving, self-justifying, biasing tendencies. One symptom of *groupthink* is the tendency to perceive one's own group as moral and strong, the opposition as evil and weak. Terrorist acts that are despicable brutality to most people are "holy war" to others. Indeed, the mere fact of being in a group triggers an *ingroup bias*. And negative *stereotypes,* once formed, are often resistant to contradictory evidence.

Given these seeds of social misperception, it should not surprise us, though it should sober us, to discover that people in conflict form distorted images of one another. Even the types of misperception are intriguingly predictable.

Mirror-Image Perceptions

To a striking degree, the misperceptions of those in conflict are mutual. They attribute similar virtues to themselves and vices to the other. When American psychologist Urie Bronfenbrenner (1961) visited the Soviet Union in 1960 and

Misperceptions

True incompatibilty

FIGURE 15-3 *Most conflicts contain a core of truly incompatible goals surrounded by a larger exterior of misperceptions.*

TABLE 15-2 *Mirror Image Perceptions that Fed the Arms Race*

ASSUMPTION	SAMPLE STATEMENT BY THE U.S. PRESIDENT	SAMPLE STATEMENT BY THE SOVIET GENERAL SECRETARY
1: "We prefer mutual disarmament."	"We want more than anything else to join with them in reducing the number of weapons." (*New York Times*, 6/15/84)	"We do not strive . . . for military superiority over them; we want termination, not continuation of the arms race." (*New York Times*, 3/12/85)
2: "We must avoid disarming while the other side arms."	"We refuse to become weaker while potential adversaries remain committed to their imperialist adventures." (*New York Times*, 6/18/82)	"Our country does not seek [nuclear] superiority, but it also will not allow superiority to be gained over it." (*Pravda* 4/9/84)
3: "Unlike us, the other side aims for military superiority."	"For the Soviet leaders peace is not the real issue; rather, the issue is the attempt to spread their dominance using military power." (*New York Times*, 6/28/84)	"The main obstacle—and the entire course of the Geneva talks is persuasive evidence of this—is the attempts by the U.S. and its allies to achieve military superiority." (*Pravda*, 1/13/84)

Adapted from Plous, 1985.

conversed with many ordinary citizens in Russian, he was astonished to hear them saying the same things about America that Americans were saying about the U.S.S.R. The Soviets said that the U.S. government was militarily aggressive; that it exploited and deluded the American people; that in diplomacy it was not to be trusted. "Slowly and painfully, it forced itself upon one that the Russians' distorted picture of us was curiously similar to our view of them—a mirror image."

Analyses of American and Soviet perceptions by psychologists (such as Ralph White, 1984) and political scientists (such as Robert Jervis, 1985) indicate that mirror-image perceptions persisted into the 1980s. The American government viewed the Soviet involvement in Afghanistan much as the Soviet government viewed American involvement in Vietnam. As the Soviets viewed American "warmongering" in support of guerrillas trying to overthrow the Nicaraguan government, so Americans viewed the communist "evil empire's" support of guerrillas trying to overthrow the El Salvadoran government. Similar ingroup favoritism occurred with positive acts: American students perceived their own country's effort to save whales by smashing through ice as more altruistic and less self-serving than the same act by the Soviet Union. But dispassionate outsiders—Canadian students—attributed comparable Soviet and American acts to similar motives (Sande & others, 1989).

Such mirror-image perceptions fueled the arms race. Studies of politicians and political statements reveal that people in both nations (1) preferred mutual disarmament to all other outcomes, (2) wanted above all to avoid disarming while the other side armed, but (3) perceived the other side as preferring to achieve military superiority (Plous, 1985; Table 15-2). Thus though both nations claimed to prefer disarmament, both felt compelled to arm themselves to counter the other's weapons buildup.

In times of tension—as prevails during international crisis—rational think-

"The present tensions with their threat of national annihilation are kept alive by two great illusions. The one, a complete belief on the part of the Soviet world that the capitalist countries are preparing to attack it; that sooner or later we intend to strike. And the other, a complete belief on the part of the capitalist countries that the Soviets are preparing to attack us; that, sooner or later, they intend to strike."
General Douglas MacArthur (1966)

The less simplistic views that characterized American and Russian views of one another during the late 1980s and early 1990s helped reverse their arms race.

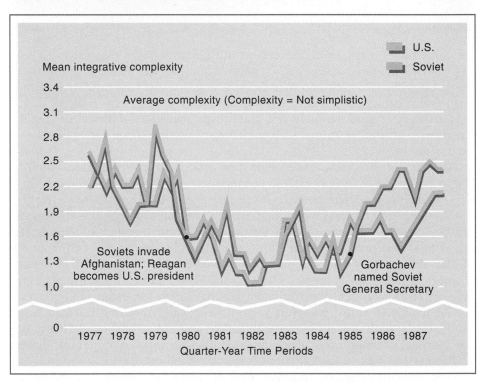

FIGURE 15-4 *Complexity of official U.S. and Soviet policy statements, 1977–1986.*
(From Tetlock, 1988.)

ing becomes more difficult (Janis, 1988). Views of the enemy become more simplistic and stereotyped, and premature seat-of-the-pants judgments become more likely. Social psychologist Philip Tetlock (1988) observed this phenomenon when analyzing the complexity of Soviet and American rhetoric since 1945. During the Berlin blockade, the Korean war, and the Soviet invasion

of Afghanistan, political statements became simplified into stark, good-versus-bad terms. At other times—notably after Mikhail Gorbachev became the Soviet General Secretary (Figure 15-4)—political statements acknowledged that each country's motives were complex.

Such shifts away from simplistic we-are-good–they-are-bad rhetoric typically preceded new U.S.-Soviet agreements, reports Tetlock. His optimism was confirmed when President Reagan in 1988 traveled to Moscow to sign the American-Soviet intermediate-range nuclear force (INF) treaty, and then Gorbachev visited New York and told the United Nations that he would remove 500,000 Soviet troops from eastern Europe and suggested:

> We should jointly seek the way leading to the supremacy of the universal human idea over the endless multitude of centrifugal forces. . . . I would like to believe that our hopes will be matched by our joint effort to put an end to an era of wars, confrontation and regional conflicts, to aggressions against nature, to the terror of hunger and poverty as well as to political terrorism. This is our common goal and we can only reach it together.

Gorbachev displayed the complex style of thinking that facilitates reaching mutually beneficial agreements. But, as the collapse of the former Soviet Union shows, even complex thinkers can be overwhelmed by intractable economic problems and conflicts of interest.

When, however, the two sides have clashing perceptions, at least one of the two is misperceiving the other. And when such misperceptions exist, noted Bronfenbrenner, "It is a psychological phenomenon without parallel in the gravity of its consequences . . . for *it is characteristic of such images that they are self-confirming.*" As we have seen, if A expects B to be hostile, A may treat B in such a way that B fulfills A's expectations, thus beginning a vicious circle. Morton Deutsch (1986) explained:

■ BEHIND THE SCENES

I am a contrarian at heart. Whenever I see a consensus emerging in a group, I wonder what kind of mistake we are about to make. Life often feels like a process of juggling competing values (work vs. family, savings vs. consumption, intimacy vs. autonomy). My initial hypothesis therefore was that "complexity" is good. It helps us to understand would-be adversaries. It sensitizes us to alternative viewpoints. And it confers protection against judgmental failings such as the fundamental attribution error, overconfidence, and belief perseverance.

Then it occurred to me that it is far too simple to say we should always be complex. Complexity can be costly—it requires considerable mental effort. Complexity can be confused for weakness (lots of Russians saw Gorbachev that way). Complexity can be a sign of confusion. In short, we need to be complex in thinking about complexity. One can be too open-minded.

PHILIP E. TETLOCK, *University of California, Berkeley*

You hear the false rumor that a friend is saying nasty things about you; you snub him; he then badmouths you, confirming your expectation. Similarly, if the policy-makers of East and West believe that war is likely and either attempts to increase its military security vis-à-vis the other, the other's response will justify the initial move.

Some observers of the Arab-Israeli conflict have concluded that negative **mirror-image perceptions** are a chief obstacle to peace. Both sides insist that ''we'' are motivated by our need to protect our security and our territory, while ''they'' want to obliterate us and gobble up our land (Heradstveit, 1979; R. K. White, 1977). Both sides have difficulty appreciating how their own actions sustain the other's fear and anger. Given such intense mistrust, negotiation is difficult.

Northern Ireland, too, suffers from mirror-image perceptions. At the University of Ulster, J. A. Hunter and his colleagues (1991) showed Catholic and Protestant students videos of a Protestant attack at a Catholic funeral and a Catholic attack at a Protestant funeral. Most students attributed the other side's attack to ''bloodthirsty'' motives but attributed its own side's attack to retaliation or self-defense. Muslims and Hindus in Bangladesh exhibit the same biased ingroup-favoring perceptions (Islam & Hewstone, 1991).

Destructive mirror-image perceptions also operate in conflicts between small groups and between individuals. As we saw in the dilemma games, both parties may say, ''We want to cooperate. But their refusal to cooperate forces us to react defensively.'' In a study of executives, Kenneth Thomas and Louis Pondy (1977) uncovered similar self-serving attributions. Asked to describe a significant recent conflict, 12 percent felt the other party was cooperative, though 74 percent perceived themselves as cooperative. The executives explained that they had ''suggested,'' ''informed,'' and ''recommended,'' while their antagonist had ''demanded,'' ''disagreed with everything I said,'' and ''refused.''

International conflicts are fueled and prolonged by an illusion that the enemy's top leaders are evil and coercive, while their people, though controlled and manipulated, are pro-us. This evil leader–good people perception characterized Americans' and Soviets' views of each other during the cold war. Likewise, the United States entered the Vietnam war believing that in areas dominated by the communist Vietcong ''terrorists,'' many of the people were our

Mirror-image perceptions: Reciprocal views of one another often held by parties in conflict; for example, each may view itself as moral and peace-loving and the other as evil and aggressive.

As alliances and conflicts wax and wane, yesterday's friends can become tomorrow's enemies. Manuel Noreiga, Ferdinand Marcos, and Saddam Hussein are cases in point.

allies-in-waiting. As suppressed information later revealed, these beliefs were mere wishful thinking. Ralph White (1969, p. 37) wondered: "Suppose our policy-makers had known that most of the emotionally involved [Vietnamese] people were against us, and had known it clearly, at the time they were making those fateful commitments and staking American prestige on the outcome. . . . Would we now have all the tragedy of the Vietnam War? . . . I doubt it."

Another type of mirror-image perception is each side's exaggeration of the other's position. People with opposing views on issues such as abortion and capital punishment often differ less than they suppose. Each side overestimates the extremity of the other side's views and presumes that *our* beliefs *follow* from the facts while *their* beliefs *dictate* their interpretation of facts (Robinson & others, 1991).

Shifting Perceptions

If misperceptions accompany conflict, then they should appear and disappear as conflicts wax and wane. And they do, with startling ease. The same processes that create the enemy's image can reverse that image when the enemy becomes an ally. Thus the "bloodthirsty, cruel, treacherous, buck-toothed little Japs" of World War II became, soon after—in American minds (Gallup, 1972) and in the American media—our "intelligent, hardworking, self-disciplined, resourceful allies." Our World War II allies, the Soviets, then became the "warlike, treacherous" ones.

The Germans, whom Americans after two world wars hated, then admired, and then again hated, were once again admired—apparently no longer plagued by what earlier was presumed to be cruelty in their national character. So long as Iraq was attacking Iran many nations supported it. Our enemy's enemy is our friend. When Iraq ended its war with Iran and invaded oil-rich Kuwait, Iraq's behavior, including its previous use of chemical weapons and massacring of its Kurdish people, suddenly became "barbaric." Clearly, our images of our enemies not only justify our actions but also adjust with amazing ease.

The extent of misperceptions during conflict provides a chilling reminder that people need not be insane or abnormally evil to form distorted, diabolical images of their antagonists. When in conflict with another nation, another group, or simply a roommate or parent, we readily develop misperceptions that allow us to perceive our own motives and actions as wholly good and the other's as totally evil. Our antagonists usually form a mirror-image perception of us. So the conflict continues until something enables us both to peel away our misperceptions and work at reconciling our actual differences.

■ PEACEMAKING

We have seen how conflicts are ignited: by social traps, perceived injustices, competition, and social misperceptions. The picture appears grim—but not hopeless. Sometimes hostilities evolve into friendships, conflicts into harmony. Social psychologists have focused on four strategies for helping enemies become comrades. We can remember these as the four C's of peacemaking: contact, cooperation, communication, conciliation.

"We know more about war than we do about peace—more about killing than we know about living."
General Omar Bradley, former U.S. Army Chief of Staff

CONTACT

Might putting two conflicting individuals or groups into close contact enable them better to know and like each other? We have previously noted some reasons it might. In Chapter 13, we saw that proximity—and the accompanying interaction, anticipation of interaction, and mere exposure—boosts liking. In Chapter 4, we noted that the recent downturn in blatant racial prejudice in the United States followed closely on the heels of desegregation, showing that "attitudes follow behavior." If this social-psychological principle now seems obvious, remember: That's how things usually seem—once you know them. To the U.S. Supreme Court in 1896 (*Plessy v. Ferguson*), the idea that desegregated behavior might influence racial attitudes was anything but obvious. What seemed obvious at the time was, "Legislation is powerless to eradicate racial instincts."

During the last 30 years in the United States, segregation and prejudice have diminished together. But was interracial contact the *cause* of these improved attitudes? Were those who actually experienced desegregation affected by it?

Does Desegregation Improve Racial Attitudes?

School desegregation has produced measurable benefits, such as small improvements in Black reading achievement (at no costs in White achievement), leading more Blacks to attend and succeed in college (Stephan, 1988). Does desegregation of neighborhoods, workplaces, and schools also produce favorable social results? The evidence is mixed.

On the one hand, many studies conducted during and shortly after the desegregation following World War II found Whites' attitudes toward Blacks improving markedly. Whether the people were department store clerks and customers, merchant marines, government workers, police officers, neighbors, or students, racial contact led to diminished prejudice (Amir, 1969; T. F. Pettigrew, 1969). For example, near the end of World War II, the Army partially desegregated some of its rifle companies (Stouffer & others, 1949). When asked their opinions of such desegregation, 11 percent of the White soldiers in segregated companies and 60 percent of those in desegregated companies approved.

When Morton Deutsch and Mary Collins (1951) took advantage of a made-to-order natural experiment, they observed similar results. In accord with state law, New York City desegregated its public housing units; it assigned families to apartments without regard to race. In a similar development in Newark, Blacks and Whites were assigned to separate buildings. When surveyed, White women in the desegregated development were far more likely to favor interracial housing and to say their attitudes toward Blacks had improved. Exaggerated stereotypes had wilted in the face of reality. As one woman, put it, "I've really come to like it. I see they're just as human as we are."

These encouraging findings influenced the Supreme Court's 1954 decision to desegregate U.S. schools and helped fuel the civil rights movement of the 1960s (Pettigrew, 1986). Yet studies of the effects of school desegregation have been less encouraging. Social psychologist Walter Stephan (1986) reviewed all such studies and concluded that racial attitudes have been little affected by desegregation. Sometimes desegregation has led to increased prejudice (especially by Whites toward Blacks) and sometimes to decreased prejudice (especially by Blacks toward Whites). But on balance the effects are minimal for both

Under what conditions does desegregation of workforces, schools, and neighborhoods serve to reduce prejudice and increase interracial friendships?

Black and White students. For Blacks the more noticeable consequence of desegregated schooling is a long-term one—an increased likelihood of enrolling in integrated (or predominantly White) colleges, of living in integrated neighborhoods, and of working in integrated settings.

Many student exchange programs have likewise had less-than-hoped-for positive effects on student attitudes toward their host countries. For example, when eager American students study in France, often living with other Americans as they do so, their stereotypes of the French tend not to improve (Stroebe & others, 1988).

Some readers may be bewildered by such conflicting evidence: Sometimes desegregation improves racial attitudes; sometimes it doesn't. Such disagreements excite the scientist's detective spirit. When one set of research findings points to one conclusion and another to a differing one, an important factor is probably at work. So far, we've been lumping all desegregation together. Actual desegregation occurs in many ways and under vastly different conditions.

When Does Desegregation Improve Racial Attitudes?

To discern the crucial differences between our two sets of studies, we could compare them in detail. But there is a simpler method. Drawing upon theories developed from laboratory research, we can speculate what factors might make a difference and then see whether these factors are indeed present in one set of studies but not the other.

Let us go back to where we began: Is the amount of interracial *contact* a factor? Indeed it seems to be. Researchers have gone into dozens of desegregated schools and observed with whom children of a given race eat, loiter, and talk. Though less decisive than sex, race is nevertheless a potent factor. Whites disproportionately associate with Whites, Blacks with Blacks (Schofield, 1982, 1986). Academic tracking programs often amplify resegregation by separating

academically advantaged White students into predominantly White classes. Researchers Andrew Sagar and Janet Ward Schofield (1980) conclude that "simply throwing alienated groups together in the same school offers little hope of . . . dispelling the misunderstandings, biases, and fears which continue to divide the American people."

In contrast, the more encouraging older studies of store clerks, soldiers, and housing project neighbors involved considerable interracial contact. Other studies involving prolonged, personal contact—between Black and White prison inmates and between Black and White girls in an interracial summer camp—show similar benefits (Clore & others, 1978; Foley, 1976).

The social psychologists who advocated desegregation never claimed that contact of *any* sort would improve attitudes. They expected less-than-favorable results when contacts were competitive, unsupported by authorities, and unequal (Pettigrew, 1988; Stephan, 1987). Before 1954, many prejudiced Whites had ample contact with Blacks—with the latter in subordinate roles as shoeshine boys and domestic workers. As we saw in Chapter 11, contacts on such an unequal basis breed attitudes that merely justify the continuation of such relations. So it's important that people in contact have **equal status.** The contacts between the store clerks, the soldiers, the neighbors, the prisoners, the summer campers were of this kind.

This kind of contact has been lacking in desegregated schools: Researchers report that White students are often more active, more influential, more successful (Cohen, 1980a; Riordan & Ruggiero, 1980). When a seventh-grade Black girl from an academically inferior school is dropped suddenly into a predominantly White middle-class junior high school with White middle-class teachers who expect less of her, she will likely be perceived by her classmates and herself as having lower academic status.

Equal-status contact:
Contact made on an equal basis. Just as a relationship between people of unequal status breeds attitudes consistent with their relationship, so do relationships between those of equal status. Thus, to reduce prejudice, interracial contact should be between persons equal in status.

COOPERATION

Although equal-status contact can help, it is sometimes not enough. It didn't help when Sherif stopped the Eagles versus Rattlers competition and brought the groups together for noncompetitive activities, such as watching movies, shooting off fireworks, and eating. By this time, their hostility was so strong that mere contact provided the opportunity for taunts and attacks. When an Eagle was bumped by a Rattler, his fellow Eagles urged him to "brush off the dirt." Obviously, desegregating the two groups had hardly promoted their social integration.

Given such entrenched hostilities, peacemaking may seem hopeless. What can a peacemaker do? Think back to the successful and unsuccessful desegregation efforts. The Army's racial mixing of rifle companies not only brought Blacks and Whites into equal-status contact but also made them interdependent. Together, they were fighting against a common enemy, striving toward a shared goal.

Contrast this interdependence with the competitive situation in the typical classroom, desegregated or not. Students compete for good grades, teacher approval, and various honors and privileges. Is the following scene familiar (Aronson, 1988)? The teacher asks a question. Several students' hands shoot up; other students sit, eyes downcast, trying to look invisible. When the teacher calls on one of the eager faces, the others hope for a wrong answer, giving them

a chance to display their knowledge. Those who fail to answer correctly and those with the downcast looks who already feel like losers in this academic sport, often resent those who succeed and may disparage them as "nerds" or "geeks." The situation abounds with both competition and painfully obvious status inequalities; we could hardly design it better to create divisions among the children.

Does this suggest a second factor that predicts whether the effect of desegregation will be favorable? Does competitive contact divide and *cooperative* contact unite? Consider what happens to people who together face a common predicament or work together toward a shared goal.

Common External Threats

Together with others, have you ever been victimized by the weather; harassed as part of your initiation into a group; punished by a teacher; or persecuted and ridiculed because of your social, racial, or religious identity? If so, you may recall feeling close to those who shared the predicament with you. Perhaps previous social barriers were dropped as you helped one another dig out of the snow or struggled to cope with your common enemy.

Such friendliness is common among those who experience a shared threat. John Lanzetta (1955) observed this when he put four-man groups of Naval ROTC cadets to work on problem-solving tasks and then began informing them over a loudspeaker that their answers were wrong, their productivity inexcusably low, their thinking stupid. Other groups did not receive this harassment. Lanzetta observed that the group members under duress became friendlier to one another, more cooperative, less argumentative, less competitive. They were in it together. And the result was a cohesive spirit.

The unifying effect of having a common enemy was also evident within the groups of competing boys in Sherif's camping experiments and in many subsequent experiments (Dion, 1979). Conflicts with Germany and Japan during World War II, with the Soviet Union during the cold war, with Iran during 1980, and with Iraq during 1991 aroused Americans' feelings of patriotism and heightened their sense of unity. Soldiers who together face combat often maintain lifelong ties with their comrades (Elder & Clipp, 1988). Few things so unite a people as having a common hatred.

Times of interracial strife may therefore be times of heightened group pride. For Chinese university students in Toronto, facing discrimination heightens a sense of kinship with other Chinese (Pak & others, 1991). Just being reminded of an outgroup (say, a rival school) heightens people's responsiveness to their own group (Wilder & Shapiro, 1984). When keenly conscious of who "they" are, we also know who "we" are.

Leaders may even *create* a threatening external enemy as a technique for building group cohesiveness. George Orwell's novel *Nineteen Eighty-Four* illustrates the tactic: The leader of the protagonist nation uses border conflicts with the other two major powers to lessen internal strife. From time to time the enemy shifts, but there is always an enemy. Indeed, the nation seems to *need* an enemy. For the world, for a nation, for a group, having a common enemy is powerfully unifying. Soviet Foreign Ministry spokesperson Gennady Gerasimov (1988) recognized this during the Reagan-Gorbachev Moscow summit. "We are going to do something awful to you," he explained to a U.S. television audience. "We are going to deprive you of an enemy."

"I couldn't help but say to [Mr. Gorbachev], just think how easy his task and mine might be in these meetings that we held if suddenly there was a threat to this world from some other species from another planet. [We'd] find out once and for all that we really are all human beings here on this earth together."
Ronald Reagan, December 4, 1985, speech

Finding solidarity in shared hatreds. Having a common enemy (as did these Cold War anti-Communist marchers during the 1950s) unites a group.

Superordinate Goals

Superordinate goal:
A shared goal that necessitates cooperative effort; a goal that overrides people's differences from one another.

Closely related to the unifying power of an external threat is the unifying power of **superordinate goals**, goals compelling for all in a group and requiring cooperative effort. To promote harmony among his warring campers, Sherif introduced such goals. He created a problem with the camp water supply, necessitating their cooperation to restore the water. Given an opportunity to rent a movie, one expensive enough to require the joint resources of both groups, they again cooperated. When a truck "broke down" on a camping trip, a staff member casually left the tug-of-war rope nearby, prompting one boy to suggest that they all pull the truck to get it started. When it started, a backslapping celebration ensued over their victorious "tug-of-war against the truck."

After working together to achieve such superordinate goals, the boys began eating together and enjoyed themselves around a campfire. Friendships sprouted across group lines. Hostilities plummeted (Figure 15-5). On the last day, the boys decided to travel home together on one bus. During the trip they no longer sat by groups. As the bus approached Oklahoma City and home, they, as one, spontaneously sang "Oklahoma" and then bade their friends farewell. With isolation and competition, Sherif made strangers into bitter enemies. With superordinate goals, he made enemies into friends.

Are Sherif's experiments mere child's play? Or can pulling together to achieve superordinate goals be similarly beneficial with adults in conflict? Robert Blake and Jane Mouton (1979) wondered. So in a series of two-week experiments involving more than 1000 executives in 150 different groups, they recreated the essential features of the situation experienced by the Rattlers and Eagles. Each group first engaged in activities by itself, then competed with another group, and then cooperated with the other group in working toward

jointly chosen superordinate goals. Their results were indeed similar to Sherif's, providing, in the words of the researchers, "Unequivocal evidence that adult reactions parallel those of Sherif's younger subjects."

Extending these findings, Samuel Gaertner, John Dovidio, and their collaborators (1989, 1990, 1991) report that working cooperatively has especially favorable effects under conditions that lead people to define a new, inclusive group that dissolves their former subgroups. If, for example, the members of two groups sit alternately around a table (rather than on opposite sides), give their new group a single name, and then work together, their old feelings of bias against the former outsiders will diminish. "Us" and "them" become "we." During World War II, the United States and the U.S.S.R., along with other nations, formed one united group named the Allies to combat the Axis powers, Germany, Italy, and Japan. So long as the superordinate goal of defeating a common enemy lasted, so did supportive U.S. attitudes toward the Soviets.

Recall that the cooperative efforts by Rattlers and Eagles ended in success. Would the same harmony have emerged if the water had remained off, the movie unaffordable, the truck still stalled? Likely not. In experiments with University of Virginia students, Stephen Worchel and his associates (1977, 1978, 1980) confirmed that *successful* cooperation between two groups boosts their attraction for one another. However, if previously conflicting groups *fail* in a cooperative effort *and* if conditions allow them to attribute their failure to each other, the conflict may worsen. Sherif's groups were already feeling hostile to one another. Thus, failure to raise sufficient funds for the movie might have been attributed to the one group's "stinginess" and "selfishness." This would have exacerbated rather than alleviated their conflict.

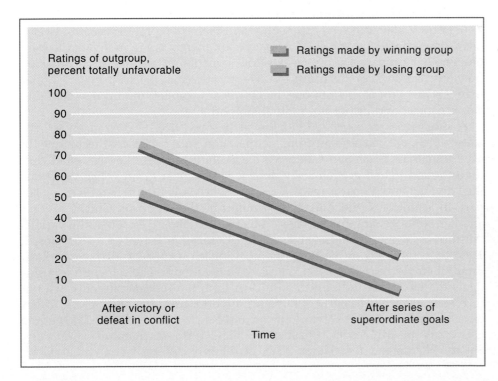

FIGURE 15-5 *After competition, the Eagles and Rattlers rated each other unfavorably. After they worked cooperatively to achieve superordinate goals, hostility dropped sharply.* (Data from Sherif, 1966, p. 84)

Cooperative Learning

So far we have noted the apparently meager social benefits of typical school desegregation and the apparently dramatic social benefits of successful, cooperative contacts between members of rival groups. Could putting these two findings together suggest a constructive alternative to traditional desegregation practices? Several independent research teams speculated yes. Each wondered whether, without restraining academic achievement, we could promote interracial friendships by replacing competitive learning situations with cooperative ones. Given the diversity of their methods, the consistently positive results are striking and very heartening.

Are students who participate in existing cooperative activities, such as interracial athletic teams and class projects, less prejudiced? Robert Slavin and Nancy Madden (1979) analyzed survey data from 2400 students in 71 American high schools and found encouraging results. Those of different races who play and work together are more likely to report having friends of another race and to express positive racial attitudes. Charles Green and his colleagues (1988) confirmed this in a study of 3200 Florida middle school students. Compared to students at traditional, competitive schools, those at schools that emphasized interracial learning "teams" had more positive racial attitudes.

From this correlational finding, can we conclude that cooperative interracial activity improves racial attitudes? One way to find out is to experiment. Randomly designate some students, but not others, to work together in racially mixed groups. Slavin (1985) and his colleagues developed a way to divide classes into interracial teams, each composed of four or five students from all achievement levels. The team members sit together, study a variety of subjects together, and at the end of each week compete with the other teams in a class tournament. All members contribute to the team score by doing well, sometimes by competing with other students whose recent achievements are similar to their own, sometimes by competing with their own previous scores. Everyone has a chance to succeed. Moreover, team members are motivated to help one another prepare for the weekly tournament—by drilling each other on fractions, spelling, or historical events—whatever is the next event. Rather than isolating students from one another, team competition brings them into closer contact and draws out mutual support.

Another research team, led by Elliot Aronson (1978, 1979; Aronson & Gonzalez, 1988), elicited similar group cooperation with a "jigsaw" technique. In experiments in Texas and California elementary schools, they assigned children to racially and academically diverse six-member groups. The topic was then divided into six parts, with each student becoming the expert on his or her part. In a unit on Chile, one student might be the expert on Chile's history, another on its geography, another on its culture, and so on. First, the various "historians," "geographers," and so forth got together to master their material. Then each returned to the home group to teach it to their classmates. Each group member held, so to speak, a piece of the jigsaw. The self-confident students therefore had to listen to and learn from the reticent students, who in turn soon realized they had something important to offer their peers. Other research teams—led by David Johnson and Roger Johnson (1987, 1989) at the University of Minnesota, Elizabeth Cohen (1980) at Stanford University, Shlomo Sharan and Yael Sharan (1976) at Tel Aviv University, and Stuart Cook

(1985) at the University of Colorado—have devised additional methods for cooperative learning.

From all this research, what can we conclude? With cooperative learning, students learn not only the material but other lessons as well. The investigators speak for themselves: Slavin (1980) said cooperative learning is an "effective means of increasing positive race relations and achievement in desegregated schools." Aronson reported that "children in the interdependent, jigsaw classrooms grow to like each other better, develop a greater liking for school, and develop greater self-esteem than children in traditional classrooms" (1980, p. 232).

Researchers also note that cross-racial friendships begin to blossom, that the exam scores of minority students improve (perhaps because academic achievement is now peer-supported), and that many teachers continue using cooperative learning after the experiments are over (D. W. Johnson & others, 1981; Slavin, 1990). "It is clear," wrote race-relations expert John McConahay (1981), that cooperative learning "is the most effective practice for improving race relations in desegregated schools that we know of to date." So encouraging were the results that more than 25,000 teachers were soon using interracial cooperative learning in their classrooms (Kohn, 1987).

Should we have "known it all along"? At the time of the 1954 Supreme Court decision, Gordon Allport spoke for many social psychologists in predicting, "Prejudice . . . may be reduced by equal status contact between majority and minority groups in the pursuit of common goals" (1954, p. 281). Unfortunately, school desegregation seldom met these conditions. Cooperative learning experiments have confirmed Allport's insight. Robert Slavin (1985) is therefore optimistic: "Thirty years after Allport laid out the basic principles operationalized in cooperative learning methods, we finally have practical, proven methods for implementing contract theory in the desegregated classroom."

So, because cooperative, equal-status contacts exert a positive influence on boy campers, industrial executives, college students, and schoolchildren, can we assume that the principle extends to all levels of human relations? Are families unified by pulling together to farm the land, restore an old house, or sail a sloop? Are communal identities forged by barn raisings, group singing, or cheering on the football team? Is international understanding bred by international collaboration in science and space, by joint efforts to feed the world and conserve resources, by friendly personal contacts between people of different nations? Indications are that the answer to all these questions is yes (Brewer & Miller, 1988; Desforges & others, 1991; Deutsch, 1985). Thus an important challenge facing our divided world is to identify and agree on our superordinate goals and to structure cooperative efforts to achieve them.

COMMUNICATION

Conflicting parties have other ways to resolve their differences. When husband and wife, or labor and management, or nation X and nation Y disagree, they can **bargain** with one another directly. They can ask a third party to **mediate** by making suggestions and facilitating their negotiations. Or they can **arbitrate** by submitting their disagreement to someone who will study the issues and impose a settlement.

"The greenhouse effect, the depletion of the ozone layer and the global ecological crisis [is] the most serious issue facing this country and the world. . . . We know how to solve the problem. It will be unimaginably difficult. The cooperation required will be unprecedented. But we know what to do." U.S. Senator Albert Gore (1989)

Bargaining: Seeking an agreement through direct negotiation between parties to a conflict.

Bargaining

When conflicts are neither intense nor at an impasse, people usually prefer to bargain on their own (Rubin, 1980). If you or I want to buy or sell a new car, are we better off adopting a tough bargaining stance—opening with an extreme offer so that splitting the difference will yield a favorable result? Or are we better off beginning with a sincere "good-faith" offer?

Experiments suggest no simple answer. On the one hand, those who demand more will often get more (Deutsch, 1980). Robert Cialdini, Leonard Bickman, and John Cacioppo (1979) provide a typical result: In a control condition, they approached various Chevrolet dealers and asked the price of a new Monte Carlo sports coupe with designated options. In an experimental condition, they approached other dealers and first struck a tougher bargaining stance, asking for and rejecting a price on a *different* car ("I need a lower price than that. . . . That's a lot"). When they then asked the price of the Monte Carlo, exactly as in the control condition, they received offers that averaged some $200 lower.

Tough bargaining may lower the other party's expectations, making the other side willing to settle for less (Yukl, 1974). But toughness can sometimes backfire. Many a conflict is not over a pie of fixed size but over a pie that shrinks if the conflict continues. When a strike is prolonged, both labor and management lose. Being tough can also diminish the chances of actually reaching an agreement. If the other party responds with an equally extreme stance, both may be locked into positions from which neither can back down without losing face. In the weeks before the Persian Gulf war, President Bush threatened, in the full glare of publicity, to "kick Saddam's ass." Saddam Hussein communicated in kind, threatening to make "infidel" Americans "swim in their own blood." After such belligerent statements, it was difficult for each side to evade war and save face.

Mediation

Mediation:
An attempt by a neutral third party to resolve a conflict by facilitating communication and offering suggestions.

A third-party mediator may offer suggestions that enable conflicting parties to make concessions and still save face (Pruitt, 1981). If my concession can be attributed to a mediator, who is gaining an equal concession from my antagonist, then neither of us will be viewed as caving in to the other's demands.

Turning Win-Lose into Win-Win

Mediators also help resolve conflicts by facilitating constructive communication. Their first task is to help the parties rethink the conflict and to gain information about the other party's interests (Thompson, 1991). By prodding them to set aside their conflicting demands and opening offers and to think instead about underlying needs, interests, and goals, the mediator aims to replace a competitive "win-lose" orientation with a cooperative "win-win" orientation that aims at a mutually beneficial resolution. In experiments, Leigh Thompson (1990) found that, with experience, negotiators become better able to make mutually beneficial tradeoffs and thus to achieve win-win resolutions.

A classic story of such a resolution concerns the two sisters who quarreled over an orange (Follett, 1940). Finally they compromise and split the orange in half, whereupon one sister squeezed her half for juice while the other used the peel to make a cake. In experiments at the State University of New York at Buffalo, Dean Pruitt and his associates induced bargainers to search for **inte-**

grative agreements. If the sisters had agreed to split the orange, giving one sister all the juice and the other all the peel, they would have hit on such an agreement, one that integrates both parties' interests (Kimmel & others, 1980; Pruitt & Lewis, 1975, 1977). Compared to compromises, in which each party sacrifices something important, integrative agreements are more enduring. Because they are mutually rewarding, they also lead to better ongoing relationships (Pruitt, 1986).

Integrative agreements:
Win-win agreements that reconcile both parties' interests to their mutual benefit.

Unraveling Misperceptions with Controlled Communications

Communication often helps by reducing self-fulfilling misperceptions. Perhaps you can recall experiences similar to that of the following college student:

> Often, after a prolonged period of little communication, I perceive Martha's silence as a sign of her dislike for me. She, in turn, thinks that my quietness is a result of my being mad at her. My silence induces her silence, which makes me even more silent . . . until this snowballing effect is broken by some occurrence that makes it necessary for us to interact. And the communication then unravels all the misinterpretations we had made about one another.

The outcome of such conflicts often depends on *how* people communicate their feelings to one another. Roger Knudson and his colleagues (1980) invited married couples to come to the University of Illinois psychology laboratory and relive, through role playing, one of their past conflicts. Before, during, and after their conversation (which often generated as much emotion as their actual previous conflict), the couples were closely observed and questioned. Couples who evaded the issue—by failing to make their positions clear or failing to acknowledge their spouse's position—left with the illusion that they were more in harmony and agreement than they really were. Often, they came to believe they now agreed more when actually they agreed less. In contrast, those who engaged the issue—by making their positions clear and by taking one another's views into account—achieved more actual agreement and gained more accurate information about one another's perceptions. That helps explain why happily married couples communicate their concerns directly and openly (Grush & Glidden, 1987).

Conflict researchers believe that a key factor is *trust*. If you believe the other person is well-intentioned, not out to exploit you, you are then more likely to divulge your needs and concerns. Lacking such trust, you probably will be cautious, fearing that being open will give the other party information that might be used against you.

When the two parties mistrust each other and communicate unproductively, a third-party mediator—a marriage counselor, a labor mediator, a diplomat—sometimes helps. After coaxing the conflicting parties to rethink their perceived win-lose conflict, the mediator often has each party identify and rank its goals. When there is little actual incompatibility of goals, the ranking procedure makes it easier for each to concede on less important goals so that both achieve their chief goals (Erickson & others, 1974; Schulz & Pruitt, 1978). For example, once labor and management both believe that management's goal of higher productivity and profit is compatible with labor's goal of better wages and working conditions, they can begin to work for an integrative win-win solution.

When the parties then convene to communicate directly, they are usually *not* set loose in the hope that, eyeball to eyeball, the conflict will resolve itself. In

■ FOCUS: How to Fight Constructively

With every close relationship comes conflict. If managed constructively, conflict provides opportunities for reconciliation and a more genuine harmony. University of Western Ontario psychologists Ian Gotlib and Catherine Colby (1988) offer advice on how to avoid destructive quarrels and to have good quarrels.

DO NOT

1. Apologize prematurely.
2. Evade the argument, give the silent treatment, or walk out on it.
3. Use your intimate knowledge of the other person to hit below the belt and humiliate.
4. Bring in unrelated issues.
5. Feign agreement while harboring resentment.
6. Tell the other party how they are feeling.
7. Attack indirectly by criticizing someone or something the other person values.
8. Undermine the other by intensifying their insecurity or threatening disaster.

DO

1. Fight privately, away from children.
2. Clearly define the issue and repeat the other's arguments in your own words.
3. Divulge your positive and negative feelings.
4. Welcome feedback about your behavior.
5. Clarify where you agree and disagree and what matters most to each of you.
6. Ask questions that help the other find words to express the concern.
7. Wait for spontaneous explosions to subside, without retaliating.
8. Offer positive suggestions for mutual improvement.

the midst of a threatening, stressful conflict, emotions often disrupt the ability to understand the other party's point of view. Communication may become most difficult just when it is most needed (Tetlock, 1985). The mediator will therefore often structure the encounter to help each party understand and feel understood by the other. The mediator may ask the conflicting parties to restrict their arguments to statements of fact, including statements of how they feel and how they respond when the other acts in a given way: "I enjoy having music on. But when it's loud, I find it difficult to concentrate. That makes me crabby." Also, the mediator may ask people to reverse roles and argue the other's position, or to restate one another's positions before replying with their own: "My turning up the stereo bugs you." Such communication floods people with information that overwhelms their accumulated misperceptions. This differs from everyday life, where we receive contradictory information bit by bit, making it easier to rationalize or dismiss each contradictory bit (Jervis, 1973).

Neutral third parties may also suggest mutually agreeable proposals that would be dismissed—"reactively devalued"—if offered by either side. Constance Stillinger and her colleagues (1991) found that a nuclear disarmament proposal which Americans dismissed when attributed to the Soviet Union seemed more acceptable when attributed to a neutral third party. Likewise, people will often reactively devalue a concession offered by an adversary ("they must not value it"); the same concession may seem less like a token gesture when suggested by a third party.

These peacemaking principles, based partly on laboratory experiments, partly on practical experience, have helped mediate both international and industrial conflicts (Blake & Mouton, 1962, 1979; Burton, 1969; Wehr, 1979).

One small team of Arab and Jewish Americans, led by social psychologists Herbert Kelman and Stephen Cohen (1986), have conducted workshops bringing together influential Arabs and Israelis, and Pakistanis and Indians. Using methods such as those we've considered, Kelman and Cohen counter misperceptions and have participants creatively seek solutions for their common good. Isolated, the participants are free to speak directly to their adversaries without fearing their constituents' second-guessing what they are saying. The result? Those from both sides typically come to understand the other's perspective and how the other side responds to their own group's actions.

When direct communication is impossible, a third party can meet with one party, then the other. Henry Kissinger's "shuttle diplomacy" in the two years after the Arab-Israeli war of 1973 produced three disengagement agreements between Israel and its Arab neighbors. Kissinger's strategy gave him control over the communications and enabled both sides to concede to him without appearing to capitulate to one another (Pruitt, 1981).

The complex process of international negotiation sometimes receives an added boost from smaller mediating efforts. In 1976, Kelman drove an Egyptian social scientist, Boutros Ghali (who in 1992 became the UN Secretary General), to the Boston airport. En route, they formulated plans for an Egyptian conference on misperceptions in Arab-Israeli relations. The conference later took place, and Kelman conveyed its promising results to influential Israelis. A year later, Ghali became Egypt's acting foreign minister, and Egyptian President Anwar Sadat made his historic trip to Israel, opening a road to peace. Afterward, Ghali said happily to Kelman, "You see the process that we started at the Boston airport last year" (Armstrong, 1981).

A year later, mediator Jimmy Carter secluded Sadat and Israeli Prime Minister Menachem Begin at Camp David. Rather than begin by having each side

Skillful mediation sometimes penetrates walls of misperception and mistrust. President Carter facilitated peace between Egypt and Israel by enabling each side to attain its chief goals.

state their demands, Carter had them identify their underlying interests and goals—security for Israel, authority over its historic territory for Egypt. Thirteen days later, the trio emerged with "A Framework for Peace in the Middle East," granting each what they desired (Rubin, 1989). Six months later, after further mediation by President Carter during visits to both countries, Begin and Sadat signed a treaty ending a state of war that had existed since 1948.

Arbitration

Arbitration:
Resolution of a conflict by a neutral third party who studies both sides and imposes a settlement.

Some conflicts are so intractable, the underlying interests so divergent, that a mutually satisfactory resolution is unattainable. Israelis and Palestinians cannot both have jurisdiction over the same homelands. In a divorce dispute over custody of a child, both parents cannot enjoy full custody. In these and many other cases (involving disputes over tenants' repair bills, athletes' wages, and national territories), a third-party mediator may—or may not—help resolve the conflict.

"In the research on the effects of mediation one finding stands out: The worse the state of the parties' relationship is with one another, the dimmer the prospects that mediation will be successful."
Kenneth Kressel & Dean Pruitt (1985)

If not, the parties may turn to *arbitration* by having the mediator or another third party *impose* a settlement. Disputants usually prefer to settle their differences without arbitration, so they retain control over the outcome. Neil McGillicuddy and others (1987) observed this preference in an experiment involving disputants coming to the Dispute Settlement Center in Buffalo, New York. When people knew they would face an arbitrated settlement if mediation failed, they tried harder to resolve the problem, exhibited less hostility, and thus were more likely to reach agreement.

However, in cases where differences seem large and irreconcilable, the prospect of arbitration may have an opposite effect (Pruitt, 1986). The disputants may freeze their positions, hoping to gain an advantage when the arbitrator chooses a compromise. To combat this tendency, some disputes, such as those involving salaries of major league baseball players, are settled with "final-offer arbitration" in which the third party chooses one of the two final offers. Final-offer arbitration motivates each party to make a reasonable proposal.

Typically, however, the final offer is not so reasonable as it would be if each party, free of self-serving bias, saw its own proposal through others' eyes. Negotiation researchers report that most disputants are made stubborn by overconfidence. Successful mediation is hindered when, as often happens, both parties believe they had a two-thirds chance of winning a final-offer arbitration (Bazerman, 1986).

CONCILIATION

Sometimes tension and suspicion run so high that communication, much less resolution, becomes all but impossible. Each party may threaten, coerce, or retaliate against the other. Unfortunately, such acts tend to be reciprocated, thus escalating the conflict. So, would an opposite strategy—appeasing the other party by being unconditionally cooperative—produce a satisfying result? Often not. In laboratory games, those who are 100 percent cooperative often get exploited. Politically, a one-sided pacifism is out of the question anyway.

GRIT

Is there a third alternative—one that is conciliatory, rather than retaliatory, yet strong enough to discourage exploitation? Charles Osgood (1962, 1980), a Uni-

"Don't worry, dear—it's just a *peace* offensive."

People perceive that they re-spond more favorably to concil-iation, but that others might be responsive to coercion.

versity of Illinois social psychologist, has long advocated one such alternative. Osgood calls it "graduated and reciprocated initiatives in tension reduction," nicknamed **GRIT**, a label that suggests the determination it requires. GRIT aims to reverse the conflict spiral by triggering reciprocal deescalation. To do so, it draws upon social-psychological concepts, such as the norm of reciprocity and research on attribution of motives.

GRIT requires one side to initiate a few small deescalatory actions, under-taken in ways that encourage reciprocation. The first steps in the strategy are to *announce a conciliatory intent.* The initiator states its desire to reduce tension, declares each conciliatory act prior to making it, and invites the adversary to reciprocate. Such announcements create a framework that helps the adversary interpret correctly what otherwise might be seen as weak or tricky actions. They also elicit public pressure on the adversary to follow the reciprocity norm.

Next, the initiator establishes credibility and genuineness by carrying out, exactly as announced, several verifiable *conciliatory acts.* This intensifies the pressure to reciprocate. Making conciliatory acts diverse—perhaps offering medical information, closing a military base, and lifting a trade ban—keeps the initiator from making a significant sacrifice in any one area and leaves the adversary freer to choose its own means of reciprocation. If the adversary reciprocates voluntarily, its own conciliatory behavior may soften its attitudes.

GRIT *is* conciliatory. But it is not "surrender on the installment plan." The remaining aspects of the plan protect each side's self-interest by *maintaining retaliatory capability.* The initial conciliatory steps entail some small risk but do not jeopardize either one's security; rather, they are calculated to begin edging both sides down the tension ladder. If one side takes an aggressive action, the

GRIT:
Acronym for "graduated and reciprocated initiatives in tension reduction"—a strategy designed to deesca-late international tensions.

other side reciprocates in kind, making it clear it will not tolerate exploitation. Yet, the reciprocal act is not an overresponse that would likely reescalate the conflict. If the adversary offers its own conciliatory acts, these, too, are matched or even slightly exceeded. Conflict expert Morton Deutsch (1991) captures the spirit of GRIT in advising negotiators to be "firm, fair, and friendly: *firm* in resisting intimidation, exploitation, and dirty tricks; *fair* in holding to one's moral principles and not reciprocating the other's immoral behavior despite provocation; and *friendly* in the sense that one is willing to initiate and reciprocate cooperation."

Does GRIT really work? In laboratory dilemma games the most successful strategy has proved to be simple "tit-for-tat," which begins with a cooperative opening play and thereafter matches the other party's last response (Axelrod & Dion, 1988; Smith, 1987). Tit-for-tat tries to cooperate and is forgiving, yet does not tolerate exploitation. In a lengthy series of experiments at Ohio University, Svenn Lindskold and his associates (1976 to 1988) have tested other aspects of the GRIT strategy. Lindskold (1978) reports that his own and others' studies provide "strong support for the various steps in the GRIT proposal." In laboratory games, announcing cooperative intent does boost cooperation. Repeated conciliatory acts do breed greater trust (although self-serving biases often make one's own acts seem more conciliatory and less hostile than those of the adversary). Maintaining an equality of power does protect against exploitation.

Lindskold is not contending that the world of the laboratory experiment mirrors the more complex world of everyday life. Rather, as we noted in Chapter 1, experiments enable us to formulate and verify powerful theoretical principles, such as the reciprocity norm and the self-serving bias. Notes Lindskold (1981): "It is the theories, not the individual experiments that are used to interpret the world."

Applications in the Real World

GRIT-like strategies have occasionally been tried outside the laboratory, with promising results. During the Berlin crisis of the early 1960s, U.S. and Soviet tanks faced one another barrel to barrel. The crisis was defused when the Americans pulled back their tanks step by step. At each step, the Soviets reciprocated. More recently, small concessions by Israel and Egypt (for example, Israel allowing Egypt to open up the Suez Canal, Egypt allowing ships bound for Israel to pass through) helped reduce tension to a point where the negotiations became possible (Rubin, 1981).

To many, the most significant attempt at GRIT was the so-called Kennedy experiment (Etzioni, 1967). On June 10, 1963, President Kennedy gave a major speech, "A Strategy for Peace." In it he noted, "Our problems are man-made . . . and can be solved by man," and then announced his first conciliatory act: The United States was stopping all atmospheric nuclear tests and would not resume them unless another country did. In the Soviet Union, Kennedy's speech was published in full. Five days later Premier Khrushchev reciprocated, announcing he had halted production of strategic bombers. There soon followed further reciprocal gestures: The United States agreed to sell wheat to Russia, the Soviets agreed to a "hot line" between the two countries, and the two countries soon achieved a test-ban treaty. For a time, these conciliatory initiatives warmed relations between the two countries.

As they warmed again, within all our memories, President Bush in 1991

Parties in conflict can ease back down the conflict ladder as they venture small, reciprocal conciliatory gestures, like this public dismantling of U.S. cruise missiles.

ordered the elimination of all land-based U.S. tactical nuclear warheads and took strategic bombers off high alert, putting their bombs in storage. Although leaving intact his least vulnerable and most extensive nuclear arsenal—submarine-based missiles—he invited Mikhail Gorbachev to reciprocate his conciliatory gesture. Eight days later Gorbachev did, taking his bombers off alert, storing their bombs, and announcing the removal of nuclear weapons from short-range rockets, ships, and submarines.

The Enduring Commitment to Coercion

Despite these occasional conciliatory successes, belief in the power of coercion remains strong. The belief led Nazi Germany in 1940 to think that bombing British cities would move the British toward surrender. It led the Allies later to believe that bombing raids over Germany would diminish the Germans' "will to resist." It led the Japanese in 1941 to assume that a devastating attack on Pearl Harbor might dissuade the United States from waging war in the western Pacific. It led the United States in 1965 to assume that sustained bombing of North Vietnam would decrease its "will to wage war" and bring the North

Vietnamese to the negotiating table. In each case, the attempted coercion instead strengthened the resolve to resist.

Myron Rothbart and William Hallmark (1988) experimentally explored this belief in the power of coercion. After assuming the role of defense minister of a hypothetical nation, subjects perceived that *they* would be more responsive to a conciliatory than to a coercive gesture from another country but that the *other* country would be relatively more responsive to coercion. So, how can we foresee the likely effect of our behavior on another party? Rothbart and Hallmark suggest asking ourselves how we would react if that action were directed against us: "If they treated me the way I'm going to treat them, how would I feel?"

Might conciliatory efforts also help reduce tension between individuals? There is every reason to expect so. When a relationship is strained and communication nonexistent, it sometimes takes only a conciliatory gesture—a soft answer, a warm smile, a gentle touch—for both parties to begin easing down the tension ladder, to a rung where communication and conflict resolution become possible.

■ SUMMING UP

CONFLICT

Whenever two people, two groups, or two nations interact, their perceived needs and goals may conflict. In this chapter, we identified some common ingredients of conflicts, and we considered ways to resolve conflict constructively and peacefully.

Social Dilemmas

Many social problems arise as people pursue their individual self-interests, to their collective detriment. Two laboratory games, the Prisoner's Dilemma and the Commons Dilemma, capture this clash of individual versus communal well-being. In each, the participants choose whether to pursue their immediate interests or to cooperate for their common betterment. Ironically and tragically, each game often traps well-meaning participants into decisions that shrink their common pie. In real life, as in laboratory experiments, we can avoid such traps by establishing rules that regulate self-serving behavior; by keeping social groups small so people feel responsibility for one another; by enabling communication, thus reducing mistrust; by changing payoffs to make cooperation more rewarding; and by invoking altruistic norms.

Competition

When people compete for scarce resources, human relations often sink into prejudice and hostility. In his famous experiments, Muzafer Sherif found that win-lose competition quickly made strangers into enemies, triggering outright warfare even among normally upstanding boys.

Perceived Injustice

Conflicts also arise when people feel unjustly treated. According to equity theory, people define justice as the distribution of rewards in proportion to

people's contributions. Conflicts occur when people disagree on the extent of their contributions and thus on the equity of their outcomes. Other theorists argue that people sometimes define justice not as equity, but as equality, or even in terms of people's needs.

Misperception

Conflicts frequently contain a small core of truly incompatible goals, surrounded by a thick layer of misperceptions of the adversary's motives and goals. Often, conflicting parties have *mirror-image perceptions*—each attributing the same virtues to themselves and vices to the other. When both sides believe "we are peace-loving—they are hostile," each may treat the other in ways that provoke confirmation of its expectations. International conflicts are also fed by an evil leader–good people illusion. They perceive the enemy's leaders as evil and coercive, but its own people as sympathetic to one's own point of view. Such perceptions of our antagonists easily adjust themselves as conflicts wax and wane.

PEACEMAKING

Although conflicts are readily kindled and fueled by these ingredients, some equally powerful forces can transform hostility into harmony.

Contact

Might putting people into close contact reduce their hostilities? There are good reasons to think so. Yet, despite some encouraging early studies of desegregation, other studies show that in schools mere desegregation has little effect upon racial attitudes. However, in most schools, interracial contact is seldom prolonged or intimate. When it is, and when it is structured to convey *equal status*, hostilities often lessen.

Cooperation

Contacts are especially beneficial when people work together to overcome a common threat or to achieve a superordinate goal. In his boys' camp experiments, Sherif used the unifying effect of a common enemy to create cohesive groups. Then he used the unifying power of cooperative effort to reconcile the warring groups. Taking their cue from experiments on cooperative contact, several research teams have replaced competitive classroom learning situations with opportunities for cooperative learning. Their heartening results suggest how to constructively implement desegregation and strengthen our confidence that cooperative activities can benefit human relations at all levels.

Communication

Conflicting parties can also seek to resolve their differences by bargaining either directly with one another or through a third-party mediator. When a pie of fixed size is to be divided, adopting a tough negotiating stance tends to gain one a larger piece (for example, a better price). When the pie can vary in size, as in the dilemma situations, toughness more often backfires. Third-party mediators can help by prodding the antagonists to replace their competitive win-lose view of their conflict with a more cooperative win-win orientation. Mediators can also structure communications that will peel away misperceptions and increase mutual understanding and trust. When a negotiated settlement is not

reached, the conflicting parties may defer the outcome to an arbitrator, who either dictates a settlement or selects one of the two final offers.

Conciliation

Sometimes tensions run so high that genuine communication is impossible. In such times, small conciliatory gestures by one party may elicit reciprocal conciliatory acts by the other party. Thus tension may be reduced to a level where communication can occur. One such conciliatory strategy, GRIT (graduated and reciprocated initiatives in tension reduction), aims to alleviate tense international situations.

Those who mediate tense labor-management and international conflicts sometimes use one other peacemaking strategy. They instruct the participants, as this chapter instructed you, in the dynamics of conflict and peacemaking. The hope is that understanding—understanding how conflicts are fed by social traps, perceived injustice, competition, and misperceptions and understanding how conflicts can be resolved through equal-status contact, cooperation, communication, and conciliation—can help us establish and enjoy peaceful, rewarding relationships.

■ FOR FURTHER READING

Johnson, D. W., & Johnson, R. T. (1987). *Learning together and alone: Cooperative, competitive and individualistic learning* (2d ed.). Englewood Cliffs, NJ: Prentice-Hall. Offers teachers strategies for implementing various goals, including steps for creating interdependent learning activities.

Katz, P. A., & Taylor, D. A. (1988). *Eliminating racism: Profiles in controversy.* New York: Plenum. Prominent researchers explore modern racism and evaluate various efforts to reduce it.

Pruitt, D. G., & Rubin, J. Z. (1986). *Social conflict: Escalation, stalemate, and settlement.* New York: Random House. Two prominent social psychologists draw on both research and anecdote to explain how conflicts arise, escalate, and are resolved.

Rubin, J. Z., & Rubin, C. (1989). *When families fight: How to manage conflict with those you love.* New York: Arbor House/William Morrow. Identifies the reasons families fight and how they can manage conflict more constructively.

Wagner, R. V., de Rivera, J., & Watkins, M. (Eds.). (1988). *Psychology and the promotion of peace* [Special issue]. *Journal of Social Issues, 44*(2). A state-of-the art summary of the dynamics of international conflict and likely routes to peace.

White, R. K. (Ed.). (1986). *Psychology and the prevention of nuclear war.* New York: New York University Press. A helpful collection of 35 classic and contemporary essays on the psychological roots of war and peace.

Wollman, N. (Ed.). (1985). *Working for peace: A handbook of practical psychology and other tools.* San Luis Obispo, CA: Impact Publishers. Three dozen experts offer suggestions for organizing peace workers, reducing conflict, and changing attitudes.

GLOSSARY

Acceptance: Conformity that involves both acting and believing in accord with social pressure.

Adaptation-level phenomenon: The tendency to adapt to a given level of stimulation and thus to notice and react to changes from that level.

Aggression: Physical or verbal behavior intended to hurt someone.

Aggression: Physical or verbal behavior intended to hurt someone. In laboratory experiments, this might mean delivering electric shocks or saying something likely to hurt another's feelings. By this social psychological definition, one can be socially assertive without being aggressive.

Altruism: Concern and help for others that asks nothing in return; devotion to others without conscious regard for one's self-interests.

Arbitration: Resolution of a conflict by a neutral third party who studies both sides and imposes a settlement.

Attitude: A favorable or unfavorable evaluative reaction toward something or someone, exhibited in one's beliefs, feelings, or intended behavior.

Attractiveness: Having qualities which appeal to an audience. An appealing communicator (often someone similar to the audience) is most persuasive on matters of subjective preference.

Attribution theory: The theory of how people explain others' behavior—for example, by attributing it either to internal *dispositions* (enduring traits, motives, and attitudes) or to external *situations*.

Autokinetic phenomenon: Self (*auto*) motion (*kinetic*). The apparent movement of a stationary point of light in the dark. Perhaps you have experienced this when thinking you have spotted a moving satellite in the sky, only to realize later that it was merely an isolated star.

Availability heuristic: An efficient but fallible rule-of-thumb that judges the likelihood of things in terms of their availability in memory. If instances of something come readily to mind, we presume it to be commonplace.

Bargaining: Seeking an agreement through direct negotiation between parties to a conflict.

Barnum effect: The tendency to accept as valid favorable descriptions of one's personality that are generally true of everyone, such as those found in astrology books and horoscopes.

Base-rate fallacy: The tendency to ignore or underuse base-rate information (information that describes most people) and instead to be influenced by distinctive features of the case being judged.

Behavioral confirmation: A type of self-fulfilling prophecy whereby people's social expectations lead them to act in way that cause others to confirm their expectations.

Behavioral medicine: An interdisciplinary field that integrates and applies behavioral and medical knowledge about health and disease.

Belief perseverance: Persistence of one's initial conceptions, as when the basis for one's belief is discredited but an explanation of why the belief might be true survives.

Bogus pipeline: A false procedure that fools people into disclosing their attitudes. Participants are first convinced that a new machine can use their psychological responses to measure their private attitudes. Then they are asked to predict the machine's reading, thus revealing their attitudes.

Burnout: Hostility, apathy, or loss of idealism resulting from the requirements of a role or from conflict between those in antagonistic roles.

Bystander effect: The finding that a person is less likely to provide help when there are other bystanders.

Catharsis: Emotional release. The catharsis view of aggression is that aggressive drive is reduced when one "releases" aggressive energy, either by acting aggressively or by fantasizing aggression.

Central route persuasion: Persuasion that occurs when interested people focus on the arguments and respond with favorable thoughts.

Channel of communication: The way the message is delivered—whether face to face, in writing, on film, or in some other way.

Clinical psychology: The study, assessment, and treatment of people with psychological difficulties.

Coactors: A group of people working simultaneously and individually on a noncompetitive task.

Cognitive dissonance: Tension that arises when one is simultaneously aware of two inconsistent cognitions. For example, dissonance may occur when we realize that we have, with little justification, acted contrary to our attitudes or made a decision favoring one alternative despite reasons favoring another.

Cohesiveness: A "we feeling"—the extent to which members of a group are bound together, such as by attraction for one another.

Collectivism: The concept of giving priority to the goals of one's groups (often one's extended family or work group) and defining one's identity accordingly.

Companionate love: The affection we feel for those with whom our lives are deeply intertwined.

Complementarity: The supposed tendency, in a relationship between two people, for each to complete what is missing in the other. The questionable complementarity hypothesis proposes that people attract those whose needs are different, in ways that complement their own.

Compliance: Conformity that involves publicly acting in accord with social pressure while privately disagreeing.

Confederate: An accomplice of the experimenter.

Confirmation bias: A tendency to search for information that confirms one's preconceptions.

Conflict: A perceived incompatibility of actions or goals.

Conformity: A change in behavior or belief as a result of real or imagined group pressure.

Correlational research: The study of the naturally occurring relationships among variables.

Counterfactual thinking: Imagining alternative scenarios and outcomes that might have happened, but didn't.

Credibility: Believability. A credible communicator is perceived as both expert and trustworthy.

Crowding: A subjective feeling of not enough space per person.

Cult: A group typically characterized by (1) the distinctive ritual of its devotion

to a god or a person, (2) isolation from the surrounding "evil" culture, and (3) a living, charismatic leader.

Culture: The enduring behaviors, ideas, attitudes, and traditions shared by a large group of people and transmitted from one generation to the next.

Deindividuation: Loss of self-awareness and evaluation apprehension; occurs in group situations that foster anonymity and draw attention away from the individual.

Demand characteristics: Cues in an experiment that tell the participant what behavior is expected.

Dependent variable: The variable being measured, so-called because it may *depend* on manipulations of the independent variable.

Depressive realism: The tendency of mildly depressed people to make accurate rather than self-serving judgments, attributions, and predictions.

Disclosure reciprocity: The tendency for one person's intimacy of self-disclosure to match that of a conversational partner.

Discrimination: Unjustifiable negative behavior toward a group or its members.

Displacement: The redirection of aggression to a target other than the source of the frustration. Generally, the new target is a safer or more socially acceptable target.

Door-in-the-face technique: A strategy for gaining a concession. After someone first turns down a large request (the door-in-the-face), the same requester counteroffers with a more reasonable request.

Egoism: The motivation (supposedly underlying all behavior) to increase one's own welfare. The opposite of *altruism*, which aims to increase another's welfare.

Empathy: The vicarious experience of another's feelings; putting oneself in another's shoes.

Equal-status contact: Contact made on an equal basis. Just as a relationship between people of unequal status breeds attitudes consistent with their relationship, so do relationships between those of equal status. Thus, to reduce prejudice, interracial contact should be between persons equal in status.

Equity: A condition in which the outcomes people receive from a relationship are proportional to what they contribute to it. Note: Equitable outcomes needn't always be equal outcomes.

Ethnocentrism: A belief in the superiority of one's own ethnic and cultural group, and a corresponding disdain for all other groups.

Evaluation apprehension: Concern for how others are evaluating us.

Evolutionary psychology: The study of how natural selection predisposes adaptive traits and behavior tendencies.

Experimental realism: Degree to which an experiment absorbs and involves its participants.

Experimental research: Studies which seek clues to cause-effect relationships by manipulating one or more factors (independent variables) while controlling others (holding them constant).

False consensus effect: The tendency to overestimate the commonality of one's opinions and one's undesirable or unsuccessful behaviors.

False uniqueness effect: The tendency to underestimate the commonality of one's abilities and one's desirable or successful behaviors.

Field research: Research done in natural, real-life settings outside the laboratory.

Foot-in-the-door phenomenon: The tendency for people who have first agreed to a small request to comply later with a larger request.

Free riders: People who benefit from the group but give little in return.

Frustration: The blocking of goal-directed behavior.

Fundamental attribution error: See Chapter 3.

Fundamental attribution error: The tendency for observers to underestimate situational influences and overestimate dispositional influences upon others' behavior. (Also called "correspondence bias," because more often than we should we see behavior as corresponding to a disposition.)

Gender role: A set of behavior expectations (norms) for males or females.

Gender: In psychology, the characteristics, whether biologically or socially influenced, by which people define male and female. Because "sex" is a biological category, social psychologists often refer to biologically based gender differences as "sex differences."

GRIT: Acronym for "graduated and reciprocated initiatives in tension reduction"—a strategy designed to deescalate international tensions.

Group polarization: Group-produced enhancement of members' preexisting tendencies; a strengthening of the members' *average* tendency, not a split within the group.

Group: Two or more people who, for longer than a few moments, interact with and influence one another and perceive one another as "us."

Groupthink: "The mode of thinking that persons engage in when concurrence-seeking becomes so dominant in a cohesive ingroup that it tends to override realistic appraisal of alternative courses of action." Irving Janis (1971)

Health psychology: A subfield of psychology that provides psychology's contribution to behavioral medicine.

Hindsight bias: The tendency to exaggerate *after* learning the outcome, one's ability to have foreseen how something turned out. Also known as the I-knew-it-all-along phenomenon.

Hostile aggression: Aggression driven by anger and performed as an end in itself.

Hypothesis: A testable proposition that describes a relationship that may exist between events.

Illusion of control: Perception of uncontrollable events as subject to one's control or as more controllable than they are.

Illusory correlation: A false impression that two variables correlate. See Chapter 2.

Illusory correlation: Perception of a relationship where none exists, or perception of a stronger relationship than actually exists.

Independent variable: The experimental factor that a researcher manipulates.

Individualism: The concept of giving priority to one's own goals over group goals and defining one's identity in terms of personal attributes rather than group identifications.

Informational influence: Conformity that results from accepting evidence about reality provided by other people.

Informed consent: An ethical principle requiring that research participants be told enough to enable them to choose whether they wish to participate.

Ingratiation: The use of strategies, such

as flattery, by which people seek to gain another's favor.

Ingroup bias: The tendency to favor one's own group.

Ingroup: "Us"—group of people who share a sense of belonging, a feeling of common identity.

Inoculation: Exposing people to weak attacks upon their attitudes so that when stronger attacks come, they will have refutations available.

Instinctive behavior: An innate, unlearned behavior pattern exhibited by all members of a species.

Instrumental aggression: Aggression that is a means to some other end.

Insufficient justification effect: Reduction of dissonance by internally justifying one's behavior when external justification is "insufficient."

Integrative agreements: Win-win agreements that reconcile both parties' interests to their mutual benefit.

Interaction: The effect of one factor (such as biology) depends on another factor (such as environment).

Just-world phenomenon: The tendency of people to believe the world is just and that people therefore get what they deserve and deserve what they get.

Kin selection: The idea that evolution has selected altruism toward one's close relatives to enhance the survival of mutually shared genes.

Leadership: The process by which certain group members motivate and guide the group.

Levels of explanation: See Chapter 1.

Low-ball technique: A tactic for getting people to agree to something. People who agree to an initial request will often still comply when the requester ups the ante. People who receive only the costly request are less likely to comply with it.

Matching phenomenon: The tendency for men and women to choose as partners those who are a "good match" in attractiveness and other traits.

Mediation: An attempt by a neutral third party to resolve a conflict by facilitating communication and offering suggestions.

Mere-exposure effect: The tendency for novel stimuli to be liked more or rated more positively after the rater has been repeatedly exposed to them.

Minimax: Minimize costs, maximize rewards.

Minority influence: See pages 335–339.

Mirror-image perceptions: Reciprocal views of one another often held by parties in conflict; for example, each may view itself as moral and peace-loving and the other as evil and aggressive.

Moral exclusion: The perception of certain individuals or groups as outside the boundary within which one applies moral values and rules of fairness. Moral *inclusion* is regarding others as within one's circle of moral concern.

Mundane realism: Degree to which an experiment is superficially similar to everyday situations.

Naturalistic fallacy: The error of defining what is good in terms of what is observable. For example: What's typical is normal; what's normal is good.

Non-zero-sum games: Games in which outcomes need not sum to zero. With cooperation, both can win; with competition, both can lose. (Also called *mixed-motive situations.*)

Normative influence: Conformity based on a person's desire to fulfill others' expectations, often to gain acceptance.

Norms: Rules for accepted and expected behavior. Norms *prescribe* "proper" behavior. (In a different sense of the word, norms also *describe* what most others do—what is *normal.*)

Outgroup homogeneity effect: Perception of outgroup members as more similar to one another than are ingroup members. Thus "they are alike; we are diverse."

Outgroup: "Them"—group that people perceive as distinctively different from or apart from their ingroup.

Overconfidence phenomenon: The tendency to be more confident than correct—to overestimate the accuracy of one's beliefs.

Overjustification effect: The result of bribing people to do what they already like doing; they may then see their action as externally controlled rather than intrinsically appealing.

Overjustification effect: See Chapter 4.

Passionate love: A state of intense longing for union with another. Passionate lovers are absorbed in one another, feel ecstatic at attaining their partner's love, and are disconsolate on losing it.

Peripheral route persuasion: Persuasion that occurs when people are influenced by incidental cues, such as a speaker's attractiveness.

Personal space: The buffer zone we like to maintain around our bodies. Its size depends on our familiarity with whomever is near us.

Physical-attractiveness stereotype: The presumption that physically attractive people possess other socially desirable traits as well: What is beautiful is good.

Pluralistic ignorance: A false impression of how other people are thinking, feeling, or responding.

Prejudice: An unjustifiable negative attitude toward a group and its individual members.

Primacy effect: Other things being equal, information presented first usually has the most influence.

Priming: Activating particular associations in memory.

Prosocial behavior: Positive, constructive, helpful social behavior; the opposite of antisocial behavior.

Proximity: Geographical nearness. Proximity (more precisely, "functional distance") powerfully predicts liking.

Racism: (1) Individual's prejudicial attitudes and discriminatory behavior toward people of a given race, or (2) institutional practices (even if not motivated by prejudice) that subordinate people of a given race.

Random assignment: The process of assigning participants to the conditions of an experiment such that all persons have the same chance of being in a given condition. (Note the distinction between random *assignment* in experiments and random *sampling* in surveys. Random assignment helps us infer cause and effect. Random sampling helps us generalize to a population.)

Random sample: Survey procedure in which every person in the population being studied has an equal chance of inclusion.

Reactance: A motive to protect or restore one's sense of freedom. Reactance arises when someone threatens our freedom of action.

Realistic group conflict theory: The theory that prejudice arises from competition between groups for scarce resources.

Recency effect: Information presented last sometimes has the most influence. Recency effects are less common than primacy effects.

Reciprocity norm: An expectation that

people will help, not hurt, those who have helped them.

Regression toward the average: The statistical tendency for extreme scores or extreme behavior to return toward one's average.

Relative deprivation: The perception that one is less well off than others to whom one compares oneself.

Representativeness heuristic: The strategy of judging the likelihood of things by how well they represent, or match, particular prototypes; may lead one to ignore other relevant information.

Reward theory of attraction: The theory that we like those whose behavior is rewarding to us or whom we associate with rewarding events.

Role: A set of norms that define how people in a given social position ought to behave.

Self-awareness: A self-conscious state in which attention focuses on oneself. Makes people more sensitive to their own attitudes and dispositions.

Self-disclosure: Revealing intimate aspects of oneself to others.

Self-efficacy: A sense that one is competent and effective. Distinguished from self-esteem, a sense of one's self-worth. A bombardier might feel high self-efficacy and low self-esteem.

Self-fulfilling prophecy: The tendency for one's expectations to evoke behavior that confirms the expectations.

Self-handicapping: Protecting one's self-image by creating a handy excuse for failure.

Self-monitoring: Being attuned to the way one presents oneself in social situations and adjusting one's performance to create the desired impression.

Self-perception theory: The theory that when unsure of our attitudes, we infer them much as would someone observing us—by looking at our behavior and the circumstances under which it occurs.

Self-presentation: The act of expressing oneself and behaving in ways designed to create a favorable impression or an impression that corresponds to one's ideals. (Self-presentation is a prime example of "impression management.")

Self-reference effect: The tendency to process efficiently and remember well information related to oneself.

Self-serving bias: The tendency to perceive oneself favorably.

Sexism: (1) Individual's prejudicial attitudes and discriminatory behavior toward people of a given sex, or (2) institutional practices (even if not motivated by prejudice) that subordinate people of a given sex.

Sleeper effect: A delayed impact of a message; occurs when we remember the message but forget a reason for discounting it.

Social comparison: Evaluating one's opinions and abilities by comparing oneself to others.

Social facilitation: (1) Original meaning—the tendency of people to perform simple or well-learned tasks better when others are present. (2) Current meaning—the strengthening of dominant (prevalent, likely) responses due to the presence of others.

Social learning theory: The theory that we learn social behavior by observing and imitating and by being rewarded and punished.

Social loafing: The tendency for people to exert less effort when they pool their efforts toward a common goal than when they are individually accountable.

Social psychology: The scientific study of how people think about, influence, and relate to one another.

Social representations: Socially shared beliefs. Widely held ideas and values, including our assumptions and cultural ideologies. Our social representations help us make sense of our world.

Social-exchange theory: The theory that human interactions are transactions that aim to maximize one's rewards and minimize one's costs.

Social-responsibility norm: An expectation that people will help those dependent upon them.

Stereotype: A belief about the personal attributes of a group of people. Stereotypes can be overgeneralized, inaccurate, and resistant to new information.

Superordinate goal: A shared goal that necessitates cooperative effort; a goal that overrides people's differences from one another.

Theory: An integrated set of principles that explain and predict observed events.

Two-factor theory of emotion: Arousal + label = emotion.

Two-step flow of communication: The process in which media influence often occurs through opinion leaders, who in turn influence others.

Ultimate attribution error: Bias characterized by granting the benefit of the doubt to members of one's own group, but not to members of other groups. Thus people attribute outgroup members' negative behavior to their dispositions but explain away positive behavior. (Also called "group-serving bias.")

REFERENCES

Abbey, A. (1987). Misperceptions of friendly behavior as sexual interest: A survey of naturally occurring incidents. *Psychology of Women Quarterly*, **11**, 173–194.

Abbey, A. (1991). Misperception as an antecedent of acquaintance rape: A consequence of ambiguity in communication between women and men. In A. Parrot (Ed.), *Acquaintance rape*. New York: John Wiley.

Abelson, R. (1972). Are attitudes necessary? In B. T. King & E. McGinnies (Eds.), *Attitudes, conflict and social change*. New York: Academic Press.

Abelson, R. P., Kinder, D. R., Peters, M. D., & Fiske, S. T. (1982). Affective and semantic components in political person perception. *Journal of Personality and Social Psychology*, **42**, 619–630.

Abrams, D. (1991). AIDS: What young people believe and what they do. Paper presented at the British Association for the Advancement of Science conference.

Abrams, D., Wetherell, M., Cochrane, S., Hogg, M. A., & Turner, J. C. (1990). Knowing what to think by knowing who you are: Self-categorization and the nature of norm formation, conformity and group polarization. *British Journal of Social Psychology*, **29**, 97–119.

Abramson, L. Y. (Ed.). (1988). *Social cognition and clinical psychology: A synthesis*. New York: Guilford.

Abramson, L. Y., Metalsky, G. I., & Alloy, L. B. (1989). Hopelessness depression: A theory-based subtype. *Psychological Review*, **96**, 358–372.

Adair, J. G., Dushenko, T. W., & Lindsay, R. C. L. (1985). Ethical regulations and their impact on research practice. *American Psychologist*, **40**, 59–72.

Adams, D. (Ed.) (1991). *The Seville statement on violence: Preparing the ground for the constructing of peace*. UNESCO.

Aderman, D., & Berkowitz, L. (1970). Observational set, empathy, and helping. *Journal of Personality and Social Psychology*, **14**, 141–148.

Aderman, D., & Berkowitz, L. (1983). Self-concern and the unwillingness to be helpful. *Social Psychology Quarterly*, **46**, 293–301.

Adler, R. P., Lesser, G. S., Meringoff, L. K., Robertson, T. S., & Ward, S.

(1980). *The effects of television advertising on children*. Lexington, Mass.: Lexington Books.

Adorno, T., Frenkel-Brunswik, E., Levinson, D., & Sanford, R. N. (1950). *The authoritarian personality*, New York: Harper.

Agres, S. J. (1987). Rational, emotional and mixed appeals in advertising: Impact on recall and persuasion. Paper presented at the American Psychological Association convention. (Available from Lowe Marschalk, Inc., 1345 Avenue of the Americas, New York, N.Y., 10105.)

Aiello, J. R., Thompson, D. E., & Brodzinsky, D. M. (1983). How funny is crowding anyway? Effects of room size, group size, and the introduction of humor. *Basic and Applied Social Psychology*, **4**, 193–207.

Ajzen, I. (1982). On behaving in accordance with one's attitudes. In M. P. Zanna, E. T. Higgins, & C. P. Herman (Eds.). *Consistency in social behavior: The Ontario Symposium*, vol. 2. Hillside, N.J.: Erlbaum.

Ajzen, I., & Fishbein, M. (1977). Attitude-behavior relations: A theoretical analysis and review of empirical research. *Psychological Bulletin*, **84**, 888–918.

Ajzen, I., & Timko, C. (1986). Correspondence between health attitudes and behavior. *Basic and Applied Social Psychology*, **7**, 259–276.

Albee, G. (1979, June 19). Politics, power, prevention, and social change. Keynote address to Vermont Conference on Primary Prevention of Psychopathology.

Alicke, M. D., & Davis, T. L. (1989). The role of *a posteriori* victim information in judgments of blame and sanction. *Journal of Experimental Social Psychology*, **25**, 362–377.

Allee, W. C., & Masure, R. M. (1936). A comparison of maze behavior in paired and isolated shell-parakeets (*Melopsittacus undulatus Shaw*) in a two-alley problem box. *Journal of Comparative Psychology*, **22**, 131–155.

Allen, J. B., Kenrick, D. T., Linder, D. E., & McCall, M. A. (1989). Arousal and attraction: A response facilitation alternative to misattribution and negative

reinforcement models. *Journal of Personality and Social Psychology*, **57**, 261–270.

Allen, V. L., & Levine, J. M. (1969). Consensus and conformity. *Journal of Experimental Social Psychology*, **5**, 389–399.

Allen, V. L., & Wilder, D. A. (1979). Group categorization and attribution of belief similarity. *Small Group Behavior*, **10**, 73–80.

Allen, V. L., & Wilder, D. A. (1980). Impact of group consensus and social support on stimulus meaning: Mediation of conformity by cognitive restructuring. *Journal of Personality and Social Psychology*, **39**, 1116–1124.

Alley, T. R., & Cunningham, M. R. (1991). Averaged faces are attractive, but very attractive faces are not average. *Psychological Science*, **2**, 123–125.

Allgeier, A. R., Byrne, D., Brooks, B., & Revnes, D. (1979). The waffle phenomenon: Negative evaluations of those who shift attitudinally. *Journal of Applied Social Psychology*, **9**, 170–182.

Allison, S. T., Jordan, M. R., & Yeatts, C. E. (1992). A cluster-analytic approach toward identifying the structure and content of human decision making. *Human Relations*, **45**, in press.

Allison, S. T., & Messick, D. M. (1985). The group attribution error. *Journal of Experimental Social Psychology*, **21**, 563–579.

Allison, S. T., & Messick, D. M. (1987). From individual inputs to group outputs, and back again: Group processes and inferences about members. In C. Hendrick (Ed.), *Group processes: Review of personality and social psychology*, Vol. 8. Newbury Park, Ca.: Sage.

Allison, S. T., Messick, D. M., & Goethals, G. R. (1989). On being better but not smarter than others: The Muhammad Ali effect. *Social Cognition*, **7**, 275–296.

Allison, S. T., Redpath, L. M., & Schaerfl, L. M. (1992). Social decision making processes and the equal partitionment of shared resources. *Journal of Experimental Social Psychology*, **28**, in press.

Allison, S. T., Worth, L. T., & King, M. W. C. (1990). Group decisions as social inference heuristics. *Journal of Personality and Social Psychology*, **58**, 801–811.

Alloy, L. B., & Abramson, L. Y. (1979). Judgment of contingency in depressed and nondepressed students: Sadder but wiser? *Journal of Experimental Psychology: General*, **108**, 441–485.

Alloy, L. B., Albright, J. S., Abramson, L. Y., & Dykman, B. M. (1990). Depressive realism and nondepressive optimistic illusions: The role of the self. In R. E. Ingram (Ed.), *Contemporary psychological approaches to depression: Theory, research and treatment*. New York: Plenum.

Alloy, L. B., & Clements, C. M. (1991). The illusion of control: Invulnerability to negative affect and depressive symptoms following laboratory and natural stressors. *Journal of Abnormal Psychology*, in press.

Allport, F. H. (1920). The influence of the group upon association and thought. *Journal of Experimental Psychology*, **3**, 159–182.

Allport, G. (1954). *The nature of prejudice*. Cambridge, Mass.: Addison-Wesley.

Allport, G. W. (1958). *The nature of prejudice* (abridged). Garden City, NY: Anchor Books.

Allport, G. W. (1978). *Waiting for the Lord: 33 Meditations on God and Man* (Edited by P. A. Bertocci). New York: Macmillan.

Allport, G. W., & Postman, L. (1958). *The psychology of rumor*. New York: Henry Holt and Co., 1975. (Originally published, 1947). Also in E. E. Maccoby, T. M. Newcomb, & E. L. Hartley (Eds.), *Readings in social psychology*. New York: Holt, Rinehart and Winston.

Allport, G. W., & Ross, J. M. (1967). Personal religious orientation and prejudice. *Journal of Personality and Social Psychology*, **5**, 432–443.

Altemeyer, B. (1988). *Enemies of freedom: Understanding right-wing authoritarianism*. San Francisco: Jossey-Bass.

Altemeyer, B. (1992). Six studies of right-wing authoritarianism among American state legislators. Unpublished manuscript, University of Manitoba.

Altman, I., & Taylor, D. (1973). *Social penetration: The development of interpersonal relations*. New York: Holt, Rinehart and Winston.

Altman, I., & Vinsel, A. M. (1978). Personal space: An analysis of E. T. Hall's proxemics framework. In I. Altman & J. Wohlwill (Eds.), *Human behavior and the environment*. New York: Plenum Press.

Alwin, D. F. (1990). Historical changes in parental orientations to children. In N. Mandell (Ed.), *Sociological studies of child development*, Vol. 3. Greenwich, Ct.: JAI Press.

Amabile, T. M., & Glazebrook, A. H. (1982). A negativity bias in interpersonal evaluation. *Journal of Experimental Social Psychology*, **18**, 1–22.

Amato, P. R. (1979). Juror-defendant similarity and the assessment of guilt in politically motivated crimes. *Australian Journal of Psychology*, **31**, 79–88.

Amato, P. R. (1986). Emotional arousal and helping behavior in a real-life emergency. *Journal of Applied Social Psychology*, **16**, 633–641.

Amato, P. R. (1990). Personality and social network involvement as predictors of helping behavior in everyday life. *Social Psychology Quarterly*, **53**, 31–43.

American Enterprise (1991, March/April). Women and the use of force. Pp. 85–86.

American Psychological Association (1981). Ethical principles of psychologists. *American Psychologist*, **36**, 633–638.

American Psychological Association (1992). Ethical principles of psychologists. Washington, D.C.: American Psychological Association, in press.

Amir, Y. (1969). Contact hypothesis in ethnic relations. *Psychological Bulletin*, **71**, 319–342.

Anderson, C. A. (1982). Inoculation and counter-explanation: Debiasing techniques in the perseverance of social theories. *Social Cognition*, **1**, 126–139.

Anderson, C. A. (1988). Attributions as decisions: A two-stage information processing model. Paper presented to the Third Attribution Conference, California School of Professional Psychology, Los Angeles.

Anderson, C. A. (1989). Temperature and aggression: Ubiquitous effects of heat on occurrence of human violence. *Psychological Bulletin*, **106**, 74–96.

Anderson, C. A., & Anderson, D. C. (1984). Ambient temperature and violent crime: Tests of the linear and curvilinear hypotheses. *Journal of Personality and Social Psychology*, **46**, 91–97.

Anderson, C. A., & Harvey, R. J. (1988). Discriminating between problems in living: An examination of measures of depression, loneliness, shyness, and social anxiety. *Journal of Social and Clinical Psychology*, **6**, 482–491.

Anderson, C. A., Horowitz, L. M., & French, R. D. (1983). Attributional style of lonely and depressed people. *Journal of Personality and Social Psychology*, **45**, 127–136.

Anderson, C. A., Lepper, M. R., & Ross, L. (1980). Perseverance of social theories: The role of explanation in the persistence of discredited information. *Journal of Personality and Social Psychology*, **39**, 1037–1049.

Anderson, C. A., & Riger, A. L. (1991). A controllability attributional model of problems in living: Dimensional and situational interactions in the prediction of depression and loneliness. *Social Cognition*, **9**, 149–181.

Anderson, C. A., & Sechler, E. S. (1986). Effects of explanation and counter-explanation on the development and use of social theories. *Journal of Personality and Social Psychology*, **50**, 24–34.

Anderson, N. H. (1968). A simple model of information integration. In R. B. Abelson, E. Aronson, W. J. McGuire, T. M. Newcomb, M. J. Rosenberg, & P. H. Tannenbaum (Eds.), *Theories of cognitive consistency: A sourcebook*. Chicago: Rand McNally.

Anderson, N. H. (1974). Cognitive algebra: Integration theory applied to social attribution. In L. Berkowitz (Ed.), *Advances in experimental social psychology*, Vol. 7. New York: Academic Press.

Anthony, T., Copper, C., & Mullen, B. (1992). Cross-racial facial identification: A social cognitive integration. *Personality and Social Psychology Bulletin*, **18**, 296–301.

Antill, J. K. (1983). Sex role complementarity versus similarity in married couples. *Journal of Personality and Social Psychology*, **45**, 145–155.

Apsler, R. (1975). Effects of embarrassment on behavior toward others. *Journal of Personality and Social Psychology*, **32**, 145–153.

Archer, D., & Gartner, R. (1976). Violent acts and violent times: A comparative approach to postwar homicide rates. *American Sociological Review*, **41**, 937–963.

Archer, D., & Gartner, R. (1984). *Violence and crime in cross-national perspective*. New Haven, CT: Yale University Press.

Archer, D., Iritani, B., Kimes, D. B., & Barrios, M. (1983). Face-ism: Five studies of sex differences in facial prominence. *Journal of Personality and Social Psychology*, **45**, 725–735.

Archer, J. (1991). The influence of testosterone on human aggression. *British Journal of Psychology, 82,* 1–28.

Archer, R. L., Berg, J. M., & Burleson, J. A. (1980). Self-disclosure and attraction: A self-perception analysis. Unpublished manuscript, University of Texas at Austin.

Archer, R. L., Berg, J. M., & Runge, T. E. (1980). Active and passive observers' attraction to a self-disclosing other. *Journal of Experimental Social Psychology, 16,* 130–145.

Archer, R. L., & Burleson, J. A. (1980). The effects of timing of self-disclosure on attraction and reciprocity. *Journal of Personality and Social Psychology, 38,* 120–130.

Archer, R. L., & Cook, C. E. (1986). Personalistic self-disclosure and attraction: Basis for relationship or scarce resource. *Social Psychology Quarterly, 49,* 268–272.

Arendt, H. (1963). *Eichmann in Jerusalem: A report on the banality of evil.* New York: Viking Press.

Arendt, H. (1971). Organized guilt and universal responsibility. In R. W. Smith (Ed.), *Guilt: Man and society.* Garden City, N.Y.: Doubleday Anchor Books. Reprinted from *Jewish Frontier,* 1945, **12.**

Argote, L. (1989). Agreement about norms and work-unit effectiveness: Evidence from the field. *Basic and Applied Social Psychology, 10,* 131–140.

Argyle, M. (1988). A social psychologist visits Japan. *The Psychologist, 1,* 361–363.

Argyle, M., & Henderson M. (1985). *The anatomy of relationships.* London: Heinemann.

Argyle, M., Shimoda, K., & Little, B. (1978). Variance due to persons and situations in England and Japan. *British Journal of Social and Clinical Psychology, 17,* 335–337.

Arkes, H. R. (1990). Some practical judgment/decision making research. Paper presented at the American Psychological Association convention.

Arkes, H. R., Faust, D., Guilmette, T. J., & Hart, K. (1988). Eliminating the hindsight bias. *Journal of Applied Psychology, 73,* 305–307.

Arkin, R. M., Appleman, A., & Burger, J. M. (1980). Social anxiety, self-presentation, and the self-serving bias in causal attribution. *Journal of Personality and Social Psychology, 38,* 23–35.

Arkin, R. M., & Baumgardner, A. H. (1985). Self-handicapping. In J. H. Harvey & C. Weary (Eds.), *Attribution: Basic issues and applications.* New York: Academic Press.

Arkin, R. M., & Burger, J. M. (1980). Effects of unit relation tendencies on interpersonal attraction. *Social Psychology Quarterly, 43,* 380–391.

Arkin, R. M., Cooper, H., & Kolditz, T. (1980). A statistical review of the literature concerning the self-serving attribution bias in interpersonal influence situations. *Journal of Personality, 48,* 435–448.

Arkin, R. M., Lake, E. A., & Baumgardner, A. H. (1986). Shyness and self-presentation. In W. H. Jones, J. M. Cheek, & S. R. Briggs (Eds.), *Shyness: Perspectives on research and treatment.* New York: Plenum.

Arkin, R. M., & Maruyama, G. M. (1979). Attribution, affect, and college exam performance. *Journal of Educational Psychology, 71,* 85–93.

Arms, R. L., Russell, G. W., & Sandilands, M. L. (1979). Effects on the hostility of spectators of viewing aggressive sports. *Social Psychology Quarterly, 42,* 275–279.

Armstrong, B. (1981). An interview with Herbert Kelman. *APA Monitor,* January, pp. 4–5, 55.

Aron, A., & Aron, E. (1989). *The heart of social psychology,* 2nd ed. Lexington, MA: Lexington Books.

Aron, A., Dutton, D. G., Aron, E. N., & Iverson, A. (1989). Experiences of falling in love. *Journal of Social and Personal Relationships, 6,* 243–257.

Aronson, E. (1988). *The social animal.* New York: Freeman.

Aronson, E., Blaney, N., Stephan, C., Sikes, J., & Snapp, M. (1978). *The jigsaw classroom.* Beverly Hills, Calif.: Sage Publications.

Aronson, E., Brewer, M., & Carlsmith, J. M. (1985). Experimentation in social psychology. In G. Lindzey & E. Aronson (Eds.), *Handbook of social psychology,* vol. 1. Hillsdale, N.J.: Erlbaum.

Aronson, E., & Bridgeman, D. (1979). Jigsaw groups and the desegregated classroom: In pursuit of common goals. *Personality and Social Psychology Bulletin, 5,* 438–446.

Aronson, E., & Gonzalez, A. (1988). Desegregation, jigsaw, and the Mexican-American experience. In P. A. Katz & D. Taylor (Eds.), *Towards the elimination of racism: Profiles in controversy.* New York: Plenum.

Aronson, E., & Linder, D. (1965). Gain and loss of esteem as determinants of interpersonal attractiveness. *Journal of Experimental Social Psychology, 1,* 156–171.

Aronson, E., & Mettee, D. R. (1974). Affective reactions to appraisal from others. *Foundations of interpersonal attraction.* New York: Academic Press.

Aronson, E., & Mills, J. (1959). The effect of severity of initiation on liking for a group. *Journal of Abnormal and Social Psychology, 59,* 177–181.

Aronson, E., Turner, J. A., & Carlsmith, J. M. (1963). Communicator credibility and communicator discrepancy as determinants of opinion change. *Journal of Abnormal and Social Psychology, 67,* 31–36.

Asch, S. E. (1946). Forming impressions of personality. *Journal of Abnormal and Social Psychology, 41,* 258–290.

Asch, S. E. (1955, November). Opinions and social pressure. *Scientific American,* pp. 31–35.

Asch, S. E. (1956). Studies of independence and conformity: A minority of one against a unanimous majority. *Psychological Monographs, 70,* (9, Whole No. 416).

Asendorpf, J. B. (1987). Videotape reconstruction of emotions and cognitions related to shyness. *Journal of Personality and Social Psychology, 53,* 541–549.

Asher, J. (1987, April). Born to be shy? *Psychology Today,* pp. 56–64.

Ashmore, R. D. (1990). Sex, gender, and the individual. In L. A. Pervin (Ed.), *Handbook of personality: Theory and research.* New York: Guilford Press.

Associated Press (1988, July 10). Rain in Iowa. *Grand Rapids Press,* p. A6.

Astin, A. & others (1991). *The American freshman: National norms for Fall 1991.* Los Angeles: American Council on Education and UCLA.

Astin, A. W. (1972). *Four critical years.* San Francisco: Jossey-Bass.

Astin, A. W., Green, K. C., & Korn, W. S. (1987). *The American freshman: Twenty year trends.* Los Angeles: Higher Education Research Institute, UCLA. *(a)*

Astin, A. W., Green, K. C., Korn, W. S., & Schalit, M. (1987). *The American freshman: National norms for Fall 1987.* Los Angeles: Higher Education Research Institute, UCLA. *(b)*

Atwell, R. H. (1986, July 28). Drugs on campus: A perspective. *Higher Education & National Affairs,* p. 5.

Augoustinos, M., & Innes, J. M. (1990). Towards an integration of social representations and social schema theory. *British Journal of Social Psychology, 29,* 213–231.

Austin, W. (1980). Friendship and fairness: Effects of type of relationship and task performance on choice of distribution rules. *Personality and Social Psychology Bulletin, 6,* 402–408.

Averill, J. R. (1983). Studies on anger and aggression: Implications for theories of emotion. *American Psychologist, 38,* 1145–1160.

Axelrod, R., & Dion, D. (1988). The further evolution of cooperation. *Science, 242,* 1385–1390.

Axsom, D. (1989). Cognitive dissonance and behavior change in psychotherapy. *Journal of Experimental Social Psychology, 25,* 234–252.

Axsom, D., & Cooper, J. (1985). Cognitive dissonance and psychotherapy: The role of effort justification in inducing weight loss. *Journal of Experimental Social Psychology, 21,* 149–160.

Axsom, D., Yates, S., & Chaiken, S. (1987). Audience response as a heuristic cue in persuasion. *Journal of Personality and Social Psychology, 53,* 30–40.

Ayres, I. (1991). Fair driving: Gender and race discrimination in retail car negotiations. *Harvard Law Review, 104,* 817–872.

Azrin, N. H. (1967, May). Pain and aggression. *Psychology Today,* pp. 27–33.

Babad, E. (1987). Wishful thinking and objectivity among sports fans. *Social Behaviour, 2,* 231–240.

Babad, E., Bernieri, F., & Rosenthal, R. (1991). Students as judges of teachers' verbal and nonverbal behavior. *American Educational Research Journal, 28,* 211–234.

Bachman, J. G., Johnston, L. D., O'Malley, P. M., & Humphrey, R. N. (1988). Explaining the recent decline in marijuana use: Differentiating the effects of perceived risks, disapproval, and general lifestyle factors. *Journal of Health and Social Behavior, 29,* 92–112.

Bachman, J. G., & O'Malley, P. M. (1977). Self-esteem in young men: A longitudinal analysis of the impact of educational and occupational attainment. *Journal of Personality and Social Psychology, 35,* 365–380.

Baer, R., Hinkle, S., Smith, K., & Fenton, M. (1980). Reactance as a function of actual versus projected autonomy. *Journal of Personality and Social Psychology, 38,* 416–422.

Bairagi, R. (1987). Food crises and female children in rural Bangladesh. *Social Science, 72,* 48–51.

Bandura, A. (1979). The social learning perspective: Mechanisms of aggression. In H. Toch (Ed.), *Psychology of crime and criminal justice.* New York: Holt, Rinehart & Winston.

Bandura, A. (1982). Self-efficacy: Mechanism in human agency. *American Psychologist, 37,* 122–147.

Bandura, A. (1986). *Social foundations of thought and action: A social cognitive theory.* Englewood Cliffs, N.J.: Prentice-Hall.

Bandura, A. (1989). Perceived self-efficacy in the exercise of personal agency. *The Psychologist, 10,* 411–424.

Bandura, A., Ross, D., & Ross, S. A. (1961). Transmission of aggression through imitation of aggressive models. *Journal of Abnormal and Social Psychology, 63,* 575–582.

Bandura, A., & Walters, R. H. (1959). *Adolescent aggression.* New York: Ronald Press.

Bandura, A., & Walters, R. H. (1963). *Social learning and personality development.* New York: Holt, Rinehart and Winston.

Barash, D. (1979). *The whisperings within.* New York: Harper & Row.

Bargh, J. A. (1989). Conditional automaticity: Varieties of automatic influence in social perception and cognition. In J. S. Uleman & J. A. Bargh (Eds.), *Unintended thought: Causes and consequences for judgment, emotion, and behavior.* New York: Guilford.

Barnes, R. D., Ickes, W., & Kidd, R. F. (1979). Effects of the perceived intentionality and stability of another's dependency on helping behavior. *Personality and Social Psychology Bulletin, 5,* 367–372.

Barnett, M. A., King, L. M., Howard, J. A., & Melton, E. M. (1980). Experiencing negative affect about self or other: Effects on helping behavior in children and adults. Paper presented at the Midwestern Psychological Association convention.

Barnett, P. A., & Gotlib, I. H. (1988). Psychosocial functioning and depression: Distinguishing among antece-

dents, concomitants, and consequences. *Psychological Bulletin, 104,* 97–126.

Baron J., & Hershey, J. C. (1988). Outcome bias in decision evaluation. *Journal of Personality and Social Psychology, 54,* 569–579.

Baron, L., & Straus, M. A. (1984). Sexual stratification, pornography, and rape in the United States. In N. M. Malamuth & E. Donnerstein (Eds.), *Pornography and sexual aggression.* New York: Academic Press.

Baron, R. A. (1976). The reduction of human aggression: A field study of the influence of incompatible reactions. *Journal of Applied Social Psychology, 6,* 260–274.

Baron, R. A. (1977). *Human aggression.* New York: Plenum Press.

Baron, R. M., Mandel, D. R., Adams, C. A., & Griffen, L. M. (1976). Effects of social density in university residential environments. *Journal of Personality and Social Psychology, 34,* 434–446.

Baron, R. S. (1986). Distraction-conflict theory: Progress and problems. In L. Berkowitz (Ed.), *Advances in experimental social psychology,* Orlando, Fla.: Academic Press.

Baron, R. S., Burgess, M. L., & Kao, C. F. (1991). Detecting and labeling prejudice: Do female perpetrators go undetected? *Personality and Social Psychology Bulletin, 17,* 115–123.

Bar-Tal, D. (1982). Sequential development of helping behavior: A cognitive-learning approach. *Development Review, 2*(2), 101–124.

Barzun, J. (1975). *Simple and direct.* New York: Harper & Row, pp. 173–174.

Batson, C. D. (1983). Sociobiology and the role of religion in promoting prosocial behavior: An alternative view. *Journal of Personality and Social Psychology, 45,* 1380–1385.

Batson, C. D. (1991). *The altruism question: Toward a social-psychological answer.* Hillsdale, NJ: Erlbaum.

Batson, C. D., Bolen, M. H., Cross, J. A., & Neuringer-Benefiel, H. E. (1986). Where is the altruism in the altruistic personality? *Journal of Personality and Social Psychology, 50,* 212–220.

Batson, C. D., Cochran, P. J., Biederman, M. F., Blosser, J. L., Ryan, M. J., & Vogt, B. (1978). Failure to help when in a hurry: Callousness or conflict? *Personality and Social Psychology Bulletin, 4,* 97–101.

Batson, C. D., Coke, J. S., Jasnoski, M. L., & Hanson, M. (1978). Buying kindness: Effect of an extrinsic incentive for helping on perceived altruism. *Personality and Social Psychology Bulletin*, **4**, 86–91.

Batson, C. D., Duncan, B. D., Ackerman, P., Buckley, T., & Birch, K. (1981). Is empathic emotion a source of altruistic motivation? *Journal of Personality and Social Psychology*, **40**, 290–302.

Batson, C. D., Flink, C. H., Schoenrade, P. A., Fultz, J., & Pych, V. (1986). Religious orientation and overt versus covert racial prejudice. *Journal of Personality and Social Psychology*, **50**, 175–181.

Batson, C. D., Fultz, J., & Schoenrade, P. A. (1987). Distress and empathy: Two qualitatively distinct vicarious emotions with different motivational consequences. *Journal of Personality*, **55**, 19–40.

Batson, C. D., Fultz, J., Schoenrade, P. A., & Paduano, A. (1987). Critical self-reflection and self-perceived altruism: When self-reward fails. *Journal of Personality and Social Psychology*, **53**, 594–602.

Batson, C. D., Harris, A. C., McCaul, K. D., Davis, M., & Schmidt, T. (1979). Compassion or compliance: Alternative dispositional attributions for one's helping behavior. *Social Psychology Quarterly*, **42**, 405–409.

Batson, C. D., Oleson, K. C., Weeks, J. L., Healy, S. P., Reeves, P. J., Jennings, P., & Brown, T. (1989). Religious prosocial motivation: Is it altruistic or egoistic? *Journal of Personality and Social Psychology*, **57**, 873–884.

Batson, C. D., Schoenrade, P. A., & Pych, V. (1985). Brotherly love or self-concern? Behavioural consequences of religion. In L. B. Brown (Ed.), *Advances in the psychology of religion*. Oxford: Pergamon Press.

Batson, C. D., & Ventis, W. L. (1982). *The religious experience: A social psychological perspective*. New York: Oxford University Press.

Baumann, D. J., Cialdini, R. B., & Kenrick, D. T. (1981). Altruism as hedonism: Helping and self-gratification as equivalent responses. *Journal of Personality and Social Psychology*, **40**, 1039–1046.

Baumeister, R. F. (1982). A self-presentational view of social phenomena. *Psychological Bulletin*, **91**, 3–26.

Baumeister, R. F. (1985). Four selves and two motives: Outline of self-presentation theory. Paper presented to the Midwestern Psychological Association convention.

Baumeister, R. F. (1991). *Meanings of life*. New York: Guilford.

Baumeister, R. F., Chesner, S. P., Senders, P. S., & Tice, D. M. (1988). Who's in charge here? Group leaders do lend help in emergencies. *Personality and Social Psychology Bulletin*, **14**, 17–22.

Baumeister, R. F., & Ilko, S. A. (1991). Shallow gratitude: Public and private acknowledgement of external help in accounts of success. Unpublished manuscript, Case Western Reserve University.

Baumeister, R. F., & Scher, S. J. (1988). Self-defeating behavior patterns among normal individuals: Review and analysis of common self-destructive tendencies. *Psychological Bulletin*, **104**, 3–22.

Baumeister, R. F., & Steinhilber, A. (1984). Paradoxical effects of supportive audiences on performance under pressure: The home field disadvantage in sports championships. *Journal of Personality and Social Psychology*, **47**, 85–93.

Baumeister, R. F., & Wotman, S. R. (1992). *Breaking hearts: The two sides of unrequited love*. New York: Guilford.

Baumgardner, A. H. (1991). Claiming depressive symptoms as a self-handicap: A protective self-presentation strategy. *Basic and Applied Social Psychology*, **12**, 97–113.

Baumgardner, A. H., & Brownlee, E. A. (1987). Strategic failure in social interaction: Evidence for expectancy disconfirmation process. *Journal of Personality and Social Psychology*, **52**, 525–535.

Baumgardner, A. H., Kaufman, C. M., & Levy, P. E. (1989). Regulating affect interpersonally: When low esteem leads to greater enhancement. *Journal of Personality and Social Psychology*, **56**, 907–921.

Baumhart, R. (1968). *An honest profit*. New York: Holt, Rinehart & Winston.

Baxter, T. L., & Goldberg, L. R. (1987). Perceived behavioral consistency underlying trait attributions to oneself and another: An extension of the actor-observer effect. *Personality and Social Psychology Bulletin*, **13**, 437–447.

Bayer, E. (1929). Beitrage zur zeikomponenten theorie des hungers. *Zeitschrift fur Psychologie*, **112**, 1–54.

Bazerman, M. H. (1986, June). Why negotiations go wrong. *Psychology Today*, pp. 54–58.

Beaman, A. L., Barnes, P. J., Klentz, B., & McQuirk, B. (1978). Increasing helping rates through information dissemination: Teaching pays. *Personality and Social Psychology Bulletin*, **4**, 406–411.

Beaman, A. L., Cole, C. M., Preston, M., Klentz, B., & Steblay, N. M. (1983). Fifteen years of foot-in-the-door research: A meta-analysis. *Personality and Social Psychology Bulletin*, **9**, 181–196.

Beaman, A. L., & Klentz, B. (1983). The supposed physical attractiveness bias against supporters of the women's movement: A meta-analysis. *Personality and Social Psychology Bulletin*, **9**, 544–550.

Beaman, A. L., Klentz, B., Diener, E., & Svanum, S. (1979). Self-awareness and transgression in children: Two field studies. *Journal of Personality and Social Psychology*, **37**, 1835–1846.

Beauvois, J. L., & Dubois, N. (1988). The norm of internality in the explanation of psychological events. *European Journal of Social Psychology*, **18**, 299–316.

Beck, A. T., & Young, J. E. (1978, September). College blues. *Psychology Today*, pp. 80–92.

Beck, S. B., Ward-Hull, C. I., & McLear, P. M. (1976). Variables related to women's somatic preferences of the male and female body. *Journal of Personality and Social Psychology*, **34**, 1200–1210.

Becker, B. J. (1986). Influence again: Another look at studies of gender differences in social influence. In J. S. Hyde & M. Linn (Eds.), *The psychology of gender: Advances through meta-analysis*. Baltimore: Johns Hopkins University Press.

Bell, B. E., & Loftus, E. F. (1988). Degree of detail of eyewitness testimony and mock juror judgments. *Journal of Applied Social Psychology*, **18**, 1171–1192.

Bell, B. E., & Loftus, E. F. (1989). Trivial persuasion in the courtroom: The power of (a few) minor details. *Journal of Personality and Social Psychology*, **56**, 669–679.

Bell, P. A. (1980). Effects of heat, noise, and provocation on retaliatory evaluative behavior. *Journal of Social Psychology*, **110**, 97–100.

Bell, R. Q., & Chapman, M. (1986). Child effects in studies using experimental or brief longitudinal ap-

proaches to socialization. *Developmental Psychology, 22,* 595–603.

Belson, W. A. (1978). *Television violence and the adolescent boy.* Westmead, England: Saxon House, Teakfield Ltd.

Bem, D. J. (1972). Self-perception theory. In L. Berkowitz (Ed.), *Advances in experimental social psychology.* Vol. 6. New York: Academic Press.

Bem, D. J., & McConnell, H. K. (1970). Testing the self-perception explanation of dissonance phenomena: On the salience of premanipulation attitudes. *Journal of Personality and Social Psychology, 14,* 23–31.

Bennis, W. (1984). Transformative power and leadership. In T. J. Sergiovani & J. E. Corbally (Eds.), *Leadership and organizational culture.* Urbana: University of Illinois Press.

Benson, P. L., Dehority, J., Garman, L., Hanson, E., Hochschwender, M., Lebold, C., Rohr, R., & Sullivan, J. (1980). Intrapersonal correlates of nonspontaneous helping behavior. *Journal of Social Psychology, 110,* 87–95.

Benson, P. L., Karabenick, S. A., & Lerner, R. M. (1976). Pretty pleases: The effects of physical attractiveness, race, and sex on receiving help. *Journal of Experimental Social Psychology, 12,* 409–415.

Benvenisti, M. (1988, October 16). Growing up in Jerusalem. *New York Times Magazine,* pp. 34–37.

Berg, J. H. (1984). Development of friendship between roommates. *Journal of Personality and Social Psychology, 46,* 346–356.

Berg, J. H. (1987). Responsiveness and self-disclosure. In V. J. Derlega & J. H. Berg (Eds.), *Self-disclosure: Theory, research, and therapy.* New York: Plenum.

Berg, J. H., & McQuinn, R. D. (1986). Attraction and exchange in continuing and noncontinuing dating relationships. *Journal of Personality and Social Psychology, 50,* 942–952.

Berg, J. H., & McQuinn, R. D. (1988). Loneliness and aspects of social support networks. Unpublished manuscript, University of Mississippi.

Berg, J. H., & Peplau, L. A. (1982). Loneliness: The relationship of self-disclosure and androgyny. *Personality and Social Psychology Bulletin, 8,* 624–630.

Berger, P. (1963). *Invitation to sociology: A humanistic perspective.* Garden City, N.Y.: Doubleday Anchor Books.

Berglas, S., & Jones, E. E. (1978). Drug choice as a self-handicapping strategy in response to noncontingent success. *Journal of Personality and Social Psychology, 36,* 405–417.

Berkowitz, L. (1954). Group standards, cohesiveness, and productivity. *Human Relations, 7,* 509–519.

Berkowitz, L. (1968, September). Impulse, aggression and the gun. *Psychology Today,* pp. 18–22.

Berkowitz, L. (1972). Frustrations, comparisons, and other sources of emotional arousal as contributors to social unrest. *Journal of Social Issues, 28,* 77–91. *(a)*

Berkowitz, L. (1972). Social norms, feelings, and other factors affecting helping and altruism. In L. Berkowitz (Ed.), *Advances in experimental social psychology* (Vol. 6). New York: Academic Press. *(b)*

Berkowitz, L. (1978). Whatever happened to the frustration-aggression hypothesis? *American Behavioral Scientists, 21,* 691–708.

Berkowitz, L. (1981, June). How guns control us. *Psychology Today,* pp. 11–12.

Berkowitz, L. (1983). Aversively stimulated aggression: Some parallels and differences in research with animals and humans. *American Psychologist, 38,* 1135–1144.

Berkowitz, L. (1984). Some effects of thoughts on anti-and prosocial influences of media events: A cognitive-neoassociation analysis, *Psychological Bulletin, 95,* 410–427.

Berkowitz, L. (1987). Mood, self-awareness, and willingness to help. *Journal of Personality and Social Psychology, 52,* 721–729.

Berkowitz, L. (1989). Frustration-aggression hypothesis: Examination and reformulation. *Psychological Bulletin, 106,* 59–73.

Berkowitz, L., & Geen, R. G. (1966). Film violence and the cue properties of available targets. *Journal of Personality and Social Psychology, 3,* 525–530.

Berkowitz, L., & LePage, A. (1967). Weapons as aggression-eliciting stimuli. *Journal of Personality and Social Psychology, 7,* 202–207.

Bernard, J. (1976). *Sex differences: An overview.* New York: MSS Modular Publications.

Berry, D. S., & Zebrowitz-McArthur, L. (1988). What's in a face: Facial maturity and the attribution of legal responsibility. *Personality and Social Psychology Bulletin, 14,* 23–33.

Berscheid, E. (1981). An overview of the psychological effects of physical attractiveness and some comments upon the psychological effects of knowledge of the effects of physical attractiveness. In W. Lucker, K. Ribbens, & J. A. McNamera (Eds.), *Logical aspects of facial form (craniofacial growth series).* Ann Arbor: University of Michigan Press.

Berscheid, E. (1985). Interpersonal attraction. In G. Lindzey & E. Aronson (Eds.), *The handbook of social psychology.* New York: Random House.

Berscheid, E., Boye, D., & Walster (Hatfield), E. (1968). Retaliation as a means of restoring equity. *Journal of Personality and Social Psychology, 10,* 370–376.

Berscheid, E., Dion, K., Walster (Hatfield), E., & Walster, G. W. (1971). Physical attractiveness and dating choice: A test of the matching hypothesis. *Journal of Experimental Social Psychology, 7,* 173–189.

Berscheid, E., Graziano, W., Monson, T., & Dermer, M. (1976). Outcome dependency: Attention, attribution, and attraction. *Journal of Personality and Social Psychology, 34,* 978–989.

Berscheid, E., & Peplau, L. A. (1983). The emerging science of relationships. In H. H. Kelley, E. Berscheid, A. Christensen, J. H. Harvey, T. L. Huston, G. Levinger, E. McClintock, L. A. Peplau, & D. R. Peterson (Eds.), *Close relationships.* New York: Freeman.

Berscheid, E., Snyder, M., & Omoto, A. M. (1989). Issues in studying close relationships: Conceptualizing and measuring closeness. In C. Hendrick (Ed.), *Review of personality and social psychology,* Vol. 10. Newbury Park, Ca.: Sage.

Berscheid, E., & Walster (Hatfield), E. (1978). *Interpersonal attraction.* Reading, Mass.: Addison-Wesley.

Berscheid, E., Walster, G. W., & Walster (Hatfield), E. (1978). Effects of accuracy and positivity of evaluation on liking for the evaluator. Unpublished manuscript, 1969. Summarized by E. Berscheid and E. Walster (Hatfield) in *Interpersonal attraction.* Reading, Mass.: Addison-Wesley.

Bersoff, D. N. (1987). Social science data and the Supreme Court: Lockhart as a case in point. *American Psychologist, 42,* 52–58.

Bickman, L. (1975). Bystander intervention in a crime: The effect of a mass-media campaign. *Journal of Applied Social Psychology, 5,* 296–302.

Bickman, L. (1979). Interpersonal influence and the reporting of a crime. *Personality and Social Psychology Bulletin, 5,* 32–35.

Bickman, L., & Green, S. K. (1977). Situational cues and crime reporting: Do signs make a difference? *Journal of Applied Social Psychology, 7,* 1–18.

Bickman, L., & Kamzan, M. (1973). The effect of race and need on helping behavior. *Journal of Social Psychology, 89,* 73–77.

Bickman, L., & Rosenbaum, D. P. (1977). Crime reporting as a function of bystander encouragement, surveillance, and credibility. *Journal of Personality and Social Psychology, 35,* 577–586.

Bierbrauer, G. (1979). Why did he do it? Attribution of obedience and the phenomenon of dispositional bias. *European Journal of Social Psychology 9,* 67–84.

Bierhoff, H. W., Klein, R., Kramp, P. (1991). Evidence for the altruistic personality from data on accident research. *Journal of Personality, 59,* 263–280.

Bierly, M. M. (1985). Prejudice toward contemporary outgroups as a generalized attitude. *Journal of Applied Social Psychology, 15,* 189–199.

Biernat, M. (1991). Gender stereotypes and the relationship between masculinity and femininity: A developmental analysis. *Journal of Personality and Social Psychology, 61,* 351–365.

Biernat, M., & Wortman, C. B. (1991). Sharing of home responsibilities between professionally employed women and their husbands. *Journal of Personality and Social Psychology, 60,* 844–860.

Bigam, R. G. (1981). Voir dire: The attorney's job. *Trial 13,* March 1977, p. 3. Cited by G. Bermant & J. Shepard in "The voir dire examination, juror challenges, and adversary advocacy." In B. D. Sales (Ed.), *Perspectives in law and psychology (Vol. II): The trial process.* New York: Plenum Press.

Billig, M., & Tajfel, H. (1973). Social categorization and similarity in intergroup behaviour. *European Journal of Social Psychology, 3,* 27–52.

Biner, P. M. (1991). Effects of lighting-induced arousal on the magnitude of goal valence. *Personality and Social Psychology Bulletin, 17,* 219–226.

Binham, R. (1980, March-April). Trivers in Jamaica. *Science 80,* pp. 57–67.

Bishop, G. D. (1991). Understanding the understanding of illness: Lay disease representations. In J. A. Skelton & R. T. Croyle (Eds.), *Mental representation in health and illness.* New York: Springer-Verlag.

Blackburn, R. T., Pellino, G. R., Boberg, A., & O'Connell, C. (1980). Are instructional improvement programs off target? *Current Issues in Higher Education, 1,* 31–48.

Blackstone, W. (1980). *Commentaries on the laws of England of public wrongs.* Boston: Beacon Press, 1972. (Originally published 1769). Cited by M. F. Kaplan and C. Schersching in "Reducing juror bias: An experimental approach." In P. D. Lipsitt & B. D. Sales (Eds.), *New directions in psychological research.* New York: Van Nostrand Reinhold.

Blair, S. L., & Lichter, D. T. (1991). Measuring the division of household labor: Gender segregation of housework among American couples. *Journal of Family Issues, 12,* 91–113.

Blake, R. R., & Mouton, J. S. (1962). The intergroup dynamics of win-lose conflict and problem-solving collaboration in union-management relations. In M. Sherif (Ed.), *Intergroup relations and leadership.* New York: Wiley.

Blake, R. R., & Mouton, J. S. (1979). Intergroup problem solving in organizations: From theory to practice. In W. G. Austin and S. Worchel (Eds.), *The social psychology of intergroup relations.* Monterey, Calif.: Brooks/Cole.

Blanchard, F. A., & Cook, S. W. (1976). Effects of helping a less competent member of a cooperating interracial group on the development of interpersonal attraction. *Journal of Personality and Social Psychology, 34,* 1245–1255.

Blanck, P. D., Rosenthal, R., & Cordell, L. H. (1985). The appearance of justice: Judges' verbal and nonverbal behavior in criminal jury trials. *Stanford Law Review, 38,* 89–164.

Blass, T. (1990). Psychological approaches to the Holocaust: Review and evaluation. Paper presented to the American Psychological Association convention.

Blass, T. (1991). Understanding behavior in the Milgram obedience experiment: The role of personality, situations, and their interactions. *Journal of Personality and Social Psychology, 60,* 398–413.

Block J., & Funder, D. C. (1986). Social roles and social perception: Individual differences in attribution and error. *Journal of Personality and Social Psychology, 51,* 1200–1207.

Blundell, W. E. (1986). *Storyteller step by step: A guide to better feature writing.* New York: Dow Jones. Cited by S. H. Stocking & P. H. Gross (1989), *How do journalists think? A proposal for the study of cognitive bias in newsmaking.* Bloomington, IN: ERIC Clearinghouse on Reading and Communication Skills, Smith Research Center, Indiana University.

Bodenhausen, G. V. (1988). Stereotypic biases in social decision making and memory: Testing process models of stereotype use. *Journal of Personality and Social Psychology, 55,* 726–737.

Bodenhausen, G. V. (1990). Stereotypes as judgmental heuristics: Evidence of circadian variations in discrimination. *Psychological Science, 1,* 319–322.

Boggiano, A. K., Barrett, M., Weiher, A. W., McClelland, G. H., & Lusk, C. M. (1987). Use of the maximal-operant principle to motivate children's intrinsic interest. *Journal of Personality and Social Psychology, 53,* 866–879.

Boggiano, A. K., Harackiewicz, J. M., Bessette, J. M., & Main, D. S. (1985). Increasing children's interest through performance-contingent reward. *Social Cognition, 3,* 400–411.

Boggiano, A. K., & Ruble, D. N. (1985). Children's responses to evaluative feedback. In R. Schwarzer (Ed.), *Self-related cognitions in anxiety and motivation.* Hillsdale, N.J.: Erlbaum.

Bohner, G., Bless, H., Schwarz, N., & Strack, F. (1988). What triggers causal attributions? The impact of valence and subjective probability. *European Journal of Social Psychology, 18,* 335–345.

Bolt, M., & Brink, J. (1991, November 1). Personal correspondence.

Bond, C. F., Jr., & Anderson, E. L. (1987). The reluctance to transmit bad news: Private discomfort or public display? *Journal of Experimental Social Psychology, 23,* 176–187.

Bond, C. F., Jr., DiCandia, C. G., & MacKinnon, J. R. (1988). Responses to violence in a psychiatric setting: The role of patient's race. *Personality and Social Psychology Bulletin, 14,* 448–458.

Bond, C. F., Jr., & Titus, L. J. (1983). Social facilitation: A meta-analysis of 241 studies. *Psychological Bulletin,* **94,** 265–292.

Bond, M. H. (1988). Finding universal dimensions of individual variation in multi-cultural studies of values: The Rokeach and Chinese Value Surveys. *Journal of Personality and Social Psychology,* **55,** 1009–1015.

Borchard, E. M. (1932). *Convicting the innocent: Errors of criminal justice.* New Haven: Yale University Press. Cited by E. R. Hilgard & E. F. Loftus (1979) "Effective interrogation of the eyewitness." *International Journal of Clinical and Experimental Hypnosis,* **17,** 342–359.

Borgida, E. (1981). Legal reform of rape laws. In L. Bickman (Ed.), *Applied social psychology annual.* Vol. 2. Beverly Hills, Calif.: Sage Publications, pp. 211–241.

Borgida, E., & Brekke, N. (1985). Psycholegal research on rape trials. In A. W. Burgess (Ed.), *Rape and sexual assault: A research handbook.* New York: Garland.

Borgida, E., Locksley, A., & Brekke, N. (1981). Social stereotypes and social judgment. In N. Cantor & J. Kihlstrom (Eds.), *Cognition, social interaction, and personality.* Hillsdale, N.J.: Lawrence Erlbaum.

Borgida, E., & White, P. (1980). Judgmental bias and legal reform. Unpublished manuscript, University of Minnesota.

Bornstein, G., & Rapoport, A. (1988). Intergroup competition for the provision of step-level public goods: Effects of preplay communication. *European Journal of Social Psychology,* **18,** 125–142.

Bornstein, G., Rapoport, A., Kerpel, L., & Katz, T. (1989). Within- and between-group communication in intergroup competition for public goods. *Journal of Experimental Social Psychology,* **25,** 422–436.

Bornstein, R. F. (1989). Exposure and affect: Overview and meta-analysis of research, 1968–1987. *Psychological Bulletin,* **106,** 265–289.

Bornstein, R. F., Kale, A. R., & Cornell, K. R. (1990). Boredom as a limiting condition on the mere exposure effect. *Journal of Personality and Social Psychology,* **58,** 791–800.

Bossard, J. H. S. (1932). Residential propinquity as a factor in marriage selection. *American Journal of Sociology,* **38,** 219–224.

Bothwell, R. K., Brigham, J. C., & Malpass, R. S. (1989). Cross-racial identification. *Personality and Social Psychology Bulletin,* **15,** 19–25.

Bothwell, R. K., Deffenbacher, K. A., & Brigham, J. C. (1987). Correlation of eyewitness accuracy and confidence: Optimality hypothesis revised. *Journal of Applied Psychology,* **72,** 691–695.

Bowen, E. (1988, April 4). What ever became of Honest Abe? *Time,* p. 68.

Bower, G. H. (1986). Prime time in cognitive psychology. In P. Eelen (Ed.), *Cognitive research and behavior therapy: Beyond the conditioning paradigm.* Amsterdam: North Holland Publishers.

Bower, G. H. (1987). Commentary on mood and memory. *Behavioral Research and Therapy,* **25,** 443–455.

Bower, G. H., & Masling, M. (1979). Causal explanations as mediators for remembering correlations. Unpublished manuscript, Stanford University.

Bradbury, T. N., & Fincham, F. D. (1990). Attributions in marriage: Review and critique. *Psychological Bulletin,* **107,** 3–33.

Bradley, W., & Mannell, R. C. (1984). Sensitivity of intrinsic motivation to reward procedure instructions. *Personality and Social Psychology Bulletin,* **10,** 426–431.

Brandon, R., & Davies, C. (1973). *Wrongful imprisonment: Mistaken convictions and their consequences.* Hamden, Conn.: Archon Books.

Bray, R. M., & Kerr, N. L. (1982). Methodological considerations in the study of the psychology of the courtroom. In N. L. Kerr & R. M. Bray (Eds.), *The psychology of the courtroom.* Orlando, Fla.: Academic Press.

Bray, R. M., & Noble, A. M. (1978). Authoritarianism and decisions of mock juries: Evidence of jury bias and group polarization. *Journal of Personality and Social Psychology,* **36,** 1424–1430.

Breckler, S. J., & Wiggins, E. C. (1989). Affect versus evaluation in the structure of attitudes. *Journal of Experimental Social Psychology,* **25,** 253–271.

Bregman, N. J., & McAllister, H. A. (1982). Eyewitness testimony: The role of commitment in increasing reliability. *Social Psychology Quarterly,* **45,** 181–184.

Brehm, J. W. (1956). Post-decision changes in desirability of alternatives. *Journal of Abnormal Social Psychology,* **52,** 384–389.

Brehm, S., & Brehm, J. W. (1981). *Psychological reactance: A theory of freedom and control.* New York: Academic Press.

Brehm, S. S., & Smith, T. W. (1986). Social psychological approaches to psychotherapy and behavior change. In S. L. Garfield & A. E. Bergin (Eds.), *Handbook of psychotherapy and behavior change,* 3rd ed. New York: Wiley.

Brenner, S. N., & Molander, E. A. (1977). Is the ethics of business changing? *Harvard Business Review,* January-February, pp. 57–71.

Bretl, D. J., & Cantor, J. (1988). The portrayal of men and women in U.S. television commercials: A recent content analysis and trends over 15 years. *Sex Roles,* **18,** 595–609.

Brewer, M. B. (1979). In-group bias in the minimal intergroup situation: A cognitive-motivational analysis. *Psychological Bulletin,* **86,** 307–324.

Brewer, M. B. (1987). Collective decisions. *Social Science,* **72,** 140–143.

Brewer, M. B. (1988). A dual process model of impression formation. In T. Srull & R. Wyer (Eds.), *Advances in social cognition,* Vol. 1. Hillsdale, N.J.: Erlbaum.

Brewer, M. B., & Lui, L. (1984). Categorization of the elderly by the elderly: Effects of perceiver's category membership. *Personality and Social Psychology Bulletin,* **10,** 585–595.

Brewer, M. B., & Miller, N. (1988). Contact and cooperation: When do they work? In P. A. Katz & D. Taylor (Eds.), *Towards the elimination of racism: Profiles in controversy.* New York: Plenum.

Brewer, M. B., & Silver, M. (1978). In-group bias as a function of task characteristics. *European Journal of Social Psychology,* **8,** 393–400.

Brickman, P. (1978). Is it real? In J. Harvey, W. Ickes, & R. Kidd (Eds.), *New directions in attribution research.* Vol. 2. Hillsdale, N.J.: Erlbaum.

Brickman, P., & Campbell, D. T. (1971). Hedonic relativism and planning the good society. In M. H. Appley (Ed.), *Adaptation-level theory.* New York: Academic Press.

Brickman, P., Coates, D., & Janoff-Bulman, R. J. (1978). Lottery winners and accident victims: Is happiness relative? *Journal of Personality and Social Psychology,* **36,** 917–927.

Brickner, M. A., Harkins, S. G., &

Ostrom, T. M. (1986). Effects of personal involvement: Thought-provoking implications for social loafing. *Journal of Personality and Social Psychology,* **51,** 763–769.

Brigham, J. C. (1990). Target person distinctiveness and attractiveness as moderator variables in the confidence-accuracy relationship in eyewitness identifications. *Basic and Applied Social Psychology,* **11,** 101–115.

Brigham, J. C., & Cairns, D. L. (1988). The effect of mugshot inspections on eyewitness identification accuracy. *Journal of Applied Social Psychology,* **18,** 1394–1410.

Brigham, J. C., & Malpass, R. S. (1985). The role of experience and contact in the recognition of faces of own- and other-race persons. *Journal of Social Issues,* **41,** 139–155.

Brigham, J. C., Ready, D. J., & Spier, S. A. (1990). Standards for evaluating the fairness of photograph lineups. *Basic and Applied Social Psychology,* **11,** 149–163.

Brigham, J. C., & Williamson, N. L. (1979). Cross-racial recognition and age: When you're over 60, do they still all look alike? *Personality and Social Psychology Bulletin,* **5,** 218–222.

British Psychological Society (1991). *Code of conduct ethical principles & guidelines.* Leicester.

Brock, T. C. (1965). Communicator-recipient similarity and decision change. *Journal of Personality and Social Psychology,* **1,** 650–654.

Brock, T. C., & Brannon, L. A. (1991, April 4). Tobacco ad warning should be shocking (letter). *Wall Street Journal.*

Brockner, J., & Hulton, A. J. B. (1978). How to reverse the vicious cycle of low self-esteem: The importance of attentional focus. *Journal of Experimental Social Psychology,* **14,** 564–578.

Brockner, J., Rubin, J. Z., Fine, J., Hamilton, T. P., Thomas, B., & Turetsky, B. (1982). Factors affecting entrapment in escalating conflicts: The importance of timing. *Journal of Research in Personality,* **16,** 247–266.

Brodt, S. E., & Zimbardo, P. G. (1981). Modifying shyness-related social behavior through symptom misattribution. *Journal of Personality and Social Psychology,* **41,** 437–449.

Bronfenbrenner, U. (1961). The mirror image in Soviet-American relations. *Journal of Social Issues,* **17**(3), 45–56.

Brook, P. (1969). Filming a masterpiece. *Observer Weekend Review,* July 26, 1964. Cited by L. Tiger in *Men in groups.* New York: Random House, p. 163.

Brown, D. (1971). *Bury my heart at Wounded Knee.* New York: Holt, Rinehart, & Winston.

Brown, J. D. (1986). Evaluations of self and others: Self-enhancement biases in social judgments. *Social Cognition,* **4,** 353–376.

Brown, J. D. (1990). Evaluating one's abilities: Shortcuts and stumbling blocks on the road to self-knowledge. *Journal of Experimental Social Psychology,* **26,** 149–167.

Brown, J. D. (1991). Accuracy and bias in self-knowledge: Can knowing the truth be hazardous to your health? In C. R. Snyder & D. F. Forsyth (Eds.), *Handbook of social and clinical psychology: The health perspective.* New York: Pergamon Press.

Brown, J. D., Collins, R. L., & Schmidt, G. W. (1988). Self-esteem and direct versus indirect forms of self-enhancement. *Journal of Personality and Social Psychology,* **55,** 445–453.

Brown, J. D., Novick, N. J., Lord, K. A., & Richards, J. M. (1992). When Gulliver travels: Social context, psychological closeness, and self-appraisals. *Journal of Personality and Social Psychology,* **62,** 717–727.

Brown, J. D., & Rogers, R. J. (1991). Self-serving attributions: The role of physiological arousal. *Personality and Social Psychology Bulletin,* **17,** 501–506.

Brown, J. D., & Siegel, J. M. (1988). Attributions for negative life events and depression: The role of perceived control. *Journal of Personality and Social Psychology,* **54,** 316–322.

Brown, J. D., & Taylor, S. E. (1986). Affect and the processing of personal information: Evidence for mood-activated self-schemata. *Journal of Experimental Social Psychology,* **22,** 436–452.

Brown, R. (1965). *Social psychology.* New York: Free Press.

Brown, R., & Smith, A. (1989). Perceptions of and by minority groups: The case of women in academia. *European Journal of Social Psychology,* **19,** 61–75.

Brownmiller, S. (1980). Comments on the "pornography and aggression" symposium at the American Psychological Association convention.

Brownmiller, S. (1984, November). Comments in debate on "The place of pornography," *Harper's,* pp. 31–45.

Bruck, C. (1976, April). Zimbardo: Solving the maze. *Human Behavior,* pp. 25–31.

Bryan, J. H., & Test, M. A. (1967). Models and helping: Naturalistic studies in aiding behavior. *Journal of Personality and Social Psychology,* **6,** 400–407.

Buckhout, R. (1974, December). Eyewitness testimony. *Scientific American,* pp. 23–31.

Bulletin of the Atomic Scientists (1991, May). Nuclear pursuits. P. 49.

Bundy, T. (1989, January 25). Interview with James Dobson. *Detroit Free Press,* pp. 1A, 5A.

Burchill, S. A. L., & Stiles, W. B. (1988). Interactions of depressed college students with their roommates: Not necessarily negative. *Journal of Personality and Social Psychology,* **55,** 410–419.

Burger, J. M. (1986). Temporal effects on attributions: Actor and observer differences. *Social Cognition,* **4,** 377–387.

Burger, J. M. (1987). Increased performance with increased personal control: A self-presentation interpretation. *Journal of Experimental Social Psychology,* **23,** 350–360

Burger, J. M. (1991). Changes in attributions over time: The ephemeral fundamental attribution error. *Social Cognition,* **9,** 182–193.

Burger, J. M., & Burns, L. (1988). The illusion of unique invulnerability and the use of effective contraception. *Personality and Social Psychology Bulletin,* **14,** 264–270.

Burger, J. M., & Palmer, M. L. (1991). Changes in and generalization of unrealistic optimism following experiences with stressful events: Reactions to the 1989 California earthquake. *Personality and Social Psychology Bulletin,* **18,** 39–43.

Burger, J. M., & Pavelich, J. L. (1991). Attributions for presidential elections: The situational shift over time. Unpublished manuscript, Santa Clara University.

Burgess, R. L., & Huston, T. L. (Eds.) (1979). *Social exchange in developing relationships.* New York: Academic Press.

Burns, D. D. (1980). *Feeling good: The new mood therapy.* New York: Signet.

Burnstein, E., & Kitayama, S. (1989). Persuasion in groups. In T. C. Brock & S. Shavitt (Eds.), *The psychology of persuasion.* San Francisco: Freeman.

Burnstein, E., & Vinokur, A. (1977). Persuasive argumentation and social

comparison as determinants of attitude polarization. *Journal of Experimental Social Psychology, 13,* 315–332.

Burnstein, E., & Worchel, P. (1962). Arbitrariness of frustration and its consequences for aggression in a social situation. *Journal of Personality, 30,* 528–540.

Burr, W. R. (1973). *Theory construction and the sociology of the family.* New York: Wiley.

Burros, M. (1988, February 24). Women: Out of the house but not out of the kitchen. *New York Times.*

Burton, J. W. (1969). *Conflict and communication.* New York: Free Press.

Bushman, B. J., & Cooper, H. M. (1990). Effects of alcohol on human aggression: An integrative research review. *Psychological Review, 107,* 341–354.

Bushman, B. J., & Geen, R. G. (1990). Role of cognitive-emotional mediators and individual differences in the effects of media violence on aggression. *Journal of Personality and Social Psychology, 58,* 156–163.

Buss, D. M. (1984). Toward a psychology of person-environment (PE) correlation: The role of spouse selection. *Journal of Personality and Social Psychology, 47,* 361–377.

Buss, D. M. (1985). Human mate selection. *American Scientist, 73,* 47–51.

Buss, D. M. (1987). Sex differences in human mate selection criteria: An evolutionary perspective. In C. Crawford, M. Smith, & D. Krebs (Eds.), *Sociobiology and psychology: Issues, ideas, and findings.* Hillsdale, N.J.: Erlbaum.

Buss, D. M. (1988). The evolution of human intrasexual competition: Tactics of mate attraction. *Journal of Personality and Social Psychology, 54,* 616–628.

Buss, D. M. (1989). Sex differences in human mate preferences: Evolutionary hypotheses tested in 37 cultures. *Behavioral and Brain Sciences, 12,* 1–49.

Buss, D. M. (1991). Evolutionary personality psychology. *Annual Review of Psychology.* Palo Alto: CA: Annual Reviews, Inc.

Butcher, S. H. (1951). *Aristotle's theory of poetry and fine art.* New York: Dover Publications.

Buunk, B. P., & Van Yperen, N. W. (1991). Referential comparisons, relational comparisons, and exchange orientation: Their relation to marital satisfaction. *Personality and Social Psychology Bulletin, 17,* 709–717.

Byrne, D. (1971). *The attraction paradigm.* New York: Academic Press.

Byrne, D., & Clore, G. L. (1970). A reinforcement model of evaluative responses. *Personality: An International Journal, 1,* 103–128.

Byrne, D., & Nelson, D. (1965). Attraction as a linear function of proportion of positive reinforcements. *Journal of Personality and Social Psychology, 1,* 659–663.

Byrne, D., & Wong, T. J. (1962). Racial prejudice, interpersonal attraction, and assumed dissimilarity of attitudes. *Journal of Abnormal and Social Psychology, 65,* 246–253.

Bytwerk, R. L. (1976). Julius Streicher and the impact of *Der Stürmer. Wiener Library Bulletin, 29,* 41–46.

Bytwerk, R. L., & Brooks, R. D. (1980). Julius Streicher and the rhetorical foundations of the holocaust. Paper presented to the Central States Speech Association convention.

Cacioppo, J. T., Claiborn, C. D., Petty, R. E., & Heesacker, M. (1991). General framework for the study of attitude change in psychotherapy. In C. R. Snyder & D. R. Forsyth (Eds.), *Handbook of social and clinical psychology.* New York: Pergamon.

Cacioppo, J. T., & Petty, R. E. (1986). Social processes. In M. G. H. Coles, E. Donchin, & S. W. Porges (Eds.), *Psychophysiology.* New York: Guilford Press.

Cacioppo, J. T., Petty, R. E., Kao, C. F., & Rodriguez, R. (1986). Central and peripheral routes to persuasion: An individual difference perspective. *Journal of Personality and Social Psychology, 51,* 1032–1043.

Cacioppo, J. T., Petty, R. E., & Morris, K. J. (1983). Effects of need for cognition on message evaluation, recall, and persuasion. *Journal of Personality and Social Psychology, 45,* 805–818.

Cacioppo, J. T., Tassinary, L. G., Stonebraker, T. B., & Petty, R. E. (1987). Self-report and cardiovascular measures of arousal fractionation during residual arousal. *Biological Psychology, 25,* 1–17.

Cacioppo, J. T., Uchino, B. N., Crites, S. L., Snydersmith, M. A., Smith, G., Berntson, G. G., & Lang, P. J. (1991). Relationship between facial expressiveness and sympathetic activation in emotion: A critical review, with emphasis on modeling underlying mechanisms and individual differences. *Jour-*

nal of Personality and Social Psychology, 62, 110–128.

Calhoun, J. B. (1962, February). Population density and social pathology. *Scientific American,* pp. 139–148.

Callero, P. L., & Piliavin, J. A. (1983). Developing a commitment to blood donation: The impact of one's first experience. *Journal of Applied Social Psychology, 13,* 1–16.

Campbell, D. T. (1975). On the conflicts between biological and social evolution and between psychology and oral tradition. *American Psychologist, 30,* 1103–1126. *(b)*

Campbell, D. T. (1975). The conflict between social and biological evolution and the concept of original sin. *Zygon, 10,* 234–249. *(a)*

Campbell, E. Q., & Pettigrew, T. F. (1959). Racial and moral crisis: The role of Little Rock ministers. *American Journal of Sociology, 64,* 509–516.

Cann, A., Calhoun, L. G., & Selby, J. W. (1979). Attributing responsibility to the victim of rape: Influence of information regarding past sexual experience. *Human Relations, 32,* 57–67.

Cantril, H., & Bumstead, C. H. (1960). *Reflections on the human venture.* New York: New York University Press.

Caplan, N. (1970). The new ghetto man: A review of recent empirical studies. *Journal of Social Issues, 26,* 59–73.

Carducci, B. J., Cosby, P. C., & Ward, D. D. (1978). Sexual arousal and interpersonal evaluations. *Journal of Experimental Social Psychology, 14,* 449–457.

Carli, L. L. (1991). Gender, status, and influence. In E. J. Lawler & B. Markovsky (Ed.), *Advances in group processes: Theory and research,* vol. 8. Greenwich, CT: JAI Press.

Carli, L. L., Columbo, J., Dowling, S., Kulis, M., & Minalga, C. (1990). Victim derogation as a function of hindsight and cognitive bolstering. Paper presented at the American Psychological Association convention.

Carli, L. L., & Leonard, J. B. (1989). The effect of hindsight on victim derogation. *Journal of Social and Clinical Psychology, 8,* 331–343.

Carlo, G., Eisenberg, N., Troyer, D., Switzer, G., & Speer, A. L. (1991). The altruistic personality: In what contexts is it apparent? *Journal of Personality and Social Psychology, 61,* 450–458.

Carlsmith, J. M., & Anderson, C. A.

(1979). Ambient temperature and the occurrence of collective violence: A new analysis. *Journal of Personality and Social Psychology, 37,* 337–344.

Carlsmith, J. M., Ellsworth, P., & Whiteside, J. (1978). Guilt, confession and compliance. Unpublished manuscript, Stanford University, 1968. Cited by J. L. Freeman, D. O. Sears, & J. M. Carlsmith in *Social psychology.* Englewood Cliffs, N.J.: Prentice-Hall, pp. 275–276.

Carlsmith, J. M., & Gross, A. E. (1969). Some effects of guilt on compliance. *Journal of Personality and Social Psychology, 11,* 232–239.

Carlson, J., & Hatfield, E. (1992). *The psychology of emotion.* Fort Worth, TX: Holt, Rinehart & Winston.

Carlson, J., & Miller, N. (1987). Explanation of the relation between negative mood and helping. *Psychological Bulletin, 102,* 91–108.

Carlson, M., Charlin, V., & Miller, N. (1988). Positive mood and helping behavior: A test of six hypotheses. *Journal of Personality and Social Psychology, 55,* 211–229.

Carlson, M., Marcus-Newhall, A., & Miller, N. (1990). Effects of situational aggression cues: A quantitative review. *Journal of Personality and Social Psychology, 58,* 622–633.

Carlson, S. (1985). A double-blind test of astrology. *Nature, 318,* 419–425.

Carlston, D. E., & Shovar, N. (1983). Effects of performance attributions on others' perceptions of the attributor. *Journal of Personality and Social Psychology, 44,* 515–525.

Cartwright, D. S. (1975). The nature of gangs. In D. S. Cartwright, B. Tomson, & H. Schwartz (Eds.), *Gang delinquency.* Monterey, Calif.: Brooks/Cole.

Carver, C. S., & Scheier M. F. (1978). Self-focusing effects of dispositional self-consciousness, mirror presence, and audience presence. *Journal of Personality and Social Psychology, 36,* 324–332.

Carver, C. S., & Scheier, M. F. (1981). *Attention and self-regulation.* New York: Springer-Verlag.

Carver, C. S., & Scheier, M. F. (1986). Analyzing shyness: A specific application of broader self-regulatory principles. In W. H. Jones, J. M. Cheek, & S. R. Briggs (Eds.), *Shyness: Perspectives on research and treatment.* New York: Plenum.

Cash, T. F. (1981). Physical attractiveness: An annotated bibliography of theory and research in the behavioral sciences (Ms. 2370). *Catalog of Selected Documents in Psychology, 11,* 83.

Cash, T. F., & Janda, L. H. (1984, December). The eye of the beholder. *Psychology Today,* pp. 46–52.

Caspi, A., & Herbener, E. S. (1990). Continuity and change: Assortative marriage and the consistency of personality in adulthood. *Journal of Personality and Social Psychology, 58,* 250–258.

Cass, R. C., & Edney, J. J. (1978). The commons dilemma: A simulation testing the effects of resource visibility and territorial division. *Human Ecology, 6,* 371–386.

Castro, J. (1990, Fall issue on women). Get set: Here they come. *Time.* Pp. 50–52.

Ceci, S. J., & Peters, D. (1984). Letters of reference: A naturalistic study of the effects of confidentiality. *American Psychologist, 39,* 29–31.

Ceci, S. J., Toglia, M. P., & Ross, D. F. (1987). *Children's eyewitness memory.* New York: Springer-Verlag.

Centerwall, B. S. (1989). Exposure to television as a risk factor for violence. *American Journal of Epidemiology, 129,* 643–652.

Chagnon, N. A. (1988). Life histories, blood revenge, and warfare in a tribal population. *Science, 239,* 985–991.

Chaiken, S. (1979). Communicator physical attractiveness and persuasion. *Journal of Personality and Social Psychology, 37,* 1387–1397.

Chaiken, S. (1980). Heuristic versus systematic information processing and the use of source versus message cues in persuasion. *Journal of Personality and Social Psychology, 39,* 752–766.

Chaiken, S. (1987). The heuristic model of persuasion. In M. P. Zanna, J. M. Olson, & C. P. Herman (Eds.), *Social influence: The Ontario symposium,* Vol. 5. Hillsdale, N.J.: Erlbaum.

Chaiken, S., & Eagly, A. H. (1976). Communication modality as a determinant of message persuasiveness and message comprehensibility. *Journal of Personality and Social Psychology, 34,* 605–614.

Chaiken, S., & Eagly, A. H. (1983). Communication modality as a determinant of persuasion: The role of communicator salience. *Journal of Personality and Social Psychology, 45,* 241–256.

Chan, V., & Momparler, M. (1991, May/June). George Bush's report card. *Mother Jones,* pp. 44–46.

Chance, J. E. (1985). Faces, folklore, and research hypotheses. Presidential address to the Midwestern Psychological Association convention.

Chance, J. E., & Goldstein, A. G. (1981). Depth of processing in response to own- and other-race faces. *Personality and Social Psychology Bulletin, 7,* 475–480.

Chapman, L. J., & Chapman, J. P. (1969). Genesis of popular but erroneous psychodiagnostic observations. *Journal of Abnormal Psychology, 74,* 272–280.

Chapman, L. J., & Chapman, J. P. (1971, November). Test results are what you think they are. *Psychology Today,* pp. 18–22, 106–107.

Charny, I. W. (1982). *How can we commit the unthinkable? Genocide: The human cancer.* Boulder, Co.: Westview Press.

Check, J., & Malamuth, N. (1984). Can there be positive effects of participation in pornography experiments? *Journal of Sex Research, 20,* 14–31.

Check, J. M., & Melchior, L. A. (1990). Shyness, self-esteem, and self-consciousness. In H. Leitenberg (Ed.), *Handbook of social and evaluation anxiety.* New York: Plenum.

Chen, S. C. (1937). Social modification of the activity of ants in nest-building. *Physiological Zoology, 10,* 420–436.

Cherry, F. (1991). *The stubborn particulars of social psychology.* London: Routledge.

Chickering, A. W., & McCormick, J. (1973). Personality development and the college experience. *Research in Higher Education,* No. 1, 62–64.

Chodorow, N. J. (1978). *The reproduction of mother: Psychoanalysis and the sociology of gender.* Berkeley, CA: University of California Press.

Chodorow, N. J. (1989). *Feminism and psychoanalytic theory.* New Haven, CT: Yale University Press.

Christensen, L. (1988). Deception in psychological research: When is its use justified? *Personality and Social Psychology Bulletin, 14,* 664–675.

Christian, J. J., Flyger, V., & Davis, D. E. (1960). Factors in the mass mortality of a herd of sika deer, *Cervus Nippon. Chesapeake Science, 1,* 79–95.

Church, G. J. (1986, January 6). China. *Time,* pp. 6–19.

Chwalisz, K., Diener, E., & Gallagher, D. (1988). Autonomic arousal feedback

and emotional experience: Evidence from the spinal cord injured. *Journal of Personality and Social Psychology, 54,* 820–828.

Cialdini, R. B. (1984). *Influence: How and why people agree to things.* New York: William Morrow.

Cialdini, R. B. (1988). *Influence: Science and practice.* Glenview, Il.: Scott, Foresman/Little, Brown.

Cialdini, R. B. (1991). Altruism or egoism? That is (still) the question. *Psychological Inquiry, 2,* 124–126.

Cialdini, R. B., Bickman, L., & Cacioppo, J. T. (1979). An example of consumeristic social psychology: Bargaining tough in the new car showroom. *Journal of Applied Social Psychology, 9,* 115–126.

Cialdini, R. B., Borden, R. J. Thorne, A., Walker, M. R., Freeman, S., & Sloan, L. R. (1976). Basking in reflected glory: Three (football) field studies. *Journal of Personality and Social Psychology, 39,* 406–415.

Cialdini, R. B., Cacioppo, J. T., Bassett, R., & Miller, J. A. (1978). Lowball procedure for producing compliance: Commitment then cost. *Journal of Personality and Social Psychology, 36,* 463–476.

Cialdini, R. B., Darby, B. L., & Vincent, J. E. (1973). Transgression and altruism: A case for hedonism. *Journal of Experimental Social Psychology, 9,* 502–516.

Cialdini, R. B., Green, B. L., & Rusch, A. J. (1992). When tactical pronouncements of change become real change: The case of reciprocal persuasion. *Journal of Personality and Social Psychology,* in press.

Cialdini, R. B., Kallgren, C. A., & Reno, R. R. (1991). A focus theory of normative conduct: A theoretical refinement and reevaluation of the role of norms in human behavior. *Advances in Experimental Social Psychology, 24,* 201–234.

Cialdini, R. B., & Kenrick, D. T. (1976). Altruism as hedonism: A social development perspective on the relationship of negative mood state and helping. *Journal of Personality and Social Psychology, 34,* 907–914.

Cialdini, R. B., Kenrick, D. T., & Baumann, D. J. (1981). Effects of mood on prosocial behavior in children and adults. In N. Eisenberg-Berg (Ed.), *The development of prosocial behavior.* New York: Academic Press.

Cialdini, R. B., & Richardson, K. D. (1980). Two indirect tactics of image management: Basking and blasting. *Journal of Personality and Social Psychology, 39,* 406–415.

Cialdini, R. B., & Schroeder D. A. (1976). Increasing compliance by legitimizing paltry contributions: When even a penny helps. *Journal of Personality and Social Psychology, 34,* 599–604.

Cialdini, R. B., Vincent, J. E., Lewis, S. K., Catalan, J., Wheeler, D., & Danby, B. L. (1975). Reciprocal concessions procedure for inducing compliance: The door-in-the-face technique. *Journal of Personality and Social Psychology, 31,* 206–215.

Clark, K., & Clark, M. (1947). Racial identification and preference in Negro children. In T. M. Newcomb & E. L. Hartley (Eds.), *Readings in social psychology.* New York: Holt.

Clark, M. S. (1984). Record keeping in two types of relationships. *Journal of Personality and Social Psychology, 47,* 549–557.

Clark, M. S. (1986). Evidence for the effectiveness of manipulations of desire for communal versus exchange relationships. *Personality and Social Psychology Bulletin, 12,* 414–425.

Clark, M. S., & Bennett, M. E. (1992). Research on relationships: Implications for mental health. In D. Ruble, P. Costanzo, & M. Oliveri (eds.), *Basic social psychological processes in mental health.* New York: Guilford, in press.

Clark, M. S., & Mills, J. (1979). Interpersonal attraction in exchange and communal relationships. *Journal of Personality and Social Psychology, 37,* 12–24.

Clark, M. S., Mills, J., & Corcoran, D. (1989). Keeping track of needs and inputs of friends and strangers. *Personality and Social Psychology Bulletin, 15,* 533–542.

Clark, M. S., Mills, J., & Powell, M. C. (1986). Keeping track of needs in communal and exchange relationships. *Journal of Personality and Social Psychology, 51* 333–338.

Clark, R. D., III (1974). Effects of sex and race on helping behavior in a nonreactive setting. *Representative Research in Social Psychology, 5,* 1–6.

Clark, R. D., III, & Maass, A. (1990). The effects of majority size on minority influence. *European Journal of Social Psychology, 20,* 99–117.

Clark, R. D., III, & Maass, S. A. (1988). The role of social categorization and perceived source credibility in minority influence. *European Journal of Social Psychology, 18,* 381–394.

Clark, R. D., III, & Maass, S. A. (1988). Social categorization in minority influence: The case of homosexuality. *European Journal of Social Psychology, 18,* 347–364.

Clarke, A. C. (1952). An examination of the operation of residual propinquity as a factor in mate selection. *American Sociological Review, 27,* 17–22.

Clary, E. G., & Snyder, M. (1991). A functional analysis of altruism and prosocial behavior: The case of volunteerism. In M. Clark (Ed.), *Prosocial behavior.* Newbury Park, CA: Sage.

Cleghorn, R. (1980, October 31). ABC News, meet the Literary Digest. *Detroit Free Press.*

Clifford, M. M., & Walster, E. H. (1973). The effect of physical attractiveness on teacher expectation. *Sociology of Education, 46,* 248–258.

Cline, V. B., Croft, R. G., & Courrier, S. (1973). Desensitization of children to television violence. *Journal of Personality and Social Psychology, 27,* 360–365.

Clore, G. L., Bray, R. M., Itkin, S. M., & Murphy, P. (1978). Interracial attitudes and behavior at a summer camp. *Journal of Personality and Social Psychology, 36,* 107–116.

Clore, G. L., Wiggins, N. H., & Itkin, G. (1975). Gain and loss in attraction: Attributions from nonverbal behavior. *Journal of Personality and Social Psychology, 31,* 706–712.

Coates, B., Pusser, H. E., & Goodman, I. (1976). The influence of "Sesame Street" and "Mister Rogers' Neighborhood" on children's social behavior in the preschool. *Child Development, 47,* 138–144.

Codol, J.-P. (1976). On the so-called superior conformity of the self behavior: Twenty experimental investigations. *European Journal of Social Psychology, 5,* 457–501.

Cohen, B., Waugh, G., & Place, K. (1989). At the movies: An unobtrusive study of arousal attraction. *Journal of Social Psychology, 129,* 691–693.

Cohen, D. (1980, March). Familiar faces at the British psychology society meeting. *APA Monitor,* p. 13.

Cohen, E. G. (1980). A multi-ability approach to the integrated classroom.

Paper presented at the American Psychological Association convention. *(b)*

Cohen, E. G. (1980). Design and redesign of the desegregated school: Problems of status, power and conflict. In W. G. Stephan & J. R. Feagin (Eds.), *School desegregation: Past, present, and future.* New York: Plenum Press. *(a)*

Cohen, M., & Davis, N. (1981). *Medication errors: Causes and prevention.* Philadelphia: G. F. Stickley Co. Cited by R. B. Cialdini (1989). Agents of influence: Bunglers, smugglers, and sleuths. Paper presented at the American Psychological Association convention.

Cohen, S. (1980). Training to understand TV advertising: Effects and some policy implications. Paper presented at the American Psychological Association convention.

Cohen, S., & Williamson, G. M. (1991). Stress and infectious disease in humans. *Psychological Bulletin, 109,* 5–24.

Colasanto, D. (1989, November). Americans show commitment to helping those in need. *Gallup Report,* No. 290, pp. 17–24.

Cole, D. L. (1982). Psychology as a liberating art. *Teaching of Psychology, 9,* 23–26.

Coleman, L. M., Jussim, L., & Abraham, J. (1987). Students' reactions to teachers' evaluations: The unique impact of negative feedback. *Journal of Applied Social Psychology, 17,* 1051–1070.

Colman, A. M. (1991). Crowd psychology in South African murder trials. *American Psychologist, 46,* 1071–1079. See also, A. M. Colman (1991), Psychological evidence in South African murder trials. *The Psychologist, 14,* 482–486.

Condon, J. W., & Crano, W. D. (1988). Inferred evaluation and the relation between attitude similarity and interpersonal attraction. *Journal of Personality and Social Psychology, 54,* 789–797.

Converse, P. E., & Traugott, M. W. (1986). Assessing the accuracy of polls and surveys. *Science, 234,* 1094–1098.

Conway, F., & Siegelman, J. (1979). *Snapping: America's epidemic of sudden personality change.* New York: Delta Books.

Conway, M., & Ross, M. (1984). Getting what you want by revising what you had. *Journal of Personality and Social Psychology, 47,* 738–748.

Conway, M., & Ross, M. (1985). Remembering one's own past: The construction of personal histories. In R. Sorrentino & E. T. Higgins (Eds.), *Handbook of motivation and cognition.* New York: Guilford.

Cook, S. W. (1985). Experimenting on social issues: The case of school desegregation. *American Psychologist, 40,* 452–460.

Cook, T. D., & Curtin, T. R. (1987). The mainstream and the underclass: Why are the differences so salient and the similarities so unobtrusive? In J. C. Masters & W. P. Smith (Eds.), *Social comparison, social justice, and relative deprivation: Theoretical, empirical, and policy perspectives.* Hillsdale, N.J.: Erlbaum.

Cook, T. D., & Flay, B. R. (1978). The persistence of experimentally induced attitude change. In L. Berkowitz (Ed.), *Advances in experimental social psychology.* Vol. 11. New York: Academic Press.

Cooper, H. (1983). Teacher expectation effects. In L. Bickman (Ed.), *Applied social psychology annual,* Vol. 4. Beverly Hills, Ca.: Sage.

Cooper, J., & Fazio, R. H. (1984). A new look at dissonance theory. In L. Berkowitz (Ed.), *Advances in experimental social psychology,* Vol. 17. New York: Academic Press.

Cota, A. A., & Dion, K. L. (1986). Salience of gender and sex composition of ad hoc groups: An experimental test of distinctiveness theory. *Journal of Personality and Social Psychology, 50,* 770–776.

Cotton, J. L. (1981). Ambient temperature and violent crime. Paper presented at the Midwestern Psychological Association convention.

Cotton, J. L. (1986). Ambient temperature and violent crime. *Journal of Applied Social Psychology, 16,* 786–801.

Cottrell, N. B., Wack, D. L., Sekerak, G. J., & Rittle, R. M. (1968). Social facilitation of dominant responses by the presence of an audience and the mere presence of others. *Journal of Personality and Social Psychology, 9,* 245–250.

Court, J. H. (1985). Sex and violence: A ripple effect. In N. M. Malamuth & E. Donnerstein (Eds.), *Pornography and sexual aggression.* New York: Academic Press.

Cousins, N. (1978, September 16). The taxpayers revolt: Act two. *Saturday Review,* p. 56.

Cousins, N. (1989). *Head first: The biology of hope.* New York: Dutton.

Cousins, S. D. (1989). Culture and self-perception in Japan and the United States. *Journal of Personality and Social Psychology, 56,* 124–131.

Coyne, J. C., Burchill, S. A. L., & Stiles, W. B. (1991). In C. R. Snyder & D. O. Forsyth (Eds.), *Handbook of social and clinical psychology: The health perspective.* New York: Pergamon.

Craig, M. E. (1990). Coercive sexuality in dating relationships: A situational model. *Clinical Psychology Review, 10,* 395–423.

Cramer, R. E., McMaster, M. R., Bartell, P. A., & Dragna, M. (1988). Subject competence and minimization of the bystander effect. *Journal of Applied Social Psychology, 18,* 1133–1148.

Crandall, C. S. (1988). Social contagion of binge eating. *Journal of Personality and Social Psychology, 55,* 588–598.

Crano, W. D., & Mellon, P. M. (1978). Causal influence of teachers' expectations on children's academic performance: A cross-legged panel analysis. *Journal of Educational Psychology, 70,* 39–49.

Crawford, T. J. (1974). Sermons on racial tolerance and the parish neighborhood context. *Journal of Applied Social Psychology, 4,* 1–23.

Crocker, J. (1981). Judgment of covariation by social perceivers. *Psychological Bulletin, 90,* 272–292.

Crocker, J., & Gallo, L. (1985). The self-enhancing effect of downward comparison. Paper presented at the American Psychological Association convention.

Crocker, J., Hannah, D. B., & Weber, R. (1983). Personal memory and causal attributions. *Journal of Personality and Social Psychology, 44,* 55–56.

Crocker, J., & Luhtanen, R. (1990). Collective self-esteem and ingroup bias. *Journal of Personality and Social Psychology, 58,* 60–67.

Crocker, J., & McGraw, K. M. (1984). What's good for the goose is not good for the gander: Solo status as an obstacle to occupational achievement for males and females. *American Behavioral Scientist, 27,* 357–370.

Crocker, J., & Park, B. (1985). The consequences of social stereotypes. Unpublished manuscript, Northwestern University.

Crocker, J., Thompson, L. L., McGraw, K. M., & Ingerman, C. (1987). Downward comparison, prejudice,

and evaluations of others: Effects of self-esteem and threat. *Journal of Personality and Social Psychology*, **52**, 907–916.

Crosby, F., Bromley, S., & Saxe, L. (1980). Recent unobtrusive studies of black and white discrimination and prejudice: A literature review. *Psychological Bulletin*, **87**, 546–563.

Crosby, F., Pufall, A., Snyder, R. C., O'Connell, M., & Whalen, P. (1989). The denial of personal disadvantage among you, me, and all the other ostriches. In M. Crawford & M. Gentry (Eds.), *Gender and thought*. New York: Springer-Verlag.

Cross, P. (1977). Not *can* but *will* college teaching be improved? *New Directions for Higher Education*, Spring, No. 17, pp. 1–15.

Croxton, J. S., Eddy, T., & Morrow, N. (1984). Memory biases in the reconstruction of interpersonal encounters. *Journal of Social and Clinical Psychology*, **2**, 348–354.

Croxton, J. S., & Miller, A. G. (1987). Behavioral disconfirmation and the observer bias. *Journal of Social Behavior and Personality*, **2**, 145–152.

Croxton, J. S., & Morrow, N. (1984). What does it take to reduce observer bias? *Psychological Reports*, **55**, 135–138.

Croyle, R. T., & Cooper, J. (1983). Dissonance arousal: Physiological evidence. *Journal of Personality and Social Psychology*, **45**, 782–791.

Crutchfield, R. A. (1955). Conformity and character. *American Psychologist*, **10**, 191–198.

Cunningham, J. D. (1981). Self-disclosure intimacy: Sex, sex-of-target, cross-national, and generational differences. *Personality and Social Psychology Bulletin*, **7**, 314–319.

Cunningham, M. R. (1986). Measuring the physical in physical attractiveness: Quasi-experiments on the sociobiology of female facial beauty. *Journal of Personality and Social Psychology*, **50**, 925–935.

Cunningham, M. R. (1988). Does happiness mean friendliness? Induced mood and heterosexual self-disclosure. *Personality and Social Psychology Bulletin*, **14**, 283–297.

Cunningham, M. R. (1991). A psycho-evolutionary, multiple-motive interpretation of physical attractiveness. Paper presented at the American Psychological Association convention.

Cunningham, M. R., Shaffer, D. R., Barbee, A. P., Wolff, P. L., & Kelley, D. J. (1990). Separate processes in the relation of elation and depression to helping: Social versus personal concerns. *Journal of Experimental Social Psychology*, **26**, 13–33.

Cunningham, M. R., Steinberg, J., & Grev, R. (1980). Wanting to and having to help: Separate motivations for positive mood and guilt-induced helping. *Journal of Personality and Social Psychology*, **38**, 181–192.

Curry, T. J., & Emerson, R. M. (1970). Balance theory: A theory of interpersonal attraction? *Sociometry*, **33**, 216–238.

Curtis, R. C., & Miller, K. (1986). Believing another likes or dislikes you: Behaviors making the beliefs come true. *Journal of Personality and Social Psychology*, **51**, 284–290.

Cutler, B. L., Fisher, R. P., & Chicvara, C. L. (1989). Eyewitness identification from live versus videotaped lineups. *Forensic Reports*, **2**, 93–106.

Cutler, B. L., Moran, G., & Narby, D. J. (1991). Jury selection in insanity defense cases. Unpublished manuscript, Florida International University.

Cutler, B. L., & Penrod, S. D. (1988). Context reinstatement and eyewitness identification. In G. M. Davies & D. M. Thomson (Eds.), *Context reinstatement and eyewitness identification*. New York: Wiley. *(a)*

Cutler, B. L., & Penrod, S. D. (1988). Improving the reliability of eyewitness identification: Lineup construction and presentation. *Journal of Applied Psychology*, **73**, 281–290. *(b)*

Cutler, B. L., Penrod, S. D., & Dexter, H. R. (1989). The eyewitness, the expert psychologist and the jury. *Law and Human Behavior*, **13**, 311–332.

Cutler, B. L., Penrod, S. D., & Martens, T. K. (1987). The reliability of eyewitness identification: The role of system and estimator variables. *Law and Human Behavior*, **11**, 233–258.

Cutler, B. L., Penrod, S. D., & Stuve, T. E. (1988). Juror decision making in eyewitness identification cases. *Law and Human Behavior*. **12**, 41–55.

Dabbs, J. M., & Janis, I. L. (1965). Why does eating while reading facilitate opinion change? An experimental inquiry. *Journal of Experimental Social Psychology*, **1**, 133–144.

Dabbs, J. M., Jr., de La Rue, D., & Williams, P. M. (1990). Testosterone and occupational choice: Actors, ministers, and other men. *Journal of Personality and Social Psychology*, **59**, 1261–1265.

Dabbs, J. M., Jr., & Morris, R. (1990). Testosterone, social class, and antisocial behavior in a sample of 4,462 men. *Psychological Science*, **1**, 209–211.

Dabbs, J. M., Jr., Ruback, R. B., Frady, R. L., Hopper, C. H., & Sgoutas, D. S. (1988). Saliva testosterone and criminal violence among women. *Personality and Individual Differences*, **7**, 269–275.

Dallas, M. E. W., & Baron, R. S. (1985). Do psychotherapists use a confirmatory strategy during interviewing? *Journal of Social and Clinical Psychology*, **3**, 106–122.

Daniels, R. (1975). *The decision to relocate the Japanese Americans*. New York: Lippincott.

Darley, J. (1992). Review essay. *Psychological Science*, in press.

Darley, J. M., & Batson, C. D. (1973). From Jerusalem to Jericho: A study of situational and dispositional variables in helping behavior. *Journal of Personality and Social Psychology*, **27**, 100–108.

Darley, J. M., & Berscheid, E. (1967). Increased liking as a result of the anticipation of personal contact. *Human Relations*, **20**, 29–40.

Darley, J. M., Fleming, J. H., Hilton, J. L., & Swann, W. B., Jr. (1988). Dispelling negative expectancies: The impact of interaction goals and target characteristics on the expectancy confirmation process. *Journal of Experimental Social Psychology*, **24**, 19–36.

Darley, J. M., & Gross, P. H. (1983). A hypothesis-confirming bias in labelling effects. *Journal of Personality and Social Psychology*, **44**, 20–33.

Darley, J. M., & Latané, B. (1968). Bystander intervention in emergencies: Diffusion of responsibility. *Journal of Personality and Social Psychology*, **8**, 377–383.

Darley, J. M., & Latané, B. (1968, December). When will people help in a crisis? *Psychology Today*, pp. 54–57, 70–71.

Darley, J. M., Teger, A. I., & Lewis, L. D. (1973). Do groups always inhibit individuals' response to potential emergencies? *Journal of Personality and Social Psychology*, **26**, 395–399.

Darley, S., & Cooper, J. (1972). Cognitive consequences of forced noncompliance. *Journal of Personality and Social Psychology*, **24**, 321–326.

Darrow, C. (1933), cited by E. H. Sutherland & D. R. Cressy, *Principles of criminology.* Philadelphia: Lippincott, 1966, p. 442.

Dashiell, J. F. (1930). An experimental analysis of some group effects. *Journal of Abnormal and Social Psychology,* **25,** 190–199.

Davis, B. M., & Gilbert, L. A. (1989). Effect of dispositional and situational influences on women's dominance expression in mixed-sex dyads. *Journal of Personality and Social Psychology,* **57,** 294–300.

Davis, J. H., Kameda, T., Parks, C., Stasson, M., & Zimmerman, S. (1989). Some social mechanics of group decision making: The distribution of opinion, polling sequence, and implications for consensus. *Journal of Personality and Social Psychology,* **57,** 1000–1012.

Davis, J. H., Kerr, N. L., Atkin, R. S., Holt, R., & Meek, D. (1975). The decision processes of 6- and 12-person mock juries assigned unanimous and two-thirds majority rules. *Journal of Personality and Social Psychology,* **32,** 1–14.

Davis, J. H., Kerr, N. L., Strasser, G., Meek, D., & Holt, R. (1977). Victim consequences, sentence severity, and decision process in mock juries. *Organizational Behavior and Human Performance,* **18,** 346–365.

Davis, K. E. (1985, February). Near and dear: Friendship and love compared. *Psychology Today,* pp. 22–30.

Davis, K. E., & Jones, E. E. (1960). Changes in interpersonal perception as a means of reducing cognitive dissonance. *Journal of Abnormal and Social Psychology,* **61,** 402–410.

Davis, L., Laylasek, L., & Pratt, R. (1984). Teamwork and friendship: Answers to social loafing. Paper presented at the Southwestern Psychological Association, New Orleans.

Davis, M. H. (1979). The case for attributional egotism. Paper presented at the American Psychological Association convention.

Davis, M. H., & Franzoi, S. L. (1986). Adolescent loneliness, self-disclosure, and private self-consciousness: A longitudinal investigation. *Journal of Personality and Social Psychology,* **51,** 595–608.

Davis, M. H., & Stephan, W. G. (1980). Attributions for exam performance. *Journal of Applied Social Psychology,* **10,** 235–248.

Dawes, R. M. (1976). Shallow psychology. In J. S. Carroll & J. W. Payne (Eds.), *Cognition and social behavior.* Hillsdale, N.J.: Lawrence Erlbaum.

Dawes, R. M. (1980). Social dilemmas. *Annual Review of Psychology,* **31,** 169–193.

Dawes, R. M. (1980). You can't systematize human judgment: Dyslexia. In R. A. Shweder (Ed.), *New directions for methodology of social and behavioral science: Fallible judgment in behavioral research.* San Francisco: Jossey-Bass.

Dawes, R. M. (1989, January). Resignation letter to the American Psychological Association. *APS Observer,* pp. 14–15.

Dawes, R. M. (1990). The potential non-falsity of the false consensus effect. In R. M. Hogarth (Ed.), *Insights in decision making: A tribute to Hillel J. Einhorn.* Chicago: University of Chicago Press.

Dawes, R. M. (1991). Social dilemmas, economic self-interest, and evolutionary theory. In D. R. Brown & J. E. Keith Smith (Eds.), *Frontiers of mathematical psychology: Essays in honor of Clyde Coombs.* New York: Springer-Verlag.

Dawes, R. M., Faust, D., & Meehl, P. E. (1989). Clinical versus actuarial judgment. *Science,* **243,** 1668–1674.

Dawes, R. M., McTavish, J., & Shaklee, H. (1977). Behavior, communication, and assumptions about other people's behavior in a commons dilemma situation. *Journal of Personality and Social Psychology,* **35,** 1–11.

Dawkins, R. (1976). *The selfish gene.* New York: Oxford University Press.

Dawson, N. V., Arkes, H. R., Siciliano, C., Blinkhorn, R., Lakshmanan, M., & Petrelli, M. (1988). Hindsight bias: An impediment to accurate probability estimation in clinicopathologic conferences. *Medical Decision Making,* **8,** 259–264.

de Vries, N. K., & Van Knippenberg, A. (1987). Biased and unbiased self-evaluations of ability: The effects of further testing. *British Journal of Social Psychology,* **26,** 9–15.

Deci, E. L., & Ryan, R. M. (1985). *Intrinsic motivation and self-determination in human behavior.* New York: Plenum.

Deci, E. L., & Ryan, R. M. (1987). The support of autonomy and the control of behavior. *Journal of Personality and Social Psychology,* **53,** 1024–1037.

Deci, E. L., & Ryan, R. M. (1991). A mo-tivational approach to self: Integration in personality. *Nebraska Symposium on Motivation,* in press.

Deford, F. (1983, November 7). Sometimes the good die young. *Sports Illustrated,* pp. 44–50.

DeJong-Gierveld, J. (1987). Developing and testing a model of loneliness. *Journal of Personality and Social Psychology,* **53,** 119–128.

Delgado, J. (1973). In M. Pines, *The brain changers.* New York: Harcourt Brace Jovanovich.

Dembroski, T. M., Lasater, T. M., & Ramirez, A. (1978). Communicator similarity, fear arousing communications, and compliance with health care recommendations. *Journal of Applied Social Psychology,* **8,** 254–269.

Dengerink, H. A., & Myers, J. D. (1977). Three effects of failure and depression on subsequent aggression. *Journal of Personality and Social Psychology,* **35,** 88–96.

DePaulo, B. M., Kenny, D. A., Hoover, C. W., Webb, W., & Oliver, P. V. (1987). Accuracy of person perception: Do people know what kinds of impressions they convey? *Journal of Personality and Social Psychology,* **52,** 303–315.

Dermer, M., Cohen, S. J., Jacobsen, E., & Anderson, E. A. (1979). Evaluative judgments of aspects of life as a function of vicarious exposure to hedonic extremes. *Journal of Personality and Social Psychology,* **37,** 247–260.

Dermer, M., & Pyszczynski, T. A. (1978). Effects of erotica upon men's loving and liking responses for women they love. *Journal of Personality and Social Psychology,* **36,** 1302–1309.

Desforges, D. M., Lord, C. G., Ramsey, S. L., Mason, J. A., Van Leeuwen, M. D., West, S. C., & Lepper, M. R. (1991). Effects of structured cooperative contact on changing negative attitudes toward stigmatized social groups. *Journal of Personality and Social Psychology,* **60,** 531–544.

Desmond, E. W. (1987, November 30). Out in the open. *Time,* pp. 80–90.

DeStefano, L., & Colasanto, D. (1990, February). Unlike 1975, today most Americans think men have it better. *Gallup Poll Monthly,* No. 293, 25–36.

Deutsch, F. M. (1990). Status, sex, and smiling: The effect of role on smiling in men and women. *Personality and Social Psychology Bulletin,* **16,** 531–540.

Deutsch, M. (1980). Fifty years of conflict. In L. Festinger (Ed.), *Retrospectives on social psychology*. New York: Oxford University Press.

Deutsch, M. (1985). *Distributive justice: A social psychological perspective*. New Haven: Yale University Press.

Deutsch, M. (1986). Folie à deux: A psychological perspective on Soviet-American relations. In M. P. Kearns (Ed.), *Persistent patterns and emergent structures in a waving century*. New York: Praeger.

Deutsch, M. (1990). Psychological roots of moral exclusion. *Journal of Social Issues, 46*, 21–25.

Deutsch, M. (1991). Educating for a peaceful world. Presidential address to the Division of Peace Psychology, American Psychological Association convention.

Deutsch, M. (1991). Egalitarianism in the laboratory and at work. In R. Vermunt & H. Steensma (Eds.), *Social justice in human relations*. New York: Plenum.

Deutsch, M., & Collins, M. E. (1951). *Interracial housing: A psychological evaluation of a social experiment*. Minneapolis: University of Minnesota Press.

Deutsch, M., & Gerard, H. B. (1955). A study of normative and informational social influence upon individual judgment. *Journal of Abnormal and Social Psychology, 51*, 629–636.

Deutsch, M., & Krauss, R. M. (1960). The effect of threat upon interpersonal bargaining. *Journal of Abnormal and Social Psychology, 61*, 181–189.

deVaux, R. (1965). *Ancient Israel (Vol. 2): Religious institutions*. New York: McGraw-Hill.

Devine, P. G. (1989). Stereotypes and prejudice: Their automatic and controlled components. *Journal of Personality and Social Psychology, 56*, 5–18.

Devine, P. G., Hirt, E. R., & Gehrke, E. M. (1990). Diagnostic and confirmation strategies in trait hypothesis testing. *Journal of Personality and Social Psychology, 58*, 952–963.

Devine, P. G., & Malpass, R. S. (1985). Orienting strategies in differential face recognition. *Personality and Social Psychology Bulletin, 11*, 33–40.

Devine, P. G., Monteith, M. J., Zuwerink, J. R., & Elliot, A. J. (1991). Prejudice with and without compunction. *Journal of Personality and Social Psychology, 60*, 817–830.

Dickson, D. H., & Kelly, I. W. (1985). The "Barnum effect" in personality assessment: A review of the literature. *Psychological Reports, 57*, 367–382.

Diehl, M., & Stroebe, W. (1991). Productivity loss in idea-generating groups: Tracking down the blocking effect. *Journal of Personality and Social Psychology, 61*, 392–403.

Diener, E. (1976). Effects of prior destructive behavior, anonymity, and group presence on deindividuation and aggression. *Journal of Personality and Social Psychology, 33*, 497–507.

Diener, E. (1979). Deindividuation, self-awareness, and disinhibition. *Journal of Personality and Social Psychology, 37*, 1160–1171.

Diener, E. (1980). Deindividuation: The absence of self-awareness and self-regulation in group members. In P. Paulus (Ed.), *The psychology of group influence*. Hillsdale, N.J.: Erlbaum.

Diener, E., & Crandall, R. (1979). An evaluation of the Jamaican anticrime program. *Journal of Applied Social Psychology, 9*, 135–146.

Diener, E., Fraser, S. C., Beaman, A. L., & Kelem, R. T. (1976). Effects of deindividuation variables on stealing among Halloween trick-or-treaters. *Journal of Personality and Social Psychology, 33*, 178–183.

Diener, E., & Wallbom, M. (1976). Effects of self-awareness on antinormative behavior. *Journal of Research in Personality, 10*, 107–111.

Dillard, J. P., Hunter, J. E., & Burgoon, M. (1984). Sequential-request persuasive strategies: Metaanalysis of foot-in-the-door and door-in-the-face. *Human Communication Research 10*, 461–488.

Dillehay, R. C., & Nietzel, M. T. (1980). Constructing a science of jury behavior. In L. Wheeler (Ed.), *Review of personality and social psychology* (Vol. 1). Beverly Hills, Calif.: Sage Publications.

Dion, K. K. (1972). Physical attractiveness and evaluations of children's transgressions. *Journal of Personality and Social Psychology, 24*, 207–213.

Dion, K. K. (1973). Young children's stereotyping of facial attractiveness. *Developmental Psychology, 9*, 183–188.

Dion, K. K. (1979). Physical attractiveness and interpersonal attraction. In M. Cook & G. Wilson (Eds.), *Love and attraction*. New York: Pergamon Press.

Dion, K. K., & Berscheid, E. (1974). Physical attractiveness and peer perception among children. *Sociometry, 37*, 1–12.

Dion, K. K., & Dion, K. L. (1978). Defensiveness, intimacy, and heterosexual attraction. *Journal of Research in Personality, 12*, 479–487.

Dion, K. K., & Dion, K. L. (1985). Personality, gender, and the phenomenology of romantic love. In P. R. Shaver (Ed.), *Review of personality and social psychology*, vol. 6. Beverly Hills, Ca.: Sage.

Dion, K. K., & Dion, K. L. (1991). Psychological individualism and romantic love. *Journal of Social Behavior and Personality, 6*, 17–33.

Dion, K. K., Pak, A. W-P., & Dion, K. L. (1990). Stereotyping physical attractiveness: A sociocultural perspective. *Journal of Cross-Cultural Psychology, 21*, 378–398.

Dion, K. K., & Stein, S. (1978). Physical attractiveness and interpersonal influence. *Journal of Experimental Social Psychology, 14*, 97–109.

Dion, K. L. (1979). Intergroup conflict and intragroup cohesiveness. In W. G. Austin, & S. Worchel (Eds.), *The social psychology of intergroup relations*. Monterey, Calif.: Brooks/Cole.

Dion, K. L. (1985). Responses to perceived discrimination and relative deprivation. In J. M. Olson, C. P. Herman, & M. P. Zanna (Eds.), *Relative deprivation and social comparison: The Ontario symposium*, vol. 4. Hillsdale, N.J.: Erlbaum.

Dion, K. L. (1987). What's in a title? The Ms. stereotype and images of women's titles of address. *Psychology of Women Quarterly, 11*, 21–36.

Dion, K. L., & Cota, A. A. (1991). The Ms. stereotype: Its domain and the role of explicitness in title preference. *Psychology of Women Quarterly, 15*, 403–410.

Dion, K. L., & Dion, K. K. (1988). Romantic love: Individual and cultural perspectives. In R. J. Sternberg & M. L. Barnes (Eds.), *The psychology of love*. New Haven, Conn.: Yale University Press.

Dion, K. L., Dion, K. K., & Keelan, J. P. (1990). Appearance anxiety as a dimension of social-evaluative anxiety: Exploring the ugly duckling syndrome. *Contemporary Social Psychology, 14*(4), 220–224.

Dion, K. L., & Schuller, R. A. (1991). The Ms. stereotype: Its generality and

its relation to managerial and marital status stereotypes. *Canadian Journal of Behavioural Science, 23,* 25–40.

Dixon, B. (1986, April). Dangerous thoughts: How we think and feel can make us sick. *Science 86,* pp. 63–66.

Dobson, K., & Franche, R-L. (1989). A conceptual and empirical review of the depressive realism hypothesis. *Canadian Journal of Behavioural Science, 21,* 419–433.

Doise, W. (1986). *Levels of explanation in social psychology.* Cambridge: Cambridge University Press.

Dollard, J., Doob, L., Miller, N., Mowrer, O. H., & Sears, R. R. (1939). *Frustration and aggression.* New Haven, Conn.: Yale University Press.

Donnerstein, E. (1980). Aggressive erotica and violence against women. *Journal of Personality and Social Psychology, 39,* 269–277.

Donnerstein, E., & Berkowitz, L. (1981). Victim reactions in aggressive erotic films as a factor in violence against women. *Journal of Personality and Social Psychology, 41,* 710–724.

Donnerstein, E., Linz, D., & Penrod, S. (1987). *The question of pornography.* London: Free Press.

Doob, A. N., & Kirshenbaum, H. M. (1973). Bias in police lineups—partial remembering. *Journal of Police Science and Administration, 1,* 287–293.

Doob, A. N., & McLaughlin, D. S. (1989). Ask and you shall be given: Request size and donations to a good cause. *Journal of Applied Social Psychology, 19,* 1049–1056.

Doob, A. N., & Roberts, J. (1988). Public attitudes toward sentencing in Canada. In N. Walker & M. Hough (Eds.), *Sentencing and the public.* London: Gower.

Doty, R. M., Peterson, B. E., & Winter, D. G. (1991). Threat and authoritarianism in the United States, 1978–1987. *Journal of Personality and Social Psychology, 61,* 629–640.

Douglass, F. (1845/1960). *Narrative of the life of Frederick Douglass, an American slave: Written by himself.* (B. Quarles, Ed.). Cambridge, Mass.: Harvard University Press.

Dovidio, J. F. (1991). The empathy-altruism hypothesis: Paradigm and promise. *Psychological Inquiry, 2,* 126–128.

Dovidio, J. F., Allen, J. L., & Schroeder, D. A. (1990). Specificity of empathy-induced helping: Evidence for altruistic motivation. *Journal of Personality and Social Psychology, 59,* 249–260.

Dovidio, J. F., Gaertner, S. L., Anastasio, P. A., & Sanitioso, R. (1992). Cognitive and motivational bases of bias: Implications of aversive racism for attitudes toward Hispanics. In S. Knouse, P. Rosenfeld, & A. Culbertson (Eds.), *Hispanics and work.* Newbury Park, CA: Sage, in press.

Dovidio, J. F., Mann, J., & Gaertner, S. L. (1989). Resistance to affirmative action: The implications of aversive racism. In F. Blanchard & F. Crosby (Eds.), *Affirmative action in perspective.* New York: Springer-Verlag.

Downs, A. C., & Lyons, P. M. (1991). Natural observations of the links between attractiveness and initial legal judgments. *Personality and Social Psychology Bulletin, 17,* 541–547.

Drabman, R. S., & Thomas, M. H. (1974). Does media violence increase children's toleration of real-life aggression? *Developmental Psychology, 10,* 418–421.

Drabman, R. S., & Thomas, M. H. (1975). Does TV violence breed indifference? *Journal of Communications, 25*(4), 86–89.

Drabman, R. S., & Thomas, M. H. (1976). Does watching violence on television cause apathy? *Pediatrics, 57,* 329–331.

Driskell, J. E., & Mullen, B. (1990). Status, expectations, and behavior: A meta-analytic review and test of the theory. *Personality and Social Psychology Bulletin, 16,* 541–553.

Duclos, S. E., Laird, J. D., Schneider, E., Sexter, M., Stern, L., & Van Lighten, O. (1989). Emotion-specific effects of facial expressions and postures on emotional experience. *Journal of Personality and Social Psychology, 57,* 100–108.

Duncan, B. L. (1976). Differential social perception and attribution of intergroup violence: Testing the lower limits of stereotyping of blacks. *Journal of Personality and Social Psychology, 34,* 590–598.

Dunning, D., Griffin, D. W., Milojkovic, J. D., & Ross, L. (1990). The overconfidence effect in social prediction. *Journal of Personality and Social Psychology, 58,* 568–581.

Dunning, D., Meyerowitz, J. A., & Holzberg, A. D. (1989). Ambiguity and self-evaluation. *Journal of Personality and Social Psychology, 57,* 1082–1090.

Dunning, D., & Parpal, M. (1989). Mental addition versus subtraction in counterfactual reasoning: On assessing the impact of personal actions and life events. *Journal of Personality and Social Psychology, 57,* 5–15.

Dunning, D., Perie, M., & Story, A. L. (1991). Self-serving prototypes of social categories. *Journal of Personality and Social Psychology, 61,* 957–968.

Dunning, D., & Ross, L. (1988). Overconfidence in individual and group prediction: Is the collective any wiser? Unpublished manuscript, Cornell University.

Dutton, D. G. (1971). Reactions of restauranteurs to blacks and whites violating restaurant dress regulations. *Canadian Journal of Behavioural Science, 3,* 298–302.

Dutton, D. G. (1973). Reverse discrimination: The relationship of amount of perceived discrimination toward a minority group and the behavior of majority group members. *Canadian Journal of Behavioural Science, 5,* 34–45.

Dutton, D. G., & Aron, A. (1989). Romantic attraction and generalized liking for others who are sources of conflict-based arousal. *Canadian Journal of Behavioural Science, 21,* 246–257.

Dutton, D. G., & Aron, A. P. (1974). Some evidence for heightened sexual attraction under conditions of high anxiety. *Journal of Personality and Social Psychology, 30,* 510–517.

Dutton, D. G., & Lake, R. A. (1973). Threat of own prejudice and reverse discrimination in interracial situations. *Journal of Personality and Social Psychology, 28,* 94–100.

Duval, S. (1976). Conformity on a visual task as a function of personal novelty on attitudinal dimensions and being reminded of the object status of self. *Journal of Experimental Social Psychology, 12,* 87–98.

Duval, S., Duval, V. H., & Neely, R. (1979). Self-focus, felt responsibility, and helping behavior. *Journal of Personality and Social Psychology, 37,* 1769–1778.

Duval, S., & Wicklund, R. A. (1972). *A theory of objective self-awareness.* New York: Academic Press.

Eagly, A. H. (1986). Some meta-analytic approaches to examining the validity of gender-difference research. In J. S. Hyde & M. C. Linn (Eds.), *The psychology of gender: Advances through meta-analysis.* Baltimore: Johns Hopkins University Press.

Eagly, A. H. (1987). Sex differences in social behavior: A social-role interpretation. Hillsdale, N.J.: Erlbaum.

Eagly, A. H., Ashmore, R. D., Makhijani, M. G., & Longo, L. C. (1991). What is beautiful is good, but . . .: A meta-analytic review of research on the physical attractiveness stereotype. *Psychological Bulletin, 110,* 109–128.

Eagly, A. H., & Carli, L. L. (1981). Sex of researcher and sex-typed communications as determinants of sex differences in influenceability: A meta-analysis of social influence studies. *Psychological Bulletin, 90,* 1–20.

Eagly, A. H., & Chaiken, S. (1992). *The psychology of attitudes.* San Diego: Harcourt Brace Jovanovich.

Eagly, A. H., & Crowley, M. (1986). Gender and helping behavior: A meta-analytic review of the social psychological literature. *Psychological Bulletin, 100,* 283–308.

Eagly, A. H., & Johnson, B. T. (1990). Gender and leadership style: A meta-analysis. *Psychological Bulletin, 108,* 233–256.

Eagly, A. H., & Karau, S. J. (1991). Gender and the emergence of leaders: A meta-analysis. *Journal of Personality and Social Psychology, 60,* 685–710.

Eagly, A. H., Mladinic, A., & Otto, S. (1991). Are women evaluated more favorably than men? *Psychology of Women Quarterly, 15,* 203–216.

Eagly, A. H., & Steffen, V. J. (1986). Gender and aggressive behavior: A meta-analytic review of the social psychological literature. *Psychological Bulletin, 100,* 309–330.

Eagly, A. H., & Wood, W. (1985). Gender and influenceability: Stereotype versus behavior. In V. E. O'Leary, R. K. Unger, & B. S. Wallston (Eds.), *Women, gender, and social psychology.* Hillsdale, N.J.: Erlbaum.

Eagly, A. H., & Wood, W. (1988). Explaining sex differences in social behavior: A meta-analytic perspective. Paper presented to the American Psychological Association convention.

Eagly, A. H., & Wood, W. (1991). Explaining sex differences in social behavior: A meta-analytic perspective. *Personality and Social Psychology Bulletin, 17,* 306–315.

Eagly, A. H., Wood, W., & Chaiken, S. (1978). Casual inferences about communicators and their effect on opinion change. *Journal of Personality and Social Psychology, 36,* 424–435.

Early, P. C. (1989). Social loafing and collectivism: A comparison of the United States and the People's Republic of China. *Administrative Science Quarterly, 34,* 565–581.

Ebbesen, E. B., Duncan, B., & Konecni, V. J. (1975). Effects of content of verbal aggression on future verbal aggression: A field experiment. *Journal of Experimental Social Psychology, 11,* 192–204.

Edney, J. J. (1979). The nuts game: A concise commons dilemma analog. *Environmental Psychology and Nonverbal Behavior, 3,* 252–254.

Edney, J. J. (1980). The commons problem: Alternative perspectives. *American Psychologist, 35,* 131–150.

Edney, J. J., & Harper, C. S. (1978). The commons dilemma: A review of contributions from psychology. *Environmental Management, 2,* 491–507.

Edwards, C. P. (1991). Behavioral sex differences in children of diverse cultures: The case of nurturance to infants. In M. Pereira & L. Fairbanks (Eds.), *Juveniles: Comparative socioecology.* Oxford: Oxford University Press.

Efran, M. G. (1974). The effect of physical appearance on the judgment of guilt, interpersonal attraction, and severity of recommended punishment in a simulated jury task. *Journal of Research in Personality, 8,* 45–54.

Eisenberg, N., Fabes, R. A., Schaller, M., Miller, P., Carlo, G., Poulin, R., Shea, C., & Shell, R. (1991). Personality and socialization correlates of vicarious emotional responding. *Journal of Personality and Social Psychology, 61,* 459–470.

Eisenberg, N., & Lennon, R. (1983). Sex differences in empathy and related capacities. *Psychological Bulletin, 94,* 100–131.

Eiser, J. R., Sutton, S. R., & Wober, M. (1979). Smoking, seat-belts, and beliefs about health. *Addictive Behaviors, 4,* 331–338.

Elashoff, J. R., & Snow, R. E. (1971). *Pygmalion reconsidered.* Worthington, Ohio: Charles A. Jones.

Elder, G. H., Jr. (1969). Appearance and education in marriage mobility. *American Sociological Review, 34,* 519–533.

Elder, G. H., Jr., & Clipp, E. C. (1988). Wartime losses and social bonding: Influences across 40 years in men's lives. *Psychiatry, 51,* 177–197.

Eldersveld, S. J., & Dodge, R. W. (1954). Personal contact or mail propaganda? An experiment in voting turnout and attitude change. In D. Katz, D. Cartwright, S. Eldersveld, & A. M. Lee (Eds.), *Public opinion and propaganda.* New York: Dryden Press.

Elkin, I. (1986). Outcome findings and therapist performance. Paper presented at the American Psychological Association convention.

Ellickson, P. L., & Bell, R. M. (1990). Drug prevention in junior high: A multi-site longitudinal test. *Science, 247,* 1299–1305.

Elliott, G. C. (1986). Self-esteem and self-consistency: A theoretical and empirical link between two primary motivations. *Social Psychological Quarterly, 49,* 207–218.

Elliott, L. (1989, June). Legend of the four chaplains. *Reader's Digest,* pp. 66–70.

Ellis, H. D. (1981). Theoretical aspects of face recognition. In G. H. Davies, H. D. Ellis, & J. Shepherd (Eds.), *Perceiving and remembering faces.* London: Academic Press.

Ellsworth, P. (1985, July). Juries on trial. *Psychology Today,* pp. 44–46.

Ellsworth, P. (1989, March 6). Supreme Court ignores social science research on capital punishment. Quoted by *Behavior Today,* pp. 7–8.

Ellyson, S. L., Dovidio, J. F., & Brown, C. E. (1991). The look of power: Gender differences and similarities in visual dominance behavior. In C. Ridgeway (Ed.), *Gender and interaction: The role of microstructures in inequality.* New York: Springer-Verlag.

Elwork, A., Sales, B. D., & Alfini, J. J. (1982). *Making jury instructions understandable.* Charlottesville, Va.: The Michie Co.

Emswiller, T., Deaux, K., & Willits, J. E. (1971). Similarity, sex, and requests for small favors. *Journal of Applied Social Psychology, 1,* 284–291.

Engs, R., & Hanson, D. J. (1989). Reactance theory: A test with collegiate drinking. *Psychological Reports, 64,* 1083–1086.

Ennis, B. J., & Verrilli, D. B., Jr. (1989). Motion for leave to file brief amicus curiae and brief of Society for the Scientific Study of Religion, American Sociological Association, and others. U.S. Supreme Court Case No. 88–1600, Holy Spirit Association for the Unification of World Christianity, *et al.,* v. David Molko and Tracy Leal. On petition for write of certiorari to the Su-

preme Court of California. Washington, DC: Jenner & Block, 21 Dupont Circle NW.

Ennis, R., & Zanna, M. P. (1991). Hockey assault: Constitutive versus normative violations. Paper presented at the Canadian Psychological Association convention.

Enzle, M. E., & Hawkins, W. L. (1992). A priori actor negligence mediates a posteriori outcome. *Journal of Experimental Social Psychology*, in press.

Epstein, S. (1980). The stability of behavior: II. Implications for psychological research. *American Psychologist*, **35**, 790–806.

Epstein, S., & Feist, G. J. (1988). Relation between self- and other-acceptance and its moderation by identification. *Journal of Personality and Social Psychology*, **54**, 309–315.

Erickson, B., Holmes, J. G., Frey, R., Walker, L., & Thibaut, J. (1974). Functions of a third party in the resolution of conflict: The role of a judge in pretrial conferences. *Journal of Personality and Social Psychology*, **30**, 296–306.

Erickson, B., Lind, E. A. Johnson, B. C., & O'Barr, W. M. (1978). Speech style and impression formation in a court setting: The effects of powerful and powerless speech. *Journal of Experimental Social Psychology*, **14**, 266–279.

Ernst, J. M., & Heesacker, M. (1991). Application of the Elaboration Likelihood Model of attitude change to assertion training. Unpublished manuscript, University of Florida.

Eron, L. D. (1985). The social responsibility of the researchers. In J. H. Goldstein (Ed.), *Reporting science: The case of aggression*. Hillsdale, N.J.: Erlbaum.

Eron, L. D. (1987). The development of aggressive behavior from the perspective of a developing behaviorism. *American Psychologist*, **42**, 425–442.

Eron, L. D., & Huesmann, L. R. (1980). Adolescent aggression and television. *Annals of the New York Academy of Sciences*, **347**, 319–331.

Eron, L. D., & Huesmann, L. R. (1984). The control of aggressive behavior by changes in attitudes, values, and the conditions of learning. In R. J. Blanchard & C. Blanchard (Eds.), *Advances in the study of aggression*, vol. 1. Orlando, Fla.: Academic Press.

Eron, L. D., & Huesmann, L. R. (1985). The role of television in the development of prosocial and antisocial behav-

ior. In D. Olweus, M. Radke-Yarrow, and J. Block (Eds.), *Development of antisocial and prosocial behavior*. Orlando, Fla.: Academic Press.

Esser, J. K., & Lindoerfer, J. S. (1989). Groupthink and the space shuttle Challenger accident: Toward a quantitative case analysis. *Journal of Behavioral Decision Making*, **2**, 167–177.

Esses, V. M., & Webster, C. D. (1988). Physical attractiveness, dangerousness, and the Canadian criminal code. *Journal of Applied Social Psychology*, **18**, 1017–1031.

Etzioni, A. (1967). The Kennedy experiment. *The Western Political Quarterly*, **20**, 361–380.

Etzioni, A. (1972, June 3). Human beings are not very easy to change after all. *Saturday Review*, 45–47.

Evans, C. R., & Dion, K. L. (1991). Group cohesion and performance: A meta-analysis. *Small Group Research*, **22**, 175–186.

Evans, G. W. (1979). Behavioral and physiological consequences of crowding in humans. *Journal of Applied Social Psychology*, **9**, 27–46.

Evans, R. I., Smith, C. K., & Raines, B. E. (1984). Deterring cigarette smoking in adolescents: A psycho-social-behavioral analysis of an intervention strategy. In A. Baum, J. Singer, & S. Taylor (Eds.), *Handbook of psychology and health: Social psychological aspects of health*, vol. 4, Hillsdale, N.J.: Erlbaum.

Farquhar, J. W., Maccoby, N., Wood, P. D., Alexander, J. K., Breitrose, H., Brown, B. W., Jr., Haskell, W. L., McAlister, A. L., Meyer, A. J., Nash, J. D., & Stern, M. P. (1977, June 4). Community education for cardiovascular health. *Lancet*, 1192–1195.

Faust, D., & Ziskin, J. (1988). The expert witness in psychology and psychiatry. *Science*, **241**, 31–35.

Fazio, R. (1987). Self-perception theory: A current perspective. In M. P. Zanna, J. M. Olson, & C. P. Herman (Eds.), *Social influence: The Ontario symposium*, vol. 5. Hillsdale, N.J.: Erlbaum.

Fazio, R. H. (1981). On the self-perception explanation of the overjustification effect: The role of the salience of initial attitude. *Journal of Experimental Social Psychology*, **17**, 417–426.

Fazio, R. H. (1990). Multiple processes by which attitudes guide behavior: The mode model as an integrative framework. *Advances in Experimental Social Psychology*, **23**, 75–109.

Fazio, R. H., & Zanna, M. P. (1981). Direct experience and attitude-behavior consistency. In L. Berkowitz (Ed.), *Advances in experimental social psychology*, Vol. 14. New York: Academic Press.

Fazio, R. H., Zanna, M. P., & Cooper, J. (1979). On the relationship of data to theory: A reply to Ronis and Greenwald. *Journal of Experimental Social Psychology*, **15**, 70–76.

Fazio, R. H., Zanna, M. P., & Cooper, J. (1977). Dissonance versus self-perception: An integrative view of each theory's proper domain of application. *Journal of Experimental Social Psychology*, **13**, 464–479.

Feather, N. T. (1983). Causal attributions and beliefs about work and unemployment among adolescents in state and independent secondary schools. *Australian Journal of Psychology*, **35**, 211–232. *(a)*

Feather, N. T. (1983). Causal attributions for good and bad outcomes in achievement and affiliation situations. *Australian Journal of Psychology*, **35**, 37–48. *(b)*

Feierabend, I., & Feierabend, R. (1968, May). Conflict, crisis, and collision: A study of international stability. *Psychology Today*, pp. 26–32, 69–70.

Feierabend, I., & Feierabend, R. (1972). Systemic conditions of political aggression: An application of frustration-aggression theory. In I. K. Feierabend, R. L. Feierabend, & T. R. Gurr (Eds.), *Anger, violence, and politics: Theories and research*. Englewood Cliffs, N.J.: Prentice Hall.

Fein, S., & Hilton, J. L. (1992). Attitudes toward groups and behavioral intentions toward individual group members: The impact of nondiagnostic information. *Journal of Experimental Social Psychology*, **28**, 101–124.

Fein, S., Hilton, J. L., & Miller, D. T. (1990). Suspicion of ulterior motivation and the correspondence bias. *Journal of Personality and Social Psychology*, **58**, 753–764.

Feingold, A. (1988). Matching for attractiveness in romantic partners and same-sex friends: A meta-analysis and theoretical critique. *Psychological Bulletin*, **104**, 226–235.

Feingold, A. (1990). Gender differences in effects of physical attractiveness on romantic attraction: A comparison across five research paradigms. *Journal of Personality and Social Psychology*, **59**, 981–993.

Feingold, A. (1991). Sex differences in the effects of similarity and physical attractiveness on opposite-sex attraction. *Basic and Applied Social Psychology,* **12,** 357–367.

Feldman, K. A., & Newcomb. T. M. (1969). *The impact of college on students.* San Francisco: Jossey-Bass.

Feldman, R. S., & Prohaska, T. (1979). The student as Pygmalion: Effect of student expectation on the teacher. *Journal of Educational Psychology,* **71,** 485–493.

Feldman, R. S., & Theiss, A. J. (1982). The teacher and student as Pygmalions: Joint effects of teacher and student expectations. *Journal of Educational Psychology,* **74,** 217–223.

Felson, R. B. (1984). The effect of self-appraisals of ability on academic performance. *Journal of Personality and Social Psychology,* **47,** 944–952.

Fenigstein, A. (1984). Self-consciousness and the overperception of self as a target. *Journal of Personality and Social Psychology,* **47,** 860–870.

Fenigstein, A., & Carver, C. S. (1978). Self-focusing effects of heartbeat feedback. *Journal of Personality and Social Psychology,* **36,** 1241–1250.

Fernandez-Collado, C., & Greenberg, B. S., with Korzenny, F., & Atkin, C. K. (1978). Sexual intimacy and drug use in TV series. *Journal of Communication,* **28**(3), 30–37.

Feshbach, N. D. (1980). The child as "psychologist" and "economist": Two curricula. Paper presented at the American Psychological Association convention.

Feshbach, N. D. & Feshbach, S. (1981). Empathy training and the regulation of aggression: Potentialities and limitations. Paper presented at the Western Psychological Association convention.

Feshbach, S. (1980). Television advertising and children: Policy issues and alternatives. Paper presented at the American Psychological Association convention.

Festinger, L. (1954). A theory of social comparison processes. *Human Relations,* **7,** 117–140.

Festinger, L. (1957). *A theory of cognitive dissonance.* Stanford: Stanford University Press.

Festinger, L. (1964). Behavioral support for opinion change. *Public Opinion Quarterly,* **28,** 404–417.

Festinger, L., & Carlsmith, J. M. (1959). Cognitive consequences of forced compliance. *Journal of Abnormal and Social Psychology,* **58,** 203–210.

Festinger, L., & Maccoby, N. (1964). On resistance to persuasive communications. *Journal of Abnormal and Social Psychology,* **68,** 359–366.

Festinger, L., Pepitone, A., & Newcomb, T. (1952). Some consequences of de-individuation in a group. *Journal of Abnormal and Social Psychology,* **47,** 382–389.

Festinger, L., Schachter, S., & Back, K. (1950). *Social pressures in informal groups: A study of human factors in housing.* New York: Harper & Bros.

Feynman, R. (1967). *The character of physical law.* Cambridge, Mass.: MIT Press.

Fichter, J. (1968). *America's forgotten priests: What are they saying?* New York: Harper.

Fiebert, M. S. (1990). Men, women and housework: The Roshomon effect. *Men's Studies Review,* **8,** 6.

Fiedler, F. E. (1987, September). When to lead, when to stand back. *Psychology Today,* pp. 26–27.

Fiedler, K. (1991). The tricky nature of skewed frequency tables: An information loss account of distinctiveness-based illusory correlations. *Journal of Personality and Social Psychology,* **60,** 24–36.

Fiedler, K., Semin, G. R., & Koppetsch, C. (1991). Language use and attributional biases in close personal relationships. *Personality and Social Psychology Bulletin,* **17,** 147–155.

Fields, J. M., & Schuman, H. (1976). Public beliefs about the beliefs of the public. *Public Opinion Quarterly,* **40,** 427–448.

Finch, J. F., & Cialdini, R. B. (1989). Another indirect tactic of (self-) image management: Boosting. *Personality and Social Psychology Bulletin,* **15,** 222–232.

Fincham, F. D., & Jaspars, J. M. (1980). Attribution of responsibility: From man the scientist to man as lawyer. In L. Berkowitz (Ed.), *Advances in experimental social psychology* (Vol. 13). New York: Academic Press.

Findley, M. J., & Cooper, H. M. (1983). Locus of control and academic achievement: A literature review. *Journal of Personality and Social Psychology,* **44,** 419–427.

Fineberg, H. V. (1988). Education to prevent AIDS: Prospects and obstacles. *Science,* **239,** 592–596.

Fischhoff, B. (1982). Debiasing. In D. Kahneman, P. Slovic, & A. Tversky (Eds.), *Judgment under uncertainty: Heuristics and biases.* New York: Cambridge University Press.

Fischhoff, B., & Bar-Hillel, M. (1984). Diagnosticity and the base rate effect. *Memory and Cognition,* **12,** 402–410.

Fischhoff, B., Slovic, P., & Lichtenstein, S. (1977). Knowing with certainty: The appropriateness of extreme confidence. *Journal of Experimental Psychology: Human Perception and Performance,* **3,** 552–564.

Fishbein, D., & Thelen, M. H. (1981). Husband-wife similarity and marital satisfaction: A different approach. Paper presented at the Midwestern Psychological Association convention. *(a)*

Fishbein, D., & Thelen, M. H. (1981). Psychological factors in mate selection and marital satisfaction: A review (Ms. 2374). *Catalog of Selected Documents in Psychology,* **11,** 84. *(b)*

Fishbein, M., & Ajzen, I. (1974). Attitudes toward objects as predictive of single and multiple behavioral criteria. *Psychological Review,* **81,** 59–74.

Fisher, G. H. (1968). Ambiguity of form: Old and new. *Perception and Psychophysics,* **4,** 189–192.

Fisher, R. P., Geiselman, R. E., & Amador, M. (1989). Field test of the cognitive interview: Enhancing the recollection of actual victims and witnesses of crime. *Journal of Applied Psychology,* **74,** 722–727.

Fisher, R. P., Geiselman, R. E., & Raymond, D. S. (1987). Critical analysis of police interview techniques. *Journal of Police Science and Administration,* **15,** 177–185.

Fiske, S. T. (1989). Interdependence and stereotyping: From the laboratory to the Supreme Court (and back). Invited address, American Psychological Association convention.

Fiske, S. T., Bersoff, D. N., Borgida, E., Deaux, K., & Heilman, M. E. (1991). Social science research on trial: The use of sex stereotyping research in *Price Waterhouse v. Hopkins. American Psychologist,* **46,** 1049–1060.

Fiske, S. T., & Pavelchak, M. A. (1986). Category-based versus piecemeal-based affective responses: Developments in schema-triggered affect. In B. M. Sorrentino & E. T. Higgins (Eds.), *The handbook of motivation and cognition:*

Foundations of social behavior. New York: Guilford Press.

Fitzpatrick, A. R., & Eagly, A. H. (1981). Anticipatory belief polarization as a function of the expertise of a discussion partner. *Personality and Social Psychology Bulletin,* 1, 636–642.

Flay, B. R., Ryan, K. B., Best, J. A., Brown, K. S., Kersell, M. W., d'Avernas, J. R., & Zanna, M. P. (1985). Are social-psychological smoking prevention programs effective? The Waterloo study. *Journal of Behavioral Medicine,* 8, 37–59.

Fleming, I., Baum, A., & Weiss, L. (1987). Social density and perceived control as mediators of crowding stress in high-density residential neighborhoods. *Journal of Personality and Social Psychology,* 52, 899–906.

Fleming, J. H., & Darley, J. M. (1990). The purposeful-action sequence and the "illusion of control": The effects of foreknowledge and target involvement on observers' judgments of others' control over random events. *Personality and Social Psychology Bulletin,* 16, 346–357.

Fletcher, G. J. O., Danilovics, P., Fernandez, G., Peterson, D., & Reeder, G. D. (1986). Attributional complexity: An individual differences measure. *Journal of Personality and Social Psychology,* 51, 875–884.

Fletcher, G. J. O., Fincham, F. D., Cramer, L., & Heron, N. (1987). The role of attributions in the development of dating relationships. *Journal of Personality and Social Psychology,* 53, 481–489.

Fletcher, G. J. O., Fitness, J., & Blampied, N. M. (1990). The link between attributions and happiness in close relationships: The roles of depression and explanatory style. *Journal of Social and Clinical Psychology,* 9, 243–255.

Fletcher, G. J. O., Reeder, G. D., & Bull, V. (1990). Bias and accuracy in attitude attribution: The role of attributional complexity. *Journal of Experimental Social Psychology,* 26, 275–288.

Fletcher, G. J. O., & Ward, C. (1989). Attribution theory and processes: A cross-cultural perspective. In M. H. Bond (Ed.), *The cross-cultural challenge to social psychology.* Newbury Park, Ca.: Sage.

Foa, U. G., & Foa, E. B. (1975). *Resource theory of social exchange.* Morristown, N.J.: General Learning Press.

Foley, L. A. (1976). Personality and situational influences on changes in prejudice: A replication of Cook's railroad game in a prison setting. *Journal of Personality and Social Psychology,* 34, 846–856.

Follett, M. P. (1940). Constructive conflict. In H. C. Metcalf & L. Urwick (Eds.), *Dynamic administration: The collected papers of Mary Parker Follett.* New York: Harper.

Forer, B. R. (1949). The fallacy of personal validation: A classroom demonstration of gullibility. *Journal of Abnormal and Social Psychology,* 44, 118–123.

Forgas, J. P. (1987). The role of physical attractiveness in the interpretation of facial expression cues. *Personality and Social Psychology Bulletin,* 13, 478–489.

Forgas, J. P., Bower, G. H., & Krantz, S. E. (1984). The influence of mood on perceptions of social interactions. *Journal of Experimental Social Psychology,* 20, 497–513.

Forgas, J. P., & Moylan, S. (1987). After the movies: Transient mood and social judgments. *Personality and Social Psychology Bulletin,* 13, 467–477.

Form, W. H., & Nosow, S. (1958). *Community in disaster.* New York: Harper.

Försterling, F. (1986). Attributional conceptions in clinical psychology. *American Psychologist,* 41, 275–285.

Forsyth, D. R., Berger, R. E., & Mitchell, T. (1981). The effects of self-serving vs. other-serving claims of responsibility on attraction and attribution in groups. *Social Psychology Quarterly,* 44, 59–64.

Forward, J. R., & Williams, J. R. (1970). Internal-external control and black militancy. *Journal of Social Issues,* 26(1), 75–92.

Foss, R. D. (1978). The role of social influence in blood donation. Paper presented at the American Psychological Association convention.

Foss, R. D. (1981). Structural effects in simulated jury decision making. *Journal of Personality and Social Psychology,* 40, 1053–1062.

Foulke, E., & Sticht, T. G. (1969). Review of research on the intelligibility and comprehension of accelerated speech. *Psychological Bulletin,* 72, 50–62.

Frank, J. (1974). *Persuasion and healing: A comparative study of psychotherapy.* New York: Schocken.

Frank, J. D. (1982). Therapeutic components shared by all psychotherapies. In J. H. Harvey & M. M. Parks (Eds.), *The master lecture series: Vol. 1. Psychotherapy research and behavior change.* Washington, DC: American Psychological Association.

Frank, M. G., & Gilovich, T. (1988). The dark side of self and social perception: Black uniforms and aggression in professional sports. *Journal of Personality and Social Psychology,* 54, 74–85.

Frank, M. G., & Gilovich, T. (1989). Effect of memory perspective on retrospective causal attributions. *Journal of Personality and Social Psychology,* 57, 399–403.

Frankel, A., & Snyder, M. L. (1987). Egotism among the depressed: When self-protection becomes self-handicapping. Paper presented at the American Psychological Association convention.

Franklin, B. J. (1974). Victim characteristics and helping behavior in a rural southern setting. *Journal of Social Psychology,* 93, 93–100.

Freedman, J. L. (1988). Television violence and aggression: What the evidence shows. In S. Oskamp (Ed.), *Television as a social issue. Applied social psychology annual,* Vol. 8. Newbury Park, Ca.: Sage.

Freedman, J. L., Birsky, J., & Cavoukian, A. (1980). Environmental determinants of behavioral contagion: Density and number. *Basic and Applied Social Psychology,* 1, 155–161.

Freedman, J. L., & Fraser, S. C. (1966). Compliance without pressure: The foot-in-the-door technique. *Journal of Personality and Social Psychology,* 4, 195–202.

Freedman, J. L., & Perlick, D. (1979). Crowding, contagion, and laughter. *Journal of Experimental Social Psychology,* 15, 295–303.

Freedman, J. L., & Sears, D. O. (1965). Warning, distraction, and resistance to influence. *Journal of Personality and Social Psychology,* 1, 262–266.

Freedman, J. S. (1965). Long-term behavioral effects of cognitive dissonance. *Journal of Experimental Social Psychology,* 1, 145–155.

French, J. R. P. (1968). The conceptualization and the measurement of mental health in terms of self-identity theory. In S. B. Sells (Ed.), The definition and measurement of mental health. Washington, D.C.: Department of Health, Education, and Welfare. (Cited by M.

Rosenberg, 1979, *Conceiving the self.* New York: Basic Books.)

Friedman, H. S. (1991). *The self-healing personality: Why some people achieve health and others succumb to illness.* New York: Holt.

Friedman, H. S., & Booth-Kewley, S. (1987). The "disease-prone personality": A meta-analytic view of the construct. *American Psychologist, 42,* 539–555.

Friedman, H. S., Riggio, R. E., & Casella, D. F. (1988). Nonverbal skill, personal charisma, and initial attraction. *Personality and Social Psychology Bulletin, 14,* 203–211.

Friedrich, L. K., & Stein, A. H. (1973). Aggressive and prosocial television programs and the natural behavior of preschool children. *Monographs of the Society of Research in Child Development,* **38** (4, Serial No. 151).

Friedrich, L. K., & Stein, A. H. (1975). Prosocial television and young children: The effects of verbal labeling and role playing on learning and behavior. *Child Development, 46,* 27–38.

Frieze, I. H., Olson, J. E., & Russell, J. (1991). Attractiveness and income for men and women in management. *Journal of Applied Social Psychology, 21,* 1039–1057.

Froming, W. J., Walker, G. R., & Lopyan, K. J. (1982). Public and private self-awareness: When personal attitudes conflict with societal expectations. *Journal of Experimental Social Psychology, 18,* 476–487.

Fulbright, J. W. (1972). United Press International, April 5, 1971. Cited by A. C. Elms, *Social psychology and social reliance.* Boston: Little, Brown.

Fultz, J., Batson, C. D., Fortenbach, V. A., McCarthy, P. M., & Varney, L. L. (1986). Social evaluation and the empathy-altruism hypothesis. *Journal of Personality and Social Psychology, 50,* 761–769.

Funder, D. C. (1987). Errors and mistakes: Evaluating the accuracy of social judgment. *Psychological Bulletin, 101,* 75–90.

Funder, D. C., & Colvin, C. R. (1991). Explorations in behavioral consistency: Properties of persons, situations, and behaviors. *Journal of Personality and Social Psychology, 60,* 773–794.

Furnham, A. (1982). Explanations for unemployment in Britain. *European Journal of Social Psychology, 12,* 335–352.

Furnham, A., & Gunter. B. (1984). Just world beliefs and attitudes towards the poor. *British Journal of Social Psychology, 23,* 265–269.

Furst, C. J., Burnam, M. A., & Kocel, K. M. (1980). Life stressors and romantic affiliation. Paper presented at the Western Psychological Association convention.

Gabrenya, W. K., Jr., Wang, Y.-E., & Latané, B. (1985). Social loafing on an optimizing task: Cross-cultural differences among Chinese and Americans. *Journal of Cross-Cultural Psychology, 16,* 223–242.

Gaebelein, J. W., & Mander, A. (1978). Consequences for targets of aggression as a function of aggressor and instigator roles: Three experiments. *Personality and Social Psychology Bulletin, 4,* 465–468.

Gaertner, S. L. (1973). Helping behavior and racial discrimination among liberals and conservatives. *Journal of Personality and Social Psychology, 25,* 335–341.

Gaertner, S. L. (1975). The role of racial attitudes in helping behavior. *Journal of Social Psychology, 97,* 95–101.

Gaertner, S. L., & Bickman, L. (1971). Effects of race on the elicitation of helping behavior. *Journal of Personality and Social Psychology, 20,* 218–222.

Gaertner, S. L., & Dovidio, J. F. (1977). The subtlety of white racism, arousal, and helping behavior. *Journal of Personality and Social Psychology, 35,* 691–707.

Gaertner, S. L., & Dovidio, J. F. (1986). The aversive form of racism. In J. F. Dovidio & S. L. Gaertner (Eds.), *Prejudice, discrimination, and racism.* Orlando, Fl.: Academic Press.

Gaertner, S. L., & Dovidio, J. F. (1991). Reducing bias: The common ingroup identity model. Unpublished manuscript, University of Delaware.

Gaertner, S. L., Mann, J. A., Dovidio, J. F., Murrell, A. J., & Pomare, M. (1990). How does cooperation reduce intergroup bias? *Journal of Personality and Social Psychology, 59,* 692–704.

Gaertner, S. L., Mann, J., Murrell, A., & Dovidio, J. F. (1989). Reducing intergroup bias: The benefits of recategorization. *Journal of Personality and Social Psychology, 57,* 239–249.

Galanter, M. (1989). *Cults: Faith, healing, and coercion.* New York: Oxford University Press.

Galanter, M. (1990). Cults and zealous self-help movements: A psychiatric perspective. *American Journal of Psychiatry, 147,* 543–551.

Galizio, M., & Hendrick, C. (1972). Effect of musical accompaniment on attitude: The guitar as a prop for persuasion. *Journal of Applied Social Psychology, 2,* 350–359.

Gallup, G. H. (1972). *The Gallup poll: Public opinion 1935–1971.* (Vol. 3). New York: Random House, pp. 551, 1716.

Gallup, G., Jr. (1984, March). Religion in America. *The Gallup Report,* Report No. 222.

Gallup, G., Jr., & Hugick, L. (1990, June). Racial tolerance grows, progress on racial equality less evident. *Gallup Poll Monthly,* pp. 23–32.

Gallup, G., Jr., & Newport, F. (1990, December). Americans now drinking less alcohol. *Gallup Poll Monthly,* pp. 2–6.

Gallup Organization (1989, July). Cigarette smoking at 45-year low. *Gallup Poll Monthly,* No. 286, pp. 23–26.

Gallup Organization (1990). April 19–22 survey reported in *American Enterprise,* September/October, 1990, p. 92.

Gamson, W. A., Fireman, B., & Rytina, S. (1982). *Encounters with unjust authority.* Homewood, Ill.: Dorsey Press.

Garbarino, J., & Bronfenbrenner, U. (1976). The socialization of moral judgment and behavior in cross-cultural perspective. In T. Lickona (Ed.), *Moral development and behavior: Theory, research, and social issues.* New York: Holt, Rinehart and Winston.

Gastorf, J. W., Suls, J., & Sanders, G. S. (1980). Type A coronary-prone behavior pattern and social facilitation. *Journal of Personality and Social Psychology, 8,* 773–780.

Gates, M. F., & Allee, W. C. (1933). Conditioned behavior of isolated and grouped cockroaches on a simple maze. *Journal of Comparative Psychology, 15,* 331–358.

Gavanski, I., & Hoffman, C. (1987). Awareness of influences on one's own judgments: The roles of covariation detection and attention to the judgment process. *Journal of Personality and Social Psychology, 52,* 453–463.

Gavanski, I., & Wells, G. L. (1989). Counterfactual processing of normal and exceptional events. *Journal of Experimental Social Psychology, 35,* 314–325.

Gayoso, A., Cutler, B. L., & Moran, G. (1991). Assessing the value of social

scientists as trial consultants: A consumer research approach. Unpublished manuscript, Florida International University.

Gazzaniga, M. (1985). *The social brain: Discovering the networks of the mind.* New York: Basic Books.

Gecas, V. (1989). The social psychology of self-efficacy. *Annual Review of Sociology,* **15,** 291–316.

Geen, R. G., & Gange, J. J. (1983). Social facilitation: Drive theory and beyond. In H. H. Blumberg, A. P. Hare, V. Kent, & M. Davies (Eds.), *Small groups and social interaction,* Vol. 1. London: Wiley.

Geen, R. G., & Quanty, M. B. (1977). The catharsis of aggression: An evaluation of a hypothesis. In L. Berkowitz (Ed.), *Advances in experimental social psychology* (Vol. 10). New York: Academic Press.

Geen, R. G., Rakosky, J. J., & Pigg, R. (1972). Awareness of arousal and its relation to aggression. *British Journal of Social and Clinical Psychology,* **11,** 115–121.

Geen, R. G., & Thomas, S. L. (1986). The immediate effects of media violence on behavior. *Journal of Social Issues,* **42**(3), 7–28.

Gelman, D. (1990, July 23). The mind of the rapist. *Newsweek,* pp. 48–49.

Gerard, H. B., & Mathewson, G. C. (1966). The effects of severity of initiation on liking for a group: A replication. *Journal of Experimental Social Psychology,* **2,** 278–287.

Gerard, H. B., Wilhelmy, R. A., & Conolley, E. S. (1968). Conformity and group size. *Journal of Personality and Social Psychology,* **8,** 79–82.

Gerasimov, G. (1988). Quoted in *Parade,* July 10, 1988, p. 2.

Gerbasi, K. C., Zuckerman, M., & Reis, H. T. (1977). Justice needs a new blindfold: A review of mock jury research. *Psychological Bulletin,* **84,** 323–345.

Gerbner, G. (in press). The politics of media violence: Some reflections. In C. Hamelink & O. Linne (Eds.), *Mass communication research: On problems and policies.* Norwood, NJ: Ablex Publishing.

Gerbner, G., Gross, L., Morgan, M., & Signorielli, N. (1986). Living with television: The dynamics of the cultivation process. In J. Bryant & D. Zillman (Eds.), *Perspectives on media effects.* Hillsdale, N.J.: Erlbaum.

Gerbner, G., Gross, L., Morgan, M., & Signorielli, N. (in press). Growing up with television: The cultivation perspective. In J. Bryant & D. Zillmann (Eds.), *Media effects: Advances in theory and research.* Hillsdale, NJ: Erlbaum.

Gerbner, G., Gross, L., Signorielli, N., Morgan, M., & Jackson-Beeck, M. (1979). The demonstration of power: Violence profile No. 10. *Journal of Communication,* **29,** 177–196.

Gerbner, G., & Signorielli, N. (1990). Violence profile 1967 through 1988–89: Enduring patterns. Unpublished manuscript, Annenberg School of Communications, University of Pennsylvannia.

Gergen, K. E. (1982). *Toward transformation in social knowledge.* New York: Springer-Verlag.

Gergen, K. J., Gergen, M. M., & Barton, W. N. (1973, October). Deviance in the dark. *Psychology Today,* pp. 129–130.

Gerrig, R. J., & Prentice, D. A. (1991). The representation of fictional information. *Psychological Science,* **2,** 336–340.

Gibbons, F. X. (1978). Sexual standards and reactions to pornography: Enhancing behavioral consistency through self-focused attention. *Journal of Personality and Social Psychology,* **36,** 976–987.

Gibbons, F. X., & Gerrard, M. (1989). Effects of upward and downward social comparison on mood states. *Journal of Social and Clinical Psychology,* **8,** 14–31.

Gibbons, F. X., & Wicklund, R. A. (1982). Self-focused attention and helping behavior. *Journal of Personality and Social Psychology,* **43,** 462–474.

Gifford, R., & Peacock, J. (1979). Crowding: More fearsome than crime-provoking? Comparison of an Asian city and a North American city. *Psychologia,* **22,** 79–83.

Gilbert, D. T., & Hixon, J. G. (1991). The trouble of thinking: Activation and application of stereotypic beliefs. *Journal of Personality and Social Psychology,* **60,** 509–517.

Gilbert, D. T., & Jones, E. E. (1986). Perceiver-induced constraint: Interpretations of self-generated reality. *Journal of Personality and Social Psychology,* **50,** 269–280.

Gilbert, D. T., Pelham, B. W., & Krull, D. S. (1988). On cognitive busyness: When person perceivers meet persons perceived. *Journal of Personality and Social Psychology,* **54,** 733–740.

Gilkey, L. (1966). *Shantung compound.* New York: Harper & Row.

Gilligan, C. (1982). *In a different voice: Psychological theory and women's development.* Cambridge, Mass.: Harvard University Press.

Gilligan, C., Lyons, N. P., & Hanmer, T. J. (Eds.) (1990). *Making connections: The relational worlds of adolescent girls at Emma Willard School.* Cambridge, MA: Harvard University Press.

Gillis, J. S., & Avis, W. E. (1980). The male-taller norm in mate selection. *Personality and Social Psychology Bulletin,* **6,** 396–401.

Gilmor, T. M., & Reid, D. W. (1979). Locus of control and causal attribution for positive and negative outcomes on university examinations. *Journal of Research in Personality,* **13,** 154–160.

Gilovich, T. (1981). Seeing the past in the present: The effect of associations to familiar events on judgments and decisions. *Journal of Personality and Social Psychology,* **40,** 797–808.

Gilovich, T. (1984). Judgmental biases in the world of sports. In W. F. Straub & J. M. Williams (Eds.), *Cognitive sport psychology.* New York: Sports Science Associates.

Gilovich, T. (1987). Secondhand information and social judgment. *Journal of Experimental Social Psychology,* **23,** 59–74.

Gilovich, T. (1988). How we know what isn't so: The foundations of questionable and erroneous beliefs. Unpublished manuscript, Cornell University.

Gilovich, T. (1991). *How we know what isn't so: The fallibility of human reason in everyday life.* New York: Free Press.

Gilovich, T., & Douglas, C. (1986). Biased evaluations of randomly determined gambling outcomes. *Journal of Experimental Social Psychology,* **22,** 228–241.

Ginossar, Z., & Trope, Y. (1987). Problem solving in judgment under uncertainty. *Journal of Personality and Social Psychology,* **52,** 464–474.

Ginsburg, B., & Allee, W. C. (1942). Some effects of conditioning on social dominance and subordination in inbred strains of mice. *Physiological Zoology,* **15,** 485–506.

Glass, D. C. (1964). Changes in liking as a means of reducing cognitive discrepancies between self-esteem and aggression. *Journal of Personality,* **32,** 531–549.

Glenn, N. D. (1980). Aging and attitudi-

nal stability. In O. G. Brim, Jr., & J. Kagan (Eds.), *Constancy and change in human development*. Cambridge, Mass.: Harvard University Press.

Glenn, N. D. (1981). Personal communication.

Glick, D., Gottesman, D., & Jolton, J. (1989). The fault is not in the stars: Susceptibility of skeptics and believers in astrology to the Barnum effect. *Personality and Social Psychology Bulletin*, **15**, 572–583.

Goethals, G. R., Messick, D. M., & Allison, S. T. (1991). The uniqueness bias: Studies of constructive social comparison. In J. Suls & T. A. Wills (Eds.), *Social comparison: Contemporary theory and research*. Hillsdale, NJ: Erlbaum.

Goethals, G. R., & Nelson, E. R. (1973). Similarity in the influence process: The belief-value distinction. *Journal of Personality and Social Psychology*, **25**, 117–122.

Goethals, G. R., & Zanna, M. P. (1979). The role of social comparison in choice shifts. *Journal of Personality and Social Psychology*, **37**, 1469–1476.

Goggin, W. C., & Range, L. M. (1985). The disadvantages of hindsight in the perception of suicide. *Journal of Social and Clinical Psychology*, **3**, 232–237.

Gold, J. A., Ryckman, R. M., & Mosley, N. R. (1984). Romantic mood induction and attraction to a dissimilar other: Is love blind? *Personality and Social Psychology Bulletin*, **10**, 358–368.

Goldberg, P. (1968, April). Are women prejudiced against women? *Transaction*, pp. 28–30.

Golding, W. (1962). *Lord of the flies*. New York: Coward-McCann.

Goldman, C. (1980). An examination of social facilitation. Unpublished manuscript, University of Michigan, 1967. Cited by R. B. Zajonc in, Compresence, in P. B. Paulus (Ed.), *Psychology of group influence*. Hillsdale, N.J.: Lawrence Erlbaum.

Goldman, W., & Lewis, P. (1977). Beautiful is good: Evidence that the physically attractive are more socially skillful. *Journal of Experimental Social Psychology*, **13**, 125–130.

Goldstein, A. G., Chance, J. E., & Schneller, G. R. (1989). Frequency of eyewitness identification in criminal cases: A survey of prosecutors. *Bulletin of the Psychonomic Society*, **27**, 71–74.

Goldstein, J. H. (1982). Sports violence. *National Forum*, **62**(1), 9–11.

Goldstein, J. H., & Arms, R. L. (1971). Effects of observing athletic contests on hostility. *Sociometry*, **34**, 83–90.

Goleman, D. (1985, March 5). Great altruists: Science ponders soul of goodness. *New York Times*, pp. C1, C2.

Goleman, D. (1990, May 29). As bias crime seems to rise, scientists study roots of racism. *New York Times*, pp. C1, C5.

Gonzales, M. H., Aronson, E., & Costanzo, M. A. (1988). Using social cognition and persuasion to promote energy conservation: A quasi-experiment. *Journal of Applied Social Psychology*, **18**, 1049–1066.

Goodhart, D. E. (1986). The effects of positive and negative thinking on performance in an achievement situation. *Journal of Personality and Social Psychology*, **51**, 117–124.

Gorsuch, R. L. (1988). Psychology of religion. *Annual Review of Psychology*, **39**, 201–222.

Gotlib, I. H., & Colby, C. A. (1988). How to have a good quarrel. In P. Marsh (Ed.), *Eye to eye: How people interact*. Topsfield, MA: Salem House.

Gotlib, I. H., & Lee, C. M. (1989). The social functioning of depressed patients: A longitudinal assessment. *Journal of Social and Clinical Psychology*, **8**, 223–237.

Gottlieb, J., & Carver, C. S. (1980). Anticipation of future interaction and the bystander effect. *Journal of Experimental Social Psychology*, **16**, 253–260.

Gould, M. S., & Shaffer, D. (1986). The impact of suicide in television movies: Evidence of imitation. *New England Journal of Medicine*, **315**, 690–694.

Gould, R., Brounstein, P. J., & Sigall, H. (1977). Attributing ability to an opponent: Public aggrandizement and private denigration. *Sociometry*, **40**, 254–261.

Gould, S. J. (1988, July). Kropotkin was no crackpot. *Natural History*, pp. 12–21.

Gouldner, A. W. (1960). The norm of reciprocity: A preliminary statement. *American Sociological Review*, **25**, 161–178.

Gray, C., Russell, P., & Blockley, S. (1991). The effects upon helping behaviour of wearing pro-gay identification. *British Journal of Social Psychology*, **30**, 171–178.

Gray, J. D., & Silver, R. C. (1990). Opposite sides of the same coin: Former spouses' divergent perspec-

tives in coping with their divorce. *Journal of Personality and Social Psychology*, **59**, 1180–1191.

Graziano, W., Brothen, T., & Berscheid, E. (1978). Height and attraction: Do men and women see eye-to-eye? *Journal of Personality*, **46**, 128–145.

Greeley, A. M. (1976). Pop psychology and the Gospel. *Theology Today*, **23**, 224–231.

Greeley, A. M. (1991). *Faithful attraction*. New York: Tor Books.

Greeley, A. M., & Sheatsley, P. B. (1971). Attitudes toward racial integration. *Scientific American*, **225**(6), 13–19.

Green, C. W., Adams, A. M., & Turner, C. W. (1988). Development and validation of the school interracial climate scale. *American Journal of Community Psychology*, **16**, 241–259.

Greenberg, J. (1979). Group vs. individual equity judgments: Is there a polarization effect? *Journal of Experimental Social Psychology*, **15**, 504–512.

Greenberg, J. (1980). Attentional focus and locus of performance causality as determinants of equity behavior. *Journal of Personality and Social Psychology*, **38**, 579–585.

Greenberg, J. (1986). Differential intolerance for inequity from organizational and individual agents. *Journal of Applied Social Psychology*, **16**, 191–196.

Greenberg, J., Pyszczynski, T., Solomon, S., Rosenblatt, A., Veeder, M., Kirkland, S., & Lyon, D. (1990). Evidence for terror management theory II: The effects of mortality salience on reactions to those who threaten or bolster the cultural worldview. *Journal of Personality and Social Psychology*, **58**, 308–318.

Greenwald, A. G. (1968). Cognitive learning, cognitive response to persuasion, and attitude change. In A. G. Greenwald, T. C. Brock, & T. M. Ostrom (Eds.), *Psychological foundations of attitudes*. New York: Academic Press.

Greenwald, A. G. (1975). On the inconclusiveness of crucial cognitive tests of dissonance versus self-perception theories. *Journal of Experimental Social Psychology*, **11**, 490–499.

Greenwald, A. G. (1980). The totalitarian ego: Fabrication and revision of personal history. *American Psychologist*, **35**, 603–618.

Greenwald, A. G. (1990). What cognitive representations underlie prejudice? Presentation to the American Psychological Association convention.

Greenwald, A. G. (1990). What cognitive representations underlie social attitudes? *Bulletin of the Psychonomic Society,* **28,** 254–260.

Greenwald, A. G., Carnot, C. G., Beach, R., & Young, B. (1987). Increasing voting behavior by asking people if they expect to vote. *Journal of Applied Psychology,* **72,** 315–318.

Griffin, B. Q., Combs, A. L., Land, M. L., & Combs, N. N. (1983). Attribution of success and failure in college performance. *Journal of Psychology,* **114,** 259–266.

Griffitt, W. (1970). Environmental effects on interpersonal affective behavior. Ambient effective temperature and attraction. *Journal of Personality and Social Psychology,* **15,** 240–244.

Griffitt, W. (1987). Females, males, and sexual responses. In K. Kelley (Ed.), *Females, males, and sexuality: Theories and research.* Albany: State University of New York Press.

Griffitt, W., & Veitch, R. (1971). Hot and crowded: Influences of population density and temperature on interpersonal affective behavior. *Journal of Personality and Social Psychology,* **17,** 92–98.

Griffitt, W., & Veitch, R. (1974). Preacquaintance attitude similarity and attraction revisited: Ten days in a fallout shelter. *Sociometry,* **37,** 163–173.

Grofman, B. (1980). The slippery slope: Jury size and jury verdict requirements—legal and social science approaches. In B. H. Raven (Ed.), *Policy studies review annual* (Vol. 4). Beverly Hills, Calif.: Sage Publications.

Gross, A. E., & Crofton, C. (1977). What is good is beautiful. *Sociometry,* **40,** 85–90.

Grove, J. R., Hanrahan, S. J., & McInman, A. (1991). Success/failure bias in attributions across involvement categories in sport. *Personality and Social Psychology Bulletin,* **17,** 93–97.

Grube, J. W., Kleinhesselink, R. R., & Kearney, K. A. (1982). Male self-acceptance and attraction toward women. *Personality and Social Psychology Bulletin,* **8,** 107–112.

Gruder, C. L. (1977). Choice of comparison persons in evaluating oneself. In J. M. Suls & R. L. Miller (Eds.), *Social comparison processes.* Washington: Hemisphere Publishing.

Gruder, C. L., Cook, T. D., Hennigan, K. M., Flay, B., Alessis, C., & Kalamaj, J. (1978). Empirical tests of the absolute sleeper effect predicted from the discounting cue hypothesis. *Journal of Personality and Social Psychology,* **36,** 1061–1074.

Gruman, J. C., & Sloan, R. P. (1983). Disease as justice: Perceptions of the victims of physical illness. *Basic and Applied Social Psychology,* **4,** 39–46.

Grunberger, R. (1971). *The 12-year-Reich: A social history of Nazi Germany 1933–1945.* New York: Holt, Rinehart & Winston.

Grush, J. E. (1976). Attitude formation and mere exposure phenomena: A nonartifactual explanation of empirical findings. *Journal of Personality and Social Psychology,* **33,** 281–290.

Grush, J. E. (1980). Impact of candidate expenditures, regionality, and prior outcomes on the 1976 Democratic presidential primaries. *Journal of Personality and Social Psychology,* **38,** 337–347.

Grush, J. E., & Glidden, M. V. (1987). Power and satisfaction among distressed and nondistressed couples. Paper presented at the Midwestern Psychological Association convention.

Grush, J. E., McKeough, K. L., & Ahlering, R. F. (1978). Extrapolating laboratory exposure research to actual political elections. *Journal of Personality and Social Psychology,* **36,** 257–270.

Gudykunst, W. B. (1989). Culture and intergroup processes. In M. H. Bond (Ed.), *The cross-cultural challenge to social psychology.* Newbury Park, Ca.: Sage.

Guerin, B. (1986). Mere presence effects in humans: A review. *Journal of Personality and Social Psychology,* **22,** 38–77.

Guerin, B., & Innes, J. M. (1982). Social facilitation and social monitoring: A new look at Zajonc's mere presence hypothesis. *British Journal of Social Psychology,* **21,** 7–18.

Gupta, U., & Singh, P. (1982). Exploratory study of love and liking and type of marriages. *Indian Journal of Applied Psychology,* **19,** 92–97.

Gutmann, D. (1977). The cross-cultural perspective: Notes toward a comparative psychology of aging. In J. E. Birren & K. Warner Schaie (Eds.), *Handbook of the psychology of aging.* New York: Van Nostrand Reinhold.

Hacker, H. M. (1951). Women as a minority group. *Social Forces,* **30,** 60–69.

Hackman, J. R. (1986). The design of work teams. In J. Lorsch (Ed.), *Handbook of organizational behavior.* Englewood Cliffs, N.J.: Prentice-Hall.

Hadden, J. K. (1969). *The gathering storm in the churches.* Garden City, N.Y.: Doubleday.

Haemmerlie, F. M. (1987). Creating adaptive illusions in counseling and therapy using a self-perception theory perspective. Paper presented at the Midwestern Psychological Association, Chicago.

Haemmerlie, F. M., & Montgomery, R. L. (1982). Self-perception theory and unobtrusively biased interactions: A treatment for heterosocial anxiety. *Journal of Counseling Psychology,* **29,** 362–370.

Haemmerlie, F. M., & Montgomery, R. L. (1984). Purposefully biased interventions: Reducing heterosocial anxiety through self-perception theory. *Journal of Personality and Social Psychology,* **47,** 900–908.

Haemmerlie, F. M., & Montgomery, R. L. (1986). Self-perception theory and the treatment of shyness. In W. H. Jones, J. M. Cheek, & S. R. Briggs (Eds.), *A sourcebook on shyness: Research and treatment.* New York: Plenum.

Hafner, H., & Schmidtke, A. (1989). Do televised fictional suicide models produce suicides? In D. R. Pfeffer (Ed.), *Suicide among youth: Perspectives on risk and prevention.* Washington, DC: American Psychiatric Press.

Hagiwara, S. (1983). Role of self-based and sample-based consensus estimates as mediators of responsibility judgments for automobile accidents. *Japanese Psychological Research,* **25,** 16–28.

Halberstadt, A. G., & Saitta, M. B. (1987). Gender, nonverbal behavior, and perceived dominance: A test of the theory. *Journal of Personality and Social Psychology,* **53,** 257–272.

Hall, C. S. (1978). The incredible Freud. *Contemporary Psychology,* **23,** 38–39.

Hall, J. A. (1984). *Nonverbal sex differences: Communication accuracy and expressive style.* Baltimore: Johns Hopkins University Press.

Hall, J. A. (1987). On explaining gender differences: The case of nonverbal communication. In P. Shaver & C. Hendrick (Eds.), *Sex and gender: Review of personality and social psychology,* Vol. 7. Beverly Hills: Sage.

Hall, T. (1985, June 25). The unconverted: Smoking of cigarettes seems to be becoming a lower-class habit. *Wall Street Journal,* pp. 1, 25.

Hallmark Cards (1990). Cited in *Time,* Fall special issue on women.

Hamblin, R. L., Buckholdt, D., Bushell, D., Ellis, D., & Feritor, D. (1969). Changing the game from get the teacher to learn. *Transaction,* January, pp. 20–25, 28–31.

Hamill, R., Wilson, T. D., & Nisbett, R. E. (1980). Insensitivity to sample bias: Generalizing from atypical cases. *Journal of Personality and Social Psychology,* **39,** 578–589.

Hamilton, D. L. (1981). Illusory correlation as a basis for stereotyping. In D. L. Hamilton (Ed.), *Cognitive processes in stereotyping and intergroup behavior.* Hillsdale, N.J.: Erlbaum.

Hamilton, D. L., & Bishop, G. D. (1976). Attitudinal and behavioral effects of initial integration of white suburban neighborhoods. *Journal of Social Issues,* **32**(2), 47–67.

Hamilton, D. L., & Gifford, R. K. (1976). Illusory correlation in interpersonal perception: A cognitive basis of stereotypic judgments. *Journal of Experimental Social Psychology,* **12,** 392–407.

Hamilton, D. L., & Rose, T. L. (1980). Illusory correlation and the maintenance of stereotypic beliefs. *Journal of Personality and Social Psychology,* **39,** 832–845.

Hamilton, D. L., & Sherman, S. J. (1989). Illusory correlations: Implications for stereotype theory and research, In D. Bar-Tal, C. F. Graumann, A. W. Kruglanski, & W. Stroebe (Eds.), *Stereotypes and prejudice: Changing conceptions.* New York: Springer-Verlag.

Hamilton, D. L., Sherman, S. J., & Ruvolo, C. M. (1990). Stereotype-based expectancies: Effects on information processing and social behavior. *Journal of Social Issues,* **46,** 35–60.

Hamilton, D. L., & Zanna, M. P. (1972). Differential weighting of favorable and unfavorable attributes in impressions of personality. *Journal of Experimental Research in Personality,* **6,** 204–212.

Hampson, R. B. (1984). Adolescent prosocial behavior: Peer-group and situational factors associated with helping. *Journal of Personality and Social Psychology,* **46,** 153–162.

Hans, V. P., & Vidmar, N. (1981). Jury selection. In N. L. Kerr & R. M. Bray (Eds.), *The psychology of the courtroom.* New York: Academic Press.

Hansen, C. H. (1989). Priming sex-role stereotypic event schemas with rock music videos: Effects on impression favorability, trait inferences, and recall of a subsequent male-female interaction. *Basic and Applied Social Psychology,* **10,** 371–391.

Hansen, C. H., & Hansen, R. D. (1988). Priming stereotypic appraisal of social interactions: How rock music videos can change what's seen when boy meets girl. *Sex Roles,* **19,** 287–316.

Hansen, C. H., & Hansen, R. D. (1990). Rock music videos and antisocial behavior. *Basic and Applied Social Psychology,* **11,** 357–369.

Hardin, G. (1968). The tragedy of the commons. *Science,* **162,** 1243–1248.

Hardy, C., & Latané, B. (1986). Social loafing on a cheering task. *Social Science,* **71,** 165–172.

Haritos-Fatouros, M. (1988). The official torturer: A learning model for obedience to the authority of violence. *Journal of Applied Social Psychology,* **18,** 1107–1120.

Harkins, S. G. (1981). Effects of task difficulty and task responsibility on social loafing. Presentation to the First International Conference on Social Processes in Small Groups, Kill Devil Hills, North Carolina.

Harkins, S. G., & Jackson, J. M. (1985). The role of evaluation in eliminating social loafing. *Personality and Social Psychology Bulletin,* **11,** 457–465.

Harkins, S. G., Latané, B., & Williams, K. (1980). Social loafing: Allocating effort or taking it easy? *Journal of Experimental Social Psychology,* **16,** 457–465.

Harkins, S. G., & Petty, R. E. (1981). Effects of source magnification of cognitive effort on attitudes: An information-processing view. *Journal of Personality and Social Psychology,* **40,** 401–413.

Harkins, S. G., & Petty, R. E. (1982). Effects of task difficulty and task uniqueness on social loafing. *Journal of Personality and Social Psychology,* **43,** 1214–1229.

Harkins, S. G., & Petty, R. E. (1987). Information utility and the multiple source effect. *Journal of Personality and Social Psychology,* **52,** 260–268.

Harkins, S. G., & Szymanski, K. (1989). Social loafing and group evaluation. *Journal of Personality and Social Psychology,* **56,** 934–941.

Harper's Index (1991, September). *Harper's Magazine,* p. 15. Data from Amateur Athletic Foundation of Los Angeles.

Harper's Magazine (1989, November). Harper's index. P. 15.

Harries, K. D., & Stadler, S. J. (1988). Heat and violence: New findings from Dallas field data, 1980–1981. *Journal of Applied Social Psychology,* **18,** 129–138.

Harris, M. J., & Rosenthal, R. (1985). Mediation of interpersonal expectancy effects: 31 meta-analyses. *Psychological Bulletin,* **97,** 363–386.

Harris, M. J., & Rosenthal, R. (1986). Four factors in the mediation of teacher expectancy effects. In R. S. Feldman (Ed.), *The social psychology of education.* New York: Cambridge University Press.

Harris, T. G. (1978). Introduction to E. H. Walster and G. W. Walster, *A new look at love.* Reading, Mass.: Addison-Wesley.

Harrison, A. A. (1977). Mere exposure. In L. Berkowitz (Ed.), *Advances in experimental social psychology* (Vol. 10). New York: Academic Press, pp. 39–83.

Harvey, J. H., Town, J. P., & Yarkin, K. L. (1981). How fundamental is the fundamental attribution error? *Journal of Personality and Social Psychology,* **40,** 346–349.

Hass, R. G., Katz, I., Rizzo, N., Bailey, J., & Eisenstadt, D. (1991). Cross-racial appraisal as related to attitude ambivalence and cognitive complexity. *Personality and Social Psychology Bulletin,* **17,** 83–92.

Hassan I. N. (1980). Role and status of women in Pakistan: An empirical research review. *Pakistan Journal of Psychology,* **13,** 36–56.

Hastie, R., Penrod, S. D., & Pennington, N. (1983). *Inside the jury.* Cambridge, Mass.: Harvard University Press.

Hastorf, A., & Cantril, H. (1954). They saw a game: A case study. *Journal of Abnormal and Social Psychology,* **49,** 129–134.

Hatfield, E. (1988). Passionate and compassionate love. In R. J. Sternberg & M. L. Barnes (Eds.), *The psychology of love.* New Haven, Conn.: Yale University Press.

Hatfield, E., Cacioppo, J. T., & Rapson, R. (1992). The logic of emotion: Emotional contagion. In M. S. Clark (Ed.), *Review of Personality and Social Psychology.* Newbury Park, CA: Sage.

Hatfield, E., & Rapson, R. L. (1987). Passionate love: New directions in research. In W. H. Jones & D. Perlman (Eds.), *Advances in personal relationships,* Vol. 1. Greenwich, Ct.: JAI Press.

Hatfield, E. & Sprecher, S. (1986).

Mirror, mirror: The importance of looks in everyday life. Albany, N.Y.: SUNY Press.

Hatfield, E., Traupmann, J., Sprecher, S., Utne, M., & Hay, J. (1985). Equity and intimate relations: Recent research. In W. Ickes (Ed.), *Compatible and incompatible relationships.* New York: Springer-Verlag.

Hawkins, S. A., & Hastie, R. (1990). Hindsight: Biased judgments of past events after the outcomes are known. *Psychological Bulletin,* **107,** 311–327.

Headey, B., & Wearing, A. (1987). The sense of relative superiority— central to well-being. *Social Indicators Research,* **20,** 497–516.

Hearold, S. (1986). A synthesis of 1043 effects of television on social behavior. In G. Comstock (Ed.), *Public communication and behavior,* Vol. 1. Orlando, Fl.: Academic Press.

Heath, L., & Petraitis, J. (1987). Television viewing and fear of crime: Where is the mean world? *Basic and Applied Social Psychology,* **8,** 97–123.

Heaton, A. W., & Sigall, H. (1989). The "championship choke" revisited: The role of fear of acquiring a negative identity. *Journal of Applied Social Psychology,* **19,** 1019–1033.

Heaton, A. W., & Sigall, H. (1991). Self-consciousness, self-presentation, and performance under pressure: Who chokes, and when? *Journal of Applied Social Psychology,* **21,** 175–188.

Heesacker, M. (1989). Counseling and the elaboration likelihood model of attitude change. In J. F. Cruz, R. A. Goncalves, & P. P. Machado (Eds.), *Psychology and education: Investigations and interventions.* (Proceedings of the International Conference on Interventions in Psychology and Education, Porto, Portugal, July, 1987.) Porto, Portugal: Portugese Psychological Association.

Heider, F. (1958). *The psychology of interpersonal relations.* New York: Wiley.

Heilman, M. E. (1976). Oppositional behavior as a function of influence attempt intensity and retaliation threat. *Journal of Personality and Social Psychology,* **33,** 574–578.

Hellman, P. (1980). *Avenue of the righteous of nations.* New York: Atheneum.

Hemsley, G. D., & Doob, A. N. (1978). The effect of looking behavior on perceptions of a communicator's credibility. *Journal of Applied Social Psychology,* **8,** 136–144.

Hendrick, C. (1988). Roles and gender in relationships. In S. Duck (Ed.), *Handbook of personal relationships.* Chichester, England: Wiley.

Hendrick, C., & Hendrick, S. (1993). *Romantic love.* Newbury Park, CA: Sage.

Hendrick, S. S., Hendrick, C., & Adler, N. L. (1988). Romantic relationships: Love, satisfaction, and staying together. *Journal of Personality and Social Psychology,* **54,** 980–988.

Hendrick, S. S., Hendrick, C., Slapion-Foote, J., & Foote, F. H. (1985). Gender differences in sexual attitudes. *Journal of Personality and Social Psychology,* **48,** 1630–1642.

Henley, N. (1977). *Body politics: Power, sex, and nonverbal communication.* Englewood Cliffs, N.J.: Prentice-Hall.

Hennigan, K. M., Del Rosario, M. L., Health, L., Cook, T. D., Wharton, J. D., & Calder, B. J. (1982). Impact of the introduction of television on crime in the United States: Empirical findings and theoretical implications. *Journal of Personality and Social Psychology,* **42,** 461–477.

Henslin, M. (1967). Craps and magic. *American Journal of Sociology,* **73,** 316–330.

Hepworth, J. T., & West, S. G. (1988). Lynchings and the economy: A time-series reanalysis of Hovland and Sears (1940). *Journal of Personality and Social Psychology,* **55,** 239–247.

Heradstveit, D. (1980). *The Arab-Israeli conflict: Psychological obstacles to peace* (Vol. 28). Oslo, Norway: Universitetsforlaget, 1979. Distributed by Columbia University Press. Reviewed by R. K. White, *Contemporary Psychology,* **25,** 11–12.

Herek, G. M. (1986). The instrumentality of attitudes: Toward a neofunctional theory. *Journal of Social Issues,* **42,** 99–114.

Herek, G. M. (1987). Can functions be measured? A new perspective on the functional approach to attitudes. *Social Psychology Quarterly,* **50,** 285–303.

Herek, G. M. (1990). The context of antigay violence: Notes on cultural and psychological heterosexism. *Journal of Interpersonal Violence,* **5,** 316–333.

Hewstone, M. (1988). Causal attribution: From cognitive processes to collective beliefs. *The Psychologist,* **8,** 323–327.

Hewstone, M. (1990). The ultimate attribution error'? A review of the litera-ture on intergroup causal attribution. *European Journal of Social Psychology,* **20,** 311–335.

Hewstone, M., Hantzi, A., & Johnston, L. (1991). Social categorisation and person memory: The pervasiveness of race as an organizing principle. *European Journal of Social Psychology,* **21,** 517–528.

Hewstone, M., Hopkins, N., & Routh, D. A. (1992). Cognitive models of stereotype change: (1) Generalization and subtyping in young people's views of the police. *European Journal of Social Psychology,* **22,** 219–234.

Hewstone, M., & Ward, C. (1985). Ethnocentrism and causal attribution in southeast Asia. *Journal of Personality and Social Psychology,* **48,** 614–623.

Higbee, K. L., Millard, R. J., & Folkman, J. R. (1982). Social psychology research during the 1970s: Predominance of experimentation and college students. *Personality and Social Psychology Bulletin,* **8,** 180–183.

Higgins, E. T., & Bargh, J. A. (1987). Social cognition and social perception. *Annual Review of Psychology,* **38,** 369–425.

Higgins, E. T., & McCann, C. D. (1984). Social encoding and subsequent attitudes, impressions and memory: "Context-driven" and motivational aspects of processing. *Journal of Personality and Social Psychology,* **47,** 26–39.

Higgins, E. T., & Rholes, W. S. (1978). Saying is believing: Effects of message modification on memory and liking for the person described. *Journal of Experimental Social Psychology,* **14,** 363–378.

Higgins, E. T., Rholes, W. S., & Jones, C. R. (1977). Category accessibility and impression formation. *Journal of Experimental Social Psychology,* **13,** 141–154.

Hilgard, E. R., & Loftus, E. F. (1979). Effective interrogation of the eyewitness. *International Journal of Clinical and Experimental Hypnosis,* **27,** 342–357.

Hill, T., Lewicki, P., Czyzewska, M., & Boss, A. (1989). Self-perpetuating development of encoding biases in person perception. *Journal of Personality and Social Psychology,* **57,** 373–387.

Hill, T., Smith, N. D., & Lewicki, P. (1989). The development of self-image bias: A real-world demonstration. *Personality and Social Psychology Bulletin,* **15,** 205–211.

Hill, W. F. (1978). Effects of mere exposure on preferences in nonhuman ani-

mals. *Psychological Bulletin, 85,* 1177–1198.

Hilton, J. L., & Darley, J. M. (1985). Constructing other persons: A limit on the effect. *Journal of Experimental Social Psychology, 21,* 1–18.

Hilton, J. L., & von Hippel, W. (1990). The role of consistency in the judgment of stereotype-relevant behaviors. *Personality and Social Psychology Bulletin, 16,* 430–448.

Hinde, R. A. (1984). Why do the sexes behave differently in close relationships? *Journal of Social and Personal Relationships, 1,* 471–501.

Hinkle, S., Brown, R., & Ely, P. G. (1992). Social identity theory processes: Some limitations and limiting conditions. *Revista de Psicologia Social,* in press.

Hinsz, V. B. (1990). Cognitive and consensus processes in group recognition memory performance. *Journal of Personality and Social Psychology, 59,* 705–718.

Hinsz, V. B., & Davis, J. H. (1984). Persuasive arguments theory, group polarization, and choice shifts. *Personality and Social Psychology Bulletin, 10,* 260–268.

Hirschman, R. S., & Leventhal, H. (1989). Preventing smoking behavior in school children: An initial test of a cognitive-development program. *Journal of Applied Social Psychology, 19,* 559–583.

Hirt, E. R. (1990). Do I see only what I expect? Evidence for an expectancy-guided retrieval model. *Journal of Personality and Social Psychology, 58,* 937–951.

Hirt, E. R., & Kimble, C. E. (1981). The home-field advantage in sports: Differences and correlates. Paper presented at the Midwestern Psychological Association convention.

Hodges, B. H. (1974). Effect of valence on relative weighting in impression formation. *Journal of Personality and Social Psychology, 30,* 378–381.

Hodgkinson, V. A., & Weitzman, M. S. (1990). *Giving and volunteering in the United States: Findings from a national survey.* Washington, DC: Independent Sector.

Hodgkinson, V. A., Weitzman, M. S., & Kirsch, A. D. (1990). From commitment to action: How religious involvement affects giving and volunteering. In R. Wuthnow, V. A. Hodgkinson & Associates (Eds.), *Faith and philanthropy in America: Exploring the role of religion*

in *America's voluntary sector.* San Francisco: Jossey-Bass.

Hoffman, C., & Hurst, N. (1990). Gender stereotypes: Perception or rationalization? *Journal of Personality and Social Psychology, 58,* 197–208.

Hoffman, L. W. (1977). Changes in family roles, socialization, and sex differences. *American Psychologist, 32,* 644–657.

Hoffman, M. L. (1981). Is altruism part of human nature? *Journal of Personality and Social Psychology, 40,* 121–137.

Hofling, C. K., Brotzman, E., Dairymple, S., Graves, N., & Pierce, C. M. (1966). An experimental study in nurse-physician relationships. *Journal of Nervous and Mental Disease, 143,* 171–180.

Hogg, M. A., & Abrams, D. (1988). *Social identifications: A social psychology of intergroup relations and group processes.* London: Routledge.

Hogg, M. A., Turner, J. C., & Davidson, B. (1990). Polarized norms and social frames of reference: A test of the self-categorization theory of group polarization. *Basic and Applied Social Psychology, 11,* 77–100.

Hokanson, J. E., & Burgess, M. (1962). The effects of three types of aggression on vascular processes. *Journal of Abnormal and Social Psychology, 64,* 446–449. (b)

Hokanson, J. E., & Burgess, M. (1962). The effects of frustration and anxiety on overt aggression. *Journal of Abnormal and Social Psychology, 65,* 232–237. (a)

Hokanson, J. E., & Edelman, R. (1966). Effects of three social responses on vascular processes. *Journal of Personality and Social Psychology, 3,* 442–447.

Hokanson, J. E., & Shetler, S. (1961). The effect of overt aggression on physiological arousal. *Journal of Abnormal and Social Psychology, 63,* 446–448.

Hollander, E. P. (1958). Conformity, status, and idiosyncrasy credit. *Psychological Review, 65,* 117–127.

Hollander, E. P. (1985). Leadership and power. In G. Lindzey & E. Aronson (Eds.), *The handbook of social psychology,* 3rd ed. New York: Random House.

Holmberg, D., & Holmes, J. G. (in press). Reconstruction of relationship memories: A mental models approach. In N. Schwarz & S. Sudman (Eds.), *Autobiographical memory and the validity of retrospective reports.* New York: Springer-Verlag.

Holmes, J. G., & Rempel, J. K. (1989). Trust in close relationships. In C. Hendrick (Ed.), *Review of personality and social psychology,* Vol. 10. Newbury Park, Ca.: Sage.

Holtgraves, T., & Srull, T. K. (1989). The effects of positive self-descriptions on impressions: General principles and individual differences. *Personality and Social Psychology Bulletin, 15,* 452–462.

Holtzworth, A., & Jacobson, N. S. (1988). An attributional approach to marital dysfunction and therapy. In J. E. Maddux, C. D. Stoltenberg, & R. Rosenwein (Eds.), *Social processes in clinical and counseling psychology.* New York: Springer-Verlag.

Holtzworth-Munroe, A., & Jacobson, N. S. (1985). Causal attributions of married couples: When do they search for causes? What do they conclude when they do? *Journal of Personality and Social Psychology, 48,* 1398–1412.

Hoorens, V., Nuttin, J. M., Herman, I. E., & Pavakanun, U. (1990). Mastery pleasure versus mere ownership: A quasi-experimental cross-cultural and cross-alphabetical test of the name letter effect. *European Journal of Social Psychology, 20,* 181–205.

Hoover, C. W., Wood, E. E., & Knowles, E. S. (1983). Forms of social awareness and helping. *Journal of Experimental Social Psychology, 19,* 577–590.

Hormuth, S. E. (1986). Lack of effort as a result of self-focused attention: An attributional ambiguity analysis. *European Journal of Social Psychology, 16,* 181–192.

Hornstein, H. (1976). *Cruelty and kindness.* Englewood Cliffs, N.J.: Prentice-Hall.

House, R. J., & Singh, J. V. (1987). Organizational behavior: Some new directions for I/O psychology. *Annual Review of Psychology, 38,* 669–718.

Hovland, C. I., Lumsdaine, A. A., & Sheffield, F. D. (1949). *Experiments on mass communication. Studies in social psychology in World War II* (Vol. III). Princeton, N.J.: Princeton University Press.

Hovland, C. I., & Sears, R. (1940). Minor studies of aggression: Correlation of lynchings with economic indices. *Journal of Psychology, 9,* 301–310.

Howes, M. J., Hokanson, J. E., & Loewenstein, D. A. (1985). Induction of depressive affect after prolonged exposure to a mildly depressed individual.

Journal of Personality and Social Psychology, 49, 1110–1113.

Huesmann, L. R., Lagerspetz, K., & Eron, L. D. (1984). Intervening variables in the TV violence-aggression relation: Evidence from two countries. *Developmental Psychology, 20*, 746–775.

Hui, C. H. (1988). Measurement of individualism-collectivism. *Journal of Research in Personality, 22*, 17–36.

Hui, C. H. (1990). West meets East: Individualism versus collectivism in North America and Asia. Invited address, Hope College.

Hui, C. H., Triandis, H. C., & Yee, C. (1991). Cultural differences in reward allocation: Is collectivism the explanation? *British Journal of Social Psychology, 30*, 145–157.

Hull, J. G., & Bond, Jr., C. F. (1986). Social and behavioral consequences of alcohol consumption and expectancy: A meta-analysis. *Psychological Bulletin, 99*, 347–360.

Hull, J. G., Levenson, R. W., Young, R. D., & Sher, K. J. (1983). Self-awareness-reducing effects of alcohol consumption. *Journal of Personality and Social Psychology, 44*, 461–473.

Hull, J. G., & Young, R. D. (1983). The self-awareness-reducing effects of alcohol consumption: Evidence and implications. In J. Suls & A. G. Greenwald (Eds.), *Psychological perspectives on the self*, Vol. 2. Hillsdale, N.J.: Erlbaum.

Humphrey, R. (1985). How work roles influence perception: Structural-cognitive processes and organizational behavior. *American Sociological Review, 50*, 242–252.

Hunt, M. (1990). *The compassionate beast: What science is discovering about the humane side of human kind*. New York: William Morrow.

Hunt, P. J., & Hillery, J. M. (1973). Social facilitation in a location setting: An examination of the effects over learning trials. *Journal of Experimental Social Psychology, 9*, 563–571.

Hunter, J. A., Stringer, M., & Watson, R. P. (1991). Intergroup violence and intergroup attributions. *British Journal of Social Psychology, 30*, 261–266.

Huston, T. L. (1973). Ambiguity of acceptance, social desirability, and dating choice. *Journal of Experimental Social Psychology, 9*, 32–42.

Hutchinson, R. R. (1983). The pain-aggression relationship and its expression in naturalistic settings. *Aggressive Behavior, 9*, 229–242.

Hyde, J. S. (1986). Gender differences in aggression. In J. S. Hyde & M. C. Linn (Eds.), *The psychology of gender: Advances through meta-analysis*. Baltimore: Johns Hopkins University Press.

Hyman, H. H., & Sheatsley, P. B. (1956 & 1964). Attitudes toward desegregation. *Scientific American, 195*(6), 35–39, and **211**(1), 16–23.

Hyman, R. (1981). Cold reading: How to convince strangers that you know all about them. In K. Frazier (Ed.), *Paranormal borderlands of science*. Buffalo, N.Y.: Prometheus Books.

Ickes, B. (1980). On disconfirming our perceptions of others. Paper presented at the American Psychological Association convention.

Ickes, W., & Layden, M. A. (1978). Attributional styles. In J. H. Harvey, W. Ickes, & R. F. Kidd (Eds.), *New directions in attribution research* (Vol. 2). Hillsdale, N.J.: Lawrence Erlbaum.

Ickes, W., Layden, M. A., & Barnes, R. D. (1978). Objective self-awareness and individuation: An empirical link. *Journal of Personality, 46*, 146–161.

Ickes, W., Patterson, M. L., Rajecki, D. W., & Tanford, S. (1982). Behavioral and cognitive consequences of reciprocal versus compensatory responses to preinteraction expectancies. *Social Cognition, 1*, 160–190.

Ickes, W., Snyder, M., & Carcia, S. (1990). Personality influences on the choice of situations. In S. Briggs, R. Hogan, & W. Jones (Eds.), *Handbook of Personality Psychology*. New York: Academic Press.

Ingham, A. G., Levinger, G., Graves, J., & Peckham, V. (1974). The Ringelmann effect: Studies of group size and group performance. *Journal of Experimental Social Psychology, 10*, 371–384.

Insko, C. A., Nacoste, R. W., & Moe, J. L. (1983). Belief congruence and racial discrimination: Review of the evidence and critical evaluation. *European Journal of Social Psychology, 13*, 153–174.

Insko, C. A., Smith, R. H., Alicke, M. D., Wade, J., & Taylor, S. (1985). Conformity and group size: The concern with being right and the concern with being liked. *Journal of Personality and Social Psychology, 11*, 41–50.

Insko, C. A., & Wilson, M. (1977). Interpersonal attraction as a function of social interaction. *Journal of Personality and Social Psychology, 35*, 903–911.

Institute of Medicine (1989). *Behavioral influences on the endocrine and immune systems*. Washington, DC: National Academy Press.

Isen, A. M., Clark, M., & Schwartz, M. F. (1976). Duration of the effect of good mood on helping: Footprints on the sands of time. *Journal of Personality and Social Psychology, 34*, 385–393.

Isen, A. M., Horn, N., & Rosenhan, D. L. (1973). Effects of success and failure on children's generosity. *Journal of Personality and Social Psychology, 27*, 239–247.

Isen, A. M., & Means, B. (1983). The influence of positive affect on decision-making strategy. *Social Cognition, 2*, 28–31.

Isen, A. M., Shalker, T. E., Clark, M., & Karp, L. (1978). Affect, accessibility of material in memory, and behavior: A cognitive loop. *Journal of Personality and Social Psychology, 36*, 1–12.

Islam, M. R., & Hewstone, M. (1991). Intergroup attributions and affective consequences in majority and minority groups. Unpublished manuscript, University of Bristol.

Isozaki, M. (1984). The effect of discussion on polarization of judgments. *Japanese Psychological Research, 26*, 187–193.

ISR Newsletter (1975). Institute for Social Research, University of Michigan, 3(4), 4–7.

Iwao, S. (1988). Social psychology's models of man: Isn't it time for East to meet West? Invited address to the International Congress of Scientific Psychology, Sydney, Australia. Cited by H. C. Triandis (1989). The self and social behavior in differing cultural contexts. *Psychological Review, 96*, 506–520.

Jackman, M. R., & Senter, M. S. (1981). Beliefs about race, gender, and social class different, therefore unequal: Beliefs about trait differences between groups of unequal status. In D. J. Treiman & R. V. Robinson (Eds.), *Research in stratification and mobility* (Vol. 2). Greenwich, Conn.: JAI Press.

Jackson, D. J., & Huston, T. L. (1975). Physical attractiveness and assertiveness. *Journal of Social Psychology, 96*, 79–84.

Jackson, J. (1981, July 19). Syndicated newspaper column.

Jackson, J., & Williams, K. D. (1985). Social loafing on difficult tasks: Working collectively can improve performance. *Journal of Personality and Social Psychology, 49*, 937–942.

Jackson, J. M., & Latané, B. (1981). All alone in front of all those people: Stage fright as a function of number and type of co-performers and audience. *Journal of Personality and Social Psychology,* **40,** 73–85.

Jackson, L. A. (1989). Relative deprivation and the gender wage gap. *Journal of Social Issues,* **45**(4), 117–133.

Jacobs, R. C., & Campbell, D. T. (1961). The perpetuation of an arbitrary tradition through several generations of a laboratory microculture. *Journal of Abnormal and Social Psychology,* **62,** 649–658.

Jacoby, S. (1986, December). When opposites attract. *Reader's Digest,* pp. 95–98.

Jaffe, Y., Shapir, N., & Yinon, Y. (1981). Aggression and its escalation. *Journal of Cross-Cultural Psychology,* **12,** 21–36.

Jaffe, Y., & Yinon, Y. (1983). Collective aggression: The group-individual paradigm in the study of collective antisocial behavior. In H. H. Blumberg, A. P. Hare, V. Kent, & M. Davies (Eds.), *Small groups and social interaction,* Vol. 1. Cambridge: Wiley.

Jain, U. (1990). Social perspectives on causal attribution. In G. Misra (Ed.), *Applied social psychology in India.* New Delhi: Sage.

James, W. (1890, reprinted 1950). *The principles of psychology,* vol. 2. New York: Dover Publications.

James, W. (1976). *Talks to teachers on psychology: And to students on some of life's ideals.* New York: Holt, 1922, p. 33. (Originally published, 1899). Cited by W. J. McKeachie, Psychology in America's bicentennial year. *American Psychologist,* **31,** 819–833.

James, W. (1902, reprinted 1958). *The varieties of religious experience.* New York: Mentor Books.

Jamieson, D. W., Lydon, J. E., Stewart, G., & Zanna, M. P. (1987). Pygmalion revisited: New evidence for student expectancy effects in the classroom. *Journal of Educational Psychology,* **79,** 461–466.

Jamieson, D. W., Lydon, J. E., & Zanna, M. P. (1987). Attitude and activity preference similarity: Differential bases of interpersonal attraction for low and high self-monitors. *Journal of Personality and Social Psychology,* **53,** 1052–1060.

Janis, I. (1989). Crucial decisions: Leadership in policymaking and crisis management. New York: Free Press.

Janis, I. L. (1971, November). Groupthink. *Psychology Today,* pp. 43–46.

Janis, I. L. (1982). Counteracting the adverse effects of concurrence-seeking in policy-planning groups: Theory and research perspectives. In H. Brandstatter, J. H. Davis, & G. Stocker-Kreichgauer (Eds.), *Group decision making.* New York: Academic Press.

Janis, I. L., Kaye, D., & Kirschner, P. (1965). Facilitating effects of eating while reading on responsiveness to persuasive communications. *Journal of Personality and Social Psychology,* **1,** 181–186.

Janis, I. L., & Mann, L. (1977). *Decision-making: A psychological analysis of conflict, choice and commitment.* New York: Free Press.

Janoff-Bulman, R., Timko, C., & Carli, L. L. (1985). Cognitive biases in blaming the victim. *Journal of Experimental Social Psychology,* **21,** 161–177.

Jason, L. A., Rose, T., Ferrari, J. R., & Barone, R. (1984). Personal versus impersonal methods for recruiting blood donations. *Journal of Social Psychology,* **123,** 139–140.

Jeffery, R. (1964). The psychologist as an expert witness on the issue of insanity. *American Psychologist,* **19,** 838–843.

Jelalian, E., & Miller, A. G. (1984). The perseverance of beliefs: Conceptual perspectives and research developments. *Journal of Social and Clinical Psychology,* **2,** 25–56.

Jellison, J. M., & Green, J. (1981). A self-presentation approach to the fundamental attribution error: The norm of internality. *Journal of Personality and Social Psychology,* **40,** 643–649.

Jemmott, J. B., III, & Gonzalez, E. (1989). Social status, the status distribution, and performance in small groups. *Journal of Applied Social Psychology,* **19,** 584–598.

Jemmott, J. B., III., & Locke, S. E. (1984). Psychosocial factors, immunologic mediation, and human susceptibility to infectious diseases: How much do we know? *Psychological Bulletin,* **95,** 78–108.

Jennings, D. L., Amabile, T. M., & Ross, L. (1982). Informal covariation assessment: Data-based vs theory-based judgments. In D. Kahneman, P. Slovic, & A. Tversky (Eds.), *Judgment under uncertainty: Heuristics and biases.* New York: Cambridge University Press.

Jervis, R. (1973). Hypotheses on misperception. In M. Halperin & A. Kanter (Eds.), *Readings in American foreign policy.* Boston: Little, Brown.

Jervis, R. (1985, April 2). Quoted by D. Goleman, Political forces come under new scrutiny of psychology. *New York Times,* pp. C1, C4.

Jervis, R. (1985). Perceiving and coping with threat: Psychological perspectives. In R. Jervis, R. N. Lebow, & J. Stein (Eds.), *Psychology and deterrence.* Baltimore: Johns Hopkins University Press.

Johnson, B. T., & Eagly, A. H. (1989). Effects of involvement on persuasion: A meta-analysis. *Psychological Bulletin,* **106,** 290–314.

Johnson, B. T., & Eagly, A. H. (1990). Involvement and persuasion: Types, traditions, and the evidence. *Psychological Bulletin,* **107,** 375–384.

Johnson, D. J., & Rusbult, C. E. (1989). Resisting temptation: Devaluation of alternative partners as a means of maintaining commitment in close relationships. *Journal of Personality and Social Psychology,* **57,** 967–980.

Johnson, D. W., & Johnson, R. T. (1987). *Learning together and alone: Cooperative, competitive, and individualistic learning,* 2nd ed. Englewood Cliffs, N.J.: Prentice-Hall.

Johnson, D. W., & Johnson, R. T. (1989). *A meta-analysis of cooperative, competitive, and individualistic goal structures.* Hillsdale, N.J.: Erlbaum.

Johnson, D. W., & Johnson, R. T. (1989). *Cooperation and competition: Theory and research.* Edina, MN: Interaction Book.

Johnson, D. W., Maruyama, G., Johnson, R., Nelson, D., & Skon, L. (1981). Effects of cooperative, competitive, and individualistic goal structures on achievement: A meta-analysis. *Psychological Bulletin,* **89,** 47–62.

Johnson, E. J., & Tversky, A. (1983). Affect, generalization, and the perception of risk. *Journal of Personality and Social Psychology,* **45,** 20–31.

Johnson, J. T., Gain, L. M., Falke, T. L., Hayman, J., & Perillo, E. (1985). The "Barnum Effect" revisited: Cognitive and motivational factors in the acceptance of personality descriptions. *Journal of Personality and Social Psychology,* **49,** 1378–1391.

Johnson, J. T., Jemmott, III, J. B., & Pettigrew, T. F. (1984). Causal attribution and dispositional inference: Evidence of inconsistent judgments. *Journal of*

Experimental Social Psychology, **20**, 567–585.

Johnson, M. H., & Magaro, P. A. (1987). Effects of mood and severity on memory processes in depression and mania. *Psychological Bulletin*, **101**, 28–40.

Johnson, M. K., & Sherman, S. J. (1990). Constructing and reconstructing the past and the future in the present. In E. T. Higgins & R. M. Sorrentino (Eds.), *Handbook of motivation and cognition*. New York: Guilford.

Johnson, P. (1988, November 25–27). Hearst seeks pardon. *USA Today*, p. 3A.

Johnson, R. D., & Downing, L. J. (1979). Deindividuation and valence of cues: Effects of prosocial and antisocial behavior. *Journal of Personality and Social Psychology*, **37**, 1532–1538.

Johnston, L., & Hewstone, M. (1992). Cognitive models of stereotype change: Subtyping and the perceived typicality of disconfirming group members. *Journal of Experimental Social Psychology*, in press.

Johnston, L. D., Bachman, J. G., & O'Malley, P. M. (1991, January 23). Press release with accompanying tables. Ann Arbor: University of Michigan News and Information Services.

Johnston, L. D., Bachman, J. G., & O'Malley, P. M. (1992, January 27). Press release with accompanying tables. Ann Arbor: University of Michigan News and Information Services.

Jonas, K. (1991). Modeling and suicide: A test of the Werther effect hypothesis. Unpublished manuscipt, University of Tubingen.

Jones, E. E. (1964). *Ingratiation*. New York: Appleton-Century-Crofts.

Jones, E. E. (1976). How do people perceive the causes of behavior? *American Scientist*, **64**, 300–305.

Jones, E. E., & Davis, K. E. (1965). From acts to dispositions: The attribution process in person perception. In L. Berkowitz (Ed.), *Advances in experimental social psychology* (Vol. 2). New York: Academic Press.

Jones, E. E., & Harris, V. A. (1967). The attribution of attitudes. *Journal of Experimental Social Psychology*, **3**, 2–24.

Jones, E. E., & Nisbett, R. E. (1971). *The actor and the observer: Divergent perceptions of the cases of behavior*. Morristown, N.J.: General Learning Press.

Jones, E. E., Rhodewalt, F., Berglas, S., & Skelton, J. A. (1981). Effects of strate-

gic self-presentation on subsequent self-esteem. *Journal of Personality and Social Psychology*, **41**, 407–421.

Jones, E. E., Rock, L., Shaver, K. G., Goethals, G. R., & Ward, L. M. (1968). Pattern of performance and ability attribution: An unexpected primacy effect. *Journal of Personality and Social Psychology*, **10**, 317–340.

Jones, E. E., & Sigall, H. (1971). The bogus pipeline: A new paradigm for measuring affect and attitude. *Psychological Bulletin*, **76**, 349–364.

Jones, J. M. (1983). The concept of race in social psychology: From color to culture. In L. Wheeler & P. Shaver (Eds.), *Review of personality and social psychology*, Vol. 4. Beverly Hills, Ca.: Sage.

Jones, J. M. (1988). Piercing the veil: Bicultural strategies for coping with prejudice and racism. Invited address at the national conference, "Opening Doors: An Appraisal of Race Relations in America," University of Alabama, June 11.

Jones, J. M. (1990). Promoting diversity in an individualistic society. Keynote address, Great Lakes College Association conference, "Multiculturalism transforming the 21st century." Hope College, Holland, Michigan.

Jones, R. A., & Brehm, J. W. (1970). Persuasiveness of one- and two-sided communications as a function of awareness there are two sides. *Journal of Experimental Social Psychology*, **6**, 47–56.

Jones, W. H., Carpenter, B. N., & Quintana, D. (1985). Personality and interpersonal predictors of loneliness in two cultures. *Journal of Personality and Social Psychology*, **48**, 1503–1511.

Jones, W. H., Freemon, J. E., & Goswick, R. A. (1981). The persistence of loneliness: Self and other determinants. *Journal of Personality*, **49**, 27–48.

Jones, W. H., Hobbs, S. A., & Hockenbury, D. (1982). Loneliness and social skill deficits. *Journal of Personality and Social Psychology*, **42**, 682–689.

Jorgenson, D. O., & Papciak, A. S. (1981). The effects of communication, resource feedback, and identifiability on behavior in a simulated commons. *Journal of Experimental Social Psychology*, **17**, 373–385.

Josephson, W. L. (1987). Television violence and children's aggression: Testing the priming, social script, and disinhibition predictions. *Journal of*

Personality and Social Psychology, **53**, 882–890.

Jourard, S. M. (1964), *The transparent self*. Princeton, N.J.: Van Nostrand.

Judd, C. M., Kenny, D. A., & Krosnick, J. A. (1983). Judging the positions of political candidates: Models of assimilation and contrast. *Journal of Personality and Social Psychology*, **44**, 952 963.

Judd, C. M., & Park, B. (1988). Outgroup homogeneity: Judgments of variability at the individual and group levels. *Journal of Personality and Social Psychology*, **54**, 778–788.

Judd, C. M., Ryan, C. S., & Park, B. (1991). Accuracy in the judgment of in-group and out-group variability. *Journal of Personality and Social Psychology*, **61**, 366–379.

Jussim, L. (1986). Self-fulfilling prophecies: A theoretical and integrative review. *Psychological Review*, **93**, 429–445.

Jussim, L. (1989). Teacher expectations: Self-fulfilling prophecies, perceptual biases, and accuracy. *Journal of Personality and Social Psychology*, **57**, 469–480.

Jussim, L. (1990). Social reality and social problems: The role of expectancies. *Journal of Social Issues*, **46**, 9–34.

Jussim, L. (1991). Social perception and social reality: A reflection-construction model. *Psychological Review*, **98**, 54–73.

Juster, F. T., & Stafford, F. P. (1991). The allocation of time: Empirical findings, behavioral models, and problems of measurement. *Journal of Economic Literature*, in press.

Kagan, J. (1989). Temperamental contributions to social behavior. *American Psychologist*, **44**, 668–674. (p. 78)

Kagehiro, D. K. (1990). Defining the standard of proof in jury instructions. *Psychological Science*, **1**, 194–200.

Kahle, L. R., & Berman, J. (1979). Attitudes cause behaviors: A cross-lagged panel analysis. *Journal of Personality and Social Psychology*, **37**, 315–321.

Kahn, A. S., & Gaeddert, W. P. (1985). From theories of equity to theories of justice. In V. W. O'Leary, R. K. Unger, & B. S. Wallston (Eds.), *Women, gender, and social psychology*. Hillsdale, N.J.: Erlbaum.

Kahn, M. W. (1951). The effect of severe defeat at various age levels on the aggressive behavior of mice. *Journal of Genetic Psychology*, **79**, 117–130.

Kahneman, D., & Miller, D. T. (1986). Norm theory: Comparing reality to its alternatives. *Psychological Review*, **93**, 75–88.

Kahneman, D., & Tversky, A. (1979). Intuitive prediction: Biases and corrective procedures. *Management Science*, **12**, 313–327.

Kalick, S. M. (1981). *Plastic surgery, physical appearance, and person perception*. Unpublished doctoral dissertation, Harvard University, 1977. Cited by E. Berscheid in, An overview of the psychological effects of physical attractiveness and some comments upon the psychological effects of knowledge of the effects of physical attractiveness. In W. Lucker, K. Ribbens, & J. A. McNamera (Eds.), *Logical aspects of facial form* (craniofacial growth series). Ann Arbor: University of Michigan Press.

Kalick, S. M. (1988). Physical attractiveness as a status cue. *Journal of Experimental Social Psychology*, **24**, 469–489.

Kallgren, C. A., & Wood, W. (1986). Access to attitude-relevant information in memory as a determinant of attitude-behavior consistency. *Journal of Experimental Social Psychology*, **22**, 328–338.

Kalven, H., Jr., & Zeisel, H. (1966). *The American jury*. Chicago: University of Chicago Press.

Kamen, L. P., Seligman, M. E. P., Dwyer, J., & Rodin, J. (1988). Pessimism and cell-mediated immunity. Unpublished manuscript, University of Pennsylvania.

Kammer, D. (1982). Differences in trait ascriptions to self and friend: Unconfounding intensity from variability. *Psychological Reports*, **51**, 99–102.

Kandel, D. B. (1978). Similarity in real-life adolescent friendship pairs. *Journal of Personality and Social Psychology*, **36**, 306–312.

Kanekar, S., & Nazareth, A. (1988). Attributed rape victim's fault as a function of her attractiveness, physical hurt, and emotional disturbance. *Social Behaviour*, **3**, 37–40.

Kaplan, M. F. (1989). Task, situational, and personal determinants of influence processes in group decision making. In E. J. Lawler (Ed.), *Advances in group processes* (vol. 6). Greenwich, CT: JAI Press.

Kaplan, M. F., & Anderson, N. H. (1973). Information integration theory and reinforcement theory as approaches to interpersonal attraction. *Journal of Personality and Social Psychology*, **28**, 301–312.

Kaplan, M. F., & Schersching, C. (1980). Reducing juror bias: An experimental approach. In P. D. Lipsitt & B. D. Sales (Eds.), *New directions in psycholegal research*. New York: Van Nostrand Reinhold, pp. 149–170.

Kaplan, M. F., Wanshula, L. T., & Zanna, M. P. (1992). Time pressure and information integration in social judgment: The effect of need for structure. In O. Svenson & J. Maule (Eds.), *Time pressure and stress in human judgment and decision making*. Cambridge: Cambridge University Press.

Karabenick, S. A., Lerner, R. M., & Beecher, M. D. (1973). Relation of political affiliation to helping behavior on election day, November 7, 1972. *Journal of Social Psychology*, **91**, 223–227.

Kassin, S. M., Ellsworth, P. C., & Smith, V. L. (1989). The "general acceptance" of psychological research on eyewitness testimony: A survey of the experts. *American Psychologist*, **44**, 1089–1098.

Kassin, S. M., & Wrightsman, L. S. (1979). On the requirements of proof: The timing of judicial instruction and mock juror verdicts. *Journal of Personality and Social Psychology*, **37**, 1877–1887.

Kato, P. S., & Ruble, D. N. (1992). Toward an understanding of women's experience of menstrual cycle symptoms. In V. Adesso, D. Reddy, & R. Fleming (Eds.), *Psychological perspectives on women's health*. Washington, DC: Hemisphere.

Katz, A. M., & Hill, R. (1958). Residential propinquity and marital selection: A review of theory, method, and fact. *Marriage and Family Living*, **20**, 237–335.

Katz, E. (1957). The two-step flow of communication: An up-to-date report on a hypothesis. *Public Opinion Quarterly*, **21**, 61–78.

Katz, I., Cohen, S., & Glass, D. (1975). Some determinants of cross-racial helping behavior. *Journal of Personality and Social Psychology*, **32**, 964–970.

Katzev, R., Edelsack, L., Steinmetz, G., & Walker, T. (1978). The effect of reprimanding transgressions on subsequent helping behavior: Two field experiments. *Personality and Social Psychology Bulletin*, **4**, 126–129.

Kaufman, J., & Zigler, E. (1987). Do abused children become abusive parents? *American Journal of Orthopsychiatry*, **57**, 186–192. (p. 80)

Keating, C. F. (1985). Gender and the physiognomy of dominance and attractiveness. *Social Psychology Quarterly*, **48**, 61–70.

Keating, J. P., & Brock, T. C. (1974). Acceptance of persuasion and the inhibition of counterargumentation under various distraction tasks. *Journal of Experimental Social Psychology*, **10**, 301–309.

Kellerman, J., Lewis, J., & Laird, J. D. (1989). Looking and loving: The effects of mutual gaze on feelings of romantic love. *Journal of Research in Personality*, **23**, 145–161.

Kelley, H. H. (1973). The process of causal attribution. *American Psychologist*, **28**, 107–128.

Kelley, H. H. (1979). *Personal relationships: Their structures and processes*. Hillsdale, N.J.: Lawrence Erlbaum.

Kelley, H. H., & Stahelski, A. J. (1970). The social interaction basis of cooperators' and competitors' beliefs about others. *Journal of Personality and Social Psychology*, **16**, 66–91.

Kelley, K., Dawson, L., & Musialowski, D. M. (1989). Three faces of sexual explicitness: The good, the bad, and the useful. In D. Zillmann & J. Bryant (Eds.), *Pornography: Reesearch advances and policy considerations*. Hillsdale, NJ: Erlbaum.

Kelman, H. C., & Cohen, S. P. (1986). Resolution of international conflict: An interactional approach. In S. Worchel & W. G. Austin (Eds.), *Psychology of intergroup relations*, 2nd ed. Chicago: Nelson-Hall.

Kennedy, J. F. (1956). *Profiles in courage*. New York: Harper.

Kenny, D. A., & Albright, L. (1987). Accuracy in interpersonal perception: A social relations analysis. *Psychology Bulletin*, **102**, 390–402.

Kenny, D. A., & Nasby, W. (1980). Splitting the reciprocity correlation. *Journal of Personality and Social Psychology*, **38**, 249–256.

Kenrick, D. T. (1987). Gender, genes, and the social environment: A biosocial interactionist perspective. In P. Shaver & C. Hendrick (Eds.), *Sex and gender: Review of personality and social psychology*, vol. 7. Beverly Hills, Ca.: Sage.

Kenrick, D. T., Baumann, D. J., & Cialdini, R. B. (1979). A step in the socialization of altruism as hedonism: Effects of negative mood on children's gener-

osity under public and private conditions. *Journal of Personality and Social Psychology, 37,* 747–755.

Kenrick, D. T., & Cialdini, R. B. (1977). Romantic attraction: Misattribution versus reinforcement explanations. *Journal of Personality and Social Psychology, 35,* 381–391.

Kenrick, D. T., Cialdini, R. B., & Linder, D. E. (1979). Misattribution under fear-producing circumstances: Four failures to replicate. *Personality and Social Psychology Bulletin, 5,* 329–334.

Kenrick, D. T., & Gutierres, S. E. (1980). Contrast effects and judgments of physical attractiveness: When beauty becomes a social problem. *Journal of Personality and Social Psychology, 38,* 131–140.

Kenrick, D. T., Gutierres, S. E., & Goldberg, L. L. (1989). Influence of popular erotica on judgments of strangers and mates. *Journal of Experimental Social Psychology, 25,* 159–167.

Kenrick, D. T., & Keefe, R. C. (1992). Age preferences in mates reflect sex differences in reproductive strategies. *Behavioral and Brain Sciences,* in press.

Kenrick, D. T., & MacFarlane, S. W. (1986). Ambient temperature and horn-honking: A field study of the heat/aggression relationship. *Environment and Behavior, 18,* 179–191.

Kenrick, D. T., & Trost, M. R. (1987). A biosocial theory of heterosexual relationships. In K. Kelly (Ed.), *Females, males, and sexuality.* Albany: State University of New York Press.

Kenrick, D. T., & Trost, M. R. (1989). Reproductive exchange model of heterosexual relationships: Putting proximate economics in ultimate perspective. In C. Hendrick (Ed.), *Review of personality and social psychology,* Vol. 10. Newbury Park, Ca.: Sage.

Kerr, N. L. (1978). Beautiful and blameless: Effects of victim attractiveness and responsibility on mock jurors' verdicts. *Journal of Personality and Social Psychology, 4,* 479–482. *(a)*

Kerr, N. L. (1978). Severity of prescribed penalty and mock jurors' verdicts. *Journal of Personality and Social Psychology, 36,* 1431–1442. *(b)*

Kerr, N. L. (1981). Effects of prior juror experience on juror behavior. *Basic and Applied Social Psychology, 2,* 175–193.

Kerr, N. L. (1983). Motivation losses in small groups: A social dilemma analysis. *Journal of Personality and Social Psychology, 45,* 819–828.

Kerr, N. L. (1989). Illusions of efficacy: The effects of group size on perceived efficacy in social dilemmas. *Journal of Experimental Social Psychology, 25,* 287–313.

Kerr, N. L. (1992). Norms in social dilemmas. In D. Schroeder (Ed.), *Social dilemmas: Psychological perspectives.* New York: Praeger.

Kerr, N. L., Atkin, R. S., Stasser, G., Meek, D., Holt, R. W., & Davis, J. H. (1976). Guilt beyond a reasonable doubt: Effects of concept definition and assigned decision rule on the judgments of mock jurors. *Journal of Personality and Social Psychology, 34,* 282–294.

Kerr, N. L., & Bruun, S. E. (1981). Ringelmann revisited: Alternative explanations for the social loafing effect. *Personality and Social Psychology Bulletin, 7,* 224–231.

Kerr, N. L., & Bruun, S. E. (1983). Dispensibility of member effort and group motivation losses: Free-rider effects. *Journal of Personality and Social Psychology, 44,* 78–94.

Kerr, N. L., Harmon, D. L., & Graves, J. K. (1982). Independence of multiple verdicts by jurors and juries. *Journal of Applied Social Psychology, 12,* 12–29.

Kerr, N. L., & MacCoun, R. J. (1985). The effects of jury size and polling method on the process and product of jury deliberation. *Journal of Personality and Social Psychology, 48,* 349–363.

Kidd, J. B., & Morgan, J. R. (1969). A predictive information system for management. *Operational Research Quarterly, 20,* 149–170.

Kidd, R. F., & Berkowitz, L. (1976). Effect of dissonance arousal on helpfulness. *Journal of Personality and Social Psychology, 33,* 613–622.

Kiesler, C. A. (1971). *The psychology of commitment: Experiments linking behavior to belief.* New York: Academic Press.

Kiesler, C. A., & Kiesler, S. B. (1969). *Conformity.* Reading, Mass.: Addison-Wesley.

Kiesler, S. B., & Baral, R. L. (1970). The search for a romantic partner: The effects of self-esteem and physical attractiveness or romantic behavior. In K. Gergen & D. Marlowe (Eds.), *Personality and social behavior.* Reading, Mass.: Addison Wesley.

Kimmel, M. J., Pruitt, D. G., Magenau, J. M., Konar-Goldband, E., & Carnevale, P. J. D. (1980). Effects of trust, aspiration, and gender on negotiation tactics. *Journal of Personality and Social Psychology, 38,* 9–22.

Kinder, D. R., & Sears, D. O. (1985). Public opinion and political action. In G. Lindzey & E. Aronson (Eds.), *The handbook of social psychology,* 3rd ed. New York: Random House.

Kirmeyer, S. L. (1978). Urban density and pathology: A review of research. *Environment and Behavior, 10,* 257–269.

Klaas, E. T. (1978). Psychological effects of immoral actions: The experimental evidence. *Psychological Bulletin, 85,* 756–771.

Klayman, J., & Ha, Y-W. (1987). Confirmation, disconfirmation, and information in hypothesis testing. *Psychological Review, 94,* 211–228.

Kleck, R. E., & Strenta, A. (1980). Perceptions of the impact of negatively valued physical characteristics on social interaction. *Journal of Personality and Social Psychology, 39,* 861–873.

Klein, J. G. (1991). Negative effects in impression formation: A test in the political arena. *Personality and Social Psychology Bulletin, 17,* 412–418.

Kleinke, C. L. (1977). Compliance to requests made by gazing and touching experimenters in field settings. *Journal of Experimental Social Psychology, 13,* 218–223.

Klentz, B., Beaman, A. L., Mapelli, S. D., & Ullrich, J. R. (1987). Perceived physical attractiveness of supporters and nonsupporters of the women's movement: An attitude-similarity-mediated error (AS-ME). *Personality and Social Psychology Bulletin, 13,* 513–523.

Klopfer, P. M. (1958). Influence of social interaction on learning rates in birds. *Science, 128,* 903–904.

Knight, J. A., & Vallacher, R. R. (1981). Interpersonal engagement in social perception: The consequences of getting into the action. *Journal of Personality and Social Psychology, 40,* 990–999.

Knight, P. A., & Weiss, H. M. (1980). Benefits of suffering: Communicator suffering, benefitting, and influence. Paper presented at the American Psychological Association convention.

Knowles, E. S. (1983). Social physics and the effects of others: Tests of the effects of audience size and distance on social judgment and behavior. *Journal of Personality and Social Psychology, 45,* 1263–1279.

Knox, R. E., & Inkster, J. A. (1968). Postdecision dissonance at post-time.

Journal of Personality and Social Psychology, **8,** 319–323.

Knudson, R. M., Sommers, A. A., & Golding, S. L. (1980). Interpersonal perception and mode of resolution in marital conflict. *Journal of Personality and Social Psychology,* **38,** 751–763.

Koehler, D. J. (1991). Explanation, imagination, and confidence in judgment. *Psychological Bulletin,* **110,** 499–519.

Koestner, R., & Wheeler, L. (1988). Self-presentation in personal advertisements: The influence of implicit notions of attraction and role expectations. *Journal of Social and Personal Relationships,* **5,** 149–160.

Kohn, A. (1987, October). It's hard to get left out of a pair. *Psychology Today,* pp. 53–57.

Kolominsky, Y. (1991). Soviet psychology today. Invited address by Vice-President, Soviet Psychological Society, Hope College.

Komorita, S. S., & Barth, J. M. (1985). Components of reward in social dilemmas. *Journal of Personality and Social Psychology,* **48,** 364–373.

Koop, C. E. (1987). Report of the Surgeon General's workshop on pornography and public health. *American Psychologist,* **42,** 944–945.

Korabik, K. (1981). Changes in physical attractiveness and interpersonal attraction. *Basic and Applied Social Psychology* **2,** 59–66.

Koriat, A., Lichtenstein, S., & Fischhoff, B. (1980). Reasons for confidence. *Journal of Experimental Psychology: Human Learning and Memory,* **6,** 107–118.

Koss, M. P. (1990, August 29). Rape incidence: A review and assessment of the data. Testimony on behalf of the American Psychological Association before the U.S. Senate Judiciary Committee.

Koss, M. P., & Burkhart, B. R. (1989). A conceptual analysis of rape victimization. *Psychology of Women Quarterly,* **13,** 27–40.

Koss, M. P., Dinero, T. E., Seibel, C. A., & Cox, S. L. (1988). Stranger and acquaintance rape. *Psychology of Women,* **12,** 1–24.

Kramer, G. P., Kerr, N. L., & Carroll, J. S. (1990). Pretrial publicity, judicial remedies, and jury bias. *Law and Human Behavior,* **14,** 409–438.

Kraus, S. J. (1991). Attitudes and the prediction of behavior. Doctoral dissertation, Harvard University.

Kraut, R. E. (1973). Effects of social labeling on giving to charity. *Journal of Experimental Social Psychology,* **9,** 551–562.

Kraut, R. E., & Poe, D. (1980). Behavioral roots of person perception: The deception judgments of customs inspectors and laymen. *Journal of Personality and Social Psychology,* **39,** 784–798.

Kravitz, D. A., & Martin, B. (1986). Ringelmann rediscovered: The original article. *Journal of Personality and Social Psychology,* **50,** 936–941.

Krebs, D. (1970). Altruism—An examination of the concept and a review of the literature. *Psychological Bulletin,* **73,** 258–302.

Krebs, D. (1975). Empathy and altruism. *Journal of Personality and Social Psychology,* **32,** 1134–1146.

Krebs, D., & Adinolfi, A. A. (1975). Physical attractiveness, social relations, and personality style. *Journal of Personality and Social Psychology,* **31,** 245–253.

Krech, D., Crutchfield, R. A., & Ballachey, E. I. (1962). *Individual in society.* New York: McGraw-Hill.

Kressel, K., & Pruitt, D. G. (1985). Themes in the mediation of social conflict. *Journal of Social Issues,* **41,** 179–198.

Krosnick, J. A. (1989). Attitude importance and attitude accessibility. *Personality and Social Psychology Bulletin,* **15,** 297–308.

Krosnick, J. A., & Alwin, D. F. (1989). Aging and susceptibility to attitude change. *Journal of Personality and Social Psychology,* **57,** 416–425.

Krosnick, J. A., Li, F., & Lehman, D. R. (1990). Conversational conventions, order of information acquisition, and the effect of base rates and individuating information on social judgments. *Journal of Personality and Social Psychology,* **59,** 1140–1152.

Krosnick, J. A., & Schuman, H. (1988). Attitude intensity, importance, and certainty and susceptibility to response effects. *Journal of Personality and Social Psychology,* **54,** 940–952.

Krueger, J., & Rothbart, M. (1988). Use of categorical and individuating information in making inferences about personality. *Journal of Personality and Social Psychology,* **55,** 187–195.

Kruglanski, A. W., & Ajzen, I. (1983). Bias and error in human judgment. *European Journal of Social Psychology,* **13,** 1–44.

Kruglanski, A. W., & Freund, T. (1983). The freezing and unfreezing of lay-inferences: Effects of impressional primacy, ethnic stereotyping, and numerical anchoring. *Journal of Experimental Social Psychology,* **19,** 448–468.

Kruglanski, A. W., & Webster, D. M. (1991). Group members' reactions to opinion deviates and conformists at varying degrees of proximity to decision deadline and of environmental noise. *Journal of Personality and Social Psychology,* **61,** 212–225.

Kuiper, N. A., & Higgins, E. T. (1985). Social cognition and depression: A general integrative perspective. *Social Cognition,* **3,** 1–15.

Kuiper, N. A., & Rogers, T. B. (1979). Encoding of personal information: Self-other differences. *Journal of Personality and Social Psychology,* **37,** 499–514.

Kunda, Z. (1990). The case for motivated reasoning. *Psychological Bulletin,* **108,** 480–498.

Kunda, Z., & Sanitioso, R. (1989). Motivated changes in the self-concept. *Journal of Experimental Social Psychology,* **25,** 272–285.

Kunst-Wilson, W. R., & Zajonc, R. B. (1980). Affective discrimination of stimuli that cannot be recognized. *Science,* **207,** 557–558.

La Rochefoucauld (1965). *Maxims,* 1665. Translated by J. Heard, 1917. Boston: International Pocket Library.

LaFrance, M. (1985). Does your smile reveal your status? *Social Science News Letter,* **70** (Spring), 15–18.

Lagerspetz, K. (1979). Modification of aggressiveness in mice. In S. Feshbach & A. Fraczek (Eds.), *Aggression and behavior change.* New York: Praeger.

Lagerspetz, K. M. J., Bjorkqvist, K., Berts, M., & King, E. (1982). Group aggression among school children in three schools. *Scandinavian Journal of Psychology,* **23,** 45–52.

Laird, J. D. (1974). Self-attribution of emotion: The effects of expressive behavior on the quality of emotional experience. *Journal of Personality and Social Psychology,* **29,** 475–486.

Laird, J. D. (1984). The real role of facial response in the experience of emotion: A reply to Tourangeau and Ellsworth, and others. *Journal of Personality and Social Psychology,* **47,** 909–917.

Lalancette, M-F., & Standing, L. (1990). Asch fails again. *Social Behavior and Personality,* **18,** 7–12.

Lalljee, M., Lamb, R., Furnham, A., & Jaspars, J. (1984). Explanations and

information search: Inductive and hypothesis-testing approaches to arriving at an explanation. *British Journal of Social Psychology, 23*, 201–212.

Lamal, P. A. (1979). College student common beliefs about psychology. *Teaching of Psychology, 6*, 155–158.

Landers, A. (1973). Syndicated newspaper column. April 8, 1969. Cited by L. Berkowitz in, The case for bottling up rage. *Psychology Today*, September, pp. 24–31.

Landers, A. (1985, August). Is affection more important than sex? *Reader's Digest*, pp. 44–46.

Landers, S. (1988, July). Sex, drugs n' rock: Relation not causal. *APA Monitor*, p. 40.

Landman, J. (1987). Regret and elation following action and inaction: Affective responses to positive and negative outcomes. *Personality and Social Psychology Bulletin, 13*, 524–536.

Landy, D., & Sigall, H. (1974). Beauty is talent: Task evaluation as a function of the performer's physical attractiveness. *Journal of Personality and Social Psychology, 29*, 299–304.

Langer, E. J. (1977). The psychology of chance. *Journal for the Theory of Social Behavior, 7*, 185–208.

Langer, E. J., & Benevento, A. (1978). Self-induced dependence. *Journal of Personality and Social Psychology, 36*, 886–893.

Langer, E. J., & Imber, L. (1980). The role of mindlessness in the perception of deviance. *Journal of Personality and Social Psychology, 39*, 360–367.

Langer, E. J., Janis, I. L., & Wofer, J. A. (1975). Reduction of psychological stress in surgical patients. *Journal of Experimental Social Psychology, 11*, 155–165.

Langer, E. J., & Rodin, J. (1976). The effects of choice and enhanced personal responsibility for the aged: A field experiment in an institutional setting. *Journal of Personality and Social Psychology, 334*, 191–198.

Langer, E. J., & Roth, J. (1975). Heads I win, tails it's chance: The illusion of control as a function of the sequence of outcomes in a purely chance task. *Journal of Personality and Social Psychology, 32*, 951–955.

Langlois, J. H., & Roggman, L. A. (1990). Attractive faces are only average. *Psychological Science, 1*, 115–121.

Langlois, J. H., Roggman, L. A., Casey, R. J., Ritter, J. M., Rieser-Danner, L. A., & Jenkins, V. Y. (1987). Infant preferences for attractive faces: Rudiments of a stereotype? *Developmental Psychology, 23*, 363–369.

Langlois, J. H., & Stephan, C. W. (1981). Beauty and the beast: The role of physical attractiveness in the development of peer relations and social behavior. In S. S. Brehm, S. M. Kassin, & F. X. Gibbons (Eds.), *Developmental social psychology*. New York: Oxford University Press.

Lanzetta, J. T. (1955). Group behavior under stress. *Human Relations, 8*, 29–53.

Lapidus, J., Green, S. K., & Baruh, E. (1985). Factors related to roommate compatibility in the residence hall—a review. *Journal of College Student Personnel, 26*, 420–434.

LaPiere, R. T. (1934). Attitudes versus actions. *Social Forces, 13*, 230–237.

Larsen, K. (1974). Conformity in the Asch experiment. *Journal of Social Psychology, 94*, 303–304.

Larsen, K. S. (1990). The Asch conformity experiment: Replication and transhistorical comparisons. *Journal of Social Behavior and Personality, 5*(4), 163–168.

Larsen, R. J., & Diener, E. (1987). Affect intensity as an individual difference characteristic: A review. *Journal of Research in Personality, 21*, 1–39.

Larson, R. J., Csikszentmihalyi, N., & Graef, R. (1982). Time alone in daily experience: Loneliness or renewal? In L. A. Peplau & D. Perlman (Eds.), *Loneliness: A sourcebook of current theory, research and therapy*. New York: Wiley.

Larwood, L. (1978). Swine flu: A field study of self-serving biases. *Journal of Applied Social Psychology, 18*, 283–289.

Larwood, L., & Whittaker, W. (1977). Managerial myopia: Self-serving biases in organizational planning. *Journal of Applied Psychology, 62*, 194–198.

Lassiter, G. D., & Dudley, K. A. (1991). The *a priori* value of basic research: The case of videotaped confessions. *Journal of Social Behavior and Personality, 6*, 7–16.

Lassiter, G. D., & Irvine, A. A. (1986). Videotaped confessions: The impact of camera point of view on judgments of coercion. *Journal of Applied Social Psychology, 16*, 268–276.

Latané, B. (1981). The psychology of social impact. *American Psychologist, 36*, 343–356.

Latané, B., & Dabbs, J. M., Jr. (1975). Sex, group size and helping in three cities. *Sociometry, 38*, 180–194.

Latané, B., & Darley, J. M. (1970). *The unresponsive bystander: Why doesn't he help?* New York: Appleton-Century-Crofts.

Latané, B., & Nida, S. (1981). Ten years of research on group size and helping. *Psychological Bulletin, 89*, 308–324.

Latané, B., & Rodin, J. (1969). A lady in distress: Inhibiting effects of friends and strangers on bystander intervention. *Journal of Experimental Social Psychology, 5*, 189–202.

Latané, B., Williams, K., & Harkins. S. (1979). Many hands make light the work: The causes and consequences of social loafing. *Journal of Personality and Social Psychology, 37*, 822–832.

Laughlin, P. R., & Adamopoulos, J. (1980). Social combination processes and individual learning for six-person cooperative groups on an intellective task. *Journal of Personality and Social Psychology, 38*, 941–947.

Laughlin, P. R., VanderStoep, S. W., & Hollingshead, A. B. (1991). Collective versus individual induction: Recognition of truth, rejection of error, and collective information processing. *Journal of Personality and Social Psychology, 61*, 50–67.

Layden, M. A. (1982). Attributional therapy. In C. Antaki & C. Brewin (Eds.), *Attributions and psychological change: Applications of attributional theories to clinical and educational practice*. London: Academic Press.

Leary, M. R. (1982). Hindsight distortion and the 1980 presidential election. *Personality and Social Psychology Bulletin, 8*, 257–263.

Leary, M. R. (1984). *Understanding social anxiety*. Beverly Hills, Ca.: Sage.

Leary, M. R. (1986). The impact of interactional impediments on social anxiety and self-presentation. *Journal of Experimental Social Psychology, 22*, 122–135.

Leary, M. R., & Kowalski, R. M. (1990). Impression management: A literature review and two-component model. *Psychological Bulletin, 107*, 34–47.

Leary, M. R., & Maddux, J. E. (1987). Progress toward a viable interface between social and clinical counseling psychology. *American Psychologist, 42*, 904–911.

Lebow, R. N., & Stein, J. G. (1987). Beyond deterrence. *Journal of Social Issues, 43*(4), 5–71.

Lee, J. A. (1988). Love-styles. In R. J. Sternberg & M. L. Barnes (Eds.), *The*

psychology of love. New Haven: Yale University Press.

Lefcourt, H. M. (1982). *Locus of control: Current trends in theory and research.* Hillsdale, N.J.: Erlbaum.

Lefebvre, L. M. (1979). Causal attributions for basketball outcomes by players and coaches. *Psychological Belgica,* **19,** 109–115.

Lehman, D. R., Lempert, R. O., & Nisbett, R. E. (1988). The effects of graduate training on reasoning: Formal discipline and thinking about everyday-life events. *American Psychologist, 43,* 431–442.

Lehman, D. R., & Nisbett, R. E. (1985). Effects of higher education on inductive reasoning. Unpublished manuscript, University of Michigan.

Lehman, E. R., & Reifman, A. (1987). Spectator influence on basketball officiating. *Journal of Social Psychology, 127,* 673–675.

Leippe, M. R. (1985). The influence of eyewitness nonidentification on mock-jurors. *Journal of Applied Social Psychology, 15,* 656–672.

Leippe, M. R., Brigham, J. C., Cousins, C., & Romanczyk, A. (1988). The opinions and practices of criminal attorneys regarding child eyewitnesses: A survey. In S. J. Ceci, D. F. Ross, & M. P. Toglia (Eds.), *Perspectives on children's testimony.* New York: Springer-Verlag.

Leippe, M. R., & Elkin, R. A. (1987). Dissonance reduction strategies and accountability to self and others: Ruminations and some initial research. Presentation to the Fifth International Conference on Affect, Motivation, and Cognition, Nags Head Conference Center.

Leippe, M. R., & Elkin, R. A. (1987). When motives clash: Issue involvement and response involvement as determinants of persuasion. *Journal of Personality and Social Psychology, 52,* 269–278.

Leippe, M. R., & Romanczyk, A. (1989). Reactions to child (versus adult) eyewitnesses: The influence of jurors' preconceptions and witness behavior. *Law and Human Behavior, 13,* 103–132.

Lemyre, L., & Smith, P. M. (1985). Intergroup discrimination and self-esteem in the minimal group paradigm. *Journal of Personality and Social Psychology, 49,* 660–670.

Lenihan, K. J. (1965). Perceived climates as a barrier to housing desegregation.

Unpublished manuscript, Bureau of Applied Social Research, Columbia University.

Leon, D. (1979). *The Kibbutz: A new way of life.* London: Pergamon Press, 1969. Cited by B. Latané, K. Williams, & S. Harkins in, Many hands make light the work: The causes and consequences of social loafing. *Journal of Personality and Social Psychology, 37,* 822–832.

Lepper, M. R., & Greene, D. (Eds.) (1979). *The hidden costs of reward.* Hillsdale, N.J.: Erlbaum.

Lepper, M. R., Ross, L., & Lau, R. R. (1986). Persistence of inaccurate beliefs about the self: Perseverance effects in the classroom. *Journal of Personality and Social Psychology, 50,* 482–491.

Lerner, M. J. (1980). *The belief in a just world: A fundamental delusion.* New York: Plenum.

Lerner, M. J., & Miller, D. T. (1978). Just world research and the attribution process: Looking back and ahead. *Psychological Bulletin, 85,* 1030–1051.

Lerner, M. J., & Simmons, C. H. (1966). Observer's reaction to the "innocent victim": Compassion or rejection? *Journal of Personality and Social Psychology, 4,* 203–210.

Lerner, M. J., Somers, D. G., Reid, D., Chiriboga, D., & Tierney, M. (1991). Adult children as caregivers: Egocentric biases in judgments of sibling contributions. *The Gerontologist, 31,* 746–755.

Lerner, R. M., & Frank, P. (1974). Relation of race and sex to supermarket helping behavior. *Journal of Social Psychology, 94,* 201–203.

Leung, K., & Bond, M. H. (1984). The impact of cultural collectivism on reward allocation. *Journal of Personality and Social Psychology, 47,* 793–804.

Leventhal, H. (1970). Findings and theory in the study of fear communications. In L. Berkowitz (Ed.), *Advances in experimental social psychology* (Vol. 5). New York: Academic Press.

Lever, J. (1978). Sex differences in the complexity of children's play and games. *American Sociological Review, 43,* 471–483.

Levin, I. P. (1987). Associative effects of information framing. *Bulletin of the Psychonomic Society, 25,* 85–86.

Levin, I. P., Schnittjer, S. K., & Thee, S. L. (1988). Information framing effects in social and personal decisions. *Journal of Experimental Social Psychology, 24,* 520–529.

Levine, A. (1990, May 7). America's youthful bigots. *U.S. News and World Report,* pp. 59–60.

Levine, J. M. (1989). Reaction to opinion deviance in small groups. In P. Paulus (Ed.), *Psychology of group influence: New perspectives.* Hillsdale, N.J.: Erlbaum.

Levine, J. M., & Moreland, R. L. (1985). Innovation and socialization in small groups. In S. Moscovici, G. Mugny, & E. Van Avermaet (Eds.), *Perspectives on minority influence.* Cambridge: Cambridge University Press.

Levine, J. M., & Russo, E. M. (1987). Majority and minority influence. In C. Hendrick (Ed.) *Group processes: Review of personality and social psychology,* Vol. 8. Newbury Park, Ca.: Sage.

Levine, R., & Uleman, J. S. (1979). Perceived locus of control, chronic self-esteem, and attributions to success and failure. *Journal of Personality and Social Psychology, 5,* 69–72.

Levinger, G. (1987). The limits of deterrence: An introduction. *Journal of Social Issues, 43*(4), 1–4.

Levy, S., Lee, J., Bagley, C., & Lippman, M. (1988). Survival hazards analysis in first recurrent breast cancer patients: Seven-year follow-up. *Psychosomatic Medicine, 50,* 520–528.

Levy-Leboyer, C. (1988). Success and failure in applying psychology. *American Psychologist, 43,* 779–785.

Lewicki, P. (1983). Self-image bias in person perception. *Journal of Personality and Social Psychology, 45,* 384–393.

Lewicki, P. (1985). Nonconscious biasing effects of single instances on subsequent judgments. *Journal of Personality and Social Psychology, 48,* 563–574.

Lewin, K. (1936). *A dynamic theory of personality.* New York: McGraw-Hill.

Lewinsohn, P. M., Hoberman, H., Teri, L., & Hautziner, M. (1985). An integrative theory of depression. In S. Reiss & R. Bootzin (Eds.), *Theoretical issues in behavior therapy.* New York: Academic Press.

Lewinsohn, P. M., Mischel, W., Chapline, W., & Barton, R. (1980). Social competence and depression: The role of illusionary self-perceptions. *Journal of Abnormal Psychology, 89,* 203–212

Lewinsohn, P. M., & Rosenbaum, M. (1987). Recall of parental behavior by acute depressives, remitted depressives, and nondepressives. *Journal of Personality and Social Psychology, 52,* 611–619.

Lewis, C. S. (1960). *Mere Christianity.* New York: Macmillan.

Lewis, C. S. (1974). *The horse and his boy.* New York: Collier Books.

Leyens, J. P., Camino, L., Parke, R. D., & Berkowitz, L. (1975). Effects of movie violence on aggression in a field setting as a function of group dominance and cohesion. *Journal of Personality and Social Psychology, 32,* 346–360.

Leyens, J-P. (1989). Another look at confirmatory strategies during a real interview. *European Journal of Social Psychology, 19,* 255–262.

Lichtenstein, S., & Fischhoff, B. (1980). Training for calibration. *Organizational Behavior and Human Performance, 26,* 149–171.

Lieberman, S. (1956). The effects of changes in roles on the attitudes of role occupants. *Human Relations, 9,* 385–402.

Liebert, R. M., & Baron, R. A. (1972). Some immediate effects of televised violence on children's behavior. *Developmental Psychology, 6,* 469–475.

Liebrand, W. B. G., Messick, D. M., & Wolters, F. J. M. (1986). Why we are fairer than others: A cross-cultural replication and extension. *Journal of Experimental Social Psychology, 22,* 590–604.

Life (1988, Spring). What we believe. Pp. 69–70.

Lind, E. A., Erickson, B. E., Friedland, N., & Dickenberger, M. (1978). Reactions to procedural models for adjudicative conflict resolution. *Journal of Conflict Resolution, 22,* 318–341.

Lind, E. A., Thibaut, J., & Walker, L. (1976). A cross-cultural comparison of the effect of adversary and inquisitorial processes on bias in legal decision making. *Virginia Law Review, 62,* 271–283.

Lindsay, R. C. L., & Wells, G. L. (1985). Improving eyewitness identifications from lineups: Simultaneous versus sequential lineup presentation. *Journal of Applied Psychology, 70,* 556–564.

Lindsay, R. C. L., Wells, G. L., & Rumpel, C. H. (1981). Can people detect eyewitness-identification accuracy within and across situations? *Journal of Applied Psychology, 66,* 79–89.

Lindskold, S. (1978). Trust development, the GRIT proposal, and the effects of conciliatory acts on conflict and cooperation. *Psychological Bulletin, 85,* 772–793.

Lindskold, S. (1979). Conciliation with simultaneous or sequential interaction: Variations in trustworthiness and vulnerability in the prisoner's dilemma. *Journal of Conflict Resolution, 27,* 704–714.

Lindskold, S. (1979). Managing conflict through announced conciliatory initiatives backed with retaliatory capability. In W. G. Austin and S. Worchel (Eds.), *The social psychology of intergroup relations.* Monterey, Calif.: Brooks/Cole.

Lindskold, S. (1981). The laboratory evaluation of GRIT: Trust, cooperation, aversion to using conciliation. Paper presented at the American Association for the Advancement of Science convention.

Lindskold, S. (1983). Cooperators, competitors, and response to GRIT. *Journal of Conflict Resolution, 27,* 521–532.

Lindskold, S., & Aronoff, J. R. (1980). Conciliatory strategies and relative power. *Journal of Experimental Social Psychology, 16,* 187–198.

Lindskold, S., Bennett, R., & Wayner, M. (1976). Retaliation level as a foundation for subsequent conciliation. *Behavioral Science, 21,* 13–18.

Lindskold, S., Betz, B., & Walters, P. S. (1986). Transforming competitive or cooperative climate. *Journal of Conflict Resolution, 30,* 99–114.

Lindskold, S., & Collins, M. G. (1978). Inducing cooperation by groups and individuals. *Journal of Conflict Resolution, 22,* 679–690.

Lindskold, S., & Finch, M. L. (1981). Styles of announcing conciliation. *Journal of Conflict Resolution, 25,* 145–155.

Lindskold, S., & Han, G. (1988). GRIT as a foundation for integrative bargaining. *Personality and Social Psychology Bulletin, 14,* 335–345.

Lindskold, S., Han, G., & Betz, B. (1986). Repeated persuasion in interpersonal conflict. *Journal of Personality and Social Psychology, 51,* 1183–1188. (b)

Lindskold, S., Han, G., & Betz, B. (1986). The essential elements of communication in the GRIT strategy. *Personality and Social Psychology Bulletin, 12,* 179–186. (a)

Lindskold, S., Walters, P. S., Koutsourais, H., & Shayo, R. (1981). Cooperators, competitors, and response to GRIT. Unpublished manuscript, Ohio University.

Linville, P., Fischer, G., & Fischhoff, B. (1992). Perceived risk and decision making involving AIDS. In J. B. Pryor & G. D. Reeder (Eds.), *The social psychology of HIV infection.* Hillsdale, NJ: Erlbaum.

Linville, P. W., Gischer, G. W., & Salovey, P. (1989). Perceived distributions of the characteristics of in-group and out-group members: Empirical evidence and a computer simulation. *Journal of Personality and Social Psychology, 57,* 165–188.

Linz, D. G., Donnerstein, E., & Adams, S. M. (1989). Physiological desensitization and judgments about female victims of violence. *Human Communication Research, 15,* 509–522.

Linz, D. G., Donnerstein, E., & Penrod, S. (1988). Effects of long term exposure to violent and sexually degrading depictions of women. *Journal of Personality and Social Psychology, 55,* 758–768.

Lipset, S. M. (1966). University students and politics in underdeveloped countries. *Comparative Education Review. 10,* 132–162.

Lipsitz, A., Kallmeyer, K., Ferguson, M., & Abas, A. (1989). Counting on blood donors: Increasing the impact of reminder calls. *Journal of Applied Social Psychology, 19,* 1057–1067.

Locke, E. A., & Latham, G. P. (1990). Work motivation and satisfaction: Light at the end of the tunnel. *Psychological Science, 1,* 240–246.

Locke, K. D., & Horowitz, L. M. (1990). Satisfaction in interpersonal interactions as a function of similarity in level of dysphoria. *Journal of Personality and Social Psychology, 58,* 823–831.

Locksley, A., Borgida, E., Brekke, N., & Hepburn, C. (1980). Sex stereotypes and social judgment. *Journal of Personality and Social Psychology, 39,* 821–831.

Locksley, A., Hepburn, C., & Ortiz, V. (1982). Social stereotypes and judgments of individuals: An instance of the base-rate fallacy. *Journal of Experimental Social Psychology, 18,* 23–42.

Locksley, A., Ortiz, V., & Hepburn, C. (1980). Social categorization and discriminatory behavior: Extinguishing the minimal intergroup discrimination effect. *Journal of Personality and Social Psychology, 39,* 773–783.

Lofland, J., & Stark, R. (1965). Becoming a worldsaver: A theory of conversion to a deviant perspective. *American Sociological Review, 30,* 862–864.

Loftin, C., McDowall, D., Wiersema, B., & Cottey, T. J. (1991). Effects of restrictive licensing of handguns on

homicide and suicide in the District of Columbia. *New England Journal of Medicine*, 325, 1615–1620.

Loftus, E. F. (1974, December). Reconstructing memory: The incredible eyewitness. *Psychology Today*, pp. 117–119.

Loftus, E. F. (1979). *Eyewitness testimony.* Cambridge, Mass.: Harvard University Press. *(a)*

Loftus, E. F. (1979). The malleability of human memory. *American Scientist*, 67, 312–320. *(b)*

Loftus, E. F. (1980). Impact of expert psychological testimony on the unreliability of eyewitness identification. *Journal of Applied Social Psychology*, 65, 9–15.

Loftus, E. F., Miller, D. G., & Burns, H. J. (1978). Semantic integration of verbal information into a visual memory. *Journal of Experimental Social Psychology: Human Learning and Memory*, 4, 19–31.

Loftus, E. F., & Palmer, J. C. (1973). Reconstruction of automobile destruction: An example of the interaction between language and memory. *Journal of Verbal Learning and Verbal Behavior*, 13, 585–589.

Loftus, E. F., & Zanni, G. (1975). Eyewitness testimony: The influence of the wording in a question. *Bulletin of the Psychonomic Society*, 5, 86–88.

Lombardo, J. P., Weiss, R. F., & Buchanan, W. (1972). Reinforcing and attracting functions of yielding. *Journal of Personality and Social Psychology*, 21, 359–368.

London, P. (1970). The rescuers: Motivational hypotheses about Christians who saved Jews from the Nazis. In J. Macaulay & L. Berkowitz (Eds.), *Altruism and helping behavior*. New York: Academic Press.

Lonner, W. J. (1989). The introductory psychology text and cross-cultural psychology: Beyond Ekman, Whorf, and biased I.Q. tests. In D. Keats, D. R. Munro & L. Mann (Eds.), *Heterogeneity in cross-cultural psychology*.

Lord, C. G., Desforges, D. M., Ramsey, S. L., Trezza, G. R., & Lepper, M. R. (1991). Typicality effects in attitude-behavior consistency: Effects of category discrimination and category knowledge. *Journal of Experimental Social Psychology*, 27, 550–575.

Lord, C. G., Lepper, M. R., & Preston, E. (1984). Considering the opposite: A corrective strategy for social judgment. *Journal of Personality and Social Psychology*, 47, 1231–1243.

Lord, C. G., Ross, L., & Lepper, M. (1979). Biased assimilation and attitude polarization: The effects of prior theories on subsequently considered evidence. *Journal of Personality and Social Psychology*, 37, 2098–2109.

Lord, C. G. & Saenz, D. S. (1985). Memory deficits and memory surfeits: Differential cognitive consequences of tokenism for tokens and observers. *Journal of Personality and Social Psychology*, 49, 918–926.

Losch, M. E., & Cacioppo, J. T. (1990). Cognitive dissonance may enhance sympathetic tonus, but attitudes are changed to reduce negative affect rather than arousal. *Journal of Experimental Social Psychology*, 26, 289–304.

Lott, A. J., & Lott, B. E. (1961). Group cohesiveness, communication level, and conformity. *Journal of Abnormal and Social Psychology*, 62, 408–412.

Lott, A. J., & Lott, B. E. (1974). The role of reward in the formation of positive interpersonal attitudes. In T. Huston (Ed.), *Foundations of interpersonal attraction*. New York: Academic Press.

Louw-Potgieter, J. (1988). The authoritarian personality: An inadequate explanation for intergroup conflict in South Africa. *Journal of Social Psychology*, 128, 75–87.

Lovdal, L. T. (1989). Sex role messages in television commercials: An update. *Sex Roles*, 21, 715–724.

Lowe, C. A., & Goldstein, J. W. (1970). Reciprocal liking and attributions of ability: Mediating effects of perceived intent and personal involvement. *Journal of Personality and Social Psychology*, 16, 291–297.

Lowe, R. H., & Wittig, M. A. (1989). Comparable worth: Individual, interpersonal, and structural considerations. *Journal of Social Issues*, 45, 223–246.

Lowenthal, M. F., Thurnher, M., Chiriboga, D., Beefon, D., Gigy, L., Lurie, E., Pierce, R., Spence, D., & Weiss, L. (1975). *Four stages of life.* San Francisco: Jossey-Bass.

Loy, J. W., & Andrews, D. S. (1981). They also saw a game: A replication of a case study. *Replications in Social Psychology*, 1(2), 45–59.

Luginbuhl, J. (1992). Comprehension of judges' instructions in the penalty phase of a capital trial: Focus on mitigating circumstances. *Law and Human Behavior*, in press.

Luginbuhl, J., & Middendorf, K. (1988). Death penalty beliefs and jurors' responses to aggravating and mitigating circumstances in capital trials. *Law and Human Behavior*, 12, 263–281.

Lumsdaine, A. A., & Janis, I. L. (1953). Resistance to "counter-propaganda" produced by one-sided and two-sided "propaganda" presentations. *Public Opinion Quarterly*, 17, 311–318.

Lumsden, A., Zanna, M. P., & Darley, J. M. (1980). When a newscaster presents counter-additional information: Education or propaganda? Paper presented to the Canadian Psychological Association annual convention.

Lydon, J E. Jamieson, D. W., & Zanna, M. P. (1988). Interpersonal similarity and the social and intellectual dimensions of first impressions. *Social Cognition*, 6, 269–286.

Lynn, M., & Oldenquist, A. (1986). Egoistic and nonegoistic motives in social dilemmas. *American Psychologist*, 41, 529–534.

Lynn, M., & Shurgot, B. A. (1984). Responses to lonely hearts advertisements: Effects of reported physical attractiveness, physique, and coloration. *Personality and Social Psychology*, 10, 349–357.

Maass, A., Brigham, J. C., & West, S. G. (1985). Testifying on eyewitness reliability: Expert advice is not always persuasive. *Journal of Applied Social Psychology*, 15, 207–229.

Maass, A., & Clark, R. D., III (1984). Hidden impact of minorities: Fifteen years of minority influence research. *Psychological Bulletin*, 95, 428–450.

Maass, A., & Clark, R. D., III (1986). Conversion theory and simultaneous majority/minority influence: Can reactance offer an alternative explanation? *European Journal of Social Psychology*, 16, 305–309.

MacArthur, D. (1973). Quoted in J. D. Frank's statement on psychological aspects of international relations before a hearing of the Committee on Foreign Relations, United States Senate, May 25, 1966. Reprinted in D. E. Linder (Ed.), *Psychological dimensions of social interaction: Readings and perspectives*. Reading, Mass.: Addison-Wesley.

Maccoby, N. (1980). Promoting positive health behaviors in adults. In L. A. Bond & J. C. Rosen (Eds.), *Competence and coping during adulthood*. Hanover, N.H.: University Press of New England.

Maccoby, N., & Alexander, J. (1980). Use of media in lifestyle programs. In P. O. Davidson & S. M. Davidson (Eds.). *Behavioral medicine: Changing health lifestyles.* New York: Brunner/Mazel.

MacCoun, R. J., & Kerr, N. L. (1988). Asymmetric influence in mock jury deliberation: Jurors' bias for leniency. *Journal of Personality and Social Psychology, 54,* 21–33.

Mack, D., & Rainey, D. (1990). Female applicants' grooming and personnel selection. *Journal of Social Behavior and Personality, 5,* 399–407.

MacKay, J. L. (1980). Selfhood: Comment on Brewster Smith. *American Psychologist, 35,* 106–107.

Mackie, D. M. (1987). Systematic and nonsystematic processing of majority and minority persuasive communications. *Journal of Personality and Social Psychology, 53,* 41–52.

Mackie, D. M., Worth, L. T., & Asuncion, A. G. (1990). Processing of persuasive in-group messages. *Journal of Personality and Social Psychology, 58,* 812–822.

MacLachlan, J. (1979, November). What people really think of fast talkers. *Psychology Today,* pp. 113–117.

MacLachlan, J., & Siegel, M. H. (1980). Reducing the costs of TV commercials by use of time compressions. *Journal of Marketing Research, 17,* 52–57.

Maddux, J. E. (1991). Personal efficacy. In V. Derlega, B. Winstead, & W. Jones (Eds.), *Personality: Contemporary theory and research.* Chicago: Nelson-Hall.

Maddux, J. E., Norton, L. W., & Leary, M. R. (1988). Cognitive components of social anxiety: An investigation of the integration of self-presentation theory and self-efficacy theory. *Journal of Social and Clinical Psychology, 6,* 180–190.

Maddux, J. E., & Rogers, R. W. (1983). Protection motivation and self-efficacy: A revised theory of fear appeals and attitude change. *Journal of Experimental Social Psychology, 19,* 469–479.

Magnuson, E. (1986, March 10). "A serious deficiency": The Rogers Commission faults NASA's "flawed" decision-making process. *Time,* pp. 40–42, international ed.

Magnusson, S. (1981). *The flying Scotsman.* London: Quartet Books.

Major, B. (1989). Gender differences in comparisons and entitlement: Implications for comparable worth. *Journal of Social Issues, 45,* 99–116.

Major, B., & Adams, J. B. (1983). Role of gender, interpersonal orientation, and self-presentation in distributive-justice behavior. *Journal of Personality and Social Psychology, 45,* 598–608.

Major, B., Schmidlin, A. M., & Williams, L. (1990). Gender patterns in social touch: The impact of setting and age. *Journal of Personality and Social Psychology, 58,* 634–643.

Malamuth, N. M. (1984). Aggression against women: Cultural and individual causes. In N. M. Malamuth & E. Donnerstein (Eds.), *Pornography and sexual aggression.* Orlando, Fla.: Academic Press.

Malamuth, N. M. (1986). Predictors of naturalistic sexual aggression. *Journal of Personality and Social Psychology, 50,* 953–962.

Malamuth, N. M. (1989). The attraction to sexual aggression scale: Part one. *Journal of Sex Research, 26,* 26–49.

Malamuth, N. M., & Check, J. V. P. (1981). The effects of media exposure on acceptance of violence against women: A field experiment. *Journal of Research in Personality, 15,* 436–446.

Malamuth, N. M., & Check, J. V. P. (1984). Debriefing effectiveness following exposure to pornographic rape depictions. *Journal of Sex Research, 20,* 1–13.

Malkiel, B. G. (1985). *A random walk down Wall Street,* 4th ed. New York: W. W. Norton.

Malpass, R. S., & Devine, P. G. (1984). Research on suggestion in lineups and photo-spreads. In G. L. Wells & E. F. Loftus (Eds.), *Eyewitness identification: Psychological perspectives.* New York: Cambridge University Press.

Manis, M. (1977). Cognitive social psychology. *Personality and Social Psychology Bulletin, 3,* 550–566.

Manis, M. Cornell, S. D., & Moore, J. C. (1974). Transmission of attitude-relevant information through a communication chain. *Journal of Personality and Social Psychology, 30,* 81–94.

Manis, M., Nelson, T. E., & Shedler, J. (1988). Stereotypes and social judgment: Extremity, assimilation, and contrast. *Journal of Personality and Social Psychology, 55,* 28–36.

Mann, L. (1981). The baiting crowd in episodes of threatened suicide. *Journal of Personality and Social Psychology, 41,* 703–709.

Mantell, D. M. (1971). The potential for violence in Germany. *Journal of Social Issues, 27*(4), 101–112.

Manucia, G. K., Baumann, D. J., & Cialdini, R. B. (1984). Mood influences on helping: Direct effects or side effects? *Journal of Personality and Social Psychology, 46,* 357–364.

Marcus, S. (1974). Review of *Obedience to authority.* New York Times Book Review, January 13, pp. 1–2.

Marks, G., & Miller, N. (1987). Ten years of research on the false-consensus effect: An empirical and theoretical review. *Psychological Bulletin, 102,* 72–90.

Marks, G., Miller, N., & Maruyama, G. (1981). Effect of targets' physical attractiveness on assumptions of similarity. *Journal of Personality and Social Psychology, 41,* 198–206.

Markus, G. B. (1986). Stability and change in political attitudes: Observe, recall, and "explain." *Political Behavior, 8,* 21–44.

Markus, H., & Kitayama, S. (1991). Culture and the self: Implications for cognition, emotion, and motivation. *Psychological Review, 98,* 224–253.

Markus, H., & Wurf, E. (1987). The dynamic self-concept: A social psychological perspective. *Annual Review of Psychology, 38,* 299–337.

Marler, P. (1974). Aggression and its control in animal society. Presentation to the American Psychological Association convention.

Marshall, W. L. (1989). Pornography and sex offenders. In D. Zillmann & J. Bryant (Eds.), *Pornography: Research advances and policy considerations.* Hillsdale, NJ: Erlbaum.

Martin, C. L. (1987). A ratio measure of sex stereotyping. *Journal of Personality and Social Psychology, 52,* 489–499.

Marty, M. E. (1982). Watch your language. *Context,* April 15, p. 6.

Maruyama, G., & Miller, N. (1981). Physical attractiveness and personality. In B. A. Maher & W. B. Maher (Eds.), *Progress in experimental personality research.* New York: Academic Press.

Maruyama, G., Rubin, R. A., & Kingbury, G. (1981). Self-esteem and educational achievement: Independent constructs with a common cause? *Journal of Personality and Social Psychology, 40,* 962–975.

Marvelle, K., & Green, S. (1980).

Physical attractiveness and sex bias in hiring decisions for two types of jobs. *Journal of the National Association of Women Deans, Administrators, and Counselors, 44*(1), 3–6.

Maslach, C. (1978). The client role in staff burnout. *Journal of Social Issues, 34*(4), 111–124.

Maslach, C. (1982). *Burnout: The cost of caring.* Englewood Cliffs, N.J.: Prentice-Hall.

Maslach, C., & Jackson, S. E. (1979, May). Burn-out cops and their families. *Psychology Today*, pp. 59–62.

Maslow, A. H., & Mintz, N. L. (1956). Effects of esthetic surroundings: I. Initial effects of three esthetic conditions upon perceiving "energy" and "well-being" in faces. *Journal of Psychology, 41*, 247–254.

Maslow, B. G. (Ed.) (1972). *Abraham H. Maslow: A memorial volume.* Monterey, Calif.: Brooks/Cole.

Matthews, K. A. (1988). CHD and Type A behaviors: Update on and alternative to the Booth-Kewley and Friedman quantitative review. *Psychological Bulletin, 104*, 373–380.

Maxwell, G. M. (1985). Behaviour of lovers: Measuring the closeness of relationships. *Journal of Personality and Social Psychology, 2*, 215–238.

Mayer, J. D., & Salovey, P. (1987). Personality moderates the interaction of mood and cognition. In K. Fiedler & J. Forgas (Eds.), *Affect, cognition, and social behavior.* Toronto: Hogrefe.

McAlister, A., Perry, C., Killen, J., Slinkard, L. A., & Maccoby, N. (1980). Pilot study of smoking, alcohol and drug abuse prevention. *American Journal of Public Health, 70*, 719–721.

McAndrew, F. T. (1981). Pattern of performance and attributions of ability and gender. *Journal of Personality and Social Psychology, 7*, 583–587.

McArthur, L. A. (1972). The how and what of why: Some determinants and consequences of causal attribution. *Journal of Personality and Social Psychology, 22*, 171–193.

McArthur, L. Z., & Friedman, S. A. (1980). Illusory correlation in impression formation: Variations in the shared distinctiveness effect as a function of the distinctive person's age, race, and sex. *Journal of Personality and Social Psychology, 39*, 615–624.

McCann, C. D., & Hancock, R. D. (1983). Self-monitoring in communicative interactions: Social cognitive consequences of goal-directed message modification. *Journal of Experimental Social Psychology, 19*, 109–121.

McCarrey, M., Edwards, H. P., & Rozario, W. (1982). Ego-relevant feedback, affect, and self-serving attributional bias. *Personality and Social Psychology Bulletin, 8*, 189–194.

McCarthy, J. D., & Hoge, D. R. (1984). The dynamics of self-esteem and delinquency. *American Journal of Sociology, 90*, 396–410.

McCarthy, J. F., & Kelly, B. R. (1978). Aggression, performance variables, and anger self-report in ice hockey players. *Journal of Psychology, 99*, 97–101. (b)

McCarthy, J. F., & Kelly, B. R. (1978). Aggressive behavior and its effect on performance over time in ice hockey athletes: An archival study. *International Journal of Sport Psychology, 9*, 90–96. (a)

McCauley, C. (1989). The nature of social influence in groupthink: Compliance and internalization. *Journal of Personality and Social Psychology, 57*, 250–260.

McCauley, C., & Stitt, C. L. (1978). An individual and quantitative measure of stereotypes. *Journal of Personality and Social Psychology, 36*, 929–940.

McCauley, C. R., & Segal, M. E. (1987). Social psychology of terrorist groups. In C. Hendrick (Ed.), *Group processes and intergroup relations: Review of personality and social psychology*, Vol. 9. Newbury Park, Ca.: Sage.

McConahay, J. B. (1981). Reducing racial prejudice in desegregated schools. In W. D. Hawley (Ed.), *Effective school desegregation.* Beverly Hills, Calif.: Sage.

McCullough, J. L., & Ostrom, T. M. (1974). Repetition of highly similar messages and attitude change. *Journal of Applied Psychology, 59*, 395–397.

McFarland, C., & Ross, M. (1985). The relation between current impressions and memories of self and dating partners. Unpublished manuscript, University of Waterloo.

McFarland, C., Ross, M., & DeCourville, N. (1989). Women's theories of menstruation and biases in recall of menstrual symptoms. *Journal of Personality and Social Psychology, 57*, 522–531.

McGillicuddy, N. B., Welton, G. L., & Pruitt, D. G. (1987). Third-party intervention: A field experiment comparing three different models. *Journal of Personality and Social Psychology, 53*, 104–112.

McGillis, D. (1979). Biases and jury decision making. In I. H. Frieze, D. Bar-Tal, & J. S. Carroll, *New approaches to social problems.* San Francisco: Jossey-Bass.

McGrath, J. E. (1984). *Groups: Interaction and performance.* Englewood Cliffs, N.J.: Prentice-Hall.

McGuire, W. J. (1964). Inducing resistance to persuasion: Some contemporary approaches. In L. Berkowitz (Ed.), *Advances in experimental social psychology* (Vol. 1). New York: Academic Press.

McGuire, W. J. (1978). An information-processing model of advertising effectiveness. In H. L. Davis & A. J. Silk (Eds.), *Behavioral and management sciences in marketing.* New York: Ronald Press.

McGuire, W. J. (1986). The myth of massive media impact: Savagings and salvagings. In G. Comstock (Ed.), *Public communication and behavior*, Vol. 1. Orlando, Fl.: Academic Press.

McGuire, W. J., & McGuire, C. V. (1986). Differences in conceptualizing self versus conceptualizing other people as manifested in contrasting verb types used in natural speech. *Journal of Personality and Social Psychology, 51*, 1135–1143.

McGuire, W. J., McGuire, C. V., Child, P., & Fujioka, T. (1978). Salience of ethnicity in the spontaneous self-concept as a function of one's ethnic distinctiveness in the social environment. *Journal of Personality and Social Psychology, 36*, 511–520.

McGuire, W. J., & Padawer-Singer, A. (1978). Trait salience in the spontaneous self-concept. *Journal of Personality and Social Psychology, 33*, 743–754.

McGuire, W. J., McGuire, C. V., & Winton, W. (1979). Effects of household sex composition on the salience of one's gender in the spontaneous self-concept. *Journal of Experimental Social Psychology, 15*, 77–90.

McKelvie, S. J. (1990). Student acceptance of a generalized personality description: Forer's graphologist revisited. *Journal of Social Behavior and Personality, 5*(4), 91–95.

McKenzie-Mohr, D., & Zanna, M. P. (1990). Treating women as sexual ob-

jects: Look to the (gender schematic) male who has viewed pornography. *Personality and Social Psychology Bulletin, 16*, 296–308.

McMillen, D. L., & Austin, J. B. (1971). Effect of positive feedback on compliance following transgression. *Psychonomic Science, 24*, 59–61.

McMillen, D. L., Sanders, D. Y., & Solomon, G. S. (1977). Self-esteem, attentiveness, and helping behavior. *Journal of Personality and Social Psychology, 3*, 257–261.

McNeel, S. P. (1980). Tripling up: Perceptions and effects of dormitory crowding. Paper presented at the American Psychological Association convention.

McNeill, B. W., & Stoltenberg, C. D. (1988). A test of the elaboration likelihood model for therapy. *Cognitive Therapy and Research, 12*, 69–79.

Medalia, N. Z., & Larsen, O. N. (1958). Diffusion and belief in collective delusion: The Seattle windshield pitting epidemic. *American Sociological Review, 23*, 180–186.

Meehl, P. E. (1954). *Clinical vs. statistical prediction: A theoretical analysis and a review of evidence.* Minneapolis: University of Minnesota Press.

Meehl, P. E. (1986). Causes and effects of my disturbing little book. *Journal of Personality Assessment, 50*, 370–375.

Meeus, W. H. J., & Raaijmakers, Q. A. W. (1986). Administrative obedience: Carrying out orders to use psychological-administrative violence. *European Journal of Social Psychology, 16*, 311–324.

Meindl, J. R., & Lerner, M. J. (1984). Exacerbation of extreme responses to an out-group. *Journal of Personality and Social Psychology, 47*, 71–84.

Melton, G. B., Monahan, J., & Saks, M. J. (1987). Psychologists as law professors. *American Psychologist, 42*, 502–509.

Menand, L. (1991, May 20). Illiberalisms. *New Yorker*, pp. 101–107.

Mendonca, P. J., & Brehm, S. S. (1983). Effects of choice on behavioral treatment of overweight children. *Journal of Social and Clinical Psychology, 1*, 343–358.

Merton, R. K., & Kitt, A. S. (1950). Contributions to the theory of reference group behavior. In R. K. Merton & P. F. Lazarsfeld (Eds.), *Continuities in social research: Studies in the scope and method of the American soldier.* Glencoe, Ill.: Free Press.

Messé, L. A., Kerr, N. L., & Sattler, D. N. (1992). "But some animals are more equal than others": The supervisor as a privileged status in group contexts. In S. Worchel, W. Wood, & J. Simpson (Eds.) *Group process and productivity.* Newbury Park, CA: Sage.

Messé, L. A., & Sivacek, J. M. (1979). Predictions of others' responses in a mixed-motive game: Self-justification or false consensus? *Journal of Personality and Social Psychology, 37*, 602–607.

Messick, D. M., Bloom, S., Boldizar, J. P., & Samuelson, C. D. (1985). Why we are fairer than others. *Journal of Experimental Social Psychology, 21*, 480–500.

Messick, D. M., & Sentis, K. P. (1979). Fairness and preference. *Journal of Experimental Social Psychology, 15*, 418–434.

Messick, D. M., Wilke, H., Brewer, M. B., Kramer, R. M., Zemke, P. E., & Lui, L. (1983). Individual adaptations and structural change as solutions to social dilemmas. *Journal of Personality and Social Psychology, 44*, 294–309.

Meyer, D. S. (1975). *The winning candidate: How to defeat your political candidate.* New York: Heinemann, 1966. Cited by P. Suedfeld, D. Rank, and R. Borre in Frequency of exposure and evaluation of candidates and campaign speeches. *Journal of Applied Social Psychology, 15*, 118–126.

Michaels, J. W., Blommel, J. M., Brocato, R. M., Linkous, R. A., & Rowe, J. S. (1982). Social facilitation and inhibition in a natural setting. *Replications in Social Psychology, 2*, 21–24.

Middlemist, R. D., Knowles, E. S., & Matter, C. F. (1976). Personal space invasions in the lavatory: Suggestive evidence for arousal. *Journal of Personality and Social Psychology, 33*, 541–546.

Middlemist, R. D., Knowles, E. S., & Matter, C. F. (1977). What to do and what to report: A reply to Koocher. *Journal of Personality and Social Psychology, 35*, 122–124.

Miell, E., Duck, S., & La Gaipa, J. (1979). Interactive effects of sex and timing in self disclosure. *British Journal of Social and Clinical Psychology, 18*, 355–362.

Mikula, G. (1984). Justice and fairness in interpersonal relations: Thoughts and suggestions. In H. Taijfel (Ed.), *The social dimension: European developments in social psychology*, Vol. 1, Cambridge: Cambridge University Press.

Milgram, S. (1961, December). Nation-

ality and conformity. *Scientific American*, December, pp. 45–51.

Milgram, S. (1965). Some conditions of obedience and disobedience to authority. *Human Relations, 18*, 57–76.

Milgram, S. (1974). *Obedience to authority.* New York: Harper and Row.

Milgram, S. (1992). Cyranoids. In S. Milgram, *The individual in a social world.* New York: McGraw-Hill.

Milgram, S., Bickman, L., & Berkowitz, L. (1969). Note on the drawing power of crowds of different size. *Journal of Personality and Social Psychology, 13*, 79–82.

Milgram, S., & Sabini, J. (1983). On maintaining social norms: A field experiment in the subway. In H. H. Blumberg, A. P. Hare, V. Kent, and M. Davies (Eds.), *Small groups and social interaction*, Vol. 1. London: Wiley.

Millar, M. G., & Tesser, A. (1985). Effects of affective and cognitive focus on the attitude-behavior relationship. Unpublished manuscript, Institute for Behavioral Research, University of Georgia.

Millar, M. G., & Tesser, A. (1986). Thought-induced attitude change: The effects of schema structure and commitment. *Journal of Personality and Social Psychology, 51*, 259–269.

Millar, M. G., & Tesser, A. (1989). The effects of affective-cognitive consistency and thought on the attitude-behavior relation. *Journal of Experimental Social Psychology, 25*, 189–202.

Miller, A. (trans. H. & H. Hannum). (1990). *For your own good: Hidden cruelty in child-rearing and the roots of violence.* New York: Noonday Press.

Miller, A. G. (1986). *The obedience experiments: A case study of controversy in social science.* New York: Praeger.

Miller, A. G., Ashton, W., & Mishal, M. (1990). Beliefs concerning the features of constrained behavior: A basis for the fundamental attribution error. *Journal of Personality and Social Psychology, 59*, 635–650.

Miller, A. G., Gillen, G., Schenker, C., & Radlove, S. (1973). Perception of obedience to authority. *Proceedings of the 81st annual convention of the American Psychological Association, 8*, 127–128.

Miller, C. E., & Anderson, P. D. (1979). Group decision rules and the rejection of deviates. *Social Psychology Quarterly, 42*, 354–363.

Miller, C. T., & Felicio, D. M. (1990).

Person-positivity bias: Are individuals liked better than groups? *Journal of Experimental Social Psychology, 26,* 408–420.

Miller, D. T. (1977). Altruism and threat to a belief in a just world. *Journal of Experimental Social Psychology, 13,* 113–124.

Miller, D. T., & McFarland, C. (1987). Pluralistic ignorance: When similarity is interpreted as dissimilarity. *Journal of Personality and Social Psychology, 53,* 298–305.

Miller, D. T., Taylor, B., & Buck, M. L. (1991). Gender gaps: Who needs to be explained? *Journal of Personality and Social Psychology, 61,* 5–12.

Miller, D. T., & Turnbull, W. (1986). Expectancies and interpersonal processes. In M. R. Rosenzweig & L. W. Porter (Eds.), *Annual review of psychology,* Vol. 37. Palo Alto: Annual Reviews.

Miller, G. R., & Fontes, N. E. (1979). *Videotape on trial: A view from the jury box.* Beverly Hills, Calif.: Sage Publications.

Miller, J. B. (1986). *Toward a new psychology of women,* 2nd ed. Boston, MA: Beacon Press.

Miller, J. G. (1984). Culture and the development of everyday social explanation. *Journal of Personality and Social Psychology, 46,* 961–978.

Miller, J. G., Bersoff, D. M., & Harwood, R. L. (1990). Perceptions of social responsibility in India and in the United States: Moral imperatives or personal decisions? *Journal of Personality and Social Psychology, 58,* 33–47.

Miller, K. I., & Monge, P. R. (1986). Participation, satisfaction, and productivity: A meta-analytic review. *Academy of Management Journal, 29,* 727–753.

Miller, L. C. (1990). Intimacy and liking: Mutual influence and the role of unique relationships. *Journal of Personality and Social Psychology, 59,* 50–60.

Miller, L. C., Berg, J. H., & Archer, R. L. (1983). Openers: Individuals who elicit intimate self-disclosure. *Journal of Personality and Social Psychology, 44,* 1234–1244.

Miller, L. C., Berg, J. H., & Rugs, D. (1989). Selectivity and sharing: Needs and norms in developing friendships. Unpublished manuscript, Scripps College.

Miller, L. E., & Grush, J. E. (1986). Individual differences in attitudinal versus normative determination of behavior. *Journal of Experimental Social Psychology, 22,* 190–202.

Miller, N., & Campbell, D. T. (1959). Recency and primacy in persuasion as a function of the timing of speeches and measurements. *Journal of Abnormal and Social Psychology, 59,* 1–9.

Miller, N., & Marks, G. (1982). Assumed similarity between self and other: Effect of expectation of future interaction with that other. *Social Psychology Quarterly, 45,* 100–105.

Miller, N., Maruyama, G., Beaber, R. J., & Valone, K. (1976). Speed of speech and persuasion. *Journal of Personality and Social Psychology, 34,* 615–624.

Miller, N. E. (1941). The frustration-aggression hypothesis. *Psychological Review, 48,* 337–342.

Miller, N. E., & Bugelski, R. (1948). Minor studies of aggression: II. The influence of frustrations imposed by the in-group on attitudes expressed toward out-groups. *Journal of Psychology, 25,* 437–442.

Miller, P. A., & Eisenberg, N. (1988). The relation of empathy to aggressive and externalizing/antisocial behavior. *Psychological Bulletin, 103,* 324–344.

Miller, P. C., Lefcourt, H. M., Holmes, J. G., Ware, E. E., & Saley, W. E. (1986). Marital locus of control and marital problem solving. *Journal of Personality and Social Psychology, 51,* 161–169.

Miller, R. L., Brickman, P., & Bolen, D. (1975). Attribution versus persuasion as a means for modifying behavior. *Journal of Personality and Social Psychology, 31,* 430–441.

Miller, R. S., & Schlenker, B. R. (1985). Egotism in group members: Public and private attributions of responsibility for group performance. *Social Psychology Quarterly, 48,* 85–89.

Miller, R. S., & Simpson, J. A. (1990). Relationship satisfaction and attentiveness to alternatives. Paper presented at the American Psychological Association convention.

Millett, K. (1975). The shame is over. *Ms.,* January, pp. 26–29.

Millett, K. (1979). *The basement: Meditations on human sacrifice.* New York: Simon & Schuster.

Mills, J., & Clark, M. S. (in press). Communal and exchange relationships: New research and old controversies. In R. Gilmour (Ed.), *Theoretical frameworks for personal relationships.* Hillsdale, NJ: Erlbaum.

Mims, P. R., Hartnett, J. J., & Nay, W. R. (1975). Interpersonal attraction and help volunteering as a function of physical attractiveness. *Journal of Psychology, 89,* 125–131.

Minard, R. D. (1952). Race relationships in the Pocohontas coal field. *Journal of Social Issues, 8*(1), 29–44.

Mirels, H. L., & McPeek, R. W. (1977). Self-advocacy and self-esteem. *Journal of Consulting and Clinical Psychology, 45,* 1132–1138.

Mischel, W. (1968). *Personality and assessment.* New York: Wiley.

Mita, T. H., Dermer, M., & Knight, J. (1977). Reversed facial images and the mere-exposure hypothesis. *Journal of Personality and Social Psychology, 35,* 597–601.

Moghaddam, F. M. (1987). Psychology in the three worlds: As reflected by the crisis in social psychology and the move toward indigenous third-world psychology. *American Psychologist, 42,* 912–920.

Moghaddam, F. M. (1990). Modulative and generative orientations in psychology: Implications for psychology in the three worlds. *Journal of Social Issues, 46,* 21–41.

Monge, P. T., & Kirste, K. K. (1980). Measuring proximity in human organization. *Social Psychology Quarterly, 43,* 110–115.

Monson, T. C., Hesley, J. W., & Chernick, L. (1982). Specifying when personality traits can and cannot predict behavior: An alternative to abandoning the attempt to predict single-act criteria. *Journal of Personality and Social Psychology, 43,* 385–399.

Monson, T. C., & Snyder, M. (1977). Actors, observers, and the attribution process: Toward a reconceptualization. *Journal of Experimental Social Psychology, 13,* 89–111.

Moody, K. (1980). *Growing up on television: The TV effect.* New York: Times Books.

Moore, B. S., Underwood, B., & Rosenhan, D. L. (1973). Affect and altruism. *Developmental Psychology, 8,* 99–104.

Moore, D. L., & Baron, R. S. (1983). Social facilitation: A physiological analysis. In J. T. Cacioppo & R. Petty (Eds.), *Social psychophysiology.* New York: Guilford Press.

Moran, G., & Comfort, J. C. (1982). Scientific juror selection: Sex as a mod-

erator of demographic and personality predictors of impaneled felony juror behavior. *Journal of Personality and Social Psychology*, **43**, 1052–1063.

Moran, G., & Comfort, J. C. (1986). Neither "tentative" nor "fragmentary": Verdict preference of impaneled felony jurors as a function of attitude toward capital punishment. *Journal of Applied Psychology*, **71**, 146–155.

Moran, G., & Cutler, B. L. (1991). The prejudicial impact of pretrial publicity. *Journal of Applied Social Psychology*, **21**, 345–367.

Moran, G., Cutler, B. L., & Loftus, E. F. (1990). Jury selection in major controlled substance trials: The need for extended voir dire. *Forensic Reports*, **3**, 331–348.

Moreland, R. L., & Zajonc, R. B. (1977). Is stimulus recognition a necessary condition for the occurrence of exposure effects? *Journal of Personality and Social Psychology*, **35**, 191–199.

Moreland, R. L., & Zajonc, R. B. (1982). Exposure effects in person perception: Familiarity, similarity and attraction. *Journal of Experimental Social Psychology*, **18**, 395–415.

Morgan, R. (1980). Theory and practice: Pornography and rape. In L. Lederer (Ed.), *Take back the night: Women on pornography*. New York: Morrow.

Morris, W. N., & Miller, R. S. (1975). The effects of consensus-breaking and consensus-preempting partners on reduction of conformity. *Journal of Experimental Social Psychology*, **11**, 215–223.

Morrison, D. M. (1989). Predicting contraceptive efficacy: A discriminant analysis of three groups of adolescent women. *Journal of Applied Social Psychology*, **19**, 1431–1452.

Morse, S. J. & Gruzen, J. (1976). The eye of the beholder: A neglected variable in the study of physical attractiveness. *Journal of Psychology*, **44**, 209–225.

Moscovici, S. (1985). Social influence and conformity. In G. Lindzey & E. Aronson (Eds.), *The handbook of social psychology*, 3rd ed. Hillsdale, N.J.: Erlbaum.

Moscovici, S. (1988). Notes towards a description of social representations. *European Journal of Social Psychology*, **18**, 211–250.

Moscovici, S., Lage, S., & Naffrechoux, M. (1969). Influence of a consistent minority on the responses of a majority in a color perception task. *Sociometry*, **32**, 365–380.

Moscovici, S., & Zavalloni, M. (1969). The group as a polarizer of attitudes. *Journal of Personality and Social Psychology*, **12**, 124–135.

Moyer, K. E. (1976). *The psychobiology of aggression*. New York: Harper & Row.

Moyer, K. E. (1983). The physiology of motivation: Aggression as a model. In C. J. Scheier & A. M. Rogers (Eds.), *G. Stanley Hall Lecture Series*, Vol. 3. Washington, D.C.: American Psychological Association.

Moynihan, D. P. (1979). Social science and the courts. *Public Interest*, **54**, 12–31.

Mucchi-Faina, A., Maass, A., & Volpato, C. (1991). Social influence: The role of originality. *European Journal of Social Psychology*, **21**, 183–197.

Muehlenhard, C. L. (1988). Misinterpreted dating behaviors and the risk of date rape. *Journal of Social and Clinical Psychology*, **6**, 20–37.

Mueller, C. W., Donnerstein, E., & Hallam, J. (1983). Violent films and prosocial behavior. *Personality and Social Psychology Bulletin*, **9**, 83–89.

Mullen, B. (1986). Atrocity as a function of lynch mob composition: A self-attention perspective. *Personality and Social Psychology Bulletin*, **12**, 187–197. (a)

Mullen, B. (1986). Stuttering, audience size, and the other-total ratio: A self-attention perspective. *Journal of Applied Social Psychology*, **16**, 139–149. (b)

Mullen, B. (1991). Group composition, salience, and cognitive representations: The phenomenology of being in a group. *Journal of Experimental Social psychology*, **27**, 297–323.

Mullen, B., & Baumeister, R. F. (1987). Group effects on self-attention and performance: Social loafing, social facilitation, and social impairment. In C. Hendrick (Ed.), *Group processes and intergroup relations: Review of personality and social psychology*, Vol. 9. Newbury Park, Ca.: Sage.

Mullen, B., Copper, C., & Driskell, J. E. (1990). Jaywalking as a function of model behavior. *Personality and Social Psychology Bulletin*, **16**, 320–330.

Mullen, B., & Goethals, G. R. (1990). Social projection, actual consensus and valence. *British Journal of Social Psychology*, **29**, 279–282.

Mullen, B., & Hu, L. (1989). Perceptions of ingroup and outgroup variability: A meta-analytic integration. *Basic and Applied Social Psychology*, **10**, 233–252.

Mullen, B., & Johnson, C. (1990). Distinctiveness-based illusory correlations and stereotyping: A meta-analytic integration. *British Journal of Social Psychology*, **29**, 11–28.

Mullen, B., Johnson, C., & Salas, E. (1991). Productivity loss in brainstorming groups: A meta-analytic integration. *Basic and Applied Social Psychology*, **12**, 3–23.

Mullen, B., & Riordan, C. A. (1988). Self-serving attributions for performance in naturalistic settings: A meta-analytic review. *Journal of Applied Social Psychology*, **18**, 3–22.

Mullen, B., Salas, E., & Driskell, J. E. (1989). Salience, motivation, and artifact as contributions to the relation between participation rate and leadership. *Journal of Experimental Social Psychology*, **25**, 545–559.

Muller, S., & Johnson, B. T. (1990). Fear and persuasion: A linear relationship? Paper presented to the Eastern Psychological Association convention.

Mumford, M. D. (1986). Leadership in the organizational context: A conceptual approach and its applications. *Journal of Applied Social Psychology*, **16**, 508–531.

Murphy-Berman, V., Berman, J. J., Singh, P., Pachauri, A., & Kumar, P. (1984). Factors affecting allocation to needy and meritorious recipients: A cross-cultural comparison. *Journal of Personality and Social Psychology*, **46**, 1267–1272.

Murphy-Berman, V., & Sharma, R. (1986). Testing the assumptions of attribution theory in India. *Journal of Social Psychology*, **126**, 607–616.

Murray, J. P., & Kippax, S. (1979). From the early window to the late night show: International trends in the study of television's impact on children and adults. In L. Berkowitz (Ed.), *Advances in experimental social psychology*, vol. 12. New York: Academic Press.

Murray, J. P., & Lonnborg, B. (1989). Using TV sensibly. Cooperative Extension Service, Kansas State University.

Murstein, B. L. (1986). *Paths to marriage*. Newbury Park, Ca.: Sage.

Muson, G. (1978). Teenage violence and the telly. *Psychology Today*, March, pp. 50–54.

Musser, L. M., & Graziano, W. F. (1991). Behavioral confirmation in children's

interaction with peers. *Basic and Applied Social Psychology*, **12**, 441–456.

Myers, D. G. (1978). Polarizing effects of social comparison. *Journal of Experimental Social Psychology*, **14**, 554–563.

Myers, D. G. (1992). *Psychology*, 3rd ed. New York: Worth.

Myers, D. G. (1992). *The pursuit of happiness: Who is happy—and why.* New York: William Morrow.

Myers, D. G., & Bach, P. J. (1976). Group discussion effects on conflict behavior and self-justification. *Psychological Reports*, **38**, 135–140.

Myers, D. G., & Bishop, G. D. (1970). Discussion effects on racial attitudes. *Science*, **169**, 778–789.

Nadler, A. (1991). Help-seeking behavior: Psychological costs and instrumental benefits. In M. S. Clark (Ed.), *Prosocial behavior*. Newbury Park, CA: Sage.

Nadler, A., & Fisher, J. D. (1986). The role of threat to self-esteem and perceived control in recipient reaction to help: Theory development and empirical validation. In L. Berkowitz (Ed.), *Advances in Experimental Social Psychology*, vol. 19. Orlando, FL: Academic Press.

Nadler, A., Goldberg, M., & Jaffe, Y. (1982). Effect of self-differentiation and anonymity in group on deindividuation. *Journal of Personality and Social Psychology*, **42**, 1127–1136.

Nagar, D., & Pandey, J. (1987). Affect and performance on cognitive task as a function of crowding and noise. *Journal of Applied Social Psychology*, **17**, 147–157.

Napolitan, D. A., & Goethals, G. R. (1979). The attribution of friendliness. *Journal of Experimental Social Psychology*, **15**, 105–113.

National Safety Council (1991). *Accident facts*. Chicago: Author.

Naylor, T. H. (1990). Redefining corporate motivation, Swedish style. *Christian Century*, **107**, 566–570.

NBC News Poll (1979). November 29–30, 1977. Cited by *Public Opinion*, January-February, p. 36.

NCTV (1988). TV and film alcohol research. *NCTV News*, **9**(3–4), 4.

Neal, A. M., & Wilson, M. L. (1989). The role of skin color and features in the black community: Implications for black women and therapy. *Clinical Psychology Review*, **9**, 323–333.

Neimeyer, G. J., MacNair, R., Metzler, A. E., & Courchaine, K. (1991).

Changing personal beliefs: Effects of forewarning, argument quality, prior bias, and personal exploration. *Journal of Social and Clinical Psychology*, **10**, 1–20.

Neimeyer, R. A., & Mitchell, K. A. (1988). Similarity and attraction: A longitudinal study. *Journal of Social and Personal Relationships*, **5**, 131–148.

Nelson, T. E., Biernat, M. R., & Manis, M. (1990). Everyday base rates (sex stereotypes): Potent and resilient. *Journal of Personality and Social Psychology*, **59**, 664–675.

Nemeth, C. (1977). Interactions between jurors as a function of majority vs. unanimity decision rules. *Journal of Applied Social Psychology*, **7**, 38–56.

Nemeth, C. (1979). The role of an active minority in intergroup relations. In W. G. Austin and S. Worchel (Eds.), *The social psychology of intergroup relations*. Monterey, Calif.: Brooks/Cole.

Nemeth, C. (1986). Intergroup relations between majority and minority. In S. Worchel and W. G. Austin (Eds.), *Psychology of intergroup relations*. Chicago: Nelson-Hall.

Nemeth, C., & Chiles, C. (1988). Modelling courage: The role of dissent in fostering independence. *European Journal of Social Psychology*, **18**, 275–280.

Nemeth, C., & Wachtler, J. (1974). Creating the perceptions of consistency and confidence: A necessary condition for minority influence. *Sociometry*, **37**, 529–540.

Nemeth, C. J. (1992). Minority dissent as a stimulant to group performance. In S. P. Worchel, W. Wood, & Simpson, J. L. (Eds.). *Group process and productivity*. Newbury Park, CA: Sage.

Nemeth, C. J., & Staw, B. M. (1989). The tradeoffs of social control and innovation in groups and organizations. *Advances in Experimental Social Psychology*, **22**, 175–210.

Neter, E., & Ben-Shakhar, G. (1989). The predictive validity of graphological inferences: A meta-analytic approach. *Personality and Individual Differences*, **10**, 737–745.

Neuberg, S. L. (1989). The goal of forming accurate impressions during social interactions: Attenuating the impact of negative expectancies. *Journal of Personality and Social Psychology*, **56**, 374–386.

Newcomb, T. M. (1961). *The acquaintance process*. New York: Holt, Rinehart and Winston.

Newman, H. M., & Langer, E. J. (1981). Post-divorce adaptation and the attribution of responsibility. *Sex Roles*, **7**, 223–231.

Nias, D. K. B. (1979). Marital choice: Matching or complementation? In M. Cook and G. Wilson (Eds.), *Love and attraction*. Oxford: Pergamon.

Nicholson, N., Cole, S. G., & Rocklin, T. (1985). Conformity in the Asch situation: A comparison between contemporary British and U. S. university students. *British Journal of Social Psychology*, **24**, 59–63.

Nielsen Media Research (1990). *Report on television*. Summarized in *American Enterprise*, July/August, 1990, p. 98.

Niemi, R. G., Mueller, J., & Smith, T. W. (1989). *Trends in public opinion: A compendium of survey data*. New York: Greenwood Press.

Nigro, G. N., Hill, D. E., Gelbein, M. E., & Clark, C. L. (1988). Changes in the facial prominence of women and men over the last decade. *Psychology of Women Quarterly*, **12**, 225–235.

Nisbett, R. (1988, Fall). The Vincennes incident: Congress hears psychologists. *Science Agenda* (American Psychological Association), p. 4.

Nisbett, R. E., & Bellows, N. (1977). Verbal reports about causal influences on social judgments: Private access versus public theories. *Journal of Personality and Social Psychology*, **35**, 613–624.

Nisbett, R. E., Borgida, E., Crandall, R., & Reed, H. (1976). Popular induction: Information is not necessarily informative. In J. S. Carroll and J. W. Payne (Eds.), *Cognition and social behavior*. Hillsdale, N.J.: Erlbaum.

Nisbett, R. E., Fong, G. T., Lehman, D. R., & Cheng, P. W. (1987). Teaching reasoning. *Science*, **238**, 625–631.

Nisbett, R. E., & Ross, L. (1980). *Human inference: Strategies and shortcomings of social judgment*. Englewood Cliffs, N.J.: Prentice-Hall.

Nisbett, R. E., & Ross, L. (1991). *The person and the situation*. New York: McGraw-Hill.

Nisbett, R. E., & Schachter, S. (1966). Cognitive manipulation of pain. *Journal of Experimental Social Psychology*, **2**, 227–236.

Nisbett, R. E., & Smith, M. (1989). Predicting interpersonal attraction from small samples: A reanalysis of Newcomb's acquaintance study. *Social Cognition*, **7**, 67–73.

Nisbett, R. E., & Wilson, T. D. (1977). Telling more than we can know: Verbal reports on mental processes. *Psychological Review, 84*, 231–259.

Nisbett, R. E., Zukier, H., & Lemley, R. E. (1981). The dilution effect: Nondiagnostic information weakens the implications of diagnostic information. *Cognitive Psychology, 13*, 248–277.

Noel, J. G., Forsyth, D. R., & Kelley, K. N. (1987). Improving the performance of failing students by overcoming their self-serving attributional biases. *Basic and Applied Social Psychology, 8*, 151–162.

Nolen-Hoeksema, S., Girgus, J. S., & Seligman, M. E. P. (1986). Learned helplessness in children: A longitudinal study of depression, achievement, and explanatory style. *Journal of Personality and Social Psychology, 51*, 435–442.

Noller, P., & Fitzpatrick, M. A. (1990). Marital communication in the eighties. *Journal of Marriage and the Family, 52*, 832–843.

Noon, E., & Hollin, C. R. (1987). Lay knowledge of eyewitness behaviour: A British survey. *Applied Cognitive Psychology, 1*, 143–153.

Norem, J. K., & Cantor, N. (1986). Defensive pessimism: Harnessing anxiety as motivation. *Journal of Personality and Social Psychology, 51*, 1208–1217.

Nuttin, J. M., Jr. (1987). Affective consequences of mere ownership: The name letter effect in twelve European languages. *European Journal of Social Psychology, 17*, 318–402.

O'Dea, T. F. (1968). Sects and cults. In D. L. Sills (Ed.), *International encyclopedia of the social sciences* (Vol. 14). New York: Macmillan.

O'Gorman, H. J., & Garry, S. L. (1976). Pluralistic ignorance—a replication and extension. *Public Opinion Quarterly, 40*, 449–458.

Ohbuchi, K., & Kambara, T. (1985). Attacker's intent and awareness of outcome, impression management, and retaliation. *Journal of Experimental Social Psychology, 21*, 321–330.

O'Leary, V. E., & Ickovics, J. R. (1992). Cracking the glass ceiling: Overcoming stereotypes and isolation. In U. Sekeran & F. Leong (Eds.), *Pathways to excellence: New patterns for human resource utilization.* Beverly Hills, CA: Sage, in press.

Oliner, S. P., & Oliner, P. M. (1988). *The altruistic personality: Rescuers of Jews in Nazi Europe.* New York: The Free Press.

Olson, J. M., & Cal, A. V. (1984). Source credibility, attitudes, and the recall of past behaviours. *European Journal of Social Psychology, 14*, 203–210.

Olson, J. M., & Zanna, M. P. (1981). Promoting physical activity: A social psychological perspective. Report prepared for the Ministry of Culture and Recreation, Sports and Fitness Branch, 77 Bloor St. West, 8th Floor, Toronto, Ontario M7A 2R9, November.

Olweus, D. (1979). Stability of aggressive reaction patterns in males: A review. *Psychological Bulletin, 86*, 852–875.

Olweus, D., Mattsson, A., Schalling, D., & Low, H. (1988). Circulating testosterone levels and aggression in adolescent males: A causal analysis. *Psychosomatic Medicine, 50*, 261–272.

Opotow, S. (1990). Moral exclusion and injustice: An introduction. *Journal of Social Issues, 46*, 1–20.

Orbell, J. M., van de Kragt, A. J. C., & Dawes, R. M. (1988). Explaining discussion-induced cooperation. *Journal of Personality and Social Psychology, 54*, 811–819.

Orive, R. (1984). Group similarity, public self-awareness, and opinion extremity: A social projection explanation of deindividuation effects. *Journal of Personality and Social Psychology, 47*, 727–737.

Osberg, T. M., & Shrauger, J. S. (1986). Self-prediction: Exploring the parameters of accuracy. *Journal of Personality and Social Psychology, 51*, 1044–1057.

Osgood, C. E. (1962). *An alternative to war or surrender.* Urbana, Ill.: University of Illinois Press.

Osgood, C. E. (1973). Statement on psychological aspects of international relations. Committee on Foreign Relations, United States Senate, May 25, 1966. Reprinted in D. G. Linder (Ed.), *Psychological dimensions of social interaction.* Reading, Mass.: Addison-Wesley.

Osgood, C. E. (1980). GRIT: A strategy for survival in mankind's nuclear age? Paper presented at the Pugwash Conference on New Directions in Disarmament, Racine, Wis.

Oskamp, S. (1971). Effects of programmed strategies on cooperation in the prisoner's dilemma and other mixed-motive games. *Journal of Conflict Resolution, 15*, 225–229.

Oskamp, S. (1991). Curbside recycling: Knowledge, attitudes, and behavior. Paper presented at the Society for Experimental Social Psychology meeting, Columbus, Ohio.

Osterhouse, R. A., & Brock, T. C. (1970). Distraction increases yielding to propaganda by inhibiting counterarguing. *Journal of Personality and Social Psychology, 15*, 344–358.

Ostling, R. H. (1991, April 29). A revolution hoping for a miracle. *Time*, pp. 52–53.

Ozer, E. M., & Bandura, A. (1990). Mechanisms governing empowerment effects: A self-efficacy analysis. *Journal of Personality and Social Psychology, 58*, 472–486.

Padgett, V. R. (1989). Predicting organizational violence: An application of 11 powerful principles of obedience. Paper presented at the American Psychological Association Convention.

Pak, A. W., Dion, K. L., & Dion, K. K. (1991). Social-psychological correlates of experienced discrimination: Test of the double jeopardy hypothesis. *International Journal of Intercultural Relations, 15*, 243–254.

Pallak, M. S., Mueller, M., Dollar, K., & Pallak, J. (1972). Effect of commitment on responsiveness to an extreme consonant communication. *Journal of Personality and Social Psychology, 23*, 429–436.

Pallak, S. R., Murroni, E., & Koch, J. (1983). Communicator attractiveness and expertise, emotional versus rational appeals, and persuasion: A heuristic versus systematic processing interpretation. *Social Cognition, 2*, 122–141.

Palmer, E. L., & Dorr, A. (Eds.) (1980). *Children and the faces of television: Teaching, violence, selling.* New York: Academic Press.

Paloutzian, R. (1979). Pro-ecology behavior: Three field experiments on litter pickup. Paper presented at the Western Psychological Association convention.

Pandey, J., Sinha, Y., Prakash, A., & Tripathi, R. C. (1982). Right-left political ideologies and attribution of the causes of poverty. *European Journal of Social Psychology, 12*, 327–331.

Papastamou, S., & Mugny, G. (1990). Synchronic consistency and psychologization in minority influence. *European Journal of Social Psychology, 20*, 85–98.

Park, B., & Rothbart, M. (1982). Perception of out-group homogeneity and levels of social categorization: Memory for the subordinate attributes of in-group and out-group members. *Journal of Personality and Social Psychology*, **42**, 1051–1068.

Parke, R. D., Berkowitz, L., Leyens, J. P., West, S. G., & Sebastian, J. (1977). Some effects of violent and nonviolent movies on the behavior of juvenile delinquents. In L. Berkowitz (Ed.), *Advances in experimental social psychology* (Vol. 10). New York: Academic Press.

Pascarella, E. T., & Terenzini, P. T. (1991). *How collects affects students: Findings and insights from twenty years of research.* San Francisco: Jossey-Bass.

Patterson, G. R., Littman, R. A., & Bricker, W. (1967). Assertive behavior in children: A step toward a theory of aggression. *Monographs of the Society of Research in Child Development* (Serial No. 113), **32**, 5.

Patterson, T. E. (1980). The role of the mass media in presidential campaigns: The lessons of the 1976 election. *Items*, **34**, 25–30. Social Science Research Council, 605 Third Avenue, New York, N.Y. 10016.

Paulhus, D. (1982). Individual differences, self-presentation, and cognitive dissonance: Their concurrent operation in forced compliance. *Journal of Personality and Social Psychology*, **43**, 838–852.

Pauling, L. (1962). Quoted by Etzioni, A. *The hard way to peace: A new strategy.* New York: Collier.

Paulus, P. B., Dzindolet, M. T., Poletes, G. W., & Camacho, L. M. (1992). Perception of performance in group brainstorming: The illusion of group productivity. *Personality and Social Psychology Bulletin,* in press.

Pelham, B. W. (1991). On the benefits of misery: Self-serving biases in the depressive self-concept. *Journal of Personality and Social Psychology*, **61**, 670–681.

Penner, L. A., Dertke, M. C., & Achenbach, C. J. (1973). The "flash" system: A field study of altruism. *Journal of Applied Social Psychology*, **3**, 362–370.

Pennington, N., & Hastie, R. (1990). Practical implications of psychological research on juror and jury decision making. *Personality and Social Psychology Bulletin*, **16**, 90–105.

Pennington, N., & Hastie, R. (1992). A theory of explanation-based decision making. In G. Klein & J. Orasanu (Eds.), *Decision making in complex worlds,* in preparation.

Penrod, S., & Cutler, B. L. (1987). Assessing the competence of juries. In I. B. Weiner & A. K. Hess (Eds.), *Handbook of forensic psychology.* New York: Wiley.

Peplau, L. A., & Gordon, S. L. (1985). Women and men in love: Gender differences in close heterosexual relationships. In V. E. O'Leary, R. K. Unger, & B. S. Wallston (Eds.), *Women, gender, and social psychology.* Hillsdale, N.J.: Erlbaum.

Perdue, C. W., Dovidio, J. F., Gurtman, M. B., & Tyler, R. B. (1990). Us and them: Social categorization and the process of intergroup bias. *Journal of Personality and Social Psychology*, **59**, 475–486.

Perloff, L. S. (1987). Social comparison and illusions of invulnerability. In C. R. Snyder & C. R. Ford (Eds.), *Coping with negative life events: Clinical and social psychological perspectives.* New York: Plenum.

Perloff, R. M., & Brock, T. C. (1980). ". . . And thinking makes it so": Cognitive responses to persuasion. In M. E. Roloff & G. R. Miller (Eds.), *Persuasion: New directions in theory and research.* Beverly Hills: Sage Publications.

Perls, F. S. (1973). *Ego, hunger and aggression: The beginning of Gestalt therapy.* Random House, 1969. Cited by Berkowitz in The case for bottling up rage. *Psychology Today,* July, pp. 24–30.

Perrin, S., & Spencer, C. (1981). Independence or conformity in the Asch experiment as a reflection of cultural or situational factors. *British Journal of Social Psychology*, **20**, 205–209.

Perry, L. C., Perry, D. G., & Weiss, R. J. (1986). Age differences in children's beliefs about whether altruism makes the actor feel good. *Social Cognition*, **4**, 263–269.

Pessin, J. (1933). The comparative effects of social and mechanical stimulation on memorizing. *American Journal of Psychology*, **45**, 263–270.

Pessin, J., & Husband, R. W. (1933). Effects of social stimulation on human maze learning. *Journal of Abnormal and Social Psychology*, **28**, 148–154.

Peterson, C. (1991). The meaning and measurement of explanatory style. *Psychological Inquiry*, **2**, 1–10.

Peterson, C., & Barrett, L. C. (1987). Explanatory style and academic performance among university freshmen. *Journal of Personality and Social Psychology*, **53**, 603–607.

Peterson, C., Schwartz, S. M., & Seligman, M. E. P. (1981). Self-blame and depression symptoms. *Journal of Personality and Social Psychology*, **41**, 253–259.

Peterson, C., & Seligman, M. E. P. (1987). Explanatory style and illness. *Journal of Personality*, **55**, 237–265.

Peterson, C., Seligman, M. E. P., & Vaillant, G. E. (1988). Pessimistic explanatory style is a risk factor for physical illness: A thirty-five-year longitudinal study. *Journal of Personality and Social Psychology*, **55**, 23–27.

Peterson, J. L., & Zill, N. (1981). Television viewing in the United States and children's intellectual, social, and emotional development. *Television and Children*, **2**(2), 21–28.

Pettigrew, T., & Meertens, R. (1991). Relative deprivation and intergroup prejudice. Unpublished manuscript, University of Amersterdam.

Pettigrew, T. F. (1958). Personality and socio-cultural factors in intergroup attitudes: A cross-national comparison. *Journal of Conflict Resolution*, **2**, 29–42.

Pettigrew, T. F. (1969). Racially separate or together? *Journal of Social Issues*, **2**, 43–69.

Pettigrew, T. F. (1978). Three issues in ethnicity: Boundaries, deprivations, and perceptions. In J. M. Yinger & S. J. Cutler (Eds.), *Major social issues: A multidisciplinary view.* New York: Free Press.

Pettigrew, T. F. (1979). The ultimate attribution error: Extending Allport's cognitive analysis of prejudice. *Personality and Social Psychology Bulletin*, **55**, 461–476.

Pettigrew, T. F. (1980). Prejudice. In S. Thernstrom et al. (Eds.), *Harvard encyclopedia of American ethnic groups.* Cambridge, Mass.: Harvard University Press.

Pettigrew, T. F. (1986). The intergroup contact hypothesis reconsidered. In M. Hewstone & R. Brown (Eds.), *Contact and conflict in intergroup encounters.* Oxford: Basil Blackwell.

Pettigrew, T. F. (1987, May 12). "Useful" modes of thought contribute to prejudice. *The New York Times*, pp. 17–20.

Pettigrew, T. F. (1988). Advancing racial justice: Past lessons for future use. Paper for the University of Alabama

Conference: "Opening Doors: An Appraisal of Race Relations in America."

Pettigrew, T. F., & Meertens, R. W. (1991). Subtle racism: Its components and measurement. Paper presented at the Three Days on Racism Conference, Paris, France.

Pettingale, K. W., Morris, T., Greer, S., & Haybittle, J. L. (1985, March 30). Mental attitudes to cancer: An additional prognostic factor. Lancet, p. 750.

Petty, R. E., & Brock, T. C. (1979). Effects of "Barnum" personality assessments on cognitive behavior. Journal of Consulting and Clinical Psychology, 47, 201–203.

Petty, R. E., & Cacioppo, J. T. (1977). Forewarning cognitive responding, and resistance to persuasion. Journal of Personality and Social Psychology, 35, 645–655.

Petty, R. E., & Cacioppo, J. T. (1979). Effects of forewarning of persuasive intent and involvement on cognitive response and persuasion. Personality and Social Psychology Bulletin, 5, 173–176. (a)

Petty, R. E., & Cacioppo, J. T. (1979). Issue involvement can increase or decrease persuasion by enhancing message-relevant cognitive responses. Journal of Personality and Social Psychology, 37, 1915–1926. (b)

Petty, R. E., & Cacioppo, J. T. (1986). Communication and persuasion: Central and peripheral routes to attitude change. New York: Springer-Verlag.

Petty, R. E., & Cacioppo, J. T. (1986). The elaboration likelihood model of persuasion. In L. Berkowitz (Ed.), Advances in experimental social psychology, Vol. 19. New York: Academic Press.

Petty, R. E., Cacioppo, J. T., & Goldman, R. (1981). Personal involvement as a determinant of argument-based persuasion. Journal of Personality and Social Psychology, 41, 847–855.

Petty, R. E., Gleicher, F., & Baker, S. M. (1991). Multiple roles for affect in persuasion. In J. Forgas (Ed.), Emotion and social judgments. London: Pergamon.

Petty, R. E., Ostrom, T. M., & Brock, T. C. (Eds.). (1981). Cognitive responses in persuasion. Hillsdale, N.J.: Erlbaum.

Phillips, D. P. (1982). The impact of fictional television stories on U.S. adult fatalities: New evidence on the effect of the mass media on violence. American Journal of Sociology, 87, 1340–1359.

Phillips, D. P. (1983). The impact of mass media violence on U.S. homicides. American Sociological Review, 48, 560–568.

Phillips, D. P. (1985). Natural experiments on the effects of mass media violence on fatal aggression: Strengths and weaknesses of a new approach. In L. Berkowitz (Ed.), Advances in experimental social psychology, Vol. 19. Orlando, Fla.: Academic Press.

Phillips, D. P., Carstensen, L. L., & Paight, D. J. (1989). Effects of mass media news stories on suicide, with new evidence on the role of story content. In D. R. Pfeffer (Ed.), Suicide among youth: Perspectives on risk and prevention. Washington, DC: American Psychiatric Press.

Piliavin, I. M., Rodin, J., & Piliavin, J. A. (1969). Good Samaritanism: An underground phenomenon. Journal of Personality and Social Psychology, 13, 289–299.

Piliavin, J. A., Evans, D. E., & Callero, P. (1982). Learning to "Give to unnamed strangers": The process of commitment to regular blood donation. In E. Staub, D. Bar-Tal, J. Karylowski, & J. Reykawski (Eds.), The development and maintenance of prosocial behavior: International perspectives. New York: Plenum.

Piliavin, J. A., & Piliavin, I. M. (1973). The Good Samaritan: Why does he help? Unpublished manuscript, University of Wisconsin.

Piner, K. E., & Berg, J. H. (1988). The effects of availability on verbal interaction styles. Paper presented at the American Psychological Association convention.

Platz, S. J., & Hosch, H. M. (1988). Cross-racial/ethnic eyewitness identification: A field study. Journal of Applied Social Psychology, 18, 972–984.

Pliner, P., Hart, H., Kohl, J., & Saari, D. (1974). Compliance without pressure: Some further data on the foot-in-the-door technique. Journal of Experimental Social Psychology, 10, 17–22.

Plous, S. (1985). Perceptual illusions and military realities: A social-psychological analysis of the nuclear arms race. Journal of Conflict Resolution, 29, 363–389.

Pomazal, R. J., & Clore, G. L. (1973). Helping on the highway: The effects of dependency and sex. Journal of Applied Social Psychology, 3, 150–164.

Pomerleau, O. F., & Rodin, J. (1986). Behavioral medicine and health psychology. In S. L. Garfield & A. E. Bergin (Eds.), Handbook of psychotherapy and behavior change, 3rd ed. New York: Wiley.

Porter, N., Geis, F. L., & Jennings (Walstedt), J. (1983). Are women invisible as leaders? Sex Roles, 9, 1035–1049.

Powell, J. (1989). Happiness is an inside job. Valencia, CA: Tabor.

Powell, J. L. (1988). A test of the knew-it-all-along effect in the 1984 presidential and statewide elections. Journal of Applied Social Psychology, 18, 760–773.

Pozo, C., Carver, C. S., Wellens, A. R., & Scheier, M. F. (1991). Social anxiety and social perception: Construing others' reactions to the self. Personality and Social Psychology Bulletin, 17, 355–362.

Prager, I. G., & Cutler, B. L. (1990). Attributing traits to oneself and to others: The role of acquaintance level. Personality and Social Psychology Bulletin, 16, 309–319.

Prager, K. J. (1986). Intimacy status: Its relationship to locus of control, self-disclosure, and anxiety in adults. Personality and Social Psychology Bulletin, 12, 91–109.

Pratkanis, A. R., & Farquhar, P. H. (1992). A brief history of research on phantom alternatives: Evidence for seven empirical generalizations about phantoms. Basic and Applied Social Psychology, 13, 103–122.

Pratkanis, A. R., Greenwald, A. G., Leippe, M. R., & Baumgardner, M. H. (1988). In search of reliable persuasion effects: III. The sleeper effect is dead. Long live the sleeper effect. Journal of Personality and Social Psychology, 54, 203–218.

Pratt, M. W., Pancer, M., Hunsberger, B., & Manchester, J. (1990). Reasoning about the self and relationships in maturity: An integrative complexity analysis of individual differences. Journal of Personality and Social Psychology, 59, 575–581.

Prentice-Dunn, S., & Rogers, R. W. (1980). Effects of deindividuating situational cues and aggressive models on subjective deindividuation and aggression. Journal of Personality and Social Psychology, 39, 104–113.

Prentice-Dunn, S., & Rogers, R. W. (1989). Deindividuation and the self-regulation of behavior. In P. B. Paulus (Ed.),

Psychology of group influence, 2nd ed. Hillsdale, N.J.: Erlbaum.

Price, G. H., Dabbs, J. M., Jr., Clower, B. J., & Resin, R. P. (1979). At first glance—Or, is physical attractiveness more than skin deep? Paper presented at the Eastern Psychological Association convention, 1974. Cited by K. L. Dion & K. K. Dion. Personality and behavioral correlates of romantic love. In M. Cook & G. Wilson (Eds.), *Love and attraction.* Oxford: Pergamon.

Pruitt, D. G. (1981). Kissinger as a traditional mediator with power. In J. Z. Rubin (Ed.), *Dynamics of third party intervention: Kissinger in the Middle East.* New York: Praeger. *(a)*

Pruitt, D. G. (1981). *Negotiation behavior.* New York: Academic Press. *(b)*

Pruitt, D. G. (1986, July). Trends in the scientific study of negotiation. *Negotiation Journal,* pp. 237–244.

Pruitt, D. G. (1986). Achieving integrative agreements in negotiation. In R. K. White (Ed.), *Psychology and the prevention of nuclear war.* New York: New York University Press.

Pruitt, D. G., & Kimmel, M. J. (1977). Twenty years of experimental gaming: Critique, synthesis, and suggestions for the future. *Annual Review of Psychology,* **28,** 363–392.

Pruitt, D. G., & Lewis, S. A. (1975). Development of integrative solutions in bilateral negotiation. *Journal of Personality and Social Psychology,* **31,** 621–633.

Pruitt, D. G., & Lewis, S. A. (1977). The psychology of integrative bargaining. In D. Druckman (Ed.), *Negotiations: A social-psychological analysis.* New York: Halsted.

Pruitt, D. G., & Rubin, J. Z. (1986). *Social conflict.* San Francisco: Random House.

Pryor, J. B. (1987). Sexual harassment proclivities in men. *Sex Roles,* **17,** 269–290.

Public Opinion (1984, August/September). Need vs. greed (summary of Roper Report 84–1), p. 25.

Public Opinion (1984, August/September). Vanity fare, p. 22.

Purvis, J. A., Dabbs, Jr., J. M., & Hopper, C. H. (1984). The "opener": Skilled user of facial expression and speech pattern. *Personality and Social Psychology Bulletin,* **10,** 61–66.

Pyszczynski, T., & Greenberg, J. (1983). Determinants of reduction in intended effort as a strategy for coping with an-

ticipated failure. *Journal of Research in Personality,* **17,** 412–422.

Pyszczynski, T., & Greenberg, J. (1987). Self-regulatory perseveration and the depressive self-focusing style: A self-awareness theory of reactive depression. *Psychological Bulletin,* **102,** 122–138.

Pyszczynski, T., Greenberg, J., & Holt, K. (1985). Maintaining consistency between self-serving beliefs and available data: A bias in information evaluation. *Personality and Social Psychology Bulletin,* **11,** 179–190.

Pyszczynski, T., Hamilton, J. C., Greenberg, J., & Becker, S. E. (1991). Self-awareness and psychological dysfunction. In C. R. Snyder & D. O. Forsyth (Eds.), *Handbook of social and clinical psychology: The health perspective.* New York: Pergamon.

Quattrone, G. A. (1982). Behavioral consequences of attributional bias. *Social Cognition,* **1,** 358–378.

Quattrone, G. A., & Jones, E. E. (1980). The perception of variability within ingroups and out-groups: Implications for the law of small numbers. *Journal of Personality and Social Psychology,* **38,** 141–152.

Rachlinski, J. (1990). Prospect theory and civil negotiation. Working paper No. 17. Stanford Center on Conflict and Negotiation, Stanford University.

Radecki, T. (1989, February-March). On picking good television and film entertainment. *NCTV NEWS,* **10**(1–2), pp. 5–6.

Ramirez, A. (1988). Racism toward Hispanics: The culturally monolithic society. In P. A. Katz & D. A. Taylor (Eds.) *Eliminating racism: Profiles in controversy.* New York: Plenum.

Rank, S. G., & Jacobson, C. K. (1977). Hospital nurses' compliance with medication overdose orders: A failure to replicate. *Journal of Health and Social Behavior,* **18,** 188–193.

Rapoport, A. (1960). *Fights, games, and debates.* Ann Arbor: University of Michigan Press.

RCAgenda(1979). November-December, p. 11. 475 Riverside Drive, New York, N.Y. 10027.

Reed, D. (1989, November 25). Video collection documents Christian resistance to Hitler. Associated Press release in *Grand Rapids Press,* pp. B4, B5.

Reeder, G. D., Fletcher, G. J., & Furman, K. (1989). The role of observers' ex-

pectations in attitude attribution. *Journal of Experimental Social Psychology,* **25,** 168–188.

Reeder, G. D., McCormick, C. B., & Esselman, E. D. (1987). Self-reference processing and recall of prose. *Journal of Educational Psychology,* **79,** 243–248.

Regan, D. T., & Cheng, J. B. (1973). Distraction and attitude change: A resolution. *Journal of Experimental Social Psychology,* **9,** 138–147.

Regan, D. T., & Fazio, R. (1977). On the consistency between attitudes and behavior: Look to the method of attitude formation. *Journal of Experimental Social Psychology,* **13,** 28–45.

Regan, D. T., Williams, M., & Sparling, S. (1972). Voluntary expiation of guilt: A field experiment. *Journal of Personality and Social Psychology,* **24,** 42–45.

Reifman, A. S., Larrick, R. P., & Fein, S. (1991). Temper and temperature on the diamond: The heat-aggression relationship in major league baseball. *Personality and Social Psychology Bulletin,* **17,** 580–585.

Reis, H. T., Nezlek, J., & Wheeler, L. (1980). Physical attractiveness in social interaction. *Journal of Personality and Social Psychology,* **38,** 604–617.

Reis, H. T., & Shaver, P. (1988). Intimacy as an interpersonal process. In S. Duck (Ed.), *Handbook of personal relationships: Theory, relationships and interventions.* Chichester, England: Wiley.

Reis, H. T., Wheeler, L., Spiegel, N., Kernis, M. H., Nezlek, J., & Perri, M. (1982). Physical attractiveness in social interaction: II. Why does appearance affect social experience? *Journal of Personality and Social Psychology,* **43,** 979–996.

Reis, H. T., Wilson, I. M., Monestere, C., Bernstein, S., Clark, K., Seidl, E., Franco, M., Gioioso, E., Freeman, L., & Radoane, K. (1990). What is smiling is beautiful and good. *European Journal of Social Psychology,* **20,** 259–267.

Reisenzein, R. (1983). The Schachter theory of emotion: Two decades later. *Psychological Bulletin,* **94,** 239–264.

Reitzes, D. C. (1953). The role of organizational structures: Union versus neighborhood in a tension situation. *Journal of Social Issues,* **9**(1), 37–44.

Remley, A. (1988, October). From obedience to independence. *Psychology Today,* pp. 56–59.

Renaud, H., & Estess, F. (1961). Life history interviews with one hundred nor-

mal American males: "Pathogenecity" of childhood. *American Journal of Orthopsychiatry*, **31**, 786–802.

Ressler, R. K., Burgess, A. W., & Douglas, J. E. (1988). *Sexual homicide patterns.* Boston: Lexington Books.

Reston, J. (1975, March 14). Proxmire on love. *New York Times*.

Reychler, L. (1979). The effectiveness of a pacifist strategy in conflict resolution. *Journal of Conflict Resolution*, **23**, 228–260.

Reyes, R. M., Thompson, W. C., & Bower, G. H. (1980). Judgmental biases resulting from differing availabilities of arguments. *Journal of Personality and Social Psychology*, **39**, 2–12.

Rhine, R. J., & Severance, L. J. (1970). Ego-involvement, discrepancy, source credibility, and attitude change. *Journal of Personality and Social Psychology*, **16**, 175–190.

Rhodes, N., & Wood, W. (1992). Self-esteem and intelligence affect influenceability: The mediating role of message reception. *Psychological Bulletin*, **111**, 156–171.

Rhodewalt, F. (1987). Is self-handicapping an effective self-protective attributional strategy? Paper presented at the American Psychological Association convention.

Rhodewalt, F., & Agustsdottir, S. (1986). Effects of self-presentation on the phenomenal self. *Journal of Personality and Social Psychology*, **50**, 47–55.

Rhodewalt, F., Saltzman, A. T., & Wittmer J. (1984). Self-handicapping among competitive athletes: The role of practice in self-esteem protection. *Basic and Applied Social Psychology*, **5**, 197–209.

Rholes, W. S., Newman, L. S., & Ruble, D. N. (1990). Understanding self and other: Developmental and motivational aspects of perceiving persons in terms of invariant dispositions. In E. T. Higgins & R. M. Sorrentino (Eds.), *Handbook of motivation and cognition: Foundations of social behavior*, Vol. 2. New York: Guilford.

Rice, B. (1985, September). Performance review: The job nobody likes. *Psychology Today*, pp. 30–36.

Rice, M. E., & Grusec, J. E. (1975). Saying and doing: Effects on observer performance. *Journal of Personality and Social Psychology*, **32**, 584–593.

Richardson, L. F. (1960). Generalized foreign policy. *British Journal of Psychol-*

ogy *Monographs Supplements*, 1969, **23**. Cited by A. Rapoport in *Fights, games, and debates*. Ann Arbor: University of Michigan Press, p. 15.

Riess, M., Rosenfeld, P., Melburg, V., & Tedeschi, J. T. (1981). Self-serving attributions: Biased private perceptions and distorted public descriptions. *Journal of Personality and Social Psychology*, **41**, 224–231.

Riggio, R. E., & Woll, S. B. (1984). The role of nonverbal cues and physical attractiveness in the selection of dating partners. *Journal of Social and Personal Relationships*, **1**, 347–357.

Riordan, C. A. (1980). Effects of admission of influence on attributions and attraction. Paper presented at the American Psychological Association convention.

Riordan, C. A., & Ruggiero, J. (1980). Producing equal status interracial interaction: A replication. *Social Psychology Quarterly*, **43**, 131–136.

Robberson, M. R., & Rogers, R. W. (1988). Beyond fear appeals: Negative and positive persuasive appeals to health and self-esteem. *Journal of Applied Social Psychology*, **18**, 277–287.

Robertson, I. (1987). *Sociology*. New York: Worth Publishers.

Robinson, C. L., Lockard, J. S., & Adams, R. M. (1979). Who looks at a baby in public. *Ethology and Sociobiology*, **1**, 87–91.

Robinson, J. P. (1988, December). Who's doing the housework? *American Demographics*, pp. 24–28, 63.

Robinson, R. J., Keltner, D., & Ross, L. (1991). Misconstruing the views of the "other side": Real and perceived differences in three ideological conflicts. Working Paper No. 18, Stanford Center on Conflict and Negotiation, Stanford University.

Rodin, J. (1992). *Body traps*. New York: William Morrow.

Roese, N. J., & Jamieson, D. W. (1991). Twenty years of bogus pipeline research: Review and meta-analysis. Paper presented at the American Psychological Association convention.

Rogers, C. R. (1958). Reinhold Niebuhr's *The self and the dramas of history*: A criticism. *Pastoral Psychology*, **9**, 15–17.

Rogers, C. R. (1980). *A way of being*. Boston: Houghton Mifflin.

Rogers, R. W., & Mewborn, C. R. (1976). Fear appeals and attitude change: Effects of a threat's noxiousness, prob-

ability of occurrence, and the efficacy of coping responses. *Journal of Personality and Social Psychology*, **34**, 54–61.

Rogers, R. W., & Prentice-Dunn, S. (1981). Deindividuation and anger-mediated interracial aggression: Unmasking regressive racism. *Journal of Personality and Social Psychology*, **41**, 63–73.

Rohrer, J. H., Baron, S. H., Hoffman, E. L., & Swander, D. V. (1954). The stability of autokinetic judgments. *Journal of Abnormal and Social Psychology*, **49**, 595–597.

Rokeach, M. (1968). *Beliefs, attitudes, and values*. San Francisco: Jossey-Bass.

Rokeach, M., & Mezei, L. (1966). Race and shared beliefs as factors in social choice. *Science*, **151**, 167–172.

Romer, D., Gruder, D. L., & Lizzadro, T. (1986). A person-situation approach to altruistic behavior. *Journal of Personality and Social Psychology*, **51**, 1001–1012.

Rook, K. S. (1984). Promoting social bonding: Strategies for helping the lonely and socially isolated. *American Psychologist*, **39**, 1389–1407.

Rosenbaum, M. E. (1986). The repulsion hypothesis: On the nondevelopment of relationships. *Journal of Personality and Social Psychology*, **51**, 1156–1166.

Rosenbaum, M. E., & Holtz, R. (1985). The minimal intergroup discrimination effect: Out-group derogation, not in-group favorability. Paper presented at the American Psychological Association convention.

Rosenberg, L. A. (1961). Group size, prior experience and conformity. *Journal of Abnormal and Social Psychology*, **63**, 436–437.

Rosenblatt, A., & Greenberg, J. (1988). Depression and interpersonal attraction: The role of perceived similarity. *Journal of Personality and Social Psychology*, **55**, 112–119.

Rosenblatt, A., & Greenberg, J. (1991). Examining the world of the depressed: Do depressed people prefer others who are depressed? *Journal of Personality and Social Psychology*, **60**, 620–629.

Rosenfeld, D. (1979). The relationship between self-esteem and egotism in males and females. Unpublished manuscript, Southern Methodist University.

Rosenfeld, D., Folger, R., & Adelman, H. F. (1980). When rewards reflect competence: A qualification of the overjustification effect. *Journal of Per-*

sonality and Social Psychology, **39,** 368–376.

Rosenhan, D. L. (1970). The natural socialization of altruistic autonomy. In J. Macaulay & L. Berkowitz (Eds.) *Altruism and helping behavior.* New York: Academic Press.

Rosenhan, D. L. (1973). On being sane in insane places. *Science, 179,* 250–258.

Rosenthal, A. M. (1987, February 12). The 39th witness. *New York Times,* I 31: 1, 2, 3.

Rosenthal, R. (1985). From unconscious experimenter bias to teacher expectancy effects. In J. B. Dusek, V. C. Hall, & W. J. Meyer (Eds.), *Teacher expectancies.* Hillsdale, N.J.: Erlbaum.

Rosenthal, R. (1987, December). Pygmalion effects: Existence, magnitude, and social importance. *Educational Researcher,* pp. 37–41.

Rosenthal, R. (1991). Teacher expectancy effects: A brief update 25 years after the Pygmalion experiment. *Journal of Research in Education,* **1,** 3–12.

Rosenthal, R., & Jacobson, L. (1968). *Pygmalion in the classroom: Teacher expectation and pupils' intellectual development.* New York: Holt, Rinehart & Winston.

Rosenzweig, M. R. (1972). Cognitive dissonance. *American Psychologist,* **27,** 769.

Ross, C. (1979, February 12). Rejected. *New West,* pp. 39–43.

Ross, L. D. (1977). The intuitive psychologist and his shortcomings: Distortions in the attribution process. In L. Berkowitz (Ed.), *Advances in experimental social psychology* (Vol. 10). New York: Academic Press.

Ross, L. D. (1981). The "intuitive scientist" formulation and its developmental implications. In J. H. Havell & L. Ross (Eds.), *Social cognitive development: Frontiers and possible futures.* Cambridge, England: Cambridge University Press.

Ross, L. D. (1988). Situationist perspectives on the obedience experiments. Review of A. G. Miller's *The obedience experiments. Contemporary Psychology,* **33,** 101–104.

Ross, L. D., Amabile, T. M., & Steinmetz, J. L. (1977). Social roles, social control, and biases in social-perception processes. *Journal of Personality and Social Psychology,* **35,** 485–494.

Ross, L. D., & Anderson, C. A. (1982). Shortcomings in the attribution process: On the origins and maintenance of erroneous social assessments. In D. Kahneman, P. Slovic, & A. Tversky (Eds.), *Judgment under uncertainty: Heuristics and biases.* New York: Cambridge University Press.

Ross, L. D., & Lepper, M. R. (1980). The perseverance of beliefs: Empirical and normative considerations. In R. A. Shweder (Ed.), *New directions for methodology of behavioral science: Fallible judgment in behavioral research.* San Francisco: Jossey-Bass.

Ross, M., & Fletcher, G. J. O. (1985). Attribution and social perception. In G. Lindzey & E. Aronson (Eds.), *The Handbook of Social Psychology,* 3rd ed. New York: Random House.

Ross, M., McFarland, C., & Fletcher, G. J. O. (1981). The effect of attitude on the recall of personal histories. *Journal of Personality and Social Psychology,* **40,** 627–634.

Ross, M., & Sicoly, F. (1979). Egocentric biases in availability and attribution. *Journal of Personality and Social Psychology,* **37,** 322–336.

Ross, M., Thibaut, J., & Evenbeck, S. (1971). Some determinants of the intensity of social protest. *Journal of Experimental Social Psychology,* **7,** 401–418.

Rossi, A. (1978, June). The biosocial side of parenthood. *Human Nature,* pp. 72–79.

Roszell, P., Kennedy, D., & Grabb, E. (1990). Physical attractiveness and income attainment among Canadians. *Journal of Psychology,* **123,** 547–559.

Roth, B. M. (1990). Social psychology's "racism." *The Public Interest,* **98,** 26–36.

Roth, D. L., Snyder, C. R., & Pace, L. M. (1986). Dimensions of favorable self-presentation. *Journal of Personality and Social Psychology,* **51,** 867–874.

Rothbart, M., & Birrell, P. (1977). Attitude and perception of faces. *Journal of Research Personality,* **11,** 209–215.

Rothbart, M., Fulero, S., Jensen, C., Howard, J., & Birrell, P. (1978). From individual to group impressions: Availability heuristics in stereotype formation. *Journal of Experimental Social Psychology,* **14,** 237–255.

Rothbart, M., & Hallmark, W. (1988). Ingroup—out-group differences in the perceived efficacy of coercion and conciliation in resolving social conflict. *Journal of Personality and Social Psychology,* **55,** 248–257.

Rothbart, M., & John, O. P. (1985). Social categorization and behavioral episodes: A cognitive analysis of the effects of intergroup contact. *Journal of Social Issues,* **41**(3), 81–104.

Rothbart, M., & Lewis, S. (1988). Inferring category attributes from exemplar attributes: Geometric shapes and social categories. *Journal of Personality and Social Psychology,* **55,** 861–872.

Rothbart, M., & Park, B. (1986). On the confirmability and disconfirmability of trait concepts. *Journal of Personality and Social Psychology,* **50,** 131–142.

Rotter, J. (1973). Internal-external locus of control scale. In J. P. Robinson & R. P. Shaver (Eds.), *Measures of social psychological attitudes.* Ann Arbor: Institute for Social Research.

Rotton, J., & Frey, J. (1985). Air pollution, weather, and violent crimes: Concomitant time-series analysis of archival data. *Journal of Personality and Social Psychology,* **49,** 1207–1220.

Rowe, D. (1986). Letter. *Bulletin of the British Psychological Society,* **39,** 425–426.

Ruback, R. B., Carr, T. S., & Hopper, C. H. (1986). Perceived control in prison: Its relation to reported crowding, stress, and symptoms. *Journal of Applied Social Psychology,* **16,** 375–386.

Rubin, J. Z. (1980). Experimental research on third-party intervention in conflict: Toward some generalizations. *Psychological Bulletin,* **87,** 379–391.

Rubin, J. Z. (1989). Some wise and mistaken assumptions about conflict and negotiation. *Journal of Social Issues,* **45,** 195–209.

Rubin, J. Z. (Ed.) (1981). *Third party intervention in conflict: Kissinger in the Middle East.* New York: Praeger.

Rubin, J. Z. (1986). Can we negotiate with terrorists: Some answers from psychology. Paper presented at the American Psychological Association convention.

Rubin, L. B. (1985). *Just friends: The role of friendship in our lives.* New York: Harper & Row.

Rubin, R. B. (1981). Ideal traits and terms of address for male and female college professors. *Journal of Personality and Social Psychology,* **41,** 966–974.

Rubin, Z. (1970). Measurement of romantic love. *Journal of Personality and Social Psychology,* **16,** 265–273.

Rubin, Z. (1973). *Liking and loving: An invitation to social psychology.* New York: Holt, Rinehart and Winston.

Rule, B. G., Taylor, B. R., & Dobbs, A. R. (1987). Priming effects of heat on aggressive thoughts. *Social Cognition, 5,* 131–143.

Rusbult, C. E. (1980). Commitment and satisfaction in romantic associations: A test of the investment model. *Journal of Experimental Social Psychology, 16,* 172–186.

Rusbult, C. E., Johnson, D. J., & Morrow, G. D. (1986). Impact of couple patterns of problem solving on distress and nondistress in dating relationships. *Journal of Personality and Social Psychology, 50,* 744–753.

Rusbult, C. E., Morrow, G. D., & Johnson, D. J. (1987). Self-esteem and problem-solving behaviour in close relationships. *British Journal of Social Psychology, 26,* 293–303.

Rushton, J. P. (1975). Generosity in children: Immediate and long-term effects of modeling, preaching, and moral judgment. *Journal of Personality and Social Psychology, 31,* 459–466.

Rushton, J. P. (1976). Socialization and the altruistic behavior of children. *Psychological Bulletin, 83,* 898–913.

Rushton, J. P. (1991). Is altruism innate? *Psychological Inquiry, 2,* 141–143.

Rushton, J. P., Brainerd, C. J., & Pressley, M. (1983). Behavioral development and construct validity: The principle of aggregation. *Psychological Bulletin, 94,* 18–38.

Rushton, J. P., & Campbell, A. C. (1977). Modeling, vicarious reinforcement and extraversion on blood donating in adults: Immediate and long-term effects. *European Journal of Social Psychology, 7,* 297–306.

Rushton, J. P., Chrisjohn, R. D., & Fekken, G. C. (1981). The altruistic personality and the self-report altruism scale. *Personality and Individual Differences, 2,* 293–302.

Rushton, J. P., Fulker, D. W., Neale, M. C., Nias, D. K. B., & Eysenck, H. J. (1986). Altruism and aggression: The heritability of individual differences. *Journal of Personality and Social Psychology, 50,* 1192–1198.

Rushton, J. P., Russell, R. J. H., & Wells, P. A. (1984). Genetic similarity theory: Beyond kin selection. *Behavior Genetics, 14,* 179–193.

Russell, B. (1930/1980). *The conquest of happiness.* London: Unwin Paperbacks.

Russell, G. W. (1983). Psychological issues in sports aggression. In J. H. Goldstein (Ed.), *Sports violence.* New York: Springer-Verlag.

Rutkowski, G. K., Gruder, C. L., & Romer, D. (1983). Group cohesiveness, social norms, and bystander intervention. *Journal of Personality and Social Psychology, 44,* 545–552.

Ruzzene, M., & Noller, P. (1986). Feedback motivation and reactions to personality interpretations that differ in favorability and accuracy. *Journal of Personality and Social Psychology, 51,* 1293–1299.

Saal, F. E., Johnson, C. B., & Weber, N. (1989). Friendly or sexy? It may depend on whom you ask. *Psychology of Women Quarterly, 13,* 263–276.

Sabini, J., & Silver, M. (1982). *Moralities of everyday life.* New York: Oxford University Press.

Sacco, W. P., & Dunn, V. K. (1990). Effect of actor depression on observer attributions: Existence and impact of negative attributions toward the depressed. *Journal of Personality and Social Psychology, 59,* 517–524.

Sacks, C. H., & Bugental, D. P. (1987). Attributions as moderators of affective and behavioral responses to social failure. *Journal of Personality and Social Psychology, 53,* 939–947.

Sadalla, E. K., Kenrick, D. T., & Vershure, B. (1987). Dominance and heterosexual attraction. *Journal of Personality and Social Psychology, 52,* 730–738.

Sagar, H. A., & Schofield, J. W. (1980). Integrating the desegregated school: Perspectives, practices and possibilities. In M. Wax (Ed.), *Comparative studies in interracial education.* Washington, D.C.: Government Printing Office. (a)

Saks, M. J. (1974). Ignorance of science is no excuse. *Trial, 10*(6), 18–20.

Saks, M. J. (1977). *Jury verdicts.* Lexington, Mass.: Heath.

Saks, M. J., & Hastie, R. (1978). *Social psychology in court.* New York: Van Nostrand Reinhold.

Sakurai, M. M. (1975). Small group cohesiveness and detrimental conformity. *Sociometry, 38,* 340–357.

Sales, S. M. (1972). Economic threat as a determinant of conversion rates in authoritarian and nonauthoritarian churches. *Journal of Personality and Social Psychology, 23,* 420–428.

Sales, S. M. (1973). Threat as a factor in authoritarianism: An analysis of archival data. *Journal of Personality and Social Psychology, 28,* 44–57.

Salovey, P., Mayer, J. D., & Rosenhan, D. L. (1991). Mood and healing: Mood as a motivator of helping and helping as a regulator of mood. In M. S. Clark (Ed.), *Prosocial behavior.* Newbury Park, CA: Sage.

Saltzman, A. (1991, June 17). Trouble at the top. *U.S. News & World Report,* pp. 40–48.

Saltzstein, H. D., & Sandberg, L. (1979). Indirect social influence: Change in judgmental processor anticipatory conformity. *Journal of Experimental Social Psychology, 15,* 209–216.

Sampson, E. E. (1975). On justice as equality. *Journal of Social Issues, 31*(3), 45–64.

Samuelson, C. D., Messick, D. M., Rutte, C. G., & Wilke, H. (1984). Individual and structural solutions to resource dilemmas in two cultures. *Journal of Personality and Social Psychology, 47,* 94–104.

Sanbonmatsu, D. M., & Fazio, R. H. (1990). The role of attitudes in memory-based decision making. *Journal of Personality and Social Psychology, 59,* 614–622.

Sandberg, G. G., Jackson, T. L., & Petretic-Jackson, P. (1985). Sexual aggression and courtship violence in dating relationships. Paper presented at the Midwestern Psychological Association convention.

Sande, G. N., Goethals, G. R., Ferrari, L., & Worth, L. T. (1989). Value-guided attributions: Maintaining the moral self-image and the diabolical enemy-image. *Journal of Social Issues, 45,* 91–118.

Sande, G. N., Goethals, G. R., & Radloff, C. E. (1988). Perceiving one's own traits and others': The multifaceted self. *Journal of Personality and Social Psychology, 54,* 13–20.

Sanders, G. S. (1981). Driven by distraction: An integrative review of social facilitation and theory and research. *Journal of Experimental Social Psychology, 17,* 227–251. (a)

Sanders, G. S. (1981). Toward a comprehensive account of social facilitation: Distraction/conflict does not mean theoretical conflict. *Journal of Experimental Social Psychology, 17,* 262–265. (b)

Sanders, G. S., & Baron, R. S. (1977). Is social comparison irrelevant for producing choice shifts? *Journal of Experimental Social Psychology, 13,* 303–314.

Sanders, G. S., Baron, R. S., & Moore,

D. L. (1978). Distraction and social comparison as mediators of social facilitation effects. *Journal of Experimental Social Psychology, 14*, 291–303.

Sanislow, C. A., III, Perkins, D. V., & Balogh, D. W. (1989). Mood induction, interpersonal perceptions, and rejection in the roommates of depressed, nondepressed-disturbed, and normal college students. *Journal of Social and Clinical Psychology, 8*, 345–358.

Sanitioso, R., Kunda, Z., & Fong, G. T. (1990). Motivated recruitment of autobiographical memories. *Journal of Personality and Social Psychology, 59*, 229–241.

Sansone, C. (1986). A question of competence: The effects of competence and task feedback on intrinsic interest. *Journal of Personality and Social Psychology, 51*, 918–931.

Sapadin, L. A. (1988). Friendship and gender: Perspectives of professional men and women. *Journal of Social and Personal Relationships, 5*, 387–403.

Sarason, I. G., Sarason, B. R., Pierce, G. R., Shearin, E. N., & Sayers, M. H. (1991). A social learning approach to increasing blood donations. *Journal of Applied Social Psychology, 21*, 896–918.

Sarawathi, T. S., & Dutta, R. (1988). *Invisible boundaries: Grooming for adult roles.* New Delhi: Northern Book Centre. Cited by R. Larson & M. H. Richards (1989). Introduction: The changing life space of early adolescence. *Journal of Youth and Adolescence, 18*, 501–509.

Sarnoff, I., & Sarnoff, S. (1989). *Love-centered marriage in a self-centered world.* New York: Hemisphere.

Sato, K. (1987). Distribution of the cost of maintaining common resources. *Journal of Experimental Social Psychology, 23*, 19–31.

Schachter, S. (1951). Deviation, rejection and communication. *Journal of Abnormal and Social Psychology, 46*, 190–207.

Schachter, S., & Singer, J. E. (1962). Cognitive, social and physiological determinants of emotional state. *Psychological Review, 69*, 379–399.

Schafer, R. B., & Keith, P. M. (1980). Equity and depression among married couples. *Social Psychology Quarterly, 43*, 430–435.

Schaffner, P. E. (1985). Specious learning about reward and punishment. *Journal of Personality and Social Psychology, 48*, 1377–1386.

Schaffner, P. E., Wandersman, A., & Stang, D. (1981). Candidate name exposure and voting: Two field studies. *Basic and Applied Social Psychology, 2*, 195–203.

Schaller, M., & Cialdini, R. B. (1988). The economics of empathic helping: Support for a mood management motive. *Journal of Experimental Social Psychology, 24*, 163–181.

Scheier, M. F., & Carver, C. S. (1992). Effects of optimism on psychological and physical well-being: Theoretical overview and empirical update. *Cognitive Therapy and Research,* in press.

Schein, E. H. (1956). The Chinese indoctrination program for prisoners of war: A study of attempted brainwashing. *Psychiatry, 19*, 149–172.

Scher, S. J., & Cooper, J. (1989). Motivational basis of dissonance: The singular role of behavioral consequences. *Journal of Personality and Social Psychology, 56*, 899–906.

Schiffenbauer, A., & Schiavo, R. S. (1976). Physical distance and attraction: An intensification effect. *Journal of Experimental Social Psychology, 12*, 274–282.

Schlenker, B. R. (1976). Egocentric perceptions in cooperative groups: A conceptualization and research review. Final Report, Office of Naval Research Grant NR 170–797.

Schlenker, B. R. (1986). Self-identification: Toward an integration of the private and public self. In R. Baumeister (Ed.), *Public self and private self.* New York: Springer-Verlag.

Schlenker, B. R. (1987). Threats to identity: Self-identification and social stress. In C. R. Snyder & C. E. Ford (Eds.), *Coping with negative life events: Clinical and social psychological perspectives.* New York: Plenum Press.

Schlenker, B. R., & Leary, M. R. (1982). Audiences' reactions to self-enhancing, self-denigrating, and accurate self-presentations. *Journal of Experimental Social Psychology, 18*, 89–104. *(a)*

Schlenker, B. R., & Leary, M. R. (1982). Social anxiety and self-presentation: A conceptualization and model. *Psychological Bulletin, 92*, 641–669. *(b)*

Schlenker, B. R., & Leary, M. R. (1985). Social anxiety and communication about the self. *Journal of Language and Social Psychology, 4*, 171–192.

Schlenker, B. R., & Miller, R. S. (1977). Egocentrism in groups: Self-serving biases or logical information processing? *Journal of Personality and Social Psychology, 35*, 755–764. *(b)*

Schlenker, B. R., & Miller, R. S. (1977). Group cohesiveness as a determinant of egocentric perceptions in cooperative groups. *Human Relations, 30*, 1039–1055. *(a)*

Schlenker, B. R., Miller, R. S., Leary, M. R., & McGown, N. E. (1979). Group performance and interpersonal evaluations as determinants of egotistical attributions in groups. *Journal of Personality, 47*, 575–594.

Schlenker, B. R., & Weigold, M. F. (1992). Interpersonal processes involving impression regulation and management. *Annual Review of Psychology, 43*, in press.

Schlenker, B. R., Weigold, M. E., & Hallam, J. R. (1990). Self-serving attributions in social context: Effects of self-esteem and social pressure. *Journal of Personality and Social Psychology, 58*, 855–863.

Schlesinger, A., Jr. (1991, July 8). The cult of ethnicity, good and bad. *Time,* p. 21.

Schlesinger, A. M., Jr. (1972). *A thousand days.* Boston: Houghton Mifflin, 1965. Cited by I. L. Janis in *Victims of groupthink.* Boston: Houghton Mifflin, p. 40.

Schofield, J. (1982). *Black and white in school: Trust, tension, or tolerance?* New York: Praeger.

Schofield, J. W. (1986). Causes and consequences of the colorblind perspective. In J. F. Dovidio & S. L. Gaertner (Eds.), *Prejudice, discrimination, and racism.* Orlando, Fl.: Academic Press.

Schooler, J. W., Gerhard, D., & Loftus, E. F. (1986). Qualities of the unreal. *Journal of Experimental Psychology: Learning, Memory, and Cognition, 12*, 171–181.

Schopler, J., Insko, C. A., Graetz, K. A., Drigotas, S. M., & Smith, V. A. (1991). The generality of the individual-group discontinuity effect: Variations in positivity-negativity of outcomes, players' relative power, and magnitude of outcomes. *Personality and Social Psychology Bulletin, 17*, 612–624.

Schroeder, D. A., Dovidio, J. F., Sibicky, M. E., Matthews, L. L., & Allen, J. L. (1988). Empathic concern and helping behavior: Egoism or altruism: *Journal of Experimental Social Psychology, 24*, 333–353.

Schulz, J. W., & Pruitt, D. G. (1978). The effects of mutual concern on joint wel-

fare. *Journal of Experimental Social Psychology*, **14**, 480–492.

Schulz, R., & Decker, S. (1985). Long-term adjustment to physical disability: The role of social support, perceived control, and self-blame. *Journal of Personality and Social Psychology*, **48**, 1162–1172.

Schuman, H., & Kalton, G. (1985). Survey methods. In G. Lindzey & E. Aronson (Eds.), *Handbook of Social Psychology*, Vol. 1. Hillsdale, N.J.: Erlbaum.

Schuman, H., & Ludwig, J. (1983). The norm of even-handedness in surveys as in life. *American Sociological Review*, **48**, 112–120.

Schuman, H., & Scott, J. (1987). Problems in the use of survey questions to measure public opinion. *Science*, **236**, 957–959.

Schuman, H., & Scott, J. (1989). Generations and collective memories. *American Sociological Review*, **54**, 359–381.

Schwartz, S. H. (1975). The justice of need and the activation of humanitarian norms. *Journal of Social Issues*, **31**(3), 111–136.

Schwartz, S. H., & Ames, R. E. (1977). Positive and negative referent others as source of influence: A case of helping. *Sociometry*, **40**, 12–21.

Schwartz, S. H., & Gottlieb, A. (1981). Participants' post-experimental reactions and the ethics of bystander research. *Journal of Experimental Social Psychology*, **17**, 396–407.

Schwarz, N., Bless, H., & Bohner, G. (1991). Mood and persuasion: Affective states influence the processing of persuasive communications. In M. Zanna (Ed.), *Advances in experimental social psychology*, vol. 24. New York: Academic Press.

Schwarz, N., & Kurz, E. (1989). What's in a picture? The impact of face-ism on trait attribution. *European Journal of Social Psychology*, **19**, 311–316.

Schwarz, N., Strack, F., Kommer, D., & Wagner, D. (1987). Soccer, rooms, and the quality of your life: Mood effects on judgments of satisfaction with life in general and with specific domains. *Journal of Applied Social Psychology*, **17**, 69–79.

Schwarzwald, J., Bizman, A., & Raz, M. (1983). The foot-in-the-door paradigm: Effects of second request size on donation probability and donor generosity. *Personality and Social Psychology Bulletin*, **9**, 443–450.

Scott, J. P., & Marston, M. V. (1953). Nonadaptive behavior resulting from a series of defeats in fighting mice. *Journal of Abnormal and Social Psychology*, **48**, 417–428.

Sears, D. O. (1979). Life stage effects upon attitude change, especially among the elderly. Manuscript prepared for Workshop on the Elderly of the Future, Committee on Aging, National Research Council, Annapolis, Md., May 3–5.

Sears, D. O. (1986). College sophomores in the laboratory: Influences of a narrow data base on social psychology's view of human nature. *Journal of Personality and Social Psychology*, **51**, 515–530.

Sedikides, C., & Anderson, C. A. (1992). Causal explanations of defection: A knowledge structure approach. *Personality and Social Psychology Bulletin*, in press.

Segal, H. A. (1954). Initial psychiatric findings of recently repatriated prisoners of war. *American Journal of Psychiatry*, **61**, 358–363.

Segal, N. L. (1984). Cooperation, competition, and altruism within twin sets: A reappraisal. *Ethology and Sociobiology*, **5**, 163–177.

Segall, M. H., Dasen, P. R., Berry, J. W., & Poortinga, Y. H. (1990). *Human behavior in global perspective: An introduction to cross-cultural psychology*. New York: Pergamon.

Selby, J. W., Calhoun, L. G., & Brock, T. A. (1977). Sex differences in the social perception of rape victims. *Personality and Social Psychology Bulletin*, **3**, 412–415.

Seligman, C., Fazio, R. H., Zanna, M. P. (1980). Effects of salience of extrinsic rewards on liking and loving. *Journal of Personality and Social Psychology*, **38**, 453–460.

Seligman, M. E. P. (1975). *Helplessness: On depression, development and death*. San Francisco: W. H. Freeman.

Seligman, M. E. P. (1988). Why is there so much depression today? The waxing of the individual and the waning of the commons. The G. Stanely Hall Lecture, American Psychological Association convention.

Seligman, M. E. P. (1989). Explanatory style: Predicting depression, acheivement, and health. In M. D. Yapko (Ed.), *Brief therapy approaches to treating anxiety and depression*. New York: Brunner/Mazel.

Seligman, M. E. P. (1991). *Learned optimism*. New York: Knopf.

Seligman, M. E. P., Nolen-Hoeksema, S., Thornton, N., & Thornton, K. M. (1990). Explanatory style as a mechanism of disappointing athletic performance. *Psychological Science*, **1**, 143–146.

Seligman, M. E. P., & Schulman, P. (1986). Explanatory style as a predictor of productivity and quitting among life insurance sales agents. *Journal of Personality and Social Psychology*, **50**, 832–838.

Seltzer, L. F. (1983). Influencing the "shape" of resistance: An experimental exploration of paradoxical directives and psychological reactance. *Basic and Applied Social Psychology*, **4**, 47–71.

Seta, C. E., & Seta, J. J. (1992). Increments and decrements in mean arterial pressure levels as a function of audience composition: An averaging and summation analysis. *Personality and Social Psychology Bulletin*, **18**, 173–181.

Seta, J. J. (1982). The impact of comparison processes on coactors' task performance. *Journal of Personality and Social Psychology*, **42**, 281–291.

Shaheen, J. G. (1990, August 19). Our cultural demon—the "ugly Arab." *Washington Post*, Outlook Section.

Sharan, S., & Sharan, Y. (1976). *Small group teaching*. Englewood Cliffs, N.J.: Educational Technology.

Sharma, N. (1981). Some aspect of attitude and behaviour of mothers. *Indian Psychological Review*, **20**, 35–42.

Shaver, P., Hazan, C., & Bradshaw, D. (1988). Love as attachment: The integration of three behavioral systems. In R. J. Sternberg & M. L. Barnes (Eds.), *The psychology of love*. New Haven: Yale University Press.

Shavit, H., & Shouval, R. (1980). Self-esteem and cognitive consistency effects on self-other evaluation. *Journal of Experimental Social Psychology*, **16**, 417–425.

Shaw, M. E. (1981). *Group dynamics: The psychology of small group behavior*. New York: McGraw-Hill.

Sheppard, B. H., & Vidmar, N. (1980). Adversary pretrial procedures and testimonial evidence: Effects of lawyer's role and machiavelianism. *Journal of Personality and Social Psychology*, **39**, 320–322.

Shepperd, J. A., & Arkin, R. M. (1991). Behavioral other-enhancement: Strategically obscuring the link between per-

formance and evaluation. *Journal of Personality and Social Psychology*, **60**, 79–88.

Shepperd, J. A., & Wright, R. A. (1989). Individual contributions to a collective effort: An incentive analysis. *Personality and Social Psychology Bulletin*, **15**, 141–149.

Sherif, M. (1937). An experimental approach to the study of attitudes. *Sociometry*, **1**, 90–98.

Sherif, M. (1966). *In common predicament: Social psychology of intergroup conflict and cooperation*. Boston: Houghton Mifflin.

Sherif, M., & Sherif, C. W. (1969). *Social psychology*. New York: Harper & Row.

Sherman, S. J. (1980). On the self-erasing nature of errors of prediction. *Journal of Personality and Social Psychology*, **39**, 211–221.

Sherman, S. J., Cialdini, R. B., Schwartzman, D. F., & Reynolds, K. D. (1985). Imagining can heighten or lower the perceived likelihood of contracting a disease: The mediating effect of ease of imagery. *Personality and Social Psychology Bulletin*, **11**, 118–127.

Sherman, S. J., & Fazio, R. H. (1983). Parallels between attitudes and traits as predictors of behavior. *Journal of Personality*, **51**, 308–345.

Sherman, S. J., & Gorkin, L. (1980). Attitude bolstering when behavior is inconsistent with central attitudes. *Journal of Experimental Social Psychology*, **16**, 388–403.

Sherman, S. J., Presson, C. C., Chassin, L., Bensenberg, M., Corty, E., & Olshavsky, R. (1983). Smoking intentions in adolescents: Direct experience and predictability. *Personality and Social Psychology Bulletin*, **8**, 376–383.

Short, J. F., Jr. (Ed.) (1969). *Gang delinquency and delinquent subcultures*. New York: Harper & Row.

Shotland, R. L. (1989). A model of the causes of date rape in developing and close relationships. In C. Hendrick (Ed.), *Review of Personality and Social Psychology*, Vol. 10. Beverly Hills: Sage.

Shotland, R. L., & Craig, J. M. (1988). Can men and women differentiate between friendly and sexually interested behavior? *Social Psychology Quarterly*, **51**, 67–73.

Shotland, R. L., & Stebbins, C. A. (1983). Emergency and cost as determinants of helping behavior and the slow accumulation of social psychological

knowledge. *Social Psychology Quarterly*, **46**, 36–46.

Shotland, R. L., & Straw, M. K. (1976). Bystander response to an assault: When a man attacks a woman. *Journal of Personality and Social Psychology*, **34**, 990–999.

Shouval, R., Venaki, S. K., Bronfenbrenner, U., Devereus, E. C., & Kiely, E. (1975). Anomalous reactions to social pressure of Israeli and Soviet children raised in family versus collective settings. *Journal of Personality and Social Psychology*, **32**, 477–489.

Showers, C., & Ruben, C. (1987). Distinguishing pessimism from depression: Negative expectations and positive coping mechanisms. Paper presented at the American Psychological Association convention.

Shrauger, J. S. (1975). Responses to evaluation as a function of initial self-perceptions. *Psychological Bulletin*, **82**, 581–596.

Shrauger, J. S. (1983). The accuracy of self-prediction: How good are we and why? Paper presented at the Midwestern Psychological Association convention.

Shure, G. H., Meeker, R. J., & Hansford, E. A. (1965). The effectiveness of pacifist strategies in bargaining games. *Journal of Conflict Resolution*, **9**(1), 106–117.

Sigall, H. (1970). Effects of competence and consensual validation on a communicator's liking for the audience. *Journal of Personality and Social Psychology*, **16**, 252–258.

Sigall, H., & Page, R. (1971). Current stereotypes: A little fading, a little faking. *Journal of Personality and Social Psychology*, **18**, 247–255.

Silver, M., & Geller, D. (1978). On the irrelevance of evil: The organization and individual action. *Journal of Social Issues*, **34**, 125–136.

Simon, H. A. (1957). *Models of man: Social and rational*. New York: Wiley.

Simpson, J. A. (1987). The dissolution of romantic relationships: Factors involved in relationship stability and emotional distress. *Journal of Personality and Social Psychology*, **53**, 683–692.

Simpson, J. A., Campbell, B., & Berscheid, E. (1986). The association between romantic love and marriage: Kephart (1967) twice revisited. *Personality and Social Psychology Bulletin*, **12**, 363–372.

Simpson, J. A., Gangestad, S. W., & Lerma, M. (1990). Perception of physical attractiveness: Mechanisms involved in the maintenance of romantic relationships. *Journal of Personality and Social Psychology*, **59**, 1192–1201.

Singer, J. L., & Singer, D. G. (1988). Some hazards of growing up in a television environment: Children's aggression and restlessness. In S. Oskamp (Ed.), *Television as a social issue: Applied Social Psychology Annual*, Vol. 8. Newbury Park, Ca.: Sage.

Singer, M. (1979, July-August). Interviewed by M. Freeman. Of cults and communication: A conversation with Margaret Singer. *APA Monitor*, pp. 6–7. *(b)*

Singer, M. (1979). Cults and cult members. Address to the American Psychological Association convention. *(a)*

Sissons, M. (1981). Race, sex, and helping behavior. *British Journal of Social Psychology*, **20**, 285–292.

Sivard, R. L. (1991). *World military and social expenditures*. Washington, DC: World Priorities.

Six, B., & Krahe, B. (1984). Implicit psychologists' estimates of attitude-behavior consistencies. *European Journal of Social Psychology*, **14**, 79–86.

Skaalvik, E. M., & Hagtvet, K. A. (1990). Academic achievement and self-concept: An analysis of causal predominance in a developmental perpsective. *Journal of Personality and Social Psychology*, **58**, 292–307.

Skinner, B. F. (1971). *Beyond freedom and dignity*. New York: Knopf.

Skov, R. B., & Sherman, S. J. (1986). Information-gathering processes: Diagnosticity, hypothesis-confirmatory strategies, and perceived hypothesis confirmation. *Journal of Experimental Social Psychology*, **22**, 93–121.

Slavin, R. E. (1980). Cooperative learning and desegregation. Paper presented at the American Psychological Association convention.

Slavin, R. E. (1985). Cooperative learning: Applying contact theory in desegregated schools. *Journal of Social Issues*, **41**(3), 45–62.

Slavin, R. E. (1990, December/January). Research on cooperative learning: Consensus and controversy. *Educational Leadership*, pp. 52–54.

Slavin, R. E., & Madden, N. A. (1979). School practices that improve race relations. *Journal of Social Issues*, **16**, 169–180.

Sloan, J. H., Kellerman, A. L., Reay, D. T., Ferris, J. A., Koepsell, T., Rivara, F. P., Rice, C., Gray, L., & LoGerfo, J. (1988). Handgun regulations, crime, assaults, and homicide: A tale of two cities. *New England Journal of Medicine, 319,* 1256–1261.

Slovic, P. (1972). From Shakespeare to Simon: Speculations—and some evidence—about man's ability to process information. *Oregon Research Institute Research Bulletin,* **12**(2).

Slovic, P. (1985, January 30). Only new laws will spur seat-belt use. *Wall Street Journal.*

Slovic, P., & Fischhoff, B. (1977). On the psychology of experimental surprises. *Journal of Experimental Psychology: Human Perception and Performance, 3,* 455–551.

Slowiaczek, L. M., Klayman, J., Sherman, S. J., & Skov, R. B. (1991). Information selection and use in hypothesis testing: What is a good question, and what is a good answer? Unpublished manuscript, State University of New York at Albany.

Smart, R. G., & Adlaf, E. M. (1989). The Ontario student drug use survey: Trends between 1977–1989. Toronto: Addiction Research Foundation of Ontario.

Smedley, J. W., & Bayton, J. A. (1978). Evaluative race-class stereotypes by race and perceived class of subjects. *Journal of Personality and Social Psychology, 3,* 530–535.

Smith, A. (1976). *The wealth of nations.* Book 1. Chicago: University of Chicago Press. (Originally published, 1776.)

Smith, D. E., Gier, J. A., & Willis, F. N. (1982). Interpersonal touch and compliance with a marketing request. *Basic and Applied Social Psychology, 3,* 35–38.

Smith, D. S., & Strube, M. J. (1991). Self-protective tendencies as moderators of self-handicapping impressions. *Basic and Applied Social Psychology, 12,* 63–80.

Smith, E. R. (1991). Illusory correlation in a simulated exemplar-based memory. *Journal of Experimental Social Psychology, 27,* 107–123.

Smith, H. (1979) *The Russians.* New York: Balantine Books, 1976. Cited by B. Latané, K. Williams, and S. Harkins in, Many hands make liht the work. *Journal of Personality and Social Psychology, 37,* 822–832.

Smith, H. W. (1981). Territorial spacing on a beach revisited: A cross-national exploration. *Social Psychology Quarterly, 44,* 132–137.

Smith, M. B. (1978). Psychology and values. *Journal of Social Issues, 34,* 181–199.

Smith, M. L., Glass, G. V., & Miller, R. L. (1980). *The benefits of psychotherapy.* Baltimore: Johns Hopkins Press.

Smith, P. B., & Tayeb, M. (1989). Organizational structure and processes. In M. Bond (Ed.), *The cross-cultural challenge to social psychology.* Newbury Park, Ca.: Sage.

Smith, S. M., & Shaffer, D. R. (1991). Celerity and cajolery: Rapid speech may promote or inhibit persuasion through its impact on message elaboration. *Personality and Social Psychology Bulletin, 17,* 663–669.

Smith, T. W. (1990, December). Personal communication. Chicago: National Opinion Research Center.

Smith, V. L. (1991). Impact of pretrial instruction on jurors' information processing and decision making. *Journal of Applied Psychology, 76,* 220–228.

Smith, V. L. (1991). Prototypes in the courtroom: Lay representations of legal concepts. *Journal of Personality and Social Psychology, 61,* 857–872.

Smith, V. L., & Ellsworth, P. C. (1987). The social psychology of eyewitness accuracy: Misleading questions and communicator expertise. *Journal of Applied Psychology, 72,* 294–300.

Smith, V. L., Kassin, S. M., & Ellsworth, P. C. (1989). Eyewitness accuracy and confidence: Within-versus between-subjects correlations. *Journal of Applied Psychology, 74,* 356–359.

Smith, W. P. (1987). Conflict and negotiation: Trends and emerging issues. *Journal of Applied Social Psychology, 17,* 641–677.

Sniderman, P. M., Piazza, T., Tetlock, P. E., & Kendrick, A. (1991). The new racism. *American Journal of Political Science, 35,* 423–447.

Snodgrass, M. A. (1987). The relationships of differential loneliness, intimacy, and characterological attributional style to duration of loneliness. *Journal of Social Behavior and Personality, 2,* 173–186.

Snodgrass, S. E., Higgins, J. G., & Todisco, L. (1986). The effects of walking behavior on mood. Paper presented at the American Psychological Association convention.

Snyder, C. R. (1978). The ''illusion'' of uniqueness. *Journal of Humanistic Psychology, 18,* 33–41.

Snyder, C. R. (1980). The uniqueness mystique. *Psychology Today,* March, pp. 86–90.

Snyder, C. R., & Fromkin, H. L. (1980). *Uniqueness; The human pursuit of difference.* New York: Plenum.

Snyder, C. R., & Higgins, R. L. (1988). Excuses: Their effective role in the negotiation of reality. *Psychological Bulletin, 104,* 23–35.

Snyder, C. R., & Smith, T. W. (1986). On being ''shy like a fox'': A self-handicapping analysis. In W. H. Jones et al. (Eds.), *Shyness: Perspectives on research and treatment.* New York: Plenum.

Snyder, M. (1981). Seek, and ye shall find: Testing hypotheses about other people. In E. T. Higgins, C. P. Herman, & M. P. Zanna (Eds.), *Social cognition: The Ontario symposium on personality and social psychology.* Hillsdale, N.J.: Erlbaum. *(a)*

Snyder, M. (1983). The influence of individuals on situations: Implications for understanding the links between personality and social behavior. *Journal of Personality, 51,* 497–516.

Snyder, M. (1984). When belief creates reality. In L. Berkowitz (Ed.), *Advances in Experimental Social Psychology,* Vol. 18. New York: Academic Press.

Snyder, M. (1987). *Public appearances/ private realities: The psychology of self-monitoring.* New York: Freeman.

Snyder, M. (1988). Experiencing prejudice first hand: The ''discrimination day'' experiments. *Contemporary Psychology, 33,* 664–665.

Snyder, M. (1991). Selling images versus selling products: Motivational foundations of consumer attitudes and behavior. *Advances in Consumer Research,* in press.

Snyder, M., Berscheid, E., & Glick, P. (1985). Focusing on the exterior and the interior: Two investigations of the initiation of personal relationships. *Journal of Personality and Social Psychology, 48,* 1427–1439.

Snyder, M., Berscheid, E., & Matwychuk, A. (1988). Orientations toward personnel selection: Differential reliance on appearance and personality. *Journal of Personality and Social Psychology, 54,* 972–979.

Snyder, M., Campbell, B., & Preston, E. (1982). Testing hypotheses about human nature: Assessing the accuracy

of social stereotypes. *Social Cognition*, **1**, 256–272.

Snyder, M., & Copeland, J. (1989). Self-monitoring processes in organizational settings. In R. A. Giacalone & P. Rosenfeld (Eds.), *Impression management in the organization*. Hillsdale, N.J.: Erlbaum.

Snyder, M., & DeBono, K. G. (1987). A functional approach to attitudes and persuasion. In M. P. Zanna, J. M. Olson, & C. P. Herman (Eds.), *Social influence: The Ontario symposium*, Vol. 5. Hillsdale, N.J.: Erlbaum.

Snyder, M., & DeBono, K. G. (1989). Understanding the functions of attitudes: Lessons from personality and social behavior. In A. R. Pratkanis, S. J., Breckler, & A. G. Greenwald (Eds.), *Attitude structure and function*. Hillsdale, N.J.: Erlbaum.

Snyder, M., Grether, J., & Keller, K. (1974). Staring and compliance: A field experiment on hitch-hiking. *Journal of Applied Social Psychology*, **4**, 165–170.

Snyder, M., & Haugen, J. A. (1991). Why does behavioral confirmation occur? A functional perspective on the role of the perceiver. Unpublished manuscript, University of Minnesota.

Snyder, M., & Ickes, W. (1985). Personality and social behavior. In G. Lindzey & E. Aronson (Eds.), *Handbook of social psychology* (3rd ed.). New York: Random House.

Snyder, M., & Omoto, A. M. (1991). Who helps and why? The psychology of AIDS volunteerism. In S. Oskamp & S. Spacapan (Eds.), *Helping and being helped: Naturalistic studies*. Newbury Park, CA: Sage.

Snyder, M., & Simpson, J. (1985). Orientations toward romantic relationships. In S. Duckk & D. Perlman (Eds.), *Understanding personal relationships*. Beverly Hills, Ca.: Sage.

Snyder, M., & Swann, W. B., Jr. (1976). When actions reflect attitudes: The politics of impression management. *Journal of Personality and Social Psychology*, **34**, 1034–1042.

Snyder, M., Tanke, E. D., & Berscheid, E. (1977). Social perception and interpersonal behavior: On the self-fulfilling nature of social stereotypes. *Journal of Personality and Social Psychology*, **35**, 656–666. *(b)*

Snyder, M., & Thomsen, C. J. (1988). Interactions between therapists and clients: Hypothesis testing and behavioral confirmation. In D. C. Turk & P. Salovey (Eds.), *Reasoning, inference, and judgment in clinical psychology*. New York: Free Press.

Sokoll, G. R., & Mynatt, C. R. (1984). Arousal and free throw shooting. Paper presented at the Midwestern Psychological Association convention, Chicago.

Solano, C. H. Batten, P. G., & Parish, E. A. (1982). Loneliness and patterns of self-disclosure. *Journal of Personality and Social Psychology*, **43**, 524–531.

Solomon, H., & Solomon, L. Z. (1978). Effects of anonymity on helping in emergency situations. Paper presented at the Eastern Psychological Association convention.

Solomon, H., Solomon, L. Z., Arnone, M. M., Maur, B. J., Reda, R. M., & Rother, E. O. (1981). Anonymity and helping. *Journal Social Psychology*, **113**, 37–43.

Solomon, L. Z., Solomon, H., & Stone, R. (1978). Helping as a function of number of bystanders and ambiguity of emergency. *Personality and Social Psychology Bulletin*, **4**, 318–321.

Sommer, R. (1969). *Personal space*. Englewood Cliffs, N.J.: Prentice-Hall.

Sonne, J., & Janoff, D. (1979). The effect of treatment attributions on the maintenance of weight reduction: A replication and extension. *Cognitive Therapy and Research*, **3**, 389–397.

Sorrentino, R. M., Bobocel, D. R., Gitta, M. Z., Olsen, J. M., & Hewitt, E. C. (1988). Uncertainty orientation and persuasion: Individual differences in the effects of personal relevance on social judgments. *Journal of Personality and Social Psychology*, **55**, 357–371.

Sparacino, J., & Hansell, S. (1979). Physical attractiveness and academic performance: Beauty is not always talent. *Journal of Personality*, **47**, 449–469.

Sparrell, J. A., & Shrauger, J. S. (1984). Self-confidence and optimism in self-prediction. Paper presented at the American Psychological Association convention.

Spector, P. E. (1986). Perceived control by employees: A meta-analysis of studies concerning autonomy and participation at work. *Human Relations*, **39**, 1005–1016.

Speer, A. (1971). *Inside the Third Reich: Memoirs*. (P. Winston & C. Winston. trans.). New York: Avon Books.

Spiegel, D., Bloom, J. R., Kraemer, H. C., & Gottheil, E. (1989, October 14). Effect of psychosocial treatment on survival of patients with metastatic breast cancer. *The Lancet*, 888–891.

Spiegel, H. W. (1971). *The growth of economic thought*. Durham, N.C.: Duke University Press.

Spitzberg, B. H., & Hurt, H. T. (1987). The relationship of interpersonal competence and skills to reported loneliness across time. *Journal of Social Behavior and Personality*, **2**, 157–172.

Spivak, J. (1979, June 6). *Wall Street Journal.*

Spivey, C. B., & Prentice-Dunn, S. (1990). Assessing the directionality of deindividuated behavior: Effects of deindividuation, modeling, and private self-consciousness on aggressive and prosocial responses. *Basic and Applied Social Psychology*, **11**, 387–403.

Sprecher, S. (1987). The effects of self-disclosure given and received on affection for an intimate partner and stability of the relationship. *Journal of Personality and Social Psychology*, **4**, 115–127.

St. Lawrence, J. S., & Joyner, D. J. (1991). The effects of sexually violent rock music on males' acceptance of violence against women. *Psychology of Women Quarterly*, **15**, 49–63.

Standing, L., & Keays, G. (1986). Computer assessment of personality: A demonstration of gullibility. *Social Behavior and Personality*, **14**, 197–202.

Stark, R., & Bainbridge, W. S. (1980). Networks of faith: Interpersonal bonds and recruitment of cults and sects *American Journal of Sociology*, **85**, 1376–1395.

Stasser, G. (1991). Pooling of unshared information during group discussion. In S. Worchel, W. Wood, & J. Simpson (Eds.), *Group process and productivity*. Beverly Hills, CA: Sage.

Stasser, G., Kerr, N. L., & Bray, R. M. (1981). The social psychology of jury deliberations: Structure, process, and product. In N. L. Kerr & R. M. Bray (Eds.), *The psychology of the courtroom*. New York: Academic Press.

Staub, E. (1989). *The roots of evil: The origins of genocide and other group violence*. Cambridge: Cambridge University Press.

Staub, E. (1990). Moral exclusion: Personal goal theory, and extreme destructiveness. *Journal of Social Issues*, **46**, 47–64.

Staub, E. (1991). Altruistic and moral motivations for helping and their translation into action. *Psychological Inquiry,* **2,** 150–153.

Staub, E. (1991). Psychological and cultural origins of extreme destructiveness and extreme altruism. In W. Kurtines & J. Gewirtz (Eds.), *The handbook of moral behavior and development.* Hillsdale, NJ: Erlbaum.

Staub, E. (1992). The origins of caring, helping and nonaggression: Parental socialization, the family system, schools, and cultural influence. In S. Oliner & P. Oliner (Eds.), *Embracing the other: Philosophical, psychological, and theological perspectives on altruism.* New York: New York University Press.

Steblay, N. M. (1987). Helping behavior in rural and urban environments: A meta-analysis. *Psychological Bulletin,* **102,** 346–356.

Steele, C. M. (1988). The psychology of self-affirmation: Sustaining the integrity of the self. In L. Berkowitz (Ed.), *Advances in experimental social psychology,* Vol. 21. Orlando, Fl.: Academic Press.

Steele, C. M., & Southwick, L. (1985). Alcohol and social behavior I: The psychology of drunken excess. *Journal of Personality and Social Psychology,* **48,** 18–34.

Steele, C. M., Southwick, L. L., & Critchlow, B. (1981). Dissonance and alcohol: Drinking your troubles away. *Journal of Personality and Social Psychology,* **41,** 831–846.

Stein, A. H., & Friedrich, L. K. (1972). Television content and young children's behavior. In J. P. Murray, E. A. Rubinstein, & G. A. Comstock (Eds.), *Television and social learning.* Washington, D.C.: Government Printing Office.

Stein, D. D., Hardyck, J. A., & Smith, M. B. (1965). Race and belief: An open and shut case. *Journal of Personality and Social Psychology,* **1,** 281–289.

Steinem, G. (1988). Six great ideas that television is missing. In S. Oskamp. (Ed.), *Television as a social issue: Applied Social Psychology Annual,* Vol. 8. Newbury Park, Ca.: Sage.

Steiner, I. D. (1982). Heuristic models of groupthink. In M. Brandstatter, J. H. Davis, & G. Stocker-Kreichgauer (Eds.), *Group decision making.* New York: Academic Press, pp. 503–524.

Stephan, C. W., & Stephan, W. G. (1986). Habla Ingles? The effects of language translation on simulated juror decisions. *Journal of Applied Social Psychology,* **16,** 577–589.

Stephan, W. G. (1986). The effects of school desegregation: An evaluation 30 years after *Brown.* In R. Kidd, L. Saxe, & M. Saks (Eds.), *Advances in applied social psychology.* New York: Erlbaum.

Stephan, W. G. (1987). The contact hypothesis in intergroup relations. In C. Hendrick (Ed.), *Group processes and intergroup relations.* Newbury Park, Ca.: Sage.

Stephan, W. G. (1988). School desegregation: Short-term and long-term effects. Paper presented at the national conference "Opening doors: An appraisal of race relations in America,' University of Alabama.

Stephan, W. G., Berscheid, E., & Walster, E. (1971). Sexual arousal and heterosexual perception. *Journal of Personality and Social Psychology,* **20,** 93–101.

Stephenson, G. M., Abrams, D., Wagner, W., & Wade, G. (1986). Partners in recall: Collaborative order in the recall of a police interrogation. *British Journal of Social Psychology,* **25,** 341–343. *(a)*

Stephenson, G. M., Brandstatter, H., & Wagner, W. (1983). An experimental study of social performance and delay on the testimonial validity of story recall. *European Journal of Social Psychology,* **13,** 175–191.

Stephenson, G. M., Clark, N. K., & Wade, G. S. (1986). Meetings make evidence? An experimental study of collaborative and individual recall of a simulated police interrogation. *Journal of Personality and Social Psychology,* **50,** 1113–1122. *(b)*

Sternberg, R. J. (1988). Triangulating love. In R. J. Sternberg & M. L. Barnes (Eds.), *The psychology of love.* New Haven: Yale University Press.

Sternberg, R. J., & Grajek, S. (1984). The nature of love. *Journal of Personality and Social Psychology,* **47,** 312–329.

Stewart, J. E., II. (1980). Defendant's attractiveness as a factor in the outcome of criminal trials: An observational study. *Journal of Applied Social Psychology,* **10,** 348–361.

Stewart, J. E., II. (1983). Appearance as a factor in conviction and sentencing: The attraction-leniency effect in the courtroom. Paper presented at the Midwestern Psychological Association convention.

Stille, R. G., Malamuth, N., & Schallow, J. R. (1987). Prediction of rape proclivity by rape myth attitudes and hostility toward women. Paper presented at the American Psychological Association convention.

Stillinger, C., Epelbaum, M., Keltner, D., & Ross, L. (1991). The "reactive devaluation" barrier to conflict resolution. Unpublished manuscript, Stanford University.

Stockdale, J. E. (1978). Crowding: Determinants and effects. In L. Berkowitz (Ed.), *Advances in experimental social psychology* (Vol. 11). New York: Academic Press.

Stocking, S. H., & Gross, P. H. (1989). *How do journalists think? A proposal for the study of cognitive bias in newsmaking.* Bloomington, IN: ERIC Clearinghouse on Reading and Communication Skills, Smith Research Center, Indiana University.

Stokes, J., & Levin, I. (1986). Gender differences in predicting loneliness from social network characteristics. *Journal of Personality and Social Psychology,* **51,** 1069–1074.

Stone, A. A., Hedges, S. M., Neale, J. M., & Satin, M. S. (1985). Prospective and cross-sectional mood reports offer no evidence of a "blue Monday" phenomenon. *Journal of Personality and Social Psychology,* **49,** 129–134.

Stone, A. L., & Glass, C. R. (1986). Cognitive distortion of social feedback in depression. *Journal of Social and Clinical Psychology,* **4,** 179–188.

Stoner, J. A. F. (1962). A comparison of individual and group decisions involving risk. Unpublished master's thesis, Massachusetts Institute of Technology, 1961. Cited by D. G. Marquis in, Individual responsibility and group decisions involving risk. *Industrial Management Review,* **3,** 8–23.

Storms, M. D. (1973). Videotape and the attribution process: Reversing actors' and observers' points of view. *Journal of Personality and Social Psychology,* **27,** 165–175.

Storms, M. D., & Thomas, G. C. (1977). Reactions to physical closeness. *Journal of Personality and Social Psychology,* **35,** 412–418.

Stouffer, S. A., Suchman, E. A., DeVinney, L. C., Star, S. A., & Williams, R. M., Jr. (1949). *The American soldier: Adjustment during army life* (Vol. 1.). Princeton, N.J.: Princeton University Press.

Strack, F., Martin, L. L., & Stepper, S. (1988). Inhibiting and facilitating

conditions of the human smile: A nonobstrusive test of the facial feedback hypothesis. *Journal of Personality and Social Psychology,* **54,** 768–777.

Strack, S., & Coyne, J. C. (1983). Social confirmation of dysphoria: Shared and private reactions to depression. *Journal of Personality and Social Psychology,* **44,** 798–806.

Straub, E. (1978). *Positive social behavior and morality: Social and personal influences,* vol. 1. New York: Academic Press.

Strauss, M. A., & Gelles, R. J. (1980). *Behind closed doors: Violence in the American family.* New York: Anchor/ Doubleday.

Strenta, A., & DeJong, W. (1981). The effect of a prosocial label on helping behavior. *Social Psychology Quarterly,* **44,** 142–147.

Stroebe, W., & Insko, C. A. (1989). Stereotype, prejudice, and discrimination: Changing conceptions in theory and research. In D. Bar-Tal, C. F. Graumann, A. W. Kruglanski, & W. Stroebe (Eds.), *Stereotyping and prejudice.* New York: Springer-Verlag.

Stroebe, W., Insko, C. A., Thompson, V. D., & Layton, B. D. (1971). Effects of physical attractiveness, attitude similarity, and sex on various aspects of interpersonal attraction. *Journal of Personality and Social Psychology,* **18,** 79–91.

Stroebe, W., Lenkert, A., & Jonas, K. (1988). Familiarity may breed contempt: The impact of student exchange on national stereotypes and attitudes. In W. Stroebe & A. W. Kruglanski (Eds.), *The social psychology of intergroup conflict.* New York: Springer-Verlag.

Stroessner, S. J., Hamilton, D. L., & Lepore, L. (1990). Intergroup categorization and intragroup differentiation: Ingroup-outgroup differences. Paper presented at the American Psychological Association convention.

Strong, S. R. (1968). Counseling: An interpersonal influence process. *Journal of Counseling Psychology,* **17,** 81–87.

Strong, S. R. (1978). Social psychological approach to psychotherapy research. In S. L. Garfield & A. E. Bergin (Eds.), *Handbook of psychotherapy and behavior change,* 2nd ed. New York: Wiley.

Strong, S. R. (1991). Social influence and change in therapeutic relationships. In C. R. Snyder & D. R. Forsyth (Eds.), *Handbook of social and clinical psychology.* New York: Pergamon Press.

Stroufe, B., Chaikin, A., Cook, R., & Freeman, V. (1977). The effects of physical attractiveness on honesty: A socially desirable response. *Personality and Social Psychology,* **3,** 59–62.

Strumpel, B. (1976). Economic lifestyles, values, and subjective welfare. In B. Stumpel (Ed.), *Economic means for human needs.* Ann Arbor, Mich.: Institute for Social Research, University of Michigan.

Sue, S., Smith, R. E., & Caldwell, C. (1973). Effects of inadmissible evidence on the decisions of simulated jurors: A moral dilemma. *Journal of Applied Social Psychology,* **3,** 345–353.

Suedfeld, P., Rank, D., & Borrie, R. (1975). Frequency of exposure and evaluation of candidates and campaign speeches. *Journal of Applied Social Psychology,* **5,** 118–126.

Suls, J., & Tesch, F. (1978). Students' preferences for information about their test performance: A social comparison study, *Journal of Applied Social Psychology,* **8,** 189–197.

Suls, J., Wan, C. K., & Sanders, G. S. (1988). False consensus and false uniqueness in estimating the prevalence of health-protective behaviors. *Journal of Applied Social Psychology,* **18,** 66–79.

Summers, G., & Feldman, N. S. (1984). Blaming the victim versus blaming the perpetrator: An attributional analysis of spouse abuse. *Journal of Social and Clinical Psychology,* **2,** 339–347.

Sundstrom, E., De Meuse, K. P., & Futrell, D. (1990). Work teams: Applications and effectiveness. *American Psychologist,* **45,** 120–133.

Svenson, O. (1981). Are we all less risky and more skillful than our fellow drivers? *Acta Psychologica,* **47,** 143–148.

Swann, W. B., Jr. (1984). Quest for accuracy in person perception: A matter of pragmatics. *Psychological Review,* **91,** 457–475.

Swann, W. B., Jr. (1987). Identity negotiation: Where two roads meet. *Journal of Personality and Social Psychology,* **53,** 1038–1051.

Swann, W. B., Jr. (1990). To be adored or to be known? The interplay of self-enhancement and self-verification. In R. M. Sorrentino & E. T. Higgins (Eds.), *Foundations of social behavior,* vol. 2. New York: Guilford.

Swann, W. B., Jr. (1992). Seeking "truth," finding despair: Some un-

happy consequences of a negative self-concept. *Current Directions in Psychological Science,* **1,** 15–18.

Swann, W. B., Jr., & Ely, R. J. (1984). A battle of wills: Self-verification versus behavioral confirmation. *Journal of Personality and Social Psychology,* **46,** 1287–1302.

Swann, W. B., Jr., & Giuliano, T. (1987). Confirmatory search strategies in social interaction: How, when, why, and with what consequences. *Journal of Social and Clinical Psychology,* **5,** 511–524.

Swann, W. B., Jr., Giuliano, T., & Wegner, D. M. (1982). Where leading questions can lead: The power of conjecture in social interaction. *Journal of Personality and Social Psychology,* **42,** 1025–1035.

Swann, W. B., Jr., Hixon, J. G., & De La Ronde, C. (1992). Embracing the bitter "truth": Negative self-concepts and marital commitment. *Psychological Science,* in press.

Swann, W. B., Jr., Hixon, J. G., Stein-Seroussi, A., & Gilbert, D. T. (1990). The fleeting gleam of praise: Cognitive processes underlying behavioral reactions to self-relevant feedback. *Journal of Personality and Social Psychology,* **59,** 17–26.

Swann, W. B., Jr., & Predmore, S. C. (1985). Intimates as agents of social support: Sources of consolation or despair? *Journal of Personality and Social Psychology,* **49,** 1609–1617.

Swann, W. B., Jr. & Read, S. J. (1981). Acquiring self-knowledge: The search for feedback that fits. *Journal of Personality and Social Psychology,* **41,** 1119–1128. *(a)*

Swann, W. B., Jr., & Read, S. J. (1981). Self-verification processes: How we sustain our self-conceptions. *Journal of Experimental Social Psychology,* **17,** 351–372. *(b)*

Swann, W. B., Jr., Stein-Seroussi, A., & Giesler, R. B. (1992). Why people self-verify. *Journal of Personality and Social Psychology,* **62,** 392–401.

Swann, W. B., Jr., Stein-Seroussi, A., & McNulty, S. E. (1992). Outcasts in a white lie society. The enigmatic worlds of people with negative self-conceptions. *Journal of Personality and Social Psychology,* **62,** 618–624.

Swann, W. B., Jr., Wenzlaff, R. M., Krull, D. S., & Pelham, B. W. (1991). Seeking truth, reaping despair: Depression, self-verification and selection of relationship partners. *Journal of Abnormal Psychology,* in press.

Swap, W. C. (1977). Interpersonal attraction and repeated exposure to rewarders and punishers. *Personality and Social Psychology Bulletin, 3,* 248–251.

Swedish Information Service (1980). *Social change in Sweden,* September, No. 19, p. 5. (Published by the Swedish Consulate General, 825 Third Avenue, New York, N.Y. 10022.)

Sweeney, J. (1973). An experimental investigation of the free rider problem. *Social Science Research, 2,* 277–292.

Sweeney, P. D., Anderson, K., & Bailey, S. (1986). Attributional style in depression: A meta-analytic review. *Journal of Personality and Social Psychology, 50,* 947–991.

Swim, J., Aikin, K., Hunter, B., & Hall, W. (1991). Sexism and racism: Old fashioned and modern prejudices. Unpublished manuscript, Pennsylvania State University.

Swim, J., Borgida, E., Maruyama, G., & Myers, D. G. (1989). Joan McKay vs. John McKay: Do gender stereotypes bias evaluations? *Psychological Bulletin, 105,* 409–429.

Symons, D. (interviewed by S. Keen). (1981, February). Eros and alley cop. *Psychology Today,* p. 54.

Tajfel, H. (1970, November). Experiments in intergroup discrimination. *Scientific American,* pp. 96–102.

Tajfel, H. (1981). *Human groups and social categories: Studies in social psychology.* London: Cambridge University Press.

Tajfel, H. (1982). Social psychology of intergroup relations. *Annual Review of Psychology, 33,* 1–39.

Tajfel, H., & Billig, M. (1974). Familiarity and categorization in intergroup behavior. *Journal of Experimental Social Psychology, 10,* 159–170.

Takooshian, H., & Bodinger, H. (1982). Bystander indifference to street crime. In L. Savitz & N. Johnston (Eds.), *Contemporary criminology.* New York: Wiley.

Tanke, E. D., & Tanke, T. J. (1979). Getting off a slippery slope: Social science in the judicial processes. *American Psychologist, 34,* 1130–1138.

Tapp, J. L. (1980). Psychological and policy perspectives on the law: Reflections on a decade. *Journal of Social Issues, 36*(2), 165–192.

Taylor, D. A. (1979). Motivational bases. In G. J. Chelune (Ed.), *Self-disclosure: Origins, patterns, and implications of openness in interpersonal relationships.* San Francisco: Jossey-Bass.

Taylor, D. A., Gould, R. J., & Brounstein, P. J. (1981). Effects of personalistic self-disclosure. *Personality and Social Psychology Bulletin, 7,* 487–492.

Taylor, D. G., Sheatsley, P. B., & Greeley, A. M. (1978). Attitudes toward racial integration. *Scientific American, 238*(6), 42–49.

Taylor, D. M., & Doria, J. R. (1981). Self-serving and group-serving bias in attribution. *Journal of Social Psychology, 113,* 201–211.

Taylor, D. M., Wright, S. C., Moghaddam, F. M., & Lalonde, R. N. (1990). The personal/group discrimination discrepancy: Perceiving my group, but not myself, to be a target for discrimination. *Personality and Social Psychology Bulletin, 16,* 254–262.

Taylor, S. E. (1979). Remarks at symposium on social psychology and medicine, American Psychological Association convention.

Taylor, S. E. (1981). A categorization approach to stereotyping. In D. L. Hamilton (Ed.), *Cognitive processes in stereotyping and intergroup behavior.* Hillsdale, N.J.: Erlbaum.

Taylor, S. E. (1989). *Positive illusions: Creative self-deception and the healthy mind.* New York: Basic Books.

Taylor, S. E., & Brown, J. D. (1988). Illusion and well-being: A social psychological perspective on mental health. *Psychological Bulletin, 103,* 193–210.

Taylor, S. E., Crocker, J., Fiske, S. T., Sprinzen, M., & Winkler, J. D. (1979). The generalizability of salience effects. *Journal of Personality and Social Psychology, 37,* 357–368.

Taylor, S. E., & Fiske, S. T. (1978). Salience, attention, and attribution: Top of the head phenomena. In L. Berkowitz (Ed.), *Advances in experimental social psychology* (Vol. 11). New York: Academic Press.

Taylor, S. E., Fiske, S. T., Etcoff, N. L., & Ruderman, A. J. (1978). Categorical and contextual bases of person memory and stereotyping. *Journal of Personality and Social Psychology, 36,* 778–793.

Taylor, S. P., & Leonard, K. E. (1983). Alcohol and human physical aggression. *Aggression, 2,* 77–101.

Taylor, S. P., & Pisano, R. (1971). Physical aggression as a function of frustration and physical attack. *Journal of Social Psychology, 84,* 261–267.

Tedeschi, J. T., Nesler, M., & Taylor, E. (1987). Misattribution and the bogus pipeline: A test of dissonance and impression management theories. Paper presented at the American Psychological Association convention.

Teger, A. I. (1980). *Too much invested to quit.* New York: Pergamon Press.

Teigen, K. H. (1986). Old truths or fresh insights? A study of students' evaluations of proverbs. *British Journal of Social Psychology, 25,* 43–50.

Telch, M. J., Killen, J. D., McAlister, A. L., Perry, C. L., & Maccoby, N. (1981). Long-term follow-up of a pilot project on smoking prevention with adolescents. Paper presented at the American Psychological Association convention.

Tennen, H., & Affleck, G. (1987). The costs and benefits of optimistic explanations and dispositional optimism. *Journal of Personality, 55,* 377–393.

Tennov, D. (1979). *Love and limerence: The experience of being in love.* New York: Stein and Day, p. 22.

Tesser, A. (1988). Toward a self-evaluation maintenance model of social behavior. In L. Berkowitz (Ed.), *Advances in experimental social psychology,* Vol. 21. San Diego, Ca.: Academic Press.

Tesser, A., Millar, M., & Moore, J. (1988). Some affective consequences of social comparison and reflection processes: The pain and pleasure of being close. *Journal of Personality and Social Psychology, 54,* 49–61.

Tesser, A., & Paulhus, D. (1983). The definition of self: Private and public self-evaluation management strategies. *Journal of Personality and Social Psychology, 44,* 672–682.

Tesser, A., Rosen, S., & Conlee, M. C. (1972). News valence and available recipient as determinants of news transmission. *Sociometry, 35,* 619–628.

Tetlock, P. E. (1981). Pre- to post-election shifts in presidential rhetoric: Impression management or cognitive adjustment. *Journal of Personality and Social Psychology, 41,* 207–212.

Tetlock, P. E. (1982). Accountability and complexity of thought. *Journal of Personality and Social Psychology, 45,* 74–83.

Tetlock, P. E. (1985). Integrative complexity of American and Soviet foreign policy rhetoric: A time-series analysis. *Journal of Personality and Social Psychology, 49,* 1565–1585.

Tetlock, P. E. (1988). Monitoring the integrative complexity of American and Soviet policy rhetoric: What can be

learned? *Journal of Social Issues,* **44,** 101–131.

Tetlock, P. E., & Boettger, R. (1989). Accountability: A social magnifier of the dilution effect. *Journal of Personality and Social Psychology,* **57,** 388–398.

Thibodeau, R. (1989). From racism to tokenism: The changing face of blacks in *New Yorker* cartoons. *Public Opinion Quarterly,* **53,** 482–494.

Thomas, G. C., & Batson, C. D. (1981). Effect of helping under normative pressure on self-perceived altruism. *Social Psychology Quarterly,* **44,** 127–131.

Thomas, G. C., Batson, C. D., & Coke, J. S. (1981). Do Good Samaritans discourage helpfulness? Self-perceived altruism after exposure to highly helpful others. *Journal of Personality and Social Psychology,* **40,** 194–200.

Thomas, K. W., & Pondy, L. R. (1977). Toward an "intent" model of conflict management among principal parties. *Human Relations,* **30,** 1089–1102.

Thomas, L. (1978). Hubris in science? *Science,* **200,** 1459–1462.

Thomas, L. (1981). Quoted by J. L. Powell. Testimony before the Senate Subcommittee on Science, Technology and Space, April 22.

Thompson, L. (1990a). An examination of naive and experienced negotiators. *Journal of Personality and Social Psychology,* **59,** 82–90.

Thompson, L. (1990b). The influence of experience on negotiation performance. *Journal of Experimental Social Psychology,* **26,** 528–544.

Thompson, L. (1991). Information exchange in negotiation. *Journal of Experimental Social Psychology,* **27,** 161–179.

Thompson, L. L., & Crocker, J. (1985). Prejudice following threat to the self-concept. Effects of performance expectations and attributions. Unpublished manuscript, Northwestern University.

Thompson, W. C., Cowan, C. L., & Rosenhan, D. L. (1980). Focus of attention mediates the impact of negative affect on altruism. *Journal of Personality and Social Psychology,* **38,** 291–300.

Thompson, W. C., Fong, G. T., & Rosenhan, D. L. (1981). Inadmissible evidence and juror verdicts. *Journal of Personality and Social Psychology,* **40,** 453–463.

Thompson, W. C., & Schumann, E. L. (1987). Interpretation of statistical evidence in criminal trials. *Law and Human Behavior,* **11,** 167–187.

Thorndike, R. L. (1968). Review of *Pygmalion in the classroom. American Educational Research Journal,* **5,** 707–711.

Tice, D. M. (1991). Esteem protection or enhancement? Self-handicapping motives and attributions differ by trait self-esteem. *Journal of Personality and Social Psychology,* **60,** 711–725.

Tice, D. M., & Baumeister, R. F. (1985). Masculinity inhibits helping in emergencies: Personality does predict the bystander effect. *Journal of Personality and Social Psychology,* **49,** 420–428.

Time (1990, Fall issue on women). Asia: Discarding daughters. P. 40.

Timko, C., & Moos, R. H. (1989). Choice, control, and adaptation among elderly residents of sheltered care settings. *Journal of Applied Social Psychology,* **19,** 636–655.

Tindale, R. S., Davis, J. H., Vollrath, D. A., Nagao, D. H., & Hinsz, V. B. (1990). Asymmetrical social infuence in freely interacting groups: A test of three models. *Journal of Personality and Social Psychology,* **58,** 438–449.

Toronto News (1977, July 26).

Towson, S. M. J., & Zanna, M. P. (1983). Retaliation against sexual assault: Self-defense or public duty? *Psychology of Women Quarterly,* **8,** 89–99.

Travis, L. E. (1925). The effect of a small audience upon eye-hand coordination. *Journal of Abnormal and Social Psychology,* **20,** 142–146.

Triandis, H. C. (1981). Some dimensions of intercultural variation and their implications for interpersonal behavior. Paper presented at the American Psychological Association convention.

Triandis, H. C. (1982). Incongruence between intentions and behavior: A review. Paper presented at the American Psychological Association convention.

Triandis, H. C., Bontempo, R., Villareal, M. J., Asai, M., & Lucca, N. (1988). Individualism and collectivism: Cross-cultural perspectives on self-ingroup relationships. *Journal of Personality and Social Psychology,* **54,** 323–338.

Triandis, H. C., Brislin, R., & Hui, C. H. (1988). Cross-cultural training across the individualism-collectivism divide. *International Journal of Intercultural Relations,* **12,** 269–289.

Trimble, J. E. (1988). Stereotypical images, American Indians, and prejudice. In P. A. Katz & D. A. Taylor (Eds.), *Eliminating racism: Profiles in controversy.* New York: Plenum.

Triplet, R. G., Cohn, E. S., & White, S. O. (1988). The effect of residence hall judicial policies on attitudes toward rule-violating behaviors. *Journal of Applied Social Psychology,* **18,** 1288–1294.

Triplett, N. (1898). The dynamogenic factors in pacemaking and competition. *American Journal of Psychology,* **9,** 507–533.

Trolier, T. K., & Hamilton, D. L. (1986). Variables influencing judgments of correlational relations. *Journal of Personality and Social Psychology,* **50,** 879–888.

Trope, Y., Bassok, M., & Alon, E. (1984). The questions lay interviewers ask. *Journal of Personality,* **52,** 90–106.

Trost, M. R., Maass, A., & Kenrick, D. T. (1992). Minority influence: Personal relevance biases cognitive processes and reverses private acceptance. *Journal of Experimental Social Psychology,* in press.

Tumin, M. M. (1958). Readiness and resistance to desegregation: A social portrait of the hard core. *Social Forces,* **36,** 256–273.

Turner, C. W., Hesse, B. W., & Peterson-Lewis, S. (1986). Naturalistic studies of the long-term effects of television violence. *Journal of Social Issues,* **42**(3), 51–74.

Turner, J. C. (1984). Social identification and psychological group formation. In H. Tajfel (Ed.), *The social dimensions: European developments in social psychology,* vol. 2. London: Cambridge University Press.

Turner, J. C. (1987). *Rediscovering the social group: A self-categorization theory.* New York: Basil Blackwell.

Turner, M. E., Pratkanis, A. R., Probasco, P., & Leve, C. (1992). Threat, cohesion, and group effectiveness: Testing a collective dissonance reduction perspective on groupthink. *Journal of Personality and Social Psychology,* in press.

TV Guide (1977, January 26), pp. 5–10.

Tversky, A. (1985, June). Quoted by Kevin McKean, Decisions, decisions. *Discover,* pp. 22–31.

Tversky, A., & Gilovich, T. (1989a). The cold facts about the "hot hand" in basketball. *Chance: New directions for statistics and computing,* **2**(1), 16–21.

Tversky, A., & Gilovich, T. (1989b). The "hot hand": Statistical reality or cognitive illusion. *Chance: New directions for statistics and computing,* **2**(4), 31–34.

Tverksy, A., & Kahneman, D. (1974). Judgment under uncertainty: Heuristics and biases. *Science*, 185, 1123–1131.

Tversky, A., & Kahneman, D. (1981). The framing of decisions and the psychology of choice. *Science*, 211, 453–458.

Tversky, A., & Kahneman, D. (1983). Extensional versus intuitive reasoning: The conjunction fallacy in probability judgment. *Psychological Review*, 90, 293–315.

Tyler, T. R. (1988). What is procedural justice? Criteria used by citizens to assess the fairness of legal procedures. *Law and Society Review*, 22, 103–135.

Tyler, T. R. (1989). The psychology of procedural justice: A test of the group-value model. *Journal of Personality and Social Psychology*, 57, 830–838.

Tyler, T. R., & Cook, F. L. (1984). The mass media and judgments of risk: Distinguishing impact on personal and societal level judgments. *Journal of Personality and Social Psychology*, 47, 693–708.

Tyler, T. R., & Lind, E. A. (1990). Intrinsic versus community-based justice models: When does group membership matter? *Journal of Social Issues*, 46, 83–94.

Tyler, T. R., & Schuller, R. A. (1991). Aging and attitude change. *Journal of Personality and Social Psychology*, 61, 689–697.

Ugwuegbu, C. E. (1979). Racial and evidential factors in juror attribution of legal responsibility. *Journal of Experimental Social Psychology*, 15, 133–146.

Uleman, J. S. (1989). A framework for thinking intentionally about unintended thoughts. In J. S. Uleman & J. A. Bargh (Eds.), *Unintended thought: The limits of awareness, intention, and control*. New York: Guilford.

Umberson, D., & Hughes, M. (1987). The impact of physical attractiveness on achievement and psychological well-being. *Social Psychology Quarterly*, 50, 227–236.

Underwood, B., & Moore, B. (1982). Perspective-taking and altruism. *Psychological Bulletin*, 91, 143–173.

Unger, R. K. (1979). Whom does helping help? Paper presented at the Eastern Psychological Association convention, April.

Unger, R. K. (1985). Epistomological consistency and its scientific implications. *American Psychologist*, 40, 1413–1414.

UPI. (1970). September 23, 1967. Cited by P. G. Zimbardo, in The human choice: Individuation, reason, and order versus deindividuation, impulse, and chaos. In W. J. Arnold & D. Levine (Eds.), *Nebraska symposium on motivation, 1969*. Lincoln: University of Nebraska Press.

U.S. Department of Justice. (1980). *Sourcebook of criminal justice statistics*. Washington, D.C.: Government Printing Office.

U.S. Supreme Court, Plessy v. Ferguson. (1986). Quoted by L. J. Severy, J. C. Brigham, & B. R. Schlenker, *A contemporary introduction to social psychology*. New York: McGraw-Hill, p. 126.

Vaillant, G. E. (1977). *Adaptation to life*. Boston: Little, Brown.

Vallone, R. P., Griffin, D. W., Lin, S., & Ross, L. (1990). Overconfident prediction of future actions and outcomes by self and others. *Journal of Personality and Social Psychology*, 58, 582–592.

Vallone, R. P., Ross, L., & Lepper, M. R. (1985). The hostile media phenomenon: Biased perception and perceptions of media bias in coverage of the "Beirut Massacre." *Journal of Personality and Social Psychology*, 49, 577–585.

Vancouver, J. B., Rubin, B., & Kerr, N. L. (1991). Sex composition of groups and member motivation III: Motivational losses at a feminine task. *Basic and Applied Social Psychology*, 12, 133–144.

Van der Plight, J., Eiser, J. R., & Spears, R. (1987). Comparative judgments and preferences: The influence of the number of response alternatives. *British Journal of Social Psychology*, 26, 269–280.

Vanderslice, V. J., Rice, R. W., & Julian, J. W. (1987). The effects of participation in decision-making on worker satisfaction and productivity: An organizational simulation. *Journal of Applied Social Psychology*, 17, 158–170.

Van Lange, P. A. M. (1991). Being better but not smarter than others: The Muhammad Ali effect at work in interpersonal situations. *Personality and Social Psychology Bulletin*, 17, 689–693.

Van Staden, F. J. (1987). White South Africans' attitudes toward the desegregation of public amenities. *Journal of Social Psychology*, 127, 163–173.

Van Yperen, N. W., & Buunk, B. P. (1990). A longitudinal study of equity and satisfaction in intimate relationships. *European Journal of Social Psychology*, 20, 287–309.

Vaughan, K. B., & Lanzetta, J. T. (1981). The effect of modification of expressive displays on vicarious emotional arousal. *Journal of Experimental Social Psychology*, 17, 16–30.

Vaux, A. (1988). Social and personal factors in loneliness. *Journal of Social and Clinical Psychology*, 6, 462–471.

Verplanken, B. (1991). Persuasive communication of risk information: A test of cue versus message processing effects in a field experiment. *Personality and Social Psychology Bulletin*, 17, 188–193.

Vidmar, N. (1979). The other issues in jury simulation research. *Law and Human Behavior*, 3, 95–106.

Vidmar, N., & Laird, N. M. (1983). Adversary social roles: Their effects on witnesses' communication of evidence and the assessments of adjudicators. *Journal of Personality and Social Psychology*, 44, 888–898.

Visher, C. A. (1987). Juror decision making: The importance of evidence. *Law and Human Behavior*, 11, 1–17.

Visintainer, M. A., & Seligman, M. E. (1983, July/August). The hope factor. *American Health*, pp. 59–61.

Visintainer, M. A., & Seligman, M. E. P. (1985). Tumor rejection and early experience of uncontrollable shock in the rat. Unpublished manuscript, University of Pennsylvania. See also, M. A. Visintainer et al. (1982). Tumor rejection in rats after inescapable versus escapable shock. *Science*, 216, 437–439.

Vitelli, R. (1988). The crisis issue assessed: An empirical analysis. *Basic and Applied Social Psychology*, 9, 301–309.

Vollrath, D. A., Sheppard, B. H., Hinsz, V. B., & Davis, J. H. (1989). Memory performance by decision-making groups and individuals. *Organizational Behavior and Human Decision Processes*, 43, 289–300.

Wachtel, P. L. (1989). *The poverty of affluence: A psychological portrait of the American way of life*. Philadelphia: New Society Publishers.

Wachtler, J., & Counselman, E. (1981). When increasing liking for a communicator decreases opinion change: An attribution analysis of attractiveness. *Journal of Experimental Social Psychology*, 17, 386–395.

Wagstaff, G. (1982). Attitudes to rape: The "just world" strikes again? *Bulletin of the British Psychological Society*, 35, 277–279.

Wagstaff, G. F. (1983). Attitudes to poverty, the Protestant ethic, and political affiliation: A preliminary investigation. *Social Behavior and Personality*, **11**, 45–47.

Walker, I., & Mann, L. (1987). Unemployment, relative deprivation, and social protest. *Personality and Social Psychology Bulletin*, **13**, 275–283.

Walker, M., Harriman, S., & Costello, S. (1980). The influence of appearance on compliance with a request. *Journal of Social Psychology*, **112**, 159–160.

Wallace, M. *New York Times*, November 25, 1969.

Wallach, M. A., & Wallach, L. (1983). *Psychology's sanction for selfishness: The error of egoism in theory and therapy*. San Francisco: Freeman.

Wallbott, H. G. (1988). In and out of context: Influences of facial expression and context information on emotion attributions. *British Journal of Social Psychology*, **27**, 357–369.

Walster (Hatfield), E. (1965). The effect of self-esteem on romantic liking. *Journal of Experimental Social Psychology*, **1**, 184–197.

Walster (Hatfield), E., Aronson, V., Abrahams, D., & Rottman, L. (1966). Importance of physical attractiveness in dating behavior. *Journal of Personality and Social Psychology*, **4**, 508–516.

Walster (Hatfield), E., & Festinger, L. (1962). The effectiveness of "overheard" persuasive communications. *Journal of Abnormal and Social Psychology*, **65**, 395–402.

Walster (Hatfield), E., & Walster, G. W. (1978). *A new look at love*. Reading, MA: Addison-Wesley.

Walster (Hatfield), E., Walster, G. W., & Berscheid, E. (1978). *Equity: Theory and research*. Boston: Allyn and Bacon.

Ward, W. C., & Jenkins, H. M. (1965). The display of information and the judgment of contingency. *Canadian Journal of Psychology*, **19**, 231–241.

Warnick, D. H., & Sanders, G. S. (1980). The effects of group discussion on eyewitness accuracy. *Journal of Applied Social Psychology*, **10**, 249–259.

Wason, P. C. (1960). On the failure to eliminate hypotheses in a conceptual task. *Quarterly Journal of Experimental Psychology*, **12**, 129–140.

Watson, D. (1982). The actor and the observer: How are their perceptions of causality divergent? *Psychological Bulletin*, **92**, 682–700.

Watson, R. I., Jr. (1973). Investigation into deindividuation using a cross-cultural survey technique. *Journal of Personality and Social Psychology*, **25**, 342–345.

Watts, W. A. (1967). Relative persistence of opinion change induced by active compared to passive participation. *Journal of Personality and Social Psychology*, **5**, 4–15.

Weary, G., Harvey, J. H., Schwieger, P., Olson, C. T., Perloff, R., & Pritchard, S. (1982). Self-presentation and the moderation of self-serving biases. *Social Cognition*, **1**, 140–159.

Wehr, P. (1979). *Conflict regulation*. Boulder, Colo.: Westview Press.

Weiner, B. (1980). A cognitive (attribution)-emotion-action model of motivated behavior: An analysis of judgments of help-giving. *Journal of Personality and Social Psychology*, **39**, 186–200.

Weiner, B. (1981). The emotional consequences of causal ascriptions. Unpublished manuscript, UCLA.

Weiner, B. (1985). "Spontaneous" causal thinking. *Psychological Bulletin*, **97**, 74–84.

Weiner, B., Graham, S., Peter, O., & Zmuidinas, M. (1991). Public confession and forgiveness. *Journal of Personality*, **59**, 281–312.

Weinstein, N. D. (1980). Unrealistic optimism about future life events. *Journal of Personality and Social Psychology*, **39**, 806–820.

Weinstein, N. D. (1982). Unrealistic optimism about susceptibility to health problems. *Journal of Behavioral Medicine*, **5**, 441–460.

Weiss, J., & Brown, P. (1976). Self-insight error in the explanation of mood. Unpublished manuscript, Harvard University.

Wells, G. L. (1984). The psychology of lineup identifications. *Journal of Applied Social Psychology*, **14**, 89–103.

Wells, G. L. (1986). Expert psychological testimony. *Law and Human Behavior*, **10**, 83–95.

Wells, G. L., Ferguson, T. J., & Lindsay, R. C. L. (1981). The tractability of eyewitness confidence and its implications for triers of fact. *Journal of Applied Psychology*, **66**, 688–696.

Wells, G. L., & Leippe, M. R. (1981). How do triers of fact enter the accuracy of eyewitness identification? Memory for peripheral detail can be misleading. *Journal of Applied Psychology*, **66**, 682–687.

Wells, G. L., Lindsay, R. C. L., & Ferguson, T. (1979). Accuracy, confidence, and juror perceptions in eyewitness identification. *Journal of Applied Psychology*, **64**, 440–448.

Wells, G. L., Lindsay, R. C. L., & Tousignant, J. P. (1980). Effects of expert psychological advice on human performance in judging the validity of eyewitness testimony. *Law and Human Behavior*, **4**, 275–285.

Wells, G. L., & Luus, C. A. E. (1990). Police lineups as experiments: Social methodology as a framework for properly conducted lineups. *Personality and Social Psychology Bulletin*, **16**, 106–117.

Wells, G. L., & Murray, D. M. (1983). What can psychology say about the *Neil v. Biggers* criteria for judging eyewitness accuracy? *Journal of Applied Psychology*, **68**, 347–362.

Wells, G. L., & Murray, D. M. (1984). Eyewitness confidence. In G. L. Wells & E. F. Loftus (Eds.), *Eyewitness testimony: Psychological perspectives*. New York: Cambridge University Press.

Wells, G. L., & Petty, R. E. (1980). The effects of overt head movements on persuasion: Compatibility and incompatibility of responses. *Basic and Applied Social Psychology*, **1**, 219–230.

Wells, G. L., & Turtle, J. W. (1986). Eyewitness identification: The importance of lineup models. *Psychological Bulletin*, **99**, 320–329.

Wells, G. L., & Turtle, J. W. (1987). Eyewitness testimony research: Current knowledge and emergent controversies. *Canadian Journal of Behavioral Science*, **19**, 363–388.

Wells, G. L., Wrightsman, L. S., & Miene, P. K. (1985). The timing of the defense opening statement: Don't wait until the evidence is in. *Journal of Applied Social Psychology*, **15**, 758–772.

Wener, R., Frazier, W., & Farbstein, J. (1987, June). Building better jails. *Psychology Today*, pp. 40–49.

Wenzlaff, R. M., & Prohaska, M. L. (1989). When misery prefers company: Depression, attributions, and responses to others' moods. *Journal of Experimental Social Psychology*, **25**, 220–233.

Werner, C. M., & Kagehiro, D. K., & Strube, M. J. (1982). Conviction proneness and the authoritarian juror: Inability to disregard information or

attitudinal bias? *Journal of Applied Psychology,* **67,** 629–636.

West, S. G., & Brown, T. J. (1975). Physical attractiveness, the severity of the emergency and helping: A field experiment and interpersonal simulation. *Journal of Experimental Social Psychology,* **11,** 531–538.

West, S. G., Whitney, G., & Schnedler, R. (1975). Helping a motorist in distress: The effects of sex, race, and neighborhood. *Journal of Personality and Social Psychology,* **31,** 691–698.

Wetzel, C. G., & Insko, C. A. (1982). The similarity-attraction relationship: Is there an ideal one? *Journal of Experimental Social Psychology,* **18,** 253–276.

Weyant, J. M. (1984). Applying social psychology to induce charitable donations. *Journal of Applied Social Psychology,* **14,** 441–447.

Weyant, J. M., & Smith, S. L. (1987). Getting more by asking for less: The effects of request size on donations of charity. *Journal of Applied Social Psychology,* **17,** 392–400.

Wheeler, L., Koestner, R., & Driver, R. E. (1982). Related attributes in the choice of comparison others: It's there, but it isn't all there is. *Journal of Experimental Social Psychology,* **18,** 489–500.

Wheeler, L. Reis, H. T., & Bond, M. H. (1989). Collectivism-individualism in everyday social life: The middle kingdom and the melting pot. *Journal of Personality and Social Psychology,* **57,** 79–86.

White, G. L. (1980). Physical attractiveness and courtship progress. *Journal of Personality and Social Psychology,* **39,** 660–668.

White, G. L., Fishbein, S., & Rutsein, J. (1981). Passionate love and the misattribution of arousal. *Journal of Personality and Social Psychology,* **41,** 56–62.

White, G. L., & Kight, T. D. (1984). Misattribution of arousal and attraction: Effects of salience of explanations for arousal. *Journal of Experimental Social Psychology,* **20,** 55–64.

White, M. J., & Gerstein, L. H. (1987). Helping: The influence of anticipated social sanctions and self-monitoring. *Journal of Personality,* **55,** 41–54.

White, P. A. (1991). Ambiguity in the internal/external distinction in causal attribution. *Journal of Experimental Social Psychology,* **27,** 259–270.

White, P. A., & Younger, D. P. (1988). Differences in the ascription of transient internal states to self and other.

Journal of Experimental Social Psychology, **24,** 292–309.

White, R. (1984). *Fearful warriors: A psychological profile of U.S.-Soviet relations.* New York: Free Press.

White, R. K. (1969). Three not-so-obvious contributions of psychology to peace. *Journal of Social Issues,* **25**(4), 23–39.

White, R. K. (1971, November). Selective inattention. *Psychology Today,* pp. 47–50, 78–84.

White, R. K. (1977). Misperception in the Arab-Israeli conflict. *Journal of Social Issues,* **33**(1), 190–221.

Whitley, B. E., Jr. (1987). The effects of discredited eyewitness testimony: A meta-analysis. *Journal of Social Psychology,* **127,** 209–214.

Whitley, B. E., Jr., & Frieze, I. H. (1985). Children's causal attributions for success and failure in achievement settings: A meta-analysis. *Journal of Educational Psychology,* **77,** 608–616.

Whitman, R. M., Kramer, M., & Baldridge, B. (1963). Which dream does the patient tell? *Archives of General Psychology,* **8,** 277–282.

Whittaker, J. O., & Meade, R. D. (1967). Social pressure in the modification and distortion of judgment: A cross-cultural study. *International Journal of Psychology,* **2,** 109–113.

Whyte, G. (1992). Escalating commitment in individual and group decision making: A prospect theory approach. *Organizational Behavior and Human Decision Processes,* in press.

Wicker, A. W. (1969). Attitudes versus actions: The relationship of verbal and overt behavioral responses to attitude objects. *Journal of Social Issues,* **25,** 41–78.

Wicker, A. W. (1971). An examination of the "other variables" explanation of attitude-behavior inconsistency. *Journal of Personality and Social Psychology,* **19,** 18–30.

Wicklund, R. A. (1979). The influence of self-awareness on human behavior. *American Scientist,* **67,** 187–193.

Wicklund, R. A. (1982). Self-focused attention and the validity of self-reports. In M. P. Zanna, E. T. Higgins, & C. P. Herman (Eds.), *Consistency in social behavior: The Ontario symposium,* Vol. 2. Hillsdale, N.J.: Erlbaum.

Widom, C. S. (1989). Does violence beget violence? A critical examination of the literature. *Psychological Bulletin,* **106,** 3–28. (p. 80)

Widom, C. S. (1989). The cycle of violence. *Science, 244,* 160–166. (p. 80)

Wiegman, O. (1985). Two politicians in a realistic experiment: Attraction, discrepancy, intensity of delivery, and attitude change. *Journal of Applied Social Psychology,* **15,** 673–686.

Wiesel, E. (1985, April 6). The brave Christians who saved Jews from the Nazis. *TV Guide,* pp. 4–6.

Wilder, D. A. (1977). Perception of groups, size of opposition, and social influence. *Journal of Experimental Social Psychology,* **13,** 253–268.

Wilder, D. A. (1978). Perceiving persons as a group: Effect on attributions of causality and beliefs. *Social Psychology,* **41,** 13–23.

Wilder, D. A. (1981). Perceiving persons as a group: Categorization and intergroup relations. In D. L. Hamilton (Ed.). *Cognitive processes in stereotyping and intergroup behavior.* Hillsdale, N.J.: Lawrence Erlbaum.

Wilder, D. A. (1990). Some determinants of the persuasive power of in-groups and out-groups: Organization of information and attribution of independence. *Journal of Personality and Social Psychology,* **59,** 1202–1213.

Wilder, D. A., & Shapiro, P. (1991). Facilitation of outgroup stereotypes by enhanced ingroup identity. *Journal of Experimental Social Psychology,* **27,** 431–452.

Wilder, D. A., & Shapiro, P. N. (1984). Role of out-group cues in determining social identity. *Journal of Personality and Social Psychology,* **47,** 342–348.

Wilder, D. A., & Shapiro, P. N. (1989). Role of competition-induced anxiety in limiting the beneficial impact of positive behavior by out-group members. *Journal of Personality and Social Psychology,* **56,** 60–69.

Wiley, M. G., Crittenden, K. S., & Birg, L. D. (1979). Why a rejection? Causal attribution of a career achievement event. *Social Psychology Quarterly,* **42,** 214–222.

Wilkes, J. (1987, June). Murder in mind. *Psychology Today,* pp. 27–32.

Wilkinson, G. S. (1990, February). Food sharing in vampire bats. *Scientific American,* **262,** 76–82.

Williams, C. L. (1989). *Gender differences at work: Women and men in nontraditional occupations.* Berkeley: University of California Press.

Williams, J. E., & Best, D. L. (1990a).

Measuring sex stereotypes: A multination study. Newbury Park, CA: Sage.

Williams, J. E., & Best, D. L. (1990b). *Sex and psyche: Gender and self viewed cross-culturally.* Newbury Park, CA: Sage.

Williams, K. D. (1981). The effects of group cohesion on social loafing. Paper presented at the Midwestern Psychological Association convention.

Williams, K. D., Harkins, S., & Latané, B. (1981). Identifiability as a deterrent to social loafing: Two cheering experiments. *Journal of Personality and Social Psychology,* **40,** 303–311.

Williams, K. D., Jackson, J. M., & Karau, S. J. (1992). Collective hedonism: A social loafing analysis of social dilemmas. In D. A. Schroeder (Ed.), *Social dilemmas: Social psychological perspectives.* New York: Praeger.

Williams, K. D., & Karau, S. J. (1991). Social loafing and social compensation: The effects of expectations of coworker performance. *Journal of Personality and Social Psychology,* **61,** 570–581.

Williams, K. D., Nida, S. A., Baca, L. D., & Latané, B. (1989). Social loafing and swimming: Effects of identifiability on individual and relay performance of intercollegiate swimmers. *Basic and Applied Social Psychology,* **10,** 73–81.

Williams, R. M., Jr. (1975). Relative deprivation. In L. Coser (Ed.), *The idea of social structure: Papers in honor of Robert K. Merton.* New York: Harcourt Brace Jovanovich.

Williams, T. M. (Ed.) (1986). *The impact of television: A natural experiment in three communities.* Orlando, Fl.: Academic Press.

Williamson, G. M., & Clark, M. S. (1989). Providing help and desired relationship type as determinants of changes in moods and self-evaluations. *Journal of Personality and Social Psychology,* **56,** 722–734.

Willis, F. N., & Hamm, H. K. (1980). The use of interpersonal touch in securing compliance. *Journal of Nonverbal Behavior,* **5,** 49–55.

Wills, T. A. (1978). Perceptions of clients by professional helpers. *Psychological Bulletin,* **85,** 968–1000.

Wills, T. A. (1981). Downward comparison principles in social psychology. *Psychological Bulletin,* **90,** 245–271.

Wilson, D. K., Kaplan, R. M., & Schneiderman, L. J. (1987). Framing of decisions and selections of alternatives in health care. *Social Behaviour,* **2,** 51–59.

Wilson, D. K., Purdon, S. E., & Wallston, K. A. (1988). Compliance to health recommendations: A theoretical overview of message framing. *Health Education Research,* **3,** 161–171.

Wilson, D. K., Wallston, K. A., & King, J. E. (1987). The effects of message framing and self-efficacy on smoking cessation. Paper presented at the Southeastern Psychological Association Convention.

Wilson, D. W., & Donnerstein, E. (1979). Anonymity and interracial helping. Paper presented at the Southwestern Psychological Association convention.

Wilson, E. O. (1978). *On human nature.* Cambridge, Mass.: Harvard University Press.

Wilson, J. P., & Petruska, R. (1984). Motivation, model attributes, and prosocial behavior. *Journal of Personality and Social Psychology,* **46,** 458–468.

Wilson, R. C., Gaft, J. G., Dienst, E. R., Wood, L., & Bavry, J.L. (1975). *College professors and their impact on students.* New York: Wiley.

Wilson, R. S., & Matheny, Jr., A. P. (1986). Behavior-genetics research in infant temperament: The Louisville twin study. In R. Plomin & J. Dunn (Eds.), *The study of temperament: Changes, continuities, and challenges.* Hillsdale, N.J.: Erlbaum.

Wilson, T. D. (1985). Strangers to ourselves: The origins and accuracy of beliefs about one's own mental states. In J. H. Harvey & G. Weary (Eds.), *Attribution in contemporary psychology.* New York: Academic Press.

Wilson, T. D., Dunn, D. S., Kraft, D., & Lisle, D. J. (1989). Introspection, attitude change, and attitude-behavior consistency: The disruptive effects of explaining why we feel the way we do. In L. Berkowitz (Eds.), *Advances in experimental social psychology,* Vol. 22. San Diego, Ca.: Academic Press.

Wilson, T. D., Laser, P. S., & Stone, J. I. (1982). Judging the predictors of one's mood: Accuracy and the use of shared theories. *Journal of Experimental Social Psychology,* **18,** 537–556.

Wilson W. R. (1979). Feeling more than we can know: Exposure effects without learning. *Journal of Personality and Social Psychology,* **37,** 811–821.

Winch, R. F. (1958). *Mate selection: A study of complementary needs.* New York: Harper & Row.

Wing, R. R., & Jeffery, R. W. (1979). Outpatient treatments of obesity: A comparison of methodology and clinical results. *International Journal of Obesity,* **3,** 261–279.

Winter, F. W. (1973). A laboratory experiment of individual attitude response to advertising exposure. *Journal of Marketing Research,* **10,** 130–140.

Wispe, L. G., & Freshley, H. B. (1971). Race, sex, and sympathetic helping behavior: The broken bag caper. *Journal of Personality and Social Psychology,* **17,** 59–65.

Wittenberg, M. T., & Reis, H. T. (1986). Loneliness, social skills, and social perception. *Personality and Social Psychology Bulletin,* **12,** 121–130.

Wixon, D. R., & Laird, J. D. (1976). Awareness and attitude change in the forced-compliance paradigm: The importance of when. *Journal of Personality and Social Psychology,* **34,** 376–384.

Wolf, S. (1987). Majority and minority influence: A social impact analysis. In M. P. Zanna, J. M. Olson, & C. P. Herman (Eds.), *Social influence: The Ontario symposium on personality and social psychology,* Vol. 5. Hillsdale, N.J.: Erlbaum.

Wolf, S., & Latané, B. (1985). Conformity, innovation and the psychosocial law. In S. Moscovici, G. Mugny, & E. Van Avermaet (Eds.), *Perspectives on minority influence.* Cambridge: Cambridge University Press.

Wolf, S., & Montgomery, D. A. (1977). Effects of inadmissible evidence and level of judicial admonishment to disregard on the judgments of mock jurors. *Journal of Applied Social Psychology,* **7,** 205–219.

Woll, S. (1986). So many to choose from: Decision strategies in videodating. *Journal of Social and Personal Relationships,* **3,** 43–52.

Women on Words and Images (1972). *Dick and Jane as victims: Sex stereotyping in children's readers.* Princeton: Women on Words and Images. Cited by C. Tavris & C. Offir (1977) in *The longest war: Sex differences in perspective.* New York: Harcourt Brace Jovanovich, p. 177.

Wood, J. V. (1989). Theory and research concerning social comparisons of personal attributes. *Psychological Bulletin,* **106,** 231–248.

Wood, J. V., Saltzberg, J. A., & Goldsamt, L. A. (1990). Does affect induce self-focused attention? *Journal of Personality and Social Psychology,* **58,** 899–908.

Wood, J. V., Saltzberg, J. A., Neale, J. M., Stone, A. A., & Rachmiel, T. B. (1990). Self-focused attention, coping responses, and distressed mood in everyday life. *Journal of Personality and Social Psychology, 58,* 1027–1036.

Wood, W., & Eagly, A. H. (1981). Stages in the analysis of persuasive messages: The role of causal attributions and message comprehension. *Journal of Personality and Social Psychology, 40,* 246–259.

Wood, W., & Rhodes, N. (1991). Sex differences in interaction style in task groups. In C. Ridgeway (Ed.), *Gender and interaction: The role of microstructures in inequality.* New York: Springer-Verlag.

Worchel, S., & Andreoli, V. M. (1978). Facilitation of social interaction through deindividuation of the target. *Journal of Personality and Social Psychology, 36,* 549–556.

Worchel, S., Andreoli, V. A., & Folger, R. (1977). Intergroup cooperation and intergroup attraction: The effect of previous interaction and outcome of combined effort. *Journal of Experimental Social Psychology, 13,* 131–140.

Worchel, S., Axsom, D., Ferris, F., Samah, G., & Schweitzer, S. (1978). Deterrents of the effect of intergroup cooperation on intergroup attraction. *Journal of Conflict Resolution, 22,* 429–439.

Worchel, S., & Brown, E. H. (1984). The role of plausibility in influencing environmental attributions. *Journal of Experimental Social Psychology, 20,* 86–96.

Worchel, S., & Norvell, N. (1980). Effect of perceived environmental conditions during cooperation on intergroup attraction. *Journal of Personality and Social Psychology, 38,* 764–772.

Word, C. O., Zanna, M. P., & Cooper, J. (1974). The nonverbal mediation of self-fulfilling prophecies in interracial interaction. *Journal of Experimental Social Psychology, 10,* 109–120.

Workman, E. A., & Williams, R. L. (1980). Effects of extrinsic rewards on intrinsic motivation in the classroom. *Journal of School Psychology, 18,* 141–147.

Worringham, C. J., & Messick, D. M. (1983). Social facilitation of running: An unobtrusive study. *Journal of Social Psychology, 121,* 23–29.

Wright, E. F., Lüüs, C. A., & Christie, S. D. (1990). Does group discussion facilitate the use of consensus information in making causal attributions? *Journal*

of *Personality and Social Psychology, 59,* 261–269.

Wright, P., & Rip. P. D. (1981). Retrospective reports on the causes of decisions. *Journal of Personality and Social Psychology, 40,* 601–614.

Wrightsman, L. (1978). The American trial jury on trial: Empirical evidence and procedural modifications. *Journal of Social Issues, 34,* 137–164.

Wu, C., & Shaffer, D. R. (1987). Susceptibility to persuasive appeals as a function of source credibility and prior experience with the attitude object. *Journal of Personality and Social Psychology, 52,* 677–688.

Wu, D. Y. H., & Tseng, W. S. (1985). Introduction: The characteristics of Chinese culture. In D. Y. H. Wu and W. S. Tseng (Eds.), *Chinese culture and mental health.* San Diego, Ca.: Academic Press.

Wylie, R. C. (1979). *The self-concept (Vol. 2): Theory and research on selected topics.* Lincoln, Neb.: University of Nebraska Press.

Yinon, Y., Sharon, I., Gonen, Y., & Adam, R. (1982). Escape from responsibility and help in emergencies among persons alone or within groups. *European Journal of Social Psychology, 12,* 301–305.

Young, W. R. (1977, February). There's a girl on the tracks! *Reader's Digest,* pp. 91–95.

Younger, J. C., Walker, L., & Arrowood, J. A. (1977). Postdecision dissonance at the fair. *Personality and Social Psychology Bulletin, 3,* 284–287.

Yuchtman (Yaar), E. (1976). Effects of social-psychological factors on subjective economic welfare. In B. Strumpel (Ed.), *Economic means for human needs.* Ann Arbor: Institute for Social Research, University of Michigan.

Yuille, J. C., & Cutshall, J. L. (1986). A case study of eyewitness memory of a crime. *Journal of Applied Psychology, 71,* 291–301.

Yukl, G. (1974). Effects of the opponent's initial offer, concession magnitude, and concession frequency on bargaining behavior. *Journal of Personality and Social Psychology, 30,* 323–335.

Yzerbyt, V. Y., & Leyens, J-P. (1991). Requesting information to form an impression: The influence of valence and confirmatory status. *Journal of Experimental Social Psychology, 27,* 337–356.

Zabelka, G. (1980, August). I was told it

was necessary. *Sojourners,* pp. 12–15. (Interview by C. C. McCarthy.)

Zajonc, R. B. (1965). Social facilitation. *Science, 149,* 269–274.

Zajonc, R. B. (1968). Attitudinal effects of mere exposure. *Journal of Personality and Social Psychology, 9,* Monograph Suppl. No. 2, part 2.

Zajonc, R. B. (1970, February). Brainwash: Familiarity breeds comfort. *Psychology Today,* pp. 32–35, 60–62.

Zajonc, R. B. (1980). Feeling and thinking: Preferences need no inferences. *American Psychologist, 35,* 151–175.

Zajonc, R. B., & Sales, S. M. (1966). Social facilitation of dominant and subordinate responses. *Journal of Experimental Social Psychology, 2,* 160–168.

Zander, A. (1969). Students' criteria of satisfaction in a classroom committee project. *Human Relations, 22,* 195–207.

Zanna, M. P. (in press). Message receptivity: A new look at the old problem of open- vs. closed-mindedness. In A. Mitchell (Ed.), *Advertising: Exposure, memory and choice.* Hillsdale, NJ: Erlbaum.

Zanna, M. P., Crosby, F., & Loewenstein, G. (1987). Male reference groups and discontent among female professionals. In B. A. Gutek & L. Larwood (Eds.), *Women's career development.* Newbury Park, Ca.: Sage.

Zanna, M. P., Haddock, G., & Esses, V. M. (1990). The nature of prejudice. Paper presented at the Nags Head Conference on Stereotypes and Intergroup Relations, Kill Devil Hills, North Carolina.

Zanna, M. P., Klosson, E. C., & Darley, J. M. (1976). How television news viewers deal with facts that contradict their beliefs: A consistency and attribution analysis. *Journal of Applied Social Psychology, 6,* 159–176.

Zanna, M. P., & Olson, J. M. (1982). Individual differences in attitudinal relations. In M. P. Zanna, E. T. Higgins, & C. P. Herman, *Consistency in social behavior: The Ontario symposium,* Vol. 2. Hillsdale, N.J.: Erlbaum.

Zanna, M. P., Olson, J. M., & Fazio, R. H. (1981). Self-perception and attitude-behavior consistency. *Personality and Social Psychology Bulletin, 7,* 252–256.

Zanna, M. P., & Pack, S. J. (1975). On the self-fulfilling nature of apparent sex differences in behavior. *Journal of Experimental Social Psychology, 11,* 583–591.

Zanna, M. P., & Rempel, J. K. (1988). Attitudes: A new look at an old concept. In D. Bar-Tal & A. Kruglanski (Eds.), *The social psychology of knowledge*. New York: Cambridge University Press.

Zebrowitz-McArthur, L. (1988). Person perception in cross-cultural perspective. In M. H. Bond (Ed.), *The cross-cultural challenge to social psychology*. Newbury Park, Ca.: Sage.

Zeisel, H., & Diamond, S. S. (1978). The jury selection in the Mitchell-Stans conspiracy trial. *American Bar Foundation Research Journal, 1976,* **1,** 151–174 (see p. 167). Cited by L. Wrightsman, The American trial jury on trial: Empirical evidence and procedural modifications. *Journal of Social Issues,* **34,** 137–164.

Zenker, S., Leslie, R. C., Port, E., & Kosloff, J. (1982). The sequence of outcomes and ESP: More evidence for a primacy effect. *Journal of Personality and Social Psychology,* **8,** 233–238.

Zillmann, D. (1988). Cognition-excitation interdependencies in aggressive behavior. *Aggressive Behavior,* **14,** 51–64.

Zillmann, D. (1989). Aggression and sex: Independent and joint operations. In H. L. Wagner & A. S. R. Manstead (Eds.), *Handbook of psychophysiology: Emotion and social behavior*. Chichester: John Wiley.

Zillmann, D. (1989). Effects of prolonged consumption of pornography. In D. Zillmann & J. Bryant (Eds.), *Pornography: Research advances and policy considerations*. Hillsdale, NJ: Erlbaum.

Zimbardo, P. G. (1970). The human choice: Individuation, reason, and order versus deindividuation, impulse, and chaos. In W. J. Arnold & D. Levine (Eds.), *Nebraska symposium on motivation, 1969*. Lincoln: University of Nebraska Press.

Zimbardo, P. G. (1971). *The psychological power and pathology of imprisonment*. A statement prepared for the U.S. House of Representatives Committee on the Judiciary, Subcommittee No. 3: Hearings on Prison Reform, San Francisco, Calif., October 25.

Zimbardo, P. G. (1972). The Stanford prison experiment. A slide/tape presentation produced by Philip G. Zimbardo, Inc., P. O. Box 4395, Stanford, Calif. 94305.

Zimbardo, P. G., Ebbesen, E. B., & Maslach, C. (1977). *Influencing attitudes and changing behavior*. Reading, Mass.: Addison-Wesley.

Zimbardo, P. G., & Hartley, C. F. (1985). Cults go to high school: A theoretical and empirical analysis of the initial stage in the recruitment process. *Cultic Studies Journal,* **2,** 91–147.

Zukier, H. A. (1982). The dilution effect: The role of the correlation and the dispersion of predictor variables in the use of nondiagnostic information. *Journal of Personality and Social Psychology,* **43,** 1163–1174.

ACKNOWLEDGMENTS

CHAPTER 1

Text Quotes: p. 2: Milgram, S. (1984). Cyranoids. From talk delivered by Stanley Milgram at the American Psychological Association Convention, Aug. 16, 1984, Toronto, Canada, and published in Milgram, S. (1992). *The individual in a social world: Essays and experiments*, 2nd ed., 343. New York: McGraw-Hill Book Company. Copyright 1992 Alexandra Milgram. / p. 2: Schlesinger, A. M., Jr. (1972). *A thousand days*, 255. Copyright © 1972. Reprinted by permission of Houghton Mifflin Company. / p. 18: Schulman, H., & Scott, J. (1987). Problems in the use of survey questions to measure public opinion. *Science*, **236**, 957-959. Copyright 1987 by the American Association for the Advancement of Science. / p. 19: Tversky, A., & Kahneman, D. (1981). The framing of decisions and the psychology of choice. *Science*, **221**, 453-458. Copyright 1981 by the American Association for the Advancement of Science.
Photos: p. 1: Robert Brenner/PhotoEdit / p. 4: John Lei/Omni Photo / p. 8 (Fig. 1-2): Ronald C. James / p. 13: Robert E. Murowchick/Photo Researchers / p. 17: Rhoda Sidney/The Image Works / p. 20: Bob Daemmrich/Stock, Boston / p. 28: UPI/Bettmann Newsphotos
Cartoons: p. 7: © 1981 by Sidney Harris—American Scientist /Magazine. / p. 18: Doonesbury copyright 1980 G. B. Trudeau. Reprinted with permission of Universal Press Syndicate. All rights reserved. / p. 26: © 1988 by Sidney Harris—American Scientist Magazine.

CHAPTER 2

Text Quotes: p. 36: Eliot, T. S. (1924, 1925). The hollow men. Copyright 1930, 1940, 1941, 1942, 1943, © 1958, 1962, 1963 by T. S. Eliot. Copyright 1954, © 1956, 1959, 1963 by Thomas Stearns Eliot. Copyright 1934, 1936 by Harcourt, Brace & World, Inc. All rights reserved. / p. 37: Lewis, C. S. (1943, 1960). *Mere Christianity*, 18-19. Copyright © 1943, 1960. Reprinted by permission of HarperCollins London. / p. 39: Roethke, T. (1966). Lines upon leaving a sanitarium. *The collected poems of Theodore Roethke*. Copyright © 1937, 1954, 1957, 1958, 1959, 1960, 1961, 1962, 1963, 1964, 1965, 1966 by Beatrice Roethke as Administratrix of the Estate of Theodore Roethke. Copyright © 1932, 1934, 1935, 1936, 1937, 1938, 1939, 1940, 1941, 1942, 1946, 1947, 1948, 1949, 1950, 1951, 1952, 1953, 1954, 1955, 1956, 1957, 1958, 1961 by Theodore Roethke. / p. 52: Fischhoff, B., & Bar-Hillel, M. (1984). Diagnosticity and the base rate effect. *Memory and Cognition*, **12**, 402-410. Reprinted by permission of the Psychonomic Society, Inc., and the author. / p. 53: Zukier, H. A. (1982). The dilution effect: The role of the correlation and the dispersion of predictor variables in the use of nondiagnostic information. *Journal of Personality and Social Psychology*, **43**, 1163-1174. Reprinted by permission of the American Psychological Association. / p. 54: Allport, G. (1954). *The nature of prejudice*. © 1979 by Addison-Wesley Publishing Company, Inc. Reprinted by permission.
Figures: p. 41, Fig. 2-1: Vallone, R. P., Ross, L., & Lepper, M. R. (1985). The hostile media phenomenon: Biased perception and perceptions of media bias in coverage of the "Beirut Massacre."

Journal of Personality and Social Psychology, 49, 577-585. Copyright 1985 by the American Psychological Association. Reprinted by permission. / p. 58, Fig. 2-3: McFarland, C., Ross, M., & DeCourville, N. (1989). Women's theories of menstruation and biases in recall of menstrual symptoms. *Journal of Personality and Social Psychology,* **57**, 522-531. Copyright 1989 by the American Psychological Association. Reprinted by permission.
Photos: p. 34: Bill Gallery/Stock, Boston / p. 36: Richard Pasley/Stock, Boston / p. 39: Bob Daemmrich/Stock, Boston / p. 42: Daid Madison/Duomo / p. 43 (Fig. 43): Myron Rothbart / p. 44: Tom Cheek/Stock, Boston / p. 46: D. Hill/The Image Works / p. 48: Reuters/Bettmann Newsphotos / p. 51: UPI/Bettman Newsphotos / p. 54: Spencer Grant/Photo Researchers / p. 56: Robert Nichols/Black Star / p. 60: Brad Bower/Stock, Boston
Cartoon: p. 59: By permission of Peter Steiner.

CHAPTER 3

Text Quotes: pp. 92 and 95: La Rochefoucauld, F. (1965). *Maxims, 1665.* Translated by J. Heard. Reprinted by permission of Branden Publishing, Boston / p. 93: Taylor, S. E. (1989). *Positive illusions: Creative self-deception and the healthy mind.* Copyright 1989. Reprinted by permission of Basic Books, a Division of HarperCollins Publishers. / p. 93: Allport, G. W. (1978). *Waiting for the Lord: 33 Mediations on God and Man* (edited by P. A. Bertocci). Copyright © 1978 by Peter Bertocci. Reprinted by permission of Macmillan Publishing Company. / pp. 96, 103, 56a: James, W. (1890, 1950). *The principles of psychology, volume 2.* Reprinted by permission of Dover Books. / p. 105: MacKay, J. L. (1980). Selfhood: Comment on Brewster Smith. *American Psychologist,* **35**, 106-107. Copyright © 1980 by the American Psychological Association. Reprinted by permission. / p. 107: Bandura, A. (1982). Self-efficiency: Mechanism in human agency. *American Psychologist,* **37**, 106-107. Reprinted by permission of the American Psychological Association.
Figures: p. 77, Fig. 3-1: Kelly, H. H. (1973). The Process of Causal attribution. *American Psychologist,* **28**, 106-107. Reprinted by permission of the American Psychological Association. / p. 79, Fig. 3-2: Jones, E. E., & Harris, V. A. (1967). The attribution of attitudes. *Journal of Experimental Social Psychology,* **3**, 2-24. Reprinted by permission. / p. 82, Fig. 3-3: Ross, L. D., Amabile, T. M., & Steinmetz, J. L. (1977). Social Roles, social control, and biases in social-perception processes. *Journal of Personality and Social Psychology,* **35**, 485-494. Reprinted by permission of the American Psychological Association and the author.
Photos: p. 72: Bob Daemmrich/The Image Works / p. 75: Grant DeLuc/Monkmeyer / p. 80: Richard B. Levine / p. 83: A. Tannenbaum/Sygma / p. 85: Laura Luongo/Gamma Liaison / p. 89: Carol Palmer/The Picture Cube / p. 92: Grace Davies/Omni Photo Communications / p. 97: Dave Bartruff/Photo 20-20 / p. 99: Barbara Rios/Photo Researchers / p. 103: Shelly Katz/Black Star / p. 106: Reuters/Bettman Newsphotos

Cartoons: p. 76: Drawing by Modell; © 1976 The New Yorker Magazine, Inc. / p. 91: Drawing by Sempe; © 1984 The New Yorker Magazine, Inc. / p. 94: Drawing by R. Chast; © 1990 The New Yorker Magazine, Inc. / p. 95: Drawing by Ross; © 1988 The New Yorker Magazine, Inc. / p. 102: Drawing by Dana Fradon; © 1983 The New Yorker Magazine, Inc. / p. 107: Drawing by Koren; © 1983 The New Yorker Magazine, Inc.

CHAPTER 4

Text Quotes: p. 113: Eliot, T. S. (1924, 1925). The hollow men. Copyright 1930, 1940, 1941, 1942, 1943, © 1958, 1962, 1963 by T. S. Eliot. Copyright 1954, © 1956, 1959, 1963 by Thomas Stearns Eliot. Copyright 1934, 1936 by Harcourt, Brace & World, Inc. All rights reserved. / p. 119: La Rochefoucauld, F. (1965). *Maxims, 1665.* Translated by J. Heard. Reprinted by permission of Branden Publishing, Boston. / p. 124: Hyman, R. (1981). Cold reading: How to convince strangers that you know all about them. In K. Frazier (Ed.), *Paranormal borderlands of science.* Reprinted by permission of *Skeptical Inquirer,* Buffalo, New York. / p. 127: Arendt, H. (1945). Organized guilt and universal responsibility. *Jewish Frontier,* 1945, **12**. © Jewish Frontier. Reprinted by permission. / p. 129: Grunberger, R. (1971). *The 12-Year-Reich: A social history of Nazi Germany 1933-1945.* Copyright Henry Holt & Company, Inc. Reprinted by permission. / p. 137: Lewis, C. S. (1943, 1960). *Mere Christianity.* Copyright © 1943, 1960. Reprinted by permission of HarperCollins London. / p. 131: James, W. (1890; reprinted 1950). *The principles of psychology, volume 2.* Reprinted by permission of Dover Books.
Figures: p. 119, Fig. 4-2: Lieberman, S. (1956). The effects of changes in roles on the attitudes of role occupants. *Human Relations,* **9**, 385-402. Reprinted by permission of Plenum Press and the author. / p. 121, Fig. 4-3: Festinger, L., & Carlsmith, J. M. (1959). Cognitive consequences of forced compliance. *Journal of Abnormal and Social Psychology,* **58**, 203-210. Reprinted by permission of the American Psychological Association.
Photos: p. 110: Owen Franken/Stock, Boston / p. 113: Bettmann Archive / p. 118: Michael Newman/PhotoEdit / p. 122: Bob Daemmrich/The Image Works / p. 128: Cindy Karp/Black Star / p. 130: Sybil Shelton/Monkmeyer / p. 132: Christina Rose Mufson/Comstock / p. 139 A & B: Courtesy of Fritz Strack / p. 141 A, B, & C: Bernieri, F., Davis, J., Rosenthal, R., & Knee, C. (1991). Interactional synchrony and the social affordance of rapport: A validation study. Unpublished manuscript, Oregon State University, Corvallis, OR.
Cartoons: p. 123: © 1984 The New Yorker and Joseph Farris. / p. 125: Born Loser reprinted by permission of UFS, Inc. / p. 133: Drawing by Weber; © 1987 The New Yorker Magazine, Inc. / p. 140: Drawing by Frascino; © 1991 The New Yorker Magazine, Inc. / p. 143: Sally Forth by Greg Howard. Reprinted with special permission of North America Syndicate. / p. 146: Drawing by C. Barsotti; © 1988 The New Yorker Magazine, Inc.

CHAPTER 5

Text Quotes: p. 153: Forer, B. R. (1949). The fallacy of personal validation: A classroom demonstration of gullibility. *Journal of Abnormal and Social Psychology,* **44,** 118-123. Reprinted by permission of the American Psychological Association. / p. 155: Jeffrey, R. (1964). The Psychologist as an expert witness on the issue of insanity. *American Psychologist,* **19,** 838-843. Reprinted by permission of the American Psychological Association. / pp. 157, 158: Rosenhan, D. L. (1973). On being sane in insane places. *Science,* **179,** 250-258. Copyright 1973 by the American Association for the Advancement of Science. / pp. 158, 159: Snyder, M. (1981). Seek, and ye shall find: Testing hypotheses about other people. In E. T. Higgins, C. P. Herman, & M. P. Zanna (Eds.), *Social cognitions: The Ontario symposium on personality and social psychology.* Reprinted by permission of Lawrence Erlbaum Associates, Inc., and the author. / p. 160: Meehl, P. E. (1986). Causes and effects of my disturbing little book. *Journal of Personality Assessment,* **50,** 370-375. Reprinted by permission of Lawrence Erlbaum Associates, Inc., and the author. / p. 160: Dawes, R. M. (1976). Shallow psychology. In J. S. Carroll & J. W. Payne (Eds.), *Cognition and social behavior.* Reprinted by permission of Lawrence Erlbaum Associates, Inc., and the author. / p. 162: Thomas, L. (1978). Hubris in science? *Science,* **200,** 1459-1462. Copyright 1978 by the American Association for the Advancement of Science. / p. 163: Taylor, S. E. (1989). *Positive illusions: Creative self-deception and the healthy mind.* Copyright © 1989. Reprinted by permission of Basic Books, Inc., a Division of HarperCollins Publishers. / p. 164: La Rochefoucauld, F. (1965). *Maxims, 1665.* Translated by J. Heard. Reprinted by permission of Branden Publishing, Boston.

Figures: p. 154, Fig. 5-1: Johnson, J. T., Gain, L. M., Falke, T. L., Hayman, J., & Perillo, E. (1985). The "Barnum Effect" revisited: Cognitive and motivational factors in the acceptance of personality descriptions. *Journal of Abnormal and Social Psychology,* **49,** 1378-1391. Reprinted by permission of the American Psychological Association. / p. 166, Fig. 5-3: Forgas, J. P., Bower, G. H., & Krantz, S. E. (1984). The influence of mood on perceptions of social interactions. *Journal of Experimental Social Psychology,* **20,** 497-513. Reprinted by permission of Academic Press, Inc., and the author.

Photos: p. 150: Bob Daemmrich/Stock Boston / p. 153: John Eastcott/Yva Momatuk/The Image Works / p. 156: Adam J. Stoltman/Duomo / p. 157: AP/World Wide Photos / p. 161: David H. Wells/The Image Works / p. 168: Ed Lettau/Photo Researchers / p. 170: Frank Siteman/The Picture Cube / p. 172: Daniel Needham/Envision / p. 174: Michael Hayman/Photo Researchers / p. 177: Ellis Herwig/Stock, Boston

CHAPTER 6

Text Quotes: p. 187: Robertson, I. (1987). *Sociology,* 67. Reprinted by permission of Worth Publishers, New York. / p. 195: Auden, W. H. (1977). Some thirty inches from my nose. *The Faber Book of Epigrams and Epitaphs.* Copyright © by The Estate of W. H. Auden. / p. 199: Hassan, I. N. (1980). Role and status of women in Pakistan: An empirical research review. *Pakistan Journal of Psychology,* **13,** 36-56. Reprinted by permission of Pakistan Journal of Psychology. / p. 199: Hall, J. A. (1985). *Nonverbal sex differences: Communication accuracy and expressive style,* 152-153. Reprinted by permission of The Johns Hopkins University Press, Baltimore and London. / p. 203: Zimbardo, P. G. (1971). *The psychological power and pathology of imprisonment.* A statement prepared for the U.S. House of Representatives Committee on the Judiciary, Subcommittee No. 3: Hearings on Prison Reform, San Francisco, California, October 25. Reprinted by permission of Philip G. Zimbardo, Inc. / p. 209: Baumeister, R. F. (1991). *Meanings of life.* Reprinted by permissin of Guilford Press.

Figures: p. 191, Fig. 6-1: Cialdini, R. B., Kallgren, C. A., & Reno, R. R. (1991). A focus theory of normative conduct: A theoretical refinement and reevaluation of the role of norms in human behavior. *Advances in Experimental Social Psychology,* **24,** 201-234. Reprinted by permission of Academic Press, Inc., and the author. / p. 214, Fig. 6-2: Eagley, A. H., & Wood, W. (1991). Explaining sex differences in social behavior: A meta-analytic perspective. *Personality & Social Psychology Bulletin,* **17,** 306-315. Reprinted by permission of Sage Publications, Inc.

Photos: p. 184: Kaku Kurita/Gamma Liaison / p. 186: A. Tannenbaum/Sygma / p. 189: Shelley Rotneck/Omni Photo Communications / p. 191: Kat/Nicol/Woodfin Camp Associates / p. 195: P. Durand/Sygma / p. 198: (top) Institute Creative Bank; (bottom) Eunice Harris/The Picture Cube / p. 201: (right) Tony Korody/Sygma; (left) Memo Zack/Sygma / p. 202: Philip Zimbardo / p. 207: (left) Bob Deammrich/The Image Works; (right) Willie Hill, Jr./The Image Works / p. 213: Evelyn Scolney/Monkmeyer Press.

Cartoons: p. 193: Drawing by P. Steiner; © 1980 The New Yorker Magazine, Inc. / p. 194: Drawing by Handelsman; © 1979 The New Yorker Magazine, Inc. / p. 196: Drawing by Mankoff; © 1988 The New Yorker Magazine, Inc. / p. 199: Sally Forth by Greg Howard. Reprinted with special permission of North America Syndicate. / p. 200: Drawing by W. Steig; © 1989 The New Yorker Magazine, Inc. / p. 208: Doonesbury copyright 1989 G. B. Trudeau. Reprinted by permission of Universal Press Syndicate. All rights reserved. / p. 210: Drawing by Frascino; © 1991 The New Yorker Magazine, Inc.

CHAPTER 7

Text Quotes: p. 228: Ross, L. D. (1988). Situationist perspectives on the obedience experiments. Review of A. G. Miller's *The obedience experiments. Contemporary Psychology,* **33,** 101-104. Reprinted by permission of the American Psychological Association. / pp. 229, 231, 233, 234, 236, 237: Milgram, S. (1974). *Obedience to authority.* Copyright © 1974 by Stanley Milgram. Reprinted by permission of HarperCollins Publishers Inc. / p. 232: Fisher, R. (1981, March). Preventing nuclear war. *Bulletin of the Atomic Scientists,* 11-17. Copyright © 1981 by the Educational Foundation for Nuclear Science, 6042 South Kimbark, Chicago, Illinois 60637, USA. A one-year subscription is $30. / p. 239: Arendt, H. (1963). *Eichmann in Jerusalem: A report on the banality of evil.* Copyright © 1963, 1964 by Hannah Arendt. Used by permission of Viking Penguin, a division of Penguin Books USA Inc. / p. 255: Berger, P. (1963). *Invitation to sociology: A humanistic perspective.* Reprinted by permission of Anchor Books, an imprint of Bantam Doubleday Dell Publishing Group Inc. / pp. 255-256: McGuire, W. J., McGuire, C. V., Child, P., & Fujioka, T. (1978). Salience of ethnicity in the spontaneous self-concept as a function of one's ethnic distinctiveness in the social environment. *Journal of Personality and Social Psychology,* **36,** 511-520. Reprinted by permission of the American Psychological Association.

Figures: p. 223, Fig. 7-1: Sherif, M., & Sherif, C. W. (1969). *Social psychology.* Copyright © 1969 by Muzafer Sherif and Carolyn W. Sherif. Reprinted by permission of HarperCollins Publishers. / p. 230, Fig. 7-4: Milgram, S. (1965). Some conditions of obedience and disobedience to authority. *Human Relations,* **18,** 57-76. Reprinted by permission of Plenum Press and Mrs. Alexandra Milgram. / p. 240, Fig. 7-5: Milgram, S., Bickman, L., & Berkowitz, L. (1969). Note on the drawing power of crowds of different size. *Journal of Personality and Social Psychology,* **13,** 79-82. Copyright 1969 by the American Psychological Association. Reprinted by permission. / p. 242, Fig. 7-6: Based on data from Asch, S. E. (1955, November). Opinions and social pressure. *Scientific American,* 31-35. Copyright © 1955 by Scientific American, Inc. All rights reserved. / p. 252: Fig. 7-8: Remley, A. (1988, October). From obedience to independence. *Psychology Today,* 56-59. Copyright © 1988 Sussex Publishers, Inc. Reprinted by permission.

Photos: p. 218: Art Stein/Folio, Inc. / p. 224: AP/World Wide Photos / p. 227: William Vendivert / p. 229: 1965 by Stanley Milgram, from the film Obedience, distributed by the Pennsylvania State University, PCR. / p. 233: Andrew Holbrooke/Black Star / p. 235: Bob Krist/Black Star / p. 238: Seth Resnick/Stock, Boston / p. 241: The Photo Works / p. 243: Photofest / p. 244: AP/Wide World Photos / p. 251: S. Chester/Comstock / p. 254: Photofest

Cartoons: p. 221: Drawing by W. B. Park; © 1988 The New Yorker Magazine, Inc. / p. 222: Drawing by Booth; © 1977 The New Yorker Magazine, Inc. / p. 245: Drawing by Mankoff; © 1980 The New Yorker Magazine, Inc. / p. 249: The Far Side by Gary Larson. Reprinted by permission of Chronicle Features, San Francisco. / p. 253: Calvin and Hobbes copyright 1985 Universal Press Syndicate. Reprinted by permission. All rights reserved.

CHAPTER 8

Text Quotes: p. 273: Strunk, W. & White, E. B. (1979). *The elements of style,* 3rd edition. Copyright © 1979 by Macmillan Publishing Company. Reprinted by permission of Macmillan Publishing Company. / pp. 289, 289: Conway, F., & Siegelman, Jr. (1979). *Snapping: America's epidemic of sudden personality change,* 234, 236. Copyright © 1979 by Jim Siegelman & Flo Conway. Reprinted by permission of Sterling Lord Literistic, Inc.

Figures: p. 271, Fig. 8-2: Janis, I. L., Kaye, D., & Kirschner, P. (1965). Facilitating effects of eating while reading on responsiveness to persuasive communications. *Journal of Personality and Social Psychology,* **1,** 181-186. Copyright 1965 by the American Psychological Association. Reprinted by permission. / p. 274, Fig. 8-3: Aronson, E., Turner, J. A., & Carlsmith, J. M. (1963). Communicator credibility and communicator discrepancy as determinants of opinion change. *Journal of Abnormal and Social Psychology,* **67,** 31-36. Copyright 1963 by the American Psychological Association. Reprinted by permission. / p. 275, Fig. 8-4: Hovland, C. I., Lumsdaine, A. A., & Sheffield, F. D. (1949). *Experiments on mass communication: Studies in social psychology in World War II,* **3.** Copyright © 1949 by Princeton University Press. © renewed 1977. Reprinted by permission of Princeton University Press. / p. 278, Fig. 8-6: McGuire, W. J. (1978). An information-processing model of advertising effectiveness. In H. L. Davis & A. J. Silk (Eds). *Behavioral and management sciences in marketing.* Copyright © 1978 by John Wiley & Sons, Inc. All rights reserved. Reprinted by permission of Ronald Press, a Division of John Wiley & Sons, Inc. / p. 280, Fig. 8-7: Maccoby, N. (1980). Promoting positive health behaviors in adults. In L. A. Bond & J. C. Rosen (Eds.) *Competence and coping during adulthood.* Reprinted by permission

of the Vermont Conference on Primary Prevention. / p. 281, Fig. 8-8: Chaiken, S., & Eagly, A. H. (1978). Communication modality as a determinant of message persuasiveness and message comprehensibility. *Journal of Personality and Social Psychology, 34,* 605-614. Copyright 1978 by the American Psychological Association. Reprinted by permission. / p. 285, Fig. 8-9: Petty, R. E., Cacioppo, J. T., & Goldman, R. (1981). Personal involvement as a determinant of argument-based persuasion. *Journal of Personality and Social Psychology, 41,* 847-855. Copyright 1981 by the American Psychological Association. Reprinted by permission. / p. 294, Fig. 8-11: McAlister, A., Perry, C., Killen, J., Slinkard, L. A., & Maccoby, N. (1980). Pilot study of smoking, alcohol and drug abuse prevention. *American Journal of Public Health, 70,* 719-721. Reprinted by permission of the American Public Health Association.

Photos: p. 260: Institute Creative Bank / p. 263: Courtesy NW Ayer, Partnership for a Drug-Free America / p. 264: Courtesy Swan Technologies / p. 269: David Butow/Black Star / p. 273: Bill Swersey/Gamma Liaison / p. 283: R. Bossu/Sygma / p. 287: Ken Harp/Omni Photo Communications / p. 291: D. Wells/The Image Works / p. 297: Tony Freeman/PhotoEdit
Cartoons: p. 266: Drawing by C. Barsotti; © 1987 The New Yorker Magazine, Inc. / p. 288: Drawing by Charles Addams; © 1982 The New Yorker Magazine, Inc. / p. 290: The Far Side copyright 1987 Universal Press Syndicate. Reprinted by permission. All rights reserved.

CHAPTER 9

Text Quotes: p. 320: Zimbardo, P. G., Ebbesen, E. B., & Maslach, C. (1977). *Influencing attitudes and changing behavior,* 186. Reprinted by permission of McGraw-Hill Book Company. / p. 330: Schlesinger, A. M., Jr. (1965). *A thousand days,* 255. Reprinted by permission of Houghton Mifflin Company. / p. 330: Speer, A. (1971). *Inside the Third Reich: Memoirs,* 379. Translated by P. Winston & C. Winston. Reprinted by permission of Avon Books and Macmillan, Inc. / p. 333: Box 9-1: Janis, I. L. (1982). Counteracting the adverse effects of concurrence-seeking in policy-planning groups: Theory and research perspectives. In H. Brandstatter, J. H. Davis, & G. Stocker-Kreichgauer (Eds). *Group decision making,* 477-501. Adapted by permission of Academic Press and the author.
Figures: p. 308, Fig. 9-1: Zajonc, R. B., & Sales, S. M. (1966): Social facilitation of dominant and subordinate responses. *Journal of Experimental and Social Psychology, 2,* 160-168. Reprinted by permission of Academic Press and the author. / p. 314, Fig. 9-4: Jackson, J. M., & Williams, K. D. (1988). Social loafing: A review and theoretical analysis. Unpublished manuscript, Fordham University. Reprinted by permission of Jeffrey M. Jackson. / p. 319, Fig. 9-6: Diener, E., Fraser, S. C., Beaman, A. L., & Kelem, R. T. (1976). Effects of deindividuation variables on stealing among Halloween trick-or-treaters. *Journal of Personality and Social Psychology, 33,* 178-183. Copyright 1976 by the American Psychological Association. Reprinted by permission. / p. 325, Fig. 9-8: Myers, D. G., & Bishop, G. D. (1970). Discussion effects on racial attitudes. *Science, 221,* 8/21, 778ff. Copyright 1970 by the American Association for the Advancement of Science. Reprinted by permission. / p. 328, Fig. 9-9: Myers, D. G. (1978). Polarizing effects of social comparison. *Journal of Experimental Social Psychology, 14,* 554-563. Reprinted by permission of Academic Press and the author. / p. 332, Fig. 9-10: Janis, I. L., & Mann, L. (1977). *Decision-making: A psychological analysis of conflict, choice and commitment,* 132. Copyright © 1977 by The

Free Press. Reprinted by permission of The Free Press, a Division of Macmillan, Inc.
Photos: p. 302: Alan Oddie/PhotoEdit / p. 306: Ted Streshinsky/Photo 20-20 / p. 309: Duomo / p. 310 (Fig. 9-2): James Terkurst/Herman Miller, Inc. / p. 313 (Fig. 9-3): Alan G. Ingham / p. 315: Courtesy of the author / p. 317: Rob Crandall/CNN/Stock, Boston / p. 318 (Fig. 9-5): Courtesy of Philip Zimbardo / p. 321: Bettman Archive / p. 336: Peter Turnley/Black Star / p. 339: David Witbeck/Picture Group
Cartoon: p. 331: Drawing by H. Martin; © 1979 The New Yorker Magazine, Inc.

CHAPTER 10

Figures: p. 348, Fig. 10-1: Buckhout, R. (1974). Eyewitness testimony. *Scientific American,* December, 26. Copyright © 1974 by Scientific American, Inc. All rights reserved. / p. 348, Fig. 10-2: Fisher, G. H. (1968). Ambiguity of form: Old and new. *Perception and Psychophysics, 4,* 189-192. Reprinted by permission of the Psychonomic Society, Inc. / p. 366, Fig. 10-5: Hastie, R., Penrod, S. D., & Pennington, N. (1983). Adapted and reprinted by permission of the publisher from *Inside the jury* by Reid Hastie, Steven D. Penrod, and Nancy Pennington, Cambridge, Mass.: Harvard University Press, Copyright © 1983 by the President and Fellows of Harvard College.
Photos: p. 342: Jim Pickerell/Folio, Inc. / p. 349 (Fig. 10-3): Courtesy of Elizabeth Loftus / p. 350: Dale A. Dunaway/Cincinnati Post / p. 358: Les Stone/Sygma / p. 360: AP/Wide World Photos / p. 363: Billy Barnes/Stock, Boston / p. 367: James L. Schaffer/PhotoEdit
Cartoons: p. 346: Drawing by Joe Mirachi; © 1984 The New Yorker Magazine, Inc. / p. 352: The Far Side copyright 1985 Universal Press Syndicate. Reprinted with permission. All rights reserved. / p. 355: The Far Side by Gary Larson. Reprinted by permission of Chronicle Features, San Francisco. / p. 357: Drawing by C. Barsotti; © 1988 The New Yorker Magazine, Inc. / p. 359: Drawing by Lorenz; © 1977 The New Yorker Magazine, Inc.

CHAPTER 11

Text Quotes: pp. 388, 388, 389, 395: Allport, G. (1954, 1958). *The nature of prejudice.* © 1979 by Addison-Wesley Publishing Company, Inc. Reprinted by permission. / p. 391: Kipling, R. (1926). We and they. *Debits and Credits.* Copyright 1940 by Elsie Kipling Bambridge. Copyright 1926, 1927, 1928, 1929, 1930, 1932, 1933, 1934, 1935 by Rudyard Kipling. Copyright 1939 by Caroline Kipling. All rights reserved.
Figures: p. 378, Fig. 11-1: Adapted in part from Gallup, G., Jr., & Hugick, L. (1990). Racial tolerance grows, progress on racial equality less evident. *Gallup Poll Monthly,* June, 23-32. Used by permission of Gallup Poll News Service. Adapted in part from Niemi, R. G., Mueller, J., & Smith, T. W. (1989). *Trends in public opinion: A compendium of survey data.* Copyright © by Greenwood Publishing Group, Inc., Westport, Connecticut. Used by permission. Adapted in part from Smith, T. W. (1990, December). Personal communication. National Opinion Research Center. Used by permission. / p. 380, Fig. 11-2: Rogers, R. W., & Prentice-Dunn, S. (1981). Deindividuation and anger-mediated interracial aggression: Unmasking regressive racism. *Journal of Personality and Social Psychology, 41,* 63-73. Copyright 1981 by the American Psychological Association. Reprinted by permission. / p. 383, Fig. 11-4: Adapted in part from Niemi, R. G., Mueller, J., & Smith, T. W. (1989). *Trends in public opinion: A compendium of survey data.* Copyright © by Greenwood Publishing Group, Inc., Westport, Connecticut.

Used by permission. Adapted in part from Smith, T. W. (1990). Personal communication. National Opinion Research Center. Used by permission. / p. 401, Fig. 11-5: Devine, P. G., & Malpass, R. S. (1985). Orienting strategies in differential face recognition. *Personality and Social Psychology Bulletin, 11,* 33-40. Reprinted by permission of Sage Publications, Inc.
Photos: p. 374: Joyce R. Wilson/Photo Researchers / p. 374: Valerie Massey/Photo 20-20 / p. 382 (Fig. 11-3): Porter & Geis, 1981 / p. 384: Paul Conklin / p. 387: (left) Library of Congress; (right) Kashahara/AP/Wide World Photos / p. 393: Ken Kaminsky/The Picture Cube / p. 396: F. Lochon/Gamma Liaison / p. 398: Topham/The Image Works / p. 402: Eastcott/Momatiuk/The Image Works / p. 411: Ann Hagen Griffiths/Omni Photo Communications
Cartoons: p. 385: Drawing by Vietor; © 1981 The New Yorker Magazine, Inc. / p. 391: Drawing by Ed Fisher; © 1987 The New Yorker Magazine, Inc. / p. 394: Drawing by Maslin; © 1985 The New Yorker Magazine, Inc. / p. 406: Drawing by Fradon; © 1992 The New Yorker Magazine, Inc. / p. 408: Drawing by Mankoff; © 1981 The New Yorker Magazine, Inc.

CHAPTER 12

Text Quotes: p. 432: Hennigan, K. M., Del Rosario, M. L., Heath, L., Cook, T. D., Wharton, J. D., & Calder, B. H. (1982). Impact of the introduction of television on crime in the United States: Empirical findings and theoretical implications. *Journal of Personality and Social Psychology, 42,* 461-477. Reprinted by permission of the American Psychological Association and the author. / p. 432: La Rochefoucauld, F. (1965). *Maxims,* 1665. Translated by J. Heard. Reprinted by permission of Branden Publishing, Boston. / p. 436: Azrin, N. H. (1967). Pain and aggression. *Psychology Today,* May, 27-33. Copyright © 1987 Sussex Publishers, Inc. Reprinted by permission. / p. 443: Bundy, T. (1989). Interview with James Dobson. *Detroit Free Press,* January 25, 1A, 5A. Reprinted by permission of United Press International, Inc.
Figures: p. 420, Fig. 12-3: Archer, D., & Gartner, R. (1984). *Violence and crime in cross-national perspective.* Reprinted by permission of Yale University Press. / p. 423, Fig. 12-4: Dollard, J., Doob, L., Miller, N., Mowrer, O. H., & Sears, R. R. (1939). *Frustration and aggression.* Reprinted by permission of Yale University Press. / p. 428, Fig. 12-6: Adapted in part from Niemi, R. G., Mueller, J., & Smith, T. W. (1989). *Trends in public opinion: A compendium of survey data.* Copyright © by Greenwood Publishing Group, Inc., Westport, Connecticut. Used by permission. / Smith, T. W. (1990). Personal communication. National Opinion Research Center. Used by permission. / p. 430, Fig. 12-7: Bandura, A. (1979). The social learning perspective: Mechanisms of aggression. In H. Toch (Ed.), *Psychology of crime and criminal justice.* Reprinted by permission of the author. / p. 435, Fig. 12-8: Carlsmith, J. M., & Anderson, C. A. (1979). Ambient temperature and the occurrence of collective violence: A new analysis. *Journal of Personality and Social Psychology, 37,* 337-344. Copyright 1979 by the American Psychological Association. Reprinted by permission. / p. 438, Fig. 12-9: Ambient temperature and violent crime: Tests of the linear and curvilinear hypotheses. *Journal of Personality and Social Psychology, 46,* 91-97. Copyright 1984 by the American Psychological Association. Reprinted by permission. / p. 441, Fig. 12-11: Donnerstein, E. (1980). Aggressive erotica and violence against women. *Journal of Personality and Social Psychology.* Copyright 1980 by the American Psycholog-

ical Association. Reprinted by permission. / p. 444, Fig. 12-12: Eron, L. D., & Huesmann, L. R. (1984). The control of aggressive behavior by changes in attitudes, values, and the conditions of learning. In R. J. Blanchard & C. Blanchard (Eds.), *Advances in the study of aggression*, **1**. Reprinted by permission of Academic Press and the author. / p. 449, Fig. 12-13: Jaffe, Y., Shapir, N., & Yinon, Y. (1981). Aggression and its escalation. *Journal of Cross-Cultural Psychology*, **12**, 21-36. Reprinted by permission of Sage Publications, Inc.

Table: Table 12-1: Adapted in part from Fernandez-Collado, D., & Greenberg, C. S., with Korzenny, F., & Atkin, D. K. (1978). Sexual intimacy and drug use in TV series. *Journal of Communication*, **28**(3), 30-37. Used by permission of Oxford University Press Journals. Adapted in part from Gerbner, G., Cross, L., Morgan, J., & Signorielli, N. (1986). Living with television: The dynamics of the cultivation process. In J. Bryant & D. Zillman (Eds.), *Perspectives on media effects*. Used by permission of Lawrence Erlbaum Associates. Adapted in part from Greeley, A. M. (1991). *Faithful attraction*. Reprinted by permission of Tom Doherty Associates.

Photos: p. 416: IPA/The Image Works / p. 421: Bettmann Archive / p. 425: Jeff Share/Black Star / p. 427: Dan Burns/Monkmeyer / p. 431: Everett Collection / p. 434: Suzanne Murphy / p. 437: Dr. Nathan Arzin / p. 443: UPI/Bettmann Newsphotos / p. 450: Photofest / p. 455: Leif Skoogfors/Woodfin Camp Associates

Cartoons: p. 422: Reprinted by permission of Saturday Review, Omni International Ltd. / p. 430: Peanuts reprinted by permission of UFS, Inc. / p. 453: Reprinted by permission of Dan Perkins.

CHAPTER 13

Text Quotes: p. 463: La Rochefoucauld, F. (1965). *Maxims*, 1665. Translated by J. Heard. Reprinted by permission of Branden Publishing, Boston. / p. 469: Harburg, E. Y. (1947). When I'm not near the girl I love. *Finian's Rainbow*. Music by Burton Lane, lyrics by E. Y. Harburg, book by E. Y. Harburg and Fred Saidy. Copyright 1947 by The Players Music Corp. New York, Crawford Music Corp. New York, Chappell & Co. Ltd. London. All rights reserved. / p. 474: Berscheid, E. (1981). An overview of the psychological effects of physical attractiveness and some comments upon the psychological effects of knowlege of the effects of physical attractiveness. In W. Lucker, K. Ribbens, & J. A. McNamera (Eds.), *Logical aspects of facial form*. Craniofacial Growth Series, Monograph No. 11. Center for Human Growth and Development, University of Michigan, Ann Arbor. Reprinted by permission of the author. / p. 478: Kenrick, D. T., & Gutierres, S. E. (1980). Contrast effects and judgments of physical attractiveness: When beauty becomes a social problem. *Journal of Personality and Social Psychology*, **38**, 131-140. Reprinted by permission of the American Psychological Association and the author. / p. 479: Hammerstein, O., II (1957). Do I love you. *Cinderella*. Music by Richard Rodgers, book and lyrics by Oscar Hammerstein II. Copyright © 1962 by Richard Rodgers, and Dorothy Hammerstein, William Hammerstein and Howard E. Reinheimer as Executors of the Estate of Oscar Hammerstein II, dec'd. All rights reserved. / p. 486: Aronson, E. (1988). *The social animal*, 323. Reprinted by permission of W. H. Freeman & Co., Publishers. / p. 490: Baumeister, R. F. (1991). *Meanings of life*. Reprinted by permission of The Guilford Press. / p. 493: Dion, K. K., & Dion, K. L. (1985). Personality, gender, and the phenomenology of romantic love. In P. R.

Shaver (Ed.), *Review of personality and social psychology*, **6**. Reprinted by permission of Sage Publications, Inc. / p. 496: UPI (1981). Endless love? Emotions were bottled up. *Milwaukee Journal*, August 27, p. 1. Reprinted by permission of United Press International, Inc. / p. 499: Sternberg, R. J. (1988). Triangulating love. In R. J. Sternberg & M. L. Barnes (Eds.), *The psychology of love*. Reprinted by permission of Yale University Press.

Figures: p. 466, Fig. 13-2: Festinger, L., Schachter, S., & Back, K. (1950). *Social pressures in informal groups: A study of human factors in housing*. Copyright © 1950. Reprinted by permission of Stanford University Press, Stanford, California. / p. 468, Fig. 13-3: Zajonc, R. B. (1968). Attitudinal effects of mere exposure. *Journal of Personality and Social Psychology*, **9**, Monograph Supplement No. 2, part 2. Copyright 1968 by the American Psychological Association. Reprinted by permission. / p. 488 Fig. 13-5: Sternberg, R. J. (1988). Triangulating love. In R. J. Sternberg & M. L. Barnes (Eds.), *The pyschology of love*. Reprinted by permission of Yale University Press. / p. 492 Fig. 13-6: Adapted in part from Gupta, U., & Singh, p. (1982). Exploratory study of love and liking and type of marriages. *Indian Journal of Applied Psychology*, **19**, 92-97. Adapted in part from Simpson, J. A., Campbell, B., & Bersheid, E. (1986). The association between romantic love and marriage: Kephart (1967) twice revisited. *Personality and Social Psychology Bulletin*, **12**, 367-372. Used by permission of Sage Publications, Inc.

Photos: p. 460: Eastcott/Momatiuk/The Image Works / p. 463: Ellis Herwig/Stock, Boston / p. 465 (Fig. 13-1): Pawel Lewicki/University of Tulsa / p. 467: Steelcase, Inc. Corporate Development Center / p. 469: Peter Blakely/SABA / p. 477 (from left): Rick Smolan/Sock, Boston; Paul Lau/Gamma Liaison; Catherine Karnow/Woodfin Camp & Associates; David R. Frazier/Folio, Inc. / p. 487: Myrleen Ferguson/PhotoEdit / p. 491: David Ryan/Photo 20-20 / p. 497: Rhoda Sidney/Monkmeyer

Cartoons: p. 446: © Mell Lazarus. By permission of Mell Lazarus and Creators Syndicate. / p. 478: © 1991 by Sidney Harris—American Scientist / p. 480: Drawing By Miller; © 1992 The New Yorker Magazine, Inc. / p. 493: Reprinted by permission of Mike Marland. / p. 498: Drawing by Weber; © 1990 The New Yorker Magazine, Inc.

CHAPTER 14

Text Quotes: p. 504: Millett, K. (1979). *The basement: Meditations on human sacrifice*. Reprinted by permission of Georges Borchardt, Inc. / p. 504: Darley, J. M., & Latane, B. (1968). When will people help in a crisis? *Psychology Today*, December, 54-57, 70-71. Copyright © 1968 Sussex Publishers, Inc. Reprinted by permission. / pp. 504-505: Deford, F. (1983). Sometimes the good die young. *Sports Illustrated*, November 7, 44-50. Copyright © 1983 Time, Inc. All rights reserved. / p. 521: Darley, J. M., & Batson, C. D. (1973). From Jerusalem to Jericho: A study of situational and dispositional variables in helping behavior. *Journal of Personality and Social Psychology*, **27**, 100-108. Reprinted by permission of the American Psychological Association and the author.

Figures: p. 509, Fig. 14-1: Batson, C. D., Fultz, J., & Schoenrade, P. A. (1987). Distress and empathy: Two qualitatively distinct vicarious emotions with different motivational consequences. *Journal of Personality*, **55 (1)**, 19-40. Copyright 1987 by Duke University Press. Reprinted with permission of the publisher, and

the author. / p. 517, Fig. 14-3: Latane, B., & Darley, M. N. (1968). Group inhibition of bystander intervention in emergencies. *Journal of Personality and Social Psychology*, **10**, 215-221. Copyright 1968 by the American Psychological Association. Adapted by permission. / p. 529, Fig. 14-4: Isen, A. M., Clark, M., & Schwartz, M. F. (1976). Duration of the effect of good mood on helping: Footprints on the sands of time. *Journal of Personality and Social Psychology*, **34**, 385-393. Copyright 1976 by the American Psychological Association. Reprinted by permission. / p. 530, Fig. 14-5: Gallup, G., Jr. (1984). Religion in America. *The Gallup Report*, **222**, March. Reprinted by permission of Gallup Poll News Service.

Photos: p. 502: Kindra Clineff/The Picture Cube / p. 507: Anne Marie Rousseau/The Image Works / p. 510: Bob Daemmrich/The Image Works / p. 512: Scott Shaw, The Odesa (Texas) American / p. 514: Alan Carey/The Image Works / p. 519: Mark Zemnick / p. 523: Trevor, Inc./ Monkmeyer / p. 526: The Photo Works / p. 533: American Red Cross / p. 536: Owen Franken/Stock, Boston

Cartoon: p. 508: Drawing by B. Tobey; © 1972 The New Yorker Magazine, Inc.

CHAPTER 15

Text Quotes: p. 544: Richardson, L. F. (1969). Generalized foreign policy. *British Journal of Psychology Monographs Supplements*, 23. Reprinted by permission of the British Psychological Society. / p. 562: Deutsch, M. (1986). Folie a deux: A psychological perspective on Soviet-American relations. [Adapted from Deutsch, M. (1985). Preventing World War III: A psychological perspective. In Deutsch, M. *Distributive justice: A social psychological perspective* (Yale University Press).] In M. P. Karns (Ed.), *Persistent patterns and emergent structures in a waning century*. Reprinted by permission of Greenwood Publishing Group, Inc., Westport, Connecticut. / p. 563: White, R. K. (1969). Three not-so-obvious contributions of psychology to peace. *Journal of Social Issues*, **25**(4), 23-39. Reprinted by permission of the Society for the Psychological Study of Social Issues and the author. / p. 591: Allport, G. (1954, 1958). *The nature of prejudice*. © 1979 by Addison-Wesley Publishing Company, Inc. Reprinted by permission.

Figure: p. 560, Fig. 15-4: Tetlock, P. E. (1988). Monitoring the integrative complexity of American and Soviet policy rhetoric: What can be learned? *Journal of Social Issues*, **44**, 101-131. Reprinted by permission of the author.

Tables: p. 556, Table 15-1: DeStefano, L., & Colasanto, D. (1990). Unlike 1975, today most Americans think men have it better. *Gallup Poll Monthly*, **293**, 25-36. Reprinted by permission of Gallup Poll News Service. / p. 559, Table 15-2: Plous, S. (1985). Perceptual illusions and military realities: A social-psychological analysis of the nuclear arms race. *Journal of Conflict Resolution*, **29**, 363-389. Reprinted by permission of Sage Publications, Inc.

Photos: p. 542: Haviv/SABA / p. 544: Robert Holmes/Photo 20-20 / p. 553: Mark Richards/PhotoEdit / p. 554: Muzafer Sherif / p. 557: Andree Abecassis/Photo 20-20 / p. 560: AP/Wide World Photos / p. 562: (left) AP/Wide World Photos; (center) Contact Press Images/Woddfin Camp & Associates; (right) AP/Wide World Photos / p. 565: Herb Snitzer/Stock, Boston / p. 568: UPI/Bettmann Newsphotos / p. 575: Sygma / p. 579: AP/Wide World Photos

Cartoons: p. 548: Reprinted by permission of Tribune Media Services, Inc. / p. 577: From The Wall Street Journal—permission, Cartoon Features Syndicate.

NAME INDEX

SUBJECT INDEX